Aq 3013
766-5355

and Decoration

Sherrill Whiton

J. B. Lippincott Company

NEW YORK HAGERSTOWN PHILADELPHIA SAN FRANCISCO

Drawings by Gilbert Werlé

Cover photograph courtesy Ezra Stoller @ ESTO.
Residence of Warren Platner, Guilford, Conn.
Interior designed by Warren Platner.
Furniture designed by Warren Platner.

Library of Congress Cataloging in Publication Data

Whiton, Augustus Sherrill, 1887–1961.
 Interior design and decoration.

 Editions for 1937–1944 published under title:
Elements of interior decoration; for 1951–1963
under title: Elements of interior design and
decoration.
 Includes bibliographies.
 1. Interior decoration. 2. Decoration and
ornament. I. Title.
NK2110.W55 1974 747 73–19987
College Edition: ISBN 0-397-47302-8
Trade Edition: ISBN 0-397-47315-X

Preface

EDITOR'S NOTE: *The following preface was prepared by Sherrill Whiton, Jr., a short time before his death cut short his participation in the work on this edition.*

The fourth edition of *Elements of Interior Design and Decoration* represents a more extensive revision than any since the original publication in 1937. The acceleration of change in world events and in the arts has made it essential to adopt a more radical approach to the material in the text.

The value of studying the arts is not limited to the stimulation of creativity or the development of the imagination. The cultural awareness that is acquired in the process is also a significant benefit. The roots of the arts entwine themselves around nearly all branches of human thought and activity, and an understanding of them will aid greatly in the development of one's ability to analyze and judge human affairs. Even if no professional career is anticipated, an acquaintance with these subjects will enhance the enjoyment of life and open vistas which have previously been obscured.

Period decoration as a profession has existed for 20,000 years, since early artists painted the murals in the caves at Altamira and Lascaux. The Pre-Renaissance and Renaissance artists Giotto, Masaccio, and many others decorated chapels throughout Italy many years after these structures were built. And what marvelous work they did! The Sistine chapel is not especially noted for the beauty of its architecture but for the decorations by Perugino, Ghirlandaio, Botticelli, and the overwhelming achievement of Michelangelo's ceiling.

The role of the decorator is one of an artist striving for beauty. But time does not stand still. Today the interior designer may often be a partner of the architect and must have a fund of architectural knowledge upon which he can readily rely. New art concepts have developed through inevitable changes in our environmental patterns. New materials and the distribution of space for modern living are two of the factors which are here reconsidered and analyzed. These changes have brought about a growing integration between the work of the various types of designers who contribute toward our total ecology. Furthermore, as the architect becomes more and more involved with industrial building and town planning, the interior designer should look ahead to the day when he will qualify for the role of residential architect.

We have therefore divided the book broadly into two parts. Part one is a description of the dominant influences and characteristics of historical interiors, furniture, ornamental design, and architecture. Since the decorative arts were in the past a branch of architecture, and architectural styles have been fundamentally an outgrowth of changes in structure, it is essential to trace briefly what these changes have been. The serious student should be aware of the elements of period design because they are an essential background to the contemporary scene. This section of the book remains largely unchanged from previous editions.

The remainder of the text has been updated, reorganized, and focuses primarily on the interior design and architecture of our times and their close relationship. Chapter 22, Socio-Psychological Aspects of Design, is entirely new. The decisions people make in selecting their interior and exterior environments are too often taken for granted. Why people like or become disenchanted by the surroundings in which they live and grow has complex psychological implications. Chapters 10 and 11 were first included in the third edition, but they have been revised and brought up to date.

Ideas about color have changed in the past decade to the extent that we are more willing than we once were to accept brighter, stronger colors and striking contrasts. Traditional interiors often presented curved lines and paneling, and colors were generally muted. Because of a stronger linear feeling in contemporary interiors, bolder colors are usually required to achieve a desired impact. A new chapter on this subject was therefore essential.

The chapter on Furniture Arrangement has been combined with the chapter on Space Planning since both relate to the allocation and distribution of areas which function for specific purposes. This chapter also attempts to explain the most recent changes and newest concepts in the use of space.

A bibliography of textual and illustrative material has been added to each chapter for those who desire to do further reading in particular areas.

The book may be considered a compendium of information that has been gleaned from many authorities over a long period of time. In the preparation of the original text the editor would like to acknowledge the generous contributions of Marcel Breuer, William Breger, Inez Croom, Curt Hasenclever, Richard Neutra, Jens Risom, Edward Wormley, and Frank Lloyd Wright.

This edition has been made possible by the contributions of several co-authors and the assistance of others whose professional skills and knowledge are evident throughout the book. The editor is especially grateful to Gilbert Werlé and Arthur Satz for their continuous help and advice. He is grateful also to the authors of chapters new to this edition, all authorities in their specialties: to Sheila Chapline and Olga San Giuliano Menaker for the chapter on Color, James L. Nuckolls for the chapter on Lighting, John Winters for the chapter on Window Treatments, Susan and Stanley Salzman and Marjorie Helsel for the chapter on Space Planning and Furniture Arrangement, and Ann Ferebee for the final chapter on Socio-Psychological Aspects of Design.

Chapters 1 through 7 and 9 were revised by Alvin Ross; Stanley and Susan Salzman assisted with the revision of chapters 10 and 11; Louis Tregre contributed to chapters 12 and 16; John La Marre revised chapters 8, 19 and 20; and Jeanne Weeks and Curt Hasenclever brought chapter 17 up to date. Jeanne Weeks, together with Berkley Urie, also contributed to chapter 15.

The authors have made every effort to represent the most significant points of view commensurate with the overall objectives of the text. If there are errors or omissions, these were not intentional, but rather reflect the imperfections inherent in most large endeavors.

Contents

PART ONE

Period Decoration and Furniture

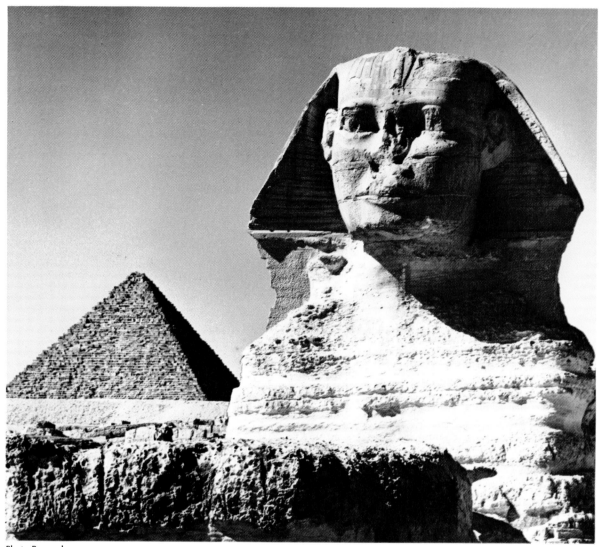

A view of the Sphinx and Pyramid of Menkure at Gizeh near Cairo, Egypt.

CHAPTER 1

The Styles of Antiquity

Prehistoric painting of a wild boar, found on the walls of the cave of Altamira, Spain. The action and anatomy of the animal were well understood by the artist and realistically portrayed.

PREHISTORIC ART

Anthropologists have discovered remains of fossil man that are hypothetically stated to be 1,000,000 years old. Other fossils are supposed to have lived 500,000 and 100,000 years ago. These relics have been found in Java, China, Africa, and other locations. Practically nothing is known of the living conditions or developments of these early creatures. It is perhaps not even entirely wise to associate them with the human race. There is only one point of importance to the art student in mentioning them. In fossils belonging to late eras, there is a larger cranial capacity. One may conclude that as the brain enlarged, intelligence gradually increased, and during each millennium descendants learned from their predecessors. Although this theory is not supported by all scientists, it would appear that the aggregate of all knowledge and experience at any one time benefited future generations.

The term *civilization* implies an organized state of existence. However primitive its character, there must be a sense of reciprocity, justice, and consideration of others in the same group or tribe. Some form of production of objects and materials useful to man's existence is also assumed. There is a long gap between the early prehuman life and the beginnings of civilized man, but there must have been a gradual progress in intelligence. There are abundant records of prehistoric human existence in Europe that date from approximately 25,000 B.C., and there have been other discoveries indicating sequences of development of men who have lived at later periods but long before history commences.

Cro-Magnon man, the first civilized ancestor of the modern European, is supposed to have made his entrance into Europe from Asia or Africa about 25 millenniums ago. The infiltration was slow and probably extended over thousands of years. He was over six feet tall and physically strong. He set up elaborate housekeeping in caves and decorated the walls of his home with sculpture and painting. He had heat, light, and clothing, developed efficient tools and was an expert technician in cutting and decorating stone and ivory. He had superstitions and some form of religion. The birth of religion probably is closely interwoven with the origins of art. He buried his ancestors with the greatest of care, surrounding their bodies with personal belongings, indicating a belief in the existence of

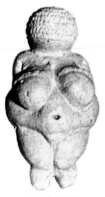

The Venus of Willendorf found in Austria in 1909 dating from 30,000 B.C.

the soul after death. He invented eating utensils such as spoons, knives, and two-pronged forks, which he made from bone and wood. He lived on the wild vegetation of his locality and hunted the bison, horse, stag, boar, reindeer, mammoth, and other animals that roamed the plains of Europe. He may have been a cannibal. There is no evidence that he domesticated any animals, nor did he cultivate the land. He knew nothing about the making of pottery or the value of metals, but he modeled both the human figure and animals in stone, ivory, and clay. Evidences of feminine glamour and appeal have been proved by the discovery of shell necklaces and of cosmetics. Trade was carried on by using beads, amulets, pendants, and ivory buttons as a medium of exchange. The existence of needles would indicate that he knew how to sew, and possibly embroider and weave.

The earliest discovered evidences of artistic effort date from about 25,000 to 10,000 B.C. and show a highly developed achievement.

The Cro-Magnon people, whose records are found mainly in France and Spain, were neither childlike nor savage in their art conceptions. They boldly and accurately depicted in line drawings and paint, on the walls and ceilings of their caves and on their tools and other *artifacts*, human, animal, and plant forms, the drawing of which must have demanded a high mental concentration and much preliminary training. The different classifications of animals are realistically drawn, with thorough understanding of their anatomy and action. The earliest drawings show profiles only, but simple perspective and foreshortening were attempted later, and there is some evidence of a conception of composition in grouping. Undecipherable motifs have also been found which may have been the earliest attempts of hieroglyphic inscriptions.

The purpose of these drawings is not yet fully understood. Undoubtedly they had decorative value, but they may also have had religious significance or been intended to bring good luck in hunting. A symbolism would seem proved in an analysis of the clay sculpture of the human form, most of which was limited to the representation of the female. Conventionalization rather than realism was here indicated. The head, hands, and feet were either omitted or only slightly indicated, while the parts related to reproduction were greatly enlarged, possibly as a divine appeal for progeny.

Art as indicated by these discoveries is then millenniums older than history and may be stated to have commenced as man evolved from the animal to the human state. Creative expression in art can therefore be claimed to be instinctive. The origin of the art of interior design can be dated from the dawn of human civilization and is an integrated part of human needs. While the discoveries of the early civilizations have to date been found mainly in Europe, it is probable that man also existed and developed at the same time in Asia, Africa, and, possibly, America. History does not begin until a record of events was kept by man in some sort of written form. The earliest readable inscriptions probably do not predate the thirty-seventh century B.C.

THE HISTORIC PERIODS

Mesopotamia and Palestine. Just as there are long mysterious lapses in the records of prehistoric civilizations, so the steps that lead from them to historical periods are unknown. The dawn of history about 4000 B.C. finds a highly developed culture in many parts of the Near East, particularly in Iraq on the borders of the Tigris and Euphrates and on the shore of the Persian Gulf, usually considered the locality from which all Western civilization has sprung. It is self-evident that there must have been an evolutionary development. The enormous advances in the cultures of these early historical groups over the prehistoric types could not have been spontaneous.

It was these Near Eastern civilizations that

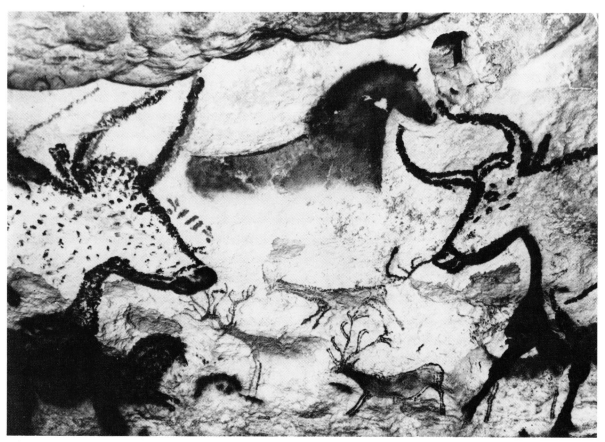

Scala

Prehistoric painting of animals in action in the caves at Lascaux, France.

have given us some of the earliest needs of orderly existence. They developed agriculture; the domestication of animals; the principles of trade and coinage; legal government; principles of justice; the potter's wheel; the wagon wheel; the alphabet; the arts of architecture, decoration, sculpture, music, literature, and dancing; the sciences of mathematics and astronomy; and the philosophical standards of monotheism and monogamy.

Authorities differ as to the primogeniture of early civilizations, but it is not a matter of great importance. Perhaps future discoveries of the archaeologist will clarify many points. All the countries of the East were constantly trading with each other, so that in the exchange of ideas, contemporary civilizations often had similar features. Various authorities claim the Caucasus, Mesopotamia, Persia, and Egypt as the birthplace of Western thought, but a civilization known as Sumerian existed along the deltas of the Euphrates River in Mesopotamia at a very early date— perhaps 6000 B.C. From where the Sumerians came and the causes of their disintegration and diffusion are not known, but their records inscribed in *cuneiform* characters on clay are extensive and have been transcribed. They have left us tales of the creation and those of a deluge that correspond closely to Old Testament descriptions. They have related the class struggles,

the inequality of men, the wealth and luxury enjoyed by the strong and intelligent, and the subservience and labor required of the masses and their interminable demand for betterment that invariably ended in economic paralysis. Thus, from the very beginnings of our culture, was established the basic theme of political history.

Although none of the Sumerian buildings has endured, there are descriptions of palaces treated with colored tiles and enriched with semiprecious stones, with interiors treated in exotic woods and inlaid with alabaster, onyx, lapis lazuli, agate, and gold, and decorated with the statues of gods, heroes, and animals. Architecture, beauty, and luxury commence with explosive violence and our complete ignorance of their immediate origins.

The Sumerian civilization was superseded by those of Babylonia and Chaldea that date from as early as 4000 B.C. The buildings of these nations were constructed in sun-dried brick, but later surfaced with delicately carved translucent alabaster and bas-reliefs; interiors often were hung with magnificent fabrics. Arches were first used in these countries to span openings for important entrance gates, probably because the lack of large stones precluded the use of the beam and the column.

The great palace of Nebuchadnezzar with its "hanging gardens" was in New Babylon, and it was from here he marched with his hosts to Jerusalem about 585 B.C. to destroy the temple of Solomon. There is nothing left of old Babylon, the site of the famous Tower of Babel. Its name has become synonymous with splendor, vice, and luxury, and the city passed to its downfall as described in the Bible. Its ruins became a quarry for the construction of Bagdad. Only mounds now indicate its site. The Babylonians were an agricultural, material-minded people who built rambling palaces in sun-dried brick constructed on arch and vault principles. The many rooms of the buildings were brightened with colorful glazed tiles in designs show-

ing the *tree of life*, lotus, *rosette, palmette,* winged bulls, genii, and animal motifs. Low-reliefs in color depicted hunting activities and court scenes.

The Assyrians from the north of Mesopotamia dominated the valley from about 700 B.C. The ruins of the Palace of Sargon in Khorsabad near Nineveh give some conception of the magnificence associated with their buildings in which are found some of the early decorative and structural uses of the arch form. The entrance portals were flanked by great towers and with man-headed winged bulls carved in stone, which in turn supported a semicircular arch covered with brilliantly colored tile.* The rooms were lined with alabaster sculptured *dadoes.* Domed forms are shown as motifs in some of the relief decorations, although no actual structures of this type have remained.

The Assyrians were the great military power of the Near East; they were fighters and huntsmen, and their incised wall sculptures portray their vigor if not cruelty. They were great builders, engineers, scientists, musicians, poets, and astronomers. Their wall tablets show the use of chairs, couches, and tables.

While these great nations of the Mesopotamian plains were maintaining a civilization for three thousand years, farther west along the banks of the Mediterranean Sea, the Hebrews

* The earliest arches were the "stepped" form, appearing like inverted stone stairways. The origin of the true arch form built with wedge-shaped stones or bricks is clouded. It is probable that the Babylonians used the principle in the construction of drains as early as 3000 B.C. In the Assyrian Palace of Sargon at Khorsabad, the entrance consisted of arched gateways. The Etruscans of northern Italy used the arch for drains, tombs, and gateways about 500 B.C., and the Romans developed the arch and dome, as they are used today, after the Etruscan invasions. This form became the most important structural and decorative feature of Roman architectural design. In such buildings as the Colosseum it saved an immense amount of labor and material in supporting the rows of seats.

were building in an architectural style borrowed from Babylon, Egypt, and Phoenicia. Little is left of their structures, long since obliterated by Romans, Christians, Moslems, and Crusaders.

The Bible gives a description of the great temple of Solomon, built in Jerusalem about 1012 B.C. The author of the Book of Kings seems to have been impressed by the ostentation and great expense involved rather than by any practical or aesthetic values. He describes the dimensions of the building, which was not large, although it was surrounded by enormous colonnaded courtyards. The roof beams rested on projecting wall brackets; the windows were narrow. The stone used for the walls was cut at the quarry so that no hammer or axe or any tool of iron would be heard at the place of construction. The temple was apparently three stories high, the floors connected by stairways. The entire interior was lined with cedar. The doors were made of olive wood carved with ornament. The interior walls were decorated with carved cherubim, palm tree motifs, and open flowers. The floor was made of fir. Walls, doors, trim, and floor were overlaid with gold. Cedar, olive, and fir must have been rare woods in Palestine at the time of Solomon.

Egypt. The art of ancient Egypt was her most momentous contribution to world culture. Here at the very beginning of history is found a quite vigorous and matured civilization that had developed from prehistoric eras, the details of which are hidden in the mists of antiquity. Here were constructed colossal engineering works and majestic buildings, designed according to the most ingenious and honest aesthetic standards. Few other peoples, ancient or modern, have conceived of structures on such a vast scale, so grandiose and yet so sublime.* Egypt developed

* Herodotus the Greek historian, who visited Egypt in the fifth century B.C., stated "that there is no country that possesses so many wonders, nor any that has such a number of works that defy description."

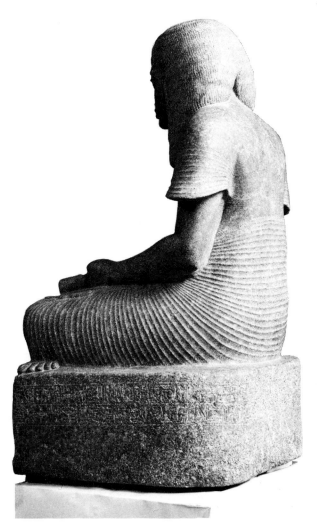

Metropolitan Museum of Art

Statue of Harmhab, 1355 B.C.

a native art independent of preceding foreign cultures that satisfied and uniquely reflected the character of its own people. It was one of the greatest, most powerful, and yet most refined cultures in history.

The land of Egypt is a gift of the Nile. It consists geographically of a stretch of territory approximately thirty miles wide and eight hundred miles long, entirely dependent upon the river for its vegetation and subsistence. Bordered

by deserts and the sea, its inaccessibility served as a protection against invading hordes and gave the Egyptian people an unusual opportunity for a continuous and unadulterated racial and cultural development. This isolation, however, contributed to a constant repetition of art forms during the whole period of Egyptian history, and this unchanging character is one of the most pronounced features of Egyptian art.* The Egyptians devoted themselves more than any other people in the world to the preservation of the memory of past actions. Changes in thought, custom, habit, and art were extraordinarily slow in spite of occasional invasions and social upheavals. Egyptian art followed rises and declines. New ideas were introduced, but the basic forms were constantly revived, and, in comparison to styles of other nations, their style is considered immutable.

The climate of the valley of the Nile was peculiarly delightful, the sky serene, and the atmosphere gently tempered, almost without rain; thus nature contributed to the preservation of its monuments. Social conditions permitted the development of a wealthy and highly cultured ruling class and a middle class, both of which were supported by vast numbers of slaves, who were either native-born or the captured inhabitants of conquered nations. Wealth was concentrated in the hands of the few, and labor was excessively cheap; even the artists and craftsmen were often of the slave classes.

Nature had endowed the land with large quantities of hard and durable building stones such as *granite*, *basalt*, and *diorite*. Limestone, a much softer and more easily cut material, was also available for use in protected places. A limited lumber supply necessitated the use of the palm tree and the papyrus reed where wood was needed for structural purposes. The acacia and sycamore fig tree were also used to some extent, and heavy lumber was occasionally imported from Syria. The leaves and branches of these trees and the wild flowers from the banks of the Nile became the principal inspiration for ornamental design.

Religion played an important part in the life of every inhabitant. The Egyptian believed that life on earth was but temporary and that one's duty, while here, was to prepare for an eternal existence in the hereafter.† It was, therefore, the habit of the upper classes to build resting places or tombs for their bodies after death. This explains the existence of the many pyramids and *mastaba* tombs which were constructed with the idea that they would exist for eternity. The future life was believed to be spiritual in its character, but material objects were needed to sustain the body of the spirit. When an Egyptian of rank was buried, his mummified body was surrounded with household goods, clothing, food, and mummified animals. The discoveries of many of these tombs, such as that of Tut-ankh-Amen in 1922, has given a very complete knowledge of the daily life of the royal families.

The culture of Egypt was so firmly established that, in the few foreign invasions that occurred during a long history, the culture of the conquerors was always completely submerged. Even Alexander in the fourth century B.C. was politically and socially snubbed by the Egyptians, and was forced to found his own city. Alexandria later became one of the greatest of commercial ports, a center of learning, and a luxurious playground for all Mediterranean peo-

* The Egyptians were the superconservatives of history. With long intervals of peace, and wars principally conducted in foreign lands, their power and success developed a feeling of both security and superiority, which, though contributing greatly to their arts, eventually acted as an opiate to their national consciousness and military vigor.

† The Egyptians were the first to claim that the soul was immortal. According to Herodotus, they believed that after a transmigration of three thousand years, it would return to the human body.

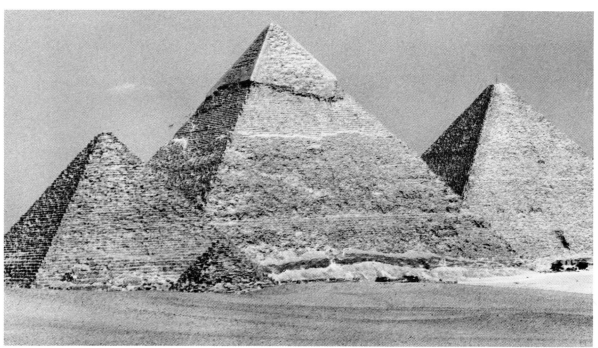

Magnum

The Great Pyramids of Gizeh: Menkure, Khafre, and Khufu.

ple, but, in spite of the Greek culture which it represented, the Egyptians refused to accept the foreign influences, and elsewhere continued the philosophy and customs of their ancestors. The palaces at Edfu and Philae, partly built during the Alexandrian Era, retained the style of the Pharaohs in their design.

The Egyptians were mighty navigators and sent their ships to all the ports of the Mediterranean Sea. The early tribes of Greece, the inhabitants of the islands of the Aegean Sea, even the primitive occupants of the Spanish and Italian peninsulas, all felt the influence of the Egyptian traders, and Egyptian motifs and trends are to be seen in their early arts.

THE MAIN DIVISIONS OF EGYPTIAN HISTORY. The history of Egypt is derived from the Bible, from Greek and Roman authors, and from a history written in Greek about the year 300 B.C. by Manetho, an Egyptian priest. Leading authorities differ greatly upon many of the early dates,

but the generally accepted divisions are as follows:

1. ANCIENT KINGDOM, Dynasties I-VIII (4500–2445 B.C.)
 During this period the capital was at Memphis, and the great pyramids of Gizeh were built.

2. MIDDLE KINGDOM, Dynasties IX-XVII (2445–1580 B.C.)
 During this period the capital was at Thebes, and in the latter portion of this period Egyptian art history was interrupted by the invasions of the Shepherd Kings, known as the "Hyksos."

3. NEW EMPIRE, Dynasties XVIII-XXV (1580–633 B.C.)
 During this period the capital was again at Thebes, and many of the great temples, such as those at Luxor and Karnak, were erected. This was the most prolific period of Egyptian history, known politically as "The Age of

Conquest." The reigns of Thotmes I, Hat-shepsu, Rameses I, Rameses II, Nefertiti, Tut-ankh-a-men, and others.

4. SAITIC AND PERSIAN PERIODS, Dynasties XXVI-XXXI (663–332 B.C.)
 Period of decline in art, with constant foreign invasion, barren of important monuments.

5. GRECO-ROMAN PERIOD (332 B.C.–A.D. 640)
 a. Alexander the Great and the Ptolemaic period (332–30 B.C.). Construction of the palaces at Edfu and Philae.
 b. Roman period (30 B.C.–A.D. 395). The age of Caesar, Antony and Cleopatra, and Constantine.
 c. Byzantine or Coptic period (395–640 A.D.). Christianized Egypt.
 d. Arab domination. Egypt becomes Mohammedan.

THE PYRAMIDS. The oldest and mightiest extant examples of architecture are the pyramids of Gizeh near Cairo. These were built about 3700 B.C.,* and were the production of experienced designers and engineers. The purpose of the buildings was religious rather than architectural. They were the tombs of the kings of the early dynasties, and their form was probably inspired by prehistoric burial mounds. The engineering methods employed in their construction are still the subject of speculation. Much of the granite of which they are built was quarried 700 miles away. It is difficult to conceive of the labor or the toll in human lives required for their erection.

* Some Egyptologists claim that the pyramids do not predate 2700 B.C.

Model of the hypostyle hall in the temple at Karnak, Upper Nile, showing the interior columns supporting the lintels that in turn support the roof. Notice the conventionalized papyrus capital.

Metropolitan Museum of Art

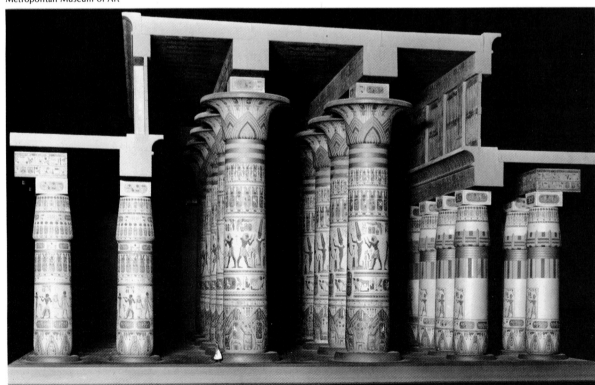

CHARACTER OF THE EGYPTIAN BUILDINGS. The extant buildings of ancient Egypt consist of colossal palaces, temples, and tombs. The first builders of the historic period unquestionably inspired themselves from two prehistoric types of structure, one of which was the wall built of clay or sun-dried brick. These were soft materials that necessitated making the lower portion of a wall thicker than the upper portion, resulting in slanting sides. The other type was an enclosure built of a row of vertical tree trunks that supported wooden beams, which, in turn, were covered with branches and clay.

With the invention of stonecutting tools, the slanting form of the brick walls was imitated in granite. This is a typical example of the perpetuation of tradition in Egyptian design. With the use of granite, the strongest of stones, the walls could have been carried to great heights at the same thickness. Stone pillars or columns were substituted for tree trunks. These stone supports were either round or polygonal, very sturdy in appearance, and were carved to imitate a cluster of papyrus reeds or palm tree trunks that in wooden construction had been tied together for greater strength. This treatment produced an effect of vertical convex ribs, which was the prototype of the flutings or grooves cut in later columns. The branches at the top of the tree were also frequently conventionalized in the stone column, and formed an ornamental feature, bell-shaped in appearance and known as a campaniform capital. Other capitals were inspired from palm branches, from single or clustered lotus buds, and from the curling leaves of the papyrus. Granite was used for the exterior walls of buildings. Because of the primitive nature of the tools that were available, simple forms and few moldings were used in Egyptian architecture and decoration. The tops of walls were usually crowned with a hollow roll molding, concave in shape, sometimes known as a bird's beak or *cavetto*. Limestone, a much softer material, was often used to line the interior walls, as it was easier to cut into ornamental patterns.

Rectangular forms and straight lines dominated Egyptian architecture. Massiveness, solidity, and the effect of perpetuity were the principal characteristics expressed. Walls were excessively thick, and supports were proportionately heavy and sturdy. The Egyptians had little knowledge of the principles of arch construction, so that vaulted ceilings and arched doors or window openings were not used. The columns were spanned by heavy stone beams or lintels that were of enormous size and of great weight, and, due to the material, the length of the span was extremely limited, and frequent supports were necessary. Lines of lintels were set close together so that stone roof slabs could be in turn placed upon them. In wide rooms, numerous columns had to be placed in the interior to support the short stone beams. These interior columns were arranged in long rows and richly decorated with carving and color. Many of the rooms appeared to be a forest of columns, as the desire for permanence precluded the use of wooden beams which would have spanned greater distances. This system of column and lintel is known as *trabeated construction* and is the most characteristic feature of Egyptian design. Many of the temples and palaces were of vast size. In spite of the fact that they were considered as temporary abodes, great wealth was lavished upon them, and they were decorated with luxury and splendor. Over the entrance door was carved a welcoming sentence. Courtyards were treated with colorful decorations, and awnings screened the noonday sun.

CHARACTER OF EGYPTIAN WALL DECORATION AND ORNAMENT. The exterior walls were often treated with brilliant color applied to incised wall carvings. These decorations were made by first drawing outline sketches on the wall with charcoal. A groove was then chiseled around the outline of each motif. The figure or pattern was slightly modeled, but did not project beyond the

View of the interior of the temple at Karnak showing part of a row of columns. Notice the massiveness of the columns, the detail of the capitals, the close spacing, and the incised carved ornament shown on the shaft in the foreground.

face of the wall. It was next covered with a thin layer of plaster, which when still wet was colored a flat tone. The colors used were limited in number, and gradations, showing highlights, shades, or shadows, were not indicated. In the interiors of buildings the walls were often faced with soft limestone slabs that were decorated with colored carvings in low relief.

The subject matter of Egyptian mural decorations included representations of actions in the daily life of the individual, allegorical and religious events, and many other scenes that have given historians an accurate and detailed knowledge of Egyptian civilization. In the great temple of Queen Hatshepsut, the interior natural rock walls were covered with brilliant paintings of her activities and hobbies. Other rooms depict with astonishing accuracy the Nile, its boats and barges, the flowers and birds, and the desert, where every kind of wild animal is being hunted. The dancer, the musician, the warrior, the peasant, and the worker are represented. Humor and tragedy are shown accompanied with brief sentences, jokes, and catchwords of the period. The purpose of the murals was to tell a story, to record history, or to show various consecutive phases of some event. Usually the whole area of a wall surface was covered with figures, patterns, or *hieroglyphics** (inscrip-

* Hieroglyphics were originally a form of pictorial writing which later was simplified by the substitution of symbols for the complete forms. Their use was largely limited to inscriptions on stone walls. They were read from right to left. An abridged form known as *hieratic*, cursive in character, was reserved for religious writings. Ordinary correspondence, conducted by the public scribes, was written in *demotic*, a still further abridged form. The transcription of Egyptian inscriptions was not possible until the discovery, in 1799, of the Rosetta Stone on the banks of the Nile. This small monument, which dates from 196 B.C., contains praises of Ptolemy incised in hieroglyphics, demotic, and Greek. It was found by one of Napoleon's soldiers. Champollion, the French Egyptologist, properly transcribed the Egyptian text and made possible the reading of a great number of inscriptions clarifying historical records.

tions), so that the eye could wander from point to point and finally comprehend the whole story. No central point of interest was placed in the mural composition, and the decoration was intended to accentuate the wall, rather than hide it.

The human figure was usually shown with the face, legs, and feet in profile, while the shoulders and one eye were drawn as though

Egyptian limestone relief painting, 1600 B.C.

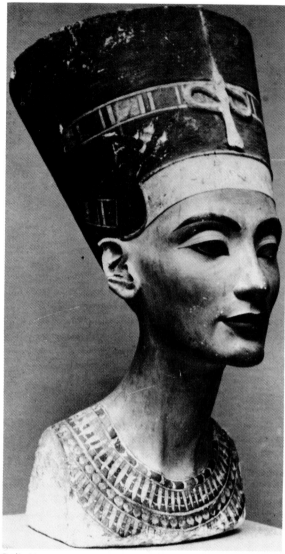

Berlin Museum

Bust of Queen Nefertiti, mother-in-law of Tut-ankh-a-men, 1360 B.C.

seen from the front. The principles of perspective drawing were ignored in favor of symbolic conventions. Depth was indicated by placing one figure above the other. Important persons were drawn at large scale; the unimportance of slaves and enemies was indicated by drawing them small in size. Women were usually drawn smaller than men. Religious symbolism was attached to most of the ornamental motifs. The sun disk or globe and the vulture with outstretched wings were considered symbols of protection. The sacred beetle or scarab symbolized eternal life. The lotus bud and flower, extensively used in architecture, sculpture, and painted ornament, were the symbols of purity, and the serpent was the badge of royalty. Other motifs originating in Egyptian decoration were the *guilloche, palmette, wave pattern,* and *spiral.*

EGYPTIAN SCULPTURE. The art of sculpture in the round was developed to a high degree of perfection. Portraits and allegorical figures such as the sphinx and the falcon were produced in great quantities. Figures were usually modeled in a state of repose, symmetrically balanced, so that the best view could be obtained from the front. Much Egyptian sculpture, because of the hardness of the stone from which it was carved, is extremely simple in detail. The surfaces are smooth, and a dignified, majestic effect is obtained by simple, vigorous masses. Many of the stone statues were brilliantly colored in flat tones. Male figures were usually shown with red faces and females with light yellow skin. Exquisite and accurate copies of animal and bird life were often modeled both in relief and in the round.

EGYPTIAN FURNITURE. Egyptian cabinetmakers and woodworkers developed a high degree of technical ability. The houses of the wealthy were furnished with chairs, stools, tables, and other articles of great beauty, and a Greek historian informs us that "from the earliest dynasty furnishings were of the greatest luxury indicating an extravagant mode of life." Some of the chairs were similar to a modern folding campstool, while others had elaborately carved legs, backs, and arms. Many of the chairs were very low, which obliged the occupants to sit in a cramped position, but as they had been accustomed to squatting on the floor, this was not considered an inconvenience.

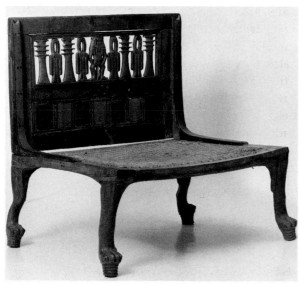

Metropolitan Museum of Art

Egyptian chair, c. 1494 B.C. Boxwood and Acacia.

with beautiful tableware made of pottery, alabaster, bronze, gold, and silver. Linen, constantly washed, was always marked with the owner's name and was kept in baskets and chests. The Egyptians also possessed personal accessories of great beauty made of gold, enamel, precious gems, and other materials, which show how luxurious was the life of the upper classes. Direct evidence of the elaborate character of these articles was given when, in the tomb of the mother of Cheops, builder of the Great Pyramid, personal objects were discovered that were fashioned of precious metals and jewels, and finished in the most perfect technique. There were gold vases, gold and enamel-embossed chests, and gold toilet articles enriched with rare stones. A bed and chair of wood were covered with gold plaques. There was also a great wooden framework for draperies to hang

The most characteristic feature in the chair and bed designs was the use of lion- or dog-leg forms. The hind leg of the animal was represented in the rear of the chair and the foreleg in the front of the chair. The feet were carved paws placed on small blocks of wood so that the ornamental portion would stand above the straw matting which covered the floors. Lion, swan, and duck heads were frequently used to enrich portions of the furniture. Ivory and ebony were used as inlay. Gold ornament in symbolical motifs was also applied to the woodwork. Brightly colored loose cushions covered in cotton, painted leather, and gold and silver fabric were used for comfort. The Egyptian craftsman thoroughly understood his material. Knowing that wood would warp, twist, split, and shrink, he treated his design and construction so as to render these defects as negligible as possible. Wood was used with proper economy. Comfort was considered in shaping both the seat and back of the chair to fit the human form.

EGYPTIAN ACCESSORIES. From the earliest dates the affluent Egyptian home was furnished

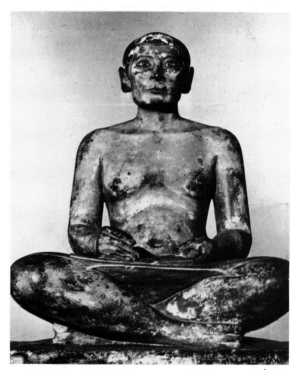

Louvre

The Scribe, an Egyptian polychromed limestone statue of 2700 B.C.

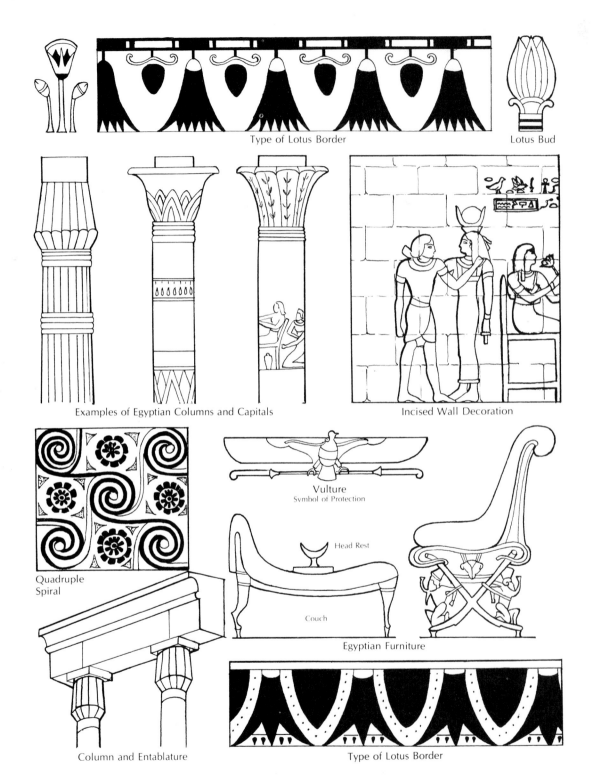

Type of Lotus Border

Lotus Bud

Examples of Egyptian Columns and Capitals

Incised Wall Decoration

Quadruple
Spiral

Vulture
Symbol of Protection

Head Rest

Couch

Egyptian Furniture

Column and Entablature

Type of Lotus Border

Examples of Egyptian architecture, furniture, and other details.

over her throne when her soul returned to her body. The exquisite detail in these pieces shows the perfection of Egyptian craftsmanship even at a date previous to the building of the pyramids.

Egyptian art was fundamentally an honest aesthetic expression of the inhabitants of Egypt. The use of material was always consistent with its nature. Ornament was so designed that it was calculated to increase rather than conceal the vigor and purpose of the structure and to heighten its characteristic beauty and texture. Limited as the craftsmen were in variety of materials and tools, and having behind them a traditional conservatism that was unchangeable throughout the centuries, their art productions in every medium were carried to the limit of their possibilities. The Egyptian artists, superbly skillful and imaginative, accomplished the most that they could with the means and knowledge they had; no greater compliment can be paid to any art.

Persia and Crete. In a rapid survey of the historical periods of art, it is impossible to describe in detail those of the early periods of Crete, Persia, and the Greece of Homer. These countries contributed definite principles that have become the heritage of later styles.

Between 3000 and 1100 B.C. there lived on the islands in the Aegean Sea a pleasure-loving people who were ruled by the famous sea kings of Greek mythology. The art of this group has been called Cretan or Minoan, after the name of Minos, the greatest of the sea kings, who built the Palace at Cnossus with its renowned underground labyrinth where, according to mythology, fourteen of the finest Athenian youths and maidens were annually fed to the great Minotaur. The palace was a large, rambling building, and its interior walls were decorated with brilliantly colored *frescoes* of naturalistic flowers, flying fish, and bullfights and other court activities. Not less beautiful then the frescoes are the

fragments of Minoan metalwork and pottery, decorated with geometric patterns, naturalistic designs of fish, dolphins, octopi, interlaced birds, and spiral bands, which have been found in the same rooms.

From 1600 to 1200 B.C. a similar art was produced on the mainland of Asia Minor in the cities of Troy and Tyre, and in Mycenae, in Greece; this is generally termed Mycenaean art. Like the Cretans, the Mycenaeans erected large palaces of wood and decorated the interiors with bas-reliefs and brightly colored frescoes. They also made pottery and metalwork painted with geometrical and conventional designs.

From the arts of Assyria and Egypt, the roving Shepherd Kings of Persia (539–331 B.C.) derived the principles and motifs that they combined in their lavish palaces at Susa and Persepolis. They borrowed the lintel system of construction from the Egyptians and decorated it with the enameled tile of the Assyrians. The great halls of their palaces were forests of columns crowned with capitals carved to resemble the heads of bulls. Friezes of colored tile, showing archers and animals, covered the walls. Their hunting scenes, winged monsters, griffins, and tree-of-life patterns became a basic part of the designs used by the later Persians (A.D. 226–1736) in weaving the silks and rugs that were eagerly sought by all Europe.

Greece. The beginnings of civilization in western Europe may be traced to the culture that originated in the Grecian peninsula and adjoining islands as far back as 2000 B.C. The early inhabitants of this part of the Mediterranean were endowed by nature with an unusually logical and observing mentality, a creative instinct, an extraordinary imagination, and a high ambition. They desired to attain perfection in all accomplishments, great or small. This characteristic is evidenced in the great heights they eventually attained in philosophy, literature, and the fine arts.

Originally the Greeks are thought to have been Indo-European nomads who migrated to the Greek peninsula about 2000 B.C. The early classical writers called the indigenous population Pelasgians. Whether their descendants or the Mycenaeans are the Achaean heroes of whom Homer sings in the *Iliad* is a matter of conjecture, but, at any rate, the pictures of the kings and gods sketched in that epic and the *Odyssey* reveal a civilized people who settled Greece and conquered Troy about the year 1200 B.C. These in turn were overrun by the barbarous Dorians, who invaded and settled the islands of the Aegean Sea, and finally Sparta and Corinth. In Asia Minor, the Ionians, who had migrated before and during the Dorian invasions, built powerful cities and carried on a vast trade with the East. Northern Greece was civilized by the Aeolians. The mingling of these three tribes and the union of their independent city-states under the name of *Hellas* made up the Greece whose history commences about 776 B.C., the year of the first Olympic games. The early period of this civilization, known as Archaic, lasted until the battle of Marathon in 490 B.C., which ended the Persian war. This was followed by slightly less than a century of peace and plenty called the Golden Age. Under the enlightened rule of Pericles, Grecian art and culture rose to a supreme height that has perhaps never been equaled. The Peloponnesian war saw the destruction of Athens by the Spartans in 404 B.C. With the decline of Athens, the Macedonians soon rose to power, and finally Phillip and his son Alexander about 323 B.C. conquered nearly the whole of the then-known world. Alexander moved his capital to Alexandria, the city he built in Egypt. Greece came under Roman rule in 146 B.C., but its culture and political thought dominated the whole of the Mediterranean until the rise of Christianity.

The climate and geography of the Grecian peninsula were different from those of Egypt. The ragged coastline with many bays and inlets bounded a fertile land of sunshine and rain. Tall mountains containing minerals and quarries of rich marble towered above a land abundant and colorful. The ample rainfall and the availability of beautiful soft building stone such as marble greatly influenced the character and detail of Grecian architecture and decoration.

THE CHARACTER OF THE GREEK PEOPLE. The geographical location and character of the Grecian peninsula served to develop a seafaring race of people, which in turn subjected them to foreign and often subversive ideas. The mountainous topography of the land tended to hinder intercommunication between neighboring communities, which resulted in misunderstandings, jealousies, and lack of amity. Internecine strife was constant, and complete political cohesion was never attained. Independence of thought was a dominant characteristic. The Athenians were the great individualists of antiquity. They were adamant in their desire for freedom to act, speak, and think as they wished. They considered as barbarians all those who lived under despots, accepted rule blindly, or lived without liberty, and these included most of the then-known world. They regarded wisdom as the greatest of human attributes, and to attain this, it was essential to be both curious and inquisitive, to doubt and to question all things until they were proved. To know truth and to understand were the Athenians' first passions. Religion, fostered by a romantic landscape, was the worship of Nature, and special gods existed for every event and every place. Man was the measure of all things, hence the legendary deities were the personification of human beings, with like qualities and weaknesses. A mass enthusiasm exacted universal perfection which was considered attainable only by logic, supreme intelligence, and unlimited effort. The useful, good, and beautiful were inexorably bound together, and the collective aesthetic conscience evidenced the perpetual conflict between emotional impulse and intellect, in which intellect

and self-restraint always rose supreme. Emotional satisfactions attained full scope in festivals, games, religion, and private life. Idealism was maintained in all the best creative efforts. Superlative form, line, rhythm, and symmetry were adored. In the enjoyment of literature, the Greeks were less interested in the contents than in the way the contents were presented. Art was real, a part of the spirit, constantly present, and a valuable commercial asset. As a nation, the Athenians were essentially proud and convinced, not without reason, that they were superior to all others as warriors, artists, philosophers, mathematicians, and writers. The first duty of the citizen was service to the state, which included its glorification and the promotion of its cultural development. It was such an atmosphere that impregnated their close approach to a cultural zenith that has proved its eternal value.

Qualities of self-discipline and courage dominated the lives of the Doric Spartans for purposes of conquest and material gain. They were a nation of soldiers, which in the end enabled them to dominate Athens for a short period, but they were without philosophers, historians, or artists. All information concerning them is gleaned solely from Athenian writers, and they left nothing of value to posterity except a realization of the futility of force. Athenian idealism and its cultural results have proved to be immortal. It was the dominance of envious traits in the character of the Greeks which prevented political unity and eventually led to their downfall.

THE MAIN DIVISIONS OF GREEK ART. While the earliest influences of Greek art were of Oriental origin, the later growth reflected a vigorous native ability that resulted in an unusually homogeneous aesthetic expression. The consolidation of the independent cities closely paralleled the blending of the independent racial arts that formed the basis of the perfection of the Periclean age.

The dates of the Greek periods are some-what arbitrary, but the following arrangement will aid in identifying the successive developments.

1. PRIMITIVE PERIOD (2000–1000 B.C.)
This was the period of the Dorian invasions in 1500 B.C. and their destruction of Cretan and Mycenaean civilization in 1400 B.C. It was succeeded by the Homeric era in the tenth century B.C.—the age of the Olympian gods and goddesses—and later by an age of plunder which terminated in the Trojan War. The dark ages of barbarian invasions followed, with Greek expansion to Asia Minor (1200–1000 B.C.). A period barren of art products save for the Cretan and Mycenaean civilizations.

2. ARCHAIC PERIOD (1000–480 B.C.)
A period of extensive maritime commerce with Italy and Egypt, and of Greek colonization on the coasts of the Mediterranean, Aegean, and Black seas. The age of Thales, the philosopher, and Sappho, the poet. The first coinage of money and the first Olympic games. This era was followed by the rise of tyrants and the rise of small city-states. It was marked by an artistic development of crafts—beautiful pottery and coins. In sculpture, it was a period of striving to achieve perfection in rendering the human form, but, though much progress was made, the period closed with an insufficient knowledge of anatomical representation. In architecture, the development of the Doric and Ionic orders was begun.

3. GOLDEN AGE (480–400 B.C.)
During this period the Greeks were victorious in the Persian wars, which were followed by the rise of Athens as a naval power. It was the age of Pericles and the Athenian democracy, of the development of the Greek drama and theater under Aeschylus, Sophocles, Euripides, and Aristophanes. Erection of the Parthenon under the supervision of Phidias, the sculptor, and Ictinus, the architect. Athens

was the center of culture and produced the great historians Herodotus and Thucydides and the poet Pindar. This period culminated in the defeat of Athens in 404 B.C., and is considered the greatest period of culture of all times. In sculpture it was a period of perfection and idealization in rendering the human form, and in architecture, of perfect balance and harmony, with the refinement of the Doric and Ionic orders. Socrates, the master of philosophers, died in 399 B.C.

4. FOURTH CENTURY (400–336 B.C.)
This period witnessed the decline of the city-state and the further expansion of Greek civilization. It was the age of Demosthenes, the orator; Hippocrates, the "father of medicine"; Plato and Aristotle, the philosophers; and Praxiteles, the sculptor. In art, realism and sentiment replaced Phidian idealism, with increasing emphasis on technical perfection.

5. ALEXANDRIAN AGE (336–323 B.C.)
A period of expansion of Greek rule and spread of Greek culture through the conquests of Alexander the Great. Invasions of Asia Minor, Egypt, Persia, and India. In art, a period of great realism and monumental effects. Development of the Corinthian order.

6. HELLENISTIC AGE (323–30 B.C.)
The disintegration of Alexander's empire was followed by the Greco-Macedonian rule of the Hellenized world. It was a period of great advance in science and mathematics; but in art it was a period of realism, which sometimes descended into sentimentalism and theatricalism. They excelled in the art of portraiture, which influenced the Romans. Greece became a Roman province in the second century B.C.

EARLY GRECIAN ARCHITECTURE. The prehistoric inhabitants of Greece undoubtedly built their homes of wood cut from the ample forests that covered the hills and valleys of the peninsula. Many authorities believe that at the beginning of the Stone Age the early masons, lacking precedent for their designs, modeled the details of their buildings after the old wooden structures. There is much evidence in the early stone architecture of the Greeks that details and ornament were cut to imitate original wooden features, following the procedure of the early Egyptian builders.

During the Archaic period of Grecian civilization, large limestone and stucco temples were built by the Dorians, both in Greece and in the Greek colonies in Sicily and elsewhere. They were massive in proportion, and their design was dominated by the use of rows of columns on the outside of the buildings. After 500 B.C., an improvement occurred in the general proportions and detail, and greater refinement was evidenced in the character of the sculpture that was used as ornament. The great extant examples of architecture of the early period are the Apollo Temple at Corinth, the Temple of Zeus at Selinus, in Sicily, and several temples at Paestum, in southern Italy.

During the early years of the fifth century B.C., the descendants of the Ionians were also occupied in the construction of magnificent temples in Asia Minor, in some of the Greek islands, and in Greece itself. These were similar in general design to those built by the Dorians, but they differed in proportions and detail. Notable among them was the Temple of Zeus at Olympia, where the religious ceremonies accompanying the Olympic games were held.

THE PARTHENON. The crowning achievement of Grecian art was the construction of a group of religious and civic structures on the hill known as the Acropolis, in Athens. The buildings were erected under the administration of Pericles during the latter half of the fifth century B.C., as a result of the national enthusiasm that developed after the successful termination of the Persian wars, with the subsequent glory and wealth that came to Athens. At the highest point on the hill was erected the Parthenon, a structure which is generally considered the greatest

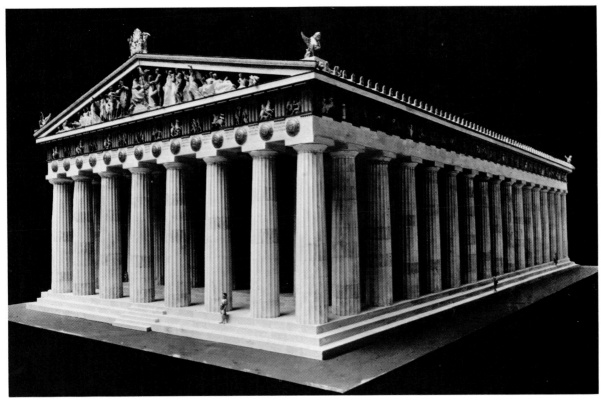

Metropolitan Museum of Art

Model showing the Parthenon in a restored condition. The order used is the Greek Doric.

masterpiece of architecture in the world. Its perfection of line, proportion, and detail, and the beauty of its sculptured enrichment have been the envy and the inspiration of artists in every country and every period.

The Parthenon was designed by Ictinus and Callicrates, the architects, and by Phidias, the sculptor, and was completed in 438 B.C. It was dedicated to the virgin goddess, Athena, whose forty-foot statue, made of gold and ivory with precious stones used for eyes, was in its sacred precincts. The pediments were filled with sculpture, and remains of colors have been found on the stonework. Along its exterior wall was the great frieze of Phidias, carved in relief and showing a procession of cavalry, chariots, musicians, maidens, and gods. The building is a rectangular

temple surrounded by a covered portico 228 feet long, supported by 46 Doric columns 33 feet high. The interior was also treated with rows of columns that were covered with gold and color. There probably has never been in history greater thought placed upon the design of any building. It is full of refinements intended to correct optical illusions. Long horizontal features which seem straight are slightly curved so that they will not appear to sag. Vertical features incline slightly inward to counteract the tendency to appear to lean outward. The corner columns are slightly heavier in their proportions than are the others, and are placed closer together to give an appearance of greater strength to the silhouette. The top line of inscriptions on walls was cut in the tallest letters, the lower lines were each re-

duced in height for the reason that they were nearer to the eye, and thus all letters would appear the same size. The Parthenon was considered a perfect and precious jewel not only intended to enshrine a goddess and to hold the treasure of the nation, but to feed the pride and spirit of every Athenian. Its beauty still sparkles through its ruins; its glamour has been maintained for twenty-five centuries. The architectural principles and forms which reached the acme of perfection in this magnificent work have been used as inspiration and model by civilizations from the Roman period to modern times. The building has been used as a pagan temple, Christian church, and Moslem mosque, and was destroyed in 1687 by a bombardment. It has been restored to some extent in recent years.

THEORIES OF GREEK DESIGN. Archaeologists have often tried to prove that the Parthenon and other Greek temples were designed by the use of geometrical formulas and that the agreeable proportions of pure design are based on mathematics. Conclusions have been arrived at by analysis of existing buildings that there are simple mathematical relationships between parts and proportions, but this is a reversal of reasoning, and it is doubtful whether the Greeks predetermined their designs by any such method. The mind through the eye instinctively enjoys assembled forms that have an appearance of unity, interrelationship, and proper structure. Perhaps the visual experience of inherited generations has taught us which goals are most closely approached and may form the basis of our judgment as to the degree of perfection that we consider as beauty in certain types of design. The Greeks seemed to have attained so high a degree of sensitivity to form, line, and proportion that mathematical calculations were unnecessary.

GREEK STRUCTURAL PRINCIPLES AND MATERIALS. The early Greek artists were undoubtedly strongly influenced by Egyptian art. This is seen not only in the continued use of the column and lintel form of construction but also in the resemblance of the early sculptural forms. The Greeks refined the column, made it less a copy of natural forms, made it more graceful, and used more moldings for its enrichment. The Egyptian effort to reproduce the clustered trunks of trees and reeds in the length of their columns was discontinued, and concave grooves called *flutings* took their place. The Greeks were the first to use the column as a feature on the outside of a building. A rainy climate necessitated the portico and colonnade. In the temples, the roof extended beyond the main walls of the building a distance of about ten feet. This projection had to be supported, and the column, used for this purpose, automatically dominated the design and appearance of the exterior. Great care was given to its proportions and detail. Greek buildings attain unity and appear as a complete composition, in which every detail is related and plays its part in the whole. The Greeks probably did not fully understand the construction of the arch or dome, and did not use them, but in their smaller buildings they developed the wooden truss instead of the stone beam or lintel for roof construction and ceiling support, which thus eliminated interior columns and permitted walls to be placed a greater distance apart. The slanting rafters of the truss furnished a pitch to the roof for the discharge of rainwater. The roof of the Parthenon was supported by a series of stepped stones that served as a lintel. These had to be partially supported by interior columns. The end trusses on a building were covered with masonry arranged to follow the triangular shape of the truss itself, and in the monumental buildings this area, called a pediment, was decorated with moldings and sculptured ornament. The Greeks also discovered a way to cut stone in a quarry that maintained greater strength in the material. This permitted the use of longer stone lintels when needed, and increased the span between the columns.

Marble and limestone, the materials used for

the exteriors and interiors of these buildings, were soft white stones, the surfaces of which took a high polish. They differed greatly in ease of cutting from the granite of Egypt, which explains the use of numerous small moldings in Greek architecture and decoration, and may also be considered an important factor in the development in Greece of the art of sculpture. The ornament on the surface of Greek buildings was carved in relief, rather than being incised, as had been the practice in Egypt. The pattern projected from the face of the stonework, and was effective because of the highlights, shades, and shadows produced by the projection rather than because of the addition of color.

Greek architecture is basically functional, which implies that every feature had a useful and practical purpose. Columns were used solely for support, never for decoration. Little was introduced solely for its decorative effect, and although structural surfaces were enriched, the ornament was never applied to a degree where the appearance of the structure itself became of secondary importance in the design. Walls of the great temples were in solid marble throughout, a material which was of sufficient beauty to serve as the interior decorative finish. The stones were so accurately cut that it was not necessary to use mortar in the joints. Craftsmanship in building was carried to a supreme degree of perfection. The charm of Grecian architecture is in its intellectual rather than emotional appeal. It is a beauty emphasized by line, form, and proportion, rather than color and surface ornament.

Certain forms originally used for exterior architecture were adapted to the interiors of the buildings. The detail and the proportioning of Greek moldings, the method of their application, and the character of ornament have been especially followed by later designers in nearly all periods of art. It becomes essential, therefore, to study some of the details of architecture as seen in the Parthenon and other buildings on the Acropolis.

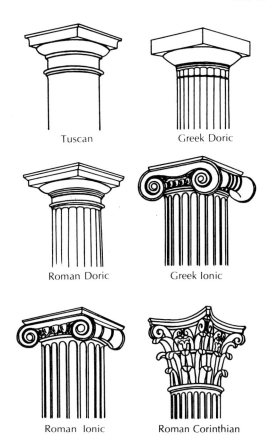

Examples of Greek and Roman capitals.

THE ORDERS OF ARCHITECTURE. The Greek buildings were built in one of three styles or *orders of architecture*, known as *Doric, Ionic,* and *Corinthian.* The orders of architecture were probably the interpretation in stone of the prehistoric wooden post-and-beam structure, agreeably proportioned and enriched. As in the Egyptian structures, the wooden post eventually became the cylindrical stone column. To the wooden beam or stone lintel which the column carried were added moldings and ornament, creating the *entablature.* An order consists of a column and an entablature.

The orders differ from one another in proportion and detail. The chief distinguishing feature in each order is the capital of the column.

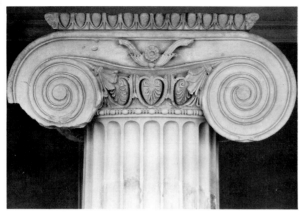

Metropolitan Museum of Art

Greek Ionic capital from Sardis, Asia Minor.

The capital consists of a series of moldings and ornaments placed at the top of the column. The most simple capital is that used with the Doric order, in which the principal features consist of a large square block at the top, called an *abacus*, underneath which is a curved molding known as an *echinus* which springs from the main body of the column. The Ionic capital is characterized by two large *volutes* or spirals, and the Corinthian by two rows of vertical acanthus leaves below four small volutes that are applied to a bell-shaped form resembling the Egyptian campaniform capital. A column has two additional parts. The lower portion of the Ionic and Corinthian column is treated with a series of moldings called the base. No base was used for the Greek Doric column. The central and longest part of a column, called the *shaft*, is frequently treated with vertical concave grooves called flutings. A slightly curved taper toward the top of the shaft is known as the *entasis*.

The entablature is also constructed in three main divisions. The lower portion or lintel is called the *architrave*, and is sometimes enriched by the addition of several simple moldings. The central portion, a wide, flat surface, is known as the *frieze*, and is frequently treated with some form of carved enrichment. The upper portion, consisting of a series of moldings, is known as the *cornice*. Portions of the cornice project out over the frieze to protect the carving on the frieze from the weather, and also to create a shadow beneath it that will accent and give a finished effect to the top of the building. The moldings at the top of the cornice usually encase a gutter along the edge of the roof of the building to catch the rainwater that runs down the slope.

In addition to the parts of the order mentioned above, the Greeks frequently placed the column on a high block called the *stylobate*, which the Romans later enlarged and elaborated into the *pedestal*. This pedestal is the origin of the modern interior dado. The triangular portion at the front and rear of the building, formed by the cornice and the line of the roof, is treated with moldings and sculpture. This feature is known as the pediment. Originating in Greek architecture, it was often used by the Romans and in later styles of architecture, decoration, and furniture design as an ornamental feature. Details of a typical order are shown on page 25.

In the Doric order, the proportions are rather sturdy and heavy, the forms and moldings are simple, and only a small amount of enrichment is used. This order was selected for buildings in which the aesthetic expression was to be one of strength and vigor. The Ionic order is lighter in appearance, more elaborate in detail, and was used where dignity was required without the solid strength represented by the Doric. The Corinthian order was still more delicate in appearance, and was selected where the effect of grace, lightness, richness, or gaiety was necessary; it was an outgrowth of the Ionic form, a late development in Greek architecture, and was not frequently used until the Roman period.

The architectural features, all originating structurally, were eventually used by the Romans and others for decorative purposes as well.

In the study of interior decoration it is advantageous to learn to identify the architectural orders and to learn their parts by name. The column, pilaster, entablature, architrave, frieze, cornice, pedestal, and pediment have been a constant source of inspiration, since their introduction by the Greeks, for interior wall treatments, the designs of furniture, and other forms of industrial art. It is likewise valuable to know the origin and meaning of these terms.

MOLDINGS AND MOLDING ORNAMENTS. The Greeks created the various molding forms that are now used and known by their Latin names. Moldings are the means by which a designer may produce highlight, shade, and shadow upon any surface. They serve to divide the surface into smaller parts and create interest and variety. The Greek moldings were extremely graceful in silhouette and were designed by the freehand stroke of the artist rather than by mechanical means. They resemble portions of the mathematical curves known as the ellipse, parabola, and hyperbola. These curves are complex, the degree of curvature increasing in their length.

The Roman moldings were more simple but less beautiful, and their silhouettes were made by combining various compass or mechanical curves. Many of the moldings were enriched by ornament that was designed to fit the shape of the molding itself.

The principal moldings were:

1. The *fillet,* a small, flat, plain surface used to separate other moldings.
2. The *fascia,* a wide, straight surface, usually plain, used to contrast with and accentuate smaller moldings.
3. The *ovolo* (egglike), a convex-curved surface approximating the exterior curve of a quarter-circle. It frequently follows the line of a parabola, and is often enriched with an ornament known as the *egg and dart.*
4. The *cavetto,* a concave surface approximating the interior curve of a quarter-circle.
5. The *cyma recta,* an S-shaped, curved surface that starts and ends horizontally. It is frequently enriched with a *honeysuckle* motif. This is sometimes called "the Hogarth line of beauty."

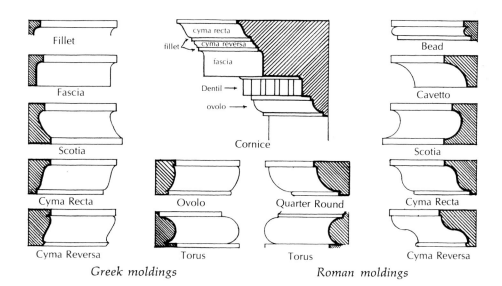

Greek moldings *Roman moldings*

Typical classical moldings. The Greek moldings are curves produced by the free-hand stroke of the artist. The Roman moldings are produced mechanically by the use of the compass.

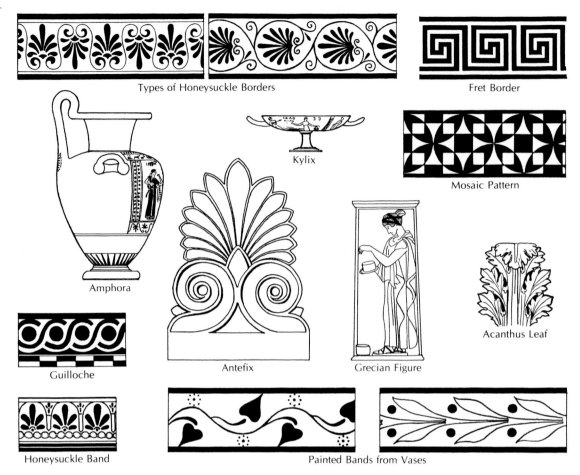

Examples of typical Grecian ornaments.

6. The *cyma reversa*, an S-shaped, curved surface that starts and ends vertically, frequently enriched with an ornament known as the *waterleaf*.

7. The *torus*, a convex surface approximating the exterior curve of a semicircle. When enriched, it is treated with the guilloche or with overlapping laurel leaves tied with crossed ribbon bands.

8. The *bead*, a small torus molding (semicircle) cut to imitate a string of beads of varying size.

9. The *scotia*, a deep, hollow, concave molding, seldom ornamented, and usually found only on the base of a column.

GREEK ORNAMENT. In addition to these molding ornaments, the Greeks developed a great number of ornamental forms that were later borrowed by the Romans and, in turn, by the designers of western Europe from the fifteenth century onward. Although color was often used in connection with Greek ornament, the play of light, shade, and shadow was of greater value in accentuating form and line, the principal elements of beauty that intrigued and delighted the Greek mind and so vitalized their arts. The Greeks produced no all-over patterns, but were most interested in enriching structural forms in such a way that the structure was accentuated

rather than hidden. Although the fundamental forms of Greek ornament were constantly repeated during the whole history of Greek decoration, the variations were so multitudinous and the combinations so complex that exact duplications were practically nonexistent.

Among the ornamental forms borrowed from vegetation were the *acanthus* leaf, lotus bud and flower, palmette, and *anthemion*. From the animal world, the artists represented the complete forms or portions of the bodies of the horse, lion, ox, birds, fish, and other fauna. Mythical and fanciful creations such as the sphinx, griffin, and chimera were also freely used. Ox skulls (bucrania) were combined with ribbons, festoons, and garlands. Of geometrical motifs, the *fret* or *meander* wave or scroll, the rosette, the conventionalized honeysuckle, and the double interlacing scroll or guilloche were the most frequently used. The spiral and the *swastika,* although seen in primitive Greek art, are also associated with the arts of other primitive races, and the use of these forms was discontinued at an early date.

During the Alexandrian period the *rinceau* and the *arabesque* were developed, through a combination of scroll, spiral, vine, and acanthus leaf motifs. The human figure was also extensively used for decorative purposes as well as for sculpture, and the *caryatid* or female form crowned with a capital and used as a supporting structural feature was a development of Grecian architecture.

GREEK SCULPTURE. It is generally accepted that the art of sculpture reached its zenith during the period of Greek civilization. The initiative of the Greeks, inspired by the sculpture of the Trojans, Minoans, and Egyptians, was, in this art, additionally actuated by the fact that in the Greek peninsula, as well as the adjoining islands, and especially the island of Paros, there was available a magnificent white stone that was softer than granite, and harder than alabaster. Marble was a material that had a fine grain and texture and could be cut easily into minute de-

tails. The developments in this art were so great that progress was made almost independently of any previous style. The evolution may be broadly subdivided into three parts: the Archaic, Hellenic, and Hellenistic.

The oldest marble statue dates from about 620 B.C. This was more primitive in character than the sculpture produced in Egypt in her earliest history. The Greek advancement was rapid, however, and in two centuries reached its highest point of development. During the Archaic period (620–480 B.C.) sculptural forms were highly conventionalized. Figures were influenced by Egypt, Assyria, Crete, and Ionia. By 550 B.C. the first figure was made in which movement was indicated by the position of the legs, and emotion was expressed in the face by a sort of grimace, now called the Archaic smile. Eyes were modeled with an Oriental slant, and the eyeballs bulged in a convex surface. These characteristics continued during the whole of the period.

After Marathon (490 B.C.) a great advance occurred in both relief and freestanding sculpture. Many statues were made commemorating heroic contests. The enthusiasm aroused by the Persian defeat and culminating in the Golden Age of Pericles was reflected in the enrichment of the new temples with sculptural work of the greatest magnificence. During the latter portion of the fifth century, the work of the three greatest sculptors was produced. Phidias, who was responsible for the adornment of Athens and particularly the pediment and friezes of the Parthenon,* dominated the trio, which included Myron and Polyclitus. Polyclitus was the first sculptor to show figures in action, standing on one foot. Myron is particularly famous for his unexcelled statues of athletes in motion in which every muscle is indicated strongly in tension.

* Much of this sculpture is now in the British Museum in London. The fragments are known as the *Elgin Marbles.*

The style during the Golden Age expressed the Greek adoration of the human body, which approached the majesty and grace attributed to the deities, and delineated physical perfection. Faces were slightly conventionalized and expressed the dignity, strength, and serenity that characterized the people of this period.

After the humiliation of Athens by Sparta (404 B.C.) sculpture increased in emotional representations. Praxiteles and Scopas were the great artists of this period. Their work expressed enthusiasm, pathos, and elegance; there is greater freedom of motion, more realism, and accuracy of detail. Facial expressions indicate a deeper consciousness and intensity of spiritual struggle; hair is modeled more naturally; the head becomes more oval; eyes are deep set; passion and nervousness are apparent. When clothing or draperies are shown, their structure and movement are clearly visible. In the *Victory of Samothrace* in the Louvre, by an unknown sculptor of this period, the figure is represented as standing on the prow of a ship; a windswept tunic covers her body; every fold is indicated, but one is sensitively conscious of the flesh underneath, of the magnificent grace of the figure, and even of the sea breeze which it is supposed to be resisting.*

The period of Alexander carries Greek sculpture into a theatricalism that was intended to dazzle the populace and reflect the splendor and grandeur of the regime. The center of culture moved from Athens to Alexandria, and the term *Hellenistic* is usually applied to this style, which lasted until Greece became a Roman colony. Realism is expressed to a supreme degree. Anguish, pain, violence, and confusion become the dominant assertions. These are emotions that are not again approached in sculpture until modern times. Portraiture commences as well as the representation of landscapes and rural scenes.

Many of the most poignant examples of Greek sculpture are seen in the funereal monuments and gravestones known as *stelae*, on which the deceased are represented as in life. Husbands and wives are often shown in attitudes expressive of their affection and companionship.

Greek sculpture was often colored, and in many examples fragments of pigmentation remain. Most of the originals of the greatest examples of Greek sculpture have disappeared, but the works are known through the contemporary literature. Roman sculptors also made many accurate copies that have been identified.

GREEK DOMESTIC ARCHITECTURE. Little remains of Greek dwellings, and the records that are obtainable are those of the historians. The houses were small, built around courtyards, and were without windows, the light entering through the doors of the rooms. Undoubtedly the general plan and treatment was similar to the houses uncovered in the ruins of Pompeii, an Italian city of Greek origin.

GREEK WALL DECORATION AND COLOR. Many of the Greek buildings were covered with painted or glazed color both inside and out. Brick and stone were often covered with a cement stucco that was polished so highly it reflected like a mirror. Scenic decoration and conventional ornament were used to enrich marble, wood, and plaster. Painted decoration was at first entirely subordinate to the architecture; later it became an independent art. Little remains of Greek painting, but that art never equaled the perfection reached in rendering the human form in marble and bronze.

FURNITURE. The Greeks used marble, bronze, iron, and wood for the construction of their furniture. These materials were frequently

* The value placed upon Greek sculpture even in antiquity is well indicated by the fact that records indicate that King Nicomedes offered to pay the entire public debt of the Cnidians providing they would give him their statue of Aphrodite by Praxiteles. His offer was refused.

Greek and Roman furniture.

decorated by relief carving and by painting. The ornamental motifs were borrowed from the architectural forms. The legs of chairs and tables often showed the use of *disk-turnings* or animal forms. The feet are frequently dog or lion paws. Chairs had back rails curved in a concave or *klismos* form roughly following the curve of the human back. In some vase paintings and relief sculpture chairs are shown with gracefully curved plain legs, the front leg curving forward and the rear leg curving backward.*

GREEK MINOR ARTS. One of the most interesting and oldest of the Greek minor arts was that of pottery making, and it has been through

the decorations of the vases and jars of this craft that one sees some of the earliest applications of the laws of unity and the proportional relationships of pure design. The pictorial motifs with which some are adorned have served to inform posterity concerning many of the Greek customs. The purpose of the subject matter was not only ornamental but educational as well. In these vases which were common in all households was found a convenient method to educate the youth. Every possible event in the daily life of the people was represented as well as the legendary history of the deities. The sports, such as running, wrestling, and ball games, were beautifully indicated as well as the proper methods of ploughing, sowing, harvesting, weaving, baking, and butchering. Boys learned how to use spears, shields, and armor. Religious processions, altar and funerary

* These features were revived in the early nineteenth-century furniture of France, England, and the United States.

ceremonies, chariot races, and hunting scenes were beautifully represented, and lovers were instructed in the methods of showing their affection. The human figure, both draped and nude, was usually drawn in profile with full expression and understanding of its structural anatomy, physical power, action, and grace. The pagan mind adored the body as much as the Christian mind adored the soul. There were six principal shapes; the *amphora*, with two handles and a cover, was a large vase for the storage of grain; the *kylix* was a flat-shaped drinking cup; the *hydria* was intended for the storage of water and had three handles used for carrying or pouring; the *oinochoë* was pitcherlike in appearance, with one handle; the *lekythos*, a tall narrow form, was used for storing and pouring oil; and the *krater* was a bowl with a wide top used for mixing.

The Greeks used the potter's wheel, and while the forms were undoubtedly decided upon by the individual worker, the curved silhouettes were always ovoid and generally followed the changing degrees of curvature associated with the mathematical curves. The shapes were primarily functional and practical for the purposes of the vase, and the handles were designed and located for convenience in use, but were also related to the silhouette of the vase itself. The earliest vases, known as Dipylons, were for funerary use and date from 1200 to 700 B.C. These were enriched with horizontal bands painted with primitively drawn flat figures, animals, and symbolic motifs. In the sixth century the background of vases was in reddish *terracotta*, painted with patterns in a black glaze. On a series of band courses, highlights were sometimes shown with slight tints of white or purple. By 525 B.C., red figures with slightly incised outlines were shown on a soft black background, and the character of the drawing resembled that of archaic sculpture. This type was superseded about 500 B.C. by black backgrounds with figures both incised and in slight relief, more naturalistic drawing, and a tendency of showing the

Greek vase forms.

third dimension, indicating a greater influence of the painting of the period.

Another art at which the Greeks were supreme was that of making coins, gems, and seals. These were produced with figures, human profiles, animals, and ornaments in low miniature relief, but they were so technically perfect in their modeling that it must have required extraordinary eyesight and a deft and sensitive hand to produce the perfection of their delineation.

THE INFLUENCE OF GREECE ON OTHER CIVILIZATIONS. No nation or race of people has had more cultural influence upon western civilization

than has ancient Greece. Its architecture, decoration, literature, and sculpture have rarely been equaled and have stood as models of perfection for centuries.

The immediate successor to Greek civilization was that of the Romans, who, however, never approached the perfection of Greece in any of their art products. Rome copied and adapted many Greek forms and principles, however, and thus preserved much of Greek culture which otherwise would have been lost forever.

The Greek arts are of the intellect. Their beauty is attributed to exquisite proportions and graceful lines. While color and surface ornament are often an integrated part, the emotions aroused by means of these features never exceeded the intellectual appreciation derived from the gracefulness of form inherent in every object of Greek design and craftsmanship. It was this spiritual quality in Greek art that inspired Keats's remark concerning a thing of beauty, "Its loveliness increases; it will never pass into nothingness."

Rome. The founding of Rome in 753 B.C. is part of the legendary story of Romulus and Remus. The early growth of the city witnessed the struggles and final collaboration of Latins, Sabines, and Etruscans. The Roman insatiable desire for conquest and her consciousness of destiny commence with the final defeat of Carthage in 146 B.C. As Greece had risen supreme after Marathon, Rome, with the destruction of her chief rival, became the supreme power in the Mediterranean and prepared not only to rule the world, but to enjoy the fruits of victory. She continued to spread her control to Greece, Spain, Asia Minor, Africa, Gaul, and Britain. Caesar's conquests made Rome not only the mistress of the older civilizations, but the civilizer of barbarians. The fatal alliance between Antony and Cleopatra brought Egypt into the fold. The period of the empire, established by Augustus in the first century B.C., was the beginning of the Golden Age of Roman culture. For two hundred years the Pax Romana endured, during which period the Roman citizen became the ideal of men. Literature and the arts also first became important, and these were invariably based on Greek prototypes, and Greek became the language of the upper classes and the intelligentsia.

THE CHARACTER OF ROMAN CIVILIZATION. The strongest passion of the Roman people was for political dominance of colonies and for the prospect of draining these of their wealth and manpower to contribute to the luxury and service of the Roman citizens, who collectively were convinced of their own superior governing capacities. During the entire period of her existence, Rome was controlled by a senatorial dictatorship dominated by the patricians. The plebeians could rise from their class, and slaves obtain their liberty, but slave rebellions were cruelly crushed. Rome was never a true democracy. The great blemish on the character of the Roman leaders was their utter disregard for the laws of humanity in gaining their ends. The Romans needlessly burned the cities of the conquered, destroyed whole populations, murdered hostages, broke treaties, provoked unnecessary wars, falsely accused other nations of delinquencies, committed aggression by both propaganda and force, and under the empire began to persecute those who differed in religion.

In comparison with Greece, philosophy and the arts were of secondary importance. Moral standards permitted the legal acceptance of murder in gladiatorial contests. The Roman gods, appropriated from the Hellenic pantheon, were given Latin names. Religion was allied to the state and used for national advancement. The personal religion of the individual was less important than in Greece. Idealism was subordinated to realism.

The Romans recognized from the first the supremacy of Athenian culture. They borrowed

The Maison Carrée, Nimes, France. It was the model of many later structures in Europe and America.

and frequently subverted every Greek concept, principle, or material object that seemed to be useful. Their cultural blood was vitalized by the elixir of Greek thought in all its ramifications. They imported Greek scholars to teach their youth, enslaved Greek craftsmen to educate their artists, and copied Greek art in all its forms. Horace pithily admitted the intellectual conquest in his remark, "Captive Greece has made her captor captive." Lacking the idealistic impulse of the Greeks and steeped in materialism, within two generations the Romans developed a consciousness of might with complete disregard of benevolent qualities.

The world nevertheless owes the Romans a debt for transmitting to the people of western Europe their interpretation of Hellenistic culture. The Romans were an extremely practical people and excelled as organizers and lawgivers; they eventually established justice and order throughout most of the empire, but for those who refused to accept their government and religion, slavery and mistreatment were carried to extremes.

In the eastern colonies, the oppression of those who believed in one God eventually re-

acted upon the national unity. A persistent faith, conscious of its righteousness, finally permeated among the lowly in all parts of the empire and eventually undermined the pagan philosophy. Christianity was opposed because it taught submission and humility rather than what were considered the manly virtues; it was, however, not the cause but the result of the disintegration of the Roman state. Political selfishness and dishonesty created lack of respect for leadership and destroyed civic pride. The enormous taxes required to support the two armies of soldiers and bureaucrats burdened the masses to a degree where they concluded the empire was not worth saving. Patriotism was crushed. Meddling with the law of supply and demand caused economic chaos. Exhaustion of natural resources, lowered moral standards, pestilences, and barbarian successes developed a hopelessness that finally wrecked the national initiative. The year A.D. 476 marks the end of the original Roman Empire and the election of Odoacer, the barbarian, as the first king of Italy.

ROMAN ARCHITECTURE. Early Roman art was inspired by both the *Etruscan* and archaic Greek forms. The structures in this style dated mostly from the fifth and sixth centuries B.C. Rome did not develop as a great metropolis until Greece became a Roman colony. Rome then began to accept the heritage of Hellenistic culture. The major portion of the great buildings that were erected in all Roman cities were built as a result of the unusual economic conditions that existed between the first century B.C. and the third century A.D. Slave labor served greatly to economize costs of construction, but created indolence and unemployment among the plebeians, who paradoxically enjoyed their leisure and complained of their lack of opportunities to earn a living. In gestures of generosity over a long period, the authorities repeatedly allotted food supplies furnished by the colonies. They established programs of public improvements that temporarily ameliorated labor conditions

and had the appearance of enabling the public to share the wealth and luxury, which had been pre-empted by the patricians. An important part of these sops to political unrest was the building of vast structures for public use and entertainment. Among these were the great *basilicas,* or commercial exchanges, that were later to be the model for Christian churches; amphitheaters, such as the Colosseum, for pageants and mortal combats; majestic baths, where bathing was secondary to amusement; circuses for chariot races; and religious edifices that have inspired designers for a score of centuries. The great forums built in the center of every city were used for political demonstrations and social gatherings. Exquisite temples and shrines, set in landscaped vistas enriched with statuary, were used for votive purposes or museums containing Greek sculpture. Elaborate temporary decorations were erected for the great festivals such as the Saturnalia, when class distinctions were suspended, and streets vibrated with revelry.

The residences of the patricians were elaborately planned, with rooms for every purpose and arcaded courtyards containing gushing fountains that centuries later were imitated in ecclesiastical *cloisters* and college quadrangles. In-

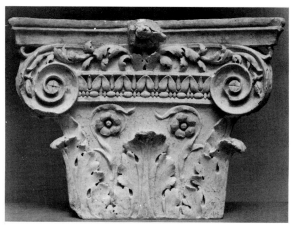

A Composite order capital.

teriors were enriched with marble incrustations, statuettes, floors of colored mosaic, frescoed walls, and expensive furnishings that were the inspiration of Donatello and Raphael. Many of the houses had roof gardens. Terrariums, aquariums, and flower boxes were frequently featured. The details of decoration contributed to the real or suggested tempering of climatic conditions. Cool water was carried by lead pipes to elaborate baths, pools, and drinking taps. Heat was obtained by portable charcoal-burning braziers.

The architecture of a civilization such as Rome produced could not fail to be powerful, magnificent, and ostentatious. Grandeur and boldness were the most characteristic aesthetic expressions of the public buildings, sublimity that of the city of Rome itself. Domestic interiors reflected wealth if not always refinement of design and at times had both charm and spiritual mood. To administer the heterogeneous population of the empire, they built with haste and seldom needed or understood subtleties of design in either composition or detail. Bulk, surface enrichment, and rarity of material served them to better advantage in arousing prideful emotions and a sense of security in their untutored subjects. Their art admirably reflected their virtues and faults.

ROMAN CONSTRUCTION AND THE ARCH. The Roman builders adopted the principles of Greek construction in using the column, lintel, and truss. In addition, they developed the arch built of radiating wedge-shaped stones, a feature that became an indigenous part of their architecture and greatly affected both external and internal design. From the arch, the Romans evolved the barrel vault, or curved ceiling, and the *dome.* This method of spanning the distance between two walls with a fireproof material permitted wider rooms than either the Greeks or Egyptians were able to construct. The span of the dome of the Pantheon is 142 feet, and the arched concrete ceiling in the Baths of Caracalla spanned a distance of 80 feet. Arch forms were limited

to semicircular and segmental curves. The arch was also used for decorative purposes in doorways, windows, arcades, and niches. Its use served to introduce a variety of line in Roman design that did not exist in earlier styles.

The structural problem in the stone arch lay in the fact that the thrust of its weight gravitated both downward and sideways. A supporting wall had to be of sufficient thickness to resist the side thrust, or the lower parts of the arch itself had to be tied together unprepossessingly by iron rods. It was nearly a thousand years before builders learned the secret of supporting an arched ceiling on slender uprights.

THE USE OF CONCRETE. Another important structural development in Roman design that completely differentiates it from earlier styles was the use of concrete. This inexpensive and strong material was made by a mixture of small stones, sand, lime, and water that was poured into a wooden form, becoming a solid mass (*monolithic*) when dry. As concrete was considered unpretentious and unsuitable for finished effects, its surface was covered with slabs of marble, alabaster, brick, or stucco, which veneers also served as a protection. Thus Roman walls were less honest aesthetically than Greek walls that were built of marble throughout. Concrete was used mainly where downward pressure was the principal force, such as in walls, arches, and domes. There is no evidence that Roman engineers knew of the principles of modern methods of reinforcement of concrete by iron rods, so that the material was never used for beams that were subjected to a bending stress. *Cantilever* beams and projections, so much a part of modern design, were unknown.

VITRUVIUS AND THE STANDARD PROPORTIONS OF THE ROMAN ORDERS. The lack of highly trained designers and the necessity for speed in the construction of the various administrative buildings throughout the colonies necessitated a method of facilitating the work of the local builders and stonecutters who lacked aesthetic feeling. During the administration of Augustus, an architect named Vitruvius established certain rules for standardizing the Greek orders of architecture. The proportions and details were slightly changed from the originals, and practically all the Roman buildings were afterward designed on Vitruvian principles. In the fifteenth century, the Italian architects rediscovered these rules, translated the works of Vitruvius, and they form the basis of all the Renaissance styles of western Europe.

The Romans added two orders to the Greek Doric, Ionic, and Corinthian. These were the *Tuscan,* a simplified Doric form which was originally of Etruscan origin and had no flutings on the shaft of the column, and the *Composite,* a combination order, having for the design of its capital the two rows of acanthus leaves of the Corinthian and the large volutes of the Ionic.

The Doric order was not extensively used by the Romans. They slenderized the proportions of the column, added additional moldings to the capital, and used a base. Occasionally the flutings were omitted.

In the Ionic order, the volutes of the Roman capital are smaller than the Greek, and the ornament on the necking below the volutes is omitted. The Romans also sometimes repeated the volutes on four sides of the capital instead of two.

The Corinthian order, little used by the Greeks until the Hellenistic period, was the most commonly used in Roman buildings. It was always richly treated with ornament. The Roman capital is slightly smaller than the Greek, and the character of the acanthus leaves differs.

The Romans introduced the pedestal as a feature of exterior architectural design and later used it as a feature in room interiors. This consisted of a high base upon which the column could stand. It was the Roman development of

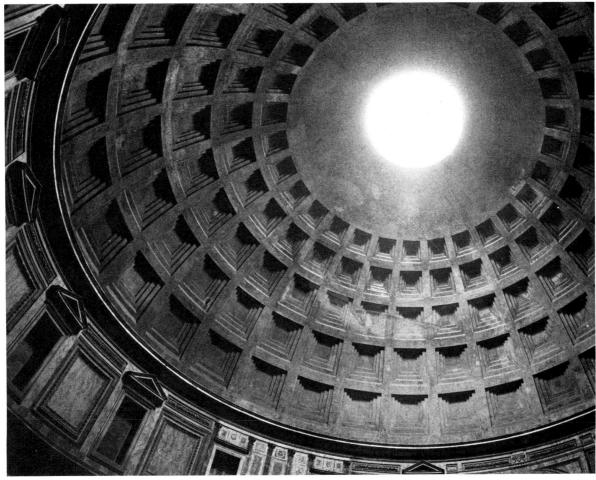

Photo Researchers

*Interior of the Pantheon in Rome built by Emperor Hadrian (*A.D. *second and third centuries), showing a view of the interior ceiling with oculus, or opening.*

the Greek stylobate. The height of the pedestal was about one-fourth or one-third the height of the column. It was treated with moldings at the top and a projecting block at the bottom. It became the prototype for the dado of later periods of interior design. The Romans also used the pilaster, which has a square rather than a round shaft, is always attached to the wall, and usually projects from the wall a dimension that is about one-fourth of its width. As the pilaster was a part of the wall, it had little structural value. Its use was primarily decorative and to break the wall surface into vertical subdivisions to be treated as individual panels.

The principles of proportioning the orders based on the rules of Vitruvius were as follows: A measuring unit called a *module* was to be taken for each order; this unit was the *diameter* of the column at the base of the shaft.* By de-

* In some cases the measuring unit was taken as half the diameter.

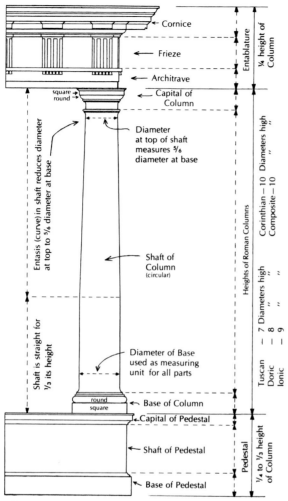

Labels on diagram:
Cornice
Frieze
Architrave
Capital of Column
square / round
Diameter at top of shaft measures ⁵⁄₆ diameter at base
Entasis (curve) in shaft reduces diameter at top to ⁵⁄₆ diameter at base
Shaft of Column (circular)
Shaft is straight for ⅓ its height
Diameter of Base used as measuring unit for all parts
round / square
Base of Column
Capital of Pedestal
Shaft of Pedestal
Base of Pedestal
Entablature — ¼ height of Column
Heights of Roman Columns: Corinthian — 10 Diameters high; Composite — 10 "; Ionic — 9 "; Doric — 8 "; Tuscan — 7 Diameters high
Pedestal — ¼ to ⅓ height of Column

The Tuscan order and its parts as standardized by Vitruvius.

ciding first upon this measurement, the height of the column and entablature became a fixed size, measured in diameters. On this basis the following proportions were fixed:

COLUMN	HEIGHT IN DIAMETERS
Tuscan	7
Doric	8
Ionic	9
Corinthian	10
Composite	10

The entablature in each case was one-fourth the height of the column. The shaft was one-sixth smaller in diameter at its top than at its base. Standard designs were arranged for column bases and capitals. A fixed number of flutes were designated for the shafts. The form and the sequence of moldings used in the entablature were settled upon. The Greek forms of ornament were used, and, in addition, arabesques, rinceaux, *grotesques*, dolphins, griffins, wreaths, ribbons, eagles, masks, swans, lions, and other animal forms were introduced.

The majority of the Roman buildings remaining today were originally monumental structures for public use. The domestic architecture and decoration of the Romans of the first century after Christ can best be studied in the ruins of Pompeii.

ROMAN SCULPTURE. Sculpture both in bas-relief and freestanding figures was first inspired by Etruscan art. Etruria, believed to have been settled by immigrants from Asia Minor, became a Roman province in 283 B.C. Its culture had been strongly influenced from an early period by trade with Greece. About 150 B.C. the Romans commenced a methodical pillage of Greek buildings, and statues were imported to adorn the villas and gardens of Roman patricians. When a sufficient number of examples was not available, the Greek sculpture was copied by both Roman sculptors and Greeks who came to Italy for that purpose, and the major portion of Roman examples are of this type. About A.D. 100, during the reign of Trajan, there developed a school of portraiture in which all conventional imitation was eliminated and lifelike representations of Roman leaders were made in which every detail and facial blemish was indicated. This style disappeared with the fall of the empire in the fifth century, and such realism in sculpture did not reappear until the end of the Gothic period.

ROMAN ORNAMENT. Roman ornament was based almost entirely upon the Greek forms, although certain motifs, used more profusely

than others, varied slightly in character from the Grecian interpretations. The scroll and leaf patterns were extensively used as both rinceaux and arabesques. The acanthus leaf became slightly more conventionalized, more solid in appearance, and less foliated. Human figures and *amorini* shown both in repose and in action were profusely applied to architectural surfaces, panels, and ornamental accessories. Natural forms, such as the serpent, swan, eagle, lion, and ox, or portions of these animals also were used. Imaginary forms such as sphinxes, griffins, genii, and grotesques formed parts of decorative compositions, and their torsos often protruded from a base of acanthus petals.

Floral and leaf arrangements, composed as wreaths, festoons, and garlands, were also used, and the Greek fret, swastika, honeysuckle, anthemion, spiral, wave pattern, waterleaf, egg and dart, bead, and *dentil* continued as characteristic decorative forms for moldings, borders, or panels.

These forms of ornament were used in all mediums. They were cut in stone, cast in bronze, and formed portions of the painted decoration, their character or degree of delicacy slightly changed to suit the material. The Romans also developed the technique of casting stucco or plaster composition into these same patterns and applying the motifs to stucco surfaces. This comparatively inexpensive method of enrichment was studied by the Adam brothers and extensively used by them in English eighteenth-century decoration.

Unable to attain the Greek beauty of line and form, the Romans depended upon the use of ornament to give richness of effect in their buildings. Limestone and stucco did not permit as much delicacy of cutting as marble, so that the Roman relief ornament is usually finished in comparatively coarse detail.

The Roman moldings are coarser than the Greek and lack the refined mathematical curvature; they are profiled as single or compound segments of circles and are given interest by the addition of such ornaments as the egg and dart, waterleaf, or acanthus leaf.

POMPEIAN DOMESTIC ARCHITECTURE. The city of Pompeii, which was completely covered with ashes by an eruption of Mount Vesuvius in A.D. 79, was a small Greco-Roman town in the southern part of Italy, near Naples. The

Comparative plate of Greek and Roman orders, showing the entablature heights for each and the increase in delicacy of proportion from the Greek Doric to the Roman Corinthian.

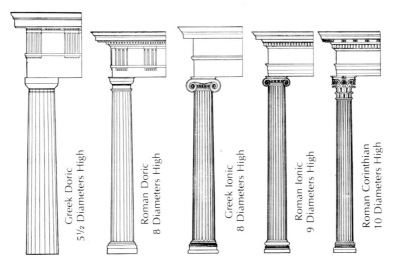

Greek Doric
5½ Diameters High

Roman Doric
8 Diameters High

Greek Ionic
8 Diameters High

Roman Ionic
9 Diameters High

Roman Corinthian
10 Diameters High

Metropolitan Museum of Art

Comparison and development of Greek and Roman sculpture from conventionalization to realism: Archaic Greek, 600 B.C.—Periclean, 450 B.C.—Hellenistic, 300 B.C.—Roman, first century B.C.

ruins have been excavated since the year 1753, and at the present time about one-third of the city stands much as it was left twenty centuries ago.

Pompeii was a summer resort for wealthy Romans, intended for amusement, recreation, and pleasure. It had its forum and residential streets, but there were buildings erected for games of chance, cockfights, theaters, baths, restaurants, nightclubs, pawnshops, and an amphitheater for gladiatorial fights.

The exteriors of Pompeian houses lacked the splendor that was dominant in the public architecture of Rome. For the most part, the buildings were plain and finished with cheap stucco. The fronts were built directly on the streets and were frequently flanked with small shops. Because of the hot climate, the rooms were constructed without windows and were lighted solely by doors opening on a central courtyard.

The houses were usually two stories high, having an entrance hall opening on the street and extending back, much like a modern foyer, into the *atrium*, a roofed courtyard. The center of this roof was pierced by an opening that permitted daylight to enter. Directly under the opening was usually located a small pool or basin that caught the rainwater and served both as a cooling and decorative feature. The atrium also served as the reception room for guests. It was surrounded by small rooms and by stalls for animals. From the atrium an opening led to the *peristyle* or rear court garden where the private life of the family was centered. Bedrooms, the *triclinium* (dining room), and rooms for the family were grouped around the peristyle. The kitchen and pantry were located nearby, and a garden extended beyond the peristyle. Servants lived in separate quarters.

The interior of the house was elaborately decorated. Patterned mosaics in either black and white or colored marbles covered the floor. The ceilings were painted in various geometrical pat-

terns or intertwining floral and leaf patterns, often accented with perched or flying birds. Sometimes gilded timbers or panels were used. Since the wall space was usually unbroken by windows, it was commonly painted in an ordered arrangement of architectural and decorative forms in which a relief effect was produced by a careful rendering of highlights, halftones, and shadows. Usually the walls were divided into three horizontal sections—the lower section being treated as a pedestal or dado, the high middle section reserved for decorative paintings, and the top painted with a frieze or cornice.

POMPEIAN WALL DECORATION. The eruption of Vesuvius has preserved for nearly two thousand years wall decorations of the Roman period and has enabled us to study the genius for realism of the Pompeian artists. Practically all rooms were treated with painted architectural decorations, explained perhaps by the fact that painting was a comparatively inexpensive and safe method of adding architectural interest to the interior of dwellings that were subject to frequent earthquake damage.

The main area of the walls was divided vertically into panels by painted columns or pilasters, crowned with entablatures realistically represented in perspective, and the panels thus formed were filled with decorative frescoes. The painted architectural features were often reduced to the most delicate and slender proportions, showing that the painter understood the possibilities of his medium, which was not subject to structural limitations. The panel centers were treated in one of three ways; they were either a plain color framed with painted moldings, or enclosed an arabesque or scenic pattern.

In plain panel areas, the color was generally a yellowish-red or black. The moldings on four sides formed a rectangular frame realistically painted with natural highlight, shade, and shadow effect, with the light indicated as coming from the door of the room. Sometimes a small figure or other motif was placed in the

Carved stone arabesque found in the Roman Forum.
The left edge is obviously the center of the pattern.

from an infinite number of sources. Mythology, allegory, history, landscape, still life, humor, city streets, portraiture, and animals were charmingly depicted. Playful nymphs and satyrs were shown in woodland settings. The draperies of a dancing girl would so accurately indicate the movement of her body that one could almost feel the rhythm of the dance. A forest grove would spiritually transport a city-dweller to a verdant retreat. A painted view through an imaginary open window would lead the eye down a shady path by waterfalls or splashing fountains, and serve to enlarge the appearance of the room as well as beguile the occupant. Members of the family were often shown seated in chairs, giving us a record of the wooden furniture, costumes, and hairdresses. Shops, taverns, and other business houses were decorated with subjects appropriate to their activities. The barber, butcher, shoemaker, and fortune-teller had special symbols depicting their talents and wares. Some of the murals give striking proof of the indelicacy of ancient manners.

The drawing and coloring of figures and animals were technically excellent, but the mathematical principles of perspective were not understood, and such representations were inaccurately made. The chief charm in the murals lies in the variety and gaiety of spirit of the subject matter, which is of a character and sufficiently well preserved to arouse the emotions of modern men. The colors were comparatively brilliant, as necessary in rooms having only a dim light. The medium was true fresco, the pigments being applied to and absorbed by the wet plaster; when dried, the surface was waxed and polished for protective purposes. Backgrounds were most commonly in black, white, or red, but other colors were also used.

MOSAICS AND INSCRIPTIONS. Because of its permanency, *mosaic* was frequently used for both wall panels and floor decoration. Patterns and pictures were made of small cubes of glass or marble set in cement, often so carefully com-

center of the panel or a picture was painted as though hung on the wall, with the frame and the shadow realistically indicated. The panels in the pedestal or dado often imitated marble slabs or a balcony balustrade.

Where conventional arabesque patterns were used, they were sometimes combined with naturalistic climbing ivy or leaf forms that spiraled around the slender columns and continued upward forming part of the ceiling decoration.

By far the most interesting of the Pompeian mural decorations were those showing scenic effects in which the subject matter was drawn

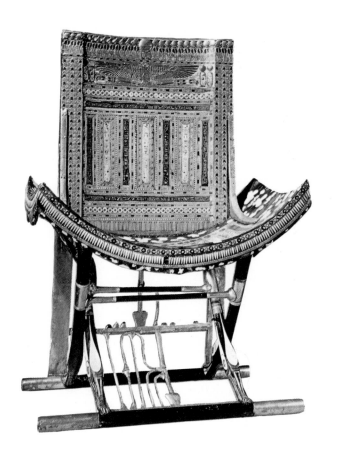

← A throne chair of Tutankhamen, who reigned from 1358–1349 B.C. in the third phase of the Eighteenth Dynasty. His is the only Pharaonic tomb discovered in modern times with all of its contents undisturbed. The wooden chair is covered with gold and multicolored inlays of faience, glass and stone. The x-shaped legs are similar to those found on folding stools used by traveling dignitaries. The monumental appearance of the back is characteristic of Egypian art.

Photo by F. L. Kenett © George Rainbird Ltd.

This red-figured Calyx Krater (bowl for → mixing wine and water) is signed by the potter Euxitheos and by the painter Euphronios and dates ca. 515 B.C. The front view depicts Sleep and Death carrying the body of Sarpedon, son of Zeus, from the battlefield. Note the perfection of the anatomical details, which Euphronios was first to understand fully and render correctly. What distinguishes Greek vases from all other decorated pottery is that their decoration, both in content and technique, rises above the level of ornamentation and justifies the special term, vase painting.

Metropolitan Museum of Art

↟ *A Pompeian interior of I Century B.C. The wall space was usually unbroken by windows and was therefore painted in an arrangement of architectural and decorative forms. Note the relief effect produced by careful rendering of highlights, shades and shadows. The walls were generally divided into three main horizontal sections—the lower section serving as pedestal or dado, the middle section reserved for decorative paintings for a vista effect, and the top painted with a frieze or cornice.*
Metropolitan Museum of Art

↟ *A Byzantine Mosaic depicting the Empress Theodora and her court ca. 547. Mosaic is in the apse of S. Vitale, Ravenna. In this panel we find an ideal of human beauty quite distinct from the squat, large headed figures encountered in the 4th and 5th centuries.*
SCALA New York/Florence

The Vatican

A Roman trompe l'oeil *floor showing food particles.*

posed that, viewed from a distance, the finished mosaic resembled a painting. The panels were usually framed with a geometrical or floral design. The usual patterns for wall panels show birds and animals or groupings of masks, heads, garlands, and wreaths. Alert pigeons drink from a bowl, parrots strut, ducks waddle, and cocks lower their heads in preparation for the fight. Wit and humor are sometimes expressed in both subject matter and titles. The field of floor mosaics was generally treated with a repeating motif, although one of the most magnificent examples ever made, which covered a floor in a Pompeian villa, shows a battle scene between Alexander and Darius. The mosaic of a barking dog on a vestibule floor is combined with the inscription, "Beware of the dog." A justifiable criticism of the Roman floor mosaics has often been made claiming that the patterns contrast too strongly with their backgrounds and frequently appear to project from the floor. The designs often intentionally accentuate the highlight and shadow values, causing one unwittingly to fear to fall or stub one's toe. Motifs used in a floor pattern should be flat and unobtrusive, but this principle was apparently considered unimportant to the Roman mosaic designer who imitated the painter and sculptor as closely as possible. In addition to the titles associated with mosaics, there are many interesting inscriptions scratched on the walls of Pompeian buildings. Although these are not directly con-

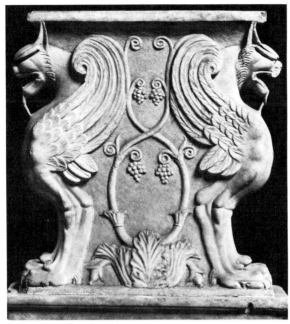

Carved support of a marble table found in Pompeii.

Alexandrian origin, showing an early appreciation of antiques. Furniture was made in wood, marble, bronze, iron, and precious metals, enriched with carving or relief ornament, such as arabesques, grotesques, animal features, griffins, and foliage, or inlaid with mosaic, tortoiseshell, ivory, and rare woods. Wooden supports were sometimes treated with disk-turnings resembling a series of unevenly piled platters; metal supports often imitated the wooden ones of this type, resulting in an aesthetic falsity. Bronze and marble supports were frequently designed as a dog's, lion's, or ram's legs and feet.

The most elaborate rooms were the dining rooms or tricliniums, so called because they contained three couches, each for three people, placed on three sides of a central table. The men dined in a reclining position; the women sat on chairs. The couches were covered with tapestries and cushions made in Egypt or Babylon and embroidered in gold and silver thread. The main table was low to accommodate the recumbent guests, and additional small individual tables were used for sumptuous tableware. The tabletops were made of richly grained *thuya wood*, a rare wood from Africa. On festive occasions, floors were strewn with flowers or covered with cedar sawdust mixed with saffron and cinnabar.

The bedroom was divided by curtains into three parts, one being a section for the attendant, another for dressing, and another for the sleeping quarters. The bed, made of wood or metal, was the only article of furniture and was stretched with ropes or metal strips supporting a straw or wool mattress covered with silk cushions and costly Oriental textiles. The drawing room or *exedra* was furnished only with tables and chairs.

Chairs were made in many types. The design of benches, folding stools, side chairs, armchairs, and thrones usually included the use of Greek curves. Seats and backs were shaped to fit the human body.

nected with the decorative arts, they give an excellent insight into the character and daily life of the inhabitants. In one case someone slyly tells his enemy to "go hang yourself." What political oratory is joined with such modern-appearing words as "Elect Marcellinus"? One can easily surmise the associated incidents in reading "Romula trysted here with Stephylus," or when a youth expressed his feelings with "Cestilia, queen of the Pompeians, sweet soul, greetings to you." On a Pompeian wall originated the often quoted jingle, "Fools' names, like their faces, are always seen in public places."

POMPEIAN FURNITURE. Furniture in the Pompeian rooms was sparse and limited to essentials, an aesthetic necessity when walls were so elaborately treated. Each piece was a work of art—made by the hands of an experienced craftsman and intended to be a pride of the owner. Many of the objects were of Greek or

The lighting of rooms was extremely inadequate compared to modern standards, but much thought was placed upon the design of lamps, torches, and candelabra. These were made in metal and terra cotta and enriched with low relief ornament or colored glass. The lamps had only one small wick. The candelabra, holding several lights, were often designed as a column, human figure, or decorated shaft standing on a pedestal or supported by a tripod in the form of animal legs.

ROOM ACCESSORIES. Some of the minor crafts were developed to a high point of perfection. This was particularly true of glassware. The Romans created types and finishes that have never been duplicated. The most famous was a fragile opalescent ware known as *murrhine* used to fashion ornamental vases and drinking cups. The *Portland vase*, for which at first a huge sum of money had been refused by the owner, was finally purchased by the British Museum. It was a blue-black glass upon which were superimposed opaque white figures having the effect of a cameo, a process of manufacturing which is unknown today. Much of the ornamental glassware came from Alexandria, where it was

Stone mosaic of two masks from the late Roman period.

Scala

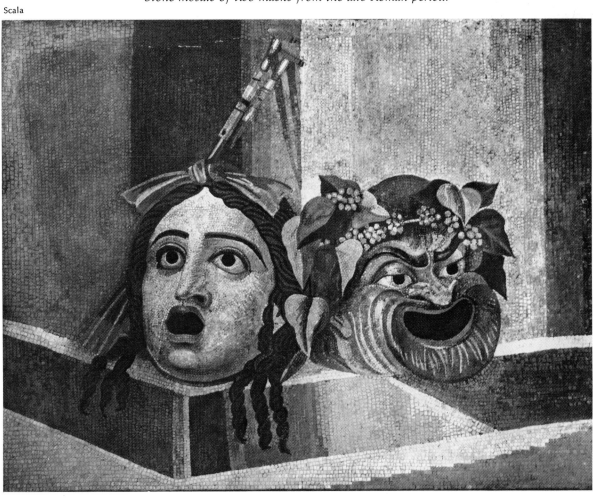

—44—

first made. Bowls, cups, bottles, and cosmetic containers were made of colored blown glass and by fusing strips of different colors, creating such beautiful finishes that the specimens became collectors' items, and vast sums were offered for unusual examples.

Mirrors were of polished bronze or silver, made in small sizes for hand use or to hang on the wall. Large-sized mirrors were set on casters to be easily moved about.

Dining services were made of gold, silver, and a red glazed pottery. Earthenware and terra cotta were used for the production of small household ornaments designed in the form of human, animal, and bird statuettes. In the museum at Naples can be seen pens and inkstands, kitchen utensils, musical instruments, and toilet articles.

THE INFLUENCE OF POMPEIAN ART ON LATER CIVILIZATIONS. When in the middle of the eighteenth century, Italian, French, and English excavators discovered the ruins of Pompeii, hosts of artists and designers immediately went to Naples to study the domestic arts of the ancient Roman city. The forms and patterns found there were transmitted to Paris and London and strongly influenced the design of the productions in practically every art industry. The influence of the Pompeian decorative details upon other European arts during the eighteenth century is of major importance. Since the Pompeian artist was mainly called upon to produce the effect of three-dimensional forms of decoration by the use of two dimensions only, he wisely took advantage of his opportunity and permitted fantasy to dominate his imagination. The designer in heavy materials necessarily rejected the use of delicate proportions, but after the discoveries at Pompeii became common knowledge, both the architecture and the decoration of Europe showed a more distinct tendency toward lightness of line, in contrast with the earlier classic forms that had received their interpretation through the eyes of the Italian Renaissance designers.

BIBLIOGRAPHY

Bohr, R. L. *Classical Art*. Dubuque, Iowa: William C. Brown, 1968.

Breasted, J. H. *A History of Egypt from the Earliest Times to the Persian Conquest*. New York: Charles Scribner's Sons, 1909.
An illustrated history of Egypt.

Buhlman, J. *Classic and Renaissance Architecture*. New York: William Helburn. Reprint.
Brief text with scaled drawings. Excellent for tracing.

Carcopino, Jerome. *Daily Life in Ancient Rome: The People and the City at the Height of the Empire*. New Haven: Yale, 1940.

Esquié, P. *The Five Orders of Architecture*. New York: William Helburn.
Scaled drawings based on the system of Vignola.

Gusman, P. *La Décoration Murale à Pompei*. Paris: Éditions Albert Morancé, 1924.
Excellent color reproductions of Pompeian murals.

Hale, William Harlan. *The Horizon Book of Ancient Greece*. New York: Doubleday, 1965.

Lucas, Alfred. *Ancient Egyptian Materials and Industries (4th Ed.)*. New York: St. Martins Press, 1962.

Matz, Friedrich. *The Art of Crete and Early Greece* (Art of the World Library). New York: Crown Publishers, Inc.

Mau, A. *Pompeii: Its Life and Art.* Translated by Kelsey. New York: Macmillan Co., 1902.
 Illustrated text. Standard authority.
Murray, Alexander Stuart. *Handbook of Greek Archaeology.* (Vases, Bronzes, gems, sculpture, terra-cottas, mural paintings, architecture, etc.)
Richter, G. *A Handbook of Greek Art.* 6th ed. London and New York: Phaidon, 1969.
Richter, G. *Ancient Furniture.* New York: Oxford University Press, 1926.
 An excellent treatment of furniture, with illustrations.
Wheeler, Sir Mortimer. *Roman Art and Architecture.* New York: Frederick A. Praeger, 1968.
Zervos, C. *L'art en Grèce.* Paris, 1934.
 Beautiful photographs of Grecian buildings and statuary.

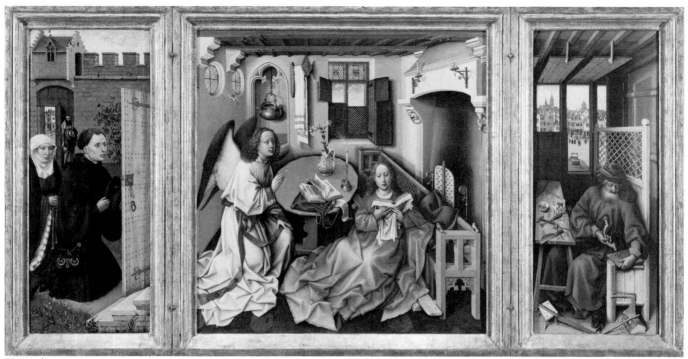

The Merode altarpiece by Robert Campin, a Flemish fifteenth-century painting which is the earliest instance of the Annunciation occurring in an everyday environment.

CHAPTER 2

The Styles of the Middle Ages

Christ with Angels in a thirteenth-century pen drawing.

The arts of Europe between the fourth and the fifteenth centuries after Christ, though distantly related to those of modern times, were of great brilliance and interest. The thousand years frequently referred to as the "Dark Ages" produced forms of architecture and decoration that were the fervent expression of the souls of the faithful at a time when political order was at its lowest ebb. Misery existed in all branches of human existence and there was little to live for but the hope of peace and happiness in the hereafter. The masses were fed the incomprehensible, magical, mysterious, and invisible. Such logic that existed was limited to the clerics. Probably no period of art history has been more expressive of the contemporary character of its people.

The Middle Ages were years of magnificent architectural development. Architecture so dominated the minds of the artists and craftsmen of the lesser arts that its forms were copied and applied to the limit of their possibilities. The weaver, wood-carver, carpenter, painter, metalworker, book illuminator, and hosts of others borrowed the structural and ornamental forms of buildings and adapted them to their own particular mediums.

Since religion was the dominent interest of Europe, architecture consisted primarily of church construction. Secular and domestic building was given little attention until toward the end of the period. It becomes necessary, therefore, to examine the historical, social, and political events of this period which were responsible for the remarkable impetus in the construction of cathedrals and other ecclesiastical buildings in nearly every city and town of Europe.

The main divisions of the arts of the Middle Ages are:

1. BYZANTINE (330–1453).

 The style developed in Constantinople from the time when it became the capital of the Eastern Roman Empire until its capture by the Turks. The style is characterized as a fusion between a debased Roman art and Oriental forms. Domed ceilings are typical.

2. EARLY CHRISTIAN (330–800).

 The style developed in central Italy and to some extent in other countries bordering the eastern Mediterranean. Churches were built on the basilica plan from stones taken from the ruins of pagan temples. Flat ceilings.

3. ROMANESQUE AND NORMAN (800–1150).

 These styles developed in France and other Western countries, respectively. They were characterized by simple, vigorous structural forms with semicircular arched openings used for doors, windows, and ornamental forms. Vaulted ceilings.

4. GOTHIC (1150–1500).

 The style originated in France and spread over the whole of western Europe. It was an outgrowth and elaboration of the Romanesque, characterized by the use of the pointed arch, *buttress, tracery,* and large windows, with a corresponding reduction in wall areas. Pointed, arched ceilings supported by ribs carried down to slender clustered column supports. Structure dominated by balancing *thrust* and *counterthrust.* Dominance of the vertical line. Oak used for woodwork and furniture. Furniture designs borrowed from architectural forms.

INTRODUCTION OF CHRISTIANITY IN THE ROMAN EMPIRE. In the second century of the Christian Era, important events developed in Rome that were eventually to shake the foundations of the empire. The Roman legions had suffered defeats that weakened the confidence of the

people in their existing government. Insurrections, civil wars, and murders of emperors were frequent occurrences. The examples of moral degradation and dishonesty set by the patricians, who endeavored to forget their waning glories in riotous living, were imitated by the middle and lower classes. The pious philosophy of the Christian religion, which had first appealed to the oppressed groups in the Roman provinces of Asia Minor, had been accepted by the lower classes in Rome, whose prayers to the pagan gods had remained unanswered, and who willingly grasped at the simple beliefs and hopes offered by the early Christians.

The teachings of Christ came to the civilized world when they were most needed. The twilight of the power of force and terrorism was to fade before the dawn of the power of humility. The Christians, who were considered the radicals of the period, were in severe conflict with the government of Rome during the first three centuries of our era, and were forced to use the stone quarries of Rome, known as the *catacombs*, as places of refuge, worship, and burial. On the walls of the catacombs still can be seen the sculptured and painted decorations which consist of early Christian symbols and portraits of the early saints and martyrs.

THE ROMAN EMPIRE SPLIT INTO TWO PARTS. By the beginning of the fourth century the Christians had become a sufficiently powerful political party to obtain representation in the Roman senate, and the conflict between the Christians and the followers of pagan beliefs was finally brought to a crisis when Constantine the Great came to the throne, in A.D. 323.

Constantine permitted the Christians to worship without molestation, and later he himself adopted Christianity. Because of this and other considerations he felt that it was impossible to rule the empire from Rome. On his visits and conquests in the outlying districts of the empire he had had ample opportunity to observe the great beauty and the incomparable position of the city of Byzantium, guarded by nature against hostile attack and accessible to commercial intercourse. Like Alexander the Great, Constantine was not insensible to the ambition to found a city that would glorify and perpetuate his name. He decided to leave the confusion at Rome in the hands of a local governor, while he and his followers removed to the banks of the Bosporus. In the year 330 he changed the name of the provincial city to Constantinople and officially proclaimed it the new capital of the Roman Empire, which subsequently became known as the Byzantine Empire.

The wisdom of Constantine was confirmed by the turmoil that continued in Rome during the next century and a half. Rome, repeatedly invaded by "barbarians" from the North, finally fell in 476; Odoacer, a barbarian from the North, proclaimed himself king of Italy, thereby officially extinguishing the Roman Empire of the West. During the next five centuries western Europe was in the throes of establishing the political leaderships which eventually culminated in the nations of today.

THE BYZANTINE PERIOD

Among the followers of Constantine were many leaders of Roman and Greek culture and all types of craftsmen who had been trained in the best classical traditions. As generation succeeded generation, time and distance served to lessen the Roman influence. The new capital became a melting pot for an infinite number of diverse races. Its wealth increased rapidly. The population became lazy, profligate, vicious, and uncooperative, and required a strong-handed leadership that created fear in the hearts of the people and demanded an intense loyalty to the church organization with which the state was synonymous. In spite of these conditions, the Imperial court functioned for over a thousand years and preserved the culture of the ancients while the whole of western Europe was in a

state of chaos. The Eastern Church developed doctrinal differences with the Church of Rome, some of which greatly affected the character of ecclesiastical decoration. The iconoclastic movement of the eighth century forbade the representation in sculpture of all human or animal forms, believing that it savored too much of idolatry and was a violation of the second commandment concerning "graven images." This also eventually culminated in the split between the Roman and Greek Orthodox churches. Roman cultural elements became mixed with infiltrations from Persia and Arabia. From the fusion of debased Roman art forms with those of the Orient, both affected by Christian doctrine, sprang the culture, splendor, and the magnificent arts of the Byzantine or Eastern Empire.

The brilliance and ostentatiousness of the interiors of Byzantine churches contrast strongly with the severe and simple treatment of the buildings of the corresponding period in western Europe. Each type reflected the intellectual level and respective wealth of the people who built them. While the Eastern Empire was experiencing its most opulent period, France and England were buried in despair and poverty, and lacked the courage or desire to protest until the return of the Crusaders.

Little remains of the domestic architecture of the period. The Byzantine style is primarily important and interesting due to developments in construction methods and the richness of the interior decoration of the first and oldest Christian church, Hagia Sophia in Constantinople. The beauty, magnificence, and color of the interior of this structure overwhelmed the Crusaders, who viewed it with awe and astonishment; the splendor of its ritual was never equaled in the West.

STRUCTURAL CHARACTER AND PENDENTIVES OF HAGIA SOPHIA. Constantius II in the year 360 built a church on the basilica plan, which after a fire was rebuilt by Theodosius III in 415. The present building was erected by Justinian in 532. It was called at first Hagia Sophia, meaning Divine Wisdom, later St. Sophia. Upon the capture of Constantinople by the Turks in 1453 it became a mosque, and after World War I was made a public museum.

The plan of the church retains its basilica form, and it is roofed by a series of domes and half-domes, features that since have become characteristic of Near Eastern Moslem architecture. The intersection is crowned by a great brick dome 107 feet in diameter, the outward thrust of which is counteracted on two sides by two half-domes of the same diameter leaning against the lower portion and by two enormous buttresses on the other two sides. The Romans were accustomed to building domes on circular structures, but in Hagia Sophia the dome is supported at the square intersection by four heavy piers, one at each corner. This square substructure, intended to support a circular dome, presented a new problem in architectural construction. It was solved by the Byzantine engineers, who by a fantastic feat created an entirely new architectural form known as a *pendentive*. A pendentive is a concave triangular stone surface that starts at a point on the corner of a pier, rises and spreads out to the two upper points of the triangle in a concave-curved fanlike shape until it approaches a horizontal and meets the circle of the lowest part of the dome, which the masonry of the pendentive supports. Each pendentive supports one quarter of the dome. Considering the enormous size, weight, and thrust of the dome, this form of support was a miracle in stonecutting. In Hagia Sophia each pendentive rises sixty feet and curves forward twenty-five feet. This structural principle was later used by the Renaissance architects and is a feature of St. Peter's in Rome.

THE INTERIOR ARCHITECTURAL FEATURES OF HAGIA SOPHIA. The standard proportions of the architectural orders established by Vitruvius had been disregarded by the time Hagia Sophia was built. Columns were made in a variety of

Agence Top

Interior of Hagia Sophia, Istanbul, showing the triangular pendentives supporting the great central dome.

proportions; the entasis on the shaft was omitted, and the capitals became crude interpretations of Corinthian forms with clumsily carved acanthus leaves and volutes, or they were carved with a lacelike ornament of Eastern origin. A few of the columns are of green jasper and *porphyry* taken from Roman temples. Moldings and entablatures were omitted. The semicircular arch was used exclusively and extensively for both structural and decorative purposes in windows and openings. Where rows of columns were used as a substitute for the lintel, a semicircular arch sprang from each column. The ratio between the height of the arch and its width varied greatly.

THE WALL TREATMENT AND MOSAICS OF HAGIA SOPHIA. Due to the ecclesiastical dogma forbidding the use of sculptured forms in decoration, the art of the mosaic worker reached its

apex in Hagia Sophia, the interior of which is one of indescribable color. Every inch of wall surface is covered with colored glass mosaic set in a sparkling golden background, or by exotic marble slabs arranged so that the graining shows a pattern arrangement. The small windows admit the slanting sun rays, which pierce the atmosphere and produce a mysterious and reverential effect. The purpose of such splendor was to impress the worshipper with the power and magnificence of his church and state and cause him to forget his own afflictions while contemplating a heaven on earth.

The four pendentives were decorated with representations of the Archangels, and the figure of Christ can still be seen above the *apse.* Other patterns show biblical scenes, saints, historical personages, or symbolic figures ·such as the peacock, which stood for immortality, the

endless knot representing eternity, and the monogram of Christ. The dust and smoke of ages has laid a filmy surface over the lustrous colors, softly blending them into complete harmony. Borders, frames, and band courses were sometimes made in brickwork set diagonally or in herringbone patterns. The acanthus leaf and other small decorative motifs are occasionally shown in incised carvings rather than in relief. The windows are sometimes filled with thin slabs of translucent colored marble through which the sun glows, giving them the effect of stained glass. Many of the Christian mosaics were covered with stucco after the Turks captured Constantinople, but some of these have recently been uncovered revealing extraordinary examples of the surface decoration of the eighth and tenth centuries.

THE MINOR ARTS. The inhabitants of the Byzantine Empire were more concerned with abstract questions of theology than with artistic triumphs. Early church history is filled with the discussions that eventually established the dogmas, doctrines, and tenets of Christian organizations. In Constantinople, the church and state were one, and the church drew within its folds the artists and craftsmen as well as the philosophers and leaders. There were practically no secular arts, but within the walls of the monasteries minor arts were lavishly produced. From the tenth to the twelfth centuries exquisite religious *cloisonné* and *champlevé enamelware*, ivory carvings, brass utensils, and textiles were made. Many monks spent their lives working on richly illuminated manuscripts. The expenditure of effort and labor was of no consideration so long as it resulted in a perfect object of lasting beauty which would contribute to the glory of the church.

After the capture of Constantinople, many of the eastern monks resorted to caves and sheltered rocks in inaccessible places, became hermits, and spent their lives in poverty, inaction, prayer, and meditation. The locations of many of the original hermitages are still known; they often commanded magnificent views midst a paradise of beauty. Though little furniture was used, the occupants had their personal altars, kitchen gardens, and rock-cut wells, and for companionship they treasured their dogs and grazed their cattle. Their asceticism was largely mental, as they had the material necessities of life, and their hardships were mitigated by an ardor that produced exhilaration. The monks of the Western Church shared a similar asceticism until the thirteenth century, when the Dominican and Franciscan orders felt their duty was to spread the teachings of Christianity and to improve the conditions of the illiterate and downtrodden peasants of Europe by living among them.

THE INFLUENCE OF THE BYZANTINE ARTS. Byzantine art is reflected in the styles of modern Greece, Russia, and other countries where the Greek Orthodox church has been the dominant religious organization. The influence of Byzantium was also felt in the Gothic arts of France and England after the return of the Crusaders, who had observed the Oriental magnificence and superior civilization of the East.

The Byzantine Empire continued until the year 1453, when Sultan Mohammed II captured and pillaged Constantinople and made it the capital of the Turkish Empire. The fall of Constantinople, its control by the Turks, and the difficulty, thereafter, of trading with the Orient were the greatest contributing factors in the decision of Columbus to find a new route to the East. The capture of Constantinople, therefore, became one of the most important events in the history of the world. It closed the long period of Byzantine culture; the crescent supplanted the cross, and Christian churches became Mohammedan mosques.

The Byzantine coins had been stamped with a design of a crescent, symbolizing the shape of the harbor of Constantinople, which was known as the Golden Horn. After the fall of Constan-

tinople, the Turks adopted this symbol as their national emblem, and it was frequently used as an ornamental motif in textiles, rugs, and other patterned designs.

EXAMPLES OF BYZANTINE ARCHITECTURE AND DECORATION. The Byzantine style extended to the portion of Europe that came under the control of the eastern emperors. Examples are found in Greece and Asia Minor. San Vitale was erected in Ravenna in 547, but the most interesting western example is St. Mark's in Venice, erected in 1071 and known to every tourist. St. Mark's is a Roman Catholic cathedral built in the form of a Greek Cross, roofed with five domes supported on pendentives. The exterior and interior are covered with brilliantly colored mosaics. The building is situated on the great Piazza of San Marco with a background of the deep Venetian sky and the glistening waves of the blue Adriatic. Its domes are crowned in gold, and its façade sparkles in the brilliant sunshine. The arches forming its portals support the great horses taken from Nero's triumphal arch.

The Russian churches were the inheritors of the style and show in their general design and detail much that is of Byzantine origin.

THE EARLY CHRISTIAN PERIOD

The term *Early Christian* refers to the style of art that existed principally in Rome and neighboring towns after the official adoption of the Christian religion by the people of the Roman Empire.

Several years before his death in 337, Constantine allowed Christian churches to be built as co-existing with pagan temples in Rome. In the wave of religious enthusiasm following this command, haste was important, and no stone quarries were more convenient than the ruined temples of the gods of classic mythology. The splendid columns, capitals, moldings, and other stones, many of which had been imported from distant lands, were reassembled to play their

parts in the erection of the new churches built in a plan resembling somewhat the Latin cross. This type of building was called a basilica. It resembled the Roman building of this form. The astonishing feature of these Early Christian churches was that a reassemblage of architectural fragments originally designed for other buildings should produce such remarkable results.

With the growth of Christian organization came the gradual loss of faith in civic control, law, and order, and the almost complete disintegration of national spirit. It was inevitable that under such conditions the craftsmen should also disregard established traditions of art. Teachers were no longer at hand to instruct in the old way, nor were they even desired. Not many generations were to pass before a new art would be in the making and new traditions established.

The "barbarians" who had overrun and sacked Rome had been sufficiently awed by the merits of Christianity to refrain from invading the precincts of the Christian church. The Romans, realizing this fact, transferred much of their wealth and many of their most valuable belongings to the religious orders. The Church drew within its gates many of the descendants of the old patrician families, who sought the protection of its robe and veil. Thus was established some of the early wealth of the Roman church, which was later used to build, decorate, and furnish some of the most elaborate buildings ever constructed.

THE CHARACTER OF THE EARLY CHRISTIAN BASILICAS. In the rearrangement of the stones and ornamental details taken from Roman buildings for use in the construction of the early basilicas, columns were frequently used without entablatures. Semicircular arched forms were featured in the construction, and, as in the Byzantine style, arches frequently rose directly from the capitals without intervening moldings. The walls of Early Christian churches were straight, rose to a considerable height, were

Anderson

Interior of the early Christian church of Saint Paul's Beyond the Walls.

pierced with windows at the top, and supported an elaborate horizontal wood-paneled ceiling. In the decoration of the walls, mosaics, paintings, and marble incrustations produced brilliant and colorful surfaces. The growing wealth of the church and the elaboration of its ritual gradually contributed to the enrichment of the equipment and furnishings.

Reconstructed buildings in the Early Christian style were not extensively produced in the Roman colonies, because there were few pagan temples to be razed for reerection. A few examples exist, but the colonies hesitated to destroy their most noble and impressive civic adornments.

EXAMPLES OF EARLY CHRISTIAN ARCHITECTURE. The extant remains of the Early Christian style consist of several churches, *baptisteries*, and sepulchral structures. In Rome, St. Paul's Beyond the Walls was built in 386 by Theodosius, and S. Maria Maggiore in 432. In Ravenna, S. Apollinare Nuovo, built by Theodoric the Goth, and S. Apollinare-in-Classe are still standing. Early Christian architecture may be found in the Church of the Nativity, Bethlehem, and the Church of the Ascension, Jerusalem.

Anderson

Mural painting in Vatican of eighth-century early Christian basilica showing method of construction, roofing, and clerestory windows.

THE ROMANESQUE AND NORMAN PERIOD

The term *Romanesque* is applied to the style of art that arose in Italy and southern France after the time of Charlemagne and continued until it evolved into the forms of the twelfth century that are known as Gothic. It progressed slowly until the year 1000. The style was carried by William the Conqueror in 1066 to England, where it is known as "Norman." The northern Romanesque differs in character from southern

Romanesque because of dissimilarities in climatic conditions and the temperaments of the people.

The activating cause of the Romanesque style was the comparative tranquillity that settled upon Europe after the barbarian invasions, which was followed by a hunger of the masses for peace and security. These essentials were offered by a leadership that carried a cross as well as a sword, furnished religious salvation, and proposed a practical system of daily life. The response, impelled by loyalty and necessity, resulted in the construction of churches throughout Europe that were to serve not only as places of worship, but as strongholds, schools, libraries, town halls, museums, and centers of social life.

The monks, as amateur architects, were the planners. They taught the enthusiastic natives elementary masonry, carpentry, and ironworking. Untrained as designers, it was logical that the builders used the only models that were at hand. The designs were their own crude conception of Roman architecture adapted to Christian requirements and limited by the materials, craftsmanship, and tools that were available in each locality.* The buildings that resulted were massive and strong, simple in surface enrichment, and often forbidding in appearance, but they faultlessly expressed the naïve spirit of a simple people and the vigor of the early church. Romanesque art must be judged with a realization of the intellectual level and general condition of western society at the time it was produced.

THE CONDITION OF WESTERN EUROPE FROM THE YEAR 476. After the fall of Rome, the western colonies were thrown upon their own resources. Intellectual stagnation increased as tribal war-fare developed, and countless local leaders endeavored to establish their supremacy. Out of the warring rose Charlemagne (742–814), who conquered and united the barbaric tribes under his rule. He was the great early patron of the arts in western Europe, but as evidence of the utter ignorance into which the people of this period had fallen, it is stated that Charlemagne himself could read, but could not write. Nevertheless, he surrounded himself with the most learned men of the time. The period of Charlemagne was followed by the invasions of the Normans in France and Italy, the Crusades, and the establishment of feudalism, an economic and social system binding the serfs to the land, requiring military service in payment for land use, and taxes paid to the suzerain by giving a portion of the agricultural production.

THE RELIGIOUS ECSTASY OF THE MIDDLE AGES. Charlemagne fostered the Benedictine order, which had been founded in 529 at Monte Cassino† in Italy. This order had monopolized and preserved all the records of science, letters, and arts of antiquity through the periods of the invasions of Europe by the Huns, Goths, Visigoths, Vandals, and Saracens. It had undertaken to educate the youth and to control the spiritual and temporal affairs of the masses through the period of confusion. Many other religious orders such as the Carthusians, Knights Templars, Dominicans, and Franciscan Friars were later established, and these assumed the responsibility of peacefully conquering Europe for the Roman popes and establishing some semblance of justice and peace. The monks became the messengers of a new civilization and followed the forest paths into the European wilderness to establish Christianity.

* The stone carvers of the early Romanesque had only the ax as a cutting tool. The chisel was not used until the end of the period.

† This monastery, standing on a mountaintop, was used as a fortress by the Germans in World War II. It was unfortunately almost completely destroyed by the necessary American bombardment.

Interior of the Basilica of Vezelay, France. Late eleventh century. Semicircular vaulted roof and Byzantine influence in the contrasting voussoirs of the arches are shown. The choir is Gothic.

In the tenth century the native population of northern and western Europe dwelt in hovels of mud and straw. For centuries they had been degraded, murdered, dispossessed, and lacked competent leadership. Many believed the superstition that the world would end in the year 1000 and prepared themselves for this event. When the millennium passed without disaster, the surprise and joy of the people developed into a tremendous spiritual reaction, which was to benefit greatly the ecclesiastical organizations. The monks, who were the confidants of the people, needed administration buildings, hospitals, schools, shelters for the weak, poor, and orphaned, and they needed churches in which to congregate the faithful and to demonstrate the benefits of Christian principles. The people grasped at the opportunities that were offered to them, and with gratitude and enthusiasm donated their bodies and souls, their time, energy, and worldly goods to the promotion of a Christian civilization and its external evidences. Church construction was closest to their hearts,

Byzantine double capital showing Oriental influence in its lacelike design.

Metropolitan Museum of Art

Romanesque capital of the educational type.

Metropolitan Museum of Art

Romanesque capital showing leaf type.

Ruins of the Temple of Diana, Nimes, France, considered the prototype of Romanesque construction. The pile of stones supported by the side arch was necessary to resist the weight and thrust of the main semicircular vaulted roof.

and became an urgent necessity.* Such was the degree of zeal and religious frenzy that for five centuries produced the most sublime and awe-inspiring buildings ever created by man.

STRUCTURE OF ROMANESQUE CHURCHES. Some of the early Romanesque churches in Italy were constructed in part from the ruins of ancient

* An abbot who wrote in the twelfth century describes the spirit in building one of the great cathedrals as follows: "... who has ever before heard of powerful princes of the world, brought up in honor and wealth, and nobles, both men and women, who have bent their proud and haughty necks to the harness of carts, and like beasts of burden, dragged to the abode of Christ, wagons loaded with wines, grains, oil, stone, wood, and all that is necessary for the wants of life or for the construction of the Church? While they draw these burdens —often when 1000 persons and more are attached to the wagons—so great is their difficulty—yet they march in such silence, not a murmur is heard.... The priests preside over each wagon exhorting every one to penitence, confession of faults, or a resolution to a better life ... old people, young people, little children call on the Lord with a suppliant voice ... with words of glory and praise." Transcribed from *Mont-Saint-Michel and Chartres* by Henry Adams, published by Houghton Mifflin Company, Boston, 1913.

Roman buildings, but in western Europe, and particularly southern France, there was an insufficient number of these to fulfill the demand. The stone that was required for the new structures often had to be transported from distant quarries, and the character of the arched construction necessitated that such materials be cut into small sizes. The Christians did not have the slave and military labor that had been available to the Romans, but many of the workers contributed their services as a religious obligation. Without this economic system, the majority of the great cathedrals could never have been built.

Many of the Early Christian churches had been destroyed by fire, due to the use of wood in their roof construction. Romanesque builders depended entirely upon the stone arch. The Temple of Diana in Nimes, France, was an example of a second-century building which was roofed by a semicircular vault supported on col-

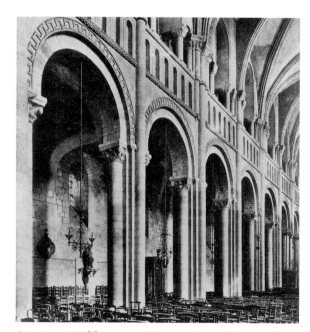

Interior of Abbaye-aux-Dames, Caen, France, showing the nave and side aisle. The church was erected in the time of William the Conqueror.

umns, the thrust being counteracted by the weight of an additional small arch placed on either side. This structure is generally accepted as the prototype of all Romanesque and later Gothic churches.

The basilica plan, perhaps for sentimental reasons, gave way to one in the form of a *Latin cross* by the introduction of the *transept*. The church was usually made to face westward to enable worshipers seated in the *nave* to face eastward toward the altar. The Roman semicircular arched vault was used not only in the construction of the roof, but this arch form was eventually to become the shape of all doors, windows, and other openings, and finally was used for purely ornamental purposes. The semicircular arch form is the most characteristic decorative feature of the Romanesque style.

The nave of the church was separated from the side aisles by a row of heavy columns proportioned without regard to Vitruvian standards, concerning which nothing was known. A semicircular arch rose directly from the capital of each column, and spanned to an adjoining column. This row of arches supported a wall pierced with *clerestory* windows. The arched ceiling was supported by the ribs that crossed the nave both at right angles and diagonally.

ROMANESQUE ORNAMENT. For the benefit of an illiterate people, the ornament used to enrich the interiors of Romanesque churches was largely informative or instructional in character. Sculptured panels and column capitals showed scriptural subjects, allegorical scenes indicating the rewards of virtue and the punishment of vice, seasonal occupations, historical events, foliage, and fantastic animals. The sculptured figures were ascetic in character, ill-proportioned, and often intended to terrorize sinners. Capitals of columns showed leaves that are reminiscent of Corinthian classic forms intertwined with biblical personages. The abstract patterns included the *checkerboard*, the *chevron* or zigzag, rosettes, and embattlements resembling the fret.

Scala

Aerial view of Notre Dame, Paris.

The technique of the carving was crude and clumsy, and motifs were often conventionalized.

EXAMPLES OF ROMANESQUE ARCHITECTURE AND DECORATION. The most characteristic examples of Romanesque art are the Cathedral and Leaning Tower of Pisa, Italy (1172); the porch of St. Trophime, Arles, France (twelfth century); portions of Mont Saint-Michel, France; the Abbaye-aux-Hommes (1066) and the Abbaye-aux-Dames (1083), Caen, France; the abbey (commenced 860) at Vezelay, France; and the Durham (1096–1133) and Peterborough (1117–1190) cathedrals, England.

THE GOTHIC PERIOD

The term *Gothic*, meaning "barbarous," is a misnomer as applied to the arts of the Middle Ages. The word was first used by the Italian

Vasari (1511–1574), the painter, architect, and biographer, who found his ideals in the arts of Greece and Rome, and applied the term in derision to the arts of western Europe. The term, however, is so generally associated with the architecture and other arts in Europe produced between the twelfth and the sixteenth centuries that it has become a fixture in the language, and its implied inferiority has disappeared.

The Gothic style was the florescence of the sturdy Romanesque period and the architectural and aesthetic expression of a civilization in which religion and the spiritual side of existence were the most important interests in the life of everyone, and in which a large portion of each individual's wealth and effort was contributed to the glory of the Almighty. The Gothic cathedral, built by the people rather than by the clergy, became the center of town life and filled the requirements of the modern town hall, library, school, museum, and picture gallery. No buildings have ever been constructed that have surpassed the Gothic cathedrals in their effect of exaltation, mystery, awe, and inspiration.

Gothic art in all its branches was conventional and idealistic. The spirit of piety, humility, and asceticism, which was the fundamental teaching of the Church during the Middle Ages, was expressed in architecture, sculpture, painting, and all the minor arts. Starting with vigorous, massive construction, the tendency of architectural design was constantly toward height and lightness, until extreme delicacy of structural form and overornamentation gradually led to its fall. While the purpose of Romanesque art had been to teach, that of Gothic art was to appeal to the emotional side of a joyless people who were steeped in ignorance and superstition. Through the Church, however, the learning and wisdom of the ancients were preserved through a thousand years of social and political turmoil.

THE EFFECT OF THE CRUSADES. The seven Crusades that occurred between the years 1096 and 1270 were of great political, economic, and artistic importance. A spontaneous outburst of overpowering sentiment and self-sacrifice, this movement included all classes of people and resulted in a lessening of the social distance between suzerain and serf. Expansion of knowledge occurred, and an impulse was given to trade and commerce. The outfitting of the Crusaders alone demanded an enormous expenditure of money and an introduction to a degree of luxury that many had never known. Elaborate furs, emboideries, gold ornaments, colorful banners, and shining armor were among the splendors introduced. The eastward march brought the Crusaders into contact with the extravagant architecture and wealth of Constantinople, the silk textiles of Damascus, Mosul, and Alexandria, the exquisite glassware of Tyre, and the jewels and pearls of the Byzantine and

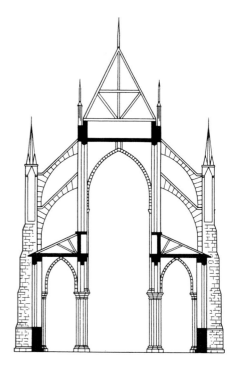

Section of Gothic church showing flying buttresses located to resist thrust of arch over nave. Section of clerestory windows is shown above roof of side aisles.

Mohammedan merchants. These and a vast number of other rich products of art and industry were purchased and sent to the homes of western Europe.

The Crusades did not accomplish any lasting good so far as their original purpose was concerned. They brought, however, a great change in the thought and in the manner of living of the people of Europe that was first noticeable in the Gothic period. They awakened interest at home in the ancient civilizations of Greece, Asia Minor, and the highly developed culture of the Eastern Empire, and they developed a doubt concerning some of the doctrines of the established Roman church, that later formed the roots of the Renaissance.*

The orders of chivalry that had originated in the eighth century were greatly expanded during the Crusades. The knight swore to be the champion of God and woman, to speak the truth, to maintain the right, to protect the distressed, and to practice gallantry, courtesy, and generosity. His military duties, however, forced him into distant lands for long periods, and his wife was not always the recipient of his attentions. Chivalry fostered domestic intercourse, affection, sentiment, a greater respect for women, a refinement of manners in speech and action, and contributed greatly to the development of the home by increasing its privacy,

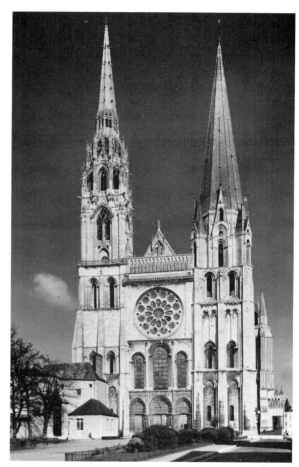

A. F. Kersting

West front of Chartres Cathedral.

comforts, conveniences, and luxuries. In the absence of the husband, the interests, activities, and responsibilities of the wife were increased. Women were left to take care of themselves and to assume the management of estates. They were generally placed on a higher plane.† Entertainment was furnished by wandering troubadours accompanied by jongleurs, dancers, mummers, and minstrels, who with their

* The Crusades were not wholly to the credit side of Christianity. In the early years of the thirteenth century a large group of independent Christians in Albi in southern France who opposed the doctrines and asceticism of the Church of Rome were all put to death by Simon de Montfort, who attacked the city with half a million men. A few years later, under the religious hypnosis, occurred the hopeless Children's Crusade, when ninety thousand boys and girls left their firesides in Germany and France to drive the Turks from Palestine. These children were nearly all lost by shipwreck or sold as slaves to Mohammedans before they reached their goal. Other disastrous results of the Crusades were the introduction into western Europe of leprosy, influenza, and the bubonic plague.

† During the early Middle Ages, the character of man and woman was much more similar than it is in modern times. Men did not hesitate to show their emotions, and women often used vulgar language.

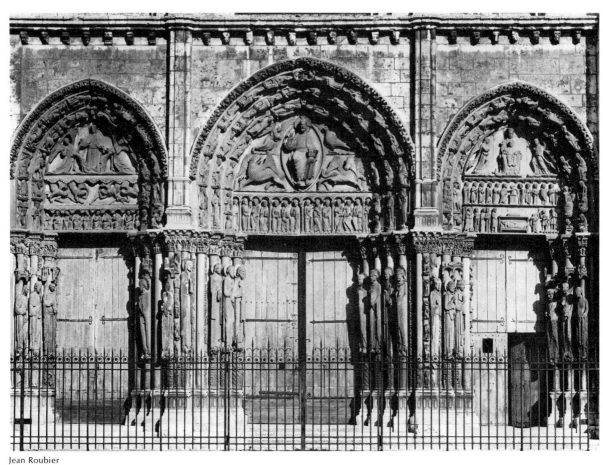

Jean Roubier

Detail of the west front of Chartres.

chansons-de-geste supplied gayer music than the Gregorian chants of the Church. These songs were the origin of all later secular music.

THE INFLUENCE OF THE MADONNA UPON ART. In the early days of the Christian church great reverence was given the relics of the saints. The original cross was claimed to have been found in Jerusalem in 328 by St. Helena, and supposed portions of the shroud of Christ and the tunic of the Virgin were distributed throughout Christendom. *Reliquaries* were made in gold and enamel and inlaid with precious jewels to hold sacred fragments of all kinds. By the tenth century a large commerce had developed in these objects, which sold for enormous prices and often were later proved to be spurious. The sale of relics was forbidden by the pope in 1198 without effect. The exhibition in church pageants of dismembered corpses was finally ridiculed, and people turned from the relics in disgust. The Church authorities, realizing a change in the practice was necessary, began to substitute images of the Virgin for adoration. Christ was considered too sublime, too regal, for this purpose; his divinity placed him aloof, and he alone could be worshipped, but not even the frailest or most sinful would fear to approach or reverence one whose attributes were infinite humility, love, pity, and forgiveness. The Virgin was human, could be addressed in person, and

understood the griefs and passions of a lowly peasant who fully realized that his king and queen also constantly called upon her for help. So Mary, who had long been the patron saint of the Eastern church, was raised to the position of "Regina Coeli," Queen of Heaven, in the Roman church, and thereafter her image was carried at the head of every procession, adorned the walls of every hut and castle, and was placed at the masthead of every ship. Her importance began to overshadow the Trinity. Shrines were erected to her. One church in every town was dedicated to *Notre Dame*, and the *Lady Chapel*, the one of greatest beauty in every church, was placed behind the high altar and decorated in the most feminine taste, with softened colors, and was dimly lit to enable the worshiper to commune in silence, feel her presence and sympathy, and address her in person. The earliest development of an aesthetic sense and appreciation among the masses of western Europe can be traced to the emotional reactions occurring from constant contact with the representations of Mary and her Infant. The painter, stonecutter, glassworker, or sculptor who worked on her chapel felt that he was in the Virgin's employ and that his mistress knew even better than he the quality of his workmanship, and he understood that he would be compensated in the life hereafter on the basis of his efforts and ability. Such ardor could only be the parent of perfection!

The Madonna, as an ideal of artists in every medium, has been used in every art period of the Christian world. Only the style of representing her has changed. The conception of her character has varied from deep compassion and sorrow to one of joyful, healthy motherhood. Her association with theological doctrines has caused a greater financial expenditure by Christians than any single motive except war. Many representations of the Madonna were made in stained glass, stone, wood, and in tempera and fresco. In the Russian *ikons* she is framed in wrought gold studded with precious gems, and the Aztec Indians interpreted her in their own primitive manner to add to the charm and spirit of the Franciscan missions in California.

THE CHARACTERISTICS OF GOTHIC CHURCH ARCHITECTURE. The transition from the Romanesque to the Gothic occurred during the early part of the twelfth century. Gothic art reached its height during the thirteenth century in France and England, when the religious sublimity, enthusiasm, and faith of man combined to conceive the superb cathedrals of the period. The detail of the exteriors of these buildings became the inspiration for the design of contemporary secular buildings, dwellings, and objects used for interior decoration including furniture, wainscots, tapestries, paintings, and other accessories. The care and effort given to the design, construction, and decoration of these churches covered every inch of their surface. Where ornament and pattern were omitted, textural interest was introduced. Adjoining stones were usually of different shapes, sizes, and colors, or chiseled with different surface effects to weather differently and give the effect of a richly woven fabric. The cathedrals of Europe stand today as the supreme creative achievements of Western culture and are only equaled in logic of design by the Parthenon. Yet the names of the men who designed them are in most cases unknown.

The plans are usually in the form of a *Latin cross*. The main body of the building formed the nave, flanked on the sides by low aisles, off which were sometimes built chapels dedicated to saints. Connected with the cathedrals were arcaded cloisters surrounded by the monastic administrative and living quarters. The cross portion of the plan, called the *transept*, furnished additional seating capacity and entrances. At the head of the plan were located the choir and altar, and at the rear of the altar was placed the Lady Chapel with the image of the Madonna. The nave walls were high, and, at a

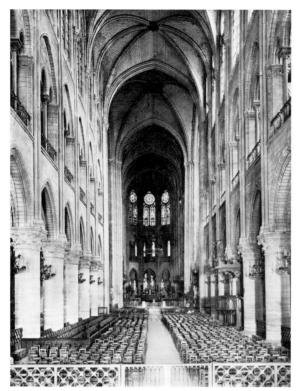

Interior of Notre Dame from choir looking toward nave and clearly showing the ribbed vaulting.

the fact that the exterior walls of churches served to enclose the building, but were not used to support the arched roof and ceilings, these being sustained on very slender isolated piers, designed as groups of clustered columns with overlapping shafts, and crowned with capitals treated with intertwining foliage forms. This new method of supporting a great arched roof on slender stone piers is the basic principle of Gothic design and was the fundamental cause of the visual details that are usually considered the characteristics of the style.

The use of the isolated supports for the arched roof permitted the introduction of enormous windows, especially in northern France and England, where the sun was welcomed. The elimination of the wall precluded the possibility

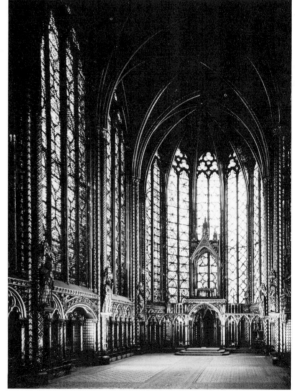

Vast areas of stained glass in the upper chapel of Ste-Chapelle create a space seemingly without walls.

point above the low roofs of the adjoining aisles, they were pierced by *clerestory* windows which served to illuminate the central portion of the church. A great stone arched vault covered the length of the nave, and at each window a vault of equal height was required, which intersected the nave vault at right angles. This arrangement of intersecting vaults is one of the most characteristic features of Gothic design and required an almost miraculous solution of structural problems in order to maintain stability. The Gothic designers, however, continually under the urge of the great spiritual movement, hesitated at nothing.

Gothic ecclesiastical architecture was structurally similar to the Romanesque but was elaborated and enriched a hundredfold. The basic structural difference from the earlier style was

Detail of a stained glass window in Chartres Cathedral. The mosaic type of pattern is typical of the early glass window. Patterns were produced by small areas of glass held in place by leaden strips that delineated the drawing. These were additionally braced by slender iron bars that served to support the whole window. The jewel-like colors give a wonderfully warm and vibrant effect. The large window areas, "translucent walls," admit far less light than one might expect. They act as huge multicolor diffusing filters that change the quality of ordinary daylight, endowing it with poetic and symbolic values.

Interior in the Alhambra, Granada, with its horseshoe arches, tiled wainscot and flooring and the yeseria ornament on the upper part of walls.
Raffaello Bencina/Scala

The Adam interior known as the Etruscan Room, ca. 1775 at Osterley Park. Note the revival of extremely refined Classical ornament and the influence of Pompeian decoration.
Jeremy Whitaker

of mosaic and paint for adding color to the interior and created the necessity for colored window-glass decoration, which resulted in the development of the art of the stained-glass worker. The windows, which often were twenty feet wide and thirty feet high, were too large for glass areas without intermediate supports of slender stone subdivisions called *mullions*. The mullion pattern was known as *tracery*. Tracery patterns, originating as a structural requirement, were later adapted as ornamental motifs for furniture and woodwork panels. The early tracery consisted of vertical mullions crowned with simple pointed arches. In the final development of the Gothic style, the arches were *ogive* in type, each side following an "S" curve. This latter form was called *flamboyant*, meaning flamelike, and the term was later used as a designation for the whole late Gothic style.

Above the main entrance portal of the cathedral façades was usually placed a large circular opening called a *rose window*, which was treated with a spokelike design of tracery filled with ruby, violet, and blue glass through which the rays of the afternoon sun would cast a warm and mysterious glow.

The elimination of the supporting wall often placed too great weight upon the piers, a problem that was solved by making the pier thicker in depth by the introduction of a *buttress* on the outside. Where a single buttress was still insufficient in weight, another buttress was built a short distance beyond, which was connected to the pier buttress by an arch. This arrangement was called a *flying buttress*. Buttresses were also given greater weight by crowning them with an ornamental *finial* motif or a *pinnacle*. The buttress, a structural necessity, later became an ornamental feature in furniture design.

Great rivalry developed between towns and villages to outdo each other in the beauty, size, and grandeur of their cathedrals. This resulted in a trend toward larger and higher buildings.

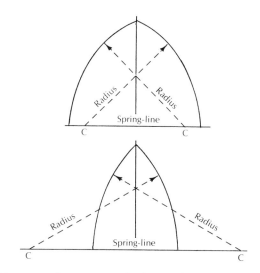

Diagram showing method of designing pointed arches of similar height but varying width.

As the construction was by rule of thumb rather than by scientific principles, many of the buildings fell before completion and were rebuilt with stronger supports.

The whole problem of Romanesque and Gothic design was a contest in equilibrium between the weight of the stone arches and the economy of material in the buttresses. It was a matter of equalizing the thrust and counterthrust. This problem differed from the simplicity of Roman design, where heavy walls had such inert stability and were so extravagant of stonework that they could resist the thrust of almost any arch that could be placed upon them. Gothic structures were built of small stones and much mortar, which enabled the designers to introduce curved forms with greater ease than could have been accomplished with massive blocks. Marble was not available. There was great necessity for economy in the use of material due to the cost of labor and transportation. There are no monolithic features or concrete used in Gothic design.

The second important feature in Gothic design was the introduction of the pointed arch,

1100 and thereafter became the most important decorative feature in Gothic design.

Gothic ceilings were built by first constructing heavy arched *ribs* composed of a series of wedge-shaped stones connecting directly opposite piers. Other ribs starting from each support ran in a diagonal direction to the adjoining opposite piers. This resulted in an X-shaped pattern of ribs. When this construction was completed, the space between the ribs was filled in with masonry supported by the ribs. As the ribs were visible and projected below the ceiling masonry, the pattern formed by the infinite number of rib intersections produced a gossamer effect.

Metropolitan Museum of Art

Twelfth-century figure showing architectural emphasis in the accentuation of vertical line in mass and detail, the arms close to the body, and the folds of the garment in parallel lines.

Metropolitan Museum of Art

Fourteenth-century Madonna showing "Gothic sway."

which was substituted for the semicircular arch of Romanesque use. The pointed form had been used in ancient times but never to the extent to which it was applied in the Gothic period. The shape probably developed from the necessity for having arches of the same height starting at the same level but of varying spans. The arch across the nave was often fifty feet wide, whereas the arch from pier to pier along the length of the nave averaged twenty feet, yet the design called for near similarity in height. As the height of a semicircular arch is only half its width, similar heights could not be attained from the same spring line. The pointed arch fulfilled this requirement, which produced a more harmonious and unified effect in the design and permitted higher windows for nave illumination. The pointed arch form was first used at Vezelay about

Metropolitan Museum of Art

Medieval book covers. LEFT: *Cover in filigree and cabochon, framing a carved ivory plaque showing the crucifixion as represented in the twelfth century. The figure of Christ is erect, and his feet are standing firmly on a support.* RIGHT: *Cover in enamel with ivory plaque insert showing the crucifixion as represented from the fourteenth century onward. The figure of Christ is limp and lifeless; the legs are crossed; pity and pain are expressed and the head is surrounded by a crown of thorns.*

Ribbed construction was one of the most characteristic features of Gothic design.

Gothic design endeavored to accentuate the vertical line, which accounts for the great height of the cathedrals and the use of towers as part of their façades. The verticality was accentuated by the shadows of the buttresses and by the elimination of many of the horizontal moldings and cornices associated with classical design. There may also have been a religious or sentimental feeling that the vertical line symbolized the aspirations of the faithful, and pointed toward their future abode. At least these lines avoided any resemblance to the horizontal accentuation of the pagan temples of antiquity.

Gothic architecture, like Greek, is functional

and honest. The main elements were determined by structural requirements, and barring sculptured ornament, nothing was introduced that had only visual appeal. It is therefore one of the great styles in art history. The early examples were comparatively simple in detail, vigorous, and masculine. The final development produced fantastic forms of lacelike stonework with intersecting ribs and intertwining tracery that were graceful in character. The warmth, bliss, and exaltation that one feels when in a Gothic cathedral can be only fully experienced when kneeling in its enclosure or contemplating the firmament.

It is essential that the decorator should know and understand the details of the exterior

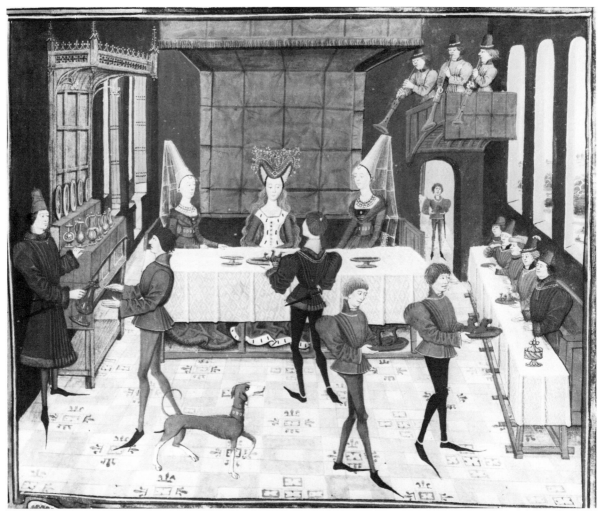

R. LaLance

French manuscript showing the interior of a fifteenth-century room.

stone structural and ornamental forms, as these eventually became the sole inspiration and basis of design for woodworkers, cabinetmakers, metalworkers, ivory carvers, book illuminators, weavers, enamelers, and all other craftsmen of the period.

GOTHIC ORNAMENT AND SCULPTURE. Gothic structural features were often ornamental in themselves, but they were also enriched with a great variety of carved forms. At the top of the windows the arched mullions were often treated with *quatrefoils* and *cinquefoils*, resembling

four-leafed or five-leafed clovers, forming *cusps* between them. Statues of kings, saints, and other religious personages were extensively used. Less dignified figures such as dwarfs, grinning goblins, devils, monkeys, donkeys, and fabulous animals were introduced in unexpected places to amuse the people. Figures of those who labored on the buildings often were used as decoration. A bust of the architect in a quandary, the mason straining to lift a stone, the carpenter with his raised hammer, or the painter with his symbolic brush and palette would be given due recogni-

tion. The finials crowning vertical forms were enriched with *crockets,* cut in the form of projecting buds or leaves. Gutter ends and waterspouts were *gargoyles* often carved in fantastic animal forms. Niches were formed with pointed tops to frame the important statuary, or projecting *canopies* were placed above freestanding statues. Geometrical forms such as frets, dog teeth, chevrons, zigzags, battlements, and crenelations often formed running ornament. Family crests, monograms, coiling stems with foliage recalling the classical arabesque, and the oak branch and leaf were the most common forms of ornamental motifs. Much of the sculptured representation had a Christian historical or symbolic association, such as St. Peter with his key, St. George and the Dragon, the Creation of Man, Jonah and the Whale, the Wise and Foolish Virgins, and the Last Supper. To the medieval mind nearly everything was symbolic, and the ornament of the church was an encyclopedia in stone.

Practically all of the sculpture of the Gothic period was designed to fill a particular place in the building. The early human figures had a strong architectural quality, standing stiff and erect, with arms close to elongated bodies, and clothing in minute vertical folds accentuating the perpendicular. The faces of early examples were rather crudely modeled and ascetic in aspect, although portraiture was often intended. The later statues became more realistic in character with larger and more naturalistic folds in the clothing, less rigid bodies, and faces expressing sentiments of meekness and humility. Much of the figure sculpture was painted in natural colorations.

A favorite decorative and religious motif of Romanesque and Gothic designers was the crucifix, a representation of Christ on the cross. From the first appearance of the crucifix, in the tenth century, until the middle of the thirteenth century, the figure of Christ was always shown with halo, head erect, feet resting on a support,

and one nail driven through each foot. In later centuries a more pathetic attitude of the figure was represented, the body sagged, the head bent under the crown of thorns, the eyes were closed, blood streamed from His wound, pain and exhaustion were indicated, and the feet were crossed and nailed with a single nail.

Stained glass. As the very quality of lightness in Gothic form replaced the solid wall masses of previous architecture, the stained-glass window superseded mosaic and mural decoration without, however, completely replacing it.

Stained-glass windows achieved the dual purpose of transmitting light and providing decoration. Colored pieces of glass were joined by grooved strips of lead producing a geometric pattern in the rose windows of the main façade and transept and pictorial biblical themes in the nave. An often repeated subject was the tree of Jesse, in which the divisionist theme lent itself admirably to the technical restrictions of the medium. Early stained glass was limited to the use of small pieces of colored glass juxtaposed in a manner not unlike that of mosaic. Fine twelfth- and thirteenth-century examples of its use in this manner are in the windows of the cathedrals of Chartres, Canterbury, and Cologne. By the time of the middle Gothic of the fourteenth century there was achieved a wedding of the craft of glazier and painter. The taste for increased naturalism demanded modeling in terms of light and shade that was achieved in different ways. The most common was to paint in the shadows. The resultant opacity was often alleviated by stippling while the color was still wet. Another method was to scratch out part of the color painted into these shadows. The late Gothic was marked by the ultimate dominance of the painter, who usurped the premier position of the glazier. His larger sections of glass were used as a surface that was completely enameled with biblical illustrations. The effect was less harmonious with the aes-

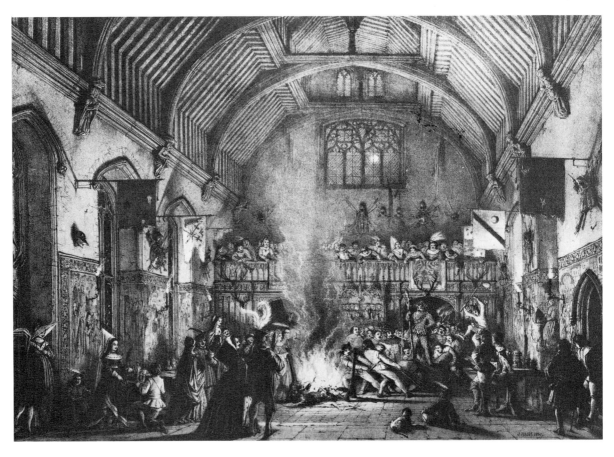

The great hall at Penshurst, Kent, England, showing the minstrel gallery over the entrance and the fire in the center of the room. The roof is wood truss construction, built in the form of a pointed arch to carry out the style.

thetic demands of Gothic spirit and anticipated the realism of oil painting of the Renaissance.

A more recent revival of stained glass in its better form is seen in the windows designed by the Americans John La Farge and Louis Comfort Tiffany and those of Marc Chagall in the prayer chapel of the Hadassah Hospital in Israel.

DOMESTIC ARCHITECTURE AND DECORATION. The social and political conditions of the Middle Ages permitted little comfort or luxury in domestic living except in the feudal fortress castles of the nobles. The mass of the population lived in log or stone houses roofed with thatch. It was not until the thirteenth century that the medie-

val castle began to look less like a fortress and to have a few conveniences and comforts.*

The walls of Constantinople that had stood for one thousand years and had never been entered against the will of the inhabitants were breached in 1453 by a new weapon—an enormous cannon firing stone balls weighing 600 pounds. As a result, the old fortified castles became obsolete, and with the increasing power

* The fortress Palace of the Popes in Avignon and the fortified monastery of Mont Saint-Michel are indicative of the degree of amiability and security enjoyed even by the religious orders of the fourteenth century.

and efficiency of the laws, it was no longer necessary to consider strength before convenience in residential design. Instead of seeking a hilltop or other strong position, people began to choose situations for dwellings that were agreeable or beautiful, where they might be protected from the inclemency of the weather, and where gardens and orchards could be planted advantageously.

In northern Europe the winter was a chill, dark, and damp period. Glass for windows did not become common in dwellings until the fifteenth century. Before that period the windows had wooden shutters, pierced with small holes that were filled with mica, waxed cloth, or horn to admit a small amount of light. During the Middle Ages the rooms were heated with braziers or with open fires built on the stone or brick floors in the middle of the room. The smoke filled the room until it made its escape through a door, window, or hole in the roof. Later, the discomfort of this awkward arrangement stirred the Gothic builders to create the fireplace and chimney.

In the houses of the common people, the stone walls were often bare or covered with rough plaster. The interior walls of the castles were sometimes painted in imitation of hung textiles or with mural decorations of historical and religious scenes or legends of chivalry. The paintings were treated in a flat manner, with few gradations of coloring and no perspective in the drawing. After 1400, tapestries from Arras, France, were extensively used in the princely castles of both France and England to cover walls, to hang over windows and doors, and to enclose beds, or as partitions to subdivide large rooms for greater privacy.

The ceilings of the rooms usually showed the exposed beams or trusses of the roof construction, frequently enriched with colorful painted ornament. On plaster ceilings gold star patterns on a blue or green ground were often painted. When flat-beamed ceilings were used, the ends of the beams were supported by projecting ornamental brackets, variously shaped or carved into figures.

Floors were in stone, brick, or tile, and generally covered with straw or leaves. The first Oriental rugs were imported into England in the thirteenth century, but were very rare objects for many years.

THE GREAT HALL. The castles of the nobility of both England and France were built around the *great hall*, principally used for the assemblies of vassals, banquets, trials, and entertainments. The entrance was at one end under a balcony known as the *minstrel gallery*. At the opposite end was a raised platform known as a *dais* that was reserved for the owner and his family. On the dais stood two thrones or chairs of honor, having arms and high backs that terminated in rooflike canopies. A temporary table supported on trestles was brought in at mealtimes; the rest of the dais furniture consisted of a sideboard or *credence*, a chest, and possibly a few stools or benches.

The center of the room was meagerly furnished with benches built or placed against the wall. Sometimes a high post bed surrounded with draperies was placed in the corner of the great hall, although separate bedrooms were eventually introduced.

The plaster walls of the great hall were hung with tapestries or covered with an oak wainscot to a height of about twelve feet. On the upper portion of the walls were hung armor, trophies of the hunt, and colorful flags and standards.

FIREPLACES. The great halls at first had a fireplace located in the middle of the room. This was needed for both heating and cooking, but, during the fourteenth century, the fire was moved from the center of the hall to a side wall, and a projecting hood was built over it to direct the smoke out through either a wall hole or a chimney. The projecting hood was frequently ornamented with architectural forms or with a carved coat of arms. Chairs or benches and a

or parchment pattern, or carved with a design imitating window tracery. Oak branches, leaves, and acorns were occasionally used as decorative motifs for paneled surfaces.

The framework holding the panels was rectangular, composed of vertical *stiles* and horizontal *rails* with molded edges on only three sides of each panel frame. The top rail and the two stiles of each were usually treated with a simple curved molding; the lower rail was plain and *splayed* (slanted downward). This method of treating a panel frame was due to the woodworker's basing his design on that of the stoneworker, who placed a trim molding on three sides of a window with a slanting sill at the bottom to carry off rainwater. A few moldings

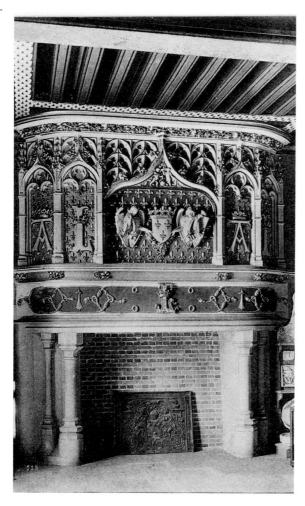

Late Gothic mantel in the chateau at Blois, France, showing Gothic architectural forms used in a decorative manner.

small rug were frequently placed before the fire. It was at this time that the fireplace and the hearth became the symbols of the home.

WALL PANELING. Oak-paneled wainscots were built in both ecclesiastical and domestic interiors to give greater warmth and finish to a room. The panels of the Gothic period were of small dimensions and were usually placed vertically. The panel field was never wider than a single plank of oak. It was sometimes left plain, but was more often decorated with a *linenfold*

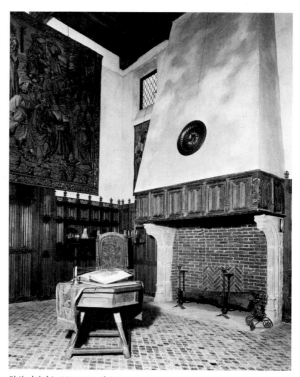

French Gothic interior showing projecting hooded mantel, oak wainscot with panels decorated in the linenfold motif, high beamed ceiling, tile floor, and large tapestry high on the wall.

Gothic furniture and decorative and architectural details.

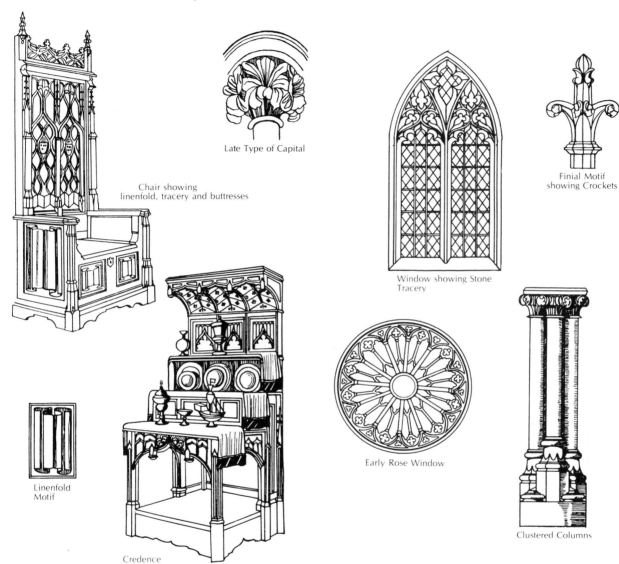

Late Type of Capital

Chair showing
linenfold, tracery and buttresses

Window showing Stone
Tracery

Finial Motif
showing Crockets

Early Rose Window

Clustered Columns

Linenfold
Motif

Credence

Oak Chest with Tracery Carving

ran along the top of the wainscot, and the cresting was often treated with a carved tracery design and finial motifs. The average dimension for a Gothic panel was about nine inches wide by two or three feet high. The wood was generally waxed.

FURNITURE. Nearly all furniture of the Gothic period was in natural-finished oak. Occasionally walnut was used. Thrones and seats of honor were sometimes gilded. Most of the

pieces were heavy in their proportions and dimensions and rectangular in design. The parts were assembled with wooden *dowels, mortises,* and *tenons,* and with hand-cut *dovetails.* The ornamental forms consisted almost entirely of small-scale carved architectural motifs such as tracery, pointed arches, rose windows, buttresses, finials, and crockets. Sometimes the face of the stiles and rails of the case furniture were enriched by parallel grooves or reeds running lengthwise; as these features were cut before the piece was assembled, the grooves did not *miter* at the corners. Furniture panels were usually enriched with carved linenfold and tracery motifs or coats of arms, and, as in the winscoting, moldings were placed only on the top and two sides of the panel, the lower stile having a splayed edge.

The *chest* was the most important piece of furniture, because it could be easily transported, a necessary advantage during unsettled political conditions. The chair was a small chest with arms and a high back, and was reserved for the use of important persons. The panel in the back was usually decorated with a carved pattern and often crowned with a wooden canopy. The dominant lines of the design of chairs were straight; the seat was square and covered with a loose cushion for comfort. The cupboard was a chest on legs. The credence or serving table originally derived its name from the Latin word *credere,* meaning "to believe," because food placed upon it was tested by a servant before it was offered to the master of the house, who lived in dread of poison potions.

Gothic beds were gorgeously carved and were sheltered with a canopy and curtains hung from the ceiling or supported by corner posts. Sometimes the canopy was made larger than the bed, to enclose a chair within the drawn curtains. A *hutch* or chest containing the family valuables was placed at the foot of the bed where it could be watched by its owners. A lamp hung within the canopy, and a stool or step was placed beside the bed. Beds were covered with mattresses,

finely woven linen sheets, and many pillows. Servants or children frequently slept on a low truckle or *trundle bed* that was stored under the large bed and pulled out at night. A few benches and stools were placed in the smaller rooms, and in front of the fireplace was placed a bench with a movable back that could be swung so that the occupants could sit with either their faces or their backs to the fire.

Dining tables were merely planks supported on temporary trestles. Linen tablecloths in evenly spaced folds hung well over each side to hide the supports. Guests sat at one side of the table, the other being left free for service. Individual plates were seldom used, but a large dish was placed in the middle of the table, in which all dipped their fingers. No forks were used, as it was customary to eat with the fingers until about the sixteenth century. Before dining, everyone washed his hands at the table, that he might give assurance of his cleanliness to the other guests. At the end of the meal, the washing again took place. Forks and table-service knives were not used in England until 1600. Knives were used to cut food from an early date, but they belonged to the individual, were carried in his belt, and were not part of the regular eating equipment furnished to the guest. Use of individual plates did not become common until the eighteenth century. The earliest plates were made of metal. The word *plate* originally meant "silver," and had no relation to the shape of the dish, but indicated the material from which it was made. The use of crockery for tableware did not occur until the middle of the sixteenth century. The *trencher* was originally a slice of bread upon which food was placed. Later, pieces of wood in this shape were used, and the word finally came to mean a plate upon which food is served.

The hardware on doors and Gothic case furniture was in hammered wrought iron and was always placed on the surface of the woodwork. Hinges, locks, and bolts with scroll and foliage designs were used.

Important Gothic Structures

IN FRANCE

Ecclesiastical Structures:

Cathedral, Paris (1163–1214)
Chartres Cathedral (1194–1240)
Rheims Cathedral (1212–1241)
Amiens Cathedral (1220–1288)
Bourges Cathedral
Notre Dame Cathedral, Rouen (1202–1530)
St. Ouen, Rouen (1318–1515)
St. Maclou, Rouen (1432–1500)
Mont Saint-Michel (13th–15th c.)

Secular Structures:

Palais de Justice, Rouen (1499–1508)
House of Jacques Cœur, Bourges (1443)
Château at Pierrefonds (14th c.)
Château at Coucy (1220–1230)
Walled City of Carcassonne
Walled City of Aigues-Mortes

IN ENGLAND

Ecclesiastical Structures:

Westminster Abbey (1245–1269)
Salisbury Cathedral (1220–1258)
Wells Cathedral (1214–1465)
York Cathedral (1261–1324)
Lincoln Cathedral (1185–1200)
Ely Cathedral (1198–1322)

Secular Structures:

Penshurst Place, Kent (1335)

Windsor Castle (1359–1373)
Stokesay Castle

IN ITALY

Ecclesiastical Structures:

Milan Cathedral (1385–1418)
Florence Cathedral (1294–1462)
Siena Cathedral (1243–1284)

Secular Structures:

Palace of the Ca d'Oro, Venice
Doges Palace, Venice (1424–1442)
Palazzo Vecchio, Florence (1298)

IN SPAIN

Ecclesiastical Structures:

Seville Cathedral (1401–1520)
Burgos Cathedral (1221–1567)
Barcelona Cathedral (1298–1329)
Toledo Cathedral (1227–1290)

Secular Structures:

Porta Serraños, Valencia (1482)
Casa Consistorial, Barcelona (1369–1378)

IN GERMANY

Ecclesiastical Structure:

Cologne Cathedral (1270–1322)

Secular Structure:

Wartburg Castle (1150)

MINOR ARTS. One of the greatest of the minor arts of the Gothic period was that of tapestry weaving, carried on during the fifteenth century principally in the cities of Arras and Tournai. Elaborately ornamented metalwork in the form of military armor, church utensils, and reliquaries were made in France, Spain, and Italy. The city of Limoges became famous for its enamelware from the twelfth to the fourteenth century. Ivory carving reached its greatest period in the Paris productions of the fourteenth century. Ecclesiastical embroideries of the most magnificent types were made to enrich the elaborate church ritual. The arts of book-illuminating and hand-lettering attained their highest point of development, but were abruptly terminated after the invention of printing in the middle of the fifteenth century.

EXAMPLES OF GOTHIC ARCHITECTURE AND DECORATION. Nearly all the large cities of western Europe contain buildings of the Gothic period. Each country showed slight variations in the development of the style, because of differences in climate and taste, and for other local reasons. The table above includes the most important examples of Gothic architecture.

BIBLIOGRAPHY

Adams, H. *Mont-Saint-Michel and Chartres*. Boston: Houghton Mifflin Co., 1913.
Beautifully written text covering history, romance, and art. Few illustrations.

Anthony, E. W. *A History of Mosaics*. Boston: Porter Sargent, 1935.
Excellent illustrated text tracing the development and use of mosaics from pre-classic times through the twentieth century.

Beckwith, John. *Early Medieval Art*. London: Thames and Hudson, 1964.

Branner, Robert. *Chartres Cathedral*. New York: W. W. Norton and Co., 1969.

Brantl, Ruth. *Medieval Culture: the Image and the City*. New York: Braziller, 1966.

Bury, J. B., Gevatkin, and Whitney. *The Cambridge Medieval History*. New York: Cambridge University Press, 1966.

Clark, Kenneth. *The Gothic Revival*. Baltimore: Penguin Books, 1964.

Crump, Charles George and Jacob, E. F. *The Legacy of the Middle Ages*. New York: Oxford University Press, 1926.

Didron, Adolphe Napoleon. *Christian Iconography* (The History of the Christian Art in the Middle Ages) (2 Vols.). New York: Ungar.

Durant, W. *The Story of Civilization*. Vol. 4. *The Age of Faith*. New York: Simon and Schuster, 1950.
An excellent description of all aspects of the Middle Ages.

Fitchen, John. *Construction of Gothic Cathedrals*. New York: Oxford University Press, 1961.

Focillon, Henri. *The Age of the West*. Parts I and II. New York: Phaidon, 1969.

Garner and Stratton. *Domestic Architecture in England during the Tudor Period*. New York: William Helburn, 1926.
Photographs of exteriors and interiors of late Gothic works.

Grabar, André. *Byzantine Painting*. Translated by Stuart Gilbert. Skira, 1953.
Excellent text and superb color plates.

Gromort, G. *L'Architecture Romane*. 3 vols. Paris: Vincent, Fréal, 1928–1931.
Excellent plates.

Hale, John Rigby. *Europe in the Late Middle Ages*. Illinois: Northwestern, 1965.

Hamilton, J. A. *Byzantine Architecture and Decoration*. New York: B. T. Batsford, 1933.
A standard book. Well illustrated.

Harvey, J. *Gothic England, 1300–1550*. New York: B. T. Batsford, 1947.
An excellent architectural history of this period.

Harvey, John. *The Gothic World 1100–1600*. London: Batsford, 1950.

Hinks, Roger P. *Carolingian Art*. Michigan: Ann Arbor Books, 1962. University of Michigan. Paperback.

Lowrie, W. *Monuments of the Early Church*. New York: Macmillan Co., 1923.
An illustrated handbook of Christian archaeology.

Quenedy, R. *La Normandie*. 5 vols. Paris: F. Contet, 1927–1931.
Plates of exteriors of medieval French domestic architecture.

Tipping, H. Avray. *English Homes* Period 1–Vol. 1. Norman and Plantagenet 1066–1485.

Violet-le-Duc, E. *Dictionnaire Raisonné d'Architecture.* Paris: B. Bance, 1868.
Out of print. Standard book on the art and architecture of the Middle Ages. French text. Available in most large art libraries.

Violet-le-Duc, Eugent Emanuel. *Dictionnaire Raisonné de l'Architecture Francois de XI–XVI Siecle* (10 Vols.) Paris: Morel, 1861–75. Libraries—imprimeries reunies, 1958–1968.

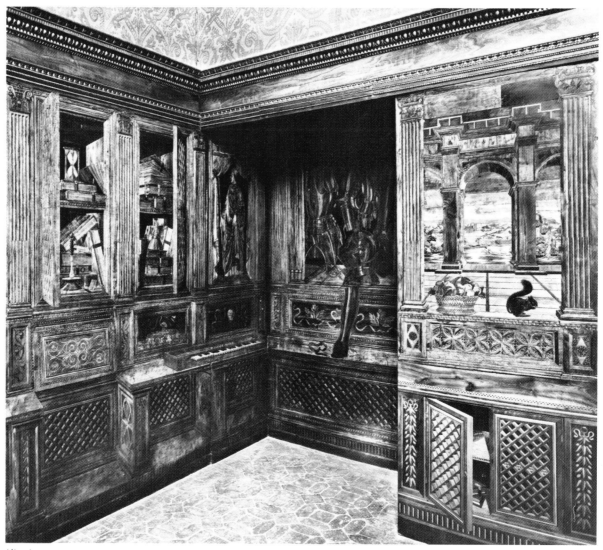

An example of intarsia from the fifteenth-century Ducal Palace in Urbino.

CHAPTER 3

The Italian Renaissance

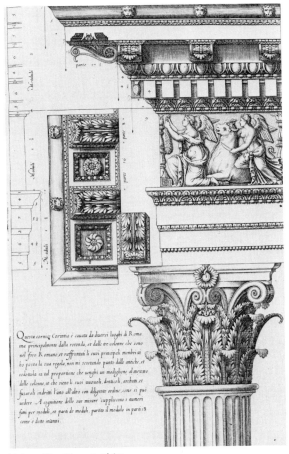

An architectural drawing by Vignola.

Because of an advantageous geographical location, Italy during the Middle Ages became the distributing point for the trade of the Orient with western Europe. On mule, camel, and elephant, the salt, spices, silks, and other luxuries were brought from the East to the shores of the Black Sea, transshipped to Adriatic ports, and thence distributed to Florence, Venice, and other cities of northern Italy. As a consequence of the Crusades and the voyage of Marco Polo, Italy became the merchandising and banking center of Europe. Buyers from the North and from the West made their annual pilgrimage there in search of supplies.

During the Middle Ages the misery of the masses had been intense, and doubts arose in the minds of certain intellectual leaders concerning religious doctrines as well as the statements of the Church relating to natural phenomena. Later, scientific discoveries were made which conflicted with the claims of the Roman church and aided in shaking the faith of the people in the established order. The conclusion that the earth was spherical in form and revolved about the sun and the principle of the compass were among these discoveries. An intellectual group known as the "Humanists" was organized, with the purpose of investigating and eliminating some of the superstitions and mysticisms that were current, and of protesting against the authority of the Church in matters of secular importance. By the fifteenth century the works of Dante, Petrarch, and Boccaccio had had ample opportunity to influence the thought of the people. These three authors had carefully studied the philosophies and political treatises of antiquity. Writing in Italian rather than in Latin, which was the language of the scholars, they contrasted the pagan ideals of the early Greeks and the Romans with current conditions. The fundamental thought of the times seemed to be that the nations of antiquity had been better organized, better controlled, and on the whole happier than those of western Europe during the Middle Ages. The invention of printing in the fifteenth century aided the spread of the new knowledge. The revival of interest in classical philosophy was aided by the sight of the ruined architectural masterpieces of the Roman Empire that stood at nearly every crossroad to remind the inhabitants of the achievements of their race. The fall of Constantinople in 1453 caused an influx into Italy of Greek scholars and craftsmen who were steeped in classical knowledge.

The time was also ripe for a reaction against the suppression of the joyous human emotions, which had been brought about by the ascetic attitude of the Middle Ages. As the pleasures of human existence were realized, less was thought of the spiritual side of man. Naturalism and realism were reflected in thought and action. Art returned to earth to represent the joy of living, the beauties of nature, the happiness of youthful faces, the charm of graceful form and movement, and the less ethereal emotions. Lorenzo the Magnificent expressed the kernel of the thought of the period in his stanzas that open with "How fair is Youth, though speeds its day. Let heart be ardent while it may"—a philosophy thoroughly excoriated by Savonarola.

The term *Renaissance* is used as the name of the intellectual protest that resulted in the revival of classical philosophy and art, beginning in Florence about the year 1400. Although the word implies "rebirth," and the forms of art produced during this period were based on classical inspiration, the movement eventually developed into one of extreme aesthetic originality. The Renaissance was not the revival of antiquity alone, but its union with the Italian people. It could only have been conceived in the land of Augustan memories replete with alluring landscapes, with a turquoise sea, glowing sun, and the olive, grape, cedar, and cypress that served to rationalize a heaven on earth.

THE CHARACTER OF ITALIAN SOCIETY. The Italians of the Renaissance were the inheritors of the Greek ideal of individualism. During the Middle Ages the northern Italians had, in their own opinion, maintained a higher intellectual level than the "barbarians" of northern Europe, and it was perhaps inevitable, though paradoxical, that, in the geographical and administrative heart of the Roman church, men should first react against the inaccuracies, limitations, and negations of medieval thought. While accepting the Church as an organization, the Italian discarded it as an authority to control his private life, and, as his lack of faith and respect for the civil authorities was quite understandable, he had no alternative but to take the law into his own hands and decide for himself between right and wrong. When emotional restraints were violated, the Church pardoned them by the sale of indulgences, a policy which became a scandal when major crimes could be condoned by the cost of a mass. The state, often tyrannical, despotic, and illegitimate, was usually dominated by an egotistical leader, who had established and maintained his supremacy by violence and the Machiavellian standard claiming that the end justified the means. Egotism was obviously successful, and its processes, adopted by most Italians, produced an excessive individualism, which was the cause of both the greatest faults and most commendable qualities of the race. With blunted morals, the most flagrant crimes were committed, and public standards reached a point where perpetrators were absolved if the motive was revenge and the act accomplished with theatrical courage. These actions, first practiced by the nobility, set a precedent for the whole population, and, as usual, the masses tended to ape the classes.

In the thirteenth century, Dante had taught that man was master of his own destiny and that he should not be the intellectual slave of either church or state. Bonds are inherently irksome, and it is a primal law of nature to hold in aversion whatever savors of the obligatory. The movement toward individualism lessened the class distinctions of the Middle Ages. Birth and origin were of little importance unless they were combined with wealth. The intelligent, regardless of class, had an opportunity to rise to power. The Italian came to feel, in truth, that he was a citizen of the most advanced nation of his time; he took pride in being unlike his neighbor and developed a morbid passion for fame. Women became completely emancipated and were recognized to have the minds and courage of men.

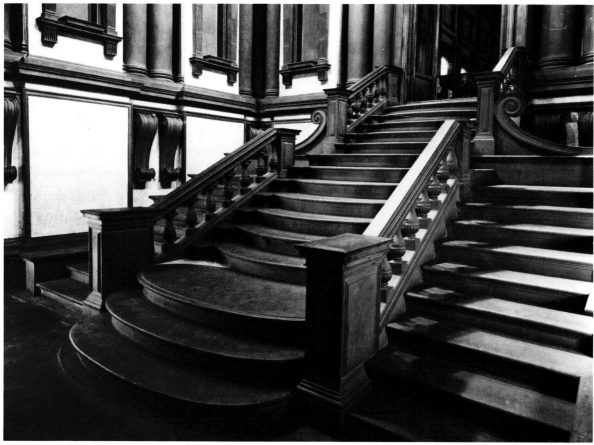

Alinari

Laurentian Library staircase designed by Michelangelo.

In the fourteenth century, the public felt the need of new ideals and a new authority for personal guidance. Antiquity was an obvious recourse. It was the symbol of past greatness and the highest claim to glory that Italy possessed. Petrarch had climbed the ruins of Roman buildings and recalled the history that passed beneath his feet. The empire of Augustus, prostrate for a thousand years, possessed the popular mind.

Literature was the first of the arts to spread the new doctrines of realistic paganism. Dante had spoken of the reverence due the stones of ancient Rome. Boccaccio had surpassed Ovid and openly violated all the restraints of medievalism in describing feminine pulchritude. Another author referred to laughter as "a radiance of the soul." Petrarch was the first to enjoy the view of a landscape and from a mountaintop had looked down on the clouds and urged men to go forth to admire lofty hills, broad seas, roaring torrents, and the stars, and forget their own selves while doing so. The pleasures of contemplating savage scenery had been unknown to the Italians of the thirteenth century.

The Latin language was easy for the Italians, and the memory of pagan Rome aided the development of a national and secular sentiment. The movement, explosive in character and conflicting with established religious standards, spread to all branches of human thought and creative

effort. A desire developed to prove that nobility could be found outside the bounds of theology, that omniscience was not limited to cloistered walls, and that the emotions of man could be expressed without dishonor. In the development of this individualism, both public and private morals reached extreme levels. By the side of the greatest corruption were found the most noble of sentiments, and the most vicious of human expressions contrasted with those of highest artistic splendor. The stoic philosophies of Cicero and Seneca had as many adherents as the Epicurean devotees of pleasure.

Although disturbing changes occurred in the outlook of the upper-class Italian, the fever for religious crusading had subsided, and the fear of foreign invasion lessened. This enabled him to plan his life according to the opportunities offered by a peaceful prospect. It affected the character of his residence. In the house plan, rooms became smaller and were distributed and used for the purposes that they are today. In the activities of daily life the Italian found time to develop the customs and amenities of modern social intercourse. Manners, promoted by sincerity and kindliness, became polished and conventionalized; the Florentine dialect was adopted as the standard of refined people, and conversation became intellectual, witty, humorous, and gay; dress became elaborate and varied for every occasion; and individual table cutlery was first used. In social gatherings the entertainment consisted of indoor and outdoor sports played by young and old, reading from the classics, or listening to the music of the lute, lyre, and viol. Dilettantism and connoisseurship developed in the arts and crafts. Novelty and originality became essential qualities in any creative effort. Public festivals were celebrated with glamorous pageants and tournaments. Boccaccio in his *Decameron* produced the first "novelle." Palestrina later popularized the motet and madrigal, and the opera was evolved from the fusion of ancient Greek drama, music, song, and the deco-rative arts. Pantomime and the classical ballet were finally established. The antique revival penetrated into every cultural activity.

An accidental combination of pertinent historical events, geographical locale, economic and political conditions, scientific discoveries, and the protest against excessive ecclesiastical conservatism impregnated the Italian intellect and creative instinct, and caused it to blossom into an artistic force that spread its seeds on the whole of Western civilization.

THE CONDITION AND ATTITUDE OF THE CHURCH. The Church, with its head in Rome, had, during the Middle Ages, developed tremendous power at a time when faith in political leadership was at its lowest ebb. Coincident with the attainment of this supreme position, the luxury and the morals of some of the clergy were the extreme opposites of those adopted by the founders of the Christian church. Combined with excessive taxation by ecclesiastical authorities, violent protests developed against the doctrines, the misconduct, and the worldliness of certain church leaders.

The Dominican monk Savonarola was burned at the stake in Florence in 1498 in spite of his many efforts to reform the Church from within. Martin Luther, more safely located, issued his ninety-five Theses from faraway Wittenberg in 1517, and was excommunicated by the pope in 1520. Nearly the whole of northwestern Europe eventually refused to acknowledge the supremacy of Rome, in spite of war and intrigue. Protestantism was the result of independent thinking and feeling in contrast to the maintenance of the doctrines of the Roman church.

To counteract the weakening effect of the spreading Reformation, a movement started by the Jesuits developed within the Roman church. This was known as the Counter-Reformation, and, as will later be seen, had an important influence upon the decorative arts. The Church objected to the freedom and liberty that came

from the revival of pagan thought, but the exposure of the evils of church administration contributed to the growth of the protest in art as well as in religion. During the Middle Ages all education and culture had been restricted to the precincts of the Church, and it was natural that the authorities taught only that which would be most advantageous to them. In the arts it was necessary to promote what was related to sacred life, such as religious history and the philosophy of the Church. Secular tendencies were at first regarded with hostility, but the spread of classical thought among the masses became too overwhelming to be crushed by ecclesiastical edict. After the failure to halt the Reformation, the Church became powerless against the renewed interest in the arts of antiquity and adapted these products of secular mentality to her own use, finally succumbing wholeheartedly and embracing them with open arms.

THE PATRONS OF THE ARTS. For a thousand years after the fall of Rome, Italy had been divided into petty sovereignties that were constantly at war with each other. Leaders had risen to power only to be destroyed by other claimants. By the fifteenth century, the wealth that had been brought to Italy by its trade became concentrated in several distinct groups, which, once the financial control of the country was in their hands, grasped also the political and ecclesiastical control. Each city and town was dominated by one or more leading families. Intermarriage was frequent, but the condition of ethics and morals was such that mutual confidence could not be sufficiently developed to

The Villa Capra, better known as La Rotonda, designed by Andrea Palladio, inspired copies in England and Jefferson's work in the United States.

Photo Researchers

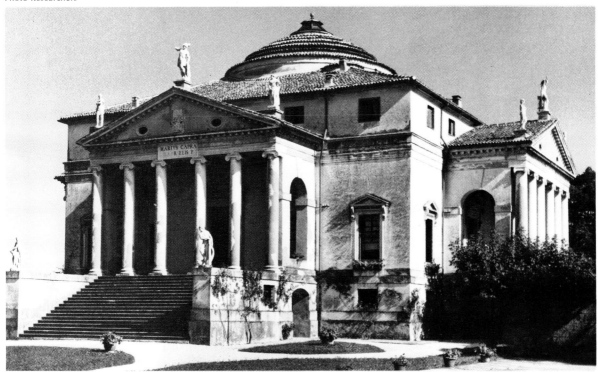

permit alliances that might have eventually aided in the growth of a national consciousness.

In spite of political weakness, great civic pride developed. This was fostered by the controlling families as a matter of pleasure, but also, in part, to hide their own extravagances. Palatial dwellings, with rich furnishings produced by the most able artists and craftsmen, were built to outshine each other in splendor and magnificence. The villas of Florence and Rome, surrounded by elaborate formal gardens, almost equaled in size and beauty those built for the ancient Roman emperors.

The better-known of the Italian Renaissance families were the Medici, Pitti, Strozzi, and Riccardi of Florence; the Sforza and Visconti of Milan; the Colonna, Este, Borgia, Orsini, and Borghese of Rome; the Vendrimini of Venice; and others in Genoa, Verona, Siena, Ferrara, and Vicenza. Members of these families exerted immense power for both good and evil. Much of their wealth was spent in patronizing the arts and artists, and the rivalry thus developed contributed greatly to the extraordinary achievements of the period.

From the middle of the fifteenth century, art and the appreciation of art formed the principal subject of conversation of every Italian. John A. Symonds in his book *Renaissance in Italy* states, "It has been granted only to two nations, the Greeks and the Italians, and to the latter only at the time of the Renaissance, to invest every phase and variety of intellectual energy with the form of art. . . . From the Pope upon St. Peter's chair to the clerks in a Florentine countinghouse, every Italian was a judge of art. Art supplied the spiritual oxygen without which the life of the Renaissance must have been atrophied. During that period of prodigious activity the entire nation seemed to be endowed with an instinct for the beautiful, and with the capacity for producing it in every conceivable form."

Many artists and craftsmen were placed on the annual payroll of the great patrons. Studios and workshops were furnished by generous benefactors. Time was not a consideration in the completion of any work of art. This system of remuneration contributed greatly to the quality of the productions and eliminated the economic risk on the part of the artist, whose whole effort, continuous and repeated, could be applied toward the attainment of perfection.

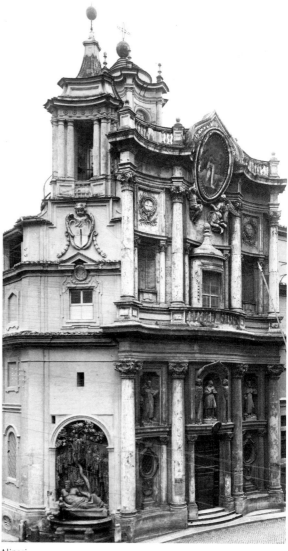

Alinari

Facade, S. Carlo alle Quattro Fontane (1665–1667) by the baroque architect Francesco Borromini.

THE VERSATILITY OF THE ARTISTS. The tremendous popular interest in art, linked with the financial security and the rewards offered for the works of the artists, developed an astounding group of creative craftsmen in all forms of aesthetic endeavor. Not the smallest mark of their genius was their wonderful versatility. Many worked in several mediums and expressed themselves with nearly equal effectiveness as architects, painters, sculptors, decorators, musicians, engineers, poets, philosophers, or as craftsmen in the minor arts.

To mention but a few of the immortals—the earliest Renaissance constructions were the Hospital of the Innocents (1445) and the dome of the Cathedral of Florence (1434), designed by the architect Brunelleschi, a goldsmith by training. In connection with this church is the equally notable Baptistery, an earlier building that contains the bronze doors made by the sculptor and goldsmith Ghiberti, which Michelangelo is said to have called the "Gates of Paradise." Giotto and Cimabue seem almost to have invented painting. Fra Angelico, the mystical monk of San Marco in Florence, transferred the sweetness of the art of the illuminator of Christian manuscripts to wall decoration. Leonardo da Vinci, one of the greatest painters who ever lived, wrote a letter to the king of France describing his abilities as a constructor of fortresses, and modestly added a postscript stating that he could paint as well as any other man. Botticelli, the painter of "Spring," was one of the most fashionable and decorative artists of his day. The della Robbia family, great sculptors, reproduced their swaddled babes and other exquisite figures and patterns in glazed terracotta to enrich the exteriors and interiors of the Florentine buildings. Bramante was the first architect of St. Peter's and epitomized the High Renaissance in his small chapel, "Il Tempietto." Michelangelo, the profound poet, deeply religious, dignified the human figure and in the ceiling of the Sistine Chapel painted it as none

Photo Researchers

Portrait of Michelangelo by Daniele da Volterna.

had done before; he carved the world-renowned David in marble and designed the great dome of St. Peter's. Raphael, the youthful and prolific painter, mural decorator, architect, tapestry designer, and ornamenter of pottery, is most famous for his paintings of the Madonna. Palladio and Vignola rediscovered the standardized proportions of the Roman architectural orders established by Vitruvius and left a written record of them for future designers. Benvenuto Cellini, the autobiographer, wastrel, and sculptor of the Perseus in the Loggia of the Lanzi in Florence, was one of the greatest of goldsmiths. Donatello, the sculptor, when youthful, thin, and poor, slaved with pickax and shovel to un-

earth the buried treasures of antiquity in Rome and was seized with paroxysms of joy when he discovered a column, a capital, a statue, or even a few old stones.

SUBDIVISIONS OF THE ITALIAN RENAISSANCE PERIOD. The Italian art periods are usually given the names of the centuries in which they occur, and the Italian names are used in referring to them. As in all art periods, there is much overlapping of styles, which explains the apparent conflict in the dates given herewith.

1. QUATTROCENTO (1400–1500). Early Renaissance

 The transitional period between the Gothic arts and the classical revival, characterized by the use of architectural forms, ornament, and detail of both styles in decoration, furniture and other arts.

2. CINQUECENTO (High Renaissance 1500–1520). (Late Renaissance 1520–1600)

 The first half of this century is considered the high period of the Italian Renaissance, and the word *cinquecento*, as the name of an art style, is usually applied only to the work produced during those years. Classical forms used, with beauty of line and mass more important than surface enrichment. The period of activity of most of the greatest artists.

3. BAROQUE (1600–1720) and Rococo (1720–c. 1755)

 The Jesuit style that commenced with the construction of large churches, followed by the overdecoration of both ecclesiastical and secular buildings. Use of concave and convex walls and cornices, spiral columns, and movement and asymmetry in design. Florid and meaningless ornament. Optical illusion and false use of materials for effect. Boisterous and theatrical types of design. First operatic performances. Beginning of the eclipse of Italian dominance in the arts.

4. FOREIGN INFLUENCE (1650–1815)

 The French and English styles in the decorative arts influenced the Italians, who emulated the leading political powers. This influence was started during the Rococo period and extended through the Napoleonic period.

THE PALACE. The use of gunpowder by the armies of Europe was greatly increased during the fifteenth century. By 1450 the medieval fortified castle with its moat, drawbridge, and portcullis was of little value for defensive purposes, and as the forts were removed to more strategic outlying districts, the towns themselves burst the bounds of their ancient walls, and the construction of the more luxurious city dwelling and suburban villa commenced. The feudal system had never obtained a firm foothold in Italy. Destiny, therefore, permitted the Italians to be the earliest designers of a type of domestic architecture in which comfort, convenience, and beauty were the important considerations, rather than safety, strength, and protection. The beginning of the modern art of interior design is coincident with that of domestic architecture.

The exteriors of the palaces built during the fifteenth century showed evidence of the Gothic influence in design and retained some of the vigorous characteristics of the old fortified castles, but, as the century progressed, the use of the architectural forms of classical antiquity greatly increased, and these were applied to the decorative treatment of the important rooms of the interior. Pedestal, column, pilaster, entablature, pediment, and panel were employed for both structural and ornamental purposes, and these features aided in producing rooms of great formality, dignity, and magnificence. Column capitals, on the whole, followed classical lines, but novelties and variations were introduced. Door and window openings were treated with architrave moldings as trim. In the more elaborate examples, openings were frequently flanked with pilasters supporting triangular, segmental, or semicircular pediments. To supplement the architectural forms, painted frescoes, elaborate embroideries, velvets, or tapestries were used on the walls. The subject matter for the mural

decorations consisted of scenes of antique ruins, distant garden views, scenes from classical history and mythology, religious and astronomical subjects, and portrayals of memorable events in the owner's family history.

In the latter years of the fifteenth century, the Italians discovered the mathematical principles of linear perspective. This discovery greatly benefited painters and artists in other mediums. Even woodworkers endeavored to show their abilities by producing *intarsia* (inlay) pictorial panels representing buildings and other objects drawn with proper foreshortening. Designers hit upon the ingenious device of giving a larger aspect to a room by lining its walls with wainscots treated with intarsia showing accurate perspective views of cabinets with open doors and shelves containing armor, vases, musical instruments, bird cages, books, etc. Architectural features were also introduced by using contrasting colored woods to produce the effect of natural highlights and shadows on the moldings.

During the cinquecento and later, elaborate use was made of colored marble slabs for wall treatments and architectural trim. Wall panel effects were produced by the use of borders or stripes in one color, with contrasting fields. Columns and pilasters with gilt-bronze capitals were added for further enrichment. Moldings and relief ornament were either carved or made of gilded stucco. Cast plaster heraldic devices, flower and leaf forms, amorini (cherubs), and grotesques eventually increased in size and number. Wood-paneled walls left in a natural finish or decorated with paint were a late development.

Examples of Renaissance interiors may be seen in the Palazzo Vecchio in Florence, the Farnese Palace in Rome, the Villa d'Este in Tivoli, and in many other palaces throughout northern Italy. The majority of rooms in these palaces are of a degree of richness in decoration that is far beyond the requirements of the present day.

Examples of Renaissance design. ABOVE: *Characteristic pilaster capital. The design is based on the Corinthian form, but the details are entirely novel in conception.* BELOW: *Arabesque wood carving. The design is symmetrical in mass, but variations in detail are introduced to produce interest.*

Alinari

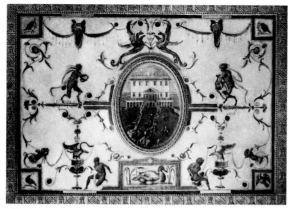

Alinari

Painted arabesque ornament of the fifteenth century in the Palazzo Vecchio in Florence. The design was inspired by classical art.

THE VILLA. During the early Renaissance many smaller palaces and country villas were built by wealthy merchants. These were decorated in a more modest fashion than the homes of the nobility. The academic architectural forms were used reservedly or were omitted in such interiors, and the thick stone walls were pierced by doors and windows having deep reveals without trim. The openings were treated either with a flat lintel or had a segmental or semicircular arch. The *Florentine arch*, usually used in arcades, was semicircular, and consisted of an architrave molding springing from a classical column. The coarse sand plaster used on the walls was accentuated by an irregular surface produced by the plasterer's trowel, giving an interest and richness in tone and texture. Walls were sometimes painted to imitate hung textiles; not only the pattern of the fabric, but the folds, nails, highlights, and shadows, as well, were reproduced. The rooms of these smaller dwellings were large in comparison with those of a modern home.

CEILINGS. Ceilings were high, and the general scale of details was correspondingly heavy. They were often elaborately treated in either wood or plaster or a combination of the two. The wood ceilings consisted of enormous walnut, oak, cedar, or cypress beams, spaced several feet apart, spanning the width of the room. The large beams in turn supported smaller beams, spaced one or two feet apart, running in the opposite direction, and supporting the floor above. The beams were striped with paint in vivid colors, and an occasional *cartouche*, *medallion*, or coat of arms was introduced in the center. Wood-paneled and *coffered* ceilings also were used in which both the wood and the panel were decorated with painted arabesques, conventional ornament, or scenic patterns. The plaster ceilings were usually flat and appeared to be supported at the wall with *coved* arches springing from brackets resembling pilaster capitals. Vaulted ceilings were also sometimes made in the form of a low segmental arch.

FLOORS. Tile, brick, and marble were the materials most suitable for floors in a warm climate, and all were extensively used. The accessibility and supply of colorful marbles made them popular for flooring. Checkerboard and scroll patterns in black, white, gray, and color were made. Floors were also made of a crushed colored marble mixed with cement, known as *terrazzo*. Tiles were usually six- or eight-inch squares or hexagons, and were both plain and patterned. Brick floors were usually laid following a herringbone design. Plank floors of oak and walnut were used, as well, in the early period, and after 1600 elaborate *parquetry* patterns in rarer, colored woods came into use. When floor coverings were used, they consisted of small Oriental rugs placed where most needed.

FIREPLACES AND MANTELS. The hooded fireplace was used in rooms of the late Gothic period in Italy, and with the introduction of Renaissance forms, the same general arrangement for carrying out the smoke was used; the detail of enrichment, however, gradually assumed a classic architectural character, and the projection of the hood was greatly reduced.

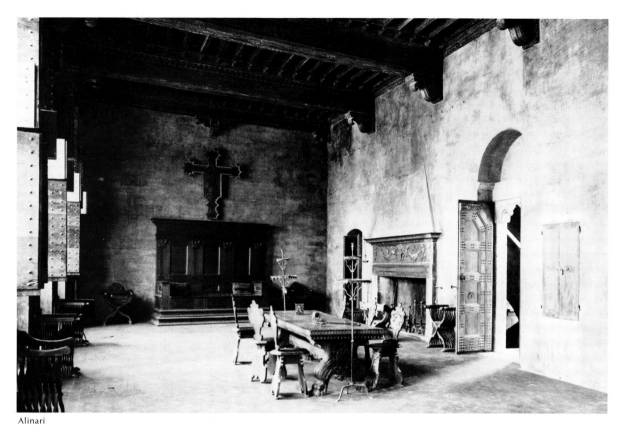

Alinari

Room in the Palazzo Davanzati, Florence, Italy, showing early Renaissance details and furniture.

When the fireplace opening was countersunk in the wall, the opening was trimmed on three sides with a flat architrave molding. The *bolection molding*, used as a trim, was also very typical. This latter form consisted of a heavy torus molding grouped with smaller moldings projecting several inches from the wall. In the more elaborate fireplace treatments, the architrave form of trim was crowned with a carved frieze and projecting cornice moldings, forming a mantelshelf. Dwarf columns, pilasters, caryatids, and acanthus leaf *brackets* were also used as side supporting motifs to support the entablature or cornice. Ornament consisted of carvings, marble inlay, and paint, showing arabesques and rinceaux, classical figures, heraldic forms, portrait busts, or grouped foliage patterns.

BUILT-IN FEATURES. The niche, a recessed wall space, was borrowed from classical architecture and adopted by the Renaissance interior designers for both ornamental and useful purposes. The ornamental niche, both with and without flanking pilasters, usually contained a statue in bronze, marble, or glazed or painted terra-cotta. The useful niche was used as a storage space and sometimes contained shelves or a washbasin. It often had two wooden doors or shutters that were plain, painted, or treated with a simple pattern. The niche heads were flat, segmental, or semicircular.

An ornamental feature that was frequently built into the wall was the glazed terra-cotta *plaque* or panel. The della Robbia family of sculptors became particularly famous for the

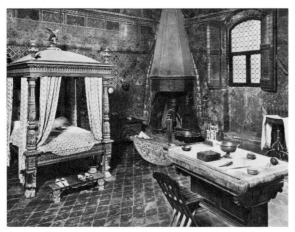

Interior of the late Gothic period in the Palazzo Davanzati, Florence.

Cell of Savonarola in the Museum of Saint Mark, Florence, showing the simplicity of treatment characteristic of the early Renaissance.

production of these panels, which were valuable as decorations and for color interest where plain plaster walls existed.* The plaques were modeled in high relief and consisted of cherubs, human figures, and wreaths and garlands of fruit, vegetables, and leaves. The coloring of the background was principally in light blue, with white used for relief ornament and figures.† Small portions of the pattern were sometimes colored in yellow, green, or purple.

THE BAROQUE STYLE. The term *baroque* is a word that possibly originated from the Portuguese "Barocco," which means misshapen, irregular, or ugly. The meaning at first was derogatory and seems to have been used as such in the late eighteenth or early nineteenth century after a revival of classicism. The limiting dates of the style are debatable, but its earliest evidences were seen in St. Peter's in Rome (1506); it reached its height in Italy about 1650 and then evolved into the rococo, a style which

had its roots in Italy but its most extensive development in France. Italy later borrowed the French forms, and the rococo terminated as a result of the Pompeian discoveries in c. 1755. Aesthetically the development of the baroque was a revolt against the frigidity and lack of spirit in the Vitruvian formulas as interpreted by Vignola and Palladio. Freedom in design was needed to express the ebullient qualities of the seventeenth century rather than to surround them with an antique framework. The Counter-Reformationists, headed by the Jesuits, recognized their opportunity, harnessed the movement to suit their requirements, and through a boisterous art endeavored to restore the religious wanderers to the fold and to confound the skeptics.

The baroque was discontinued in Rome after 1670 but was adopted by the Spaniards, Portuguese, Mexicans, and Bavarians, in whose countries it approached a theatricalism that was never equaled in Italy. A Protestantism that adored simplicity prevented its absorption by England. France under Louis XIV remodeled it to suit his needs, and out of it grew a French rococo that reached a zenith in originality.

* See Chapter 19.

† The most notable of these products were the swaddled *bambini* which decorate the spandrels of the Hospital of the Innocents in Florence, copies of which are sold popularly.

ST. PETER'S. The early baroque style was seen at its best in St. Peter's Cathedral in Rome (1506–1626), which was built on such a colossal scale that it is almost impossible visually to gauge its dimensions. St. Peter's is 710 feet long, and covers 227,000 square feet. Its dome is 450 feet high; the nave is 84 feet wide, roofed by a great barrel vault 150 feet high, and the supporting Corinthian pilasters are 84 feet from base to capital. The colonnade of its forecourt encloses an area that has contained 250,000 persons. Over a period of 120 years many famous architects and artists were employed in building it. Among them were Bramante, Raphael, Michelangelo, and Bernini, the latter being among the greatest of the high baroque. The statues of the saints in its niches are 16 feet in height, and the cherubs are 7 feet. The interior is a vast surface of arches, columns, pilasters, and other classical architectural features in colored marbles, frescoes, mosaics, sculpture, grilles, candelabra, paintings, intarsia, organ pipes, and gilded plaster ornament. Alabaster altars and chapels are ornamented with gold, rock crystal, and enamel.

St. Peter's magnificent throne occupies the western apse. Emotions become ecstatic as one looks at the high altar, crowned by the great *baldachino* of Bernini that is placed under the center of the dome and over the traditional

The nave of Saint Peter's, Rome, looking toward the baldachino centered under the dome above the crossing. The baldachino is 100 feet high and covers the High Altar built over the alleged tomb of Saint Peter. The interior overall length of the church is 600 feet. The nave is 84 feet wide.

Alinari

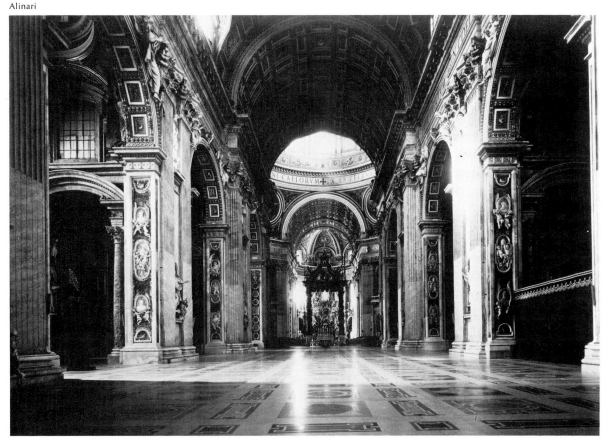

grave of the saint.* The baldachino is 100 feet high, supported by gigantic spiral columns and enriched with a wild extravagance of detail. The upward vista from this point includes in its perspective the great pendentives that support the *drum*, and reaches to the top of Michelangelo's dome, a point 350 feet above the marble floor. Its soaring effect is intensified by dramatic lighting. The rays of the sun infiltrate through the upper windows, penetrate the mist and drifting smoke from the burning incense, and produce a celestial effect. The cathedral is one of the most awe-inspiring works of man.

THE HIGH BAROQUE. Although St. Peter's was never afterwards surpassed in its scale or dimensions, it was used as an inspirational model for hundreds of churches built throughout Christendom, and the richness of its interior decoration formed the basis for the high baroque that occurred in Italy between 1630 and 1670. This was a style that discarded bulk and large scale but increased surface enrichment and color brilliance, a type of decoration that made a stronger emotional impression upon the masses.

The high baroque used curved forms instead of straight for structural as well as ornamental purposes. Walls were often planned with undulating curves, and the orders of architecture were often ornaments as well as structural elements. Columns were sometimes twisted into spirals and shamelessly supported nothing. Entablatures and moldings followed bulging shapes, or were warped into three-dimensional curves. Scroll and serpentine pediments were broken in two, and each half faced in the wrong direction. Angels, cherubs, and genii, in various

* It is believed that Peter suffered martyrdom under Nero in A.D. 67. Tradition says that he was crucified with his head downward on the Vatican Hill. In Matthew 16:13–20 it is stated he was given the keys to heaven. This established him as the first pope of the Roman church. The keys to heaven have always been used in the decorative arts to symbolize St. Peter.

attitudes and realistic coloring, seemed to be flying through the air or emerging from clouds. An extensive use was made of *peintures-vivantes*, high reliefs of religious groups, modeled and colored in lifelike reality, framed in fanciful architectural detail, and lit by natural and artificial means that brought them to the verge of animation. Elaborate gilt ornament often smothered structural forms under its mass. Honesty of material was disregarded; theatricalism and scenic effect were the first requirements, and if plaster or tin could substitute for marble or gold, the artistic conscience did not suffer.

The baroque church decoration spread to palace and villa and merged with garden design. Balconies, belvederes, fountains, terraces, and flower beds showed an outburst of dynamic effects. Artists and craftsmen in every medium produced furnishings and household accessories that were in accord with the architectural movement and the public demand for aesthetic turbulency. In palace decoration the walls were frequently covered with rich brocades, brocatelles, velvets, and damasks, and hung with paintings or huge mirrors in gilt frames. Elaborate frescoes simulating architectural features were also introduced. Stucco ornament replaced the carved wood and marble of the classic cinquecento. Ceilings were at times loaded down with plaster cherubs flying here and there supporting heavily fringed stucco draperies in full color. Walls were sometimes japanned or lacquered; dadoes were of ivory, of marble, or of painted imitation marble. Mother-of-pearl, silver, and tortoiseshell inlay were used in doors, paneling, and furniture.

FURNITURE. In the early Renaissance, furniture was sparingly used, and what existed was consistent with the large dimensions of the rooms. By the middle of the quattrocento a more general demand for improved richness and comfort in the movable furnishings of the house was prevalent, and, as great thought was placed upon entertaining, the general design and ar-

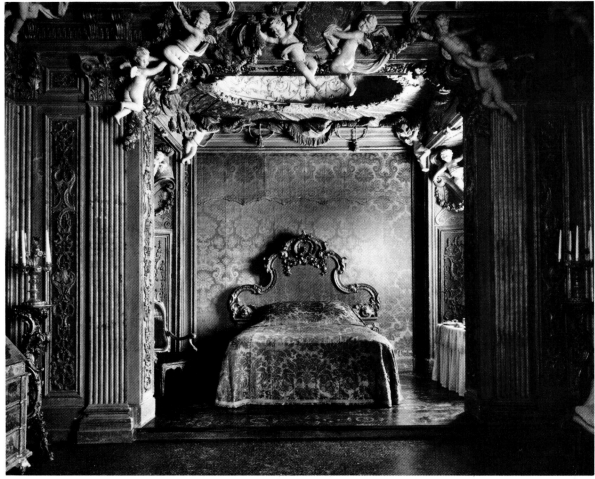

Metropolitan Museum of Art

Characteristic early eighteenth-century Italian interior showing a strong French baroque and rococo influence.

rangement of the furniture was made with this activity in view.

A great deal of the furniture was monumental in character, and its logical position was against the wall, forming a dominant note in the wall composition, with such subordinate motifs as chairs, decorative wall plaques, portrait busts on brackets, heavily framed paintings, or panels of relief sculpture.

There were certain characteristics of Italian furniture that carried through the whole period of native design from 1400 to 1700. The principal one was the use of walnut as a cabinet wood. The fertile soil and temperate climate of Italy were particularly suitable to this tree, which often grew to a height of seventy-five feet. Walnut planks with beautiful grain and rich brown color could be had over three feet wide, and these were made into table tops or panel fields. While various other woods were used by the country cabinetmakers, almost 90 percent of the furniture of these centuries was made of walnut.

The earliest Renaissance cabinetmakers followed the principles of their Gothic predecessors in applying architectural forms to the

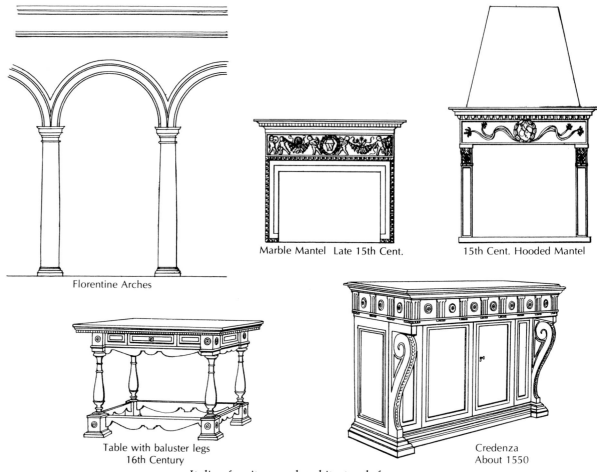

Florentine Arches

Marble Mantel Late 15th Cent.

15th Cent. Hooded Mantel

Table with baluster legs
16th Century

Credenza
About 1550

Italian furniture and architectural forms.

ornament and decoration of their furniture. The change required only the substitution of classic orders, acanthus leaf, *grotesque,* and arabesque for pointed arch, tracery, and linenfold. The straight Gothic structural lines produced by stile and rail were maintained. Italian Gothic furniture frequently had painted panels showing historical or religious groups, events, and sequences, and the charm of this type of enrichment caused it to persist well into the fifteenth century. *Gesso* ornament, made of chalk and white lead cast in a mold, was also used to make relief patterns that were to be gilded or *polychromed,* and where repetition of motif was

admissible, the advantages of this material were obvious.

Certain types of furniture decoration were local in origin. In the vicinity of Lombardy, small ivory inlay patterns were set in the woodwork. This ornamentation was known as *certosina.* Venice produced much furniture that was covered with intricate scroll and arabesque patterns, made by inlaying different colored woods—an enrichment known as wood intarsia. From the beginning of the cinquecento, Renaissance furniture was enriched both by carved relief patterns and painted decorations consisting of cartouches, rinceaux, arabesques, grotesques, ga-

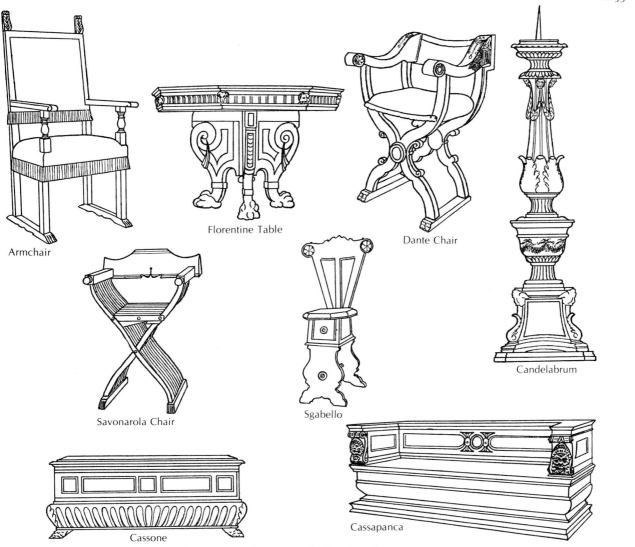

Armchair

Florentine Table

Dante Chair

Candelabrum

Savonarola Chair

Sgabello

Cassone

Cassapanca

Sixteenth-century Italian furniture.

droons, dolphins, and other forms borrowed from antiquity. The ornament on Florentine furniture was frequently touched up with dull gold, which gave it added sparkle and interest and caused it to harmonize well with all other colors used in a room.

In spite of characteristics featured in particular localities, the same forms were almost immediately copied in other parts of Italy. By the middle of the cinquecento, gesso and painted decoration were less applied to furniture, and the Roman method of carving the ornament became popular. At the same time, curved structural forms began to be introduced with the baroque influence in architecture. Ornament increased in quantity and capriciousness. Venice became particularly noted for the extravagant forms that were later partly influenced by foreign models.

The panels on the early furniture were small

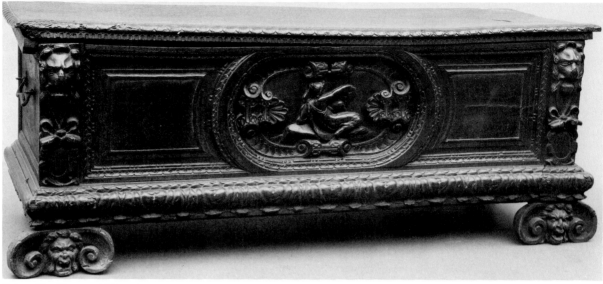

Metropolitan Museum of Art

A carved walnut cassone from the sixteenth century. These were commonly used as marriage chests.

and rectangular in shape, although the dimensions were often larger than those of the Gothic period. The early panels were sunk below the stiles and rails and were bordered on four sides with simple moldings. Sometimes narrow stripes of color-contrasting woods formed part of the panel framework, and borders in checkerboard effects were also seen. When decorated, the early panels were painted with scenes or arabesques. Wood intarsia and carving enriched the later panels. During the baroque and rococo period, the panels were made in irregular shapes, and the field often projected beyond the stile, producing the raised or bolection panel. Semiprecious stones and other materials such as lapis lazuli, onyx, amber, ivory, and *crystal* were also used for inlay purposes. Many of the larger pieces of Italian furniture stood on low pedestals or projecting steps, to give them added dignity. Beds, chests, and heavy *case furniture* were often built up from the floor without the use of legs for support. Italian furniture, as a general rule, is called by its Italian name. The important pieces are described in the following paragraphs.

The *cassone* was a chest or box of any kind, from the small jewel casket to the enormous and immovable wedding or dowry chest that was the most important piece of furniture in the Italian room. The cassone was also used as traveling baggage. The lid was hinged at the top, and when the piece was closed, it could be used as a seat or a table. The cassone served the purposes of the modern closet.

The *cassapanca* was a large cassone with a back and arms added to it to form a settee or sofa. This was particularly a Florentine production. Loose cushions were used for comfort.

The *credenza* was a cabinet-sideboard with doors and drawers intended for the storage of linen, dishes, and silverware. It was made in various sizes. The small type was known as a credenzetta. The credenza often had an ornamental wooden back rising from its shelf.

The *sgabello* was a light wooden chair used for dining and other purposes. The early types had three legs, small octagonal seats, and stiff backs. The later examples show two trestles or *splat* supports, and when carving was introduced, both the trestles and backs were elabo-

rately treated. The sgabello was also made without a back, forming a low bench.

The *sedia* was a chair, of which there were several varieties, all lacking comfort, if judged by modern standards. The armchair was rectangular in its main lines, with square, straight legs. The legs were connected with stretchers, which were sometimes placed so as to rest on the floor. A characteristic feature was the upward extension of the rear legs to form the back uprights, which were terminated with a finial motif intended to represent an acanthus leaf bracket. The arm support was usually turned in a *baluster* form. Upholstery of back and seat consisted of velvet, damask, or ornamental leather, trimmed with silk fringe. The smaller side chair was built on the same general lines as the armchair, but often was made entirely of wood and enriched with simple turnings. Seats were made of rush, wood, or textile. Ornamental nailheads were used with leather upholstery. Other chairs were of the folding or X-shaped type, of which there were three varieties. The "Savonarola" type was composed of interlacing curved slats and usually had a carved wooden back and arms. The "Dante" or "Dantesque" type had heavy curved arms and legs, and usually had a leather or cloth back and seat. The "monastery" type was smaller and was built of interlacing straight splats. Folding chairs were also made of wrought iron with brass trimmings and cushion seats.

The *letto*, or bed, was often a massive structure with paneled headboard and footboard, the whole surrounded by cassoni standing solidly on the floor without legs. Other beds were of the four-poster variety, with *tester* above. All were treated with richly carved, painted, or intarsia ornament and draperies.

Tables were made in all sizes. Large rectangular *refectory* tables often had tops made of single planks of walnut. The supports were elaborately carved trestles, dwarf Doric columns, or turned baluster forms. Both plain and carved *stretchers* were used. Small tables often had hexagonal and octagonal tops, and were supported by carved central pedestals. The edges of the tabletops were usually treated with ornamented moldings.

Drop-lid writing cabinets, double-deck storage cabinets, wardrobes, framed pictures and mirrors, pedestal supports for statues and ornaments, clothes racks, bookcases, firescreens, and hanging shelves completed the list of furniture types used in the Italian interior before the eighteenth century.

During the high baroque and the latter years of the seventeenth century, the same lavishness displayed in interior architecture was also to be found in furniture design and construction. Cassones were eliminated, but variations of the credenza remained. Raised panels were used on enormous cabinets. All furniture was large and heavy. Nailheads continued to be arranged in patterns on leather- and fabric-covered chairs. Furniture inlay offered lavish decorative possibilities, with the introduction of pietra dura, lapis lazuli, onyx, ivory, mosaic, rock crystal, marble, and other semiprecious stones. Decorative painting was also frequently resorted to for the enrichment of furniture, particularly on panels and on the headboards of beds. Furniture woods, if of an inferior grade, showed painted surfaces and decorations to help conceal the inferior construction.

Minor arts and accessories. The love of beauty so penetrated the Italian mind that the most insignificant article of household use was designed with care and thought. As a result, most of the decorative accessories used in the rooms were of extraordinary charm and maintained the standard of excellence set by the productions of the greater artists, many of whom had spent their apprenticeships in the metal, jewelry, and glass ateliers, or as designers of pottery or textiles.

The fine arts of painting and sculpture during the Italian Renaissance need no emphasis

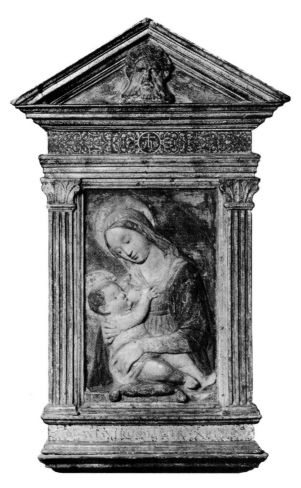

Polychromed stucco relief panel of the Virgin and Child, sculptured by Benedetto da Maiano in the fifteenth century. It is framed with the characteristic architectural frame of the period.

here. The smaller easel paintings of the masters and their pupils were in constant demand as room decorations and were usually given places of honor on the walls. Pedestals, wall brackets, niches, and architectural treatments were designed for pieces of sculpture. Carved picture frames frequently took the form of architectural compositions, with pedestals, pilasters, entabulatures, and pediments. Small relief panels, similarly framed, often showing the Madonna and Child, were carved in marble, cast in plaster, and made in glazed or painted terra-cotta.

Among the most important accessories in the Italian rooms of the sixteenth century were the large enameled earthenware plates which were known as *majolica* ware. Their principal value was as ornament. Their manufacture was centered in the town of Deruta, Faenza, and Urbino. They were painted by minor artists, although Raphael is known to have been employed in this manner in his youth. The range of colors was limited, because of the difficulty of obtaining pigments that would not fade in the kiln. The decoration was in either arabesque or pictorial form, covering both rim and center. Scenes of classical history and mythology were often shown. The drawing was generally naïve in character. Pitchers, vases, pharmacy pots, and other useful articles were also made in this ware.*

The Italians developed extraordinary ability as workers in both precious and base metals. Cellini's greatest ability was as a goldsmith, though his genius was also exceptional as jeweler, sculptor, and author. While such men as Sansovino, Maiano, Donatello, Ghiberti, and Verrocchio are best known for their figure sculpture, they did not hesitate to design for bronze reproduction, decorative relief panels, lanterns, candelabra, inkstands, andirons, door hardware, knockers, and other articles of architectural and household use. Sculptors such as Il Riccio and Vittoria devoted themselves to small objects, and the production of bronze statuettes by the *cire-perdue* process, in imitation of large classical originals, was a flourishing art that enriched mantel, shelf, and table.

Venice was the center of the ornamental glass and table glassware industry, and from medieval times her painted products had been exported to other European countries. Small wall

* See Chapter 19.

the larger homes. Lacemaking became an important industry in northern Italy, and the materials were largely used for both clothing and interior decoration. Oriental rugs were frequently used for table covers as well as for floor coverings.

COLOR SCHEMES. The Italians had a sophisticated understanding of the use of color for interior work. The large scale of many of the

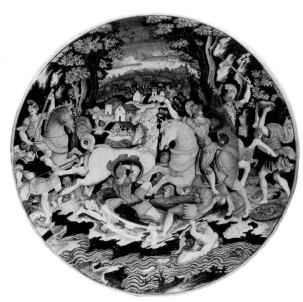

Metropolitan Museum of Art

Sixteenth-century majolica plate made in Urbino, showing a pattern in which the difference in the height between rim and center is disregarded.

mirrors, substituted for polished metal, were introduced during the fifteenth century. So costly and valued were the early mirrors that they were usually covered with a wooden door or panel, and great attention was paid to their frames. In the sixteenth century, mirrors increased in size, and the convex mirror increased in popularity. Rock crystal carving, the enameling of metal panels, and the carving of *cameo* and *intaglio* medallions were also extensively carried on in Italy.

Italian textiles used for draperies and upholstery were usually of silk. Velvets and damasks were the most common weaves during the early Renaissance; brocades and brocatelles, during the late period. Patterns were large. Dress velvets made in Genoa were used for loose cushions and for the upholstery of the smaller pieces of furniture. Flemish and Italian handmade tapestries were used as wall hangings in

Sixteenth-century bronze statue of a centaur modeled after the antique and cast by the cire-perdue *process.*

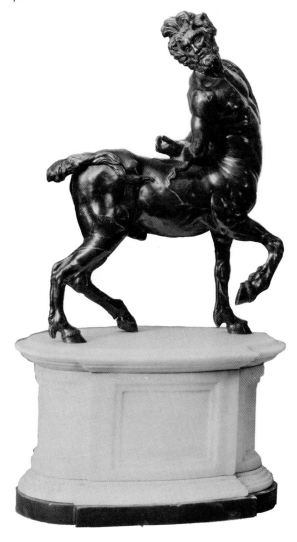

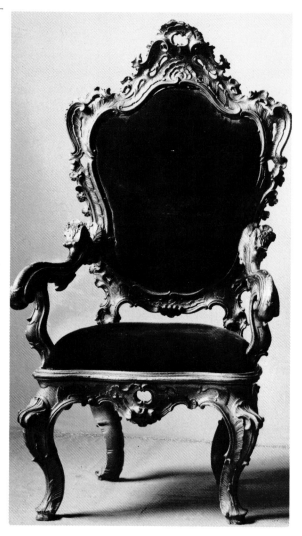

Venetian chair of about 1735 showing extremely florid French rococo character.

rooms permitted strong tones in *primary colors* to be used, although discretion was maintained in the distribution. When plain, neutral-colored plaster was used for a wall, draperies and accessories could afford to be in brilliant reds, blues, yellows, purples, and greens. In the later Renaissance, colors were softened. When brocades and damasks were used for wall treatments, the size of the room was taken into consideration in the selection of the colors. Strong

tones were still used in the larger rooms, but delicate shades were selected for the smaller ones.

THE DECLINE AND ITS CAUSES. The decline of the Italian dominance of style dates from c. 1650 and coincides with the transfer of the political, financial, and cultural control of Europe to France under Louis XIV and later to England under Queen Anne. The vast funds collected through the exorbitant taxes levied by Louis, and spent in enriching his palaces, attracted the artistic talent of the world to Paris, where the rewards were high. The Italian trade with the Orient lessened as the discovery of America occupied the attention of Europe. The decline in the wealth of Italy and the establishment of superior French and English prestige in Europe were the final blows to the creative spirit of the Italians. The magnificent and novel productions of the Parisian ateliers began to set the standards of industrial art for the whole of Europe. Italian artists were forced to meet the demand for foreign designs. In imitating the products of other nations, they produced many crudities, although an effort was made to copy the general character of the originals. The products of this period in Italy clearly show a far less capable conception of good form than was maintained by the designers of the originals, and yet the productions were not lacking in a charm and quaintness of their own.

THE ROCOCO (1720–1750). The style known as the rococo in Italy started well before the high baroque had exhausted itself, and to some extent may be considered merely a further development. Although its first manifestations were seen in Italy, the transfer of the economic and artistic leadership of Europe from Italy to France was in progress, and the real development of the style occurred in the latter country. The Italians looked across the Alps for their inspiration. The name of the style was taken from the initial letters of both the Italian and French words for rock and cockleshell. These were fea-

tures borrowed from nature that eventually were commonly imitated in architectural stonework and ornament. Decorative designers in search of novelty also seized upon book engravings of the period that were beginning to show fantastic leaf and scroll ornaments never intended to be produced in relief. These motifs began to be applied to walls and furniture in wood carving and plaster and metalwork. The most able Italian designers who went to France at the invitation of Louis XIV carried the ideas with them, and the rococo style developed in France even more rapidly than it did in Italy. Although its roots began before the end of the seventeenth century, it did not reach its culmination in France until the middle of the eighteenth century. During this period there was a constant interchange of both ideas and workers between France and Italy. The French interpretation of the style returned to Italy, where it received still further development in the exaggerations of curved lines and forms, although the scale was smaller than during the baroque period.

Italian rococo art, as compared to the contemporary French art of the period, was sometimes coarse, and tended toward artistic vulgarity. Ornament was badly designed and was applied without regard to suitability. Proportions were usually awkward in comparison to the French originals. Much gilding was used. The Italian creative imagination tended toward theatrical effects. In the matter of furniture design, the Italians also turned extensively to England, and the William and Mary and Queen Anne styles were freely copied. Lacquer was employed for furniture decoration, and in the desire for lacquered effects, colored engravings were cut out, glued to furniture surfaces, and covered with a heavy coating of varnish. The Chinese influence was also introduced in design forms as well as in finish. The work of the Englishmen William Kent and Chippendale fired the Italian imagination. The Italians often confused

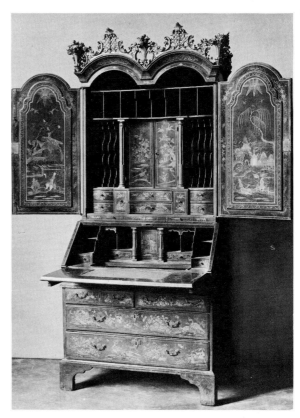

Venetian secretary made about 1720 showing English Queen Anne design influence. The lacquer was often simulated by the application of painted and highly varnished paper veneers.

Late eighteenth-century settee with painted medallions showing Pompeian influence.

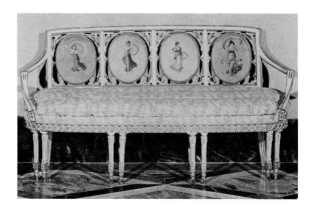

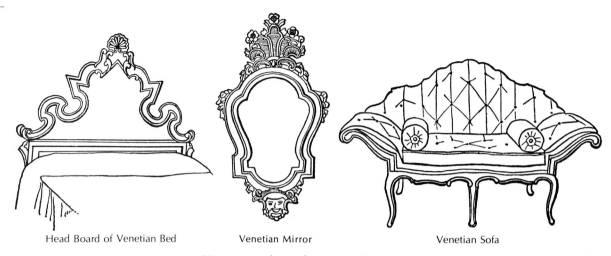

Head Board of Venetian Bed Venetian Mirror Venetian Sofa

Venetian eighteenth-century furniture.

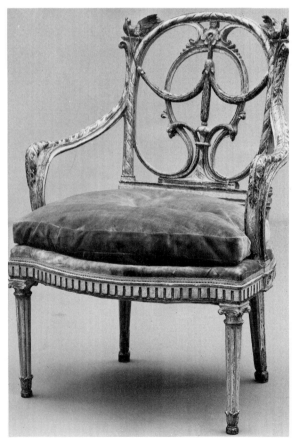

Metropolitan Museum of Art

Late eighteenth-century carved and polychromed wood chair.

and combined the styles of eighteenth-century France and England.

The social life in Italy of the eighteenth century emulated the French; artists, scholars, cavaliers, ecclesiastics, and ballet dancers hobnobbed with dukes and princes. The great families of the early Renaissance were extinct. The finances of the petty kingdoms of Italy were at a low ebb. Venice and the papacy alone maintained their power and prestige. The frivolity and gaiety of the eighteenth century were largely centered in the ancient city of the doges. As the elite of Venice squandered their time and resources in pleasure and vanity, trade and industry were at a standstill, and the end was inevitable.

Italian rococo decoration and furniture is often labeled "Venetian," because of the orgy of decoration in that city during the eighteenth century. Furniture in imitation of the French styles was made and used in many cities of northern Italy and is sometimes designated as Italian-Louis XIV, Italian-Louis XV, or Italian-Louis XVI. Much of the furniture made for the less important houses during the eighteenth century was simple in design, yet gay, colorful, and romantic in effect, and very adaptable to homes of today.

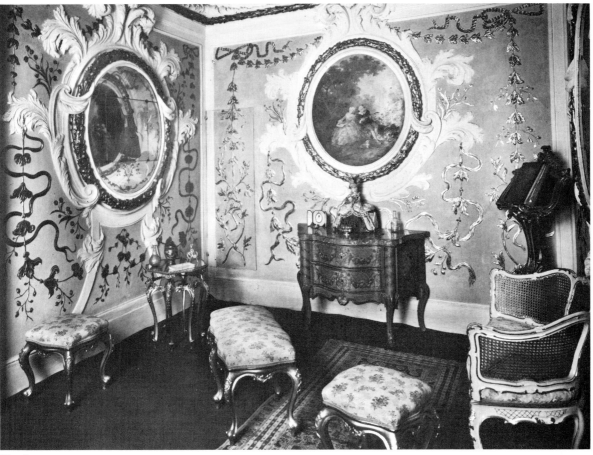

Alinari

Venetian eighteenth-century salon showing strong French influence in its extravagant design.

THE CLASSIC REVIVAL IN ITALY. Toward the end of the eighteenth century and in the early years of the nineteenth, the Italian people felt the influence, in spite of their comparative poverty, of the excavation of antique cities going on in their midst. All Europe was engaged in the search of Roman and Pompeian ruins. It would have been strange, indeed, if Italy had not shared in this enthusiasm. The continued adherence of the Italian aristocracy to French modes and manners further centered their attention on the use of French decoration, which in turn had been inspired by the discoveries of Pompeii and Herculaneum. The Italians, how-

ever, accused the French of being too correct in the use of the antique style, and they felt that the Adam leadership in England produced a style that was too cold and bloodless for southern temperaments. Interior designers in Italy, inspired by their natural exuberance and love of florid decoration, continued to draw upon their imaginations for innovations and variations of the northern styles. Toward the end of the century, greater delicacy and refinement were seen.

Marquetry patterns and marble intarsia or inlay were extensively used for furniture enrichment, and this type of ornament enabled

the craftsmen to produce some of the loveliest contributions to eighteenth-century art. Painted furniture continued to be much in favor, and many of Italy's most talented decorative painters, such as Cipriani, Pergolesi, Zucchi, and Piranesi, produced in their delightful paintings an art of unrivaled charm. Both the English and the French, by offers of greater compensation, induced Italian painters who had studied the antique details to leave Italy and pursue their activities away from home. Other countries also benefited by Italian talents.

THE EMPIRE STYLE IN ITALY. With the exception of France, probably nowhere else was the Empire style as originally and successfully expressed as in Italy. Napoleon was master of Italy for ten months in 1796. His sister, Pauline, married into the princely house of Borghese and further stimulated the devotion to the arts of France. Napoleon himself became emperor of Italy in 1805, made his stepson viceroy of Naples, and later called his infant son the king of Rome. Many of the old Italian palaces were redecorated in the French Empire style and were enriched with furniture and accessories made in Parisian workshops.

LEADERS IN THE ARTS OF ITALY

The following list contains the names of the best-known leaders in the Italian arts, together with the dates when they flourished and a statement of the work for which they were noted:

Alberti, Leone Battista (1404–1472). Early Renaissance architect, scholar, and author.

Angelico, Fra (1387–1455). Poetical and mystical painter of religious subjects.

Bernini, Giovanni Lorenzo (1598–1680). A leading architect of the baroque period. Sculptor and painter. Designer of the *baldachino* in St. Peter's and the colonnade.

Boccaccio, Giovanni (1313–1375). Novelist of pagan ideals, author of the *Decameron*.

Borromini, Francesco (1599–1667). Most imaginative of the Roman baroque style. Influenced most of Bavarian baroque style as well as St. Paul's Cathedral, London.

Botticelli, Sandro (1444–1510). Poetical painter of classical mythology and allegorical subjects.

Bramante, Donato d'Agnolo (1444–1514). Painter and architect of St. Peter's in Rome.

Brunelleschi, Filippo (1377–1446). Considered the earliest Renaissance architect. Designed the dome of the Cathedral and the Hospital of the Innocents in Florence.

Cellini, Benvenuto (1500–1571). Goldsmith and sculptor.

Cimabue, Giovanni (1240?–1302?). Florentine painter, the teacher of Giotto. Designed mosaics and frescoes.

da Caravaggio, Michelangelo (1569–1609). First Italian realist painter.

da Vignola, Giacomo Barozzi (1507–1573). Italian architect who wrote the *Treatise on the Five Orders* and revived the standardized proportions of Vitruvius.

da Vinci, Leonardo (1452–1519). Great Florentine painter, sculptor, architect, scientist, engineer, writer, and musician. One of the most imaginative and inventive of men.

Dante Alighieri (1265–1321). Poet and father of vernacular literature, author of *Divina Commedia*.

Della Robbia family: Luca, Andrea, Giovanni, Girolamo (1400–1566). Sculptors and originators of Della Robbia *faïence*.

Donatello (1386–1466). Florentine sculptor of the naturalistic school. Great student of the antique.

Ghiberti, Lorenzo (1378–1455). Sculptor famous for his bronze doors in the Baptistery of Florence.

Giorgione da Castelfranco (1478–1510). First Renaissance painter among the Venetians.

Giotto di Bondone (1266?–1337?). Florentine painter, sculptor, and architect. Important influence on the Renaissance.

Masaccio, Tommaso Guidi (1401–1428). First Florentine painter of naturalism.

Michelangelo Buonarroti (1475–1564). Painter, sculptor, architect, and poet. Called the father of the baroque.

Palladio, Andrea (1518–1580). Architect and excavator of Roman ruins. Author of book on antique architecture. Designer of villas.

Petrarch, Francesco (1304–1374). Scholar, humanist, and author.

Pinturicchio, Bernardino (1454–1513). Decorative painter.

Raphael Sanzio (1483–1520). Painter and architect.

Sansovino, Jacopo (1486–1570). Venetian architect and sculptor of the sixteenth century.

Savonarola, Girolamo (1452–1498). Italian monk and reformer who was burned at the stake.

Tintoretto, Il (1518–1594). Venetian painter renowned for his grandiose effects achieved by the play of light and shadow. Real name Jacopo Robusti.

Titian (1489?–1576). Venetian painter of the sensuous spirit of the Renaissance. Real name Tiziano Vecelli.

Veronese, Paolo (1528–1588). Painter of the luxurious Venetian life, renowned for his silvery tones.

BIBLIOGRAPHY

Baumgart, Fritz. *A History of Architectural Styles.* New York: Praeger Publishers, 1970.

Bazin, Germain. *Baroque and Rococo Art.* New York: Praeger Publishers, 1964.

Brunelli. *Ville del Brenta.* Milan, c. 1936.
Italian text and illustrations of Italian eighteenth-century villas.

Burckhardt, J. *Civilization of the Renaissance in Italy.* Oxford University Press, 1944 (reprint).
One of the finest books on this subject.

Durant, W. *The Renaissance.* New York: Simon and Schuster, 1953.
A comprehensive history.

Eberlein, H. D. *Interiors, Fireplaces & Furniture of the Italian Renaissance.* New York: Architectural Book Pub. Co., 1916.

Hartt, Frederick. *History of Italian Renaissance Art.* Englewood Cliffs, N.J.: Prentice-Hall.

Hunter, G. L. *Italian Furniture and Interiors.* New York: Helburn, 1918.

Kimball, Fiske. *The Creation of the Rococo.* New York: W. W. Norton and Co., 1964.

Lowell, G. *Smaller Italian Villas and Farm Houses.* New York: Architectural Book Publishing Co., 1929.
Text with photographs.

Marazzoni, G. *Il Mobile Veneziano Del'700.* Milan: Casa Editrice d'Arte Bestetti e Tumminelli, 1927.
Italian text with excellent photographs of Venetian furniture.

Martinelli, Guiseppi, Ed. *The World of Renaissance Florence.* New York: Wittenborn and Co., 1968.

Masson, Georgina. *Italian Villas and Palaces.* London: Thames and Hudson, 1951.

Odom, W. M. *A History of Italian Furniture.* Garden City, N.Y.: Doubleday and Co., 1918.
Excellent illustrated text.

Pevsner, N. *Pioneers of Modern Design.* Baltimore: Penguin Books, 1960.

Réalités, Ed. *Great Houses of Italy.* New York: G. P. Putnam's Sons, 1968.

Richards, J. M. *An Introduction to Modern Architecture.* Baltimore: Penguin Books, 1967.

Rosenburg, L. C. *The Davanzati Palace, Florence, Italy.* New York: Architectural Book Publishing Co., 1922.
Brief text with measured drawings of the restored fourteenth-century palace.

Schottmuller, F. *Furniture and Interior Decoration of the Italian Renaissance.* New York: Brentano's, 1921.
An introductory text with fine collection of photographs.

Sewter, A. C. *Baroque and Rococo.* New York: Harcourt Brace Jovanovich, 1972.

Symonds, J. A. *The Renaissance in Italy: The Fine Arts.* London: Smith, Elder and Co., 1899.
A beautifully written text on the lives and works of the Italian artists. A standard book.

Thomas, W. G., and Fallon, J. T. *Northern Italian Details.* New York: The American Architect, 1916.
Text with measured drawings and photographs.

Witkower, Rudolf. *Art and Architecture in Italy, 1600–1750.* Baltimore: Penguin Books, 1958.

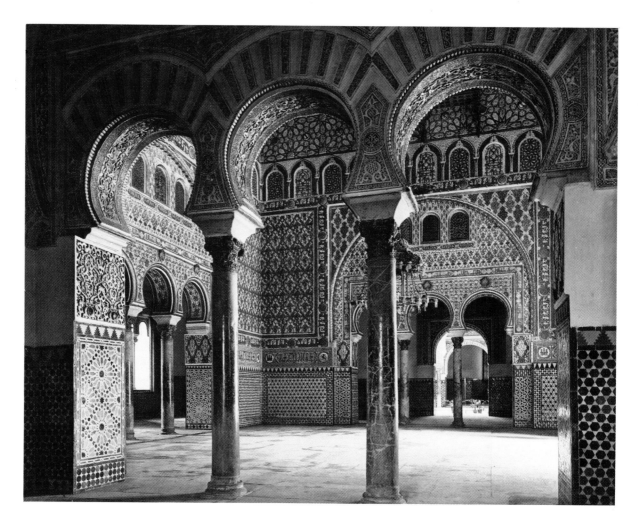

Hall of Ambassadors in the Alcazar, Seville.

CHAPTER 4

The Hispanic Periods

Hispano-Mauresque dish made about 1500.

The civilizations of the Iberian Peninsula are unique among the countries of modern Europe. They have linked the cultures of the Near East and the Western world and enjoyed the riches of both. On their soil was placed that spectacular drama of Moor and Christian fanatic that lasted nearly a thousand years, and ended in a blending of characteristics of the two races that has produced the modern Spaniard and Portuguese.

RACIAL ORIGINS AND EARLY HISTORY. Nearly all the great nations of antiquity made settlements in the peninsula. The original inhabitants were the Iberians, who at some time were fused with a Celtic stock. The Basques in the Pyrenees are supposed to be the most direct descendants of these groups and are probably nearer to the aboriginal Europeans than any other people. Settlements were made by Phoenicians, Greeks, Carthaginians, Berbers, and Romans, the latter calling the area Hispania. Each of these peoples have left their marks, and the Romans have left impressive architectural ruins. When the bar-

barians struck at the heart of the Roman Empire, the most distant Roman legions were recalled to the banks of the Tiber for the last stand against the invading hordes, and Hispania was one of the first localities to suffer the loss of Roman military protection. In the first decades of the fifth century the Visigoths, a Teutonic people who had become partly Christianized, crossed the Pyrenees, occupied the Roman settlements, and, unmolested, commenced the construction of churches and dwellings.

The Visigoths traded with Constantinople, and their art was strongly under Byzantine as well as other Near Eastern influences. There are examples of Visigothic architecture remaining in Spain, the most renowned being those in Toledo. The other evidences of Visigothic culture are largely those of the goldsmith's art, as proven by the discovery in the last century of a buried treasure, consisting, among other objects, of golden crowns set with pearls and semiprecious stones. In the realm of thought and letters, the Visigoth Saint Isidore of Seville distinguished himself by compiling an encyclopedia which was to become an authoritive book of learning in the Middle Ages. Of importance, too, was a codification of laws known as the *Fueros Juzgos*. In the main, however, Visigothic civilization was of insufficient potency to leave a permanent impress or to modify subsequent influences.

In the early years of the eighth century, the Moors, of Saracenic origin, who were then at the height of their vigor and glory, crossed the Straits of Gibraltar and found a weak and disorganized group of feudal states having only the Christian faith in common. The frenzied zeal of the Mohammedan, his reverence for the Koran, and his faith in Allah developed a psychology that made the destruction of adherents to rival creeds both a duty and a pleasure.

The battles at the Guadalete River and Jerez de la Frontera (A.D. 711) were followed by the fall of Granada, Cordova, Valencia, Seville, and other southern cities. After temporary setbacks

—109—

at Covadonga in 718, the victorious Arabs marched northward, bent only on spreading their faith and crushing the growing power of Christianity.* In the year 732, they crossed the Pyrenees and were met by the Franks, under Charles Martel, the grandfather of Charlemagne, near the city of Tours. There, one of the decisive battles of world history was fought, a battle that released western Europe from the political and religious influence of the Koran. The Moors retreated across the Pyrenees. From their strongholds in southern Spain, they waged for five centuries a bitter struggle against the slowly but inexorably advancing Christian armies, aided, at the beginning, by Charlemagne.† In the thirteenth century the Moorish holdings were reduced to the kingdom of Granada. The early exploits and encounters of the Christians and the "infidels" form the subject matter of the "Chansons de Roland" and of the legends, romance, and minstrelsy so poetically related in the epic of El Cid.

In the first days of the year 1492 the city of Granada surrendered to the united armies of the ambitious King Ferdinand of Aragon and his able wife, Queen Isabella of Castile. The Moorish King Boabdil was forced to take refuge in North Africa. The eight-century-old process of the Reconquest was brought to its conclusion. The inhabitants were given the choice of con-version to Christianity or emigration. Much disorder occurred, and it was not until 1609 that the final expulsion of the Moors took place. The union of the kingdoms of Aragon and Castile was effected by 1506 and, joined by the less powerful states, formed the nucleus of the present Spanish nation.‡

During the period of the Spanish invasion, the Moors were at the height of their civilization. The leaders were said to be models of integrity and justice, and to be tolerant in their treatment of the conquered. Philosophers and creative artists, the Moors established schools and universities and, in collaboration with the Jews, who were the leaders of commerce and industry, dominated the cultural life of the peninsula for 800 years. When Spain finally overthrew the Mohammedans, she found imperishable traces of the Orient in her blood, her customs, her arts, and her intellect.

PERIOD OF DISCOVERY AND CONQUEST. In the latter years of the fifteenth century, Castile and Portugal launched forth on careers of discovery and exploration. The voyage of Columbus that legend says was made possible by Isabella's pawning her jewels astounded the world and aroused the interest of Europe in the Western Hemisphere. The discovery was an event which developed untold enthusiasm and a sense of national unity and ambition in the Spanish people. Pinzon, de Cordova, Magellan, Balboa, de Soto, de Leon, and Coronado set sail for unknown shores and aided in establishing an empire upon which the sun never set. Vasco

* There was not as much difference between Mohammedan and Christian philosophy as is supposed. The Mohammedan culture at this period far outshone the Christian. Mohammed the prophet of Islam, who was born in Mecca and died in 632, considered himself the last of the prophets and successor to Jesus. Upon his death his followers, in an explosive enthusiasm combined with a martial ardor, developed an urge to spread his teachings throughout the world.

† Charlemagne, however, was considered an intruder, and his rear guard was ambushed and destroyed by the Basques in 778 at Roncesvalles in the Pyrenees. It was in this battle that Roland and Oliver were slain.

‡ Portugal was at intervals under the crown of Spain, but this arrangement was never acceptable to her people. She finally regained her independence and her former empire in 1665, but her people are of the same racial and cultural origins as those of Spain; her language is easily understood by the Spaniard and differs less than Catalan and Basque from the best Castilian. Portugal faces the ocean, turns her back on Spain, and waits for the world to discover her.

da Gama, for Portugal, rounded the Cape of Good Hope to India and brought untold wealth to his nation. Cabral discovered Brazil. The Portuguese, by an astounding expansion of their shipping, obtained their Indian, African, Chinese, and Brazilian colonies, and discovered the Azores. Portugal became one of the great empires of the world. Within the next century the Spanish conquistadores, Cortez and Pizarro, conquered Mexico and Peru, and for a century, Spanish galleons returned to Cadiz loaded with quantities of silver and gold. The ships that sailed under the Portuguese banner returned to Lisbon with the spices, silks, porcelains, and other products of both the East and the West. These events were later to influence greatly the arts of their respective countries.

POLITICAL SUPREMACY AND DECLINE. In 1518 Charles I of Spain succeeded to a throne worth governing. This was the age of Spanish glory, and as the Holy Roman emperor Charles V, he united Flanders, Austria, and Germany under a single sovereignty. Charles was succeeded in 1555 by his son, Philip II, a zealous Catholic, who was determined to promote the power of Rome and to destroy the nations that had established heretical teachings. Holland, groaning under Spanish control, and Elizabethan England incurred special antagonism. In 1588 Philip, supported by the pope, amassed the "Invincible Armada" that jubilantly set sail to invade the English shores and crush the nation that was beginning to threaten him with serious conflict in the Western Hemisphere. The English fleet, under the leadership of Lord High Admiral Howard of Effingham, aided by the weather, completely routed the Spaniards in one of the world's decisive naval battles that permitted the growth of Protestantism and the English and Dutch colonial development. Spain never fully recovered from this overwhelming defeat.

During the latter part of the fifteenth century the Inquisition had been instituted. While this policy helped to maintain the power of the Church, it crushed liberty of thought, eliminated initiative, prevented reforms, and limited the creative imagination that was essential for the growth of the arts. The military splendor of Spain vanished at Rocroy, where the Grand Condé of France at twenty-one defeated a reputedly invincible infantry in 1643. The Dutch struggles, ending in 1648, wasted Spain's energies, and with the loss of her naval and military prestige, she relinquished her temporary position as the leading political and maritime nation of Europe.

Under Philip IV and his son Charles II (1621–1700) the Spanish domains were still the largest held by any European monarch, but wars continually bled the public treasury despite the influx of gold from across the seas. Lack of administrative skill, high taxation, and the maintenance of a vast pleasure-loving court led to a disastrous state of affairs. While immense wealth was concentrated in a landowning and office-holding aristocracy, fiscal conditions could neither keep alive a prosperous middle class nor ameliorate the abject poverty of the peasant. Corruption in colonial administration was widespread, and the decline that started in the seventeenth century continued until the war with the United States in 1898 bereft Spain of all her colonial glory.

CHARACTER OF THE PEOPLE. Spain is a mountainous, arid country where pigment-soaked skies and landscapes alternate with snowy peaks that reflect the southern sun. The topography has tended to develop isolated groups of people having different interests and customs. Politically the nation was for centuries a collection of small states unified only by the fact that one king ruled them all, and this unity was created by religious rather than political or economic methods. Spain has always been a land of unrest; emotional qualities dominate the will power of her inhabitants, and they prefer

to postpone inconvenient but necessary tasks to a future time. The people are honest, simple, genial, stoical, individualistic, romantic, tenacious of their traditions, and true to their own instincts. They are gay in manner, but have a capacity for violence in action and submit willingly to pain and suffering. Chivalry lasted longer in Spain than elsewhere in Europe, and the Spaniards flatter their vanity and accentuate their romantic qualities by the often heard remark concerning their language, "English for commerce, French for diplomacy, Italian for song, but Spanish is the language of love." There is a love of leisure, and earning a living is less important than the joy of living. Women are generally considered superior to men, and nature has dealt the feminine sex a generous largess in pulchritude. The Berber social organization was entirely matriarchal, and in Spanish countries it is still the custom to add a mother's name or initial to a father's surname. In spite of a languorous appearance, the women are robust and alert, and the traveler is impressed with the beauty of both aristocrat and peasant.

The philosophy of the Spanish nation was largely established by Cervantes, who in his *Don Quixote*, the world's greatest novel, ridiculed the social, ecclesiastical, and intellectual conditions of the Middle Ages and called for individualism and realism in thought. The Reformation never obtained a foothold in a land that was too occupied with the extermination of heretics to worry about an internecine religious strife, but the Council of Trent was proposed, and strongly backed, by Spanish cardinals and bishops.

It was natural that the emotional qualities that characterized the people of the Iberian Peninsula should culminate in the pyrotechnics of art that were produced in the seventeenth and early eighteenth centuries. Today there is universal pride in the cultural glories of bygone centuries. There are places in Europe more beautiful than Spain; there are people who have accomplished more in politics, art, and industry, but there is an inimitable charm that permeates the whole atmosphere of the peninsula and reechoes in the breeding and gallantry that are dominant in the character of every inhabitant.

THE SUBDIVISIONS OF THE SPANISH AND PORTUGUESE PERIODS. Because of the widely divergent influences affecting Spanish art, there is less cohesion and less consecutive development of style in the arts of Spain than in other European countries.

The general divisions of the post-Visigothic periods are as follows:

1. a. HISPANO-MAURESQUE OR HISPANO-MOORISH (eighth to fifteenth centuries).
 The art of Mohammedan Spain, seen particularly in Andalusia and as far north as Toledo.
 b. MUDEJAR (OR MORISCO ART) (thirteenth to seventeenth centuries).
 The work of the Christianized Moor or the traditional continuance of Moorish art in Christian territory; either purely Moorish or a mingling of Moorish and Christian art.
 c. MOZARABIC.
 Art of the Christians living in the Mohammedan territories of Spain, and the influence of this art in other sections of the country.
2. ROMANESQUE AND GOTHIC (twelfth to early sixteenth centuries).
 Though under French, Italian, Flemish, and German influences, Spanish art of these periods shows manifestations of an individualistic character.
3. PLATERESCO (end of fifteenth to middle of sixteenth century).
 Usually considered the most beautiful of the Spanish styles. Derives its name from *platero*, meaning silversmith. Refers to the minutely scaled ornament in imitation of silversmiths'

work used for embellishment of architecture and the minor arts of both the late Gothic and Renaissance periods. The terms *Isabellina* in Spain and *Manuelino* in Portugal are often applied to the Gothic phase. The abundance of precious metals from America did not occur until after 1500, and minutely scaled ornament had been a Moorish specialty. During this period there was also a Flemish influence in art and manners.

4. RENAISSANCE AND DESORNAMENTADO (sixteenth to middle of seventeenth century). The unornamented style. A reaction from the Plateresco. The arts developed under the influence of the Italian Renaissance. The leading exponent was Juan de Herrera, who built the enormous Escorial (1559–1584). The omission of ornamental detail caused the style to be known as the *Desornamentado*.

5. CHURRIGUERESCO OR BAROQUE-ROCOCO (early seventeenth to mid-eighteenth century).
The reaction from the Herrera style. Exuberance in form and ornament, splendor in color. The Churrigueresco marks an extravagant epoch in Spain as well as in her American possessions. The baroque persisted at the side of the rococo. During this period Portugal was being largely infiltrated with ideas from the East.

6. FOREIGN INFLUENCES (1700–1815).
The rise of power and increase in wealth of France and England enabled these countries to set new artistic standards that were copied by the Spanish artists and craftsmen. Portugal's trade with the East also added Indian and Chinese influences in her arts.

GENERAL CHARACTER OF THE ART OF THE PENINSULA. In awarding opportunities for the development of a consistent national style of art, destiny did not deal so kindly with the Spanish and Portuguese people as with other European nations. The repeated military, ecclesiastical, and intellectual invasions by conflicting races and groups with opposing customs and philosophies prevented a continuous aesthetic evolution. The mountainous character of the peninsula hindered transportation and the rapid exchange of ideas, so that a similarity of art forms in all parts of the country was not possible. Artists and craftsmen worked independently. Time, however, aided by nature, produced an emotional people, effervescent in temperament and given to fanciful dreams, who in spite of their handicaps created virile art expressions. Spain's supremacy as a world power was of such short duration, and her sovereigns, surrounded by intrigue, were so uncertain of their political position that patronage of the arts was not established on as firm a basis as occurred in Italy and France. In Spain, the decorative arts were never promoted as a national industry as in France. The Spanish kings, however, supported the arts for their own benefit, and the Prado Museum is filled with contributions from the royal collections, none of which were developed by confiscation from other countries as a result of war.

The climate tended to perpetuate the use of materials that were most suitable to southern temperatures, and the Moorish elements that best fulfilled those requirements will probably persist as long as the Spanish sun continues to shine. The arts of the peninsula were never dainty; they have always been distinctly masculine and frequently brutal. Their most chaste period was seen in the art of the Christianized Moor; the most exuberant and far-reaching was that of the seventeenth century, when restraint was cast to the winds, and the warmth of the Arabian blood combined with a Christian religious fanaticism was visible in the most daring and sumptuous effects in both architecture and decoration. Spanish and Portuguese art were the opposite of the Greek conception, inasmuch as the examples emphasize the dominance of the emotional rather than the intellectual qualities

in the nature of the people. In every medium of expression the artists have been more under foreign influence than those of other nations of Europe.* The Moors, Italians, French, and English have each in their turn been the inspiration of production, and both India and China have strongly influenced the Portuguese. Spain and Portugal have, however, produced great personalities, and such men as Lull, Cervantes, Camoens, Velasquez, El Greco, Herrera, Murillo, Churriguero, Goya, and Picasso have in their own mediums and in their own times been unique and unsurpassed. Lesser known craftsmen in ceramics, precious and base metalwork, ivory carving, and other materials have also shown a technical ability and artistic understanding of a supremely high order.

MOORISH ARCHITECTURE AND DECORATION. Although the Moor was the hereditary enemy of the Spaniard, he left to Spanish culture far more than he took from it. The cities and villages of Andalusia are filled with the evidences of his occupation. The most marked characteristic of the important Moorish buildings is the sharp contrast between a plain exterior and an exquisitely ornate interior. This was a development in permanent form of the nomad's tent, the interior of which was richly hung with handwoven decorative textiles. The Moors were from the beginning exquisite planners and craftsmen. Castles, palaces, mosques, bazaars, hospitals, and caravansaries enriched every settlement. The Great Mosque in Cordova (A.D. 786) was the glory of Western Islam until it became a Christian church in 1238.[†] This building was built in part from the ruins of Roman structures, and the interior is rich in jasper and porphyry columns and colored marbles; its arches retain the semicircular Roman form, and its floors are treated with sparkling mosaics in glass and gold.

The Alhambra in Granada (1309–1354), made famous to Americans by Washington Irving, was the sultan's pleasure palace from which Boabdil was driven by Ferdinand. It was the last of the palaces constructed by the Moors and remains today the supreme pearl of Moorish architecture and decoration. It is a fragile structure that stands on an eminence overlooking the city and in spite of its adobe brick construction has defied centuries of neglect, yet it eloquently expresses the magical and dreamlike qualities that are associated with the tales from the *Thousand and One Nights*. The building is planned around numerous arcaded courtyards, and the interior walls are covered with fantastic and minutely colored ornamental details that are subordinated to the effect of the whole. The architecture is agreeably blended with gardens, fountains, and reflecting pools, and one seldom loses the sound of splashing waters or the perfume of jasmine and orange. Its enclosing walls retain the desired Oriental seclusion, while arched openings create vistas that overlook the distant snowy peaks. The interior is a perfect

* The most indigenous art development in Spain has been that of the classic dance, a ritualistic expression closest to the heart of the masses. The Spaniards have always been impressed with rhythmic sound, an inheritance from their North African ancestors. The native dances are directly descended from Egyptian, Greek, and Roman prototypes, and the literature of the Caesars frequently mentions entertainments by the dancers brought from Hispania. Spanish dancing is unique in that it requires complete coordination and simultaneous movement of the arms, torso, and feet, combined with facial expressions that run the gamut of passions. The grace and emotional excitement that enter into the chacona, fandango, malagueña, bolero, and seguidilla are unequaled in the dance styles of other races, and the accompanying rhythm of the castanets alternately expresses anger, cajolery, revery, and romance. The flamenco dancing practiced by the gypsies carries with it an unsurpassed frenzy and fire, and although impudent, is never vulgar. Of recent years, the art has been influenced by modern elements borrowed from the former Spanish colonies in America.

† The mosque at Cordova still stands and is the largest religious edifice in the world.

expression of the times in which it was built, and reflects the luxurious life of ease maintained by its occupants. In the private apartments of the sultan and his favorite wife is a gallery for the use of blinded musicians. Elaborate baths contained taps from which spouted cold, hot, and perfumed water. The building is unrivaled elsewhere in Mohammedan countries and proves that the Moors were supreme in decorative talent as well as structural design. The majority of the rooms are treated with tiled wainscoting in colorful geometric patterns to a height of about four feet, above which there is a wall surface covered with plaster all-over ornament of minute scale, delicately tinted in various colors, a type of work known as *yesería*. Near the ceiling the walls are treated with a frieze usually enriched by decorative cursive inscriptions stating that "There is no God but Allah." These are placed on a groundwork of an elaborate abstract pattern. In some cases the friezes contain a running geometrical motif of intersecting polygons, stars, and crosses.

The Alcazar in Seville, another important monument, dates from the middle of the fourteenth century. It has suffered from the ravages of time and is in a state of partial ruin. The portions that are extant, and many other smaller buildings of the same date, show in their interiors a type of decoration that is similar to that used in the Alhambra.

The villas of the Moors were usually located on sloping ground. Structurally they were simple, with plain exterior walls and few windows. They were built around a landscaped *patio* off which the rooms were placed. Elaborate arrangements were made for reception rooms, master's quarters, and baths, and an isolated section with a private garden was walled for the use of the women and children. The Moor was adept at formal gardening and used this art to its fullest extent as a contribution to the enjoyment of life. His gardens, closely related to the composition of the house, were terraced and trellised

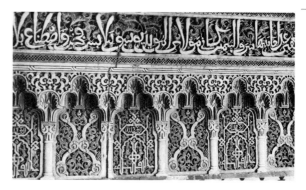

Yesería ornament showing stalactite arches and Arabic script, Alhambra.

with winding pathways lined with black cedars, tamarisks, myrtle, and orange trees. Alleys of trimmed hedges and rosaries of scented thorn were located for surprise vistas showing pavilions or extensive landscapes. Short flights of low brick steps connected the various levels, each of which was treated differently. Circular and semicircular landings enclosed with balustrades were paved with pebbles arranged in mosaic patterns. Fountains, troughs, and squirting jets of water played their cooling streams in all directions.

These dwellings contained little furniture—benches were often built-in and attached to the wall. Cushions and straw mattresses were placed on the floor, a custom that carried over from nomad times. Rugs were used in profusion on floors, benches, and as wall hangings. Leather and wood chests were used for the storage of clothes. Pottery, bronze, and copper were the materials for cooking and eating utensils. Elaborate embroideries, laces, and loom-made textiles added color and pattern interests. Bottles, flasks, and perfume containers were made of an iridescent glassware of great beauty.

An important structural feature in Moorish architecture was the *horseshoe arch*, the origin of which has not definitely been traced. This form is sometimes called a Moorish arch. The horseshoe form is seen in Visigothic ruins, but

Photo Researchers

Old iron decorative gate from Seville.

it is possible that the Moors introduced it independently, and that both races inherited it from early Syrian architecture. The curve of the arch forms approximately three-fourths of a circle and springs directly from a column capital. The arch is often enclosed in a rectangular frame showing inscriptions from the Koran and other ornamental motifs.

Two other arch types were also occasionally used in Moorish buildings. These were the pointed form and the *multifoil* or scalloped arch, the latter being somewhat similar to the Gothic cusped arch.

Columns were slender, with straight shafts. Capitals were frequently square and covered with minutely carved scrolls, crescent-shaped forms, and other highly conventionalized motifs.

A form of ornament known as *stalactite work* was also used; this consisted of several rows of minute niches, the upper rows projecting over the lower ones, bringing the square capital down to the round shaft by easy gradations.

The interior walls were treated with plain plaster, colored tiles treated with a geometrical pattern, brickwork, colored plaster ornament in relief, and ornamental leather, or a combination of these materials. Woodwork was limited to the doors and ceiling. The floors were in tile, brick, or stone, and were covered with rugs of both tapestry and pile weave in Mohammedan patterns. Heavy earthenware pottery was arranged in definite compositions on shelves and walls. Colors used for tilework, plaster ornament, painted woodwork, and in the rich wool textiles were the brilliant primary hues inherited from nomadic forebears.

MOORISH ORNAMENT. The rules of the Koran forbade the copying of natural forms. Therefore, the Moors, who were excellent mathematicians, resorted to geometry for pattern inspiration, and they developed an extraordinary originality in the design of surface ornament. The most intricate arrangements of interlacing straight and curved lines were devised. Squares and rectangles were usually avoided, but stars, crescents, crosses, hexagons, octagons, and many other forms were used.*

Geometrical ornament was particularly adapted to wood, plaster, tile, and textile designs, and was accentuated by gorgeous coloring in red, blue, green, while, silver, and gold. The pine cone and the cockleshell, regarded as good luck symbols, were extensively used as

* There were two Mohammedan sects, the Sunni, who were the more orthodox and completely excluded living forms from their ornament, and the Shi'a, who were more tolerant of their use. In the fourteenth century a Sunni traveler visiting Granada was shocked by the evidence of lowered morals as indicated by the pictorial representation of human figures, animals, and flowers.

decorative motifs, and the latter was carried over into Christian art as the symbol of Santiago. The yesería and painted all-over patterns produced by the Moor were invariably at a minuscule scale, a characteristic of design in which he seemed to be a specialist.

To the Moor also is attributed the development of the arabesque, a designation that was later misapplied to similar forms of classical ornament. This pattern consists of a stem rising from a root, from which branch conventionalized flowers, fruits, leaves, and abstract shapes that overlap and interlace. The conception of the arabesque was probably originally taken from the Assyrian tree-of-life pattern.

MOORISH TILE WORK AND CERAMICS. While the Moors did not introduce the manufacture of pottery in the Spanish peninsula, they greatly expanded the use of this material for decorative and practical purposes and added ceramic refinements such as the lead and tin glazes as well as the luster technique.

The floors of rooms were frequently covered with small quarry or baked clay tiles of a dull red color. Color accents were often introduced by insertions of glazed tiles in contrasting tones. Black and white checker effects were popular. Brick floors were usually laid in square or herringbone patterns.

Tile was also used for dadoes carried up the walls to a height of three or four feet. These were invariably in polychrome effects and in geometrical patterns. A band course at the top of the wainscot, consisting of a repeating conventionalized pine tree motif, varied the pattern of the field. Door and window facings, window jambs and seats, risers of steps, linings of niches, fountains, and washbasins were also made of this material. After the subjection of the Moors, human and animal figures and Christian symbols were more commonly represented in the tile patterns.

In addition to the production of the architectural and ornamental wall tiles, vast quantities

of heavy earthenware plates, jugs, ewers, vases, and pitchers were made. Hispano-Mauresque ware, often miscalled *majolica*, was made in many small southern Spanish towns. The major portion of these useful pieces, however, came from Malaga, Valencia, and Seville. Patterns were both stamped and painted on the ware, and consisted of geometrical and abstract forms, coats of arms, figures, and conventionalized floral forms, covered with an enamel glaze or luster. Pitchers and vases were scattered profusely on shelves, and plates of all sizes were

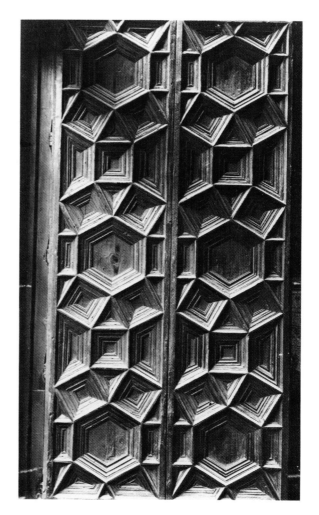

Geometric paneling used for window shutter, sixteenth century.

hung on the walls in circles, curves, and other arrangements often producing a dazzling appearance. These products were considered of such high quality that in 1455 the Venetian senate decreed that "the majolica of Valencia should be admitted duty-free (to Venice) for such is their quality that local kilns cannot compete with them."

MOORISH WOODWORK. The Moorish carpenter was far more skilled than his northern fellow worker. He applied his ability particularly to the design and construction of ceilings and doors, which were the only visible wooden portions of the Moorish house.

There were two kinds of wooden ceilings. One was the exposed structural beam type that consisted of heavy wooden girders spaced some distance apart, in turn supporting closely spaced smaller beams running at right angles to the girders. Both the beams and the girders were painted with ornamental motifs. This was a simple structural arrangement seen in all countries. The other type of ceiling was of Mohammedan origin, and was therefore more local in character and more unique in design; it consisted of shallow wooden panels arranged in complicated geometrical shapes. Stars, hexagons, and irregular forms were produced by the use of series of moldings forming the framework of the panels, which often occupied greater space than the field of the panel itself. Doors were subdivided into a multitude of small panels of irregular geometrical shapes.

Moorish woodwork was known as *artesonado* and was made from local cedar, a soft wood of fine grain, somewhat resembling red pine. In dwellings, the wood-paneled ceilings and doors were usually left in natural finish; in public buildings, gilding or color was sometimes used.

THE ORNAMENTAL NICHE IN MOORISH INTERIORS. A special decorative feature that was popular in the Moorish house was the wall niche. Recessed for a distance of about eighteen inches, it started at the top of the wainscot and normally carried two hinged doors similar to modern window shutters. Sometimes the doors were pierced with silhouettes or painted with bright patterns on both sides. The rear and sides of the niches were treated with colored tiles or painted in brilliant colors, forming a strong point of contrast with the neutral plaster walls. The niches were furnished with shelving which supported useful and ornamental accessories.

THE MUDÉJAR AND MOZARABIC PERIODS. Perhaps the most interesting periods of Spanish decoration were the transitional styles produced by the fusion of the arts of the Moor with the Gothic forms and later with the arts of sixteenth-century Italy.

There was much that was beautiful in the Moorish decorative materials and patterns, and those that were suitable and free from Mohammedan religious significance continued to be used by Christian builders. As Renaissance features were gradually popularized and transposed from church to secular construction, they were used simultaneously with the Moorish elements. The forms and proportions of classical architecture and ornamental detail, however, were not well understood by Moorish craftsmen, and this lack of knowledge often produced awkward results. The finer designs were unquestionably produced by Italian designers and workmen or by Spaniards and Moors working under Italian masters. Much of the work in these fused styles was seen in accessory production such as pottery, textiles, furniture, and metalwork.

The tile floor and low dado maintained their popularity. Polychrome ornament in geometrical patterns persisted in spite of the introduction of painted figures. Plain plaster walls were often enriched by heavy silk textiles or tapestries hung in loose folds. Tile panels showing heraldic devices were frequently inserted in the wall near the ceiling, and the extensive ornamental use of majolica plates and ewers continued for a long time to count as an important feature in the

Room in the reputed house of El Greco, Toledo, showing tile dado, etc.

color interest of the rooms. Windows were small, as a rule, with deep reveals, and the glass, if any, was leaded in either circular or rectangular forms. Heavy wooden interior shutters with pierced holes or *spindled* panels for ventilation were common. Segmental, semicircular, and horseshoe forms were employed for arched openings. The *persiana* or *venetian blind* was also used. Where *colonnades* were used, the column capitals often consisted of brackets extending outward on both sides to support a lintel.

The ceilings and doors continued to be treated with elaborately designed wood panels, as they had been in the Moorish rooms. Fireplaces began to assume the early Italian Renaissance character, with projecting hoods and with lower portions treated in a classical architectural manner. Framed paintings hung on the wall were more common than mural decoration, and pottery continued to be extensively used for both practical and ornamental purposes.

THE HISPANIC ROMANESQUE AND GOTHIC STYLES. These arts were chiefly introduced into Spain by the Cistercian monks of Cluny. Churches with sculptured portals and their adjacent cloisters, famous for their carved columns and capitals, rose along the roads that were used by the pilgrims to visit Santiago de Compostela, shrine of the national patron saint, in northwestern Spain. Throughout other sections of Christian Spain, ecclesiastical edifices, domed or roofed, attest to the art and originality of Romanesque architects and artists.

Although the Gothic cathedrals of Burgos, Toledo, Leon, Salamanca, and Seville are of a later date than those in France,* they give evidence of the splendor and power of the movement. The Cathedral of Seville, the second largest church in Christendom, was probably designed by a German, but the others are distinctly of French origin. The "Giralda" tower, a part of the Seville Cathedral, was originally the *minaret* of the mosque that formerly stood in the same location. The tower is considered one of the most beautiful structures of its type ever erected. The romance of the period is exemplified by the legend current in Burgos that the ornaments in its cathedral were worked by the hands of angels. The shrine of Toledo, impressive by its location on the crest of a rocky hill, appears to point a pathway to paradise.

These and other cathedrals with their almost incredible wealth of altarpieces, sculptured alabaster, polychromed woodwork, gilded wrought iron grills, and marble tombs are treasure houses of unforgettable inspiration. The Spanish Gothic churches usually have smaller

* Alfonso the Wise (1221–1284), who reigned during the construction of most of the great Gothic cathedrals, contributed greatly to their support. He advanced education and was quite conscious of his abilities and judgment. He is perhaps best remembered by his remark that he could have suggested improvements in the universe had the Creator consulted him. He also passed a law that permitted an impoverished father to sell his son, and allowed a starving father, if in a besieged city, to eat his children.

Eighteenth-century Ecce Homo, showing agonized expression that is typical of many Spanish representations of this subject.

fenestration than those in northern climates, a necessity for tempering the glare of the southern sun. The large wall areas produce a marked austerity, and there is an extensive amount of surface ornament due to Moorish influence. Geometrical patterns and the horseshoe arch are often used. The somberness of the interiors accentuates the brilliance of the color on the walls and pavements produced by the diagonal rays of the sun through the stained-glass windows. In the darker corners there is an impressive use of candlelight.

The religious sculpture of the Spanish Gothic churches deserves special mention. It was generally more realistic than contemporary work in the northern countries. Greater emotion is shown in figure work, and this is particularly in evidence in many of the representations of the crucifix in which a starved Christ is frequently seen in the most excruciating pain and gruesome aspect. The Spanish religious painters had a similar conception of reality, and in the fiestas and religious processions, images of the most repulsive character were often exhibited.

The Middle Ages were a great period of castle-building. There are probably a larger number of extant fortified castles in Spain than in any other European country. These were mostly built on precipitous heights and were not only of formidable defensive strength, but in their residential sections elaborately treated in Gothic detail. It was not without reason that the phrase "castles in Spain" became synonymous in both the French and English languages for an impossible achievement, and one of the most important Spanish provinces, Castile, was so named because of the number and splendor of the castles which it contained.

GOTHIC FURNITURE. The peninsular furniture of the fourteenth and fifteenth centuries was similar to the contemporary types in northern Europe. Detail was taken from Christian Gothic architectural elements, but many pieces show Mudéjar influence in the use of geometrical inlay. Heavy proportions were the rule; the pieces were well joined and were often braced with wrought iron.

The chest with a hinged lid was the most common piece and was used in nearly every room; it served for storage for the elaborate clothes used at banquets, fiestas, jousting tournaments, and bullfights, and could also be used as a seat, table, writing desk, or couch. It was made in all sizes and in many different woods and was often covered with embossed leather,

decorated with metal ornaments, and furnished with complicated locks.

Contemporary paintings and inventories clearly indicate the few types of furniture that were used at this time. Chairs of honor, benches, stools, folding seats, simple desks, canopied beds, occasional sideboards, and cabinets with drawers were seen. Loose planks set on trestles were used for tables, and these were generally covered with an Oriental rug. Much of the Gothic furniture was painted in bright colors and gold.

ITALIAN INFLUENCES. At the end of the fifteenth century, it was only natural that Spain, with its close ecclesiastical association with Rome, should come under the vitalizing influence of the Italian Renaissance. Spain had great political influence in the Italian states, and Spanish officials who visited Italy returned to their homes dazzled by the evidences of Italy's culture, luxury, and beauty. The accretions of Naples and Sicily to the Spanish crown also increased the maritime influence of Spain in the Mediterranean and revitalized her commercial relations with Italy. Influences were shuttled back and forth between the two countries.

Even before this period, Italian intellectual influence had strongly penetrated Spain, and, finding there a groundwork similar in many respects to its own, it persisted until well into the seventeenth century, through the exchange of artists and writers. Spain, however, did not have the advantages of Italy in the variety and number of Roman buildings to use as reference. She could not, to the same extent, delve into the grottoes of the Forum for source information. The Renaissance details of architecture and decoration were obtained secondhand, and the local artist and designer lacked the opportunities to study classical composition and proportions, or the models for sculptural motifs. Broadly speaking, the Renaissance in Spain, in the majority of instances, must be considered a provincial interpretation of Italian forms with added local variations that produced its native character and created its unquestioned charm.

THE PLATERESCO. This term, taken from the Spanish word for silversmith, *platero*, originated in the sixteenth century. It referred to the influence upon the architects and designers made by the beauty and fine detail of the products of the craftsmen in precious metals during the late Gothic and early Renaissance periods. The term was not exact in its application, however, because the glut of gold and silver did not occur until after America had been discovered. The excess of small-scale ornament covering wide surfaces was more likely a carry-over from Moorish decoration, as this race had always been lovers of the microscopic in pattern design. Spanish authorities use the word *Isabellina* and the Portuguese the word *Manuelino* as names for the Gothic phase of minutely scaled ornamental superabundance and apply *Plateresco* to the Renaissance examples.

The Plateresco was primarily a style exemplified in exterior architectural treatments, patios, formal rooms in churches and public buildings, and for furniture and accessory design; it was not extensively used as a style for the interior walls of dwellings,* but domestic interiors of this period began to reflect the greater richness of detail, increase in types of furniture, and improvements in comfort and conveniences that were seen in contemporary Italian rooms. Walls usually consisted of plain or painted plaster or they were hung with leather or textile coverings. Plaster figures in relief and ornamental motifs in color and gold leaf were placed in important locations. In the main public room the master's prerogatives were maintained by an *estrado* or raised platform placed at one end, which was

* During this period many houses were built only one story high. This was due to a legal imposition that required the second story of every house to be at the disposal of the king. As royalty traveled with hundreds of courtiers and guests, local inhabitants were often greatly inconvenienced.

Jean Roubier

Exterior view of El Escorial showing severity untypical of Spanish architecture in general.

furnished with two elaborate seats of honor, a table, and cabinet. The walls surrounding the platform were enriched with tapestries, Oriental rugs, and other hangings. The rest of the room contained a formal arrangement of seats, tables, and cabinets. Chairs and benches were covered with velvet cushions enriched with fringes and *appliqué* ornamentation. Sideboards, cabinets, desks, and tables were at first treated with silver, ivory, and ebony inlay and eventually with elaborate carved detail. Family coats of arms, *cartouches*, amorini clasping garlands, the scallop-shell of Santiago, and the eagle of San Juan played prominent roles in the decorative motifs. Columns, pilasters, pedestals, cornices,

and pediments of classical architecture became integral parts of furniture design. Paintings by famous masters of subjects not always consistent with Christian thought were hung on the walls. Majolica ware, small mirrors with elaborately carved and gilded frames, religious statuary in gold, silver, and ivory, and iron and brass braziers that exuded a perfumed smoke completed the decorative details of the formal rooms. The braziers were often designed as circular tables, and their location formed a center for conversational groups.

THE DESORNAMENTADO. The unornamented and austere character of the architecture and decoration designed by Juan de Herrera, a pupil

of Michelangelo, under Philip II, for the vast, gray Escorial (1559–1584) precluded the general application of this style for domestic use. Architecturally the style was one of classical purity, effective by its grandeur, but the interiors were too aesthetically frigid to permit their application in the homes of the middle classes, who had inherited a love of color and ornament. The style was so correct in its use of Vitruvian forms that there was no opportunity to inject in it evidences of Spanish imagination, spirit, and temperament. The Escorial appears as a lonesome pile in a desolate wilderness and resolutely reflects the orders given to the architect by Philip. "Above all do not forget what I have told you—simplicity of form, severity in the whole, nobility without arrogance, majesty without ostentation." The bareness of the building is partly due to the fact that granite was used in its construction.

For a time the Herrera influence was extremely strong. Many other buildings were designed which are impressive, but they are all melancholy, monotonous, and morbid in appearance. One of the finest was the Alcazar in Toledo, unhappily destroyed in the revolution of 1936; it was in this building that a stairway was introduced that was on such a grand scale that Philip, when mounting it, stated that it made him *feel* like an emperor.*

Many Italian works of art were imported during this period, and Spanish artists went to Italy to study.

The Churrigueresco. The architecture

* It is perhaps interesting here to note that the Spaniards about 1500 were the designers of the first interior neweled and handrailed stairway built in an open square stairwell with straight runs meeting at a landing halfway up. The earliest example was at Holy Cross Hospital in Toledo, which was destroyed in 1936. This stairway was later to be the model for the English Tudor period stairways. Medieval castles had contained concealed steps, and the Italian buildings had straight stairways placed between two walls.

The office of Philip II in the Escorial.

and decoration of the peninsula came into its own in the century between 1650 and 1750. During this period was produced a style that was not only unique and incapable of being created by other races, but one that was steeped in a riotous enrichment that seemed to express the volatile Spanish character in its most passionate moments. With the death of Herrera in 1597 a reaction against the severity of the Desornamentado quickly developed. This style had always been limited to court structures and ecclesiastical buildings, and it had never been fully suitable to domestic use. The substitute movement was one which revived the use of excessive ornamentation. Due to the necessity of reasserting the vigor of the Roman church after the Reformation movement, the Jesuits promoted the new style because of its emotional effect on the masses, whose intellect had not permitted them to appreciate the classical proportions and lack of detail of the Desornamentado. The new architectural conceptions were promoted by José Churriguero (1665–1725) and his family of architects, whose surname was later used to designate the style.

The Churrigueresco was primarily a style of surface decoration, rather than one of structural

Spanish Tourist Office

Interior and detail of Sacristy of La Cartuja, Granada (1727), characteristic of the Churrigueresco style.

changes. Its most characteristic features were applied to exterior entrance doorways and to the interior decoration of churches and palaces. In a considerably subdued form it reached the homes of the people, although it was seen in the furniture and accessories rather than in the decorative treatment of the walls. The movement attained great popularity, spread throughout the peninsula, and eventually crossed the Atlantic to Latin America, where, fused with indigenous elements, it intoxicated the colonials and Christianized Indians with combinations of color, ornament, sculpture, and twisted architectural forms that stagger description. The new style differed from the Plateresco in the scale of its detail; natural objects used for the ornamental motifs were in bold relief and frequently were heroic in size. In the design of public buildings the rules of Vitruvius were entirely discarded, and the orders became elements of applied deco-

ration without structural meaning. Columns and pilasters had spiral and baluster-form shafts or lost their identity by heavy *rustication*. Entablatures and moldings bulged upward or outward or were tortured into writhing masses. Broken and scroll pediments were misplaced in the design and ended in squirming volutes; Doric capitals sprouted Corinthian acanthus leaves; brackets were nonsupporting, and pyramidal forms stood on their apexes. Stucco decoration was modeled to imitate rock formations, waterfalls, and drapery swags. Nude figures cringed under heavy loads; cherubim and seraphim emerged from plaster clouds, and religious symbols were in important locations; optical illusions bewildered their observers; and transparent alabaster carvings glowed with the light from dozens of candles. Silver, tortoiseshell, and ivory inlay enriched the remaining wall surfaces. Phantasmagoria and anarchy ruled everywhere in detail,

although a mass balance and compositional approach to symmetry was usually attempted.

The style was anathema to the purist, and has been attacked by countless critics, but its force and splendor have kept it close to the hearts of its adherents. The peasants adored it, and even in the poorest districts money poured into the church coffers for the construction of religious edifices that would satisfy their pride and fervency. The great examples of the Churrigueresco are the church at Loyola, the birthplace of St. Ignatius, the Provincial Hospital in Madrid, the interior of the Sacristy of La Cartuja in Gr. nada, and the Transparente in the Toledo cathedral, the latter the supreme theatrical combination of sculpture, painting, and architecture with optical illusions and dazzling illumination of religious figures and scenes.*

The style was found to be particularly suitable in the design of the retables, altars, and screens of the cathedrals, where colored stucco ornamentation vied with the gold ritual accessories. Its most important example in residential work is the Palace of the Marques de Dos Aguas at Valencia (built 1744). In the minor dwellings the style was expressed by elaborate fresco wall decorations showing floral and tropical growth combined with distorted architectural forms in plaster, gilded stucco cartouches, heraldic motifs, and exaggerated door and window trim. Many rooms were finished in plain sand-finish plaster and left a natural color, which served to accentuate the brilliancy of the drapery and cushion materials. Small wall niches were sometimes introduced, an idea inherited from Moorish interiors; these were lined with patterned tiles or painted in bright colors. They usually contained shelves for pottery and sometimes a water tank and washbasin. Parquetry and inlaid floor patterns became popular, and beamed or frescoed ceilings completed the interior.

The Churrigueresco continued at full pace until the accession of Philip V, grandson of Louis XIV, to whom it seemed uncouth. This sophisticated Frenchman preferred that the more dignified character of Versailles should serve as a model for royal use, and his palace at Aranjuez faintly reflected the grandeur of his ancestor's masterpiece. From this period the Churrigueresco commenced to fade in its native land, but for a long time it was to continue to express its capriciousness in the lands across the sea.

PORTUGUESE HISTORICAL INFLUENCES UPON THE ARTS. In the development of Portuguese culture, there were many influences differing from those of Spain that contribute to unique characteristics. An indigenous quality was also developed by the national pride that resented Spanish leadership. Portugal had freed herself of Moorish control long before Spain, as a result of the victory of Ourique (1140), and first gained independence from the Spanish at the battle of Aljubarrota (1385). This victory was memorialized by the erection of the Monastery of Santa Maria of Victory, completed in 1433, on the spot where the battle occurred. The building stands today as the most beautiful example of Gothic art in Portugal. The Manuelino style which followed was brought to its apotheosis during the reign of Dom Manuel I (1495-1521) and roughly corresponded in point of time and character to the Spanish Plateresco. The Portuguese style, however, was more hybrid in origin and included reminiscences of Roman structure, Gothic arches, Arabian and East Indian architectural features, and marine ornaments that were chosen because they seemed to symbolize the destiny of the country. Among these were rope, cockleshells, sails, prows of vessels, pennants, sea plants, and armillary spheres.

* The Transparente is perhaps the most extreme example of Western iconography. The modest intellect is perhaps awed in viewing it, but the mature art student is only impressed if he retains his sense of humor.

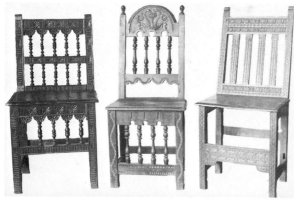

Seventeenth-century Spanish chairs.

Portugal fell once more under the control of Spain at the accession of Philip II, who was the legitimate grandson of Dom Manuel, and during his reign was greatly influenced by the brilliancy of the contemporary Spanish intellect.

Since the Gothic period, the Portuguese have produced great works of literature and exquisite examples of the minor arts. The blue enameled ware known as *azulejos* was often used to line interior walls and substituted for the tapestries used in the northern countries. Transparent porcelains of great beauty are still made at Vista Alegre. The ironwork at Coimbra and the embroideries of Madeira are world renowned. A unique feature of Portuguese interiors has been the use of cork. Since the Middle Ages, sheets of this material have been used as wall linings, as it has insulating qualities. Cork also has been used for cabinet construction in the making of doors, benches, and tables.

SPANISH FURNITURE OF THE SIXTEENTH AND SEVENTEENTH CENTURIES. The Italians of the Renaissance introduced luxury of living to the Spaniard. Practically all Spanish furniture from 1500 to 1650 was of Italian inspiration. Local conditions affected the designs, which were often of hybrid origin and awkward appearance. Little was produced that was entirely indigenous. The fact that some of the finest furniture

was created for the church affected the character of ornament, which included such symbols as the pope's miter, the keys to heaven, and the instruments of the Passion.

The woods most commonly used for furniture construction were walnut, chestnut, cedar, oak, pine, pear, box, and orange, with ebony, ivory, and tortoiseshell used for inlay purposes. There was also a tendency at this time among Spanish cabinetmakers to cover inferior workmanship with paint; hence, from an early date, polychrome effects were more common in Spain than in other European countries. The Spaniards were the first Europeans to use mahogany (about 1550) as a cabinet wood. This wood, which had been discovered in the West Indies, because of the enormous size of the trees was first employed in the construction of the Spanish galleons. When these ships were wrecked or became superannuated, the wood was salvaged for smaller structures and furniture.

In constructing furniture, the Spaniard often paid more attention to strength than to design. As a result, unnecessarily heavy proportions may frequently be seen. In many pieces of furniture the separate parts were joined by nails that were left visible, although joinery was well understood.

The character of the carving in Spanish furniture varied greatly. On the best Renaissance pieces the work was probably done by Italian woodcarvers, and it shows an accurate interpretation of classical motifs, but in the smaller towns and country districts carved enrichment was designed in naturalistic and conventional patterns unrelated to traditional classic forms. Much of it seems to have been created as the carver proceeded in his work. There was no set standard, and the carving was lacking in unity of composition. One of the most frequent methods of surface enrichment was by chiseling a series of short grooves in a wavy line along a rail or chair leg, a form that seems unsuitable to the shape of the surface upon which it was

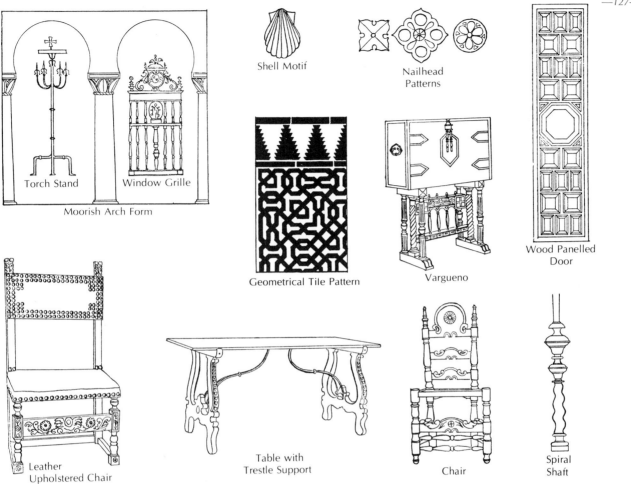

Torch Stand Window Grille

Moorish Arch Form

Shell Motif

Nailhead Patterns

Geometrical Tile Pattern

Vargueno

Wood Panelled Door

Leather Upholstered Chair

Table with Trestle Support

Chair

Spiral Shaft

Spanish furniture and architectural details.

placed. Panel areas often consisted of square, diamond-shaped, or circular rosettes distributed on the surface as an all-over pattern.

Moldings and turnings lacked the smoothness of line and the refined curves of the Italian workmanship. Short *clavated* turnings* were common in furniture supports; these lacked the graceful lines seen in the Italian baluster forms. The use of the splayed or slanting leg was typical. Nailheads of both iron and brass were large

and elaborate and were constantly used, not only to secure upholstery materials, but by themselves as the decoration of plain surfaces. Metal ornaments, for use as furniture enrichment, were made of both iron and silver in the form of rosettes, scallop shells, and stars, and in pierced sheet patterns.

Wrought iron was extensively used as a material for the production of many types of household equipment. Chairs, beds, chests, washbasins, candlestands, tables, and other objects were frequently made entirely in this material, and it was often used in combination with

* These are sometimes known as spool or disk turnings.

wood; chair backs and table-leg bracings were also made in graceful curves, with hammered ornament.

Of the individual pieces of furniture, the chest or *arca* continued to be the most common and, as in Italy, was made in all sizes. The ornament consisted of wooden and ivory inlays, metal mounts, carving, and color. Many were covered with leather or velvet.

Chairs of the Dante type were made, although the upper portion was often larger than the support, creating a top-heavy appearance. Italian Renaissance chairs of rectangular design were also copied. These have both velvet and tooled or embossed leather seats and backs. Sometimes a double row of ornamental nails was used to attach the leather to the wood frame. Wooden seats with loose cushions for comfort were used, and rush seats were very common even in the most elaborate homes. Through the seventeenth century Spanish ladies often used floor cushions for seats both at home and while attending Mass; they also carried at all times cosmetic boxes of great beauty. In Barcelona, a form of *ladder-back* chair was made, in which the topmost slat was greatly enlarged and elaborately carved. Chair legs were braced by stretchers ornamented with simple rosettes and short or long chiseled grooves.

Tables were unusually characteristic; the tops frequently had a long overhang, with plain, square-cut edges. Table supports were of two types, the four-legged and the trestle. Legs represented straight or spiral classical columns or balusters. The trestle supports were much simpler than those found in Italy; they were usually pierced and silhouetted in a series of contrasting curves often taking the approximate shape of a lyre. Both table legs and trestles were often splayed and braced by a diagonal wooden or curved iron piece which started at the center point of the underside of the tabletop and ended at the stretcher connecting the end legs, near the floor. Many of the tables were

collapsible. Beds were made both with and without corner posts. Spiral posts with valances and ornaments were frequently used. Headboards were sometimes separate from the bed, and were either elaborately painted, designed as an architectural pediment, or carved with a pattern of intricate scrolls. Beds were usually draped with silk damask enriched by fringes and tassels.

THE VARGUEÑO. The Spaniards developed only one piece of furniture more extensively than the Italians, and that was the writing cabinet known as the *vargueño.* No Spanish interior was complete without one of these pieces. The origin of the name is uncertain; some authorities claim the piece came originally from Flan-

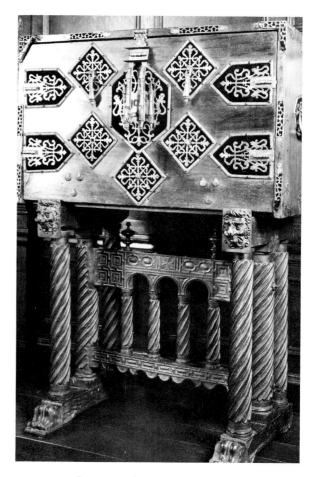

Seventeenth-century vargueno.

ders, others that it was first made in the small town of Bargas near Toledo. It was introduced during the Plateresco period, and the earliest examples were simple unadorned boxes, with a hinged lid at both the top and the front, which were furnished with strong locks. Handles were always placed at each end, so that the vargueño could be quickly transported. The interior was subdivided into many drawers and compartments, some with secret sections, and the front of each subdivision was elaborately decorated with geometrical or other inlaid patterns made of ivory, mother-of-pearl, and wood, or with miniature classical architectural motifs. The body was always separate from its supports, and the latter varied greatly in design—simple trestles, turned legs braced by wrought iron forms, and elaborate tables with column and arch supports. Pulls were provided to support the lid when it was used as a writing surface. The vargueño was usually made of walnut, but in the early years of the seventeenth century, mahogany was sometimes used. In the later examples the front of the drop lid became highly decorated with inlay or with lacelike pierced metal mounts, gilded and applied to small squares of velvet that were distributed in a pattern over the woodwork. The locks, corner braces, keyholes, bolts, and handles were both numerous and decorative and were often supplemented with ornamental nailheads arranged

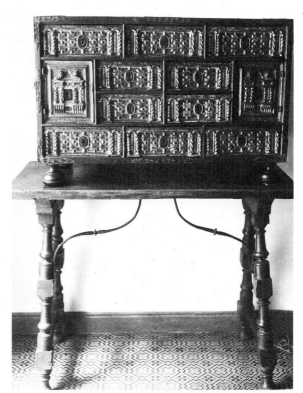

Seventeenth-century papelera and table.

in patterns such as swags, circles, and geometric shapes. A smaller chest of compartments without a drop lid was known as the *papelera*.

PORTUGUESE FURNITURE OF THE SIXTEENTH AND SEVENTEENTH CENTURIES. All of the types of furniture used in Spain were seen in Portugal; in fact many novelties introduced in Portugal were copied by the Spaniards. The Portuguese exaggerated the size of the turnings that were used for chair and table supports and for the headboards of beds. Spiral and bulbous shapes were also more common. The most important difference, however, was seen in the East Indian and, later, the Chinese influence in Portuguese furniture, which was the result of a monopolistic commerce conducted with these countries. It is claimed that furniture caning and the *cabriole* leg were first used in Europe by the Portuguese, who brought them from China.

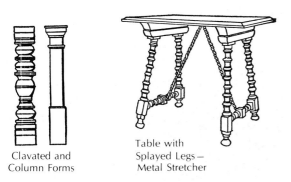

Clavated and
Column Forms

Table with
Splayed Legs—
Metal Stretcher

Spanish furniture and details.

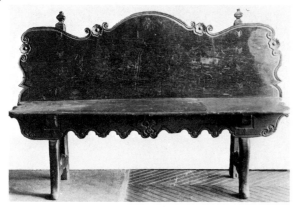

Ruiz Vernacci

Eighteenth-century carved bench.

The Indo-Portuguese furniture manufactured in Goa,* on the Malabar Coast of western India, was made in teak, ebony, and amboyna with ivory inlay or veneer. The Hindu craftsmen often endeavored to copy Western designs. Pierced metal patterns, nailheads, and carving form the ornamental detail. Lacquered furniture was also brought from the Far East, and Oriental woven and printed textiles were first imported into western Europe by the Portuguese traders.

During the Manuelino period (1495–1521), in such places as Batalha and Tomar, the East Indian influence was very strong and expressed itself in an extravagantly rich detail that seemed to be inspired by crustacean and tropical vegetation forms that were the first Far Eastern influence on Western art.

FRENCH AND ENGLISH INFLUENCES OF THE EIGHTEENTH CENTURY. The development of France as a dominant political power in Europe and the intermarriage of the French and Spanish royal families contributed greatly to the influence that French cultural life had upon that of Spain.

* Goa was the principal center of activity of St. Francis Xavier, one of the greatest missionaries, and the first to bring Christianity to the Far East. He died in 1552 and is buried there.

After the power of Louis XIV had been established, the French political, social, and artistic influences were seen in architecture and decoration, and by the middle of the eighteenth century, nearly all important new buildings in Spain were based on French prototypes. In the early years of the eighteenth century, the rising power of England under Queen Anne also impressed both the Spaniards and the Portuguese. The glittering luxury and brilliance of English social life was beginning to triumph, and the styles prevalent in England were borrowed by the designers, who themselves seemed to be incapable of creative imagination. As this trend was contemporary with the social developments in the Latin American colonies, it was natural that there, too, evidences of it were seen. These foreign influences in Portugal created the style locally known as "Pombalino" named after the Marquez de Pombal, who rebuilt the city of Lisbon along French lines after it had been destroyed by the great tidal wave of 1755.

THE EIGHTEENTH-CENTURY INTERIOR. By 1725 the nobility and the upper classes of both Spain and Portugal began to decorate and furnish rooms in the French manner. Rooms became smaller, and furniture was reduced in scale. By the middle of the eighteenth century, the curved line dominated the shapes of the wooden wall panels and the design of all furniture. Lacquered panels were brought from the Orient and inserted in both wall and cabinet paneling. The Spanish craftsmen, in copying the French forms, usually lost some of the refinement of the proportions and detail of the originals and did not cater to feminine demands to the same degree as did the French. The charm of the designs lay in the suggestion of barbaric richness and exaggeration of form, color, and ornament, and productions were heavier in appearance than the French. There was a general tendency to finish furniture in white lacquer and gold or in pastel tints. Mirrors played a prominent part in interior design and were in-

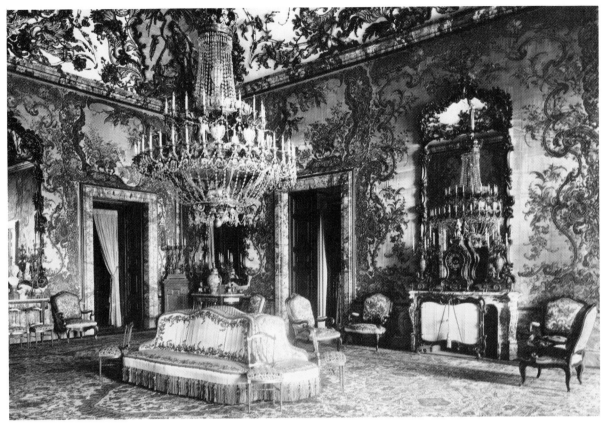

Moreno

Eighteenth-century room in the Royal Palace, Madrid, showing an extravagant adaptation of French rococo detail.

serted in the wall panels or placed in elaborately carved frames and hung on the wall. Many new types of furniture were introduced, such as card tables, consoles, varieties of sofas and settees, clocks, and commodes. Comfortable upholstery was introduced. The Spaniards remained loyal to the use of leather, and often applied this to French furniture framework.

From the beginning of the eighteenth century the English also shipped a great deal of furniture to both Spain and Portugal. The style of Queen Anne became popular and was extensively copied by local craftsmen. The chair backs, however, were usually much higher than in the English examples. Later in the century

the Chippendale forms were adopted. England made special furniture for export, and many of the English pieces were finished in red lacquer, to appeal to the Latin tastes. With this finish, cheaper woods could be used in construction, with the result that both tables and chairs often required the use of stretchers. Many of the chairs had caned seats and backs. In much of the furniture made in Spain, both English and French elements were combined in the same piece.

The Mediterranean regions, Valencia, Catalonia, and the Balearic Islands, came strongly under Venetian influence. This accounts for the fine lacquered furniture, at first imported and

Vernacci

Spanish eighteenth-century secretary showing English Queen Anne influence.

later copied locally, found in these regions. Chairs, console and corner tables, and handsome secretary cabinets were generally lacquered in red, yellow, green, and sometimes in blue. The surface decoration, consisting of *chinoiseries* or stylized eighteenth-century motifs, was applied in different shades of gold, reinforced with black lines. The preferred type of chair was a splat back with cabriole legs based on modified Queen Anne models. The earlier secretary cabinets were often crowned with elaborately curved and ornamented pediments, but in the later examples a more classic type of pediment was used.

Another Venetian influence was seen in the copious employment of mirrors, with or without lighting fixtures, hung against the brilliant red or yellow damask wall coverings.

Toward the end of the century, both interiors and furniture began to be influenced by the Adam brothers of England, who had studied the ruins of Pompeii and other cities of antiquity. Antique classical, rather than Renaissance forms, also came through French designers who were creating the neoclassical style called Louis XVI. The straight line was substituted for the curved or rococo forms; the cabriole leg was eliminated; and all the sentimental elements of design associated with Louis XVI and Marie Antoinette became fashionable. The English Hepplewhite and Sheraton furniture in satinwood and painted finishes was also much in demand.* Silk woven textiles for draperies and upholstery followed the French patterns, and the East Indian cotton prints were extensively used in both Spain and Portugal.

The period of Napoleon also had its influence upon Spanish decoration. Joseph Bonaparte, the brother of Napoleon, was a justifiably unpopular and inefficient king of Spain for four years until 1813, but it was long enough to introduce the French Empire style of decoration into some of the royal palaces. With the fall of Napoleon, however, the industrial age began to affect the arts of Europe. The English nineteenth-century Victorian period, which bore a similarity to the Louis-Philippe and Napoleon III styles in France, was adopted wholeheartedly by the Spanish upper classes.† While these changes were occurring, the masses continued to retain their old ways of living.

* These forms should be studied in the chapters on French and English furniture.

† The romantic love match between Eugenie, the daughter of a Spanish nobleman, and Napoleon III played its part in reviving the French styles that were of eclectic origin.

Spanish
Commode
Louis XVI Infl.

Spanish Chair Louis XVI Infl.

Spanish Chair
Queen Anne Infl.

Spanish Door 18th Cent.
Louis XV Infl.

Examples of eighteenth-century Spanish furniture.

In designating the Spanish and Portuguese styles that developed through external influences, it is customary to use the foreign names as an appendage to the native designation; for example, Spanish-Louis XV, Spanish-Queen Anne, and Spanish-Empire.

SPANISH TEXTILES AND LEATHERS. In spite of a Mohammedan ruling against the use of silk, the Moors produced silk textiles of great beauty. The patterns, usually arranged in bands, were mainly of the geometrical type, often combined with Arabic inscriptions. Highly conventionalized floral and animal patterns were also used. Colors were brilliant. Embroideries were made in silver and gold thread. During the Renaissance, the textiles used for draperies, cushions, and upholstery were either imported from Italy, or velvets, damasks, and brocades were woven in Spain in Italian designs. Walls in the royal palaces and mansions of the nobles were often hung with tapestries from Flanders. In the eighteenth century, Portuguese cotton prints were also in favor, and many ecclesiastical chasubles, dalmatics, and other church vestments were made in rich embroidered patterns.

The Moors in Cordova produced superb examples of decorated leather called *guadamacileria*. The sumptuous horse trappings of a tenth-century caliph have been well described by eyewitnesses. An edict in 1502 by Queen Isabella forbade the sale of leather passing as Cordova leather but made elsewhere. The material was used for wall and floor coverings and for cushions. The finish was in several colors, including gold and silver, and enrichment was added by tooling and *embossing*. Tooled, punched, and quilted leather of a very fine black and deep chocolate finish was used in the sixteenth and seventeenth centuries for chair seats and backs. Portuguese leather upholstered chairs are unmatched in their decorative beauty; mythological or other figural subjects were introduced amidst rich baroque scrollwork, and the beauty of the leather was further enhanced by bold brass nailheads, which fastened the material to the wooden frames. With the expulsion of the Moors in the first part of the seventeenth century, the leathercraft began a decline in Spain, while it prospered in Italy, France, and the Netherlands, where it had been established

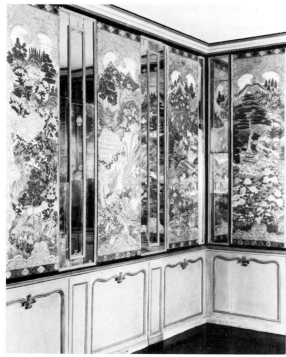

Art Institute of Chicago

A Portuguese eighteenth-century wall treatment showing French influence with Oriental lacquered walls alternating with mirror panels.

some years previously. Leather was a particularly warm material for lining walls, and a demand developed for the Cordovan product in the northern countries of Europe, where colder winters required greater interior protection. Exquisite examples of rooms lined in this material still exist. A room in a Roman palace still retains its turquoise leather. One of the rooms in the Governor's Palace in Williamsburg, Virginia, has walls covered with a beautiful example of embossed and painted leather. Many of the rooms in the châteaux built in France in the early sixteenth century were also treated with this material.

TILE AND METALWORK. No description of the decorative arts of Spain would be complete without mention of the remarkable metalwork produced by Spanish craftsmen from the time

of the earliest civilized settlements. Spain has always been rich in the production of silver, gold, lead, iron, and tin. The supply of precious metals in Spain was greatly augmented after the conquest of Mexico and Peru in the early sixteenth century.

Exquisite objects for church and household were made in gold and silver, ornamented by *repoussé* and embossing. The silversmith used *filigree* ornament, of fine twisted wires; *damascening*, consisting of gold inlay; precious stone insets; and *enamel*, to enhance the hammered and cast forms.

The Spanish steelworker became famous for his armor and, from the time of the Roman settlements, for the production of Toledo blades and daggers. The ironworker produced sparkling grilles, gates, hardware, lighting fixtures, screens, metal furniture, and accessories in wrought material in which the pattern and interest were obtained by bending, hammering, twisting, and repoussé work.

The use of tile as a decorative feature was carried over into the eighteenth-century work. Porcelain rooms in the Royal Palace in Madrid (1765) and the palace at Aranjuez (1760), both completed by Charles III, are remarkable for the

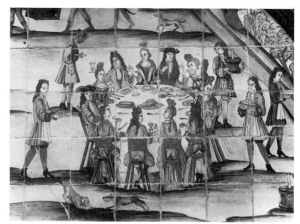

Catalonian Museum of Art

Spanish eighteenth-century decorative tile wall panel.

use of this material. Charles had imported the craftsmen and molds from the factory at Capo-di-Monte near Naples and installed them at the factory of Buen-Retiro in the park of his palace in Madrid, where figurines, vases, and other ornamental forms were produced in designs based upon both Oriental and Western motifs. These were used in profusion as plaques and appliqué ornaments on the walls of the rooms, and groups of figures were supported on rococo brackets and combined with elaborate gilded and polychromed plaster ornamentation, designed in sensuous curves and floral detail. Contemporary scenes showing the daily activities of all classes were also painted on tile and used as dado and wall panels. The Portuguese produced similar tiles known as "azulejos" that added great brilliancy to their rooms.

INFLUENCES IN LATIN AMERICA. From the discovery of Columbus to the early years of the nineteenth century, practically the whole of Central America and South America and a large portion of the West Indies were under Spanish or Portuguese control. The work of the early conquistadores had been completed by the middle of the sixteenth century, and almost immediately the settlers, directed by their leaders and by the Franciscan and Dominican padres, began to construct religious and administrative edifices of considerable size. These predate, by about sixty years, the first primitive white settlements in New England and Virginia, and, by nearly two hundred years, buildings of equal importance. It was natural that the amateur architects who designed the first buildings were lacking in a knowledge of design principles, and the craftsmen whom they employed were mainly the Indian natives. The designs, on the whole, were dictated by structural requirements. It is remarkable to contemplate the size and splendor of some of these early buildings, in which Moorish, Gothic, Plateresco, Aztec, and Mayan details and patterns were naïvely and unintentionally mixed. In the middle years of the seven-

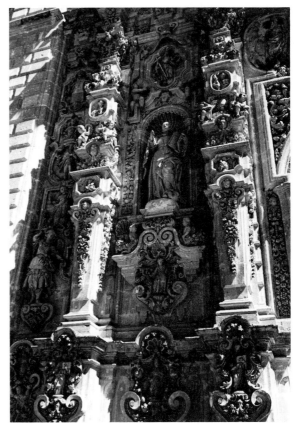

Photo Researchers

Detail of Churrigueresco decoration in the church at Tepoztlan, Mexico.

teenth century trained designers began to arrive in the colonies. Most of them had already become imbued with the spirit of the Churrigueresco, and as this style seemed particularly appreciated by the white pioneers and Christianized natives, it was these exuberant types of design that were used for nearly all the important structures erected from Rio de Janeiro to Havana and from Santiago de Chile to the borders of Texas and up the coast of California. These countries were filled with buildings that in many cases are more fantastic in appearance than those in Europe. In the countries on the Pacific coast there was also some Chinese influence due to the trade with the Orient. The enormous

mineral wealth of Mexico and Peru, combined with the religious fanaticism of the natives, permitted the interiors of many churches to be freely covered with gold. Indians spent their whole lives on the wood carvings. The gleam and glitter of the prodigiously ornate treatments, combined with the most brilliant colors and gold, are often bewildering in their effects.*

The residences of these countries were more simple in construction and detail. The majority of dwellings built with adobe brick followed the Spanish patio plan, and the interior decoration and furnishings reflected the style changes in Spain and Portugal. During the eighteenth century French and English furniture was both imported and reproduced in such local woods as mahogany, embuya, pine, jacaranda (rosewood), larch, and other hardwoods. The most frequently copied styles were those of Queen Anne and Louis XV. There was a general tendency in the furniture reproductions to create heavy proportions, which caused the pieces to lack the grace of the originals. Both carving and inlay enriched the surfaces of the woodwork. The

Latin love for brilliant color dominated the chromatic treatment of rooms, and both walls and textiles were often far more intense in color than those in northern countries.

An additional craft that was carried to the New World was that of pottery making. Potters from Talavera, Spain, emigrated to the Mexican city of Puebla, where they reproduced the wares of the homeland and also introduced Chinese forms and modes of decoration copied from the porcelain vases brought from the Orient to the Pacific port of Acapulco. These are still important decorative accessories in Mexican homes.

The nineteenth century saw the use of many of the Victorian forms of furnishing with a final tendency toward the eclecticism that was seen throughout Europe and North America. The difficulties of transportation that handicapped many of the Latin American countries caused a lag in their culture that was finally eliminated with the invention of the airplane. Since World War I there has been an enormous development of economic resources and an advantageous increase in foreign travel. The people of these countries have inherited the personal charm and cordiality of their European ancestors, and they offer a true friendship to those who reciprocate. Today there is great study and appreciation of modern movements in architecture, decoration, and the industrial arts, and all countries have developed designers of the first rank.

* Among the most notable examples in this style erected between 1560 and 1780 are the churches at Tlaxcala, Taxco, San Caystano, Tepoztlan, and Oaxaca in Mexico; at Lima, Cuzco, and Arequipa in Peru; at Quito in Ecuador; at Bahia in Brazil; and at Popayan in Colombia.

LEADERS IN THE HISPANIC ARTS

The following list contains the names of the best-known leaders in the Hispanic arts, together with the dates when they flourished and a statement of the work for which they are noted:

Aranda, Buenaventura, Count of. Art patron and founder of Alcora ceramic factory (1727).

Arfe, or Arphe (fifteenth and sixteenth centuries). Family of famous German silversmiths whose work influenced the Plateresco architectural ornament.

Calderón de la Barca, Pedro (1600–1681). The greatest of the Spanish dramatic poets.

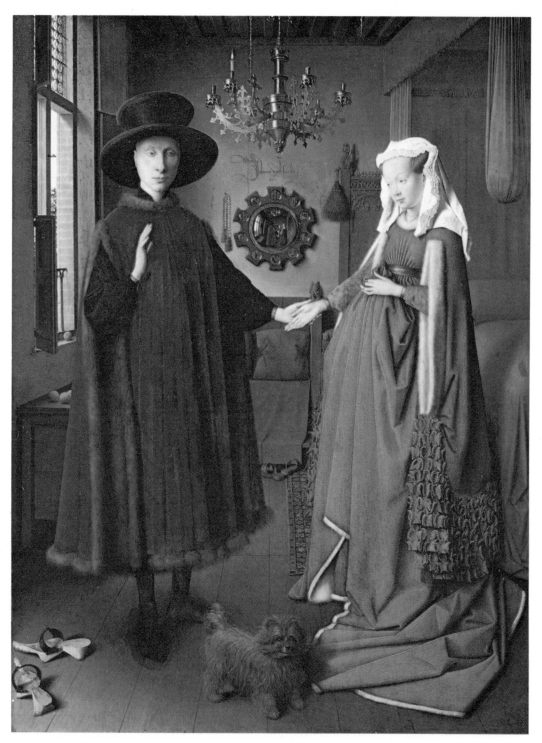

The famous Flemish portrait of "Jan Arnolfini and His Wife" by Jan Van Eyck painted in 1434. It marked the first tendencies toward naturalism and a perception of the external world, in contrast to Gothic conventionalism.

National Gallery, London

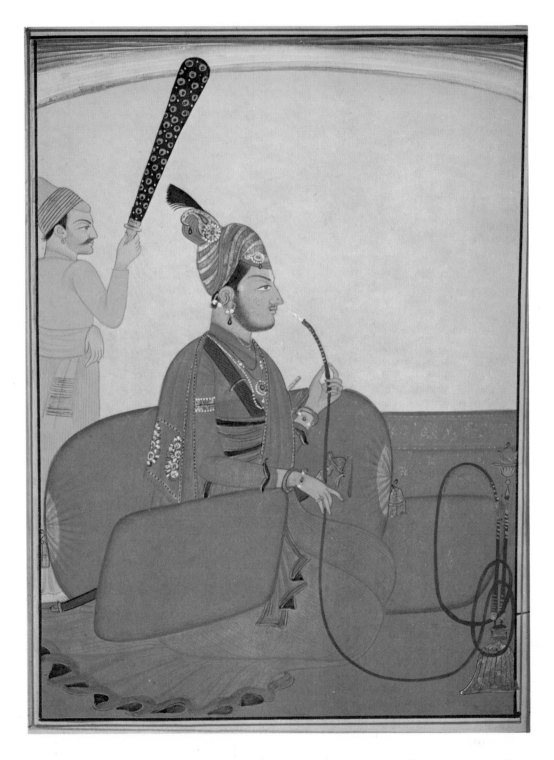

Bir Singh of Nurpur. An early 19th century Indian Painting from Punjab Hills. Its great appeal is in the massing of a single vivid hue which breaks beyond the usual limits and in the two-dimensional character of the painting.

Courtesy of James Ivory. Lent by Asia Society

Camoens, or Camöes, Luiz Vaz de (c. 1524–1579). Portuguese poet, author of *The Lusiads*, one of the great poems of the world.

Cervantes Saavedra, Miguel de (1547–1616). Author of *Don Quixote*, the world's greatest novel, which was important in forming the thought of the Spanish Renaissance.

Churriguera, José (1665–1725). Most outstanding member of a family of architects, who were mainly responsible for the baroque and rococo styles in Spain, which were later known as the Churrigueresco. Powerful influence in Latin America.

Egas, Enrique de (d. 1534). Plateresco architect; designed Holy Cross Hospital in Toledo (destroyed).

Goya Y Lucientes, Francisco de (1764–1828). Aragonese realistic artist, tapestry designer. Portrayed scathing and macabre scenes of Spanish life.

Greco, El (Domenikos Theotocopoulos) (1541–1614). Greek artist, Titian's pupil, who worked in Spain and imbued his paintings with the spirit of Spanish mysticism.

Guas, Juan and Enrique (fifteenth century). Plateresco architects, perhaps of French origin.

Hernandez, Gregorio (1566–1636). Baroque sculptor of northern Spain, noted for polychrome statues.

Herrera, Juan de. Architect of the Escorial (1575–1584). Protagonist of the Desornamentado style. Pupil of Michelangelo.

Juvara, Felipe (eighteenth century). Architect, pupil of Bernini. Worked in Turin; was called to Spain to design the Royal Palace.

Lull, Ramon (c. 1236–1315). Catalan philosopher and missionary who tried to convert the Moslems to Christianity.

Martinez, Antonio (eighteenth century). Silversmith; work influenced by Pompeian discoveries.

Murillo, Bartolome Estaban (1618–1682). Deeply religious painter of Madonnas and Andalusian beggar boys.

Palomino y Velasco, Acisclo Antonio (1653–1726). Painter and author.

Picasso, Pablo (1881–1973). Modern exploratory painter and sculptor, a founder of cubism. Worked chiefly in France. His style, technique, and general approach to art were subject to constant changes.

Ribera, José (or Juseppe) de (1591–1652). Valencian painter; worked in Naples for Spanish viceroys.

Rodrigue, Ventura (1717–1785). Architect, became leading exponent of neoclassic style.

Rovira, Hipolito. Churrigueresco architect; designed Palace of the Marquis de Dos Aguas at Valencia (1740–1745).

Sarcillo, Francisco (1707–1748). Sculptor. Most of his productions were in terra-cotta.

Siloe, Diego de (c. 1495–1563). Early Renaissance architect; designed the cathedral at Granada and the "golden staircase" of Burgos cathedral.

Valdevira, Pedro (d. 1565). The cathedral of Jaen, the style of which had an important influence in Latin America, was begun under him.

Vandergoten, Jacobo (d. 1725). Brussels tapestry maker called to Madrid by Philip V. Directed the Royal manufactory of tapestries and rugs.

Velasquez de Silva, Diego (1599–1660). Of Andalusian and Portuguese ancestry. Court painter of Philip IV. Noted for portraits of royal family and their buffoons. One of the greatest painters of all times.

Villapando, Francisco Corral de (d. 1561). Architect; designed silver choir screen of Cathedral of Toledo.

Zurbaran, Francisco (1598–1664). Baroque painter.

Xavier, Saint Francis (1506–1552). Basque Jesuit missionary to India and the Far East. Aided in developing trade with these countries.

BIBLIOGRAPHY

Bevan, Bernard. *History of Spanish Architecture.* New York: Charles Scribner's Sons, 1939.
An excellent short history, well illustrated.

Bueno, Luis Perez and Domenech, Raphael. *Antique Spanish Furniture.* New York: Towse, 1965.

Burlington Magazine. Monograph II, "Spanish Art." London: B. T. Batsford, 1927.
Excellent text with photographs and colored plates.

Burr, Grace H. *Hispanic Furniture.* New York: Hispanic Society of America, 2nd Ed., 1964.
Excellently prepared guide to the Spanish collections of this society. Text and illustrations.

Byne, A., and Byne, M. S. *Decorated Wooden Ceilings in Spain.* New York: Hispanic Society of America, 1920.
Collection of photographs and measured drawings with descriptive text.

Byne, A., and Byne, M. S. *Spanish Architecture of the Sixteenth Century.* New York: G. P. Putnam's Sons, 1917.
An illustrated survey of the Plateresco and Herrera styles.

Byne, A., and Byne, M. S. *Spanish Interiors and Furniture.* 2 vols. William Helburn, 1921–1922.
Brief text with fine collection of photographs.

Byne, M. S. *Popular Weaving and Embroidery in Spain.* New York: William Helburn, 1924.
Illustrated text.

Contreras, J. de. *Historia del Arte Hispanico.* 4 vols. Barcelona: Salvat Editores, S. A., 1934.
The standard history covering all branches of Spanish art, copiously illustrated. Reprint, 1945.

Domémech, R., and Bueno, L. P. *Meubles Antiquos Españoles.* New York: William Helburn.
Folio of photographs.

Eberlein, H. D. *Spanish Interiors, Furniture and Details From 14th to 17th Century.* New York: Architecture Book Pub. Co., 1925.

Ellis, H. *The Soul of Spain.* New York: Houghton Mifflin Co.
A beautifully written description of Spain and her people.

Hispanic Society of America. *Catalogue of the Library of the Hispanic Society of America* (10 Vols.). Boston: Hall, 1962.

Mack, G., and Gibson, T. *Architectural Details of Northern and Central Spain.* New York: William Helburn, 1930.
Measured drawings and photographs.

Mack, G., and Gibson, T. *Architectural Details of Southern Spain.* New York: William Helburn, 1928.
Measured drawings and photographs.

Madariaga, Salvador de. *Spain.* New York: Creative Age Press, 1943.
Excellent political and cultural history from earliest times through the civil war.

Mayer, A. L. *Architecture and Applied Arts in Old Spain.* New York: Brentano's, 1921.
Brief text with fine photographs.

Michener, James A. *Iberia: Spanish Travels and Reflections.* New York: Random House, 1968.

Prentice, A. N. *Renaissance Architecture and Ornament in Spain.* London: B. T. Batsford, 1893.
Text and measured drawings.

Saladin, H. *L'Alhambra de Granade*. Paris, 1920.
 Brief Spanish text and photographs.
Sordo, Enrique. *Moorish Spain*. Translated by Ian Michael. New York: Crown Publishers, 1963.
 Superb photographs by William Swaan.
Tatlock, Robert. *Spanish Art:* an introductory review of architecture, painting, sculpture, textiles, ceramics, woodwork, metal work. New York: Weyhe, 1927.

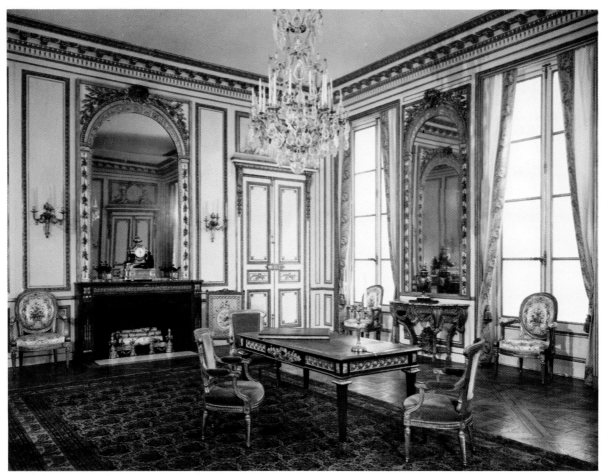

Louis XVI room, circa 1770–1775. Wood painted gray with carved and gilded decoration; overdoors of sculptured stucco.

CHAPTER 5

The French Periods

A drawing by Jean Pillement showing Oriental influence.

During the early years of the fifteenth century, Saint Joan of Arc, by what appeared to a simple peasant people to be supernatural means, aroused the national consciousness of France by expelling the last of the English and ending the Hundred Years' War. The years immediately following the victory of Joan witnessed a consolidating of political and nationalistic gains and an organizing for foreign conquest. This period was coincident with the decline of Gothic art. Medieval mysticism and spiritual man were fading before the onset of a more worldly and realistic philosophy. The flamboyant poems in stone of the Middle Ages had reached their zenith, and a new aesthetic interpretation was needed to reflect the vigor, ideals, and ambitions of the emancipated nation.

THE ITALIAN INFLUENCE. From the period of Charles VIII (1483–1498), the eyes of the French kings had looked with both jealousy and envy across the Alps. Primarily interested in political gains, they also had the opportunity to contrast their own fortresslike castles with the splendor, comfort, and luxury that surrounded the Italian nobility. The questionable military victories of Charles and his successor, Louis XII, were followed by an invitation to Italian craftsmen to visit France. This movement culminated under Francis I, who induced both Leonardo da Vinci, in 1516, and Cellini, in 1537, to work at the French court. Vignola, the architect, Primaticcio, the mural decorator, Andrea del Sarto, and others followed.

To the reign of Francis I (1515–1547) is ascribed the true beginning of the Renaissance arts in France. Certainly Francis, more than his immediate predecessors, was responsible for the direct encouragement of both art and literature. Francis had been unsuccessful in his military ventures, and in 1525 had been defeated by Charles V in Italy and held prisoner in Pavia. There he had had ample opportunity to observe the fruits of the great cinquecento, and after his release, his greatest ambition was to make his reign notable for the glories of art rather than for military or political successes.

Francis's domestic interest lay primarily in the province of Touraine, some 150 miles southwest of Paris. He developed the social life of the nobility in this region and built many delightful châteaux along the Loire River.

Francis was followed by Henry II (1547–1559), who married the Italian Catherine de' Medici, a woman of cruel but forceful character, who completely controlled him and their three sons, each of whom succeeded to the throne. She was instrumental in giving additional impetus to the Italian arts in France. She surrounded herself with Italian courtiers, who aided in introducing at the French court the amenities of Florentine social existence. Catherine died in 1588 after an active life as the central figure of the religious wars. Tradition ascribes to her the instigation of the Massacre of St. Bartholomew's (1572), which occurred during the reign of her son, Charles IX. ·

SPANISH AND FLEMISH INFLUENCE. Henry IV (1589–1610), the successor of Henry III, was born in Navarre, a small kingdom in the Pyrenees. Originally a Protestant, he turned Catholic to gain the crown of France, stating that "Paris is worth a mass," and married Marie de' Medici, of Florence. Henry was an enemy of fanaticism,

—141—

a friend of the people, and thought that groups of conflicting beliefs could live in amity. He was active in the final settlement of the religious difficulties of the people, and by the Edict of Nantes (1598) created a religious tolerance that brought peace to the country, permitted untrammeled activity, and encouraged the development of the industrial arts. As a result of the edict, many Protestant artists and craftsmen, who had been persecuted under the Spanish control of the Low Countries, emigrated to France. By this means, the Flemish interpretation of the Spanish crafts was popularized in France.

Henry IV was succeeded by his son, Louis XIII, when Louis was nine years old. His mother, Marie de' Medici, continued to rule as regent. She was a woman without principles, who lavished the resources of her crown upon nobles and leagued herself in various ways with Spain. Louis XIII himself was a feeble ruler. He eventually banished his mother, but there was little peace in France until Cardinal Richelieu, spiritual adviser to the court, became the virtual ruler of France from 1622 to 1642.

The king, according to Richelieu, was "the first man in Europe, but the second in his own kingdom." Richelieu wore alternately the helmet of generalissimo of the French army and the cardinal's hat. He was a statesman of extraordinary genius. He was also a great patron of art and literature; it was he who established the French Academy—those Forty Immortals. Richelieu left his mark on French history and culture.

With a Spanish wife, Louis was hostile to the Hapsburgs of both Austria and Spain. Spanish and Flemish influence, however, continued in the arts, which began to show elegance, grandeur, and heaviness.

During the reign of Louis XIII, the influence of both Italy and Spain gradually lessened, and during his final years, the way was paved for the development of the first truly native French artistic triumphs under his successor.

FRANCE ESTABLISHED AS THE CULTURAL CENTER OF EUROPE. A few months after the death of Richelieu, Louis XIII died, leaving his son Louis XIV—a child of five—to reign for seventy-two years (1643–1715), first under the restraint of Mazarin, and later as absolute monarch. Louis XIV attained complete cohesion of the conflicting political parties in France and established the French settlements in the Mississippi and St. Lawrence river valleys in America. The development of trade with the Western Hemisphere contributed greatly to Louis's wealth and power and played an important part in the advancement of the decorative arts. Under the unbroken influence of a long reign, all the arts flourished to an extraordinary degree. *Le Roi Soleil* ("The Sun-King"), lover of pomp and splendor, ruled with a magnificence and state unknown since the days of the Roman Empire. French taste became the standard of excellence, and the French court the social and artistic arbiter of Europe. Louis was the most regal of kings, and his reign one of the most extravagant of modern times. The resources of the realm were so taxed by foreign wars, by the building of his palace and gardens at Versailles, and by his extravagant entertainments that the seeds of the French Revolution may be traced to these events. In his daily life he established elaborate forms of etiquette and surrounded himself with nobles who sought advancement through his favor. Architecture, decoration, and art in general were an essential part of his system to create work and emphasize the glory of king and state. Festivals, plays, ballets, banquets, and dazzling fireworks were the costly amusements of his vast entourage. Poets, artists, and scholars were richly patronized. It was the age of Molière, Racine, and Corneille, the great French dramatists; of Lulli, the musician; and of La Fontaine, the fabulist. His whole reign seemed crowned with a halo of splendor and fascination which made French fashions, literature, language, and arts the envy of Europe.

At the height of his career Louis made his greatest error in the revocation of the Edict of Nantes (1685), which denied freedom of worship to the Huguenots, many of them talented craftsmen, and was followed by terrible persecutions. As a result, thousands of Frenchmen were forced to emigrate to Holland, Switzerland, England, and America.

When Louis died, he left France burdened with debt, its resources exhausted, its credit gone, its ships and foreign trade subservient to England, and its people impoverished. The mobs rejoiced and cheered in unison "Vive le Roi," but Louis had left as a heritage the ultimate of all the arts. He had taught the people the art of living.

Louis XV (1715–1774) was a great-grandson of Louis XIV. He was five years old when he inherited the crown. A regent was appointed until he was thirteen, after which he assumed control of the realm. During the regency, a reaction of frivolity and pleasure set in against the austerity which Louis XIV had imposed upon the court of Versailles in his declining years, when he was under the religious and moral influence of Madame de Maintenon. But underneath this gaiety, the economic state of France was chaotic. To replenish the emptied coffers of the French treasury, the regent undertook unwise financial risks. A period of feverish speculation and inflation resulted, followed by a disastrous panic. The economic importance of this financial fiasco was its tempering of the social order, so that rank and dignity by birth gave place to a new society, whose standard was wealth, elegance, and refinement of manner.

When Louis XV attained his majority and reigned with absolute authority, he continued the mad round of pleasure that the courtiers had instigated under the regent, and indulged himself with unlimited luxury and entertainment. Although for a while economic conditions improved, the country was overburdened with taxation to keep up the extravagances of the court and of the king's favorites, Pompadour and Du Barry. The reign ended in that lurid deathbed prophecy of the king: "After me, the deluge."

The France inherited by the physically and mentally immature Louis XVI was a nation stripped of its American colonies, without prestige in the eyes of other European nations, and torn by political and religious strife within. The condition of affairs had been both aggravated and made public by the writings of Rousseau and Voltaire. France needed stronger hands than those of Louis XVI and his impulsive Austrian wife, Marie Antoinette. Together, lacking sympathy with a licentious court, they stood childlike on the edge of a volcano. Court scandals developed, and, while revolution smouldered, the queen played dairymaid in her improvised hamlet at Versailles and picnicked amidst ribbons and laces, satins and curls.

This was the period that preceded and precipitated the destruction of the Bastille, the execution of the king, and the other events which marked the reign of terror of a bloodthirsty and bitter mob. The battle of Valmy in 1792, in which a French nonprofessional army defeated the highly trained Prussian troops, ended the effort to restore the king to the throne and established the control of the state by the people rather than by the aristocracy. Liberty, equality, and fraternity were proclaimed.

SOCIAL EFFECTS OF THE REVOLUTION. The Revolution was followed by the Directorate (1795–1799), a period of slow reorganization and of little constructive effort along aesthetic lines. The fortunes of the nobility, dispersed during the Revolution, gradually fell into the hands of a new group, many of whose members had little acquaintance with the credentials of culture.

Napoleon was proclaimed consul after his campaigns in Austria and Egypt, and in 1804 became emperor of France. He appointed his brothers kings of Holland, Westphalia, Naples,

and Spain. As emperor his career was brief, but of great importance to France and to the rest of the Western world. He improved public buildings, and he gave France the basis of contemporary French law, in the "Code Napoléon."

Socially and economically, the Napoleonic period created a new distribution of wealth and honors. The royal aristocrats had been destroyed or had emigrated to foreign countries, and in their place was established a new nobility, created by the favoritism of Napoleon and by the obligations he incurred. The *nouveaux riches* had neither the suavity, the culture, nor the sophistication of the *ancien régime*, yet they desired to surround themselves with the luxuries and the evidences of wealth proper to their position, without recalling too vividly the prerevolutionary forms. Thus a new art period known as "Empire" was created, which, like other periods of French decoration, spread throughout Europe and influenced established local styles until about 1830.

THE SUBDIVISIONS OF THE FRENCH PERIODS. The French art periods are often called after the names of the reigning monarchs, but as the changes in the art forms do not exactly correspond to the lifetimes of the rulers, it is preferable to use the nomenclature given herewith.

1. EARLY RENAISSANCE (1484–1547). Reigns of Charles VIII, Louis XII, and Francis I. Transitional period. Mixture of Gothic structural forms with Italian Renaissance architectural detail and ornament.
2. MIDDLE RENAISSANCE (1547–1589). Reigns of Henry II, Francis II, Charles IX, and Henry III. Gradual elimination of Gothic forms, with greater use of Italian ornament and Renaissance architectural detail, with local variations. Catherine de' Medici dominates the kingdom.
3. LATE RENAISSANCE (1589–1643). Reigns of Henry IV and Louis XIII. Continuation of Italian Renaissance influence mixed with Dutch and Flemish influence. Enlargement of wall paneling. More formal effects. Edict of Nantes issued 1598.
4. BAROQUE STYLE (1643–1700). Reign of Louis XIV, 1643–1715. Golden age. The first of the purely native styles. Splendor and magnificence. The use of classic architectural orders. Rectangular wooden wall paneling. Enormous rooms, large-scale furniture. Richly carved ornamentation and strong color contrasts. Curves formed by the compass. Edict of Nantes revoked 1685.
5. REGENCY STYLE (1700–1730). Regency 1715–1723. Beginnings of economy in architecture and decoration. Large scale of rooms continues, but free curved forms are introduced. Transitional style.
6. ROCOCO STYLE (1730–1760). Reign of Louis XV, 1723–1774. Further economies in decorative art production. Smaller-scale rooms and furniture. Effeminacy and sentimentality introduced. Artificialities, pastorals, and conventionalizations. Accentuation of free curved forms and delicate color schemes. Elimination of classic orders. Introduction of Oriental influence.
7. NEOCLASSIC STYLE (1760–1789). Reign of Louis XVI, 1774–1789. Further economies in production. Return to naturalism and simplicity in decorative forms. Straight lines and compass curves. Revival of classic architectural orders. Pompeian, Greek, and English Adam influence dominant.
8. REVOLUTION AND DIRECTOIRE (1789–1804). Temporary stagnation. Effort to eliminate previous forms of art. Introduction of military motifs. Transitional style.
9. EMPIRE STYLE (1804–1820). Napoleon 1804–1815. Symbols of Napoleon's victories. Egyptian motifs, allegorical symbols of Roman and Grecian architecture, decoration, and furniture.
10. RESTORATION STYLES (1830–1870). Reigns of Louis XVIII, Charles X, Louis-Philippe, and Napoleon III. Revivals of late eighteenth-

century furniture and industrial art forms, cheapened by machine manufacturing. General decline of good taste.

FRENCH INITIATIVE IN THE ARTS. France is distinctly a spiritual as well as geographical and political entity. From time immemorial distinguished persons of divergent origin have flocked to her protective confines, have contributed to her racial and cultural development, and have become as loyal to her as her native sons. She has welcomed with open arms the thinkers and creative artists of every race and has benefited greatly by this elixir.* The attraction has existed because the soul of France has been nourished for centuries by the existence of a completely free intellectual atmosphere. Although France has both profited and suffered from the results of this policy, this freedom has saturated her people with a lust for life and a restless energy and has impelled her continually onward. The motto of Paris, *Fluctuat nec mergitur* (She rocks but never founders), has characterized the spirit of the country as a whole. The modern philosophy of her people commences with Rabelais, the first of her Renaissance scholars who preached the joy of living, tolerance, and the candid acknowledgment of human instincts that the Middle Ages had preferred to screen; Montaigne, who followed him, taught the futility of fanaticism and the value of skepticism; and finally Descartes, the analyst of doubt, became the forefather of democracy and the intellectual ancestor of Franklin, Washington, and Jefferson.

In spite of the diverse origin of her people and varied geographical and climatic conditions, France has been a closely knit country with citizens proud of their birthright. The essence of French thought has been derived from roots buried in Paris. From this city have come the imagination and explorative efforts in the arts

that have ranged from magnificence to absurdity, but which have been necessary elements in the French intellectual development.† The truth-delving qualities of the French mind, the insistence upon quality in industrial and artistic production, the traditions of individualism and desire for novelty have made Paris the arbiter of elegance for over four hundred years. For the major portion of this period, France has been the most advanced outpost of European civilization, and all the countries of western Europe and their progeny in the Americas have turned to her for artistic nourishment.

PSYCHOLOGICAL AND ECONOMIC INFLUENCES. There are two fundamental characteristics of the French mind that have contributed greatly to the charm and originality of French art. These are the love of romance and the love of order. Each of these conflicting qualities has tempered the other, and each has in turn dominated.

The kings of France promoted the art industries partly through their natural desire for luxury and beauty, and partly because such support advanced the economic condition of the country. Extravagances of this type might have been endured had it not been for the added weight of the unsuccessful military ventures attempted by the French kings, the too liberal policy of distribution from the treasury to favorites, and the diversion of government funds to the pockets of petty officials. All French art until the nineteenth century was essentially monarchical and palatial in character, and the history of French decoration must be traced by a study of the royal residences, many of which were designed in a manner that is more elabo-

* Charlemagne, Mazarin, Napoleon, Chopin, Zola, Mme. Curie, Stravinsky, Picasso, and Le Corbusier, as well as many of royal blood, were of alien origin.

† Since the Middle Ages, the literature of every century has proclaimed the allure of Paris, but each generation has nostalgically asserted that "Paris is not what it used to be." The Parisians paradoxically remark, *"Plus ça change, plus c'est la même chose,"* but the road to Paris has always been one of hope and expectation.

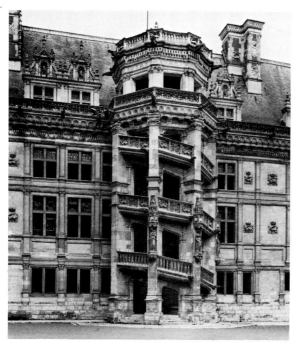

Agence Top

The exterior staircase at the château of Blois built by Francis I.

rate than today's democratic conditions would warrant.

It was not until the eighteenth century was well started that the financial status of the French nobility forced them to build and decorate their homes along comparatively simple lines and to search for materials and mediums of expression that have become reasonably adaptable to the living conditions of today. It is essential, however, for a proper understanding of French art, to study the development of the Renaissance influences from the beginning.

INTERIORS OF THE RENAISSANCE PERIOD (1484–1643). Buildings and interiors during the reign of Louis XII were more truly Gothic than Renaissance. In only occasional instances were Italian features seen, and although the importation of Italian artists and craftsmen began during this period, substantial evidences of the new style were not seen until Francis I ascended the throne in 1515. The social life of Francis de-

manded the construction of numerous small châteaux in Touraine, the exteriors of which strongly recall the medieval fortress in miniature, with the embattlements, towers, and *machicolated* galleries becoming mere ornaments, since gunpowder had made their practical use obsolete.*

The rooms of this period were large, dark in appearance, and often had plaster walls treated with painted patterns or with Cordovan leather, or hung with Arras tapestries. Gothic wood paneling also continued to be used. Floors were in colored or decorated tile. Ceilings revealed structural beams of comparatively small size, placed close together, and ornamented with colorful stripes, armorial devices, and cartouche forms. The mantel was the most important decorative feature in the room, and projected from the wall as in the Gothic period. The overmantel was frequently supported by columns or pilasters, the designs of which were inspired by classic detail but not always by classic proportions. The Francis I rooms at Fontainebleau show walls treated with both orders and paneling which follow closely the Italian Renaissance version of the Vitruvian forms. Ornamental motifs borrowed from Italy, such as the arabesque and the candelabra form, were combined in wood and stone with Gothic pointed arches, finial motifs, and decorated buttresses. The letter "F," in monogram form, and the salamander, selected as a symbol by Francis because of its fabled ability to withstand fire, were everywhere used as ornamental motifs.

Under Henry II and his three sons, the decorative use of Gothic elements dwindled. Rooms were treated in much the same general manner as in the preceding period. There occurred, however, a better understanding of the

* Examples of these châteaux are seen at Blois, Chambord, Azay-le-Rideau, Chaumont, Chenonceaux, and Fontainebleau, and in a portion of the Louvre in Paris.

The sixteenth century in France developed a small group of artists whose versatility was second only to that of the Italians. Among them were Pierre Lescot, Jean Goujon, Jacques du Cerceau, and Philibert Delorme.

During the Henry IV and Louis XIII periods, France commenced to be more self-conscious in her art expression. The Gothic forms of design were by this time completely eliminated, and attempts were made to create interiors that were less foreign in feeling. Royal patronage and protection of the artists became an established policy. The rooms of the palaces became more dignified and formal. The architectural orders commenced to be used more frequently as an important feature of decoration. Wall panels in wood were greatly enlarged, and were seen in a diversity of shapes. The moldings used to form the panels were heavy, and the fields of the panels began to be painted and carved with large baroque patterns borrowed from Italian, Spanish, and Flemish sources. Painted wall decorations were used for overmantel areas and in wall panels that reached from floor to ceiling.

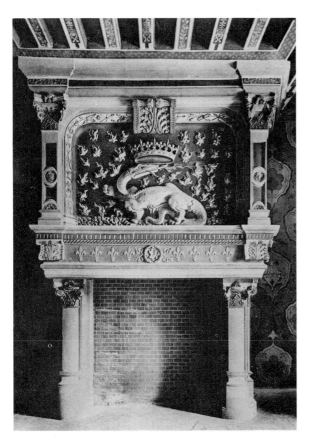

Fireplace from the château at Blois in the Francis I style showing early Renaissance forms and the Salamander.

true classical proportions in the use of the orders. In many rooms the walls continued to be covered with wood paneling of small Gothic proportions, but the field of the panels was often carved or painted with Renaissance arabesque forms. Ceilings were still beamed, but the coffered panel was also introduced. In some rooms of this period have been found fragments of *domino wallpaper*, in marbled effects, probably imported from Italy. Henry adopted the crescent as a symbol and an ingenious monogram of the letters "H" and "D," the latter being the initial of Diane de Poitiers. Both motifs were frequently carved in the woodwork of this period.

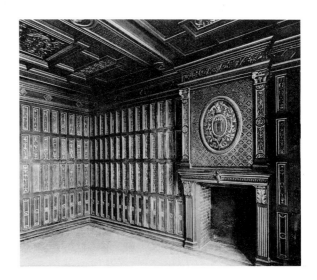

Room of the Henri II period in the château of Blois. The Gothic form of paneling is still used, although Renaissance forms and arabesques are introduced.

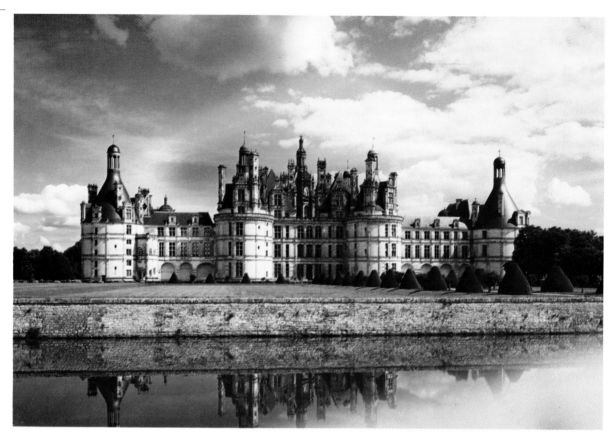

Château of Chambord 1526–44. Typically early Renaissance in its regularity and symmetry, surrounded by a moat combining curving and angular motifs.

Floors were in marble squares or parquet wood patterns. Ceilings continued to be beamed or in coffered panels.

FURNITURE DURING THE RENAISSANCE PERIODS. The rooms of the early Renaissance châteaux were sparingly furnished. The furniture was massively built, and the structural forms of the Gothic period continued in use, although the ornamental forms of the Italian Renaissance were gradually applied. Both oak and walnut were used as cabinet woods. As a result of the fact that a large number of Italian cabinet-makers were in France, and that many of the pieces made by these men were entirely Italian in character, French design characteristics were not in evidence much before the middle of the sixteenth century. The important chairs maintained the aspect of thrones and were built up from small chest underbodies. Stools and benches, the X-shaped chair, and the *escabelle*, similar to the Italian sgabello, were used. The *caquetoire* or small conversational chair standing on four legs was first used in the middle of the sixteenth century. The credence and an Italian form of double cabinet known as the *armoire*, enriched with an excess of miniature classical architectural motifs, became typically French pieces. Panels were beautifully carved with graceful figures, arabesques, and grotesques. *Gadrooning* was common as an ornamental motif. Small rectangular insets of jasper, onyx, and other semiprecious stones were some-

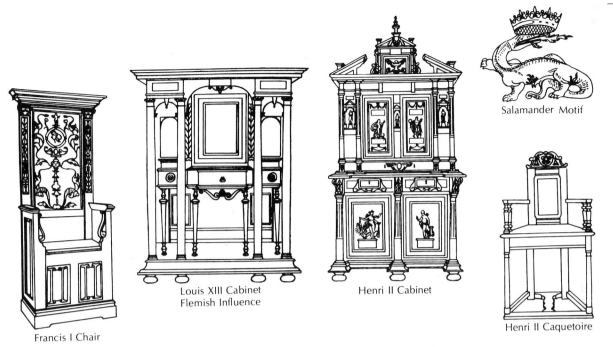

Salamander Motif

Francis I Chair

Louis XIII Cabinet
Flemish Influence

Henri II Cabinet

Henri II Caquetoire

French Renaissance furniture and details.

times added to the designs. Both carved trestle supports and column legs were used for heavy tables, some of which had extension tops. The bed was massive, with four heavily carved posts supporting a cornice from which hung velvets or tapestries. Hugues Sambin and Jacques du Cerceau were the leading designers of furniture during the latter years of the sixteenth century.

Under Henry IV and Louis XIII the Flemish influence was more strongly seen in furniture than in decoration. Walnut and oak continued to be used, but ebony also became popular as a furniture wood. In case furniture, made in the north of France by less expert craftsmen, panels were of the pyramidal type with either three or four sides. *Bun feet* or *Flemish feet* with scrolls were used, and supports consisted of slender classic column forms or spiral turnings. Flat stretchers arranged in the shape of a letter "X" with a vase form or turned finial placed at the intersection were introduced to brace table and cabinet legs. In the better grade of furniture, ornaments were carved or inlaid in woods of contrasting colors, in tortoiseshell, semiprecious stones, and gilded bronze. Upholstery consisted of elaborately embossed Cordovan leather, velvet, damask, and needlework, often trimmed with fringes.

LOUIS XIV AND THE PALACE OF VERSAILLES. Early in the reign of Louis XIV, the king had as minister of finance a man named Nicolas Fouquet who had built (1655–1661) for himself on the outskirts of Paris a château that was known as Vaux-le-Vicomte.* One day Fouquet invited the king and his court to visit him. What greeted Louis's eyes was a structure and gardens the splendor of which he had never seen before. It surpassed in novelty any of the royal palaces. It was incredible. The king, intolerant of rivalry,

* This château had been designed by LeVau and decorated by Lebrun. It is still in existence.

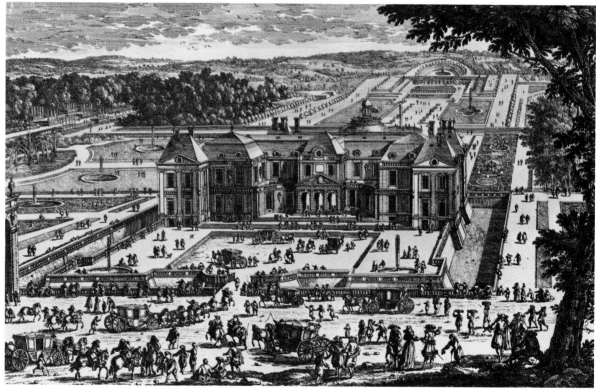

Vaux le Vicomte, the splendid palace which was the inspiration for Versailles.

suspected irregularities in the royal accounts, discovered them, jailed Fouquet for life, and decided to build a palace that would never be excelled in size or beauty. Thus was conceived Versailles, which up to that moment had been but a small hunting lodge erected by Louis XIII. This building, which was planned to house 10,000 persons comprising the immense retinue and guests of the king, was the supreme architectural and decorative achievement of his reign. Charles Lebrun, the painter, a man of inexhaustible ingenuity, was appointed art director of the realm. Louis LeVau, the architect, commenced the building in 1668, but Jules Hardouin-Mansart, a follower of Vignola, continued it after 1679. Bernini, the great Italian baroque architect, was also consulted. Decorators, sculp-

tors, painters, industrial designers, and master craftsmen were collected from far and wide to plan and embellish the new building. The greatest French artists in all mediums were placed on the royal payroll, among them Antoine Coysevox, Lefèvre, Boulle, Marot, Berain, and Lepautre. The palace became a city in itself. It was the first complex dwelling that was planned in contact with nature. The great park and gardens planned by Le Nôtre have been the prototype of all town planning since their inception. The plan consisted of vast parterres of "green carpets," flowers, lakes, canals, fountains, interminable radiating avenues, vistas, and arbored walks; its canals were filled with gondolas and luxury craft, and provision was made for every sort of activity—sports, hunting, fishing, festivals, and

lovemaking. The most important public room in the palace was the great *Galérie des Glaces*, or Hall of Mirrors, designed by Mansart and decorated by Lebrun. This room is 240 feet long, 34 feet wide, and 43 feet high. Its walls are lined with Corinthian pilasters of green marble which alternately separate arched windows and arched mirrors. The ceiling, which springs from a richly treated entablature, is a semicircular plaster vaulted arch painted by Lebrun.*

In addition to the palace at Versailles, Louis built many small châteaux. Perreault and Le Vau designed the great colonnade at the east end of the Louvre. Louis purchased the Gobelins tapestry looms in 1662, appointed Lebrun director and chief designer, and later purchased the Beauvais looms. The Gobelins factory not only made tapestries but embroideries, furniture, mosaics, bronzes, and goldsmiths' work for the royal palaces and for presentation purposes. In 1666 the French Academy in Rome was founded. The Savonnerie rug factory was eventually combined with the Gobelins factory; the potteries at Rouen and St. Cloud were given royal encouragement, as were many other art industries. The French National School of Fine Arts and the Paris Conservatory of Music were organized; stately government buildings were erected; libraries were founded; halls of science, astronomy, botany, and zoology were established. The arts and sciences were welcome and useful allies in aiding the king to make the court of France the most magnificent in Europe.

INTERIORS OF THE BAROQUE PERIOD. The public rooms in the Palace of Versailles, which are all of great size, were designed for entertaining vast assemblages in the most regal manner. This purpose created the key to the whole style, and explains why it is called the French baroque. Great formality of design and pompousness,

produced by large-scale detail and extravagance of workmanship and material, were the most characteristic decorative features. In the salons, the permanent elements of the large rooms, such as walls, ceilings, doors, and windows, were the important features of decoration. Movable objects and furniture were regarded as secondary motifs. As a result, most of the furniture was placed against the walls, leaving the center of the room clear. The walls and ceilings were treated as one magnificent composition of decorative paintings, carvings, tapestries, paneling, and mirrors.

An architectural arrangement in which the orders were used in true classical proportions formed the basis of the wall design. Columns, pilasters, and entablatures were enriched with gilded metal and carved ornaments. In the more formal public rooms, stone and colored marble were used for both the orders and walls. In the private apartments wood paneling was more generally used. The pilasters either rose from the floor or stood on a pedestal which formed a low dado around the room, and the wall area between them was enriched with one or more large panels of great height, extending from the dado to the underside of the architrave. Wide panels alternated with narrow ones. An *attic* was often placed above the entablature, and above the attic the ceiling was curved downward in a quarter circle called a *cove* to meet the woodwork of the wall.

The panels were sometimes painted with portraits and historical or mythological scenes. Large plate glass mirrors, considered the height of luxury and extravagance at that time, were also used as panel enrichment. The wood panels were in oak, framed with large moldings ornamented with finely detailed carving. The panel shapes were rectangular, although at the tops the moldings would sometimes follow a semicircular or segmental curve. Circular frames above the panels enclosed portraits or flower paintings. Carved ornamental forms enriched

* Here King William of Prussia was proclaimed German emperor in 1871, and the Germans in 1919 were obliged to sign the Treaty of Versailles.

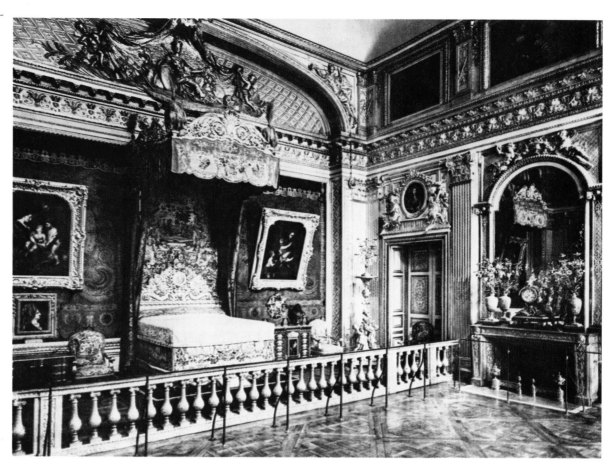

Extraordinary bedroom of Louis XIV in the palace at Versailles. The supreme example of royal magnificence, vigor, and splendor typified by large-scale orders and detail, strong color contrasts, and gilt ornament.

the panel field at the top and bottom, and a conventional medallion or naturalistic drop motif was often placed in the center. Wooden walls were usually painted, although some were of waxed oak left in a natural finish. It was customary to gild the moldings and carved ornament to contrast with a background painted in an off-white tone. This produced an exceedingly regal effect and became a standard method of decorating the woodwork. The French word *boiserie* is generally used to designate the carved wood paneling of all the French periods.

Door and window trim was architecturally treated with a heavy molding, crowned with a cornice. Overdoors were frequently enriched with wooden sculpture in high relief showing cherubs surrounded by foliage or portraits framed in the woodwork. Mantels of enormous size were invariably in colored marble, sumptuously carved with ornament, the shelves slightly shaped, with molded edges. Overmantels were in mirror or painted panels framed in an architectural treatment.

Floors were oak parquet patterns or black and white marble squares. The floor coverings were usually Savonnerie pile rugs in colors and

patterns that harmonized with the architecture and carved ornament. Coves were elaborately enriched by plaster panels and painted ornament, and the central portion of ceilings was painted with celestial scenes. Crystal or carved wood chandeliers hung in the center of the room, but additional light was given by *torchères,* wall brackets, and elaborate candlestands. The character of the ornamental motifs alternated between the abstract and the realistic; flower and leaf forms, masks, grotesques, and religious symbols were used in the carving. The king's monogram, two intertwining "L's" in script form, was often placed in a cartouche located over a door or window or in the center of a panel. The king's symbol, a sun with spreading rays, was also frequently used. Accessories consisted of busts, hanging mirrors, Oriental pottery, terra-cotta urns, statues in bronze or marble, paintings, and portraits, and an exensive use of wall tapestries of the Gobelins and Beauvais looms. The large scale and great richness of the interiors of the Louis XIV period make them inappropriate for modern use.

FURNITURE OF THE BAROQUE PERIOD. With the ushering in of the baroque influence, the design of furniture and accessories assumed a richness of character equal to the room treatments. The furniture industry in France was very well organized as early as the sixteenth century. Individual pieces were usually made only upon order until the period of Louis XV. The earliest furniture makers were known as *huchiers-menuisiers,* or hutch-carpenters. These were later divided into *menuisiers d'assemblage,* makers of solid wooden furniture, and *menusiers de placage et de marquetrie,* makers of veneers and marquetry. About the middle of the eighteenth century, the term *ébéniste* (cabinetmaker) became common, although ebony as a cabinet wood had lost its popularity, and the title *maître-ébéniste* (master cabinetmaker) was given to those who had served their apprenticeship,

passed the required tests, and received a royal license to practice their trade. Records have been retained of most of these names, and, as the makers usually branded their products with their initials or surname, the origin and approximate dates of manufacture of most of the finest of the old French pieces can be accurately identified. A special guild of cabinetmakers and apprentices was organized by Lebrun, who appointed André-Charles Boulle *maître-ébéniste* to the king. The cabinetmakers were given quarters in the Louvre, and were directed to create more magnificent, more beautiful, and more novel furniture than had ever before been produced. Boulle had the ability to execute such an order, and his influence upon subsequent French cabinetmakers and upon the cabinet productions of other European countries was phenomenal. Boulle established the tradition of French cabinetmaking that was carried on by his sons, by his pupil Charles Cressent, who became particularly famous for his priceless chased metalwork, and, later, by Jacques and Philippe Caffieri.

The large rooms of the period, to maintain a consistent effect, called for heaviness of proportions and structure in the furnishings. Rectangular forms dominated in furniture design, with compass curves used where required. The typical furniture legs were heavy, square, and tapered, braced by square-sectioned diagonal stretchers. Wood-carving was popular, and many pieces were gilded. Two new types of furniture enrichment were developed by Boulle. *Ormolu* (gilded bronze) motifs and moldings were used as applied ornaments, which, in addition, served to brace the structure of the furniture, and panels were decorated with what is today known as *boulle work,* which consists of marquetry patterns made from sheets of tortoiseshell and German silver, brass, or pewter. Boulle work was very typical of baroque furniture, but its use was discontinued in the later French

Ornament for
Panel Corner

Carved Wood
Panel

Wood Carving
Detail of Chapel Door, Versailles

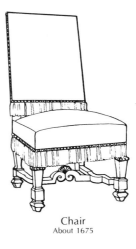

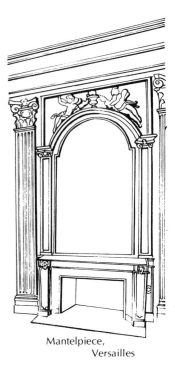

Showing Ormolu Mounts and
Tortoise Shell and Pewter Marquetry
Boulle Cabinet

Chair
About 1675

Mantelpiece,
Versailles

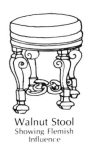

Walnut Stool
Showing Flemish
Influence

Baroque furniture details.

periods. The use of ormolu, however, was characteristic of all the styles that followed, the only change being in the modeling, scale, and subject matter of the motifs, which were altered to correspond to the patterns of each style.

Ebony, oak, walnut, chestnut, and sycamore, as well as rarer woods, were used for wooden framework. Tabletops were of marble. Comfortable upholstered and cushioned chairs and sofas were made, the upholstery materials consisting of tapestry, needlepoint, leather, cane, and heavy silk textiles such as damasks and plain or brocaded velvets. Upholstery trimmings were elaborate handwoven fringes or gold or silver nailheads. The textiles used for draperies were the same as those used for the upholstery. Patterns were large, and the colors of the figures contrasted strongly in tone with the backgrounds. Chromatic values were comparatively brilliant, a necessary feature in the large rooms.

Toward the end of the reign of Louis XIV and during the regency, when the curvilinear period of design was beginning, the cabriole leg was first used. This was a curved form of support conventionalizing an animal leg, with knee and ankle usually terminating in the form of a goat's hoof. Curvilinear forms were also used for chair and table stretchers.

INTERIORS OF THE REGENCY PERIOD. The art style designated by the term *regency* does not coincide with the political period of the same name, but the word is used as a convenient method of describing the transitional forms which were seen as early as the closing years of the seventeenth century. In brief, this style maintains the scale and richness of the Louis XIV treatments, yet it begins to show some of the gracefulness and curvilinear elements that qualify the style named for his successor. This transitional form applied both to the wall paneling and the furniture. The regency overlapped and blended with the two styles from which it drew its forms, so that a clear division was imperceptible. The style (1700–1730) was a bridge between the classic severity of that of the Sun-King and the romanticism that developed during the reign of his great-grandson, Louis XV. The change in art forms was slow, but the demand for austerity, grandeur, and formality lessened with the political misfortunes of the closing years of the reign of the great Louis. The temper of the king must have been softened greatly in his old age, if we are to judge by his statement to Mansart that he wished to see playing children instead of classical heroes used as subjects of decoration. By the early years of the eighteenth century the decorative arts had become popularized. Nobles as well as the wealthy bourgeoisie vied with each other in the purchase of art products and in procuring the services of artists. Even the farmers began to feel the return of prosperity and required stylized furniture for their cupboards, dressers, and wardrobes. Everyone began to take pride in his

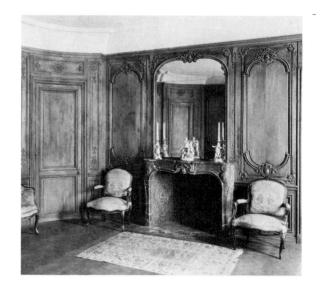

A charming regency room in natural oak. The extreme rococo forms of paneling and ornament had not yet been introduced when this room was made. The forms are closer to the Louis XIV type, but much reduced.

home furnishings. The beginnings of much greater economy, however, were noticeable in the construction of smaller dwellings, with rooms suitable for more simple living and a more intimate type of entertaining than had been in vogue before. The demand for a reaction from the severity of existing social formalities was reflected in the value placed upon small pleasures, which was, in turn, reflected in the decoration of rooms in a more playful, fanciful spirit. The change was perhaps first reflected in the work of the painters. The style of Watteau, who began to dominate the arts after the death of Lebrun in 1690, was a complete reversal of the overpowering impressiveness of the work of the former art director, and Watteau was able to reflect the change in the thought of the times. Smilingly, but with a melancholy soul, he painted imaginary paradises and *fêtes galantes* showing the aristocracy charmingly and delicately playing at the game of love. His masterpiece in the

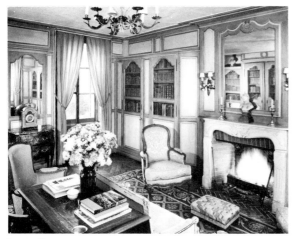

Agence Top

French provincial library.

Louvre, *Embarkation for Cythera,* expresses the hopeful escape from the social formalities of the period to an island, the epithet of Aphrodite, where lovemaking was prolonged eternally.

INTERIORS OF THE ROCOCO PERIOD. The style commonly known as Louis XV is preeminently one of interior decorative rather than of architectural application; the term *rococo,* to which it alone has claim, originates in a combination of the two French words *rocaille,* originally referring to rockeries, artificial grottoes, and rustic treatments, and *coquille,* meaning cockleshell. Both of these motifs had been represented in the pottery designs of Palissy in the sixteenth century, but they were revived and simplified by the designers of the eighteenth century and applied to the industrial arts. Meissonier, an Italian who came to Paris in 1723, is generally credited as being the early influence in the development of the style. He produced a book of engraved designs using the shell motif in deft and engaging compositions that caught the fancy of the French craftsmen, who began to adapt his designs to woodwork and cabinetmaking. The whole concept of Louis XV art was the reverse of that of Louis XIV, in which every-

thing had been sacrificed for splendor. In the rococo style, human comforts were paramount, and practical changes occurred; the rooms were reduced in size, and many were added for special purposes. There were definite public and private subdivisions of the house—reception rooms for winter and summer use, drawing rooms, small private libraries, boudoirs, and sitting, dressing, writing, conversation, coffee, play, music, and powder rooms—in fact, every type that is used today excepting the bath. There were, also, *cabinets particuliers,* or secret rooms, for private rendezvous, that were entered through the back of wardrobes or through sliding panels in the boiserie; the private dining room planned for Louis in the Petit Trianon contained a table that could be lowered through the floor to the pantry beneath for resetting between courses—an arrangement that enabled the king and his guests to carry on a conversation that could not be heard by the servants. Inventions were made for the improvement of heating, which, also, caused a change in the design of the clothing that was worn.

The rococo style in its spatial development was wholly of French nativity, although its germs had come from Italy. Its florescence was as untrammeled by foreign influence as had been the Gothic, and it was one of those immaculate conceptions of the imagination that art history has occasionally witnessed. It was fathered by nothing and vanished in a vacuum when the Vesuvian dusts were swept from Pompeii, yet it was imitated throughout nearly the whole of Europe. Whereas the purpose of the art of the baroque had been to glorify the king, the art of the rococo was for everyone, and particularly for pretty women—to please them, to accentuate their physical attractions, and to establish their supremacy and power. With the greater participation of women in politics, in literature, and in active life, French art became effeminate, sensuous, and pagan, yet light, graceful, and

fantastic; its purpose was not the expression of a heavy dignity, but to please its beholder by an emotional and often voluptuous appeal.

During the regency, the germs of rococo forms had already appeared and were blended with the great traditions formulated by Lebrun. With the reduction in scale of the decorative forms to suit smaller rooms, there also occurred a progressive change in the character of linear and mass composition. The straight lines and the compass curves of the Louis XIV period gradually gave way to freehand and often riotous curves, which were eventually used at every opportunity. The orders, inconsistent and inharmonious with the new forms, were completely eliminated in interior architecture. The eye was to be distracted and amused by continuous but irregular flowing motion produced by abstract detail that resembled nothing more than constantly changing froth, flames, or splashing water.

The later rococo rooms were extraordinarily charming, precious, and almost doll-like in their artistic concept. Small in their dimensions, they were consistent to the most minute detail, and their decorative treatment bespoke cordiality, warmth, comfort, and convenience to a supreme degree. In such an atmosphere their occupants, dressed in luscious silks, could not refrain from the most genteel amenities, which foredoomed them to mutual flattery and amorous conversation. In the boudoirs the ladies of the court would receive their friends and admirers seated *en deshabille* on their *chaises-longues* while perfuming, rouging, or placing a beauty spot on their cheek, but modesty decreed that they should at least conceal their bare feet with an embroidered coverlet. France is still flooded with small châteaux and country houses created during this period. Many of the rooms in the Palace of Versailles were redecorated in an elaborate interpretation of the new style, but the most interesting were those built in the minor resi-

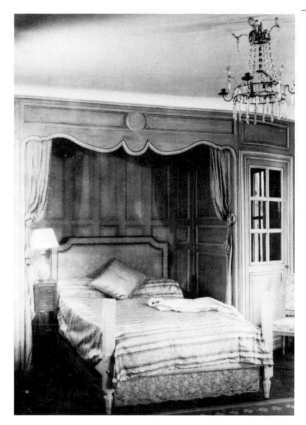

French provincial bedroom of about 1765, showing recessed bed and rococo frame for niche.

dences. Foyers and entrance halls were usually treated in panel designs of marble or *Caen stone*, but in the living quarters the walls were covered with wood paneling. The dado was used less frequently, and it was usually lower than in the previous style. The orders of architecture were always omitted, the wall being finished at the top with a simple architrave molding—never a complete entablature—and rising from this molding was a decorated plaster cove that eliminated the angle between wall and ceiling. There was a constant effort to avoid straight intersections where possible, and the corners of the rooms were often curved in plan. The panel moldings were much reduced in size, and at the

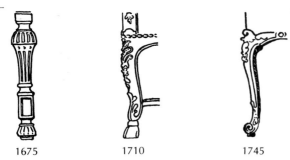

1675 1710 1745

Typical French Baroque, Regency, and Rococo chair supports.

top and bottom of the panels they were curved, in a form resembling a woman's upper lip, or were in irregular free curves gracefully combined in a continuous line. The corners of the panels were often broken or softened by the addition of a covering ornament. There was also a tendency toward asymmetry in panel shapes in which the top and bottom molding would form an irregular curve reaching its apex or ornamental motif at the corner rather than the center of the panel. Panel shapes were always vertical in their proportions. Anything approaching a square was usually avoided, and variety was introduced by alternating wide panels with narrow ones, the latter being formed by very small moldings. There was an attempt to panel opposite walls in a similar manner. In the royal palaces the moldings and panel fields were treated with gilded carved ornament, but in the smaller dwellings the moldings were plain and painted a color similar to, or contrasting with, the panel surface. As a substitute for the earlier, more expensive carved ornamentation, the panel centers were often enriched with a painted scenic decoration or floral composition in delicate colors by Watteau, Boucher, Fragonard, Pillement, or one of their imitators. These decorative artists were strongly influenced by the life that fluttered around them. Their work was sensual, but purified by a grace and winsome

beauty that exhilarated and quickened the heartbeat. In some rooms the oak woodwork was merely polished with wax, but in the majority, the background woodwork was painted either rose, turquoise, straw, mustard, putty, or pale green. During this period, textiles were sometimes stretched in the panel centers as a substitute for the painted decoration; these were either painted or moiré silks, or printed cottons, and their use confirmed the tendencies toward economy in the production of decorative effects. Painted and decorated mirrors also were much used for their glamorous reflections of flickering candlelights, exquisite costumes, and feminine pulchritude.

The king's favorite, Madame de Pompadour (1721–1764), a woman of great culture and refinement, was intensely interested in the decorative arts and spent both time and money in furthering them. She contributed large sums for the excavations in Herculaneum and Pompeii. She also obtained royal patronage for the ceramics manufactory at Sèvres, where exquisitely delicate pieces were produced, and where new chemicals were discovered to produce the rose, king's blue, and gold for which the ware became famous. Pompadour was also interested financially in an Oriental trading company, and succeeded in popularizing Oriental importations.* Artists, seeking her favor, contributed to the vogue, and not only were Oriental patterns reproduced in various mediums, but several decorative artists developed an extraordinary degree

* The Compagnie des Indes, in which Pompadour was interested, was the French equivalent to the British East India Company. It was responsible for the enormous importations of silks, pottery, porcelain, wallpaper, and other varieties of eastern products. Ships sailed to China as well as India, and the French established factories in these countries that manufactured products that would appeal to the home markets. The company started operation in 1664. It was particularly prosperous around 1750. Clive defeated the French in India in 1761, and the company was disbanded in 1769.

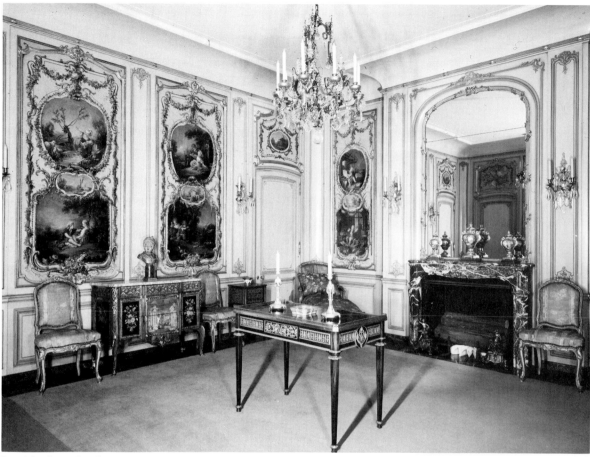

Louis XV paneling and chandelier. Louis XVI table. The panels are by François Boucher.

of originality in creating designs based on Chinese motifs for use in wall panels, screens, fans, and wall paintings. Among these artists were Pillement and Christophe Huet, who produced the most fantastic arrangements of mandarins, pagodas, parasols, monkeys, ladders, and foliage. A host of imitators added to the popularity of the movement, the designs being known as chinoiseries and *singeries*, according to their use of Chinese or of monkey motifs. Another inspiration for painted panel designs was obtained from Turkish sources, and decorations *à la turque* represented beauties of the harem, men in turban or fez, pashas, dervishes, odalisques,

and other Mohammedan types, intertwined with delicate arabesques.

The ornamental motifs in all mediums often reflected the purpose of the room or the interests of its occupants. Pastoral scenes and objects, such as the shepherdess's hat, basket, and crook, were extremely popular; music was often symbolized by the bagpipe, violin, flageolet, horn, and tambourine; hunting, fishing, science, and literature were represented; bouquets and garlands of roses, daisies, narcissi, eglantine, and sweetbrier were arranged with sprays and tendrils. The attributes of love, such as Cupid with his bow, quiver, and arrows, the blazing

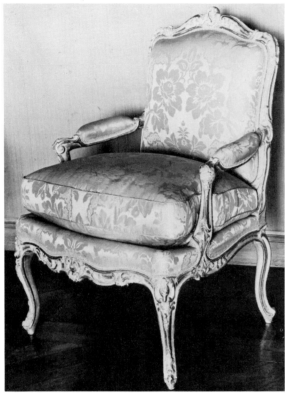

French Cultural Services

Louis XV armchair, typically rococo in style.

torch, and pairs of burning hearts, were frequently introduced toward the end of the period. The conventionalized cockleshell was one of the most common motifs used for the enrichment of both furniture and wall paneling; it usually formed a crowning or central feature in the design and was accompanied by sprigs of leaves.

The demand for decorated wall panels in the Chinese manner extended to the middle classes, and was supplied through the importation of Chinese hand-painted wallpapers, which could be had for less than French artists demanded for their work. Wallpaper, which had first been made in France by Jean Papillon in the latter years of the seventeenth century, was thus popularized. *Flock paper* imitating velvets and damasks was imported from England and was much in demand in the smaller residences.

Mantels were made in marble, with sweeping curved shelves and fire openings. The overmantel, known as a *trumeau*, combined woodwork, mirror, and painting, and a large mirror above a console was placed on the wall directly opposite the mantel to increase the illumination by an infinite number of reflections of the candlelight. Elaborate cast iron firebacks, gilded bronze lighting fixtures, and andirons in rococo forms were used. Textile patterns were reduced in scale and consisted of scrolls, ribbons, flowers, and shells in a flowing or all-over pattern that would harmonize with the curved lines of the panels and furniture. Brocades, damasks, taffetas, satins, moirés, and other fine silk weaves were used for draperies and other decorative purposes. Printed cottons were introduced in the *toiles de Jouy* made by Oberkampf, who designed pictorial groups in large repeats in red, blue, green, and eggplant, and printed them on a white ground.* Window treatments were sumptuous, with full curtains and valances. Colors were light in value, and soft, neutral hues were used.

Floors were in rectangular parquet patterns or in elaborate marquetry arrangements made in contrasting woods. The public rooms had floors in marble squares. Floor coverings were made at the Aubusson and Savonnerie looms in rococo patterns and delicate colors.

The height of the rococo style was reached about 1760, and the use of the exuberant forms lessened thereafter, as the public tired of the artificiality and supersophistication of the period. The exquisite taste of Madame de Pompadour was a dominant influence in the movement toward greater restraint. At least fifteen years before the death of Louis XV, the character of the interiors as well as the detail of furniture and accessories began to assume the classical forms usually called "Louis XVI."

* See Chapter 17.

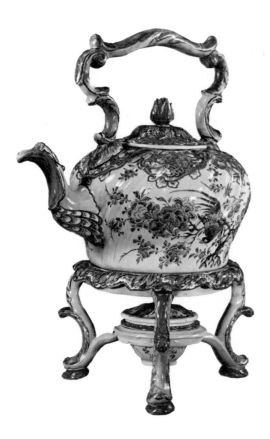

← Late 18th century Dutch Delft teapot and brazier with polychrome decoration. Tin-enameled earthenware.

Metropolitan Museum of Art

Chinese cloissoné vase. This → art was probably learned from Byzantine sources, though the pattern is decidedly oriental, in contrast to the more geometrical Byzantine type.

Pennsylvania Academy of Fine Arts

← Florentine sculpture from the workshop of Andrea della Robbia, XV century. Glazed terracotta bas-relief: Adoration.

Metropolitan Museum of Art

The color of this → Chinese lapis lazuli vase accents the delicate perfection of its carved decoration. Probably Era of Ch'ien Lung, A.D. 1736–96.

University of Pennsylvania Museum

The most important public room at the Palace of Versailles was the Galerie des Glaces or Hall of Mirrors, designed by Mansart and decorated by Lebrun. It was built in 1678 to replace a terrace on the garden side of the palace and was used as a hall linking the north and south apartments. Its walls are lined with Corinthian pilasters of green marble which alternately separate arched windows and arched mirrors. The ceiling is a semicircular plaster vaulted arch painted by Lebrun. The beautiful Versailles pattern of the parquet flooring is seen to advantage here. Originally the hall was furnished with a sumptuous silver set of orange-tree casings, tables and forty-one chandeliers and candelabra. The windows were hung with white damask curtains bearing the King's gold insignia and the floor was partly covered with two huge Savonnerie carpets matching the colors of the vault.

Musees Nationaux

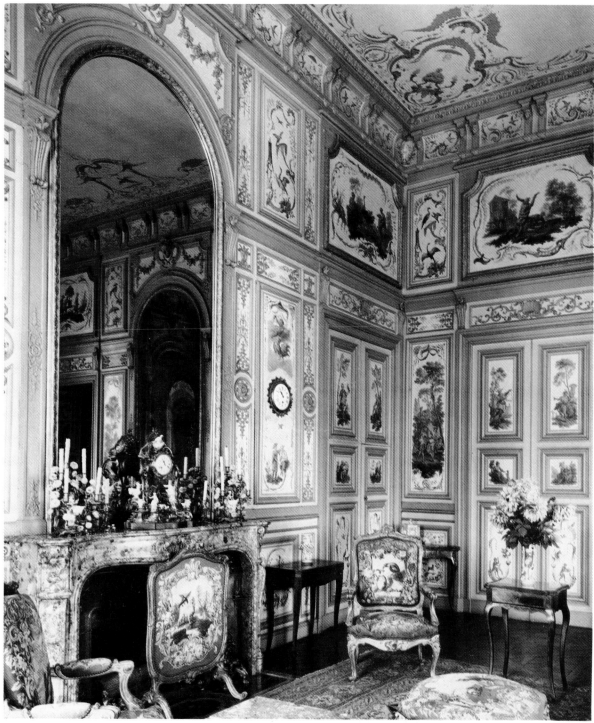

René Jacques

Louis XV room. The paneling is by Huet, a decorative painter at the court of Louis XV.

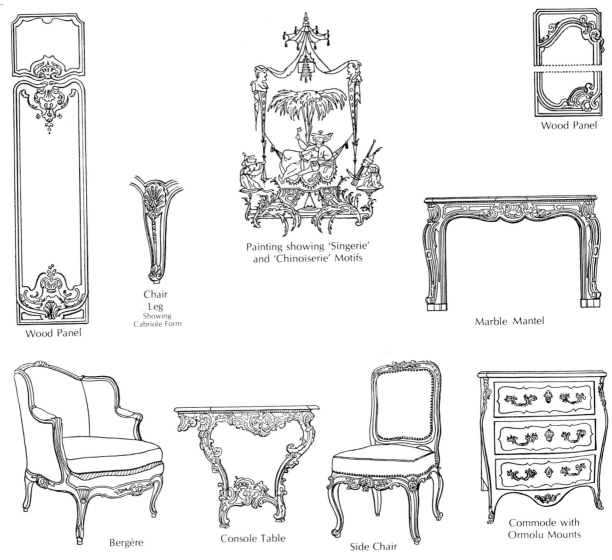

Wood Panel

Chair
Leg
Showing
Cabriole Form

Painting showing 'Singerie'
and 'Chinoiserie' Motifs

Wood Panel

Marble Mantel

Bergère

Console Table

Side Chair

Commode with
Ormolu Mounts

Wood Panel

Rococo furniture and details.

FURNITURE OF THE ROCOCO PERIOD. The cabinetmakers of the rococo or Louis XV period developed so many new types of furniture that they left few possibilities to their successors, and they reached the limits of perfection in technique and comfort. Rococo furniture was designed to fit human dimensions and not intended for pomp or pageantry. While some examples were of overpowering splendor, most of them were small and unpretentious. The infallible characteristic was the use of the curvilinear form at all times and particularly the cabriole leg with a scroll foot instead of the goat's hoof. The straight line was diligently avoided; the framework of the furniture was designed to eliminate the appearance of joints; legs appeared to flow into the upper framework in an unbroken line, and the principle of con-

tinuity was maintained wherever possible. The ornament was designed for a particular location and for its relationship to the whole design; it was never overwhelming and always served its purpose of enriching the structure without competing with it. Turned forms were never used except in country-made pieces. The furniture was always described as having "an agreeable contour," perhaps unconsciously following the lines of the feminine form. Much of the case furniture had bulging fronts known as *bombé* or *serpentine*. The cabinetmakers performed structural miracles in adapting wood, a straight-grained product of nature, to curved yet adequately strong assemblages. The cabriole support, when well designed, appeared to have all the muscular qualities of the leg of a vigorous animal. The enrichment consisted of carving, marquetry, paint and lacquer or *ormolu mounts*, or a combination of these. The woods that were used were infinite in variety and were drawn from both domestic and exotic sources. Walnut, oak, wild cherry, beech, and elm were the most common, but many pieces were made in whole or in part of the fruit woods, apricot, pear, and plum, or the imported almond, palm, mahogany, rosewood, olive, ebony, sandalwood, or satinwood. Marquetry designs were made in tulipwood, kingwood, violetwood, yew, amaranth, palisander, and lignum vitae. Black whalebone was used for narrow strips.

Although some painted furniture had been made in earlier periods, this finish became common toward the middle of the eighteenth century. The colors were always pale and neutral, and moldings frequently were accentuated by contrasting hues. Gilding was occasionally applied.

Chinese lacquer, which had been imitated in the seventeenth century, was introduced as a furniture finish by four brothers named Martin, who discovered its secret process and maintained it as a monopoly. They founded their Royal Manufactory in 1748. The early products of the Martins maintained the curvilinear forms which were lacquered with copies of Oriental patterns finished in black and gold. Later they introduced polychromed effects using Western motifs. Their lacquer was known as *Vernis-Martin*, which term was later used to designate their furniture. Their success was phenomenal, and the ownership of one of their productions was considered expressive of the height of refinement and luxury. The Martins applied their secret finish to every conceivable kind of object, such as snuffboxes, fans, *spinets*, *sedan chairs*, coaches, and every type of furniture. Many of their competitors, confronted with the vogue for the Oriental, sent panels, drawer fronts, and other parts of furniture to China to be lacquered. When these portions were returned to France, they were inserted in the locally made framework. The real Chinese lacquer was of better quality than that made by the Martins, and was often applied to *coromandel* wood.

Ormolu mounts continued as furniture enrichment, but the patterns changed to reflect the reduced scale of the furniture and to correspond to the subject matter and style of the period. Jean Jacques Caffieri and Gouthière were the great *ciseleurs*, and their metalwork for clocks, lighting fixtures, shelf ornaments, and furniture was equal to jewelry in chiseling and finish; edges were sharp, undercuts were deep, and modeling was of the highest quality.

Many pieces of furniture were enriched with marquetry, but the curved surfaces of the panels made this type of enrichment difficult to produce with the inferior adhesives then available. The marquetry patterns included squares, lozenge shapes, herringbone, and floral or figural representations.

Many tables and nearly all the consoles, commodes, and low case furniture had colored marble tops that harmonized with the room color. Library tables and desks usually had a Morocco leather or velvet top. The interior of

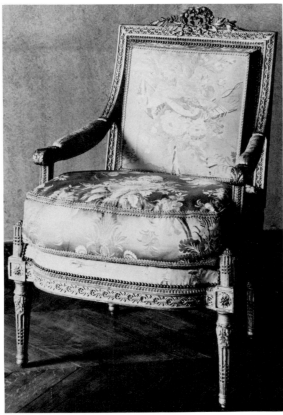

French Cultural Services

Armchair of the Jewel period of Louis XVI signed by Georges Jacob, circa 1775.

dresser drawers was often lined with a textile or wallpaper. Ordinary dining tables, which were usually round, were not decoratively designed, as they were entirely covered with linen when in use and with an ornamental cover between meals. Trestle tables on temporary supports were used for dining when numerous guests attended.

The leading cabinetmakers of the period were Jean François Oeben and Georges Jacob, whose principal customer was Pompadour. Among other *maître-ébénistes* were René Dubois, Michel Cresson, Jean Baptiste Boulard, Mathieu Criaerd, and Adrien Fleury.

The principal textiles used for upholstery were brocades, damasks, velours, lampas, Aubusson tapestry, needlepoint, colored leathers, and cotton and linen prints. The patterns definitely avoided straight lines. Stripes were in waves, and all-over patterns were used to harmonize with the curved forms of the furniture. *Toile-de-Jouy* prints made by Oberkampf were also extremely popular. Less costly chairs had seats in caning, rush, and straw.

At the end of this chapter is a list of the types of furniture which were produced during the rococo period. As there is no exact equivalent in English for many pieces, the French name is given with a description of the piece or its nearest name in English. In a few cases names of pieces that were made in other than the rococo period have been included. These have been noted.

INTERIORS OF THE NEOCLASSIC PERIOD. When Louis XVI came to the throne, the nobility were exhausted financially and fatigued by a half-century of superficial pleasures. The protests of the mobs had already begun to rumble and to demand vehemently a cessation of the public policies. Both prudence and boredom with their life called for a change in the outward living conditions of the aristocrats, and a definite trend toward simplicity was the art reaction of this movement. For several years the designers of Paris had been divided by insoluble problems of aesthetic legalities concerning the use of the straight and curved line. One group supported their stand on the claim that the straight line does not exist in nature—even the ocean's horizon being a curve—while the other group argued that excessively curved forms violate every sound structural principle. The actual root of the argument was the natural desire for variety and change. The curved forms had been universally used for upwards of sixty years, and changes in fashion are irrepressible.

The neoclassic interiors retained all the charm and intimacy of the previous period, while discarding the rococo curves. Changes

were in the forms and details. Architectural orders were revived; the free curve gave way to the semicircle, segment, and ellipse; and all panels were rectangular. Carving and ornament, delicate in scale, were used less profusely, and the motifs were borrowed either from natural flowers, sentimental allegories, or classical leaf and scroll patterns that were inspired by the Pompeian discoveries of 1755. Piranesi, the Italian painter and engraver, had flooded Paris with his drawings of Roman monuments, vases, candelabra, and bas-reliefs, and this contributed greatly to the popular revival of interest in antiquity.

The majority of the rooms in châteaux were treated with wood paneling, and there was usually an attempt to design each as a symmetrical composition. This was often accomplished by placing a large panel as a central feature with subordinate flanking panels, or a false door was introduced to balance a real door, or, if an opening was located inconveniently in the composition, a secret door to cover it was placed in the paneling. Opposite walls were similarly treated and architecturally balanced if possible. Real bookcases were often imitated by book-backs placed on false shelves, and overmantel mirrors were balanced with mirrors placed over a console table on the opposite wall.

The walls usually had low dadoes. In high rooms the paneling was crowned with a complete entablature, while low rooms had merely a cornice or a small cove at the top. The orders were smaller than those used in the Louis XIV period. Panel moldings were sometimes painted a color contrasting with the field, or a narrow paint stripe would be added near the edge of the panel to accentuate the frame. Panel centers were often left undecorated, but in the more elaborate rooms they were painted or enriched by stucco relief patterns showing arabesques combined with classical figures and naturalistic flowers, arranged in garlands and drop ornaments. In Marie Antoinette's bedroom in Fon-

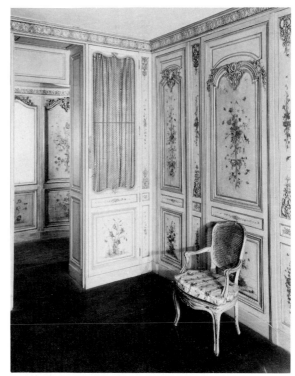

Museum of Fine Arts, Boston

Painted room showing transition between rococo and neoclassic styles about 1760. The fine scale of detail and low ceiling are typical.

tainebleau, the background treatment of the wood panels is silver leaf rubbed with dull gold, and on this sparkling surface are painted classical arabesques. Classical and Sèvres vase forms holding bouquets of garden flowers often formed a part of the painted decoration. Colors tended toward pale tints. The French were extremely adept at combining conventional and realistic motifs.

The tendency toward economy in the smaller houses was evidenced in the use of stretched textiles and wallpaper for panel centers. There were also many rooms in which wood paneling was omitted; the walls of these were merely painted or covered with wallpaper or textiles. Réveillon, the paper manufacturer, combined with Oberkampf to produce similar

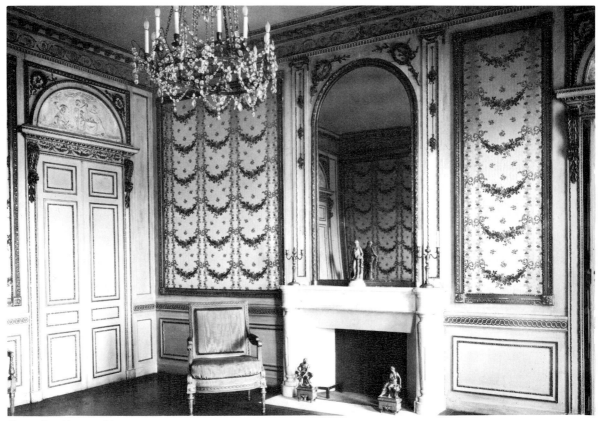

Unusual example of a provincial neoclassic room from Dijon, France. Characterized by fine-scale classical architectural detail, with rectangular panels and semicircular curves. The panel fields are hung with brocade. The overdoor is a plaster cast showing an allegorical grouping of amorini.

designs in wallpaper and printed cotton. Scenic papers also began to be made for formal rooms. Overmantel and overdoor decorations often consisted of grisaille paintings. These were highly realistic monochromes imitating bas-relief sculptured panels, in which the painter considered the actual direction of the light that entered the room in planning highlights and shadows. The subject matter was usually cupids or classical figures. In entrance halls plaster walls were often painted to imitate marble paneling.

Mantels were comparatively low and almost invariably made in marble. The designs were simple with classical moldings and detail. The fireplace openings were rectangular, and the mantelshelf was straight. The overmantel usually consisted of a trumeau composed of a framed mirror combined with a superimposed painting or some other decoration. Doors and windows had elaborate trims; in salons and in the public rooms of the house they were treated with a complete entablature and an overdoor decoration. Ceilings were usually left plain, but sometimes they were painted in sky and cloud effects. Floors were usually in oak parquet patterns and were covered with Aubusson, Savonnerie, or Oriental rugs.

The ornamental forms and motifs used in

all branches of the decorative arts during the neoclassic period consisted of garlands, festoons, swags, and wreaths composed of natural roses, daisies, and chrysanthemums, commonly tied by a ribbon bowknot with floating ends; Pompeian arabesques and rinceaux; Greek ornaments such as the honeysuckle, fret, and guilloche; sentimental objects such as cherubs and cupid's bow and darts; scenes from La Fontaine's fables; and pastoral motifs such as shepherd figures, farm tools, wheat sheaves, and beribboned hats. Pillement continued to produce his delightful chinoiseries, and the classical influence was seen in the use of both nude and draped mythological figures, sphinxes, vases, and masks. Drop ornaments composed of musical instruments, hunting paraphernalia, and other objects of symbolism were often used. Montgolfier had invented the first successful balloon in 1783, and it made such an impression upon the French people that pictures, textiles, and wallpapers showing patterns related to this subject became extremely popular for decorative use.

The outstanding decorative artists of the period were Houdon, the realistic sculptor, who made portrait busts of the aristocracy, artists, and philosophers, and who later came to America and modeled the early Federal statesmen; Clodion, famous for his decorative terra-cotta nymphs and satyrs; Saint Memin, known for his crayon portraits; and Hubert Robert, noted for his paintings and panel decorations of imaginary Roman ruins and landscapes. Fragonard lived until the turn of the century, and the influence of Boucher continued in the work of his pupils.

THE PETIT TRIANON. The most important and interesting structure that characterized the neoclassic style is the small château or garden pavilion designed by Gabriel for the park at Versailles. This building was commenced in 1762 at the suggestion of Pompadour. As her death occurred in 1764, it was occupied upon its completion in 1768 by the Countess du Barry.

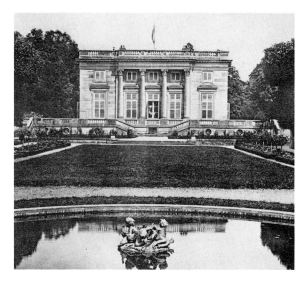

View of Petit Trianon, Versailles, designed by Gabriel. Built 1762–1768.

History, however, has associated the building with the activities of Marie Antoinette. The Trianon at the time it was built represented a complete novelty and a reaction from the rococo forms that preceded it. Its design was perhaps inspired by similar residences erected by the architects Adam and Chambers in England. Both without and within it is almost wholly of classical inspiration. In only one or two places does the interior paneling indicate a form reminiscent of the rococo, and the ornamental details are the classical acanthus, rosette, guilloche, garland, and wreath. All the rooms are rectangular; there are no rounded corners; the ceilings are flat; complete entablatures are generally used with the customary classical molding ornaments; panels are rectangular; and compass curves are used. Gilding and lacquering of surfaces are avoided and most of the rooms are painted an off-white.

Near the Trianon was built the picturesque "hamlet" for Marie Antoinette, a group of Normandy half-timber thatched cottages located on the bank of an artificial lake. These consisted of a small manor house, mill, dairy, keeper's house,

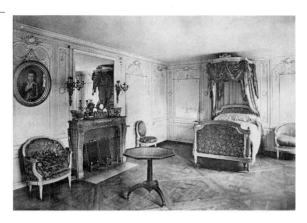

Marie Antoinette's bedroom in the Petit Trianon at Versailles. Contrasts are subdued, scale is small, and comparative simplicity of effect is developed.

and farmhouse, all of which were furnished in a provincial manner. These buildings, which are still in existence, were planned by Hubert Robert in 1782 to permit the queen and her ladies to indulge in an idyllic life, a desire that had developed after reading Rousseau's *Le Devin du Village.*

FURNITURE OF THE NEOCLASSIC PERIOD. This period, short as it was, saw a reaction in furniture design. The same pieces of furniture that had been developed in the preceding period continued to be made; proportions remained light and delicate; but the free curve gave way to the mechanical curve; the dominant line of design was straight; and the silhouette became rectangular. A short transitional period occurred during which elements of both styles were seen in the same piece.

The furniture supports are the distinguishing feature of the style. During the transitional period, the cabriole leg began to straighten out with less curvature between the knee and the ankle. The scroll foot disappeared. By 1770 the legs of all pieces of furniture were straight and tapered, either round or square in section, and the surface was usually enriched with vertical or spiral flutings. The leg was almost invariably

crowned at the top by a square block, on which was carved a rosette set in a small sinkage. Cabinet pieces and case furniture were rectangular from both front and side views, and were enriched with either wood or metal moldings forming rectangular panels that sometimes had their corners broken around a rosette. Tables of all kinds had straight-edged tops. Chair seat frames had sides that were either straight or elliptical, and chair backs were usually rectangular or oval. Some beds were made with headboards of equal height. The four-poster returned to popularity, and the canopied and alcoved beds of the previous period continued to be used. Many small tables and much of the case furniture were topped with colored marble. Writing tables and desks usually had tooled leather covers.

The woods for both construction and veneer were the same as in the previous period. Mahogany was used more extensively as greater appreciation developed for grained effects, and ebony again became popular. Painted furniture also became more common, but Oriental lacquer lessened in use. Furniture ornamentation consisted of simple carving, marquetry, ormolu mounts, and painted decoration. The ornamental motifs were naturalistic roses, garlands, festoons, ribbon bowknots with flying ends, bouquets, Cupid's bows and darts, lyre forms, acanthus leaves, rinceaux, and arabesques. Architectural details such as colonnettes and miniature pilasters were frequently employed for both structure and decoration, but the Louis XVI style borrowed from the antique only what was compatible with comfort. Sèvres porcelain and English Wedgwood plaques showing classical figures and urns were often applied to furniture in small cameolike decoration.

About 1780 many books were issued on Greek, Etruscan, and Egyptian art and architecture, with a result that artists in all mediums began to use motifs drawn from these sources. Sphinxes, winged vultures, sarcophagi, hawks,

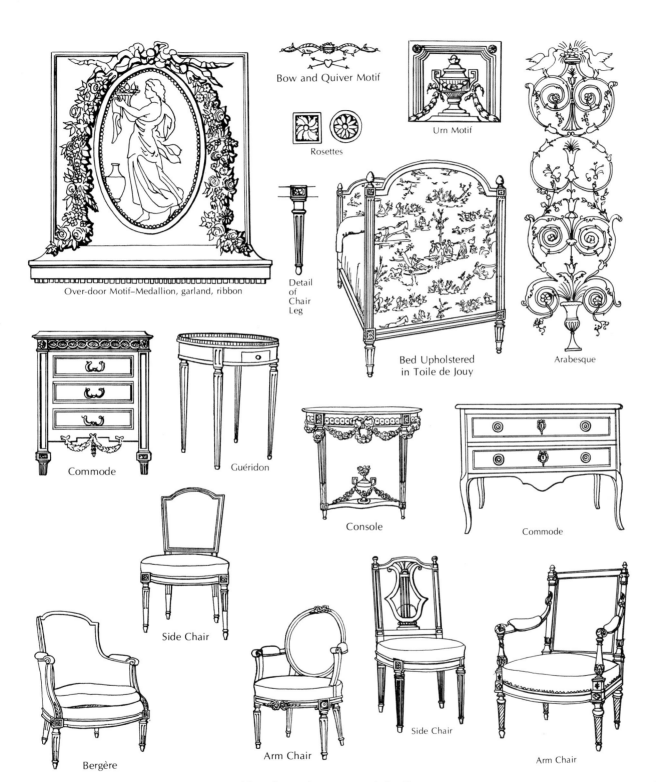

Bow and Quiver Motif

Rosettes

Urn Motif

Over-door Motif—Medallion, garland, ribbon

Detail of Chair Leg

Bed Upholstered in Toile de Jouy

Arabesque

Commode

Guéridon

Console

Commode

Side Chair

Bergère

Arm Chair

Side Chair

Arm Chair

Neo-classic furniture and details.

Agence Top

A transitional chair between Louis XVI and Empire.

jackals, palm, lotus, fret, guilloche, and *acroteria* began to appear. The contemporary critics complained that everything from snuffboxes and costumes to furniture and architecture was *à la grecque*. The leading *ébénistes* of the period were Riesener, who had been Oeben's pupil; Carlin, who was the earliest proponent of the classical revival; Beneman; Jacob; and Weisweiler.

Upholstery materials were Aubusson tapestries, needlepoint, tooled leather, plain striped and moiré silks, brocades, damasks, taffetas, and printed cottons. All colors were in light tones. Caning and rush were also used for the seats and backs of chairs and sofas.

ACCESSORIES IN EIGHTEENTH-CENTURY ROOMS. The accessories used in French rooms during the eighteenth century were numerous, always of the highest quality, and extremely important in their contribution to the character of the decoration. Mantelshelves usually had an ormolu clock or a terra-cotta or marble bust in the center, with vases, perfume burners, or porcelain figurine groups at each side. Sometimes crystal *lustres* or brass candlesticks formed part of the shelf composition. Brass fireplace accessories stood on the floor at the side of the hearth. High rooms were lighted by hanging Bohemian crystal chandeliers; sconces or *appliques* and table lamps also frequently added to the illumination. Wall accessories consisted of ormolu hanging clocks, decorative wooden barometers and thermometers, and small rectangular or oval framed mirrors. Many pictures were used; these included period oil paintings, watercolors, pastels, engravings, and ink and *sanguine drawings*. French and Oriental glass paintings and small hand-painted wallpaper panels were also frequently seen. Other accessories were Roman and Pompeian bronze statues and small objects of Chinese, Japanese, and East Indian origin. There were also no end of examples of St. Cloud, Sèvres, and Dresden ceramics. Leather, enamel, porcelain, silver, and gold cases were studded with precious jewels. Books with tooled leather bindings were placed on shelves and tables, and vases were filled with flowers that harmonized in color with the hues of the room.

POPULARIZATION OF THE DECORATIVE ARTS. During, and following, the last quarter of the eighteenth century, interest in the subject of home decoration spread much more generally to the middle classes, whereas it had previously been limited to the aristocracy. This was in part due to the cheapening of production by mechanical methods and the introduction of many products that could be used as substitutes for

costly ones. Typical of these were wallpapers used to replace the hand-painted panel and hand-blocked linens and cottons introduced as substitutes for silk damasks and brocades. The French people had always been instinctively conscious of art and beauty in all of their manifestations, and the royal promotion and support of the art industries was observed by the bourgeois society. The simplification of living and the reaction from the extravagances of the past tended toward the production of rooms whose costs were within the economic limits of a greater proportion of the population. The beauty and originality of the styles that were produced at that time have persistently permeated the cultures of other countries to the present day.

The Revolution and the Directoire periods (1789–1804). The years of the Revolution were destructive rather than constructive so far as the decorative arts were concerned. During the Directoire period were produced the transitional forms of art that filled the gap between the periods of Louis XVI and Napoleon. Elements of both styles were seen, although the short political duration of the "Directorate" did not permit the construction of many examples of either architecture or decoration.

During the Reign of Terror and the events that followed, many of the craftsmen were ill supported; lacking clients, they entered other fields, and with the disorganization of the apprentice system, much of the exquisite tradition of French art of the eighteenth century was lost. Craftsmen who were able to continue work endeavored to maintain their sense of tradition and good proportion and searched for art forms and details of ornament that were not associated with the old aristocracy. During the Directoire period, in what little that was produced, the delicacy of the forms and some of the refinement of detail of the Louis XVI period were continued, but new ornamental motifs were introduced. Both woodcarvers and painters inspired themselves from military objects such as spears, drums, trumpets, stars, and the Phrygian or Liberty cap of the revolutionary armies. Since Pompeii and Egypt had nothing to do with the French kings, the use of architectural forms and ornament drawn from these sources continued. Motifs were also introduced to reflect the growing power of the agricultural classes, such as the plough, flail, scythe, and sheaves of wheat.

Paneled rooms continued to be produced, but the details were much simplified. Very little carving was used, and painted decoration continued to be influenced by classical forms, although rustic scenes and figures sometimes formed the subject matter. The plain painted wall and striped wallpaper became popular. Walls were also decorated with draped and plaited textiles hung from below a draped wall valance that extended around the room. Printed cottons showing revolutionary subject matter continued to be used for draperies and upholstery.

The furniture of the Directoire began to show structural forms that were borrowed from ancient Greece. These included the use of Greek curves wherever possible, such as the slight backward roll at the top of a chair back, the klismos chair back, and the outward curve given sofa arms. On many chairs the front legs curved forward and the rear legs backward, while on case furniture a slight outward flair occurred in the short supports. Straight turned legs that had previously been seen only in provincial furniture began to be used by the Parisian cabinetmakers. Another structural and ornamental form of support was the Egyptian or Grecian head used at the top of a square leg that was tapered and slightly reduced in section at the bottom and ended with two human feet. Headboards of beds and tops of cabinets often were crested with a low-pitched pedimented form, or the uprights of headboards were given a slight curve outward at the top. Bent wrought iron and bronze furniture, with tripod supports designed in the Greek manner, became popular.

Roger Viollet

A salon from the Empire period.

Color schemes showed a tendency to use stronger hues and tonal contrasts than in the earlier styles, and one of the most popular was based on the colors of the new Republican flag —large white areas accented with small areas or lines of scarlet and bright blue for trimmings, edgings, and small moldings.

THE EMPIRE STYLE. The Empire style was so designated because of its association with Napoleon, who was proclaimed emperor of the French in 1804. The importance of this style is due to the immense political, economic, and social changes that occurred as a result of Napoleon's victories. Every European artist and craftsman during the first quarter of the nineteenth century came under the hypnotic spell of the movement, and the results were diffused over the whole of Europe and the Americas. The promotion and growth of the style were sudden and arbitrary and were completely out of proportion to the short career of Napoleon himself. The Empire period was the first in art history in which an attempt was made to impose a decorative style upon a people by artificial methods rather than to permit it to develop by natural evolution. The movement was contemporary with the beginnings of factory and mass production and with the growing importance and self-consciousness of labor. The style commenced when there was still vitality in French art tradition and the hand-craftsman maintained pride in his product; it ended when steam power could manufacture an inferior object at one-tenth the cost of the hand product—resulting in an economic appeal that was more potent than the artistic.* The Empire was the last of the French styles to produce what is today known as the real "antique."

Napoleon's coronation was the first act, after the storming of the Bastille, in the return of the French people to a monarchical form of government and social organization. A new aristocracy, the *nouveaux riches*, trained in military tactics and get-rich-quick abilities rather than social amenities, had had little opportunity to develop a true connoisseurship of the arts. The emperor, however, with history in mind, recognized the value of promoting a public appreciation of the arts, and the satisfaction of his ego required visual evidence of his imperial glory. He was determined to invest his court with every form of external expression that would reflect and magnify his grandeur and power.

Jacques Louis David, who had been one of the signers of the death warrant of Louis XVI, was appointed court painter and art director of France and strove to emulate his famous predecessor Lebrun. Although handicapped by the self-conceits of Napoleon, David became the man of the hour in art, politics, and society. He had founded the classical school of painting during the Revolution and had received widespread acclaim. David was acquainted with the *Classical Antiquities of Athens*, written by the Eng-

* This predicament was even more true of England, where industrialization had progressed further than in France, a predominantly agricultural country.

lishmen Stuart and Revett and published in 1762, a book which enabled the world for the first time to see depicted the glories of Athenian architecture. His first great picture was *Blind Belisarius Asking Alms*, and was followed by *The Oath of the Horatii, Brutus, The Coronation of Napoleon in Notre Dame, The Rape of the Sabines, Madame Recamier* and *Death of Socrates*, the last in the Metropolitan Museum of Art, New York City. His influence upon the intellectual life of the period was enormous. Proud, cold, austere, he was at first a believer in Spartan simplicity, but with the rise in power of Bonaparte he first turned to the splendors of Greece and then to Rome for inspiration consistent with the emperor's desire for majestic grandeur.

The new society despised the immediate past and desired an art expression that represented it alone. What could be more appropriate for an emperor who had conquered nearly the whole of Europe than a revival of the paraphernalia and pomp of Alexander and Caesar? Alexander had conquered Egypt; Caesar had crossed the Rubicon, but not the Rhine or the Danube; the Little Corporal had crossed all three and had conducted a spectacular campaign in Egypt when he was only twenty-nine years of age. The artists and designers, in an urge to cooperate with David's plans, and having convinced themselves that antiquity had reached the pinnacle of perfection in art, informed the public that every creative idea from the time of Pericles and Rameses to Constantine was logical and perfect. Thus was the style conceived!

The style reached its height about the time that Bonaparte returned from Elba. Waterloo in 1815 did not entirely crush the movement, which continued with diminishing vitality until about 1830. Its demise was due as much to the changed economic conditions, which resulted from the growth of the industrial revolution and machine production, as it was to the elimi-

French Cultural Services

Gilded wood armchair of the Empire period signed by Georges Jacob.

nation of Napoleon's influence. An effort was made to revive its external forms during the reign of Louis Napoleon and Eugenie from 1852 to 1870.

The Empire style spread to Austria as a result of Napoleon's marriage to Princess Marie Louise, and it later was popularized in both Germany and Austria as the Biedermeier style. The Bernadottes introduced it into Sweden; Pauline Borghese, Napoleon's sister, brought it to Italy; Joseph Bonaparte promoted the style in Spain; its influence was strongly felt in England during the regency period; and its earmarks were plainly visible in the homes of North America, South America, and Central America.

Courtesy Carlhian, Paris

Room in house in Paris using authentic Empire furniture and grisaille scenic wallpaper.

INTERIORS OF THE EMPIRE PERIOD. Napoleon upon his accession appointed Percier and Fontaine as government architects. These two men, who made many studies of classical ruins, became official interpreters and leaders of the new style in architecture and decoration. They designed every detail of the interiors of their buildings including furniture, textiles, hardware, ornament, wallpaper, and utilitarian objects. The spirit behind their designs was to maintain dignity and masculinity and to avoid the slightest effect of frivolity or gaiety. Rooms were often square in plan, though many of them had semicircular or segmental ends imitating those in ancient Roman palaces. The partners redecorated rooms in the Louvre, Versailles, Com-

piegne, Fontainebleau, and other châteaux; one of their best-known works was Malmaison near Paris, the residence of Josephine, the first wife of Napoleon, who occupied it during Napoleon's campaigns and after her divorce.

Nearly all Empire rooms had architectural features of Pompeian inspiration. These consisted of columns or pilasters spaced at intervals around the room, or forming part of door and window treatments, or arranged with an arched form to constitute an overmantel decoration. Door and window arches were either semicircular or segmental. The majority of rooms had cornices, and many were crowned with a complete entablature. There was often an oversize painted frieze that contrasted with the color of

the wall and was enriched with spaced vases, medallions, or classical figures that were connected by rinceaux, or garlands made of husks or of laurel leaves. Occasionally delicate Pompeian arabesques were introduced to enrich vertical panels. Doors had either square panels with center rosettes or rectangular panels that contained a diamond-shaped interior panel. Windows were hung with two or three sets of complicated draperies with elaborate valances, fringes, tassels, jabots, and swags. The textiles were silk, wool, and cotton, and all three fibers were frequently combined in the same set of draperies.

The walls of Empire rooms were often in plain painted plaster, decorated with painted classical motifs and finished in a semigloss polish. Marbleized effects were also common. Wood paneling and wallpapers were also used, but the most novel wall treatments were those hung with stretched, shirred, or loosely draped textiles; these occupied the whole area from the underside of the cornice to the top of the dado or baseboard. When the textiles were draped, they were caught up at intervals and held with tassels and gold-headed nails. Josephine's bedroom at Malmaison was circular and represented the interior of a Roman emperor's military tent; its walls were draped in red silk that appeared to be supported at intervals by tent posts; the ceiling was also in draped cloth that was partly enriched with gold appliqué ornaments.

Marble mantels were severely classical in detail, with plain straight shelves. In palace rooms, they were often richly carved under the shelf and were supported at the sides by caryatids or dwarf columns. In the small houses, the carving was often omitted; the side supports were simple pilasters; and interest was maintained by the color and graining of the marble. In the latter type, moldings were reduced to a minimum. The mantelshelf was usually furnished with an ormolu clock, designed with Grecian standing figures and covered with a

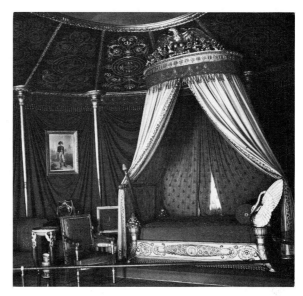

Military tent bedroom built by Percier and Fontaine for Empress Josephine's use in Malmaison. The panels are draped in red silk. The bed drapery is lined with ermine.

glass dome. The side shelf ornaments varied from Grecian or Egyptian caryatids holding multibranched candelabra to reproductions of classical vases filled with artificial flowers.

Floors were often left bare and were built with black and white marble squares or wooden parquet patterns; when covered, both Aubusson and Oriental rugs were used.

Accessories were nearly always classical or Egyptian in character, or represented adjuncts of the Napoleonic regime. Many framed engravings and relief silhouettes of Napoleon's family and officers were used as indications of loyalty. These were combined with busts and statues, Greek vases, sphinxes, Pompeian bronze table lamps, and other objects. Wall sconces, torches, and hanging chandeliers were usually of bronze in designs adapted from Roman prototypes.

FURNITURE OF THE EMPIRE PERIOD. Under the Directorate, cabinetmakers eagerly endeavored to prove their loyalty to the republic and attempted to eliminate patterns and designs that recalled the old regime. They found difficulty,

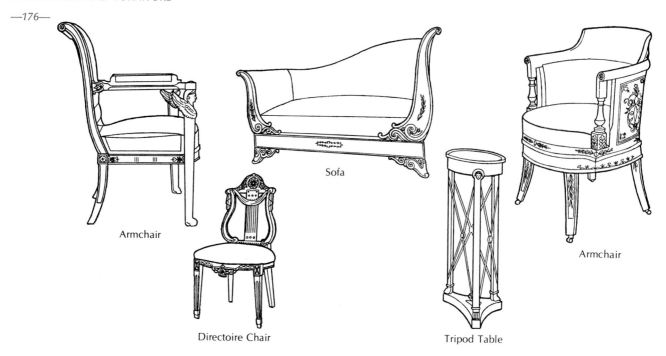

Armchair

Sofa

Directoire Chair

Tripod Table

Armchair

Empire furniture and details.

however, in creating an artistic revolution that was as sudden and complete as were the cataclysmic changes in politics, philosophy, and social life. Furniture design retained the delightful lines and proportions of the monarchy, but economic conditions forced a cheapening of construction, a lowering of quality in materials, and the using of less carved ornament.

The Directoire ornamental forms merged into those of the Empire, but a change occurred in the structural proportions of furniture. The leading cabinetmakers, Jacob, Jacob-Desmalter, Lignereux, Rascalon, and Burette, were imbued with the cult of antiquity, but they were confronted with the necessity of producing types of furniture that did not exist in the ancient periods. It was necessary to invent nearly everything and to maintain the spirit of the antique by applying its ornamental detail rather than to make exact copies. Percier and Fontaine were in sympathy with the compromise, but they in-

sisted that furniture at least should look as though it had been made for Caesar. The designers therefore turned their backs on all the intimacy and gracefulness of the eighteenth century and began to work on a grand, severe, and masculine scale, whether or not it was comfortable and convenient. The basic forms of the furniture were simple, with definite and severe outlines; rather heavy in proportion, with sharp corners; and often were monolithic in appearance. Moldings and panels practically disappeared, and the doors, sides, and lids of case furniture were one solid piece of veneer in which the graining and polish were the sole element of beauty. The heavy Tuscan and Doric orders were used in a simplified form for both structural and ornamental detail. The capitals and bases were in metal, and the shafts usually stood on a heavy block. Both square-sectioned and straight turned legs were used. The baluster form was never seen. Rigid symmetry was al-

ways attempted in the general composition. Carving was largely eliminated, and ormolu mounts in classical detail were used promiscuously for hardware and ornament. While such ciseleurs as Odiot, Ravrio, and Thomire maintained the traditions of Gouthière, much of the metalwork was cheaply cast, untouched by the chisel, unsuitably designed, inaccurate in scale, and poorly distributed. The furniture was often smothered with metal ornament which tended to hide the graining of the veneers.

Few new types of furniture were introduced. Nearly all tables were round or octagonal with marble tops, and many were supported by a central pedestal leg, which rested on a triangular block. Tripod tables with metal and wooden supports were made in imitation of those found in Pompeii. Empire beds were usually designed to be placed sideways against the wall, and were called boat-beds; the rear posts were higher than the front ones and were crowned with a vase form; the board connecting the head and foot piece was sometimes shaped in a segmental curve. Klismos, round-about, rolled, and Greek curve chair backs and sofa arms were common. The front legs of chairs were usually straight, the rear legs slightly curved. In some cases both front and rear legs were curved forward or backward respectively. Spring seats were used for upholstery. There was an infinite variety of chair designs. Consoles were made with either rectangular or halfmoon tops, and the lower portion was often backed by a mirror. The standing floor mirror or *pier glass* that pivoted horizontally, known as a *psyche*, was often seen in Empire rooms. The piano superseded the harpsichord about 1800.

The most popular wood for furniture was mahogany, but elm, yew, maple, and lemon were also used. Woods for veneers were imported from Africa, the West Indies, and the East Indies, such as thuya, amboyna, amaranth, palisander, and rosewood. Marquetry and flut-

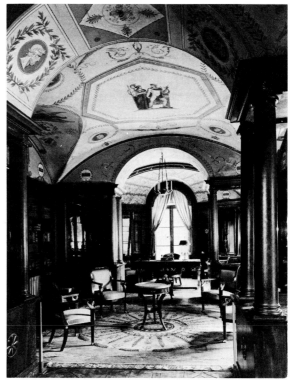

French Cultural Service

Library from Malmaison showing typical Empire furniture and motifs. Designed by Percier and Fontaine.

ing were completely avoided, but ebony, silver, and other metals were sometimes used for inlay. Gilding was often applied. Much of the furniture was made with inferior materials.

EMPIRE ORNAMENT. Ornamental forms were almost entirely drawn from antique or military sources, and the same ones were used in every medium of design—stone, wood, metal, plaster, textiles, and wallpaper. The sphinx with upraised wings, winged lions and disks, vultures, cobras, obelisks, and hieroglyphics were taken from Egypt. Some of the more common classical motifs that were revived were the fret, rinceau, arabesque, guilloche, and honeysuckle; anthemion, antefix, amphora, and krater vase forms; Roman lamps and torches; Winged Vic-

tories; caryatids; dancing girls; sacrificial scenes; heads of Bacchus, Hermes, and Apollo; rams' and horses' heads; and masks of wild beasts. The griffin and chimera were used for both ornaments and structural supports of tables and consoles, as well as for arms of chairs. Swans were seen in astonishing quantities. Cornucopias, laurel wreaths, fasces, Neptune's trident, casques, cuirasses, swords, lances, and military musical instruments were some of the motifs of symbolical origin.

EMPIRE TEXTILES AND WALLPAPERS. The invention by Jacquard in 1801 of the first mechanical loom to weave multicolored patterns eliminated the more costly hand-woven textiles of the royal periods. The weaves that were mainly produced were lampas, damask, and velvet. The patterns were usually of the spot variety formed by victory wreaths, rosettes, palm branches, laurel sprigs, torches, fasces, the initial "N," and the bee, the last selected by Napoleon as an emblem because of its traditional symbolism. The rose and the swan were symbols of Josephine, and Empire patterns frequently show the rose surrounded by bees sipping its honey. Textile colors were of the darker tones but chromatically more brilliant than those used in the preceding periods. Patterns contrasted strongly with backgrounds. Deep browns, violets, olive and emerald greens, and clarets were the most popular colors. Gold thread was often used in the weaving. The toiles de Jouy continued to be made by Oberkampf, the patterns being changed to please the new regime.

During the Empire period, wallpaper greatly increased in use; the greatly lowered costs had been due to the invention of the cylinder printing process. The all-over patterns were similar to those used in textiles, and flock papers imitating velvets and damasks were much in vogue. Patterns were also made to give the effect of plaited and draped textiles. Some designs showed repetitions of vignetted groups of Empire costumed figures in garden settings. Stripes and marbleized papers were also used. Panels reproducing the bas-relief sculpture of the Parthenon frieze were made for overdoor and overwindow enrichment. Narrow border strips with the wave, guilloche, egg and dart, and waterleaf were also used at the tops of walls, above the dado cap, and around door and window trim. Some of the greatest of the scenic papers were made during this period by Dufour, Jacquemart, and others. These usually represented classical groups of figures, scenes that glorified Napoleonic events, or other contemporary subject matter.*

THE FRENCH PROVINCIAL STYLES. In studying the interior decoration in the provinces of France it is often difficult to draw a line between the provincial and peasant types. Whereas the term *provincial* usually refers to rooms that were more or less designed according to the styles of Paris, there were many peasant rooms the decorations of which were more naïve in their appearance, but were still taken from the same source. Expert craftsmanship is possible only when groups of connoisseurs and amateurs exist who will appreciate and pay for this grade of workmanship. For centuries throughout France there has been a liberal patronage of the arts in all classes. It is a common sight today to see two laborers in one of the regional museums discussing the relative merits of a painting. Arts and artists have a broader public appreciation and recognition in France than in any other country. This is exemplified by the fact that many streets of Paris have been named after

*It is generally acknowledged that the finest scenic paper ever made was the set issued in 1816 by Dufour known as "Cupid and Psyche." Other equally famous sets printed before 1815 were "Bonaparte Crowned," "The Battle of Austerlitz," "The King of Rome in the Gardens at Malmaison," and "The Monuments of Paris."

France's greatest men of art,* as well as statesmen, military heroes, and others.

From the Louis XV period onward, many farmers' and fishermen's homes contained furniture that was beautifully designed, expertly made, and enriched with carved ornament. In addition to these there are the distinct peasant types, unrelated to the Parisian styles, most of which are in the eastern and southern parts of the country. The provincial styles near the borders were partly influenced by adjoining countries. Thus the styles near the Pyrenees were influenced by Spain; in the Northeast, by Flanders and Germany; and in Provence,† by Italy. Normandy and Brittany on the west coast were more sensitive to the changes in royal fashions and aped the Parisians.

SEVENTEENTH-CENTURY PROVINCIAL STYLES. The provinces were slow in outgrowing the Gothic style. The Renaissance forms that had been introduced between Francis I and Louis XIV were largely limited to the royal châteaux. In the latter years of the seventeenth century, the lesser nobility and well-to-do merchants of the provincial districts were still living in rooms having walls hung with imported textiles, leather, or tapestries, or with oak wainscots designed in small Gothic paneling. The ceiling beams were exposed, and the floors were in tile

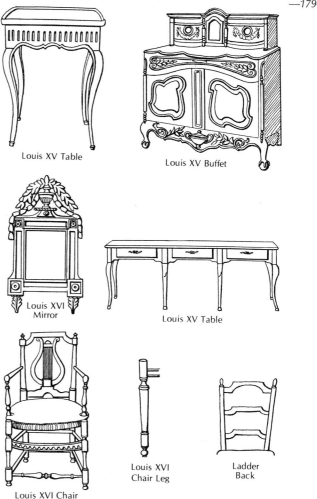

Louis XV Table

Louis XV Buffet

Louis XVI Mirror

Louis XV Table

Louis XVI Chair Leg

Ladder Back

Louis XVI Chair

French provincial furniture.

* Among those who have been so honored are Fragonard, Boucher, Pigalle, Garnier, Toulouse-Lautrec, Gustave Doré, Lebrun, Mansart, Boulle, Houdon, Champollion, Oberkampf, Rabelais, Massenet, Ingres, Gounod, and many others, to say nothing of such foreigners as Rembrandt, Rubens, Raphael, Ibsen, Goethe, Cervantes, Velasquez, and Michelangelo.

† The Provençal style should not be confused with the term *provincial*. Provence, one of the old county subdivisions of southern France, was settled and named by the Romans. It adjoins Italy; many of its inhabitants are of Italian blood; and it has a culture, language, and literature that differ considerably from those in other parts of France.

or wide oak planks. The mantels had projecting hoods and were detailed in mixed Gothic and Renaissance detail. The furniture was based upon Italian forms.

EIGHTEENTH-CENTURY PROVINCIAL STYLES. The Louis XIV style was little imitated beyond the royal palaces, due to its costliness and the lack of competent craftsmen to produce it, but it served as an agent of propaganda in engaging the attention of the public in matters of home furnishings. By the middle of the eighteenth

century the interest in the new styles of decoration and furniture was widespread, and the demand for stylized furnishings in turn caused an increase in the number of provincial designers and craftsmen of all degrees of competency. By 1750 the rococo style was adopted wholeheartedly by the provinces. Its comfort, scale, warmth, gaiety, and novelty had a universal appeal, and its popularity continued well into the nineteenth century. With few exceptions, the inhabitants of the provinces were more conservative and slower of thought than those of Paris; they remained truer to the royal regime during the Revolution and persisted in the use of the decorative style popularized by the Bourbons. The provincial style of France is dominantly that of Louis XV. As a result it is difficult to judge the age of this type of furniture by its design. The Louis XVI and Empire forms were never manufactured to the same extent.

In general all provincial work was simplified and less costly to produce than the Parisian models. Economy was ever the watchword. Rooms were often completely lined with wood paneling, but frequently only one wall was so treated, the other walls being either painted or covered with textile or wallpaper, or stenciled to imitate a wallpaper pattern. The panel moldings were simple, and the curved forms at the tops and bottoms of the frame varied between having graceful and vigorous lines to those that seemed to be uncertain in their direction and ending. The woodwork was generally painted in the delicate colors of the period, and the moldings were often accented by a contrasting color. There was less carved ornament in the provincial paneling, and such as existed was concentrated in important locations in the design. Some of the paneling was enriched with painted decoration, which usually consisted of landscape subject matter, and every room had a mantel and trumeau above. Mirrors were often set into the woodwork, and large mirror areas were usually assembled in small rectangles.

Bookshelves were built in, and sleeping rooms contained alcoves for the beds. The rooms were often small, but of the utmost charm.

The selection of textiles depended upon the wealth of the owner. Silks and printed cottons were used for panel areas, draperies, and upholstery, and the toiles de Jouy were in great demand over a period of two generations. Full credit must be given to the nimble fingers of the French peasants and housewives, whose persistence and energy with the needle, bobbin, and shuttle produced some of the most delightful, colorful, and original textiles ever made. These contributed profusely to the decoration of the country rooms of this and subsequent periods as well as to the regional costumes. Embroidery of all kinds, including *gros point* and *petit point* needlework, was used for draperies, bedcovers, and upholstery of both formal and informal rooms and added to the gaiety of the provincial interior. Hand-painted and stenciled linens were also made. The wallpaper consisted of all-over floral and flock patterns, and at the turn of the century scenic types became popular.

The Louis XV types of provincial furniture were reproduced in local woods such as cherry, elm, apple, oak, beech, walnut, and ash. Mahogany and ebony were occasionally used. All pieces were simplified in design, with less carving and ormolu. While the provincial nobility sometimes purchased their furniture in Paris and Versailles, the smaller landowners supported the local craftsmen. There was less style consistency in the furniture of the country rooms. Through reasons of economy, owners were less willing to discard old pieces unless they had become completely dilapidated. Even the Louis XIII types continued to be used in the same rooms as those of Louis XV and XVI.

Local varieties and types of furniture were developed. Among these were the *ménagère* and *vaisselier*, both of which were low cabinets upon which were open shelves with racks and guard-

rails for the storage and display of china and dining table accessories. The *panetière* was intended to store bread and cakes. The dough-mixing table was often an elaborately designed box furnished with a lid that could be used as a table. Practically every room had its armoire or wardrobe; this piece was usually the important dowry present of every bride, necessitated by the fact that closets were not an integrated part of French residential architecture. As the armoire was often of large dimensions, it became the dominating feature in every room in which it was used; it was usually made in oak, and the doors were always elaborately paneled and carved, hung with large hinges and hardware elaborated by escutcheons of sheet brass treated with a pierced pattern.

In the simpler types of homes, benches, settees, and chairs were made with straight turned legs and with wooden or rush seats upon which were placed cushions covered in silk or a homespun material. The peasants often had beds that were enclosed in closets that had doors or shutters pierced for ventilation; while these must have been unsanitary, they were at least warm at a time when heating was still of a primitive character.

The decorative accessories of a provincial home were naturally of a less luxurious sort than were found in the royal palaces. Much local pottery painted in gay colors was used, and those who could afford it purchased the beautiful examples from Rouen, St. Cloud, and other French and German potteries. Pewter was the common substitute for silver. The ships that landed at Bordeaux and Lorient brought from the Far East useful and decorative objects made of porcelain, wood, paper, and glass, and such as were not destined for Paris were eagerly purchased by the provincials.

LEADERS IN THE FRENCH DECORATIVE ARTS

Architects, Designers, and Craftsmen

Bérain, Jean (1638–1710). Designer at the court of Louis XIV. Designed much of the ornament, notably engraved arabesques and cartouche forms.

Boucher, François (1703–1770). Decorative painter under Louis XV.

Cerceau, Jacques du. Sixteenth-century architect and furniture designer under Henry IV.

Clodion (1738–1814). Sculptor of amorous nymphs and satyrs in terra-cotta. Real name Claude Michel.

Coysevox, Antoine (1640–1720). Sculptor under Louis XIV.

David, Jacques Louis (1748–1825). Revolutionary and Empire painter. Director of art under Napoleon.

Delorme, Philibert (1515–1570). Court architect under Francis I, Henry II, and Charles IX.

Fontaine, Pierre-François-Léonard (1762–1853). Architect and designer, whose association with Percier made them the leaders of the Empire style.

Fragonard, Jean-Honoré (1732–1806). Decorative painter.

Gabriel, Jacques-Ange (1698–1782). Architect of the Petit Trianon and Place de la Concorde under Louis XV.

Goujon, Jean (1510–1566). Architect and sculptor who worked on the Louvre.

Gouthière, Pierre (1740–1806). *Ciseleur* and metal sculptor, who made ormolu mounts, ornaments, and lighting fixtures.

Houdon, Jean-Antoine (1741–1828). Sculptor, notable for portrait busts.

Huet, Christophe (d. 1759). Decorative painter at the court of Louis XV.

Huet, Jean-Baptiste (1745–1811). Designer of toiles de Jouy for Oberkampf and wallpaper for Reveillon.

Jacquard, Joseph-Marie (1752–1834). Inventor of the Jacquard attachment for producing colored woven patterns in machine-made textiles.

Jacquemart and Benard. Wallpaper manufacturers, successors to Reveillon, 1791–1840.

LaSalle, Philippe de (1720–1803). Designer and manufacturer of textiles, and inventor of devices for weaving, under Louis XVI. Most famous for his lampases and realistic floral patterns.

Lebrun, Charles (1619–1690). Director of fine arts under Louis XIV.

Lenôtre, André (1613–1700). Architect famous for his garden designs at Versailles and Vaux-le-vicomte.

Lepautre, Jean (1618–1682). Royal architect under Louis XIV.

Lescot, Pierre (1510–1578). Architect under Henry II; worked on the Louvre.

Mansart, Jules Hardouin (1646–1708). Royal architect of Louis XIV. Most notable works: Dome of the Invalides and Palace of Versailles.

Marot, Daniel (1661–1720?). Designer of ornament, paneling, and furniture under Louis XIV. After the revocation of the Edict of Nantes, he emigrated to Holland and established the French baroque style there; later, he introduced it in England.

Oberkampf, Christophe-Philippe (1738–1815). Creator of toile de Jouy and founder of Jouy manufactory.

Palissy, Bernard (1510–1589). Early potter, inventor of enameled pottery.

Papillon, Jean (1661–1723). Wallpaper designer and maker.

Percier, Charles (1764–1838). Architect and designer who, with Fontaine, established the Empire style in France.

Pillement, Jean (1727–1808). Decorative painter, noted for his chinoiseries.

Ravrio, Antoine André. Brilliant *ciseleur* in the Empire period.

Reveillon, J. B. Wallpaper designer and maker from 1752 to 1789.

Robert, Hubert (1733–1808). Painter and decorator under Louis XV and Louis XVI. Noted for his landscapes and paintings of Roman ruins.

Sambin, Hugues. Architect and furniture designer under Catherine de' Medici.

Thomire, Pierre Philippe. Brilliant *ciseleur* in the Empire period.

Watteau, Antoine (1684–1721). Decorative painter under Louis XIV and XV.

Cabinetmakers

For a complete list of the French cabinetmakers of the eighteenth century readers are referred to François Salverte, *Les Ebénistes du XVIIIe Siècle*, Paris, 1927. The most important ones are listed below.

The year of appointment as Maître-Ebéniste is given following the letters *M. E.* Dates in parentheses give years of birth and death.

Beneman, Guillaume, M. E. 1785. Most important craftsman before Revolution. Worked for Marie Antoinette at St. Cloud. Also produced some of Percier's designs.

Boulard, Jean Baptiste (1725–1789). M. E. 1754. Both ébéniste and sculptor. His most important work was a magnificent bed for Louis XVI at Fontainebleau.

Boulle, André Charles (1642–1732). In 1672 appointed head cabinetmaker to Louis XIV.

Boulle, André Charles, Jr., and Charles Joseph, sons of above. M. E. 1745.

Burette, Charles Marin. Flourished toward the end of the Empire period.

Caffieri, Jacques (1678–1755), and son, Philippe (1714–1774). Cabinetmakers and sculptors under Louis XIV and XV.

Canabas, Joseph (1712–1797). M. E. 1766. Particularly noted for mechanical contrivances, such as folding tables, for armies or to be carried aboard ships.

Carlin, Martin. M. E. 1766. Made charming, delicate furniture during Louis XVI period, using rosewood and Sèvres porcelain.

Cochois, Jean-Baptiste. M. E. 1770. Inventor of dual-purpose and changeabout furniture, such as a chiffonière which became a night table.

Cressent (d. 1749). M. E. 1715. Ebéniste to Duc d'Orleans.

Cressent, Charles (1685–1768). Pupil of Boulle, famous for ormolu work.

Cresson, Michel (b. 1709). M. E. 1740.

Criard (or Criaerd), Mathieu. M. E. 1747.

Cucci, Domenico. Cabinetmaker under Louis XIV.

Delanois, Louis (1731–1792). M. E. 1761. Protégé of Mme. Du Barry; did much of the furniture for Versailles.

Dubois, René. M. E. 1755. Cabinetmaker to Louis XV and Louis XVI.

Evalde, Maurice. M. E. 1765. Originally German. Worked for Marie Antoinette. Famous piece was a jewel cabinet he made for her.

Fleury, Adrien. Worked between 1740 and 1775.

Gambard. M. E. 1779. In the services of the court at Versailles between 1771 and 1779.

Gaudreau, Antoine Robert (1680–1751). Worked for the court from 1726, on the Tuileries, and on the Bibliothèque Nationale.

Guillemart, Francois (d. 1724). M. E. 1706. Active under Louis XIV and the regency. Built two commodes for the king's room at Marly.

Huffelé, Lambert (d. 1766). M. E. 1745. A collaborator of André Charles Boulle, the son of the famous ébéniste of Louis XIV.

Jacob, Georges. M. E. 1784. One of the most famous cabinetmakers of France, active during Louis XVI, Directoire, and Empire periods.

Jacob-Desmalter, François Honoré (1770–1841?). The son of Georges Jacob, very active as a cabinetmaker, in business with his older brother during the Empire period. Made furniture for Percier and Fontaine.

Joubert, Gilles (1689–1775). M. E. 1749? Renowned for small furniture, such as tables and secretaries, ornamented with wood inlay. Date of appointment as maître-ébéniste not definitely established. Employed at court from 1748.

Lelarge, Jean Baptiste. M. E. 1786. There were three members of the same family with the same name. This one worked at Fontainebleau and made bergères and fauteuils.

Leleu, Francois (1729–1807). M. E. 1764. Famous for marquetry. Worked under Oeben, on Versailles. Also worked for Mme. Du Barry.

Levasseur, Etienne (1721–1798). M. E. 1767. Made furniture for the Petit Trianon. Very celebrated.

Lignereux, Martin Eloy (1750–1809). Associated with Jacob-Desmalter about 1798 in the furniture business, chiefly during the Louis XVI period. Previously had directed the design, making, and sale of various decorative accessories. Firm believed to have been discontinued in 1800.

Macret, Pierre (1727–1796). M. E. 1758. Made furniture for Versailles.

Martin brothers. Cabinetmakers during the reign of Louis XV. The four brothers introduced Chinese lacquer as a finish on French furniture. The finish and the furniture so treated are called Vernis Martin.

Montigny, Philippe Claude (1734–1800). M. E. 1766. Repaired much of Boulle's furniture. That furniture which he made was inspired by the work of Boulle, but he copied his predecessor with taste.

Oeben, Jean Francois (d. 1765). M. E. 1754. Worked for Mme. Pompadour. Trained Riesener. Louis XV period.

Rascalon, Barthelemy (b. circa 1745). M. E. 1781?.

Riesener, Jean Henri (1734–1806). M. E. 1768. Worked for Marie Antoinette. First worked under Oeben, and became his successor.

Roentgen, David (1743–1807). M. E. 1780. Of German origin. Worked for Marie Antoinette.

Weisweiler, Adam. M. E. 1778. Louis XVI ébéniste.

BIBLIOGRAPHY

Arnott, J., and Wilson, H. *The Petit Trianon.* London: B. T. Batsford, 1908; New York: Architectural Book Publishing Co., 1914.
 Series of measured drawings and photographs of the entire building, supplemented with a historical account.

Blunt, Anthony. *Art and Architecture in France, 1500–1700.* Baltimore: Penguin Books, 1954.

Contet, F. *Anciens Châteaux de France.* 22 vols. Paris: F. Contet.
 Excellent portfolios of plates covering the various styles of architecture.

Contet, F. *Intérieurs Directoire et Empire.* Paris: F. Contet, 1932.
 Color plates of designs reproduced from the original works of the artists of these periods.

Contet, F. *Le Style Empire.* 5 vols. Paris: F. Contet, 1925.
 Portfolio of very fine plates.

Contet, F. *Les Vieux Hôtels de Paris.* Paris: F. Contet, 1908–1934.
 Twenty-one volumes of plates, showing both interiors and exteriors of old French architecture. A standard work.

Cooper, Douglas, ed. *Great Private Collections.* Introduction by Kenneth Clark. London: Weidenfeld and Nicolson, 1963.
 Excellently illustrated examples of paintings and sculpture in interiors.

Editors of Connaissance Des Arts. *Decoration.* New York: French and European Pub., 1963.

Evans, Joan. *Art in Medieval France.* New York: Phaidon, 1957.

French, L., Jr., and Eberlein, H. D. *The Smaller Houses and Gardens of Versailles, from 1680 to 1815.* New York: Pencil Points Press, 1926.
 Brief text with excellent illustrations.

Gebelin, Francois. *The Chateaux of France.* New York: G. P. Putnam's Sons, 1964.

Gélis-Didot, P., and Laffillée, H. *La Peinture Décorative en France.* 2 vols. Paris: Ancienne Maison, Morel, 1888–1890.
 French text with beautiful color plates.

Gelit, P. *Le Mobilier Alsacien.* Paris, 1925.
 Photographs of Alsacian interiors and furniture.

Germain, A. *Meubles et Ensembles Bressans.* Paris: C. Massin, 1959.

Goodwin, P. L., and Milliken, H. O. *French Provincial Architecture.* New York: Charles Scribner's Sons, 1924.
 Excellent text and photographs of exteriors, gardens, and interiors.

Gromort, G. *Choix d'Elements Empruntés a l'Architecure Classique.* Paris: Aug. Vincent, 1904.
 Plates of measured drawings.

Guerber, A. *A Short History of France.* New York: W. W. Norton and Co., 1946.
 Well-written outline of the development of French culture.

Havard, Henri. *Dictionnaire de l'Ameublement.* Paris, 1891.
 A book of source material on French furniture.

Hinckley, F. Lewis. *A Directory of Antique Furniture.* New York: Crown Publishers, 1953.
 Excellent comparative photographs.

Hourticq, L. *Art in France*. New York: Charles Scribner's Sons, 1917.
Illustrated general history of French art.

Keim, A. *Le Beau Meuble en France*. Paris, c. 1934.
Excellent history of French furniture. French text.

Kimball, F. *Creation of the Rococo*. Philadelphia: Philadelphia Museum of Art, 1943;
New York: W. W. Norton and Co., 1964.
Standard text on this subject.

LeClerc, Leon. *Meubles et Ensembles Normands*. Paris: C. Massin, 1960.

Longnon, H., and Huard, F. W. *French Provincial Furniture*. Philadelphia: J. B. Lippincott Co., 1927.
Excellent illustrated text.

Maillard, E. *Old French Furniture and Its Surroundings* (1610–1815). London: Heinemann, 1925.

Meubles et Ensembles Auvergnats. Paris: C. Massin, 1961.

Ricci, S. de. *Louis XIV and Regency Furniture and Decoration*. New York: William Helburn, 1929.
Excellent photographs with brief text.

Ricci, S. de. *Louis XVI Furniture*. London: W. Heinemann, 1913.
Introductory text to an excellent collection of photographs.

Salverte, François. *Les Ebénistes du XVIIIe Siècle*. Paris, 1927.
A book of source material concerning the French cabinetmakers of the eighteenth century.

Strange, T. A. *French Interiors, Furniture, Decoration during the 17th and 18th Centuries*. New York: Charles Scribner's Sons.
Line drawings and photographs with descriptive text.

Verlet, Pierre. *18th Century in France—Society, Decoration, Furniture*. New York: Wittenborn, 1967.

Verlet, Pierre. *French Royal Furniture*. New York: Towse, 1963.

Viaux, Jacqueline. *French Furniture*. New York: G. P. Putnam's Sons, 1964.

Ward, W. H. *A History of French Renaissance Architecture*. 2 vols. London: B. T. Batsford, 1926.
An excellent illustrated history.

Glossary of French Furniture Terms

Acajou. Mahogany.

Ajouré. A design in ceramics metal, wood, or other material, in which a design has been produced by piercing holes.

Applique. An applied motif, a wall bracket or sconce.

Armoire. Clothes wardrobe. (Gothic and later.)

Banquette. Bench.

Bergère. All upholstered armchair.

Bibelot. Small art object for personal use or as decoration.

Bibliothèque. Bookcase.

Bobêche. Candle socket.

Bombé. A swelling curve; when the curve is applied to the front of a piece of furniture, it swells outward toward the center, at which point it recedes again.

Bonheur-du-jour. Small desk with cabinet top.

Bonnetière. Hat cabinet.

Bouillotte. Small table with gallery edge. Also a foot-warmer. (Louis XVI.)

Boiserie. Carved woodwork.

Bronze-doré. Gilded bronze.

Buffet. Sideboard or cupboard. (Gothic and later.)

Bureau. Desk.

Bureau-à-cylindre. Roll-top desk.

Bureau-à-pente. Folding slant-lid desk.

Cabinet-sécretaire. Desk with cabinet above.

Cabinet-vitrine. Cabinet with glass doors.

Cabriolet. Any chair with a concave back.

Cachepot. Pot of china or porcelain used as container.

Canapé. Sofa.

Canapé-à-corbeille. Kidney-shaped sofa.

Caquetoire or caqueteuse. Conversation chair. (Early Renaissance.)

Chaise. Side chair.

Chaise-à-capucine. Low slipper chair.

Chaise-brisée. Chaise-longue in two parts (with foot rest).

Chaise-longue. Literally "long chair," or chair for reclining.

Chandelier. Hanging lighting fixture.

Chêne. Oak.

Chenets. Andirons.

Chevet. Bedside.

Chiffonier. Chest of drawers.

Chinoiserie. Decorative motif in the Chinese manner.

Ciseleur. A craftsman who ornaments bronze and other metals by chiselling. A chiseller.

Coffre. Chest.

Coiffeuse. Dressing table.

Confortable. Name used for the first all-upholstered chair.

Commode. Low chest of drawers.

Compotier. Container for stewed fruit, jellies, jams, etc.

Confidante. Three seats attached as a single unit.

Console. Wall table.

Console-desserte. Serving table.

Crédence. Sideboard.

Cremaillere. Swinging crane. Hearth.

Demilune. Semicircular.

Desserte. Serving table or sideboard.

Dos-à-dos. Chair with two attached seats arranged so that they face in opposite directions.

Duchesse. Chaise-longue in one piece.

Duchesse-brisée. Chaise-longue with separate foot-piece.

Ecran. Screen.

Ecran-à-cheval. Frame with sliding panel used as fire screen.

Encoignure. Corner cabinet or table.

Encrier. Inkwell.

Entresol. A mezzanine floor.

Escabelle. Chair supported on trestles. (Early Renaissance.)

Etagère. Hanging or standing open shelves.

Etui. Container or box.

Eventail. Fan.

Faïence. Terra cotta.

Fauteuil. Upholstered armchair with open arms.

Garde-robe. Wardrobe.

Garniture. Any motif used for enrichment.

Girandole. Wall sconce for candles, often mirrored.

Guéridon. Small ornamental stand or pedestal.

Huche. Hutch or chest.

Jardinière. Plant container.

Laqué. Lacquered.

Lambrequin. Valance board for draperies.

Lavabo. Table and washstand.

Lit. Bed.

Lit-à-la-Francaise. Bed placed sidewards against wall, with canopy.

Lit-à-la-Polonaise. Bed with pointed crown canopy.

Lit-à-travers. Bed placed sideways against wall, without canopy.

Lit canapé. Sofa bed.

Lit d'ange. Bed with small canopy.

Lit duchesse. Bed with large canopy.

Lustre. Table light or wall sconce in crystal.

Manchette. Padded arm cushion.

Marquise. Small sofa.

Menagère. Dresser with open shelves for crockery.

Meridienne. Sofa with one arm higher than the other. (Empire.)

Miroir. Mirror.

Noyer. Walnut.

Objet d'art. Any small art object.

Ormoulu. Gilded bronze. Ormolu.

Panier. Basket or scrap basket.

Panetière. Bread box.

Petite-commode. Small table with three drawers.

Placage. Veneering.

Poudreuse. Powder or toilet table.

Psyche. Cheval glass. (Empire.)

Rafraîchissoir. Refrigerator.

Rez-de-chaussée. Ground floor.

Rognon. Kidney-shaped.

Scrutoire. Slope-top desk, which has a lid that opens to form a horizontal writing surface.

Sécretaire. Desk.

Sécretaire-à-abattant. Drop-lid desk.

Semainier. Tall bedroom chest with seven drawers.

Singerie. Decorative motif using the monkey as subject matter.

Table-à-écran. Table with sliding screen.

Table-à-jeu. Game table.

Table-à-l'anglaise. Dining room extension table. (Louis XVI and later.)

Table-à-l'architect. Table with hinged top.

Table-de-chevet. Night table.

Table-jardinière. Table with top pierced for plant containers.

Tabouret. Stool.

Tambour. Literally a drum. Drum-shaped.

Terre-cuite. Terra cotta.

Tôle. Painted sheet metal or tin.

Tric-trac table. Backgammon table.

Tricoteuse. Small sewing table.

Trumeau. Overmantel or overdoor panelling, usually with mirror with superimposed picture.

Vaisselier. Dining room cabinet and shelves.

Verrier. Glassware cabinet.

Vis-à-vis. Two seats facing in opposite directions, attached in the center.

Vitrine. Curio cabinet with glass front. (Louis XVI.)

Early Georgian knotty pine room from Hatton Garden, built around 1735. The design continues the use of the academic architectural forms, with a tendency toward heaviness of detail. The bolection molding has given place to a simpler form.

CHAPTER 6

The English Periods

Room in a half-timber house of the Elizabethan period. The vertical posts form the skeleton structure and become a part of the interior decoration.

The British people, product of the fusion of the Celts, Angles, Saxons, Jutes, Danes, and Normans, have been to modern history what the Roman nation was to antiquity. The most important British contribution to civilization has been her colonization of distant lands and, with rare exception, the establishment therein of justice to minorities, of order, of industry, and of progress.

British history commences with Caesar, who invaded the island. The Romans established camps that later became cities and have left some well-built roads and baths. Upon the fall of the empire in the fifth century, the Teutonic invaders settled in the western and northern sections, became Christians, and established kingdoms that endured until the time of Harold in the eleventh century.

The religious ecstasy of France during the Middle Ages crossed the Channel in 1066 with William the Conqueror, and was recorded in art by the construction of the romantic Norman and Gothic cathedrals at Durham, York, Lincoln, Salisbury, Canterbury, Wells, and else-

where. For 500 years the English kings were loyal to the See of Rome. The growing dissatisfaction with the pope's administration of English affairs, the visit of Erasmus, the Dutch humanist, to the English court in 1498, and finally the refusal to the king of a divorce from Catherine of Aragon culminated in Henry VIII's throwing off the papal authority and separating the Church of England from the papal see.

From the beginning, owing to her isolated position, Great Britain had necessarily developed a seafaring race. The activities of Spain and Portugal in the New World during the fifteenth century were observed with envious glances, and the bleak coast of Labrador had been the sole reward of the efforts of John and Sebastian Cabot. The rising power of Spain under Ferdinand and the political and cultural ambitions of Francis I provoked Henry VIII to action. The unsurpassable splendor exhibited in the tournament on the "Field of the Cloth of Gold" contributed to the belated but growing desire on the part of the English nobility to surround themselves with some of the refinements and luxuries of Italy, which were then being adopted by her neighbor nations. English navigation and commerce began to expand; the seeds of the British Empire were sown; and with the increase in wealth, Henry strove to enrich court life. Holbein, the German painter, John of Padua, the Italian architect, and other artists and craftsmen were invited to work in England at a time when the English knew of no style but the Gothic. The Renaissance forms at first bewildered the English, and they did not become popular until about one hundred years after they were used in Italy, where they had already become a past style.

Elizabeth's reign (1558–1603) has been called the Golden Age of England and compared with Greece under Pericles. After the defeat of the Spanish Armada in 1588, which gave England control of the seas, her attention turned

to economic development. Elizabeth regarded with amusement the looting of Spanish treasure ships by Drake, and constantly encouraged English trade with foreign countries. The increase in the wealth of the middle class permitted the development of country estates and the building of manorial houses. Textile manufacturing was stimulated by the influx of weavers and tradesmen from the Netherlands, who fled from the persecutions of the Spanish Inquisition. Sir Walter Raleigh attempted to settle Virginia. The inborn love of liberty and independence of thought of the English people, first evidenced by the demand for the Magna Charta in 1215, gave birth during Elizabeth's reign to the Puritan and Pilgrim movements, which were later to have such an important influence upon the development of the American colonies. The theater became the favorite form of amusement, under the auspices of Ben Jonson and Shakespeare. All England bloomed under a regime of peace, increased wealth, and the influence of Renaissance ideas.

After the death of Elizabeth, political disorder occurred during the reigns of her successors, James I and Charles I. Van Dyck, the Flemish painter, went to England to paint portraits of the court nobility. Inigo Jones introduced the Palladian style of architecture. The East India Company was organized. Charles I was tried and executed in 1649. The English civil war was a period of great destruction of both ecclesiastical and private property, and was followed by the protectorate under Cromwell. To the Puritans art had been associated with corruption, immorality, and inefficiency, and a ban was placed on everything that had any sensual appeal.

In 1660 the monarchy was restored, and Charles II was called to the throne. Charles was sympathetic with his cousin, Louis XIV of France; in his reaction to the repressed and subdued spirit that had prevailed during the Puritan protectorate, he endeavored to imitate the lavishness and extravagances of the French court. The Great Fire, which destroyed a large part of London, occurred in his reign, and this disaster gave impetus to the construction of new homes, public buildings, and churches. Sir Christopher Wren, the architect, became the leading influence in the artistic life of the period and was called upon to design St. Paul's Cathedral in London and to redesign Hampton Court Palace, the home of the English king. Sir Christopher was strongly influenced by Palladio, the Italian architect, and by French architects. Many French and Flemish craftsmen, among them Daniel Marot, came to England upon the revocation of the Edict of Nantes, and Charles supported several art industries, including the tapestry factory at Mortlake outside of London. It is said that 40,000 French weavers entered England at this time.

The corruptions of Charles's reign created a reaction after his death. James II succeeded to the throne, but was ousted because he attempted to restore the Church of Rome as state church. James's daughter, Mary, and her husband, William, prince of Orange, a Stadtholder of Holland, were invited to rule as joint sovereigns. Prosperity, economy, and simplicity characterized their reign. The reigns of Queen Anne and George I (1702–1727) witnessed a further expansion of the empire. England, by the Treaty of Utrecht with France, obtained Nova Scotia, Newfoundland, Hudson Bay, and the West Indies. Trade with India, the Far East, Virginia, and New England increased. Wealth poured into the nation. New ways of thinking, new modes of life helped to develop social intercourse. The nobility settled down to enjoy comfort and culture. While the men followed the hounds or drank their flip and ale, women consumed tea, played cards, and plied their needles.

The reigns of George II and George III

(1727–1810) continued along the same lines of social development as those of their immediate predecessors. In spite of the loss of the American colonies, great industrial changes were wrought in manufacturing by the inventions of machinery. In 1764 the spinning jenny was invented by Arkwright, the steam engine by Watt in 1769, cylinder printing for textile manufacturing in 1783, and the power loom in 1785. The excavations at Pompeii strongly influenced the arts.

England's ships carried English products to all shores, and returned with holds filled with the luxuries and necessities produced in foreign lands. The eighteenth century was a period of cultural, as well as industrial, growth. The Society of the Dilettanti was organized in 1733 with the idea of promoting the arts, and it influenced greatly the development of public taste in architecture and decoration. In literature the eighteenth century produced such men as Johnson, Pope, Fielding, Richardson, Defoe, Swift, and Goldsmith; in science, Newton and Halley; in statesmanship it brought forth such men as Burke and Walpole; in religion and philosophy, Locke and Wesley; in history, Edward Gibbon.

In 1810 George IV became regent, because of the illness of George III. Napoleon's ten years of threats and actions were brought to a close at Waterloo by Wellington. Once more England and Europe had an opportunity for the development of peacetime pursuits. With the aid of the new mechanical inventions, old industries began to produce on a much larger scale. Home production with one's own tools gave way to large-scale production in the factory. Population began to increase and concentrate in the cities. Manufacturing began to compete with agriculture. The greatly increased wealth became concentrated in the hands of the newly rich, who dazzled the world with their display. The post-Napoleonic era witnessed a reaction in the manners and customs of society, from the self-discipline imposed during the uncertainty of war years to liberty and license carried to extremes that were not counteracted until the youthful Victoria inherited the crown.

The effort of the Greeks to throw off the yoke of Turkey had a strong sentimental appeal for the English people. Keats, Shelley, and Byron romanticized the classic spirit in their poetry, and with the additional influence of the standards of taste of the French Empire, classic —and particularly Greek—forms in the decorative arts were revived.

Queen Victoria came to the throne in 1837. The industrial age continued to expand to unimagined proportions. Wealth came from quantity rather than quality production. The craftsmanship of the handworker in industry was submerged by the economic advantage of machine work. The appreciation on the part of the public for beauty in line, form, texture, and color vanished as though it had never existed.

CHARACTER OF THE BRITISH PEOPLE. The insular position of Great Britain has contributed greatly to an unusual homogeneity of race and a mutual understanding of the classes. A peerage has been acceptable because it has been a recompense for public service and because its members have justified their existence by fully realizing the meaning of *noblesse oblige*. Leaders have considered honor more important than personal gain, and the country has been ruled by law rather than by autocratic methods. Reforms in public policies have been slowly made, but they have been made by peaceful means. The English have learned to argue rather than to battle and to choose a middle way of compromise and concession by the use of the logic of experience rather than theory alone. The Britisher has been a lover of liberty and individualism and, throughout most of his history, has felt that the best government is the least government, a theory that has been seriously questioned as governments have assumed the

responsibilities of social welfare. The basic economic policy until World War I was to retain the privilege of manufacturing into salable products the raw materials furnished by the colonies and dominions. This policy was highly successful for two hundred years, but under modern war conditions, resulted in food shortages and the eventual establishment in the dominions themselves of the means of manufacturing at the expense of the homeland. Great memories, persistent traditions, and courageous loyalties have rhythmically echoed in the heart of every son of Albion, and these have served to build the tenacity and pride of the nation.

The verdure of the rolling, luscious countryside is nourished by the mists that roll in from the adjacent seas, and has contributed to the love of outdoor life. Rural activities have built the physical vigor of the nation and have contributed to a social existence that has strongly influenced the charm and character of English country architecture and decoration. Interest in sports has taught the Englishman to lose with equanimity and helped to form a characteristic that is at the base of its democracy. Art has never been a national industry as in France. The decorative arts have evolved conservatively because the Britisher has loved the past and has been content to live in a home mellowed by vines and ivy. Except in literature and gardening, the arts of England have been freely borrowed, although isolation, security from invasion, moist climate, and ample resources have in times of peace aided in the development of nationalistic art expressions. The placidity of the British character never prevented a richness of expression in the decorative arts, but at no time did the English reach the degree of prodigality that typified the rococo excesses of the continental nations.

THE SUBDIVISIONS OF THE ENGLISH PERIODS, 1500–1900. The English Renaissance periods of decorative arts are by some authorities divided according to the popular woods used for furniture-making. The Age of Oak lasted from about 1500 to 1680; the Age of Walnut, from 1680 to 1710; the Age of Mahogany, from 1710 to 1770; and the Age of Satinwood, from 1770 to 1820. The usual historical divisions are as follows:

1. EARLY RENAISSANCE (1500–1660. The Age of Oak).
 a. Tudor (1500–1558).
 (Reigns of Henry VII, Henry VIII, Edward VI, and Mary)
 Transitional period. Gothic forms dominated; gradual introduction of Italian Renaissance forms.
 b. Elizabethan (1558–1603).
 Transitional period. Additional Renaissance features introduced.
 c. Jacobean (1603–1649).
 (Reigns of James I and Charles I)
 Transitional period. Few remaining Gothic elements. Flemish influence. Strapwork carving. Renaissance forms used. Inigo Jones.
 d. Cromwellian (1649–1660).
 Religious wars. Period of industrial and artistic stagnation.

2. MIDDLE RENAISSANCE (1660–1750).
 e. Restoration, Stuart, or Carolean period (1660–1689).
 (Reigns of Charles II and James II)
 Flemish and French baroque influence. Greater formalism in design. Rooms treated with large wooden paneling. Influence of Wren and Gibbons, with accurate conception of Renaissance architecture. Elaborate carving and rich textiles used in furniture.
 f. William and Mary (1689–1702).
 Interiors same as in previous period. Changes principally in furniture. Little carving. Enrichment by wood graining and marquetry. The Age of Walnut.
 g. Queen Anne (1702–1714).
 Interiors slightly simplified. Wallpaper be-

came popular. Curvilinear influence in furniture. Walnut and mahogany used. Oriental influence in design and finish. Continuation of Wren's and Gibbons's influences.

 h. Early Georgian (1714–1750).
(George I and portion of George II's reign) Architectural interiors in pine and walnut. Tendency toward heaviness of proportion and detail. Furniture made exclusively of mahogany. Early Chippendale work. Curvilinear furniture designs. Swan and Kent influence.

3. LATE RENAISSANCE (1750–1830).

 i. Middle Georgian (1750–1770).
(Portions of George II's and George III's reigns) Reaction toward lighter proportions in interior design and furniture. Chippendale period. The Age of Mahogany (1710–1765).

 j. Late Georgian (1770–1810).
(End of George III's reign) Adam leadership in the arts. Pompeian and Greek influence. Chippendale, Hepplewhite, and Sheraton. The Age of Satinwood.

 k. Regency (1810–1820, style continued until 1837).
Period of severe neoclassicism. Influence of Sir John Soane and French Empire. Decline of handcrafts.

 l. Victorian (1830–1901).
Growth of industrialism and quantity production. Eclecticism.

INTERIORS OF THE EARLY RENAISSANCE PERIODS (1500–1660). English domestic interior decoration commences with the charming *half-timber*, brick, and stone dwellings erected during the sixteenth century. The feudal castle was less necessary in England than on the Continent, and was of little protective value after the cannon superseded the bows of the yeomanry and nullified the value of the moat and draw-

Museum of Fine Arts, Boston

Oak Tudor room from Somersetshire, England.

bridge. The castle gave way to the rambling country house, situated in the center of exquisite gardens and velvety lawns beautified by the alternating sunshine and mist of the English climate. The transition from the habits and customs of the Gothic period was slow, however, and the great hall persisted well into the Tudor period. Many of the houses were built in irregular shapes, around quaint quadrangular courtyards.

The general character of all early English decoration was vigorous, masculine, somber, and austere. The rooms were spacious and dignified in appearance, and many of them were extremely long and narrow, or planned in the shape of the letters "L," "E," and "H." Variations in floor levels frequently occurred, and adjoining rooms or wings were connected by several steps. The bay window built up from the ground and the *oriel*, an upper story projecting window supported externally on a large bracket or *corbel*, were typical and persistent features, and were at times so large that either one formed almost an extra room by itself. The windows were designed in the manner of those in the Gothic church, although the glass was usually limited to small rectangular or diamond-

shaped panes separated by narrow strips of lead. Color was confined to small patterns showing coats of arms, although even the plain squares of glass had various unintended color tints. The window openings were subdivided with stone or wooden mullions, joined at the top in a flat pointed form known as a *Tudor arch*. The same type of arch was also extensively used for the heads of doors, for fireplace openings, and for other decorative features. The interior walls of brick and stone houses were sometimes in rough-finished plaster, covered with a wainscot treated with small oak panels in Gothic detail and proportions. The panels were not always superimposed; they varied in dimensions, and their arrangement sometimes lacked symmetry. The field of the panel was sometimes plain, but was frequently enriched by a linenfold carving or diamond-shaped motif. The wood was usually left in its natural finish or rubbed with oil and beeswax. In half-timber houses, the heavy posts of the structure, placed about two feet apart, with an occasional one in a slanting position for extra bracing, were exposed on both the exterior and the interior. These posts, being visible, became an unintentional feature of the interior decoration.

From the Tudor period onward, interior treatments included the architectural orders borrowed from the Italian Renaissance, although not in correct classical proportions. Pilasters, columns, and entablatures were combined with small wood panels, two or more vertical rows of panels being placed between each pilaster. In low rooms the wall panels sometimes rose from the baseboard at the floor to the few moldings forming a cornice at the ceiling. In high rooms an oak dado or pedestal motif about three feet high was used from the floor, and the wall paneling started from the molding at the top of the dado and was crowned by an entablature, the whole wainscot being about ten or twelve feet high. In the Jacobean period the panels were slightly enlarged, and geometrical forms,

broken corners, hexagons, arches, and other irregular shapes were introduced. The flooring in the ground floor of these early houses was usually of flagstone or slate. The upper floors had irregular or random-width oak planks of the size of the log from which they were cut.

Ceiling beams were exposed, and the beams varied in size, but were always heavy, with moldings at the corners and patterns of oak leaves, stems, and acorns occasionally carved on their sides. In narrow rooms the ceilings were flat or slightly slanted upward to a point in the middle. In wide rooms elaborate triangular wooden truss forms were used, composed of many small beams fitted together to support a steeply pitched ceiling. In great public rooms the *hammer-beam truss* was used for roof support. This consisted of enormous wooden Tudor arch forms supported on large wooden brackets projecting from the wall, the whole being elaborately carved.

Decorative plaster work became an important feature in ceiling treatment during the latter part of the sixteenth century. The rough beams were covered with a flat plaster ceiling, and the plasterers endeavored to imitate the wooden beams by means of applied plaster moldings, as both the moldings and the carved ornament of the wood could be more economically produced in plaster. The plasterers, however, were not limited to the straight-line forms of the beams, and soon developed elaborate all-over patterns of curved and geometrical interlacing forms, enriched with cast plaster ornament in relief, showing *Tudor roses*, scroll motifs, portraits, cartouches, and *fleurs-de-lis*. Color was sometimes applied to these plaster patterns, producing a very rich effect. This type of ceiling treatment is known as *pargework* or *pargetry*.

Because of the dampness of the English climate, fireplaces and mantels played a more important part in the decoration of English houses than in those on the Continent. During

Victoria and Albert Museum

Oak Jacobean room from Bromley-by-Bow, England. Built in 1606. Notice the slight enlargement of the panel sizes, the introduction of classical architectural forms, and the pargework ceiling.

the sixteenth and first half of the seventeenth century, the stone fireplace opening was usually in the form of a Tudor arch, but the woodwork at the side and that of the overmantel consisted of academic architectural features and of richly carved forms of classically inspired ornament.

The stairhall in the early house was made a special feature, the climate precluding the use of an exterior stairway. Of immense size, the staircase was built with elaborately carved newel posts, rich balustrading, and the side walls were treated with small oak panels and leaded glass windows similar to those of the main rooms.

The rooms of the early period were sparsely furnished. Accessories were few, according to modern standards. Arras tapestries, helpful in keeping the rooms warm in temperature and color effect, frequently decorated the walls and at times were used as partitions for dividing large rooms into smaller parts. Armor and trophies of the chase were fastened to the walls, and portraits were hung over the fireplace and in other important positions.

During the reigns of Henry VIII and Elizabeth, England established her naval supremacy, and English ships traveled to distant shores with little molestation. The Far East and India were

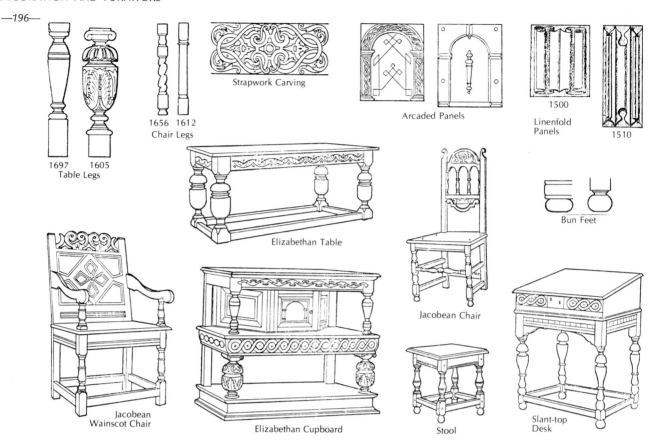

Characteristic details of early English furniture and ornament.

not neglected, and many Oriental objects of household adornment were brought to enrich the homes of the king and nobility. Chinese pottery, porcelains, paintings, Turkish rugs, and East Indian hand-painted cottons were most in demand. The East Indian painted cotton fabrics, known as *palampores*, were frequently decorated with a pattern of religious significance, known as the "tree of life." This type of pattern, consisting of interlacing branches and foliage with peacocks and various birds, became immensely popular in England and was reproduced in paint and crewel embroidery, and was later manufactured by the hand-block process. Variations of this pattern eventually became the most frequently used designs in English weaving.

Lighting fixtures, as a rule, were in wrought iron or brass. Silver, *pewter*, and heavy earthenware platters and drinking cups stood on the shelves of dressers and cupboards.

FURNITURE OF THE EARLY RENAISSANCE. The sources of inspiration in the design of the furniture of the early Renaissance in England were the same as those in France. Both types were a fusion of Gothic and Italian Renaissance forms, differing, however, in the wood that was used and in the character and design quality of ornamental detail. The English, less closely associated with Italy both geographically and intellectually, were slower to adopt the Italian forms, and in the early stages did not understand the correct proportions of classical architecture as

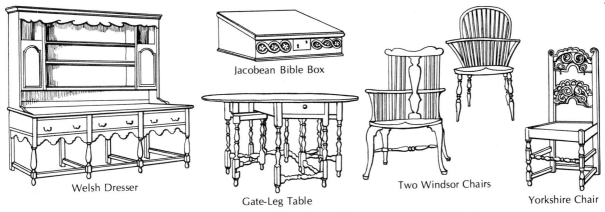

Jacobean Bible Box

Welsh Dresser

Gate-Leg Table

Two Windsor Chairs

Yorkshire Chair

Examples of seventeenth- and early eighteenth-century provincial furniture.

a basis of furniture design. In England the use of oak, the great wood of the Gothic period, persisted well through the seventeenth century, whereas in France walnut, a fine-grained wood, was substituted during the early years of the sixteenth century, and permitted the development of more minutely carved ornament and smaller moldings.

During the Tudor and Elizabethan periods, English social life was boisterous in its manners and customs. These characteristics are reflected in the strength of the furniture, which was made for service rather than for comfort. The principal pieces used were chests, cupboards, wardrobes, desk-boxes, dressers for tableware, settles, chairs, stools, tables, beds, and cradles. All pieces were heavily constructed and massive in appearance. The structural forms were rectangular, continuing the Gothic tradition, the various parts being held together by wooden dowels and pins, and by the mortise-and-tenon or dovetail joint.

The structure of the case and cabinet furniture was similar to that of the wainscots. The stiles and rails, however, were often enriched by simple surface grooving, by a narrow strip of inlay in contrasting wood or checker effect, or by a crudely carved pattern in low relief, inspired by the classical rinceau, arabesque, or guilloche. The field of the panel was usually carved with a linenfold or a coat of arms, and as the Italian influence increased, the panels were enriched by a carved or inlaid arabesque pattern or medallion, or by a dwarf arch—the latter type being called an *arcaded panel*. During the Jacobean period the panels became larger, were treated with moldings on four sides, often had plain fields, and sometimes were shaped as diamonds, crosses, hexagons, double rectangles, and other geometrical forms.

Furniture supports during the Elizabethan period were often of the *bulbous form*, resembling a large melon and occupying all but the extreme top and bottom of the support or leg. The melon portion was usually carved at the top with a gadroon and at the bottom with an acanthus leaf. The top of the support crudely imitated a Doric or Ionic capital. During the Jacobean period, the bulbous form of support gradually gave place to dwarf columns of straight or spiral shape or to the twisted rope form.

The characteristic chairs of the Elizabethan period were those known as turned and *wainscot chairs*. The former, extremely heavy in proportions, had a triangular wooden seat with arms, back, and legs entirely composed of short, thick turnings; the latter had a nearly rectangu-

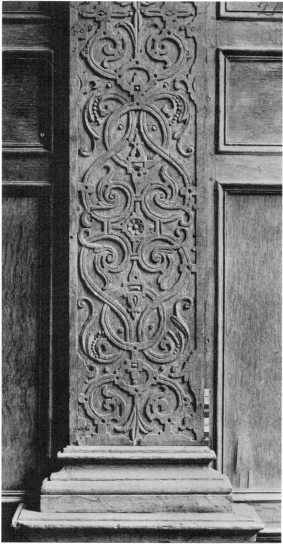

Victoria and Albert Museum

Detail of Jacobean pilaster in the Bromley room showing character of the strapwork carving.

lar wooden seat with turned or column legs, arms that were slightly shaped, and a solid, high wooden back enriched by low relief carving or inlay. During the Jacobean period, chairs were improved in comfort by the addition of upholstered seats and backs nailed to a rectangular framework. For smaller country dwellings,

chairs of lighter weight, such as the *Yorkshire* and *Derbyshire* types, were also made.

The beds used in the homes of the nobility were of great size. They were designed with four carved corner posts, often enriched by a bulbous ornament and an architectural capital that supported a wooden tester, modeled as a simplified entablature. Long velvet hangings were drawn at night for warmth and privacy.

Although temporary trestle tables continued to be used during the sixteenth century, the permanent table was also a feature of the furnishings. Large refectory tables were built with solid oak tops, some of which were of the extension type. These were used for the elaborate banquets and turbulent entertainments that took place during the holidays, after the hunt, or on special occasions when the boar's head, yule log, holly, and mistletoe were featured. Drop-leaf and gateleg tables were used in the smaller houses.

In addition to the simple inlay work and crude low relief and *strapwork* carving, furniture was sometimes enriched by an ornament known as the *split-spindle*.* This consisted of a short, turned piece of wood, often ebony, that was split into two parts and applied to the surface of the stiles of an oak cabinet or chest. Drawer-pulls and knobs at the top of chair backs were sometimes carved in a caricature of a human head; this type of finial ornamentation was known as *romayne work*. Carved Italian grotesques, face profiles, and the upper part of the human body, rising from a group of scrolls and leaves, were also used for furniture enrichment.

INTRODUCTION OF PALLADIAN INFLUENCE. Inigo Jones (1573–1652), the architect, was primarily responsible for introducing the Renaissance into England. Many Renaissance archi-

* Both of these features originated about 1565 in Flanders and are common to German, Dutch, and Flemish architecture, interior woodwork, and furniture.

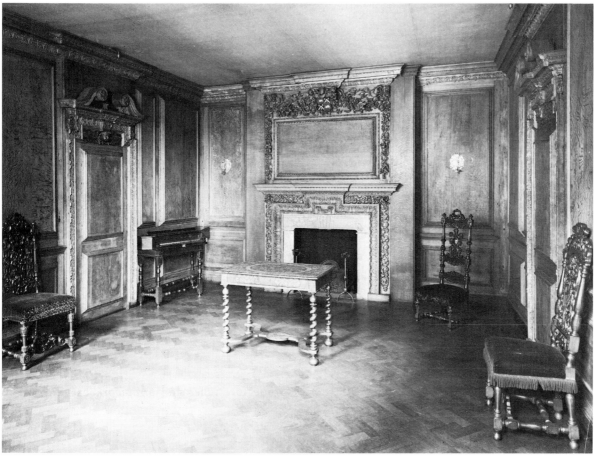

Victoria and Albert Museum

Restoration room showing the classical influence, with large bolection paneling, a tendency toward heaviness in detail, and carvings of the Grinling Gibbons type. From Clifford's Inn, London, about 1686.

tectural details and ornaments had been applied to English buildings before he entered upon the scene, but Jones's personality and his long studies in Italy of the works of Palladio made him a dominant figure in the English arts. His first designs were for the court masques and theater scenery in which the new style could be displayed without too much expense, but after 1640 he was able to apply his knowledge to the design of real structures. His most outstanding work was the great Banqueting House in Whitehall, London, the first English building where the classical architectural proportions as inter-preted during the Italian Renaissance were used in the correct manner.

INTERIORS FROM THE RESTORATION THOUGH THE MIDDLE GEORGIAN PERIODS (1660–1770). As a result of the accession of Charles II, of the Great Fire of London in 1666, of changes in social living, and of the desire to imitate the king in his introduction of French luxury, many dwellings, both large and small, were built, re-constructed, or redecorated. Jones was followed by Sir Christopher Wren (1632–1723), who had visited Versailles while the palace was under construction, and had made a careful analysis

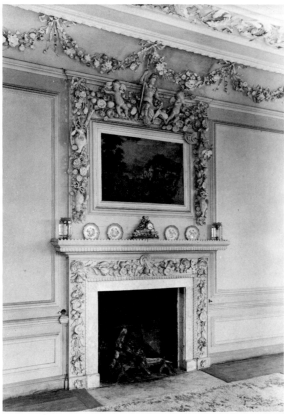

Country Life

Fireplace and overmantel designed by Grinling Gibbons at Dunsland.

of French design. In the face of such a classical architectural onslaught, all Gothic and Tudor forms completely disappeared from English decoration.

Under the Restoration, the walls of the majority of rooms continued to be treated with wood paneling, although the panels themselves were enlarged to run the full height of the room from the dado cap molding to the wooden cornice, after the manner of the new designs introduced at Versailles for Louis XIV. A small panel was also placed between the dado cap and the baseboard. The panels were rectangular, framed with a heavy *bolection molding* which permitted the field of the panel to project slightly beyond the stile. The wood, oak or walnut, was usually left in a natural waxed finish, although rich effects were sometimes produced by painting the woodwork to imitate marble. Where cheaper woods, such as fir and *deal* (pine), were used for the paneling, the wood was frequently grained to imitate walnut and olive wood. Moldings and ornament were sometimes gilded. Where wood paneling was not employed, the plaster walls were covered with stretched velvet or damask.

Door openings were formally treated with an architectural trim and complete entablature, including architrave, frieze, and pedimented cornice. Occasionally both door and window openings were framed in a heavy projecting bolection molding in marble or wood. Carved ornament on the moldings and cornice was customary in the more sumptuous interiors.

An innovation of the first years of the eighteenth century was the introduction of the built-in arched niche, which formed an important feature of the architectural composition of the room. The niche was usually decorated at the top with a large shell motif, and was lined with shelves for holding china and other ornaments. Many of these niches were framed—like door and window openings—and crowned with triangular or broken pediments.

During the latter years of the seventeenth and the early years of the eighteenth century, the work of Grinling Gibbons, the wood-carver, became popular in the enrichment of rooms of the period, and the character of his designs and modeling was adopted by artisans working in other materials, as well. Textile-weavers, stone-cutters, and decorative painters began to copy his designs. Gibbons was an unknown craftsman discovered in 1671 by John Evelyn, the diarist, who wrote, ". . . of this young artist . . . I acquainted the King and begg'd that he would give me leave to bring him and his worke to White-hall, for that I would adventure my reputation with his Majesty that he had never seene anything approach it. . . ." A few days later

Evelyn wrote, "This day din'd with me Mr. Surveyor Dr. Christopher Wren, and Mr. Pepys, two extraordinary and knowing persons.... I carried them to see the piece of carving I had recommended to the King." Thus we have the record of the start of Gibbons's success. After this introduction, Wren, who was employed in remodeling Hampton Court Palace, and other architects employed Gibbons extensively to ornament the woodwork of many buildings. Gibbons became particularly famous for his wood carvings of garlands, *swags*, and drop ornaments composed of natural objects realistically portrayed in high relief, minute detail, and with deep undercuts. The ornament was carved in fine-grained woods such as lime, box, and pine; it was then gilded, and nailed to the wood-paneled walls, and was generally used as an overmantel decoration or as a frame for portraits. The motifs reproduced included fruit, vegetables, game, fish, leaves, flowers, and other objects. The character of Gibbons's ornament continued to be used in English interiors long after his death in 1720. He had many imitators, and his designs practically dominated the ornament in English decoration for over fifty years. Gibbons, although believed to have been born in the Netherlands, was one of the most important characters in the history of the English decorative arts.

Ceilings in the smaller rooms were left plain. In the ceilings of more elaborate rooms, ornamental plaster moldings formed a border; the center portion received a painted decoration. The complex plaster motifs imitated the realistic detail of Gibbons's work. Italians, Frenchmen, and Hollanders were largely employed in both the modeling and painting.

Oriental pottery continued to be popular as a decorative accessory in the rooms of the Restoration. English and French tapestries hung in important panels. The floor was in parquet patterns in which oak, ebony, and other colored woods were used. Oriental rugs covered the

Charles II paneled interior showing use of Grinling Gibbons carving. Note plaster ceiling and influence of Gibbons style. Charles II chairs at table.

floor. Painted landscapes, hunting scenes, and mirrors were framed and placed on the walls, and the making of stump embroidery for wall hangings, and of needlepoint for upholstery materials, occupied the ladies of the household.

In the early years of the eighteenth century, the fireplace trim changed from the simple bolection molding to a complete classical architectural treatment, with dwarf columns, architrave, frieze, and a projecting cornice forming a mantelshelf. Marble was extensively used as a mantel material, and different-colored marbles were frequently employed in the design of the same mantel. The carved ornament was, as a rule, done in a white statuary marble, and its character was the bold, vigorous relief of Gibbons's inspiration. A warm, orange-colored

Metropolitan Museum of Art

Prospect of Greenwich Hospital designed by Christopher Wren. Originally it was intended as a palace for Charles II, but was afterwards converted for the use of disabled seamen.

Sienna marble and a dark green or Verde marble were used for the plain areas. The moldings and general proportions of these mantels were heavy.

Knotty pine, left in its natural color, began to be used for the wall panels, and wallpaper, as a cheap substitute for textiles, was introduced on plaster walls that had not been wainscoted. The first wallpapers were what are known as flock papers, made to imitate Italian cut velvets, and were introduced into England as early as 1634. Marble papers and papers imitating tapestry were also used, and, by the end of the eighteenth century, were replaced by pictorial and scenic papers of Chinese origin.

About the middle of the eighteenth century a romantic movement resulted in a revival of Gothic structures.* Horace Walpole's Straw-

berry Hill home was the most notable example, filled as it was with fan ribbed vaulting and tracery patterns and details of medieval tombs. The movement was extended later to garden design, which included sham Gothic ruins and later Turkish, Chinese, Moorish, and other exotic pagodas, colonnades, pavilions, sheltered seats, and *gazebos*.

FURNITURE OF THE RESTORATION PERIOD (1660–1689). The change in living conditions after the return of the monarchy in 1660 was reflected in the character of the furniture as well as in the interior treatment of the rooms. The tendency toward extravagance became widespread. John Evelyn wrote in 1673, concerning a visit to the home of an English countess, "She carried us up into her new dressing room . . . where was a bed, two glasses, silver jars, and vases, cabinets and other so rich furniture as I had seldom seen; at this excess of superfluity were we now arrived, and that not only at Court, but almost universally, even to wantonness and profusion."

Under Charles II, furniture was strongly in-

* Interest in Gothic design continued for a hundred years, was carried to the United States, and was in constant conflict with the classic influence of the Adam brothers and the later Greek revival of the early nineteenth century.

fluenced by both France and Flanders. The popularity, on the Continent, of walnut as a wood for cabinet use created a demand for this wood in England, where the tree had been a rarity. Intense cultivation of this wood developed from the middle of the sixteenth century, but it was not until the middle of the seventeenth that an English supply was available. Because of its novelty, therefore, its frequent use for furniture dates from the Restoration. As it was particularly subject to worm decay, its use was discontinued when mahogany became available, at the beginning of the eighteenth century. Walnut, however, did not displace oak entirely.

Furniture design under Charles began to show greater consideration for the comfort of the individual, as well as increased richness of form and ornament. The low relief carving of the earlier type continued to be used. The spiral turnings for legs and stretchers became much more frequent, and the most characteristic feature was the Flemish S- and C-curve, sometimes known as the *Flemish scroll*. Legs and stretchers, arm uprights, backs, aprons, and crestings were created with Flemish scroll arrangements.

The design of chairs underwent the most definite change. In addition to the use of the scroll, chairs were made with caning and covered by loose cushions. Elaborate upholstery textiles and leather, both plain and patterned, with heavy handmade silk fringes, were also used. The textile industry was greatly enlarged and perfected in England by the Huguenot immigrants after the revocation of the Edict of Nantes. Textile colors became particularly brilliant. Woodwork was gilded to some extent. The backs of large chairs were slanted for comfort. The wing-back was introduced, and was first called a "sleeping-chair," where the back could be inclined at several angles until horizontal, as in some versions of modern beach chairs. Stools and benches were also important pieces of furniture during Charles's reign, and they were made quite as elaborate as chairs. Romayne

work continued to be used as an ornamental feature of wooden chairs and other pieces of furniture.

Round tables were first introduced during the Restoration, no doubt because they afforded greater opportunity for conviviality. Smaller tables were also seen, and both marquetry and Japanese lacquer ornament were applied, although this type of enrichment did not reach its maturity until the latter part of the seventeenth century. Bookcases and gaming tables also began to be used at this time.

Firescreens were made in wood and painted to represent life-sized human beings dressed in the costumes of the day; these are called *fireside figures*. Lighting fixtures were made of iron, brass, and silver, and in large rooms, crystal chandeliers were hung from the center of the ceiling.

FURNITURE OF THE WILLIAM AND MARY PERIOD (1689–1702). When William the Hollander came to England as king, he authorized Wren to remodel and refurnish Hampton Court Palace. William had little knowledge of English traditional art, although Flemish influence had already begun to be felt in English furniture design when he arrived. William's tastes were simple, and were reflected in a tendency toward more delicate lines and proportions, with less carving than during the reign of Charles. The extravagances of Charles's reign also undoubtedly had much to do with the reaction toward more simple forms of furniture. Three changes in furniture decoration took place: (1) Thin wood veneers were applied to flat surfaces, permitting the grain of the wood its full glory of effect in panels and *cross-banding*. (2) Various forms of marquetry and of Japanese and Chinese lacquer work became more common. (3) The most important change, however, was the almost exclusive use of walnut as a furniture wood. The period of William and Mary is most characteristically known in English cabinetmaking history as the "Age of Walnut."

The Flemish scroll form gradually disappeared as a decorative motif. The legs of chairs and tables returned to the straight form. Some were square and tapered, after the French fashion of Louis XIV. Most of them were turned with large mushroom, bell, and inverted-cup turnings. Flat-shaped stretchers were usually used, and feet were made to imitate spherical or flattened balls—usually called bun feet. The *spiral leg* and *trumpet leg* were also seen in a variety of patterns. The marquetry used at this time frequently took the form of elaborate floral patterns. Colored woods and natural and stained ivory veneers added to the richness of effect. One type of marquetry design, representing minute rambling foliage, is known as *seaweed marquetry*.

Many new types of cabinets, clocks, writing desks, dressing tables, and bureau mirrors were introduced in William's reign, but the most important novelty was the *highboy*. This very characteristic piece consisted of a chest of four or five drawers supported by a table. The top of the chest was finished with a group of moldings recalling the classic entablature. The frieze of the entablature was usually in segmental form, and hid a secret drawer. The table support obtained its interest from an elaborately shaped *apron*, the curves of which carried down to the turned legs.

The furniture of the William and Mary period was usually highly polished. A few pieces, which were probably designed by Frenchmen, show carved ornamentations gilded to imitate the ormolu mounts of the French furniture of the period.

Daniel Marot, an engraver and designer, who in his youth had studied and worked under Mansart in France, had been obliged to flee that country after the revocation of the Edict of Nantes. He went to Holland and entered the service of Prince William III, of Orange, who had begun building his palace at Het Loo in Gelderland from French plans. Marot is known to have taken charge of this work in 1692, and designed the interiors and gardens, and also patterned some of the contemporary Delft pottery. About 1695, he moved to England and is known to have been employed in the design of Hampton Court, although his actual work is obscure and he was never mentioned by Wren. He is believed to have returned to Holland about 1697. His early training and reputation as an interior designer, however, probably strongly influenced his English contemporaries, and aided in the popularization of French and Dutch details of design.

Furniture upholstery materials continued to be made on the English looms set up by the French emigrants. Velvets, brocatelles, brocades, damasks, crewel embroideries, and needlepoint were used. The latter years of the seventeenth century saw the introduction of chintz as a decorative material for window and bed draperies.

FURNITURE OF THE QUEEN ANNE AND GEORGE I PERIODS (1702–1727). The early years of the eighteenth century ushered in the reign of Queen Anne, and her name has become associated with a style of furniture in the development of which she was neither interested nor influential. Many of her courtiers, her statesmen, and even the poorer people of England were beginning to take a very conscious interest in the comfort and appearance of their homes, and many of them were becoming collectors of various sorts. It has been said, relative to the importations of chinaware at this time, that everyone was "a judge of teapots and dragons." Chinaware covered every available shelf in many rooms, and was sometimes even hung on the walls.

Changes in the wall treatment of the rooms during the Queen Anne period were inconsequential. The style, which overlapped the reign of George I, was primarily one of furniture evolution. The products of the joiner and cabinet-maker were of great purity and beauty, and

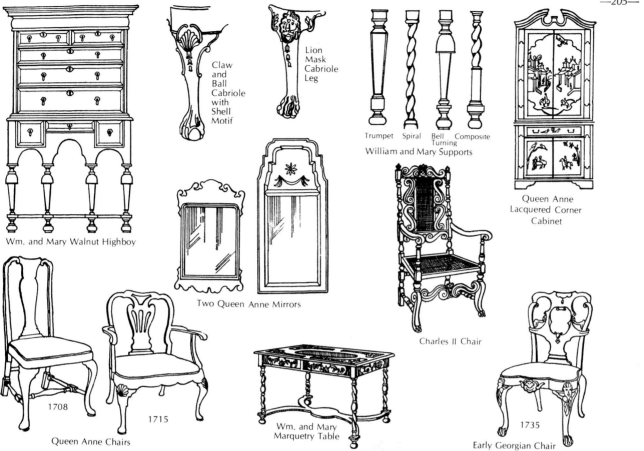

Claw and Ball Cabriole with Shell Motif

Lion Mask Cabriole Leg

Trumpet Spiral Bell Turning Composite

William and Mary Supports

Queen Anne Lacquered Corner Cabinet

Wm. and Mary Walnut Highboy

Two Queen Anne Mirrors

Charles II Chair

1708

1715

Queen Anne Chairs

Wm. and Mary Marquetry Table

1735

Early Georgian Chair

Characteristic examples of Restoration, William and Mary, Queen Anne, and early Georgian furniture.

once again showed, in turn, a complete reaction from the previous period of William and Mary. The principal characteristics were seen in the introduction of the curved line as a dominating motif in furniture design, in the first use of mahogany as a cabinet wood, in the introduction of Chinese forms in the structure of the furniture, and in the great development of the use of lacquer as a finishing material.

The curvilinear principle was most typically seen in the design of chairs, and its introduction was contemporaneous with similar forms in French furniture. The backs of chairs were given a curved top similar to a bent form, and

were made slightly concave at shoulder height. A splat was introduced in the center of the back which ran from the seat to the crest. The splat first obtained its interest only from its curved *silhouette* and beauty of grain. The frame of the seat of the chair was curved on the sides and front, and the legs were designed in a cabriole fashion, having a conventionalized knee-and-ankle form, and coming down to a pad or *clubfoot*. The cabriole form was undoubtedly inspired by Oriental designs, although it was much simplified in detail. The framework of the back of the chair near the top was frequently treated with one or two small

Queen Anne　　　　Yoke Back

Comparison of early eighteenth-century English chair backs. The yoke back indicates the beginning of the Georgian style.

breaks in the general sweep of the curve. These breaks are distinctly Chinese in origin. In armchairs, the arms also followed irregular curved forms.

The first change in the development of the Queen Anne chair was in the piercing of the splat with simple curved cutouts. The next was the addition of a small amount of carving, usually an acanthus leaf, on the shoulder of the splat, and the addition of a *scallop shell* motif on the knee of the cabriole leg. From this point the carving increased, and the splat of the back began to be pierced to a greater extent, forming a much more complicated design. The shell motif was then used in other portions of the chair, particularly in the front center of the seat frame and at the top of the back. At the same time, the clubfoot disappeared, and the *claw-and-ball foot* was introduced. This is supposed to have been taken from the Chinese symbol showing the dragon's claw clasping the "pearl of wisdom," and the English probably obtained the idea from the Dutch. Stretchers between chair legs were discontinued after 1708.

The elements of design used in the chair were applied to other types of furniture. Settees or sofas designed with two, three, and four chairbacks were introduced. Coffee, chocolate, and tea drinking became popular, and *tilt-top, piecrust,* and *gallery-top* tables for serving purposes were made in great numbers. China cabinets for side walls and corners were made to

display the collections of imported ware. Highboys were treated with a broken or scroll pediment at the top, and were made in natural mahogany finish or treated with Chinese or Japanese lacquer. The use of marquetry as an enrichment for furniture was gradually discontinued as walnut became unfashionable. Wall and table mirrors had frames in veneered woods; the lines of these were broken at the top with the same curves used in the chair backs. Cross-banding, although used to some extent during the preceding period, became more common during the reign of Queen Anne; it is a term used in veneering frames and panel borders, to indicate that the grain of the wood used in the veneer is at all places at right angles to the strip forming the frame or panel border itself. The glass for mirrors was usually made in two pieces, since there was a revenue tax on mirrors over a certain size. The edges of the glass were *beveled,* as with also the previous period of William and Mary. Case furniture, such as cabinets, bookcases, and secretary desks, had double doors with single panels that were designed with broken curves at the top.

The furniture designs known as Queen Anne greatly overlapped the early Georgian period. There is no exact line of demarcation. Many of the features introduced at the turn of the century were used until 1735. The early Georgian may be considered as the flowering of the more simple Queen Anne forms. There was evident a general tendency toward greater heaviness of structure, but the subtle curves, the natural beauty of the graining, the almost exclusive use of mahogany after 1733, and the irresistible charm of the increased carving contribute to the general opinion that the years between 1720 and 1750 produced some of the greatest examples of furniture ever made.

About 1725 occurred the "lion mask" period, in which this motif was placed on the knee of cabriole legs, or frequently used as a central motif on the apron of tables, consoles, and other

pieces of furniture. At the same time, the claw foot gave way to the lion's paw grasping the ball. Variations were seen in the use of satyr and human mask motifs as furniture feet. The Oriental element in furniture structure and finish became less common about 1725, and lacquerwork disappeared; Chippendale later revived Chinese forms during a short period.

Unquestionably, the influence of the architects Sir Christopher Wren, Batty Langley, and Abraham Swan had much to do with the introduction of classical architectural elements in furniture design. This tendency necessitated the gradual elimination of the curved line in structural and panel forms. Columns, fluted pilasters, and entablatures were once again used, with the broken or scroll pediment, in the center of which was usually placed a bust or other ornament. Mirror frames made of mahogany were frequently of architectural design, with pilasters at the side rising from pedestal moldings at the base, and crowned with a pediment; the carving on these frames was frequently gilded. At this time gilded gesso ornament was also applied in arabesque and scroll patterns to furniture frames and panels.

The claw-and-ball, lion's paw, duck, cloven hoof, grotesque mask, and scroll feet continued in use with the cabriole form of leg until about 1760. Low-built case furniture, such as bureaus and writing desks, was usually supported on *bracket feet* of varying forms and degrees of enrichment.

The splat-back chair also continued in popularity, although after 1725 the splat itself was elaborated to an extreme degree by means of piercing and carving. The tops of chair backs assumed what is known as the *yoke* form, and variations of the acanthus leaf and other types of foliage were substituted for the shell motif of the earlier part of the century. Wing armchairs and other forms of upholstered seats, stools, benches, and sofas became much more popular. Commodes, wardrobes, chests with

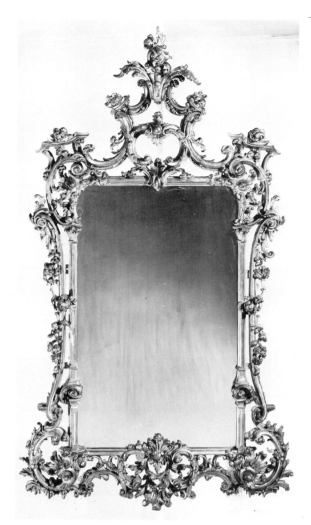

A Chippendale type carved and gilded mirror frame showing French rococo and Chinese influences.

drawers, wall tables, sideboards, dressing tables, and consoles were seen in most homes.

William Kent, architect and furniture designer, had an important influence upon English furniture between 1725 and 1750. His designs attained great popularity, although all of them showed considerable heaviness of effect. Most of them were architectural in inspiration, although a heavy cabriole leg form was generally employed. He designed many table supports for

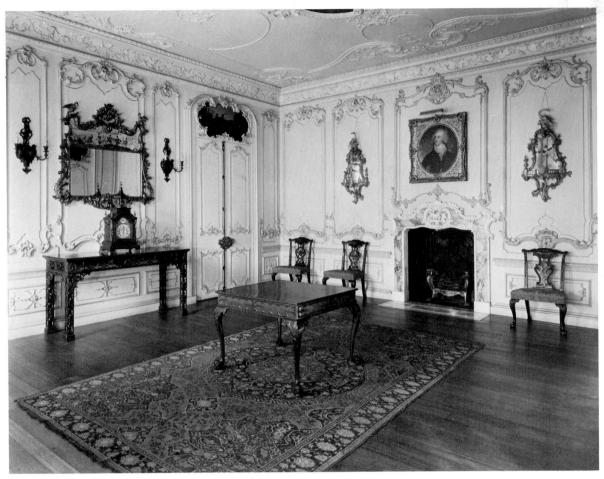

Museum of Fine Arts, Boston

A painted room attributed to Chippendale, but showing a strong French influence in the panel shapes.

boxlike lacquered cabinets that were in great demand at the height of the craze for Oriental importations.

The use of mahogany for cabinetmaking was of gradual growth. It was probably used in isolated cases in the late seventeenth century. In 1720 there was placed upon it a high import duty that was not removed until 1733. After that year its use grew to such an extent that all native woods were eliminated for cabinetmaking, except in the provincial districts. Mahogany was imported from Santo Domingo, Cuba, and Honduras. The importations from Santo Do-

mingo were considered the finest, and were of a dark, rich, red color. Mahogany trees grew to a very large size, and the wide boards that were available eliminated the necessity for veneered surfaces, which were particularly unsuitable for dining tables. The wood was free from worm attack, to which walnut was particularly subject, and, as it was also stronger than walnut, certain structural portions of furniture, such as the legs, could be made in more slender proportions. Although the graining was, perhaps, less interesting than that of walnut, mahogany could be carved for enrichment with greater ease. The

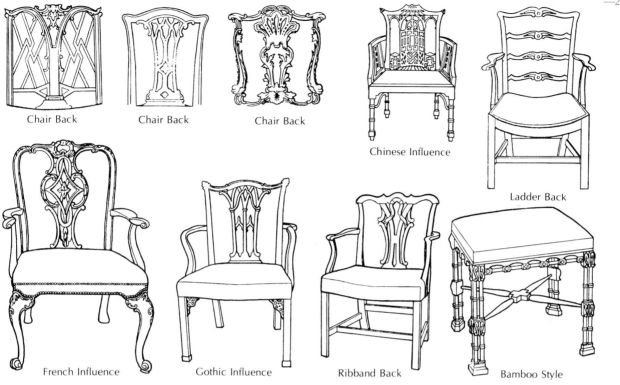

Chair Back

Chair Back

Chair Back

Chinese Influence

Ladder Back

French Influence

Gothic Influence

Ribband Back

Bamboo Style

Examples of Chippendale furniture.

popularity and advantages of this new wood were also among the causes of the decline in the use of marquetry.

ENGLISH WINDSOR CHAIRS. During the first quarter of the eighteenth century, a provincial type of chair was produced which later became known as the "Windsor." The origin of the design is unknown, but the type is supposed first to have been made by wheelwrights. The chair was based on the same principle as the Queen Anne form. The back splat, however, was not so gracefully silhouetted and often showed a small wheel in the center. Additional spindles flanked the splat; these are thought to have been wheelspokes. Some of the Windsor chairs had straight turned legs set at a slight splay, and others had typical cabriole legs. The seat was solid wood scooped to a slightly concave shape.

Farm and orchard woods were commonly used in the manufacture of these chairs, and many mahogany examples were also made. In the majority of Windsor chairs, several different woods were combined.

CHIPPENDALE FURNITURE. In the year 1754, the first edition of a book* named *The Gentleman and Cabinet-Maker's Director* was published by Thomas Chippendale, a furniture maker, who, having learned his craft from his father, also named Thomas Chippendale, had inherited a London cabinetmaking shop. The elder Chippendale had arrived from Worcester in 1727. Chippendale reached a higher pinnacle of fame than any other English cabinetmaker,

* A later edition was published in 1759 and an enlarged edition in 1762.

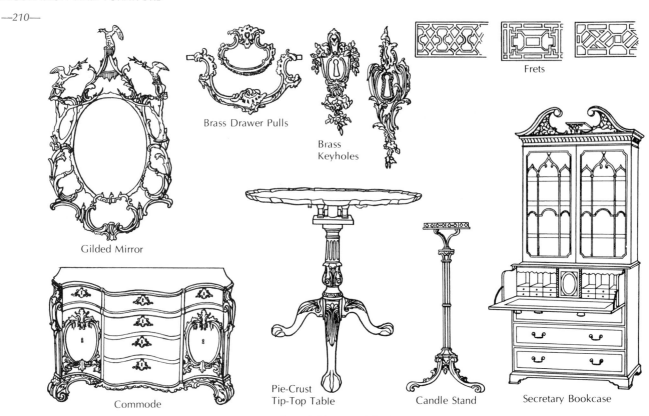

Brass Drawer Pulls

Brass
Keyholes

Frets

Gilded Mirror

Commode

Pie-Crust
Tip-Top Table

Candle Stand

Secretary Bookcase

Examples of Chippendale furniture.

and he is undoubtedly credited with accomplishing much more than he actually did, although his production must have been large for those days, as he had three shops in St. Martin's Lane. He was elected a member of the Society of Arts in 1760.* His book, which would today be called a trade catalogue, no doubt contributed greatly to the publicity given his work and name, and to the popularity of the styles of furniture shown therein. What Chippendale really did, however, was to capitalize upon the trend of the times. He took the furniture styles

that were prevalent, refined them to a certain degree, selected the finest woods, constructed his forms in a most perfect and solid manner, and, with a highly developed sense of salesmanship, unusual for his day, sold his products to the nobility and leading connoisseurs of cabinetmaking. The designs for his furniture were taken from many sources. Classic, French, Louis XV, Chinese, and Gothic forms and ornament were combined in most extraordinary harmony and unity. He worked almost exclusively in mahogany, although after 1765 he made a few pieces in satin, rose, and other exotic woods, and there are in existence a few painted, gilded, lacquered, and japanned pieces attributed to him.

The publication of his book brought hosts of imitators, and the local cabinetmakers in

* This was obvious proof of his position in the arts at this time, as others who were elected about the same period were Robert Adam; Boswell, the biographer; Benjamin Franklin; David Garrick, the actor; Gibbon, the historian; Samuel Johnson; Pitt; and Walpole.

every town in England were enabled to follow the fashions of London. Plagiarism was rampant, but Chippendale had invited it by giving instructions in the *Director* on the best methods of making his furniture. It has, therefore, become almost impossible definitely to identify furniture as having been made in the Chippendale shop, and the name *Chippendale* has been freely applied to the style in which he worked, although he did not originate it. Leading authorities on English furniture attribute specific pieces to Chippendale only providing the original bills of sale are in existence, and these are pitifully few.

The Chippendale designs are seen at their best in chairs, although all types of furniture were made, from insignificant washstands to magnificent bookcases, desks, chair-back sofas, clocks, organ cases, four-poster beds, piecrust and gallery-top tables, sofas, benches, consoles, mirrors, and dining and serving tables. Motifs in such great variety were used for ornamentation that it is difficult to classify them.

In the earlier work of Chippendale, the chair, stool, and chair-back sofa showed a great similarity to the early Georgian development of the Queen Anne type. The cabriole leg with carved foot and the elaborated splat back with a yoke form at the top were characteristic. He undoubtedly made much furniture before his *Director* was published, and, although no proof exists, he probably also used the claw-and-ball foot in many pieces. In the later work of Chippendale, the straight leg, known as the *Marlborough* form, was used, and intricate backs imitating Gothic tracery were introduced; Chinese latticework, bamboo forms, ribbon, and rococo motifs borrowed from Louis XV furniture, and ladder slats designed in graceful curved lines were also used. Greek and Chinese foliage, fretwork, flutings, paterae, husks, and cartouches were the principal ornaments. In his earlier work, in which the cabriole form of support was frequently used, the scroll foot, similar

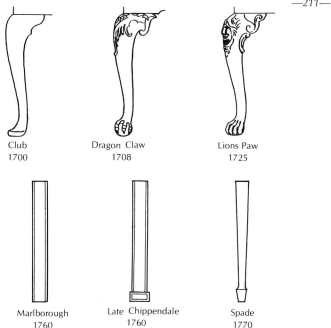

Club
1700

Dragon Claw
1708

Lions Paw
1725

Marlborough
1760

Late Chippendale
1760

Spade
1770

The development of the eighteenth-century English chair leg giving approximate date of the introduction of the various forms.

to the French rococo form, is often seen, although a great variety of foot designs was produced. No claw-and-ball foot is shown in the *Director*, and, while Chippendale may have used the feature before his book was published, it is probable that other contemporary cabinetmakers were responsible for the continued use of this typically Queen Anne detail. When Chippendale began to use the straight leg for his chairs, he added stretchers for greater strength. Chippendale designs ranged from the extreme rococo to classical severity. There are many designs in the *Director* that are so fantastic in conception that it is hardly possible that they were ever manufactured, and they were probably introduced for purposes of prestige. Undoubtedly he made many simple pieces to fulfill the needs of a less wealthy clientele, but these were not publicized.

Furniture designs in the Chinese manner have been given the specific name of *Chinese Chippendale*. While these influences are visible in many pieces, they are of unusual interest in the mirror frames, where French rococo forms were combined with Chinese figures. The frames were generally gilded and served to show the astonishing ability of Chippendale as a master of curved line; the most fantastic forms and irregular shapes were composed to produce an extraordinarily unified whole. Wall mirrors and overmantel designs were the usual types in which this decoration was prevalent. During the last years of Chippendale, his workshop was given over to making, in cooperation with the Adam brothers, furniture in which the more restrained classic forms predominated, and straight lines took the place of the early Georgian types. Furniture made under the Adam influence is considered his best. This began about 1758, and the style lasted a full quarter-century. The florid style, however, overlapped the classic to a great degree, and no exact date may be given as to when the change occurred. In general, most examples of Chippendale's type of work tend to heaviness of structure and proportion, which accounts for their durability.

The designs of Chippendale were copied extensively in both Scotland and Ireland. The Scotch craftsmen were proficient in their reproductions. The Irish, however, were more playful in their interpretation of Chippendale's work. Both the proportions and the ornament of "Irish Chippendale" furniture were less sophisticated than in the original examples.

Chippendale had a son, also named Thomas, who carried on the cabinetmaking business until his death, in 1822. The firm was of less importance, however, after the death of the father, in 1779. With grandfather, father, and son all of the same name, the Chippendale influence covered a period of nearly a century of English cabinetmaking. The use of mahogany lasted from about 1710 to 1770; this period has been called the "Age of Mahogany." There is much furniture in existence today that bears Chippendale's name, but very little that bears his credentials, and most of the pieces called Chippendale are not shown in the *Director*.

THE PUBLICATION OF ART BOOKS. Chippendale had not been the first to issue a book of furniture designs. William Jones had published one in 1739, Copeland in 1746, and other books covering the subjects of interior woodwork, mantels, cornices, and moldings had been published by Langley and Swan, but Chippendale's book had brought him such success that many cabinetmakers immediately followed suit. In 1762 Ince and Mayhew published *The Universal System of Household Furniture*, showing designs remarkably like those of Chippendale, that were described on the title page as "Designs in the most elegant taste." In 1765 Manwaring published *The Cabinet and Chair Maker's Real Friend and Companion*, the designs of which showed rococo forms carried to excess. Illustrations of iron garden furniture were also shown in this work for the first time. Robert and James Adam published three volumes on classical architecture in 1773. This was largely of the Pompeian type.

FRENCH INFLUENCES. The influence of France was seen in English furniture during the whole of the eighteenth century, and as French furniture tended to more delicate proportions during the first quarter of the century, similar characteristics became popular in England. The later work of Chippendale shows distinct signs of this trend, but it was left to other cabinetmakers to carry lightness of line to its final perfection.

Toward the end of the eighteenth century many English cabinetmakers openly copied French furniture of both Louis XV and Louis XVI types. This was particularly true of Hepplewhite and his imitators. The difference between the English work and the French (as in all cases where copies are made) was that proportions

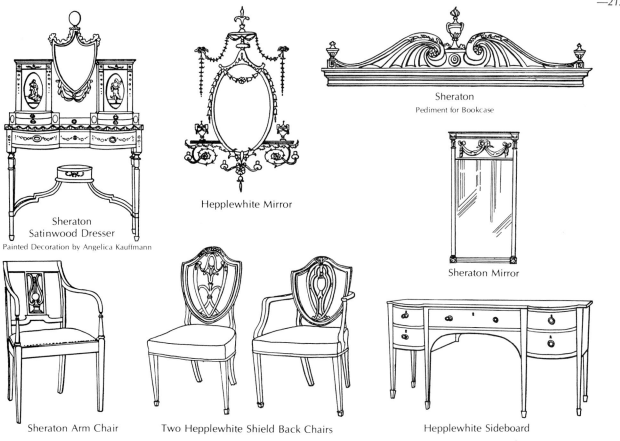

Sheraton
Pediment for Bookcase

Sheraton
Satinwood Dresser
Painted Decoration by Angelica Kauffmann

Hepplewhite Mirror

Sheraton Mirror

Sheraton Arm Chair

Two Hepplewhite Shield Back Chairs

Hepplewhite Sideboard

Examples of Hepplewhite and Sheraton furniture.

were not so carefully analyzed, with a resultant clumsiness of effect when placed side by side with an original French piece. Even an expert, however, is sometimes deceived in the identification of such pieces.

HEPPLEWHITE FURNITURE. George Hepplewhite, who made furniture in London as early as 1760, was the leader of the reaction toward delicacy of line and proportion in home furnishings. He frequently cooperated with the Adam brothers, producing furniture that they had designed. He died in 1786, but his business was carried along for a few years by his wife, Alice, who in 1788 published his posthumous work, *The Cabinetmakers' and Upholsterer's Guide.*

Hepplewhite is credited with two features of English furniture design: the popularizing of satinwood after 1765 and the use of painted motifs as a means of surface enrichment. The last quarter of the eighteenth century and first quarter of the nineteenth are sometimes called the "Age of Satinwood."

Hepplewhite's furniture was, in most cases, weak in its construction. This was partially because of the slender proportions of the design, and partially because many of the pieces were veneered on soft wood carcases. What the furniture lost in strength, however, it made up most substantially by its extreme grace and elegance, its beauty of color and enrichment, and its ex-

ceptional charm and loveliness. There are no authenticated examples of furniture made by Hepplewhite in existence.

The chair was the most typical example of Hepplewhite's designs, and the forms and ornament used in that piece were seen in nearly all other pieces. Both mahogany and satinwood were used. The legs were always straight and slender, were either round or square, tapered toward the foot, and sometimes ended in what is known as a spade, thimble, or sabot form. Five different types of backs were used: shield, camel, oval, heart, and wheel. Carved ornament was sparsely applied, and consisted of wheat blossoms, oval paterae forms, ribbons, fluting, *reeding*, vases, and festoons. Painted decorations showed the three-ostrich-feather crest of the prince of Wales, natural flowers, and classical figures in the style of Angelica Kauffmann, the painter. Marquetry was frequently seen in tulip, sycamore, yew, holly, pear, ebony, rose, cherry, and kingwood.

The top rail of the shield chair back was in the form of a serpentine curve. This curve was frequently seen in other types of furniture. The shelf of Hepplewhite sideboards, table, and console tops were usually made in this form. The testers of four-poster beds had a similar shape, and pediments and aprons on case furniture followed the same line.

Contemporaries of Hepplewhite were Gillow and Shearer. Shearer designed many pieces of furniture that fulfilled two purposes, such as chairs that opened into ladders, cabinets that were folding beds, and a firescreen that contained a writing table.

SHERATON FURNITURE. Thomas Sheraton, the third great name connected with English furniture design, ranks with Chippendale and Hepplewhite. Born about 1751, he was self-educated, became a preacher and a scholar, wrote religious tracts, studied mathematics, and tried his hand at almost everything. He arrived in London from Stockton-on-Tees in Durham

about 1790, published *The Cabinet-Maker and Upholsterer's Drawing Book* in 1791, and unquestionably designed much furniture that was made by other cabinetmakers. Leading authorities claim that he made no furniture himself after he arrived in London. After the publication of his book, however, his influence was enormous, and although he borrowed design forms from everywhere and everybody, he has been given credit for creating a furniture style. Many of his designs were of unusual originality and showed great inventive genius.

Sheraton designed furniture to be made in the same woods as had Hepplewhite, but the straight line dominated to a greater extent than in the designs of his predecessor. The serpentine form was replaced by segmental curves or surfaces that were connected by straight lines or flat areas. He worked in conjunction with the Adam brothers, Wedgwood, the potter, Angelica Kauffmann, the painter, and others. He was the first in England to use *porcelain* plaques for furniture ornamentation.

The Sheraton chair legs were the same as those of Hepplewhite. The chair backs, however, were rectangular in shape. The rear legs of the chair usually continued upward to form the side braces of the back. A horizontal rail was placed near the seat, between the two back uprights, and an ornamental rail was placed at the top. The space between the rails was filled with one or more ornamental splats, the center one often having the form of an elongated vase. Many of Sheraton's designs were for very small pieces of furniture suitable to the dressing room and boudoir. Dining room furniture was also his specialty. His book showed designs for twin beds and for Pembroke (drop-leaf) tables. Sheraton also seemed to be interested in designing folding furniture for double purposes and cabinets with secret compartments. He paid great attention to the design of the complicated mechanical contrivances that served to operate secret locks.

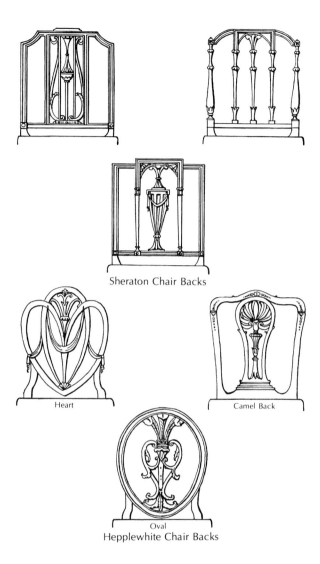

Sheraton Chair Backs

Heart

Camel Back

Oval

Hepplewhite Chair Backs

Comparison of Sheraton and Hepplewhite chair backs.

As 140 cabinetmakers in England and America subscribed to the various editions of Sheraton's book, it is no wonder that his style became popular. The Sheraton designs for chair backs have probably been imitated more than any others by modern manufacturers.

The latter portion of the Sheraton period was influenced by the French Directoire and early Empire, in which the delicate curves of Greek design were introduced into English furniture.

INTERIORS OF THE ADAM OR NEOCLASSIC PERIOD (1762–1794). The last half of the eighteenth century was signalized by investigation of everything concerning classical antiquity and its possible adaptation to contemporary use. The fashion for imitating the Italians, French, and Dutch had spent itself. The discoveries of the ruins of Pompeii and Herculaneum interested not only the rich, who traveled to Rome, Pompeii, and Athens, but the enterprising artists and architects who had been busy in the excavations. Stuart and Revett's *Antiquities of Athens* was published in 1762, and drawings of the temples in Paestum were made in 1768. This book eventually was to change completely the architecture and decorative arts of Europe and America by a return to Greek classicism after two centuries of Italian Renaissance influence. Classic forms became a standard of design, not to be copied exactly, but to be applied with such limitations of economy or technique as modern conditions would permit. In fact, the English were ahead of the French in adopting the classic inspiration, and when the movement reached its climax, the aristocrat, merchant, and tradesman, from the design of their dwellings to the smallest article of household furnishing, demanded and obtained classic precedent.

The leaders during this period were Sir William Chambers, Robert and James Adam, and Sir John Soane, architects, and Henry Holland, decorator. These men were creditably followed by a host of lesser artists. Since many books on the subject of contemporary art were published, the styles of this period spread rapidly, not only over the whole of the British Isles, but to the American colonies, as well.

An interesting feature of this period of British decoration is the fact that in it for the first time a conscious effort was made to obtain complete unity of effect in every form, orna-

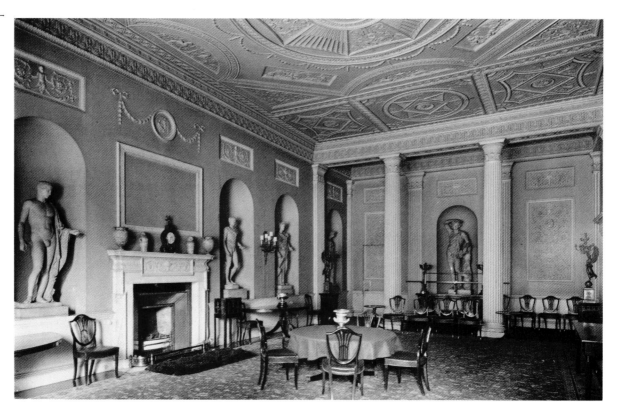

Room from Landsdowne House, London, now in the Metropolitan Museum of Art in New York. Designed by Adam, it shows the characteristic plaster niche, inspired by Roman interiors, and the profuse use of composition ornament in panels and ceiling.

ment, or object used in a single room. Robert Adam, who was the dominant figure in the artistic life of England for two decades, after having designed the walls and ceiling of a room, proceeded to design practically every article of equipment, including furniture, floor coverings, lighting fixtures, textiles, silver, pottery, and metalwork.

The general character of the rooms of the last quarter of the eighteenth century, and particularly of those attributed to the Adam brothers, showed great formality of design. The Adams themselves had made excavations and measured the ruins of Diocletian's palace in Spalato, Dalmatia, the results of which they published in 1763; they had become strongly imbued with the true classic spirit in contrast to the Italian Renaissance interpretation of antique forms. Both the exterior and interior of each Adam building reflected this enthusiasm. As royal architects, the Adams had many commissions of unusual importance which required monumental treatment with an extensive use of the orders. In only a few instances were columns or pilasters entirely omitted from an interior wall treatment, and in these cases an architectural effect was obtained by means of an entablature, arch forms, domes, and panels ornamented with classical motifs. The semicircular arched wall niche, a very common Adam feature of design, was used to frame a plaster cast or marble reproduction of an antique statue or urn.

Many of the Adam rooms had semicircular, segmental, or octagonal end walls treated with architectural orders. This was copied from old Roman prototypes.

Although Chambers and the Adam brothers were the great minds in the arts till nearly the end of the eighteenth century, their followers, designing less monumental work, produced many delightful smaller buildings and interiors.

The exclusive use of wood paneling for rooms was discontinued after the middle of the eighteenth century. Plaster walls took the place of it. In the occasional examples of wood walls, the paneling was much simplified, with small *ogee* moldings separating the stile from the panel, and the wood itself was painted. The plaster walls were sometimes left white or painted a pale color. Sunk plaster panels or panel effects, produced by applied plaster moldings, were commonly introduced. But as such moldings were pure decoration and had nothing to do with the structure of the wall finish, the panels could be separated from each other much further than in the case of wood panels, and an entirely different effect was obtained from that in a wood-paneled treatment.

Marbling and graining of both plaster and wood were frequently resorted to. Plaster panels were also occasionally enriched by the introduction of a delicate arabesque in plaster relief. This was particularly typical of the work of the Adam brothers, who had become enamored of gesso ornament during their studies in Italy. The plaster relief ornament was usually left white to contrast with the colored background.

The architectural orders that were used were those which followed the more slender proportions of the Pompeian types. The majority of the rooms had complete entablatures with delicate moldings. The moldings and friezes were enriched by painting or plaster ornament inspired by Greek or Pompeian detail. The vase form, fret, and honeysuckle were particularly used.

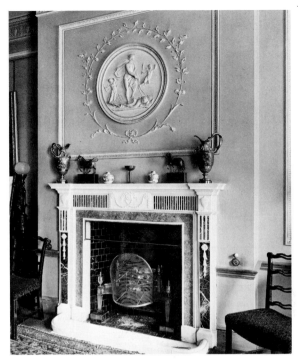

Adam mantel from Portland Place, London, showing overmantel treatment of classical medallion surrounded with composition ornament and applied plaster moldings.

The mantels designed by the Adams were very beautiful and eventually came to be the inspiration of many mantels used in the American colonial rooms. The architectural mantel consisted of an entablature with a wide projecting cornice forming a shelf, which was supported at each side by a decorative feature. This type had been used during the early eighteenth century. The Adams continued the principles of this design but slenderized the proportions of the details. The frieze under the projecting shelf was often in two different colored marbles, and a center panel was carved with delicate classical figures. Sometimes the frieze was treated with a series of vertical flutings. The supports at the side were pilasters or columns with the Greek Ionic or Pompeian Corinthian capitals. The

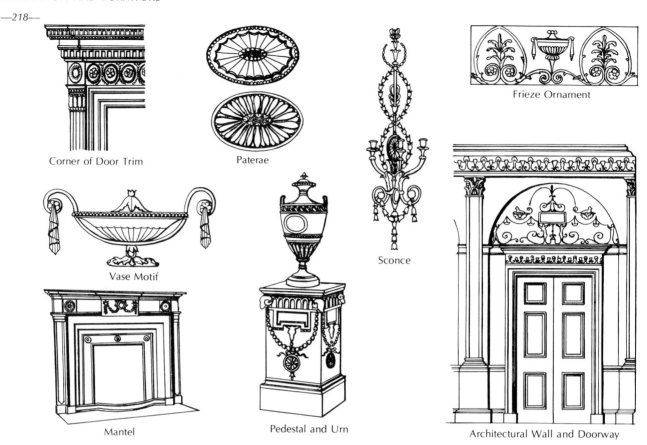

Corner of Door Trim

Paterae

Frieze Ornament

Vase Motif

Sconce

Mantel

Pedestal and Urn

Architectural Wall and Doorway

Examples of Adam architectural details and ornament.

caryatid was also used. Wood, usually pine, was often used; the ornament consisting of classical vase forms combined with garlands, *paterae*, or delicate rinceaux made in either gesso or cast lead. The woodwork was usually painted, but sometimes it was left in its natural color.

Ceilings were always in plaster. In small houses, the ceilings were plain and flat, but in the more pretentious rooms a great deal of cast plaster ornament was arranged in straight moldings and arabesque forms. The general effect was one of delicacy and refinement in contrast to the heavy ornamental forms of the Restoration period. In palatial rooms the ceilings were painted by well-known artists.

Robert Adam published a book of furniture designs which were improvements upon designs originated by the Italian Piranesi and first published in a book that the latter had dedicated to Adam. Many of Adam's designs for furniture were influenced by his architectural training. A good many designs were for very large pieces that were in scale with the palatial rooms Adam had created for his clients. When Adam commenced to cooperate with Chippendale, Hepplewhite, and other cabinetmakers, smaller pieces were produced. Because of this joint working-out of the problems of furniture design and style, it is very difficult to designate the original creators of much of the furniture of the last quarter of the eighteenth century. Certain definite ornaments that have been commonly at-

Robert Adam was not a chair designer. He was particularly noted for his designs for sideboards, side tables, settees, cabinets, and bookcases. He is credited with having developed the English sideboard as it is known today. The original sideboard table flanked by two separate pedestals was eventually made in one piece and raised on tapered legs. This occurred about 1775, and the earliest known example is of Adam design.

Bossi, an Italian who worked under Adam, developed the stone intarsia or colored patterns inlaid in marble by means of other colored cement. This material was used for table and console tops in the more elaborate examples of furniture.

The influence of Adam in the English decorative arts is nearly equaled by his influence upon American colonial architecture. The best of the postcolonial structures in the United States were based upon Adam taste and principles.

THE ADAM BROTHERS' INFLUENCE UPON OTHER ARTISTS. The Adam period is particularly noted for the influence that Robert and James Adam had upon artists and designers of decorative accessories. The most pronounced effect was on the furniture designers, Chippendale, Hepplewhite, and Sheraton. Josiah Wedgwood made lovely jasper porcelain plaques, medallions, vases, and tableware that were designed by John Flaxman and other competent sculptors to harmonize with the lovely Adam interiors. The work of the Italian painters Pergolesi, Zucchi, and particularly of Angelica Kauffmann, who was of Swiss origin, covered the walls, the overdoors, overmantels, and furniture of this period with the most delightful groupings of mythological figures, Italian landscapes, and paintings of the ruined temples of Greece and Rome.

Classical figures played an important part in the designs of all types of craftsmen. Marble-worker and plasterer, wood-carver, textile de-

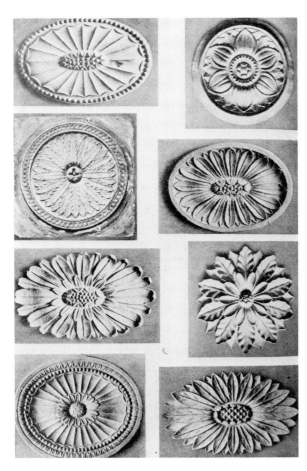

Adam Paterae motifs.

tributed to the Adam brothers were used in pieces made by others. Robert and James Adam were never cabinetmakers themselves, with the result that pieces in which cooperation is evident are called by the terms *Adam-Chippendale* or *Adam-Hepplewhite*. Sheraton, too, was greatly influenced by the Adam style, and he may have designed furniture influenced by the Adam motifs and designs.

The most characteristic ornaments popularized by Adam were the Grecian honeysuckle and fret, the fluted frieze or apron, the patera and rosette, the husk, and the several forms of urns. Husks were arranged in swags or drop ornaments and were frequently tied with ribbons.

Metropolitan Museum of Art

Etching from Robert Adam's The Works in Architecture *of the Earl of Derby's drawing room in Grosvenor Square London, 1778.*

signer, and painter turned to classical mythology and represented Mercury, Achilles, Cupid and Psyche, and the Muses.

The typical marble mantel that was characteristic of the Restoration period continued to be used during the whole of the eighteenth century. During the latter third of the century, however, moldings were made smaller, and the character of the carving followed the trend toward delicacy of detail.

On wooden mantels, composition and lead ornament was applied to the frieze under the shelf. Doors and windows were architecturally treated with slender pilasters and narrow entablatures.

Lighting fixtures consisted of crystal chandeliers and of delicate bronze and silver lanterns, *sconces,* torchères, and candelabra.

THE INCREASE IN THE USE OF ACCESSORIES. During the eighteenth and early nineteenth centuries the use of decorative accessories greatly increased. After the collection and exhibition of Oriental and domestic china became the rage, delftware was imported from Holland and Meissen ware from Germany, and the productions of the English Lowestoft, Chelsea, Derby, and Wedgwood factories were pushed to their highest point of perfection. Pictures consisted not only of portraits and figure paintings by Gainsborough, Romney, Reynolds, Lawrence, and Raeburn, but of landscapes and sporting subjects, as well. Processes of pictorial reproduction were introduced, and the use of *engravings, aquatints,* and *mezzotints* became common. The works of Hogarth, Morland, Constable, Sartorious, Alken, and Wolstenholme were particularly in demand. Other accessories included mirrors of a great variety of designs, clocks, statues, and busts in both marble and bronze.

MINOR INTERIORS OF THE LATE EIGHTEENTH CENTURY. In the simpler country houses of the late eighteenth century, furniture was comparatively scarce, considering the great amount that was used in the homes of the wealthy. Records show that the country parlors were furnished with a table, a tall clock, a looking glass, and a few chairs. Upholstered chairs were far from common. On the mantelshelf stood two candlesticks and a pair of snuffers. Box beds, with sliding doors to keep out the air at night, were the custom. All cooking was done on turnspits that were operated by dogs trained for that purpose. The dining rooms had tables, chairs, and sideboard tables, with pedestals surmounted by vases used as water coolers or knife-holders.

THE REGENCY PERIOD (1810–1820). With the regency period, English furniture design commenced its decline. Originality and quality lessened. Great masterpieces in this art had been produced during the second half of the eighteenth century, but by 1810 the creative genius of the English cabinetmaker atrophied. Imagination became exhausted. The French Empire style, glorifying Napoleon, had become antipathetic

Painted plaster walls, characteristic of Neoclassic and Regency styles, in Woodhall Park (1782).

to the British, but its splendor and its source could not fail to have their appeal. After all, Trafalgar and Waterloo had maintained the English prestige. The public, however, was fast losing its taste and becoming insensible to simple beauty. Imitation of former periods began, as the national initiative became concentrated on commercial enterprise.

Lacking better inspiration, the cabinetmakers embraced the classical forms with undivided enthusiasm. The honeysuckle, the klismos chair back, the Greek curves, the cornucopia, and other features of antiquity were not only adopted, but exaggerated to a point of ultra-classical affectation. Egyptian motifs were introduced. The forms became clumsy, almost vulgar. Ornament seemed at times to submerge the structure or to be completely unrelated to it.

Supports appeared unstructural, and construction was cheapened.

During the regency period, under the influence of Sir John Soane, the forms of Greek antiquity influenced the designers to a greater extent than did those of Pompeii. A reaction occurred from the extensive use of the plaster ornament of the Adam period. Wall surfaces were mainly in plaster, painted in rather strong dark colors, such as browns and deep reds. The heavier Greek Doric and Ionic orders were used. Ornament was largely limited to a conservative use of the honeysuckle and fret. Simplicity and severity became the keynote, although dignity

Country Life

Fan-vaulted dining room from Arbury showing Gothic revival in the late eighteenth century.

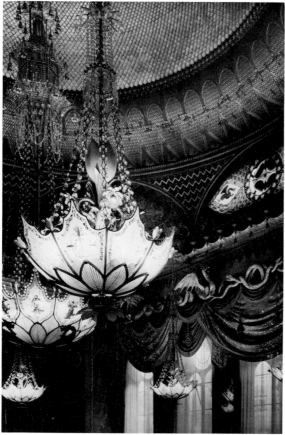

Edwin Smith

Interior detail from the Brighton Pavilion (1815) by John Nash, exemplifying the exotic "Hindoo"-oriental taste of the Regency period.

and charm were maintained. Marble busts of classical heroes and philosophers ornamented the rooms, often standing on short portions of column shafts.

THE VICTORIAN PERIOD (1837–1901).* The forms of the regency style continued until the time of Victoria, who ascended the throne when still a young girl. Her straitlaced early education was reflected in her later official acts, and her punctilious life served as an example for her people. Her interest in art was negligible, reflecting the dormant spirit of the times concerning this subject. Fashion demanded novelty, however, and furniture producers, in their mental stagnation, turned to all periods of the past for inspiration. This movement lacked intelligence, carelessly avoided both the spirit and the accuracy of detail of the original, and to a large extent intermingled the most incongruous styles and motifs.

After 1830, Greek, Turkish, Gothic, Venetian, Florentine, and Egyptian motifs were used indiscriminately as inspiration for furniture designs. The French Louis XV style, however, was probably the strongest influence, and in most cases clumsy proportions and fantastic gingerbread ornaments were used to reproduce it. Occasionally, inexpensive pressed metal ornaments were gilded and applied to the furniture. Mother-of-pearl inlay was sometimes used on tabletops in naïve floral patterns. The popular woods were black walnut, mahogany, ebony, and rosewood. Fruit, flowers, leaves, and nosegays were among the motifs used for carving. *Papier maché* furniture was introduced.

The entire output of the Victorian period, however, is not to be condemned. Occasional pieces of great beauty were produced, and several efforts were made with variable success to break away from the pall of aesthetic stagnation. Charles Eastlake, Jr., made an unsuccessful and unfortunate effort about 1865. His interiors were based upon Gothic detail, with varnished oak, glazed tiles, touches of black lacquer, and little thought of color harmony. John Ruskin and William Morris led the revolt toward the end of the century. To Morris is accredited the invention of the morris chair, though its antecedent is found in the Restoration "sleeping chair," the back of which also may be put at several inclining angles.

The most creditable industrial art development during the Victorian period took place in

* See also American Victorian period, page 264.

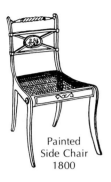

Painted
Side Chair
1800

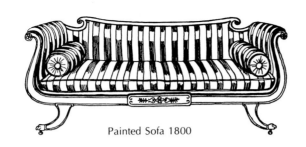

Painted Sofa 1800

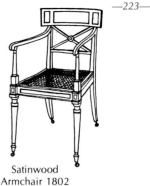

Satinwood
Armchair 1802

Examples of early nineteenth-century furniture.

the production of chintzes. Textile designers carried on the traditions of the best periods of earlier work, but with direct appeal to the flower garden, the field, the brookside, and the meadow for their design sources. These natural forms were reproduced in bright colors and did much to redeem the otherwise drab character of the period.

LEADERS IN THE ARTS OF ENGLAND

Architects, Painters, Decorators, and Craftsmen

Adam brothers: Robert (1728–1792), James (1730–1794). Designers in the neoclassic style. Known for architecture, interior architecture, and furniture.

Bromwich. Wallpaper manufacturer under George II.

Chambers, Sir William (1726–1796). First treasurer of the Royal Academy. Author of *Treatise on the Decorative Part of Civil Architecture.* Adhered to Palladian tradition during the Greek revival. Shares honors with Chippendale in adapting Chinese forms to furniture, after traveling in the Orient.

Cipriani, Giovanni Battista (1727–1785). Italian decorative painter during the Adam period.

Columbani, Placido (eighteenth century). Italian architectural designer of the school of the Adams and of Pergolesi.

Constable, John (1776–1837). Landscape painter.

Eastlake, Charles L., Jr. Architect and furniture designer. Advocate of Gothic revival. Wrote *Hints on Household Taste* in 1868.

Flaxman, John (1755–1826). Sculptor and draftsman.

Gainsborough, Thomas (1727–1788). Portrait painter of English nobility.

Gibbons, Grinling (1648–1720). Wood-carver and sculptor.

Gibbs, James (1682–1754). Architect and furniture designer. Published architectural designs in book form. Follower of Wren. Designed St. Mary la Strand, London. Most famous work is Radcliffe College, Oxford. Also designed interior architectural features, such as mantels.

Halfpenny, William (eighteenth century). Architect, influential in popularizing the Chinese taste in architecture and decoration.

Hogarth, William (1697–1764). Satirical painter of middle-class life.

Holland, Henry (1740–1806). Decorator and architect.

Jones, Inigo (1573–1652). Architect who introduced the Palladian style of architecture into England.

Kauffmann, Angelica (1741–1807). Swiss decorative painter of furniture and interiors who worked in England. Wife of Zucchi.

Kent, William (1685–1748). Collaborated with his patron the earl of Burlington in the design of Chiswick House, Chiswick, known as the Palladian Villa. Painter and landscape gardener, architect and furniture designer.

Langley, Batty (early eighteenth century). Architect and designer.

Lawrence, Sir Thomas (1769–1830). English portrait painter.

Nash, John. One of the foremost architects of the regency period.

Pergolesi, Michael Angelo (late eighteenth century). Decorative painter, architect, and furniture designer.

Piranesi, Giovanni Battista (1720–1778). Italian engraver whose engravings of ancient Roman monuments were imported into England and there influenced the designs of the architects.

Raeburn, Sir Henry (1756–1823). Scottish portrait painter.

Reynolds, Sir Joshua (1723–1792). Portrait painter of the English court and the first president of the Royal Academy of Painting and Sculpture.

Romney, George (1734–1802). Historical and portrait painter.

Soane, Sir John (1750–1837). Regency architect.

Swan, Abraham (early eighteenth century). Cabinetmaker known for his mantels, door and window trim, and staircases.

Wedgwood, Josiah (1730–1795). Staffordshire potter who established the Wedgwood works.

Wren, Sir Christopher (1632–1723). Inventor and astronomer. Architect after 1666; designed St. Paul's Cathedral in London.

Zucchi, Antonio Pietro (1726–1795). Venetian painter who did decorative paintings for interiors.

Pre-Raphaelite Brotherhood (second half of the nineteenth century): Burne-Jones, Sir Edward; Hunt, William Holman; Morris, William; Rossetti, Dante Gabriel. This group, with John Ruskin, revolted against the mechanization and eclecticism in the arts of the Victorian era and the decline in craftsmanship. They started a movement back to Italian primitives, to nature, and to hand production in the crafts.

Cabinetmakers

Bradshaw, George and William (active 1736–1750). Cabinetmakers and upholsterers.

Chippendale, Thomas I (early eighteenth century). Cabinetmaker and father of Thomas II. Went to London from Worcester in 1727. Some authorities claim that this Chippendale's Christian name was "John."

Chippendale, Thomas II (1718–1779). Cabinetmaker and furniture designer. Published *Gentleman and Cabinet-Maker's Director* in 1754. Native of Otley in Yorkshire. Was under influence of Adam brothers from 1770–1779.

Chippendale, Thomas III (1749–1822). Son of Thomas II. Carried on his father's business with Thomas Haig, but became bankrupt in 1804. Worked mostly in the regency style.

Cobb, John (d. 1778). Partner of William Vile from 1750 to 1765. Worked alone starting in 1766.

Gillow, Richard and Robert (active 1740–1811). Made furniture in Lancaster and London. Shipped much to the British colonies in the West Indies.

Goodison, Benjamin. Supplied furniture to royalty between 1727 and 1767.

Grendey, Giles (1693–1780). Georgian cabinetmaker who exported furniture on a considerable scale. Simple, domestic type, much of it japanned.

Haig, Thomas (active c. 1771–1796). Taken into partnership with Chippendale's son after the father's death, until 1796.

Hallett, William (1707–1781). Popular cabinetmaker under George II.

Hepplewhite, George (d. 1786). His *Cabinet-Maker's and Upholsterer's Drawing Book* was published in 1788. Produced satinwood and inlaid furniture in the classical style. No authentic pieces of his remain.

Hope, Thomas (1770–1831). Designer of furniture in English regency style.

Ince, William (active 1758–1810). Partner of Mayhew, with whom he published *Universal System of Household Furniture* (1759–1763). Follower of Chippendale.

Johnson, Thomas (active 1755). Carver of girandoles, etc., of eccentric and fanciful design.

Langlois, Peter (active c. 1763–1770). Probably an immigrant Frenchman who worked in a metal technique based on that of André Charles Boulle, using brass and tortoiseshell.

Linnell, John and William (active 1720–1763). John (d. 1796) was a carver and cabinetmaker. William was a carver and upholsterer. Worked in rococo, Chinese, and classical styles.

Lock, Matthias (active 1740–1769). Early rococo designer. Disciple of Chippendale and later of the Adams.

Manwaring, Robert (active 1765). Known only through his publications of *Carpenter's Complete Guide to the Whole System of Gothic Railing* and *The Cabinet and Chair-Maker's Real Friend and Companion,* 1765. His designs have originality, though the perspective is bad and the engraving is crude.

Mayhew, Thomas (active 1758–1810). Cabinetmaker, partner of William Ince.

Seddon, George (1727–1801). Active about 1760–1775. Cabinetmaker, furniture designer, and upholsterer. From 1793 to 1800 firm was known as Seddon Sons and Shackleton, Seddon having taken his sons, George and Thomas, into partnership in 1785 and 1788, and his son-in-law, Thomas Shackleton, in 1793. Made much satinwood furniture.

Shackleton, Thomas. George Seddon's son-in-law and partner, 1793–1800.

Shearer, Thomas (active c. 1788). Did twenty-nine plates in the *Cabinet-Maker's London Book of Prices* (1788), which were reissued in the same year under his name as *Designs for Household Furniture.* Designs are almost entirely limited to case furniture. Associated with Hepplewhite.

Sheraton, Thomas (1751–1806). Published *Cabinet-Maker's and Upholsterer's Drawing Book* (1791–1794). Probably only a furniture designer. No authenticated pieces of his are in existence.

Vile, William (d. 1767). Partner of John Cobb from about 1750. Responsible for the finest rococo furniture made for the crown in the early years of George III's reign.

BIBLIOGRAPHY

Blomfield, Sir R. T. *A History of Renaissance Architecture in England.* 2 vols. London: G. Bell and Sons, 1897.
Illustrated text.

Bolton, A. T. *The Architecture of Robert and James Adam.* 2 vols. New York: Charles Scribner's Sons, 1922.
Text with line drawings and photographs.

Brackett, Oliver. *English Furniture Illustrated*. New York: Macmillan Company, 1950.
Revised by H. Clifford Smith, Keeper of Woodwork, Victoria and Albert Museum.
Authoritative text and illustrations.

Cescinsky, H. *English and American Furniture*. Grand Rapids, 1929.
A handbook of English and American furniture of the seventeenth and eighteenth
centuries, profusely illustrated.

Cescinsky, H. *English Furniture of the Eighteenth Century*. 3 vols. London: George
Routledge and Sons, 1911–1912.
Illustrated text.

Cescinsky, H. *English Furniture from Gothic to Sheraton*. Grand Rapids, 1929.
Excellent text, profusely illustrated.

Cescinsky, H., and Gribble, E. R. *Early English Furniture and Woodwork*, 2 vols. Lon-
don: G. Routledge and Sons, 1922.
A thorough study of furniture and woodwork, with illustrations including dia-
grams and plans.

Dulton, R. *The English Interior, 1500–1900*. New York: B. T. Batsford.
Excellent handbook with colored illustrations.

Edwards, Ralph. *English Chairs. London:* Victoria and Albert Museum, His Majesty's
Stationery Office, 1951.
Excellently illustrated examples.

Edwards, Ralph. *Georgian Cabinet Makers*. London: Country Life, 1944.
A list of the leading known Georgian cabinetmakers with a description of their
work by an official of the Victoria and Albert Museum.

Ellwood, G. M. *English Furniture and Decoration, 1680 to 1800*. London: B. T. Bats-
ford, 1922.
Brief introduction to good collection of furniture, interiors, and architectural
details.

Hinckley, F. Lewis. *A Directory of Antique Furniture*. New York: Crown Publishers,
1953.
Excellent comparative photographs.

Jourdain, M. *English Decoration and Furniture of the Early Renaissance*. London: B. T.
Batsford, 1924.
Illustrated text.

Jourdain, M. *English Decoration and Furniture of the Later XVIIIth Century*. New
York: Charles Scribner's Sons, 1922.
Text illustrated with photographs and line drawings.

Jourdain, M. *English Interiors in Smaller Houses from the Restoration to the Regency,
1660–1830*. London: B. T. Batsford, 1923.
Text illustrated with photographs and line drawings.

Jourdain, M. *Regency Furniture, 1795–1820*. London: Country Life, 1934.
Excellent illustrated text.

Latham, C. *In English Homes*. 3 vols. New York: Charles Scribner's Sons, 1904–1909.
Fine collection of photographs taken by author.

Lenygon, F. *Decoration in England from 1660 to 1770*. New York: Charles Scribner's
Sons, 1927.
Text and photographic illustrations.

Lenygon, F. *Furniture in England from 1660 to 1760*. London: B. T. Batsford, 1914.
Text and photographic illustrations.

Lloyd, N. *A History of the English House from Primitive Times to the Victorian Period*.
New York: William Helburn, 1931.
Text with photographs and drawings.

Macquoid, P. *A History of English Furniture.* 4 vols.: *The Age of Oak; The Age of Walnut; The Age of Mahogany; The Age of Satin Wood.* New York: G. P. Putnam's Sons, 1905.
> Illustrated text. A standard authority.

Macquoid, P., and Edwards, R. *The Dictionary of English Furniture from the Middle Ages to the Late Georgian Period.* 3 vols. New York: Charles Scribner's Sons, 1927.
> Text illustrated with photographs and line drawings.

Pilcher, Donald. *The Regency Style.* New York: B. T. Batsford, 1948.
> Good description of architecture.

Ramsey, S. C., and Harvey, J. P. M. *Small Houses of the Late Georgian Period, 1750–1820.* Vol. II, *Details and Interiors.* London: Architectural Press, 1923.
> Text and photographic illustrations.

Strange, T. A. *English Furniture, Woodwork, Decoration, Etc., during the 18th Century.* New York: Charles Scribner's Sons.
> Excellent drawings of furniture, details, etc., with descriptive text.

Stratton, A. J. *The English Interior.* London: B. T. Batsford, 1920.
> Excellent illustrated text covering English homes from Tudor times to the nineteenth century.

Tipping, H. A. *English Homes.* 8 vols.: *Period I, Norman and Plantagenet; Period II, Early Tudor; Period III, Late Tudor and Early Stuart; Period IV, Late Stuart; Period V, Early Georgian; Period VI, Late Georgian.* New York: Charles Scribner's Sons, 1921.
> Text copiously illustrated with photographs.

Wenham, E. *The Collector's Guide to Furniture Design.* New York: Collector's Press, 1928.
> Fine collection of photographs with descriptive text, covering English and American furniture and accessories.

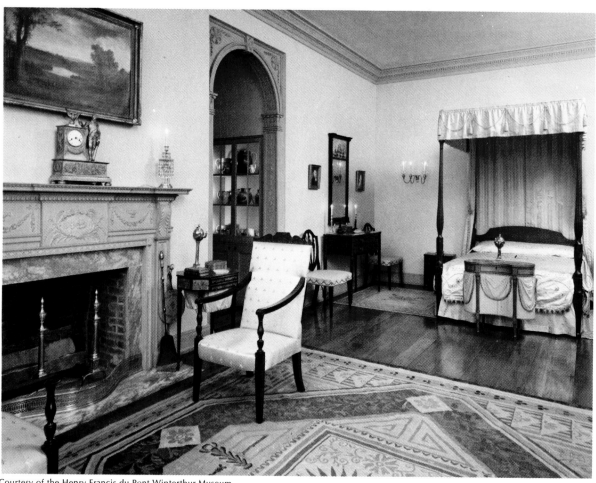

McIntire bedroom. The carved crestings on the pair of upholstered armchairs in front of the fireplace are characteristic of McIntire's work. The woodwork painted dove gray is in striking contrast with the yellow satin on the chairs in the room.

CHAPTER 7

The American Periods

Bettmann Archives

The invention of the steamboat revolutionized communication.

One of the most important influences in the development of the industrial arts in the United States has been the varied origins of its inhabitants. A large percentage of the present population of this country is descended from the English settlers of Virginia and New England who landed before 1800. Settlements of Dutch in the Hudson River valley, of French in South Carolina and Louisiana, of Germans in Pennsylvania, of Swedish in Delaware, and of Spaniards in Florida and the West have maintained local customs, but have had less bearing upon the thought of the country as a whole. The English language has become a common denominator.

The original lists of emigrants from England to New England and Virginia describe them as "persons of quality, emigrants, religious exiles, political rebels, serving men sold for a term of years, apprentices, children stolen, maidens pressed, and others." Unquestionably these early arrivals were a mixed lot, but among the early grantees in Virginia were younger sons of the English nobility who had been acquainted with the luxury and culture of their time in England. The Plymouth settlers, on the other hand, with the exception of a few outstanding leaders, were largely members of the yeomanry of England who wished to escape from the unhappy political conditions under James I and

Charles I, or who, like the Pilgrims and Puritans, had protested against what they considered religious abuse. In spite of the insupportable oppression at home, the early emigrants must have been endowed with extraordinary courage and vigor to have been willing to risk their lives traveling in the small sailing vessels of the period across an uncharted ocean to an unknown land.

DIFFERENCES BETWEEN NORTH AND SOUTH. The differences in the character of the geography and condition of the soil in Virginia and New England tended from the start to develop contrasting interests and variations in the customs and culture of the two sections.

The South had the advantage of several navigable rivers that penetrated an exceptionally fertile farming district. Plantations of thousands of acres could be worked with slave labor, and tobacco, rice, and indigo were easily exported. The owners, who had obtained their land by royal grant, lived like lords—followed the hunt, kept blooded horses, and visited the adjoining plantations in their coaches-and-six. They built elaborate dwellings, furnished them richly with imported luxuries, dispensed a generous southern hospitality, and occupied themselves with social and political life.

The North, settled largely by religious enthusiasts, developed the small town, in which the independent church was the center of thought and influence. Only small sections of farmland could be cleared of the rocks and stones that had been in New England since the glacial period. No great estates were developed, and the northerner was at first satisfied with simple living conditions. Early industry consisted of fur trading, cod and other fishing, and shipbuilding.

NATIONALISTIC DEVELOPMENTS. From 1666 to 1720 there occurred little emigration from England, largely because of the cessation of political and religious strife. This period proved a breathing space for the colonies and gave them

—229—

an opportunity to coordinate their efforts, establish their traditions, develop native industry and commerce, and strengthen their cultural foundations.

By the first years of the eighteenth century the economic condition of the country was such that it began to attract a new emigration from England and Scotland. Among the new immigrants were expert craftsmen, carpenters, and cabinetmakers. The early struggle to consolidate the eastern wilderness had been successfully completed, and the population could to a greater extent work and relax in increasingly luxurious home surroundings.

During the middle years of the eighteenth century the colonies continued to grow in wealth and to develop a realization of their self-sufficiency. This sense of nationalism was nurtured by the unreasonable taxation of George III, combined with the frequent injustices of royal governors. Unheeded protests culminated in the Revolution.

The post-Revolutionary period was undoubtedly influenced culturally by Franklin, Washington, Jefferson, and Hamilton. Both Franklin and Jefferson became ministers to France and made as deep an impression upon the court of France as the court made upon them. These four men were not only patriots and statesmen, but may also be considered among the first gentlemen in America, if one includes among the characteristics of a gentleman an affection for, and understanding of, the arts. The importance of the arts as a contribution to a full life was realized by them and by others, and their astute connoisseurship undoubtedly contributed to a more careful study and analysis of European productions by American designers, and fostered a greater demand and appreciation on the part of the upper-class public for more sophisticated home surroundings.

EARLY NINETEENTH-CENTURY CULTURAL INFLU-ENCES. The years from 1790 to 1810 produced the finest examples of postcolonial interior and exterior architecture. The tendency to look to the ancient Roman democracy for inspiration in all important branches of human activity was seen, politically, in the choice of such words as *capitol* and *senate*, in the organization of the United States government, and in the selection of a Latin motto. The Society of the Cincinnati, organized in 1783 by the officers of the Continental Army, recalled and perpetuated the virtue and simplicity of an ancient Roman hero. Architecture, decoration, furniture design, and the other industrial arts turned to Greece and Rome for ideas, and, as the population spread westward, many of the new settlements were given names of classic origin.

Americans warmly smypathized with France during her struggle toward democracy. The purchase of Louisiana in 1803 made many Frenchmen citizens of the United States. The art of the French Empire was strongly influencing English production. Therefore it is not surprising that for a while French styles were followed in the United States. The forms of French art did not displace prevailing English forms, but were frequently fused with them.

INDUSTRIAL EXPANSION AND ARTISTIC STAGNATION. The early nineteenth century in the United States witnessed the same industrial expansion that swept England, France, and other European countries. The initiative of the American people was evidenced in Whitney's invention of the cottin gin, Fulton's first steamboat, Cooper's first locomotive, and Morse's telegraph, all of them machines that were completely to revolutionize social and economic conditions. While these industrial developments were progressing, the new nation was pushing its frontier further westward, mining wealth, settling new lands, and building new cities. In these new settlements the struggle for existence was too great to permit thought of cultural or

artistic development, although at the earliest opportunity schools and colleges were established.

The spiritual side of life during the middle of the century was stimulated by prominent evangelists and by the literary productions of Irving, Cooper, Poe, Hawthorne, Whittier, Emerson, and Longfellow. Music saw the development of the American folk song and the Negro spiritual, but architecture, painting, sculpture, and the industrial arts were stagnant. The voices of such cultural giants and individualists as Horatio Greenough, Walt Whitman, Herman Melville, John Fiske, and Louis Sullivan were little more than whispers during the last half of the nineteenth century, and the truths that they uttered were not fully recognized until long after they had passed away. Problems of secession and slavery occupied the minds of the people during the middle of the century, culminating in the tragic war between the North and the South.

During the latter half of the nineteenth century, the economic advances were so notable and the "laissez faire" philosophy so successful, in a land that abounded in such natural resources, that there was little inclination on the part of the old inhabitants to alleviate the difficulties of the newer immigrants. Material prosperity and scientific discoveries solved few of the fundamental problems of the existence of the masses. The rich considered the accumulation of money as an end in itself, and there was an absence of a leisure class that could have established an art patronage. Women controlled both education and religion during a good portion of the nineteenth century and dictated the standards of art and culture. A masculine interest in the cultural branches of thought seemed to denote effeminacy.

REVIVAL OF ART APPRECIATION. The Centennial Exposition held in Philadelphia in 1876 was the first definite step toward an artistic awakening in a period of half a century. This exhibit contributed much to an aesthetic revival, which came at a time when industrialists who had profited from the natural resources of a virgin land were beginning to establish the great American fortunes, and to have sufficient funds to fulfill a natural desire for ostentation. Thus, in the last two decades of the century many of the newly rich built homes in New York, Chicago, Newport, and elsewhere which were designed to imitate Old World palaces and châteaux and furnished with antiques and reproductions of various periods.

THE SUBDIVISIONS OF THE AMERICAN PERIODS. It is more specific to delineate the American periods, though the styles produced before the nineteenth century are often linked together under the general heading *colonial*. The subdivisions are as follows:

1. EARLY AMERICAN (1608–1720 in Virginia; 1620–1720 in New England).
 Characterized by unpretentious wooden architecture and interiors, with little thought of design. Local materials used. Furniture in crude copies of Jacobean, Carolean, and William and Mary types.

2. GEORGIAN PERIOD (1720–1790).
 Increase in sophistication. Gradual introduction of Georgian architectural forms and furniture in more accurate copies of English Queen Anne, early Georgian, and Chippendale, Hepplewhite, and Sheraton forms.

3. POSTCOLONIAL OR FEDERAL PERIOD (1790–1820).
 Influence of the Adam brothers. Hepplewhite and Sheraton influence continued.

4. GREEK REVIVAL PERIOD (1820–1860).
 "Temple" style of architecture. English regency and French Empire influence in furniture design.

5. VICTORIAN PERIOD (1840–1880). Industrial developments submerged interest in the arts. Eclecticism dominated architectural and decorative designs. Romanesque, Gothic, and

Mansart influence in architecture. Belter, Louis XV, and Eastlake influence in furniture.

6. ECLECTIC PERIOD (1870–1925). An extension of the Victorian period. Architectural influence of the French National School of Fine Arts. Residential architecture influenced by colonial, English, French, Italian, Spanish, and other historic styles, with corresponding interiors and furnishings. The end of this period witnessed the beginning of the reaction against style revivals and the acceptance of functionalism as a style directive.

7. MODERN PERIOD (1925 to present day). Buildings, interiors, furnishings, and industrial arts designed to fulfill modern requirements with the possibilities and limitations of new materials dominating as style directives.

EARLY AMERICAN ARCHITECTURE. The principal difference in the development of the decorative arts in the United States and in those of European countries is that the early expression in America was that of an unsophisticated pioneer people whose demand was for satisfaction of the primary necessities of life; appearance was a nonessential, and beauty only an accidental result. The earliest productions were structural and functional in their forms; good proportions and charm of detail were gradual developments. European industrial art, on the contrary, originated in nearly every case in a conscious effort to produce luxurious surroundings for royalty or rich patrons of the arts in which visual appeal had as important a part as utility; these forms were finally imitated and cheapened for the middle classes and eventually influenced the peasant productions.

American architecture and decoration began as a distinctly provincial style in a country where the inhabitants were possessed of a humble refinement but had few of the earmarks of sophisticated culture. There was practically no thought of decoration in the earliest homes, and at least at first the early American style was the result of the effort of the first settlers to protect themselves from the weather, from the marauding beasts of the forest, and from the intermittent attacks by Indians. It was not until the early settlers felt a comparative security with regard to these dangers that they were free to devote conscious effort in the direction of comfort and beauty.

Written records by Captain John Smith and others would indicate that those who first stepped ashore from England to become permanent settlers in America built huts or wigwams of clay, mud, bark, and limbs of trees, roofing their flimsy structures with thatch, but this type of dwelling need hardly be considered in a history of the decorative arts. It is even doubtful that the log cabin type of structure was early adopted by English inhabitants. Probably the Swedes, who had come from a land of small wooden homes, and who settled in Delaware in 1638, were responsible for introducing the method of laying the trunks of trees on top of one another to form a wall, interlocking them at the ends with those of the adjoining wall, and filling the cracks with clay to make them weathertight.

Practically all houses in both New England and Virginia were built entirely of wood during the seventeenth century. Oyster shells, the early material for making lime, were difficult to obtain and made a plaster of poor quality. Other materials for making mortar were not found in abundance until around 1680. Stone houses were attempted without mortar, but were found to be too damp. A few houses were built of domestic bricks. Bricks were not imported into America, except possibly in a few cases as ships' ballast on boats sailing from Holland to New Amsterdam. When plaster became more abundant but was still expensive, only the inside of the exterior walls of the house were sealed with it; the interior partition walls remained in wood planking. Three plastered walls and one wooden

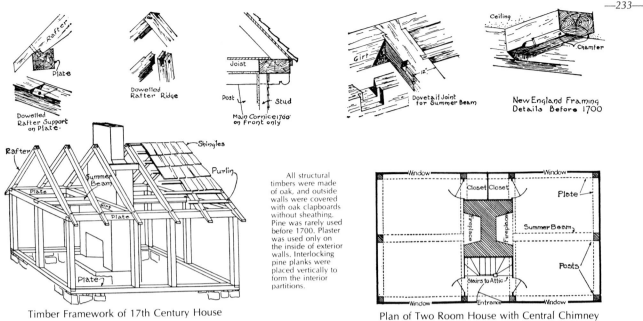

All structural timbers were made of oak, and outside walls were covered with oak clapboards without sheathing. Pine was rarely used before 1700. Plaster was used only on the inside of exterior walls. Interlocking pine planks were placed vertically to form the interior partitions.

Timber Framework of 17th Century House

Plan of Two Room House with Central Chimney

Plan, framing, and joining details of an Early American house showing twin fireplaces and location of structural posts, beams, and plates that were visible characteristics of the interior.

wall became a characteristic feature of the interior treatment of the rooms in the two-room house.

New England was extremely slow in developing an appreciation of architectural design or in adopting any of the academic forms of classical architecture for either the exterior or the interior of the house. While nearly all houses from the earliest period had wooden plank interior walls, it was not until the first years of the eighteenth century that rectangular panels became common, and some years later the design of trim began generally to be based upon classical architectural forms.

Houses in Massachusetts, Pennsylvania, and Virginia and other southern states were built of brick as early as 1670, and a few of these showed the first evidences of the use of classical trim in the interiors.

COLONIAL HOUSE PLANS. The development

of the plan of the domestic dwelling in America follows an evolution that both reflects the growth of the country and gives increasing formality to room decoration. Variations occur in each locality, but definite trends are seen. The earliest seventeenth-century houses consisted of one all-purpose room with a large fireplace that served for both cooking and heating. This was followed by the two-room house with a central chimney located in the partition dividing the rooms and having a fireplace opening toward each side. The front door was centered in the middle of the long side of the house, and opened on a small entrance hallway which enclosed a steep stairway to the attic. The four-room house with a single central chimney was then attempted, but this required a diagonally placed mantel in the corner of each room and was found to be impractical. Two chimneys were then used, each one serving two rooms, and

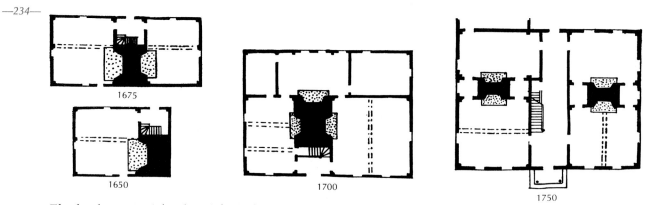

The development of the plan of the Early American house. After 1725 many more complex plans were introduced.

finally the central hallway running the full depth of the house was introduced. The saltbox type was characteristic of New England; this consisted of rooms added to the rear of the two-room house, while the rear part of the roof continued downward in the back to cover the extension. The southern houses usually had extension wings at each side added to increase their size. Virginia and the Carolinas were far in advance of the North in elaborateness of planning. In the South the first third of the eighteenth century saw many interesting arrangements intended for formal entertaining as well as comfortable living. Entrance halls and elaborate stairway designs became particularly important features. After the Revolution, the complexity of the plans increased. The Oval Room of the White House, planned in 1792, which was considered a great novelty and copied in many other localities, shows this advancement.

THE EARLY AMERICAN INTERIOR AND THE VISIBILITY OF STRUCTURAL FORMS. The early settlers found oak and pine forests had to be cleared in order to obtain land for farming purposes. With an enormous supply of waste lumber, it was natural that the earliest houses were built of these woods.

The houses were constructed by the braced framing system. This was an adaptation of the English half-timber or whole-timber house, which had been in existence since Saxon days. A skeleton frame of heavy posts, *girders*, and beams was assembled and interlocked by mortise, tenon, dowel, and dovetail. The oak members forming the skeleton were larger than structurally necessary. The spaces between the posts were filled with wattle. Oak planks were used generally to cover both the inside and outside walls until about 1700. Pine was used thereafter.

The planks on the inside of the room were placed vertically, forming what is known as a *palisade* wall. On the outside they were placed horizontally, the upper one overlapping the one below, forming a *clapboard* wall. The planks, cut from first-growth trees, were of great width, sometimes exceeding three feet each, and they were used as they came from the log, in varying dimensions. To compensate for shrinkage of the vertical planks, and to make the wall as weather-tight as possible, a tongue was cut along the edge of each plank to fit into a groove on the adjoining plank. Simple ornamental moldings of varying shapes were also added along the joints. The wall thus had both an outside and an inside layer of planks for better weatherproofing, but the structural posts and beams always protruded on the inside. The exposure of the

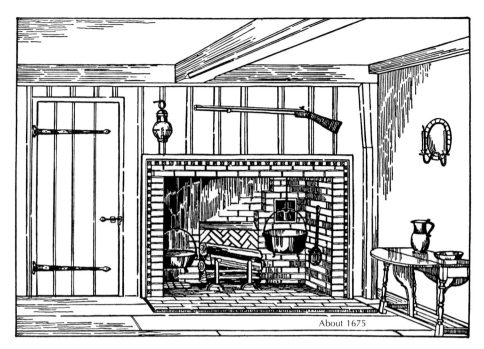

About 1675

Sketch of a typical Early American interior of about 1675, with fireplace wall treated with vertical pine planking, gun-stock corner post, summer beam, and visible structural form.

structural forms became a characteristic part of the room decoration. A very noticeable element in nearly all of these rooms was the large beam that spanned the width of the ceiling of the room near its center, one end of which was supported on the stone chimney, the other end resting on a post in the wall. This beam was known as the *summer beam.* All the woodwork was left in a natural finish; as pine became red with age, the walls were warm in color and dark in appearance.

The earliest two-room frame houses had a central stone chimney with a single flue serving a fireplace in each room. One room was used as a combination kitchen, dining, and living room; the other was used as a bedroom for the whole family. The entrance hall was placed in the center of the house, and it often contained a steep ladder or stairway to the attic. The space at the side of the masonry of the fireplaces, between the two rooms, was usually turned into closets

or cupboards. The attic was floored over, and the floorboards formed the ceiling of the first-story rooms.

The rooms were low-ceilinged, being seldom over seven feet high. The windows were at first of the casement type. Glass, oiled paper, or isinglass filled the panes, which were either rectangular or diamond-shaped, and were separated by either lead or wooden sash bars, forms borrowed from Jacobean architecture. Many windows had no glass at all, but were furnished with blinds. It is doubtful whether double-hung sliding sash were used until after 1700.

The flooring of the first story was at first just earth. Stone was used, in some cases, but pine, oak, and chestnut planks of varying widths were soon adopted.

DESIGN INFLUENCES AFTER 1700. It was not until the opening of the eighteenth century that the English trend in classical architectural forms, as introduced by Inigo Jones and Sir Chris-

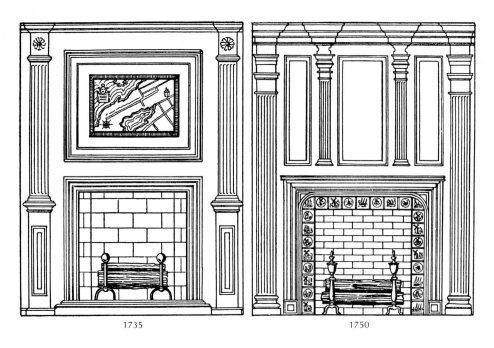

1735

1750

Two eighteenth-century Colonial mantel treatments showing the early use of academic architectural features.

topher Wren, began to be reflected in America. Considerations of form and line only gradually developed importance. The styles of England were transmitted to the colonies partly through immigration, partly through the importation of books on building and architecture, and partly by royal governors, who insisted on having for their residences houses that conformed to the dignity of their position.

The printing press was immensely influential in spreading the details of classical architecture among the general run of carpenters and builders. The English version of Palladio's work was particularly in demand, but the works of James Gibbs, Abraham Swan, Batty Langley, and William Halfpenny were eagerly purchased, and they had a very direct bearing upon the development of decoration as well as on that of architecture. The diffusion of these book designs tended to develop similarity in style in all parts of the colonies and left little to the originality of the designer.

FURNITURE OF THE EARLY AMERICAN PERIOD (1608–1720). Design and the development of furniture in the United States were influenced by the same elements that affected decoration. During the seventeenth century, the craftsmen who built the houses in many cases also produced the necessary interior equipment. The general divisions of the styles are, therefore, the same as those of architecture and interior decoration.

The major portion of American furniture followed English prototypes, and, broadly speaking, may be considered an English provincial style, since the same degree of crudity in both detail and proportion is seen that invariably occurs where furniture is imitated in a locality far removed from its original place of design and manufacture. Style changes were made slowly in the colonies, and new forms became popular several years after they had been introduced in England. In addition to the English types, styles of Holland, Germany, and France influenced the

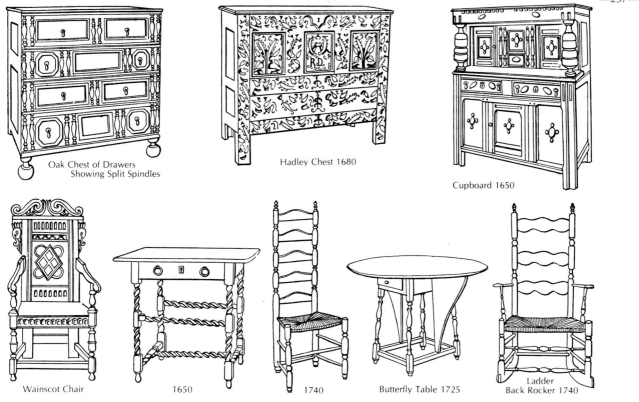

Oak Chest of Drawers
Showing Split Spindles

Hadley Chest 1680

Cupboard 1650

Wainscot Chair

1650

1740

Butterfly Table 1725

Ladder
Back Rocker 1740

Early American furniture.

furniture craft where inhabitants from those countries had settled.

The early homes were but sparsely furnished; only the essentials were made or purchased. The whole of the seventeenth century reflects the design and character of Jacobean and Restoration forms.

The chest, cupboard, and desk-box, the turned and wainscot chair, the stool and settle, the trestle table, a few smaller tables, and such space-saving types as the table-chair and the gateleg and drop-leaf table were used in the combination kitchen, living, and dining room. Four-poster beds, trundle beds, and wooden cradles formed the principal furnishings for the sleeping rooms, with additional chests for storage purposes. Clocks and mirrors were rare.

Comfort was introduced by the use of loose cushions for chairs and stools, and the materials used for covering were usually imported silks, needlepoint, and embroidery. The housewife was too busy to weave textiles that could be used only for ornament or comfort. Textiles for clothing were more important.

DIFFERENCES BETWEEN EARLY AMERICAN AND JACOBEAN FURNITURE. Although some of the early furniture was brought from England— especially the chests, which were used as travelers' trunks are today—the limited capacity of the early ships prevented quantity importation. Local carpenters and joiners were therefore called upon to produce the necessities, and it was natural that they should copy the existing imported models to the best of their ability, or

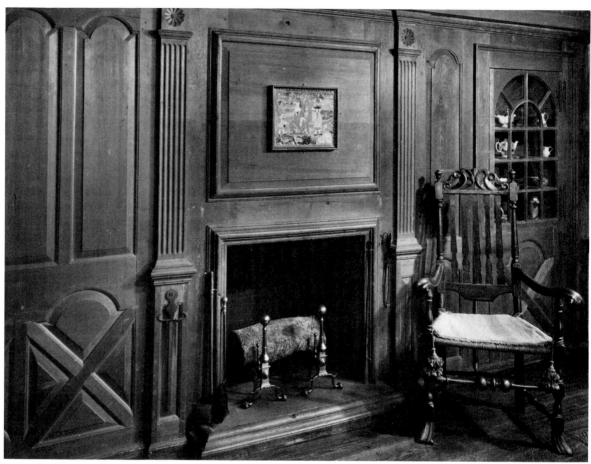

Metropolitan Museum of Art

Connecticut interior of about 1735, showing early use of pine paneling as a substitute for vertical plank walls, an architecturally designed fireplace treatment, paneled summer beam, and cross-stiles in lower wall panels.

that they should reproduce from memory the furniture they had known in England.

Certain local limitations characterized the productions of the period. Tools and facilities for fine cabinetmaking were less complete than in England. The American variety of oak and walnut was lighter grained than the English, and it was frequently found to be more convenient to use such native woods as pine, beech, ash, cherry, maple, elm, cedar, and cypress. Several different woods were frequently used in the same piece of furniture. The general tendency of furniture enrichment was toward sim-

plification of both moldings and ornament. The American reproductions were often smaller than the English originals, to fit better the smaller rooms and lower ceilings in the colonial houses. Although the rectangular construction of the furniture of Jacobean England was maintained, the execution and enrichment were of a more primitive character.

ORNAMENTAL FORMS USED WITH EARLY AMERICAN FURNITURE. The ornamentation consisted of turnings, strapwork patterns, applied split spindles, round or oval wooden handles, carving, and painting. The carved motifs were usu-

ally a crude imitation in low relief of English prototypes. Frequently they consisted of jack-knife incisions in patterns unrelated to traditional forms, obviously representing the playful fantasy of some farmer's son or apprentice joiner who chose this method of passing the long winter evenings. The Tudor rose, the tulip, the sunflower, the acanthus, and the arcaded panel were frequently seen as carved motifs.

CHARACTER OF INDIVIDUAL EARLY PIECES. The chest, used as a container or seat, was by far the most important piece of furniture in the home, and was made in a variety of forms. The lid at the top was hinged, the sides were paneled, and occasionally it had one or more drawers at the bottom. As chests were heightened, the tops were used for the display of small objects of metal or pottery, and the hinged top then became impractical. The chest eventually evolved into the chest of drawers or bureau as it is known today. A special type, known as a *Connecticut chest*, stood on four short legs, had two rows of double drawers below the chest proper, and was decorated with large split spindles painted black to imitate ebony. The handles of the drawers were wooden ovals, usually placed diagonally. The *Hadley chest*, also of Connecticut origin but misnamed for a Massachusetts town, was similar, but it generally had only one drawer and was decorated with a very crude incised ornamentation. One type of small chest was known as a desk-box; this had a flat or slanting pine top, while the sides of the box were in carved oak. It held writing materials and a few books, among them the family Bible. The desk-box was finally placed on legs, evolving into the early type of slant-lid desk.

The chest was eventually placed on higher legs and became the cupboard, very similar in form to the English Elizabethan or Jacobean cupboard. There were many variations such as court, press, and livery cupboards, and all were used for the storage of food, clothing, linen, and other articles. The cupboard was made in two sections and was the most decorative piece of furniture in the room. It was usually paneled and richly carved or ornamented.

The tables of the period had turned legs; the tops were frequently of pine and had wide overhangs. Molded stretchers connected the legs. Drawers were sometimes placed in the apron under the top. Occasionally the apron was cut into a curved silhouette.

The drop-leaf tables were designed with many different types of contrivances, such as gatelegs, swinging arms, butterfly wings, and pulls, for supporting the hinged flap.

Chairs of the seventeenth century were built on straight lines. The oak wainscot chair, reserved as the seat of honor, was more simply ornamented than its English prototype, and had a paneled back, curved arms, and turned legs. The *Carver chair*, a simplified version of the *Brewster chair* which had more spindles, had straight turned legs, the rear legs continuing upward to form the back uprights, between which were placed vertical and horizontal turned spindles. Stretchers strengthened the leg construction. *Slat-back chairs* were of similar design, but they had wide horizontal ladder rails between the back uprights. The tops of the legs and back uprights in both the Carver and slat-back types were usually terminated in a turned finial motif or a mushroom form. The seats were made of rush or of plain wood boards.

Most early chairs had heavy proportions; as the century progressed, the individual parts became lighter. Upholstered chairs with spiral turnings were introduced in the latter half of the seventeenth century, and considered both comfort and design to a greater extent than had the slat- and spindle-back chairs. The upholstery material was either leather or *turkey-work*, a crude homemade material vaguely imitating an Oriental rug weave and pile pattern, and was made by drawing wool yarn through a coarsely woven fabric backing.

Stools and long benches, called *forms*, fash-

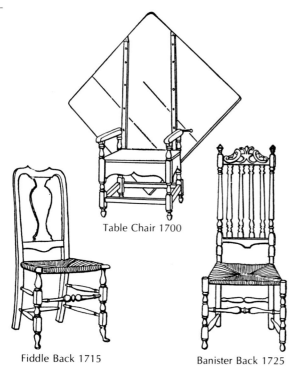

Table Chair 1700

Fiddle Back 1715

Banister Back 1725

Early American chairs.

ioned in a manner similar to the chairs, were used with loose cushions.

Toward the end of the century the influence of the Restoration period in England was noticed in the introduction of the Flemish scroll forms of ornament. The S- and C-curves were seen in the carved cresting of the chair backs or in the stretchers. The back upright sometimes consisted of split spindles or flat bars, called *banisters*, giving their name to the *banister-back* chair. The *Spanish foot* was also introduced during this period. Seats were made of caning.

At the turn of the century, trained cabinetmakers began to make furniture. The walnut forms of the William and Mary style appeared, with their bell turnings, shaped aprons, flat stretchers, and bun feet. Highboys known as tallboys, lowboys called dressing tables, and chests-on-chests were introduced in simplified designs. As a rule, the tops of these pieces were

crowned by a simple molding rather than by a complete entablature, as in the English versions. Veneering and cross-banding in walnut and butternut were first used as furniture enrichment during this period. The elaborate marquetry patterns seen in England were not adopted in America. Trade with the West Indies was conducted from the American seaports on a large scale from an early date, and mahogany, as a cabinetmaking wood, was probably first used in America about 1700, which predated its general use in England. On the whole, furniture began to be designed in more sophisticated forms in response to a demand for greater comfort and beauty in home furnishings.

INTERIORS OF GEORGIAN MANOR HOUSES (1720–1780). As more formal dwellings of stone, brick, and wood replaced the early structures, the interiors were laid out with larger rooms and higher ceilings, and the columns, pilasters, entablatures, and cornices, which were first applied to the exterior only, were brought to the interior. At first the carpenters, who were untrained as designers, merely applied classic architectural details to the trim of doors, windows, and mantels, having little consideration for the composition of the walls or for organization of the spaces that were to be filled. Even the motifs were but rudely copied, and proper scale and proportion were neglected. Moldings were either too large or too small for their purpose. Cornices and entablatures were frequently too massive in their relationship to the height or size of the room for which they were intended. Balance in the arrangement of the architectural treatment of walls was considered seriously only in the largest houses. Unsymmetrically treated walls were common in farmhouses and in town houses of lesser importance. Mantels were placed in corners or at one end of the room, and doors and windows were used wherever necessary. In the same room, panels varied considerably in size and shape.

The North saw few of the academic forms

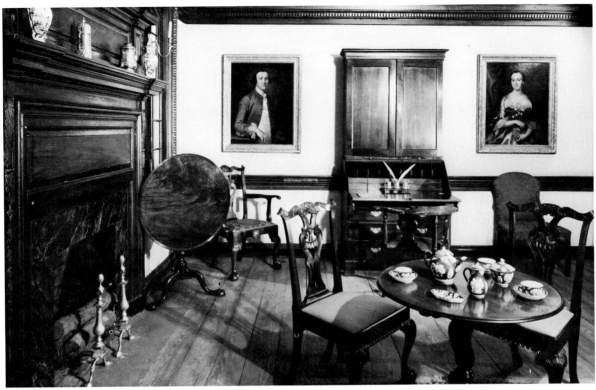

Brooklyn Museum

Parlor from the Francis Corbin House, Edenton, North Carolina, about 1725.

in architecture used until after 1725, and these were mainly employed in the design of entrance porches; the South, however, was slightly more advanced. The earliest examples were those at Graeme Park, near Philadelphia, built in 1721–1722, and at Westover, in Virginia, built about 1726. Both of these houses have wood-paneled rooms, the panels of which rise the full height of the room from a low dado to the underside of the entablature. Some of the doors were framed with architrave moldings and treated with triangular pediments. Overmantels were also elaborately crowned with well-designed pediments, and the trim of doors and windows was frequently broken by "ears." Arches were used for openings or to give an interesting form to a built-in cabinet or niche.

In general character the rooms varied con- siderably between the severe straight-line forms which dominated the designs of Palladio and the irregular curved forms evident in the scroll pediments of continental origin that were intro- duced earlier by Inigo Jones and subsequently used by Wren.

Contrary to popular belief, no authentic proof exists that any building in the colonies was ever directly designed by Wren. There exists, however, a letter written in England in 1724 by the Reverend Hugh Jones to the effect that Wren "modelled" the original building of William and Mary College in Williamsburg, Virginia. The Wren and other English influences in church and residential building developed through the local builders' application of pub- lished designs.

Pilasters and columns were extensively

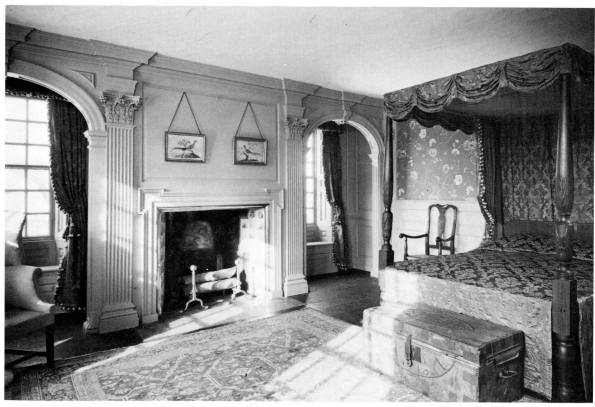

George M. Cushing

Mid-eighteenth-century bedroom in the Isaac Royall House, Medford, Massachusetts.

adopted, at first in crude proportions, but by 1760, in the traditional classic proportions. Doric and Ionic capitals were seen more frequently than Corinthian, possibly because the latter were more difficult to carve. As a general rule, pilasters were used to flank the mantel, accentuating its importance, but in a few rooms, as in the drawing room from Marmion, Virginia, now in the Metropolitan Museum, pilasters were spaced around the room, dividing the walls into vertical panels. In this room the complete order was painted to imitate marble, while the panels were painted with urn and ormolu forms, landscapes, and other decorations that were obviously copied by some itinerant painter from the illustrations of a book on French eighteenth-century art. These paintings reflect an insuffi-

cient understanding of scale relationship to the architectural features.

Until about 1765 the popular type of panel molding was one formed by a narrow quarter-round on the stile; the panel itself was beveled outward and raised so that the field of the panel was flush with the stile.* Occasionally, fireplace openings were trimmed with a large projecting bolection molding. This was borrowed from the bolection paneling introduced in England just after the Restoration period. Where the bolection molding was used, the shelf was usually omitted. Marble was frequently imported for mantel facings. Details of colonial plank and panel moldings are shown on page 233.

* See Chapter 12.

From the middle of the eighteenth century a few rooms were finished with plain painted plaster walls between dado and cornice, although mantels continued to be treated architecturally, and the structural posts at the corners of the rooms were covered with pilasters. The painting of woodwork did not become common until about 1735, after which time many hues were used—gray-blue, pearl, cream, brown, red, mustard, and white being the most popular.

Marbling and graining were also occasionally seen. Wallpapers were first imported about 1737, and from that year onward scenic and all-over patterns were used in both large and small houses.

INTERIORS OF SMALL GEORGIAN HOUSES (1720–1780). There are not many towns that can surpass the loveliness and fascination of the few remaining untouched southern and New England colonial settlements. Although at first only the

Salon from the Samuel Powel House, Philadelphia, 1768, showing one paneled wall and the other three walls covered with hand-painted Chinese wallpaper. In this room the increased refinement of design is clearly indicated.
Metropolitan Museum of Art

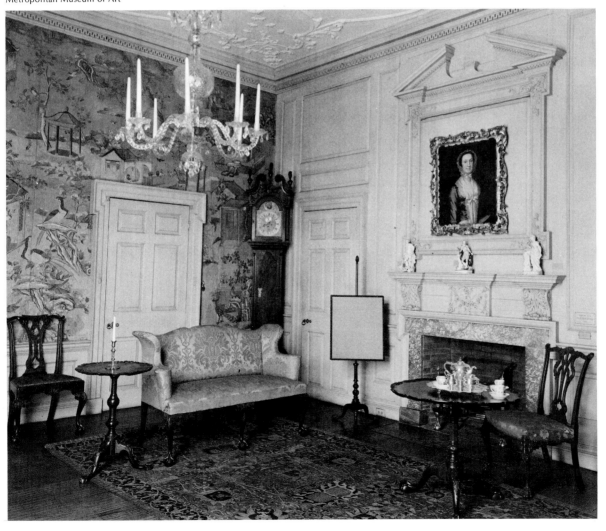

most important citizens in each locality were able to build houses with a definite architectural character, the smaller landowners and wealthier farmers soon endeavored to introduce the classical academic forms in some or all of the rooms of their houses. With less experienced local workmen, the architrave trim, pilaster, cornice, and paneled walls of the mansions were copied, and in many instances designs of extraordinary merit were created. In the majority of cases, the very lack of understanding of balance, composition, and scale became an asset. Odd forms and ideas were carried out, producing a picturesque result that was simple, charming, and expressive of the culture of the period. The colonial gentleman of the mid-eighteenth century desired and obtained home surroundings that expressed a considerable degree of culture and refinement.

In the smaller farmhouses, where wood paneling was not employed for wall decoration, the plaster walls were whitewashed, painted, or papered. Stenciling was sometimes resorted to as a decoration for both floors and walls, and many interesting old patterns still remain intact. Mural decoration was also resorted to as a means of enrichment. These paintings usually showed landscape effects; they were probably done by passing journeymen, who painted fences, barns, houses, furniture, portraits, or murals—the last two obviously showing the lack of technical ability on the part of the artist, and a resulting naïveté of interpretation that was consistent with corresponding architectural detail.

Georgian furniture (1720–1790). The new immigration of the early eighteenth century brought many craftsmen from England who had made the furnishing for the luxurious dwellings that were built in the Renaissance style. The developments in social living, in tea and coffee drinking, and in parlor games of chance had necessitated the introduction of many new forms of furniture, and the colonies were eager to adopt the rapidly changing manners and customs of the mother country. Style consciousness appeared in the early years of the eighteenth century, and people bought furniture for its design merits as well as for its use.

The cabriole leg with club foot, popularly known as the *bandy*, was followed by the claw-and-ball form. Curved lines began to dominate in the design of many pieces. The Queen Anne splat-back chair, called the *fiddleback* in America, was introduced. China cabinets to hold the precious collections of imported earthenware and porcelain were made as separate pieces of furniture and usually had triangular or scroll pediments. Oriental lacquer and japan finishes were introduced, and imitations of these were made in ordinary paint. *Japanning* and *decalcomania* became fads with young ladies.

Desks and secretaries with slant lids and cabinet tops were popular and richly treated. Sofas, daybeds, and couches with upholstered coverings or loose cushions were introduced. The tilt-top, piecrust table was adopted. Consoles, pier tables, kneehole desks and tables, and *roundabout chairs* were much in vogue. Framed mirrors with beveled glass, in both vertical and horizontal designs, were imported and copied. Tall case clocks replaced wall clocks. For the first time, furniture was turned out in sets or in matched pieces for the same room. Spurred by the interest of the English people in the work of their individual cabinetmakers—largely a result of the publication of the books of Chippendale, Manwaring, and others—the colonials, if they could afford to, hastened to follow the fashion of the times. English books on architecture, interior decoration, and furniture design had a large sale in America. From 1750 onward, the furniture of the popular cabinetmakers of England was both imported and reproduced. The reproductions were at times accurate, but they more frequently varied from the original in both detail and proportion. Soon, individual cabinetmakers in the colonies became prominent for their remarkable ability to reproduce the

Queen Anne, early Georgian, Chippendale, and later types of English furniture. Examples of their early work showed the cabriole leg with club, claw-and-ball, and lion's-paw foot. Just before the Revolution, the Marlborough form of heavy, straight, grooved leg with a small block foot was introduced. Highboys, lowboys, chests-on-chests, and bureaus were made for bedroom use. To give some idea of the type and number of household objects used in the residences during the colonial period, the following advertisement is quoted from the New York *Gazette* of March 31, 1769:

JOHN TAYLOR *Upholsterer* and *House-Broker* from *London;* BEGS leave to inform the gentlemen and ladies, and the public in general of the city of New-York, &c. that he has taken a large commodious house, situate on Cowfoot-hill in the city of New-York, aforesaid; where he intends carrying on the above branches in the most neat, elegant and newest taste possible. As the asserting the different prices of workmanship, is a thing frequently made use of to prejudice the too credulous part of mankind in favour of the advertiser, and is a means of their being exposed to impositions, which they at one time or other dearly experience, when too late to remedy; He therefore takes this method of informing them, that whoever shall be pleased to honour him with their favours, may depend on being served with any of the under described articles, with the greatest punctuality, and finished according to the above inserted manner, at the most reasonable rates, viz. Four post, bureau, table, tent, field and turnup bedsteads, with silk and worsted damask, morine, harateen, China, printed cotton or check furnitures; festoon, Venetian, and drapery window curtains, easy chairs, sophas, tent and camp equipages; floor and bed side carpets, feather beds, blankets, quilts and counterpains, sconce, chimney, pier and dressing glasses in mahogany, carved and gilt frames; card, dining, tea, dressing, and night tables; mahogany and other chairs, fire-irons, brass fenders, shovels, pokers and tongs, copper-tea-kettles, sauce-pans, and all manner of chamber, parlour and kitchen furniture too tedious to be mentioned. He likewise proposes where conveniency may suit the party, to take

in exchange for work executed, any manner of old household furniture, as he intends furnishing houses with the above articles second hand as well as new.

N.B. Plantations, estates, negroes, all manner of merchandize and household furniture bought and sold at public vendue.

FUNERALS decently performed.

A group of craftsmen who worked in these styles were located in Philadelphia, and formed what is known today as the Philadelphia school of cabinetmakers; their productions are broadly classified as "Philadelphia furniture." They were particularly famous for their mahogany chairs, highboys, lowboys, and other pieces in the early Georgian and Chippendale styles. Among these men were Thomas Affleck, John Folwell, Benjamin Randolph, William Savery, and Thomas Tufft. Many of their productions between 1742 and 1796 are considered among the finest examples of colonial craftsmanship, although they made many simple and inexpensive pieces, such as maple rush-seat chairs with slat, splat, or fiddle backs. Their successors continued to follow English fashions and produced Hepplewhite and Sheraton types of furniture in mahogany and satinwood. A great deal of this furniture is still owned by leading Pennsylvania families, and many pieces still contain the labels of the makers. The few existing labels on Savery productions state that he is a joiner who makes and sells chests of drawers (highboys), coffins, and chairs.

About 1760 in Newport, Rhode Island, John Goddard, a cabinetmaker, and his relative, John Townsend, produced remarkable desks, cabinets, and chests of drawers of the *block-front* type. This form consisted of dividing the fronts of these pieces into three vertical panels, the two outside panels convex, the central one concave. A shell motif was placed at the top of each panel. In the majority of the Goddard pieces, the bracket foot was used.

In both the Philadelphia and Newport types, the rococo influence in design predominated.

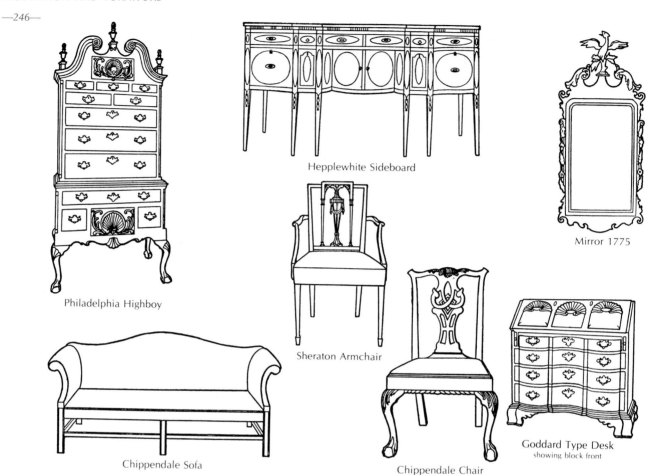

Philadelphia Highboy

Hepplewhite Sideboard

Sheraton Armchair

Mirror 1775

Chippendale Sofa

Chippendale Chair

Goddard Type Desk
showing block front

Late colonial and early federal furniture.

The curved line was seen in the legs and in steep scroll pediments. A certain amount of rich carving of French origin was also applied to small surfaces. Door panels were shaped in either rectangular or irregular Louis XV curves. The majority of pieces were made in well-selected Santo Domingo mahogany, while for others maple, cherry, and Virginia walnut were used.

THE WINDSOR CHAIR. The Windsor chair, modeled after its English prototype, became popular in America during the eighteenth century. It was probably not actually made in America until about 1725. The first official rec-ord dates from 1745, and the chairs were not made in quantity before 1750. Windsor settees appeared about 1766. By 1760 the Windsor form had completely superseded the inexpensive rush-seat chairs for common use.

The Windsor chair, although produced in great quantity and at low cost, reached a position of great dignity. Practically every house had one or more for both interior and garden use. George Washington had many at Mount Vernon. There is a record of twenty-four "ovel" back Windsors having been sold to Washington in 1796 by Gilbert and Robert Gaw of Philadelphia for use at Mount Vernon. This type of

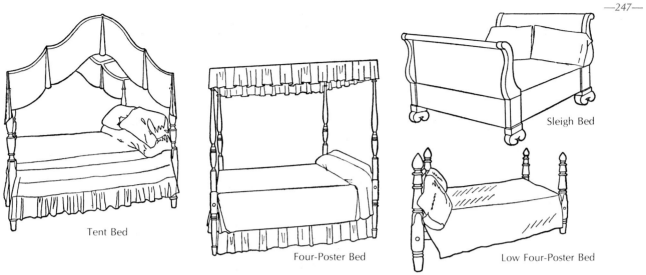

Tent Bed

Four-Poster Bed

Sleigh Bed

Low Four-Poster Bed

Various types of colonial and federal beds.

chair, which had a great number of variations, was also particularly in demand for public institutions and taverns. They were also used in dining rooms. Philadelphia was the earliest and principal place of manufacture, although great numbers were also produced in New York and Wilmington. In fact the Windsor chair was first known as a "Philadelphia chair."

The American Windsor had quite different characteristics from those of the chair produced in England. Its wooden seat was slightly shaped for comfort. Its legs and stretchers were composed of rather slender turnings, and the legs were set at a distinct slant or splay, the upper ends piercing the seat toward the middle instead of at the four corners, with a wooden wedge holding them in place. The backs were the most distinctive feature, and appeared in a great variety of forms. Hoop or sack, fan, brace, comb, and low backs were typical. The frame of the back was frequently bent and held in place by slender spindles starting from the rear of the seat. Windsors were also made to imitate bamboo. The English cabriole leg form and the pierced, ornamental, central back splat were very rare in American-made Windsors. Several

different woods were used in the same piece, and the chairs were painted in black and bright reds, greens, grays, and all other colors. White was not used. A few are recorded as having been stained or painted a mahogany color. The Windsor design continued to be manufactured throughout the eighteenth century. Rockers were made as early as 1745, although these probably had rush seats and were called "nurse chairs." The rocking chair became popular in America, and was evidently first inspired by the curved supports of the cradle. The Windsor type was the most common, but almost every other type of chair was used. The term *Boston-rocker* was later widely applied. Although this type may have been made first in Boston, it was eventually manufactured in every state in the Union. Many were exported to Europe and South America, and their popularity extended to the early years of the twentieth century.

COUNTRY-MADE FURNITURE. Traveling joiners and cabinetmakers were responsible for much country-made furniture. Kitchen and dining room dressers with open shelves, cupboards, corner cabinets, china cabinets, stools, chests, candlestands, and tables were made in local

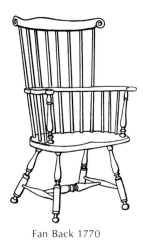

Fan Back 1770

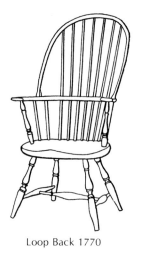

Loop Back 1770

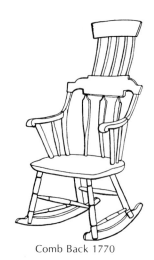

Comb Back 1770

American Windsor chairs.

woods, such as pine, hickory, walnut, butternut, maple, ash, apple, cherry, and pear. The construction and detail of these pieces was of the crudest type, the styling of the simplest, and the finish usually paint. The most logical forms usually dominated the design, and it is often impossible to date them accurately, as the ornamental detail lacks relationship to traditional style development.

PENNSYLVANIA GERMAN CRAFTS. An interesting isolated development in peasant art was seen in that of the German and Swiss Mennonites,* who settled in eastern Pennsylvania near Germantown, York, and Lancaster. These impoverished refugees began to come from the Palatinate shortly after 1683 at the invitation of William Penn, who offered them peace, freedom of worship, choice of leaders, and a fertile land, all of which had been denied them as a result of the Thirty Years' War in their homeland. The

immigration continued until the outbreak of the American Revolution and consisted of almost every type of artisan. These simple peasants were industrious and ambitious and only too anxious to establish a new life for themselves and their descendants. The fact that they were settling in a land that was predominantly inhabited by the English has caused them to the present day to be interdependent and isolated in their social, agricultural, and industrial activities. They have maintained their customs, language, religion, and arts by having little contact with their neighbors, and they have considered marriage with one outside their church a sinful union. They refuse to take oaths or bear arms and are not interested in politics. They dislike all forms of modernization, including bathrooms and electricity. Until the middle of the nineteenth century all that they used was produced by their own people, and in spite of their Quaker neighbors (who had no use for art or beauty), they never lost their love for color or sense of humor. Their productions were both ornamental as well as utilitarian. Simple lines and functional forms dominated the designs of their houses, furniture, and household acces-

* The Mennonites spoke German and called themselves "Deutsch"; their English neighbors anglicized the word and erroneously called them "Pennsylvania Dutch," a familiar designation that has persisted to the present day.

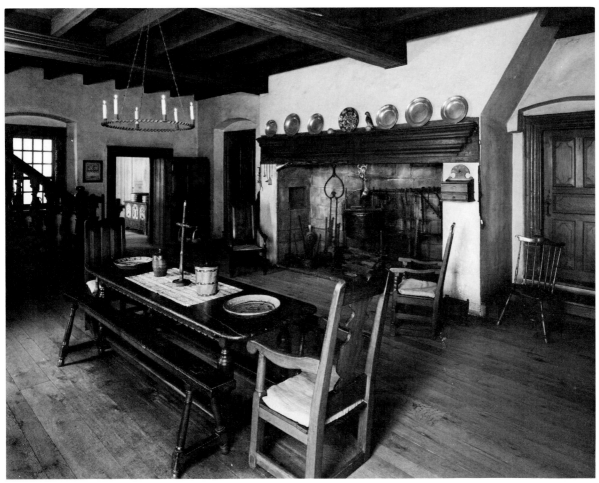

Philadelphia Museum of Art

Kitchen from Millbach, Lebanon County, Pennsylvania, 1752, showing characteristic Pennsylvania German furniture and details.

sories; symbolic ornament, gay colors, and sentiment were features of their patterns for textiles, paintings, and pottery. Their houses and barns in general resembled colonial types and were often built in local stone. The wooden buildings were usually painted red. Symbolic *hex signs*, supposed to protect the inmates from the activities of witches, are painted on many of the exteriors to the present day.

The furniture was well made, of pine, cherry, and other local woods, and was either painted or left in natural finish. Many of their chairs and seats resembled the Windsor forms. Brides' chests, hanging wall cabinets, and wardrobes were usually enriched with naïve painted motifs in bright colors. Other furniture types were spice boxes, workboxes, sawbuck tables, and dough tables. The most usual motifs in the patterns were tulips, peacocks, eagles, rosettes, hearts, farmyard birds, deer, trees of life, leaves, and hex signs. The plaster walls of the rooms were usually whitewashed, but folk pictures and

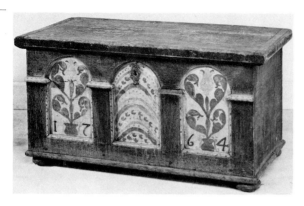

Pennsylvania German painted oak and poplar dower chest.

elaborate birth, baptismal, and wedding certificates, called *fractur paintings*, were framed and hung as decorations. These latter consisted of elaborately painted scrolls and wreaths combined with birds and other motifs with text material in German script. Wall paneling was usually frowned upon as being evidence of too great wealth, but overmantels were often treated in this manner. Pottery, tinware, and toys were ingeniously designed and decorated with characteristic patterns. Many of their productions had both the maker's name and date of manufacture painted or carved on some part of the surface. Textiles were made from home-grown flax, and the linen was embroidered in needlework and adorned with appliqué motifs. Kitchen and dining utensils were made in iron, copper, and wood, and were often hung on the walls of the kitchens as decoration.

The Dutch settlers in New York, Long Island, New Jersey, and the Hudson River valley made painted peasant-type furniture at an earlier date than that made in Pennsylvania by the Germans, but very few examples are extant.

COLONIAL MIRRORS. Looking glasses, as they were called, were not common in America until the end of the seventeenth century. From 1700 onward, they closely followed the English patterns. The Queen Anne vertical wall and dresser mirrors were the first types used. These

had plain walnut frames, often cross-banded or lacquered, with the characteristic broken curves at the top of the frame. The glass was usually beveled, following the outline of the frame, and was divided into two panels. The upper panel often had an etched floral pattern. A single piece of glass was used after 1750. The frame frequently had an elaborately silhouetted cresting at top and bottom.

The Georgian post-Revolutionary type showed a rather heavily ornamented frame of architectural forms starting from a simple pedestal; the sides consisted of fluted pilasters, and the upper portion showed a scroll pediment, with a vase or eagle sometimes placed between the scrolls. The moldings were enriched with gilded carving. This type is known as the "Constitution" mirror.

Rococo and Chinese mirror forms were also popular, particularly in shapes suitable to be placed over mantels and sideboards. The irregular curved scrolls and leaves forming the sumptuously carved frames were usually gilded or painted white. The glass was frequently divided into two or three parts, and certain varieties showed pictures, painted decorations, or por-

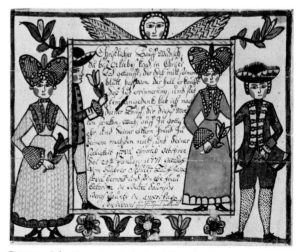

Courtesy of the Henry Francis du Pont Winterthur Museum

Pennsylvania German "fractur" record of a baptismal wish, about 1771–1780.

traits of famous men as part of the design. These types were often the product of craftsmen who had imaginative skill and a great degree of understanding of traditional design. Occasionally, candle brackets were attached.

Simple Adam and Hepplewhite mirror types in rectangular, oval, and shield-shaped frames, with the customary paterae, classical figures, husk garlands, drops, and arabesque forms, were also made in either carved wood or composition material. These were hung on walls or made for table and bureau tops, and often stood upon small boxes of drawers.

The *girandole*, dating from 1760, but popular only after the Revolution, was originally a lighting fixture, as it was always made with candle-bracket holders. The mirror portion was round and had either a concave or a convex surface. The frame was heavy, richly carved or ornamented, and was usually crowned with an eagle and gilded. This type of mirror was prominently placed in the family parlor or dining room.

The Sheraton-type mirror was architectural in design and of slender proportions. Its frame consisted of a colonette upright at each side, crowned with a simple entablature that was frequently ornamented with a row of acorns. A small glass panel at the top was painted with a conventional pattern, a patriotic motif, or a scene. The wood was usually gilded. This type was not used until after 1800.

CLOCKS. The history of clockmaking in America is of considerable interest. During the seventeenth century, all clocks were imported from Europe. These were invariably of the wall clock type, consisting of an uncovered, decorated face made to set on a wall bracket or to hang on a nail, with the weights below. This type eventually became unpopular, and the face was later inserted in a tall case to form the grandfather type.

The first clocks made in America were probably produced in Boston and Philadelphia about 1700, and by 1712 Ebenezer Parmele in Guilford, Connecticut, was hiring apprentices to make clocks. Tall case clocks came into use in the early years of the eighteenth century, and, so far as is known, the first made in America was by Bagnell in Boston in 1722. At this time the works were either in wood or brass; the case was in mahogany or maple; and the design followed the general form of the Queen Anne style.

Boston maintained the leadership in clockmaking during the first three-quarters of the eighteenth century largely because of Simon Willard and his brothers and sons. Benjamin Willard, the older brother, established a factory in Grafton, Massachusetts, about 1765. He probably made only tall case clocks. Simon lived most of his life in Roxbury, near Boston. He made both wall clocks and tall case clocks, but about 1800 he produced the banjo clock, which won immediate popularity. Willard retired from business in 1839, although his firm was continued a few years by his son, Simon, Junior. Simon Willard did not make his own cases. The wheels were always of brass, and the lower glass panels of his banjo clocks were rarely painted, and were left plain to show the swinging pendulum. The lower panels of the banjo clocks of other makers of the period were usually decorated with naval battle scenes, ships, flags, eagles, or landscapes. Aaron Willard was Simon's younger brother. After first working in Roxbury, he started a business in Boston in 1790. He made all kinds of clocks and retired a wealthy man about 1823. His banjo clocks usually showed a painted picture in the lower panel.

Daniel Burnap was a clockmaker between 1780 and 1800 at Andover, Massachusetts, and later at Hartford and East Windsor, Connecticut. Very little is known about him, except that Eli Terry worked in his shop. His tall case clocks had brass works and often had moon phase and calendar attachments. The dials of his clocks were frequently of etched metal, and the

Willard
Banjo
Clock

Early wooden
wall clock by
Eli Terry

Shelf clock
of Willard
Type

Sheraton Type
Shelf Clock
made by both
Terry and
Thomas

Late type
of shelf
clock by
Seth Thomas

Designs for clocks and clock cases.

corners of square faces were undecorated. There were several clockmakers in Hingham, Massachusetts, who specialized in making "grandfather" and "grandmother" types.

Not to be outdone by Massachusetts, Thomas Harland started a clockmaking industry in Connecticut. Harland had come to America from England in 1773 on the famous Boston Tea Party ship. He went to Norwich, Connecticut, and became the foremost clockmaker of his day, conducting a shop until he died in 1807. He advertised "Spring, musical, plain, and church clocks." Most of his clocks were sold without cases, the cases being made by local cabinetmakers.

One of Harland's apprentices was Eli Terry, who, with Seth Thomas, became the leading clockmaker in America. These two were responsible for establishing clockmaking on a large commercial footing. Terry made his first tall clock in 1792. In 1793 he moved to Watertown, Connecticut, where he made clocks with both brass and wooden works. This shop was continued until 1810, when Terry sold out to Seth Thomas and Silas Hoadley and transferred his operations to Plymouth Hollow.

Terry became particularly noted for his

shelf clock, first made in 1814, and designed with the delicate proportions popularized by Sheraton. The clock case consisted of an architectural composition with pediment and base, slender columns at the side about twenty-one inches long, and a simple molding and scroll pediment at the top. The lower glass panel covering the weights and pendulum was usually decorated with an eagle or other ornament. A similar type of shelf clock was made by Seth Thomas about 1830, but the proportions were heavier, and the clock lacked the grace and delicacy of the earlier Terry clock. Thomas, however, enlarged the clockmaking industry to an enormous extent.

MISCELLANEOUS ACCESSORIES. The accessories used in seventeenth-century American rooms were largely limited to necessary utensils: pewter cups, basins, ewers, tankards, and platters, occasional clocks, damask or needlework tablecovers, printed East Indian cottons, loose cushions, turkey carpets, spinning wheels, wrought iron and brass fireplace accessories, a lantern or two, candlesticks, copper kitchenware, pestles and mortars, and a warming pan. Pictures and maps were sometimes hung on the walls. Inventories describe, also, window cur-

tains and valances in linen and silk—the latter probably imported. Very early wills list firearms, pikes, halberds, armor, and similar articles. Earthenware and china were also often mentioned. How many of these articles were imported is not known. The colors of textiles are described as red, blue, green, and yellow. Obviously, the early householders were fond of gaiety in their homes, and they attained it to the best of their abilities. The more well-to-do had an ample supply of jewelry, silverware, and books, and a few lived in an almost manorial manner.

After 1700 the decorative accessories increased in number and improved greatly in design. Many of them were still imported, but gradually the colonists themselves began to make certain types. Tall clocks and wall and mantel clocks were added as both useful and ornamental pieces of furnishing. Window draperies, made of imported textiles, were hung with valances, swags, and jabots with elaborate fringes and tie-backs. Velvets, damasks, taffetas, and other silks were brought to America in great quantity from France, Italy, Spain, Portugal, and England. Leather and haircloth were also used for upholstery purposes. Wallpaper from China, France, and England was used in many houses. Floor coverings were imported from the Orient. The smaller homes had loom carpets made of rags, and braided and embroidered rugs. Oriental china, both useful and ornamental, was popular in all homes from very early times. English Staffordshire, Wedgwood, Worcester, Chelsea, and Derby wares were largely imported from a date just previous to the Revolution. Delft tiles frequently were used to trim fireplace openings after 1750. Stiegel started his glassmaking in Pennsylvania in 1765. The Sandwich glass factory was opened in 1825. The wares of both of these factories were popular in colonial or federal rooms.

One of the most interesting developments in late eighteenth- and early nineteenth-century decoration in New England came as a result of the expansion of American shipping. The harbors of Salem, Boston, Newport, and other towns were swarming with ships of all sizes as early as the middle of the seventeenth century, and many of these sailed to the Orient. After the Revolution, trade with the Far East developed to great proportions, and the artistic and useful products of China, Japan, and India were brought to this country. These included furniture, silk, glass paintings, fine porcelains, Canton china, hand-painted wallpapers, embroideries, and other wares that became a part of the decoration of the American house.

The use of portraits in room decoration dates from a very early period. Until after the Revolution, these were painted, as a rule, by unknown artists. A group of American portrait painters developed during the federal period, however, among whom were Gilbert Stuart, John Trumbull, and the Peales. Several French artists also came to America; among them were Saint-Memin, who worked mainly in Baltimore, and made crayon portraits, etchings, engravings, and silhouettes of great beauty between 1796 and 1810, and Houdon, the French sculptor, who modeled some of the early statesmen. Many interesting oil and watercolor folk paintings were made in the eighteenth and early nineteenth centuries by unknown painters who, with their immature ability, produced work that was highly sympathetic in character and quality to the informal interiors of the period.

Engravings were first made in America in 1729. Maps and plans were the earliest subjects, but representations of places, people, and events were soon drawn. These formed the pictorial enrichment of the colonial interior. Foreign engravings, mezzotints, and other prints were popular during all periods.

The story of the art of the silversmith in America equals the history of architecture, decoration, or furniture. The artistic standard set by these craftsmen even from a very early date was

astonishing and deserves a special study. It is perhaps sufficient to say here that Paul Revere's real gift to the American people was in metalwork, and not in his more frequently mentioned patriotic deeds.

Crystal, mirror, silver, gilded wood, *turnings*, wrought iron, tin, and pewter were used for making chandeliers, whale oil lamps, and other types of lighting fixtures.

In the early nineteenth century European manufacturers made many products for the American markets. Printed cottons, chintzes, toiles-de-Jouy, pottery and porcelain, bronze ornaments, clocks, and statues were produced showing figures of Washington, Franklin, and other American heroes. The Staffordshire potters reproduced, by transfer prints, American scenes and historical events on platters, teapots, and other earthenware pieces. All of these items served to introduce much variety and color in the decorative treatment of colonial homes.

INTERIORS OF THE POSTCOLONIAL AND FEDERAL PERIOD (1790–1820). The Revolution temporarily halted the arts, but building quickly revived. The English influence, inbred in the race, was persistent, but the Declaration of Independence was to assert itself in the arts as well as in politics. This period witnessed the first appearance in the United States of professional architects and designers. The influence of both Jefferson and Washington in promoting a classical style for federal buildings was very strong. These men had felt that the new republic should be represented by the architectural forms of democratic Greece and republican Rome. Jefferson, who had been strongly impressed by the Palladian style adopted by Wren and Chambers, the English architects, had visited, while ambassador to France, the Maison Carré in Nimes, an ancient Roman building; the Richmond Capitol, which Jefferson designed in 1789, was inspired by this building. Monticello was completed in 1809. The plans for the White House were made by Hoban of South Carolina in 1792. Charles

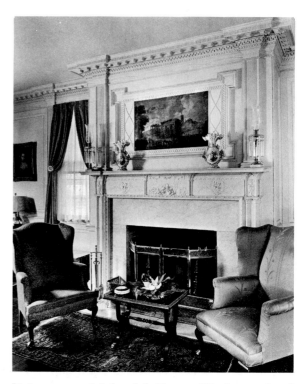

Living room of John Ash House, Charleston, South Carolina, about 1800, showing the tendency toward the delicate detail that was typical of the period.

Bulfinch of Boston and Samuel McIntire of Salem favored Adam classicism. John McComb of New York was undoubtedly influenced by the French neoclassical style. Thornton, who designed the Capitol in Washington, had strong leanings toward Greek architecture and ornament. All of these men, however, were imaginative in their conceptions and added an American interpretation to these classic forms.

Perhaps the most important development was the consciousness of designers that a basic principle of design recognizes that each material has its own possibilities and limitations and that forms produced in one material should not and need not imitate those in another. The available books on architecture showed classical orders intended to be produced in stone. The Americans were using woodwork for both exterior as

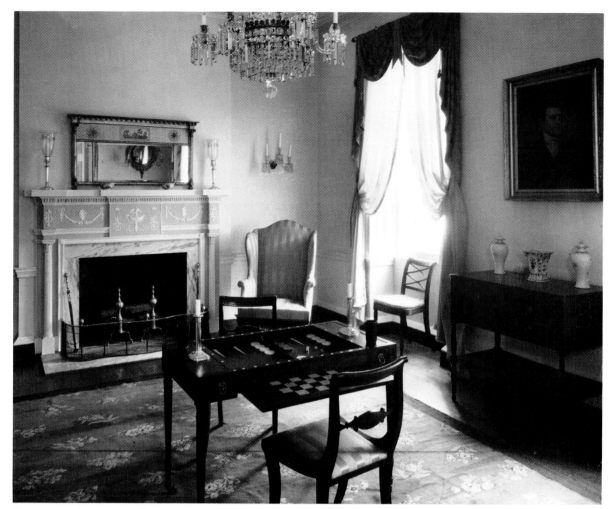

Museum of the City of New York

A formal drawing room from a New York residence built in the early years of the nineteenth century. The dignity, simplicity, and refinement of design evident here were typical of this period.

well as interior detail because it was available in large quantity, was cheap, and was easily worked. A trend developed to produce classical detail in slender proportions. Wooden columns were attenuated; moldings became relatively smaller; and ornament followed the Adam-Pompeian delicate detail and motifs. Rooms had higher ceilings in the more elaborate homes that were built as the stride of the new nation began to be asserted. Less wood paneling lined the walls, but the dado and cornice continued in use. Many rooms had only the fireplace wall covered by woodwork, the other walls being plaster, covered with paint, imported silk textiles, or wallpaper. Greater formality and symmetry were introduced. Corinthian and Ionic columns were often part of the wall treatments. Scenic papers were imported from China, England, and France. Elaborately detailed trim was used for doors, windows, mantels, and arches. Pediments often crowned the doorways. Slender columns and pilasters were often enriched by a

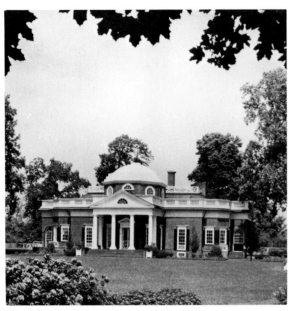

Monticello

Monticello, designed by Thomas Jefferson, the father of the classic revival in the United States.

small-scale fluting or reeding. Moldings were treated with beads, pearls, and variations of dentil forms. Both semicircular and elliptical trimmed arches separated adjoining rooms. Charmingly detailed china cupboards aided in forming interesting balanced wall compositions. Dining rooms often had a wide, shallow, trimmed niche to hold the sideboard. Many mantels were made in white and colored marbles, following designs from the current books that showed Adam forms and ornament; small panels were centered under the shelf and were carved in relief with classical figures, urns, medallions, swags, and garlands. Both carving and composition ornament were used for the wooden mantels. Ceilings were often treated with elaborate plaster relief patterns in Adam designs. Restraint and refinement in all trim was required for consistency with the more delicate proportions of the Sheraton and Hepplewhite furniture. Much unusual planning developed in residential design. Greater prominence was

given to some of the stairways. Circular, oval, and octagonal rooms were introduced in both country and city residences.

FEDERAL FURNITURE (1790–1820). The Revolution to a certain extent halted the development of furniture craftsmanship in the United States, just at the moment when rapid style changes were occurring in England. Chippendale, Hepplewhite, the Adam brothers, and Sheraton were all influencing English taste, and it was not until peace had been restored for several years that the changes in foreign fashion were reflected in the United States.

The Adam influence in America was seen more in interior architectural treatment than in furnishings, but the postwar furniture strongly reflected the designs of Hepplewhite and, more particularly, of Sheraton. The Hepplewhite sideboard, with its serpentine front, became popular. Chests of drawers and chests-on-chests were made with straight, segmental, and serpentine fronts. Fine veneering and inlay were seen. Proportions became light and delicate. Secretaries, tambour desks, dressing tables, and china cabinets were made with beautiful designs and finishes. Delicate scroll pediments enriched bookcases, cabinets, and desks. Tables were made in every shape and for every purpose. The popular woods were mahogany, satinwood, cherry, rosewood, maple, apple, and pear. Tall clocks, shelf clocks, and architecturally framed mirrors were used as accessories. Much of the furniture after the Revolution and before 1820 was the product of trained English craftsmen, who had come to the United States for just this purpose. As a result, the American product is often indistinguishable from the English by design comparison, but can be identified by the woods that were used. Pieces made in the smaller towns by Americans have a tendency to be a little clumsy in their lines and proportions as compared with the English originals.

The French Revolution brought an influx of aristocrats, who carried with them what belong-

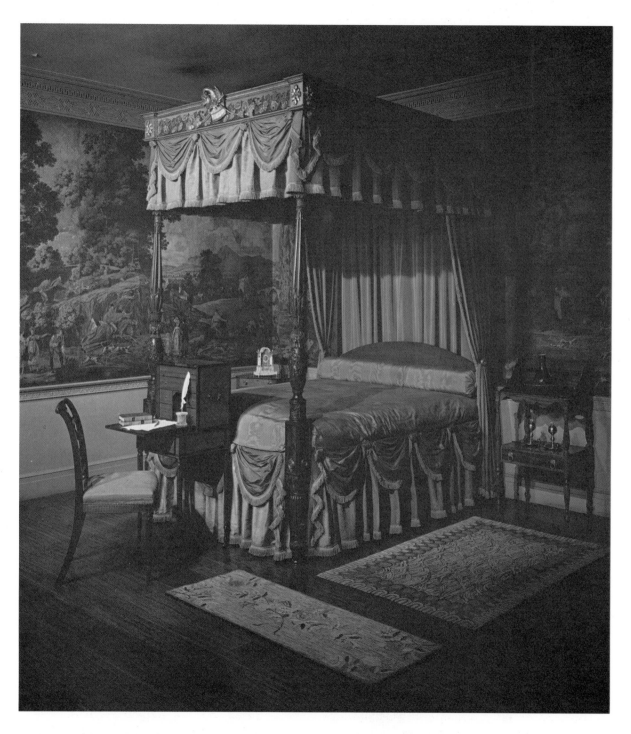

A Nineteenth Century Interior, ca. 1818, from the Duncan House, Haverhill, Massachusetts. The rich colors of the hunting scenes in the antique wallpaper are recalled in the hangings of the bed, which is of the style of Duncan Phyfe. The delicate writing chest is complemented by an American Sheraton chair. Architectural details are characteristic of an American Federal interior.

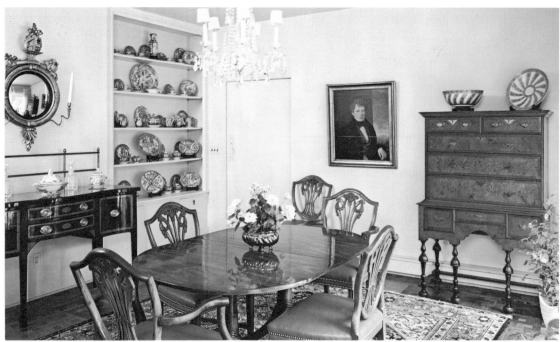

↑ *Handsome traditional furniture and accessories give style and character to a country dining room with a simple background. The asymmetrical arrangement of highboy and portrait creates interest and individuality.*

Hans Namuth

↓ *Eighteenth century antiques are happily combined with Victorian furniture in this delightful country bedroom. The green and white scheme adds freshness to the cheerful atmosphere.* Hans Namuth

Essex Institute

Salon in the Pingree House, Salem, Massachusetts, designed by Samuel McIntire in 1804. The woodwork is limited to the mantel, trim, and dado.

ings they had been able to salvage. The influence of these French furniture importations was noticeable, particularly in the southern states.

The opening years of the nineteenth century saw a definite trend toward the furniture forms of the French Empire, interpreted by American cabinetmakers in a rather heavy and, at times, ostentatious manner. Simplification in detail and ornament usually occurred, although the construction of the furniture was equal to the European models. When ormolu mounts were used, they were often of pressed and gilded wrought iron instead of cast brass.

SAMUEL McINTIRE. Salem, Massachusetts, became the capital of the state for a few years after 1774. While the British occupied Boston,

it was the most important port on the Atlantic coast and was the home of the fastest sailing ships on the ocean. Its four-masters sailed to India and China and returned with luxurious cargoes that enriched the homes of New England. Wealth flowed into Salem until the period of the War of 1812.

Samuel McIntire, the most famous citizen and craftsman-architect of Salem, was born in 1757 and was a man of many talents, according to the inscription on his tombstone, which reads, "He was distinguished for genius in Architecture, Sculpture, and Musick: Modest and Sweet manners rendered him pleasing: Industry and Integrity reputable: He professed the Religion of Jesus on his entrance on manly life; and

proved its excellence by virtuous Principles and Unblemished Conduct." In addition, he was a carpenter, who built gates, fences, and dog-houses; he designed and produced interior wood-work and furniture. He sang and taught instrumental music, and he was a great inspiration in the arts for those who followed him. In 1792 he submitted designs for the proposed Capitol in Washington, which, however, were not accepted. He designed many of the dwellings in Salem and particularly the brick houses on Chestnut Street, which street is thought by many to be, in the springtime, the most beautiful city street in the United States. He was a master of proportions, detail, and texture. He admired the work of Bulfinch and owned many of the contemporary English books on classical architectural design.

McIntire's designs for interior woodwork were greatly influenced by the Adams of England. He was particularly noted for his beautifully proportioned and carved mantels, cornices, dadoes, window and door trim, and curved stairways. The fireplace walls of his rooms were usually entirely covered with paneling. On the other three walls, plaster was used above a dado. He was also famous for his ornamental wood carving, which was sometimes reproduced in a composition material. The motifs used were baskets of fruit, horns of plenty, sprays of grapes, festoons, rosettes, eagles, urns, cherubs, female figures, musical trophies, and pastoral groups. He modeled a bust of Voltaire, a profile relief of Washington, and many of the ships-heads for the clippers that sailed from the port. He designed and made fine furniture and obviously worked from the books of both Hepplewhite and Sheraton. When he died in 1811, his son Samuel Field McIntire carried on his business for a few years but died "of intemperance" in 1819.

DUNCAN PHYFE. Duncan Phyfe (1768–1854) is popularly considered the outstanding American cabinetmaker of the early nineteenth century. There is no doubt as to his remarkable ability; whether he is to be considered superior, however, to some of his predecessors or even to some of his contemporaries is open to question. He came to the United States from Scotland as a young man, in 1784. After learning the trade of cabinetmaking in Albany, New York, he removed to New York City about 1790 and opened a shop of his own. His success was almost instantaneous, and although he died a disappointed man in 1854 at the age of eighty-six, he left a distinct mark upon the industrial arts of America. His finest work was produced between 1795 and 1818, during which years he closely followed the Sheraton designs. His best furniture was made in mahogany and satinwood and showed proportions of the most graceful sort, with exquisite delicacy of line and detail. The Grecian curve in chair backs and legs and the pedestal support for tables with concave flared legs were the principal forms that were used. Turning was also employed. Carved ornament of the most refined variety was executed with extraordinary craftsmanship. He used reeding a great deal on his frames for chairs and sofas, the legs of which often ended in conventionalized animal feet. The lyre form was fre-

Museum of the City of New York

Pedestal and sideboard with cellaret made by Duncan Phyfe for his own residence at 193 Fulton Street (about 1825–1830).

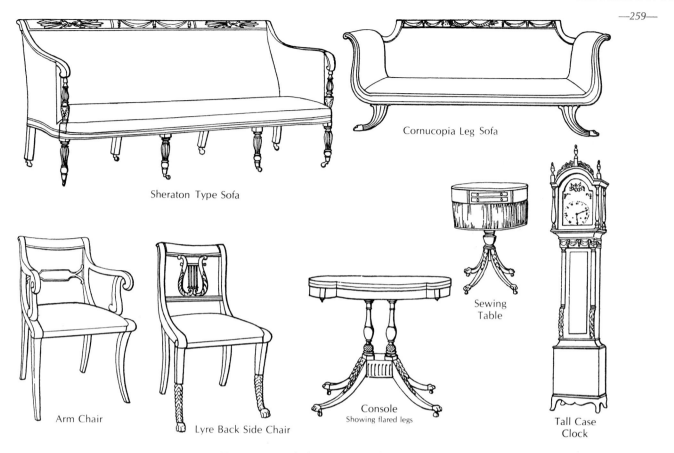

Sheraton Type Sofa

Cornucopia Leg Sofa

Arm Chair

Lyre Back Side Chair

Console
Showing flared legs

Sewing
Table

Tall Case
Clock

Furniture made by Duncan Phyfe.

quently used for chair backs, sofa arms, and sometimes for table supports. The cornucopia leg was also used. Other motifs were swags, tassels, rosettes, vase forms, bowknots, and the thunderbolt. In his later work he used maple, rosewood, and black walnut, as well as mahogany. Metal feet, roller casters, and metal surface ornaments were also occasionally employed. Toward 1830 his productions showed French Empire and English regency influences that are often referred to as "American Empire" pieces. Carved ornament followed Grecian forms, and furniture was additionally enriched with cast or wrought brass mountings. Around 1840, competition with the manufacturers of machine-made furniture caused him to produce

massive, clumsy pieces that he knew to be ugly, and in which the only agreeable feature was the graining and color of the woodwork. It is said that he referred to this furniture as "butcher furniture," and much of it was made when his shop was under the direction of his son.

THE AMERICAN EAGLE PERIOD. The wave of patriotism that developed at the time of the War of 1812 caused an increase in popularity of the use of the bald eagle as a national emblem. The Continental Congress had decreed the use of the symbol in 1782, and it had been the symbol of power used by ancient nations. American designers adopted it as a pattern motif in every medium. It was used to crown the pediment of entrance doorways; it was painted on window-

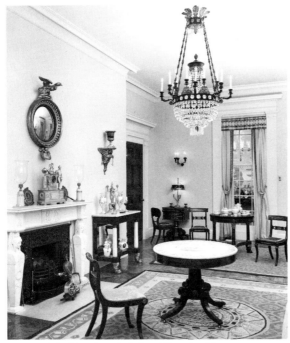

Courtesy of the Henry Francis du Pont Winterthur Museum

Empire parlor reflecting the Greek revival in architecture and furniture design prevalent between 1815 and 1840. Note eagle motif on mirror.

panes; and it was used as a finial motif on vertical features of every type in architecture and decoration. American cabinetmakers commercialized the form, and it was introduced as a support for chairs, tables, and consoles and became part of the designs for wall sconces and candelabra. Mirrors, picture frames, and clocks were crowned with the motif, and it formed the basis of glass and chinaware patterns. Every conceivable manner of drawing, painting, and carving the American eagle was utilized.

Patriotism was further expressed by painted decorations and decalcomania pictures showing the naval engagements of the War of 1812. The fight between the U.S.F. *Constitution* and the H.M.S. *Guerrière* was a particularly popular scene. Most of these scenes were placed on the upper panel of the Sheraton mirrors or on the lower portion of shelf clocks.

HITCHCOCK CHAIRS. During the early nineteenth century a "fancy chair," based on Sheraton Empire forms, was manufactured in Connecticut and widely sold among New England farmers and owners of small homes. In 1818 its originator, Lambert Hitchcock, established a factory of chair parts in Barkhamsted, Connecticut, sending them to the South for assembly. By 1823 he was assembling them himself at his factory in Hitchcocksville, Connecticut, marking them "L. Hitchcock, Hitchcocksville, Conn. Warranted." In 1832 his business failed, but before long he was busy again. During this period, the chairs bore the marking "Hitchcock,

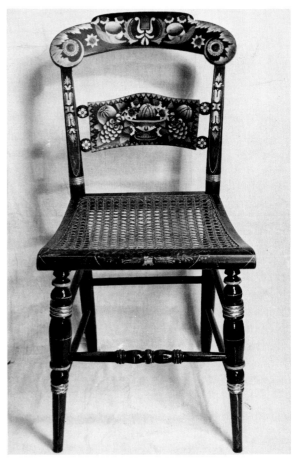

"Early American Decoration," by Brazer

An original stenciled chair labeled "L. Hitchcock, Hitchcocksville, Conn. Warrented." Made about 1827.

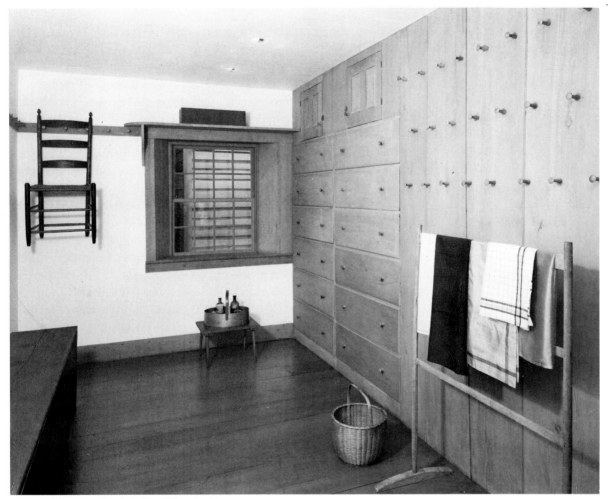

Courtesy of the Henry Francis du Pont Winterthur Museum

A Shaker storeroom.

Alford and Co. Warranted." In 1841 he established a new factory in Unionville, Connecticut, where a large production occurred. The chairs made in this factory were signed "Lambert Hitchcock." He died in 1852. His product was made in slender proportions, partly by hand and partly by machine, and was usually painted black. The legs were turned; the seat was painted rush; and the back was usually designed with horizontal rails and vertical slats. The top rail was widened, gently curved, and was stenciled or decorated with a gilt decalcomania pattern. Motifs included the horn of plenty, drinking birds, eagles, leaves, flowers, and fruits. The pattern has been imitated by other New England chair factories to the present day.

SHAKER FURNITURE. The Shakers were a communal religious sect that believed in frugality, industry, integrity, and celibacy. They produced some of the most honest and forthright furniture made in the United States during the latter part of the eighteenth and the early nineteenth century. They were active in New England, New York State, and Kentucky. Quality

of workmanship was a part of their religion, the standards for which were set by the community at Mt. Lebanon, New York, the "mother house." The furniture was plain, free from carved ornament, moldings, or veneers. Though sturdy, it was, as a rule, delicate in its proportions. The cabinetmakers were spiritually dedicated to their tasks, and every piece was made with great technical care.

The Shaker belief in the utility of every household object produced a type of furniture which bears out the modern precept that form should follow function and that true beauty rests on the suitability of an article to its purpose. The furniture was made of pine, cherry, maple, and other local woods that were lightly stained or given a thin, clear wash of red, blue, or yellow. Almost all of the furniture was made for the use of the community, and not for the "world's people." Some of it was sold to outsiders in later years. The rooms of Shaker houses were marked by the predominance of built-in cupboards, chests, and drawers, each designed for a specific storage purpose. Cleanliness and orderliness were dominating requirements of the group. All furniture was carefully joined by mortise, dowel, or dovetail. Built-in pieces and dining tables were large because their use was shared by many persons. By contrast, freestanding pieces, such as chairs, were rather light in scale, as the Shakers had nothing in their houses which could not easily be moved for cleaning. Straight chairs resembled early American ladder-backs, with seats of woven splints or brightly colored hand-woven tapes in herringbone, chevron, striped, and checked designs. Certain chairs recall the American Windsor type. Beds, usually painted green, had low head and footboards and wooden casters for easy rolling. Highboys, chests, washstands, slant-top desks, sewing cabinets, blanket chests, stools, benches, and swivel chairs were also made. Other interesting Shaker products were their handmade tools for carpentering, agriculture, and household duties.

Shaker furniture, because of its simple, clean lines and functional qualities may be successfully combined with contemporary pieces in modern interiors as well as used in informal colonial rooms.

THE GREEK REVIVAL (1820–1860). The second quarter of the nineteenth century witnessed a stylistic revival of complex origins. The early statesmen had urged the use of Greek and Roman types of architecture as being most suitable for federal buildings, and this thought penetrated the minds of the residential designers. The French Empire forms and Sir John Soane, the master of regency design in England, also had their influence. Books covering the architecture, decoration, and furnishings of these foreign styles began to flood the United States. Sympathy for the Greeks in their war of independence (1821–1827) had a powerful appeal for the public.* Byron became the literary god of the day and the secret passion of every romantic young woman. The expansion of the country and its mounting wealth and immigration developed an urgent need for new dwellings from the Atlantic to the Middle West. Magazines began to discuss architecture and the arts, showing an increasing interest in these subjects. Americans began to make the "grand tour" of Europe. Eastern cities were given Greek names, such as Athens, Troy, Ypsilanti, Sparta, Ithaca, and Syracuse. The English Renaissance forms of Wren and the Pompeian types of Adam had become old-fashioned. They were colonial. In the natural human demand for change, what

*Horatio Greenough at this time made a colossal statue of Washington, his nude body draped to represent a Greek god. The father of his country is shown surrendering the sword, the symbol of war and victory, and directing the nation to the God of peace. This statue is now in the Smithsonian Institution.

could be more worthy than the perfections of Greek art? The "temple" style of architecture, with its pedimented portico, based on the Parthenon, was being used for public buildings and churches; why not apply it to residential construction?* Style interest surged toward Hellenic forms. The Greek orders began everywhere to be used for both exterior and interior design. Consistency called for Greek detail and ornament in interior trim. Doors and windows were crowned with pseudo-Greek pediments, often simple triangular panels without moldings; friezes were enriched with *triglyphs*, rosettes, or classical figures. The anthemion, acanthus leaf, honeysuckle, and fret became the basis of all ornament. The Greek moldings of changing curvature were everywhere in evidence in both stone and wood construction. The drawing rooms or parlors in the houses of this period were usually separated from the dining room by Greek Ionic or Corinthian columns that formed an important decorative feature and were intended to frame the sliding doors between the rooms. Ceilings were high, and walls were usually painted a plain color or covered with a wallpaper. Window draperies were often treated with pressed brass valances. Furniture was designed in the heavy "American Empire" style with frequent use of the Greek curves and metal ornaments. Chair and table legs were often capped with plain or ornamental cast metal feet and usually had swivel casters.

The Greek revival was a borrowed style,

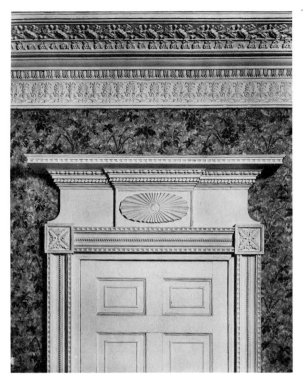

Detail of doorway and cornice showing early evidence of Greek revival.

but the adaptations produced by the American designers had charm and dignity sufficient to give it a native character. As the designs of the period were American first and Greek afterward, a continuous national stylistic expression might have evolved. The decline was due largely to the Civil War and the economic changes of the reconstruction period. The entrance of the millionaire upon the American scene, the adulation of wealth and materialism, and the sudden love of display were the death of art. The country grew more rapidly than the supply of connoisseurs, artists, and designers. Fortunes were made overnight, and the gods were those who were lucky. Ostentation and effect, regardless of the materials and methods of attainment, became more important than character, logic, and refinement of line, form, and color. The result of this

* American cities from Maine to Georgia and as far west as Michigan and Missouri are replete with examples of this style, such as the Subtreasury and the residences on Washington Square in New York City; Lee's Mansion in Arlington, Virginia; the Custom House in Boston, Massachusetts; the university buildings in Lexington, Virginia, and in Amherst, Massachusetts; the Ohio State Capitol; and many houses in Natchez, Mississippi; Athens, Georgia; Harrodsburg, Kentucky; and Charleston, South Carolina.

philosophy was seen in the last half of the century, which was characterized by boldly conceived eclectic efforts that were based on the principle that if beauty must come from a past style, why should one be limited to the Greek? The twentieth century was to question this aesthetic theory.

THE VICTORIAN TRENDS IN ARCHITECTURE AND DECORATION (1840–1880). The term *Victorian*, as applied to the mid-nineteenth-century decorative arts in America, is only partially correct. With a public mainly interested in industry, art was quite secondary. The promising seeds that were sown during the Greek revival apparently were considered inadequate to reflect the wealth and power of the rapidly growing nation. No great stylistic leaders appeared, and the few voices that expressed themselves were disregarded. Novelty was demanded, but connoisseurship was lacking. Ideas could be borrowed more rapidly than conceived, and logic and a native expression seemed unnecessary. England was the most obvious source of inspiration, although the eternal leadership of France could not be ignored. Designers also searched fields that were more distant in both time and place. The Victorian period witnessed a rapid succession of confused style revivals, all of which overlapped, were nonreflective of their times, and were impurely and inconsistently applied.

The Greek revival overlapped a Gothic revival. This had been inspired by the building of the Houses of Parliament in London, by Ruskin's, Morris's, and the later Eastlake's books, and by Pugin and Viollet le duc, the French Gothicists.* The result in the decorative arts was an absurd use of wooden pointed arches, vaults, and windows, clustered columns, jigsaw ornament, and stained glass. These details were

* The protests of these men were studied more attentively in the first quarter of the twentieth century, when "functionalism" became a much discussed aesthetic principle.

accompanied by furniture and accessories in naïve Gothic detail. Engravings and lithographs showed religious, sentimental, or depressing subject matter. However, this style, logically suited to church design, produced excellent applications of Gothic architecture in Trinity Church and Saint Patrick's Cathedral in New York City.

About 1850 Louis Napoleon had revived the style of Mansart in adding new wings to the Louvre, and Garnier later built the Paris Opera House. Napoleon's Spanish wife, Eugenie, with a sparkling personality and clothes of extraordinary chic, entranced the Western world with her cultural dictates. American builders, with a woeful lack of data, were hardly competent to interpret Mansart. Their attempts produced some fantastic architectural abortions that have been designated the "General Grant" style. Houses were given steep mansarded roofs, pierced with dormers. Facades were enriched with incorrectly proportioned classical orders. Ostentation was expressed by cupolas, porte cocheres, and large bay windows, all of which affected the interiors. Lawns were covered with hydrangeas. Cast iron dogs and stags startled approaching visitors. Cities were crowded with houses having high-stooped brownstone fronts and a standard plan with a front and rear room completely devoid of aesthetic consideration. Ceilings were high; halls were narrow; and interior rooms were without windows or lighted by the most meager of shafts. The jerry-built house was on its way.

The next influence in American design was that of H. H. Richardson, the architect who designed Trinity Church in Boston, Massachusetts. A man of extraordinary genius, he revolted against both the Gothic and Mansart revivals and turned to the primitive forms of the round-arched Romanesque. He employed John LaFarge the muralist to decorate the most colorful and famous church in the United States, finished in 1877. Richardson's influence was

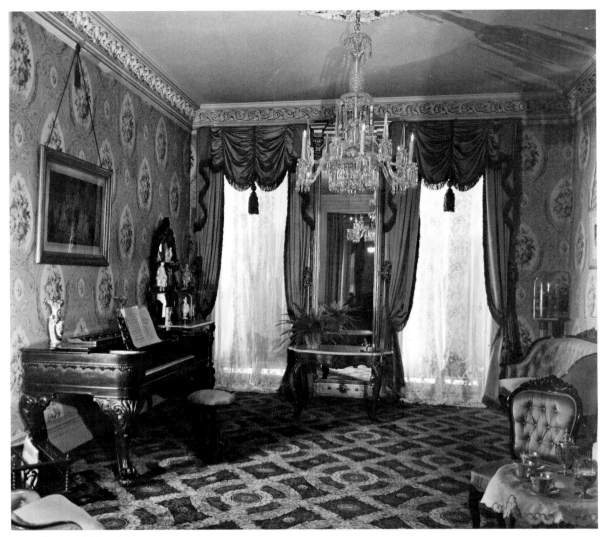

Roosevelt Memorial Association

Parlor in Theodore Roosevelt House, New York, about 1860.

enormous. The style he worked in was logical in stone, but thousands of imitators produced the Romanesque wooden house to which the appellation "Queen Anne cottage" has been misapplied. Supposedly picturesque, romantic, and rambling, this type of residence had high gabled roofs, corner towers, and balconies and was covered by shingles applied in patterns. The interiors were badly planned, and rooms were often irregular in shape, with circular bay win-dows. Ornament was almost entirely produced by the turning lathe. Machine-made detail accomplished its worst. Balusters, spindles, wooden grilles, and dwarf columns were used in profusion. The use of golden oak was the cachet of respectability. Paneled wainscots, false beamed ceilings, parquet floors, heavy wooden trim, and massive moldings in this wood were introduced in all important rooms. The con-temporary architectural and decorative publica-

tions show a very mixed effort for room adornment. Wall composition and orderly furniture arrangement were apparently disregarded. Antique furniture was little in demand, and unity of style was not contemplated at all. An excessive use of unrelated patterned surfaces on walls, floors, and upholstery often occurred. Walls were covered with wallpaper of poor design, painted stencil patterns, or real or *papier-mâché* imitation Spanish leather. Furniture and accessories of hybrid styles cluttered the rooms to a disturbing degree. The Oriental rug became popular and was often covered with a lion, tiger, or bear skin, with a head having a snarling mouth. Marble slab mantels with arched fireplace openings were often used; the ornament was crudely made with an incised and gilded line. Bright colored bricks and tiles were also used for mantel facings. Overmantels were treated with numerous shelves and vertical subdivisions. A high decorative frieze was carried around the room. Portieres were often made of glass beads, shells, or short lengths of bamboo. Windows were swathed with heavy draperies, swags, valances, and jabots, enriched with heavy fringes. The Turkish divan became the most important decorative feature in every interior.

VICTORIAN FURNITURE AND THE BEGINNINGS OF MACHINE PRODUCTION. As previously mentioned, by the beginning of the third decade of the nineteenth century the American people were dominated by industrial and geographical expansion, and science and invention, being highly profitable, occupied the imaginations of the most talented. Even those artists who had already made names for themselves had turned to industry for a living. Robert Fulton, the portrait painter, perfected the steamboat in 1806. Samuel F. B. Morse, the painter and professor of fine arts, perfected the telegraph instrument in 1844.

However, during this period, furniture had to be manufactured and sold. Many manufacturers endeavored with poor success to make the machine do what the hand had done before. Style books on furniture design continued to be produced and published in both England and America showing clumsy interpretations of the French Empire forms, of classic frets and honeysuckles, and of Egyptian motifs. For want of better inspiration, many designers harked back to the Gothic period, which had, in part, been popularized by the writings of Sir Walter Scott and Victor Hugo. Beginning about the middle of the century, the most fantastic interpretations of the rococo forms of Louis XV furniture were made in black walnut, rosewood, and imitation ebony. Few cabinetmakers had sufficient design knowledge to retain the charm of the structural curved forms of the original models. The movement continued well into the last quarter of the century. This was the result of blindly following Paris fashions, which had tended toward a revival of Louis XV work after the short restoration of the monarchy under Louis Philippe in 1830, and the popularity of French fashions under Louis Napoleon.

One of the most important developments was the introduction of all-upholstered furniture as a result of the invention of the coiled metal spring. Single seats, built-in sofas, circular seats, dos-à-dos, vis-à-vis, three-seated "confidantes," "comfortables," and a host of other cushioned types became popular as the public lost their sense of dignity and demanded Oriental ease in both public and private rooms. Upholstered furniture was made with elaborate cord, fringe, *galloon*, button, and tassel trimmings, harmonizing with the elaborate draperies of the period. Popular upholstery fabrics were bright red and green plush and black horsehair. The furniture of this period was, on the whole, unpleasant in appearance. Jigsaw ornament, which was easy to make with the new machines operated by steam, became common. Furniture legs were usually turned, because this form was inexpensive to produce. The English Eastlake influence was seen in the shallow grooves following

straight and curved lines, accentuated by gilding that was applied as ornament to the wood frames.

The Victorian period produced the *whatnot*, the *hassock* and *ottoman*, the Turkish divan, nests of tables, gaslights, papier-mâché furniture, mother-of-pearl inlay, *blackamoor* statues, parlor-gem pianos, tidies, *antimacassars*, needlework mottoes, shell and bead curtains, sentimental steel engravings, chromolithographs, and charcoal portraits. The machine production of wallpaper and rugs tended to reduce the scale and length of pattern repeats. The use of these objects continued well into the last quarter of the century.

The most complimentary statement that can be made concerning the American Victorian period is that it exactly expressed the lack of taste of the people. Interested in almost everything but art, they obtained little art. Art, beauty, and the spirit were doomed under the assaults of materialism and industry. This period is a perfect example of how the cultural level of a people is reflected in their art forms and how no art can be produced without a public which has an understanding and need for it.

BELTER FURNITURE. One of the leading furniture makers of the Victorian era was John Henry Belter, who made chairs, sofas, and case pieces in fanciful but durable designs, displaying vitality, spirit, and master craftsmanship. (Most of the forms were vaguely based on Louis XV designs, the revival of which was extremely popular.) Belter was a native of Germany, who in 1844 established a shop in New York City, and in 1856 applied for a patent on his method of making furniture. Though some pieces were of stained oak, black walnut, or "blackwood" (hardwood painted to look like ebony), the finest ones were of richly figured tropical rosewood, built up of several layers of thin veneer glued together, each layer laid at right angles to the next, then steamed and pressed in a special matrix designed to mould them into the desired

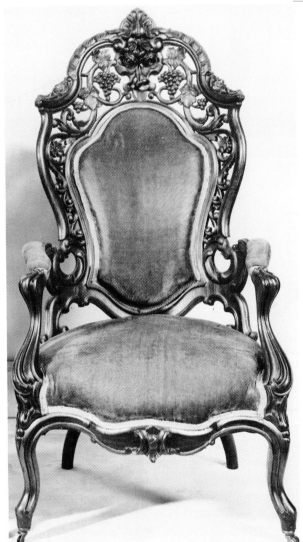

Sotheby Parke Bernet

Carved rosewood chair by Belter made about 1855.

curved surfaces. He was therefore one of the earliest cabinetmakers to use laminated products. The surfaces were pierced with elaborate lacelike openwork designs and then carved with fruit, flower, and foliage forms. Some pieces are carved, without piercing; others are plain but shaped in a serpentine curve to give them interest. Another feature of Belter's work was the application of extra pieces of solid wood to the veneers for ornament in high relief. Drawers of

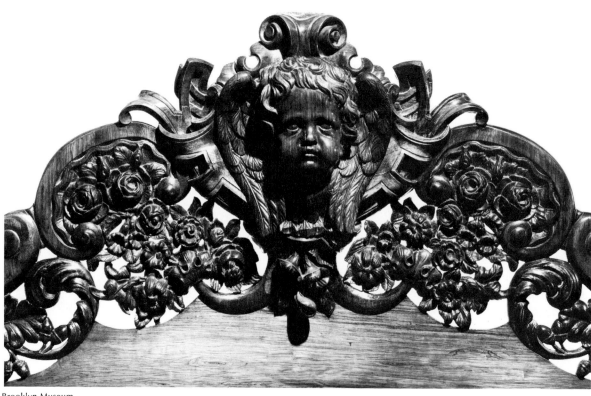

Detail of headboard by John Henry Belter.

case pieces show precise joinery and are lined with plain or bird's-eye maple. The frames of chair and sofa backs, instead of being upholstered, were often covered with rosewood veneer. Belter's designs were in great demand among the wealthy residents of New York and of other cities during the 1840s and 1850s. Evidence of the volume of his business is given by the fact that, in 1858, he owned a factory said to have employed forty apprentices. From 1860, Belter's furniture declined in popularity due to the increase in cheap mass-production goods and the disappearance of the rich market that had existed before the Civil War. After his death in 1863, Belter's partners continued production until the postwar financial depression brought about the final collapse in 1867.

VICTORIAN ACCESSORIES. During the mid-

nineteenth-century period John Rogers (1829–1904) produced small statues, in bronze or a putty-colored composition material, the use of which became popular as parlor ornaments. The subject matter was usually sentimental or historical. Civil War heroes, personages, and groups of figures taken from the popular literature of the day were represented. Characteristic titles were "One More Shot," "The Wounded Scout," and "Rip Van Winkle."

The Currier and Ives colored lithographs were also produced during this period. Currier established his business in 1835 in New York, taking Ives in as a partner in 1857. An enormous range of subject matter was covered in these prints, which wholesaled at anywhere from six cents apiece to a little over a dollar. Popular subjects were disasters, important news events,

various sentimental subjects, scenes of family life, and all types of sporting events. The pictures were not meant for drawing room use. They were hung on the walls of less ostentatious homes, schoolrooms, nurseries, stores, offices, steamboats, taverns, and hotels. The original drawings were produced by several artists, the quality of whose work varied greatly. While both the Rogers groups and the Currier and Ives productions can hardly be called works of art, they were representative of the taste of the times.

Another popular and inexpensive accessory found in almost every small home in America between 1770 and 1845 was the portrait *silhouette*. Itinerant artists peddled their skill from door to door, or held forth at country fairs. The usual method used was to reduce the shadow of the subject's profile by means of a lens, then trace or cut the image from paper. In some cases the profile was sketched by the artist and elaborately painted with very fine detail. They were of white paper mounted on a ground of black silk, velvet, or paper, or of black paper mounted on a white ground. So popular were silhouettes all over the country that many people with an urge to travel turned to this means of livelihood, sure of a welcome and a night's lodging wherever they went, selling their services for a few cents. By the 1850s, however, the popularity of silhouettes had been killed by the introduction of the *daguerreotype* process of photography. Sensing the coming change, many silhouette artists opened photographic studios. Daguerreotyping was first described by Louis Daguerre in France in 1839. The chemical process involved the coating of a copper or glass plate with silver, sensitized with a solution of iodine. On exposure of the treated plate to light, an image was produced that was afterward fixed in the plate by the application of other chemicals. The image in a daguerreotype is rather faint and must be viewed at an angle to be clearly seen. Between 1848 and 1860 these photographs were pro-

duced in great quantities, and a collection was to be found in every Victorian parlor.

Daguerreotype cases with covers represent the first use of plastics in America. They were moulded of gutta-percha, the sap or gum from a Malayan tree, mixed with a combination of wood, flour, and other bonding ingredients, in a variety of styles. Historical, patriotic, and sentimental themes, political and fraternal emblems, baroque and rococo forms, and Christmas, Easter, and Valentine designs were used as patterns. Characteristic subjects were the capture of André, the coming of Saint Nicholas, Jenny Lind, and the shield and stars. These patterns were produced on the covers in relief by means of a die. Daguerreotypes and their cases are now collectors' items, but they are also often used as accessories in modern interpretations of Victorian rooms.

INFLUENCE OF THE PHILADELPHIA EXPOSITION OF 1876. Mention has already been made of the influence of the Centennial Exposition held in Philadelphia in 1876. This exhibit undoubtedly contributed to a greater appreciation of the relative importance of art in daily life. No standards of design were set, but the art consciousness of the nation was given a definite start again, after more than a generation of lethargy. The improvement of economic conditions after the Civil War reconstruction period, the development of natural resources, and the general industrial and agricultural expansion, combined with the building of the railroads, had helped to create a more widespread wealth. Wealth brought leisure, and leisure gave impetus to a demand for art and culture. A natural urge developed among those who had acquired wealth to surround themselves with furnishings that reflected their growing culture.

IMPROVEMENT IN ART EDUCATION. The Metropolitan Museum of Art in New York City was founded in 1870. Several books were issued on home decoration, and new monthly and weekly publications on art subjects were initiated. A

movement was started urging wealthy men to leave endowments for the support of art schools and societies. One New York art monthly stated in 1885, "It is time the importance of this branch of education [architecture] was brought to the notice of our rich men, that they may do something to promote this practical and useful division of knowledge. The schools are few where the architect and decorative arts student can even learn the rudiments of his art, much less the historic and scientific parts."

The gradual improvement in comfort, speed, and safety in oceangoing vessels, which was coincident with the growth of the leisure class, increased the popularity of pleasure travel to Europe, and the visits of thousands of Americans to the well-established museums of France, England, Germany, and other countries undoubtedly contributed greatly to the growing art consciousness.

Paris, leader of style and fashion and center of the art production of the Continent, with an annual salon and many well-known art ateliers, had a particular appeal for the new American connoisseurs. American architectural students in considerable numbers attended L'École des Beaux Arts in Paris, and upon their return were called upon to design reproductions of French châteaux* to house the newly rich. The fortunes made from the railroads, from the steel and oil industries, and from the gold, silver, and copper mines paid for them. As a result, New York became the center of the art world of America, and during the decade from 1870 to 1880 many important art schools and organizations were founded there.

ECLECTICISM OF THE END OF THE NINETEENTH CENTURY. During the last two decades of the nineteenth century, many Parisian decorators,

* "Biltmore" in Asheville, North Carolina, is the most prominent extant example of this period.

finding a ready market for their *antiques* and reproductions of the Louis styles, opened branch shops in the United States. These shops promoted the use of reproductions of eighteenth-century French styles in the pseudo-French châteaux that the rich were building.

In the smaller residences in New York, little intelligent thought was given to creating an original or appropriate decorative style for interiors. The art periodicals of this period showed source material from Italy, Spain, Germany, China, Japan, India, and Turkey, and all were frequently used in the same rooms. Lack of consistency and harmony was prevalent. Sentimentalism was rampant in pictures and in accessories, and eclecticism was more important than originality.

Many of the attempts to improve home surroundings by transposing the arts of other countries were haphazard and illogical. A generation was to pass before intelligent results were seen in adapting foreign styles to local conditions, and even then, both the artists and the public little realized the anemic and unimaginative quality of an artistic effort that was imitative without being creative. The movement was not, however, entirely without merit. Many magnificent importations and accurate reproductions of Italian, Spanish, French, and English rooms were assembled. The movement served as a stepping-stone, was educational, and showed the results of the art expression of other peoples and other times, even though, for a long period, an analysis was not made of the basic principles that produced these outward forms, nor was their suitability of adaptation considered. Clients arbitrarily chose to have a Tudor mansion, a Normandy farmhouse, a Georgian manor house, an Italian villa, a medieval castle, or any one of dozens of other styles and types, so long as they were accurately reproduced, effective, comfortable, furnished in antique or correctly reproduced furniture of the style of the house, and

equipped with modern plumbing and mechanical conveniences. This trend continued during the entire first quarter of the twentieth century.

THE SPANISH MISSIONS IN NORTH AMERICA. One of the most interesting developments of Spanish colonial culture was its northward expansion across the Rio Grande between 1690 and 1836. The Franciscans and Dominicans penetrated this western wilderness to bring the aborigines within the realms of the King of Kings and the king of Spain. From Texas into California, as far north as San Francisco, the padres erected chapels, hospices, and administrative buildings in adobe brick and stone. Those that have withstood the ravages of time are among the most charming and romantic architectural groups in the United States. Outstanding are the Alamo, in the Spanish-Mexican style, and San José, with traces of the Gothic, both in San Antonio, and the California missions known as San Luis Rey, San Juan Capistrano, Santa Barbara, and San Carlos Borromeo del Rio Carmelo. The latter were founded by Fra Junipero Serra, a man of extraordinary character, who, in a labor of love, and under great hardships, gained the confidence and affection of the natives and induced them to act as willing vassals in bringing peace and plenty to the land. Considering Serra and his successors' limited technical knowledge, meager tools, and pagan craftsmen, the architectural and decorative results were astonishing in their stability and spiritual expression. The pedimented facades, colorful tile-roofed towers, graceful belfries, and cloistered patios picturesquely nestle in the hills and look down upon the blue waves of the Pacific.

The principal decorative effort was concentrated in the chapels. The interiors of these are enriched with painted imitations of archaic-appearing classical columns, pilasters, and cornice moldings. The roofs and ceilings are usually supported by exposed beams. In a few

Photo Researchers

San Antonio de Padua Mission in California.

cases barrel vaults and *catenary arches* were attempted. Walls and altars were hung with religious paintings, embroidered cloths, and Christian symbols imported from Spain and Mexico. Other decorations consisted of painted patterns that were inspired by Moorish-Gothic, Plateresco, or exuberant Churrigueresco forms. Occasionally the artisans interpolated motifs of Aztec origin, not realizing the inconsistency of these with Christian iconography. In spite of the crudeness of technique, the general effect was one of sincerity and warmth.

Such original furniture as remains shows little relationship to Spanish detail. The padres contented themselves with primitive living and the simplest of conveniences. Sturdily built, rectangular, and heavily proportioned chairs, chests, tables, and wardrobes were made in native woods, assembled and joined with mortise, tenon, and dowel. This furniture has formed the basis for modern productions of questionable merit that are known as "Spanish mission."

PROMINENT ARCHITECTS AND CRAFTSMEN IN AMERICA
FROM THE SEVENTEENTH TO THE TWENTIETH CENTURIES

Architects

Benjamin, Asher (1773–1845). Architect and author of architectural handbooks.

Bulfinch, Charles (1763–1844). Designed the capitols of Massachusetts, Maine, and Connecticut and put Thornton's plan for the Capitol at Washington into execution.

Hoban, James (1762–1831). Built the statehouse at Charleston, South Carolina.

Jefferson, Thomas (1743–1826). President of the United States and father of the classic revival in the United States. Designed Monticello and the University of Virginia.

Kearsley, Dr. John (active during the first half of the eighteenth century). Designed Christ Church in Philadelphia.

Latrobe, Benjamin Henry (1764–1820). Designed the Bank of Pennsylvania, introducing the Greek revival in the United States.

L'Enfant, Pierre Charles (1754–1825). Arrived in America at the end of the eighteenth century. Planned the city of Washington, D.C.

McComb, John (1763–1853). Designed the New York City Hall in association with Joseph Mangin, a French engineer.

McIntire, Samuel (1757–1811). Colonial architect, master carpenter, and wood-carver, who designed many of the houses built in Salem (1782–1811) in the classical tradition.

Richardson, Henry Hobson (1838–1886). Architect; leader in Romanesque revival in architecture.

Sullivan, Louis H. (1856–1924). Architect; early promoter of functional design·in architectural structures.

Thornton, Dr. William (arrived in United States in 1793). Designed the first Capitol at Washington.

Wright, Frank Lloyd (1869–1959). Architect, author, follower of Louis Sullivan in promoting functional and organic design in architecture and the industrial arts.

Cabinetmakers

Affleck, Thomas (active 1763–1795). Leading figure in the Philadelphia-Chippendale school.

Belter, John Henry (1800?–1865). New York City. Rosewood and carved laminated forms.

Folwell, John (active last quarter of the eighteenth century). Philadelphia-Chippendale school. Made the furniture for the Continental Congress. Called the Chippendale of America.

Goddard, John (b. 1723, active third quarter of the eighteenth century). Cabinetmaker of Newport, Rhode Island, who worked in the Chippendale style. Renowned for his use of the block front.

Lannuier, H. L. (active 1805–1820). Frenchman who produced Directoire and Empire styled furniture in New York City.

Miller, G. (active 1820–1830). New Yorker who made furniture following that of the Englishman Hope. Greek revival.

Phyfe, Duncan (produced 1795–1847). New York cabinetmaker and furniture designer of late eighteenth-century English and Empire styles.

Randolph, Benjamin (active last half of the eighteenth century to 1790). A leader in the Philadelphia-Chippendale school.

Savery, William (1722?–1787). Prominent in the Philadelphia-Chippendale school. Particularly noted for highboys.

Clock Manufacturers

Burnap, Daniel (active 1780–1800). Early clockmaker known for engraved faces.

Harland, Thomas (1735–1805). Came to America in 1773. Organizer of the clockmaking industry in Norwich, Connecticut.

Hoadley, Silas (1786–1870). Clockmaker and partner of Eli Terry.

Rittenhouse, David (1732–1796). Philadelphia clockmaker.

Terry, Eli (eighteenth, early nineteenth, century). Apprentice of Burnap, and later partner of Hoadley.

Thomas, Seth (1785–1859). Active in Thomaston, Connecticut, and founder of Seth Thomas clock factory.

Willard family: Simon, Benjamin, Aaron, and Ephraim (active 1743–1848). Famous family of Massachusetts clockmakers. Simon is credited with introducing the banjo clock in America from England.

Painters and Artists

Audubon, John J. (1785–1851). Ornithologist and painter. Made illustrations for *Birds of America.*

Copley, John Singleton (1737–1815). Portrait painter and member of Royal Academy in 1779.

Fulton, Robert (1765–1815). Artist as well as inventor.

Greenough, Horatio (1805–1852). Sculptor who first remarked that the design should be based on the function of the object and the possibilities of the material from which it is made.

Morse, Samuel F. B. (1791–1872). Painter and lecturer on fine arts as well as inventor of the wireless telegraph.

Peale family: Charles Willson (1741–1827); his brother, James (1749–1831); and Charles Willson's son, Rembrandt (1778–1860). Celebrated family of colonial portrait painters.

Saint-Gaudens, Augustus (1848–1907). Sculptor.

Saint Memin, Charles B. J. F. de (1770–1852). Artist and engraver, a native of Dijon, France, who, a refugee from the French Revolution, came to the United States about 1796. Made portraits of famous Americans between 1796 and 1810.

Stuart, Gilbert (1755–1828). Portrait painter, famous for his portraits of George Washington.

West, Benjamin (1738–1820). Painter of historical and mythological subjects.

Whistler, James Abbott McNeill (1834–1903). Painter and etcher.

Potters, Pewterers, and Glassmakers

Boardman, Thomas D. (1784–1873). Hartford pewterer.

Danforth, Samuel (active early nineteenth century). Hartford pewterer.

Fenton, Christopher (1806–1860). Manufacturer of Bennington pottery ware.

Hubener, George; Leedy, John; Mesz, Johannes. Pennsylvania potters who designed slip and sgraffito ware.

Greatbach, Daniel (active 1839–1860). Designer of Bennington pottery.

Spinner, David (active 1800–1811). Pennsylvania German potter.

Stiegel, Heinrich Wilhelm (1729–1785). Iron founder and manufacturer of fine glass in pre-Revolutionary days; founder of the factory at Mannheim, Pennsylvania.

Silversmiths

Coney, John (1655–1722). Boston silversmith and engraver.

Dummer, Jeremiah (1645–1718). Massachusetts silversmith.

Hull, John (1624–1683). Worked in Boston.

Kierstead, Cornelius (active during the seventeenth century). A Dutch silversmith who worked in New York and New Haven and was renowned for his tankard designs.

Le Roux family (active during the last half of the seventeenth century). Family of Huguenot silversmiths who worked in New York.

Revere, Paul (1735–1818). Boston silversmith and copperplate engraver, caricaturist, and bell-founder.

Sanderson, Robert (active 1638–1693). Boston silversmith.

Winslow, Edward (1669–1753). Boston silversmith.

Van Dyck, Peter (active during the seventeenth century). Dutch silversmith in New York.

BIBLIOGRAPHY

American Folk Art. New York: Museum of Modern Art, 1935.
A survey of the crafts of the common man in America.

American Index of Design—Pennsylvania German. New York: Metropolitan Museum of Art, 1943.
Excellent text and illustrations.

America's Historic Homes, The Living Past, Edited by Country Beautiful. New York: Wittenborn, 1967.

Bennett, G. F. *Early Architecture of Delaware.* Wilmington: Historical Press, 1932.
Photographs and measured drawings of exteriors and interiors, with a brief text.

Bjerkoe, Ethel Hall. *Cabinet Makers of America.* Garden City, N.Y.: Doubleday and Co., 1957.

Brazer, E. S. *Early American Decoration.* Springfield, Mass.: Pond-Ekberg Co., 1940.
A treatise on the technique of early American decoration.

Burchard & Bush-Brown. *The Architecture of America.* Boston: Little, Brown and Co., 1961.

Cescinsky, Herbert and Hunter. *English and American Furniture.* Dean-Hicks, 1929.

Christensen, E. O. *The Index of American Design.* New York: Macmillan Company, 1950.
Full-color illustrations from watercolor originals, and descriptive text, covering popular arts and crafts.

Coffin, L. A., Jr., and Holden, A. C. *Brick Architecture of the Colonial Period in Maryland and Virginia.* New York: Architectural Book Publishing Co., 1919.
Photographs and measured drawings with brief text.

Comstock, Helen. *The Concise Encyclopedia of American Antiques.* New York: Hawthorne Books, Inc., 1958.

Comstock, Helen. *100 Most Beautiful Rooms in America.* New York: The Viking Press, Inc., 1965.

Comstock, Helen. *American Furniture: 17th, 18th, and 19th Century Styles.* New York: The Viking Press, Inc.

Condit, Carl. *American Building: Materials and Techniques From The First Colonial Settlements to The Present.* Chicago: University of Chicago Press.

Davidson, Marshall B. *The American Heritage History of Colonial Antiques.* New York: American Heritage Publishing Co., Inc., Distributed by Simon and Schuster.

Downs, Joseph. *American Furniture: Queen Anne and Chippendale Periods 1725–1788.* New York: The Viking Press, Inc., 1967.

Drepperd, Carl W. *First Reader for Antique Collectors.* Garden City, N.Y.: Doubleday and Co., 1945.

Drepperd, Carl W. *Primer of American Antiques.* Garden City, N.Y.: Doubleday and Co., 1946.
 The two books above on American antiques are excellent with much material not found elsewhere. Text and illustration.

Dyer, W. A. *Early American Craftsmen.* New York: D. Appleton-Century Co., 1915.
 Illustrated text.

Eberlein, H. D., and Hubbard, C. V. D. *Colonial Interiors, Federal and Greek Revival.* 3d series. New York: William Helburn, 1938.
 Text and plates.

French, L., Jr. *Colonial Interiors.* New York: William Helburn, 1923.
 Photographs and measured drawings of interiors.

Gowans, Alan. *Images of American Living.* Philadelphia: J. B. Lippincott Company, 1965.

Great Georgian Houses of America. 2 vols. Drawn and compiled by the Architects' Emergency Committee, New York, 1933 and 1937.
 Excellent collection of photographs and architectural drawings.

Hamlin, Talbot. *Greek Revival Architecture in America.* New York: Oxford University Press, 1943. Text and plates.

Hipkiss, E. J. *18th Century American Arts.* The Karolik Collection. Cambridge, Mass.: Harvard University Press, 1941.
 Furniture, silver, needlework, paintings, etc.

Hornor, W. M., Jr. *Blue Book—Philadelphia Furniture, William Penn to George Washington.* Philadelphia: Philadelphia Craftsmen of 1935, 1935.
 Text for collectors illustrated with authentic examples of furniture. A standard authority.

Johnston, E. B. *The Early Architecture of North Carolina.* Chapel Hill, N.C.: University of North Carolina Press, 1941.
 Text and plates.

Kelley, J. F. *Early Connecticut Architecture.* 2 vols. New York: William Helburn, 1923, 1931.
 Excellent measured drawings of exterior and interior work.

Kelley, J. F. *The Early Domestic Architecture of Connecticut.* New Haven: Dover, 1963.
 Text illustrated with photographs and measured drawings.

Kettell, R. H. *Early American Rooms.* Portland, Maine: Southworth-Anthoensen Press, 1936.
 Excellent survey of American interior design. Colored illustrations.

Kettell, R. H. *The Pine Furniture of Early New England.* Dover, 1929. Illustrated text.

Kimball, F. *Domestic Architecture of the American Colonies and of the Early Republic.* New York: Charles Scribner's Sons, 1922.
 A good study of the background of colonial architecture. A standard authority.

Kimball, F. *Mr. Samuel McIntire, etc.* Portland, Maine: Southworth-Anthoensen Press, 1940.
 An authoritative study of his work.

Larkin, Oliver W. *Art and Life in America.* New York: Holt, Rinehart and Winston, 1960.
 Well illustrated.

Lichter, F. *Folk Art of Rural Pennsylvania.* New York: Charles Scribner's Sons, 1963.
Well-prepared presentation of German settlers.

Little, F. *Early American Textiles.* New York: D. Appleton-Century Co., 1931.
Excellent illustrated text. A survey of textile manufacturers from the first settlements through the early nineteenth century.

Lockwood, L. V. *Colonial Furniture in America.* 2 vols. New York: Charles Scribner's Sons, 1913.
Excellent photographs of American colonial furniture. A standard authority.

Lyon, I. W. *The Colonial Furniture of New England.* Boston: Houghton Mifflin Co., 1925.
A standard book for reference on this subject.

McClelland, N. *Duncan Phyfe and English Regency.* New York: William H. Scott, 1939.
Text and plates.

McClelland, N. *Furnishing the Colonial and Federal House.* Philadelphia: J. B. Lippincott Co., 1936.
An illustrated text on the complete furnishings of a home of this period.

Miller, E. G., Jr. *American Antique Furniture.* 2 vols. Baltimore: Lord Baltimore Press, 1937.
Complete text and illustrations.

Nevin and Commager. *A Short History of the United States.* New York: Modern Library, 1945.
Excellent brief outline of American history.

Newcomb, R. *Old Kentucky Architecture, Colonial, Federal, and Greek Revival.* New York: William Helburn, 1943.
Text and plates.

Nutting, W. *Furniture Treasury.* 3 vols. Framingham: Old America Co., 1928. Five thousand illustrations with descriptive text.

Ormsbee, Thomas H. *Field Guide to American Victorian Furniture.* Boston: Little, Brown and Co., 1952.
Clear drawings of many Victorian examples of furniture.

Ormsbee, Thomas H. *Field Guide to Early American Furniture.* Boston: Little, Brown and Co., 1951.
Good detailed account of early American furniture.

Pratt, Dorothy and Richard. *A Guide to Early American Houses.* New York: McGraw-Hill Book Company, 1956.

Pratt, Dorothy and Richard. *The Treasury of Early American Homes.* New York: Hawthorne Books, Inc., 1959.

Pratt, Dorothy and Richard. *Second Treasury of Early American Homes.* New York: Hawthorne Books, Inc., 1959.

Riccuiti, W. I. *New Orleans and Its Environs.* New York: William Helburn, 1938.
Plates and measured drawings.

Sale, E. T. *Colonial Interiors.* New York: William Helburn, 1930.
Photographs of authentic colonial interiors.

Stotz, C. M. *The Early Architecture of Western Pennsylvania.* New York: William Helburn, 1936.
Plates, text, and maps.

Tallmadge, T. E. *The Story of Architecture in America.* New York: W. W. Norton and Co., 1936.
An interesting illustrated history of American architecture written for the layman.

Taylor, Henry H. *Knowing, Collecting and Restoring Early American Furniture,* Philadelphia: J. B. Lippincott Company, 1930.

Vanderbilt, Cornelius, Jr. *The Living Past of America*. New York: Crown Publishers, Inc., 1955.

Williams, H. *Country Furniture of Early America*. Cranbury, N. J.: A. S. Barnes & Co., 1963.

Williams, Lionel, and Williams, Ottalie K. *Great Houses of America*. New York: G. P. Putnam's Sons, 2nd impression, 1969.

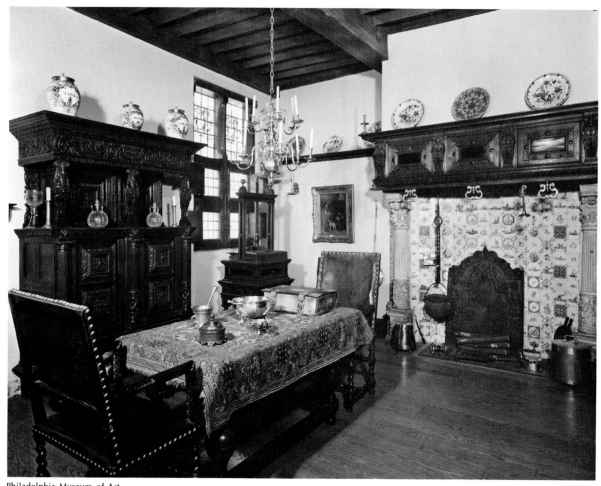

Dutch Room, Haarlem, 1608. From the house called "The Little Boat"

CHAPTER 8

Miscellaneous Styles and Arts

Headdress ornament. Colombia.

In addition to the great historical styles of art of western and southern Europe, there have been many other countries and races that have expressed themselves in terms of decorative arts that are equal in intrinsic merit to the Western and vary only in their relative importance. All of them are of interest to the decorator and connoisseur. In some cases these styles are the creative effort of great civilizations that have frequently influenced Western design, or whose productions have been valued and used in both former and modern types of Western interiors. In other cases, they are examples of the arts of sections of Europe, which, with less initiative and imagination in the decorative arts, have freely borrowed the styles of Italy, France, and England and have interpreted these arts under local conditions and influences to form variations of great interest. In addition, there are the art expressions of simple or primitive people all over the world, who, under indigenous philosophies, have produced limited but exceedingly interesting arts that are unrelated to those of Western culture. Some of these isolated arts were merely the result of a natural desire on the part of people with simple aesthetic standards to surround themselves with visual and spiritual joys; others had a deeper significance or were the result of religious impulses. Selections from these distant styles and arts, if used with discretion, may serve to contribute interest and individuality to the decoration of any room.

The character of these productions varies greatly in degree of refinement, depending upon the intellectual level of the people who produced them. Several require a life study for full appreciation and understanding, and only the merest outline of their development can be given in a text of this character. The student is referred to the bibliography for further information. Broadly, they can be classified into five main divisions, as follows:

Arts of the Far East and Islam
Renaissance arts of the Germanic nations
Peasant arts of Europe
Indian arts of the Americas
African Negro sculpture

ARTS OF THE FAR EAST AND ISLAM

Marco Polo returned from his overland trip to Cathay in the thirteenth century and created Asia for the European mind. Since then the West has been eager not only to import Eastern products, but her designers and artists have fed their imagination upon Oriental art forms.

All Eastern art, regardless of time or locality, has been entwined with religious impulses and deeply concerned with human philosophy. The mentality of the artists has been saturated with poetry and mysticism. Zest and imagination have been combined with a passion for excellence. The principles of pure design have been fully understood. Artists have vigilantly suited the spirit of their designs to the material in which they were working, and have expressed the substance of the material in the final outcome. Both intellectual and emotional appeal have been used, and in every medium there has been intrinsic beauty in expressive contours, subtle colors, and surface ornamentation. Effects have ranged from dignity and grandeur to delicacy and fragility. Realism, conventionalization, rhythm, and contrast have played their essential parts. Motion and repose

have been expressed at will. The hilarious, grotesque, and erotic have not been neglected. The indestructible vitality of the Oriental arts has been proved by their tenacity through repeated periods of discouragement and chaos.

The Oriental styles may be subdivided into those of the Far East, of which that of China is by far the dominant, and those of the Near East, which are mainly those of the Islamic countries, Persia, India, Turkey, and Moorish Spain. The Far Eastern arts were in the main indigenous from prehistoric times. Some of the Near Eastern arts are as old, but in their early periods there were Babylonian, Egyptian, and Hellenistic influences, and the Mongol invasions of the thirteenth century caused all to feel the magic touch of China.

Although the rarest products of these styles are in museums, there are many available objects of beauty, both old and new, that can be used to contribute great charm to the rooms of any style in countries that were unconceived when many of the objects were produced.

Chinese arts. Chinese civilization commences with a Stone Age that lasted from approximately 5000 B.C. until the Shang dynasty, which started about the year 1766 B.C. This dynasty is considered the first of the historical periods, and was followed by a series of dynasties known as the Ch'in, Han, Wei, Sui, Tang, Sung, and Yuan, the latter ending in A.D. 1368. During the dynasties of these thirty centuries, there were produced remarkable examples of bronze work, pottery, jewels, sacrificial vessels, articles of personal adornment, candelabra, harnesses for horses, ceremonial and religious objects, statuettes of humans and animals, and many other works of art of an astounding degree of technique and beauty. Until about A.D. 500, a large portion of Chinese art was intended for ritual and funerary purposes. Ancestor worship was responsible for the practice of painting the interior of tombs to enable the deceased to enjoy his resting place; his

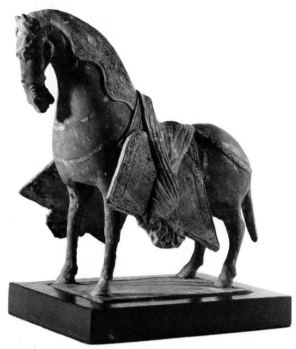

Worcester Art Museum

Chinese pottery horse. A.D. *500.*

body was surrounded with pottery and bronze food containers and other objects necessary for use in the hereafter.

Chinese art has been a native product, but in its long history it has occasionally been affected by the arts of border nations such as Scythia, Persia, and India; and China has suffered the invasions of the Mongols and the Tartars. In each case, however, the culture of the conquering nations has been submerged and assimilated in that of the conquered. Many dynasties started with brilliance and ended under the leadership of a descendant of the founder, who, with apathy and a false sense of security, often permitted himself to be ruined by unscrupulous followers. Religion as such has perhaps played a less important part in Chinese art than in that of other nations, although art has prospered under Buddhism to a

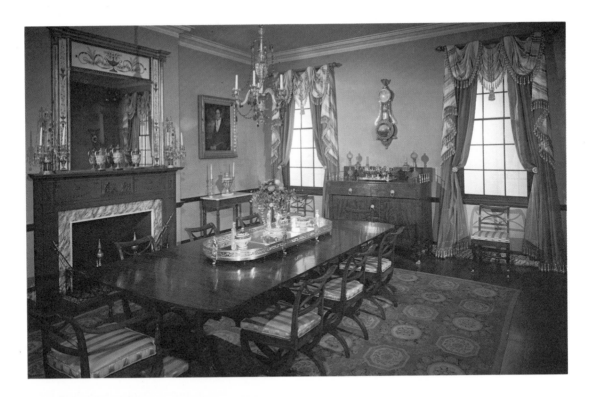

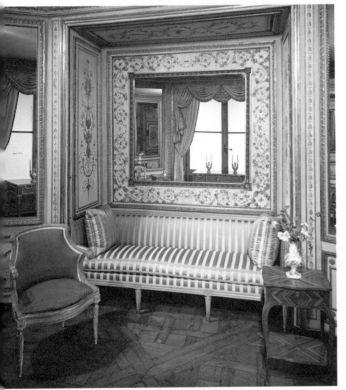

↑ A 19th Century American Dining Room in the Regency Style, ca. 1810–1815. The chairs and dining table were made in the workshop of Duncan Phyfe for a New York client. The Aubusson rug is in keeping with the elegance of this room and the mauves and pinks in the background are an excellent foil for the rich wood tones of the mahogany furniture. Above the Adam-type mantel hangs a Sheraton mirror bordered by eglomisé panels.

Metropolitan Museum of Art

← An alcove from an 18th century boudoir in the Hôtel de Crillon, Paris in the style of Louis XVI. The pastel colors of this classical revival period are used in the painted polychrome decoration, which is reminiscent of the painted decorations of Pompei. A parquet in the Versailles pattern covers the floor. The chair is signed by Georges Jacob, a cabinetmaker of the period.

Metropolitan Museum of Art

Japanese woodcut by Utamaro. It was Japanese woodcuts that finally aroused a serious interest in Far Eastern art among Western painters. Ironically it was their abstractness, not their realism, that made them interesting to Western eyes. Some of the painters of the Impressionist and Post-Impressionist schools were influenced by them.

greater extent than under Confucianism or Taoism. The Chinese have been a superstitious and fearful people; much of their art has been created for the purpose of ceremonial appeals for the rotation of the seasons, the intimidation of evil spirits, or for special benefits, and an immense symbolism has been developed for these and other purposes.

Two long and important dynasties which concern the decorator and designer are the Ming (1368–1644), noted for its architecture and pottery, and the Ch'ing or Manchu (1644–1912), noted for its porcelains of great beauty.* Of shorter duration was the Sung period, characterized by its delicate, fragile and understated charm in its porcelains and paintings.†

The Chinese periods are given:

Patriarchal period	3000–2205	B.C.
Hsia dynasty	2205–1766	B.C.
Shang dynasty	1766–1122	B.C.
Chou dynasty	1122– 255	B.C.
Ch'in dynasty	255– 206	B.C.
Han dynasty	206– 220	A.D.
San Tai, or, Three States	220– 280	A.D.
Wei	220–265	
Shu Han	221–265	
Wu	222–280	
Lu-Chao, or, Six dynasties	265– 589	A.D.

SOUTHERN

Chin	265–420
Sung	420–479
Chi	479–502
Liang	502–557
Ch'en	557–589

NORTHERN

Northern Wei	386–535	
Eastern Wei	534–543	
Western Wei	535–557	
Northern Ch'i	550–589	
Northern Chou	557–589	
Sui		A.D. 589
T'ang		618
Five small dynasties		908
Sung		960
Yuan		1280
Ming		1368
T'a Ch'ing (Manchu)		1644–1912
divided as follows:		
K'ang Hsi		1662
Yung Cheng		1723
Ch'ien Lung		1736
Chia Ch'ing		1796
Tao Kuang		1821
Hsien Feng		1851
T'ung Chih		1862
Kuang Hsu		1875
Hsuan T'ung		1909
Republican		1912

China, as other Far Eastern nations, has never developed an important style of architecture. The most interesting structures are temples and palaces, which usually have been of one-story wooden construction. The most important of these are in Peiping and include the Sacrificial Hall of the Ming Dynasty, the Forbidden City, and the Summer Palace built by Empress Tz'u Hsi in the nineteenth century. The *pagodas* are merely towers that enclose idols. None that remains is of great size or antiquity. Their aesthetic appeal is mainly in the color and patterns that are the chief features of their interior decoration. The exterior interest lies in the curving roofs covered with earthenware or stoneware tiles and their carved rafter ends and brackets. In some cases exterior walls are built of colored or patterned porcelain slabs. The interior planning of dwellings is inter-

* There have been an enormous number of human and animal figurines recently found in very early tombs. The quaint and gaily modeled equestrian figures of these periods are especially popular.

† For fuller treatment of Chinese ceramics, see Chapter 19.

esting, and partitions are often built of flimsy materials. The construction of the buildings is skeletal, with posts and beams of *nanmu*,* an aromatic lumber that turns a deep, rich brown. The woodwork is often treated in colorful designs in which mandarin red predominates. As the Chinese seldom mix their pigments, strong colors are characteristic. Windows are often covered with intricate latticework and surfaced with paper, an arrangement that casts interesting shadows by day or by night. Railings also are designed in complicated lattice patterns. Split bamboo screens and shades are also frequently used for window coverings. In important rooms, ceilings are painted with patterns. The Chinese are excellent wood-carvers and apply much of this effort to enrich door frames with elaborate relief and pierced ornament.

The majority of Chinese dwelling houses have interior courts, which are necessary to the owner for purposes of tranquillity and contemplation. These courts are planted with weeping willows, quivering ginkgos, thuyas, cypresses, bamboo, and flowering shrubs, and further beautified with potted flowers. Each house is surrounded by a garden in which foliage, moss, rocks, water, and architectural features are of equal interest; trees and shrubs cast their shade on paths, pools, and canals; stepping-stones, mosaic paths, footbridges, pavilions, archways, and walls pierced with *moon gates* or vase-shaped openings create subdivisions that contribute the surprise elements of the design. Flowers and rock gardens with dwarf growths are arranged for perfect seasonal blooming; the lotus, sacred to the Buddhist faith, grows in profusion and is the first of the spring flowers, followed by magnolias, peonies, azaleas, lilies, chrysanthemums, and many others, all of which have symbolic meanings. The gardens are often lit by colorful lanterns hanging from archways, beams, and posts.

* This is the Chinese name for Persian cedar.

Sotheby Parke-Bernet

Chinese carved teakwood chair decorated with bats and cloud motifs and painted landscape panels.

The houses of the small landowners, farmers, and peasants are of the most simple sort and do not contain the features that are customarily associated with Chinese architecture. They are built of stone or wood with simple roof lines and in appearance do not vary greatly from the small houses of southern Europe.

Rooms are sparingly furnished, but each piece of furniture or decoration is an object of quality. During the Ming period, cabinets, chairs, tables, multifold screens, and many smaller pieces were made in blackwood, coromandel, and rosewood or were lacquered in gold or silver combined with red. Bamboo was used for summer furniture and

Sotheby Parke-Bernet

Chia Ch'ing coromandel lacquered screen, nine feet four inches high, painted with landscape.

camphorwood for wardrobes and other containers. During the Ch'ien Lung reign of the Ch'ing dynasty, richly carved objects were covered with an overelaborate gold lacquer and inlaid with mother-of-pearl. During the seventeenth and eighteenth centuries, Europe demanded unlimited supplies of lacquered work. There was a decline in the quality of the Chinese technique in the nineteenth century, aggravated by competition due to the discovery in Europe of the secret formulas. Lacquer was also used as a plastic material in making such small objects as cups, saucers, scent jars, and incense burners. The majority of lacquered products that are available today are of nineteenth-century workmanship.

Wall surfaces, textiles, porcelains, and other mediums were often enriched with motifs and patterns in which symbolism played an important part. The peach, tortoise, and pine indicated longevity; the pomegranate, fecundity. Other frequently used decorative motifs were birds, cloud designs, and an infinite number of trees, flowers, and leaves, which were applied particularly to the porcelains, textiles, and wallpapers and rendered naturalistically in the most graceful patterns and colors on a very light tinted background. The swastika and other geometrical forms were also used. When scenic patterns were introduced, they were generally drawn in axonometric and isometric rather than Western linear perspective. Officials had their symbolic identifications embroidered on their robes. The five-clawed dragon was reserved for the emperor, and the four-clawed dragon for the rest of the imperial family; the phoenix was considered the symbol of the empress. The most important functionaries were identified by the white crane and unicorn, the second in rank by the golden pheasant and lion, and the third grade by the peacock and panther, with other animals for officials of less importance. Segmental curves and rectangular forms were vigorously avoided; angles and corners were generally rounded. Both realistic and conventional forms were used, but the latter never

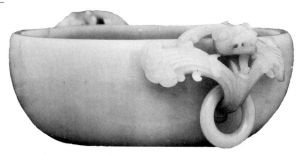

Metropolitan Museum of Art

Ch'ien Lung imperial white jade teacup, 2¾ inches high.

lose the essence of vigor, life, and action. There is much humor and grotesqueness in Chinese motifs. Gnomes, birds, and animals often are shown in intentionally comic actions, and faces are indicated with droll expressions.

The Chinese have been extraordinary carvers in semiprecious stones. Massive stone sculpture is mostly of an early date, but jade,* coral, and ivory sculpture, ornaments, and charms carved with an unbelievably painstaking technique are still being made in a style that has changed little with the centuries. Jade, the symbol of vitality and authority, is a material that has a peculiarly sensuous quality that satisfies the touch. The Chinese have realized the possibilities of an art that combines the senses of touch and sight, and in the use of jade have captured it to a greater extent than other people. Objects made of jade were used extensively in ceremonials. A jade carving of a cicada (a type of grasshopper), the symbol of everlasting life, was usually placed in the mouth of a deceased person. Much ivory carving was done in the Manchu period, and this art is carried on to the present day; particularly in carving such figures as that of Kuan-yin, the

* The term *jade* was first used in 1683. Jade includes jadeite and nephrite. The former is translucent and varies in color from cream to green; the latter, not always translucent, is a hard, fine-grained material that is found in green, red, yellow, white, and other colors.

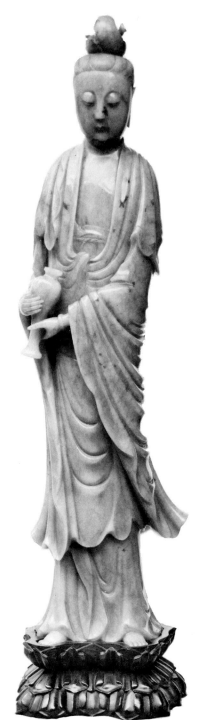

Metropolitan Museum of Art

Jadeite figure of Kuan Yin. Chinese, nineteenth century.

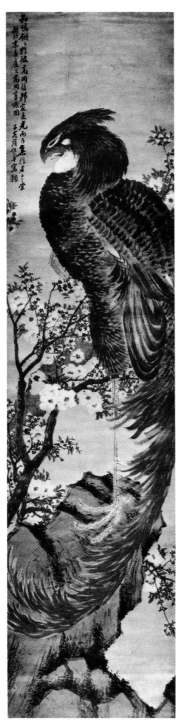

Metropolitan Museum of Art

Painting on paper, Ching Dynasty, nineteenth–twentieth century.

Goddess of Mercy, and the eight Immortals of Buddhism. Many of these carvings are large considering the limitations of the material, and there is necessarily a slight curve to the figures due to the natural form of the elephant's tusk. They show a minuteness of workmanship that could only be attempted by one for whom time is not precious. In the neighborhood of Peiping, thick lacquer surfaces were also used as a medium for carved enrichment, and carved lacquered boxes have been found in graves that date from 500 B.C.

The Chinese have almost from the beginning of their culture been great painters. The greatest periods in this art were those immediately preceding the Ming dynasty, but as the painters have been great traditionalists, copying has always been considered honorable, and many of the works of the old masters have been reproduced in later periods. The Chinese painters until recent years were always amateurs; ladies and gentlemen and even statesmen considered painting one of the necessary accomplishments for the person of rank and culture. The offer of monetary compensation for the product of one's leisure time was considered an affront.

It is generally accepted that the Chinese invented paper in A.D. 105, but it is possible that the Egyptians may have been acquainted with a version of paper long before the Christian Era. Rags, however, were not used as a component until about 1300. Chinese paintings were made on both silk and paper and usually consisted of long scroll forms which had to be unrolled from right to left in order that their significance might be appreciated. The scroll paintings were composed with rhythmically related voids and motifs that require the eye to move vertically as well as horizontally in viewing them. They are to be enjoyed in the same manner as a musical symphony because of the time element that is required to appreciate them. Many of these ancient scrolls have been cut into smaller units forming more convenient

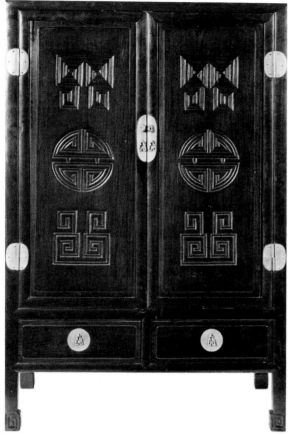

Sotheby Parke Bernet

Chinese Hung-Mu wardrobe.

shapes for framing and hanging. Fan painting was also an important art. Ink was more frequently used as a medium than color, and the artists were dexterous in the production of various shades of this material; when colors were added, they were limited to the pale tinting of the ink drawings.

The subject matter of paintings varied to a remarkable degree. Many authorities believe that the greatest periods in Chinese painting occurred during the Tang (618–907) and Sung (960–1280) dynasties. During the latter period, peaceful and imaginative scenes included fairies, beautiful women, flowers, and birds. In the Yuan or Mongol period that followed (1280–1368) remarkable

paintings were also produced; these were black and white landscapes often showing horses, pools, birds, flowers, and moons. During the Ming period, garden and household activities were represented in rich colors, and portraiture was developed. Tempera painting on paper and on glass and mirror painting were extensively practiced. Brushstroke *calligraphy* played an important part in all paintings upon which titles and descriptive matter were indicated with remarkable skill. Large calligraphic scrolls and carvings quoting the philosophy of Chinese sages are often used as decorative features in the rooms of present-day dwellings.

Cloisonné enamel work was also produced, but it is probable that this art was learned from Byzantine sources after the Western invasion of the Mongols. This type of work is still being done, and the same ancient methods are used in its manufacture. Other arts, which reached perfection, were those of textiles, rugs, porcelains, and wallpaper, descriptions of which are given elsewhere in this text.

In nearly every great decorative style in Europe, objects of Chinese origin were used from the sixteenth century onwards. Due to the intrinsic beauty and perfection of most pieces, examples of Chinese art possess the fortunate quality of being friendly with other styles, and, if intelligently used, are as much at home with contemporary decoration as they were with the historic periods. There is still an ample supply available for decorative uses.

During the twentieth century, China has begun to feel the effects of Western industrialization, and the political and economic situation has been so disturbed that a definite hiatus has occurred in the development of the arts. Architecture and decoration have strongly shown the influence of American structural methods and materials, and the industrial arts are being increasingly commercialized. Reproduction of antique examples has continued with lowering of standards, technique, and structural qualities.

Metropolitan Museum of Art

Hand scroll, colors on silk. Tenth century.

The arts of China will revive as they always have, but the twentieth century must be considered as one of those periods when the energy and creative forces of the people have, by necessity, been concentrated upon other than art production.

Japanese arts. It is almost a truism that most of Japan's art forms are rooted in the culture of China and arrived at the islands, for the most part, by way of Korea. However, one must hasten to point out that once aware of these arts the Japanese endowed them with the stamp of a character so different from the original as to be regarded unique and most deserving of consideration on their independent merits.

The essence of that which we can call Japanese is best grasped when one understands its rejection of mere outer appearances of things in nature, substituting instead an insatiable curiosity for inner meaning expressed through the geometric structure of form. The ultimate stress is upon substantive realities and the elimination of the insignificant. Beauty is viewed in terms of design and pattern and interpreted with the utmost vigor and earthiness.

Important art expression began with the introduction of Buddhism in the sixth century. Relations with the continent were sometimes strong and at other times waned as a result of turmoil between military and civil authority. This led to long periods of relative isolation, thus providing the opportunity to develop greater self-identity.

The important Japanese periods (or *jidai*) are as follows:

Nara	710–794
Heian	794–1192
Kamakura	1192–1333
Namboku-Chō	1333–1392
Muromachi	1392–1573
Momoyama	1573–1603
Edo	1603–1867

ARCHITECTURE. Inspired by the Chinese periods of the *Six Dynasties* and the *T'ang*, Buddhist monks embarked on an extensive cam-

Scala

Japanese interior.

paign of temple construction. From the beginning they used timber abundantly supplied by the hinoki tree, a remarkably durable type of cypress. The exteriors were painted with red oxide of lead and fitted with peaked roofs. The interiors were elaborately molded in relief and painted in a variety of vivid colors. During the *Heian* period roofs became taller and incurvate. Japan's isolation from the mainland from the sixteenth century onward provided the opportunity for greater self-realization. Distinct patterns began to emerge that were reflected in domestic architecture. The home became a series of oblong cubes joined by narrow corridors. The inevitable formal garden was always situated at the south. The *Muromachi* period returned again to the Chinese influence

through the introduction of *Zen Buddhism*. Its tenets fostered chasteness in art, simplicity of form, and the elimination of extraneous detail. Construction was altered to permit an ever-increasing entrance of light. By the fifteenth and sixteenth centuries, despite the intrusion of Portuguese and Dutch ideas, the Japanese style of domestic architecture became fully developed. Basic oblong ground plans were retained, and the height of the buildings sometimes extended to two stories. Wood was still the main structural material. The division of interior space was provided by movable partitions of papered vertical and horizontal wood latticework. The end result was a full realization of refinement and simplicity. Meanwhile, the garden with its pavilion for the

tea ceremony became an integral part of the household. This fully Japanese character retained its independent identity until the last half of the nineteenth century, when Western concepts were added in increasing number.

PAINTING. The earliest painters of Japan drew direct inspiration from China, where they learned the handling of rapid brush strokes with ink as the medium. Calligraphic script was as important as pictorial representation, and subject matter ranged from the religious to genre scenes. From the ninth to the fourteenth century, when Japan suspended intercourse with China, we see the emergence of a national art stylistically based on geometric forms rather than the more fluid curvilinear approach of Chinese prototypes. This national style of painting became known as the *Yamato*, which emerged in the late Heian period. In fastidious and orderly design, the new breed of painter revealed his taste for lively activity, vivid portraiture, and often considerable humor. Chinese impressionism gave way to conventions of strong patterns where even voids played a significant role.

Painting was executed on silk rolls called *kakemono* when vertical and *makimono* when horizontal. Every house had its *tokonoma*, an alcove for the hanging of scroll paintings and display of other art objects. The strong cult for the beautiful is exemplified by the practice of amassing extensive collections of scrolls that were stored in brassbound wooden boxes and alternately displayed with the change of seasons. New ties were formed with China in the fourteenth century with the introduction of *Zen Buddhism*, which brought the influence of the *Sung* taste for serenity of inner contemplation and a delicacy of interpretation of all living forms and landscapes. From the ninth century many artists were known by name but none became as famous as Sesshū (1420–1506). Considered Japan's greatest, he is noted for individuality of outlook and for the power of his swiftly executed brush strokes.

Screens were extremely popular. They were usually short in height and made of six folds. From the period of the *Momoyama* they were painted in lavish colors on gold or silver backgrounds. Subject matter included vigorous interpretations of everyday life including animals and battle scenes that were in great demand by the military class.

The sixteenth and seventeenth centuries were characterized by a variety of tastes in subject matter and interpretation. Color assumed an even more important role, and its increasing richness is especially evident in screen painting. Moronobu (1618–1694) depicted the genre world about him and also was the first to exploit this theme in the wood-block print. His followers of the eighteenth and nineteenth centuries include some of the greatest painters and designers in this new technique. Lyric naturalism had strong adherents, as typified by Ganku (1745–1834), a specialist in portraying tigers. By the latter part of the nineteenth century, Japanese painters divided into those who were content to repeat old conventions and others who succumbed to European chiaroscuro and vanishing point perspective first introduced by the Dutch.

WOOD-BLOCK PRINTS. No other art form is so exclusively the domain of one country as is the wood-block color print of Japan. The technique was known to the Chinese in the *Sui* Dynasty (581–617) and employed in Japan for printing of Buddhist textbooks as early as the eighth century. In its present form, however, the wood-block print dates from the innovations of the painter Moronobu in the seventeenth century when it was known as *ukiyo-e hanga*. It is a truly democratic art reflective of the far-reaching social changes taking place at that time. The artist used a duplicating process to put his product within the reach of a large number of people, and he selected popular themes such as the theater and scenes in the teahouse. Early seventeenth-century prints first appeared in black. Shortly after, colors painted in by hand were added, first yellow, then

Worcester Art Museum

Early nineteenth century Japanese colored print with Mt. Fuji in background.

orange, and sometimes pale green. Large patterned areas of black were often applied with a rich lustrous pigment. The first work printed in two colors with separate blocks is attributed to Masanobu in 1741. The earlier color wood-block prints are characterized by simplicity of line and mass and are most highly prized by today's collector for artistic as well as decorative merit. It must be emphasized that printing was not a purely mechanical process since the color for each block of a single print was hand-applied and often partially wiped off to create tonal effects. Harunobu was the first to produce the multicolor print in 1764. His work became immensely popular. From the great number of master print designers, the following are most worthy of mention:

Kiyonobu (1664–1729), one of the first to specialize in subjects of the theater at Edo (now Tokyo) and to portray actors known by name.

Shunsho (1726–1792), also involved in depicting theater but with deep insight into the personalities of individual members of the stage; a fine colorist, complex designer, and teacher of Shunei, Shunkō, Shunchō, and Hokusai.

Kiyonaga (1752–1815) broke away from the convention of geometric interiors to the outdoor background for his tall, elegantly groomed figures which were invariably conceived with delicacy and grace.

Utamaro (1753–1806) was deeply involved with the subject of the courtesans from the tea-houses of Edo, whom he sympathetically interpreted with consummate artistry, particularly in groupings of bust portraits within single compositions.

Sharaku, biographically little known but significant for his 1794–95 publications of strong space-filling actor portraits rendered with piercing wit and satirical humor. He carried further the traditions of Shunshō.

Toyokuni (1769–1825) was remarkable for a high degree of technical skill and sophistication in portrayal of actors.

Hokusai (1760–1849), as well as many other artists, used other names; showed a scientific interest in birds and flowers in their natural habitat under varying weather conditions and interpreted with great force; the best known of all wood-block prints is his *View through the Waves of Kanagawa* one of *Thirty-six Views of Mt. Fuji* (commonly known as *The Wave*).

Hiroshige (1797–1858) shared Hokusai's interest in subject matter but reflected his own moodiness and poetic nature in preference to the observation of surface realities. Both artists reveal an interest in occidental techniques.

Kuniyoshi (1797–1861) inclined further toward western ideas even to the use of cast shadows. He liked a great variety of subject matter including figures caricatured as animals, the revival of a practice not uncommon in twelfth-century Japanese painting.

Kunisada, active during the first half of the nineteenth century, was technically very gifted and offered a grateful public the largest number of prints produced by any single artist. His subjects included actors, warriors, and landscapes.

SCULPTURE. Buddhist belief was responsible for the first appearance of important three-dimensional art in the prehistoric period of the sixth and seventh centuries A.D. The earliest ex-

Ikari

Statue of Japanese shoki, or guardian king, from the Kamakura period. It is made of carved wood, with crystal eyes.

the human figure with the superimposition of lyrical linear drapery derived from the standard classicism of the Chinese mid-*T'ang* period. During the *Heian* period, under the rule of the *Fujiwaras*, naturalism increased to the point of departure from frontalism. The weight of a figure was often placed on one leg. Details of costume became increasingly important, as was the greater reliance on gold ornament. These tendencies were boldly expanded during the *Kamakura* period, which gave to posterity strong figures of temple guardians and generals of Buddha. The spirit of the violent warrior class is fully reflected in the qualities of articulate body gestures and the awesome appearance of grimacing faces, whose eyes were often realistically inset with rock crystal. The foremost sculptors in this milieu were Kaikei and Unkei. Meanwhile older, more serene classical images persisted with little change in their conventional form but tended toward jewellike attention to detail. Important carvers of the *Muromachi* period turned to the making of masks that were an integral part of the Nō drama, popular entertainment that combined music with acting. Such masks are prized collector items. In more recent times considerable attention has been paid to the very decorative dolls representing beauties and fully armored samurai. They are composed of exotic materials and handsomely modeled porcelain faces.

CERAMICS. The first potteries of Japan were wheel turned wares clearly derived from Korean prototypes of the *Silla* period. Chinese influence is felt from the eighth century in copies of *T'ang* funerary vases and urns but of heavier design and harder bodies. When the military ruler of Japan, the Shōgun Hideyoshi, invaded Korea in the sixteenth century, he returned with skilled potters who, serving as "guests" of Japan, helped create many new kilns. The new craze for the tea ceremony created a demand for pottery vessels of competitively individual design, hence thoroughly Japanese in character. A hard, cream-glazed, fine crackle ware was developed at the

amples were reliefs in clay and copper; later, wood, dry lacquer, and bronze. They represented Buddhas and Bodhisattvas depicted in stiff immobile frontal attitudes. It is now believed that many of the first artisans were Koreans and that they introduced the relatively inexpensive medium of dry lacquer together with the techniques of gilding and polychroming. During the *Nara* and *Heian* periods the Japanese sculptor became intrigued with the more plastic interpretation of

Japanese long swords, circa 1800.

kilns of Satsuma. Porcelain made from native materials was first produced at Arita in the seventeenth century. By this time trade had become so important as to reflect foreign influence in much that was produced. A significant contribution, however, was the Kakiemon pattern of delicate angular flowering branches painted with iron red, two tones of green and blue, and subtle touches of gold. It was copied by many western factories, notably Meissen and Chantilly. Also characteristically Japanese was the Imari pattern that employed strong floral and brocade designs painted in heavily saturated colors. Most of the current work (from the nineteenth century) is made for export and consists of eggshell tablewares or, as in so-called Satsuma, overly decorated and relief-molded pieces in many colors with a profusion of gold and gold flecked designs.

LACQUERWORK. The lacquer tree, indigenous to China, was cultivated in Japan from the sixth century, and its hardened sap, with added pigments, was employed for a wide variety of artistic objects. With utmost patience, layer upon layer was added to a base material, usually wood, then polished to a smooth brilliant surface. The eighth century produced important sculpture in this medium as well as sword scabbards, boxes, and other decorative objects often inlaid with mother-of-pearl. From the fifteenth century on, lacquerware assumed additional importance be-

cause of its use in the tea ceremony. So unique were the variety of decorative effects, particularly gold lacquering, that Chinese artisans were sent to Japan to learn the craft. Gold and silver dust or particles were introduced into the top layer of the wet lacquer before the final finishing. Furniture that was lacquered included chairs, low tables, boxes, and utensils such as sake cups and trays. From the seventeenth century considerable quantities of lacquerware were exported, and many extant pieces believed to be Chinese are in fact products of Japan. Oriental lacquerwork, both in technique and subject matter, had a strong influence on the Western world during the late seventeenth and eighteenth centuries, particularly in England and France. A prized collector item is the *inro*, a small flat oblong or oval medicine case in two to five fitted compartments attached by a silken cord to a sash and terminated by a *netsuke*, a tiny human or animal figure carved in ivory, bone, lacquer, or wood. Many fine quality examples of both the *inro* and *netsuke* were made in the early nineteenth century but are distinguishable from seventeenth- and eighteenth-century pieces by a preoccupation with minute detail.

WEAPONRY. One cannot leave the subject of Japan without mention of the ultimate expression of its national spirit and artistry—the sword (*katana*) of the samurai. The sword smith brought his craft to the peak of perfection by the tenth

century. His finely tempered blade was the equal to any produced elsewhere in the world. It was slightly convex and fashioned with parallel back and curved cutting edge. Sharing his fame and skill were the artists who designed sword fittings. These consisted of sword guards (*tsuba*), pommels (*kashira*), ring bands (*fuchi*), and ornate pegs (*menuki*). These adornments were made of bronze, iron, brass, or copper, often relief-molded and inlaid with gold, silver, or brass. Equally valued for their decorative perfection are the short swords (*wakizashi*) and the dagger (*kozuka*).

Islamic arts. The arts of the Mohammedan countries are generally classified in one group and known as *Islamic.* Several of these nations maintained a high degree of civilization long before their adoption of the Koran. They cover an enormous geographical area and contain people of the most diverse origins, but their culture has been knit by a powerful religious unity that has surpassed that of Christian peoples.

Mohammedanism dates from the flight of its founder, an Arab, from Mecca in A.D. 622. His claim of being the Prophet of the One God, Allah, was accepted with ecstasy by the masses of the Near East. The Arabians immediately determined to conquer the world and offer the blessings of their faith to a demoralized Christianity. The Koran illumined vast visions, and the Arabs almost accomplished their ambitions within a period of a century. Zeal brought them to a sudden and terrible success. Within twenty years they had subdued Syria, Mesopotamia, Egypt, North Africa, Persia, and Afghanistan. Spain fell in 713, northern India in the tenth century, and Constantinople in 1453. The Mongols from eastern Asia under Ghengis Khan, and later under Tamerlane, invaded Persia in the thirteenth century, but accepted the superior civilization and religion of the conquered people; they broke the Turkish power in Asia Minor, and in the six-

Courtesy Asia Institute

Lacquered door from Royal Palace in Isphahan, 1587.

teenth century established the Mogul dynasty and Iranian* culture in India. The Christian Copts of Egypt turned Moslem and under the Mamelukes resisted both the Mongols and Crusaders. In 732 A.D. Charles Martel saved Europe from the Koran by his defeat of the Saracens at Poitiers, France, and Ferdinand finally expelled the Moors from Spain in 1492. The last aggressive effort of

* *Iran* is the native name for Greater Persia; *Persia* is the Latinized name of one province.

Arthur A. Pope

Sixteenth-century tile decoration from the Great Mosque at Isphahan.

the Moslems resulted in the defeat of the Turks at Vienna in 1683. Thus ended the expansion of Islam.

Following each military conquest between the seventh and fourteenth centuries, great cities were built that became seats of learning, science, and art, many of them preserving the records of antiquity while western Europe was a disorganized entity. Mecca was the center of the faith; Kufa and Basra were the seats of Arabian theology. Damascus boasted of her poetry, science, industry, and lax morals. Baghdad, built on the ruins of ancient Babylon, was one of the proudest cities in the world. The mere mention of Tabriz, Isphahan, Mosul, Samarkand, and Herat recalls the entrancing descriptions and events related in the "Thousand and One Nights." Delhi, Agra, and Lahore, in India, and Cordova, Seville, and Granada, in Spain, were centers of luxury and splendor whose beauties still remain.

The Mohammedans were great architects and greater decorators. Although their designers and craftsmen were drawn from foreign and conquered lands, Islamic structures retain a unity of style that resulted from a single religious belief. There is less originality of constructive design than of surface decoration.

The greatest examples of Islamic architecture are mosques, palaces, citadels, bazaars, and mausoleums. The mosques of Cairo are outstanding in their richness of detail. The great mosque of Cordova is the largest religious edifice in the world. The Alhambra in Granada and the Alcazar in Seville are evidences of the brilliance of the Moorish occupation. Moorish elements of decoration continued to be used by the Christians of the Renaissance, and the combination of details drawn from both sources formed the basis of later Spanish design.* The Jews in Spain employed Moorish designers and workmen to build their synagogues and adopted the Moslem style for this type of building. Upon the expulsion of the Jews from Spain in 1610 the style was transported to other countries, and Moorish forms were generally used for the design of synagogues until recently. The bazaars in Teheran, Isphahan, and Baghdad show magnificent blending of colored patterns. The Indian structures of white marble glisten in the sunshine and brilliantly reflect the colors of nature; the palace at Delhi built by Shah Jehan contained his Peacock Throne of gold and jewels; the mosque of Jumma Musjid is considered one of the most splendid buildings in the world; the Taj Mahal in Agra, the tomb of Jehan and his wife, has a bulbous dome and pointed arches and is accepted as the pearl of Indian architecture.

* See Chapter 4.

The Egyptians in the tenth century were the first to use the geometrical patterns that were later to become a characteristic feature of Islamic art. The Copts used the pointed arch; the Moors preferred the horseshoe form; and the Persians, the pointed horseshoe and ogival, applying the latter form to their bulbous domes. Columns were slender and crowned with capitals that vaguely resembled the Corinthian shape but were covered with minute leaves of lacelike detail. Scrolls were developed from stems and pseudo-acanthus and palmette leaves, and from these emerged the arabesque. Walls were often given interest by alternating red and white stone courses, producing horizontal stripes, a system that was also used in the *voussoirs* of arches. Stalactite forms were occasionally used for brackets or a decoration on the underside of domes. Plain and patterned tiles and small-scaled plaster relief ornament became the most usual method for surfacing wainscots and interior walls. Stained glass was used for windows. There was usually a noticeable absence of pictures and sculpture. The prayer niche or *mihrab* was a feature of every mosque.

The patterns used in all branches of Islamic art have a wide range of origin and subject matter, and there is a tendency to use similar motifs regardless of medium. In wall decorations, textiles, rugs, ceramics, metalwork, and painting, patterns change only by the limitations of their various techniques. The Mohammedans were divided into two sects, the Sunni, represented by the Turks, Moors, and Arabs, and the Shi'as, represented by the Persians and East Indians. The former interdicted the representation of living motifs in art, on the assumption that they recalled pagan idolatry, and their designers therefore developed geometrical patterns; although violations of this ruling occurred, they were frowned upon by the orthodox. The more liberal Shi'a doctrines account for the floral, animal, and human subject matter used in their designs. Generally all patterns were relatively small in scale, and much conventionalization was used. Emphasis was al-

Courtesy Asia Institute

The jeweled Peacock Throne of Shah Jehan in Delhi.

ways placed on the decorative quality rather than the representational. Early works of art show the use of debased forms of acanthus, lotus, palmette, and scrolls undoubtedly inspired by early Asian and classical models.

In the development of geometrical patterns, the most complicated interlacements of straight lines occur. Squares, rectangles, hexagons, octagons, stars, and an infinite variety of irregular and overlapping forms are seen. In ceramic and textile design, rosettes, pearls, dots, hatchings, diamonds, circles, stars, vase forms, and many other motifs were employed. Diaper patterns were often subdivided into panels formed by lines

—296—

Shah Jahan on horseback. Leaf from an Indian manuscript. Seventeenth century.

or bands arranged in an ogival, circular, or scalloped manner.

In Shi'a productions, real and imaginary animals play a prominent part; the ibex was a royal symbol, and the lion represented power. Equestrian subjects were common. Human beings, birds, leaves, flowers, ivies, and trees were often beautifully combined in patterns or arabesques. Pinecones were considered a symbol of good luck. After the Mongol invasion, patterns often showed the use of Chinese motifs such as clouds, butterflies, rose and peony blossoms, and plants growing out of rocks.

The Persians, in particular, worshipped beauty as did the ancient Greeks, and lavished care and affection upon everything they created. They produced great works of art in the minor fields, and from the fifteenth century onward set a standard for the other parts of Islam. Their artists were frequently anonymous, and seldom signed their names; the result, only, was what mattered. They excelled in the arts of illuminating manuscripts and miniature painting. Many of these productions must be considered among the masterpieces of painting in the world. An infinite range of subject matter was used, including court and amorous scenes, folklore, historical and biblical events, landscapes, animal fights, houris of the Mohammedan paradise, and portraiture. The pictures are story-telling devices; the eye roams until the whole event is digested, and one easily imagines sequences that are not delineated. The compositions show breadth of conception, perfect balance, mastery of detail and color, and, with a high horizon line, usually appear as a bird's-eye view. Perspective was used, but shadows were generally omitted. The artists showed skill in eliminating unnecessary features and often conventionalized for the sake of simplicity. The majority of the paintings were titled or described in Kufic or cursive calligraphy, an art that was as important as that of painting itself. The Persians were masters at many other arts; their gardens intoxicate the visitor by combinations of fragrance

Courtesy Asia Institute

Fourteenth-century bronze candlestick damascened with gold and silver.

and natural beauty, and their literature will be remembered eternally by the "Rubaiyat." The achievements of the Persians in textile and rug weaving and in ceramics are described elsewhere in this text.

Extraordinary examples of stone, stucco, and wood carving were produced in every Mohammedan country. Ivory, bone, and mother-of-pearl were used for decorative plaques, jewel containers, caskets, mosaics, and furniture inlay. Door paneling was often enriched with ivory appliques. Metals were used for chests, lamps, candlesticks, ornaments, furniture, and jewelry, and were worked by casting, hammering, or embossing and filigree. In Damascus a method was introduced of inlaying patterns of gold or silver wires in base metals, by the process known as damascening.

At the Linen Closet. P. de Hooch.

RENAISSANCE ARTS OF THE GERMANIC NATIONS

Dutch and Flemish arts. The importance to America of the industrial arts of the Low Countries during the early years of the Renaissance is the result of the close trade and social relationships of these countries with England.

The section of Europe in the sixteenth century that was the approximate equivalent of Holland and Belgium today was known as Flanders, and was under the rule of Charles I of Spain, who was also Emperor Charles V of Austria, Germany, and parts of Italy. It was natural, therefore, that the cultural influences of Spain should to some extent have dominated in Flanders and Germany,

Dutch Kas

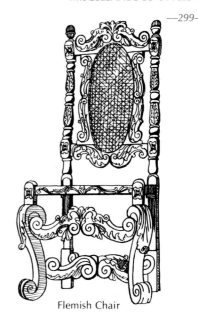

Flemish Chair

Dutch and Flemish seventeenth-century furniture.

in spite of the fact that from the early years of the Renaissance the inhabitants had protested against both the political and religious demands of Charles and his son and successor, Philip.

It was also impossible that some of the splendor and magnificence of the cinquecento of Italy should not drift northward through Germany and directly affect the arts of the Lowlands. England supported Flanders in her efforts to throw off the Spanish yoke. Through the Elizabethan days and on through the close of the Marlborough campaigns, continual help and sympathy were extended to Holland. The Dutch Republic was established in 1577, at which time Holland was a dominant power upon the high seas. The common desire to crush the pope's power and to spread the teachings of the Reformation gave an added impetus to the cooperation of England and Holland and eventually culminated, in 1689, in the English invitation to the Dutch stadtholder, William of Orange, who had married the English Princess Mary, to become king of England.

The sixteenth-century style of decoration in Flanders was essentially a Spanish provincial type. Its principal characteristics were seen in the furniture designs. The furniture of the period was made in both oak and walnut. It was primitive, heavy, massive in detail, and frequently clumsy in appearance. A vase-shaped turned leg was much used. In the smaller houses much of the furniture was of the built-in type and became a part of the architecture of the room. Furniture panels were framed in heavy moldings; panel fields were often pyramidal; and much heavy carving of the type used during the Italian Renaissance was introduced. Ornamented leather and rich velvets were used for upholstery materials.

From the middle of the sixteenth century until the end of the seventeenth century, furniture was architectural in character. Columns, pilasters, entablatures, pedestals, and other forms of classical design were used in unusual arrangements and proportions. Of particular importance were the enormous chests, cabinets, and wardrobes which were placed in nearly every room. Walnut was almost exclusively used in place of oak. The spiral leg for tables and chairs was introduced, usually braced with flat stretchers. The so-called Flemish

scroll was first used about the middle of the seventeenth century. This form was sometimes known as "ear-shaped carving" because of its resemblance to the human ear. The ball foot became common for case furniture. Toward the end of the seventeenth century marquetry was introduced, in combination with selected woods used for veneering. Marble inlay patterns were often used for tabletops.

The trade of the Dutch vessels with the Far East was responsible for the introduction of Chinese lacquer as a furniture finish and of Oriental porcelain as an important decorative accessory in the furnishing of rooms. Oriental rugs were used both for floors and as table covers. The original appearance of many of the seventeenth-century Dutch interiors is shown in the paintings of Jan Steen, Teniers, de Hooch, Dou, Vermeer, and others.

The Oriental influence eventually gave a great impetus to the development of Dutch pottery-making at the Delft and other furnaces. Ornamental plaques and platters often formed an important part of the decorative accessories and were either hung on the walls or stood on plate racks or moldings carried around the walls of the room. Small painted tiles showing biblical scenes, peasant activities, ships, and other motifs were often used for fireplace enrichment or for the construction of large freestanding stoves.

In 1685 Daniel Marot, the baroque designer, was driven from France by the revocation of the Edict of Nantes. He fled to Holland, where his ability was instantly recognized, and his stay is evidenced by the introduction of many French forms in Dutch art. Charles II of England, who had been a refugee in Holland, took the Franco-Dutch style to England upon his restoration to the throne, and this style continued in England when the Dutch William was called to the throne.

From 1700 onward the decorative arts of Flanders followed French leadership and sequence of style, although usually exaggerating the de-

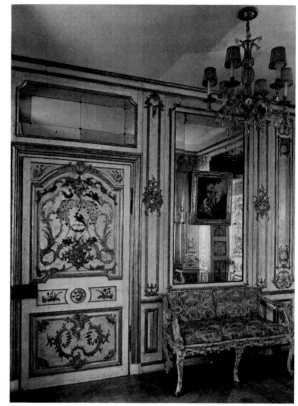

L. Alovoine & Co.

An eighteenth-century room from a castle in Bavaria showing gilt stucco decoration on a silver background, typical of the German interpretation of French work.

signs of the originals. Great luxury in living prevailed in both Antwerp and Amsterdam.

German, Austrian, and Scandinavian decoration. The Teutonic nations of Europe, although supreme in the musical arts, have never shown the same degree of creative initiative in the production of the plastic and decorative arts as have the nations of Latin origin. The political, economic, and religious confusion that for centuries was the lot of the central and north European countries precluded the development of an indigenous art tradition and an art patronage of sufficient vigor to nurture native talent. It was not until the early

years of the twentieth century that these countries began to take the initiative in various forms of industrial art.

During the Middle Ages the great ecclesiastical structures were built largely on French patterns, and the early Renaissance witnessed a migration of Italian architects and craftsmen who designed the palaces for the nobility, the town halls for the cities, and the dwellings for the wealthy burghers.

During the eighteenth century, the French aesthetic dominance of Europe not only spread across the Rhine, but reached the Scandinavian peninsula and the Baltic shores. Baroque and particularly rococo forms of art, both exotic to northern temperaments, seemed in their sumptuous fantasy an agreeable contrast to a people who had become accustomed to a rigorous medieval severity in their home surroundings. French designers who journeyed to foreign lands, perhaps less expert than those who remained at home, furnished their clients with exaggerated rococo forms in wood, paint, and plaster, often resembling confectioners' work.

Interior architectural composition frequently lacked formal symmetry and proper scale. Impurity in style was often seen in the details, and the architectural orders were improperly used or surfeited with an excess of ornamentation. In spite of these deficiencies in design, the picturesque quality of many interiors imparted an undeniable charm and was gay and rich in effect.

Pseudo-French boiseries alternated with painted decorations, plaster relief ornament, and stretched textile wall coverings. Color schemes ranged from the regal gold or silver and white to bizarre and voluptuous combinations of strong primary hues. Mural decoration showing scenes of Norse mythology or Germanic legends often enriched the walls of important rooms.

The furniture of the eighteenth century was characterized by the same influences as the interior architecture. The romantic curvilinear forms of the Louis XV period dominated all design. At times, and according to the particular craftsmen who produced them, the furniture productions had all the dignity, subtle charm, and sophistication of the best of the French work,

Biedermeier furniture.

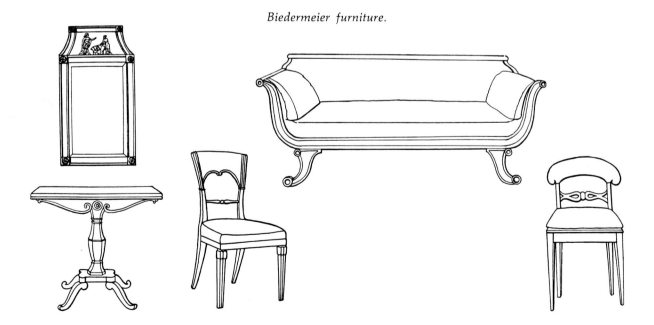

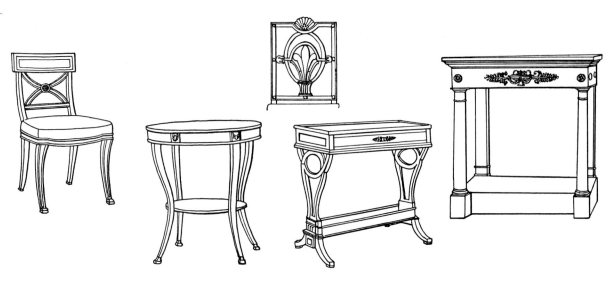

Biedermeier furniture.

while other capricious examples distinctly showed their hybrid origin in successive swellings and contractions, lack of structural quality, and inappropriate selection and distribution of ornament. The enormous palace of Schönbrun near Vienna, the "Residenz" at Würzburg, and the delightful group of playful buildings at Nymphenburg contain hundreds of rooms that are characteristic of the influence of the French decorative art of the eighteenth century upon the Teutonic designers.

In the northern countries the close of the eighteenth century and the early years of the nineteenth century were influenced by the classic trend of the styles of both France and England. In Germany the Greek revival became strongly entrenched, but the results were often heavy in appearance and unsatisfactory in detail. The Bernadotte family helped to maintain the art influence of Napoleon in Sweden for some years after it had lost its vigor in France.

Biedermeier is a name given to a style of furniture that was produced in Austria and Germany during the first half of the nineteenth century. Because of its quaintness of character, its comparative cheapness, and its harmony with other styles, it has been used in the United States in recent years. The design influences of the style were from two apparently incongruous sources, French Empire and German painted peasant work. The results were usually based on one source alone, but in many examples a mixture of the two was seen.

The name *Biedermeier* was borrowed from an imaginary character originating in cartoons published in a humorous magazine. The character was represented as a rather stout country gentleman called "Papa Biedermeier," who was well satisfied with himself and was opinionated about certain subjects concerning which he had little knowledge, among them the fine and industrial arts.

The furniture that was produced varied considerably as to quality of design and structure. As this was an imitative style, the proportions were often sturdy, rectangular, and awkward in appearance. Many small, delicate pieces were produced, however, in the design of which grace was sought by the introduction of curved forms, but the curves were clumsy, often childish, and frequently unstructural. Case furniture, such as secretary desks, wardrobes, and cabinets, was

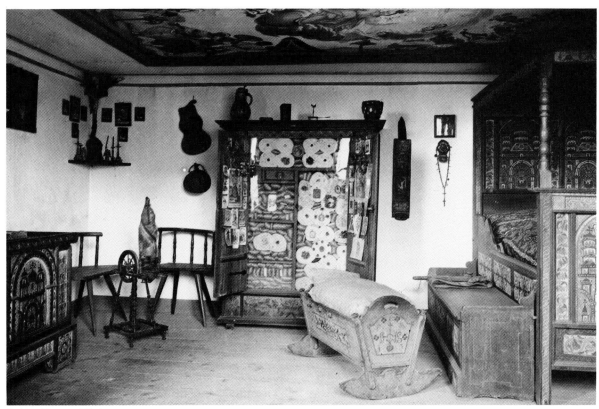

German Museum, Nürnberg

A typical Bavarian peasant interior. The enclosed bedstead is common to all peasant interiors.

architectural in character, with classical columns and pilasters of rather heavy proportions, simple classical moldings, arches, and triangular crestings simulating pediments. Little carving was used for ornament, but surface enrichment was produced with simple marquetry patterns and borders, with pressed brass ornaments of Greek inspiration, and particularly with painted forms in gilt, black, and color. The painted motifs consisted of floral, animal, and human forms and objects such as wreaths, urns, and baskets. A few classical and Chinese patterns were also used occasionally. The painted ornament was often playful and humorous in character.

The woods used for the furniture were usually the products of farm and orchard, such as maple, elm, apple, pear, cherry, and birch. Mahogany, however, was also employed, and the cabinetmaker fully appreciated the beauty of the natural color and graining of this wood for panel use. Unfortunately the separate wooden parts of individual pieces of furniture were sometimes ineffectually joined, and glue many times took the place of the more substantial dowel or tenon.

PEASANT ARTS OF EUROPE

The term *peasant art* applies to decorative homemade objects of daily usage, designed and executed in rural communities, in the conception of which local traditions and race played a governing part. The peasant styles were those produced

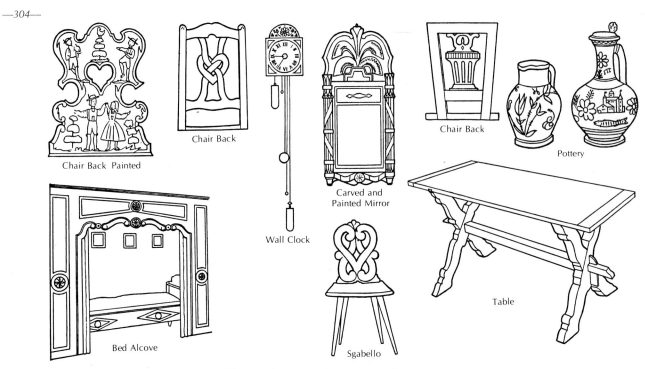

Chair Back Painted

Chair Back

Wall Clock

Carved and
Painted Mirror

Chair Back

Pottery

Bed Alcove

Sgabello

Table

Types of peasant furniture and accessories.

by the simple folk of each country whose natural love of color and beauty, often combined with traditional symbolism and superstition, enabled them to create gaily decorated rooms and to make and beautify many useful and interesting articles of home furnishings. Fishermen, shepherds, mountaineers, and farmers in all countries had their special patterns, designs, and forms for everything that they used. They knew little and cared less about the fashions of the metropolis. They made what they needed with their own hands and employed knife, chisel, hammer, paintbrush, and needle to produce their material necessities in a manner that would also contribute to their spiritual joys.

The most interesting varieties of peasant arts have been produced by the natives of central Europe, from the Balkan States northward through Czechoslovakia, Austria, Switzerland, Germany, and Scandinavia. None of these countries has produced original court styles, such as

those seen in Italy, France, and England; their peasant crafts have been their natural contribution to the industrial arts, the higher spheres of aesthetic expression having been left to foreign talent. The more distant a nation was from the centers of production of the great period styles of arts, the less discernible was the influence of a sophisticated neighbor. The closer to the soil the craftsman happened to be, the more indigenous was his art expression.

Peasant arts and crafts were, of course, produced in Italy, France, England, and Spain, but, so far as household furnishing and decoration were concerned, they were so strongly influenced by the royal fashions about them that the forms strongly overlapped, and it is often difficult to differentiate between the peasant and the provincial arts of these countries.

The introduction of easy means of transportation and communication and of cheap printing has practically throttled European peasant pro-

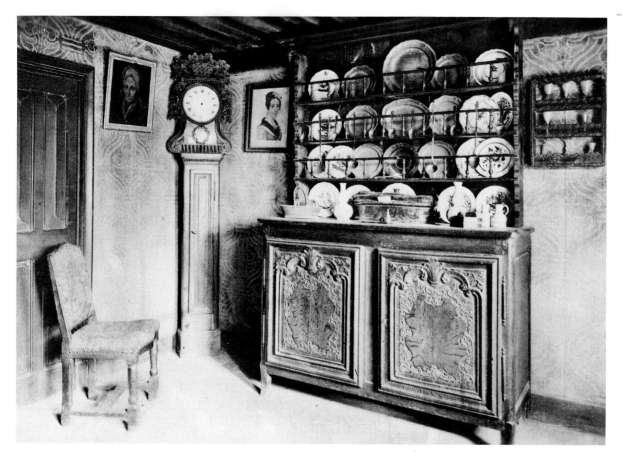

The corner of a Normandy peasant house with a Gothic door and wall treatment, the usual menagere in Louis XV style, and a Louis XIII chair.

ductions. Machine manufacturing, quantity production, and commercialization have taken the place of the hand-producing system of the country craftsman, working for himself or his neighbors and placing great care, love, and affection upon his product in his effort to carry out the unchanging traditions of his people.

The peasant art productions of all countries were, for the most part, crude. Painted patterns and naïve carving were the most usual forms of enrichment. Colors were vivid and primary; forms, gross and clumsy. But these defects were redeemed by the sincerity and conscientiousness of the craftsman and by his love for the craft.

Among the fascinating objects produced by the peasants and their industrious wives were regional costumes, embroideries, tiles, pottery, laces, textiles, toys, clocks, rugs, kitchen utensils, pewter tableware, tin and wooden moulds, jewelry, brass and iron articles, musical instruments, and ornamental harnesses.

The furniture made by the peasants was of the simplest variety. Chairs, stools, tables, freestanding and enclosed beds, chests, wardrobes, cupboards, plate shelves, dressers, and various food containers were the usual pieces.

In the peasant productions most of the patterns were geometric, particularly those of embroideries and wood carvings. Abstract design quite naturally showed regional stylizations, but

it is amazing to find that the simple mind of the peasant had so few avenues open to his creative vision that the concept was often of such a childish nature as to make its localization difficult.

Human figures and floral and animal forms quite naturally captivated the fancy of the peasant artist, who made lavish use of these subjects. The interpretation was usually exceedingly elementary and devoid of academic taint. Religious, legendary, and social influences often played a great part in the determination of patterns and forms; special articles and costumes were usually made for the celebration of holy days, for patriotic commemorations, and for special events. In the design of these, associated patterns and symbols were introduced.

The interest of the public in peasant or folk art has greatly increased during recent years, at a time when production has nearly ceased. In the decoration of traditional but informal rooms today, the use of the peasant-made articles of Europe adds much to the color and gaiety of effect.

INDIAN ARTS OF THE AMERICAS

Pre-Columbian is a term used to designate the arts produced by the indigenous inhabitants of both North America and South America before the arrival of the white man. Anthropologists believe that the Indians arrived perhaps twenty thousand years ago from Asia, via the Bering Straits. The principal migration was down the West Coast, and the major final settlements were established from Mexico to northern Chile, although stragglers moved eastward and established the Indian races of the Northern Hemisphere. Many of the living individuals of these races retain physical characteristics that confirm an Asian origin, and archaeologists claim occasional resemblances between early Indian and Asian art forms. The original settlers brought with them a knowledge of stone-chipping, basketry, and fire-making, but there is ample evidence that agriculture and the crafts of weaving

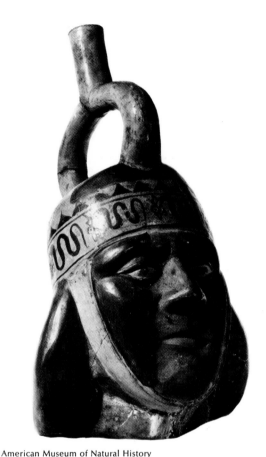

American Museum of Natural History

Early Inca pottery jar.

and pottery were not developed until long after their arrival. Although an archaic culture existed for thousands of years, their recorded history probably dates only from the beginnings of the Christian Era. The final geographical distribution of the various groups was over such an immense territory that it is doubtful that any cultural contact occurred between them, and such isolation accounts for the different character of the aesthetic expressions. There were minor parallelisms, but these were probably due to similarities of native requirements, soil, and climate, and the western groups in due time produced a civilization that cannot be lightly considered. Each developed a primitive culture that over a period of

several centuries rose to a magnificent apex and finally declined, probably due to overconfidence in their own security and the envy of neighboring tribes. Both the Peruvian and Mexican nations, who were conquered in the early years of the sixteenth century respectively by Pizarro and Cortez, were already on the decline when the Spaniards arrived, and although the conquistadores are accused of cruelties in the extermination of these civilizations, final judgment must be tempered by a consideration of the times, the conditions of the period, the customs of the natives, and the Christian fanaticism with which all Europeans were saturated.

The important examples of the arts of these ancient groups are contained in museums, but there are still available both old and recent productions of these people. The textile patterns and pottery of Indian origin are of great interest and valuable for decorative use. It must also not be forgotten that these ancient American civilizations have left modern man much that is valued. Among such items are maize, potatoes, tomatoes, pumpkins, cotton, quinine, cocaine, rubber, chicle, and such animals as the llama, alpaca, guinea pig, and turkey.

Central American Indian arts.　　The greatest and perhaps earliest Indian civilization was that of the Mayas, whose center of activity was in southern Mexico. It is estimated that their historical records date from the birth of Christ, and perhaps reached a zenith between A.D. 300 and 600. The Mayas developed hieroglyphic inscriptions as an element of surface design and measured time by an accurate knowledge of astronomy. They developed methods of irrigating their fields, which brought them great wealth and a well-organized social existence under an aristocracy who lived in the greatest splendor. Evidences of their culture are seen in the remains of the great temples and pyramids which were built under the incentive of religious fanaticism. The interiors of these buildings were decorated with

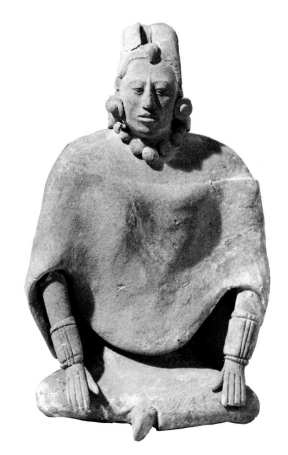

Museum of Primitive Art

Mayan female figure.

both wall sculpture and mural paintings. The patterns were well composed all-over treatments, often in geometric conventionalization, in which the dominant lines were an interplay of rectangular forms and exact forty-five-degree diagonals. Many of their sculptural and painted patterns were obviously inspired by their textiles, in which were indicated both brocade and lace techniques. In figure drawing the Mayas used less conventionalized perspective than did the ancient Egyptians or Assyrians. They produced minor arts in clay, precious and base metals, and semiprecious stones. They were excellent potters, making figures, dishes, bowls, and other containers which

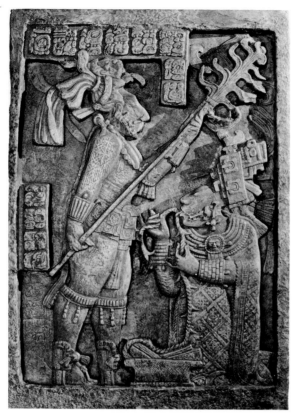

American Museum of Natural History

Mayan sculptured lintel. Yaxichilan, Mexico.

were enriched by painting, hand modeling, engraving, and stamping. Gold, silver, and copper, jadeite, turquoise, and other stones were worked into ornaments of fantastic shapes and colors. The decorative motifs used were hieroglyphics, geometrical patterns, grotesque figures, supernatural beings, and the birds and animals of the local jungles, such as monkeys and jaguars. The winged serpent or rattlesnake seemed to be the most sacred of living creatures, and a symbol of divinity; it was usually represented in a highly conventionalized, almost unrecognizable interpretation, and often clothed or enriched with human attributes and ornaments.

The Mayan supremacy ended shortly before the discovery of America. The cause of this decline has not been clarified, but Mayan civilization was inherited and developed by other Indian tribes who were of contemporary or later date. Among these were the Zapotecs in the state of Oaxaca. In the city of Mitla, which was the burial ground of the kings of this tribe, are ruins of great stone and concrete temples and tombs, the exteriors of which were covered with plaster, painted red, and decorated with frescoes done in red and black patterns on a white base, showing religious ceremonies. Sculptured figures in relief show personages and gods dressed in elaborate capes, girdles, aprons, skirts, and headdresses. Extraordinary gold jewelry has been found in the graves of Monte Alban.

The Totonacans, a tribe related to the Zapotecs, who lived near the city of Vera Cruz, produced extraordinary clay-modeled heads with slanting eyes and countenances often indicating unrestrained mirth, an expression not yet explained.

The Toltecs, who were contemporary with the Zapotecs, flourished in Yucatan and Oaxaca from A.D. 600 to 1100, and what remained of their culture is described in the writings of the Spanish conquerors. The great city and Citadel at San Juan Teltihuacan near Mexico City is the principal architectural ruin of this group. This city contains the remains of great pyramids, brightly col-

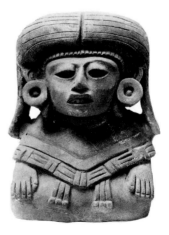
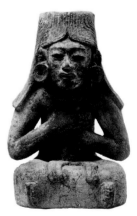

Zapotec funerary urns.

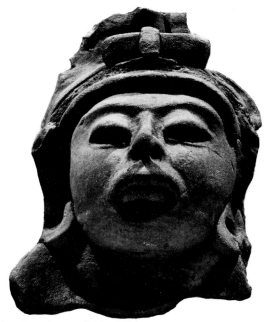

American Museum of Natural History

Mayan laughing face. Vera Cruz, Mexico.

oped a culture that was at its height. This is the only one of the ancient Indian civilizations with which contact was made at its supreme point, and concerning which knowledge has been obtained directly rather than through archaeological research. The Aztecs had inherited the civilization of the Toltecs and built (probably about A.D. 1325) their island capital in Tenochtitlan, now Mexico City. Cortez was overwhelmed by the grandeur that he saw, but this did not prevent him from destroying the ancient city and building the new city of Mexico over its ruins. Only in recent years have excavations been made that have brought to light extraordinary evidences of a rich architecture, ceremonial objects, and ancient relics of the former inhabitants. Aztec culture was completely dominated by religious fear, fanaticism, and sadism. Human sacrifices were constantly required to guarantee favorable crops

ored temples, and richly ornamented stairways. The architecture was enriched by representations of feathered serpents, shells, butterflies, and large sculptured figures. Remarkable painted pottery vases, figurines, and heads have been found, and a special type of ware that resembles cloisonné enamel was also made. Clay dolls with movable limbs were produced, and figures of the various gods were represented in fantastic personifications.

In the vicinity of Costa Rica and Panama have been found interesting types of gold work. These have been both of the plain and hollow-cast varieties and are both solid and plated on copper sheets. The process that was used in plating is not known. Many ornaments are of pure gold sheets beaten into repoussé designs. The motifs are human forms, frogs, lizards, turtles, crocodiles, jungle animals, and birds with outspread wings that were used for amulets.

When Cortez entered the highlands of southern Mexico, he found the Aztecs, who had devel-

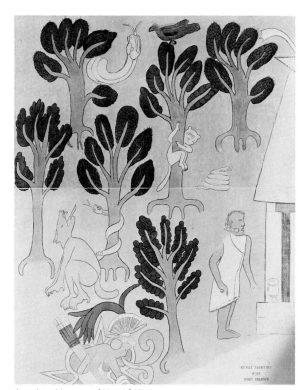

American Museum of Natural History

Mural painting from Chichen Itza, Yucatan.

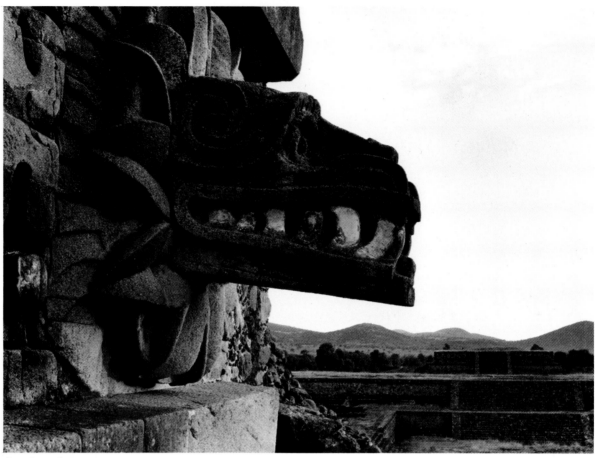

Photo Researchers

San Juan Teotihuacan, Temple of Quetzalcoatl, Mexico.

and political events. These horrible ceremonies have probably never been equaled in world history.* Wars with neighboring nations were un-

* Written records describe those in which a single victim was considered a god, was feted, given every honor, adorned with the richest of garments, given the freedom of the city, and married to the most beautiful maidens. He was expected to go willingly to the altar, uplifted by a supreme religious ecstasy. The slightest hesitancy was considered an omen of greatest misfortune. On the day of sacrifice he was stripped of his garments and mounted the steps of a pyramid, where priests cut his heart out and offered it to the god he had impersonated.

dertaken to obtain adult and child victims for these perpetual sacrifices, and thousands were often sacrificed during a single ceremony that lasted for several days.

The Aztecs had a well-organized government headed by a king who left his throne to his most able son. Their literature, inscribed on paper and deerskin and illustrated in brilliant colors, has been translated. They were extraordinary workers in many of the arts and crafts as well as the more important art of architecture. Their pottery was usually made in an orange-colored clay decorated with black painted figures of both realistic

Bird head. Vera Cruz, Mexico.

and conventionalized forms. Clay figurines were made from molds and were not as fine as the earlier hand-modeled figures produced by other races. Jadeite carving was extensively practiced, and, considering the primitive tools and the patience required for this work, the results were astounding. Jewelry was fashioned in the form of gold and mosaic decorations, consisting of turquoise, which was probably obtained through trading with the peoples north of the Rio Grande. Red jasper, jet, and shells of various colors were also used in mosaic work.

The Aztecs also excelled in feather work; their gay headdresses and cloaks were patterned with pluckings from macaws, parrots, hummingbirds, black vultures, and harpy eagles.

The Spanish conquerors, followed by their priests, ended the growth of the Aztec culture and dominance, taught the Indians such Christianity as they could absorb, and introduced the arts of their homeland.

South American Indian arts. Contemporary, but entirely independent, of the Central American Indian civilizations was that of the empire known as the Incas, which extended from Peru to Chile and included parts of Ecuador and Bolivia. Culturally related branches existed in Colombia and as far north as Panama.

When Pizarro arrived in 1532, he found a very ancient civilization with its capital at Cuzco, a city in the Andes that is 11,000 feet above sea level, where a well-organized government controlled a territory of enormous extent on the Pacific coast. Unity was maintained by well-established laws, a common religion of sun worship, and an extraordinary system of roads, canals, bridges, and aqueducts. Human sacrifice was not as extensive as in Mexico, but warriors shrank the severed heads of conquered enemies and carried them as proof of valor. When an Inca leader died, his wives and servants struggled for the

Inca pottery bowl from Peru.

honor of being buried with him, and his riches were placed in his tomb.* The intellectual level of the people was not as high as that of the northern races; they knew little of astronomy, although time was measured by the shadow of towers. They had no written language, yet they were superior to the northerners in agriculture and weaving and equaled them in many of the other crafts. Surgery was practiced, amputations successfully made, and evidences are clear that they knew the principles of skull trephining.

In their buildings, the Incas used stones of immense size that were cut to the most accurate fit. One of these stones is thirty-eight feet long, eighteen feet high, and six feet thick. They were brought from quarries thirty miles distant, and it is presumed that to place them, such stones were raised on inclined platforms by means of levers and rollers in a manner that resembled Egyptian methods. The architecture of the Incas was impressive by its size rather than by the extensive surface enrichment that is evident in the Mexican work.

Although the potter's wheel was unknown, the Incas reached a high degree in beauty of outline of container forms and decorated their ware with painted ornamental designs that run riot in conventionalization. Basket weaving was developed in both coarse and extremely fine weaves to a high degree of proficiency. Personal ornaments were made with beads, stone, bone, shell, seeds, and berries. Beads were of gold, silver, emerald, lapis lazuli, amethyst, turquoise, agate, and quartz. Bands of both solid and plated gold were worked into bracelets and finger rings, and copper, lead, and bronze ornaments were made by casting and hammering. Iron was unknown. Textiles for clothing, tapestries, and blankets were colorfully woven with finely twisted yarns and fast dyes in cotton, alpaca, and vicuña wool. Patterns were composed of highly conventionalized representations of the human figure, condor, puma, and fish, all of which seemed to have a sacred significance. Many mythological figures were shown in both surface patterns and free sculptural forms that fancifully combined human, animal, fish, and bird features. Feather weaving was also developed to a high degree.

North American Indian arts. The Indians of North America never developed a culture that equaled that of the original inhabitants of Central America and South America. There are ample evidences throughout the United States of prehistoric cave dwellings, and there many artifacts and cave paintings have been discovered, proving an archaic period. The Indians who, during the last ten centuries, inhabited the confines of the present United States were broadly divided into two main types. The nomads were warlike tribes who lived in temporary shelters, migrated from valley to valley according to their agricultural needs, and developed only the most meager of crafts. Those whose arts are of more interest were the Pueblo groups who were permanently settled, constructed large community dwellings of stone and adobe brick, established a comparatively peaceful organization, developed utilitarian crafts, and harvested their crops and stored them for use in times of shortages. The latter, who were probably the ancestors of the Hopis, Zunis, and Navajos, were mainly located and pursued their lives unmolested in the states of Arizona and New Mexico from A.D. 1000 until the coming of the Spaniards in 1540. Their descendants have carried on their arts to the present day, although many of these have become commercialized for the tourist trade.

The pueblos† consisted of a group of hun-

* The Spanish conquerors often tortured the inhabitants to force them to indicate the location of these tombs, and much of the ancient treasure was brought to Spain, where it was melted for its metal value.

† This word is taken from the Spanish word for *town*, but it is also applied to the houses and to the people themselves.

Museum of Primitive Art

American Indian basket. Arizona.

dreds of living and storage rooms, which were set against each other, usually surrounding courtyards or patios, where official and religious ceremonies were held. In these courts altars and stone seats are still intact today. The individual living areas usually consisted of one room, in which all the activities of the family were carried on. A very small door opening was covered with a blanket or rush-woven screen, and no windows existed. Fireplaces were built in the middle of the room, and stone grain-grinders adjoined one of the walls. The floor was earthen, but cloth and rush mats were used for sitting and sleeping purposes. Existing ruins show no other evidences of room decorations or furniture.

These Indians produced patterned textiles, ornamental pottery, baskets, personal ornaments, tools, and hunting implements on which much intelligent thought was placed in developing a suitable enrichment. The materials were silver, stone, gypsum, wood, clay, shell, horn, bone, grass, yucca, cotton, wool, feathers, and hides. Personal ornaments consisted of beads, pendants, necklaces, bracelets, and finger rings and earrings made of shells, turquoise, and other colored stones. Turquoise was considered a good luck stone and a defense from evil and misfortune.

Many types of baskets and mats were made of willow, reeds, and yucca, woven in plain, basket, or twill weave. Well-made baked clay products such as bowls, cups, pitchers, and bottles were made from a very early period; these were usually enriched with a painted decoration in white, black, and red. Paints were made from various minerals mixed with clay, and some were used that give the effect of a burnished or luster ware.

The most interesting of these Indian patterns are seen in their textiles and pottery. The motifs probably had a symbolic meaning, and they were as a rule of geometric conventionalizations. As the religion of the Indians consisted mainly in a worship of the forces of nature, symbols such as sunrays, lightning, clouds, rain, and thunder were frequently employed. The swastika, chevron, steps, rectangle, triangle, dish, ring, fret, dentil, zigzag, and coil were also used for borders or all-over patterns. There are also many irregular and abstract forms that were probably the product of the imagination of the individual craftsman. Diagonal and rectangular hatching were resorted to in pottery decoration and herringbone effects in woven products. The human figure, deer, foxes, bears, bush, and plant forms are represented in both naturalistic and highly conventionalized interpretations. There was no mass production, and no two objects were ever made alike.

American Museum of Natural History

New Mexico Pueblo Indian pottery.

Four Ages

Hogan (Home)

Rain (Crops)

Deer Track (Game)

Bird (Carefree)

Rain Comes

Snake (Defiance)

Gila Monster (Desert)

Bear Track (Good Omen)

Clouds (Prosperity)

Rainbow (Prosperity)

Swastika (Good Luck)

Conventional Bird Motifs

Lightning

Clouds

Rain (Prosperity)

Water

Sun Rays (Constancy)

Mountain Range

Arrow (Protection)

Seed

Star (Guidance)

Butterfly (Beauty)

Thunder Bird (Happiness)

Moon

Day and Night (Time)

Large Mountain (Abundance)

Symbolic motifs taken from Navajo and Pueblo Indian pottery and textiles.

The Indians of the Northwest coast produced an ingenious primitive art that included wooden statues closely resembling the work of other prehistoric races. When the Russians arrived at the end of the eighteenth century, the Indians were given better tools, and during the nineteenth century their arts were greatly elaborated. The Nootkas of Vancouver, the Haidas of British Columbia, and the Tlingits of Alaska have been among those who have advantageously used the timber of the giant red cedars that grew in their territory. They have constructed wooden plank dwellings, the walls and partitions of which are decorated with colorful large-scale symbolic motifs. Having no nails, the structural portions and planks are joined with cedar-root cords. Totem poles are still used to identify the inhabitants of each house;

these, and the canoes that were made by hollowing enormous tree trunks, are covered with painted relief carvings showing family crests and legends. The women of these tribes show supreme craftsmanship in basketry. Working with infinite patience, they produce the finest of grass weaves, using slips of minuscule diameters to create patterns of geometrical, animal, and marine motifs. Many of the tribes are noted for painted wooden chests, boxes, bowls, and rattles, and the northernmost tribes make blankets of mountain goat hair, which they embroider with shells. All tribes carve fantastic wooden masks for religious and pageantry uses, modeling them into symbolic, humorous, and terrifying facial expressions.

The Eskimos live in widely separated settlements near the Arctic Circle from Alaska to

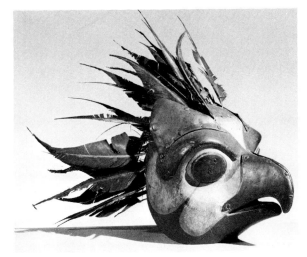

Museum of Primitive Art

Eagle headdress. British Columbia.

Greenland, in the most unpleasant climate in the world. There is neither vegetation nor natural resources. These people depend entirely on wildlife for sustenance. They are healthy and eat much raw meat and fish. They live in skin tents in summer and in underground shacks made of driftwood and earth in winter. They have invented the blubber lamp for heating and cooking. In spite of the dearth of materials and tools, they are endowed with extraordinary inventiveness in making utilitarian objects. Clothing is made from animal skins. Hunting equipment is made from driftwood and walrus tusks. The handles of tools are often carved or engraved with animal motifs. They have contributed the dogsled and the kayak to civilization. Living drab lives, they provoke humor and amusement by carving grotesque masks.

In the arts of all these northern Indians, there are individual group characteristics. The craftsmen of each remain loyal to the character of the productions and the ornamental motifs used in the art interpretations of their own group. The encroachments of civilization in recent years have greatly modified their native productions and art expressions.

AFRICAN NEGRO SCULPTURE

Despite some early attention by fifteenth-century Portuguese travelers to the continent, ethnographical art was not fully appreciated until it came to the notice of such twentieth-century artists as Picasso, Léger, Ernst, Kirchner, Brancussi, and Moore. They recognized a sympathy of interest between the enigmatic mystery of African forms and those of cubism, fauvism, expressionism, and surrealism. The materials employed were *terra-cotta*, rarely used but dating as far back as the second millennium B.C.; *stone*, mainly steatite; *wood*, the most frequently used and most readily available material; *iron*, employed in the Sudan hundreds of years before Christ; *bronze* and *brass*, with the *cire perdu* (lost wax technique), tentatively dated as early as the Egypto-Roman era and very prominent from the

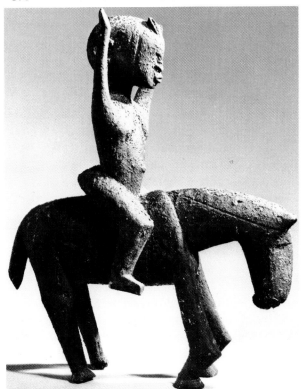

Museum of Primitive Art

Horseman. Mali: Dogon.

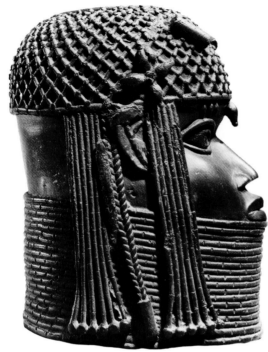

Museum of Primitive Art

Bronze head. Nigeria, circa 1550–1680.

thirteenth century; *gold,* panned over wide areas, but few examples extant; and *ivory,* largely limited to decorative utilitarian objects from the west coast and central Congo. Most scholars, with the recognition of Nubian participation in the history of ancient Egypt, acknowledge the very early contribution of Africa to world art. Early but not-too-well-recorded power incursions toward the south and west undoubtedly brought southern Egyptian Kingdom culture into other parts of Africa, particularly to the deeply forested lands below the Sahara. Further cultural links stem from the later Moslem domination of North Africa. This brings us to the point of earliest European awareness of the achievement of the African sculptor. Intrepid Portuguese explorers, motivated by gain in trade, came upon Nigeria, with its highly sophisticated arts so well exemplified by the bronze figures and portraits of Benin

and the earlier culture of Ife. The Portuguese had stumbled upon an atypical part of the African scene. Here they encountered kingdoms, groups of family tribes tenuously held together by the force of military occupation and further controlled by works of art extolling the divine power and supremacy of the reigning monarch. Most of these sculptures were eventually acquired by explorers of the nineteenth century and now reside in the ethnographic collections of museums and famous private collections. Some important pieces have been retained by newly formed African national museums.

Subject matter and its formal interpretation directly relate to the laws and customs of individual tribal groups. The artist is as integral a part of the religious and magical expression of his people as the local chieftain and witch doctor. His craft is a ritual extension of the drum's rhythm and the movement of the dance. As religious aspirations and magical incantation of secret societies change, so do the forms of his art. When a fetish figure has lost its effectiveness, a new one is carved to replace it. Powerful images seen in the religious or entertainment rituals of neighboring tribes were often faithfully copied. The most familiar examples of sculpture are the carved wood figures and masks of humans and animals. They were made of locally available material ranging from soft to hard woods and either stained or painted in brilliant colors.

The following represent some of the major cultures and salient characteristics of their styles (where not otherwise indicated, the material is wood):

BAGA, Coastal Guinea. Attained high artistic levels in its carving of cylindrical human figures in a wood hard enough to permit sharp linear detail and high polish. Painted angular sculptures were made in a synthesis of man, bird, and fish. Notable are the large nimba masks carried on the shoulders of dancers appealing to the goddess of earth and female fertility.

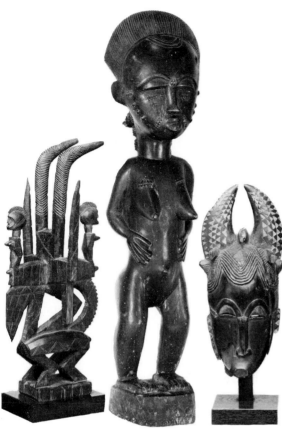

American Museum of Natural History

Carved African figures. LEFT: *Antelope and young, Sudan.* CENTER: *Figure from Ivory Coast.* RIGHT: *Gouro mask, Ivory Coast.*

MENDE, Sierra Leone. This culture is best known for its richly plastic helmet masks worn by women in the Bundu initiation rites. Sculptors show surprising individuality of style. These masks are always toned a deep black.

SENUFU, Northern Ivory Coast. Famous for its fire-spitters, a rectilinear hewn animal mask with yawning jaws and angular teeth. It is a variant of the warthog, sometimes with antelope horns and adorned with a chameleon, giver of long life. Human masks are carved with an inner strength and placidity. Birds are frequently used as symbols of protection.

DAN, Ivory Coast. Makers of masks with concave faces in blackened pale and soft wood, narrowly slit eyes, and pointed chins. They are sometimes adorned with natural hair, fiber, and pieces of sheet metal.

BAULE, Ivory Coast. Stylistically related to other cultures of the region but given to the production of ancestral masks and figures, often seated and adorned with body scarifications as existed in real life.

ASHANTI, Ghana. Best known for their small bronze and brass gold weights cast in an innumerable variety of human figures and animals, including birds and fishes. Unique were the fertility dolls carried by women to insure healthy offspring. The disk heads are round and surmount a small cylindrical body extending spikelike arms. The hardwood is stained black and polished from long handling.

BOBO, Upper Volta. The forests north of Ghana provided fine hardwood to facilitate sharply cut masks further enhanced by painting with geometric abstractions. Favored subjects were antelope heads and rectangular deity masks carrying realistic animal horns.

BAMBARA, Mali. Very characteristic and surprising in its unusual artistry are the "chiwara" male and female antelope headdresses worn during fertility dance rites. The bodies were conceived in angular openwork and long spiraling horns. These tall carvings were carried on woven straw caps. Made for the N'domo society initiation rites were masks surmounted by human or animal figures and a comblike superstructure often applied with cowrie shells and small red seeds.

DOGON, Mali. Equestrian themes representing ancestors are not uncommon. Geometric open tiered masks of great height, sometimes to sixteen feet, are a hallmark of this culture; similarly, the Kanaga masks shaped like the cross of Lorraine and used in funeral processions. Rectangular eye openings are a frequent occurrence.

Granary doors are beautifully relief carved with animals.

KURUMBA, Upper Volta. The most characteristic sculpture is the brightly painted pale wood headdress representing an antelope. The stylized neck and head are long, as are the straight horns and forward-arching ears.

IFE, Nigeria. This ancient group, which some archaeologists date to the pre-Christian era, reached aesthetic and technical heights prior to the fifteenth century. Representative are equestrian groups and royal portrait heads, realistic in facial contour and often with parallel-lined scarifications. The media are terra-cotta and bronze.

BENIN, Nigeria. This kingdom followed the tradition of the Ife, adding architectural adornment of relief-molded metal plates affixed to wooden substructures. Characteristic is the life-size bronze female portrait head with long neck circled with rings of necklaces. (Beware of the innumerable bad modern copies.)

FANG, Gabon. Mostly concerned with introspection in the production of funerary figures. They are abstractly carved in softwood, have bulging foreheads and receding lower features.

BAKOTA, Gabon. These neighbors of the Fang produced sculpture of a vastly different style. Best known are the metal plated figures with crescent-shaped helmets, incurvate oval faces, no arms or bodies, but with open lozenge-shaped lower limbs. When double-faced, these reliquaries are related to the cult of the dead twins.

BAJOKWE, Congo. Here the sculptors produce large numbers of hardwood masks and figures notable for strength of contrasting form and a splendid virility frequently described as *baroque*.

BASONGE, Congo. The sculpture of this group could never be confused with that of any others. It consists mainly of large masks, magical and somewhat frightening in appearance, with massive cubes over deep-set eyes and sharply

Museum of Primitive Art

Wooden chair. Angola.

protruding square mouths. Ancestral figures were hollowed out and filled with magic substances to frighten evil spirits.

BALUBA, Congo. Experts regard this art highly for contemplative radiance and beauty of form. In their helmet masks of darkened hardwood, facial features are delineated by sweeping curvilinear forms of remarkable grace and subtlety. In one example the head is ringed with plaited hair and forward-sweeping horns. Each sculptor strives for individual expression and is mainly motivated by temporal rather than religious or mystical inspiration.

To consider the practical aspects of this subject, certain things must be borne in mind: Future potential productivity is marred by the vast sociopolitical changes taking place in Africa. The contemporary demand for modernization in industry must force the very essence of the life-styles of previous cultures into the background. Most contemporary artists have lost the true motivating drive of their predecessors, and their work tends toward repetition of superficial form without the vitality of inner meaning. Some good pieces still find their way to the open market, but their appreciation requires an experienced eye and always a knowledge of the best standards—our fine private and museum collections.

BIBLIOGRAPHY

Ackerman, Phyllis. *Guide to the Exhibition of Persian Art, 1940.* New York: Iranian Institute.
A well-illustrated descriptive guide to the remarkable exhibit held in New York in 1940.

Adam, L. *Primitive Art.* Harmondsworth, Middlesex, England: Penguin Books, 1949.
A short but excellent illustrated text on all primitive art types.

Bennet, Wendel C. *Ancient Art of the Andes.* New York: Museum of Modern Art, 1954.

Blaser, Werner. *Structure and Form in Japan.* New York: Wittenborn, 1963.

Bossert, H. T. *Peasant Art in Europe.* Berlin, 1926.
Foreign text illustrated with photographs and color prints.

Carter, Dagny. *Four Thousand Years of China's Art.* New York: Ronald Press Co., 1948.
An excellent short but well-illustrated historical outline of the various arts of China from the earliest days.

Carver, Norman F., Jr. *Form and Space of Japanese Architecture.* Tokyo: Shokokusha, 1955.

Castedo, Leopoldo. *A History of Latin American Art and Architecture: From Pre-Columbian Times to the Present.* Translated by Phyllis Freeman. New York: Praeger, 1969.

Covarrubias, Miguel. *Indian Art of Mexico and Central America.* New York: Alfred A. Knopf, Inc., 1957.

Dimand, M. J. *A Handbook of Muhammadan Art.* New York: Hartsdale House, 1947.
An excellent outline by the curator of near eastern art of the Metropolitan Museum of Art.

Douglas and D'Harnoncourt. *Indian Art of the United States.* New York: Museum of Modern Art, 1941.
Well illustrated in color and black and white with excellent descriptive captions.

Drexler, Arthur. *Architecture of Japan.* New York: Museum of Modern Art, 1955.

Ecke, Gustav. *Chinese Domestic Furniture.* New York: Towse, 1962.

Frederic, Louis. *Japan: Art and Civilization.* New York: Harry N. Abrams, 1969.

Fry, Maxwell and Drew, Jane. *Tropical Architecture.* New York: Reinhold Publishing Company, 1964.

Fry, Roger. *Last Lectures.* New York: Macmillan Company, 1939.
Lectures on primitive arts by the professor of fine arts of Cambridge University, one of the greatest authorities on this subject. Beautifully illustrated.

Galardi, Alberto. *New Italian Architecture.* New York: Wittenborn, 1967.

Guillaume, Paul, and Munro, Thomas. *Primitive Negro Sculpture.* Merion, Pa.: Barnes Foundation.
One of the earliest publications on the subject with clear analysis of the styles.

Holme, C. *Peasant Art in Austria and Hungary.* New York: The Studio, Ltd., 1911.
Text and illustrations on Austrian, Hungarian, and Roumanian art.

Inverarity, Robert Bruce. *Art of the Northwest Coast Indians.* Berkeley: University of California Press, 1950.

Itoh, Teji. *The Essential Japanese House.* New York: Wittenborn, 1967.

Kates, C. N. *Chinese Household Furniture.* New York: Harper and Brothers, 1948.
One of the few publications in English on this subject.

Kelemen, Pat. *Baroque and Rococo in Latin America.* New York: Dover Publications, 1966.

Kramrische, Stella. *Art of India.* New York: N. Y. Graphic, 1965.

Kubler, George. *The Art and Architecture of Ancient America.* Baltimore: Penguin Books, 1962.

Kühnel, Ernest. *The Minor Arts of Islam.* Translated by Katherine Watson. Ithaca, N.Y.: Cornell University Press, 1970.

Lancaster, Clay. *The Japanese Influence in America.* New York: Twayne Publishers, 1963.

Lee, Sherman. *A History of Far Eastern Art.* New York: Harry N. Abrams, 1964.

Linton, Ralph, and Wingate, Paul, in collaboration with René d'Harnoncourt. *Arts of the South Seas.* New York: Museum of Modern Art, 1946.
Color illustrations and maps.

Mead, Charles W. *Old Civilizations of Inca Land.* American Museum of Natural History Handbook Series, no. 11. New York, 1924.

Meauzé, Pierre. *African Art.* Cleveland: World Publishing Company, 1968.

Metropolitan Museum of Art. *American Index of Design—Pennsylvania German.* New York, 1943.
Excellent illustrations and text.

Meyer, J. *Fordits Kunst: Norges Bygder.* Oslo: Norwegian Peasant Art, 1934.
Standard book on this subject.

Moller, Sevend Erik. *Modern Danish Homes.* New York: Towse.

Morse, Edward S. *Japanese Homes and Their Surroundings.* New York: Dover Publications, 1961.

Museum of Modern Art (New York).
Books and pamphlets on contemporary fine and industrial arts are frequently published by this organization and are listed in the museum's catalogue of publications.

Oliver, Paul. *Shelter in Africa.* New York: Praeger, 1971.

Paine, Robert Treat and Soper, Alexander. *The Art and Architecture of Japan.* Baltimore: Penguin Books, 1960.

Plath, Iona. *The Decorative Arts of Sweden.* New York: Dover Publications, 1966.

Pope, A. U. *Introduction to Persian Art.* New York: Charles Scribner's Sons, 1930.
Excellent text.

Rojas, Pedro. *The Art and Architecture of Mexico.* Translated by J. M. Cohen, Feltham, Middlesex, England: Hamlyn Publishing Group, 1968.

Rosenfield and Shimada. *Traditions of Japanese Art.* Cambridge, Mass.: Fogg Art Museum, Harvard University, 1970.

Rowland, Benjamin. *The Art and Architecture of India.* Baltimore: Penguin Books, 1959.

Shipway, V. C. W. *The Mexican House: Old and New.* New York: Wittenborn, 1960.

Sickman, Laurence, and Soper, Alexander. *The Art and Architecture of China.* 3d ed. Harmondsworth, Middlesex, England: Penguin Books, 1968.

Sirén, O. *Gardens of China.* New York: Ronald Press, 1949.
Beautifully illustrated authoritative book.

Spinden, Herbert J. *Ancient Civilizations of Mexico and Central America.* American Museum of Natural History Handbook Series, no. 3. New York, 1922.

Stern, Harold E. *Master Prints of Japan.* New York: Harry N. Abrams, 1969.

Sweeney, James Johnson, ed. *African Negro Art.* New York: Museum of Modern Art, 1935.

Toussaint, Manuel. *Colonial Art in Mexico.* Translated by Elizabeth Wilder Weisman. Austin, Tex.: University of Texas Press, 1967.

Warren, William. *The House on the Klong.* New York: John Weatherhill, 1968.

Willet, Frank. *African Art.* New York: Praeger, 1971.

Yoshida, Tetsuro. *The Japanese House and Garden.* New York: Praeger, 1955.

Zweig, M. *Zweites Rokoko.* Vienna: Kunstnerlag, Anton Schroll and Company, 1924.
German text with fine collection of early nineteenth-century German furniture.

The Luncheon of the Boating Party, by Pierre-Auguste Renoir.

CHAPTER 9

History of Painting and Graphics

The Death of St. Francis, by Giotto.

Pictures and books are the most significant external clues to the intellects of their owners. Conversely, for a designer, these objects are the most useful to express an individual's personality in a room. A designer is seldom concerned with books, but is often consulted in regard to pictures because these usually are part of permanent furnishings. Discretion must be used in choosing pictures for others. The satisfaction of an owner should far outweigh any decorative consideration. Pictures are to be enjoyed, and must be of interest to those who live with them; the pleasure may be that of connoisseurship, memory, amusement, or any message that conveys a worthy reaction.

To the average intellect, interest in a picture is in the subject matter or literary aspect, but as connoisseurship improves, the composition, structure, form, rhythm, design, color, and deeper meaning will be appreciated.

Mosaic and mural decorations were produced in all early periods of art, but it was in ancient Greece and Rome and again with the beginning of the Renaissance in Italy that pictures were made to hang on walls. From this origin all the arts of modern graphical representation have evolved. After the invention of printing, many methods were developed to produce pictorial decorations in quantity. The sci-

ence of photography has added to these. Each medium has its relative merits and deficiencies.

Pictures should be selected on the basis of taste, and to develop this quality, a knowledge of the history, techniques, and processes of the pictorial arts is necessary. It is impossible here to give more than a cursory outline of these subjects, and it is recommended that the student read in addition one of the many standard reference books. A list of more specialized volumes is given at the end of this chapter.

THE HISTORICAL SCHOOLS OF PAINTING

No one can claim to be broadly cultured without a knowledge of the art of painting. Modern efforts in this field cannot be intelligently judged without information concerning the works of the past that have influenced and reflected the thoughts and activities of humanity.

ITALIAN PAINTING. Italy's wealth during the Middle Ages was derived largely from her trade with the Orient, and in each city leaders competed in externally expressing their power and grandeur. The purchase of works of art was one of their methods, and great opportunities developed for the artists who excelled in reflecting the philosophy, religion, and needs of their particular patrons. Cities vied with each other, and all their citizens discussed the relative merits of the masters. The church, too, used the artist to explain its dogmas and history to the people. These developments in different localities are today known as schools of painting. In Italy the principal centers of art were in Florence and Venice, although minor schools existed in all other large cities.

The painters of the Renaissance were not greatly influenced by the arts of antiquity. It was obvious, as early as the beginning of the fourteenth century, that there was an attempt to break away from the traditions of Byzantine conventionalism and Gothic mysticism and approach the spirit of realism and classicism that

Spring, by Botticelli.

had been buried for centuries. Many of the artists, however, lacked sufficient knowledge of anatomy and foreshortening, and the painters of this period are generally referred to as *primitives*. To Cimabue of Florence, who was born about the year 1240, is usually attributed the title of the first of modern painters, although no authentic pictures by him are known. Duccio (1255–1319) and Simone Martini of Siena painted in a style closely related to that of the Byzantine mosaics and Gothic illuminated manuscripts. Both had probably been taught by Byzantine artists who had visited Florence about 1260. Duccio was the first Italian painter to enlarge the biblical manuscript illustrations and make them suitable for use as wall decorations. In these early examples, flat symbolical figures are shown in brilliant colors on gold back-

grounds, with the emphasis on the expression of religious emotion.

THE FLORENTINE, MILANESE, AND UMBRIAN SCHOOLS. Giotto (1266?–1337), who, according to tradition, was discovered by Cimabue, was the first naturalistic painter in Italy, and by his emphasis on broad structural form in his religious frescoes, he started the movement toward realism, naturalism, and the third dimension that was later to dominate the entire Florentine school. He was the first painter to paint from observation. His motto was "Follow Nature." Giotto lived shortly after St. Francis of Assisi had reacted against the tyranny of a misguided church, and he endeavored by means of his art to promote the Franciscan doctrines and to lead the people back to the simplicity of Christ's teachings. He painted some of the fres-

coes in the church at Assisi, built in honor of the saint. His aim was to tell the truth, although he lacked knowledge of the laws of perspective. He was a friend of Dante, whose portrait he painted on a wall of the Bargello in Florence. Giotto had many disciples, the greatest of whom were Masaccio (1401–1428), a realist, who, 100 years later, studied perspective with Brunelleschi, the architect of the dome of the Florence cathedral, and Uccello, who profoundly researched in mathematics and painted battle scenes with converging lines and cubical forms. Fra Angelico* (1387–1455), the Dominican monk, also eloquently interpreted the teachings of St. Francis. Vasari claims he prayed before commencing each picture, and, as this pious mentality was dominated by the cloister, he never permitted himself a secular approach. The faces of his saints and angels are visions of purity, and his paintings sing the exaltation of Christian philosophy. Donatello (1386?–1466), the sculptor, revived a waning naturalism and influenced painters who followed him. The jovial Fra Filippo Lippi, an exact antithesis of Angelico, who claimed he was only flesh and blood, combined both strength and tenderness in his work that consisted mainly of chronicles of contemporary Florentine life. Verrocchio (1435–1488) was among the first to paint landscape, light, and air. He was also a sculptor and modeled the equestrian statue of Colleone in Venice. Botticelli (1444–1510), a creative genius, who was a contemporary of Lorenzo the Magnificent and Savonarola, turned to pagan mythology and painted *Spring*, a perfect thesis for Humanism, earthly joys, and pleasures. Lorenzo saw no inconsistency in hanging paintings of Venuses next to mournful Madonnas. Thus the road was paved for Leonardo da Vinci, Michelangelo, and Raphael.

* His true name was Guido di Pietro da Mugello. He was only called Fra Angelico after his death.

The Louvre, Paris

Madonna of the Rocks, by Leonardo da Vinci.

Leonardo (1452–1519), of Vinci, a pupil of Verrocchio, was one of the most universal geniuses who ever lived, yet he was humble in self-appraisal. Tormented by a seething, creative instinct, he was author, philosopher, painter, sculptor, metalworker, inventor, scientist, musician, architect, mathematician, designer of firearms, mechanical and structural engineer, physicist, and geologist, and in all his activities he was far in advance of his times. He was a superb draftsman and a master of light, perspective, and anatomy. He discovered secrets that would have completely revolutionized contem-

Studies for the Libyan Sibyl, red chalk on paper, by Michelangelo.

porary thought if his enormous number of manuscripts had been published. His emotions were entirely controlled by his intelligence and self-discipline. Many of his paintings were unfinished or have been destroyed. His *Madonna of the Rocks* in the Louvre was among the first paintings to interpret the Virgin as a human being rather than a celestial character; she watches her Child with tenderness, but the halo and symbols of divinity have disappeared. For his crumbling *Last Supper*, an oil on plaster painting in Milan, he takes the moment when Jesus says, "One of you shall betray Me," and every face and figure portrays this tragic moment; it is one of the greatest pictorial studies in profound psychology. Tradition states that his portrait of Mona Lisa was painted shortly

after the wife of Gicconda had lost a child; the sphinxlike smile has had numerous explanations, but if the assumption is correct, it was perhaps due to the fact that Leonardo is supposed to have employed musicians and jesters to create a momentary diversion for one who was buried in grief. The portrait is probably the best-known painting in the world. Leonardo worked for a long period for Ludovico Sforza of Milan and died in the Chateau at Amboise, France, while in the employ of Francis I.

Michelangelo Buonarroti (1475–1564) was sculptor, painter, architect, engineer, and poet. He was the greatest artist of Florence, and perhaps the greatest the world has ever seen. Tireless, his titanic mentality crushed the comparatively meager efforts of all other artists of his time and ended the Florentine school. He considered himself primarily a sculptor, and his paintings largely reflect this self-appraisal. He was all absorbed in depicting the monumental form, the representation of which, both male and female, was heroic, muscular, and vital. He painted nude figures in extraordinary contortions, floating through the air, or incredibly foreshortened. He used the human figure to express intense thought. His influences go back to Masaccio, Signorelli, and Pollaioulo. In 1508, the pope commissioned him to decorate the ceiling of the Sistine Chapel. For four years he lay on his back on a scaffold to paint 10,000 square feet of plaster surface. He covered it with figures from the Old Testament, prophets and sibyls in disconcerting attitudes expressive of superhuman energy. In his old age he worked for seven years to paint *The Last Judgment*, covering the end wall of the chapel, in which he shows a colossal Christ and a terror-struck Virgin in the presence of a combat of naked giants. Michelangelo left few paintings, and they are mostly in Italy. His creations have been compared to Greek Hellenistic sculpture, which reveals a state of turbulent movement or restrained power. It is perhaps advisable here to

recall that Michelangelo also designed the dome of St. Peter's in Rome, which has influenced the design of subsequent domes in architecture.

Raffaello Sanzio (1483–1520), known as Raphael, one of the most prolific of all artists, was born in Urbino, where in his youth he decorated pottery. During his short life he became architect of St. Peter's, mural decorator of the Stanze and Logge of the Vatican, official inspector of the antiquities of Rome, designed tapestries, and was a prolific producer of easel pictures. Although an Umbrian, his best work was done in Florence and Rome. He borrowed ideas from many painters, but he was himself a master of composition. Highly imaginative and intellectual, he ranked high in illustrative ability, but his pictures are sometimes cold in color and lacking in virility. He painted many devout subjects, but lived at a time when art was losing its religious importance. He was idolized by an adoring group who overwhelmed him with orders, and his reputation has hardly suffered in nearly five centuries. Some of his greatest paintings were made during his association with his model "Bella," who was the inspiration for many of his Madonnas; in presenting this subject, he arranged his group in a triangular pattern and represented the Virgin with an expression that mixed sensuality with the ethereal. In *La Belle Jardiniere*, Mary sits in a meadow, the two children against her knees; her face is tender and human, but lacks a virginal quality. It was Raphael in his fresco, *The School of Athens*, in the Vatican, who finally summed up the essence of the Renaissance in painting. The *Fire in the Borgo*, one of his murals in the Vatican, shows violent, muscular, nude figures that indicate the influence of Michelangelo. In portraits painted shortly before his death, he retains his innate refinement, but avoids sublimity for more earthly facial characterizations. His untimely death at thirty-seven years of age stupefies the imagination as to his potential production if he had lived twice as long.

The Louvre, Paris

Concert Champêtre, attributed to Giorgione.

THE VENETIAN SCHOOL. The magnificence of life in Venice was reflected in the work of its artists. The beautiful light of the Adriatic accentuated the hue on every surface, and trade with the Orient added to the color consciousness of every individual. It was natural that the Venetian painters saw color as the dominant element in pictorial design. Accurate drawing, perspective, and anatomy were considered secondary to the emotional appeal of color symphonies. The subjects of the Venetian painters were avowedly religious, but, actually, they represented the splendor and pomp of the costumes, pageants, and social gatherings of the people. Women were portrayed as young and beautiful, and the men, strong, vigorous, and handsome. Stress was laid upon worldly joys, in contrast to the idealism of the Florentines. In the fifteenth century, Jacopo Bellini and his two sons painted monumental religious and historical frescoes that were serene and majestic. Giovanni Bellini, one of his sons, was the teacher of both Giorgione and Titian; in painting the nude he subordinated interest in the form to the beauty and sensual appeal of the flesh. This thought dominated all later Venetian painters.

The Louvre, Paris

Man with a Glove, by Titian.

Giorgione (1478?–1510) was one of the first Italians to paint a reclining female nude, such as the *Sleeping Venus* in Dresden. His allegorical *Concert Champêtre* shows an idyllic group of two nude women among two dressed musicians; in the distance is a poetic background of trees and luminous clouds. In the character of the landscape treatment and in the naturalistic subject matter this picture was a model for many later artists. Giorgione understood humanism, the moods and feelings of man, and how they are affected by the moods of nature. He was a genius in the use of color, and as a portraitist had the capacity to represent the innermost thoughts of his models. His life, like Raphael's, was unfortunately short, but his student, young Titian, finished many of Giorgione's uncompleted works.

Titian (1477–1576) inherited his master's magical use of color and surpassed him in versatility. Living to a ripe age, he painted every kind of subject. There was a feeling of gaiety in most of his pictures, and even in his religious groups one can detect a semblance of pagan ardor. His portraits, figures in landscape, religious and mythological subjects reflect a profound psychology as well as a rich understanding of technical possibilities. He was a friend of popes, princes, and politicians, who lavished favors upon him. He decorated many of the public buildings in Venice and painted the nobility of Italy. His interpretation of *Christ at Emmaus* is very different from that of Rembrandt, the figures being set in a palatial room with the Emperor Charles V as model for the figure of Luke. The *Portrait of a Man with a Glove* shows Titian's ability to portray the character of a sensitive youth with extraordinarily simple and subtle means. Titian strongly influenced the work of Rubens, Velasquez, and Reynolds.

The Counter-Reformation of 1545 changed the character of painting as well as of architecture and decoration; the purpose was to revitalize a sagging faith, and the painters set out to overawe and dazzle their public. Tintoretto (1518–1594), the pupil of Titian, carried on the ideas of Michelangelo in figure painting. He was called "Il Furioso" because of his speed in painting, which sometimes resulted in carelessness. His *Paradise* in the Ducal Palace at Venice is one of the largest paintings in the world and contains over 400 figures. He also painted portraits of many of the doges. Veronese (1528–1588), who was born in Verona but lived in Venice, was noted for his draftsmanship, rich use of color, a tendency toward silver effects, and for his custom of placing groups of figures in elaborate architectural settings. His enormous *Marriage Feast at Cana* in the Louvre is one of his best known.

Caravaggio (1569–1609), who greatly influenced Neapolitan painting, was little influenced by his contemporaries, rejected idealism, and chose a naturalistic representation of secular

Broadway Boogie Woogie, 1942–43, by Piet Mondrian. Oil on canvas 50" x 50". Mondrian, who was the most radical abstractionist of our time, called his non-representational style Neo-Plasticism. This movement, known as De Stijl, had a decisive influence on many architects abroad and soon became an international style. Museum of Modern Art

*A stark white background creates strong →
silhouettes of the handsome 19th Century
Franklin Stove and side chairs. The collec-
tion of accessories lends colorful accent
notes to the well-defined scheme.*

Hans Namuth

*← The geometrical pattern created by archi-
tectural recesses and horizontal shelving is
further enhanced by a personal collection of
items which lend distinction to a small de-
signer's office.*

Hans Namuth

Tiepolo (1696–1770), the great eighteenth-century artist, was the final exponent of the luxurious life of Venice. He continued to paint the processions and pageants and the tottering superiority of the aristocratic classes, and his work strongly influenced Goya, Delacroix, and others.

The Venetian school's contribution to art was very great; its gay and human character had a more universal appeal but was less profound than the intellectualism and sublimity of the Florentine. It became, however, the fountainhead for many later schools and was far more influential in the nineteenth century than the painters of Florence, whose only disciples were the short-lived pre-Raphaelites of England.

FLEMISH AND DUTCH SCHOOLS. The northern schools of painting developed concurrently but independently of Italy. Membership in the Hanseatic League and the French civil wars had brought wealth to the Low Countries. Brilliant courts had been established at Ghent and Bruges during the fourteenth century, and these cities, along with Florence, had become the intellectual

The Louvre, Paris

The Death of the Virgin, by Caravaggio.

and religious subjects. He painted murders, brawls, and ugly events in the lives of the dregs of humanity and used a violent lighting that accentuated the brutality of the incident. He was one of the first Italian realists who imparted a secular ambience to his religious paintings. His mature paintings reveal a sharp contrast in light and shade effects (*chiaroscuro*). His masterpiece is the *Death of the Virgin*, now in the Louvre. Perhaps not since Giotto has there been such international influence as through the works of Caravaggio. It seems that almost every great painter went through a Caravaggio phase—Rubens, Velasquez, Rembrandt, Ribera, etc.

Metropolitan Museum of Art

The Sacrifice of Abraham, by Giambattista Tiepolo.

Metropolitan Museum of Art

The Harvesters, by Pieter Breugel the Elder.

centers of Europe. They had been centers of manuscript illustration during the Middle Ages, and it is generally acknowledged that the first successful use of oil as a painter's medium* was introduced about 1426 at Bruges, perhaps by Jan van Eyck. He was a portraitist of supreme talent, and a painter of religious subjects, who established the first naturalistic tendencies in Flemish art in contrast to Gothic conventionalism. Critics frequently state that in *Giovanni Arnolfini and His Wife*, painted by Jan in 1434, perfection in art was established in its first example; the picture is today one of the most popular in the National Gallery in London. Another superb work is the *Adoration of the Lamb*, an altarpiece in Ghent.

The van Eycks were followed by Van der Weyden and Memling, both idealistic religious painters. Bosch (c. 1462–1516), with a lugubrious imagination, painted monstrosities and diabolical nightmares that both repel and attract the eye. Pieter Breugel, the Elder (c. 1525–1569), of Brussels, and his two sons introduced the painting of landscapes,

* Until this period, painters used tempera, mixing their pigments with gum and the whites of eggs.

peasant scenes, and allegories, using great inventiveness. Other Flemish artists popularized subjects related to jests, satires, and intimate activities of the people, and were the precursors of seventeenth-century Dutch *genre* painting. Those who visited Italy became saturated with concepts of splendor and offered to the burghers of Antwerp richly colored decorative subjects that prepared the way for Rubens.

Rubens (1577–1640), born in Antwerp, was one of the most prolific painters who ever lived. Of magnetic personality and supreme intellect, he numbered among his friends scholars, scientists, and kings. As a diplomat and painter, he visited Italy, and twice went to the court of Spain, where he met Velasquez, and was knighted by Charles I of England, who heedfully listened to his advice. Rubens, bursting with health and vitality, with the aid of 100 apprentices, produced over two thousand paintings. His representations of historical and allegorical events, hunting scenes, and tournaments are astounding narratives that twirl in tempestuous patterns of colors, lines, and forms, his seductive nudes are robust and sensual; his rollicking *Kermesse* in the Louvre pictures a remarkable composition of roistering villagers, protesting maidens, and mischievous children. Twice happily married, he frequently painted

Metropolitan Museum of Art

Wolf and Fox-Hunt, by Peter Paul Rubens.

Metropolitan Museum of Art

Earl of Warwick by Sir Anthony van Dyck.

portraits of himself, his wife, and children, richly costumed and blissfully clasping hands. His *Descent from the Cross* in the Antwerp Cathedral is generally considered his greatest work, though such a designation is difficult considering his vast production. If his pictures lack the psychological depth of those of the Italian masters, he was not surpassed in the other elements of painting. Every great museum in the world is replete with examples of his work.

The gigantic mentality of Rubens left no single inheritor of all his capacities. Teniers (1610–1690), his pupil, continued to paint kermesses, drinking scenes, and peasant jests that were often reproduced as tapestries. Van Dyck (1599–1641) inherited Rubens's elegance of style, but specialized in aristocratic portraiture that featured, with exquisite technique, details of silken fabrics, fine laces, and trimmings. Most of Van Dyck's work was done in England, where he flattered the nobility and prepared the way for the eighteenth-century native portraitists.

In 1648, the Dutch part of Flanders was liberated from Spanish domination and free to worship in the Protestant faith. With the establishment of the East and West India Companies, Holland captured the lion's share of the world's carrying trade, and the burghers, who benefited, organized the guilds and began to build themselves elaborate homes which needed pictures. Religious and mythological subjects were frowned upon under the new church dogmas, the people preferring genre paintings showing small-dimensioned views of street scenes, interiors, country activities, and phases of their middle-class life. Steen and de Hooch, under Flemish influence, used painstaking craftsmanship in showing tavern groups and interiors. Van Goyen, Hobbema, and the two Ruysdaels painted charming landscapes that later influenced the English school. Artists were also commissioned to paint "corporation pictures" showing group portraits of guild members.

Frans Hals (1580–1666) was the first Dutch artist to achieve fame and a lasting recognition. A man of joyous temperament, he transferred his viewpoint on life to the canvas with a full brush and glowing colors. His paintings, though lacking in depth, vibrate with vitality and a good humor that borders on the theatrical. Hals had the gift of catching a momentary expression and suitably adapting the color and composition to the subject; he became the outstanding interpreter of jocularity in art. In the characteristic *Laughing Cavalier*, a soldier stands with a quizzical expression, the details of his clothing minutely rendered; he is about to burst into uproarious laughter. Hals drank heavily and lived recklessly, which eventually led him to the

Metropolitan Museum of Art

Jonker Ramp and his Sweetheart, by Frans Hals.

was simpler and more sincere. He preferred character to beauty. It is said the only book he read was the Bible. His paintings are not only Dutch; they indicate the struggles of all humanity. His subjects were greatly varied, including corporation pictures, landscapes, and portraits, and, contrary to Dutch tradition, many biblical scenes. He painted for both rich and poor, gave interest to the most commonplace subjects, and had an extraordinary power of expressing character.

His major contribution to the art of painting was the further development of his particular technique of handling light and shadow. It was a luminosity based on Caravaggio. Lines were subordinated, and at times the main subject was left in shade, with masses merely blocked in, but a strong highlight emphasized the upper portion of the composition. The light areas were

almshouse. His spontaneity executed with crisp visible brush strokes strongly influenced nineteenth-century painters, particularly Manet.

Rembrandt van Rijn (1606–1669), one of the greatest intellects of his age, combined realism with a mystical approach, searching beneath the surface of everyday things for inner meanings. Little is known of his private life, except that it was full of sorrow. His wife Saskia, a prominent young woman, who figures in several of his early paintings, died young, leaving one son. Though at fifty Rembrandt became bankrupt, this only seemed to increase his spiritual qualities, and he toiled indefatigably till the end of his life to satisfy his creditors. While he never visited Italy, a baroque quality in his work shows study of the Italian masters, but his work

Copyright The Frick Collection

Self-portrait by Rembrandt.

treated in rich colors and explicit detail, as in the *Man with a Gold Helmet*, in which the chasing on the helmet stands out as if in relief. Transitions from light to dark were gradual, and the shadows were painted in warm colors; the result was to accent and to lift an ordinary subject to a higher plane of interest.

His most widely discussed picture is the misnamed *Night Watch* (1642), showing a company of crossbowmen readying for a daytime march. The figures are actual portraits, but he subordinated the individuals to the whole pattern, and pleased no one. From this time his fortunes began to ebb. The *Supper at Emmaus* reverently and dramatically depicts Christ before the ascension. He is seated frontward at a table, and His face is illumined by a ray of light from an upper window; with Him are two seated disciples and a serving lad, whose figures contrast, in less detail and in semidarkness. Rembrandt painted many self-portraits and frequently used his wife as a model. His etchings have probably never been surpassed; this was a field almost unexplored before his time. Recognizing the limitations of the technique, he modified his style to suit lineal reproduction and drew portraits, landscapes, and biblical subjects.

Jan Vermeer (1632–1675) was probably the "Little Dutch Master" of greatest stature next to Rembrandt. About forty paintings of his have been authenticated,* the major portion of which are interior scenes with an uncanny feeling of spaciousness. Like Rembrandt, he created a luminosity for his own convenience. His subject matter usually shows a woman at some household task; there is usually a window, a wall area broken by a map or picture, and, in the foreground, objects arranged with logical relation to the whole pattern. Analysis of the *Young Woman at a Casement* and *The Lacemaker* shows carefully contrasted linear and spatial

* During World War II, Vermeer's paintings were remarkably counterfeited.

Metropolitan Museum of Art

Young Woman with a Water Jug, by Vermeer.

relationships, yet so natural in structure, that one is unaware of the planning involved.

In the eighteenth century, Holland produced no genius, but in later centuries Jongkind (1819–1891), Van Gogh (1853–1890) the post-impressionist, and Mondrian (1872–1944) the nonobjectivist came under French influence, but each developed strong individualism in his work.

GERMAN PAINTING. The art of painting was never as extensively practiced in Germany as in the other countries of Europe. The early Renaissance produced three great painters, but a further development was prevented by the disasters of the religious wars. Dürer (1471–1528) of Nuremberg is often considered the "Leonardo of the North," but most of his masterpieces were in the medium of engraving, etching, and woodcuts. He experimented with perspective and anatomy and was also a watercolorist. His portraits are intense and earnest

Metropolitan Museum of Art

Melancolia, engraving by Albrecht Dürer.

and reflect the patronage of his day. He was the first to interpret the Italian Renaissance to the people of northern Europe. Hans Holbein, the Younger (c. 1497–1543), in the opinion of many, is unrivaled in portraiture. He lived in Basle, where he became famous for his pencil sketches. His woodcut series known as *The Dance of Death* is today popular throughout the world. He visited England and was the guest of Sir Thomas More, whose portrait he is supposed to have painted. Henry VIII authorized him to paint his fourth wife, Anne of Cleves. The collection of Holbein's chalk sketches at Windsor Castle shows him at his best. Much of his work has been destroyed, and he is judged by his smaller productions. He was frank in his treatments and never modified his subjects by unusual lighting. Cranach (1472–1553) was greatly influenced by Luther and painted many religious

pictures. He was, however, primarily noted for his nudes, who appear both naïve and humorous, but with graceful figures that lack the corpulency of the typical Teutonic woman. The German painters of later centuries had illustrative abilities but never reached the profundity of thought or technical expertness of those of other countries. Under the totalitarian regime, when any evidence of imagination was designated as "degenerate," German art reached its lowest ebb.

SPANISH PAINTING. The art of painting in Spain began at the time of the Renaissance and was first influenced by Caravaggio, the Italian realist. With a few exceptions, Spanish artists have retained realism as a characteristic feature of their work, and at times have carried its conception to a thundering climax.

Metropolitan Museum of Art

The Plowman, woodcut by Hans Holbein the Younger.

The Crucifixion, by Zurburan.

gave him life, but Toledo, the brush." His style was based less on Titian, his master, than that of Tintoretto, but he developed an individual style of great originality. He was frequently commissioned by the Church authorities, and many of his paintings are of austere religious subjects inspired by a Jesuit fanaticism. In these he shows an elongation of the human figure and a gravity of facial expressions, producing mystical and melancholy effects that are accentuated by the use of somber, grayed tones, with puzzling highlights and deep shadows. His greatest work is considered to be *The Burial of Count Orgaz* in a chapel of Santo Tomé in Toledo. This picture is in two parts; the lower part is ultrarealistic and represents the corpse being lowered into its sarcophagus by magnificently caped cardinals, surrounded by the count's former friends; the semicircular upper portion is in forceful contrast by its idealism, and shows the presentation of his soul to Christ, the Virgin, St. Peter, and the angels; the two conceptions

The seventeenth century produced Ribera and Zurburán, both of whom painted gloomy religious themes, featuring emaciated friars and aged men with shrunken faces, who typified the asceticism of the Church of the period. Murillo (1617–1682) serves as a contrasting temperament; his paintings foreshadow a charm and delicacy generally associated with the eighteenth century.

The next two centuries produced three geniuses who are unsurpassed in art history. In 1576 a Cretan whose name was Domenicos Theotocopoulos (1541–1614) arrived in Toledo after having studied with Titian in Venice. His surname in Greek can be translated "Of the Mother of God," but as a foreigner, he was derisively nicknamed "El Greco." He soon became more Spanish than the natives themselves, and after his abilities and loyalty were recognized, the Toledans covetously remarked, "Crete

View of Toledo, by El Greco.

Prado Museum

The Maids of Honor, by Velasquez.

integrate a work of emotional power that has seldom been surpassed. El Greco was also a landscapist of dramatic force; his favorite subject being the city of Toledo viewed from an adjoining hill; his *View of Toledo* is eerie in effect and shows the elements of nature during their most vicious moments. El Greco has had an enormous influence upon modern painters.

The second of the three was Velasquez (1599–1660), a Portuguese, born in Seville, who lived to be the supreme genius of Spain and one of the most gifted painters in all art history. When he was thirty-six years old, he became court painter for Phillip IV and never left the king's service. Velasquez was not interested in the visions or asceticism of El Greco, nor the religious and political turmoil that surrounded him, but concentrated mainly on pomp and splendor. He was ultranaturalistic in his interpretations, and as a technician he has perhaps been equaled but never surpassed. His portraits show a penetrating psychology. Countless times

he painted the king with the Hapsburg jaw, in every costume, aspect, and mood. With remarkable skill he produced charm in the enameled faces of the ladies of the court, and his children's portraits exquisitely reflect the innocence and sincerity of childhood, combined with a dignity that befits royal birth. His greatest works are in the Prado in Madrid. The *Maids of Honor* is a mirror reflection of the artist's studio showing him in the process of painting the Infanta surrounded by her maids, dwarfs, and dog, and a mirrored reflection of the king and queen in the rear of the room. Ranking with Titian's *Man with a Glove* is Velasquez's *Portrait of Innocent X*, in Rome, which is a miracle of subtlety, psychological effect, and paint quality. He is often considered the painter's painter. His outstanding historical picture is the *Surrender of Breda*, a beautifully patterned composition showing the Dutch general graciously handing the keys of the city to the Spanish conqueror, who is surrounded by his officers and a guard of proud lancers; the burning city, immersed in a violet atmosphere, forms a background that gives a fantastic illusion of air, space, and distance. In *The Drunkards*, painted in his youth, one clearly sees the influence of Caravaggio in combining mythology with contemporary life;

Prado Museum

The Drunkards, by Velasquez.

Prado Museum

The Nude Maja, by Francisco Goya.

Bacchus is being crowned by peasants whose faces are extraordinary characterizations; the group is painted in a soft golden light, as though it were being seen through a glass of clear wine.

The last of the great trio was Goya (1746–1828), the graphical realist of his age, who produced a complete pictorial history of Spain when her politics were at their most corrupt level. Born to low life, he rose to be the most famous Spaniard of his time. His youth was replete with escapades, and vigilant monks just prevented his elopement with a nun. He married and had twenty legitimate children. His magnetic personality finally gathered around him the greatest people in Spain. He was painter, etcher, watercolorist, and designer of tapestries. His genius was manifested in his paintings of the lower classes and his deep insight into contemporary Spanish life. His dance scenes reflect all the gaiety of these moments and suggest the lightheartedness of Fragonard. He was both a caricaturist and powerful satirist. He castigated the degenerate court of Charles IV by painting the pompous king and his dominating wife with repulsive facial expressions. In a series of etchings known as *The Caprices*, he lashed at the vices of society, and, in another series, he courageously depicted the atrocities of the French troops during the Napoleonic war, in spite of the fact that he had been appointed court painter to Joseph Bonaparte. His famous paintings were those known as the *Maja Nude* and *Maja Dressed*, believed to be the duchess of Alba, with whom Goya was in love. It is said that the duchess is the only royal nude model in art history. Goya painted her reclining body in flesh tones that vibrate with emotional tenderness. Tradition states that he hurriedly painted her clothed in the same pose, when her husband announced his intention of visiting the studio. Both pictures now hold the position of honor in the Goya room at the Prado in Madrid. He was a prolific painter of portraits of the Spanish

Prado Museum

La Gallina Ciega, by Francisco Goya.

aristocracy. Goya's daring greatly impressed Delacroix and the Romanticists of France. He was a hundred years ahead of his time and, as such, was an important influence in the work of many later artists.

Spanish painting of the late nineteenth and early twentieth centuries is represented by Sorolla and Zuloaga, both of whom tried to continue the great traditions of Spanish art. They were delightful colorists, but superficial in their conceptions. More recent artists are Sert, the muralist; Miró and Dali, quasi-surrealists; and Picasso; the latter was an internationalist and an experimentalist, influenced by the French school, who assumed leadership with able results, but his work was so powerful that he affected much of painting in the first half of the twentieth century.

THE ENGLISH SCHOOLS. During the sixteenth century, when the Continent was producing its great masters of painting, the English were not sufficiently convinced of their own artistic capabilities to support and promote a native talent; they knew only the work of for-

eign artists. Henry VIII invited Holbein to his court, and under Charles I, in the early seventeenth century, Van Dyck painted the British nobility in a manner that is a feast for the eyes. Rubens also visited England in 1629 for both diplomatic and artistic reasons and was listened to with the utmost reverence. Puritanism, however, relegated art to the infernal regions and created a hiatus in the development of a national school that was not counteracted until, with brilliant technique, Lely reflected some of the sensual qualities of the court of Charles II.

Hogarth (1697–1764) was a spontaneous development in English art. Whistler called him "the only great English artist." At least he was the first of importance and came upon the scene when England was interested only in the Italians, Flemish, and Dutch. Hogarth was unimpressed by foreigners, but was vitally interested in the homes and haunts, the qualities and vices of the middle classes. His talents, both as engraver and painter, permitted him to interpret what he saw with wit, entertainment, and satire. As moral narratives, he produced the series known as *A Harlot's Progress*, *The Rake's Progress*, and *Marriage à la Mode*, in which each final picture shows the calamitous end of the unrighteous. His family groups known as *conversation pieces* were painted like snapshots of stage sets during the progress of a drama, but he skillfully discloses the personality of each individual. His scintillating portraits thoroughly reveal the character of his models, and those of David Garrick, the Shrimp Girl, Peg Woffington, and himself with his dog "Trump" show an economy of brushwork that astounded his contemporaries. He painted many members of his own family, and it seemed that the plainer the appearance of his model, the stronger was her chance of being painted. His reputation has suffered from the tendency of historians to dwell upon the subject matter of his pictures. In 1753 he wrote the controversial "Analysis of Beauty," in which he claimed the most beautiful line in

National Gallery, London

Shortly after Marriage, by William Hogarth.

nature to be an elongated S-curve, a form that he used constantly and which ever since has been called by artists "Hogarth's Line of Beauty." Hogarth's style was not appropriated by later painters, but he aroused the creative consciousness of the English artists.

Reynolds (1723–1792) aided in establishing the Royal Academy in 1768 and became its first president. He lectured on his theories and on the proper training for artists and urged a thorough study of drawing, color, and composition, and a complete understanding of the history of painting, before creative or imaginative efforts

were undertaken. The public, however, demanded portraits, and he and his contemporaries, Gainsborough (1727–1788) and Romney (1734–1802), painted in the Van Dyck tradition, with minor influences of Rubens and Titian. Gainsborough produced several delightful landscapes, but to keep himself alive was forced to paint "potboilers";* his exquisite portraits of

* The term *potboiler* was originated by Gainsborough and, ever since, has been used by artists to refer to paintings made to appeal to the public taste and not those that the artist wished to paint.

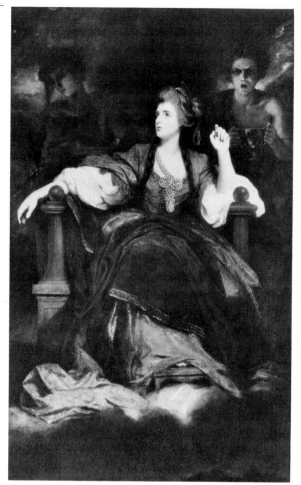

National Gallery, London

Mrs. Siddons as the Tragic Muse, by Sir Joshua Reynolds.

Mrs. Siddons, Mrs. Graham, and "The Blue Boy" are the best known. Romney was in love with his model Emma Lyon, who later became Lady Hamilton and eventually the mistress of Lord Nelson; he portrayed her in innumerable characterizations. The reputation of these three artists rests upon their immortalization in exquisite colors of the charm and refinement of a wholesome aristocracy and their ability to make women appear more beautiful than they probably were. Reynolds' pupils and successors,

Raeburn, Hoppner, and Lawrence, were worthy of their master, but their lives overlapped the decline in art that commenced in the first quarter of the nineteenth century.

At the turn of the century, a Suffolk lad named Constable (1776–1837), who loved his countryside, taught himself to paint independently of the aristocratic school of London. He specialized in landscapes and painted with a sincerity that had been previously unknown. The public was slow to accept his work, but he was convinced that his ability to catch the luminous atmosphere in both stormy and fair weather would eventually be rewarded. He won medals at the Paris Salon in 1824 and was a strong influence in the establishment of the Barbizon school. He is looked upon today as the originator of modern landscape painting.

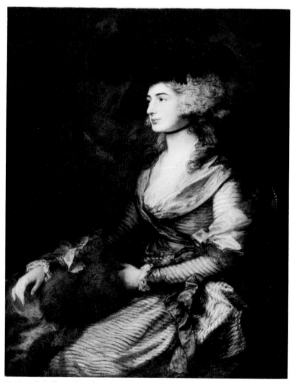

National Gallery, London

Mrs. Siddons, by Thomas Gainsborough.

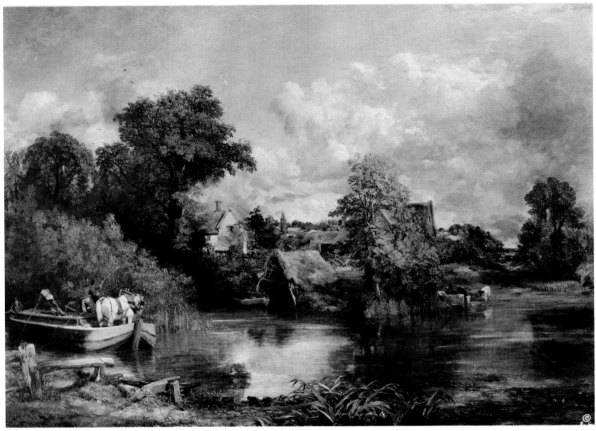

The White Horse, by John Constable.

Turner (1775–1851) was a poet who lived in a dreamland. He was a genius in his field and an accident in art history. He lacked education; was uncultured, personally offensive, and friendless; but he was bewitched with the mystery and beauty of light, sky expanse, and water reflections. He painted the atmosphere of landscapes with a broad palette, indicating stationary objects with a blurred effect. He was studied by contemporary French landscapists, and his last works may be considered precursors of the Impressionist movement. Bonington (1802–1828) studied and lived in France. He unfortunately died before his full maturity, but left several delightful landscapes and portraits.

During the middle of the nineteenth century English painting fell into a state of triviality temporarily relieved by the "Pre-Raphaelite Brotherhood" of Hunt, Rosetti, and Burne-Jones, who turned to medievalism with Botticelli as their God. They were defended by Ruskin, but world thought was soon to discard eclecticism and to search for new artistic interpretations. With the approach of the twentieth century, the English artists looked for inspiration from across the Channel.

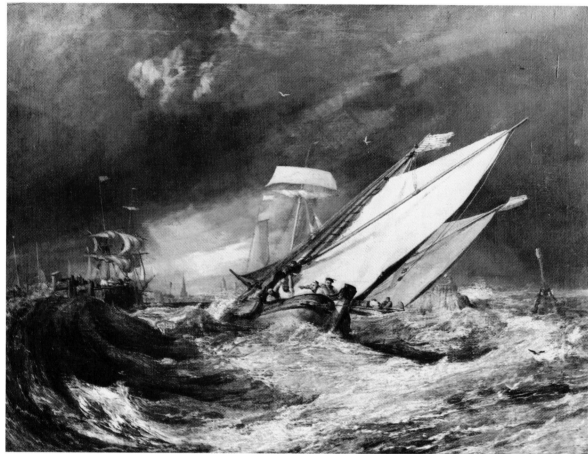

Fishing Boats Entering Calais Harbor, by J. M. W. Turner.

EARLY FRENCH PAINTING AND THE SCHOOL OF FONTAINEBLEAU. With the sixteenth-century decline of Italy's eastern commerce, France struggled for the cultural leadership of Europe. The northern countries for a time showed brilliance, and Spain had her geniuses, but France in the eighteenth century finally emerged to dominate the arts, a position she has never relinquished.

During the Gothic period, French painting was largely limited to altar decoration and religious manuscript illustration. As early as the thirteenth century, however, exquisite miniatures were painted to illustrate the new secular romances and scientific treatises. The printing press eventually served to exterminate this beautiful art. Fouquet, in 1455, made his charming pictures for the *Book of Hours* and was the first painter in France to use sensual subject matter; in his *Virgin and Child* he impiously showed Agnes Sorel, the king's mistress, as a carnal and provocative Madonna. During the sixteenth century the Clouets painted royalty with pale and reticent faces. The "school of Fontainebleau," under the leadership of Primaticcio, an Italian, gave evidence of the reaction from medieval asceticism in producing many unsigned paintings of Diane de Poitiers and other court beau-

Diana, attributed to Primaticcio.

ties, who seemed intent upon giving their contemporaries complete information concerning their physical charms.

FRENCH BAROQUE AND ROCOCO PAINTING. The Louis XIV period commenced with the work of two landscape painters, Claude Lorrain and Poussin. The former painted vistas of shimmering waters and luminous clouds seen through settings of dark trees and ruined temples. The latter also produced paintings of pagan and Christian subject matter in which figures generally play an important role within a complex architectonic composition. The king frowned upon the Le Nain brothers, who portrayed peasants in their daily activities. Le Brun was appointed director of fine arts, and under his authority absolute power was glorified, and in-

dividualism was stifled. Historical events and symbolical groups became the subject matter of all paintings, and a cold, spiritless art developed. At the king's death the French burst into a gaiety that long had been smoldering, and the painters once again could paint as they desired. Watteau (1684–1721) quickened the pulse with his exquisite colors in the portrayal of a gallantry that implied that all life had been dedicated to love; his *Embarkation for Cythera* (1717) represented young aristocrats leaving for an isle where Aphrodite could be eternally worshipped. Art was now for the beautiful women of the court, and their approval was sufficient adulation. Boucher, often vulgar but never dull, used light blues and pinks and the sinuous curves of the period in depicting boudoir scenes or voluptuous women engaged in frivolous pastimes. Lancret and Pater were influenced by the "Fêtes Champêtres" of Watteau. Fragonard (1732–1806), in such paintings as the *Storming of the Citadel*, painted alluring beauties whose virtue was a mockery. His paintings were delightful but reflected the superficiality of the period and lacked intellectual depth. The eighteenth century established an initiative in France that has caused her to be the nucleus of creative effort in many of the arts to the present day.

Embarkation of the Queen of Sheba, by Claude Lorrain.

The Louvre, Paris

Embarkation for Cythera, by Jean Antoine Watteau.

NEOCLASSICISM. Classical influences in painting were introduced more than ten years before Louis XV's death and were partly the result of the importation of Piranesi's engravings of Roman ruins, and, of course, the influence of the Pompeian discoveries through the efforts of Mme. de Pompadour. The public had already begun to weary of the license of the rococo period, and Louis XVI endeavored to appear as an honorable family man. Marie Antoinette turned at least outwardly to the simple

Copyright The Frick Collection

The Meeting, by Jean-Honoré Fragonard.

life and carried on the patronage of the arts. The painters applied their talents mainly to a portraiture that expressed purity and refined sentimentality. Greuze, Nattier, and Vigée Le Brun produced delicately colored portraits in oil and pastel, and Quentin de la Tour, the pastelist, was noted for the winsome expression of his models. The independents were Fragonard and Chardin; the former, as muralist, continued to paint amorous scenes and was accused of corrupting public morals; the latter, under Dutch influence, produced remarkable compositions showing kitchen utensils, floral groupings, and genre pictures representing informal home scenes. His insight into the humblest of objects through his subtle technique firmly established still-life painting as worthy of the highest efforts of such great masters as Titian, Velasquez, and

The Louvre, Paris

Diana Resting after her Bath, by François Boucher.

The Louvre, Paris

Still Life with a Jar of Pickled Onions, by Jean-Baptiste Chardin.

Poussin. Hubert Robert painted fanciful views of classical ruins demanded by a public entranced by antiquity.

DAVID AND INGRES. The Revolution was not only to change the social and economic life of France, but also to smother all former concepts of the art of painting. The horrors of the period began to be recorded in oil, of which the greatest masterpiece was David's *Death of Marat*. In the early years of the nineteenth century, under the influence of David (1748–1825), the art director for Napoleon, there was ushered in a ponderous solemnity and classical severity. David was imbued with a delirium for the antique. Enormous paintings of scenes from Greek and Roman history and mythology were made, and Napoleon's military victories were recorded. David's portraits of Madame Recamier and others showed the sitters in Greek-inspired costumes and settings. Official dictatorship of the painters once again provided abundant production but little evidence of imagination.

Ingres (1780–1867), a pupil of David, dominated painting until the middle of the century; he was a superb draftsman and a remarkably controlled technician, but produced frigid pictures. Portraits, seraglio scenes, and Greek god-

Royal Museum of Fine Arts, Brussels

Death of Marat, by Jacques Louis David.

The Louvre, Paris

Portrait of Monsieur Bertin, by Ingres.

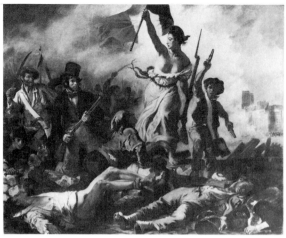

The Louvre, Paris

Liberty Leading the People, by Eugène Delacroix.

desses were portrayed with a bloodlessness that confounded nature; however, an exception is his deeply penetrating portrait of M. Bertin. He failed to grasp the changes that were occurring in life and art, and his critics accused him of trying to extinguish the sun. His influence, nevertheless, affected different periods of Renoir, Modigliani, and Picasso.

ROMANTICISM AND REACTION. Delacroix (1798–1863), a protesting contemporary of Ingres, inspired by the warmth of Rubens, turned to romanticism, vigor, and vibrant color; his ideas fell like a sledgehammer upon the conservatives who were still floundering in Hellenic dreams, and he split the art world of Paris in two. He had lived through the Revolution of 1830, and, impregnated with a passion for liberty, he fought with feverish energy to reestablish the traditional glory of France. His powerful *Liberty Leading the People* remains one of the great dramatic masterpieces of all times. He visited Morocco and painted many exotic eastern subjects, the most famous of which is *The Jewish Wedding*, which later influenced Renoir. The greatness of Delacroix was acknowledged

only on his deathbed by the visits of those who had disdained him.

By 1830 most of the arts had begun to feel the paralyzing effects of the Industrial Revolution. The painters alone maintained vitality and reacted to the changed conditions. The aristocratic patrons had been displaced by a wealthy bourgeois whose understanding of the arts was meager. The salon was established to find a new market for the artists' work. Only a few intellectuals had grasped the meaning of the democratic developments, and confusion reigned in the art world. The day of the individualist was at hand.

Courbet (1819–1877) came from his birthplace at Ornans to Paris to paint and is generally considered as the first French realist of the nineteenth century. He disregarded classicism, idealization, and romanticism and wished to produce a living art by painting what he saw around him—placid landscapes and rude peasants. His famous remark was, "Show me an angel and I will paint one." He had no love for accuracy of detail and often applied his paint with a palette knife. One of the supreme masterpieces of his time was the then scandalous *Two Women along the Banks of the Seine*. His political views eventually caused him to be ostracized by the salon and to flee the country, but his devotion to nature remained as an influence upon a host of followers. Another individualist of exquisite refinement was Corot (1796–1875), who in his late works concentrated on dawn and twilight landscapes showing distant dancing nymphs and satyrs. He arose often to see the sun creep over the horizon; at noon he "saw too well." In a self-appraisal he remarked, "Delacroix is an eagle, but I am only a lark singing songs in my gray clouds," but his misty forest scenes, rendered with an intentional lack of precision, greatly influenced his successors. The third great individualist was Daumier (1808–1879), who for many years was a lithographer

Courtesy of Wildenstein and Company, New York

The Plough, by Corot.

and were followed by Daubigny, Diaz, Dupré, Manet, Monet, and Degas. Troyon and Bonheur, the animal painters, also settled there. This group, later to be called the "Barbizon school," became known for their impressions of nature rendered in simple techniques and as such had a strong effect on the later Impressionists. The fields, tranquil waters, village streets, and daily activities of the lower classes were established as suitable material for interpretation. Thus these painters paralleled the democratization that was occurring in other fields of thought.

Manet (1832–1883) was wealthy and cared little for others' opinions. He had been early influenced by Goya, but was the backbone of Impressionism. His technique was that of a full brush with few strokes to attain his effects, and that of placing a concentration of light upon the

and a poignant cartoonist who satirized Parisian officials, city life, and the classical tradition that lingered. This early experience had taught him to penetrate deeply into human foibles and to say much with few lines and simple masses. When he commenced to paint, he eliminated unnecessary detail, and his color range tended toward the remarkable monochromaticism of Rembrandt.

THE BARBIZON SCHOOL. While the individualists were working, Theodore Rousseau (1812–1867) and Jean François Millet (1814–1875), struggling with poverty, settled, about 1836, in peaceful Barbizon near Fontainebleau. The former wandered through the forest and painted the splintered tree trunks, windswept branches, and weird rocks; his style was often crude in the use of thick dark slabs of paint, but his versatility was shown also in paintings done in minute detail and light tones. Millet concentrated on the life of the peasant and endeavored to dignify the glory of labor and promote sympathy for the agricultural classes. *The Angelus* is among the best of his pictures. By 1865 Barbizon had become the center of an enraptured group. Corot and Courbet were early visitors

Metropolitan Museum of Art

Actualités, by Honoré Daumier.

Jeu de Paumes, Paris

Olympia, by Edouard Manet.

important feature in his pictures. He painted portraits, Spanish scenes and figures, boating and garden scenes, and subjects taken from everyday life. He permitted his models to take unexpected poses. The Emperor Napoleon III conceived of a "Salon des Refusés" where rejected paintings could be seen. It was at this exhibition in 1863 that Manet's *Dejeuner sur l'Herbe* created a popular scandal, but attracted the young and future Impressionists by its direct observation. This painting shows two undressed girls picnicking on the banks of the Seine with two fully clothed men, an event that was not uncommon among the models and art students of Paris. His *Olympia* (1865) portrays a brazen courtesan, whom he painted without idealization as a protest against the sentimental nudes then in vogue.* Both pictures at first caused a tumult of protest but hang today in the Louvre.

Degas (1834–1917), though associated with both Barbizon and the Impressionists, proved to be a thorough individualist and the greatest draftsman and decorative painter of his time. He worked in both pastel and oil. From Japanese prints he adopted the high, diagonal view-

* Particularly those of Bouguereau, Gérôme, and Cabanel.

point and the abrupt cutting of his compositions by the picture frame. Colors in his pastels often resemble multicolored fireworks. Photography aided him in becoming a master of the portrayal of motion. His subject matter included portraits, landscapes, racetrack and ballet scenes, and nudes casually washing themselves or stepping from the bathtub.

THE IMPRESSIONIST SCHOOL. This name was inappropriately applied in 1874 to a loosely knit group of young French artists, some of whom had been associated with the earlier realists and social propagandists. They concentrated on subject matter of the period, but their distinguishing mark was their attempt to apply to painting the principles of light refraction. The most important were Pissarro, Monet, Whistler, Sisley, Morisot, and, later, Seurat. The theory was that, as color is produced by light rays, it was more important to paint the light that enveloped an object than to paint the object itself. As the character of daylight constantly changes, it seemed logical to paint a rapid visual impression that subordinated composition, silhouette, and detail. By juxtaposing on the canvas short

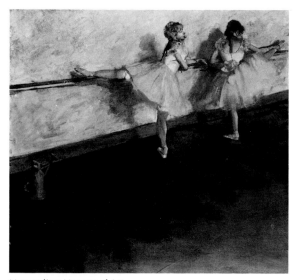

Metropolitan Museum of Art

Dancers Practicing at the Bar, by Edgar Degas.

strokes or dots of pure spectrum colors, a blending would occur by fusion of light rays rather than by mixing pigments on the palette, and the results would be more vibrant and luminous.* The salon authorities regarded these policies with opprobrium, and from 1874 to 1886 the group conducted exhibitions akin to the "Salon des Refusés," which were at first greeted by jeers, but eventually established the movement in the eyes of the public. Many of the group were gifted with extraordinary ability and versatility, and as they matured, it was impossible to restrain their individualism.

Monet (1840–1926) was primarily a landscapist interested in transitory effects. His trees and buildings were often little more than a blurred mass, and it was after his *Impression: Sunrise* was exhibited in 1874 that the term *Impressionist* was applied to his group. He painted Rouen cathedral seventeen times, under different light conditions, and always the form was indistinct and seemed trembling, but the colors glistened, whether they were the purples and grays of a moisture-laden day or the reds and yellows of a brilliant sun. One of his best-known pictures was an interior view of St. Lazare railway station,† a banal subject that he glamorized by a delicate luminosity that was diffused by smoke, steam, and a dawn-lit atmosphere. He appealed to the aesthetic emotions by color rather than by subject matter. He was a leader of the "pleinairists," who believed in working out of doors instead of in the studio.

* Greens were obtained by juxtaposing dots of pure yellow and blue, grays by using small areas of complementary hues, etc. Shadows were in colors complementary to the color of the object that cast them. Large areas of adjoining complementary colors would intensify each other and give greater vitality to the picture as a whole. Pictures painted according to these principles had to be viewed from a distance, though it was more theorized than practiced by the Impressionists.

† In the Art Institute of Chicago.

Pissarro (1830–1903), the teacher of Cézanne and Gauguin, was more conscious of structure, and his works show more contemplative use of color than those of most Impressionists. Sisley (1839–1899) imparts a fragile lyricism to Impressionism.

THE POSTIMPRESSIONISTS. Interest in Impressionism was at an end by 1886, and many of the leaders had begun to enjoy the fruits of their struggle. A new generation was coming up to take their place, and those who had been associated with the movement began to proceed along highly individual lines, so that the term *Postimpressionism* hardly classifies a cohesive trend, but rather implies a rebellion from former interests. If any concerted conception was finally indicated, it was a disregard for natural appearances and natural coloring, and this intentional indifference eventually led to cubism, futurism, abstractionism, and the later twentieth-century explorations. Many artists of the late Barbizon school, who had adopted Impressionism for a time, later discarded both ideals for the individualism upon which their frame rests. All, however, were forceful in their results. A brief list of the leaders with a description of the general character of their work follows:

Cézanne (1839–1906) must rightly be classified as a Postimpressionist due to his deep interest in structure, while benefiting from Impressionist color. His early work was influenced by El Greco and Delacroix, but his later productions were highly individualized. His rugged applications of vivid pigments and freedom in drawing caused him to be ridiculed by the critics, and, in 1879, he retired to his native Aix and courageously worked in seclusion for many years. His ability was unique in the simple handling of masses and planes that were given depth by the use of structured color and unconventional perspective. He sought to indicate the internal structure of a thing rather than the external form, thus leading the way for the later cubists and abstractionists. He carefully

Metropolitan Museum of Art

Mont Sainte-Victoire, by Paul Cézanne.

studied the anatomy of landscapes and sea-scapes and interpreted them in glowing tones. Fearful of women, he produced few nudes, but painted his uncomely wife many times. His still lifes of fruits and vegetables have rarely been surpassed. His methods revolutionized painting, and, although his leadership was not recognized until 1904, he is considered today one of the greatest contributors to the development of the art. He has been the greatest single influence in art in the first half of the twentieth century.

Renoir (1841–1919), another Postimpressionist, was influenced by Rubens and the Venetian school and was content to be an Impressionist for but a short time. He was interested in the interplay of colors caused by flickerings of sunshine and shadow, and his tone harmonies are attained by innumerable light refractions, in which hue melts into hue and produces a vibrating effect. The surface of his pictures is satinlike in quality. His subject matter was rooted to the innocent joys of life and particularly to those that were typical of his native France. One feels the bloom of pulsating youth and a lust for life in all that he painted. He was skillful in the representation of bare flesh; his nudes are indicated with a discreet

refinement and are a pure tribute to nature. His portraits attain the utmost in charm, and his flowers and trees reflect a sensitivity that embodies the redolence of spring. One of his most expressive paintings is the *Luncheon of the Boating Party,** in which he entrancingly portrays the innocent gaities of a youthful gathering on a sunny summer's day. His style was unique and was rarely adopted by later artists.

Henri Rousseau (1844–1910) was a government customs inspector—hence his nickname "Le Douanier"—who painted as a pastime. By 1885 he devoted himself entirely to painting. No amount of training could sway him from the "naïveté" of his work, which through its personal vision and decorative excellence influenced many twentieth-century painters. He is today considered an individualist of unusual talent.

Gauguin (1848–1903) had a Peruvian mother and in his youth shipped as a seaman to tropical ports. He was later employed in the stock exchange in Paris and pursued painting as a hobby. He soon became depressed with the sordidness of money-changing and in 1881 turned to painting as a lifework. Rejecting all

* In the Duncan Phillips Gallery, Washington, D.C.

The Louvre, Paris

Three Bathers, by Pierre-Auguste Renoir.

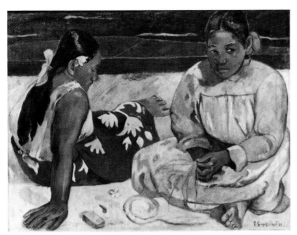

The Louvre, Paris

Two Tahitian Women, by Paul Gauguin.

previous theories, he became the most radical of the Impressionists and retired to Brittany to be close to nature. Disillusioned by the conventions of civilization, he fled, in 1891, to Tahiti to become part of the life of the South Seas, and there produced his most characteristic paintings. He loved the tropical colors, the brown-skinned natives, the luxurious landscape, and the romance of primitivism. His paintings are decorative and nonrealistic. Figures are molded in attitudes to fit a preconceived pattern, and they have a timeless, dignified calm. He applied pure color in broad flat areas and in flowing curves with only a suggestion of depth. The influences of Oriental arts are obvious, and there are resemblances to medieval tapestry and stained glass design and, surprisingly, to the academician Puvis de Chavannes.

Van Gogh (1853–1890), a Dutchman who worked in France, was considered a Postimpressionist. He first worked as a preacher in mining towns, and it was only during the last eight years of his life that he turned to painting with a passionate devotion. At first he followed Dutch tradition, but later was inspired by Millet, Delacroix, and Daumier, and finally moved from realism into an expression of tur-

bulent emotions. His life was essentially tragic, a fact apparent in all his work; colors are violent, forms deliberately contorted, and even inanimate objects seem to twist with abnormality. His unusual textural effects were produced by applying the paint with palette knife, fingers, or by stippling. His brush strokes were sometimes in obvious curves. At times he adopted the pointillism of Seurat and, later, joined an incompatible Gauguin in southern France where he painted landscapes, still lifes, portraits, and figure studies. He was not concerned with representing externals, but with hidden meanings, and therefore may be considered one of the first expressionists. During an epileptic fit he inadvertently cut off his ear, and he finally committed suicide when he realized another seizure coming. Typical examples of his work include *Sunflowers, Houses at Arles,* and *Cypresses in the Moonlight.* His style left its impact on Soutine and ultimately on abstract expressionism.

Seurat (1859–1891). Seurat's active production did not come until the end of the Impressionist period, when many artists were beginning to investigate new paths. He was not only inspired by the Impressionists' formulas, but was the supreme example of the "pointillist" group, whose painstaking technique was to create effects by the most minute juxtaposed

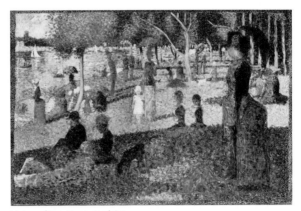

Metropolitan Museum of Art

Oil sketch (preliminary study), A Sunday Afternoon at the Grande Jatte, by Georges Seurat.

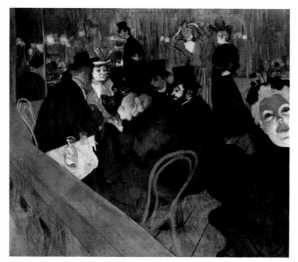

Art Institute of Chicago

At the Moulin-Rouge, by Henri de Toulouse-Lautrec.

dots of spectrum colors. He is sometimes called a Neo-Impressionist and believed that opaque objects should be made to vibrate, as well as the atmosphere. He was a student of space relationships, studying his paintings as a pattern design. He tried to reduce painting and the use of color to scientific formulas. His subject matter, which was considerably conventionalized, included park scenes, groups of bathers, and circuses. He was not a prolific producer. His greatest work, and one in which his flawless abilities are evidenced, is *La Grande Jatte,** which shows a group of holiday-makers on a riverbank near Paris, a subject typical of the period, full of local color, and having a nostalgic appeal.

Toulouse-Lautrec (1864–1901), who was influenced by Daumier, Degas, and Goya, concentrated on decorative satire, finding rich subject matter in the sordid cafés and dance halls of Paris. The fact that he was a cripple may have accounted for his cynicism. He was an excellent draftsman, but a mediocre colorist, and observed

* In the Art Institute of Chicago.

outstanding characteristics with penetrating clarity; in recording them he used the tricks of exaggeration of the caricaturist. One also notices in his work the influence of Japanese prints, and he considerably raised the art of the poster to a level never before achieved. *At the Moulin Rouge*, one of his most typical paintings, is in the Art Institute of Chicago.

Matisse (1869–1954) was the leader of the "Fauves" (wild beasts), who, after 1900, reacted vigorously against Impressionism. He was an expert draftsman, but ignored detail, and his credo is "simplification, organization, and expression." He was a painter, sculptor, and lithographer, and his paintings have an extraordinarily decorative quality with flat-patterned compositions in pure colors that dazzle the eye. The subject matter is often borrowed from Persian, African Negro, or Polynesian figures, textile patterns, and ceramics, and is usually joyful and sensuous in character. He remains among the greatest colorists of the twentieth century.

Picasso (1881–1973) was born in Malaga, Spain, and studied art in Barcelona, but became a resident of Paris in 1904. Of all artists, he probably produced the greatest variety of the-

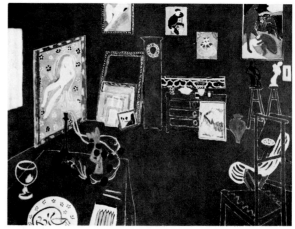

Collection, Museum of Modern Art, New York. Mrs. Simon Guggenheim Fund.

The Red Studio (1911), by Henri Matisse. Oil on canvas.

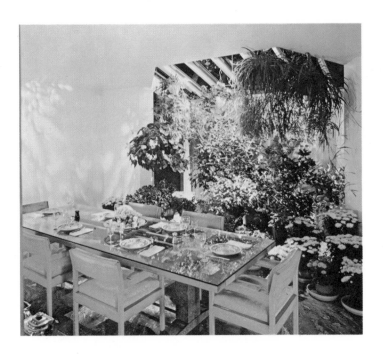

←*A country dining room doubles as a plant conservatory by day while at night the walls dissolve into light and shadow patterns created by light coming through hanging plants.*

Interior design by Warren Platner. Ezra Stoller Photo

A central cube table augments the horse- → *shoe of work surfaces in this contemporary kitchen as seen from a large bay window with banquette and table beneath hanging plant. This kitchen was planned "as an artist's studio for the creation of food."*

Interior design by Warren Platner. Ezra Stoller Photo

This charming enclosed solarium in a country house was converted from an outdoor veranda. White masonry walls and wicker furniture provide a sparkling background for the bright fresh colors of flowering plants and bird prints.

Parish-Hadley

ories, techniques, and conceptions, which he claimed were neither experiments nor researches, but merely the application to canvas of his thoughts and feelings. His purpose in each painting seems to have been to relieve himself of a momentary emotional desire. He avoided naturalism as being the opposite of art, concentrated on abstractions and form, and believed that good art is timeless. In painting symbols of thought, emotion, or internal structure, he only hinted at the representation of externals. His style changes seem to have been exploratory, rather than evolutionary, and under such theses he disregarded all canons of the past. Picasso was an exquisite draftsman, but frequently subordinated this quality in his work. His early years were a struggle for recognition, and in his blue period he painted beggars and a miserable humanity in bluish tones, exemplified by *The Old Guitarist* in the Art Institute of Chicago. This was followed by a rose period, when his outlook on life appeared to be more cheerful, and he turned to examine Greek and Negro sculpture. From 1908 to 1920 he and Braque were the leaders of the cubists, who attempted to simplify all natural forms to the shapes of cubes and geometrical solids. For a time they were interested in *collage*, where, for the purpose of textural effects, paper and other materials were used in their compositions. They also reintroduced what is known as *simultaneity* in art, a term used to indicate the concurrent presentation of two or three sides of an object, such as an overlapping profile and full face to give a comprehensive view, or multiplied legs and arms to convey the idea of motion. This technique had previously been used by the ancient Egyptians. Picasso's *Guernica*, painted after the German destruction of the peaceful inhabitants of that Spanish city, carries in gray, black, and white, a stylized symbolism of all the horrors of war, using the conventionalisms of El Greco in an exaggerated form. In later years he attempted many other styles and techniques. Much of his

Art Institute of Chicago

The Old Guitarist, by Pablo Picasso.

work is grotesque or surrealistic, with unrecognizable subject matter. Picasso also worked as an etcher, sculptor, and ceramist, and by common consent was the most powerful influence in art since Cézanne.

There were several other artists who collaborated with Picasso during the cubist period, although each contributed a personal element, and some of them eventually branched in other directions. Among these were Gris, a fellow Spaniard, who considered a canvas to be a flat surface that deserved a flat pattern, and Duchamp, who attempted to paint motion in the *Nude Descending a Staircase, No. 2*, a picture that received notoriety in the Armory Show in

On extended loan to the Museum of Modern Art, New York, from the artist.

Guernica (1937, May-early June), by Pablo Picasso. Oil on canvas.

New York in 1913. Picabia and Léger had similar approaches. Other artists proceeded along more independent lines, and there have been many theories and "isms" since the days of cubism. Most of these have been of short duration, such as futurism in Italy, suprematism in Russia, dadaism, an antiart movement, and surrealism, an attempt to interpret the subconscious. Vorticism was of English origin.

Other painters who have worked along individual lines or paralleled the Parisian movements are Derain, Vlaminck, Dufy, Rouault, and Segonzac of France; Miró and Dalí of Spain; Klee of Switzerland; Soutine of Lithuania; and Modigliani and de Chirico of Italy. Although nonfigurative abstraction had dominated the movements of painting in France since World War II, one of the foremost painters to emerge was the Polish-born realist Balthus. Rivera and Orozco were foremost Mexican muralists with a social consciousness and a deep sympathy for oppressed humanity. They were equipped with a complete historical knowledge of painting and

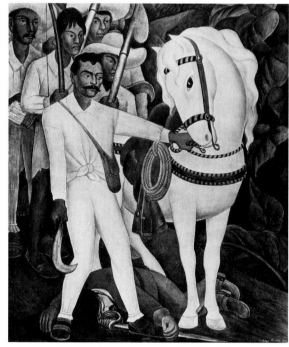

Collection, Museum of Modern Art, New York.
Abby Aldrich Rockefeller Fund.

Agrarian Leader Zapata (1931), by Diego Rivera. Fresco.

were energetic and imaginative. They specialized in reviving the art of the true fresco and decorated many public and private rooms in Mexico and the United States. Their paintings are usually on a tremendous scale and magnificently composed. The subject matter is related to the activities of the industrial age, with details and technique that reflect a mixture of the fierceness of native Indian character and the serenity of a European inheritance. The middle of the twentieth century had witnessed a vigorous resurgence of every manifestation of art in Mexico and other Latin American countries.

RÉSUMÉ OF FRENCH PAINTING. It is impossible to summarize the contemporary movements in painting because of their complexity and the constant flux that characterizes them. One is still too close to obtain a rational perspective. The only exact statement that can be made is that all the movements differ in approach and technique. Most seem to have preferred abstract form, and, in their production, the same principles have been used by which all great art has been created. There have been honesty and integrity in the work of the leaders, although some have undoubtedly pursued extremes of fantasy. Much modern painting is difficult for the uninitiated to understand, but it is perhaps a source from which the next generation will draw inspiration. In the struggle for renown there often appears an effort to shock the public; reputations are falsely gained, and confidence is often misplaced; yet no one can afford to consider genuine efforts as valueless, and logic dictates the necessity to permit the future to pass final judgment.

AMERICAN COLONIAL PAINTERS. In early colonial days American inhabitants were adjusting themselves to a new life, and no time was available for art. As time passed, and a degree of security had been attained, there arose a demand, motivated by family pride, for "face-painting," a crude form of portraiture. Self-

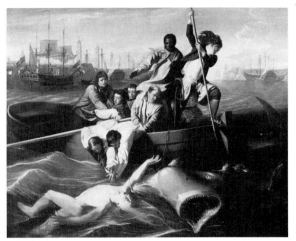

Museum of Fine Arts, Boston

Watson and the Shark, by John Singleton Copley.

taught artists known as "limners" would peddle canvases on which they had already painted a headless figure to which they could add the face of any purchaser who would sit as a model. These journeymen also undertook any other painting job in the offing, whether it was the house itself, a carriage, or a sign. Gustavus Hesselius (1682–1755), a Swede, was probably the first foreigner to arrive in America for the purpose of making a living as a portrait painter; his technique was crude, but he showed a feeling for characterization. John Smibert, a Scot who had lived in Italy, arrived in America in 1729. His group portrait painted shortly afterwards of *Bishop Berkeley and His Entourage** shows a sense of characterization and composition that technically surpasses the art of the limners. Contemporary with Smibert was the English emigrant Peter Pelham, whose chief importance lies in the fact that he was the stepfather and teacher of John Singleton Copley (1737–1815), the first great American-born painter. The work of the colonial period culmi-

* In the Yale Art Gallery, New Haven, Connecticut.

nated in the many portraits of Copley. In his *Lady Wentworth* the textures of materials are smoothly handled, and a great refinement of line and detail is apparent. Copley, disapproving of the American revolutionary ideals, left in 1774, never to return. After this he was considered an English painter, and, although he advanced technically, his late works lack the interest and character of those painted during the American period, with the exception of his very important painting *Watson and the Shark*.

Benjamin West (1738–1820), born in Pennsylvania, went to Rome as a young man and then to England, where he became the second president of the Royal Academy. Although West was primarily a portrait painter, he also produced a few historical and mythological subjects that were conceived in a romantic style that later influenced Delacroix. His painting of the *Death of General Wolfe* created a sensation in showing contemporary uniforms rather than the Roman togas that until then had been used in historical paintings. During his residence in London, West taught many Americans, among them Charles Willson Peale, Gilbert Stuart, and Samuel F. B. Morse, in whose work the impact of West is most strongly reflected.

Charles Willson Peale (1741–1827) studied under both Copley and West and settled in Philadelphia, where he took an active part in the Revolution. He painted many military portraits, and his fourteen pictures of Washington show him in a more natural manner than those of Stuart, though the latter's have been more extensively reproduced. In 1805 Peale aided in founding the Pennsylvania Academy of the Fine Arts. He was a capable draftsman, a harmonious colorist, and able at characterization. His brother James was a miniaturist, and of his eleven children, all named for famous artists, Raphaelle painted still lifes, Titian painted animals, and Rembrandt (1778–1860) painted historical pictures and portraits, several of them posthumous, of Washington. Robert Fulton (1765–1815),

Thomas Sully (1783–1872), and Samuel F. B. Morse (1791–1872) were the last of the realistic portrait painters. It was an indication of the changing economic and cultural interests of the nation that both Fulton and Morse eventually turned to scientific invention. During the second quarter of the nineteenth century, the daguerreotype temporarily submerged the art of portraiture, and wealthy Americans began to import European "old masters."

AMERICAN PRIMITIVE AND FOLK PAINTING. From the eighteenth century to the present day, America has had her amateur artists, most of whom have painted as a result of a creative urge, and for the purpose of having pictures to decorate their own homes. The middle classes had little access to professionally made pictures or prints, and what the amateurs produced was remarkably harmonious with the rest of their furnishings. Journeymen painters and house owners probably produced many of the pictures, but it was a custom for the young ladies of the family to study "art" in their finishing schools, and upon graduation they proudly exercised their modest faculty for useful purposes. The pictures that have endured were seldom signed and are mostly of anonymous origin. Most of the early folk painting was produced east of the Mississippi Valley, but Virginia, Ohio, western Pennsylvania, New England, and the Hudson River sections were replete with picturesque views and seemed to appeal to the artistic instincts of their inhabitants, who were especially prolific in this type of work. The pictures varied considerably in technical proficiency, but were usually naïve and vital in character, and were conscientious efforts. A lack of knowledge of perspective often produced entertaining results. Logical contrasts of highlights and shadows seemed sometimes to be disregarded; drawing was usually poor, and colors often unnatural. A lack of study of relative proportions caused children's faces to be too large for their bodies or legs too short for a torso. Every conceivable

subject was painted—portraits, landscapes and seascapes, village and city scenes, important public and church buildings, farmhouses, naval and military battles, ships, racehorses, and religious groups were the most common. Many of these old pictures are collector's items and are useful today in carrying out the decoration of informal rooms. They are honest representations of a definite period of American culture and should be distinguished from the work of modern painters who capitalize on the crudity of the style.

THE HUDSON RIVER SCHOOL. As a result of a developing nationalistic spirit, the building of the Erie Canal, and the romantic influence of such writers as Cooper and Irving, there developed in the early nineteenth century a group of landscape painters known as the "Hudson River school." The literature and interests of the day were reflected in the West Point and neighboring landscapes of Asher B. Durand (1796–1886), Thomas Doughty (1793–1856), and in the panoramic New England views of Thomas Cole (1801–1848). These men acquired a realistic technique, and, in the grays and browns that had been used by Claude Lorrain, fervently expressed their love of American scenery. Frederick E. Church (1826–1900) painted the natural wonders of both North America and South America. The *Heart of the Andes*, now in the Metropolitan Museum of Art in New York, is an outstanding example of his work. He was the

Metropolitan Museum of Art

Delaware Water Gap, by George Inness.

great champion and illustrator of the life and the vast spaces of the West. This school culminated in the work of George Inness (1825–1894), Homer Martin (1836–1897), and Alexander Wyant (1836–1892), who were perhaps the first Americans to paint landscapes in which the artist's conception dominated the importance of the subject matter. Although as young men these three painted in the traditional manner of their predecessors, there is an influence of the French Barbizon school, and, in Inness's *Peace and Plenty*, in the Metropolitan, and other paintings, there is a tendency to omit detail to articulate more clearly the moods of nature.

MID-NINETEENTH-CENTURY AMERICAN PAINTERS. Despite the continued tendency on the part of the wealthy to buy the works of European artists, an artistic consciousness mounted after the close of the Civil War, and several individualists produced work that was indigenous in more than its subject matter.

Winslow Homer (1836–1910) as a young man made two trips to Europe, but there is little evidence of this in his work. At first a successful illustrator for *Harper's Weekly*, in 1884 Homer retired to a small cottage on the coast of Maine and devoted the remainder of his life to depicting and interpreting the local scene. His realistic paintings acquired a distinctive force by careful organization and strong contrasts. He is considered one of the greatest of marine painters.

Thomas Eakins (1844–1916) was a painter of American life. After having studied with Gérôme in Paris, he returned to Philadelphia, his birthplace, where he taught at the Academy of Art and painted athletes and portraits. More an interpreter than a reproducer of realism,

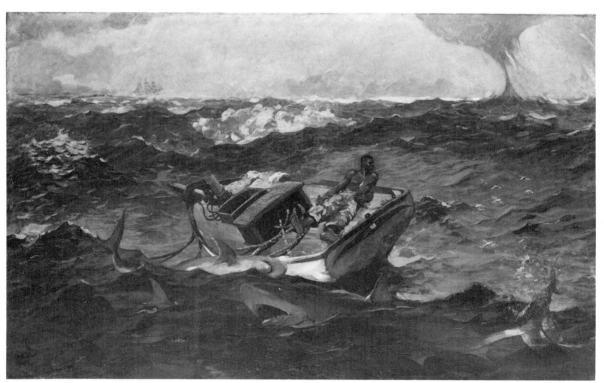

Metropolitan Museum of Art

The Gulf Stream, by Winslow Homer.

Metropolitan Museum of Art

The Writing Master: Portrait of the Artist's Father, by Thomas Eakins.

Eakins combined bold contrasts in values with serious themes. Having no social ambitions, he preferred painting people characteristic of various elements in society; although greatly criticized in his own day, he finally received recognition. He was a pioneer in scientific methods, and among his pupils were John Sloan and William Glackens.

Albert Ryder (1847–1917) shunned society and became a recluse in New York City, stating, "The artist needs but a roof and a crust of bread, and his easel and all the rest God gives him." Born in New Bedford, Massachusetts, he was attracted by the sea, the night, the moonlight, and fishing boats, and became a poet in paint. Although he had little formal training, and a certain clumsiness of technique forced him to omit many details of drawing, his paintings as a whole convey, in comparatively abstract terms, the power and mysticism of nature. He is sometimes called "the last of the Romanticists."

AMERICAN EXPATRIATES. James Abbott McNeill Whistler (1834–1903), although born in Massachusetts, was disgusted with the ignorance evidenced by the patrons of art in the 1870s and went to France and England, where he came under the influence of Courbet, Degas, and the early Impressionists. Opposing the popular and realistic snapshot technique, Whistler painted in near monotones, "harmonies," "arrangements," and "nocturnes." These titles are descriptive of his interest in juxtaposition of lines, masses, surfaces, and tonal values. His *Mother* is composed in a pattern in gray and black. His interest in tonal unities and contrasts is apparent by the fact that the field of etching was as alluring to him as that of painting. As in the paintings of Degas, many characteristics of Japanese prints are apparent in Whistler's work. He decorated the Peacock Room, now in the Freer Art Gallery in Washington.

John Singer Sargent (1856–1925) was born in Florence of American parents and remained in Europe most of his life. He tried to establish his reputation in the Paris salon with his full-length portrait *Mme. X.* The failure of acceptance contributed to his going to England, and he became the foremost fashionable portrait

The Louvre, Paris

Arrangement in Black and White, by James Abbott McNeill Whistler.

painter there as well as in the United States. His technique was bravura and swashbuckling and flattered his sitters. At the peak of his career he largely abandoned portraits to concentrate on his first love, landscape and figures in watercolor.

Mary Cassatt (1845–1926) lived most of her life in France. Her work tended toward Impressionism and was strongly influenced by her friends Renoir, Degas, and Manet, whose admiration for her genius was unlimited. She was noted particularly for her portraits of women and children, subjects that she interpreted with unusual delicacy, simplicity, and charm. She also worked as an etcher and pastelist. She took an active interest in promoting collections of art in the United States and was often called upon to act in an advisory capacity to wealthy American collectors.

LATE NINETEENTH- AND EARLY TWENTIETH-CENTURY AMERICAN PAINTING. The last third of the nineteenth century witnessed the great industrial, economic, and scientific changes in America, and these forcibly affected the artists. The large public art museums were established in New York, Boston, Philadelphia, Chicago, and Cincinnati, and these began to be filled with the work of the European artists of the past. American artists struggled with little recognition or support, and such men as Childe Hassam, John Twachtman, Alden Weir, Frederick Carl Frieseke, Jonas Lie, and Maurice Prendergast, most of whom had studied in Paris, endeavored to create an indigenous art influenced by the French Impressionists, but the buyers of pictures continued to look across the Atlantic. At the turn of the century there was a tendency to catch the American pulse in art by means of subject matter. Historical, political, economic, and social changes began to be reflected by these same artists and by others who were equally energetic, honest, and capable. Several painters formed groups to promote their work

and ideas. Robert Henri, Arthur B. Davies, George Luks, William Glackens, John Sloan, and George Bellows were among them. Some of these were members of the "Ashcan school," a designation given to them because they frequently painted backyards, deserted streets, and city slums. Great variety in style occurred. Realism, romanticism, and fantasy were among the methods adopted in the search for an American expression. Etching and lithography were used as well as oil and watercolor. The attempts, however, were only partly successful, and the public remained somnolent.

THE ARMORY SHOW OF 1913. One of the most important events in American art history occurred in 1913, when the leading American painters, cooperating with foreign artists, organized an International Exhibition of Modern Art in New York City, now known as the "Armory Show." The Americans for the first time saw a large collection of the works of Cézanne, Renoir, Van Gogh, Picasso, Duchamp, and other notable painters from Europe whose pictures were hung side by side with those of the leading American radicals. The exhibit received much advance publicity, and the impact of the opening day was tremendous. Crowds flocked through the doors, and the front pages of the newspapers were filled with the news. Many visitors were angered; others laughed, and others cried, "At last." But the consensus of opinion was that American art would never be the same. The following observation, written by Frederick J. Gregg and quoted from the catalogue of the exhibit, is significant: "There can be no life without change, as there can be no development without change. To be afraid of what is different or unfamiliar is to be afraid of the truth and to be a champion of superstition." It was the beginning of a new art movement in the United States. It awakened the public from its lethargy and revitalized the painters, sculptors, architects, decorators, and industrial designers.

Twentieth-century trends in American painting. Since the "Armory Show," painters in the United States have made a sincere and energetic effort to find an American idiom. There has been much confusion, but confusion is typical of the thought of the century. In general, however, the painters have followed one of three parallel paths. One group has endeavored to interpret the local scene in a realistic manner, using its own instinctive emotional and intellectual capacities; another group, of equal talent but less imagination, in search for a market, has unblushingly imitated the styles of some of the old masters; and a third group, inspired by the abstract processes of Picasso and Braque, has used fantasy, internal structure, symbolism, iconography, simultaneity, or humor in their interpretations. Many of the latter group have created patterns of unrecognizable or highly conventionalized subject matter, to which are given provocative or obscure titles that cause one to pause and contemplate. Techniques in all groups have varied from the extremes of immaculate drawing and sharp cleanliness to the roughest of smudges. Mediums have been oil, watercolor, and pastel. Subject matter has generally reflected political, social, and economic changes. The world wars, the depression of the 1930s, labor conditions, industrial and agricultural developments, and city growth have been basic themes from which details have been masterfully portrayed. The pleasures, pastimes, joys, and sorrows of the people, valleys and mountains, seas and streams, homes and resorts, nudes, and still lifes have also been universally mirrored. Artists have consistently increased in number, following a greater public consciousness as to the meaning and importance of the work of the painter in the daily life of the individual and were particularly encouraged by the temporary patronage of the federal Works Projects Administration (WPA). Murals were created for public buildings and easel pictures were allocated to various schools and libraries where most people had never before seen an original painting.

Without classification in the groups above mentioned, some of the recognized leaders whose paintings are exhibited in the museums throughout the United States are Thomas Hart Benton, Louis Bouché, Charles E. Burchfield, John Steuart Curry, Stuart Davis, Charles De-

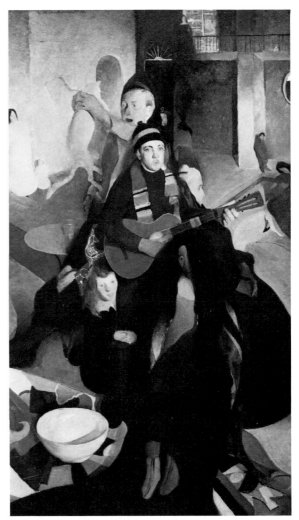

Graham Gallery

Interior, by Edwin Dickinson

Albright-Knox Gallery

Elegy to the Spanish Republic, by Robert Motherwell.

muth, Guy Pène du Bois, George Grosz, Edward Hopper, Walt Kuhn, Yasuo Kuniyoshi, John Marin, Reginald Marsh, Abraham Rattner, Charles Sheeler, Max Weber, and Grant Wood.

Contemporary with these artists, between World Wars I and II, a small group of distinguished painters were working in the abstract or semi-abstract vein: Arthur Dover, Stanton Macdonald-Wright, Georgia O'Keefe, and Edwin Dickinson. However, it was not until the advent of World War II, when many eminent avant-garde European painters came to the United States, that young Americans were attracted to abstract painting. This trend was also influenced by the work of such artist-teachers as Hans Hofmann, Josef Albers, and Laszlo Moholy-Nagy. Out of this the first major and internationally recognized art movement to come from the United States, Abstract Expressionism, was led by Jackson Pollock, Robert Motherwell, Mark Rothko, and Willem de Kooning. Theoretically, Abstract Expressionism was nonfigurative, completely subjective, and usually a highly emotionally charged statement.

The year 1962 saw the beginnings of "pop" (popular) art which generally satirized popular middle-class culture by means of anti-art or anti-esthetic statements. Its leaders were Jasper Johns, Robert Rauschenberg, and Andy Warhol. "Op" (optical) art, which soon followed, marked a return to the esthetics of abstract painting, but it was the antithesis of Abstract Expressionism in that it dealt with a completely objective, scientific, and mechanical approach to the optical sensations of colors and shapes as they related to each other. Victor Vasareley, Frank Stella, Kenneth Noland, and Ellsworth Kelly are leaders in this field. An extraordinary profusion of movements, experimental and non-experimental, have made their appearances since the 60's, often overlapping each other in time, but throughout these trends a lively force of figurative and realist painting survives. The latter class includes John Koch, Fairfield Porter, Andrew Wyeth, Paul Resika, and Alvin Ross.

Collection, Museum of Modern Art. Purchase.

Woman I (1950–1952), by Willem de Kooning. Oil on canvas.

Collection, Museum of Modern Art, New York.
Gift of G. David Thompson.

Ondho (1959–1960), by Victor Vasarely. Oil on canvas.

MISCELLANEOUS TYPES OF PICTURES

The rarity and cost of great paintings have forced the decorator to use minor works of art in various mediums to enrich the walls of rooms. There are many original works of secondary quality, and many methods of quantity production in the pictorial and graphic arts have contributed greatly to decorative room treatments. A knowledge of available material is essential.

As a general rule, reproductions of the works of great artists are only to be considered for the walls of rooms if they are done by graphic processes such as engraving and etching, in which the engraver himself has put something into the work in translating it into a medium that is different from the original picture. But even reproductions by such processes tend toward poor taste, because so many have been made that the saturation point in their use

has been reached, making them common in character and their use unoriginal. In spite of the greatness of Leonardo's *Mona Lisa* and Hals' *Laughing Cavalier*, it is advisable to avoid the use of reproductions of them or similar ones in any medium. The same is true of reproductions of the work of many of the more recent American painters, many of which have a popular appeal and false prestige attained by modern commercial methods.

There are many forms of inexpensive pictures done by professional and amateur artists that are not only good works of art but are also of decorative value because they are sincere efforts to produce the pictorial interpretation of their periods. Many of these examples are not only beautiful but have also the interest and charm that comes from accuracy and care of delineation, subject matter, naïveté, romance, sentiment, or humor.

In the following pages are given brief descriptions of various types of pictures made by professional and amateur artists that are available, suitable, comparatively inexpensive, and in good taste when used in their proper places.

WATERCOLORS. These were the earliest type of brushwork pictures, and are made of pigments soluble in water. It was the method employed by the Chinese and Persians. The true watercolor is technically called an *aquarelle*, and is produced with a transparent color mixed with water. As the mixture is usually applied to white paper, the whiteness of the background affects the tonal value of the color and plays its part in the final effect. Aquarellists must work rapidly and surely, as it is difficult to alter a color when once it has dried. In *gouache* the pigment is first mixed with a white zinc powder to make it opaque. It is then thinned to the proper consistency with water and is applied to the paper or other background, but it is sufficiently opaque to completely cover the surface, so that only the pigment shows. *Tempera*, a very old process, is similar to gouache except that the pigment is

Metropolitan Museum of Art

Limehouse, etching by James Abbott McNeill Whistler.

combined with a thin glue or with white of egg instead of water. It is, today, extensively used in poster work, designs for magazine covers, and commercial advertising. Watercolor is used as a medium by itself and to color or tint drawings or engravings. Practically all the famous artists have produced in this medium as well as in oil, and it is universally used at the present time. Watercolors make delightful decorations, and must be judged on an art basis.

WOODCUTS. These were the earliest means of making prints. The line design is drawn or pasted upon a pearwood block, and the necessary furrows are cut out with a knife or graver, to leave only the line in relief. Woodcuts are used for impressions upon paper and textiles. Lines are bold, and prints may be made in black

or color. The great period of woodcuts occurred in Germany during the life of Albrecht Dürer (sixteenth century). However, excellent woodcuts are extensively made today. In wood engravings lines are cut in a boxwood block. The design is printed from the untouched surfaces. In wood blocks, the block is cut away to leave the design intended. The surfaces are inked and pressed on paper. In color printing, separate blocks are used for the various colors.

ETCHINGS. Impressions from line drawings are made upon copper plates. The design is cut through wax with a needle. Acid bites the exposed copper, making sunken lines, a method practiced since 1513. Many of the great Renaissance masters worked in this medium, and it is a method constantly used today for the produc-

tion of black-and-white drawings covering all subjects. Recent foreign etchers of distinction include Hayler, Cameron, Segonzac, Matisse, Picasso, Forain, and Marcoussis. The leading American etchers are Whistler, Arms, Benson, Baskin, Blaustein, and Peterdi.

STEEL ENGRAVINGS. Line and wash effects are produced by parallel and fine intersecting lines cut on a steel plate, sometimes with mechanical aids for drawing lines. This process was particularly popular for book illustrations and wall pictures during the nineteenth century. The prints are black and white, sometimes hand colored. The process is used when large editions are required.

DRYPOINTS. A copper plate is scratched by a very sharp steel tool with a tapering point, used as a pencil, directly on the copper. Sunken lines result, and a "bur" is turned up which prints richly unless cut off. The plate is inked all over and then wiped clean, so that only the ink remaining in the lines prints. Sometimes a tone is left on the whole plate. Black-and-white line drawings are made by this process. Rembrandt used this method extensively for making sketches, and it has constantly been used since by etchers. More recent artists who have used this method are Cameron, Rodin, Forain, and Blaustein. Many artists combine both etching and drypoint.

MEZZOTINTS. These are made by an early process similar to engraving, but producing tonal and wash effects rather than line drawings. The plate is "rocked" by a many-toothed tool until evenly roughened. The design is procured by scraping and burnishing the higher lights. When the surface has been inked all over and wiped, the ink is retained by the roughnesses and leaves the scraped and burnished surfaces in varying degrees. On paper the print shows an almost lineless design in soft velvety black-and-white effects. Brilliant productions were made by this process in England during the eighteenth century, when the works of the English portrait painters were reproduced. Many reproductions were also made of Morland's paintings, showing pastoral scenes and figure compositions.

AQUATINTS. Aquatinting is similar to the process for making a mezzotint, but permits very subtle and delicate effects in color. The design is put on copper through a process of roughening the plate by acid "biting." Aquatints were popularized in England at the end of the eighteenth century for reproducing paintings of views, naval engagements, and sporting subjects. Goya was a master of aquatint.

LITHOGRAPHS. These are produced by a technique introduced in 1798. Impressions imitate the character of chalk drawings in black or color. Prepared soapstone is drawn on with a greasy crayon and then chemically treated. Ink rolled onto the wetted stone "takes" only where the crayon has touched, and prints only therefrom. Lithography is extensively used for both illustrations and posters, but many of the great artists—particularly Daumier, Gavarni, Tolouse-Lautrec, Bellows, and Matisse—have produced works in this medium on every variety of subject.

MONOTYPES. These are oil paintings on glass or copper transferred to a sheet of paper by pressure. The subjects are usually flowers and landscapes.

LINOLEUM CUTS. These are similar to woodcuts but coarser in detail. The original plates are cut in linoleum.

ORIGINAL DRAWINGS. In pencil, pen, pastel, and crayon, drawings are, of course, of varying merit depending upon the artist, and an appraisal of their value either as works of art or as decorations must come from experience. They have been made in all periods and are extensively used today in decoration.

In addition to pictures produced by the foregoing processes, there are prints of two

Early nineteenth-century English coaching print.

special types of subject that may be considered particularly valuable for decorative use—sporting prints and Audubon prints.

SPORTING PRINTS. Hunting, coaching, fishing, and sporting scenes were made from original oil paintings in England and France during the eighteenth and nineteenth centuries. Most of them were engravings colored in part by hand. The prints were made for wide distribution to the general public, who were as interested in hunting as were the great landowners. The works of Alken, Herring, Sartorious, and Wolstenholme were particularly notable. Many of the prints today are more valuable than the original paintings. Many reproductions have been made.

AUDUBON PRINTS. Magnificent life-size, hand-colored aquatints of hundreds of species of American birds were made by the great naturalist and engraved and colored by Havell in London between 1828 and 1837. Limited in quantity, they are of considerable value, though there have been many worthless reproductions.

PEASANT PAINTINGS AND FOLK ART. Paintings on wood, canvas, paper, velvet, and glass, of naïve and quaint subject matter have been made by peasants and amateurs in Europe and America.

WOOL SHIP PICTURES. Made by British seamen in the early years of the nineteenth century, they generally depict ships and views of foreign ports, embroidered in coarse, bright-

New-York Historical Society

Wild Turkey, an original watercolor painting by John J. Audubon.

colored yarns. Flags are usually conspicuous.

EMBROIDERIES. These were made in needlepoint and silk during all historic periods of decoration.

SAMPLERS. Sample embroideries were usually made by children and consist of local scenes, alphabets, poems, and patterns. They were made during the eighteenth and nineteenth centuries in Europe, North America, and South America.

VELVET PAINTINGS. Local scenes and portraits, these are often of a mortuary type and were made in England, France, and America during the early years of the nineteenth century.

BEAD AND SHELL PICTURES. Extraordinary combinations of colored beads or shells have been used to form scenes or patterns, placed on a fabric background.

SILHOUETTES. An extraordinary technique was developed by cutting profiles in paper and pasting them on white or colored grounds. Subject matter included figures, portraits, and flowers, in black and colors. Silhouettes were first made as a popular pastime at country fairs. They were very popular as decorations in the Biedermeier period.

WAX SILHOUETTES. Made in relief, usually showing portraits in profile, sometimes clothed in lace and jewelry, wax silhouettes were popular in seventeenth-century Germany and eighteenth-century France and England.

TINSEL PICTURES. These started as a fad for both men and women in England in the eighteenth century. Composition was produced by colored cutouts of figures and flowers combined with bright-colored tinsel and lace, with jewelry often added. Shakespearean characters were popular as subject matter. Tinsel pictures were often applied to screen decoration during the eighteenth and nineteenth centuries in England and France.

IMAGES POPULAIRES. These cheap engravings were crudely drawn, colored by hand, and made in all European countries. The "vues d'optiques" are of French architectural and garden subjects, with windows cut out so that candlelight would show through the openings. The "Epinal" pictures in France glorified Napoleon's victories. Many religious prints were also of this nature.

GLASS PAINTINGS. Done in oil on the reverse side of the glass, many of these paintings are of extraordinary beauty, while others are primitive in character. The best were made in China, but fine ones were produced in France and England during the eighteenth century. The subjects show great variety. Many amateurs in the United States made them during the federal

period, showing naval battles and historic scenes.

CURRIER AND IVES. Colored lithographs of early nineteenth-century American scenes were very popular among farmers and are now valued for historical record. Currier and Ives produced a great range of subjects: farm scenes, historical, sporting, and hunting events, early western range views, early railroad scenes, portraits of presidents, and many others.

PHOTO REPRODUCTIONS. Color photos of modern paintings remarkably imitate every detail, including the brush strokes and paint shadows. They are inexpensive and excellent substitutes for original works, providing mass production is not begun.

COLORED ENGRAVINGS. Made during the nineteenth century, they include such subjects as flowers, costumes, animals, portraits, historic scenes, and scenes of adventure. Colored engravings are often decorative and very inexpensive.

STUMPWORK. Embroideries showing figures padded to form a relief effect were popular during the Restoration period in England.

SERIGRAPHS (silk screen). Excellent reproductions of paintings were made by the silk screen process. Stencil designs are cut and placed on silk which is tightly stretched on a frame. Ink is then pressed through the silk, creating the design, which is blocked by the stencil. Many colored inks and stencils may be used to create elaborate serigraphs.

PICTURE FRAMING

The framing of pictures is a matter of great importance. Etchings, watercolors, oil paintings, Japanese prints, pencil drawings, and photographs all require varying types of frames. Some are better under glass, some without; some require ornate frames, others the simplest ones possible. The frames of a generation ago were almost invariably bad. They were too heavy and elaborate, often overloaded by shadow boxes, and in many cases were more important than the pictures they contained. Furthermore, these frames were of plaster and not of carved and gilded wood, as were the beautiful frames of the eighteenth century. Designs were poor and of a commercial character. At present antique frames are much in demand for both genuinely old paintings and prints.

Oil paintings, particularly by the old masters, demand rich frames. Gilt frames are usual, and properly so, as gold helps to harmonize rich color without competing with it. Whatever the type selected, care should generally be taken to keep the gilding dull. Italian frames of the cinquecento were usually architectural in design, flanked by columns or pilasters, the top usually centered or with a pediment, and the whole design ornamented with arabesques in relief. No better type could be found, particularly for religious subjects. The design is that of an altarpiece, for which purpose most of these paintings were made. The Renaissance in Spain produced very fine frames. The workmanship and scale of detail were possibly cruder than in Italy and France, but their striking originality has always had a marked decorative appeal.

Metropolitan Museum of Art

Stumpwork picture, English, about 1680, The Judgment of Paris.

As a rule, oil paintings should be framed without mats or glass, although today narrow borders, either painted or covered with natural-colored linen, are in vogue. Logically, modern oil paintings require simpler frames than do the old masters, although antique frames are often used on ultramodern pictures.

Pictures made on paper require glass for protection, as they grow dirty and cannot be cleaned. There are, however, many possible types of frame, varying according to the character of the picture. For colored reproductions of the old masters, the frames may be very similar to those that would be used for an original. As a matter of fact, reproductions of famous paintings are rarely seen today in well-decorated interiors; if one is particularly fond of a masterpiece of the past, however, there is no law of taste which forbids that a photograph of it be hung. Designers have encouraged their clients to buy genuine antique paintings of a decorative nature, even though these pictures may be third or fourth rate—that is, providing the client cannot afford the best. It is felt that period rooms should be hung with contemporaneous originals or at least with well-executed copies.

Portrait photographs, travel views in photography, and others of this class may be framed in simple moldings with or without mats; however, it is inadvisable to hang them on the wall. Frames for portrait photographs should have adjustable stands for table use. With less body than oil paintings, watercolors should be framed more simply; their frames should be of the simplest type, usually of natural wood, with little or no ornament; if the picture is small, a mat is usually advisable. For pencil sketches, equally simple frames are advisable. If the drawing has a considerable expanse of paper left blank around it, no mat is necessary.

In conformity with French taste and an equally French medium, pastels may be framed with gilt moldings, although a natural wood is entirely suitable. Eighteenth-century French prints and drawings should be framed with rather wide ruled paper mats, typical of the framing of the Louis XVI period. The artist's name and the title of the drawing were invariably lettered within a decorative cartouche on the matting. For modern prints, etchings, lithographs, etc., mats are ordinarily used. The mat should be cut out to fit the print, the opening being large enough to show the plate mark and the signature. Mats and backings of all pictures should be made of rag board, otherwise a beautiful or expensive work will be "burned" in time by wood pulp boards. Prints also look well framed in black lacquer with narrow gold beading or in natural, unstained wood. Some etchings approach the strong tones of painting and should be framed with relatively heavy moldings. Frames are today made of varied materials. Glass, plastic, mirror, chromium, richly grained veneers, cork, and even stretched fabrics are used. The forms of the moldings themselves vary from the conventional curves to flat splayed surfaces.

PICTURE SELECTION AND HANGING

Pictures should first be selected from the point of view of their satisfaction to the owner, but to the decorator, it is important to consider the quantity needed, the size and scale of each, their relationship to the wall composition, the colors, and the frame.

Rooms whose walls are decorated with murals, scenic paper, or strongly patterned wallpaper do not usually require a great amount of additional pictorial enrichment. If pictures are hung on wallpaper, they should be sufficiently important in size and effect not to be lost in the background. Hung pictures are at their best against a plain neutral surface.

If an owner has selected a painting as an important decorative feature, it is advantageous

Photo by Robert Perron

This arrangement of pictures of various sizes is agreeable in appearance while using unusual and contemporary means of hanging pictures in a series.

to repeat the colors of the painting in the color scheme of the room. Small pictures cannot be used for this purpose, and unless they are unusually inharmonious with the selected color scheme, they may be considered as color accents or disregarded. It is agreeable to relate the subject matter of pictures to the character and use of the room, as well as to the interests of the owner.

As a general rule, instinct will designate what wall areas should be hung with pictures or other decorative objectives such as mirrors, clocks, and sconces. One should feel that a space appears empty before a decision is made to fill it. Walls upon which many pictures are hung are, of course, more restless in appearance than those that are treated sparingly with pictorial decoration. A picture of unusual decorative or aesthetic value should be given ample wall area. The Orientals frequently hang but one picture in a room, and that one, of great beauty, is hung

in the most significant space and is changed from time to time for the sake of variety. If several pictures are hung on a wall, they should not be placed indiscriminately, but arranged in a simple geometrical grouping such as a rectangle, straight line, or triangle. Where numerous pictures of varying sizes and shapes are used, composition in balance is difficult, and it is then usually advisable to mass them in close proximity so that they "count" much the same as a mural decoration or scenic wallpaper.

The more usual method of hanging pictures is to place them singly or in small groups in important wall spaces or panels or above mantels or furniture. Groups of three should usually be balanced with the largest picture in the center, or two pictures should be of equal size. A better effect is obtained if the pictures in the same groups are similar in character and color value. Oil paintings and watercolors hung in close proximity are usually inharmonious unless similar in tonal values, and colored pictures hung close to black-and-white drawings or re-

Photo by Hans Namuth

An orderly symmetrical composition is preferable in this case where frames of similar size display an antique collection of cameos.

productions have an appearance of inconsistency. Unsymmetrical groups of pictures may be arranged in wall spaces that are not on the central axis of the room or in cases where pictures must accommodate themselves to adjoining furniture that is irregular in shape. Small pictures look best when hung at eye level. Large paintings that must be viewed from a distance may be hung at a greater height.

It is advisable to avoid showing the wires necessary for picture hanging. Pictures should be hung from nails or hooks that are driven into the wall behind the picture itself, and the picture should be hung as flat as possible against the wall. This can be done by placing the screws near the top of the frame.

BIBLIOGRAPHY

Abbot, E. R. *The Great Painters in Relation to the European Tradition.* New York: Harcourt, Brace and Co., 1927.
 Fully illustrated text.
Arms, J. T. *Handbook of Print Making and Print Makers.* New York: Macmillan Co., 1934.
 A very complete text, fully illustrated.
Arnason, H. H. *History of Modern Art.* Englewood Cliffs, N.J.: Prentice-Hall, 1969.
Art Studies, Medieval, Renaissance, and Modern. Edited by members of the departments of fine arts at Harvard and Princeton universities, 1929.
 Excellent illustrated text.
Barnes, A. C. *The Art in Painting.* New York: Harcourt, Brace and Co., 1928.
 Excellent illustrated treatment of the development of painting.
Barr, A. H. *Cubism and Abstract Art.* New York: Museum of Modern Art, 1936.
 Illustrated brief history of the modern movement toward abstract design.
Barr, A. H., ed. *Masters of Modern Art.* New York: Simon and Schuster, 1954.
 Excellent illustrations.
Berenson, B. *Florentine Painters of the Renaissance.* New York: G. P. Putnam's Sons, 1909.
 Authoritative text.
Bliss, D. P. *A History of Wood-engraving.* New York: E. P. Dutton and Co., 1928.
 Illustrated comprehensive study of the history of wood engraving.
Brunsdon, John. *The Technique of Etching and Engraving.* Reinhold Publishing Co., 1965.
Cheney, S. *Expressionism in Art.* New York: Liveright Publishing Corp., 1934.
 Illustrated text treating the modern movement.
Cortissoz, R. *The Painter's Craft.* New York: Charles Scribner's Sons, 1930.
 Illustrated collection of essays on European and American artists.
Doerner, M. *The Materials of the Artists and Their Use in Painting.* Translated by Neuhaus. New York: Harcourt, Brace and Co., 1934.
 A comprehensive book on the technique of painting.
Earp, T. W. *The Modern Movement in Painting.* New York: Studio Publications, 1935.
 Text on the Impressionist and Postimpressionist schools of painting, illustrated with color plates.
Encyclopedia of Painting, edited under the auspices of the Metropolitan Museum of Art, New York, 1955.
 An excellent alphabetical listing of artists and art subjects with many colored illustrations.

Haftmann, Werner. *Painting in the Twentieth Century*. Sixth printing. New York: Praeger, 1969.
Thorough investigation with fine reproductions of twentieth-century painting.

Hamerton, P. G. *Etching and Etchers*. London: Macmillan Co., 1876.
Out of print. A standard illustrated work.

Hind, A. M. *A Short History of Engraving and Etching*. New York: Houghton Mifflin Co., 1908.
Illustrated text.

McLanathan, Richard. *The American Tradition in the Arts*. New York: Harcourt, Brace and World, 1968.

Madsden, S. Tchudi. *Art Nouveau*. New York: McGraw-Hill, 1970.

Marle, R. van. *The Italian Schools of Painting*. 17 vols. The Hague: M. Nijhoff, 1923–1935.
Illustrated histories of the various schools from the sixth to the end of the thirteenth centuries.

Mather, F. J., Jr. *Western European Painting of the Renaissance*. New York: Henry Holt and Co., 1939.
An excellent description of these types.

Mendelowitz, Daniel M. *A History of American Art*. New York: Holt, Rinehart and Winston, 1970.

Novak, Barbara. *American Painting of the Nineteenth Century*. New York: Praeger, 1969.
An interesting view on the indigenous qualities found in American painting.

Rewald, J. *The History of Impressionism*. New York: Museum of Modern Art, 1946.
An authoritative and detailed study.

Soby, J. T. *Contemporary Painters*. New York: Museum of Modern Art, 1948.
An excellent handbook.

Taubes, Frederic. *Better Frames for Your Pictures*. New York: Viking Press, 1970.

Taylor, Francis H. *Fifty Centuries of Art*. New York: Harper and Brothers, 1954.
Excellent colored illustrations.

Vasari's Lives of the Artists. Edited and abridged by Betty Burroughs. New York: Simon and Schuster, 1946.

Weaver, Peter. *Printmaking: A Medium for Basic Design*. Reinhold Publishing Co., 1968.

Weitenkampf, F. *How to Appreciate Prints*. New York: Charles Scribner's Sons, 1932.
Illustrated text.

Weitenkampf, F. *The Quest of the Print*. New York: Charles Scribner's Sons, 1932.
An illustrated text on collecting prints.

Wilenski, R. H. *French Painting*. Boston: Hale, Cushman, and Flint, 1931.
An excellent illustrated survey of this field.

Wilenski, R. H. *Masters of English Painting*. Boston: Hale, Cushman, and Flint, 1934.
An excellent illustrated history.

PART TWO

Contemporary Design

In the UNESCO Building in Paris, Marcel Breuer has made beautiful use of exposed reinforced concrete.

CHAPTER 10

Contemporary Architecture and Interior Design

Tiffany's music room from Laurelton Hall demonstrates the organized clutter typical of late nineteenth and early twentieth-century interiors.

The Industrial Revolution and its manifestations were the greatest forces in the development of twentieth-century art. For this reason we begin our study of the twentieth century with a description of conditions and events that had their origins in the eighteenth century.

The schism between the architect and the engineer that characterized much work at the end of the eighteenth and during most of the nineteenth century was part of an overall split between art and science. The times were rich in scientific development; engineering inventiveness was evident in new materials and bold uses of old materials. As the scientist uncovered new horizons, the artist hid in the cloak of romanticism; as the engineer triumphed, the defeated architect found comfort in styles of the past.

The use and refinement of iron and the further refinement of iron into steel were essential concerns of the engineer. These developments helped solve the functional needs of enclosed space, first for industrial use, and later for commercial use. They also created new space forms.

The architect refused to face the new problems created by the Industrial Revolution; the engineer, supplying both structure and material, became deeply involved. The architecture of our century owes much to the nineteenth-century engineer, who created new enclosed space for industry through new building technology. Only when the architect confronted the problems of the Industrial Revolution did architecture resume its growth, culminating in the architecture of the present century.

In the arts, the Industrial Revolution brought a change from hand-crafted products made in the home for local use to machine-fashioned products made in the factory for national and international distribution. The change was gradual. It started in France prior to the Revolution and continued through the actual industrialization of Germany in the early decades of the present century. Its initial impact on industry came as early as 1750, when power-driven machines began to influence society, politics, industry, trade, and transportation. The tremendous growth of population and the movement of people to find work in centrally located factories stimulated both the growth of existing cities and the beginnings of new ones.

THE REVOLUTION IN TEXTILE MANUFACTURE. This first occurred in France, where Jacquard and Vaucanson employed waterpower to run machines that wove elaborately patterned fabrics. By the beginning of the nineteenth century there were more than ten thousand Jacquard looms in France. In 1797 Oberkampf introduced cylinder printing at Jouy, claiming that one machine could do the work of forty block printers. The English invented the flying

shuttle (John Kay in 1733), the spinning jenny (James Hargreaves in 1770), the water-operated roller spinning frame (Richard Arkwright in 1769–1775), and the spinning mule (Samuel Crompton in 1779). The power loom developed by Edmund Cartwright in 1785 resulted in the growth of the cotton industry and the demand for raw cotton. Whitney's cotton gin of 1793 soon made the United States the major supplier of raw cotton to the industrialized world.

The most important invention was the steam engine of James Watt (1769), which permitted rotary action as well as vertical movements of the piston, thereby facilitating the process of weaving. This permitted the expansion of the textile industry, eliminating the cumbersome use of waterpower.

THE CHANGE TO COAL AND THE REVOLUTION IN IRON. This event resulted from the inventions of the Abraham Darbys and Henry Cort, which permitted the use of coal instead of charcoal in blast furnaces and forges. Their effects were far-reaching. Although France was rich in woodland and could produce an abundance of charcoal, very little coal was mined. The opposite situation existed in England, so the inventions of the Darbys and Cort permitted England to take production leadership away from France. Iron was first used in the construction of machinery. Shortly after the first successful casting of iron rails, the first cast iron bridge was erected in 1779 over the Severn. The Theatre-Français in Paris was roofed in iron (1786), and by 1800 the use of iron construction was widespread.

THE ROMANTIC REVIVALS. These revivals, which occurred during the late eighteenth and the nineteenth centuries, are described in Chapters IV through VIII. However, they are noted here so that the romantic evasions of the architect can be contrasted with the engineer's objective contributions—at least until 1875. Naturally there is a time lag between the occurrence of specific revivals in Europe and their appearance in the United States. The classical revival came at the end of the eighteenth and beginning of the nineteenth century. The Roman revival, as shown by the neoclassic in France and the work of the Adam brothers in England, preceded the Greek revival; the Gothic revival, which at first overlapped the Greek, was followed by the Renaissance revival. A chaos, sometimes referred to as "the battle of the styles," resulted when different styles competed for public attention.

THE DEVELOPMENT OF NEW STRUCTURAL SYSTEMS. These grew out of the need for more space in factories. As cast and wrought iron were improved in quality and appearance, a new architecture of iron, wood, and glass emerged. At first, cast iron columns were used with timber girders and beams. Outer walls of masonry, called bearing walls, carried part of the roof weight and covered this framework. Later, girders made of iron were introduced, and by means of these new structural members, greater spans between cast iron columns became possible. Freestanding columns supporting iron girders and timber roofs created the typical flexible factory interiors of the mid-century.

INDUSTRIAL EXPOSITIONS. Ever-larger column-free spaces were needed to house commercial exhibits of machine-made products, paintings, and sculpture, which became popular attractions during this period. The smaller iron-framed factory, comprised of iron arches, ribs, trusses, girders, beams, and columns, was the precursor of these huge structures. Building forms were designed around a linear framework of iron. When the structural frame became self-sustaining, its covering lost structural significance, and nonstructural materials such as glass, which is able to carry only its own weight, were used for exterior surfacing. Greenhouse construction, developed early in the nineteenth century, is a fine example of the iron cage with a nonstructural glass skin.

The Crystal Palace at the London exposition

The jewel-like brilliance of the upholstery colors concentrate attention upon the restricted area of the conversation group in this white interior. The oriental patterns and the variety of shapes in the cushions give pattern movement in an otherwise tranquil atmosphere. The wooden pedestals and the wood flooring laid in a brick pattern lend warmth to the scheme.

Richard Meier, Architect. Maris/Semel Photo

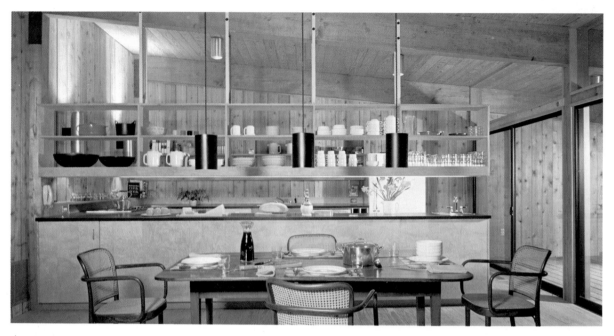

↑ *The warmth of an all wood interior provides an appropriate background in a Vermont ski house. The service counter and hung shelving for storage separate the kitchen from dining area and create a structural pattern in keeping with the rustic character of the room.* Eliot Noyes, Architect. Hans Namuth Photo

↓ *A man's study done entirely in rich browns. The walls as well as bookcases, desk, radiator covers and the end tables by sofa are covered with Formica. Bookshelves are glass. The brown ceiling and floor covering complete the monochromatic background. The recessed window is hung with a woven Roman shade.* Louis Tregre, Designer. Hans Namuth Photo

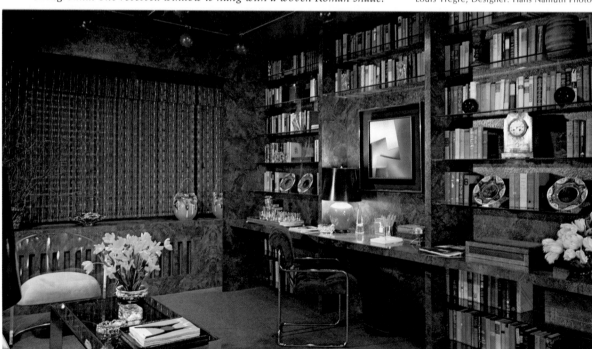

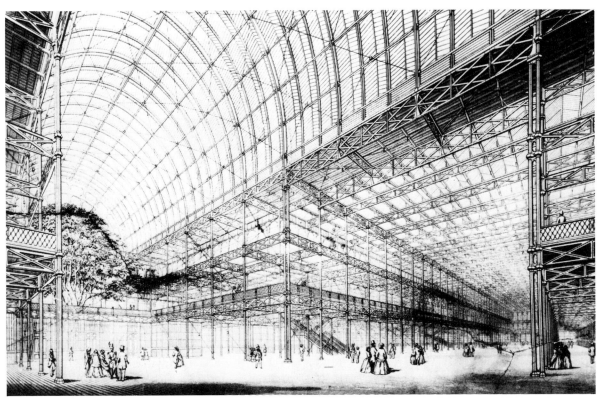

Royal Institute of British Architects

An interior view of the Crystal Palace showing the remarkable freedom of space and intensity of natural light that the modular iron frame and glass panels produced.

of 1851 was a daring demonstration of the tremendous spaces that the iron frame could span. Its floor area was four times that of St. Peter's in Rome. Joseph Paxton, the builder, achieved this great showcase of industrialization through the remarkably simple application of the best-known structural principles to the best-known materials. He placed the glass skin in wood frames and rested the frames on arches and girders of iron, which were bolted together, carrying the girders on iron columns. As each section was identical, the building could be of any length, depending upon the number of times the original structure was repeated. Paxton chose to limit the building to 1851 feet, the number corresponding exactly to the year of its construction! All parts were factory-made and

were assembled at the building site. The Crystal Palace may therefore be considered an early example of prefabrication. Once the parts were ready, the erection of the entire building took less than six months. This modular design was based upon the use of the largest pane of glass (four feet square) then manufactured. Both prefabrication and modular design were to become of great importance in twentieth-century architecture.

OTHER STEEL STRUCTURES. Large-span construction utilizing the new structural frame of iron included markets, railroad stations, department stores, libraries, and other new kinds of buildings. Large-span iron structures were used for the exhibition halls of the 1855, 1867, 1878, and 1889 Paris Expositions. The famous tower

that Gustave Eiffel erected as the center of the Paris Exposition of 1889 became the monumental symbol of the nineteenth century's creative engineering.

THE DESIGN PHILOSOPHY OF THE MACHINE-MADE PRODUCT. The social revolutions that were concurrent with industrial development created the initial incentive for the machine-made product—to turn out cheaply by the yard what had been made slowly and expensively by hand. The growth of a middle class brought new demands for symbols of success, symbols that had been the prerogatives of aristocracy. The machine reproduced in large quantities the handmade decorative arts of the upper classes, and as the number of status-seekers grew, the machine was able to satisfy the growing demand. In the designs of wallpaper, textiles, metalwork, glassware, ceramics, floor coverings, and in the joinery and carving of furniture and cabinetwork, the copying was most apparent. By 1830 there was little demand for handcrafted products, and inferior machine-made imitations flooded the market. When a machine-made product closely resembled a handmade product, it was considered good, and this criterion of evaluation carried into the first half of the present century.

THE PROBLEMS AND THE PRODUCTS OF INDUSTRIALIZATION. These contributed to the social protests of the times. God made the country; man made the city. The country is good, and the city is evil. Some moralists varied this cry: handwork is good and machine work is bad. In fact, the Industrial Revolution was making poor marks socially. It created technological unemployment, long working hours, child labor, and poor urban living conditions. Moralists argued for the suppression of industry and a return to handcrafts as the only way to correct the evils of the machine. Sermons were preached against the soullessness of the machine, and the righteousness of early Gothic design was offered as

the conscience of the times. Aside from the social objections to the effects of the machine, there were aesthetic objections to the designs that the machine produced. These protests, social and aesthetic, proved to be catalytic in the development of a new design philosophy: the making of designs that were expressive of the materials the machine had created, and that were expressive of the machine itself.

THE ARTS AND CRAFTS MOVEMENT IN ENGLAND. This movement, which burst forth about 1860, advocated the hand fabrication of products in place of machine fabrication. The leader of the new school was the pre-Raphaelite designer William Morris (1834–1896), who preached for a return to the values of the late Middle Ages. He founded the firm of Morris, Marshall, and Faulkner, which concentrated on church decoration, stained glass, textiles, carving, wall hangings, and furniture. Morris commissioned Philip Webb to design his own residence, "Red House," a building that was a far cry from the mannered revivals of the period.

The writers John Ruskin and Horace Walpole were in accord with Morris. Ruskin, the great arbiter of taste, urged in his book *The Seven Lamps of Architecture* (1849) a return to honest craftsmanship, particularly the craftsmanship of the Gothic period. This was attested by A. W. N. Pugin in England and Viollet-le-Duc in France. In England the reversion to past styles was completed early in the nineteenth century; conflict remained only over which style should be used. The style of the Houses of Parliament in London (1836), designed by Barry and Pugin, made Gothic the temporary victor.

By our standards today, Morris's contributions were most significant because he insisted that art and design be part of normal daily life and because of his idealism and honesty. That he was identified with the Neo-Gothic group is of little importance; his contribution was his questioning of how the machine would be used.

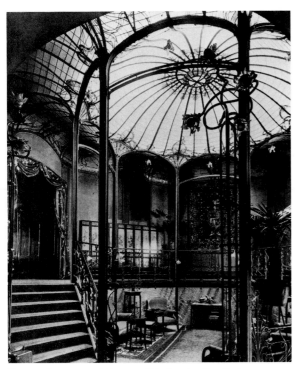

Photograph, courtesy of Museum of Modern Art, New York.

The foyer, van Eetvelde House (1895), by Victor Horta is a remarkable example of linear floral ornamentation, the hallmark of Art Nouveau.

ART NOUVEAU. While the arts and crafts movement against the machine was primarily motivated by morality, the causes of Art Nouveau were primarily aesthetic. Art Nouveau was a conscious attempt to produce a new style that owed nothing to the past; it went no further than the invention of a new kind of ornament. It was thus a style that advocated art for art's sake. The design premise was based on the asymmetrical flowing lines of plant forms. The movement, undoubtedly influenced by the drawings of the British artists Mackmurdo and Beardsley, started in Belgium in the 1880s. The Town House (1893) in Brussels, designed by Victor Horta, is the most celebrated, if not the best work of this period. Floral forms in iron are the essence of the interior ornamentation. Rail designs, floor patterns, window divisions, and column ornamentations use this same decorative source. Henri Van De Velde, the spokesman of the period, stressed function and structural clarity as part of the movement, but there is no architectural evidence that it was more than a superficial system of ornamentation.

Furniture, fabrics, and even stained glass in the style of Art Nouveau were the great successes of the Paris Exposition of 1900, and their popularity spread throughout Europe and the United States. Hector Guimard, the French architect, used Art Nouveau forms in his most attractive works, the Paris Metro (subway) entrances. Even that great engineering masterpiece the Eiffel Tower uses iron ornamentation derived from Art Nouveau. In Germany the movement was known as Jugendstil, and in Italy it was called Floreale. As it had been in Paris, the movement was the hit of the Turin Exposition of 1902.

The two great architects of Art Nouveau were the nonconformists Charles Rennie Mackintosh (1862–1928) and Antonio Gaudi (1852–1926). Mackintosh designed buildings of remarkable originality, his greatest work being the School of Art (1898) in Glasgow. The interior ornamentation combines slender verticals with panels decorated with curves, flowers, and mermaidlike forms. Gaudi's superiority lies in the great force in his work. His style was wild, vehement, and at the same time capricious. Working in stone as well as iron, he created warped surfaces that flow like molten lava and surfaces of great complexity, using unbelievable original mosaics. His most celebrated work is the Church of the Sacred Family in Barcelona (1903) and his most delightful work is the Guell Park (1900) also in Barcelona.

At best Art Nouveau was a protest movement that sought freer outlets for design, and it was most successful as a system of interior architectural ornamentation. Its historic importance derives from its originality; it was the first

style that was not influenced by the styles of the past, and, although it broke from the period styles, it soon became a period style itself. Like other design fads, it quickly faded into oblivion.

IRON CONSTRUCTION IN THE UNITED STATES. During the classical revival, as the European engineer concentrated on the development of larger column-free enclosed spaces, the American engineer became involved with the creation of a new building type, possible only through the use of iron. As land in the centers of cities became densely occupied, it also became more expensive; and as business expanded, space could no longer be extended horizontally, because additional land was both costly and scarce. Therefore the only direction to go was up, and the multistoried building became the solution. This concept resulted in the greatest building contribution of the nineteenth century—the uniquely American skyscraper.

An American, James Bogardus (1800–1874), developed the system of construction that made the skyscraper structurally feasible. While English factories used iron columns and girders for interior structure, they still used masonry bearing walls for exterior enclosure. Bogardus, who built multistoried structures employing the same principle, was the first to substitute iron columns for masonry outer walls.

His best-known design was for the publishing house of Harper and Brothers (1854). This cast iron facade, detailed in the style of the Renaissance (Bogardus was aware of the plight of architectural taste), is remarkable for its abundance of glass. The combination of a skeletal structure of iron and glass in-fill is ideal for controlling temperature and permitting good light and ventilation. After Bogardus there came a great age of iron building throughout the United States by anonymous designers. Unlike Bogardus, these designers were not familiar with the historic styles, and so they developed in New York, Philadelphia, Chicago, and particularly St. Louis extraordinarily modern buildings of iron and glass that were devoid of historic ornamentation.

The same post–Civil War period that witnessed the anonymously designed iron and glass buildings also saw the influence of the Second Empire of France and the High Victorian Gothic of England on mannered American architecture.

HENRY HOBSON RICHARDSON. After completing his training in Paris and a grand tour of European art and architecture, Richardson (1838–1886) returned to Boston. He had been deeply impressed with the French Romanesque and perceived that these massive surfaces of brick and stone with their rounded arches had an emotional identity with his own age. His first major work was Trinity Church (1872–1877) in Boston. Designed for the famous clergyman Phillips Brooks, this great building on Copley Square immediately established Richardson's reputation as an architect who was not a revivalist in the imitative sense, but was instead a creative artist inspired by the emotive qualities of the Romanesque. His best-known works are railroad stations for the Boston and Albany Line and the Marshall Field Warehouse (1887) in Chicago. The hallmarks of Richardson's work were blocks of simple, massive, arcaded masonry. He made great contributions to the development of residential architecture. His houses in Boston and New York (Richardson maintained offices in Brookline and in Brooklyn) demonstrated looser, freer, more informal planning. Casually rambling masses with freely organized fenestration and wide sprawling verandas were employed in residential designs. He believed in the continuity of masonry textures, using little or no detail. Richardson had little interest in technological advances, so he shunned new structural systems and new materials. Nevertheless, he was the first American to attempt to find an architectural expression of his times through the use of simple masonry forms. In a sense, his work was a continuation of the English country architecture inspired by the arts

Photograph, courtesy of Museum of Modern Art, New York.

Warder House, 1885–1887, interior view of hall, Washington, D. C. Richardson's feeling for the French Romanesque is seen in the stone forms used in this late nineteenth-century room.

and crafts movement. Richardson's interest in the Romanesque also influenced the design of miniature Romanesque castles that soon became very popular in city and country residential construction throughout the Northeast and Midwest.

The first American school of architecture, Massachusetts Institute of Technology, opened its doors in 1865. But the properly schooled young architect was required to study at the École in Paris and complete his education with a tour of the great buildings of Europe's past. After Richardson, a background similar to his became the only acceptable entree to the architectural profession; all young men preparing for the field turned their eyes to Paris. The teach-

ings of L'École Des Beaux Arts were manifest in eclecticism—the use of many and diverse historic styles. Thus the returning American architect was equally at home with the styles of France, England, and Italy, and even with ancient classicism. As we have seen, the attempt to satisfy the architectural needs of the nineteenth century with these styles dealt a deathblow to the architect. The dichotomy continued between the romantic architect concerned with eclectic escapes and the objective engineer concerned with new structural systems and building forms. Only Richardson and a few colleagues were able to bridge the work of both. At the 1893 Columbian Exposition in Chicago, eclecti-

cism finally won the battle, and further development of modern architecture in the United States was retarded until the 1940s.

LOUIS SULLIVAN. Sullivan possessed the engineering inventiveness of Bogardus, the architectural expressiveness of Richardson, and the art consciousness of the Art Nouveau. In fact, the culmination of architecture in the nineteenth century was reached through four American phenomena: the Otis elevator safety device, the multistoried iron frame, the great Chicago Fire, and Louis Sullivan. In 1853 Elisha Otis of New York invented the first safety device that could control the hoisting platform popular at that time. He designed the first passenger elevator in 1857, and further development of vertical commercial structures followed.

The great Chicago fire in 1871 totally destroyed the Loop (the commercial area of downtown Chicago bounded by an elevated railroad loop). The steel-framed structure provided the solution to exorbitant land costs. The elevator made vertical movement feasible, and the experiments of architect-engineers like William LeBaron Jenney resulted in that singular American architectural contribution, the skyscraper. The great fire provided the site for the Chicago school to grow, first as architecture of interior iron frame with masonry bearing walls, and later of complete, vertically soaring iron frames.

Sullivan had a spotty education, starting at M.I.T. and moving on to the École in Paris. He traveled in Europe and then returned to the United States, hoping to apprentice himself to an architect whose work aroused his enthusiasm. When he reached Chicago, where his family had originally settled, most architects were still divided between archaeology and science, principally between European influences and American resourcefulness.

In 1881 the architectural firm of Adler and Sullivan was formed, and until 1890 Sullivan designed buildings after the style of Richardson. His first great skyscraper was the Wainwright Building in St. Louis (1890–1891). In the same period he designed the Carson Pirie Scott Building and the Gage Building in Chicago and the Bayard Building in New York. Although Sullivan established the credo of early twentieth-century architecture—form follows function—and his buildings are inventive in their use of the steel frame and huge expanses of glass, his work is best characterized by the application of nonperiod naturalistic ornamentation, which clearly derived from the Art Nouveau designs he had seen in Europe. The robust Chicago school lost out, however, in the competition for designs for the Columbian Exposition of 1893. That world's fair, the "White City," was done in the style of the Venetian Renaissance, and, although Sullivan designed the provocative transportation building, the great work of the Chicago school ended. The building of skyscrapers clothed in historic styles followed as eclecticism came to dominate architecture in the United States. Adler and Sullivan separated in 1895, and by 1900 Louis Sullivan was a forgotten man.

FRANK LLOYD WRIGHT. Although his work was not recognized in this country until 1935, a young architect who had worked in the office of Adler and Sullivan carried the traditions of the arts and crafts movement, along with those of Richardson and Sullivan, to their greatest height. We refer, of course, to the American architectural genius Frank Lloyd Wright (1869–1959).

After studying engineering at the University of Wisconsin, Wright settled in Chicago and joined Adler and Sullivan at the time that the Chicago Auditorium was being designed. Wright, a favorite of Sullivan's, was soon put in charge of all the residential architecture that the office produced. By 1893, when Wright set up his own office, he had been given credit in his own name for several houses. From this time until 1910 Wright developed his now famous Prairie Houses. Usually cruciform or windmill-

like in plan, they concentrated the mechanical plants and fireplaces in the center of the house, permitting each of the four wings to have three exterior walls. Frequently two of the four wings intersected the other sides at higher levels, so that the forms interpenetrated each other. Spaces within each wing could flow into each other, and the spiral continuity from one wing into another was also exploited. Long, low, overhanging roofs accented the flat land upon which the houses were built. Horizontal fenestration and projecting balconies stressed the strong parallelism with the ground. Wright used basic materials—wood, masonry, and glass. He did not use reinforced concrete and steel until the 1930s.

The most important house of the prairie period is the Robie House, completed in Chicago in 1909. Built of brick, wood, and glass, this house develops the concept of open-planning within, as well as a visual continuity between inside and outside. Wright was certainly the most creative American architect to date, and when his work appeared in Europe in 1910, his influence upon European architects was immediately felt.

In 1911 he designed for his mother the first of his Taliesin houses. By building it on a softly rounded hilltop instead of the flat land around Chicago he achieved more variety in levels and roof lines, thus emphasizing his premise that a house must grow out of the land. At Taliesin, Wright handled walls, roof overhangs, and terraces so masterfully that complete visual continuity inside to outside was frequently achieved.

Wright was invited to Japan to design a hotel in Tokyo, so he lived there from 1915 to 1922. He received worldwide acclaim when his Imperial Hotel in Tokyo, built on floating foundations, withstood the earthquake of 1923. After returning to the United States, Wright continued designing houses in the Southwest.

Taliesin West designed by Frank Lloyd Wright. The architect used indigenous materials and low silhouette to make the building visually compatible with the Arizona desert setting.

© ESTO

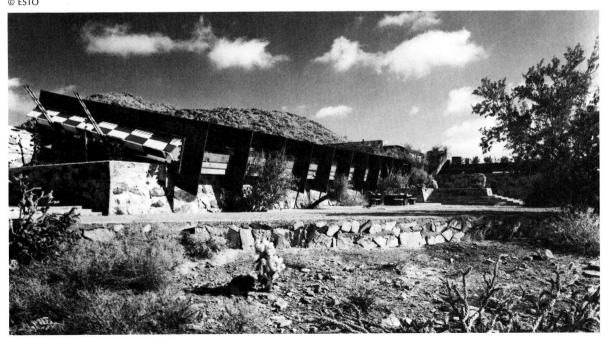

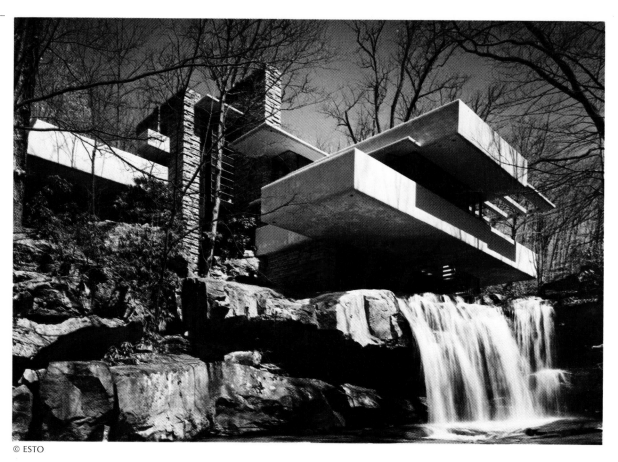

© ESTO

Wright's bold concrete forms cantilevered over a waterfall make a masterpiece of architectural placement.

Nevertheless, his work in this country was not fully recognized until the American Institute of Architects awarded him its Gold Medal in the mid-thirties. His most famous house, "Falling Water," was built in 1936. Cantilevered over a waterfall, this house carries out the principles of the old prairie houses, but through the daring use of reinforced concrete goes a step further. Although he was nearly seventy years of age when "Falling Water" was completed, Wright continued to design many houses and even built two great nonresidential buildings, the Johnson Wax Tower in Racine, Wisconsin, in 1950, and the spiral Guggenheim Museum in New York City, completed in the year of his death, 1959.

In residential architecture Frank Lloyd Wright will always be identified with (1) the positioning of his houses within a natural terrain, (2) the development of a house from inside outward, (3) the use of an original vocabulary of design without regard for traditional forms, (4) the use of primary materials and bold structural cantilevers, and finally (5) a dedication and intensity that permitted him to create his houses in a cultural environment that was violently hostile to his ideas.

EUROPEAN ARCHITECTURE AFTER 1900. Earlier we discussed the development of steel in the nineteenth century. However, the use of concrete as a building material was known long before iron. Concrete—the mixture of cement, crushed stone, sand, and water—has great com-

pressive value. It is an excellent material for bases of buildings, for foundation walls and footings. But concrete has little tensile value, while steel is excellent in tension but not as good as concrete in compression.* Imagine a lighting fixture hung from a ceiling by a shaft of concrete, or a heavy piece of sculpture on a thin pin of steel attached to the floor.

AUGUSTE PERRET (1873–1954). A French architect was the first to combine steel and concrete to make a material equally strong both in tension and compression—reinforced concrete. Since the concrete is poured in a fluid state, it takes the shape of the forms into which it is poured, making possible great design freedom, aided by the use of easily bent reinforcing bars. Auguste Perret's apartments at 25 Bis Rue Franklin (1903) employed a skeleton of reinforced concrete for the first time. It is important to note that Perret's work with reinforced concrete gave the architect still another new structural material, and, as in the case of steel, new architectural forms became possible.

After the death of Art Nouveau there remained many European architects who attempted to free design from eclecticism. Perhaps the first was Professor Otto Wagner (1814–1918) of Vienna, who wrote in his textbook *Modern Architecture* that new principles and materials must lead to new forms, and that the artist must create what the public ought to like, not what it thinks it likes. Wagner, who worked in complete isolation, was a proponent of freedom to design rather than to imitate. Two students of Wagner's, Adolf Loos (1870–1933) and Josef Hoffman (1873–1956), continued to fight for freedom of design. Hoffman's Stoclet House (1914) is particularly interesting because it was one of the first buildings to be influenced by a new aesthetic movement in Holland, with a design consisting of a cube of white stucco with straight black lines edging all of the flat surfaces or planes. The young Dutch group, known as De Stijl, claimed that as pure representation of the spirit, art will express itself in a purified, or abstract, aesthetic form. The backbone of the De Stijl movement was clarity and order. In painting, all forms were simplified into rectangles outlined in black, with only primary colors plus white and gray added. Piet Mondrian was the great painter of this school. In sculpture all forms were simplified into flat rectangular planes, and the sculptures were combinations of these flat planes (sometimes called constructivism). Malewitsch was the most successful of De Stijl sculptors. Interestingly, Frank Lloyd Wright's abstract principles of composition and form employing interpenetrating planes and hovering roofs were identical with the objective, intellectual conclusions reached by the De Stijl group.

In Germany, Peter Behrens (1868–1940) was concerned with industrial architecture and the expressive forces concealed in new materials. The titans of modern architecture—Gropius, Le Corbusier, and van der Rohe—apprenticed in Behren's studio. In Holland, H. P. Berlage (1856–1934), a great admirer of Wright, worked for the unity of the flat surface. J. J. P. Oud (1890–1963), like Berlage, built houses of brick. Oud added humanism to early twentieth-century architecture. He was concerned with scale and proportion in order to make people

* A compressive material is one that can carry great weights or forces on top of it and can withstand great forces pushing up at it. It is, in a sense, capable of being squeezed. Diagrammatically compression can be shown o $\begin{smallmatrix}\downarrow A \\ \uparrow B\end{smallmatrix}$. O is being pushed down by force A and pushed up by force B at the same time.

A material of tensile value is one that can withstand one force that pulls up and another force that pulls down simultaneously. It is capable of withstanding opposite pulls. Diagrammatically tension can be shown o $\begin{smallmatrix}\uparrow A \\ \downarrow B\end{smallmatrix}$. O is being pulled up by force A and pulled down by force B. Therefore, tension and compression are opposites.

comfortable in his spaces as well as to create simple, refined architecture. Thus the revolt begun by William Morris in the mid-nineteenth century reached architectural fruition in the early twentieth century in both Europe and the United States. However, all development was abruptly terminated with the outbreak of the First World War.

THE CONTRIBUTION OF WALTER GROPIUS TO THE DEVELOPMENT OF MODERN ARCHITECTURE. We have already noted that Germany was the last European country to industrialize. Perhaps its unification late in the nineteenth century and its lack of strong nationalistic traditions explain why this new country was able to cope successfully with the conflicts between art and the machine. The Deutsche Werkbund of 1907 sought conscientiously to synthesize "machine style" and the arts and crafts movement started by Morris. In essence this was the first attempt to effect real cooperation between the artist and the craftsman, between art and industry. Walter Gropius (1883–1969) was one of the youngest Werkbund leaders, and as early as 1910 he had helped Peter Behrens draft a "memorandum on the industrial prefabrication of houses on a unified artistic basis." Gropius's efforts to exploit the new lightness made possible by modern building construction were seen in early industrial architecture that reflected the intellectuality of the De Stijl movement in Holland and the romanticism of the recently published work of Frank Lloyd Wright.

After World War I Gropius consolidated the Art Academy and the Arts and Crafts School in Weimar, creating a consulting center for industry and the trades which he called the Bauhaus. Each student at the Bauhaus was trained by two teachers—an artist and a craftsman. The aim of the school was to unify art and technology, to unite creative imagination with a practical knowledge of craftsmanship. Thus a new sense of functional design was realized. In

Photograph, courtesy of Museum of Modern Art, New York.

The interior of this Bauhaus director's house by Gropius indicates the cold intellectuality of the early international style. Dessau, Germany, 1925–1926.

1925 the Bauhaus moved from Weimar to the buildings in Dessau designed by Gropius. By this time a new generation of teachers had been trained, each of whom was at once a creative artist, craftsman, and industrial designer. From this environment came many familiar adjuncts of contemporary life—steel furniture, modern textiles, lamps, dishes, and modern typography and layout. The spirit of functional design was carried even into the fine arts and applied to architecture and to city and regional planning. The Bauhaus faculty included, besides Gropius, the painters Klee, Kandinsky, Albers, and Feininger; the artist-typographers Bayer and Schawinsky; the textile designer Anni Albers; the architect and furniture designer Marcel Breuer; and the revolutionary scenic designer Oscar Schlemmer. During the twenties the Bauhaus was an international center of the crafts, architecture, painting, sculpture, and music. In retrospect, it was the most important

school since Louis XIV had codified art in the Institut de France and Napoleon I had united art and science in the Polytechnique. As far as education in design is concerned, Gropius established ideas that are still vital in the innovative schools of architecture and design in the United States today.

Since the Bauhaus principles could not flourish under totalitarianism, Gropius went to England before the growth of Nazi Germany and came to the United States in the late 1930s. He assumed the chairmanship of the Department of Architecture at Harvard University and established an architectural practice in New England. Since then, most American designers of consequence have studied with Gropius himself or with a Gropius-trained teacher. In the simple directness of traditional New England architecture Gropius found a response to the forthrightness of the Bauhaus ideals, and a vital American architecture utilizing forms in stone, wood, and glass resulted. Soon after World War II Gropius founded the Architects Collaborative, a group of young architects and designers dedicated to American traditions that are implicit in the concepts of the Bauhaus. Walter Gropius was not only one of the most celebrated and honored architects and teachers of the century but also one of the most virile practitioners in the design field.

LE CORBUSIER. Charles Edouard Jeanneret (1887–1968) was born in Switzerland. Like many Europeans, however, he studied and traveled extensively, and no particular country or culture can claim exclusive rights to his development. Le Corbusier traveled in Italy, Greece, Egypt, and North Africa and worked with Behrens in Germany and Perret in France. He is, however, considered a French architect. Le Corbusier is both a painter and an architect of a new generation of artists who ignored the traditional Beaux Arts training. He established several devices which are characteristic, including a skeleton structure of floors and roof supported by a few isolated steel columns located well within the walls of the building. The weight of the ceiling rested on the columns, thus permitting the free placement of both interior and exterior walls.

Le Corbusier preferred beauty of simplicity and good proportions to surface enrichment, and his designs were based on functional principles and geometric forms. His final hallmark is the use of the flat roof as a roof garden. The Savoye Villa (1929–1931) at Poissy, France, is a great house that embodies central principles of Le Corbusier's residential architecture. Here is a three-story house, the upper two stories of which are raised on freestanding columns (pilotis or stilts). The regularity of the structure on the lower floor is contrasted with the free-flowing nonstructural walls. Space flows easily through the house and above and below it. An interior ramp and stair lead to the middle floor, which reflects the rectangularity of the structural system; here again Le Corbusier ties together interior and exterior spaces. The living areas open upon a walled terrace with a large horizontal window (from outdoor terrace to free outdoor space). The terrace is open to the sky. An exterior ramp connects to the roof garden, where once more free screens protect the user from wind and sun. Here we find the Le Corbusier credo and the beginnings of the sculptural influences upon modern architecture. Although influenced by De Stijl as well as by the pioneering modern painters and the Constructivists, Le Corbusier has added a plastic poetry to the intellectual rationalization of the Bauhaus. He has also been fascinated by prefabrication, and is the author of the phrase, "A house is a machine to live in." With his celebrated Swiss Pavilion (1932) in Cité Universitaire Paris, he again demonstrated a structure floating on stilts and the play of the interior and exterior spaces. As always, Le Corbusier here

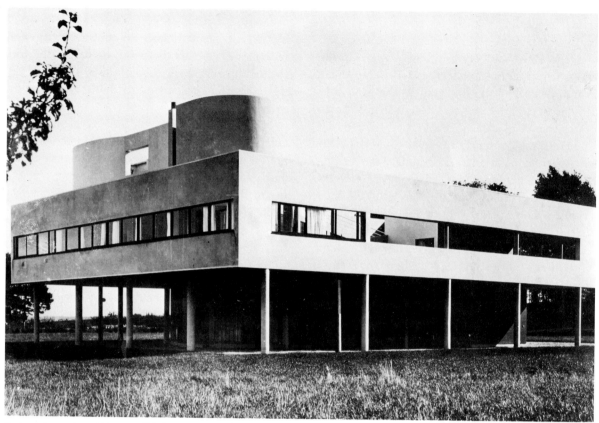

Photograph, courtesy of Museum of Modern Art, New York.

The Villa Savoye, Poissy-sur-Seine, France, designed by Le Corbusier. A remarkable juxtaposition of interior and exterior space.

contrasts the modular regularity of the concrete structure with the free plasticity of the non-structural stone wall.

In his latest works in France and in India, he again proved that his was an unending, driving creativity. Although his sketches were used for the basic design of the United Nations complex, the only American example of Le Corbusier's work is Carpenter Hall (1962) at Harvard University.

Le Corbusier has been very influential in the development of South American architecture as well as that of many European countries. He was invited to Rio de Janeiro in 1936 and prepared sketches for the Ministry of Education and Public Health. Oscar Niemeyer, profoundly

influenced by Le Corbusier, carried out the design of the building in the spirit of these sketches. This building was the most significant modern structure completed in South America since 1940, in a sense directly influencing every young South American architect. Niemeyer's great work was to design all of the buildings for Brazil's new capital, Brazilia, according to the site plan laid out by Costa.

LUDWIG MIES VAN DER ROHE. Born in Aachen, Germany, in 1886, van der Rohe had an informal early training. After four years with Peter Behrens and also working in other architectural offices, he set up a private practice in 1912. He was director of the Bauhaus following Gropius and then came to the United States in

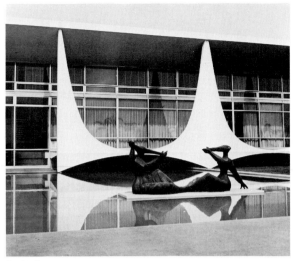

Ilse Hofman

Niemeyer's President's Palace in Brasilia. Bold, curving supports contrast with delicate smaller-scale window wall behind.

1937 to become director of architecture at the Illinois Institute of Technology. Mies van der Rohe is the rationalist of modern architecture. Using steel primarily, his work is easily understood, and his great design principle, "less is more," results in structures that are clear, modular, and understated.

The most important building of van der Rohe's European period was the Tugendhat House (1930) in Brno, Czechoslovakia. This flat-roofed structure had a free lower floor resting on regularly spaced chrome-plated columns. A 100-foot-long glass wall opened to a commanding view. A curved wooden screen and a freestanding slab of marble suggested separations between the living room, dining room, and study. Spaces were subtly subdivided by furniture arrangement and floor coverings.

Tugendhat House in Brno, Czechoslovakia (1930), designed by Mies van der Rohe, showing the importance of proportions, line texture, and the exterior to the entire composition. Living-dining area.

Photograph, courtesy of Museum of Modern Art, New York.

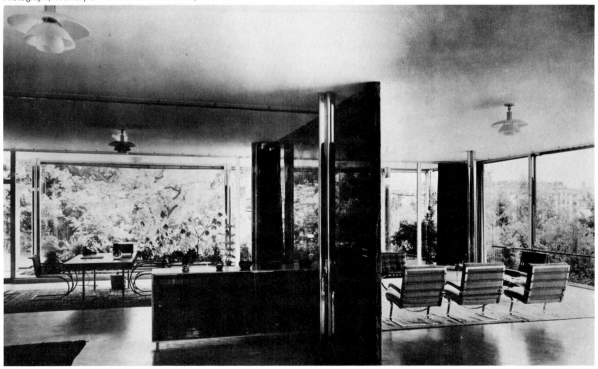

The most striking house in the United States designed by van der Rohe is the Farnsworth House (1950) in Plano, Illinois. Eight welded steel columns support the roof as well as the floor, which floats above the ground. All exterior walls are glass, from floor to ceiling. A "core" of heating plant, fireplace, kitchen, and bathroom creates the only separation in this completely open plan. Van der Rohe's influence upon American architects has been tremendous. His scientifically simple designs have caught the spirit of American technology with great success. Best known for the Lake Shore Apartments in Chicago and the Seagram Building in New York, he died in 1969.

THE BIRTH OF CONTEMPORARY ARCHITECTURE IN THE UNITED STATES. At the turn of the century Chicago's creativity declined as new contributions came from California. In the San Francisco Bay region an informal architecture using natural materials developed. The climate permitted minimal distinction between indoors and out-of-doors, and large areas of glass gave notice to the superb views of almost every site. The works of John Galen Howard, Bernard Maybeck, and the Brothers Greene offered the best contemporary regionalism of this area and fathered the current California school of Richard Neutra and William Wilson Wurster. Other American contributions to the development of modern architecture were few, aside from the work of Wright and of the Viennese Richard Neutra, who worked in Chicago with Wright and went to California in 1924. There was no significant work in the 1920s, and the depression hit the building industry in the thirties with great severity, while World War II ended what little had been done during that decade. The postwar growth of modern architecture in the United States was foretold in the late 1930s when Gropius, Breuer, and Van der Rohe came to the United States, not only to teach but also to build.

Julius Shulman

In the Kronish House, designed by Richard Neutra, the courtyard brings nature indoors. Note the texture transition from ground to pebbles to carpet. There is extensive use of glass for transparency.

The true flowering of American architecture came after World War II, and can be divided into the work of five groups: the followers of Frank Lloyd Wright who studied with him at Taliesin; the Harvard architects who studied with Gropius and Breuer and were also influenced by Le Corbusier; the Van der Rohe disciples at the Illinois Institute of Technology; the California school led by Neutra and Wurster; and those few determined individualists who were not allied with any school. Wright and van der Rohe produced followers who tended to imitate the styles of their masters. Since Gropius taught an ideology rather than a style, a more varied architecture can be found in the work of his students. This is also true of the architecture of the California school.

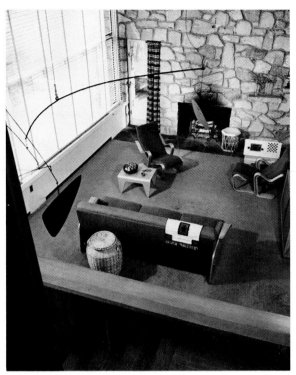

Courtesy of Marcel Breuer

The Breuer house in Lincoln, Massachusetts, shows contrasting planes of glass, rough stone, wood, and a slate floor, creating a large space simply furnished.

The houses that Walter Gropius and Marcel Breuer designed in New England just before World War II were the most important influences upon American residential architecture since the work of Wright and the early Californians. The German international style was comfortably translated into traditional clapboard and stone, and the austerity of the architecture and the Massachusetts landscape were remarkably compatible. Hugh Stubbins and Carl Koch were early American followers of Gropius and Breuer. Their houses continued the use of flat roofs, vertical boarding (usually painted white), and masonry fireplace walls. However, a warmth appears in their work, featuring the more American gabled roof and a less precise architectural

geometry. Houses by Eliot Noyes are similar in spirit. Edward L. Barnes's houses form a transition between the international style and a freer, more emotional approach in the true Gropius sense, since Barnes concerns himself with the creation of spaces that are beautiful rather than merely functional. The leader of the youngest Harvard group is Paul Rudolph, whose earlier works are a series of delightful demonstration houses in and around Sarasota, Florida. His more recent work asserts a philosophy of form for form's sake. In the thirty-five years of the Gropius school in the United States, architecture has progressed from rigid translation of the international style to a freer expression of visual delight.

As change is characteristic of the evolution of the Gropius school, refinement is true of the development of the Mies school. The chaste, one-room house, all glass and steel, built by Philip Johnson for himself in New Canaan, Connecticut, is the best residential example of Mies' influence. A brick cylinder housing the fireplace and bath is the only closed element in this completely open house. Johnson's growth can be traced in his work for his private use: a brick guest house that he built shortly after the glass house; the lagoon, pavilion, and bridge; an underground art museum; and his most successful work, a new sculpture gallery.

Early modern European architecture as well as the vigorous Chicago school combine in the work of Richard Neutra in California. William Wilson Wurster has created an architecture of wood and glass that is more informal than Neutra's work, with characteristic low rambling asymmetric houses of redwood boards and batten and glass.

On the West Coast, the influence of Japanese architecture brought an openness of plan through the use of sliding and removable partitions, care in the detailing of the wood, and simplicity in the handling of interior spaces and

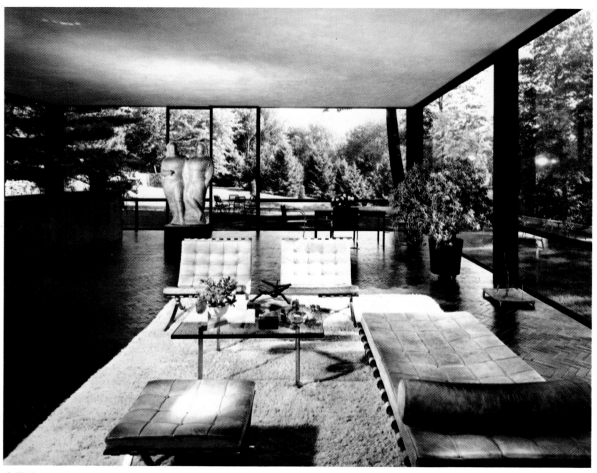

© ESTO

A successful integration of indoors and outdoors can be found in Johnson's all-glass house. The furniture was designed by Mies van der Rohe.

furnishings. Wide overhanging eaves are characteristic, and perhaps more important is the intimate relation of house to grounds and landscaping. These considerations have affected the work of many California architects and through them the work of other domestic architects throughout the country. Another vigorous regional architecture not unlike the California school has grown in the Northwest, where Italian-born Pietro Belluschi is the leading architect.

Architects such as Eero Saarinen and Edward Durell Stone do not represent specific schools. While they were certainly influenced by the European masters, most of their buildings are uniquely personal. Saarinen was born in Scandinavia and was brought to this country when his father, a great architect, took charge of Cranbrook Academy in Michigan. Saarinen completed his formal education at Yale. His best-known projects are the General Motors Research Center, the Massachusetts Institute of Technology chapel, the CBS Building and the Trans-World Airways terminal at John F. Kennedy Airport in New York. He also did some interesting houses with designer Charles Eames.

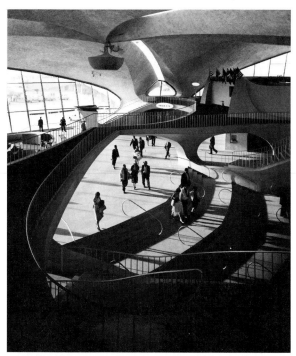

© ESTO

Saarinen's TWA terminal, where the architect used cantilevered concrete shapes and a concrete shell roof suggestive of flying.

His death in 1961 abruptly ended the career of one of the most gifted younger architects.

Even less influenced by other modernists is Edward Stone. American born and educated, he began to build modern houses in the 1930s, reaching his full growth in the fifties with his designs for the American Embassy in New Delhi and the American Pavilion at the Brussels World's Fair. Both buildings were enriched by the hallmark of Stone's work, the pre-cast perforated concrete grill.

THE ARCHITECT TODAY. In this chapter so far we have been concerned with the development of contemporary residential architecture. But credit must also be given to the great architectural firms, such as Skidmore, Owings, and Merrill, Harrison and Abramovitz, and other large-scale industrial and architectural firms. While today's architecture concentrates primar-ily on town and city planning, this is not a new realm for the architect. As we have noted, Sir Christopher Wren redesigned much of London after the great fire of 1666, and L'Enfant de-signed our federal capital. Thus the architect is tending to move away from the design of the individual building and toward the design of building complexes.

R. Buckminster Fuller (b. 1895) is not an architect in the traditional sense. He is rather a philosopher of forms that relate to twentieth-century concepts of machine aesthetics. In 1927, in accord with Le Corbusier's "A house is a machine to live in," he designed the Dymaxion (dynamic and maximum efficiency) House. The house, suspended from a central mast, was an assemblage of mechanical services in conjunc-tion with living areas. In 1932 he developed a motorized version of the house in his "Dy-maxion Three-Wheeled Auto." Fuller has since been concerned with the art of structures, lead-ing to the development of the Geodesic Dome, a structure of metal, plastic, or paper based upon octahedrons or tetrahedrons. The dome was chosen because it encloses the most space and uses the least amount of surface. In their use of standardized parts these domes reflect the as-sembly techniques developed by Paxton for the Crystal Palace.

Louis I. Kahn (b. 1901) has been practicing architecture in Philadelphia since 1924. How-ever, he did not emerge as a major creative fig-ure until the 1950s, when his Yale Art Gallery in New Haven generated his international repu-tation. This reinforced concrete building created large universal galleries that could easily be sub-divided into smaller spaces. The concrete ceiling with exposed wiring and ducts is particularly noteworthy. The highly rational Richards Medi-cal Research Building and the Salk Research Center are outstanding examples of Kahn's concrete and brick architecture. Like Fuller, he has had a tremendous impact on young archi-tects and students. He died in 1974.

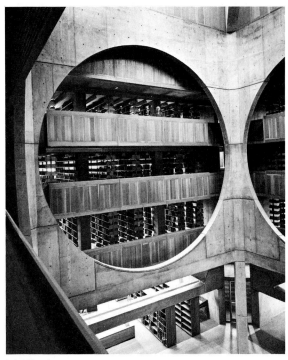

John Ebstel

In this library by Louis Kahn a large central void is created by bold exposed reinforced concrete. Note the contrast of wood and concrete.

Pier Luigi Nervi (b. 1891), an Italian architect-engineer, is remarkable in his ability to derive beauty of form from calculations, materials, and systems of structure, combining art and technology in determining dimensions and proportions based on a structural rationale. Using reinforced concrete as his medium, he developed shell construction—strength in surface alone—the most interesting technically and aesthetically the most satisfying of his achievements. There followed the immense sculptured roofs for warehouses, hangars, factories, and exhibition halls throughout Europe, and the bus terminal for the George Washington Bridge in New York. When Nervi was shown Saarinen's TWA terminal at Kennedy Airport—a six-inch shell of reinforced concrete—he commented that it was three inches too thick.

Japan produced Kenso Tange (b. 1913), who has been strongly influenced by the work of Corbusier. Tange's aim has been to integrate native architectural traditions with the needs of modern society. Two themes occur in his work—traditional post and beam construction blown up to colossal scale, and the use of plastic forms in concrete construction. Tange's major work is the Yamanashi Press and Radio Center, perhaps the most celebrated building of the 1960s. He was the chief architect and planner of Expo '70 in Osaka and is professor of architecture at Tokyo University.

Alvar Aalto (b. 1898) is known to most Americans as a furniture designer, but this Finnish designer is one of the greatest living architects. In the Jubilee Exhibition of 1929, Aalto abandoned his former classic style to produce the first expression of modern architecture in Scandinavia. He has been involved with city planning and drew the master plan for Rovaniemi. After the Second World War he entered his "red" period, named for the intense hues of the bricks that he used. His structural and spatial experiments are most successfully realized in the Town Hall at Saynatsalo. Aalto is an outstanding practitioner of organic architecture.

THE NEXT GENERATION. In the United States I. M. Pei has used reinforced concrete successfully, both poured in place and pre-cast. Society Hill in Philadelphia and Kips Bay in New York represent the finest concrete work in this country. John Johansen, strongly influenced by electronics, sees his structures as chassis, his spaces as components, and his system of circulation as connectors.

Continuing Saarinen's practice, Kevin Roche and John Dinkeloo designed the Ford Foundation Building, a controlled environment in which all offices open upon a tremendous interior garden.

In England Alison and Peter Smithson lead (since 1954) the new brutalism group, which is concerned with "super" expression—total visual

exposure of all structural and mechanical parts of a building. James Stirling, who has influenced Johansen and many young architects in the United States—he has taught at Yale University—works with industrialized components, stock greenhouse sash, steel wall panels and tubes. His buildings are particularly successful in the manipulation of light. The Engineering Laboratories at Leicester University are Stirling's most provocative structure.

Although several architects in Italy have produced buildings of consequence since the end of the Second World War, the country is still split between the conservative design of Rome (the political center) and the innovative design of Milan (the industrial center). The work in Rome, guided by the great critic Bruno Zevi, is basically rational and is concerned with low-income housing and urban design. However, Milan, with its magazines, triennali, Museum of Architecture, industrial wealth, and the patronage of the Olivetti family, supports a freer and more romantic architecture. Great praise is due to Gio Ponti for the Pirelli Tower in Milan (Ponti was also editor of the important magazine Domus); Belgiojoso, Peressutti, and Rogers (BPR) deserve praise for the Monument to the Victims of Concentration Camps and the Torre Velasca in Milan; and Franco Albini for the La Rinascente department stores.

Denmark has acquired international recognition for the human qualities and workmanlike character of its architecture. Although he died in 1972, the influence of Arne Jacobsen remains a prime force. Bellavista Housing near Copenhagen, set in a magnificent landscaped park, is a fine example of Jacobsen's work. Hallsor Gunnlogsson, a younger architect, is concerned with classical form, as seen in his Kastrup town hall; Jorn Utzon, the organic designer, was the architect for the remarkable Sydney opera house.

Sven Markelius designed the Swedish Pavilion at the New York World's Fair and a major meeting room in the United Nations Building. He is best known for the design of Vallingby, a new town in West Stockholm that has greatly influenced new towns in England and the United States.

Although Aalto is Finland's greatest architect, Viljo Revell has gained an international reputation for his bright and simple work, particularly the Toronto city hall. Feeling for materials and adaptability to natural surroundings remain the great strengths of Finnish architecture.

After the Second World War, cautious searching and groping by European professionals was a natural tendency. American influence was strengthened by the work of Gropius and van der Rohe. The Thyssen Building in Düsseldorf by Hentrich and Petschnigg is a notable departure from the boxlike typical American skyscraper. The most creative figure in German design, Professor Frei Otto, has provided a new approach to the development of shelter. Like Buckminster Fuller he is concerned with enclosing large spaces with a minimum amount of material. He specializes in tensile-stress construction, and his investigations culminated in the design of the extraordinary tent that was the German Pavilion at Expo '67 in Montreal.

In Mexico attempts have been made by Juan O'Gorman to tie the international style to native materials. The library at the University of Mexico is a simple prism, covered with mosaics, that is a confused mixture of pre-Columbian and present-day motifs. Felix Candela is the Nervi of Mexico. His concrete shells have a sense of proportion and a definition of profile that are his signature. One marvels at the fluidity of design in his Iglesia de la Medalla Milagrossa in Mexico City.

Venezuela's most prolific architect is Carlos Raul Villaneuva. He has designed the vast educational complex, Ciudad Universitaria, in Caracas. The huge auditorium with acoustic clouds designed by sculptor Alexander Calder is greatly admired. In general, his work, like most of the

work in Latin America, is strongly influenced by Corbusier.

Mention must be made of Roberto Burle Marx, the Brazilian urban designer and landscape architect. His gardens do not grow from a notion of decoration but rather from a desire to enliven our experience of nature. Abstractly, there is a strong affinity among the works of Burle Marx, Arp, and Miro.

The two great building spurts in postwar Japan were generated by the Olympic Games in 1964 in Tokyo and Expo '70 in Osaka, both projects supervised by Kenso Tange. However, such architects as Kiyoshi Kawasaki and Takeo Sato should be cited. The Mexican Embassy by Hiroshi Oe and the Gotsu city hall by Takamasa Yoshizaka are commendable.

SYSTEMS HOUSING. Prefabricated structures of concrete have been developed in France, England, and Russia. These systems for one-family and multifamily housing are now being used in the United States, since they can be built quickly and are less expensive to build than conventional construction. Habitat, the famous concrete building by the young Canadian architect Moshe Safdie, is an exciting start in systems housing. Ezra Ehrenkranz has systematized the construction of schools in southern California. Techbuilt Houses by Carl Koch and Deck Houses are two systems of wood construction that have contributed to the "second home" market. Mobile homes are factory-built inexpensive houses that are driven to the site and are ready for immediate occupancy; they now account for 18 percent of America's housing market.

The present generation remains under the influence of Corbusier, and mannered houses based upon his nineteen-twenties architecture are very popular. Richard Meier, Charles Gwathmey, and Julian Neski have been responsible for wood versions of the early concrete work. The highly personal designs of Charles Moore and Robert Venturi are praiseworthy.

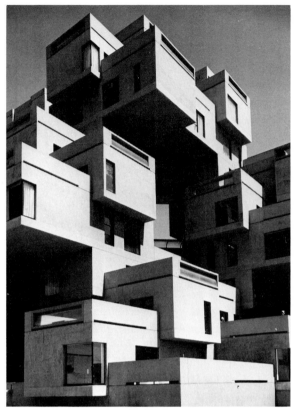

George Cserna

Habitat, designed by Safdie for the 1967 Montreal Exposition. It is an excellent example of industrially produced modular housing.

THE NEW DIRECTIONS. Despite great advances in technology, systems, and prefabrication, two groups of young architects strongly influenced by Buckminster Fuller believe that the architect is too hampered by tradition to cope successfully with today's problems. The dissenters are Archigram (Warren Chalk, Peter Cook, Dennis Crompton, David Greene, Rob Herron, and Michael Webb) in England and The Metabolists (Kiyonori Kikutake, Noriaki Kurokawa, Hiroshi Oe, and others) in Japan.

Archigram's Plug-in City is a physical structure of expendable parts. Every component of the city has a useful life. When it no longer serves contemporary living, it is unplugged, and

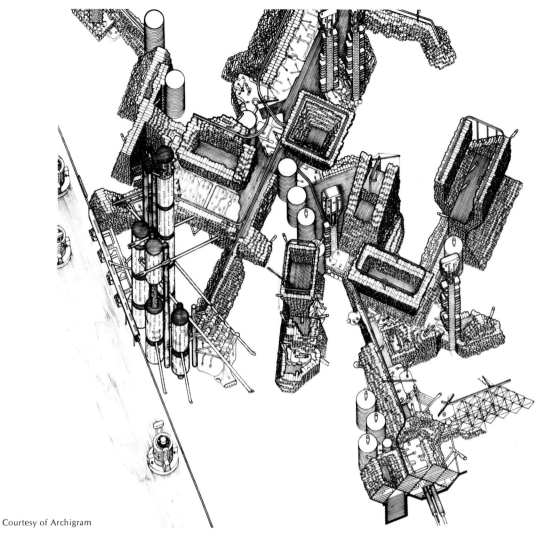

A building complex designed by the Archigram group in London.

a new component replaces it. Archigram publishes its own magazine, edited by Peter Cook, to prod and annoy traditional architects and planners. Rod Herron's Walking City can retract its supporting legs and float on a cushion of air. In the Plug-in City and the Walking City a prefabricated "capsule," the dwelling, is the basic building unit, again a Fuller concept. Archigram and The Metabolists are impatient with solutions to urban and technological problems, and both propose free structures that can adapt to advances in technology. Both create mega-structures, buildings large enough to carry a city's population. Unlike Archigram, The Metabolists are concerned with the Japanese need to increase space for living, and their most original designs are for cities over and under the sea. Archigram and The Metabolists also differ in concepts of form; the former leans to technology and science as the form-givers, and the latter to the structural and formal potentials of the man-made landscape.

BIBLIOGRAPHY

Burchard, J., and Bush-Brown, A. *The Architecture of America: A Social and Cultural Study*. Boston: Little Brown & Co., 1961.
A comprehensive study of the evolution of American architecture. Excellent.

Giedion, S. *Space, Time and Architecture*. Harvard University Press, 1947.
The definitive study of the growth of contemporary design, particularly architecture.

Giedion, S. *Walter Gropius, Work and Teamwork*. New York: Reinhold Publishing Co., 1954.
A well-illustrated account of his life and work.

Gropius, W., Gropius, I., and Bayer, H. *Bauhaus 1919–1928*. Boston: Charles T. Branford Co., 1959.
The complete history and philosophy of the Bauhaus copiously illustrated with designs by masters and students.

Gutheim, F. *On Architecture*. New York: Duell, Sloan & Pearce, Inc., 1941.
Frank Lloyd Wright, selected writings.

Hitchcock, H. R. *Built in USA*. New York: Museum of Modern Art, 1945.
Summary of modern buildings erected in the U.S. from 1923 until 1945.

Hitchcock, H. R. *Built in USA: Post-War Architecture*. New York: Museum of Modern Art, 1953.
Illustrations of the best modern buildings in the U.S. erected since 1945. Text.

Joedicke, Jurgen. *A History of Modern Architecture*. New York: Frederick A. Praeger, 1959.
Excellent survey.

Kidder-Smith, G. E. *The New Architecture of Europe*. Cleveland: World Publishing Co., Inc., 1961.
Illustrated guide book of modern buildings in sixteen countries with appraisals.

Masters of World Architecture. New York: George Braziller, Inc., 1960.
A series of books covering the life and works of the great architects of the world, including among others, Le Corbusier, Alvar Aalto, Oscar Neimeyer, Louis Sullivan and Eric Mendelsohn by such well-known authorities as A. Bush-Brown, A. Drexler, F. Gutheim, and J. M. Fitch.

Mock, E. *Built in USA: Since 1932*. New York: Museum of Modern Art, 1944.
Text and illustrations of modern architecture, both public and residential.

New Directions in Architecture. New York: George Braziller, Inc., 1969.
A nine-volume package covering recent developments in architecture throughout the world. Particularly important are *New Directions in British Architecture* by Royston Landau and *New Directions in Japanese Architecture* by Robin Boyd.

Pelint, Wolfgang, ed. *Encyclopedia of Modern Architecture*. New York: Harry N. Abrams, Inc., 1964.
A comprehensive survey of twentieth-century architecture. Unfortunately there are no color photographs.

Pevsner, N. *An Outline of European Architecture*. Baltimore: Penguin, 1961.
Excellent coverage from the sixth century to the present.

Pevsner, N. *Pioneers of Modern Design* (Pioneers of the Modern Movement). New York: Museum of Modern Art, 1949.
A study of the period from nineteenth century engineering to Walter Gropius.

Richards, J. M. *An Introduction to Modern Architecture*. Baltimore: Penguin, 1959.
Inexpensive, irreplaceable. The one book all should have.

Roth, A. *The New Architecture*. Switzerland: Erlenbach-Zurich, Les Editions D'Architecture, 1946.

Modern architecture exemplified by twenty buildings from various countries, each fully illustrated and described. (In English, French, and German.)

Salvadori, Mario, and Heller, Robert. *Structure in Architecture*. New York: Prentice-Hall, 1965.

The finest theory-of-structure book available. No background in mathematics is necessary to comprehend the material that is presented.

Spreiregen, Paul D. *Urban Design: The Architecture of Towns and Cities*. New York: McGraw-Hill Book Co., 1965.

An important book featuring not only historic background but also an analysis of the components of urban design, all magnificently illustrated by the author.

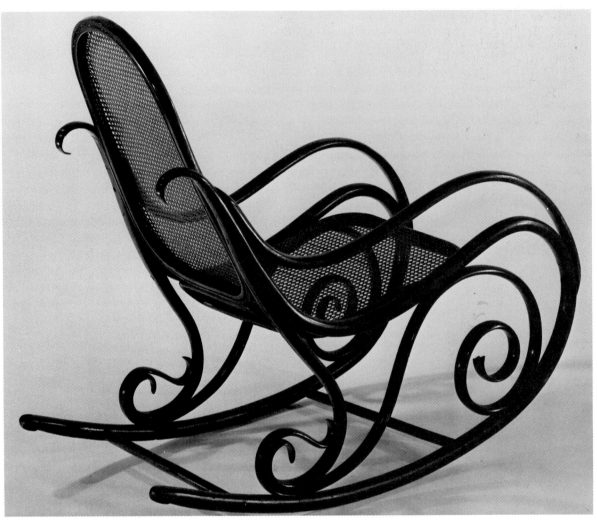

Gebrüder Thonet, rocking chair, 1860. Bent beechwood; cane.

CHAPTER 11

Contemporary Furniture

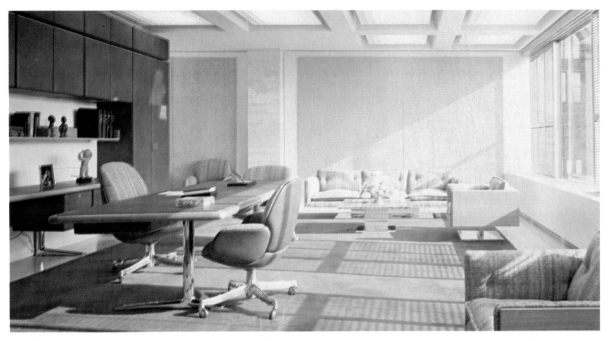

↑ *The office of the president of an investment corporation. The dignity of a monochromatic scheme is enhanced by the richness of contrasting textures. Storage units are covered with leather. Wall panels are of Chinese raw silk. Lighting is incorporated into coffered concrete ceiling. Sliding oak shutters at the windows create a panelled effect when closed.*

Interior design by Warren Platner. Furniture design by Warren Platner

↓ *The black and white theme of this living room creates an ideal background for the important Miro painting and the Giacometti sculpture.*

Hans Namuth

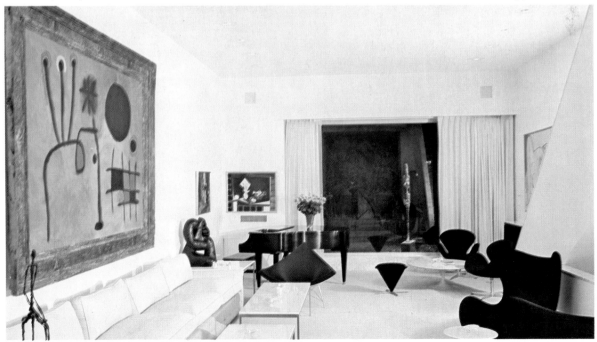

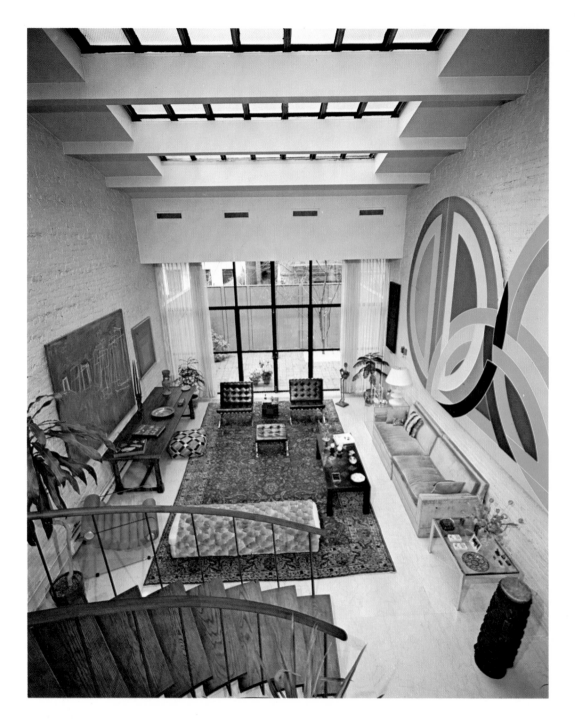

A huge room with a wall of glass facing a garden terrace. The high pitched ceiling is pierced by a large skylight which adds to the airiness of the space and affords additional natural light for the 20th century art. The hard-edged Stella dominates one entire wall and relates in scale to the boldness of the architectural background. However, the room is made more intimate and softened by the warm textures of furs, leathers and the traditional element of a large oriental rug.

Hans Namuth

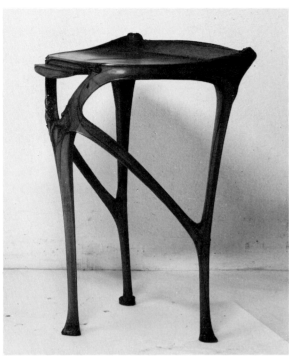

Pearwood side table by the French architect Hector Guimard (c.1908) demonstrates the curvilinear floral forms of Art Nouveau.

Historically, furniture has followed the development of architecture. The climates that have nourished the growth of twentieth-century architecture are the same that have created the furniture of today. In Chapter 10 we observed the impact of the Industrial Revolution, with its machine and machine-made products, upon contemporary design. To avoid duplication of information, here we will concentrate on the contributions of specific furniture designers rather than the historic situations that led to the design in our times.

THONET, THE FIRST FURNITURE DESIGNER TO CREATIVELY EMPLOY SYSTEMS OF MASS PRODUCTION. Michael Thonet, of Belgian descent, was born in Germany in 1796. In 1840 he invented the process of bentwood furniture production. He designed chairs of which all parts were beech-wood softened by steam and then bent into continuous structural shapes. Thonet also developed systems of bending many layers of veneer that were then shaped in heated molds. His furniture was shown at the World's Fair in London in 1851 and won the highest awards. All contemporary furniture of bentwood or plywood has been developed from these early manufacturing techniques. After Thonet's death in 1871, his family continued to manufacture furniture, and by 1891 seven million bentwood chairs of Michael Thonet's 1850 design had been produced. The components of these chairs, which were joined by simple metal screws, were shipped unassembled, a technique that has become particularly important today. By 1921 the concern owned twenty-one factories and employed more than twelve thousand people. At that time they started the mass production of tubular steel furniture and manufactured chairs designed by Breuer, van der Rohe, and Le Corbusier. Today this vast organization, Thonet Industries, manufactures significant furniture of bentwood, plywood, steel, aluminum, and plastics. The Thonet name has thus been associated with the growth of contemporary furniture since the early nineteenth century.

THE DESIGN REFORMATION IN ENGLAND. By 1850 the flood of inferior machine-made products created an effect still evident on work designed today. Although William Morris is recognized as the first to voice opposition to the abuse of the machine, the earliest reformers actually were Henry Cole, Owen Jones, and Richard Redgrave. Cole was a propagandist; Jones a decorator; and Redgrave, at best, a genre painter. This group, collectively in favor of good machine-produced design, failed because it could not define a viable approach to the visual aspects of machine-made design. Morris and his followers rank as designers of great importance because the group was composed of talented people who easily transcended the questionable moralistic values of the arts

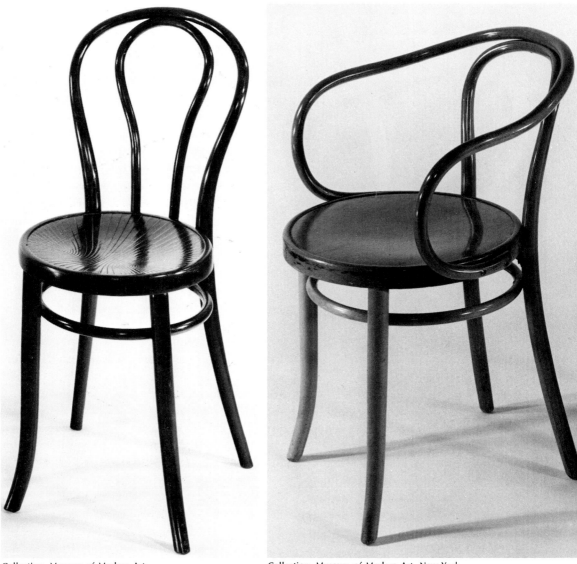

Collection, Museum of Modern Art,
New York. Purchase.

Collection, Museum of Modern Art, New York.
Gift of Thonet Industries, Inc.

LEFT, *Gebrüder Thonet, "Vienna" café chair, 1876. Bent beechwood.* RIGHT, *Gebrüder Thonet, armchair, c. 1870. Bent beechwood.*

and crafts movement. The movement suggested new design values and attempted to concentrate on honest workmanship and fair expression of materials. If this search for honesty had not led Morris back to the Middle Ages, his importance in the development of contemporary design would be unquestioned.

Certainly the most interesting designer in the Morris coterie was Philip Webb, the architect and furniture designer who designed "Red House" for Morris. This comfortable country house not only freed architecture from the pomposities of pseudo-romanticism, but also enabled Webb to design tasteful astylistic interiors and

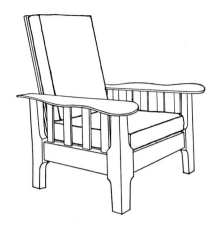

The famous Morris chair was made of heavy solid wood sections. The simplicity of construction and the honesty of concept have made this easy chair the symbol of arts and crafts furniture.

furniture (ornamented and decorated by Morris and the pre-Raphaelite Brotherhood). Though his disciples kept alive the traditions of honest workmanship, Gimson, the Barnsleys, Heal, and Voysey could not affect the development of nineteenth-century design. European furniture designers came under the influence of the design philosophy of Art Nouveau.

THE FOLLOWERS OF WILLIAM MORRIS. Ernest Gimson (1864–1919) was trained as an architect. In 1884 he met Morris and, following in Morris's footsteps, exchanged the drawing board for the workbench. Like Morris he took as his credo "art is doing, not designing." No drawing board designer can gain the technical knowledge of material and construction possessed by the working craftsman. Gimson modified this by stating that the designer must be a complete master of his craft. He made friends with two other young architects, the brothers Sidney and Ernest Barnsley, and the three were given the chance to show their furniture at Morris's Arts and Crafts Exhibition Society in 1890. The furniture was generally modest in scale and devoid of historical ornamentation. The use of oversized members gave their early

furniture a clumsy or provincial quality. At times they overstressed joinery by displaying too many dovetails. They also tended to use several different woods in the same piece, and the fussiness of banding diagonal strips of ebony and kingwood was at times ostentatious.

The architect Charles F. Annesley Voysey, a remarkable visionary, was easily fifty years ahead of his time, designing houses with long, low horizontal lines and gay colors. He also designed the furniture for his houses. Voysey attempted to apply arts and crafts thinking to machine-made furniture. Voysey's work sprang from "an urgent desire to live and work in the present and to make decorative art once more full of life and vigor." Van de Velde later acknowledged his debt to Voysey. "It was," he said, "as if spring had come all of a sudden." Sir Ambrose Heal successfully manufactured

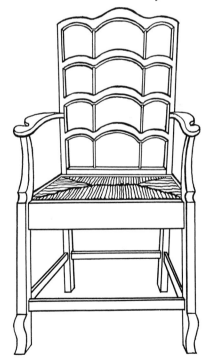

An English walnut chair designed and made by Ernest Grimson. Although similar in scale and silhouette to eighteenth-century English chairs, this side chair is devoid of historic detail and ornamentation.

contemporary furniture at the turn of the century. It had been fifty years since Morris first protested against the machine; only now did his followers see that his values were applicable to machine-made furniture. Heal's machine-made furniture was simple, clean, and carefully detailed. The natural beauty and color of unstained wood and the simple furniture forms were expressive not only of honest materials and craftsmanship but also of the machine.

ART NOUVEAU—VAN DE VELDE AND MACKINTOSH. "Morris chases ugliness out of man's heart," said Henri Van de Velde, "I, out of his intellect." The basic difference between Art Nouveau and the arts and crafts movement was the intellectual as opposed to the emotional approach to machine production. Van de Velde saw the machine as an insult to logic and reason just as Morris saw the ugliness of the machine as an offense to mankind. Henri Van de Velde was born in Antwerp, Belgium, in 1863. He studied painting and became involved with the impressionist movement in France. Then his interests changed from fine arts to applied arts, and by 1890 he was familiar with the products of the craft revival in England. Van de Velde became the spokesman for the Art Nouveau movement and, in his Les Formules, set the intellectual bases for the new art. He analyzed ornament and found that line was the common feature in nature and in styles of the past. He spoke of the dynamic quality of line and believed that line determined and completed form; that is, line developed form and did not merely ornament it. He was misunderstood, with the result that the movement grew on the premise that line as it appeared in nature should be the basis for ornamentation. The curvilinear swing subsequently associated with Art Nouveau was seen in chair legs and chair backs and in the division of glass. The flowing line, popularly called the Belgian curve (the flat segment of an ellipse), was used for wall openings, furniture supports, and furniture forms.

By 1900 and the great Paris Exposition, the parabola took the place of the ellipse, and woodwork, mirror frames, and furniture were parabolically formed and linearly ornamented with parabolic shapes. Maxim's Restaurant in Paris, 1900, exploited this theme. Although the movement was popular in France, Austria, Germany, and Italy, Belgium remained the source for new ornamental ideas, while Van de Velde still naïvely believed that Art Nouveau was the intellectual answer to the machine.

The Scottish architect Charles Rennie Mackintosh had designed many buildings that were remarkable because they showed no evidence of period styles. When it came to furniture and decoration, Mackintosh superimposed Art Nouveau ornamentation on the "Morris tradition." "Mackintosh took the wriggling tendrils of those water lily roots and with his stern hands drew them tight and held them perpendicular." This restless perpendicularity became the hallmark of Mackintosh's furniture and decoration.

THE NEW FURNITURE—RIETVELD. As the popularity of Art Nouveau waned, the moralistic principles of William Morris cleared the air once again. He had moved people and set them to thinking. New furniture came from architects rather than decorative artists, since new visual premises were the starting points for new design. It became necessary to forget the past and start all over again. The Dutch Neo-plasticists were the first to clarify "the new vision" in the historic periodical De Stijl. Here Rietveld (like Malewitsch, the constructivist sculptor, and Mondrian, the painter) stated that the framework of furniture must be simple square elements that are screwed together. The individuality of the elements must be stressed, resulting in complete articulation of all parts. Furniture was amplified into a series of vertical and horizontal planes, visually weightless in space. This manifesto was to inspire new painting, sculpture, architecture, music, and literature

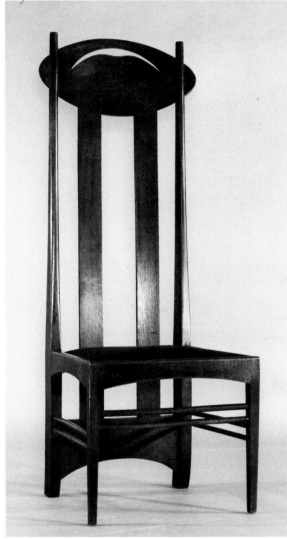

Collection, Museum of Modern Art, New York.
Gift of the Glasgow School of Art.

Charles Rennie Mackintosh, side chair, 1900. Oak, black silk.

wood reflects the new vision of Rietveld's works —clarity of structural form and precarious visual balance. Breuer analyzed form in terms of line and, in a sense, referred back to the bentwood linear forms of Michael Thonet's chairs. Breuer then began working with tubular steel and in 1925 invented the first continuous tubular steel frame, completing the design with loose canvas seat and back. In this first steel tube frame Breuer enlarged the design palette so that furniture could defy gravity visually, be of linear form, and could easily become a machine expression. By 1929 Thonet Industries were mass producing Breuer-designed tubular steel chairs, and tubular steel furniture reached its height of popularity when the resiliency of the material became apparent. Architects Stam, van der Rohe, and Le Corbusier as well as Breuer became involved with the cantilevered tubular steel frame which rested on two, rather than four, legs as part of the continuous tubular frame. At this time Breuer developed the simple chairs that were mass produced in the thirties in Europe and the United States and used throughout the western world. The Whitney Museum in New York City is an excellent example of his recent architecture. In 1972 the Metropolitan Museum of Art had a retrospective show of his work, honoring Breuer at the age of seventy.

The Finnish architect Alvar Aalto continued the work of Breuer and van der Rohe, exploiting the resilient qualities of wood, particularly Scandinavian white birch. The Nordics were familiar with molded skis, made of many veneers of wood curved under steam or heat. Actually Aalto's point of departure was a chair of tubular steel frame with a molded plywood seat and back (1932). The use of molded wood was not new; American designers had worked with this material for half a century, and Reitveld had also used curved sections of plywood. Aalto realized the cantilever potential of this material and was able to design chairs that paralleled the

as well as furniture. The new vision of Rietveld thus joined the honest expression of Morris to create the design of our times.

THE NINETEEN-TWENTIES—BREUER AND AALTO. Marcel Breuer studied at the Bauhaus, and as a designer-craftsman became the first master of its furniture workshop. His early furniture of

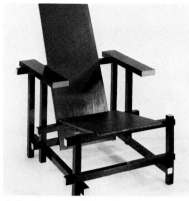

Like the constructivist sculptors, Gerritt Rietveld built this chair (1917) using articulated planes of painted wood.

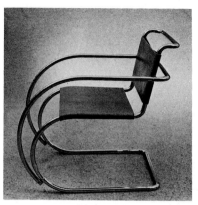

Mies van der Rohe's 1926 armchair of chrome-plated steel tube and leather anticipated the Barcelona chair.

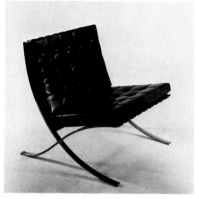

The famous "Barcelona" chair (1929) of chrome-plated steel bars and quilted leather by Mies van der Rohe, designed for the German exposition at Barcelona, has strongly influenced design in recent years.

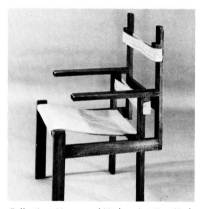

Marcel Breuer's armchair of 1924. Oak, handwoven wool. Manufactured at Bauhaus Carpentry Workshop, Germany.

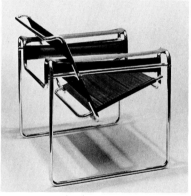

Breuer's armchair, 1925. Chrome-plated steel tube, canvas.

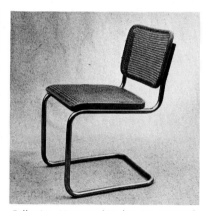

Breuer's 1928 side chair. Chrome-plated steel tube, wood, cane.

tubular steel chairs of Germany. He used the indigenous white birch as his working material because its qualities of firmness and hard surface combined with unusual pliability. Birch is also relatively knotfree and can reach immense gluing strength. The color of the wood is rather bland—pale yellow as contrasted with the stronger reddish tan of American birch. Aalto founded his own manufacturing plant, Artek Ltd., in 1936, and his furniture was distributed throughout Europe and the United States. This Scandinavian furniture was the second European collection of modern furniture to enjoy tremendous popularity (Thonet Industries became firmly

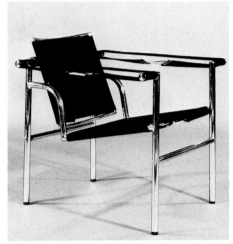

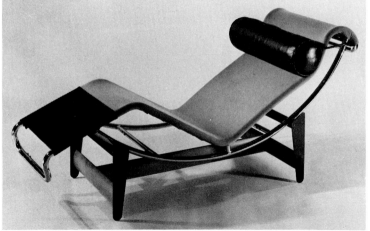

Collection, Museum of Modern Art, New York. Gift of the manufacturer, Thonet Industries, Inc.

Collection, Museum of Modern Art, New York. Gift of the manufacturer, Thonet Industries, Inc.

LEFT, *Armchair with adjustable back, 1929, by Le Corbusier (Charles-Edouard Jeanneret). Chrome-plated steel tube, black canvas.* RIGHT, *Le Corbusier's adjustable chaise longue, 1927. Chrome-plated steel tube; oval steel tubes and sheets; painted green and black; gray jersey, black leather.*

entrenched in this country in the 1920s). The Swedish Mathsson and the Danish Klint also pioneered in the development of molded wood furniture.

THE CONCLUSION OF AN ERA. The followers of Morris escaped into handcraftsmanship and were able to make peace with their times only when they designed and modified handcrafted chairs that could be manufactured by the machine. The design tradition of essentially handmade furniture modified for the machine is thus responsible for much of today's contemporary furniture. Another aspect of design was Morris's plea for honesty of material and honesty of construction. This became most important when designers abandoned the past to investigate form afresh. The resulting clarity of form, combined with Morris's values of material and construction, was the backbone of inventive design. Here, too, lies the essence of great traditional design—an aesthetic feeling of the period expressed honestly through materials and systems of construction that were unique to it. Morris's contribution was universal; the materials and the method of construction identi-

fied the period. In contrast, new materials used only for their own sake, and with little understanding of their potential expression, created the anomaly of the thirties.

THE NINETEEN-THIRTIES. Aalto, Mathsson, and Klint continued their work in Scandinavia,

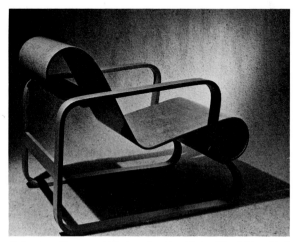

Collection, Museum of Modern Art, New York. Gift of Edgar Kaufmann, Jr.

The molded and bent birch plywood chair, c. 1934, of Alvar Aalto. Manufactured by Artek OY, Finland.

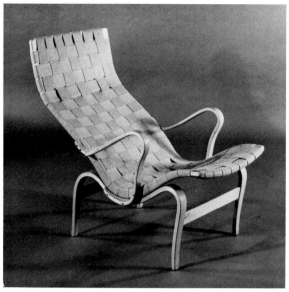

Collection, Museum of Modern Art, New York.
Edgar Kaufmann, Jr. Fund.

A Bruno Mathsson design (1940) of laminated bent birch plywood, using fiber webbing. Manufacturer: Firma Karl Mathsson, Sweden.

trialization had been reached, however, and many metals were improved and refined. Plywood was extensively used, and plastics were developed and produced. This environment of high industrialization using both new and improved materials became the first American contribution to today's furniture. Meanwhile, the center of Scandinavian furniture design shifted to Copenhagen. This change of location from Helsinki and Stockholm was due largely to the high standards of the Copenhagen Cabinetmakers' Guild, the respect for Professor Kaare Klint, and the particular work of the teacher-designers Hans Wegner and Finn Juhl. The honesty of wood construction and the introduction of sculpturelike forms are important Scandinavian contributions. Italian designers added combinations of many materials in the same piece of furniture. They also made designers aware of the textural values of materials, both

and Breuer designed a group of molded plywood furniture for Isokon in England. Much of Breuer's tubular steel furniture was copied in Europe and the United States. There was little additional significant furniture designed before World War II. Instead, French and English designers originated arbitrary, low, freely formed furniture that became known as "modernistic." Light and bleached woods were combined with clear glass, plastic, and gleaming metal. Cabinet forms were stepped and zigged, and the kidney shape became popular. New materials and new methods of manufacture were used to create this pseudo-modern style, which is also called Art Deco.

THE PERIOD AFTER WORLD WAR II—AMERICAN, SCANDINAVIAN, AND ITALIAN CONTRIBUTIONS. Although the furniture of Aalto and Mathsson had been imported since the late 1930s, there was little modern furniture manufactured in the United States. A remarkably high level of indus-

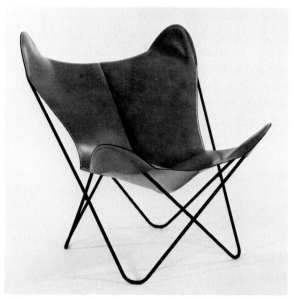

Collection, Museum of Modern Art, New York.
Edgar Kaufmann, Jr. Fund.

The delightful lounge chair, 1938, designed by Antonio Bonet, Juan Kurchan, and Jorge Ferrari-Hardoy. Metal rod, leather. Manufactured by Artek-Pascoe, Inc., U.S.A.

visual and tactile. This was the scene at the end of World War II—Scandinavian integrity of design, Italian richness of materials, and American development of materials and mechanization.

SAARINEN, EAMES, WEGNER, AND JUHL—THE POSTWAR DESIGNERS. Eero Saarinen, son of the famous architect, was born in Finland in 1910. He studied architecture at Yale and then went to work with his father at Cranbrook Academy. In 1941 Saarinen won first prize with Charles Eames in the Functional Furniture Competition of the Museum of Modern Art. The winning chairs were made of plywood shells fitted with upholstered foam rubber. The legs were attached to the shell by means of electro-welded rubber connections. Saarinen subsequently designed four groups of furniture. Included in the first was a lounge chair using an exposed molded plywood frame and an upholstered molded contour shell. The final group was dining furniture resting on a cast plastic pedestal. Saarinen felt that solid wood furniture was outmoded, and concerned himself only with man-made materials. His architecture established structural principles that were consistently applied to his furniture. Saarinen's untimely death in 1961 cut short a design evolution that might have gone beyond the tubular steel and molded plywood furniture of Breuer and Aalto.

Born in 1907 in St. Louis, Charles Eames joined the Saarinens at Cranbrook after completing his architectural education. During World War II he designed molded plywood splints for the armed forces, and in 1946 the Museum of Modern Art exhibited Eames's first group of molded plywood and metal furniture. These chairs were commerically produced and are among the most distinctive chairs designed in our time. Eames has also worked in plastics, aluminum, and steel. Unusually versatile, he has designed toys, wedding cakes, and moving pictures as well as buildings and furniture.

Of Danish origin, Hans Wegner is a trained

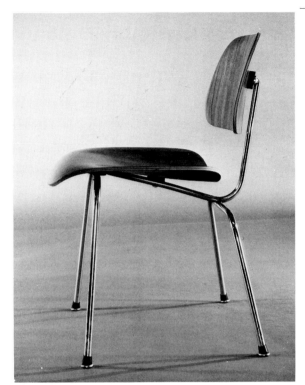

Collection, Museum of Modern Art, New York. Gift of the manufacturer, Herman Miller Furniture Co., U.S.A.

The first great post-World War II chair was this dining chair of 1946 designed by architect Charles Eames. Molded plywood seat and back attached to frame of metal rods.

furniture craftsman with a special feeling for wood. He often makes full-size models of his designs, and his chairs are not put into production until they have been tested in his own home. Wegner is a true craftsman who selects his material before making a design for it. His work typifies the high level of integrity and refinement found in Danish contemporary furniture.

Finn Juhl is another great Danish designer. His furniture is more cosmopolitan than Wegner's and often is highly sculptural. Juhl works wood to the limit of its yielding capacity, and his richly modeled curves are carried to this elastic limit.

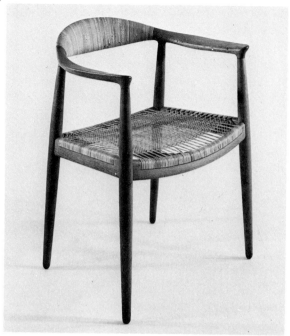

Collection, Museum of Modern Art, New York.
Gift of Georg Jensen, Inc.

Hans Wegner's oak, teak, and cane armchair (1949) is a fine example of solid wood. This is one of the first post–World War II Danish designs imported to the United States by Georg Jensen.

THE NINETEEN-FIFTIES. During this period the Barcelona chair of van der Rohe went back into production, and its influence was immediately apparent. The metal frame of stainless or chrome-plated steel won in popularity over the molded wood frames that were derived from the work of Aalto. Toward the end of the decade the four-legged chair gave way to the three-legged chair, and finally the single-legged, or pedestal, chair expressed current taste. The pedestal was certainly not new. However, pedestal tables and chairs eased the problems of table seating and offered the aesthetically appealing illusion of precarious balance. Furniture designers favored the use of one structural base that could support the sofa, the dining table, the lounge chair, and other furniture types. George Nelson, Florence Knoll, Ward Bennett, and others joined with Saarinen and Eames in the development of groups of furniture with each element supported by a uniform structural form, usually a pedestal and usually of metal. Chairs were generally upholstered in plastic or leather, and upholstery was quilted or tufted (again a van der Rohe influence). Jens Risom designed simple wood furniture in the Scandinavian tradition, and Edward Wormley and Paul McCobb worked in the solid wood traditions of William Morris and Ambrose Heal.

The tremendous expansion in commercial building during the 1950s generated a great demand for office furniture. Designers and manufacturers of residential furniture attempted to universalize furniture so that the same designs would be suitable for residences or offices. This approach created the "anonymous" room, which, save for accessories, could be a living room or an executive office.

THE NINETEEN-SIXTIES—NEW FREEDOMS IN MECHANIZED FURNITURE. While the 1950s produced furniture that was expressive of technical skills and rational processes, the sixties brought a confusion of styles. The new decade, still embracing the tenets of industrialization, produced a polyglot of furniture forms and qualities, with the market offering international-Bauhaus geometries, romantic-organic sculptures, minimal-technology shapes, and playful-subjective decorations. The rigidities of the fifties thus gave way to the freedoms of the sixties. But before the sixties flowered, the twenties and the thirties were revisited, with Breuer, van der Rohe, and Corbusier once more making the design impact. Stendig, Knoll, Laverne, and Thonet imported the master furniture of the twenties. Breuer's Wassily chair was the best-known chair of the decade. Art Deco (called modernistic by the Museum of Modern Art) enjoyed a brief popularity, though more so in accessories than in furniture. Perhaps these revisitations strengthened the young designers because they were no longer intimidated by Bauhaus objectivity. Although the sixties commenced with the dogma

of the International Style, the Bauhaus philosophy was rejected, and the new freedoms nurtured a new concept of accommodation.

Anatomic proportions vary from person to person and from civilization to civilization, and for this reason the chair has always been a challenge to the designer. Because of these anatomic differences, hard-edged furniture, that does not yield to the human form, can be comfortable only to a limited number of people and only in certain seating positions. Customarily, people accommodate themselves to chairs. The design breakthrough of the sixties brought chairs that accommodate to people. The mechanized Bauhaus approach created furniture with sharply defined shape, although parts frequently moved. The new furniture rejected preconceived form in favor of universal systems of suspension which offered greater comfort and more possible seating positions as the thickness of upholstery increased. The trend was clearly away from hard-edge furniture and toward soft-edge chairs made of structural upholstery, usually polyurethane, air, or water confined in a soft plastic enclosure, its resiliency controlled by the quantity or pressure of the content. The chair that most clearly expressed structural upholstery was "sacco" or the bean bag chair by the Italian designers Gatti, Poalini, and Teodoro, a zippered bag of soft plastic partially filled with replaceable polyurethane pellets. Thus the polarities of the sixties brought a radical change from morphic to amorphic chairs.

SYSTEMS FURNITURE. While systems for combining units of furniture vertically and horizontally were known in colonial times, true

This Italian modular seating offers enormous flexibility in room arrangement.

Aldo Ballo

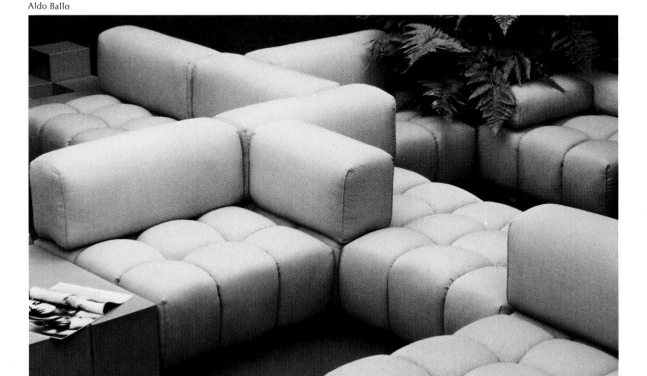

modular furniture was not manufactured in the United States until after the Second World War. During the sixties modules and components were designed not only to afford flexibility within the furniture type but also to create multiplicity of use. Systems for combining seating as well as storage units appeared. Although multi-use furniture was not new (remember the early American chair with the fold-down back that changed the chair into a table) systems furniture proclaimed a new direction. For the first time the need for individual pieces of furniture was questioned, as the chair, the table, the bed became mere components of an ever-changing living environment.

THE NEW MATERIALS. Plastics, the material of the sixties, which had often been used to make cheap copies of wood furniture, reap-

Eight Processing Techniques Used With Plastics

Laminating

A method of combing impregnated substrates into a solid integral sheet of either thermoplastic or thermoset plastic.

Calendering

Thermoplastic compounds are converted to film or sheet form, plain or textured, by pressing them between a series of warm, revolving rollers.

Compression

Cold or preheated thermosetting plastics are placed in a hot pressure mold.

Vacuum Forming

Heated thermoplastic sheets are drawn over a mold by a vacuum from below.

Injection

Heated thermoplastics are forced into a cold mold. **Compression molding:** *Cold or preheated thermosetting plastics are placed in a hot pressure mold.*

peared as fine structural, upholstery, and surface material with its own unique aesthetic qualities. Plastic interior surfaces included wall coverings of tiles, sheets, and paints; floor surfacings of carpets and furs. In addition, acoustic tile, spray-on plastic, light diffusers, and skylights became available. Innovations in furniture design featured plastic upholstery and upholstery fabrics, particularly stretch nylon, and plastics were also used in the furniture structure. While eight systems of processing plastics were used, as illustrated and described, these generally fell into two categories—thermoplastic, first softened by heat, then shaped and cooled to harden, and thermosetting, which is shaped while soft before being heated to harden. The most used plastics, vinyls, and polyurethanes are thermoplastic, as are polystyrenes

Eight Processing Techniques Used With Plastics

Rotational Molding

A relatively new molding process for thermoplastics. The molding machine consists of two or three arms extended outward, like spokes from a carousel. These arms are moved consecutively from a loading/unloading chamber to a heat chamber, then to a cooling chamber. As an arm enters each of these chambers, the mold attached to the arm is rotated. The thermoplastic adheres to the walls of the mold, forming a hollow object without internal stress, because the mold has no single orientation.

Blow Molding

A method for molding hollow thermoplastic items. A hollow tube, known as a parison, is extruded down into an opened, two-sided hollow cold mold. The mold is immediately closed around the hot, semimolten parison, nipping it closed at the top and bottom. An air jet is then blown into the parison, expanding it to the configuration of the mold.

Coating

Thermosets and thermoplastics can be used as coatings.

Drawings by Forrest Wilson, *Interior Design*

and acrylics. Epoxys, caseins, and silicones are thermosetting plastics. Stretch nylon and sheet mylar with a synthetic mirrored surface are particularly exciting since the stretch fabric can face the most complex warp, while mirrored mylar can be configured to make the simplest surface appear to be the most complex warp. Hard-edge furniture gave way to the new soft-edge when indoor-outdoor carpeting was developed in 1965. The new resilient plastic "grass" was used in Houston's Astrodome and quickly became a favorite with designers for use in floor, wall, and ceiling surfacing, and also for upholstery.

LIGHT AND ILLUSION. The sixties saw light become a quality of the environment, rather than just a means by which man could see comfortably. Neon light and light sculpture typify light as quality, though illusion can be more provocative. Slide projections on ceiling and wall can create a great variety of illusions which can be reinforced with stereo music. The holograph can be used to project three-dimensionally on a wall or on empty space; light can be turned and twisted with the laser beam and mirrored mylar.

THE LIVING ENVIRONMENT. These discussions have outlined briefly the radical departure

A floor in a New York City brownstone has been converted into a living environment by Gamal el Zoghby. Architecture and furniture are totally integrated. All horizontal surfaces are soft and vertical surfaces are white painted plywood. This sculpture-like interior is based upon the interrelationship of vertical, horizontal and 45 degree surfaces.

George Cserna

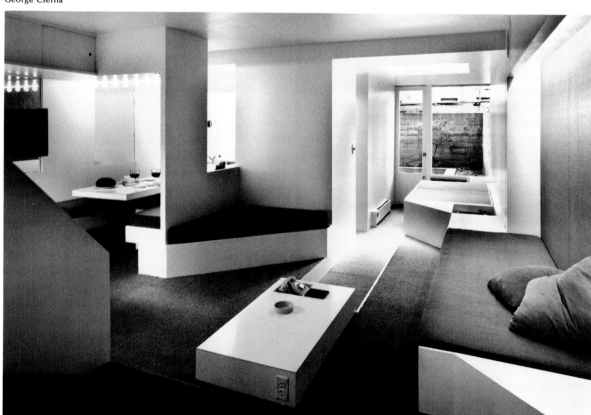

in interior and furniture design that began in the nineteen-sixties. The new direction is one in which interior space and furniture are totally integrated and the environment becomes a system of changing components. Traditionally furniture was assembled functionally in a pleasing manner and was supplemented with objets d'art and accessories. In the environment individual pieces of furniture become the objets d'art and accessories. In addition to facilities for eating, sitting, and sleeping, the environment offers aesthetically pleasing light, heat, and sound projection to stimulate all the senses. The living environment is self-supporting; it can be placed on open land or plugged into an existing room. The late Joe Colombo, referring to his living environment "Visiona 69" as a prefabri-

cated plastic living machine, recalled Corbusier's statement that the house is a machine for living. Unlike a house or an apartment, the environment is not separated into rooms, nor is it zoned for separate living functions, although it is frequently multi-leveled. Through the manipulation of the system components, the environment can be totally given to living or dining or sleeping, can be custom designed and built to order, or purchased as a prefabricated product which can be knocked down for storage or delivery.

Thus the living environment, systems components, and the soft edge are the first expressions, through interior design, of the electronic age.

BIBLIOGRAPHY

Architects' Yearbook, Vol. 4, 1949, and Vol. 6, 1955. London: Elek Books Ltd. Specific information in a yearly publication.

Aronson, Joseph. *The Encyclopedia of Furniture.* New York: Crown Publishers, 1938. All-encompassing source that needs additional pictures.

Bayer, H.; Gropius, I.; and Gropius, W. *Bauhaus: 1919–1928.* Boston: Charles T. Branford Co., 1959. A thorough documentation by the founders of the Bauhaus.

Breiner and Kocker, *Architecture and Furniture.* New York: Museum of Modern Art, 1938. Valuable source until 1938.

Fabro, Mario D. *Furniture for Modern Interiors.* New York: Reinhold Publishing Co., 1954. Drawings and details of creative modern furniture.

Giedion, S. *Mechanization Takes Command.* New York: Oxford University Press, 1948. The second book by one of our foremost art historians.

Gloag, John. *English Furniture.* London: Adam & Black, 1952. A competent summary of the growth of furniture in England.

Hornung, Clarence P. *Treasury of American Design.* 2 vols. New York: Harry N. Abrams Inc., 1973. Definitive illustrated version of the Index of American Design as originally published in 1950. A must for all design libraries.

Joel, David. *The Adventure of British Furniture.* London: Ernest Benn, Ltd., 1953. Excellent nineteenth-century coverage, overstressing the British contribution.

Karlsen, A., and Tiedemann, A. *Made in Denmark.* Copenhagen: Jul. Gjellerup, 1960. A summary of all Danish arts and crafts. Good pictures.

Kaufmann, Edgar, Jr. *What Is Modern Interior Design?* New York: Museum of Modern Art, 1953. Competently prepared and illustrated book.

Lenning, Henry F. *The Art Nouveau.* The Hague, Netherlands: Martinus Nijhoff, 1951. Successful specific study of the subject.

Margon, Lester. *World Furniture Treasures.* New York: Reinhold Publishing Co., 1954. Valuable pictorial survey of contemporary furniture.

New Furniture. Edited by Gerd Hatje. Vol. 1, 1952; Vol. 2, 1953; Vol. 3, 1955; Vol. 4, 1958. New York: George Wittenborn, Inc. Vol. 5, 1960; Vol. 6, 1962; Vol. 7, 1964; Vol. 8, 1966; Vol. 9, 1969; Vol. 10, 1971; Vol. 11, 1974. New York: Frederick A. Praeger, Inc. An encyclopedic effort that presents good worldwide furniture.

Noyes, Eliot F. *Organic Design in Home Furnishing.* New York: Museum of Modern Art, 1941. A report of the historic furniture competition.

Pevsner, Nikolaus. *Pioneers of Modern Design.* New York: Museum of Modern Art, 1941. The best history of nineteenth-century art and architecture.

PART THREE

The Basic Interior

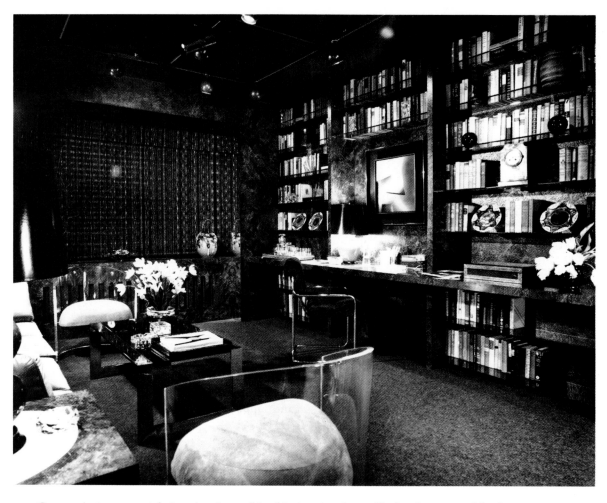

One surfacing material, formica, is used in this interior for walls, bookcases, and built-in furniture.

CHAPTER 12

Floor and Wall
Construction and Materials

An entryway combining wood, glass, tile, and plaster.

This chapter deals with architectural surfacing materials rather than with applied materials such as papers and fabrics. Applied materials can be removed at will, are not integral parts of the structure, and are therefore considered purely decorative.

The need for interior surfacing materials has not changed appreciably since man first began to construct his shelters. Until the advent of iron and steel construction, all walls, whether exterior or interior, were load-bearing. The materials employed were normally of such a coarse nature that some type of surfacing, such as plaster, stucco, marble, tile, or wood was required. Local climatic conditions and availability were important criteria determining the use and application of materials. Walls today are no longer required to bear loads. There is

still, however, a need to cover the core of a wall with some type of surfacing material.

The Renaissance encouraged all forms of artistic endeavor, and the practice of elaborately surfacing both walls and ceilings began at this time. Prior to the Renaissance, walls, both exterior and interior, were surfaced and treated in a decorative manner. However, we are more concerned with the origins of our immediate heritage. Western culture and civilization are based on the classic periods, but the remoteness of these early periods makes them irrelevant to our modern life-styles. With the Renaissance we begin to see a definite interest in finishing wall surfaces with either carved architectural woodwork or some other type of material. Ceilings complemented wall designs and were executed in molded or carved plaster; floors finished the theme and were made of parquet, marble, stone, brick, or tile. These backgrounds set the tone and form of the room and dictated the entire character of the space, even to the furnishings and appointments or accessories. Each room thus presented a single "point of view." This concept of total, single-theme design was and remains a basic tenet of good design.

When one examines, historically, the various methods of treating interior walls, it becomes apparent that there has been a gradual but persistent tendency towards simplification. Economic changes, especially a redistribution of wealth, and new building materials have influenced this development. Lack of properly trained craftsmen and a strong belief in the contemporary design idiom which decries any form of embellishment have also helped to bring this about. And since World War II, social and economic changes throughout the world have caused less sentiment to be attached to the word *home*. Whereas formerly houses were used by several generations of the same family, ease of transportation and communication have tended to diminish the importance of the home as a pivotal center. Also, the introduction of apart-

ment houses and mobile homes has contributed to this tendency, and many persons have developed nomadic habits that have lessened their interest in permanent homes. Naturally, a permanent wall treatment is the first part of the design to be deleted. In the average room of today there is usually less thought and money allotted to the design of the background than to any other part of the treatment or furnishings of the room, and with few exceptions the strong, dominating interior background has disappeared from residential design. Normally, nonresidential design still allows the interior designer the opportunity of achieving a "total design." The designer must know as much as possible about surfacing materials and trim, for it is only through their thoughtful application that he will be able to achieve some sense of total concept and a feeling of stability in his design. An interior space with only applied materials for its background will simply appear superficial.

Contemporary construction techniques allow us much greater freedom in our choice of surfacing materials, while at the same time denying us unrestricted use because of potentially high costs. Today exterior and interior walls need only support their own weight and fill the use and aesthetic requirements of the space. Interior walls are normally constructed of 2-inch by 4-inch wood or $1\frac{5}{8}$-inch to 6-inch wide metal studs placed approximately 16 inches on center or concrete cinder or other blocks. The stud wall is then sheathed with metal lath and plaster, perforated sheetrock and plaster, or sheetrock. A final finish may be ceramic tile, ½ inch marble tiles, plywood, or other laminate, or simply paint or paper. If block construction is used, the surface may be treated in any of the ways listed above. If the block walls occur in a service area, they may be painted with an oil- or water-base paint.

WOOD PANELING. Historically, wood has been by far the most popular of all surfacing materials. It is plentiful in most countries; it is easily worked; it possesses good insulating qualities; it has great personal appeal because of its warmth and richness; and it possesses great dignity and charm. Rooms treated with paneling always produce a feeling of permanency.

It is essential for interior designers to understand the design and construction of the interior architectural features which are covered by the word *trim*. The term is applied most commonly to the woodwork in a room, but is equally applicable if the elements are of stone, marble, or other materials. The stone details used as trim are similar to those of wood. In rooms of period influences, the detailing of all trim should follow, as closely as possible, that of the accepted norm of the appropriate period. Trim has been omitted from most contemporary rooms because of the high cost, or because it is felt to be unnecessary or superficial. However, even a flush metal door buck is technically a trim, so the custom has not been completely abandoned.

The term *trim*, in general, covers the following features:

Door and window trim	Mantels
Baseboards, chair rails,	Built-in
and picture moldings	cabinets
Doors and windows	(Flooring)
Cornices and coves	

All period rooms based on Renaissance design feature some of these details. Differences appear in local interpretations of detail, the materials used, and the finish given them. Variations between the Italian, French, English, Hispanic, and American use of these forms can be seen in their relative proportions, in the sections and shapes of the moldings, and in the general character of the ornament.

DOOR AND WINDOW TRIM. This term refers to the frame, composed of wood or other material, that is used to give a finished appear-

Traditional paneling updated, with bookcases, storage cabinets which also conceal television and stereo equipment, and several varieties of architectural trim.

ance to a wall opening by covering the space between the wall structure and the finished jamb and head section of the opening. A finishing trim is usually placed on both exterior and interior faces of the wall with the molding that forms the frame placed only at the top and sides of the opening. In door openings, the trim may run to the floor or butt against a plinth or plinthblock which is placed on the floor for the purpose of making a convenient junction of the trim and the baseboard of the room. In window openings the trim is cut off at, and supported by, the sill. If the window is of the French type and runs to the floor, it is treated as a door.

In a paneled room, all trim elements, including door and window trim, are designed as part of the total project. In a room with walls of a material other than wood, the trim elements must still be designed so that they represent part of a total space concept. The width and profile of the trim are determined by the demands of the period style and the scale of the room. Individual elements should never be

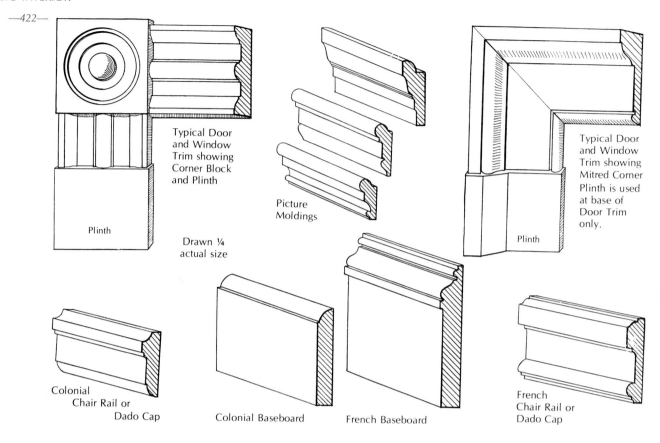

Typical Door
and Window
Trim showing
Corner Block
and Plinth

Plinth

Picture
Moldings

Drawn ¼
actual size

Typical Door
and Window
Trim showing
Mitred Corner
Plinth is used
at base of
Door Trim
only.

Plinth

Colonial
Chair Rail or
Dado Cap

Colonial Baseboard

French Baseboard

French
Chair Rail or
Dado Cap

Examples of simple types of wood trim.

designed out of context. The moldings commonly used for trim are inspired by the architrave of a classic entablature. Variations are made, and in each period style the section (silhouette) of the moldings differs. Trim should always be mitered at the corners; that is, the head or top and sides should be cut to meet at a forty-five degree angle. Properly made trim should be locked by mortise-and-tenon or joined by a dowel or wooden spline. An unsatisfactory but less expensive type of trim may be assembled by means of a square block, the trim itself being cut off at right angles and forming a butt joint against the block at each corner. The outer edge of door trim should project sufficiently far from the wall to catch the chair rail (if one exists) and the baseboard. (See page 425.) In a

room paneled completely with wood, the door and/or window trim may be very narrow or omitted entirely, as the edge of the paneling can be constructed to form a substitute for the trim.

Because of the excessive cost of carving, trim moldings today are usually rather simple. Where trim is to be painted, it should be made of white pine, birch, or any other hard, close-grained wood. If it is to be left natural, it should be finished in the same manner as the rest of the woodwork. In a room with walls of a material other than wood, the trim should be finished in a manner suitable to the design concept.

BASEBOARDS. The baseboard is used to give a finish to the lower part of a wall and to cover the space which exists between the wall

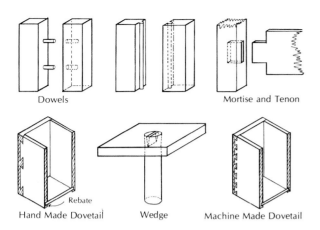

Dowels Mortise and Tenon

Hand Made Dovetail Wedge Machine Made Dovetail

Rebate

Various methods of wood joinery.

and floor surfacing material. In addition, it protects the wall surfacing material when the floor is being cleaned. The design, size, and material used for the baseboard are dictated by the period and spirit of the room. As with door and window trim, the baseboard must be designed in concert and harmony with the other trim elements. Some examples of wood baseboards are shown on page 422.

PICTURE MOLDINGS. Most period rooms are fitted with a picture molding, which was used (as the name implies) to give a continuous projecting support for picture hooks. Since pictures are no longer hung from cords and hooks, its use today would be valid only in a reproduction or an authentic period room. It also served to give a finishing line to the upper portion of the wall. The size of this molding was completely dictated by the scale of the room, but it was never an important trim element. It must be curved at the top to receive the hooks. It was normally located close to the ceiling and in conjunction with, or slightly below, the cornice molding.

CHAIR RAILS AND DADO CAPS. The term *chair rail* applies to the molding placed on a wall and running around a room at the normal height of a chair back to protect the plaster or

other surfacing material from damage. If a dado (paneling only on the lower portion of a wall) is used, the topmost member is sometimes called a dado cap. The accepted height for this chair rail is approximately 30 inches to 36 inches. If the appearance of an entire dado is desired, then the wall space between the baseboard and the chair rail may be painted the same color as the trim. A chair rail or dado cap must be designed so that its projection is less than that of any trim it abuts.

DOORS. Traditionally, the size of a piece of dressed lumber is limited by the size of the tree from which it was cut, and because of this limitation systems of paneling were developed. In the traditional manner, a door is assembled by means of stiles (vertical members in a frame or panel into which secondary members are fitted), rails (horizontal structural members), and panels. Some type of molding covers the joint between panel and stile or rail. Today, well-made doors of traditional design are still so constructed, as are some doors of contemporary design. Most contemporary doors, however, are absolutely flush and are normally referred to as hollow-core, having a segmented core with hollow pockets sheathed on both sides with plywood. The finish veneer can be of any wood. Interior doors of average size (in any period) will range in thickness from $1\frac{3}{8}$-inch to 2-inches. For fireproofing purposes, either a Kalamein or hollow metal door is used. A Kalamein door is one of wood with a galvanized sheet metal covering. It has a maximum fire rating of $1\frac{1}{2}$ hours. A hollow metal door is exactly what the name implies; it possesses a maximum fire rating of 3 hours.

A herculite or tempered glass or narrow-stile metal door with glass panels may be considered for exterior use. This type of door also is often used in nonresidential interiors, and the designer should refer to individual manufacturers for design and data.

In period paneled rooms, doors were de-

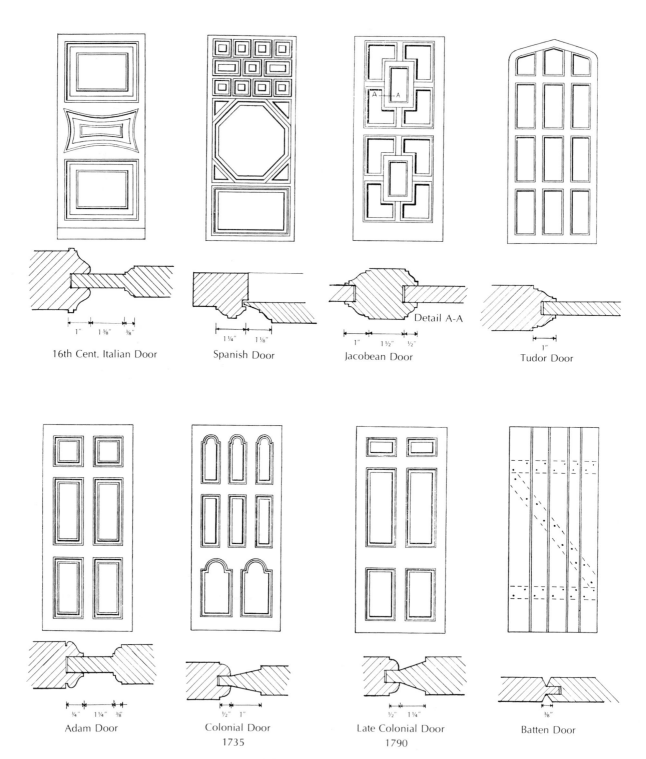

16th Cent. Italian Door

1" 1⅜" ⅜"

Spanish Door

1¼" 1⅛"

Jacobean Door

Detail A-A

1" 1½" ½"

Tudor Door

1"

Adam Door

¼" 1¼" ⅜"

Colonial Door
1735

½" 1"

Late Colonial Door
1790

½" 1¼"

Batten Door

⅜"

Period doors and door moldings.

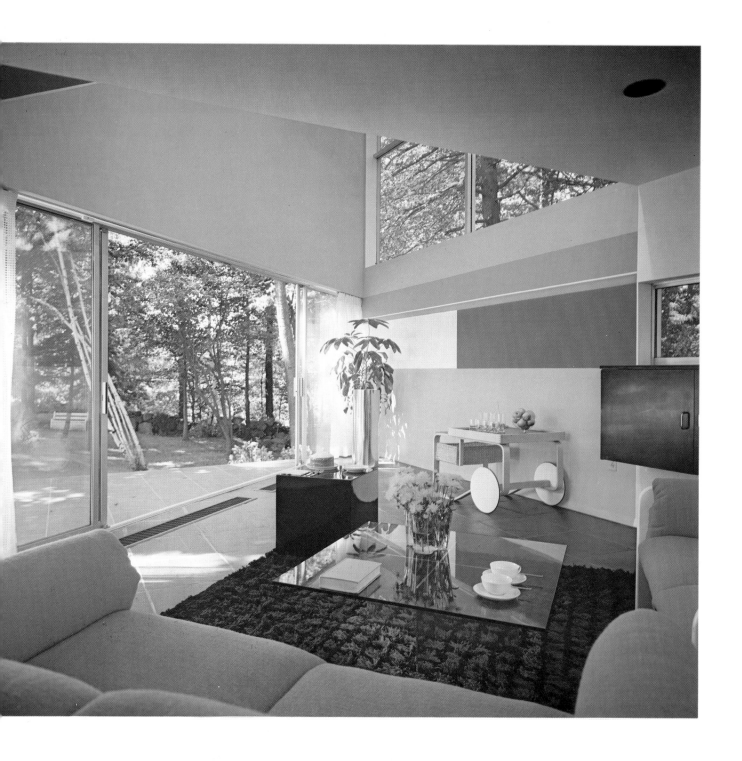

The geometrical patterns created by the super graphics on the walls help to unify and relate the large window areas in this country interior. The center of activity is planned in a square as opposed to the angled walls. The interior is extended beyond the window by the shape of the terrace.

Mayers and Schiff, Architects. Maris/Semel Photo

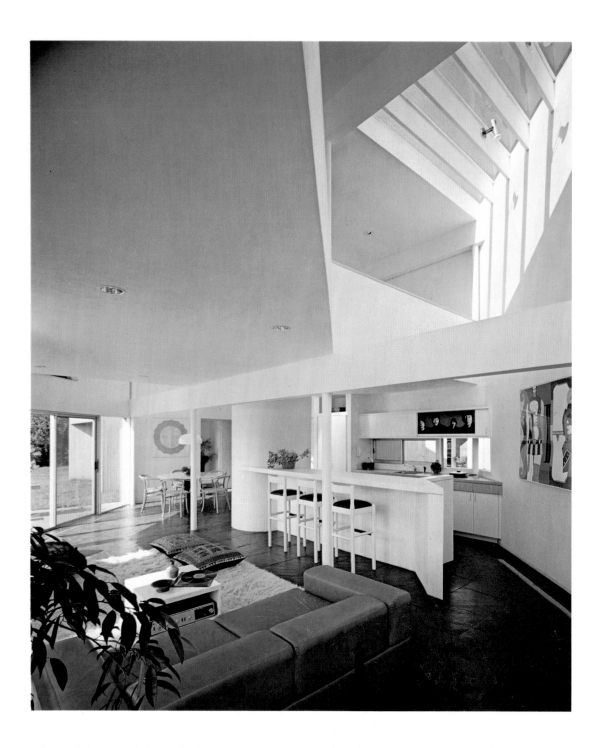

The sunlight pours through the two-story skylight to accentuate the structural elements of this contemporary interior. Built-in features such as the bar-counter become an integral part of the architecture and the furnishings, all of clean line, are held to a minimum. The white background is perfect for maximum light reflection and clear delineation of detail.

Julian and Barbara Neski, Architects. Maris/Semel Photo

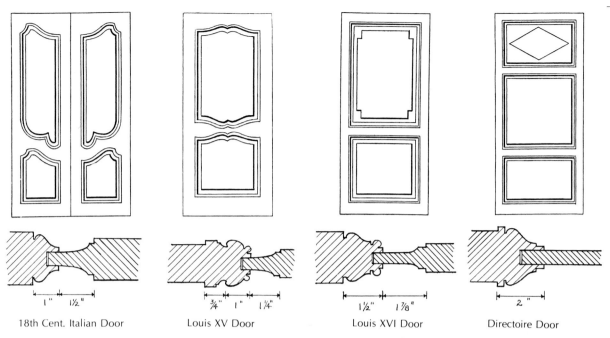

18th Cent. Italian Door Louis XV Door Louis XVI Door Directoire Door

Period doors and door moldings.

signed to complement the paneling, so each period developed different designs. Examples of these doors are shown on these pages.

WINDOWS. The two basic types of windows are casement, which are hinged at their sides, tops, or bottoms, and double-hung, which slide up and down. Variations of these two types may be called *awning, hopper, jalousie, pivoted, dormer,* or any of a number of similar terms. Whether constructed of wood or metal, all windows have the following parts: The "head" refers to the top section of both the sash and the trim. The "jamb" is the side section of both. The "stool" is the interior counterpart of the (exterior) sill and is that part upon which the jamb section is terminated. The "muntin" is a small strip used to separate the panes of glass in a sash. "Mullion" refers to a slender vertical pier between lights of a window. The term *sash* is all-inclusive and normally refers to the movable part or parts of a window.

"Fixed-sash" is just that and means that it is inoperative. Casement windows that extend to the floor are called French windows.

Usually an interior designer will not be called upon to select windows because this is the architect's responsibility. It is, however, extremely important that the designer be knowledgeable about windows, as they form the transition between exterior and interior and thus affect the character of the interior spaces.

The window sash of early periods was subdivided into small panes of glass separated by muntins. Prior to 1700, the small rectangular, diamond-shaped, or round pieces of glass were usually held in place by lead strips; hence the name *leaded-glass.* Glass at that time was made by blowing cylinders as large as possible and then cutting them into pieces. To minimize the curvature of the glass, the pieces had to be cut extremely small. Window glass today is machine-made, and the process involves still-molten glass

moving between rollers which give it an even thickness. "Single-thick" glass is normally used for windows of average size. The glass is between $\frac{1}{16}$-inch and $\frac{1}{8}$-inch in thickness and comes in sheets not larger than 28-inches by 54-inches. For larger windows, "double-thick" is used and is twice the thickness of single-thick and has a sheet size of 48-inches by 84-inches. Plate glass is used for larger windows or in locations which require the glass to have more strength. Plate glass thicknesses are $\frac{1}{4}$-inch, $\frac{3}{8}$-inch, $\frac{1}{2}$-inch, $\frac{3}{4}$-inch, or 1-inch, and the sheet size is 100 inches by 150 inches. By special order, you may have sheets of plate glass made even larger.

CORNICES AND COVES. A cornice is the top course of moldings which crowns a wall. It also serves to cover the joint between the wall and the ceiling. Since the ceiling in a paneled room is usually plaster, the cornice acts as a cap or finish for the wood-paneled wall. In rooms with a surfacing material other than wood the cornice may be made of any material.

Cornice moldings are necessary in all types of period rooms. A complete entablature is seldom necessary, except in high-ceilinged rooms with very formal architectural treatments.

The total height of all moldings in the usual classical cornice runs from $\frac{1}{10}$ to $\frac{1}{20}$ of the total height of the wall. A good proportion is about $\frac{1}{14}$ of the wall height. This space is alloted for the bed-mouldings, fascias, and crown moldings. In large cornices, the moldings are more numerous than in small cornices, and a great variety of molding forms is permissible. Examples of period cornice forms for variable room heights are shown here.

The cove is a rounded surface connecting the wall with the ceiling and should be made of plaster rather than wood. The "cove" seems to have originated in France, and may be used alone or in connection with a simple cornice form. By the use of a cove, the ceiling appears to be carried down the wall for a short distance,

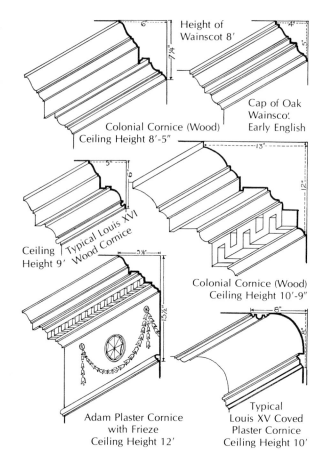

Typical cornice and cove details.

giving the ceiling a lower appearance. This effect can be heightened by painting the cove the same color as the ceiling. If desirable, the cove can also be bordered by a group of simple moldings.

MANTELS. The dictionary defines mantel as, "a beam, stone, or arch serving as a lintel to support the masonry above a fireplace; the finish around a fireplace or a shelf above a fireplace." Normally, we tend to think of a mantel as being more decorative than utilitarian, and our discussion will be confined to this aspect.

Though most architectural elements came into use through necessity, we now use many of them as embellishments or decorative items. The fireplace and its mantel are among the

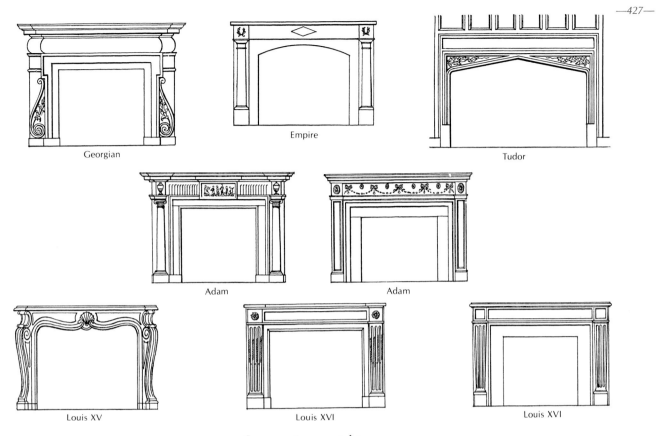

Comparative mantel types.

foremost items in this category. It was (and still is, in some areas) the only heat source in a room. For a very practical reason it was given the prime location in a room: to allow as many individuals as possible to group themselves around its warmth. For artistic or decorative purposes it was the perfect focal point in the room, and thus when the practice of embellishing interior surfaces became established, a major share of attention was given to the design of the mantel and its surroundings.

During the early Renaissance the fireplace became an integral part of rooms. Prior to this period, the heating of rooms had been a haphazard affair accomplished by various methods, depending on geographical location. In England and other northern areas, only the spaces where

people gathered were heated. Log fires were laid in the center of the room, generally in a countersunk space. There were no flues or chimneys, and smoke and sparks made their way out through openings in or near the roof. This practice accounts for the fact that so few of these structures remain today, since the roof was made almost entirely of wood.

The first fireplaces were very simple affairs consisting of a hearth, or pit, and a hooded device with a flue which ran against the wall. This arrangement was possible because of the thick masonry walls and floors which were of the same masonry or of tamped earth. The hooded fireplace remained in use for some time with little change except to become more decorative.

Mantel with detail of Bolection molding trim.

We next find the fireplace and its flue completely recessed within the wall. This arrangement permitted all manner of design possibilities. The mantelpiece came into its own, and its basic design has remained the same until today. The mantel of each period was designed on the same architectural principles as the structure which housed it. Occasionally the fireplace opening was treated with a simple trim, similar to the type used for doors and windows—a heavy bolection molding without a shelf, or with an elaborate affair consisting of side supports of columns, brackets, pilasters, etc., supporting a mantel shelf and surmounted by an entablature.

Minor factors, such as how far a mantelpiece should be from the floor, varied with each period. This sort of information is of little use except when a period room is being reproduced. However, you should be able to identify each period at a glance. A knowledge and appreciation of period styles will help to teach you scale, and a clear grasp of scale is essential to the interior designer.

It is extremely important to remember that if the mantelpiece is of wood, the fireplace surrounding it must be of a completely fireproof material. A distance of at least eight inches must be maintained between the fireplace opening and the wood. The materials are brick, stone, tile or marble, and their proper use will be determined by the style of the room. Every period style had its distinctive overmantel treatment, based on the same architectural principles

as the mantelpiece, and often enriched by carvings, paintings, or other decorative effects. The sketches on pages 427 and 428 will indicate how the mantel (including the overmantel) reflected characteristics of the various periods.

BUILT-IN CABINETS OR RECESSES. Recesses built into the walls of a room fall into two categories. The first is a purely decorative one, owing its parentage to classical architecture. These niches, or alcoves, were part of the overall design, treated the same way and with the some materials as the surrounding walls, and almost without exception were designed to contain pieces of sculpture. We find this type of recess only in classic revival structures of grand scale and proportions. Because this element is completely architectural, in that it must be built into the structure, an interior designer would rarely be called upon to execute it.

The second type, the built-in cabinet or corner cabinet, is both decorative and utilitarian. In all regions early rooms used shallow recessed spaces fitted with shelves. These cabinets were fitted with doors, shutters, or grilles, and because their contents often were valuable, locks were added. In homes of great wealth and pretense, the cabinets were used for the display of items the owner prized and valued. Thus, in elaborately designed rooms, they assumed an importance equal to that of the mantel/overmantel-piece. The storage-display cabinet became very popular, and for those who could not recess the cabinet, the corner cabinet served. A decorative wooden one would be placed in a corner, fitted with the same baseboard and painted the same color as the room, to give the cabinet a built-in look. A few examples of cabinets are shown on page 429.

DADOES, WAINSCOTS, AND PANELING. A *dado* is that part of a pedestal of a column between the base and the surbase, or the lower part of an interior wall when specially decorated or faced. The term *dado* is not synonymous with

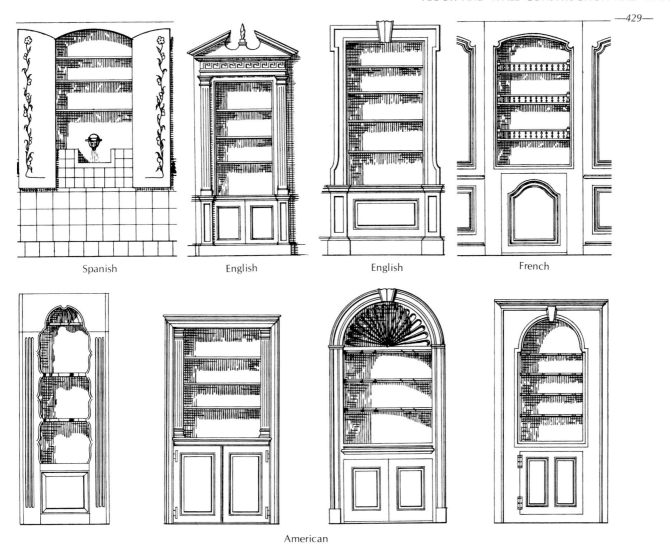

Spanish English English French

American

Examples of built-in niches and cabinets.

wood. It must be of a different material or, in the case of a wall, the lower section must be treated differently.

The dado is an architectural feature which is carried around the walls of a room, usually two to three feet high, depending on the ceiling height. The entire dado consists of a cap-molding at the top, a baseboard at the bottom, and a center section designed in panels consistent with the period style. The dado thus protects that section of a wall which receives the greatest amount of wear and tear, and it also has an aesthetic value in accenting the horizontal, thereby lessening the apparent wall height. If made of wood, the dado may be painted or left in the natural color. If painted, it may be a darker value of the wall color or a contrasting color.

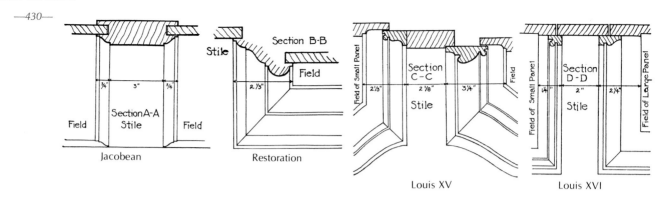

Details of construction of wood-paneled walls shown on pages 431 and 432.

A *wainscot* is a paneled wood lining of an interior wall, a lining of an interior wall irrespective of material, or the lower three or four feet of an interior wall when finished differently from the remainder of the wall. Obviously, wainscot bears a close similarity both to dado and to paneling. In today's architectural parlance, it usually refers to a surfacing material, other than wood, such as tile, marble, etc.

Paneling consists of panels joined in a continuous surface, especially decorative panels so combined. The word *paneling* may apply to any material, though the average person thinks of wood when the term is used.

Each of the periods from the Gothic to the nineteenth century produced its own type of wood paneling. Each varied in the shape and size of the panel, the kind of wood used, the finish given the surface, and the type and character of the ornament.

Because of the size limitations of wood, the dadoes, wainscoting, and paneling were designed as skeleton frameworks, composed of stiles and rails forming frames of various sizes and shapes. The frames were then filled in with a single panel or a series of boards. In the Gothic period, the edges of the stiles and rails were sometimes grooved with a molding. In the English Gothic, Elizabethan, and Jacobean periods, the panels were usually vertical rec-

tangles whose width was seldom over twelve inches. The height could run as much as three feet, and only one plank was used to form each panel. Stiles and rails were two to three inches wide and had a small cyma (a projecting molding whose profile is a double curve) or ovolo (a rounded convex molding) molding cut along their edge, and the panel was sunk below the stile. This system of rather small vertical panels produced an overall effect that virtually precluded other decorative items. At times the panels were carved with a linenfold, lozenge, or arabesque design. A simple cornice was used, although classic proportions played no part in governing the design.

In England, during the seventeenth and eighteenth centuries, the favorite woods were oak, walnut, and pine. Small twelve-inch-wide panels were no longer used. Rooms were designed with a low dado at the bottom, a cornice at the top, and panels which filled the space in between. The stiles and rails were about four inches wide, and a heavy bolection molding bordered the panel field in such a way that the field was actually about 1½ inches in front of the stile.

During the latter part of the eighteenth century, less paneling was used in England. When used, large panel sizes were employed, and there was a return to the sunken panel with

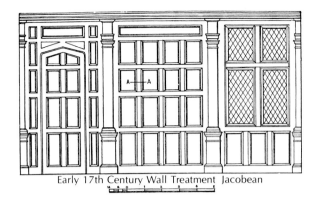

Early 17th Century Wall Treatment Jacobean

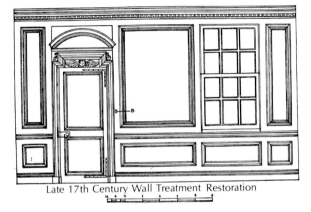

Late 17th Century Wall Treatment Restoration

Typical examples of English wood-paneled walls.

a heavy molding. The stile continued to be about four inches in width, and the paneling was most often painted.

In France, during this same period, paneled walls were elaborately carved, and the panels themselves assumed curved shapes. The stiles used in the French work were much narrower than in their English counterparts. French stiles and rails average two inches in width. The silhouette of the largest molding was also more complicated, the French often using an ovoid (egg-shaped) form. French rooms often had narrow panels alternating with wide ones, and the moldings were reduced or increased in size to harmonize in scale with the width of the panels. The field of each panel was carved, painted, left natural, or treated with a textile,

wallpaper, or mirror. Louis XVI style panel molding was of the simplest variety, and additional accentuation of the frame of the panel was produced by striping with a color that contrasted with the color of the balance of the woodwork or by using gilt.

All wood paneling in colonial America was based on contemporary work in England. Later periods reflected what was being done in France. However, the vitality and naïvete in American work made it more than a mere duplication of its European counterpart. The only period which was distinct from those in Europe was the American Federal period, a refined and less robust Georgian and, of course, still classical in feeling. Examples of typical paneled walls with the actual molding silhouettes are shown on pages 430 to 433.

The use of applied moldings to simulate paneling is not recommended. If, however, they are going to be used for an effect, their scale, profile, and placement should be the same as if they were being used as an integral part of a paneled wall.

The most successful contemporary paneling is that which is straightforward and does not attempt to be period. To reproduce period paneling is extremely costly and normally not compatible with the scale of our present-day interiors. However, when conditions are favorable, the results may be valid and acceptable provided the designer knows his period well enough to make it work within the confines and demands of his project.

It is therefore preferable to design and work in a strictly contemporary manner, which implies the use of large planes or areas of plywood with a finishing veneer and few or no embellishments. A simply executed paneled wall has the same appeal as an antique paneled wall. The richness of the graining and the color are sufficient to carry the design. The design and methods of execution of antique paneling were the direct result of the limitations of the ma-

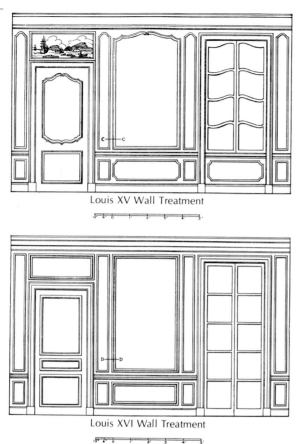

Louis XV Wall Treatment

Louis XVI Wall Treatment

Typical examples of French paneled walls.

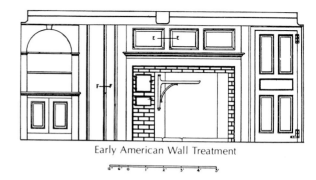

Early American Wall Treatment

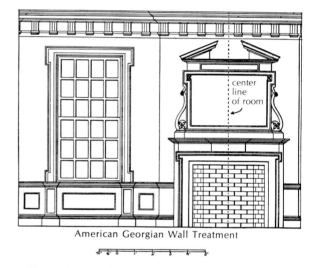

center
line
of room

American Georgian Wall Treatment

Typical examples of American wall treatments.

terials available. Present-day wood veneer laminates also have their limitations, of which the designer must be aware.

Most contemporary paneling is executed with plywood finished with a top-grade wood veneer. It is available in the following thicknesses: ¼-inch, ⁵⁄₁₆-inch, ⅜-inch, ½-inch, ⅝-inch, or ¾-inch, and in sheets 4-feet wide by 8-feet high. Larger sizes are available but are not normally stocked. The panel thickness most used is either ¼-inch or ¾-inch.

Plywood ¼-inch thick is generally factory finished and is used for inexpensive projects in areas of secondary importance. The panels may be had flush, with grooves simulating joints, or with special effects achieved by sand-blasting.

These ¼-inch thick panels may be applied directly to existing walls provided the walls are fairly flush and true, but it is recommended that furring strips (thin wood strips) be applied to the walls and the panels attached to them. The furring compensates for uneven walls and creates an insulating airspace. In new frame construction, the panels are fixed directly to the studs in much the same manner as gypsumboard.

The ¾-inch thick plywood panel is vastly superior to the ¼-inch, and is made of five-ply exclusive of the exterior finish veneers. This panel possesses many good features, including its structural strength and its ability to remain true and not warp, as well as to act as an insulation against sound and temperature. Its thick-

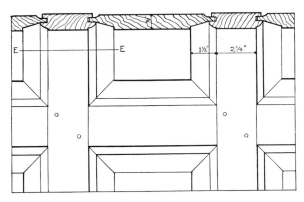

Actual construction and shape of moldings used in Colonial panelling.

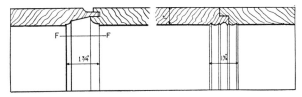

Actual shape of moldings used for Colonial plank walls.

Details of construction of wood-paneled walls shown on page 432, right.

ness enlarges the design potential, and the designer may select his own veneers or laminates (such as Formica), which are then applied. The installation is done in much the same manner as with the ¼-inch except that mastic may not be employed. Methods of detailing ¾-inch plywood are endless, and this material is now used almost exclusively for the fabrication of case pieces of furniture and built-ins. It is extremely important to remember that plywood edges must never be left exposed. Only the flat sides are finished; the edges show the various layers of wood in the plys. When detailed working drawings are prepared, a hardwood strip must be indicated to finish the edges.

If the item is to be painted, birch or some other close-grain wood should be specified as the finishing veneer. For paneling which will remain unpainted, it is best to select a wood veneer having a grain pattern that enhances your design. The simplest finish is obtained by first using a wood filler and then oiling or waxing. In order to darken or alter the natural color of the wood, a stain must be applied as the first step. In order to lighten, a bleach must be applied. A clear lacquer may be applied at the end; however, a waxed finish is considered by many to be easier to maintain. The finisher should submit a sample of the finish to the designer for his approval before the work is begun.

Wood was certainly not the only surfacing material favored by our ancestors. They used and enjoyed many materials. Their choice depended on local climatic conditions, availability, the use or function of the space in question, and the desirability of a material as decreed by fashion. In all cases, the material was treated as a veneer and was truly "a surfacing material."

PLASTER OR STUCCO. These two words have the same meaning, but because stucco is normally thought of as an exterior material and plaster as an interior surfacing material, we shall use *plaster*. It has, perhaps, been used in more locales and for a longer period of time than any other material. Plaster is made by mixing Portland cement, sand, lime, and water. It is applied in a plastic state to form a hard covering for walls, and may be given a smooth troweled finish, a sand finish, an irregular or rusticated finish, or may be molded into designs of volutes, curves, etc.

Plaster has true universal appeal, being found from the Orient to Europe—in fact in every country, on every continent. Its ability to curve and take the form of any shape makes it unique. It is the material which, in the brown or scratch coat stage, forms the base for finishing materials such as marble, scagliola (an imitation of ornamental marble, consisting of finely ground gypsum mixed with glue), and ceramic tile. In its final, or white coat, stage it takes such finishes as paint, wallpaper, vinyl wallcovering, cork, leather, or mirrors.

Other than plastering directly onto stone,

concrete cinder block, etc., plaster is usually applied in two ways. First, a partition is installed using either wood or metal studs sheathed with metal lath or perforated gypsum lath which has been nailed or fastened to the studs. A brown or scratch coat of plaster is then applied with a finish of a thinner white coat. The entire thickness, including the lath, varies from ½-inch to ¾-inch. If ⅜-inch gypsum lath is used, the plaster coat is ½-inch thick, including the thin white coat.

CERAMIC TILE. This surfacing material has long been a favorite among designers of many nationalities. Ceramic tile immediately brings to mind countries like Spain, Portugal, Italy, Holland, and, of course, the Arabic countries of North Africa and the Near East, where it has

Italian glazed ceramic tiles provide the floor surface in this foyer. Chinese screen panels conceal a coat closet and shelves.

been used extensively. However, these countries have no monopoly, since it is used in all of Europe. The variety of colors and designs which can be applied is endless. This fact, coupled with its ease of maintenance, has put tile in the first rank of surfacing materials.

The conventional method of installing ceramic tile is to apply waterproof building paper, then lath with browncoat, giving a ¾-inch maximum setting bed, then neat cement, and finally the wall tile. These tiles vary in thickness from $\frac{5}{16}$ inch to ⅜ inch. With the "thin set method," ½-inch gypsum wallboard is attached to the studs, and then a primer and adhesive are applied to support the wall tile. The primer and adhesive may be used directly on a finished plaster wall provided it is smooth and true. This second method has been used in areas subject to extreme wetting, such as showers, but there is a chance that the finished wall may not be completely waterproof.

MARBLE. Marble has enjoyed great popularity since antiquity and is usually associated with costly formal interiors. However, the cost of marble is no longer prohibitive, amounting to no more than any other first-class surfacing material. As with tile, it is extremely easy to maintain, requiring only soap and water. There is a very wide range of choice in marble, both in color and pattern or veining.

Marble is a dense material, and its weight probably limits its use more than any other factor. Except for marble tile, which is ½-inch thick, marble is normally ⅞-inch thick, and provision must be made to support this weight. It is recommended that a minimum of 1½ inches (including the ⅞-inch marble) be maintained from rough wall to finished marble face; the difference is accounted for by the plaster of paris setting wall. Marble tiles are obtainable in a maximum size of 12 inches by 12 inches. They are used and set as ceramic tile. Unfortunately, there is a disadvantage to these small

tiles in that most of the effectiveness of the veining is lost. Other natural stones, such as granite, limestone, and sandstone, as well as manufactured stone such as scagliola, are installed in much the same way as marble. They have the same design potentials as marble, and scagliola has an additional feature in that it can be molded into various shapes to form architectural trim.

NEW PANEL SYSTEMS. In recent years, many manufacturers have developed panel systems with various surfacings and backup materials. The standard sheet size of 4 feet by 8 feet has been maintained so as to conform to construction techniques, and installation is much the same as for plywood. Wood-veneered plywood has an advantage in that matching trim can be made of hardwood. The new panel systems do not have a companion trim, so other provisions must be made.

These new systems have great potential and should find wide acceptance in hard-trafficked areas and wherever maintenance is a problem. Local architectural sample centers can give the designer complete information.

MIRRORS. Mirrors used architecturally rather than decoratively can be one of the most exciting surfacing materials. By architecturally, we mean the use of large sheets applied to the walls. The designer must be certain that the use and placement of the mirrors enhance the architecture of the space and relate directly to it. Mirrors used without valid reason will appear just as false as any other surfacing material used indiscriminately. Careful studies must be made to determine whether or not the mirrors will reflect the desired and correct portions of the space in question.

The best mirror work is done with ¼-inch thick copper-backed plate glass. All edges must be polished and templates made of any projections around which the glass will be cut. The mirror is installed directly on the wall or on

A mirrored wall used architecturally rather than purely for decoration.

furring strips which are used to "level-out" the wall. A mastic is used to adhere the glass to the wall. The bottommost pieces of mirror are also supported by ½-inch white metal clips screwed into the wall. No screws taped with rosettes should be used to support the glass. "Double-thick" glass may be used in place of the ¼-inch plate. It is usually less expensive, but has the disadvantage of possessing imperfections.

GYPSUM PLASTERBOARD (SHEETROCK). Plasterboard, of all surfacing materials, is the easiest to install, least expensive, and least satisfactory. After applying the boards directly to studs (or rough walls), the joints are covered with a gum tape, spackled, and sanded. All indentations caused by the nail-heads must be similarly treated. The use of a wallcovering over the

sheetrock helps to conceal the imperfections. Sheetrock has no supportive qualities; it will not bear the weight of a picture unless the picture hook happens to strike a stud. Therefore, the designer should, if possible, plan his wall arrangements before construction and specify horizontal studs at the necessary points. In spite of its disadvantages, gypsum board or dry-wall construction is the most prevalent in this country.

BIBLIOGRAPHY

Beveridge, T. J. *English Renaissance Woodwork.* London: B. T. Batsford, Ltd., 1921. Excellent measured drawings, chiefly of the period of Sir Christopher Wren. Good for tracing and design work.

Brodatz, P. *Wood and Wood Grains: A Photographic Album for Artists and Designers.* New York: Dover, 1972.

Daly, C. *Historical Motifs of Architecture and Sculpture,* 2 Vols. New York: Wm. Helburn, Inc. Scaled drawing of French woodwork, mantels, and architectural and decorative details.

Dunning, W. J. and Robin, L. P. *Home Planning and Architectural Drawing.* New York: John Wiley and Sons, 1966.

Gale, D. W. *Specifying Building Construction: A Guide for Architects and Engineers.* New York: Reinhold, 1961.

Gatz, Conrad. *Modern Architectural Detailing.* New York: Reinhold, 1961.

Knobloch, P. *Good Practice in Construction.* New York: Pencil Points Press, 1925. Scale drawings of architectural woodwork.

Koehler, A. *The Properties and Use of Wood.* New York: McGraw-Hill, 1924.

Kribs, D. A. *Commercial Foreign Woods on the American Market.* New York: Dover, 1968.

Measured Drawings of Woodwork Displayed in the American Wing. New York: Metropolitan Museum of Art, 1925. Portfolio of scaled drawings of the woodwork exhibited in the American wing.

Newell, A. C. and Holtrop, W. F. *Coloring, Finishing and Painting Wood.* Peoria: Charles A. Bennett Co., 1961.

Ramsey, C. G., and Sleeper, H. R. *Architectural Graphic Standards for Architects, Engineers, Decorators, Builders, and Draughtsmen.* New York: John Wiley and Son, Inc., 1970. An encyclopedia of dimensions.

Schaal, R. *Curtain Walls.* New York: Reinhold, 1962.

Schuler, S. *The Wall Book.* New York: M. Evans & Co., 1974. Practical approach to wall construction in the home.

Sunset. *Ideas for Bookcases and Bookshelves.* Menlo Park: Lane, 1952.

Tanner, H. *English Interior Woodwork of the XVI, XVII, and XVIII Centuries.* New York: Architectural Book Publishing Co. Reprint. Measured drawings with descriptive text.

Tipping, H. A. *Grinling Gibbons and the Woodwork of His Age.* London: Country Life, 1914. Illustrated text.

Warne, E. J. *Furniture Mouldings.* London: Ernest Benn, Ltd., 1923. Measured details of English furniture moldings (full size).

The Sidney and Harriet Janis Collection.
Gift to Museum of Modern Art, New York.

Le Gros, 1961, by Franz Kline in which dramatic impact is achieved by strong tonal contrasts. Oil on canvas.

CHAPTER 13

Color Theory

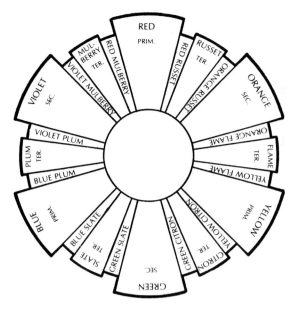

Color wheel showing the 24 basic colors in their proper relationship. Colors that are complementary are opposite each other. This arrangement is for the mixture of pigment colors only. Colors from light-rays vary in their complements from those shown above. The arrangement is for hues of full chroma or equal tonal value. Each hue is subject to an infinite number of neutralized gradations toward both white and black. The wide segments indicate the primaries and secondaries, the medium-sized segments indicate the tertiaries, and the smallest segments indicate the quaternaries.

Introduction. The study of color for the interior designer requires an understanding of the interrelationship of the physical, chemical, physiological, psychological, and aesthetic components of the subject, as well as the ability to utilize and manipulate these concepts in environmental design. Continual research in the sciences is expanding our knowledge of color in all its facets. Collaboration among color specialists from many countries has increased in recent years for the purpose of organizing and disseminating the results of this research.

The physicist defines light as the source of color. The chemist is responsible for supplying the manufacturer with dye or pigment for his particular product. The physiologist is involved with the eyes' reaction to the light rays and the transfer of this message to the brain. The psychologist explores the sensation occurring in the brain which precipitates a variety of emotional responses. Color activity can therefore be broken down into four stages. First there must be light, the source of color; secondly, the object for the light rays to act upon; thirdly, the eye which receives the reflected light from the object; and lastly, the brain which interprets this sensation. This gives us the following sequence: light, object, vision, consciousness. There are subjective colors, however, which may require no stimulation of light rays, that is, colors seen in afterimages, in dreams, from pressure on the eyeball, or colors that are experienced by taking certain psycho-chemicals such as LSD.

Color chemistry. Throughout the ages man has used his ingenuity to utilize nature as a source for color. Plant life supplied leaves, berries, and roots. Bones and vital fluids of fish, birds, and insects provided a base for pigment. Clays and minerals also made valuable contributions. The challenge to man lay in finding the best method of extracting the color from these sources.

The Roman encyclopedist Pliny the Elder describes in his *Natural History* the colors that can be obtained from certain plants and animals and gives instruction on preparation of these dyes. The Phoenicians produced the Tyrian purple dye from the gland of the murex snail found in the Mediterranean Sea. Thousands of these snails were required to make small amounts of this purple dye so a Roman emperor could wear his robe of Tyrian purple while his subjects wore unbleached cotton. The Egyptians permitted only their sun god, Ra, the use of purple, a difficult hue to produce.

The ink sac of the cuttlefish supplied man with sepia. From a tiny insect called cochineal, Mexicans and Peruvians obtained a carmine red valued in Europe during the Renaissance. Among the most important minerals supplying pigment was lapis lazuli, which was pulverized to give an ultramarine. Malachite was powdered to produce green.

For application, pigments are always mixed with a liquid, which is called a vehicle. The study of vehicles is an important part of color chemistry, and the choice of vehicle is determined by the pigment used and the object to be colored. For the ancients the vehicle was usually animal fat. Research in new dyes was limited for many centuries except for the great painters who experimented with pigments and vehicles. Egg yolk and water were mixed with powdered pigments by Italian painters in the latter part of the fifteenth century, when this egg tempera was assimilated and later superseded by oil paint. A few common vehicles are water, mineral and vegetable oils, natural and synthetic gum varnishes, cellulose solutions, and solvents.

The first breakthrough in synthetic color occurred in 1858 when William Henry Perkin, an eighteen-year-old English medical student, was trying to produce a synthetic solution of quinine. By distilling a coal tar he accidentally produced a blue-red dye. This "Perkins Mauve," our first synthetic color, was available in the commercial market a year later. Thus the science of color chemistry was launched.

How the eye sees color. The eye of the infant is first able to distinguish value contrasts, then movement, next shape, form, and, lastly, color. The eye has often been compared to a camera. It is more than that, for it develops the images formed on the retina and flashes them through the optic nerves to visual brain centers. The retina is supplied with microscopic nerves called rods and cones. These two sets of nerves fulfill special functions. The rods register the bright-ness, shape, and movement of objects, while the cones register fine details and color. When we pass from bright sunlight into a dark area, several minutes are required to adjust to the transfer from the activity of the cones to the rods. There is a threshold of illumination below which color cannot be seen, but brightness, shape, size, and movement can be detected.

Man, as a primate, has color vision, but most animals see the world in shades of gray. Exceptions are birds, lizards, turtles, and some higher species of fish. The most prevalent type of color blindness is the inability to distinguish red and green, which appear very neutral—almost as shades of gray. The red/green blindness is evident in about one man in twenty and one woman in two hundred. Very few persons are defective in yellow/blue vision, and seldom is anyone totally color-blind. Defective color vision can result from an injury but is primarily inherited through the distaff side.

Source of color. The origin of all color seen in the world is light. Light in the form of sunlight travels to us in waves. The visible color rays which are responsible for giving color to our life occupy only a small part of the electromagnetic spectrum of radiant energy. The terms are familiar, but we cannot see the other components of radiant energy—that is, gamma rays, X-rays, ultraviolet rays, radio waves, etc. Each color in the spectrum has a particular wavelength, the blue end of the spectrum being shortest and the red end longest.

The exact effect of a surface on a beam of light can be determined by a spectrophotometer. This instrument can select a colored light from a spectrum and measure the extent to which that particular wavelength is transmitted by the surface.

Action of light rays on surfaces. For centuries colors were assumed to be indigenous to the objects around us. This theory was rejected

in the seventeenth century when Isaac Newton, the eminent English scientist, permitted a small ray of sunlight to pass through a glass prism and discovered a visible rainbow of colors refracted to the opposite wall. He concluded that colors were not qualities of the object, but were contained in sunlight itself. The rainbow is the ideal example in nature of this dispersion of sunlight into a continuous gradation of colors called a spectrum, the raindrops themselves serving as tiny prisms. Therefore, when a beam of light strikes a colored surface, most of the light rays are absorbed by that surface except the color which is visible to us. The surface on which the light falls may be pigment, fabric, carpet, wallpaper, paint—it matters not—the theory holds.

Additive color mixture in light. Just as Newton produced a spectrum from the pure white beam of light, he could also reverse this process, recreating white light from the spectrum. The spectrum hues of light range from red, yellow, green, blue to violet. In order to produce a white light, we can combine the three hues equidistant on this light spectrum, red, green, and blue. These three hues, known as light primaries, overlap to form intermediate hues. This interaction, called the additive process, is the basis of color television. The inside of the picture tube is coated with tiny dots of red, green, and blue. When stimulated by appropriate electronic waves, these light primaries combine to form all other colors.

Subtractive color mixture in pigments. When dealing with light on a colored *surface*, a different phenomenon takes place. The colored surface filters or subtracts some of the colors from the white light, leaving the others visible to the eye. This ability to transmit one spectral region and absorb others is known as selective absorption. When a beam of light strikes a red surface, the green, yellow, blue, and violet rays are absorbed, and the red is reflected. When we mix red, blue, and yellow pigments, the pigment primaries, in the right proportion, we get a dark gray. Any two of these three primary pigment hues, when combined as described, give us our secondary hues, orange, purple, and green. Not only pigments, but inks, dyes, and filters will react the same.

It must be understood, however, that the same basic principle is demonstrated in both these processes of light and pigment combinations. Light still remains the source of color. Consider what actually takes place when blue and yellow pigments are mixed. The blue paint, as measured by a spectrophotometer, absorbs strongly in the red, orange, and yellow end of the spectrum. The yellow paint absorbs the rays at the opposite end, the blue and violet.

The resulting ray in the middle of the spectrum, not absorbed by either of these pigments, is green, which is reflected to the eye. This action can be demonstrated by covering each end of the spectrum as described above. Whatever sensation reaches our eye is the part of the spectrum not absorbed by the surface.

Color wheel. Before the designer can communicate color, he must learn a system of color identification. When we see a rainbow arching across the sky or observe the spectrum after a beam of light has passed through a glass prism, the resulting sequence of hues is violet, blue, green, yellow, red. The red end of the spectrum can be joined to the violet so that our curved rainbow spectrum becomes a complete circle. We now have a continuum of hues which includes all the intermediate hues produced as each hue overlaps its neighbor.

The twenty-four basic hues may be divided into what are termed *primaries*, *secondaries*, *tertiaries*, and *quaternaries*. These divisions, indicated on the color wheel, are as follows:

3 Primaries. Blue, red, and yellow.

3 Secondaries. A combination of any two primaries: violet, a combination of blue and red; orange, a combination of red and yellow; green, a combination of yellow and blue.

6 Tertiaries. A combination of a secondary color with any additional quantity of one of its constituent primaries. The generally accepted designations are: plum or blue violet; mulberry or red violet; russet or red orange; flame or yellow orange; citron or yellow green; slate or blue green.

12 Quaternaries. A combination of a tertiary with either its constituent primary or secondary. There are no standardized names for these intermediate hues, and they vary only slightly from their adjoining hues. They may best be designated by coupling the name of the tertiary with its additional admixture, such as blue plum, violet plum, yellow citron, greenish citron.

It is essential for the interior designer to recognize the relative position on the color wheel of the particular hue he is using. This location on the color wheel indicates the hue family, which is the first of the three qualities of color. A patch of color may be dark, medium, or light. The normal eye is said to be capable of differentiating one hundred steps from black to white. This second quality of color, the *lightness or darkness*, is referred to as value or tonal value. The third quality is the degree of purity, intensity, or saturation. Munsell uses the term chroma in this dimension. Students of color must recognize these three qualities in every color sample: (1) hue family (position on the color wheel), (2) tonal value (degree of lightness or darkness), and (3) chroma (degree of purity, intensity, or saturation).

Color systems. Systems of color identification generally organize the spectrum into a fixed number of hues, with varying degrees of value and intensity. Two of the major systems used today are known by the names of their creators, Wilhelm Ostwald and Albert H. Munsell. Their color charts have become standardized and are used extensively throughout the world. These systems are not primarily intended as guides for harmonizing colors, but are established to give specific color designations only.

Ostwald color system. This system arranges lettered color chips in triangles and describes them in terms of purity, whiteness, and blackness. The purest hues contain no white or black. The original system divided the spectrum of colors into twenty-four basic numbered hues with twenty-eight variations of each in lightness or darkness.

Munsell system. The Munsell system of color designation has proven the most practical for the interior designer. Professor Albert H. Munsell, born in Boston in 1858, felt the need for greater accuracy in identifying color in his painting classes. Munsell based his system on a theoretical solid form, similar to a globe. The vertical axis is graduated into nine shades of gray, with black at the base as zero and white at the top as ten. The colors of the spectrum are divided into twenty basic hues represented as vertical pie sections of the solid with their purest colors located around the perimeter or equator of the sphere. The spectrum colors are also arranged as a color wheel, each hue being indicated in its most brilliant chroma on the outside of the wheel. The hues are then neutralized in graded steps toward the center of the wheel until they approach a neutral gray axis.

The Munsell system uses charts with standardized color chips, each chip representing the three qualities of hue, tonal value, and chroma. Hue is the color family, that is, red, blue, etc., and is indicated by a single letter—R for red, G for green—or pairs of letters, such as GY for green yellow. Tonal value indicates lightness or darkness of a color on a scale ranging from zero for theoretical black to ten for

theoretical white. Chroma, indicating the purity or saturation of the color, is identified by a number preceded by a slant line following the value notation.

Each hue is set up as a chart with chips of color representing the various tones and chromas possible for that particular hue. Each chip is identified with a number representing the tonal value and a number representing the chromatic purity, and is marked in the manner of a fraction, such as 2/6, which indicates the second tonal value and the sixth chromatic step of a hue. To differentiate more easily between these two qualities for teaching color harmony, the numbers indicating the chromatic steps may be transposed into letters (2 = B, 4 = D, 6 = F), which changes a label red 2/6 into red 2/F.

The tonal values are arranged vertically from one to nine, one being black and nine being white. The chromatic steps are arranged horizontally. As we step to the right on the same horizontal line, each chip becomes brighter or more chromatic while the same tonal level is being maintained. Each chip of color, therefore, can be identified by a hue family—red, blue, yellow, etc. Each chip also has a tonal value number and a chromatic number, or, as transposed, a letter.

Color mixing. Preliminary color schemes can be made by using tempera paints, and the ability to mix these paints is a valuable tool for the interior designer.

All colors are made from the basic primary hues, red, blue, and yellow, with the addition of white and black paint if required. Our secondary or complementary colors are combinations of these three primaries:

Primaries	Secondaries
red	green (blue and yellow)
blue	orange (red and yellow)
yellow	violet (red and blue)

Besides adjusting the hue by moving it in either direction around the wheel, there are four other adjustments for a color mixture—neutralizing, intensifying, lightening, and darkening.

A brilliant pigment may be dulled or neutralized until it becomes almost a gray by adding a pigment of the color directly opposite on a standard wheel. If this is done in varying amounts, one obtains definite steps or degrees of neutralization. The most neutral step is close to a gray that has been slightly tinged by the original color. It is possible to arrange a row of samples of each hue in varying chromatic values. The pigment hues cannot be divided into the same degrees of neutrality or chromatic steps due to the varying chromatic potential of each hue at its different tonal levels. For example, the most brilliant yellow has a very light tonal value compared to the most brilliant blue or red. You will find that basic yellow pigment neutralizes very rapidly so that only a few degrees of neutralization of this hue are possible when taken to a light value. Black pigment should be used sparingly in neutralizing pigment colors, as it tends to submerge the chromatic purity very rapidly and darkens the mixture so that adjustment is necessary. Two brown tempera paints are available called sienna and umber. Sienna is a warm red-brown, and umber is a cold blue-brown. Both are valuable as neutralizers and for mixing a variety of browns and beiges. A fairly good black can be made by mixing blue and umber or violet and umber. The addition of white will give steps of gray. A color mixture can be brightened by adding the basic hue. It must be recognized, however, that tempera paints are limited in chroma potential, and it may not be possible to match some of the brilliant colors found in contemporary fabrics and wallpapers.

To darken a mixture we may add the complement, black, sienna, or umber, or a combination of these may be added. To lighten a mixture, white is added to the base pigment. If our aim is to obtain a tint, however, the

process is reversed, and a drop of pigment is added to white paint.

It is vital to remember that white paint may contain blue. Therefore, adding white to any mixture may affect the original pigment by introducing this blue tint. For example, when a drop of red is added to white paint, the result tends towards a pale violet, not pink. This is because the blue in the white paint combines with red to give a violet cast. To counteract this reaction, a drop of yellow, the complement of violet, will neutralize and eliminate the violet cast and will give the desired pink mixture. White paint added to green will swing it to the blue side. As green contains blue and yellow, the addition of yellow will adjust it. It is essential, therefore, that the presence of blue in white paint be anticipated, counteracted, and eliminated if the mixture is to retain its original color characteristic. The addition of most black pigments introduces a blue effect. Black with yellow forms a greenish olive. Black with blue tends towards violet. In an average gray scale, black with white may form bluish grays. Touches of a brown pigment like Van Dyke brown may be necessary to keep the grays neutral and free of undesired tinges.

Because the chemical constituents of pigments differ, the mixing of colors does not always result in practice as the theory would indicate. There are, for example, many different blue pigments, some having a slight tinge of green, and others having a slight tinge of red. The combination of these tinges with a second color would give a slightly different result. The only accurate method of mixing pigments is by trial and error and the correction of unwanted tinges by adding their complements and adjusting with white, black, other neutralizers, and hues as required.

Simultaneous contrast. The interior designer soon discovers that his color samples may differ in hue, tone, and chroma when placed in different surroundings.

The explanation of this color phenomenon, known as the theory of simultaneous contrast of color, is generally attributed to Michael Eugene Chevreul, a French scientist born in 1786. As director of dyes for the Gobelin tapestries, he received complaints on the lack of stability of certain colors. On investigation, Chevreul discovered that this color weakness was caused by the interaction of neighboring hues. As presented in his book, *The Law of Simultaneous Contrast of Color*, the basis of Chevreul's theory is that all three qualities of color—hue, tonal value, and chroma—influence the adjacent area. Whenever different background colors are used, or two colors placed in juxtaposition, surprising changes result. It was discovered that each hue projects its complement on the adjacent hue. To demonstrate this principle, a test can be made by taking two small squares of red. Place one on a violet background and one on an orange background. The red placed on the violet background appears tinged with yellow, the complement of violet. The red placed on the orange background is tinged with blue, the complement of orange.

As each hue projects its complement into the neighboring hue, it is obvious that maximum intensity for a color can be achieved by surrounding it with its complement. This visual phenomenon has been understood and demonstrated by artists and craftsmen for centuries. Red, the most prevalent color in primitive art, essentially an outdoor art, is the complement of green, the dominating color in nature. Italian scholars in the fifteenth century recorded that red next to green increased the vividness of each hue. Textiles made during the Renaissance also illustrate that this visual reaction was empirically grasped and applied. The French painter Delacroix used wide brush strokes of complementary colors of equal value and chroma in

order to achieve greater intensity of both hues.

Afterimage. This same phenomenon of the projection of complementary hues takes place if a color sample, gazed at for a minute or so, is replaced by a white surface. If we stare at a black, white, or colored surface and then shift our eyes to another white surface, black replaces the white, white replaces the black, and the colored area in the original is replaced by its complement. For example, if a square of green is viewed against a white wall for thirty seconds, and if the viewer continues to gaze at the wall immediately after the green sample has been removed, he will see a pink square, or tint of red, projected on the wall. A surgeon performing an operation is gazing primarily at red, and, on looking up at a white wall, he will see the afterimage of green. A tint of green is therefore generally preferred for operating room walls and surgeons' and nurses' gowns, as these green surfaces will absorb the afterimage of these green spots, thus eliminating a disturbing effect. The physiological reason for this reaction can be explained by recalling that the cone nerve ends react to the various light rays of the spectrum. When the cones sensitive to red are being used, these nerves become fatigued after a certain period, and a chemical in the eye bleaches out the red and activates the nerves which are not being used, resulting in the green afterimage.

Effect of value relations. The degree of lightness or darkness of a color is affected by adjacent color values. For example, if we take two small gray disks of similar size and tonal value, placing one on a white background and one on a black background, the disk on the white background will appear darker than the one on the black background. Strong contrasts cause the light areas to appear lighter and the dark areas to appear darker. A white disk on a black back-

ground will appear larger than a similar one placed on a gray background. The same condition results if a chart with a strip of neutral gray is flanked by varying steps of gray from off white at the top to black at the base. The solid gray center strip appears to get lighter as it descends.

Metamerism. The designer occasionally finds that some color samples may be a close match in daylight but a poor match under incandescent light. This phenomenon becomes clear when the difference between physical match and visual match is understood. If two hues match physically, that is, have identical reflectance curves as measured by the spectrophotometer, they will match under all viewing conditions. If, however, two hues that do not have similar reflectance curves are compared by the eye, they may match under one type of light and vary under a different set of conditions. The instrument used to calculate the visual response is called a colorimeter. Colors that vary under different illuminants are known as metameric colors.

This situation may be controlled by introducing a patterned or textured surface into the main or secondary areas that includes both variables of the metameric color.

The effect of natural light on color. Every type of light, whether sunlight, incandescent, or fluorescent, introduces its own indigenous color to the interior. We are therefore dealing with the spectral characteristics of the light falling on the area as well as the reaction of the surface itself to the light. The designer is responsible for the success of a color scheme in daylight and under artificial light. A combination of sun and artificial light is generally used during the daytime hours, as daylight often needs to be supplemented by artificial lighting.

For many years there has been an assumption that rooms with southern exposure should use cool colors, and rooms with northern expo-

sure should use warm colors to counteract their source of light. It cannot be assumed, however, that the *quality* of light entering a room from a specific direction is always the same. The color quality of the light reaching a surface is the average of the light that reaches it from all points in the environment. The designer must study the location and size of the windows. He must also note if there are buildings standing opposite and, if so, the amount of light reflected from those sources. Even the light reflected from green leaves outside a window will affect the colors in the room. A room facing north with a long window wall, and a white building opposite will be moderately bright even though no direct sunlight enters. Another situation would be a room facing south that is long and narrow with two small window openings at the narrow end. The windows may face the street or courtyard with a dark building opposite. Sunlight penetrates only a few feet into the room for a few hours during the day. This room, despite its southern exposure, could not be considered a light room. Therefore, selecting colors on the basis of physical orientation alone does not always apply.

There are many instances when color camouflage is not imperative. Masking the character of light in a room may not always be a desirable solution. Much depends on the mood the designer is trying to capture. He may find that playing up the quality of a room's natural light enhances its structural form and thus better expresses the room's intrinsic design. A small dark room, for example, could be painted in deep saturated tones so that the intimacy of the four walls closing in on one is really felt. The color plan of a large room could be light and airy to make one aware of the broad expanse from wall to wall. In either case, the room's architectural definitions are being heightened and reinforced. A good rule of design is not to fight the environment but join it, going along with the given qualities, designing logically and creatively around the existing elements.

The effect of artificial light on color. Too little light, as well as the wrong kind of lighting, can destroy a room at the turn of a switch. The most masterful color plan can be ruined by dim lights or by washing it out with a glare. Colors that are rich and intense by daylight can become somewhat dulled by incandescent light and completely distorted by the wrong type of fluorescent light.

Consider, for example, the use of artificial lights in a theatrical production; stage sets are painted and lighted to create atmosphere, intensifying the viewer's emotional responses. Color is made more vibrant with tinted lights to denote a cheerful or happy scene, or the set is washed in gray, cold tones to convey a depressed and gloomy atmosphere. These same principles of color and light are equally effective when applied at home.

While daylight or sunlight contains light rays throughout the visible spectrum, the incandescent light emphasizes the yellow and red, thus accentuating the reds and oranges and slightly dulling the blues and violets. Fluorescent light may have a different spectral energy distribution, which may result in emphasizing the blues and greens and dulling the reds. There are, however, fluorescent lamps available that have been modified for red-rendition to offset this reaction. An interior will have a completely different color palette and atmosphere under daylight, incandescent, warm fluorescent, and cool fluorescent lamps. Illumination level also affects the tonal value of the hues. Low levels of illumination tend to neutralize colors, and higher levels intensify them. Because of these variables in color produced by different illuminants, the designer should, if possible, select all his color samples in the room in which they are to be used. If this is not feasible, he

should at least select his color schemes under the identical light source and at approximately the same illumination level.

The effect of light on texture and finish. Color is never experienced independently, but only as one of several qualities of materials. The same yarn dyed with the same color can result in fabrics of different character if the textures vary. If, for instance, a glossy satin and a plushlike fabric are woven from the same silk, the first will have luster and light, and the second will have depth and glow. Rough textures, because of the great number of shadows produced, make colors appear darker than smooth surfaces. Light reflection is absorbed by the depth and variation of the weave. Very smooth surfaces that have a glaze or sheen reflect maximum light, causing colors to appear lighter than do fabrics with a dull finish.

Finish is a characteristic of pigment colors and refers to the absence or presence of a luster, gloss, glaze, or other light-reflecting surface. In the absence of a glossy surface, the finish is called mat. Metals, such as gold and silver, enamel paints, and glazed ceramics reflect light rays. Flat, or mat, painted surfaces appear darker than glossy finished ones due to their greater light absorption. A pile carpet or fabrics such as velvets give off entirely different color values when viewed from different directions, depending on whether one looks into the pile or at the side of the pile. These light-reflective equalities should be kept in mind when selecting colors and textures for large areas in a room.

Color aesthetics. A fundamental understanding of color in its totality provides the designer with the necessary tools and techniques to solve problems in environmental design with a high degree of predictability. Without a rationale or guiding principle, the designer can only rely on the fortuitous accident or happy circumstance in arriving at a successful color plan.

The interior designer must be sensitive to the physiological and psychological requirements of the people who will occupy the space he creates. He produces his color theme by the use of painted or stained surfaces, a variety of natural materials (wood, stone, marble), textiles, wall and floor coverings, paintings, and bibelots. All these elements contribute to the room's visual experience. He must be prepared to select colors that will produce the desired psychological response on the viewer's part. To achieve this end, the color palette must be compatible with the purpose of the room, its physical size, form, and source of light.

Many attempts have been made to reduce the principles of color harmony to a formula. This has been found to be of limited use, usually leading to static results. The more experienced designer does not use prescribed color charts, as he is aware that each room is unique, with variables that cannot be synthesized into fixed formulas. For the beginner, charts serve as a good guide, but total dependency on them will ultimately restrict the development of a more personal color sense.

Designers of textiles, wallpapers, and rugs frequently rely on charts for preliminary tests of color combinations. In such instances, charts are feasible, as the color designs are used in comparatively small areas and visualized in a constant light. The interior designer, however, has a very different problem, inasmuch as the colors he uses in a room are on surfaces that stand at various angles, vary in texture, and receive various degrees and character of light. The same wallpaper strip or fabric sample that appears muted or bold when held in hand takes on an entirely different aspect when spread out on four walls or stretched over a sofa. The tonalities in a pattern, its position in the room, and the room's light sources are all factors in

determining whether the walls or the sofa are going to fit well in the environment. There are too many variables a designer must take into account to permit the use of limited mechanical charts in developing a color plan. He can only be guided by a broad set of principles which will aid him in evaluating the room's potential and help create the desired ambience.

Principles of color harmony. The designer of interiors works with three dimensions, dealing with space, volume, textures, and lighting. He must also think in terms of backgrounds for human beings. His color selection should articulate the basis of the total design, creating a delicate balance between the room's mood, its function, and its occupants.

Although one must consider the feelings and requirements of the client, the colors themselves are actually of less importance than the ultimate result, which in great measure depends upon the *chromatic* and *tonal* values. The degree of vitality and chromatic relationships are of critical importance when bringing certain colors together.

In planning the color distribution for any interior, the first consideration must be given to the tonal and chromatic key. Does the use and purpose of the room require neutral or semibrilliant values? Does the illumination demand light, medium, or dark tonalities? Interest in a color composition is generally obtained by the contrast and variety of color areas, the interplay of chromatic and tonal values, and the use or absence of patterns. By using suitable colors, the designer can accentuate architectural elements or minimize unattractive structural parts. An understanding of optical reactions can also aid in avoiding some undesired effects. For example, wherever two colors are applied in equal areas or are equally distributed, the room tends to become fragmented, each color compelling the eye for attention. If the two hues are com-

plementary, each hue will be intensified because, as already noted, each projects its complement on the adjacent. White, gray, and black need not be counted as extra colors in a room's scheme, as their neutrality lends greater unity to divergent hues and provides an excellent background for vibrant, high-keyed colors.

For planning purposes, it is helpful to subdivide a room into the following areas:

> Main areas: floor, walls, and ceiling
> Secondary areas: window treatment and large upholstered pieces
> Minor areas: small chairs, paintings, lamps, pillows, and other accessories.

Color combinations. A room's color theme is established by the treatment of the main and secondary areas. Accent areas are important to its general effect, although greater unity is achieved when the same hue accents are repeated in various parts of the room. A bright color used on a pillow, for example, could be reflected in a lamp base, a vase of flowers, or accessories on the table. Various approaches are possible in assembling overall color compositions. The most frequently used combinations fall into the following categories.

COMPLEMENTARY. Two complementary hues are used for the main and secondary areas. These hues are generally repeated in stronger chromas in the accent areas. Practice has proved that the use of exact complements is less pleasant than using opposite colors, tinged however with the same underlying hue. A yellow-red harmonizes more agreeably with a yellow-green—the yellow relating the two complements. Or a blue-red blends with a blue-green, blue being the common color bond. Complementary combinations are visually balanced as each color is kept in check by another, with both warm and cool colors automatically included.

Everything in this interior seems to be proud to be associated with the magnificent Rothko painting. Each item recalls with sensitivity the elegance of its focal point. The analogous range of colors from reds through orange and yellow create a cheerful mood in contrast with the neutrals of the background. Conde Nast Publications Inc.

In a New York town house, this intimate dining room faces the rear garden and terrace. The garden is lighted at night to create a vista and there is no need for blinds or curtains of any kind at the sliding glass doors. Recessed lights in the ceiling replace the usual traditional chandelier and give more dramatic light over the table.

Photo by Norman McGrath. Designed by Parish-Hadley

ANALOGOUS. This technique is limited to two or three adjacent hues on the color wheel. For example, a scheme developed from the cool side of the spectrum might include green and blue, with intermediate steps between. Or it can turn to the warm side of the spectrum, ranging from yellow-orange to orange-red. A cool blue-green solution would be ideal for a beach house, whereas a warm yellow-orange would be more suitable for a ski lodge.

MONOCHROMATIC. A one-hue plan is confined to a single color family with all its varying tonal and chromatic values. This distribution is the simplest but perhaps the most unrealistic, as it seldom exists in nature. Yet, skillfully applied, it can reflect any mood desired, depending on the handling of the chromatic and tonal values. It works effectively in either traditional or contemporary settings.

If a monochromatic pattern is used upon a main area, it is advisable to continue the monochromatic palette throughout the room in order to maintain a consistent color mood. Any of the color families offers an extensive scale of tonal and chromatic variations, ranging from pastel tints to shades of intense chromatic value. For example, monochromatic colors in orange would include a range of beiges and browns, the latter bearing little resemblance to the basic hue, orange. Complementary or analogous colors are generally introduced in accent areas to offset the one-hue note.

MONOTONE. This is composed of one hue, tone, and chroma throughout. A neutral gray or beige is the most popular for this type of scheme. These neutral hues are often selected for commercial interiors such as art galleries or showrooms where an unobtrusive background is required for the display of merchandise.

Chromatic distribution. The experienced designer finds that the order of chromatic distribution is flexible. Provided the room communicates the desired effect, these chromatic differences become arbitrary. In traditional rooms, the most neutralized values are generally used in the dominant areas, and, as the areas reduce in size, the chromatic intensity is proportionately increased.

In contemporary interiors a more dynamic impact may be preferred, so this distribution is often reversed, with the most intense values used in the main areas and less intense values applied to the secondary and minor ones.

In controlling chromatic distribution, it must be kept in mind that two complementary hues placed in juxtaposition will each heighten the intensity of the other. A client with a bright red carpet, for example, may be ill-advised to use green walls, which would result in increasing the intensity of his rug. However, many forms of modern art deliberately put red and green, blue and orange in conflict with each other. This increased vibrancy may be desirable for certain interiors to achieve optimum stimulation.

Tonal distribution. It has been observed that nature conditions man to feel most comfortable with a dark value beneath his feet, medium value surrounding him, and a light value above, as exemplified in the dark tones of earth, green foliage, and a light sky. The selection and distribution of tonal values depend on the shape of the room, the height of the ceiling, the number and position of windows, and the character of room one wishes to create.

The tonal value of a color is highly influenced by adjacent values and it is made to appear lighter or darker through contrast. This interplay of tonal contrasts has a decisive role in determining the furniture placement in the room. For instance, if a sofa covered in a light value (we are only concerned with value—not hue) is placed against a dark-value wall and floor, the sofa will appear to "float" in space.

However, once the surrounding values are adjusted more closely to that of the sofa, all surfaces—wall, floor, and sofa—will sit in their proper position. This also applies to an object of dark value juxtaposed against a light background. In this case the object will appear too weighty. Visually, a hole in the floor and wall may have been created, as the tonal values are too sharply divergent. Here again, the adjustment of values will permit each area to lie in its respective position. A dark floor, medium sofa, and light wall would result in pleasing tonal intervals holding all areas in place.

If a long, narrow room has three windows on the long wall, the designer should avoid a strong contrast between wall and drapery value to avoid the effect of drapery and wall closing in, thus making the room appear more narrow. A long, narrow room with off-white wall may be relieved by a darker value used on an end wall. Perhaps a dark breakfront or wall of books would achieve the desired effect.

The patterned areas in a room, which may appear in a rug, wallpaper, or textiles, are selected to express the particular character the designer is seeking. If a bold pattern with strong tonal variations is selected to achieve a lively mood, then this impact should be sustained throughout to give consistent character to the interior. Consider, however, the different approach in tonal variation for a more serene room, keyed to a delicate eighteenth-century documentary print with slight tonal variations. In the latter, the interval for main areas should reflect the same gentle tonal intervals appearing in the print. Any attempt to force the tonal range would destroy the room's unity. Just as colors affect each other in juxtaposition, so also do patterned surfaces. A bold, flowing pattern used next to a small geometric print can diminish the impact of both. Patterns of similar scale can be combined successfully. A wallpaper with gentle meandering curves can be compatible with an oriental rug expressing the same slow curve. Similarly, small geometric or spot patterns can be combined effectively, as illustrated in many Japanese prints, oriental porcelains, and some paintings by Matisse.

Presentation of color plan. After the general character of a color plan has been formulated, the designer must then decide whether patterned surfaces are to be used, and where they are to be applied. Pattern may be employed in the dominant areas or limited only to upholstery and draperies. In either instance, the balance of hues and textiles in the room should be adapted to the predominant pattern, with suitable tonal and chromatic adjustments. If pattern is eliminated and the room is to be treated in solid hues only, then interest and contrast are provided by introducing a variety of textures and surfaces. In this type of plan, pattern is often concentrated in paintings and accessories.

Once the patterned areas of the room have been determined, the color for the walls, trim, and ceiling can then be selected. To reverse this process and begin with a wall color, may cause an incalculable loss of time and expense in shopping for patterned floor coverings and fabrics to blend with the established wall color. The most practical method, therefore, of working out a plan is to build up from a patterned floor covering, wallpaper, painting, textile, or accessory, provided the latter is sufficiently distinctive and worth emphasizing. To visualize the distribution and proportion of color, texture, and pattern, a designer prepares a presentation of each job. On this chart the walls and floors are indicated by the largest squares, with the secondary and accent areas in the smaller ones. The size of each sample is proportionate to the relative area of distribution in the room. Some changes may be made after the initial presentation, but the final scheme will include wall color or wall paper, trim, floor covering, draperies, upholstery, and accents. These presentations are kept in the designer's files for future reference.

The psychology of color. Psychologists maintain that man's color preferences are determined by his geographical location, religion, and socioeconomic background. Artists for centuries have been attracted to the Mediterranean countries, where nature's palette is vivid and exciting. Color has been associated with religious rites for centuries. The religious feasts of the Judeo-Christian calendar are reflected in the colors of the clergy's robes, the banners, and the altar coverings. Primitive cultures have tended to prefer primary colors in high chroma. This is exemplified in the totem poles of some Indian tribes of the northwest coast of North America, which show a preponderance of reds, blues, and yellows.

A survey was made of the color palettes used by artists in past centuries, and the result indicated that the works of each artist were almost exclusively in either a warm palette or a cool palette. Psychologists have theorized that the extroverted personality prefers the warmer, more vibrant colors of the spectrum. Introverted persons, they maintain, are drawn to cooler and more subtle hues. These preferences are reflected in our homes and choice of clothing. The red, orange, and yellow hues represent the warm side of the color wheel. Warmth, or heat, is often translated into such connotative terms as aggression, action, extroversion. Similarly, greens and blues are identified with the cool side of the spectrum. Coolness is associated with introversion or withdrawn characteristics. However, this elementary preference test is far too superficial to have any value for the diagnostician.

One of the most comprehensive tests available for personality analysis through color preference is the Lüscher Color Test. This is the work of Dr. Max Lüscher, whose test has been used as a major diagnostic aid to psychologists and physicians since it was first presented in 1947 at the International Congress of Psychologists in Switzerland. Lüscher presents eight colored cards that the patient is asked to select in order of preference. There is also a more extensive and detailed version of this test, containing many additional color samples for measuring human response to color.

This method is based on the premise that a preference for one color and dislike for another reflects a personality pattern which exists regardless of social environment. Not only are personality patterns revealed in this testing, but ailments in their early stages have been diagnosed. This system is also applied for vocational guidance and selecting personnel for industry.

For centuries medical science has recognized psychological as well as physiological effects of color on man. In Europe, in the latter part of the nineteenth century and early twentieth century, psychologists working in mental hospitals did research on patients by utilizing different colored walls and lights. The depressive patients were placed in rooms with bright yellow or red walls, and the hyperactive were confined in rooms with walls of blue or green. The effects manifested themselves in visibly more relaxed patients and a significant reduction in blood pressure. Experiments conducted recently indicate that muscular reaction is much faster under the influence of red lights than under green lights. In tests measuring time, results showed that the reaction to the passage of time is influenced by the colors of one's surroundings. A group of men, placed in a red room, overestimated the length of time they had spent in the room, while the subjects relegated to a room with blue walls underestimated the time that had elapsed. Tests conducted to measure temperature revealed that a significant number of people were inclined to underestimate the temperature of a blue room and overestimate that of a red room.

Black is the traditional color associated with tragedy and death. During the Middle Ages, Blackfriars Bridge, in the heart of London, was a gloomy black structure known for its high

record of suicides. After the bridge was painted a bright green, the suicide rate declined.

The psychological effect of color on digestion has been demonstrated by lighting engineers. A group was invited to a dinner party where specially designed lighting equipment had been installed. When the food was served, the normal incandescent light was switched to other illuminants which made the juicy brown steak look gray, the crisp green lettuce turn dull, the coffee a sickly yellow. Most of the guests could not eat, and those who did became nauseated. We are visually conditioned to associating particular colors with certain foods, and any variance in this pattern results in both psychological and physiological stress.

Not only hues, but tonal values have a profound effect on man. Some people find dark walls restful; others find them depressing. Dark-colored objects are generally experienced as being heavier than light-colored objects. Workers in a factory complained about the weight of their metal tool kits, which were painted a dark brown. The management was advised to repaint the boxes in a pale green. After this was completed, the complaints ceased, and several men commented on the ease of lifting the new lightweight kits.

Color, in all its characteristics of hue, tone, and chroma, can be a powerful tool for the interior designer in achieving the desired ambience, be it gay and cheerful, restful and serene, or exciting and stimulating.

Use of color in traditional interiors. Each of the historic periods of art has had its characteristic color palette. Some scholars maintain that Greek architecture and sculpture were gaily colored, although many of us may be inclined to support Rodin, who, after hearing this report, is said to have beaten his breast and explained, "I feel it here that they were never colored." Archaeologists found that the colors in Egypt

and Greece were similar and revealed bold, uninhibited use of bright and dark colors, including black, which was often used on entire walls with painted decoration. Popular colors for walls in Pompeii and Herculaneum were vivid green, vermilion red, orange, golden ochre, and azure blue—a full palette. Romans, builders rather than decorators, made extensive use of raw materials—marbles in many hues as well as gold, bronze, and mosaic.

Gothic art in Europe showed considerable evidence of color, primarily on the exteriors of churches. The cathedral of Notre Dame in Paris is said to have had color in the mouldings, columns, and sculptural ornaments. The Renaissance was noted for its lavish use of gold for ornament as well as background for decoration. Concomitant with the elaborate architectural background, we have rich, dark colors; rarely were pastel or muted colors used.

In eighteenth-century France, colors were in tints of neutralized hues which reflected the feminine influence on the French court until the revolution. Later, a strong wave of patriotism dominated the Directoire period, and sharp blues, reds, and whites, the colors of the French flag, were popular. Under the influence of David in nineteenth-century France, considerable severity marked the use of color, and many color schemes showed a dominance of somber blacks and off-grays. Empire textiles, however, displayed brilliant hues—blues, greens, and purple backgrounds, often with classical motifs in gold. Empress Josephine's more cultivated tastes apparently influenced the colors for the interiors of Malmaison, which emphasize neutralized blues, greens, and purples, with some browns and blacks.

In the last half of the eighteenth century in England, the classical French palette was reflected in the interiors of Robert Adam. These colors were muted blues, pale yellowish-green, light gray, lavender, and other tints that har-

monized with the light hues of Angelica Kauffman's decorations.

However, many of the elaborate English country houses designed by Robert Adam and his contemporaries used dark and fairly chromatic values in their marble columns and mantles, primarily in their spacious entrance halls. During the Victorian era, the so-called mauve decade, colors were often dark and neutralized, such as mulberry, bottle green, tobacco brown, and dull red.

Early American colonial colors for woodwork and walls were in well-neutralized values. Chalk blues, pea-soup greens, and white were prevalent, and terra-cotta was popular for the fireplace wall and inside the corner cabinets. The mid-eighteenth-century palette in America was similar to that of the Georgian period in England. Gold, greens, blues, and reds were popular in mid-tonal and mid-chromatic values. The Federal period saw a lightening of the palette, with pastels preferred for wall colors. Benjamin Franklin wrote to his wife from England to have their new parlor painted white, as it was all the rage in London.

The designer should be aware that the color palette always reflects the spirit of the period— the furniture, textiles, and architectural backgrounds. The heavy curve of the Queen Anne and Chippendale leg is relative to the weight of the colors used in that period. The pretentious, massive furniture of the French Empire is reflected in the raw, brassy palette of the textiles. The ponderous Victorian interior is expressed in its muddy colors.

Use of color in contemporary interiors. In his exteriors and interiors, Frank Lloyd Wright subscribed to the Japanese norm of using all materials in their natural state. If a brown wall was desired, he recommended the use of wood, stone, or cork in the desired brown tones. He maintained that if one had to paint a wall, then the wrong material had been selected. This point of view also reflected the Bauhaus movement, which had its inception in Germany in 1919. Utilization of natural forms and materials was encouraged by the innovators of this school. Founded by architect Walter Gropius, the Bauhaus had as its ideal the synthesis of all the plastic arts, combining teaching of the pure arts with the study of crafts. Josef Albers and Johannes Itten, both painters and members of the Bauhaus faculty, developed new concepts in the use of design and color, which strongly influenced the decorative arts in the following decades.

In our contemporary interiors, the general theme tends toward seemingly dissonant contrasts. Color palettes range from pale, neutralized hues to strong, unadulterated primary colors—from overscaled, sprawling patterns to minute, controlled geometric prints. The color note is generally sustained in a high key without visual relief. The psychedelic color trend as well as hard-edged graphics undoubtedly made their impact on interiors of the 1960s. The experimentation and evolvement which continually occur in all the arts—literature, painting, music, dance, theater, and films—are always reflected in the color palette of the interior designer.

BIBLIOGRAPHY

Albers, Josef. *The Interaction of Color*. New Haven: Yale University Press, 1963. The Bauhaus concept of color theory.

Birren, Faber. *Color for Interiors*. New York: Whitney Library of Design, 1963. A comprehensive review of ancient, period, and modern color styles, with sixteen charts of color samples.

Birren, Faber. *Creative Color*. New York: Van Nostrand-Reinhold Co., 1961. A basic course on color harmony.

Birren, Faber. *Light, Color, and Environment*. New York: Van Nostrand-Reinhold Co., 1969. Colors' effect on the environment and the biological and physiological aspects of color.

Birren, Faber. *Principles of Color*. New York: Van Nostrand-Reinhold Co., 1969. A review of past traditions and modern theories of color harmony.

Birren, Faber. ed. *A Grammar of Color*. New York: Van Nostrand-Reinhold Co., 1969. A basic treatise on the color system of Albert Munsell.

Chevreul, M. E. *The Principles of Harmony and Contrast of Colors and Their Applications to the Arts*. New York: Reinhold Publishing Co., 1967. Based on the first English edition of 1854.

Evans, Ralph. *An Introduction to Color*. New York: John Wiley & Sons, 1948. One of the best reviews of basic color knowledge.

Goethe's Color Theory, edited by Rupprecht Matthaei and translated by Herbert Aach. New York: Van Nostrand-Reinhold Co., 1970.

Graves, Maitland. *Color Fundamentals*. New York: McGraw-Hill Book Co., 1952. Theories of color and design for the painter and designer.

Gregory, R. L. *The Intelligent Eye*. New York: McGraw-Hill Book Co., 1970. A fascinating review of color perception and color illusions.

Halse, A. O. *Use of Color in Interiors*. New York: McGraw-Hill Book Co., 1968. Use of color for architects and interior designers.

Itten, Johannes. *The Art of Color*. New York: Van Nostrand-Reinhold Co., 1961. Color theories of the Bauhaus teacher and painter.

Itten, Johannes. *The Elements of Color*. New York: Van Nostrand-Reinhold Co., 1970. A treatise on the color system based on *The Art of Color*.

Jones, Tom Douglas. *The Art of Light and Color*. New York: Van Nostrand-Reinhold Co., 1972. All about lumia, mobile color, light, projection, much of which is related to interior design.

Lüscher, Max. *The Lüscher Color Test*, translated and edited by Ian Scott. New York: Random House, 1969. A psychological color test based on color preferences.

Rasmussen, Steen Eiler. *Experiencing Architecture*. Cambridge, Mass.: M.I.T. Press (paperback edition), 1964. How we perceive our surroundings—color in architecture.

Wilson, Jose, and Leaman, Arthur. *Color in Decoration*. New York: Van Nostrand-Reinhold Co., 1971. A book that features color in decoration, with emphasis on contemporary vogues.

Wolf, Thomas H. *The Magic of Color*. New York: Odyssey Press, 1964. Basic history and theory of color; recommended for elementary classes.

Munsell Color student charts are available from Munsell Color, Baltimore, Md. In ordering, ask for N.Y.S.I.D. Standard Charts of primaries, secondaries, and tertiaries. These are unmounted, and the instructor should have a mounted set as a model.

The authors are indebted to the periodic publications of the Inter-Society Color Council, an international organization for the purpose of coordinating research in all areas of color. We also wish to pay tribute to the late Lucy B. Taylor, who was a pupil of Albert H. Munsell and taught color theory for many years at the New York School of Interior Design.

Example of a projected ceiling design.

CHAPTER **14**

Lighting and Design

Examples of colonial lighting fixtures.

Lighting is the most practical, exciting, and mysterious of design media. It is exciting because of its ability to transform the objects it touches. It is mysterious because light rays are invisible until they strike a surface.

Lighting is a practical aesthetic based on scientific knowledge. To understand and manipulate it, the designer must learn to sympathize with its technology and create with the effects it produces.

The effects of designed lighting.

DISCLOSURE. Everyone knows that light holds the absolute power to disclose objects; try to evaluate any visual effect without it. This power has subtle ramifications.

As an example, light reveals *shape*. It can make an object appear flat, or it can increase its dimensional form. It can cause a subject to fade into the background, or it can emphasize the separation of planes.

In the theater, light's characteristic of *definition* is strikingly evident. Elderly "starlets" are made to appear young, and years are added to characters portrayed by comparative youngsters. At home, clever hostesses have acquired an intuitive knowledge about which kinds of lighting make their guests look healthy, young, and refreshed.

Illumination adds to or subtracts from the *value* of articles. Jewelry shops change glass into apparent gems through the clever manipulation of light. Interior designers realize that costly furnishings will look like dime-store copies unless properties such as sheen and color are properly revealed with light. Food stores know how to light meat counters to heighten the red "freshness" associated with good beef— even though properly aged meat may actually be grayish in color.

Environmentalists are able to delicately change the *color* balances in a space by selecting light sources with specific spectral attributes. When faced with a decor composed of red and blue tints, it is possible to change the emphasis of either color by merely supplying different artificial light sources.

PHYSIOLOGY AND PSYCHOLOGY. Lighting has both conscious and subliminal effects on our physical and mental conditions. Unfortunately, many of the reasons for these effects, and the extent of their influence, are not fully understood.

It is obvious that *glare* (extreme contrasts of light we do not like) makes everyone irritable. On the other hand, there is research showing that *sparkle* (extreme contrast we do like) leads to heightened appetite and tends to enliven conversation. Lighting specialists know that extreme or sudden changes in color, contrast, or intensity serve to stimulate the eye and mind. Yet continuing excesses lead to eye fatigue, a general sense of weariness, and a slowing down of the assimilation processes.

Traditionally, color has been strongly related to human responses, but it is difficult to separate the effects of the color of light from the color of objects.

COMPOSITION. Lighting is one of the few design elements that can be changed easily and quickly. With the flick of a switch or the turn of a dimmer, light can alter pattern, color, and intensity. In a society where increases in popu-

lation and building costs are leading to more compact urban living and working spaces, lighting can serve to vary function and mood in these spaces, ultimately softening the claustrophobia of city life.

Lighting directs attention within a space because the eye automatically seeks out the brightest and most interesting object in its field. By varying contrast and pattern, light can also direct movement within or through an environment.

Lighting is increasingly being used as a direct source of decoration. Silhouette projections form interesting surface patterns. Transparency projections can produce either impressions of detailed realism or the wildest flights of our imagination.

Historic development. Since light could not be considered as a flexible design medium until the advent of electricity, this discussion will consider only electric light. Although the development of lighting sources, hardware, and applications has been a continuous process, it is convenient to divide the history of electric light into three periods.

Necessity. About 1880, England's Swan and the United States's Edison simultaneously introduced the first electric incandescent source. It consisted of a glowing electrical conductor housed in a bulbous glass container. Initially, this device was used solely to replace gas, candles, and oil as a necessary and practical means of dispelling darkness. In those early days, electric light was understood as a comparatively safe and inexpensive medium. However, it was not always considered as an efficient and flexible source capable of being an integral part of the architecture while offering precise control in terms of direction, intensity, and color. For a painfully long time, designers relied on glare-producing and bulky chandeliers, pendants, sconces, and dubiously "decorative" table or floor lamps which were often awkward modifications of traditional light holders. Traditional lighting elements have a place in modern lighting, but they can no longer be tolerated as the sole source of illumination.

Abundance. The fluorescent source was introduced at two world fairs in the United States during 1939 and 1940. In comparison to incandescent light, fluorescent sources have several major advantages. They are efficient in producing light at low cost; their useful life is long (they produce high illumination for twelve thousand hours, while one thousand hours is typical of an incandescent); they do not produce much heat per unit of light; and they are an intrinsically diffuse source of illumination. The quantitative and cost factors were of the greatest immediate importance during this time. The use of fluorescents, and all electric light, increased tremendously.

Unfortunately, no single solution is applicable to all design problems, and this is certainly true of fluorescent light. The tendency of the fluorescent source to produce flat lighting with a low surface brightness leads to dull installations, and the light output is difficult to optically project or control. The fluorescent method of making light does not always produce a balanced color spectrum, so that color-critical installations may suffer.

Since significant amounts of illumination could now be achieved with practicality, it became important to determine accurately the quantities involved. Technicians developed the following approach, which they labeled "lighting design": 1) determine the desired level of illumination that will make a specific seeing task easy to accomplish; 2) select a light source and holder; 3) calculate the required quantity of these sources that will produce the desired light level; and 4) lay out the installation for uniformity of illumination. With minor modifications this method is still widely used today,

even though it has very little relation to light's aesthetic possibilities.

REFINEMENT. In the mid 1960s, several trends indicated a change in lighting practice. This started a period of refinement in lighting application. Architects and designers began to demand imaginative solutions that correlated *with* their schemes instead of lighting that was *applied to* their designs. The lighting industry, both light source and fixture manufacturers, started producing a great variety of solutions to satisfy varied conditions. Engineering advances, encouraged by the Illuminating Engineering Society, allowed a flexibility in techniques that freed and encouraged design application. A new breed of professional started to specialize in lighting with an aesthetic orientation—the lighting design consultant.

Application. The designer should always seek specialized advice for any lighting problem. Electricians, luminaire suppliers, power companies, and others associated with the industry will supply general information on the use of their own equipment or services. Certain lamp and luminaire manufacturers offer free publications. Excellent pamphlets and books can be purchased from the Illuminating Engineering Society through its representatives in New York City or other major communities. Difficult problems will require the paid consulting services of a licensed engineer (if the problem is mechanical) or qualified lighting design consultant (if the problem includes aesthetic decisions). Many lighting designers are members of the International Association of Lighting Designers Inc. based in New York City.

However, the availability of specialized knowledge never abrogates the responsibility of the space designer to "see" with light. Illumination must be integrated with the visual, mechanical, and economic whole.

There is no one approach to the problem of designed lighting, but the following six steps offer a useful point of departure.

VISIBILITY. The designer's first responsibility is to provide illumination that will enable an environment's occupant to see and be seen with appropriate speed, accuracy, and comfort.

ATMOSPHERE. The mood or feeling created in an illuminated space is perhaps of greatest interest to the designer, and yet this concept is the hardest to define, describe, or specify. Many questions should be considered in advance. Should the lighting create a space that is friendly or formal, emotionally cool or warm, exciting or pacifying, cheerful or deeply somber, luxurious or sparse? Many answers depend on a combination of mental and physical phenomena which are the intuitive gift of great designers.

COMPOSITION. Overall shadowless lighting does not always best define a space. The careful variation of a lighting system's direction, contrast, color, intensity, shape, pattern, and movement may best develop the visual environment.

OBJECT APPEARANCE. Objects respond differently to light. Mirrorlike surfaces are best revealed when the shape of the source and the quantity of light are considered. Diffuse or matte objects are more responsive to the direction of light, its intensity, and the brightness relationships developed within the subject and between the subject and its surroundings. White surfaces react rapidly to minor changes in intensity, while black merely absorbs additional light. Multi-hued tasks must be illuminated with spectrally complete light sources. Monochromatic objects, however, make use of only their corresponding color in light. Each object must be considered separately, as well as in coordination with the whole, as it is revealed by any lighting system.

MECHANICAL DEVELOPMENT. Light sources, instrumentation, mechanical systems, light

measurement and control, physiological factors, electricity, and electric control must all eventually be incorporated. The environmentalist must adapt lighting concepts within the limitations of structure, acoustics, air conditioning, budget, and both short- and long-range ecological criteria.

REVIEW AND CORRECTION. Before final decisions are made, the proposed lighting should be checked against established criteria. The study of recommended practices or model installations will often save the designer from making costly errors in judgment.

Light sources. Three general categories of light sources are available to designers: natural daylight, incandescent electric light, and electric discharge lighting.

NATURAL DAYLIGHT. Too often the study of daylight is neglected. There are many considerations, however, that the designer should review when working with this light source.

Natural daylight is not stable. It changes throughout the day in position, intensity, diffusion, color, and timing. It is often assumed that the sun rises in the east and sets in the west, but this is only partly true. In lands significantly north of the equator, the sun has a southerly course. In warmer regions, it may be advisable to locate principal fenestration toward the north to minimize heat. A southerly exposure will capture beneficial heat and cheerful brightness in cooler areas. The reverse is true in locations south of the equator.

Diffusion of the sun's rays is a variable caused by precipitation, haze, cloud cover, or atmospheric pollution. In any design utilizing natural daylight, three conditions should be considered: light directly from the sun combined with reflected light from a clear sky, light from a clear sky only, and light from an overcast sky.

The color of daylight changes according to the composition of the atmosphere, the inter-reflection of objects in the environment, and the time of day. Typically, daylight changes from deep red, through a range of oranges and yellows, to blue-white (skylight), and then the cycle continues in reverse.

Daylight is also affected by various indirect variables including local terrain, land- and waterscaping, fenestration, daylight control systems (shades, louvers, etc.), decor, and artificial light.

INCANDESCENT ELECTRIC LIGHT. The proper term for any artificial light source is *lamp*, not "light bulb." The bulb is only the glass used to enclose other components, such as the light-producing wire (filament), which burns to incandescence in a vacuum or atmosphere of gases. The sun and the incandescent lamp both create light by the heating of materials until they glow.

Hundreds of incandescent lamp types are commonly available, and each is designed for a particular practical or aesthetic purpose. Four classes are most important. *General service* lamps (often shaped like a pear) are the workhorses of the industry and come in a wide range of intensities and sizes. They produce light in all directions, and they should be used in equipment that will properly shield and direct their output in a useful manner. *Tungsten-halogen* (often called quartz and/or iodine) lamps are another class of incandescent lamp boasting a small size and a comparatively long life. *Reflectorized* lamps are actually fully enclosed lighting instruments. They feature a light source, reflector, and lens within a single glass enclosure that can be screwed into any socket. *Decorative* lamp classes are designed to be seen "as is" and are noted for bulb shapes that are globular, conical, tubular, chimneylike, flame-shaped, etc.

Incandescent lamps come in a variety of finishes and color coatings. The clear glass bulb

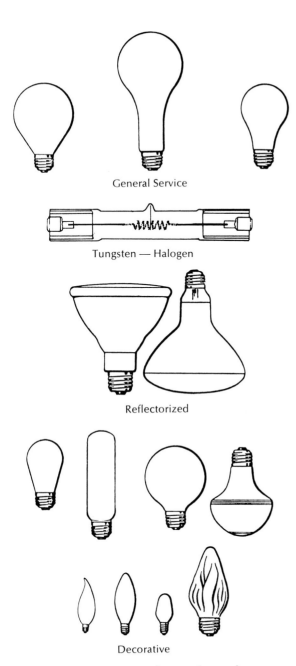

General Service

Tungsten — Halogen

Reflectorized

Decorative

Representative incandescent lamp shapes.

is useful when a compact and bright point of light is required to be further controlled by reflectors or lenses. However, any point source also creates strong shadows, and so lamp manu-

facturers produce two other standard bulb finishes to help spread the size of the source. Acid etching or sand blasting is the most efficient diffuser, but when a softer light is desired, the interior of the bulb may be coated with silica powder. Five types of color coatings are common: fragile and diffuse painted surfaces are used on some low-intensity decorative lamps; sprayed lacquers are also a relatively fragile but transparent color medium; special plastic exterior coatings have a higher resistance to abrasion and weather and are offered in a wide range of crystal-clear colors; ceramic enamels produce translucent or diffuse colors and may be used on higher-output lamps; and dichroic filters are available for high-intensity sources producing very transparent and sparkling colors.

In ordering incandescent lamps, the user must always specify the wattage desired, the shape of the bulb, its size, the base or connector (medium screw bases are common), the finish or color, and the life expectancy (expressed as average hours of life). Knowledgeable specifiers also indicate the voltage of the wiring system (see Electricity) and the light output (see Light Measurement).

ELECTRIC DISCHARGE. Electric discharge lamps are available in two types. Low-intensity discharge lamps are usually called *fluorescent*. They are tubular in shape and are common in office installations. High-intensity discharge, often called by the initials *HID*, is a family of compact light sources including mercury vapor, multi-vapor, high-pressure sodium, etc. HID sources have traditionally been used in industrial or street-lighting applications, although they are now finding applications in *all* forms of architecture. Both types have at least one vital thing in common; they must be used with a special device called a ballast. The ballast regulates the amount of electricity used. These lamps must *not* be installed in any household socket.

Fluorescent

High Intensity Discharge

Representative electric discharge lamp shapes.

All electric discharge lamps are similar in their methods of producing light. When the lamp is turned on, a flow of electricity is directed through metal terminals at either end of an enclosing chamber. After these terminals are heated, the electric current leaps between the terminals, thereby creating an arc (the "electric discharge" of the name). In the fluorescent lamp, the arc produces invisible ultraviolet en-

ergy. This energy excites fluorescent phosphors which coat the inside of the long tubular chamber. Specific phosphors are used which give off visible light. HID lamps have very short, capsulelike chambers, and the arcs within them give off directly visible light. The capsule chamber of the HID source is usually enclosed within a larger glass enclosure, and the inside may be coated with phosphors to modify light output and color quality.

The most familiar fluorescent lamp shape is the four-foot straight tube, although "U"- and ring-shaped tubes are not uncommon. A wide range of lengths, light outputs, and colors are available. HID sources have bulb shapes that are more like incandescent lamps, and their colors are typically restricted to several whitish tints.

In comparison with incandescent lamps, electric discharge sources have several advantages. Their life expectancy is extremely long; fluorescent lamps are typically rated for 12,000 to 18,000 hours of use, and HID sources may carry a 24,000+ hour rating. Electric discharge lamps are efficient because they use very little electrical energy to produce great amounts of light with relatively little heat. Unfortunately, there are also disadvantages. They must always be used with auxiliary equipment (the ballasts noted earlier), and their color-producing qualities are limited. In spite of these problems, they are finding more and more applications.

Color and light. One of the most important subjects in light and lighting is the study of how modern sources reveal color.

One useful tool in light-color analysis is the electromagnetic wave theory. This theory proposes that energy can be analyzed according to the length of its wave form. A "wave" can be compared to the ripple that is produced when a rock is dropped into a still pond. Of all the forms of energy in the electromagnetic spectrum, the waves which produce the sensation

of sight occupy a very small space. Each wavelength represents a single color (monochromatic line) which can be measured in nanometers (30 nanometers = 15 billionths of an inch).

Mixed colors can therefore be analyzed according to a spectral composition which specifies the length and intensity of each wave. Spectral compositions are usually indicated on a chart showing the vertical axis as intensity and the horizontal axis as the total range of visible wavelengths, from approximately 360 to 760 nanometers.

Colored light is created by one of two methods. Because of its electrical and/or chemical properties, a source has an inherent color characteristic. The source color may then be modified. If an absorbing filter is placed in front of a light beam, all wavelengths except those representing the filter's color will be absorbed within the filter medium. The same effect may be achieved by using a reflective color medium which allows passage of only specified wavelengths, while reflecting all others. Reflective media of this type are called dichroic filters. In addition to selectively emitting color, dichroic filtration can also be used to produce cool lighting with incandescent sources by selectively removing heat-producing wavelengths from the light beam. Dichroic heat-reduction lamps are manufactured in certain reflectorized classes. When absorbing or reflecting color media are used, color is being produced by the *subtractive* method.

When different colored light beams are mixed, additional hues are produced. For example, if primary blue and primary green light beams are focused on the same spot, that area will have a yellowish hue. When light colors are mixed together in this fashion, the *additive* method is being used. White light is not a monochromatic color, but rather a combination of colors. Well-balanced white light contains all colors (wavelengths) in nearly equal intensities. However, it is not necessary to have all the wavelengths equally present to give the impression of whiteness.

When light falls on an object, the object reflects certain wavelengths and absorbs others. The mixture of wavelengths it reflects makes up its characteristic color. For this reason, grass looks green because it reflects green light and absorbs all other colors. If the wavelength representing green were totally missing from the light source, the grass would have no color; it would appear gray. Object color is therefore dependent on light source color. If the source does not contain a particular color, the object cannot reflect that color. Similarly, light sources which are not spectrally well balanced do not reveal multi-hued objects in their natural balance.

A study of typical light sources and their spectral compositions explains the way in which they will reveal colored subjects. Sunlight has a relatively balanced and continuous spectral distribution when measured during the summer, at noon, on a slightly overcast day in a pollution-free location with a northern orientation (in North America). Sunlight rarely meets all these conditions.

Incandescent lamps produce illumination by a method similar to that of the sun, and their spectral distributions are also continuous (containing all colors). However, they are not as evenly balanced and tend to have more intensity toward 760 nanometers (the red end of the spectrum) and less intensity toward 360 nanometers (the blue end). Therefore, blue objects are dulled slightly when illuminated by incandescent sources.

Electric discharge sources produce light by a method that is much different from incandescence, and their spectral compositions are also vastly different. There are many colors of fluorescent "white" light, and many of the variations have uneven spectral distributions. The most often used "cool white" lamp suppresses reds while intensifying blue, yellow, and orange.

The popular "warm white" lamp suppresses blue, green, and red but intensifies yellow and orange. "Deluxe" lamps may also be specified. "Deluxe warm white" suppresses only blue and intensifies the warmer tones above 500 nanometers, while "deluxe cool white" neither appreciably suppresses nor intensifies any color. Unfortunately, when the fluorescent color output is more evenly balanced, light output is less efficient (deluxe colors produce one-third less light than their standard counterparts). The four colors of "white" mentioned above represent only a few of the popular whites that are available.

HID lamps produce more acute color distortions. The basic mercury vapor lamp has a discontinuous spectrum with only narrow spectral lines of green, yellow, and blue. The newer, deluxe, color-improved, and additive lamp types are better, but their color distribution is still less balanced than either incandescent or fluorescent.

It is important not to confuse a light source's *apparent* color with its ability to reveal *reflected* colors. Apparent color refers to the way that the source looks when you view it directly or see it reflected from a neutral surface. Although a source's apparent color may appear flattering and satisfactory, it would be improper to use it in a location where color rendering is critical unless it also produces a balanced spectrum.

Electric discharge sources, in spite of their color limitations, have many uses in today's architecture. Fluorescent lamps, particularly those with deluxe colors, produce light satisfactory for all but the most critical color-viewing areas. HID sources are most useful where the apparent color is satisfactory and color rendering is relatively unimportant. They might be used, for example, to light the mall areas of a large shopping center where goods are not displayed, but one should carefully consider their color limitations when recommending their placement over merchandise.

It is important to select the color of objects under the light source that will be used. In some cases, it is possible to change light sources of differing spectral quality in existing installations to heighten or soften object color effects.

Light measurement and control.

MEASUREMENT. There are four basic ways to measure light. The *lumen* refers to the quantity of light that is given off in all directions by the lamp itself. Lumen data are supplied to designers by all lamp manufacturers. Lumens are often compared with watts to give an indication of the lamp's efficiency. If one type of 100-watt lamp produces 1,750 lumens (17.5 lumens per watt) and another produces 1,490 lumens (14.9 lumens per watt), it is clear that the former gives off more light per unit of electric power. The latter lamp is an "extended service" lamp lasting for 2,500 hours, as contrasted with the former general service lamp that is rated for 750 hours of expected life. It can be generally stated that the longer the life of an incandescent lamp, the lower its efficiency in producing light.

Candlepower describes the amount of light given off in a particular direction and is measured in candelas. This measurement applies to the light issuing from a lighting fixture or a light-directing lamp (such as one of the reflectorized classes). The candlepower for all lighting fixtures can be illustrated graphically and is supplied by lighting equipment manufacturers. It is important to remember that neither lumens nor candlepower has any relation to the distance that light must travel to strike its target.

The light falling on a target (incident light) is measured in *footcandles*. The Illuminating Engineering Society (IES) publishes a list of minimum footcandle levels for adequate viewing of many average seeing tasks. However, the viewer does not see by footcandles, but rather by the light reflected from objects. Therefore,

if tasks and conditions are not average, as defined by the IES, the minimum recommendations will not apply.

A simple and inexpensive footcandle meter directly measures incident light. A formula may also be used to find the footcandles falling on a task that is directly under a light-directing source in a nonreflective space: Candelas/Distance squared. If there are many sources in a space where reflecting surfaces will affect the lighting, a more complicated formula is recommended by the IES:

$$\frac{\text{quantity of instruments} \times \text{lamps per instrument} \times \text{lumens per lamp} \times \text{C.U.} \times \text{M.F.}}{(\text{area of the space in square feet})}$$

C.U. stands for the Coefficient of Utilization. This is a number that summarizes how the instrument will perform in spaces of given size and with surfaces of given reflectances. Each lighting equipment manufacturer should supply C.U.'s for its products. M.F. is a Maintenance Factor that describes how light will depreciate in terms of dirt buildup, surface wear, etc. A M.F. of 100 would describe a maintenance-free instrument in a totally dirt-free environment. The factor decreases as maintenance problems and depreciation increase. Details and tables useful in applying this formula are available from the IES.

Light that is reflected from an object is measured in *footlamberts*, and it is therefore footlamberts that reveal the environment. Unfortunately, there are few readily useful formulas and tables to help designers deal directly with footlamberts in the creation of their visual environments. Therefore, reflected light is often considered in terms of brightness relationships.

Additional concepts of measurement have recently been introduced. A Contrast Rendition Factor is proposed to measure how well a specific lighting system produces contrast between the task and its background—the higher the contrast, the higher the visibility. Equivalent Sphere Illumination is an indication of how well a particular lighting system performs with respect to glare-free conditions. Visual Comfort Probability is a rating of specific lighting systems expressed as a percentage of people who, if seated in the most desirable location in a space, will be expected to find it acceptable. Many of these newer aids require sophisticated computations and are not easily used by the nonspecialist.

Brightness relationships. The human eye, in addition to its other adaptive and productive abilities, responds to tremendous variations in the level of brightness. It is capable of perceiving minimum differences of approximately two to one as well as maximum variations exceeding 100 to 1. Of course, extreme contrasts can cause temporary eyestrain. When the eyes are forced to adapt beyond comfortable limits, the seeing process slows down, and the viewer becomes fatigued or irritable. Contrast of some magnitude, however, is essential if seeing is to progress effectively, both physiologically and psychologically. The designer must learn to work within a desirable range.

GLARE. When contrasts in an environment are so great that they cause losses in visual performance or simple annoyance and discomfort, a glare condition exists. *Direct glare* is usually caused by poorly shielded light sources, and correct placement of baffling will improve this condition. *Reflected glare* results from disturbing reflections off mirrorlike surfaces. For example, when one tries to read a text printed on shiny paper, the reflections off the surface of the paper make the task unpleasant. When reflected glare is merely irritating, it is termed *discomfort glare*, but when the seeing task becomes difficult, a condition of *disability* or *veiling* glare exists. The best remedy for reflected glare is to direct the potentially harmful reflec-

tions away from the eye (for shiny objects, the angle of incidence is equal to the angle of reflection) or to make the surface diffuse.

DECORATIVE BRIGHTNESS ACCENTS. High-interest areas can be created with great contrast and high brightness. Glitter or sparkle is a controlled type of glare which can be stimulating to the eye. Sheen, shine, or lustre are other desirable effects if they are used sparingly and away from the direct viewing of difficult tasks.

CONTRAST RELATIONSHIPS. Desirable contrast relationships have been developed in ratio form for standard conditions among three zones. Zone 1 is the task itself; zone 2 is the surface(s) immediately surrounding the task; zone 3 is the general surrounding area. If this book is being read on a table, for example, zone 1 is the book, zone 2 the table, and zone 3 the floor and walls. Comparisons are usually made between zones 1 and 2 and zones 1 and 3.

Table of Recommeded Contrast Ratios

RATIO OF THE ZONE FOOTLAMBERTS TO THE TASK (ZONE 1)

AREA	ZONE	DESIRABLE LOW	DESIRABLE HIGH	MINIMUM ACCEPTABLE LOW	MINIMUM ACCEPTABLE HIGH
General	2	1/3	equal	1/5	equal
	3	1/5	5 X	1/10	10 X
Offices [1]	2	1/3	equal		
	3	1/5	5 X		
Residences [2]	2	1/3	equal	1/5	5 X
	3	1/5	5 X	1/10	10 X
Schools [3]	2	1/3	equal		
	3	1/3	5 X		
Industry [4]	2	1/3	3 X	1/5	5 X
	3	1/10	10 X	1/20	20 X

Example: The "general" task is reading a book on a table. If the book reflects 60 footlamberts, the most desirable table top will reflect from between 20 and 60 footlamberts. The most desirable floor and wall finishes will reflect from between 12 and 300 footlamberts.

Values derived from information printed in the *IES Handbook*, fifth edition, Illuminating Engineering Society (New York, 1972) on the following pages: [1] 11-3, [2] 15-2, [3] 11-12 and [4] 14-3.

Tables have been developed to indicate the average reflectances desirable for typical installations. Designers should not use these recommendations in place of design skill, but should refer to them in verifying their imaginative schemes. It is always possible that a recommendation covering a "general" condition may not be applicable to the design at hand.

Table of Recommended Surface Reflectances

AREA	SURFACE	RANGE OF REFLECTANCE PERCENTAGES
General	Ceilings	70–90
	Walls	40–60
	Furnishings	25–45
	Floors	20–50
Offices [1]	Ceilings	80–90
	Walls	40–60
	Furniture	25–45
	Office equipment	25–45
	Floors	20–40
Residences [2]	Ceilings	60–90
	Large curtains & draperies	35–60
	Walls	35–60
	Floors	15–35
Schools [3]	Ceilings	70–90
	Walls	40–60
	Chalk boards	up to 20
	Floors	30–50
Industry [4]	Ceilings	80–90
	Walls	40–90
	Equipment & desk tops	25–45
	Floors	20+

Values printed in the *IES Handbook*, fifth edition, Illuminating Engineering Society (New York, 1972) on the following pages: [1] 11-5, [2] 15-3, [3] 11-13 and [4] 14-3.

Luminaires for interior lighting. *Luminaire* is the correct term for what is often called a lighting fixture, since the latter expression can be confusing (i.e., to a store planner, a fixture can also refer to a coat rack). A luminaire is a total lighting instrument consisting of lamps, reflectors, lenses, housing, wires, and electrical

Lighting may be used to produce a wide variety of effects, as in the luminous panels of this room divider.

connectors. Although endless variations of luminaire design are available, most interior luminaires can be placed into one of the following four categories.

RECESSED, PENDANT, OR SURFACE-MOUNTED LUMINAIRES FOR INCANDESCENT OR HID LIGHT SOURCES. A recessed luminaire is located above the ceiling and lights through an aperture (hole). Semirecessed, surface-mounted, and pendant (hung on a stem) luminaires often have the same working parts as recessed luminaires, but they are enclosed with an outer skin (housing) which allows their application below the ceiling's surface.

This category of luminaires makes use of relatively compact light sources (typically incandescent or HID lamps). They are designed to conceal the source and control it for practical or aesthetic reasons. Since we relate to daylight coming from above, these luminaires are mounted in, on, or slightly below the ceiling surface.

The *open reflector downlight* is among the most common and efficient recessed luminaires.

It uses a general-service lamp in a polished metal reflector. The reflector redirects the otherwise wasted upper portion of the light down through the ceiling aperture. The reflector also distributes light in useful ways and may be used to minimize the bright glare of the lamp in normal viewing angles. This luminaire type is easy to maintain; one simply reaches into the aperture to change lamps and wipe clean the reflector. There are, however, certain disadvantages. Since the reflector is open, it collects dirt, and there is a limit to the degree to which light can be controlled. The *lens and reflector downlight* is not as efficient as its open-reflector counterpart, but the lens can add directional control to the light rays. The lens also covers the ceiling aperture, and this retards the collection of dirt on the reflector's delicate surface. One disadvantage of this luminaire type is that the lens tends to collect light on its surface so that the viewer may be conscious of an annoying brightness at the aperture. Since the lens must be removed for relamping, maintenance may not be easy. The *can downlight* or "high-hat" is just that—a hole in the ceiling without reflectors or lenses. This type relies on reflectorized lamps to provide the requisite light control. They have one great advantage. Whenever the lamp is changed, a clean reflector and lens are automatically provided. Since there are no external lenses or reflectors, the luminaire's housing may be less expensive. Reflectorized classes of lamp, however, are much more expensive than general-service types.

Accent lights are luminaires in which the axis of the light beam is adjustable. When they are supplied without reflectors or lenses, they rely on reflectorized lamps to direct beams of light on paintings, sculptures, and other highlighted objects. When provided with lenses, reflectors, and framing shutters, the light can be precisely "framed" to outline objects with rectilinear edges.

Wall washers are designed to coat a wall

Incandescent Luminaires — Recessed

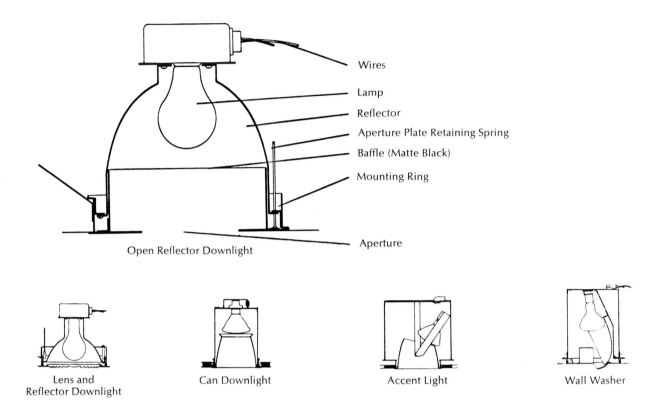

Wires

Lamp

Reflector

Aperture Plate Retaining Spring

Baffle (Matte Black)

Mounting Ring

Aperture

Open Reflector Downlight

Lens and
Reflector Downlight

Can Downlight

Accent Light

Wall Washer

Fluorescent Luminaire — Recessed

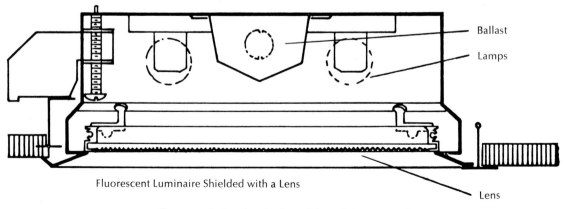

Ballast

Lamps

Fluorescent Luminaire Shielded with a Lens

Lens

Representative luminaires (viewed in section).

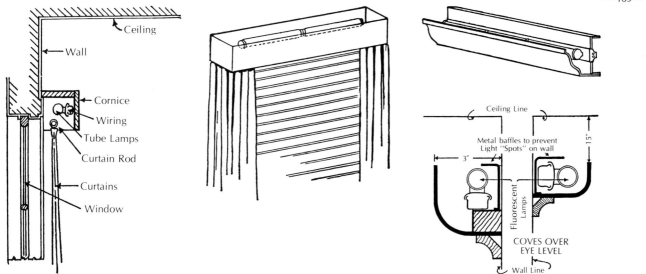

LEFT, *cross-section of cornice lighting at window;* CENTER, *lamps mounted back of valance board;* UPPER RIGHT, *section of cove for installation over windows and doors or around perimeter of a room;* LOWER RIGHT, *cross-section of two types of coves using fluorescent tube lights.*

evenly with light. They are usually located in precise lines parallel to the illuminated surface. These luminaires enable the designer to treat full vertical surfaces of a room independently from the horizontal working area.

RECESSED, PENDANT, OR SURFACE-MOUNTED LUMINAIRES FOR FLUORESCENT SOURCES. These luminaires take advantage of both the linear and diffuse properties of the fluorescent lamp. Therefore, they usually have a comparatively large luminous surface at the aperture which may be rectangular, square, or round. The 2' x 4' size is commonly used in notoriously monotonous repetition.

Fluorescent luminaires are shielded with lenses, diffusers, or open louvers. These closures may either direct or diffuse light output while concealing the lamp from view.

Fluorescent lamps may also be incorporated into the architecture. Cornices, valences, wall brackets, lighted soffits, luminous wall panels, illuminated canopies, coves, and luminous ceilings are all regularly used.

PORTABLE LUMINAIRES. These luminaire types are usually expected to be both decorative and practical. *Table and floor lamps* (luminaires) should be selected with the following precautions. Since they are used for many seeing tasks (from reading to entertaining), the quantity of their light should be controlled through dimming or variable switching. Deep and narrow shades with opaque or dark finishes should be avoided in favor of large-diameter shades with highly reflective interior finishes and diffuse light transmission. The lamp should be located so that it is shielded from the observer's eyes while directly illuminating the seeing task.

Simple *uplights* look like coffee cans with reflectorized lamps inside them. The uplight can be placed on a floor or other low surface in order to illuminate the ceiling. They are particularly effective when directed up through trees and plants, thereby casting interesting shadows on the ceiling. *Portable accent lights* are often very simple devices consisting of a reflectorized lamp in a decorative enclosure.

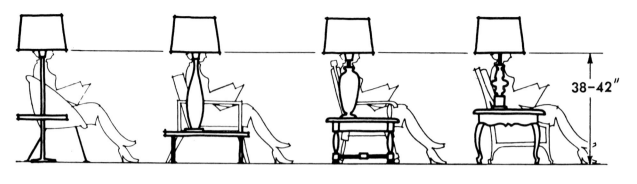

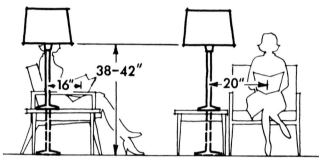

38-42"

38-42"

16"

20"

Average seated eye level is 38 to 42 inches above the floor. Lower edge of floor or table lamp shades should be at eye level when lamp is beside user. This is the correct placement for most table lamps, and for floor lamps serving furniture placed against a wall. Floor lamps with built-in tables should have shades no higher than eye level.

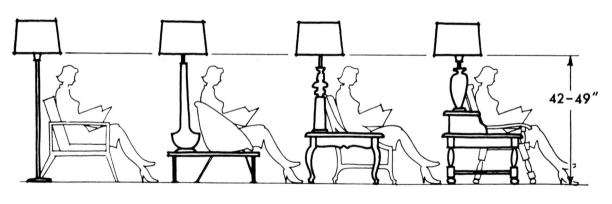

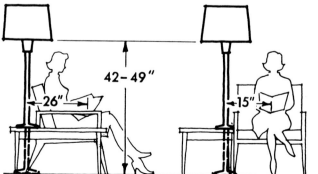

42-49"

42-49"

26"

15"

For user comfort—when floor-lamp height to lower edge of shade or lamp-base-plus-table height is above eye level (42 to 49 inches), placement should be close to right or left rear corner of chair. This placement is possible only when chairs or sofas are at least 10 to 12 inches from wall.

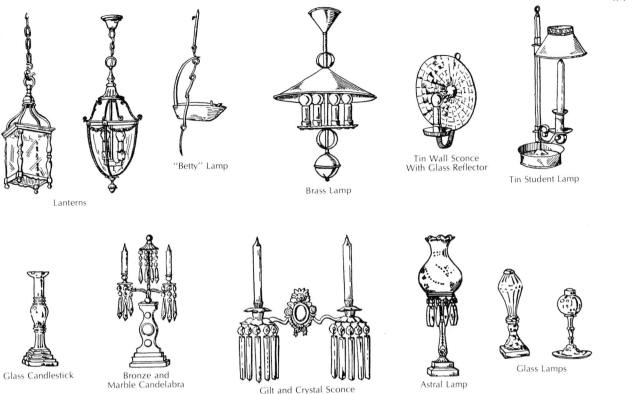

Lanterns "Betty" Lamp Brass Lamp Tin Wall Sconce With Glass Reflector Tin Student Lamp

Glass Candlestick Bronze and Marble Candelabra Gilt and Crystal Sconce Astral Lamp Glass Lamps

Examples of colonial lighting fixtures.

DECORATIVE LUMINAIRES. Decorative luminaires are more to be seen than to see by. The *chandelier* and *sconce* were not originally made as purely decorative accessories, but due to the advantages of other modern luminaires, they have largely assumed this role. Although they may add an important decorative or historical accent, they are not valuable to the working luminous environment unless engineered with uncommon skill.

Luminal art, objects that derive their artistic quality through the interplay of light, is becoming increasingly popular. They may have design value, but they require careful consideration as functional lighting sources.

Electricity and electric control for lighting. Electricity has three basic characteristics: am-perage, voltage, and wattage. Amperes measure the current or flow of electricity. Amps are used to rate fuses in lighting practice (15, 20, and 30-amp fuses are commonly found in residences). Voltage is the measurement of the tendency of electricity to move through wires. Volts are often used to describe the current available in a building's wiring (most of the United States attaches its lighting to 120-volt service). Watts represent the rate at which electric energy is changed into some other form of energy (such as light). Watts describe the electrical drawing power of lamps.

The relationship among these three characteristics is given in the formula $W = VA$ (watts equal volts times amps). Similarly, $A = W/V$ (amps equal watts divided by volts), and $V = W/A$. In other words, if a 15-amp fuse is found

—472— protecting a 120-volt circuit, 1,800 watts may theoretically be used in that circuit without blowing the fuse [1,800 = (120) (15)]. Or, if you are consuming 2,400 watts of power, a 20-amp fuse will be required [20 = 2,400 ÷ 120].

Two types of electric lighting control are typical—dimming and switching. The former has recently become increasingly popular because of technological advances which make it cheaper and safer than in the past. Wherever incandescent dimming is desired, it should be used without hesitation. Fluorescent dimming is also available, but it requires greater technical knowledge. HID dimming was recently introduced.

To allow for flexibility, every space should be supplied with an adequate number of electrical outlets. The general rule is that no point along a wall should be more than six feet from a "duplex" outlet (two convenience outlets joined together behind a single wall plate). All outlets should be controlled by switches. Dimmer control of wall outlets is not advisable, as it is easily possible to overload these relatively delicate devices and destroy them. Dimmers should be permanently connected only to electrical loads of known wattage.

BIBLIOGRAPHY

Birren, Faber. "Psychological Implications of Color and Illumination." *Illuminating Engineering*, vol. 64, no. 5 (May, 1969), pp. 397–402.

Buban, Peter, and Schmitt, Marshall L. *Understanding Electricity and Electronics*. 2d ed. New York: McGraw-Hill Book Co., 1962.

Burnham, Robert W.; Hanes, Randall M.; and Bartleson, C. James. *Color: A Guide to Basic Facts and Concepts*. New York: John Wiley and Sons, 1963.

General Electric Company. General Electric Technical Pamphlets: "TP-109, High Intensity Discharge Lamps"; "TP-110, Incandescent Lamps"; "TP-111, Fluorescent Lamps"; "TP-118, Light Measurement and Control"; "TP-119, Light and Color." Cleveland: General Electric Company.

Kaufman, John E., ed. *IES Lighting Handbook*. 5th ed. New York: Illuminating Engineering Society, 1972.

Sylvania Incorporated. Sylvania Electric Engineering Bulletins: "O-234, Incandescent Lamps"; "O-298, Dichroic Filters"; "O-341, Fluorescent Lamps." Danvers, Mass.: Sylvania Incorporated.

Westinghouse Electric Corporation. *Lighting Handbook*. Rev. ed. Bloomfield, N.J.: Westinghouse Electric Corporation, 1969.

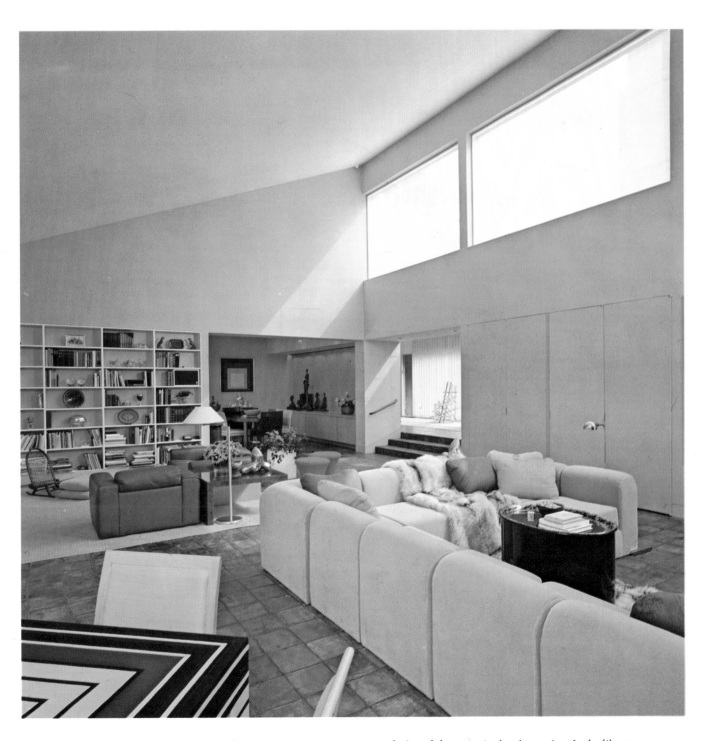

A large sweep of space encompasses the conversation center composed of modular units in the shape of an L, the library and dining areas. Light floods the space from the large clerestory windows as well as a glass wall (not shown) opening on a terrace. The warmth of a quarry tile floor punctuated with area rugs is recalled in the color accents.

Photo by Tom Yee. Design by John Saladino

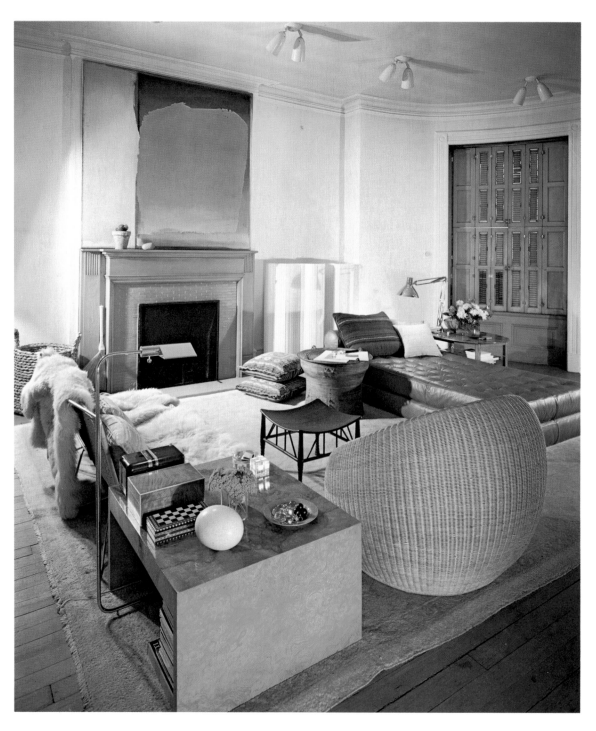

A subtle handling of forms, textures and materials in a spacious New York brownstone. A relaxed mood is achieved by the interplay of natural materials and hues creating a restful monochromatic type of scheme. Textural interest as seen in the varieties of surfaces such as wood against wicker and leather in contrast to furs, metals and stone is an important element in this type of scheme. Courtesy of Conde Nast Publications. John Saladino, Designer

Design Materials and Accessories

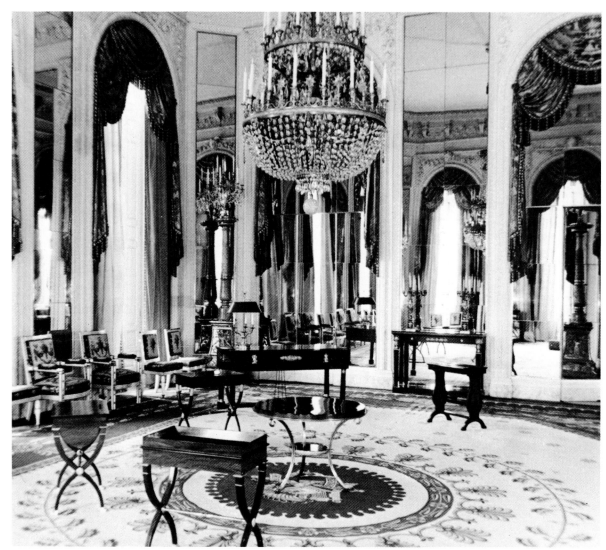

An Empire Savonnerie in the Salon des Glaces of the Grand Trianon.

CHAPTER 15

Floor Coverings

An American Indian Yei, or sandpainting figure in small rug or wall hanging.

Floor coverings were probably woven in Egypt before 3000 B.C. Pictorial records show that, in early times, patterned fabrics were placed before the Pharaohs' thrones, and only royal personages or supplicants were allowed to tread or kneel upon them. Biblical writers, Homer, Horace, Pliny, and other ancients mention them. During the Islamic expansion, and particularly in Persia, where highland sheep provided a fine, long wool, the weaving of rugs* was developed over hundreds of years into an artistic culmina-

* The English word *rug*, of Anglo-Saxon origin, is akin to "rugged" and "rough," and the early meaning was "coarse" or "shaggy." Its correct application is therefore to a pile fabric, but custom has associated it also with tapestry weaves. The word *carpet* is of Latin and Old French origin and was derived from a word that referred to the cleaning of wool. Today the two words are often synonymous, but it is perhaps convenient to apply "carpet" to the floor covering that extends to the wall and completely covers the floor. Machine-made carpets are usually known as "broadlooms" and are made in strips of wide dimensions.

tion that occurred in the sixteenth century. These Asian floor coverings were sometimes in tapestry weave, but the majority were pile fabrics woven on a loom composed of two beams between which were stretched the warp threads; colored threads of wool or silk were knotted to the warp to form a pile pattern that sometimes was composed of as many as 1000 knots to the square inch. When the knotting was completed, the ends were sheared to produce an even surface. Fabrics of this type were also used for tent walls, wall hangings, partitions, awnings, camel saddles, bed mats, covers, and portieres.

During the Middle Ages, the floors of many

This fifteenth-century Hispano-Moresque "Admiral" carpet readily illustrates the blending of both Christian and Moorish design influences.

—475—

The Textile Museum, Washington

It is possible this was a sixteenth-century Castillian tomb cover. The motto reads: "Exmemet Renascor" ("From Myself I Am Reborn,"), "Victoria Doctis" ("Victory to the Learned"). The central medallion exhibits Phoenix rising from the flames. Skull and crossbones are in the corner medallions.

of the castles in northern Europe were spread with rush and dried grass. Tradition states that Moors from Spain entered southern France in the thirteenth century and established the first rug looms in Aubusson. Spanish rugs were

brought to England in 1255 as part of the dowry of Eleanor of Castile. Carpets were exported from Turkey to England in the fifteenth century where they inspired an effort to copy them, and a magnificent rug was woven for Elizabeth in 1570. Holbein painted members of the court of Henry VIII and often showed Oriental rugs as floor coverings or table covers. In 1608 Henry IV of France employed several Persian weavers for looms that he established in the Louvre, and the Savonnerie factory was founded in 1618. The revocation of the Edict of Nantes in 1685 forced many French weavers to emigrate to Flanders, and Brussels, already a tapestry-making center, became famous also for its looped pile floor coverings. Rug-weaving guilds were established in England in the seventeenth century, and in 1740 production was accelerated by the absorption of Flemish emigrants, who introduced the Brussels type of carpet weaving and who established what was later to become a great British industry. A few years later French weavers from the Savonnerie factory went to England and improved the design of English floor coverings. Weaving of these fabrics had meanwhile started at Kidderminster and Axminster.

Hand looms were used until 1839, when the first power loom, based on Arkwright's, Cartwright's, and Jacquard's inventions, was adapted to rug weaving. From this time, the industry spread rapidly to other centers in Europe and America.

CARPET FIBERS

At one time carpet weaving was limited to the use of natural fibers—wool, cotton, flax. The discovery of rayon, the first man-made fiber, led to a whole new range of fibers. The principal man-made fibers are nylon, acrylic, polyester, and olefin/polypropylene. Of the four, nylon leads. While there is no perfect fiber made, some of these second-generation man-made

A Louis XIV Savonnerie carpet, flamboyant in style and baronial in size.

fibers outperform natural fibers and have opened up vast new areas for the use of carpets which were never considered before—classrooms, hospitals, and supermarkets, for example.

Wool. Wool, the oldest natural fiber known to man, is the classic fiber used as a yardstick against which to measure all others because of its desirable characteristics—soft hand and resiliency. Wool is hydroscopic, enabling it to absorb water, and when the fiber is moistened and heated, the staple will soften and swell. It is this ability to absorb water which makes wool easy to dye. Virtually every pound of wool used in the manufacture of carpets in the United States is imported, as domestic wool is too soft for use in the manufacture of carpets.

Carpet wool comes from countries where climatic conditions produce wools which are tough and resilient and which possess a coarseness and thickness suitable as a carpet fiber.

Wool, when sheared, is usually very dirty. About one-third of its weight is composed of natural oil or body grease, sand, seeds, and burrs, which gather in the sheep's coat. To save transportation costs, the raw wool is often scoured before baling.

THE CHARACTERISTICS OF WOOL BY COUNTRY.

New Zealand: This wool absorbs dye easily, and colors have great clarity and uniformity. The staple is lustrous and tough. The color is almost white.

Argentina: This wool, noted for its gloss and sheen, has a natural resistance to soiling. It is not as white as wool from New Zealand.

India: This wool is crush resistant.

Iraq: One of the most luxurious and costly of wools, it also has a high abrasion resistance and durability.

Scotland: The Scottish black-face sheep bear the finest of all carpet wools with staples measuring as long as fifteen inches.

It becomes quite obvious, therefore, that wool from different lands has different characteristics. To obtain a quality of yarn suitable for carpet weaving all these various wools should be blended together in varying proportions depending on the dominant characteristic needed. This is accomplished, of course, after the raw wools have been cured and dried. To create a wool yarn suitable for weaving, it is necessary first to card the fibers and spin them into a long yarn. During the spinning, the yarn is twisted to give it body. These preliminary yarns are fine, and a number of them must be twisted together to create a yarn heavy and durable enough for carpet weaving.

Man-made fibers.

NYLON. Man-made fibers have gained significance within the carpet industry. Three

quarters of all pile carpets sold have been made with these synthetic fibers. Nylon, the most widely used of all the man-made fibers, currently commands about 40 percent of the market. In commercial or contract markets nylon has an even greater lead. It has achieved this position because of its versatility and its great strength and resistance to abrasion. Nylon will outlast all natural and man-made fibers in wearability. It dyes well into a wide range of colors. Nylon is moth-proof, resists mildew and mold, and is nonallergenic. The static buildup in nylon —a fiber most prone to the static problem—has been controlled by a number of methods: (1) introducing metallic wire fibers such as Brunslon into the yarn before tufting or weaving; (2) adding a chemical to the dye solution to reduce static buildup; (3) controlling the humidity within the environment. The higher the humidity, the less the chance for static buildup. Some form of static control is most necessary in areas where computers are in operation and in hospitals and nursing homes.

ACRYLICS. Acrylic fibers for carpet use were introduced in 1957. Carpets made of acrylic fibers are often described as "woollike" because they possess warmth, durability, softness, good texture retention, and resilience. The new solution-dyed acrylics have brighter, livelier colors and are especially resistant to sun deterioration and other weather conditions. Acrylics are low in moisture retention. Like all man-made fibers, acrylic fibers cannot be damaged by carpet beetles or moths. They are also mildew-proof. Acrylic fibers have the lowest static buildup factor. Aesthetically, carpets of acrylic fibers lead the man-made fiber group because of the woollike characteristics and because of the range of styling possibilities. Acrylics in either staple (short fibers) or filament form (continuous strands) can be woven or tufted.

POLYESTER. A later fiber, polyester, is also soft and luxurious. Polyester fibers are strong, durable, and have high abrasion resistance. They dye well, producing clear, clean colors which resist fading. Polyester fibers have a low static buildup factor. Continuing improvements to allow better resilience will eventually make polyester carpets a contender in the contract field. Today, polyester, as a popular fiber, is mainly used in shags and random sheared carpets.

POLYPROPYLENES/OLEFINS. The newest of the man-made fibers is one of the most economical. Polypropylene/olefin is considered comparable to nylon in durability, strength, and wear resistance. The fibers are solution dyed— a process which allows excellent color fastness. Olefin fibers absorb little moisture, resist stains, clean well, and are almost completely free of static buildup. Carpets made of these fibers are being used extensively in the indoor-outdoor areas—on porches, around pools, and in kitchens. Research to improve this fiber, especially to enhance its aesthetic quality, is continuing.

Blends. Blends are combinations of two or more fibers into a single carpet yarn, each yarn lending to the other its dominant characteristic. It is important that the amounts of each fiber used be balanced so as to control the ultimate quality of the yarn. A blend can be made to meet the demands of a particular specification. For example, a blend of 70 percent wool and 30 percent nylon will give the yarn the abrasion resistance of nylon and the warmth and softness and luxury of wool. On the label, the dominant fiber within the blend will appear first.

As a guide to the surface fiber content of all carpets, the Fiber Products Identification Act requires that all carpets be labeled with the percentage of each fiber used on the surface. Generic names must be used in this labeling. The fiber in a particular carpet can be identified by cutting off a tuft and burning it with a match. If it shrivels and chars, the fiber is wool. Wool has a distinct odor which no one can mis-

take. If the tuft melts and forms a bead, the fiber is nylon, polyester, or an acrylic.

A blend is used to achieve one of three objectives: (1) performance standards, (2) a more appealing aesthetic quality, or (3) improved economics.

A very popular blend, especially in the contract field, is one of acrylic and nylon. Here again we get the hard, long wear of nylon and the appealing woollike appearance of acrylic. Most of the carpets used in the commercial or contract field, where performance is the primary consideration, are, regardless of fiber, usually constructed with a low, tight loop. Multicolor is preferred over solid color, and, with new dye techniques under development, pattern is coming into use.

THE DYEING PROCESS

Though not durable, the old dyes made from roots, shells, and insects gave us the richest, most jewellike colors we are ever likely to see. Alas, these are virtually obsolete. The clear color tones and subtle colors available today are the result of new dye technology.

The basic dye techniques.

RAW STOCK DYEING. The fiber is dyed in bulk before it is spun. This process is suitable for large quantities of a single color. It results in a uniform, level color throughout the dye lot and, because it is a single operation, is very economical.

SKEIN DYEING. After spinning, the yarn is made into skeins and then placed into dye vats. This process is advantageous for small batches of yarn.

SOLUTION DYEING. This method is used in the dyeing of man-made fibers. The color pigment is introduced into the liquid from which the fibers will be made. Thus it becomes an integral part of the yarn, with the color locked in. This makes the yarn virtually impervious to fading, spillage, and other forms of color deterioration.

PIECE DYEING. The manufactured carpet is dyed by the whole piece. This is an economical method of dyeing. It enables the carpet manufacturer to make up the rolls of carpeting in a natural yarn, then dye the specified length to special color. Current dye methods allow huge volumes of carpet to be processed at the same time. It should be noted, however, that only certain fibers—nylon, polyester, some olefins, and some treated wools—can be satisfactorily dyed in this manner.

DIFFERENTIAL DYEING (Sometimes known as cationic dyeing or cross dyeing). This is an effective method for creating design and multicolor effects in piece dyeing. With the growing demand for high-style carpets, this method was evolved to achieve a two-color effect in a single dye bath. This type of dyeing is effected in two ways. In the first method, yarns of the same fiber used in the finished carpet are treated with two or more chemicals, each chemical being capable of absorbing only a compatible dye. Two or more dye baths are prepared, and, as the finished carpet is dipped, only those yarns of chemical compatibility will absorb the dye in each of the baths. The result is, of course, a carpet dyed two or more colors within a specified pattern.

The second method requires a blend of yarns within the carpet, with different color baths for each of the yarns. Either way, it is possible to piece-dye a carpet in up to five different colors. In some factories these processes are controlled by computers.

SPACE DYEING. Just as a carpet that has been chemically treated will accept only the compatible dye, in this type of yarn dyeing only the treated yarns (prior to weaving or tufting) will accept certain specified dyes.

RESIST DYEING. A new development is resist dyeing—quite the opposite of differential dyeing. In this process the yarns are treated to

resist additional dyes. Unlike differential dyeing, resist dyeing produces no discernible pattern of color. It is a method used for shading only.

Ways of applying dye. The present-day dyer has an increasing number of fibers and blends that he must work with. His job combines art and science and is rapidly becoming a science exclusively.

DYESTUFF SELECTION. With the number of different dyes to work with, the dyer must select the right one for the fiber which is to be dyed. The new dyes fall roughly into three categories:

1. *Acid dyeing (wool, nylon).* These dyes have a wide range of colors that are easy to apply and are used mostly for wool.

2. *Disperse dyeing (nylon, polyester, olefin).* This is one of the oldest and most basic methods of dyeing. These are the only dyes usable on polyester and olefin and are easily applied to nylon.

3. *Basic dyeing (acrylic, wool, nylon [some types only], cotton).* Wool and nylon require special treatment before dyeing. The acrylics dye well and produce good, bright colors. Some of the colors, mostly in the browns, greens, and golds, will come out brighter when using the stock-dyed method rather than the basic method.

PRINTING

There are two basic types of printing: roller or drum printing, and screen printing. Roller or drum printing is similar to the operation of a rotary press. The dyes inside the drum are applied to the flat, moving surface of the carpet. This method of printing is very fast and inexpensive. Screen printing utilizes a series of screens (one color to a screen), consisting of a very fine mesh held within each frame under some tension. Most screens are of silk, Dacron, or steel. In the actual printing, the areas that are to receive the dye are kept open, while the

areas that do not call for the dye are sealed. In this way the pattern is created by pulling the dye up through the backing and up through the carpet by vacuumatic control. Then a secondary backing is applied to the carpet. Printed carpets are making their mark in the domestic (or residential) field, adding a new dimension of design to floor coverings.

MACHINE-MADE RUGS AND CARPETS

Basic carpet surfaces. Each carpet texture offers specific wear advantages. Some will stand up to heavy traffic; some will conceal footprints; and other types have more decorative qualities.

LEVEL LOOP PILE. The entire surface is made of uniform uncut loops. This surface has many advantages. In tweed colorations, it conceals footmarks and soilage. The denser the surface, the better it will wear, and it is particularly recommended for heavy-traffic areas and commercial installations.

LEVEL TYPE SHEAR. In this loop surface, some of the loops are cut, and some remain uncut. A carpet of this type adds an interest to colors and gives a desirable pattern effect.

CUT PILE PLUSH. The entire surface is sheared to produce a smooth, plushy effect, which gives a room a more luxurious look. This texture is subject to shading and shows foot marks. Surprisingly, some people feel that shading adds to the interest and gives a certain opulent look to the floor covering.

MULTILEVEL LOOP. The surface is made of different pile heights, all uncut loops, which tend to give a dimensional character to the carpet.

SHAG. This is a multidirectional, high pile twist, giving an attractive, informal look.

RANDOM SHEARED. The loops are sheared to different heights, forming a pattern which can be definite or irregular.

TWIST. This is an all cut pile surface made from yarns that have been tightly twisted

and the twist set by a special heating treatment. Good twists have a firm texture and wear very well. They are made in solid color or multitone effects.

Woven carpets. Carpets can be made by weaving, tufting, or knitting.

Three basic power looms are used to produce woven carpet: Wilton, Axminster, and velvet. Weaving is the traditional way of making carpet on a loom. The characteristics of the three weaves are derived from the difference in the looms. The fundamentals common to all three are that the surface pile and backing are woven simultaneously. Carpet is woven on a broad loom, and, contrary to popular belief, the term *broadloom* does not indicate quality, but merely that the carpet was made on a loom wider than three feet. The narrow loom of twenty-seven inches, which was the original standard width, is no longer popular except for the Wilton weave, which is mostly for commercial use.

Pile yarns are those forming the tufts of the carpet face. They may be cut, looped, or a combination of both. They may also be embossed, a combination of high and low pile, using any of the natural or man-made fibers.

Warp yarns are the backing yarns running lengthwise. They pass alternately over and under the weft yarns, which run crosswise the width of the carpet from selvedge to selvedge. One of the main factors determining the quality of the carpet is the pile weight. The weft yarn combined with the warp yarn binds the pile yarns together in a woven fabric. As in the warp yarns, the closeness of the weft yarns is also indicative of the quality.

The factors determining the quality are:
1. Pitch (warp)
2. Rows or wires (weft)
3. Pile height.

Pitch is the number of warp lines measured crosswise in a twenty-seven inch width of carpet. On a Wilton loom usually 256 warp lines per twenty-seven-inch width is termed a full pitch. Rows or wires are the number of weft lines measured per inch in the length of the carpet. An Axminster will have no more than eleven rows, and the velvet no more than ten rows. The Wilton weft count is referred to as wires and the Axminster weft count as rows. The Axminster weft count may be as high as ten rows to the inch or as low as five and two-thirds rows. As in the Wilton carpet a high pitch (256) is one indication of good quality, so in an Axminster a high row (ten) is a measure of a good, close weave. Ply is the number of strands of single yarn twisted together to form one pile yarn, which can be two-ply, three-ply, four-ply, etc. The weight of the yarn must be considered in judging quality. Ply by itself does not indicate quality; it merely tells you how many single yarns were used to make the final pile yarns.

Wilton. This carpet takes its name from a town in England where it was first manufactured. It is woven on a loom with a special Jacquard attachment which uses punched cards like an I.B.M. card or a piano music roll. The holes in the cards control the color in the pattern. All the cards are put together and suspended above and behind the loom. In the operation, the Jacquard mechanism selects the appropriate color yarn and feeds it into the loom to form the color design of the carpet. Wilton carpet is made in two, three, four, or five frames, each frame representing a color. The loom can be set to take more frames or colors, and, when this is done, the colors not appearing on the surface are buried in the body of the carpet. This is called "planting." As a result the carpet will have greater design flexibility. The process allows the Wilton loom to produce multi-level loop piles and cut or uncut piles.

Velvet. The simplest of all woven carpets, velvet carpets are made in solids and tweeds, in an enormous range of colors. The

pile can be cut to give a plush effect, twisted to provide a nubby frieze surface, or left uncut in loop form to give a pebbly texture. Tweed effects can be achieved by using a moresque yarn, that is, a yarn in which the single strands are of different colors. With a slight modification of the loom, geometric and stripe effects are being produced. The pile yarn can be woven through the back, just as in a Wilton carpet. This gives the carpet a strong tuft bind. All of the yarn used in the manufacture of velvet appears on the face of the carpet.

AXMINSTER. Also named for the town in England where it was first made, the Axminster loom was actually an American invention. It is a very specialized loom that permits an almost unlimited combination of color and design. The loom draws the pile yarn from spools holding the various colors. These spools are set in a frame that is the width of the carpet to be woven. Setting up the loom with the individual spools is a long and tedious job, but when the weaving starts, it proceeds at a rapid pace. Each frame carries one complete row of tufts across the carpet with each yarn strand providing a single pile tuft. It is theoretically possible to have a different color for every pile tuft. Pattern in Axminster carpet is obtainable in an endless variety—stylized, geometric, classic, modern, and floral. Thus, of all machine-woven carpet, Axminster comes closest to the versatility of hand-woven carpet, since each tuft is inserted into the pile individually.

Tufted carpets. A modern tufting machine may be compared with a giant sewing machine. The operation, simple and inexpensive, consists of a bar, holding hundreds of needles, which extends the full width of the carpet. The yarn is threaded through the eye of each needle, which is moved through the backing fabric. The backing may be of jute or one of the new synthetic materials and is called "primary" backing. The synthetic backing is being increasingly used

because of its strength, dimensional stability, and low moisture retention and because it has fewer irregularities than jute backing. A heavy layer of latex coating is applied to the back which holds the tufts permanently in place. A second backing is then applied, usually of jute, to give the finished fabric additional strength and stability.

Originally, tufted carpets were restricted to either solid or moresque colors, but today, with new innovations and dyeing methods, a great variety of texture and color combinations is possible. Tufted carpets amount to almost 90 percent of all carpets manufactured today. All the fibers, natural and man-made, are used in their manufacture.

Gauge determines the density of a tufted fabric, that is, the number of ends of surface yarn counting across the width. For example, a gauge of three-sixteenths inch would have 5.3 rows per inch, and a gauge of 5.32 inches would have 6.4 rows of tufts per inch across the width. New and finer gauges are being developed to produce a low-density carpet for heavy commercial use.

The manufacturing of tufted carpet began after World War II, and its growth has been phenomenal. Today it has become the most important type of carpeting on the market both for domestic and commercial use.

Knitted carpets. Knitted carpets are similar to woven carpets in that the pile and backing are made in a single operation. The knitting machine uses three sets of needles to loop together the pile backing yarn and the stitching yarns. They are usually of a loop construction in either solid or moresque colors. All of the fibers, natural and man-made, can be used in the manufacturing process. A coating of latex is given to the back to give additional strength and body. Practically all of the yarn appears on the surface, giving a greater wear factor and an excellent value at a moderate price.

HAND-MADE RUGS

Hand-knotted rugs. Hand-knotted rugs are the oldest type of fabric, and coming from the Orient are the historical parents of all modern knotted rugs. This kind of rug is made today in Morocco, Spain, Portugal, India, and Hong Kong. Yugoslavia and Bulgaria also produce various grades of this knotted type. These rugs are still made in almost exactly the same manner in which they were made in the Orient for hundreds of years. Two kinds of knots are used— the Ghiordes or Turkish, and the Sehna or Persian. These knots are very simple, and it is believed that they have remained unchanged for many centuries. The method of weaving makes the Persian knot closer in texture than the Turkish knot.

There is no better rug or carpet than the one knotted by hand. This is not meant to imply that all hand-knotted rugs are superior to all machine-made rugs. There is no method of combining the pile with the foundation that is better than the knot, and it cannot yet be imitated by any power loom invented. The hand-knotted rug or carpet possesses an individuality, even in its faults, which no product of a machine can attain. Hand-made rugs have a further advantage in their adaptability to requirements. A simple rug, for instance, can be made to any specified shape, size, color, and quality. It is

Early nineteenth-century American hooked rug showing an unusually fine floral pattern.

possible to produce in one piece a rug or carpet of oval, circular, or L-shaped form. In most of the decorator supply houses, interior designers and architects have the services of skilled artists with whom to consult. Hundreds of different sketches are available covering a very wide field, and it often requires only a change of coloring or a simple change of pattern to arrive at a suitable design.

Starting from an idea of what the client may want, a preliminary pencil sketch is prepared to scale, usually one and a half inches to a foot. If the design is an overall pattern, a full-scale drawing is made to the above scale; but should the design have a repeat, usually a quarter section is sufficient. When the pencil sketch has been approved by the designer and client, it is painted in the specified colors. At the same time, wool pompons to match every color are picked out from the hundreds on hand, and tufts from them are attached to the sketch and numbered. The finished sketch, when approved, is sent to

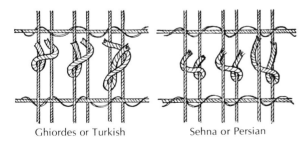

Ghiordes or Turkish Sehna or Persian

Diagram showing manner of tying knots in Oriental rugs.

the manufacturer with explicit detailed instructions on the order. The mill is required to submit its pompons for approval before proceeding to weave. In some cases, a section of the rug showing all the colors and design is requested. This is the safest guarantee of the finished appearance of the rug.

Practically all hand-knotted rugs are made from the finest grades of wool.

Hand-tufted rugs. It should be made clear that hand-tufted rugs are not necessarily the same as hand-knotted rugs. In hand tufting, the full-scale pattern is drawn in color onto a tightly woven fabric backing such as linen or heavy burlap. The colored yarns used to fill the pattern are threaded into a needle in a "hand gun" (an instrument not unlike a staple gun). The gun pierces the fabric backing, tufting in the yarn as it goes. The flexibility of this method of rug fabrication allows infinite color and design possibility. Like hand-knotted rugs, hand-tufted rugs are popular with interior designers. Both can be custom made in any size, color, style, or weight. In both cases wool is the preferred fiber.

As a matter of budget, fine hand-tufted rugs are made to specification in Puerto Rico, Hong Kong, and Japan. Most of the decorator supply houses have access to these foreign rug-tufting centers. And, as with the custom specification of a hand-knottted rug, the same procedure is followed. The interior designer provides the custom design idea or sketch and color swatches to the decorator supply house, which then completes a full-scale drawing of a repeat of the design for approval before sending the design to be manufactured.

Another major source of custom-design facilities is the larger mills. These provide a quality custom-styling service for the discriminating designer and architect. It is not generally realized what designers can obtain in terms of custom-styling and lower cost from the larger mills.

CARVED RUGS

Carving is the process of incising a design into a carpet or rug which has already been woven. It is not to be confused with the sculptured and embossed carpets made on a loom.

Hairline carving is used between colors in a multicolor design rug in order to accentuate and give the design some dimension. The design rug may be embossed, which is the process of carving in a high-low effect. Beveling is simply rounding off those parts of a carpet which already have been carved, recessed, or embossed. Beveling can be done on a solid color or multicolor carpet and on cut or loop pile construction. A combination of cut and loop pile lends itself very well to beveling. The variety of design in carving has a wide range, including a one- or two-color border design, center medallion and corner designs, and the very elegant overall designs.

The hand-tufted rugs made in Hong Kong are probably among the finest rugs of their kind. The fineness of the yarn will help to determine the type of carving to be done. For instance, very fine yarn is ideal for hairline carving.

Some of the larger carpet manufacturers in this country produce a hand-carved rug in standard sizes ranging from four by six to twelve by twenty-one feet in length. These rugs are made in a wide range of designs and colors. One particular mill, using a very intricate weaving technique, has been able to manufacture rugs with some very striking designs in multicolor simulating carved rugs very well.

OTHER CARPET CONSTRUCTION

In *needlepunched* carpet manufacturing, the fibers, usually of acrylic or polypropylene, are punched into a web of synthetic fiber to form a homogenized layer of fiber. This layer is then put under heavy compression to form the characteristic feltlike fabric. When all man-made

fibers are used, then it can truly be called an outdoor carpet. This is a fast and low-cost method of manufacturing, producing a carpet that will wear well. When a cushion of foam rubber is added to the back and the carpet has some design, it begins to approach the luxury look and feel of a cut pile carpet. Where design is called for, the printing process is used. Solution-dyed polypropylene and acrylic are most often selected for outdoor use.

Flocked carpet is a new addition to the commercial field. There are three methods of applying the flock, but the one principally used is the electrostatic method. The dyed short ends of fiber are electrostatically treated and sprayed onto an electrically charged backing sheet which has been treated with an adhesive. The fibers are held by the adhesive in an upright position with approximately seventeen thousand ends of fiber to a square inch. After the backing has been cured in an oven, a secondary backing is applied that helps to give good dimensional stability to the carpet. Should design be called for after construction, this is done by the print-dyeing method. When compared with woven or tufted carpets, the design possibilities in flocked carpets are extremely limited. The process of flocking was in use as early as the fifteenth century.

Milstar is a new and exciting carpet recently brought out by one of the leading manufacturers. This is a velvet-finish cut pile carpet. The construction involves a bonding of 70 percent acrylic fiber and 30 percent nylon fiber, fused into an impermeable backing of latex and jute. Two drums are involved, rotating toward each other; the jute backing is wrapped around each drum, and the liquid vinyl is applied to the outer side of the backing. The pile yarn is then applied to the top of the latex and fusion-bonded with it. A shearing mechanism attached to the machine cuts the fibers in half. Thus, in this new technique, two carpets can be made in the same time it takes to make one. This type

of new carpet can be print-dyed, creating various designs—geometrics, florals, and plaids.

CARPET TILES AND SQUARES

An increasing use of this new development in floor covering is evident in the commercial field. Carpet squares are produced by a process known as "felting," which is a matting together of animal hair or fibers to form a continuous fabric known as felt. The appeal of carpet squares is that they can be laid loose, are interchangeable, and adhere to the floor by their own vacuum. They are available in a wide range of colors and fibers, including all animal hair with a small addition of man-made fibers and all wool. Pattern can be created by mixing the tiles. Three new developments are:

(1) Print dyeing of patterns.
(2) Introduction of shag tiles.
(3) Heavy-gauge tiles for commercial use. These come in sizes up to twenty-four by thirty-six inches. Interior designers are recognizing the suitability of these heavier-gauge tiles for commercial use.

Installation costs for carpet tiles are considerably less than conventional methods, and damaged or worn tiles can be easily taken out and replaced.

WALLCOVERING

Some carpet manufacturers are experimenting with a number of materials. In all probability, we will see the most practical one as a carpetlike pile fabric. In some instances, a lighter-weight carpet than the one selected for the floor is being used on both walls and ceilings. With this new development in wallcovering, the interior designer has an increased opportunity to obtain warmth, comfort, and functional utility for either home or office use.

Airborne or impact noise, a factor of some importance in today's mode of living, is being

brought under control by the new wall carpet concept. An example of its practical use is the installation of wall carpet in an art gallery, where it allows pictures to be moved and replaced without showing telltale marks. It is certainly a new tool for creative interior planning.

CARPET CUSHION

Carpet cushion can be called the "hidden asset." The traditional method of installation still requires the use of a separate foundation. This foundation is referred to as "padding," "underlay," "lining," or "cushioning." Carpet cushion serves many useful functions; it increases the wearability, gives added insulation, helps deaden sound, and provides comfort underfoot.

The basic types are natural hair and jute blends and rubber. Natural paddings are specified by weight, that is, 32 ounces, 40 ounces, 50 ounces per square yard. They tend to be a little firmer than the rubber type. The hair linings are made from felted cattle hair and possess a superior resilience. Jute is mixed with hair and can be coated with a rubber waffle design on top which increases the resilience. Foam and sponge rubber cushions are made in flat sheets to a thickness of one-quarter inch. They are also available in pebble or ripple texture.

Some carpets are available with attached rubber cushion, usually referred to as "rubberback carpet." This type is cemented directly to the floor using a special adhesive and is widely used in the commercial field in narrow widths of twenty-seven or forty-eight inches.

Tests made by the Bureau of Standards show that cushioning of the proper type definitely prolongs the life of the carpet by at least 50 percent.

Omalon is a new carpet cushion developed quite recently by a leading chemical manufacturer for commercial installation. This new cushion, a high-density polymeric, is highly resilient and virtually indestructible. Omalon has a high moisture and heat resistance and can be used on radiant heated floors.

INSTALLATION

The correct installation of floor covering must be stressed. Skilled workmanship is most essential since, no matter how attractive the choice of color or fabric, the finished job on the floor is what counts.

There are three main methods employed today.

In tackless stripping, pre-tacked thin strips of plywood are fastened all around the perimeter of the space to be carpeted. The carpet is stretched up to these strips and the edge attached to the stripping, giving a smooth surface right up to the wall. This technique is a vast improvement over the old method, which was to turn under the edge and tack down, leaving an unsightly row of tacks.

The glue-down method is usually employed with a bonded carpet. A high-density foam rubber cushion is used as the secondary backing and is cemented directly to the floor. This method of installation is becoming increasingly popular.

The third method is to glue the carpet down without a cushion of any kind. The carpet is cemented directly to the floor. This method is employed mainly in hospitals or areas where wheeled equipment is used extensively.

SELECTION

When selecting a rug or carpet for installation, there are, generally speaking, five major reasons for doing so:

1. *Beauty:* Today's carpets offer a tremendous choice in color, texture, and design in both natural and man-made fibers.
2. *Comfort:* Carpet greatly reduces floor fatigue

in areas such as offices, restaurants, shops, and hospitals as well as in the home.

3. *Quietness:* Carpet serves as an acoustical floor covering, lessening airborne and impact noise. This factor is being used by architects and interior designers in their initial planning stages and can result in substantial savings in the acoustical requirements.

4. *Warmth:* The pile construction in carpet is a highly efficient insulator against cold. Here again, costs for heating can be reduced in areas that are carpeted.

5. *Tractive Safety:* There is less chance of a fall in a carpeted area than on a hard surface. When a fall does occur, the cushioning effect helps prevent serious injury.

But selection of the right carpet or rugs is based on other ponderables: durability, maintenance, and, perhaps most important of all, type and aesthetics. Wall-to-wall carpeting has shown a strong upsurge with the renewed interest in modern furniture. Also, from a practical standpoint more and more people are recognizing the convenience and comfort of covering an area entirely. Since the trend today is for apartments with smaller rooms, wall-to-wall carpeting makes a space seem larger. Modern carpets are less expensive, and the range of new fibers, colors, and textures available has opened up a vast new market.

Decide on color first. The warm colors, orange and red, can be used to make a large room seem smaller and a sunless room cozier. The cool colors, greens, blues, and lilacs, tend to recede and make a room look larger and more spacious. Next, choose texture—carved, plain, plush, or shag. Today's furniture designs go well with the shags, and here you have a very wide choice. Shags are available in a variety of lengths from simple to elegant six-inch lengths, and the obtainable colors range from solid to multi. The new technique of printing provides for elaborate designs.

The functional one-level looped carpet is good for high-traffic areas such as a recreation room, family room, den, or kitchen. In a tweed or small pattern there will be less shading and less obvious soil buildup.

Plush or cut-pile carpet will make a room look more luxurious. The fiber should be chosen according to the performance expected from the rug or carpet, and choice should be based on the soil-hiding, color-fastness, and static-free properties.

Quality is determined by the strength of the fiber used and by the density of construction. The deeper and denser the better.

Unfortunately, it seems to be a fact that the carpet is the last thing thought about in a scheme of decoration. The wall colors, curtains, etc., are decided upon before the question of the carpet arises, and if a harmonious effect is to be ensured there may be little choice left in the matter. Multicolored or patterned carpet may be either the easiest way out of the difficulty or an artistic necessity. Where possible, the carpet color or design should be chosen first and the room decorated around that. Carpets should be slightly darker in tone than any portion of a room, both because they present the largest mass of color and because they serve as a background to the furniture placed upon them. Thinly furnished rooms should have lighter carpets to avoid an overpowering mass of shade.

Where the floor is of a good parquet, the choice would be a rug with the appropriate margin, either an Oriental or one especially designed for the room. The colorful and long-wearing textured, hand-knotted Moroccan rugs and the Hispano Moresque, another hand-knotted rug in Spanish design and color are suitable for any room. There are hand-knotted and hand-tufted special order rugs from Hong Kong and Puerto Rico. The variety seems limitless in pattern and color.

In the final analysis, the sensible selection

of any floor covering will be based on a multitude of criteria. Location of area, type of traffic, and function of area as well as the design, decor, appearance, acoustical effect, cost factors, and psychological impact desired will influence the decision of the buyer.

CARPET SHADING

Wilton, tufted plush, and velvet carpet lend themselves particularly well to single-color effects. However, it should be kept in mind that this type of floor covering does shade. A plain carpet, no matter how well and carefully it is woven or tufted, cannot be expected to retain its smoothness and level color under wear. Wear is never evenly distributed since there is bound to be an uneven traffic pattern that depresses the pile unequally, causing light and dark areas to appear. This effect is called "shading" and is wrongly attributed to faulty manufacture. Shading can also occur in a figured cut pile carpet, but it is more apt to be concealed by the multicolor design.

RESILIENT AND HARD-SURFACE FLOOR COVERING

A very wide and varied choice of materials is available in hard-surface flooring. Naturally, there is a tremendous price differential, from the no-wax vinyl sheeting or asbestos tile to a rare imported marble. A new development is steel and bronze flooring. Selection has never been so extensive for patterns, shapes, and colors, especially in the ceramic tile, terra-cotta, and vinyl types. Natural wood, with its beauty, grain, and warmth, is taking its rightful place again.

The famous Thai-Teak grown in Thailand, one of the most widely used parquet floorings on the market, is being specified more and more by designers. Because the color is inherent in the wood, it can be used in heavily trafficked areas without fear that the color will be "walked off." The coldness of modern concrete and stone is offset by the natural warm tones of the wood grain.

Perma-grain. This is real wood impregnated with an acrylic solution. This method results in a flooring with a locked-in, permanent finish which is easily maintained and rarely needs refinishing. A wide range of colors and decorative effects is possible with Perma-Grain. It also has a very high abrasion resistance and does not require waxing or other protective coatings to preserve its beauty. Normal routine maintenance—sweeping and buffing—will keep its original luster. This flooring has been engineered for heavy-traffic areas where a high level of appearance is required.

Vinyl tile. One of the most popular and extensively used floor tile coverings in use today is vinyl tile. The tile is composed of a blend of plastic binders, fillers, and pigments. This solid vinyl tile is comparatively quiet and comfortable underfoot and resists indentation to a high degree. It is highly resistant to grease, oil, acids, and most solvents but may be stained by lipstick, shoe polish, and some foodstuffs.

To maintain vinyl in its best condition, the only treatment needed is an occasional washing with a mild detergent and frequent buffing. The secret is in the buffing, and very little waxing, if any, is required. Ground-in dirt and scuff marks are easily buffed out with a fine steel wool.

Most tiles are manufactured to a fine tolerance as regards thickness, and all vertical edges are cut absolutely perpendicular to the tile surface. This ensures a smooth and virtually seamless floor.

The classic look of a handcrafted Florentine leather is reproduced in a tile with a stenciled

leather look, ideally suited for dining room, foyer, or den. The old Renaissance glazed Majorca pottery designs are brought up to date with a vinyl tile which is fresh and exciting in color and design. These are just some of the many designs available in vinyl tile. In a special design for a particular space the individual talents and creative mind of the interior designer can be brought to work to produce an exciting floor.

Solid vinyl. Some of the many designs available are suitable for certain areas. A *rattan* design, which has the woven beauty of matting plus a casual elegance, goes beautifully with classic and contemporary furnishings. It can also be used to good effect in dens, dining rooms, kitchens, and breakfast rooms. *Brick* design has the shape and rough texture of the old brick. The ever-popular *Renaissance* tile is a solid vinyl with a translucent richness simulating real marble. It is eminently suitable for living rooms, foyers, and indeed for practically any room where there is a primary need for ease in maintenance and practicality.

Cushion-sheet vinyl. This vinyl is made in twelve-foot widths with a foam-rubber cushion backing. It gives foot ease and comfort in areas where people are on their feet for a long period. Until recently, this product was used for residential interiors almost exclusively, but with the continuing improvement in design and color, coupled with a heavier polyvinyl face, it is gaining acceptance for commercial installations.

Solid vinyl static-conductive tile. This specially developed nonsparking vinyl tile is impregnated throughout its entire thickness with a nonconductive material. It effectively dissipates electrostatic charges from persons wearing conductive footwear and from properly grounded equipment.

In hospital operating rooms, laboratories,

and patients' rooms, where a safe, dependable floor is necessary, this tile will work effectively. Installed with special conductive adhesive, it meets the requirements of the Underwriters Laboratories, Inc., and of the National Fire Protection Association.

Vinyl asbestos. This popular resilient flooring is made from vinyl resins and strengthened with strong asbestos fibers. It is a long-wearing, greaseproof tile and is easy to maintain. This type of tile is economically priced and is widely used in commercial installations, but advances in manufacturing have also introduced new stylings for residential use. A large range of colors and designs is available.

Spanish and Mediterranean effects offer the designer a very wide choice. Personalized custom-floor designs can be created for each client. It should be noted that this custom designing applies equally to all other types of hard flooring.

A new development in the vinyl asbestos field has cut down maintenance costs with which floor covering specifiers are becoming more concerned. It has been found that vinyl asbestos floors are best maintained if they are not waxed but only buffed. A heavy initial buffing will create a mirrorlike finish, and regular daily buffing after that will produce a high patina. When the patina has been established, it will be maintained by buffing once a week. From then on, a daily sweeping is necessary and a damp mopping twice a week as conditions dictate. The main point is that no wax should be used after that. This method brings down maintenance costs, a critical factor, especially in hospitals where administrations are becoming more cost-conscious.

Rubber tile. Until recently, rubber tile was somewhat neglected as a flooring, although at one time it was very popular. Now there is a

new interest being shown by architects and designers. The rubber tile manufacturers are providing bright, fashionable colors as well as some embossed patterns which more completely answer the needs of designers. In addition, they have produced an abrasion-resistant tile which is almost twice as effective as formerly. Also, it resists indentation better and is more soil-resistant than conventional rubber tile. This type of tile is ideal for such places of concentrated wear as school dormitories, airports, and hospitals.

Ceramic tile. Overall pattern tiles in contemporary, traditional, and geometric designs originated in the Mediterranean countries and may be obtained there and, in lesser degree, from West Germany. Interior designers, architects, and the consumer are turning more and more toward the use of ceramic tile for floors. The handmade ceramic tile is one of the oldest products used for floors. More and more there is a demand for the real handmade natural terra-cotta and decorative tiles. They are practical, beautiful, and wear-resistant, and, most important, they are authentic. There are four groups which deserve attention: (1) a very complex design used in combination with other designs; (2) brilliant solid colors in a great many hues with interesting shadings; (3) the natural hand-molded terra-cottas which can be used with color or decorative inserts; and (4) hand-molded or machine-made tiles in a definite relief pattern.

A new technology has recently been developed in the domestic ceramic tiles. This is a method of applying multicolored decals to a ceramic tile surface. These new decals are engineered for permanent fusion to the tile surface so that the design becomes an integral part of the product. The finished surface will not chip, crack, or peel. At the present time this system has been perfected for six-color application. The production is virtually automatic and enables American ceramics to compete more favorably with imported tiles from Europe.

Cork. Available in three shades and in thicknesses varying from ⅛″ to ½″, cork has excellent resilience, and its acoustical quality rates high. It may be stained but usually is used in one of the three stock shades available. It requires waxing and buffing periodically to keep its good appearance.

Steel floors. A very thin sheet of steel for flooring makes a bright smooth surface that is easily maintained. Bronze (steel and copper) flooring, which is also available, is one of the most enduring floor coverings that can be found. This can be installed on any type of floor—cement or wood—and does not present any problems in upkeep.

RUG DESIGN: ITS ORIGINS AND HISTORY

Today's rug designers are the heirs of the workers of long ago. Working today in their studios, they delve into the world's dim past and then create, always adapting their motifs to the needs of our modern civilization and our modern ways of living.

The origin of design. Design in rugs is, of course, inseparable from design in architecture and decoration generally. The exact origin and early development of design is buried in the dawn of history. The earliest historic ornament belongs to civilizations already well advanced. The vast array of design of all ages and periods appears incomprehensible until we realize that each style is founded on the one preceding it. The ornament of every age is nearly always traceable to that of some older civilization. This style, inherited or borrowed, has added new forms of its own. Hence there is a clear genealogy of design.

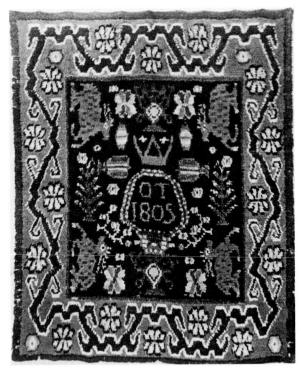

Jeanne Weeks

Finnish rug, ca. 1805. It features a red border and green, yellow and red combinations on blue and black ground.

Motifs from the remote past.

The very earliest patterns were undoubtedly geometrical in character and prehistoric in origin. It is generally assumed that the first "woven" designs were copies of the plaiting of the mats made of rushes which preceded carpets in the evolution of floor covering. Among these earliest motifs is the "zigzag," a motif of prehistoric origin evidently derived from basketry, occurring frequently in Egyptian art, where it represents the splashing of the waters of the Nile. Another is the "swastika," thought to have originated as a sacred symbol in the worship of the sun and to have signified time and eternity.

Egyptian motifs.

Of the motifs which had their origin in Egyptian art, the "lotus" is, of course, the most important, as the first flower to be represented in woven fabrics. It was a sacred bloom of Egypt, a symbol of the Nile and of the solar gods which ruled the river's waters, imparting to the valley its periodic fertility. The lotus has proved one of the most enduring of all symbols in rug design, having been adopted and adapted by rug weavers in India, China, Persia, and elsewhere. We find it today used both naturally and conventionally.

The "rosette" also comes from Egypt and is found in borders and in the formation of other patterns in domestic rugs.

Finally, the "palmette," another adaptation of the lotus, shows a cup with fan-shaped leaves. Its meaning is related to the rising sun over the Nile, according to some, while others think it may have originated in the tree of life. The palmette, persisting through Greek art, has come down through the ages to our own time.

Babylon and Assyria.

Sculptured compositions such as grotesques and monsters, part human and part beast, winged lions, winged bulls, and griffins are all peculiarly Assyrian. The winged disk, emblematical of the sun god, signified eternity and wisdom. In textile design, one of the most important Assyrian motifs is the sacred tree formed of palm leaves, marking the first appearance of the tree as such in decorative art. The tree, as used in ornament, has a religious meaning, signifying immortality and resurrection. In Mohammedan legend, in Egypt, in India, and in Japan, the tree in ornament has been adopted and preserved through centuries; a greater variety of motifs has been furnished by the tree than by any other object in nature. The "pomegranate," which began in ancient Assyria, is associated with fruitfulness and fertility. From Babylon comes a motif known as the "guilloche," formed of circular interlacing bands with an "eye" or rosette in the center. In the Middle Ages it was used in the mosaic floors of basilicas. Curiously enough, this guilloche motif is almost duplicated in one of the

early American hooked-rug patterns, known as the "chain" or "cable" pattern. Babylon was among the first cultures to employ conventionalized animal figures in textile and architectural design. This use of animals was spread to other lands by the Persian conquests, the motif being traced in Persian rugs today.

Classical motifs.　One mark of the greatness of Greek ornament is the fact that it endures in greater vigor than any other school of ornamentation. The Greeks were the first people to delight in beauty of line and form for its own sake. Vine designs, festoons of flowers, and scrolls have been adapted today in rug design. The most famous and storied of Greek motifs, however, is the "acanthus leaf." Its use in decoration dates back to the time of Socrates, who strewed acanthus leaves on the tomb of his departed—though perhaps not lamented—wife. This episode teaches us that there is a human story behind the rug motifs in use today.

Chinese motifs.　Somewhere in the mazes of the mountains that separated China, India, and Turkestan, Chinese rugs were first woven. Complete records of the Chinese weaver's art are lost in the thousands of years of the history of the "long-lived" empire. What has happened since the revolution in China cannot be clearly defined at this point, but it is abundantly clear that the weaving art has undergone a great change.

Long before Mohammed's time, the Kabala at Mecca was covered by a beautiful white Chinese carpet. This would indicate that the Chinese were early masters of weaving. The Kabala is a small black building in the courtyard of the Great Mosque at Mecca containing a sacred black stone, the chief objective of the Muslim pilgrimages. Most of the motifs that were woven into the Chinese rugs have a moral significance derived from one of three religions: Confucianism, the symbols of which relate to

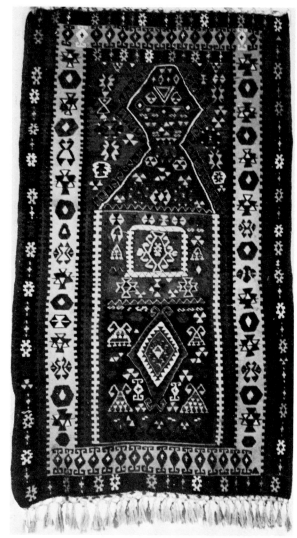

Jeanne Weeks

A Kilim rug embroidered on the loom in a traditional "church pattern" of the island of Crete.

ancestor worship; Taoism, whose signs are luck emblems to ward off demons and evil spirits; and Buddhism, which deifies all plant and animal life because of the possible presence of a soul in transmigration.

Among the Chinese motifs are adaptations of the sun and moon, and cloud and mountain forms. The cloud is really of Mongolian origin

and survives from a day when, in ancient China, it was believed that the souls of the righteous mounted to heaven from the mountains.

The dragon has been a persistent motif not only in its complete form but, as it were, piece-meal. The "claw and ball" foot of Chippendale furniture is the claw of the ancient dragon. The beautiful flowers of the country were also used. The peony, magnolia, chrysanthemum, lotus, and orchid appear to have been the favorites.

Persian motifs.　Persia was the first home of carpet weaving on an enduring and commercial scale. The rugs that the Crusaders took home with them were mainly Persian. The old Eastern idea of paradise is a garden, and this is the basic theme of many rug designs, notably the Persian. The greatest period in rug weaving occurred in Persia in the sixteenth century, during the reign of Shah Abbas, in whose palace at Ispahan looms were set up and the most celebrated weavers of his empire employed.

Floral forms, such as the date palm, iris, hyacinth, tulip, and the tree of life are typically Persian motifs, usually fairly realistically treated. The fish pattern, known as the Herati and the Fereghan design and consisting of a rosette be-tween two lancet-shaped leaves, is much em-ployed. The pattern known as the Saraband, which resembles a teardrop, is also ever-recurring.

Geometrical motifs.　Mohammed brought new faith to the Eastern empires and, with it, new laws. Among these the Prophet gave one which was rarely violated: the absolute prohibition in ornament of naturalistic representations of men, animals, or plants. This led, of course, to a purely conventional style of design. Old geo-metrical figures were revived and new ones devised.

All Mohammedan ornamentation is notable for strongly marked compartments or fields. Hence, we see the diamond, square, rhomboid,

Metropolitan Museum of Art

Seventeenth-century Persian rug, probably Kerman. Tree design with claret red ground and light-colored pattern.

and hexagon. The octagon is also used, indicat-ing the eight directions of the compass. The Moroccan rugs coming from Rabat are perfect examples of the use of the geometric motifs.

ORIENTAL RUGS

In the Orient the art of weaving rugs dates from the days of King Solomon. The history, romance, tradition, and poetry associated with the looms of the East recall the names of Croesus, Cyrus, Alexander the Great, Omar Khayyam, Genghis Khan, and Tamerlane, to say nothing of more

Metropolitan Museum of Art

Turkoman rug of the nineteenth century. Beluchistan, with light tan field and red border. The pattern in vivid colors shows the typical crudely drawn geometric figures.

modern mortals. The luxurious productions of the Eastern weavers have been in demand for the homes of Western civilization since the days of Marco Polo and the development of the earliest systems of long-distance transportation.

Previous to about 1875, the utmost care was taken in the weaving of rugs in the Orient, particularly with regard to design, material, workmanship, and permanency of dyes. Rugs woven prior to that date are usually considered antiques. Since the development of modern transportation facilities, the demand for Oriental rugs has increased to such an extent that their manufacture has become commercialized. Although Oriental rugs are still made on hand looms, as in earlier times, quantity production in factories has been attempted, with less experienced craftsmen, a speeding of effort, a cheapening of materials, and the use of aniline instead of vegetable dyes. The most salable antique patterns, however, with all their conventions and symbolisms, continue today to be blindly repeated by the makers.

The older rugs were made in the homes of the inhabitants, the designs passing from father to son and being preserved with great care. Some of the modern rugs are of nomad origin and are still produced by the old methods, but the majority are today made on a commercial scale. Antique Oriental rugs are generally of great beauty and are seldom obtained except at very high prices. They are rarely seen except in museums and the homes of wealthy collectors. It is important to note that the New York Antique Society defines "antique" as 100 years old or more, but there are those purists who feel that an Oriental rug is antique only if it dates prior to 1856, when natural dyes began to be replaced by synthetic dyes. A semi-antique rug, sometimes defined as "old," must be between fifty and 100 years of age, and "new," of course, is less than fifty years of age.

Classification. There are six main classifications of Oriental rugs, and less than fifty common kinds. The majority of these are named after their probable place of origin or the towns from which they are imported. The name of a rug does not guarantee quality, as both superior and inferior grades are made in all places. The

important essential ingredients in all rugs are design, material, and workmanship, and of these, from the decorator's standpoint, design—which includes color—is by far the most important. The six classifications are Persian, Indian, Turkoman, Caucasian, Turkish, and Chinese.

Persian rugs are profusely decorated with a great variety of flowers, leaves, vines, and occasional birds and animals woven in a freehand manner and considerably conventionalized with purely decorative intent. They generally have an all-over pattern, and the ground is almost entirely covered. The colors are soft and delicate, blending with one another in a most pleasing manner. Many of the patterns start from a central medallion. The lines of the patterns are always graceful. Among the most popular of the Persian rugs are the *Saraband*, whose entire field is covered with a repeating pattern of palm leaves, such as are used on an Indian shawl design, with a rose or blue ground; the *Ispahan* or *Herat*, having a coarse pile showing an intricate, stately design on a claret ground; the *Hamadan*, a camel's-hair rug with a coarse weave in light browns, reds, and blues; the *Kerman* and *Kermanshah*, with a fine pile in soft cream, rose, light blue, and other pastel colors; the *Sarook*, having a fine pile in dark reds and blues mixed with lighter colors; the *Bijar*, as thick as two or three ordinary rugs; the *Polonaise*, a delicately colored antique silk rug; the *Sehna*, the close-woven small rug with a minute pattern; and the *Feraghan*, usually produced with a small all-over design of flowers or conventional forms arrayed in rows.

Indian rugs are those in which flowers, leaves, vines, and occasional animals are woven in a naturalistic manner. In the earlier rugs, of which few remain, the weavers drew the flowers as though they were botanical specimens. In the later Indian rugs many copies of Persian patterns were made, but the copies are always easily recognized. The colors in these rugs are often brilliant. In broad generalization, the two classi-

Bokhara rug from Afghanistan. Late nineteenth century.

fications of Oriental rugs that are decorated almost exclusively with flowers are the Persian and the Indian, and their style and patterns are so distinct that their identification is comparatively easy. The leading place names associated with Indian rugs are *Agra, Lahore, Kashmir,* and *Srinagar.*

Turkoman rugs, comprising the products of *Turkestan, Bokhara, Afghanistan,* and *Beluchistan,* are red rugs with web fringes, or apron ends woven in kindergarten patterns—squares, diamonds, octagons, stars, and crosses. The forms are nearly always of pure geometric linear design. They are closely woven, with a short firm pile. That the wild tribes of these localities should dye their wools in the shades of blood

A seventeenth-century dragon carpet from the Caucasus.

and weave the designs of childhood is fitting and logical.

Caucasian rugs, also the product of a wild section of Central Asia, differ from the Turkoman rugs chiefly in being dyed in other colors than blood red, in omitting apron ends, and in being more crowded, elaborate, and pretentious

in geometric linear pattern. The Caucasian weaver's distinction as the Oriental cartoonist, the expert in wooden men, women, and animals, is well deserved. He holds the Oriental rug patent on Noah's-ark designs. Incidentally, Mount Ararat and Noah's grave, "shown" near Nakitchevan, are actually located on the southern border of the Caucasus.

Some of the design forms resemble snow crystals, others are not unlike the patterns of the Navaho and other American Indian blankets. The eight-pointed star is a great favorite, and forms borrowed from the Persian are occasionally used. Borders are often wide and important. The designs are bold and the colors brilliant and strongly contrasted, imitating mosaic effects. The principal rugs of the Caucasus are those of *Daghestan, Shirvan, Soumak, Kuba, Ghendje,* and *Cashmere,* the last generally attributed to India.

Turkish rugs, sometimes called *Asia-Minor,* are of both geometrical and floral design, but can be distinguished from Persian and Indian products by the ruler-drawn character of their patterns. They often show quasi-botanical forms, angularly treated. Turkish rugs that contain the

Caucasian (1806) Shirvan or Baku with indigo ground and red, blue, white, and yellow patterns showing pear or cone device which may have been of Persian origin.

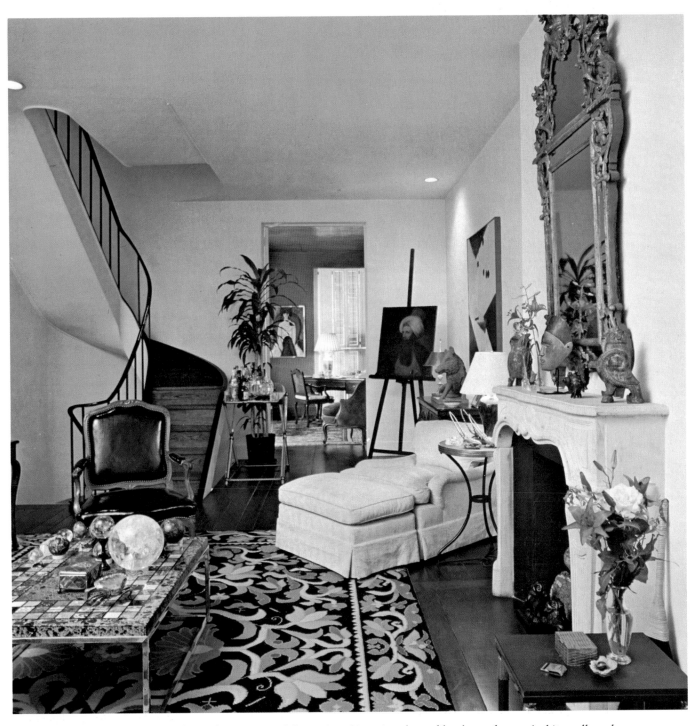

A very eclectic collection of traditional furniture and decorative objects is enhanced by the starkness of white walls and unified by the strong pattern of the Portuguese rug which unites all the basic colors in the room. The staircase has been stripped of all decorative elements in keeping with the simplicity of the background.

Photo by Norman McGrath. Designed by Parish-Hadley

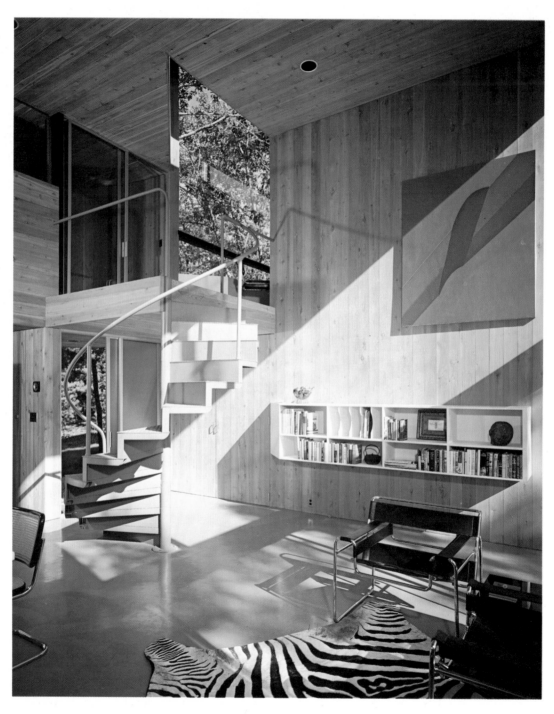

Knotty pine planks completely cover the wall and ceiling areas of this two-story living room. The texture of the wood adds warmth to the large plain surfaces and the flooring repeats the color and tonal value of the walls and ceiling for a very spacious effect. Furnishings are clean in line and held to a minimum. The circular stairway adds an interesting sculptural form and gives access to terraces on both levels.

Gwathmey and Henderson, Architects. Maris/Semel Photo

Metropolitan Museum of Art

Caucasian rug. A late eighteenth-century Soumak with rose-red ground and pattern in gray, green, white, and yellow, showing jagged-edged medallions and highly conventionalized animals and figures.

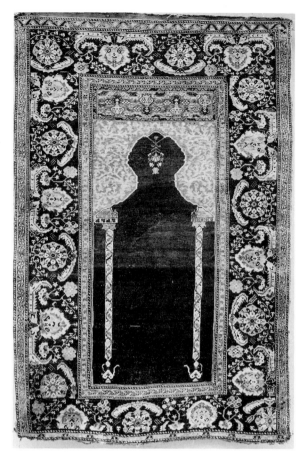

Metropolitan Museum of Art

Seventeenth-century Turkish prayer rug from Asia Minor. Bright red ground and deep blue border showing influence of sixteenth-century Turkish floral carpets.

patterns common to the Caucasian and Turkoman families can be recognized by their brighter, sharper, and more contrasting colors. The key to the identification of this most difficult rug family is to be found in the Turkish prayer rugs. To know Turkish rugs, one must see many of them; to know the other families, one need see only a few. *Ghiordes* was famous for making prayer rugs. *Bergamo* was justly esteemed for its shaggy rugs of individual designs. Many rugs actually made in the interior are attributed to *Smyrna*, a port town. The *Anatolian* and *Armenian* rugs are also classified with the Turkish.

Chinese rugs can be recognized instantly by their colors; these are determined by their backgrounds—the reverse of the Persian method, which is to make the design the principal color medium. The Chinese colors are probably best described as lighter and softer colors of silk— dull yellows, rose, salmon-red, browns, and tans, the design usually being in blue. The Chinese were the original manufacturers and dyers of silk, and they applied their silk dyes to their rugs.

The older Chinese rugs frequently show designs influenced by the Buddhist, Taoist, and

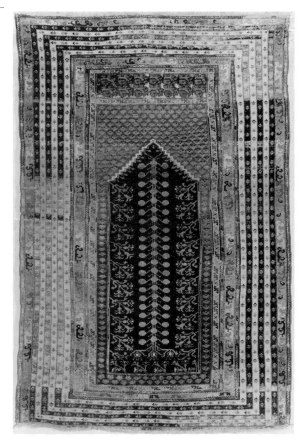

An eighteenth-century Kula rug from Asia Minor. Within the blue mihrab is a double row of chrysanthemums framed with lillies.

Lamaist faiths. Symbolism was of the utmost importance. The Precious Things, The Hundred Antiques, The Fragrant Fingers of Buddha, the peony, the waves and clouds of eternity, the mythical dragon, the fabulous lion, the heavenly dog trying to devour the moon, the horse, the bat, the butterfly serving as the symbol of Cupid, the temple bells, and other distinctive features are found in the patterns.

The best periods of antique Chinese rugs were the K'ang Hsi (1662–1723) and the Ch'ien Lung (1736–1796). The patterns of these periods have been extensively copied ever since they were originated, but unfortunately commercialism has entered the field, and many of the mod-

ern Chinese producers have disregarded the old traditions and created patterns solely to appeal to an uninformed European and American public.

Weaves and knots. The majority of Oriental rugs are woven with knots, the ends of which are cut off, forming a pile. There are two kinds woven without knots. They are *Khilims* and *Soumaks*, the latter sometimes called *Cashmere* rugs. Khilims are Oriental tapestries. The design is obtained by frequent changes of weft colors. The face and back of this rug appear to be alike. The best of Khilims, known as *Sehna*, are rightly among the most desirable of Oriental weavings. Khilims are thin and light in weight, but are often quite durable. They can be attractively used for table and couch covers and for wall hangings.

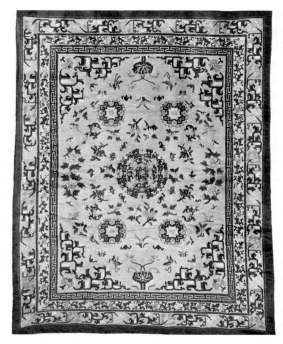

An eighteenth-century woolen carpet from China. A white ground encloses five circular medallions— the larger central one is filled with peonies. Scattered throughout the ground, or field, are numerous branches and flowers. The corners bear typically stylized flowering branches.

The Soumak rug, from Shemakha in the Caucasus, and not from India as is commonly supposed, has three parts to its weave. In addition to the warp and weft, which form only the basis of the fabric, the pattern is made by a stitch woven in and out between the warp threads. The stitch passes over four warp threads, back under two, forward over four again, and so on, making a smooth surface. The ends of the threads are left loose on the back, as on a Cashmere shawl; this has caused these rugs to be known incorrectly as Cashmeres.

The third type, or *knotted rug*, is the one most generally used. Here the weft is a mere binder, the entire surface, or pile, being formed by the ends of threads knotted around the warps. Two types of knot are used, the Ghiordes or Turkish and the Sehna or Persian. The former is used in Turkey, the Caucasus, and parts of Persia, the latter throughout the greater part of Asia, including China, Turkestan, Beluchistan, and most of Persia.

To make the Ghiordes knot, a short piece of thread is laid across two warps, and the ends are carried down outside and up between them and pulled tight. In the Sehna knot, one end is treated in this manner, but the other passes down between the two threads and up outside. In either case the pile is of wool, but the warp and weft may be of wool, cotton, or a mixture of the two, or occasionally of camel's hair or silk.

In addition to these Oriental knots, there is another used by Spanish weavers that is called a single knot. To produce this knot, each warp thread is completely circled by each pile thread, the two ends of the latter being brought upward to form the pile surface. There is a separate weft system of threads that serves to hold the warps together.

Fibers and materials. A great variety of materials is used in the making of Oriental rugs. Wool is the all-important textile of the industry; cotton, the base and binder; hair and silk, the occasional materials. Hemp, jute, and linen are also used in rug manufacturing, but to be a real judge of rugs, one must be a judge of wools. Wool is a modified form of hair, distinguishable from it by its softness, curl, and elasticity, and by the microscopic overlapping scales of its surface. It is sometimes impossible to determine whether an animal fiber is wool or hair, because the one by degrees merges into the other. Fine wool has as many as 2,800 scales to the inch. Poor wool has not more than 500. This makes a difference in Oriental rugs in the absorption and retention of dye.

The best wool is taken from the shoulders and sides of the young sheep, goat, or camel. Wool taken from old, undernourished, or dead animals is of second and third grade. The importance of the quality and condition of the wool in Oriental rugs is accentuated by the possible effects of the processes that are applied to finish them for the market. These processes, known as washing or treating, are the application to new rugs of various chemical solutions that diminish the strength of the raw dyes and colors. If carelessly applied, these solutions actually consume the fabric. When applied to good wools and dyes, they do little or no damage. As practically all modern Oriental rugs are treated, the buyer must concern himself to secure rugs that have been wisely treated.

Dyes and coloring. The dyes used exclusively in the East until a comparatively few years ago were vegetable and natural dyes. The vegetable dyes were obtained from leaves, flowers, roots, berries, bark, and nuts. Cochineal is the stock example of a natural insect dye. These were the materials that made Oriental rugs famous, and the recipes were carefully guarded secrets. Substitutes have been found for every dye, however. Alizarin dye is an artificial dyestuff obtained from coal tar. Aniline, invented in 1856, has gradually eliminated the natural dyes. Many of the aniline dyes are as

permanent as the natural or vegetable dyes. If the color schemes, designs, and wools of the Oriental rugs woven today were as satisfactory generally as are the dyes used in them, the art of rug weaving would be on a very high plane.

Defects. Oriental rugs may have defects resulting from the depredation of heels and moths and from dry rot due to age and salt water; and they may have holes, cuts, and crookedness in weave. Old rugs that are worn to the foundation in sections are much less desirable for service than those with the pile of fair depth which is worn evenly. The deep and serious defects of a rug are easily detected by holding it to the light, and by examining its back. Heavy beating to clean a rug quickly ruins it. Light beating with a wicker mat is allowable. Sweeping and vacuum cleaning can do little harm, if not too vigorously applied.

Values. There are three possible values in every Oriental rug—the utility value, the art value, and the collector's value. The utility value depends entirely upon the durability of the fabric as a floor covering. The art value depends upon the color and design rather than upon the texture. The collector's value depends upon the rarity of the art value. It follows that Oriental rugs are valued and priced according to individual worth, and that the honest dealer can neither ask more than a rug is worth nor confess attempted extortion by radical price reductions. The fairness of the price is proportionate usually to the honesty of the dealer. To judge the quality of an Oriental rug is a matter requiring considerable study, and the amateur will be well advised not to attempt this without the aid of an expert or a dealer whose reputation is unquestioned.

PEASANT RUGS

Moroccan rugs. These are available now in a wide range of stock sizes and designs. Geometric designs are generally used with a wide choice of color. One of the most interesting types of rug is made from natural wools, undyed, which give a jaspé effect. These rugs are frequently used where the interior calls for a neutral ground. They are hand-knotted, from the finest wools.

Alpujjara rugs. A province in Granada, Spain, produces these beautiful fabrics. The Alpujjara rug woven today, popular with interior designers because of bright colors and naive patterns, has been refined, slightly restyled, and recolored for the contemporary home. These rugs still retain the distinctive charm of the eighteenth and nineteenth centuries.

LAYING OF RUGS AND CARPETS

The question frequently arises as to the relative merits of rugs and carpets. Formerly rugs were preferred because they could be easily removed and cleaned, but to some extent the vacuum cleaner has eliminated this objection. The wall-to-wall carpet must be cut to fit the room, which may make it unsuited to the shape of a new one in case of removal. There are, however, wide carpets sold under trade names that are manufactured with a coating of latex on their backs which prevents ravelling in case the fabric has to be cut; these carpets may be patched in any part, or added to without a visible seam, and mosaic patterns may be easily introduced in contrasting colors. This type eliminates the principal disadvantage of wall-to-wall carpet. If parquet flooring is used in a room, many persons prefer rugs that leave a border showing the woodwork, although this tends to make a room look smaller. All-over carpets are generally recommended for rooms in cold climates. The choice between a rug and a carpet is eventually a matter of individual taste.

Carpets should be sufficiently large to fit the dimensions of the room up to the baseboard.

Where breaks occur in the shape of the room, around hearths and elsewhere, the carpet should be cut to fit, and the cut edges should be thoroughly sewed to prevent raveling. As broadloom carpets come in stock widths—9 feet, 12 feet, 15 feet, and a few 15 feet are standard—one can usually be found to correspond closely to the width of a room. Any length is obtainable.

It is advisable to have carpets laid over a layer of felt, ozite, or other inexpensive manufactured products that are made for this purpose. The extra layer of felt adds to the softness and durability of the floor covering.

Domestic carpets come in a very wide range of colors, and the color effect of a pile fabric changes according to the direction from which one looks at it, and the amount of light thrown upon it. As the pile has a tendency to bend sideways, the color effect is much darker when one looks into the pile than when one looks at the side of it. This condition must be considered in deciding in which direction a carpet should be laid. As a rule, neutral-colored, dark-toned floor coverings are the most satisfactory from every point of view. Greater novelty and more up-to-date effects may be carried out in white and light pastel shades, but because of the fact that such colors rapidly become dull from dust, they must be frequently cleaned, and the expense of upkeep is high.

BIBLIOGRAPHY

Allard, Mary. *Rug Making: Techniques and Design.* Philadelphia: Chilton Book Company, 1963.

Aslin, Elizabeth. *The Aesthetic Movement.* New York: Frederick Praeger, 1969.

Battersby, Martin. *The Decorative Twenties.* New York: Walker and Co., 1969.

Bode, W., and Kuehnel, E. *Antique Rugs from the Near East.* Translated by Riefstahl. New York: E. Weyhe Co., 1922. Illustrated text.

Calatchi, Robert de. *Oriental Carpets.* New York: George Wittenborn, 1967.

Compiled by Martha L. Hensley. An Annotated List of Literature References on Carpets and Rugs 1940–1963. Washington, D. C.: United States Department of Agriculture, June, 1965.

Dilley, Arthur U. *Oriental Rugs and Carpets.* Edited by Maurice S. Dimand. New York: J. B. Lippincott Company, 1959.

Duffin, D. J. *The Essentials of Modern Carpet Installation,* 2nd ed. New York: Van Nostrand, 1962.

Erdmann, Kurt, and Erdmann, Hanna. Spanish Copies of Turkish Carpets. *Pantheon* lv, Nov./Dec. 1965. Bruckmann Munches.

Ewing, John S.; Ewing, Norton; and Harvard, Nancy P. *Broadlooms and Business Men.* Cambridge, Mass.: Business Press, 1955.

Faraday, E. *European and American Carpets and Rugs.* Grand Rapids, 1929. An illustrated history of handwoven floor coverings of Europe and modern machine-made carpets of Europe and America. Some color illustrations.

Hackmack, A. *Chinese Carpets and Rugs.* Translated by Arnold. Tientsin: La Librairie Française. A good concise text with excellent plates, some colored. Good diagrams of Chinese symbols and their meanings.

Hangelblain, Armen E. *Les Tapis d'Orient*. Paris: Guy le Prat, n.d.

Hillier, Bevis. *Art Deco*. Great Britain: Studio Vista/Dutton Picturebooks, 1968.

Holt, Rosa Belle. *Oriental and Occidental Rugs*. Garden City, N. Y.: Garden City, 1937.

Jacobs, Bertrand. *The Story of British Carpets*. London: British Continental Trade Press, 1968.

Jacobsen, Charles W. *Oriental Rugs*. Rutland, Vermont: Charles E. Tuttle Co., 1962.

Jacoby, H. *How to Know Oriental Rugs & Carpets*. Metuchen, N.J.: Textile Bk., 1967.

Jarry, M. *The Carpets of the Manufacture de La Savonnerie*. Metuchen, N.J.: Textile Bk., 1969.

Kendrick and Tattersall. *Handwoven Carpets, Oriental and European*. Vol. 1. London: Ben Brothers, 1922.

Kuhnel, Ernest, and Bellinger, Louise. *Catalog of Spanish Rugs 12th Century to 19th Century*. Washington, D.C.: National Publishing Co., 1953.

Les Styles Française: La Decoration du Moyen Age au Moyen Style. Paris: Editions Plaisirs de France, 1965.

Lipman, Jean, and Winchester, Alice. *Flowering of American Folk Art, 1776–1876*. New York: Studio/Viking Press, 1973.

McGowan, Pearl K. *The Lore and Lure of Hooked Rugs*. Lincoln House of Sturbridge Village, Mass., 1966.

Maxwell, Gilbert. *Navajo Rugs . . . Past . . . Present and Future*. Palm Desert, Calif.: Desert Southwest Inc., 1963.

Mayers, F. J. *Carpet Designs and Designing*. London: F. Lewis, 1934. Good text illustrated with diagrams, halftones, and color prints.

Mumford, John Kimberly. *Oriental Rugs*. New York: Charles Scribner's Sons, 1902.

O'Brien, M. *The Rug and Carpet Book*. New York: New York, McGraw-Hill, 1951. An excellent handbook on domestic and imported floor coverings for the layman.

Rheims, Maurice. *The Flowering of Art Nouveau*. New York: Harry N. Abrams, n.d.

Roth, Rodris. *Floorcoverings in 18th Century America*. Washington, D.C.: Smithsonian Press, 1967.

Scheidig, Walter. *Crafts of the Weimar Bauhaus*. New York: Van Nostrand Reinhold Co., 1967.

Schlosser, Ignaz. *The Book of Rugs Oriental and European*. New York: Bonanza Books/Crown Publishing, 1963.

Tattersall, C. E. C. *A History of British Carpets*. London: F. Lewis, 1934. A complete and illustrated treatment of this subject from the introduction of the craft until the present day.

The Connoisseur Period Guides: The Tudor Period, The Stuart Period, The Early Georgian Period, The Late Georgian Period, The Regency Period, The Early Victorian Period. New York: Reynal and Co., 1958.

Walker, L. LeB. *Homecraft Rugs.* New York: Frederick A. Stokes Co., 1929. Excellent text illustrated with diagrams and color plates.

Weeks, Jeanne, and Treganowan, Ernest. *Rugs and Carpets of Europe and the Western World.* Philadelphia: Chilton Books, 1969.

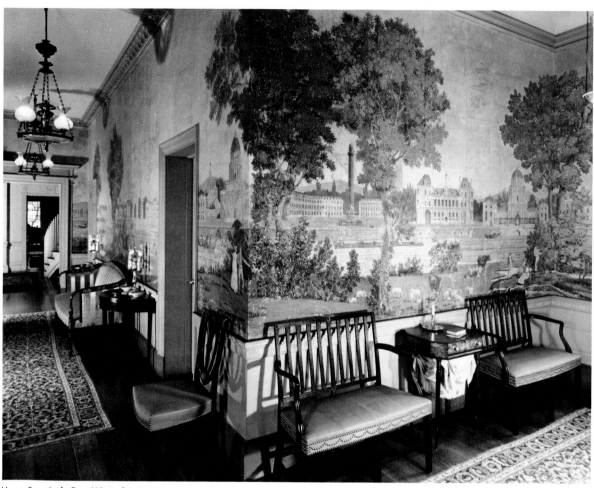

Henry Francis du Pont Winterthur Museum

French wallpaper printed in Paris in 1815 by Joseph Dufour. This scenic design was especially popular in America.

CHAPTER 16

Wallpapers, Paints and Painting

Block-printed design by William Morris in greens on a dark green field.

WALLPAPERS

The invention of wallpaper was a fortunate occurrence in the history of the decorative arts. It afforded people of little means the opportunity of decorating their walls with colorful patterns and designs—a type of decoration which before had been possible only with murals, stencils, or fabrics.

Records show that the first wallpapers were made in China around 200 B.C. This hand-painted paper was made up through the eighteenth century. In the early sixteenth century Chinese papers were imported into Europe and soon became the rage. They were made in small rectangular sheets approximately 12½ inches by 16½ inches. The Chinese, like most Orientals, have always relied heavily on nature for their design inspirations. Flowers and birds were popular subjects and were shown without definite light and shade effects but in flat tones used with con-

trasting colors. Around the middle of the eighteenth century ceremonial scenes, battles, etc., were all shown as landscapes executed in false perspective.

Wallpaper manufacturers

THE DOMINOTIERS. Since only the well-to-do could afford these imported Chinese wall-

Early eighteenth-century detail of a paper painted by hand and mounted on linen, made in China for export to England.

papers, it became necessary to find a means of creating a cheaper patterned wallpaper for the average man. In the second half of the sixteenth century a guild of painters and papermakers was established in France. They were known as the Dominotiers, and it was their charge to create a substitute for the Chinese imports.

Interior decorative fashion of the fifteenth and sixteenth centuries decreed that plaster walls be covered with paneling, leather, or tapestries. In the seventeenth century fashion switched to walls hung with brocades, velvets, and damasks. In 1620, Le François introduced a method of imitating these brocaded velvets on paper. First a pattern was printed in varnish on a colored paper; dyed powdered wool was scattered on the pattern, and, when dry, the excess was removed, leaving a paper which looked remarkably like velvet. This process was called "flocking," and the wallpaper was known as "flocked paper." The process traveled to England, where flocked papers were made as early as 1634.

PAPILLON. Jean Papillon, a Frenchman, is the real inventor of wallpaper as we know it today. He was the first to make repeating patterns on carved wood blocks that would match on all sides when separate sheets were mounted together. The large wood blocks were covered with pigments and then pressed against the paper. By using separate blocks for each color, Papillon could print his patterns in any desired number of colors.

Madame de Pompadour was a patroness of the decorative arts, and she is credited with popularizing both flocked paper and the Papillon designs. Chinoiseries and singeries were popular motifs in French art of this period. It was natural that many of the wallpapers had patterns and designs which reflected this trend.

REVEILLON. One of the most remarkable of eighteenth-century craftsmen was another Frenchman by the name of Reveillon, who, in 1752, started a wallpaper shop and factory in

A design by Jean Pillement, 1727–1808.

Paris. This factory was given over to answering the increasing demand for cheaper types of wall decorations by producing pictorial hand-blocked panels. They were intended to replace the then-popular paintings used in the fields of wood paneling. Small panels and vignettes were also made for overdoors and trumeaux. Many of Reveillon's original blocks are in existence today and are used in making copies. Reveillon escaped the French Revolution by fleeing to England, where he died in 1795. His factory was partially destroyed during the Revolution but was later put back into operation by a firm called Jacquemart and Benard, which produced papers in the then current Directoire and Empire styles.

Louis XVI wallpaper. The design is attributed to Reveillon and consists of arabesques and medallions in colors on a tan ground.

JACKSON. John Baptist Jackson was one of the most important persons connected with the English wallpaper industry. He was well qualified, having studied under Papillon and worked in Venice. In 1746 he opened a factory in Battersea, England. The subject matter of his papers included Venetian and Roman landscapes and French engravings, all of which were enclosed in hand-blocked representations of rococo stucco forms.

LATER MANUFACTURERS. During the latter part of the eighteenth century, scenic papers began to replace, to some extent, the earlier pictorial papers. Joseph Dufour of France and Jean

This paper, which is block printed in colors on pale blue ground, was made by Jacquemart et Bénard, Paris, about 1799, in honor of General Hoche.

Blue, white, and yellow Empire frieze.

Cooper-Hewitt Museum of Decorative Arts and Design,
Smithsonian Institution

French Empire paper with frieze and border, ca. 1810.

Zuber of Alsace were two of the most famous producers of these new scenic papers, which were made in a series of theme-connecting panels or strips. The end effect was a scene which cov-

ered an entire wall or walls of a room from dado to ceiling.

The popularity of these hand-blocked scenic designs spread all over Europe and America from 1800 to 1850. A great variety of subject matter was produced—landscapes, seascapes, town views, places, events, classical ruins, and mythology. Some of their designs were so intricate that they required as many as three thousand wood blocks to produce either the colored or monochromatic versions. Linen rag paper was used in the manufacture and accounts for the fact that so many of these papers have come down to us intact.

Wallpapers imported into America were heavily taxed. In 1739, Plunket Fleeson of Philadelphia printed the first American wallpapers, and because of the high import duties was able to build up a considerable business.

About 1800 the practice was started of printing long rolls of paper in all-over designs or patterns. The repeat of the design or pattern dictated the circumference of the printing roller. The 1840s saw the advent of machine printing on cheap paper and the lowering of standards of design and quality. It was not until the twentieth century that we notice a renewed appreciation for wallpaper design.

Modern manufacturing methods. There are three processes of making wallpapers in use today. The ordinary commercial types are printed by the cylinder process. Strips of paper of the required width are run through presses that are furnished with as many metal rollers as there are colors in the pattern. Each roller prints all the parts of a pattern that are similar in color. A careful setting of the rollers is required so that an accurate registry occurs for all the pattern subdivisions and colors. The speed of the press requires the use of colors that dry rapidly, but heat is supplied to the moving strip of paper to aid in this process. The second method is by the hand-block process in which each motif in a repeat is

Cooper-Hewitt Museum of Decorative Arts and Design, Smithsonian Institution

Wallpaper panel for fireboard or overdoor. Block printed in golden yellow and white on a dark blue ground, France, about 1805–1810.

imprinted by hand-pressing a separate wooden block engraved with a portion of the pattern in the proper position. The third method, which is now largely substituted for hand-blocking, is the silk-screen process. A wooden frame the full size of a pattern repeat is made for each color of the pattern. On each frame is tightly stretched a sheet of silk. On each stretch are drawn the parts of a pattern that are to be printed in the same color; the remaining portion is then varnished. A paper strip is laid flat on a long table, and each repeat is printed by applying to it the series of frames and painting the unvarnished portions of each with the required pigment that seeps through the silk. The colors are allowed to dry between the application of each frame, and it is

possible to overprint any of them with other opaque colors to produce highlights or additional shadows in the motifs. Overprinting is not possible with the cylinder presses, so hand-blocked or screen-printed papers are more interesting in appearance and are, of course, more costly to produce.

Wallpaper sizes. All scenic wallpapers, antique or contemporary, are made as a series of separate strips. A complete set has varying numbers of strips depending on the design of the paper. Antique scenics have strips approximately 19 inches wide and 6 to 10 feet long. Contemporary handpainted papers are almost exclusively made in China. They are 36 inches

Cooper-Hewitt Museum of Decorative Arts and Design,
Smithsonian Institution

Design by Walter Crane of about 1890 for children's room. Machine-printed, green, blue, pink, yellow, and orange on ivory.

wide with the designed or painted portion varying in length from 5 feet, 6 inches to 8 feet, 6 inches. The remainder of the strip is left as plain background paper. They are painted on gold or silver foil or on a paper which resembles mulberry paper. The commercially printed scenics are printed on 30 inches wide paper which trims to 28 inches. The design height is around 5 feet, 6 inches. They may be printed on any type of paper.

Contemporary patterned papers are printed on papers that vary in width; French ones are 18 inches to 22 inches wide, English 22 inches, and American 30 inches. Some, such as grass cloth and linen, are 36 inches wide.

Estimating quantities. To determine the amount of scenic paper required, first carefully measure the perimeter of the room and the height of the walls or that area to be covered. You then divide the linear measure by the width of each panel in the scenic. The presence of

doors, windows, etc., does not affect this calculation, since all of the seam edges must match. It simply means that you will have some waste.

When using an all-over pattern, you must first measure the perimeter of the room and convert the dimension to inches; then divide this total by the width, in inches, of your paper. This will give you the number of "widths" required for the room. Each width must start at

Cooper-Hewitt Museum of Decorative Arts and Design,
Smithsonian Institution

This English paper was block printed in white and darker browns on neutral brown ground about 1840.

Cooper-Hewitt Museum of Decorative Arts and Design, Smithsonian Institution

Wallpaper dado or frieze, French, about 1805, used in a house in New Orleans.

the ceiling with the top of a full repeat of the pattern. By determining the number of repeats needed for each strip you will have the correct length for each strip. Now multiply the number of widths by the length of each strip to determine the total length of paper needed for the room. Subtract large window or other areas from this total but do not deduct small areas. Wallpapers are usually priced by the single roll, but the manufacturer will fill your order, as per your directions, with single, double, triple, or even larger rolls. The larger or longer the roll, the less loss or waste there will be. Printed papers are limited to sticks no larger than five rolls. Plain papers can be had on 100-roll reels.

Vinyls. Today there are papers referred to as vinyls which are really no more than paper with a vinyl coating. These are available in the same widths as papers. We refer here to true vinyls, which are fabric-backed and can be had in different weights. They are normally 54 inches wide with no selvage edge to trim and are priced and sold by the yard. The designer must still pay strict attention to his ordering so that he will have the correct number of full lengths.

Preparation of walls. For reasons of protection it is advisable to put a lining paper on the wall before applying the finer papers. This pro-

tects the finished paper from absorbing discoloration from the plaster, and usually prevents the showing of cracks that may appear. Both the lining paper and finished paper should be applied with butt joints rather than overlapping joints.

When very expensive antique or scenic wallpaper is used, the walls should always be covered in advance with muslin, and the paper glued to the fabric. This will permit removing the paper without tearing, if occasion for this should arise. Valuable wallpaper may be *sized* (covered with a coating of glue or gelatin) and then shellacked with white shellac. This protects the paper from dirt, dust, and finger marks and permits gentle washing with a damp rag. Care should be taken in applying the size to prevent the colors from running, as many wallpapers are printed with watercolor or tempera paints that dissolve when liquids are used. The shellacking tends to give the paper a warm yellowish tone, gives it a slightly antique appearance, and causes the colors to be more brilliant and to be blended in a more harmonious effect.

Paper-backed fabrics and sized fabrics may be applied in exactly the same manner as described above. The same is true with vinyls. Vinyls, fabrics, and ordinary wallpapers all require different types of glue or paste. For this as well as other reasons it is advisable to employ only the best paperhangers.

Character of papers. Today we have an unlimited variety of wallpapers for the designer to select from. You will find papers designed for and used in every room in the house. Trends or current fads are extremely dangerous to invest in, and we cannot discuss them, for they change so quickly. It is up to the designer not only to keep abreast of contemporary wallpapers but also to help influence design trends.

Naturally, traditional wallpapers do not change in design except in their coloration.

Nancy McClelland

Moldings and borders are extremely useful for giving a finished appearance to an all-over paper design or for creating the effect of paneling.

Other papers that remain fairly constant are the ones which depict architectural elements, such as columns, pilasters, dadoes, arches, and cornice effects. They can be most effective if employed with discretion. Papers imitating marble, stone, and wood-graining also have their limited but effective uses.

After World War II Japanese grass-cloth became extremely popular. In essence it is a cloth made of grasses, left natural or dyed, mounted on a paper. It is available in many colors, textures, and designs, and is hung in much the same way as ordinary wallpapers.

In addition to wallpapers, thin wood veneers are available in rolls, sold by the square foot or the yard and installed in the same manner as vinyls. This material must be carefully used for it not to appear as wood masquerading as wallpaper. A relatively inexpensive but novel substitute for scenic papers can be achieved by having a photographer blow up an etching, engraving, etc. These can be printed in black and white or sepia and white and have the advantage of being unique.

The use of wallpaper. Patterned wallpaper is usually most effective when used in rooms of little architectural interest and where it is used as a design element and not simply as a colored pattern. A room with a strong patterned paper requires fewer accessories and wall decorations than a room with plain walls. A scenic paper usually becomes the most prominent decorative element in the room. Wallpaper has a tendency to make a room seem more lively in appearance. Patterns which are too strong fatigue the eye, and the designer should carefully consider whether to use a patterned paper or resort to plain-colored walls.

Wallpapers in pale or neutral colors, monotones, or patterns showing a large area of background, or papers in which the pattern and background are close in tonal value, are more suitable

for covering entire walls in rooms of constant use, such as living rooms. Wallpapers with patterns that contrast strongly with their backgrounds may be used to advantage in entrance halls, passageways, guest rooms, and other portions of a structure less permanently occupied. Patterns having vertical stripes tend to give an appearance of greater height to a room, but if the color contrast of the stripes is strong, the effect may be very fatiguing.

Wallpaper patterns may conflict with other wall decorations such as pictures, wall sconces, and hanging objects. If one desires to use the latter with wallpaper, it is probably better to use a paper of subtle colors and rather small-scale pattern, or, if this is not possible, to use only pictures that are large enough not to be lost in the pattern of the paper. In order to attain optical relief, if a wallpaper has a prominent pattern, curtain or drapery fabrics should be in plain colors or inconspicuous patterns and hangings themselves designed in a very simple manner.

A safe rule of thumb is to allow the colors of the wallpaper pattern to fix the color scheme for the entire room by distributing the wallpaper colors in the furnishings.

The scale of a wallpaper pattern is of the utmost importance. While there is no unalterable rule regarding this matter, generally speaking small patterns are best for small rooms and large patterns for large rooms, but much depends upon the pattern and its strength of tonal value. The subject of the pattern must also be considered from the point of view of suitability to the character of the room. Small samples of paper tested on a white wall are apt to be lighter in appearance than they will be when the walls are completely hung with the paper and the room is furnished and curtains are hung. For this reason, it is advisable to select a paper that appears a little too light in the sample to achieve the desired effect.

PAINTS AND PAINTING

The subject of paints and painting is so intimately related to effective and tasteful color use that a technical knowledge of the processes and the methods of obtaining desired results is essential as part of the equipment of all designers.

Plain painting is distinctly a trade, but in its higher forms it may approach the borderlines of art, and it invariably requires consummate craftsmanship. There are so many variations in quality of both material and workmanship that much experience is necessary before expert technical or intelligent supervisory ability may be acquired. The designer seldom handles a paintbrush himself, but he should know the language of the painter and the names of the various finishes and effects, and should have a reasonable amount of information concerning the mixtures and applications necessary to produce them.

Paint materials. Good oil paint must be made of a mixture of materials which give it a proper working consistency. It should be opaque; its pigments should be as nearly nonfading as possible; and the proportions of the various chemicals used to produce it should be such that it has the greatest durability for its particular use.

Paint is a mixture of a base, a pigment, and a binder or vehicle. The base, except for very dark paints, is *white lead*, which gives the paint its covering quality. The pigment or pigments give the paint its color and decorative quality. The binder serves to cement the pigment to the base and to the surface to be painted, and to make the consistency of the paint suitable for spreading evenly over a surface. In interior paints linseed oil is most commonly used as a binder, although varnish, glue, or casein are also used for special purposes. A cheaper grade of paint is made by adulterating the linseed oil with fish oil. A small amount of turpentine or benzine may be added to a paint mixture to di-

lute it in order to create a thinner layer to cover a larger surface area, to increase its rate of drying, and to give greater penetration of the pores of the surface to be painted. Special drying chemicals that may be added in small quantities are oxide of cobalt, iron, lead, manganese, and metallic salts; these materials also produce a harder finished surface.

In addition to white lead as a base for paint mixtures, it is usually wise to add a percentage of zinc oxide. Lead has a tendency to turn into a fine powdered chalk after it has dried for two or three years. The addition of pigments lessens this tendency. Zinc oxide may also be used as a base, but paint made of this material will eventually crack, which makes it difficult to repaint over such a surface. The majority of painters advise, as a paint base, a mixture of about 30 percent zinc to 70 percent lead; this is claimed to overcome the defects of both materials. Titanium oxide, a very white pigment, is often combined with zinc oxide, in the proportion of 20 percent zinc oxide to 80 percent titanium oxide. It has excellent hiding power, and stands up well under exposure. This pigment is frequently used by paint manufacturers for ready-mixed interior and exterior paints and enamels.

The selection of oils to be used for paint mixtures is of the utmost importance. There is nothing better than pure linseed oil for a binder, although linseed oil has a tendency to turn yellow, and when a white painted surface is desired only a small quantity should be used for interior work. It is very essential to use only the products of reputable manufacturers of linseed oil, as there are many adulterated products on sale.

Pure linseed oil may be obtained in its raw or boiled state. When raw oil is used, it is necessary to add a japan drier to the paint mixture. Boiled oil dries more rapidly by itself.

Calcimine is another word for tempera, or opaque watercolor paint. It is usually made of a very finely ground chalk, known as whiting, and a powdered pigment mixed with a binder of water and glue or casein. Calcimine is comparatively inexpensive, but is without the permanency of oil paint, and because of its water base is unwashable. If the glue is made of casein, a protein of milk, it becomes insoluble when dry, so that the finished surface is theoretically washable, but as many ready-mixed paints of this type have an insufficient content of this material, they do not fulfill this claim. Casein dries to a hard surface and only one coat need be used.

Lacquers are made of pigments mixed with solutions of pyroxylin and ethyl or alcohol, combined with a plasticizer to increase adhesion. They are very hard when dry, adhere firmly to any surface upon which they are applied, and dry rapidly. Enamels are not as hard as lacquers and are made of mixtures of pigments and varnish.

Varnishes are made of gum or resin mixed with oil, turpentine, alcohol, ether, or chloroform. They are transparent or translucent and may be mixed with a limited amount of pigmentation. They dry quickly with a glossy finish, but rubbing and polishing increase their reflecting qualities. If varnishes are mixed with liquid rubber or gutta-percha, they may be used on flexible surfaces such as leathers or textiles.

Stains are made of thin pigmented liquids that are easily absorbed by the materials upon which they are applied. As wood graining varies in density, portions of wooden surfaces absorb stains with different degrees of rapidity; the natural color of the wood is altered and the texture and graining of the wood are accentuated.

Fluorescent paints are made of substances containing radioactive elements that have luminous and high reflective qualities.

Paint mixtures and coverage. For interior work one gallon of paint will cover approximately 300 to 600 square feet, but this will vary

according to the character of the surface to be painted and the recommendations of the manufacturer. On rough surfaces or materials which are highly absorbent, the coverage of paint may be considerably less. Thin paint will go further than thick paint, but will have less opaqueness. Paint spreads further on smooth surfaces such as metalwork than it does on rough surfaces such as wood. Second-coat work requires less paint for the same area than first-coat work.

The usual proportions of materials used in making paint for interior work are as follows:

100 lb. pure white lead
1 gal. raw linseed oil
2½ gal. turpentine
1 pt. japan drier
Pigments as necessary

The above mixture produces about 6½ gallons of paint. Each subsequent coat should have a little less turpentine and more linseed oil. For a glossy finish the final coat should have about 3 gallons of oil to 1 pint of turpentine. An *eggshell* or semiflat finish should have 1 gallon of oil to 2 gallons of turpentine, and a flat finish should be mixed with 3 gallons of turpentine without any oil whatsoever. The use of zinc and lead in equal parts for a final coat of paint produces a white finish.

In rooms painted in light colors it is usually advisable to use a dull or mat finish for the wall paint. When rooms are to be finished in dark colors, an eggshell or semiflat finish is advisable because of its greater capacity to reflect light. The majority of paint manufacturers supply ready-made paints in a great variety of colors. Care, however, should be taken in selecting such materials, and the reputation of the manufacturer is often the only guarantee of quality, as many adulterants are now used, and the ingredients are not always indicated on the labels of the containers. Ready-made paints often fade rapidly, particularly when exposed to the sun,

and also tend to become brittle and crack when dry.

Synthetic paints. For many years the majority of house paints have been made with a base of white lead and oil, and these materials are still considered superior for surfaces subject to weather erosion, wear, and friction. Developments in chemistry have, however, produced several synthetic materials that indicate superior advantages for interior paints. These products are sold under trade names, but most of them are produced from alkyd enamels or latex rubber solutions.

Surfaces painted with either of these synthetics are washable. One-coat application is sufficient except on newly plastered walls, and they are fast drying and easy for the novice to apply. The alkyds are made in flat, semigloss, and high-gloss finishes, and withstand dampness well in kitchens and bathrooms. The latex types are also produced in a variety of finishes; they tend to leave brush marks but may be patched more easily if surfaces are damaged.

Both types are supplied in ready-mixed hues, and variations may be obtained by mixing these with standard pigments. Color retention and fugitiveness are the same as for the lead and oil bases. Quality in these paints is best judged by considering the reputation of the manufacturer.

Synthetic paint production is subject to constant improvements due to new discoveries, and there are optimistic claims about future developments. The use of polyvinyl acetates appears promising.

Pigments. The majority of first class painters prepare their own colors from pigments furnished by a reputable manufacturer. If the finished color is to be light in value, the pigments are slowly added to the mixture of the base and binder with constant tests and color compari-

sons with the desired sample. Colors have a tendency to dry to a slightly different tonal value than when wet, so that if an exact match is required, it is necessary to permit the sample to dry until the gloss has been eliminated. If dark colors are to be mixed, it may be necessary to add a great deal of pigment, so that usually it is better to start with a ready-mixed paint that is close to the color desired, and to which additional pigments may be added.

The following palette will be found sufficient for most types of work.

REDS

Alizarin crimson—A strong red with a bluish cast. A coal-tar color that mixes poorly with earth colors, such as sienna, ochre, or chrome yellow. Good for producing rose and violet hues.

English vermilion—A brilliant red with a yellowish cast. Made from chromate of lead. Does not mix well with cadmium and ultramarine.

Carmine—A brilliant red made from cochineal insects. Strong for tinting.

Indian red—An earth or metal color with a brownish cast. Not good for combination with yellow or blue.

BLUES

Prussian blue—A strong tinting blue, very dark with a greenish cast. Good for producing brilliant greens when combined with yellow.

Cobalt blue—A strong blue with a reddish cast. Good for mixing.

Cerulean blue—A strong blue with a greenish cast.

Ultramarine—Sometimes called French blue. It has a reddish cast and makes a beautiful purple when mixed with alizarin crimson.

YELLOWS

Cadmium—An excellent yellow that mixes well with all colors except chromes and American vermilion. Makes good greens or oranges. Should not be used with white lead. Manufactured in four tones: pale yellow, cadmium yellow, deep yellow, and orange.

Chrome—A color made from lead derivatives manufactured in four tones: light, lemon, medium, and orange. Does not mix well with ultramarine.

Yellow ochre—An earth color with a reddish brown cast. Excellent for producing tans, creams, buffs, and olive green.

GREENS

Viridian, also known as Emeraude—A very brilliant green with a yellowish cast. Excellent for mixing with all other colors.

Emerald green—A very brilliant green with a bluish cast.

BROWNS

Raw sienna—Very similar to yellow ochre. Has high tinting strength.

Burnt sienna—A dark reddish brown with characteristics similar to raw sienna. An earth color.

Raw umber—A dark greenish brown of great tinting strength. Produces very clear tints when mixed with white. An earth color.

Burnt umber—Characteristics similar to raw umber but darker and bluer.

Van Dyke brown—A dark rich purplish brown with high tinting strength. Very transparent. Its tints have a lavender cast.

BLACKS

Lamp black—Made from the smoke of burning oils. A jet black that is good for producing grays when mixed with white.

Ivory black—Made from bone charcoal. Excellent to use as a solid color.

WHITES

White lead—An excellent base for all colors. Has a tendency to turn yellow with age.

Zinc white—A permanent white, used by artists. Mixes well with all colors. Has a tendency to become brittle if exposed to the weather.

Titanium—An excellent opaque base for interior work. Retains its whiteness; should be mixed with 20 percent zinc oxide.

Permanency of pigment colors. The chemical constituents of pigments are derived from a great variety of animal, mineral, and vegetable sources, and many synthetic or aniline colors have a coal-tar origin. Some of these have a tendency to fade or to change hue. It is essential to know the nonfugitive pigments when permanent color work is planned. Some pigments are fugitive only when combined with certain others. The quality of pigments made by the different paint manufacturers varies greatly, so that no accurate indication may be given as to the permanency of all colors. In general, however, the list given below may be followed:

Permanent—Raw sienna, burnt sienna, ultramarine blue, cobalt blue, raw umber, burnt umber, yellow ochre, Van Dyke brown, ivory, lamp black, vermilion.

Semipermanent—Chrome yellow, green, cadmium yellow, Indian red, Venetian red.

Fugitive—Carmine, crimson lake, madders, Prussian blue, cerulean blue.

White lead makes a poor chemical mixture when combined with ultramarine blue, cobalt blue, English vermilion, and chrome yellows. When using oil paints, it is better to combine these pigments with zinc white for tinting.

Plain wall painting. In the painting of interior plaster walls, there are three conditions that may exist—new walls, old walls that have already been painted, and walls that require the removal of wallpaper before paint can be applied. Plaster should be thoroughly dry before any attempt is made to paint it, and it is advisable to cover a plain plaster wall with a coating of thin varnish, shellac, or size to prevent the chemical stains, which often develop in new plaster, from seeping through the several coats of paint and causing a discoloration in the finish. Some painters prefer to apply a size after the first coat of paint has been completed. If there are cracks in a plaster wall—and they often occur in new walls as well as old ones—the cracks should be "cut out" and "painted up." Cutting out means that the crack should be widened with a sharp tool so that the inside of the crack is slightly wider than its appearance on the surface. Filling up refers to filling the crack thoroughly with plaster. The fact that the crack is narrower on the wall surface creates a safer binding for the patch. It is wise to shellac the crack before the plaster filler is added. After adding the plaster, it should be smoothly troweled, then sandpapered so that it is as smooth as the wall itself, and finally shellacked again. Old walls should be washed with soda and water before the cracks are sealed. When old paint has fallen off, leaving depressions, these are usually "spackled," or filled up with a special preparation which dries quickly and makes a very smooth patch when sandpapered. "Spackled" areas must also be treated with shellac or size to prevent greater penetration of the paint than in surrounding areas.

If cost is not a prime consideration, plaster walls should first be canvassed. This procedure excludes all possibility of visible wall blemishes and is permanent. The permanency is not to be overlooked in the final cost, as the canvas may be repainted many times without the necessity of patching the plaster. There are several different grades in canvas wall coverings. Muslin and "Sanitas" make excellent surfaces for painting and may be applied to the wall with ordinary wallpaper paste.

In painting plaster walls, whether canvassed or otherwise, the first coat of paint, known as the *priming coat*, should have a considerable amount of oil used in the mixture so that the porous surface of the muslin or plaster will be thoroughly filled with both oil and pigment. After each successive coat of paint is applied, and before it begins to dry, it may be *stippled*. A stipple-brush is about the shape of a large scrubbing brush, with bristles three to four inches in length. While one man lays on the paint, another should follow him almost imme-

diately, going over the freshly painted surface with short rapid blows of the stipple-brush. This eliminates the irregularity and streaks of the brush marks, and evens the surface. If the paint is thin, the stippling will not show; but in cheap jobs, the custom is to apply thick coats of paint to save labor, and the stipple marks may be very noticeable and may produce an undesirable rough texture. The same effect may also be achieved by use of the stippling roller, which is about two inches in diameter, with a handle, and covered with a coarse pile fabric, such as a small piece of rug. Stippling is usually done only on plaster walls, not on wood.

The subsequent coats of paint should not be applied until the priming coat is entirely dry. Three coats in all are necessary in order to produce a satisfactory result, although many decorators advocate more. Usually four coats should satisfy a most fastidious client.

Suggestions for mixing paint colors. There are no scientific formulas for mixing pigments to produce other colors. One cannot state either what quantity, volume, or weight of paint to use to obtain a desired result. This is due to the fact that the chemical ingredients of certain pigments have stronger *tinting values* than others, so that relatively less of those pigments must be used in mixtures. The production of colors by pigment mixtures must be done by the trial and error method of visual examination.

In trying to obtain a certain color by a paint mixture, the designer is usually matching another color or producing a color that will be suitable for some part of a room or one that will harmonize suitably with the other hues of a tentative color scheme.

One usually starts with a container of white paint. It is usually advisable to obtain the final colors first in a small quantity, as errors in mixing large quantities are sometimes costly. Pigments should be added slowly and tests of the color should constantly be made on a flat piece

of cardboard or wood, and these should be held in their final position on wall, ceiling, or elsewhere.

In matching colors, it is advisable to look at the original and the new mixture through a "color window." This is merely a hole of about 1½ inches diameter cut out of a sheet of white paper. The two colors should be placed directly adjoining each other and compared through the hole. The white paper prevents either color from being influenced by any nearby color and the differences in hue, chroma, and tone of the two colors are easily distinguishable.

In selecting colors for walls from small samples one should always keep in mind the fact that the color is to be used in a large area and will appear more brilliant in its mass than it will in the small sample.

The constituents of mixed colors are usually more easily identified by comparison with other colors; that is, a greenish blue will look greener when placed next to a pure blue, and a certain red will look bluish or yellowish when placed next to a pure red. One can also identify the respective degree of neutrality or tonal value of a color by this same method.

For example, if one compares a group of any four varied examples of painters' pigments in which yellow dominates, one will immediately notice that one appears greenish (blue tinge), another appears to have an orange cast (red tinge), another will appear lighter (white tinge), another will appear grayer or more neutralized (violet tinge). These four colors may be made identical by adding a small amount of the complement* of their respective tinges.

To the first add orange, to the second add green, to the third add yellow, and to the last add yellow and white. The addition of the complement in each case counteracts the original tinge. This principle may be followed in making

* See Chapter 13 for explanation of this term.

all mixtures for matching other colors. A small sample of the mixture should be tested by looking at the two samples in very close contact through a color window. The comparative tinge of the mixture should be noted and corrected by adding more pigment of its complement.

Colors are light and dark only by comparison in the same light. The term light and dark is largely a relative term. While white is always light and black always dark, there are many intermediate tonal values that are hard to identify relatively unless they are seen in contrast with colors of other tonal value, when they will accentuate each other.

Removing wallpaper. Wallpaper must be thoroughly soaked before any attempt is made to remove it. In order to accomplish this, a large calcimine brush and warm water are used. When the paper has absorbed all the water it can, it should be let stand for a few minutes until the paste has been softened by the moisture. The paper may then be scraped with a putty knife and easily removed. When valuable or antique wallpaper must be removed, it is advisable to obtain the services of a professional, as it is a very long and difficult procedure. The usual method is to hang large steaming cloths about four inches from the wall over a large portion of the wall at the same time. The dampness from the cloths will eventually be absorbed by the paper or muslin upon which all valuable paper is mounted, and the paper may then be carefully pulled off the wall, strip by strip. When all traces of paper and paste have been removed from a plaster wall, the wall may be treated as new and the painting procedure carried out as described above.

Calcimining. Calcimine may be applied in one coat only; when a surface has been previously treated with a coat and is to be repainted, the old layer should first be removed by means of a large sponge and warm water. It is often customary for economical reasons to treat ceilings with this material, but this should not be done in work of good quality, and as labor costs in applying calcimine are only slightly less than in applying oil paints, there is only a minor economy in using this material.

Painting and staining wood surfaces. In painting woodwork, if the wood has a rough grain it should first be "filled" with white lead or one of the many standard fillers. It should then be entirely covered with a coat of shellac to seal the absorbent surface. Over this sealing coat of shellac the wood may be painted in the same manner as a plaster wall surface. Where it is desired to apply a coat of stain to woodwork, it is necessary first to apply a filler that is the same color as the stain. The surface need not be shellacked. The stain may be purchased from any paint store, or it may be prepared with a thin oil base mixed with pigment.

Glazing and antiquing. It is often advisable to apply a finishing coat of thin color to the whole or parts of a wall in order to give the surface greater interest and a slight variation in effect. This is usually called glazing or antiquing. Such finishes are numberless in their elaborations, but the plainer effects are simple to apply.

The customary procedure is to apply over a thoroughly dried, light neutral-colored surface a film of color of the consistency of water. The medium is usually of oil and turpentine, and a small amount of pigment is added to the mixture in the desired strength. For antiquing, walls are usually glazed with umber, which, more than any other color, seems to produce a satisfactory illusion of age.

Other tones, however, are also used for antiquing. A smooth glaze may be applied with a large brush over a whole painted surface and then stippled. In other glazes the brush marks are intentionally left visible. The latter are

known as streak glazes, and they are produced by a large calcimine brush.

Plain glazes may be softened or modulated by means of a soft cloth, sponge, or cheesecloth, but care should be taken not to produce artificial effects unrelated to antique rooms. Simple, unostentatious glazes are to be recommended. It is very easy to overglaze a surface, and such an effect is always artificial, vulgar, and in bad taste. Proper antiquing is almost imperceptible.

Glazing is particularly adaptable to paneled rooms and should be used to make the paint and woodwork appear slightly dusty. As dust invariably occurs in panel corners and on certain portions of moldings, it is advisable to put a slightly darker tone in these places. In antique paneled rooms, it was customary to wash the paint in the most accessible portions of the panel fields. This caused the centers and lower portions of the panels to be slightly lighter in tone than the tops and corners. A realistic imitation of this natural condition may often be introduced to advantage, but much discretion must be used to avoid a false effect.

Glazing is sometimes produced by means of a spatter finish that consists of covering the surface evenly with small dots of pigment that are complementary in hue to the surface color. This may be done by using a sprayer or by gently finger-snapping the hairs of a large paint brush toward the surface until the required effect is obtained. This treatment neutralizes the color of the original paint, but should be done most carefully and consistently, and never excessively. The dots should be very small and indistinguishable when viewed from a distance of six feet. Neutralizing done by this method leaves a more vibrant effect than when the paint is originally mixed with neutralizing pigments, and the method resembles that employed by the Impressionist artists of the nineteenth century.

Plaster effects. Certain types of rooms require the walls treated in the effect of rough,

sand-finished plaster. The textural charm of old walls of this type is well known, and if mellowed by age, they have an unusual appeal and are exceedingly durable. If existing walls are not of this type, the painter may be called upon to cover the wall with one of the many patented surfacing materials to produce the desired effect. It is essential, however, that the degree of roughness and irregularity of the old walls be imitated exactly. Many of the old plaster walls consisted of a coating applied to rough stonework, and the unevenness of the stones produced slight variations in the plaster surface. The plaster, although it often gave the appearance of having been applied carelessly, had irregularities which were never intentional or self-conscious in appearance, nor was the aim to produce a crude or unfinished result. Incompetent work may result in walls which are quite devoid of taste and understanding. If a textured effect is desired, it can also be obtained through the use of a variety of nonplaster contemporary wall coverings.

The preparation and application of the patented materials used for the effect of rough plaster are simple. The material, in the form of a flourlike powder, is mixed with water and, in some cases, with oil. Powdered color may be added to the mixture, thus finishing the wall in one operation. It is also possible to apply the white, colorless plaster—a thick pasty substance —alone, and when it is thoroughly dry, to add the desired color by means of a thin glaze, to give the effect of age.

For applying the plaster, a trowel or brush is customarily used. For textural variations, all sorts of implements may be employed. These plasters, as a rule, will not crack, and if cracks do occur, they may be easily filled. Most commercial products for this form of decoration are fast-drying, very hard, and permanent.

Graining and marbling. Economic conditions, short leases, and frequent changes of residence today often require substitution for the more

expensive materials of decoration. While, judged purely from the point of view of aesthetic morals, such substitutions are indefensible, they are often practical and necessary. Within this class of work comes the graining or marbling of surfaces to imitate natural wood or real marble. Such work is a highly developed craft, and can by no means be accomplished by the amateur, but painters and artists in all periods have been able to develop an extraordinary technique in this line. Although it would be impossible for the average designer to do this type of work himself, it is his duty to design the surface of the wall in panels, planks, or other divisions that would be consistent with the material that he wishes imitated.

Wooden wall panels are made a certain size and shape, according to their period, and they are held in place by moldings and stiles. If they are imitated by applied moldings on a plaster wall for economy's sake, the proper design and layout must be carried out.

A wall covered in full or in part by marble (such as a dado or baseboard) is actually covered by marble slabs about one inch thick and of varying sizes. The marble joints are always visible, and if the desired effect is to be imitated in paint, the marble slabs, stiles, panels, and other parts with visible joints should be carefully imitated.

Wood or marble graining always ends with each separate piece of wood or marble. In the adjoining piece the graining commences in a different pattern or direction. To be in good taste, painting made to imitate wood or marble must create a complete illusion, and the work must be very realistic.

Antiquing of wallpaper. Painters are often called upon to give wallpaper an antique, mellow effect. This softens the colors and draws them together. If the wallpaper pattern is printed in watercolor (tempera), the paper should first receive a coat of gelatin size, followed by a coat of shellac. The glaze itself may be in oil or turpentine, and the procedure is the same as antiquing painted surfaces.

Metal leaf. The use of silver and gold leaf surfaces in decoration has become popular in recent years. These effects are also part of the painter's work. Aluminum leaf is generally used in place of silver, as it is less expensive and does not tarnish. The application of metal leaf is accomplished by first applying a *gold size* to the surface to be treated. This is allowed to dry to a thick consistency, and the leaf is then applied to the size and allowed to dry thoroughly. It is best to varnish metal leaf for protection. Metal leaf is usually glazed over the varnish for antique effects.

BIBLIOGRAPHY

Ackerman, Phyllis. *Wallpaper: Its History, Design, and Use.* New York: Frederick A. Stokes Co., 1923.

Allen, Edward B. *Early American Wall Paintings 1710–1850.* Library of American Art, 1926.

Birren, Faber. *New Horizons in Color.* New York: Reinhold, 1955. Principles, effects, and uses of color in decorating homes, stores, restaurants, etc.

Bossert, Helmuth. *An Encyclopedia of Color Decoration from the Earliest Times to the Middle of the 19th Century.* London: Gollancy, 1928. Details of ornamental painted walls, decorations of ceilings, vaults, facades, etc., selected from all times and countries.

Cooper Union Museum. "Wall-papers in the Museum's Collections Produced before 1900." *Chronicle of the Museum for the Arts of Decoration of Cooper Union,* vol. I, no. 4, April 1938.

Cooper Union Museum. *Wallpaper: A Picture-Book of Examples in the Collection of the Cooper Union Museum.* New York: Cooper Union Museum, 1961.

Crewdson, Frederick M. *Color in Decoration and Design.* Wilmette, Ill.: Drake, 1953.

Entwisle, E. A. *The Book of Wallpaper: A History and Appreciation.* London: Arthur Barker, 1964.

Entwisle, E. A. *French Scenic Wallpapers, 1810–1850.* Leigh-on-Sea: F. Lewis, 1971.

Feangiamore, C. L. "Wallpapers Used in Nineteenth-Century America." *Antiques,* December 1972.

Hotchkiss, Horace. "Wallpapers Used in America, 1700–1850." *The Concise Encyclopedia of American Antiques,* vol. 1, edited by Helen Comstock. New York: Hawthorn Books, 1958.

Katzenbach, Lois and William. *The Practical Book of American Wallpaper.* Philadelphia: J. B. Lippincott Co., 1951.

Maery, Alois, and Rea Paul. *A Dictionary of Color,* 2nd ed. New York: McGraw-Hill, 1950. Indispensable for identifying colors by their correct names. Notes on the origin of color names.

McClelland, Nancy V. *Historic Wallpapers from Their Inception to the Introduction of Machinery.* Philadelphia: J. B. Lippincott Co., 1924.

Oman, Charles. *Catalogue of Wallpapers.* London: Victoria and Albert Museum, 1929.

Sanborn, Katherine A. *Old Time Wallpapers*. Greenwich, Conn.: The Literary Collector Press, 1905.

Vaderwalker, Fred Norman. *Drake's Cyclopedia of Painting and Decorating*. Chicago: Drake, 1945.

Waring, Janet. *Early American Wall Stencils*. New York: Dover Publications, 1968.

This dramatic vista is created by the use of fabrics on walls, ceiling, and as portals. The effect not only lengthens the perspective, but gives great character to an otherwise insignificant space.

CHAPTER 17

Decorative Textiles

:513.—Jacquard Power-looms: Stuff-manufacture.

Early fabric power looms with design controlled by Jacquard attachment.

Textiles are the most versatile and effective medium for introducing texture, color, and pattern into any type of interior. Because today's complex market offers every style of textile—traditional, transitional, or contemporary—in both natural and synthetic (man-made) fibers and in a wide price range, function and the technical aspects of any textile have, of necessity, become the primary considerations for selection. Understanding how to choose and specify a textile therefore is essential. Basic to any textile is the spinning of the yarn and the construction. It is these two elements which give each textile its aesthetic personality.

Spinning conditions the character of each yarn—its denier (thickness of thread) and its texture (sleek, twisted, or slubbed). Construction conditions the final textile—whether it is a tight, close-set cloth such as a percale, an open-set cloth such as a loose fish-net, or any of the infinite variations in between.

Construction generally refers to weave, the interlacing at right angles of the warp yarn and the filler yarns. But construction may also refer to knitting, an interlocking of loops, and to tufting, a process whereby rows of needles punch yarns into a woven fabric backing. There is yet another construction process, and it yields a nonwoven fabric, or felting. In this case, loose fibers are made to adhere to each other under pressure.

Whether or not a textile is durable, or easy to maintain, depends on the type of fiber used, the manner in which it is spun, and the construction.

Fibers can be classified as natural and synthetic, and these categories are subdivided as follows:

The natural fibers:

Plant fibers—cotton
 flax
 jute
 hemp
 ramie
Animal fibers—wool (sheep)
 hair (camel, vicuna, goat, rabbit, alpaca, horse)
Silk fibers—silkworm
Mineral fibers—asbestos
Metal fibers—threads or strips of gold, silver, copper

The synthetic fibers:

Cellulosic—(fibers synthesized from the organic woody substance found in vegetables or plants):
 Acetate
 Rayon
 Triacetate
Noncellulosic—(polymers, polyamides, glass):
 Nylon
 Acrylic
 Modacrylic
 Olefin
 Polyester
 Glass fiber

As each of the synthetic fibers, cellulosic and noncellulosic, is manufactured by more than one firm, trade names have been established for

identification of each firm's product. The government labeling program requires only that the generic name of the synthetic, or even of the natural fiber, be clearly listed on a tag attached to each textile. In the case of fiber blends (two or more fibers woven into a single textile), each fiber and its percentage must be mentioned on the label. For example, a typical blend might be 10 percent wool and 90 percent nylon or 50 percent flax and 50 percent acrylic.

CHARACTERISTICS OF THE BASIC FIBERS

The natural fibers. The history of fibers can be traced to five thousand years before Christ, when man, living in the Nile Valley, discovered that he could adapt certain fibers from plants and animals into crudely woven textiles for his personal needs. It is a testament to the inherent durability and to the aesthetic qualities of these ancient fibers, that they have remained the basics of the textile industry.

COTTON. One of the most important of all fibers is cotton, a vegetable fiber which comes from the bolls of the cotton plant and which grows prolifically in warm climates such as that of its original source, Egypt. The largest modern crop comes from the United States, but the fiber is of medium length. (Most fibers vary in length from two-thirds of an inch to over two inches.) Ranking next to the United States in cotton production are India and China; lesser quantities come from Brazil, Peru, Iran, Mexico, and Russia, among others.

The grading of cotton is dependent on the natural color, length of staple, softness, and crimpness (waviness) of the fiber. The spun thread is usually dull and limp, though it can be given a glossy appearance by mercerizing. Examined under a microscope, the thread appears spirally twisted, and when this twist is very tight, cotton becomes a stronger fiber than wool. Cotton reflects heat better than wool or silk, but more poorly than rayon or linen. Cotton

dyes well, has unlimited styling potential, has a soft hand, does not pill or fuzz, and can be blended with other fibers in a textile. Continuous exposure to sunlight will cause the fiber to disintegrate. In humid or damp climates, cotton is subject to mildew and mold. If untreated, cotton will burn at a slow rate, and as it is the most versatile of fibers and one of the most durable, it is ideal for drapery, upholstery, or slipcover textiles.

FLAX. The oldest known textile is linen made from the flax fiber. Linen was used in prehistoric times, and mummies carefully wrapped in linen cloths have been found in Egyptian tombs. Flax is a vegetable fiber found in most parts of Europe, in the northern portions of the United States, and in Argentina. (The so-called American flax plant is used only for the growing of seed for the manufacture of linseed oil and other products.)

Little spinning is necessary for the flax fiber to be transformed into a linen textile, as the fibers are very long, averaging about eighteen inches. The yarn is usually grayish in color with a silky luster. The hand is crisp and cool, and the fiber dimensionally stable. Linen textiles reflect heat better than cotton and hold their color longer under strong light conditions than other textiles made from natural fibers. Linen will disintegrate in intense sunlight. It can be bleached without fear of damage, and recent dye technology has overcome an early resistance to dye absorption. The natural—untreated—fiber does not support flame. Linen is widely used for table linens, draperies, slipcovers, and even upholstery. Flax fibers may be combined with other fibers during either the spinning or the weaving processes.

WOOL. An equally important fiber, wool comes from the fleece of sheep, and the ancestor of nearly all wool-bearing sheep is the Spanish merino. Hair from other animals—the camel, goat, mohair, alpaca, and llama—is treated as a textile wool. So is vicuna, the rarest and most

valuable of all hair, sheared from the South American camel. Although the greatest quantities of textile wool come from Australia, the fiber is shorter in length than the popular English wools.

Wool fibers are springy, resilient, soft, kinky, and extremely durable. The fibers vary in length from one inch to eighteen depending on the animal and the place where the wool was obtained. Worsteds require long fibers which are hard-twisted into threads or yarns. Softer wools require a short fiber.

Natural wools vary in color from pale neutral hues to dark browns. After bleaching, wool may be readily dyed, and the fiber will retain the color depth well over a long period of time. Wool should be mothproofed before using. It is resilient, has good resistance to abrasion, naturally resists flame, is antistatic, has a pleasingly soft hand, and can be blended. This fiber makes a beautiful textile for casements and for upholstery.

SILK. Undeniably, the most beautiful of all fibers is silk, with its marvelous natural luster. Silk, a coveted rarity in ancient days, was considered the "gold standard" in barter.

Legend tells us that silk was discovered in China about 2690 B.C. by a young empress. The process of turning it into a fabric remained a well-guarded secret until many generations later. Despite the fact that the Emperor Tiberius was introduced to the rare qualities of this exotic fabric in 325 B.C., and that during the Middle Ages caravans supplied wondrous silk textiles to Byzantium, Persia, and Asia Minor, the art of making silk into textiles was not developed in Western Europe until the sixth century, when the Emperor Justinian learned of the secret of sericulture.

Sericulture (the word comes from "Seres," the Latin word for "Chinese") is the process of turning silken threads into a textile. The process as a whole includes the growing of the tree, the rearing of the silkworm—a grayish worm which produces the cocoon—the creating of the cocoon, and the manufacture of the yarn.

After the cocoons have matured, they are killed in dry heat to facilitate unreeling. The average length of each filament is about six hundred yards, but many filaments may be far longer. The filament is extremely fine but quite strong in relation to its size. In strength, silk is surpassed only by nylon. It takes many spinnings to make a yarn the size of a human hair. For one pound of silk yarn, 2,500 cocoons are needed.

There are many grades of silk. The finest cultured silk yarn, made from the longest filaments, is called organzine or "thrown silk." Other types made from shorter or broken strands have less luster and are known as tram, spun silk, or bourette. Tussah is the wild silk made from cocoons that feed on oak or other trees. It has a rough quality, is light brown in color, and cannot be bleached white. Tussah is used for weaving the rougher textiles such as pongee, shiki, and shantung.

Silk is fragile; strong light tends to discolor it and disintegrate the fiber. Although silk has a natural affinity for dye, it will deteriorate from bleaches and most cleaning acids. In humid climates the fibers are subject to mildew and rot; they will swell when damp and shrink when dry—a condition called hiking.

If ignited, silk will burn slowly. Silk fibers will abrade, particularly if the textile is a blend of silk and a second fiber of higher tensile strength.

JUTE. A fiber which resembles flax, jute is made from the interior of the stalk of a tall plant which grows in India. It is generally used for burlap bags, twine, furniture webbing, and the bindings and backings of the cheaper grades of rugs and carpets, but it has been woven with aesthetic success into upholstery-weight fabrics. The fiber is very long and is dimensionally stable. Short fibers are used for the manufacture of wrapping paper.

HEMP. Coming from a plant located in the temperate zone, hemp is a coarse fiber used in fabrics, ropes, and gunny sacks.

RAMIE. Sometimes used as a substitute for flax and commonly known as china-grass, ramie is coarse, strong, and durable.

ASBESTOS. Differing from plant fibers, asbestos is actually a mineral with fluffy strands. These strands or fibers are generally combined with cotton to produce a textile. Its one great advantage is an absolute resistance to fire. Traditionally, asbestos has been used for theater curtains.

METAL. Threads of gold, silver, or copper have often been woven into filmy casements or wall hangings, but the natural thread does tarnish. Not so those metal yarns which were produced commercially by the Dobeckmun Company (a firm later absorbed by Dow Badische). The manufactured fiber is composed of metal, plastic-coated metal, metal-coated plastic, or a core completely covered with metal. The metal, more often than not, is aluminum foil. These metal yarns are not affected by salt water or humidity. Like fine threads of natural metal, the manufactured metal threads are used mainly for sparkle, lending a slight glitter to textiles constructed of other yarns. The trade name is Lurex.

The cellulosics

RAYON. The production of rayon for consumer use was started in 1910 by the American Viscose Company, and rayon thus became the first of the synthetic fibers. Rayon is derived from the pithy sections of plant stalks, and in the refining it remains almost pure cellulose. Because of the relatively low price, it has long been considered the poor man's silk. It is true that, with irregular bulking of the fiber and when spun and woven on the silk system, rayon does emulate silk. But when spun and woven on the linen system, it bears the same characteristics of linen. Rayon is frequently blended with more

expensive fibers such as cotton or wool, and can be found as the woven backing of velvet which bears nylon, cotton, or a silk face (pile). The fiber is reasonably light-fast, and recent modifications have produced a molecular structure for improved dimensional stability. Rayon is reasonably abrasion-resistant. Like most natural and all cellulosic fibers, however, rayon is subject to mildew and will rot under long exposure to sunlight. Textiles made from rayon have a soft hand and drape well.

Rayon is used for draperies, slip covers, and upholstery. Trade names include Avisco Avril (American Viscose); Coloray, Fibro (Courtalds); Bemberg (Beaunit Corporation); Enkrome (American Enka).

ACETATE. This fiber was developed in 1924 by the Celanese Corporation. It is a compound of cellulose acetate, a derivative of cellulose. Acetate textiles have a luxurious hand, and the fibers are generally heat-treated against wrinkling and for improved dimensional stability. Textiles of acetate are washable, are fast-drying, and do not shrink. As acetate does not absorb those dyes formulated for cotton or rayon, special dyes have been created. These dyes are colorfast, but, more interesting, cross dyes are possible in blends where acetate and other fibers, such as cotton, are woven into the same textile. For cross-dyeing, two dye baths are prepared—one for acetate, the other for the second fiber. The textile is dipped into each dye bath, and the dye "takes" only on the compatible fiber. In this way, a two-color or two-tone effect is achieved in a piece-dyed textile.

Like rayon, acetate is an economical fiber and is therefore found woven into expensive textiles such as satins, failles, crepes, brocades, and damasks.

Trade names are Celaperm, Celaloft (Celanese Corporation); Avicolor (FMC Corporation); Chromespun (Eastman Kodak Company).

TRIACETATES. Triacetate fibers were developed for production in the United States by

Celanese Corporation in 1954. They are an almost pure cellulose acetate, are shrink resistant, and will maintain a crisp finish. Most yarns made from triacetate fibers are used for textured knits and tricots. Very few textiles constructed of triacetate find their way into the home furnishings markets.

The trade name is Arnel (Celanese Corporation).

The noncellulosics

NYLON. General production of nylon in the United States by E. I. Du Pont de Nemours and Company was begun in 1939. The most common method of creating nylon requires elements of petroleum, natural gas (carbon), air (nitrogen and oxygen), and water (hydrogen). The chemical produces long chain molecules which constitute the fiber-forming substances known as polyamides. The polyamides are air-spun and stretched after cooling.

Nylon is the strongest of all fibers. It is abrasion-resistant. (In blends it is important that the nylon does not cut the other fiber or fibers within the textile blend.) Early nylons had a high luster, but recent technology has modified the sheen, and nylon today has a woollike appearance. Nylon does not absorb oil and most airborne dirt. The fibers are easily dyed, and a wide range of good, clear colors is available. Nylon textiles are washable; they are dimensionally stable and repel fungus, mildew, and moths. Nylon has one disadvantage—the fibers will deteriorate when exposed to sunlight. Nylon should be flame-proofed for use in public areas.

Nylon is a most adaptable fiber, producing rough-textured tweeds or velvets suitable for upholstery.

Trade names include Caprolan (Allied Chemical); Enkaloft, Enkalure (American Enka); Quiana, Antron, Nomex (Du Pont); Cadon (Monsanto).

ACRYLIC. This fiber was introduced in the United States by E. I. Du Pont de Nemours and Company in 1950. It is derived from elements of coal, air, water, petroleum, and limestone. Most acrylics are used in staple (short fiber) form, and the fiber is crimped before cutting. Depending on the end use, acrylic fibers are modifications of the basic formula. Most acrylic textiles are soft, light, or fluffy in construction. They are resistant to sunlight and to oil-borne and airborne dirt. Because these soiling elements are not absorbed, they remain on the surface of the textile and are easily removed by washing or cleaning. Acrylic textiles are durable, abrasion-resistant, mildew- and moth-proof.

Acrylic fibers are generally knitted into pile fabrics such as fake furs. Otherwise they are blended with polyesters or nylons to acquire a firmer hand.

Trade names include Orlon (Du Pont); Zefchrome (Dow Badische); Acrilan (Monsanto); Chemstrand (Monsanto).

MODACRYLICS. Union Carbide launched the first commercial modacrylic fiber in 1949. The fibers are made of polymer resins—elements of natural gas, coal, air, salt, and water. The fibers are easy to dye, washable, and easy to dry—drip dry. They are resistant to acids and alkalies. Equally important, these fibers are flame-resistant. They are useful for draperies and casement cloths.

Trade names include Verel (Eastman Kodak) and Dynel (Union Carbide).

OLEFINS. Although olefin monofilaments were developed in the United States for specialized use in 1949, it was not until 1961 that Hercules, Inc., developed a textile-grade monofilament propylene fiber. These fibers are a by-product of petroleum. Olefin fibers used in upholstery-weight textiles are strong, light in weight, and generally bulked. The fibers do not absorb moisture or airborne dirt. They are resistant to mildew, rot, moths, and vermin.

Olefin textiles are dimensionally stable and are used in upholstery.

Trade names include Herculon (Hercules,

Jeanne Weeks

A sheer and opaque polyester casement fabric.

Inc.); Vectra (Vectra); Marvess (Phillips Fibers Corporation).

POLYESTER. In 1953 E. I. Du Pont de Nemours and Company introduced this fiber, a derivative of coal, air, water, and petroleum, to the United States. Polyester fibers are polymers. They are strong, but probably their finest characteristic is the ability to stand up under strong sunlight. The fibers resist air- and oil-borne dirt and are easy to wash and dry—drip dry. Textiles of polyester are abrasion-resistant.

The finest voilelike casement fabrics are now made of polyester. Dacron is now being knitted into an upholstery-weight suede-cloth.

Trade names include Ancron (American Enka); Vycron (Beaunit); Dacron (Du Pont); Avlin (FMC Corporation); Trevira (Hystron Fibers); Chemstrand (Monsanto); Quintess (Phillips Fibers). These trade names refer only to those fibers produced within the United States. There are many marvelous polyester

casement cloths produced in Europe which bear other trade names.

GLASS. This fiber, in which the fiber-forming substance is glass, was produced commercially in the United States by Owens-Corning Fiberglas Corporation in 1936. It is one of the few fibers which are inherently resistant to flame. The fiber also does not absorb moisture, is dimensionally stable, and is strong. Late chemical modifications allow a soft, warm hand. These same modifications allow a greater flexibility in weaving, and today glass textiles may appear as lacy open-weave cloths, as semi-opaque casement textiles, or as tight textured-weave textiles. The fibers take dye well, and numerous glass textiles are printed with bright, colorful patterns.

They are best used as a drapery or casement cloth.

Trade names include Fiberglas (Owens-Corning); PPG Fiber Glass (PPG Industries, Inc.).

TESTING

It becomes apparent from the characteristics of various fibers that not all textiles, whether of man-made or natural fibers, can be everything to everyone. Experience ultimately becomes a major factor in selection. If, however, large quantities of textiles are being specified, it is wise to have samples of each tested first. Testing is the only assurance the specifier has that his textile will survive the normal life-span of five to eight years. The only performance standards available are set by the government, and they are available on writing. Those standards generally acceptable for most circumstances are the L-24 Series published by the American National Standards Institute, 1430 Broadway, New York, New York 10036.

Once the performance standards expected for the textile and its end use are established, the textile may be tested for most requirements

—sun rot, fading, dimensional stability, wear, etc.—at one of several laboratories, such as Better Fabric Testing Bureau, 101 West Thirty-first Street, New York, New York 10001, or United States Testing Company, Hoboken, New Jersey 07030. Outdoor fade-testing is handled at the South Florida Testing Service, 4201 N.W. Seventh Street, Miami, Florida 33126.

FINISHES

More and more upholstery and drapery textiles are being treated for soil resistance with silicone treatments which, when properly applied at the factory, literally cause the soil to roll off the textile rather than penetrating it. While these treatments may cost a little more, the treated textile costs less in the long run to maintain. Many textiles appear on the market pre-treated, in which case a tag is attached to the textile sample stating this fact. The trade names for antisoil treatment are Scotchgard (Keisling-Hess) and Zepel (Du Pont).

Every major geographical market area has a local plant for treating a textile to specification. Hand sprays for home use which appear in local stores do not sufficiently saturate the textile to afford adequate protection. Protection will erode during the first dry cleaning or laundering.

If fabrics are to be specified for public spaces, they must pass flammability standards. A few fibers, such as olefins, polyesters, and glass, are inherently flame-resistant. Virtually all other fibers must be treated with fire-retardant chemicals. Not all local governments—and each locality has its own regulation, Boston being the most rigid—will accept those fabrics with fire-retardant chemicals which are only fleeting, that is, which lessen with each washing or dry cleaning. It is wise, therefore, to check local fire regulations before specification. To date, textiles for residential use are not sub-ject to flame-resistance regulations, though such regulations do affect carpets, bedding, and certain other materials.

CONSTRUCTION

Weaving. There is little fundamental difference between the earliest known hand looms and the power looms used today. The principle of the loom is quite simple. The warp yarns, those that run the full length of the textile, are stretched taut around a drum at the back of the loom to keep the tension even. The length of the yarns on these drums varies according to the length of the textile. The raising and lowering of these warp yarns during the weaving process are controlled by two or more shafts, or heddles, originally bars of wood but now made of metal. Each heddle is threaded with strings or wires, the ends of which are looped, one loop for each warp yarn. For a plain or taffeta weave, the threading of the warp yarns through two heddles is so arranged that when one of the heddles is raised, every other warp yarn is raised. The shuttle carrying the filler yarn passes through the opening between the raised and the stationary warp yarns. This opening is called the shed. For the second row of weave, the alternate heddle lifts the balance of the warp yarns for the shuttle to pass through. This alternating process continues for the length of the textile. All weaves are a variation of this plain weave, with design variations dependent upon the number of heddles used and the manner in which they are threaded.

Though many improvements have been added to looms, the most important was the Jacquard attachment for the power loom. It must be noted that the Jacquard is an attachment only, not a loom, and it may be attached to any number of power looms, including the Nottingham lace loom. In the Jacquard system, the pattern to be woven is first drawn on a squared-off

graph paper, each square representing a colored warp yarn. Cards are then punched with corresponding holes. As the cards move across the loom, hooks slip through only those holes punched to represent a segment of the pattern. The hooks lift the warp yarn for the shuttle to pass under. For a simple pattern, with a very short repeat, there are few cards; but for an intricately designed textile, the complexities seem too great for the eye to follow. In some cases, the loom can handle two sets of warp yarns and two sets of filler yarns.

Early looms used one shuttle, limiting the fill yarn to one color; later power looms could alternate four shuttles, each with a different yarn color.

The most advanced loom is the shuttleless loom, which eliminates both the shuttle and the quill (small cone around which the filler yarn is wound and which fits into the shuttle). In their place are so-called rocket cones—a ten-pound package of dyed yarns in skeins wound on the cone. These cones measure about thirty inches high by seven or eight inches in diameter.

The shuttleless loom has many benefits, not the least of which is the high speed of weaving. It is no longer necessary, as it was with early looms, to wind each quill with the filler yarn; the skeins are automatically wound onto the rocket cone. Whereas the older power loom could accommodate a maximum of four colors (shuttles), the modern loom can accommodate a maximum of eight colors (warps); because of the size of the cone, quantities of thick-fill yarns can be used at one time.

One way to judge if a textile was woven on a shuttleless loom is by looking at the selvedge. A traditional loom produces a selvedge with fill yarns wrapped around the edge. The shuttleless loom still produces a selvedge, but the fine fill yarns are cut with a knife at the outer edge.

The old, heavy, bulky cards of the Jacquard attachment have given way to a much lighter, tough paper which is about one-third the size and weight of the old cards, making them much easier to handle and to store.

Some computers are being used to punch the holes on these new Jacquard cards. To date, their use has been successful only for the simpler patterns. For more complex patterns, it is still necessary to color each thread of the pattern on graph paper.

The basic weaves. Of the simple basic weaves, there are three general divisions: plain (taffeta), satin, and twill.

PLAIN OR TAFFETA WEAVE. In this type of weave, the filler thread crosses over every other —or second—wrap yarn. Two or more filler yarns over and under an equal number of warp yarns create a basket weave. A variation of the basket weave is the rep weave. In this weave, the filler yarn is heavier than the warp yarn with the result that a diagonal texture becomes apparent.

SATIN WEAVE. Here the warp yarns skip four to seven fillers. The filler yarns are often finer than the warp yarns and are practically invisible on the right (face) side of the textile. The unwoven or "float" yarns produce a smooth, shiny surface. The filler yarns dominate the back of the textile. Sateen, a variation of the satin weave, is made of mercerized cotton. In this case, the filler yarns dominate the face of the textile.

TWILL WEAVE. In a slightly more complex variation, the filler yarn runs under two and over one warp yarn. Each succeeding row shifts this pattern over one-half of the above rhythm with the result that a predominately diagonal pattern appears. Variations of this weave produce a herringbone.

PILE FABRIC. These textiles are generally made with two sets of warp yarns and one filler. Velvet, the most recognizable of the pile textiles, is created by weaving one of the two sets of warp yarns into a plain weave to create a solid back, while lifting the second set of warp yarns by means of a hook to form a loop slightly

Plain or Taffeta Weave

Sateen Weave

Twill Weave as in Denim

Twill Weave as in Serge

Satin Weave

Basket Weave

Common types of textile weaves.

higher than the backing weave. If these lifted looped yarns remain uncut, the textile is called a frise; if cut, a velvet. To cut the loops for a velvet, a sharp blade on the end of the wire slices the loop. The wire is withdrawn after each row is completed. For a more decorative treatment, the uncut velvet may be alternated with rows of cut loops. This creates a corduroy appearance. With a Jacquard attachment, fancy patterns of cut and uncut design are created. Velvet, considered a woven pile textile, is now being tufted on old chenille tufting looms.

LENO WEAVE. This is a loose weave in which two warp yarns are twisted together and around a filler yarn to form a knot to keep the warp yarn from slipping. This particular weave is used for most loose, netlike casement textiles.

PRINTING AND DYEING TEXTILES

The earliest known textile designs were painted by hand and antedate woven patterns by many centuries. Today, various methods of pattern printing are used.

Direct printing. For this type of printing the color is applied directly to the cloth. It can be done by hand with pen or brush, or with wooden blocks, each of which prints one color and a certain section of the design. This system is known as *block printing*. When copper-plate printing was originated, it was considered quite efficient, but was soon superseded by roller printing. At first the rollers carried only the outline of the design, which was later filled in with the necessary colors. Designs are now etched on copper rollers, one roller for each color and for a certain section of the pattern. The last roller prints the background color. Some fabrics are printed on the warp threads only. These are known as warp or shadow prints, and the design has a mottled or faded appearance.

Resist and extract printing. An old method of producing patterned fabrics, a variation of which is still in use, is the process known as *resist dyeing*. It was employed when a pattern of small light motifs was desired on a large dark background in one color. The effect was produced by coating the portions of the fabric to be left white with wax or clay. The entire fabric was then dyed. Wherever the coating had been applied, the fabric "resisted" penetration of the dye. Upon removal of the wax, a white pattern was left on the dark ground. In modern reproductions of this type of fabric, the procedure is exactly opposite from the former method, and is called *extract printing*. After the entire fabric has been dyed, a chemical is applied to certain portions, which removes the background color and forms the desired pattern. In both methods,

Brunschwig & Fils, Inc.

A warp print, "Lamoignan" taffeta.

an effect of great charm is achieved by the slight irregularities and color variations in the finished product.

Stencil and screen printing. Textiles are sometimes printed by means of stencils. The stencils are made of paper or metal with a hole cut in them to fit a certain portion of the pattern. When they are placed on the cloth in the proper position in relation to the pattern, the dye is pressed through the opening by means of a rubber strip called a "squeegee." The stencil is then moved to the same position in the next repeat. If the pattern is elaborate, many stencils are required, making the process very slow and costly. As a substitute for this, *screen printing* was invented in the early years of the twentieth century. In this process the stencil consists of a large sheet of fine silk stretched and mounted on a frame that is the same dimension as the pattern repeat and width of the fabric. The yardage is laid flat on a long table. The number of frames required is the same as the number of colors in the pattern. The complete pattern is drawn on each framed stretch. Each stretch is completely varnished except for the portions of the pattern that are of the same color. The complete series of frames produces stencils for every color for an entire repeat of the pattern. These frames are then carefully and consecutively placed over each repeat, and the dye is brushed or squeezed through the unvarnished portion of the pattern. When all the frames have been used for the full length of the fabric, the stenciling or screen printing is complete. Some of the most charming silk and cotton fabrics are made in this manner. The process permits longer repeats than cylinder printing and a more flexible use of color resembling that of the former hand-blocked processes.

Today the silk of silk screens has given way to Dacron, a more stable fiber, but the hand process continues.

For those firms for whom time is of importance, the process has become automated. The screening process is similar, but an automatic carrier moves each screen down the length of the table. The automatic process is so accurate in matching register that the design tends to become very sharp—too sharp for people who appreciate the charm of the very slight shadow or dimensional effect of the hand-screened design, which is often slightly off register. Automation also limits the number of screens possible.

Dyeing. Several different methods of dyeing are commonly practiced. *Stock-dyeing* is a process of dipping the raw fibers in a vat of dye before the thread is spun. *Yarn-dyeing* consists of dipping the yarns before weaving. *Cross-dyeing* (sometimes called *cationic dyeing*) is a process by which one fiber in a fiber-blend

textile will absorb one type of dye, and the second (or third, etc.) fiber will absorb only the dye of a different chemical formula. In this way, the woven textile can be dyed two (or more) colors, or two (or more) shades of the same color, by dipping the woven textile into two (or more) dye baths.

TEXTILE PERIOD PATTERNS

Textiles of antiquity. Historians claim that weaving was well known some five to six thousand years before Christ. The earliest authentic records come from Egypt, where, as a result of the Egyptian burial customs, almost complete evidence of their mode of living has been preserved. In the tombs were placed many objects of daily use, including clothing, and the walls of the tombs were decorated with scenes from the daily life of the Egyptians. Among the extant wall paintings is a picture of a loom then in use (about 2500 B.C.). It is very simple, yet not unlike hand looms used to this day. Fragments of actual cloth from about that date have also been found—linens, finer than anything that can be made today. The Egyptians were also familiar with cotton and wool, and with silk brought from China. The lotus was the favorite pattern motif.

The neighboring peoples of Assyria and Babylonia were equally advanced in the art of weaving, but few of their textiles have been preserved. The most famous Assyrian pattern is known as the *hom* or tree of life. As a slender stem or a rugged tree, it has reappeared down through the centuries. The ancient Persians copied the pattern, which eventually found its way to India and finally was exported in the painted cottons to England, where it had a most important influence on English textile and wallpaper designs.

Greece did little to advance the art of textile weaving. Many of the finest Greek fabrics were woven on the island of Crete, where expert weavers from the East and from Egypt gathered. The intricacies of these woven or painted patterns are clearly defined on the picturesque Greek vases. Though the early Roman emperors in the first centuries of the Christian era were lavish in their use of rich fabrics, very few were created under their régime.

Byzantine textiles. Before the days of the Mohammedan conquest Byzantium (later Constantinople) was the eastern center of the Roman Empire. The powerful emperors felt that to maintain their prestige they must have rich fabrics, not only for clothing but for presents and for a display of wealth and power. It was for the Emperor Justinian in the sixth century that the Nestorian monks smuggled from China the priceless silkworm cocoons and the seeds of the mulberry tree on which they feed. But for his desire to excel all the rich potentates of the East, the silk industry might never have been introduced into Europe. Influenced by both Persia and China and with a heritage of early Egyptian art, the Byzantine patterns were rich and colorful. Christian symbolism was introduced, though the *rondel* served as the enclosing form. The patterns were formal and symmetrical, including fantastic animals and birds, particularly the elephant. By the eleventh century the long, sweeping ogival bands, which were later so important in Italian design, came into existence.

Chinese textiles. The Chinese used handsome silks for textiles long before the people of the Mediterranean had any knowledge of them; in fact, they alone could make silk, for no one else knew its secret. Tradition states that the fine thread of the silkworm was discovered and the cocoon unraveled by a Chinese empress (about 2690 B.C.). Having spun the thread (a secret they guarded jealously), they wove the silk into rich and beautiful textiles. Silk textiles are still in existence that were made by the Chinese in the

second century B.C. Since that time, unsurpassed silks of every description have been made. Satin embroideries and brocades were produced with colored and metal threads, and many silks were enriched with hand-painted decorations. Hand-blocking of patterns also dates from a very early period. Textiles were also made of hemp, linen, wool, and cotton. Beautiful damasks and tapestries produced during the Ch'ing period (1644–1912) are still available in the markets. Their patterns were filled with religious symbolism derived from various faiths—Confucian, Buddhist, or Taoist. The royal dragon, peacocks, the swastika, various flowers, and the conventionalized cloud and wave are among the best-known motifs, and usually all of them were arranged in compact, well-planned designs.*

Japan is now almost as famous as China for silks, though it produces entirely different weaves and patterns. Japanese textile motifs have less religious significance and often include figures, particularly lovely ladies with weird headdresses and long, sweeping kimonos. Cherry blossoms and plum blossoms are typically Japanese, and even their sacred mountain, Fuji, finds its way into their designs.

Persian textiles. The influence of Persia on textile design has been almost as strong as that of China. The Persians inherited from Assyria and Babylonia a sound sense of design and were excellent craftsmen as well. They made many of the fabulous brocades so important in the romantic tales of old Persia, although they imported many others from China. These priceless fabrics, as well as bales of raw silk, were brought over the long caravan routes to such great trading centers as Baghdad. Naturally, the Persian princes selected the rarest and most beautiful silks for their own use, and in turn they sent back to China textiles of native manu-

<hr />

* See Chapter 8 for description of Chinese decorative forms and motifs.

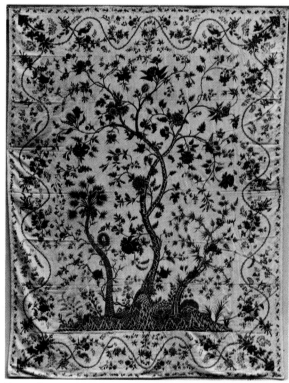

Metropolitan Museum of Art

Typical painted Indian cotton or Palampore showing the tree-of-life pattern adapted from old Persian designs and transmitted to England during the seventeenth and eighteenth centuries.

facture, to show the Chinese weavers the patterns and weaves they found most appealing. The silk velvets and brocades woven in Persia during the Safaid period (1502–1736) are the most sumptuous that have ever been produced. They were used for clothing, wall hangings, and even the tents of military officers. Patterns of this period often reproduced the most delicate effects of the contemporary miniaturists, adjusting their techniques, however, to the textile medium and taking advantage of the rich sheen of the silk pile and contrasting it with metal threads. Brocaded satins, taffetas, and twills were also produced, and embroideries and tapestries were made in silk. In the seventeenth and eighteenth centuries, Persia and India made the

hand-blocked or hand-painted cottons known as *palampores*, for which a great demand developed in western Europe, where they were often called *persanes* and *indiennes*. Extraordinary fabrics were also made of the wool of the Cashmere and Angora goats. The most typical pattern motifs consisted of flowering trees, cypresses, poppies, roses and other floral forms, and the pomegranate. Real and imaginary animals were often shown. The camel, sphinx, dragon, horse, dog, and deer were frequently combined with bird forms such as peacocks and hawks. Landscapes and rocks were also used. Hunting and coursing scenes were often represented showing turbaned horsemen following the hounds. Practically all the early designs up to the seventh century were enclosed in circles (rondels) or lozenge forms, the more familiar ones being arranged in *doublets* with the figures facing or turning their backs to each other.

Other Islamic textiles. In the Mohammedan countries that were ruled by the Sunni sect, such as Turkey and Spain, textiles were not enriched with the naturalistic motifs used in Persian design, due to the Prophet's ruling that there must be no representation of living things. Inspiration turned to geometrical and abstract forms and to the use of the flowing Arabian script quoting the wisdom of Mohammed. Small

Fragments of fourteenth-century Spanish silks showing the Mohammedan influence in geometrical and abstract patterns.

Metropolitan Museum of Art

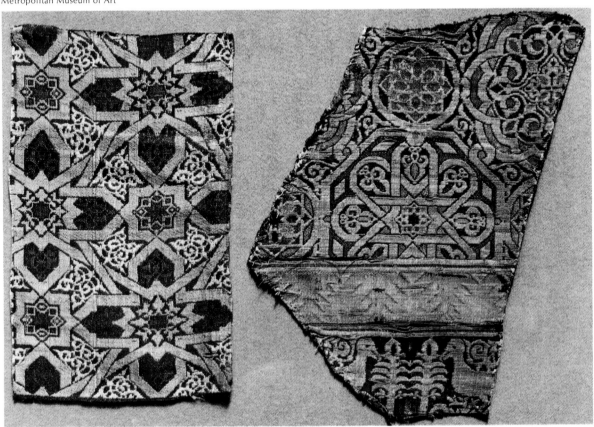

phrases lent themselves to filling the old rondel, and so satisfied two needs—praise of Allah and a worthy design. The most perfect examples of highly conventionalized Mohammedan design are to be found in Spain. Flowing arabesques, geometric figures, and interlacing lines were all woven into heavy, brilliantly colored silks. Gold and silver thread made them even more elegant. The elaborate ceremonial and social existence led by the Sultans and Caliphs required accoutrements of great splendor, and the weavers of the period furnished brilliantly patterned textiles for all purposes. When the Moors were driven from Spain in 1492, the Spanish weavers turned to Italy for new patterns. The native initiative disappeared, and Italian patterns were either exactly copied or combined with some of the Moorish geometrical forms that seemed adaptable to Christian requirements. The most outstanding examples of Renaissance textile weaving in Spain were the ecclesiastical vestments which were woven for specific dignitaries and ceremonies. Great collections of these are still to be seen in the Spanish museums and monasteries.

Italian textiles. Sicily was the leading textile center during the twelfth century. The Mohammedans, stopping there briefly, had bequeathed their conventional patterns to the weavers gathered from both Egypt and Byzantium. From this mixture of tongues and religions a new style finally evolved. Palermo was famed for beautiful silks spotted with glistening gold. The patterns were less severe than the Mohammedan or Byzantine, despite the stylized motifs set within the elongated ovals.

The weavers were driven from Sicily in the thirteenth century, and many migrated to Lucca in northern Italy. There, many of the most precious church silks were woven with patterns of saints and angels. For the first time, the faces of these figures were woven of white silk, and the rest of the fabric was heavy with gold and

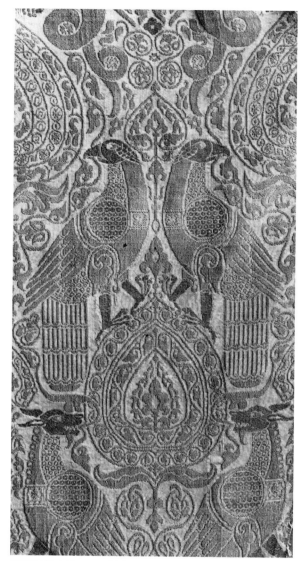

Metropolitan Museum of Art

An early Sicilian silk showing Byzantine influence in the use of pairs of conventionalized animals.

color. At the same time, in Florence, the master craftsmen were turning out amazing weaves and patterns. With the beginning of the fifteenth century came the Renaissance—that revival of interest in all the arts—with Florence as a cultural center. The patterns definitely marked as Florentine include the elongated S-scroll, which, of course, developed from the ogee curve. Com-

Metropolitan Museum of Art

A thirteenth-century Lucca silk with Gothic religious pattern of angels and stars.

Metropolitan Museum of Art

Panel of brocaded velvet, originally part of a dalmatic. Florentine, fifteenth century.

bined with the early floral forms was the well-known pomegranate or artichoke. The pomegranate, originally an essential part of all Persian designs, was unfamiliar to the Italian weavers, but they felt its similarity to their own artichoke. Very soon they had transformed the motif from a pomegranate to an artichoke, and it became one of the dominant motifs of the Renaissance. The Renaissance vase, in various forms, first holding the artichoke and later all the important floral forms, was almost equally popular. By the sixteenth century it held an enormous bouquet of fairly naturalistic flowers. The royal crown was often worked in, sus-

pended in a bouquet or seeming to hold together two of the sweeping serpentine bands.

Venice had so many facets to its artistic life that sometimes the importance of its weavers is overlooked. As Venice was an important seaport, rare fabrics from all over the world were assembled there, and the native weavers drew their designs from these rich foreign fabrics. Particularly influenced by the Chinese patterns, they scattered small flowers about, after the oriental fashion, and to give order to this arrangement, they borrowed from Persia the set patterns which helped to stabilize the whole design. Venetian velvets, too, were famed, par-

ticularly those that were small and intricate in pattern. One fashion that must be credited to Venice is the *ferronnerie* velvet, with its finely drawn design which resembles delicate wrought iron.

The fourth of the great weaving centers of Italy was Genoa, which was particularly famous for its velvets. The beautiful sixteenth-century *velours-de-Gênes* (Genoese velvet) with its jewel-like coloring was in demand all over Europe. This was woven in a small all-over pattern, and while the cloth was originally intended for clothing, it was appropriated by the upholsterers, in whose work it was extensively used. The multicolored floral pattern known as the jardiniere velvet was set against a light satin ground and had several heights of pile as well as uncut loops included to give greater variety.

French textiles. France, prior to the Renaissance, had expended all her artistic effort on the development of beautiful architectural forms. She had bought all of her valuable textiles from Italy or Spain. About the middle of the fifteenth century France began to weave tapestries in Arras. Lyons was established as a silk center by Francis I in the early years of the sixteenth century. The early designs were mainly Italian in feeling, for many of the finest weaves were imported from Italy. Gradually, influenced by the extravagant court life of France, the patterns became more luxurious, less severe, and more feminine in appeal. Tapestries, vastly important in the decorating of a great hall, were made in various weaving centers. But it was not until the reign of Louis XIV in the seventeenth century that distinctive French fabrics, quite free from Italian influence, were woven.

The baroque style of Louis XIV textile design was impressive, with its heavy garlands of fruit and flowers. The bold, large-scale, florid patterns, which were seen in velvets and brocades, were indicative of the grandeur and display of court life. Toward the end of the seven-

Metropolitan Museum of Art

Typical Louis XIV velvet showing baroque pattern of symmetrical large flower and fruit forms.

teenth century the designs were slightly subdued. Flowers became more naturalistic and patterns less complicated. Tapestries were important, and to Louis XIV and his minister Colbert can be credited the success of the Gobelins works in Paris. The king bought the factory at Gobelins, supported it with royal grants, and limited its productions to royal use. Also to this king, who ruled so long, must be attributed a great setback to textile development in France. When Louis signed the revocation of the Edict of Nantes in

Metropolitan Museum of Art

Louis XIV fabric showing densely compressed patterns and conventionalized floral forms.

charmingly disordered and lacked the splendor of the previous century. Lace motifs grew in popularity and did, indeed, provide a suitable background for the playful patterns. Long streamers of ribbon were entwined with cupids and turtledoves in asymmetrical designs with scrolls and abundant flowers. Importations from the Far East set the vogue for the adaptation of Chinese patterns, known as chinoiseries, which are so typical of this era. Everything was light and dainty in scale, color, and texture, and the curved line dominated all design.

Another reversal of style occurred in the third quarter of the century, when the neoclassical forms were introduced as a result of the

1685, a great number of skilled weavers who were Huguenots were forced to flee France. Though the French weaving industry continued to thrive, keen rivalry was felt with the countries to whom the weavers and other artisans had fled.

Louis survived several changes of style, and the graceful patterns known as Louis XV or rococo were well established before the old king died. To the reign of Louis XV belong all the romantic frivolities that took such a hold on the French people of the eighteenth century. Never have more beautiful silks been made, with more intricacy of weave, than were then produced on the looms of Lyons. There seemed no limit to what the weavers could do. The patterns were

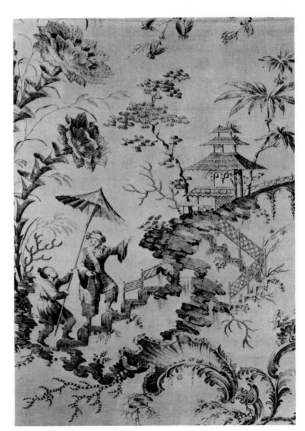

Metropolitan Museum of Art

Typical chinoiserie in the style of Pillement, with dainty Chinese figures, rococo scroll, and small-scale floral forms. About 1785–1790.

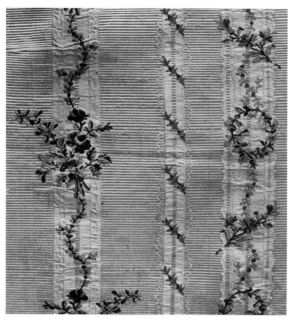

Metropolitan Museum of Art

Louis XVI brocade with delicate sprays of flowers worked over stripes.

Pompeian excavations. The curves were replaced by straight lines. Stripes were over-patterned with fragile little bouquets of flowers in natural colorings. In more magnificent brocades all the classical details that had become so important in furniture and architecture came into prominence. These were often combined with bows and arrows, the symbols of Cupid, and with bowknots with loose floating ends of ribbon. Later came the elaborate patterns with groupings of musical instruments or agricultural implements. Philippe de la Salle was one of the greatest silk designers, whose compositions were shaped by a sweeping classicism. His intricate designs are sometimes overnaturalistic, but they are justly famous as the turning point that led away from the miniature patterns of the mid-eighteenth century. He was the advance spirit of the Directoire, which was to be the next significant French style.

After the wave of fine classicism had subsided because of the dominating force of Na-

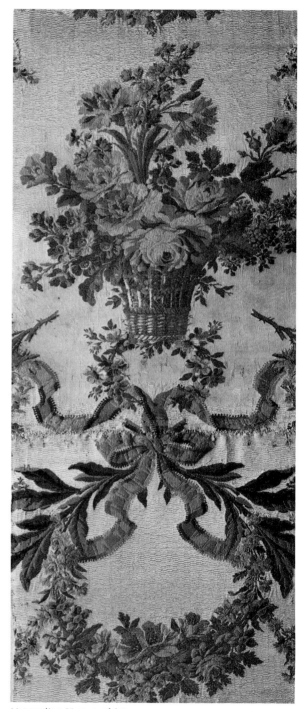

Metropolitan Museum of Art

Philippe de la Salle brocade of the Louis XVI period showing naturalistic baskets of flowers, ribbons, and wreaths.

poleon, there was another violent change of patterns in France. Although Napoleon favored certain aspects of classicism, he was insistent that all traces of his royal forerunners be obliterated. The forms of republican Rome rather than the more refined motifs of democratic Greece appealed to him. The well-known Napoleonic motifs which appear in the patterns of this period include eagles and torches, wreaths with the imperial letter "N," the star and bee, and Egyptian motifs.

From the early years of the eighteenth century efforts had been made in France to imitate the delightful printed cottons that had been imported from Persia and India, but it was left to one man to manufacture these types of materials successfully and popularize them to such an extent that there has existed an almost continuous demand for them ever since their introduction.

Christophe-Philippe Oberkampf, a Bavarian, established in the year 1760 a cotton print manufactory in the village of Jouy near Versailles. Public interest in decorating had greatly increased at that time, and as the cost of silk fabrics was extremely high, it was obvious that a cheaper substitute would find a ready market. Oberkampf was a man with a persuasive personality and great business integrity, an artist and an excellent salesman, and he had an uncanny intuition for the pulse of public taste. His first efforts were to imitate the foreign prints, the rising demand for which was beginning to surpass the supply. By frequent personal contacts with his aristocratic customers, he could advise his designers as to the motifs that would appeal to a public who maintained a high degree of connoisseurship. As his fame grew, he enlarged his plant, and his patterns became more ambitious. He turned from copying eastern repeat motifs to produce patterns that were more representative of his time and public. He began to make patterns having large repeats which showed groups of peasants or aristocrats dressed in their particular clothing in activities asso-

ciated with their daily interests. He also pictured bourgeois scenes, fables, and historical events. These prints were made in one color only—red, blue, plum, or green—and hand-blocked on a natural cream-colored background. This general type of pattern he continued to produce for nearly the whole period of the existence of his factory. To maintain his sales and record his patriotism, he was quick to take advantage of the political changes in France; the discoveries of Pompeii strongly influenced his designs, and the ornamental motifs introduced by Percier and Fontaine after Napoleon's accession were immediately adapted to his printed products. His later machine-made products have short repeats and

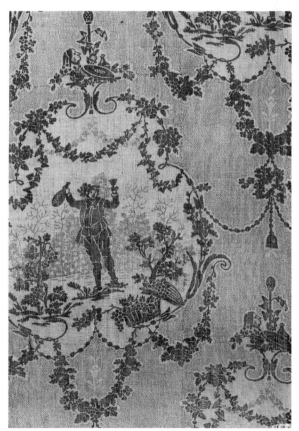

Metropolitan Museum of Art

Typical toile de Jouy entitled "Le Petit Buveur," manufactured at Jouy about 1770.

Postrevolutionary toile de Jouy designed by Jean-Baptiste Huet. The design shows the classic influence in the costumes of the figures, the ornaments, and the geometric arrangement of the motifs. Oberkampf manufactured this.

are the small floral motifs that are known as "mignonette" and "picoté" designs.

The printing process was at first entirely by the hand-block method, but by 1770 cylinder printing commenced, and his output increased enormously. It is on record that he claimed that with cylinder printing one man could do the work of forty hand-blockers. He employed many able designers, the most famous and gifted being Jean-Baptiste Huet, who worked for him from 1783 onwards. Huet's designs were full of grace and animation, with humor often added, and after the Revolution he evolved the architectural and geometrical backgrounds against which were placed medallions, classical figures, and delicate arabesques. In 1783 the factory became a "Manufacture Royal," permitting the use of the arms of the king as a trademark. Oberkampf died in 1815, and the factory continued under various owners until 1843, when, lacking the managerial inspiration of the founder, it finally closed its doors. Some of the original Oberkampf cylinders are still in existence, and many copies have been made from them. All the

original Jouy prints were marked on their selvage with the words "bon-teint," meaning fast dye. Toiles de Jouy following the original traditions are among the most popular decorative cottons today.

The second greatest name in French textile manufacturing is that of Joseph-Marie Jacquard, who was born in 1752 and died in 1834. His contribution to the decorative arts was the invention of an attachment for the power loom to weave elaborate colored patterns in imitation of handmade brocades, brocatelles, and tapestries. The device bearing his name was later adapted to the weaving of pile fabrics and floor coverings. The story of Jacquard's achievement is a record of hard work and ambition. He was the son of a poor weaver whose trade he inherited. For years he wove busily but without financial success, and he lived in extreme poverty. During the French Revolution he was called out with the troops of Lyons. After the war he returned to his meager trade and spent long nights working on his invention. When it was first shown to the public in 1801, it was instantly acclaimed.

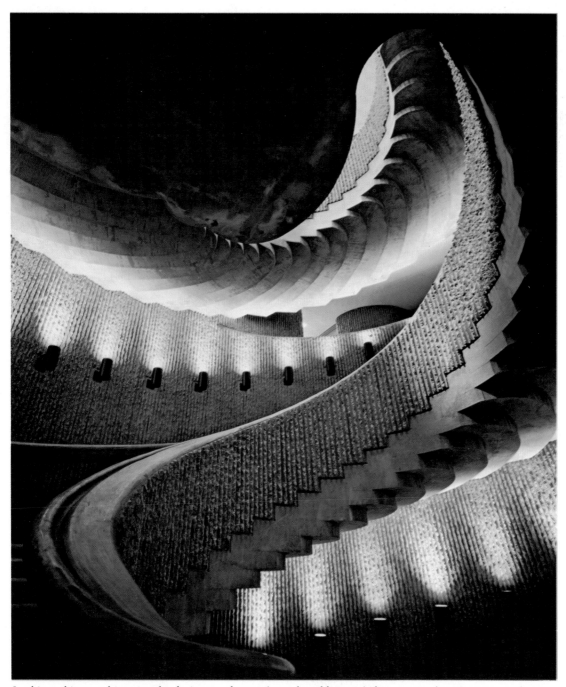

In this architectural interior the design results not from the addition of elements, such as furniture and accessories, but from the architectural forms themselves. The structure of the stair derives from a spiral and suggests a form found in nature, the shell. The strong integration between structure and decoration can be seen in the rhythm created by the vertical striping on the surface punctuated by artificial light which underlines texture and defines space. Additional spatial illusion is created by the mixture of natural and artificial light. Both the form and the ornament are suitable to the construction material, reinforced concrete.

Design by Paul Rudolph. Photograph: Robert Perron

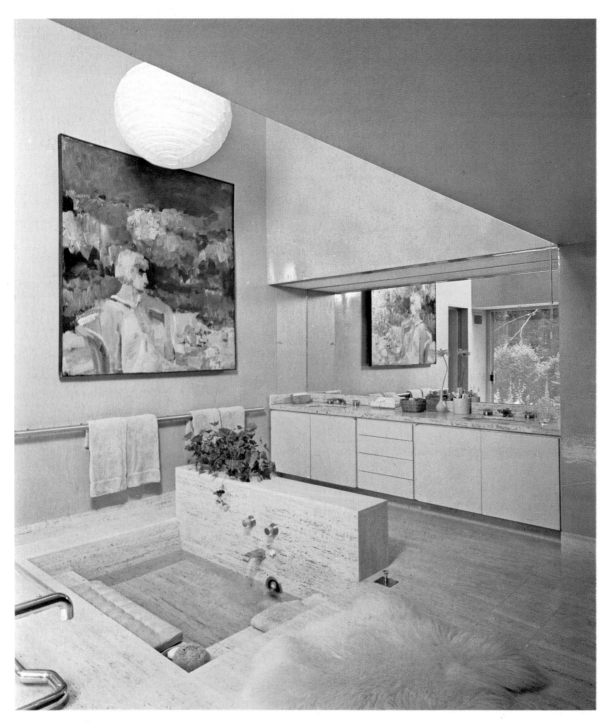

A luxurious bath which is part of a well planned complex of dressing rooms, closets and sauna. Travertine paves the floor and forms the sunken tub and console as well as the counter top with twin basins. The towel bar extends the length of the wall and the high ceiling allows hanging space for an enormous painting. Walls are covered in a pale hyacinth vinyl with a high gloss.

Photo by Tom Yee. Design by John Saladino.

But his victory was not yet complete, for his machine aroused the antagonism of the Lyons weavers, who destroyed one of the first Jacquards in a public square. Soon, however, the opposition faded, and by 1812 there were 11,000 Jacquard attachments in use in France.

English textiles. To understand the chintzes, hand-blocked linens, and crewel embroideries for which England is so justly famous, it is necessary to go back to the early days of cotton in India. It is from India that England borrowed her patterns and her technique. India and cotton have gone hand in hand from as early as 2000 B.C., though no actual pieces of cloth of that

Metropolitan Museum of Art

Cotton print picturing famous Americans in allegorical scenes. Made about 1800, and probably of English origin.

period are still in existence. But it is certain that instead of weaving patterns, they used paints and dyes to produce their designs. It is also a known fact that cotton was not woven to any extent in Europe until the thirteenth century. At about the same time, the merchants of India began to export their gay chintzes, first to the ports of the eastern Mediterranean, then to Venice, and finally to Portugal. From there the traders carried them to France and England.

The printed cottons caught the fancy of the English, and they tried in vain to reproduce them. They soon discovered it was simpler to send their designs to India and have them made there. In the seventeenth and eighteenth centuries rival trading companies brought in such quantities of printed cottons that both England and France decided to protect the home industry

Metropolitan Museum of Art

Nineteenth-century floral print on cotton adapted from the Indian printed calicoes.

Brunschwig & Fils, Inc.

A traditional English block print.

by excluding the "indiennes," as they were often called. There were several early efforts to establish cotton mills in England, but it was not until after the revocation of the Edict of Nantes, when French refugees settled in England, that there is evidence of an important print works. In the early part of the eighteenth century, the first large plant was set up in Manchester, and from that day to this, Manchester has remained the center of England's great cotton industry.

By the end of the eighteenth century, Indian patterns were out of style, and England was making designs that were distinctly adapted to cotton. The large central floral spray was, of course, derived from the original Indian pattern, but the flowers were truly English. Porcelain motifs copied from real porcelains came into vogue, and later, with the revived interest in classicism, many classical motifs were included.

This was particularly true during the Adam period, when delicate classical figures and arabesques, based on Pompeian motifs, were produced in chintz and lampas to harmonize with the Wedgwood and Kauffmann productions.

The English patterns of the early nineteenth century (Regency period) were not so ostentatious as the French, though a definite relationship between the two is apparent. Realism in pattern design was brought to the fore, but England's chintzes and hand-blocked linens are far more outstanding than any of her woven fabrics. The Victorian period of the mid-nineteenth century produced some interesting printed fabrics, mainly of realistic flower forms. Naturalism and sentimentalism were the dominant characteristics of these designs.

The later periods. Early decorative textile styles were influenced by the whim of fashion— a fashion dictated by royalty or the privileged few. The industrial revolution brought with it the ability to produce quantities of textiles for the masses. Unfortunately, style faltered, and the Victorians, blessed with mass-produced textiles, had to be content with revivals of Gothic, baroque, rococo, Renaissance, and Celtic patterns reworked for the severe limitations of the power loom.

The Aesthetic Movement. This rehash, and poor rehash it was, offended the sensitivities of a new group of taste-makers—artistic dissidents. In 1883, in simultaneous reaction, the British architect John Ruskin and his disciple William Morris, a superb craftsman, met and joined forces with a group of young artists and writers, the Pre-Raphaelites, led by Rosetti. From this clique emerged the "Aesthetic Movement." The group spurned all things produced mechanically despite an avowed credo that a standard of design should be found for machine production. The movement was in essence a return to the arts and crafts. Of the group, William Morris

Stroheim & Romann

Pattern in the William Morris style.

was the most craft-oriented. He was a weaver, an embroiderer, a furniture maker, and he patiently hand-blocked each of his own textile designs. Morris's hand-blocked textile designs pictorialized the lambent attitudes of the Aesthetic Movement. Its symbols were the lily, the peacock, and the sunflower. These he entwined with stylized leaves, curling tendrils, and serpentine stalks. The patterns covered the whole face of the textile.

Art Nouveau. In France the dissidents were less artistic. With French pragmatism, the group did not object to industry. It was "historicism" —revivalism—that they rejected. The natural style—the attenuated flowers, leaves, etc.—of the Aesthetic Movement, and of William Morris in particular, was to their liking. The French interpretation during the late 1880s of the "new look" was documented as Art Nouveau. Growing plant forms—attenuated lilies, tulips, and other verdant plants—appeared on textiles (as well as wrought iron gates, subway entrances, stair railings, etc.). Although flower forms on textiles were exuberant, the overall design was one of orderly balance and controlled form.

As the Aesthetic Movement did not offer a solution to design for mechanization, the French movement of Art Nouveau, as Dr. S. Tschudi observed, "offered no solution to the problems of how to relate the machine to esthetic norms. Art Nouveau theories were, in fact, based on the artist, and on a purely individual artistic approach to the artifact. It was perfectly natural for the society of the nineteenth century to turn to the artist to solve the form problems posed by machines and to insist on beauty of form, yet pictorial artists had no special aptitude for designing everyday objects nor for coping with the problems posed by the machine."

The modern movement. Just as the Aesthetic Movement and the William Morris philosophy and style of the mid-1880s had a visible effect on the French Art Nouveau movement, they were later to have strong influence on the Belgian designer Henri van de Velde, who, in 1906, started the School of Arts and Crafts in Weimar, Germany. Van de Velde leaned toward design for mechanization. Unfortunately, his school was short-lived, and in 1917 it was merged into the Academy of Fine Arts. The merger was consolidated under the wing of Walter Gropius, and the two schools became Das Staatliches Bauhaus Weimar, which opened its doors in 1919 following the end of the First World War. The philosophy, as propounded by Gropius, was far-reaching. It was more than a design philosophy. The Bauhaus presented a revolutionary program. Its rationale was to bring together the fine arts and crafts within a single program and to train students to design for mass production through a thorough understanding of machine technology. The objects to be designed were to encompass all useful house-

hold objects from teaspoons to houses. Students were given a regular apprenticeship, a workshop training in a trade. They were to explore in depth materials, color, and form. Gropius and his staff—many great creators of modern art, such as Paul Klee, Lionel Feininger, Wassily Kandinsky, Maholy Nagy, Johannes Itten, and Marcel Breuer—were able to fulfill this goal by stripping design of all sentimentality and replacing it with designs relating only to the technical demands of modern industrial production.

Textile designs, mainly woven on the power loom, were limited in style. Patterns for the most part were geometric—a careful balancing of areas of color. The balance was visual, with small areas of dark or "heavy" color balancing larger areas of "light" color. Stripes were broken into intervals of color versus texture. Textural or rugged yarns were used, and texture became an integral part of the design.

The Bauhaus in Weimar was short-lived—1919 to 1923—but the architectural and industrial design of today has a profound relationship to the early Bauhaus philosophy and teachings.

Simultaneous with, but not contiguous to, the later days of the German Bauhaus period was an interesting abstract and socialistic experiment, Art Deco, which derived its name from the Paris exposition of 1925, L'Exposition Internationale des Arts Décoratifs et Industriels Modernes. The exposition presented to the world an even newer style, a style somewhat less profound than that appearing from the Bauhaus. The Art Deco movement was dedicated to ending the conflict between art and industry. Creative design was adapted to the requirements of mass production. The design was radical. Detail was sacrificed to function. Designers of the movement were influenced by the simple geometrics of the pyramids, of Aztec (Indian) architecture, and of Egyptian images. Patterns were pyramidal with stepped up sides. Some were repeat, and some had design super-

imposed on design. Colors were brilliant, almost garish in their boldness. The word *jazzy* was often used to describe many of the designs of the period.

In America, architect Frank Lloyd Wright followed the traditions of the Arts and Crafts Movement. Though not recognized until 1935, Wright had built his first house (for his mother) in 1911 in Taliesin, Wisconsin. Wright abhorred the unnatural, and his materials were earth-found. His color palette was natural—earth tones including terra-cotta and moss greens. His use of texture was undoubtedly the first time this element had become a bold design statement. His woven fabrics were rugged-looking, geometric in style despite the fact they were hand-woven. Prints were large florals, almost three-dimensional in character. But Wright's textile designs were only a part of the overall interior architectural scheme —"total design."

It was to the studio of hand-weaver Dorothy Liebes, an old friend, that Frank Lloyd Wright brought many of his clients. Although his color requirements were subdued, Mrs. Liebes's color palette was not. To her, color was "a universal language." She often remarked that a "love of color is spontaneous with no barrier of age, wealth, or education. We are born with this love, but not always with color taste. . . . Color appeal is emotional rather than solely intellectual. You have to see and experience color rather than discuss it. . . . There is no bad color, only bad color combinations." Mrs. Liebes not only loved and used color in its primary state, but she mixed color in startling ways—even in clashing combinations such as "hot" pink with red or purple. More important, her revolutionary approach to color awakened modern designers to new attitudes in the use of color, not just in textiles but in the entire interior scheme.

During the nineteen-fifties and sixties the designer cult flourished. Two iconoclasts, Boris Kroll and Jack Lenor Larsen, brought—and still bring—impressive design concepts to the deco-

Jack Lenor Larsen, Inc.

Contemporary version of a Nottingham lace.

location to the woven pattern—a shadow effect, sometimes an ombré effect.

Jack Lenor Larsen, a superb craftsman, has a historical sense of design. He loves ethnic design and is a collector of ancient fabrics. Because of his understanding of construction and by his own creative energies, he has been able to devise ways for producing ethnic designs by modern technology, always adding the one ingredient to make the textile "work" for today's interior scheme. Invited by many governments to help adapt their latent and indigenous weaving or textile-printing capacities, Larsen has visited desert and mountain villages. He has taken the old, outdated designs, restyled them without losing their native charm, taught the natives new techniques for production, and distributed their textiles to delighted audiences in America and Europe. Examples include woven textured woolens from Ireland and Africa, batiks from the Far East, and printed silks from Thailand, to name only a few. His own designs, though often eclectic, bear a personal stamp of excellence recognizable anywhere in the world.

THE USES OF TEXTILES

The uses of standard weaves are given below. Many of these are now woven in both natural and synthetic yarns or in a combination of the two.

Glass curtains:
> Chiffon, dotted swiss, gauze, lace, marquisette, muslin, net, pongee, poplin, scrim, voile.

Casement curtains:
> Gauze, muslin, pongee, poplin, shantung, taffeta.

Unlined draperies:
> Broché, casement cloth, celanese, cellophane fabrics, chintz, cretonne, India prints, monk's cloth, novelty fabrics, oiled silk, pongee, taffeta, terry cloth.

rative textile scene. Both are hand weavers and, as such, have profound respect for the loom— its limitations and latent capabilities. Equally important, they have been successful in translating complex design and construction to the power loom.

Boris Kroll, the more mechanically minded, understands the nuances of the weave. For example, he revived for the power loom a contemporary warp print. The uniqueness of his warp print was the manner in which it was facilitated. The warp was first printed in three colors by a set of rollers. Then the warp was threaded on a power loom harnessed with a Jacquard attachment. The superimposed pattern was woven with fill yarns of as many as eight different colors. The result gave a slight dis-

Lined draperies:

Broché, chintz, cretonne, crewel, embroidery, damask, faille, hand-blocked linen, India prints, lampas, moiré, novelty fabrics, sateen, satin, silk velvet, taffeta, velours, velveteen, vinyl fused fabrics.

Medium-weight upholstery coverings:

Armure, leather, brocade, brocatelle, chintz, corduroy, cretonne, crewel, embroidery, damask, lampas, moiré, novelty fabrics, sateen, satin, taffeta.

Heavy-weight upholstery coverings:

Brocatelle, crewel, embroidery, damask, denim, frisé, haircloth, lampas, mohair, moiré, monk's cloth, moquette, novelty fabrics, petit point, plush, rep, satin, tapestry, twill, velours, velvet, velveteen, vinyl coated fabrics.

When one particular fabric is entirely satisfactory in a room, being suitable in weave, pattern, and color, it is sometimes difficult to know what other fabrics to combine with it. First of all the textures must be friendly, for a rough-and-ready novelty fabric will never be at home with a delicate brocade. All the finer silks—brocades, damasks, taffetas, silk velvets—are harmonious, but a denim or a coarse rep would be a jarring note if used with them. With the latter, cretonne or India prints or monk's cloth may be combined. With fine chintz, splendid cotton or wool damasks, lustrous sateens, and some of the finer novelty weaves are harmonious. With an expensive hand-blocked linen, brocatelle and velvet may be used. With the rough textures which are modern, the shiny surface of satin is effective as a decided contrast. In general, it is wise to combine like with like, avoiding too strong contrasts except for very modern effects.

It is also necessary to be exceedingly careful of scale, for a large and bold pattern (brocatelle, for instance) would be overwhelming in combination with one that is fine and dainty (French

F. Schumacher & Company

A contemporary textured twill.

broché). There are some fine geometric patterns which will harmonize with spreading floral forms, and there are some small all-over designs which can be used with highly stylized forms. In general, it is wise to keep the scale of all the fabrics fairly close together and, of course, in harmony with the scale of the room.

The selection of a pattern for a room should harmonize with the use and character of the room itself, and should correspond to the character of the occupant. It is disconcerting to introduce too many different patterns in various parts of the same room, particularly if the patterns are large or very obvious. As a rule, where a patterned rug is used, it is best to employ upholstery coverings of plain materials, and vice versa. Also, a patterned wall is usually as much patterned surface as any room can stand and calls for a restricted use of patterned materials for draperies or upholstered surfaces. Patterns in self-tones, as in damasks, may be used with more strongly contrasting materials.

The beauty and color in a pattern are best shown by contrasting the pattern with plain surfaces. Where surfaces are plain, however, it is essential to give them interest of color or texture, or both.

The basic principles of selecting decorative textiles require a thorough understanding of the subtle balance between variety and monotony, between contrast and similarity, which must be part of the ability of the true artist.

The popularity of decorative textiles is as subject to the whims of taste and fashion as are all other objects or materials of room furnishing. Decorators cannot be concerned solely with the practicality of a material for some particular use. Style changes must be considered, and these are always reflected in the current price of the goods, which may later be found marked down.

NAMES AND TYPES OF TEXTILES

Most of the names applied to decorative textiles have become standardized, and are well understood by all manufacturers, wholesalers, and decorators and by the public in general. From time to time, however, trade names are introduced for special types or combinations of weaves that become popular, and these eventually become standardized themselves. Usage and the fact that sometimes they are not legally protected causes them to become common property. Many standard textiles are now composed of synthetic as well as natural fibers. The principal textile terms are given below.

GLOSSARY OF TEXTILE TERMS

Appliqué. A pattern that is cut out and sewed or pasted on the surface of another material.

Armure. A kind of cloth with a rep background. The raised satin pattern, which is not reversible, is made of warp threads floated over the surface. The pattern usually consists of small, isolated, conventional motifs arranged to form an all-over design. A good upholstery material.

Artificial leather. A substitute for leather which is made by coating a cotton fabric with a nitrocellulose preparation. This surface is then stamped to simulate the surface of real leather. Many varieties are made, which are generally known by trade names.

Widely used, at present, for cheap grades of upholstery.

Batik. Javanese process of resist dyeing on cotton, using wax in a design, then dyeing cloth, after which wax is removed. The method is practiced by modern designers on silks and rayons and is imitated in machine printing.

Block print. Fabric printed by hand, using carved wooden blocks. Can be distinguished from modern printing with metal rollers or screens by the marks of the joining of the pattern printed by different blocks. Screen printing has now been substituted almost entirely for hand blocking in the United States.

Bobbinet. See Net.

Bouclé. Plain or twill weave in wool, rayon, cotton, silk, or linen. Distinctive by its small regularly spaced loops and flat irregular surfaces produced by the use of specially twisted yarns.

Braid. A strip composed of intertwining several strands of silk, cotton, or other materials. Used as a binding or trimming.

Broadcloth. Twill, plain, or rib weave, of wool and spun rayon, and cotton and rayon or silk. The cotton or spun rayon fabric has fine crosswise ribs.

Brocade. A kind of weave; also, a finished silk cloth which, although made on a loom, resembles embroidery. The background may be of one color or may have a warp stripe, and its weave may be taffeta, twill, satin, or damask. A floral or conventional pattern in slight relief is usually multicolored and is produced by the filler thread. It is woven with the Jacquard attachment, and the threads that do not appear on the surface are carried across the width of the back. The finest old handmade brocades all included threads of real gold or silver. Excellent for draperies and upholstery, particularly in period rooms.

Brocatelle. A heavy silk fabric resembling a damask, except that the pattern appears to be embossed. The pattern (usually large and definite) is a satin weave against a twill background. Made with two sets of warps and two sets of fillers, it is not reversible, as the linen backing produced by one set of filler threads shows plainly. Its uses are similar to those of brocade.

Broché (pronounced bro-shay). A silk fabric similar to brocade. The small floral designs, which are quite separate from the background pattern, are made with swivel shuttles to resemble embroidery. The filler threads not in use are carried only across the width of the small design and not across the entire back as in brocade.

Buckram. A strong jute cloth of plain weave, finished with glue sizing. It is used as a stiffening for valences, for interlining draperies, etc.

Burlap. Plain weave of cotton, jute, or hemp. Heavy, coarse, and loosely woven, in a variety of weights, and used for sacks, the backs of floor coverings, inside upholstery, etc.

Calico. A term formerly used for a plain woven printed cotton cloth, similar to percale. Its name is taken from Calicut, India, where it was first made.

Cambric. Plain weave linen or cotton. True linen cambric is very sheer. It is named for the original fabric made in Cambrai, France. Now coarser fabrics are called cambric and used for linings, etc.

Canvas. A heavy cotton cloth in plain weave. It may be bleached or unbleached, starched, dyed, or printed. Used for awnings, couch covers, and whenever a coarse, heavy material is required.

Casement cloth. A lightweight cloth originally made of wool and silk in plain weave. Now made of cotton, linen, mohair, silk, wool, rayon, or a combination of any two. Although usually neutral in tone, this material may be had in colors and is popular for draw curtains.

Cashmere. A soft wool textile made from Indian goat hair. The same breed of goat is now raised in the United States.

Chenille. A type of woven yarn which has a pile protruding all around at right angles to the body thread. The yarn may be of silk, wool, mercerized cotton, or rayon and is used for various types of fabrics.

Chiffon. A descriptive term which is used to indicate the light weight and soft finish of a fabric, as in "chiffon velvet"; also, a sheer, gauzelike silk fabric.

China silk. Sheer plain weave fabric which is nearly transparent and is dyed in various colors.

Chintz. A fine cotton cloth usually having a printed design. Chintz originated in India in the seventeenth century, and was called "chint," which means spotted. Practically all modern chintz is *calendered* or glazed, which makes it more resistant to dirt. In washing glazed chintz, the glaze is lost and cannot easily be renewed. The shiny surface and stiff texture produced by glazing also add to its charm. Chintz may be printed by blocks, copper plates, screens, or rollers, or it may be plain, in various colors. It is widely used for draperies, slipcovers, lamp shades, and upholstery.

Corduroy. A cotton or rayon cut pile fabric with ridges or cords in the pile which run lengthwise. Extensively used for upholstery, especially in modern treatments.

Crash. This is a term that includes a group of cotton, jute, and linen fabrics having coarse, uneven yarns and rough texture. Used for draperies and upholstery, and often hand blocked or printed.

Crepe. A descriptive term applied to a large group of materials that have a crinkled or puckered surface, which may be produced by highly twisting the yarn in weaving or by a chemical process. The materials are made of cotton, wool, silk, or a combination of fibers, woven in any basic weave.

Cretonne. A heavy cotton cloth with printed pattern similar to chintz, though the designs are usually larger and less detailed. The background may be plain or a rep weave. The name comes from the Normandy village of Creton, where it was first produced. Cretonne is usually unglazed. It is useful for draperies and upholstery.

Crewel embroidery. A kind of embroidery with a pattern of varicolored wools worked on unbleached cotton or linen. The spreading design covers only a part of the background, and usually includes a winding stem with various floral forms. It was used extensively during the English Jacobean period for upholstery as well as for draperies. The designs were often inspired by the East Indian "tree-of-life" motif.

Damask. A kind of Jacquard weave; also a fabric with a woven pattern similar to brocade, but flatter. In damask any combination of two of the three basic weaves may be used for the pattern and the background, provided that the weave of the pattern differs from that of the background. The pattern is made visible by the effect of light striking the portions of the fabric in the different weaves. Usually both warp and filler are of the same weight, quality, and color, though it may be woven in two colors. The pattern effect is usually reversible. Originally made of all silk, damasks are now made of linen, cotton, wool, and any of the synthetic fibers, or of combinations of any two. The name originated with the beautifully patterned silks woven in Damascus during the twelfth century and brought to Europe by Marco Polo. Damask is widely used for draperies and upholstery.

Denim. A kind of heavy cotton cloth, of a twill weave. Usually a small woven pattern is introduced, or warp and filler may be in contrasting colored threads. Originally called *toile de Nîmes*. Used for upholstery and draperies.

Dotted Swiss. See Swiss.

Duck. A closely woven cotton fabric, sometimes called awning stripe or awning duck, of plain or ribbed weave. The stripe may be woven in, or painted or printed on one side only. Often given protective

finishes against fire, water, and mildew. Similar to canvas.

Embroidery. The art of decorating a fabric with thread and needle. Its origin is a source of conjecture, but the form known today was developed in Italy during the sixteenth century. Handwork embroidery is little done today, and consequently most embroideries used in interior decoration antedate machine production.

Faille. A kind of fabric with a slightly heavier weft than warp, producing a flat-ribbed effect. It is often all silk and lusterless. Used for trimmings and draperies.

Felt. A material that is made by matting together and interlocking, under heat and pressure, woolen fibers, mohair, cowhair, or mixed fibers.

Fiberglas. Trade name for fabric or fine filaments of glass woven as a textile fiber. It has great strength, yet is soft and pliable, and resists heat, chemicals, and soil. It is used for curtains.

Filler. Threads which run crosswise of fabric from selvage to selvage. Same as weft.

Flannel. Wool or cotton twilled fabric of coarse soft yarns, napped. The ends of the fibers are loosened by revolving cylinders covered with bristles. It is not a pile fabric. Used for interlinings.

Fringe. Trimming for draperies and upholstery. Threads on cords are grouped together in various ways and left loose at one end.

Frisé (pronounced free-zay). Also written *frieze*. A pile fabric with uncut loops. The better quality is made with two sets of fillers to provide greater durability. Patterns are produced by cutting some of the loops, by using yarns of different colors, or by printing the surface. As it is used chiefly for upholstery, it is made of wool, mohair, or heavy cotton. The name comes from the French *frisé,* meaning "curled."

Gabardine. Hard-finished twill fabric, with a steep diagonal effect to the twill, which is firm and durable.

Gauze. Thin, transparent fabrics made of leno or plain weave or a combination of the two. Formerly made of all silk, it is now made of cotton, linen, wool, mohair, synthetic fibers, or combinations. Especially useful for glass curtains.

Gingham. A lightweight, yarn-dyed cotton material, usually woven in checks or stripes. Useful for trimmings, draperies, and bedspreads.

Grenadine. Leno weave fabric like marquisette, but finer. Plain or with woven dots or figures.

Grosgrain. Ribbed or rep silk produced by weaving heavier filler threads so that they are covered with close, fine warps. Used for ribbons and draperies.

Gros-point. See Needlepoint.

Guimpe. Narrow fabric, with heavy cord running through it, used for trimming furniture, draperies, etc., as an edging.

Hair cloth. A kind of cloth with cotton, worsted, or linen warp and horsehair filler. It is woven plain, striped, or with small patterns and is manufactured in narrow widths. As it is very durable, it is used for upholstery. It was popular during the mid-nineteenth century in England and America.

Homespun. A term applied generally to hand-loomed, woolen textiles. It is also a trade name given to imitations made on power looms. Useful for curtains and upholstery in informal types of decoration.

India print. A printed cotton cloth made in India or Persia, with clear colors and designs characteristic of each country. The many colors are printed on a white or natural ground. Useful for draperies, bedspreads, wall hangings, etc.

Indian head. "Permanent" finish cotton, smooth and lightweight. Colors are vat-dyed and guaranteed fast. Shrinkage is reduced to a minimum. The trade name is so familiar that it is becoming known as a special fabric.

Indienne. French interpretation of the Indian printed cottons which were being imported into France in the late seventeenth century and during the eighteenth century. French designers produced them to supply the demand for this type of fabric at a lower cost than that of the imported originals.

Jardinière velvet (pronounced zhar-deen-yare). A handsome silk velvet with a multicolored pattern resembling a flower grouping set against a light background. The weaving is most intricate, as there may be several heights of velvet and uncut loops set against a damask or satin background.

Jaspé (pronounced zhas-pay). A streaked or mottled effect in a fabric, produced by uneven dyeing of the warp threads. The name is derived from its resemblance to jasper.

Khaki. A heavy cotton twill fabric of an earthy color.

Lace. An openwork textile produced by needle, pin, or bobbin by the process of sewing, knitting, knotting (tatting), or crocheting. Real lace is a handmade product, but in the late eighteenth century, machines were invented to imitate the hand productions. Probably first made in Greece, lace manufacturing received a great impetus in Renaissance Italy, and particularly in Venice. Among the principal types are *filet,* embroidered on a net; *reticella,* a combination of drawn and cut work; Valenciennes, Cluny, Duchesse, and

Chantilly, elaborate bobbin-made patterns in which the ornament and fabric are identical; Irish, principally of the crocheted variety, although Limerick is made on a net and Carrickmacross is cut work. Brussels lace is of several varieties. Nottingham lace is a general term used for machine-made productions, particularly inexpensive lace curtains made in one piece.

Lampas. A patterned textile with a compound weave having two warps and two or more fillers. The distinguishing feature is that the pattern is always a twill or plain weave, the background in satin or plain weave, or both, and may be in two or more colors. Philippe de la Salle made it famous, and it was much woven in the eighteenth and nineteenth centuries, so that the pattern is usually classical in inspiration. It is similar to a two-colored damask.

Leno. Type of weave in which pairs of warp yarns are wound around each other between picks of filler yarns, resulting in a net effect. Various versions of this weave are used for glass curtain fabrics, etc.

Marquisette. A sheer cloth having the appearance of gauze and woven in a leno weave. The cotton, silk, rayon, nylon, glass, or wool thread is usually hard-twisted to give it greater serviceability. An excellent glass curtain material.

Matelassé. Fabric with two sets of warps and wefts. Its embossed pattern gives the effect of quilting. Imitations are stitched or embossed.

Mercerized materials. Materials that have a lustrous surface produced by subjecting the material to a chemical process. The cloth is treated in a cold caustic alkali bath while held in a state of tension. By this treatment the yarn is changed from a flat, ribbonlike shape to a rounded form, making the cloth more lustrous, more durable, and more susceptible to dye. Mercerized cotton has a silky appearance. The process is called after its originator, John Mercer, an English calico printer.

Metal cloth. A fabric the surface of which has a metallic appearance. It is made by weaving cotton warp threads with tinsel filling yarns. The latter are made by winding strips of metallic substance around a cotton yarn. Creases cannot be removed from this material. Useful for trimmings.

Mohair. A yarn and cloth made from the fleece of the Angora goat. The fiber is wiry and strong, making the most durable of all textiles. It is now woven in combination with cotton and linen into many types of plain, twill, and pile fabrics. Widely used for upholstery.

Moiré (pronounced mwa-ray). A finish on silk or cotton cloth which gives a watermarked appearance. Woven as a rep, the marks are produced by engraved rollers, heat, and pressure applied to the cloth after it has been folded between selvages. The crushing of the ribs produces a symmetrical pattern along the fold. The pattern is not permanent, as cleaning and pressing tend to remove it. When made of synthetic fibers moiré holds the marks better than when made of all silk.

Monk's or friar's cloth. A heavy cotton fabric of coarse weave. Groups of warp and weft threads are interlaced in a plain or basket weave. Used for hangings and upholstery in informal rooms.

Moquette. An uncut pile fabric similar to frisé. It is woven on a Jacquard loom and has small, set patterns of different colors. When used for upholstery, it is made of mohair, wool, or heavy cotton. A coarse type is used for floor coverings.

Muslin. A plain-woven, white cotton fabric, bleached or unbleached. Used for sheeting and other household purposes. Originally woven in the city of Mosul.

Needlepoint. An old-fashioned cross-stitch done on net, heavy canvas, or coarse linen. The threads are wool. The effect achieved is that of a coarse tapestry. *Petit point* and *gros point* are two variations of this embroidery. Petit point is very fine, made on a single net, and has about twenty stitches to a lineal inch. Gross point is coarse, made on a double net, and has about twelve stitches to the lineal inch.

Net. Open weave fabric. There are various types, as follows:

Bobbinet. Machine-made net with hexagonal meshes.

Cable net. Coarse mesh.

Dotted Swiss. A net with small dots.

Filet net. Square mesh, used as base for embroidery. Handmade variety has knots at corners of meshes; machine-made net has no knots.

Maline. Has a diamond mesh.

Mosquito net. Coarser than others, of cotton.

Novelty net. Made in a variety of effects.

Point d'Esprit. Cotton net with small dots over its surface in a snowflake effect.

Ninon. Often called triple voile. Sheer rayon used for glass curtains, made in various weaves.

Nottingham. A machine-made lace curtain material. First made in Nottingham, England.

Novelty weave. General name for a variety of modern fabrics, having unusual textural effects produced

by using warp and filler of different size, color, or fibers, nubby yarns, or the introduction of tinsel, metallic threads, or even cellophane. Rayon and cotton are especially adaptable.

Nylon. Generic term for a proteinlike chemical which may be formed into bristles, fibers, sheets, etc. Has extreme toughness, elasticity, and strength. Its fibers are used in almost all types of textiles where silk and rayon have been used in the past.

Oilcloth. A fabric having a cotton base that has been coated with a preparation of linseed oil and pigments. Its finish may be smooth, shiny, dull, or pebbled. Used for table and shelf coverings and other household purposes.

Oiled silk. A thin silk that is waterproofed by a process of soaking the silk in boiled linseed oil and drying it. It was formerly used only for surgical purposes, but is now used as a drapery fabric, particularly for kitchen and bathroom curtains.

Organdy. A lightweight, crisp fabric of muslin construction woven of very fine cotton threads. It may be white, piece-dyed, or printed, and is used for trimmings and glass curtains.

Paisley. Printed or woven design in imitation of the original Scotch shawl patterns made in the town of Paisley.

Palampore. Hand-painted or resist-dyed cotton, chintz, and calico, made before the invention of block printing for fabrics. Original tree of life prints were so made in India.

Panné. A term applied to pile fabrics having a shiny or lustrous surface. This appearance is produced by having the pile pressed back.

Percale. Plain closely woven fabric of muslin in dull finish, which may be bleached, dyed, or printed. Similar to chintz.

Persane. Term used to describe the French eighteenth-century printed cottons that had designs inspired by Persian originals.

Petit point. See Needlepoint.

Picoté. A type of pattern design consisting of small floral or other motifs surrounded by numerous minute dots to soften their silhouette.

Pile fabrics. See Velvet, Velours, Frisé, Moquette, Plush, Terry cloth.

Piqué. A heavy cotton fabric with raised cords running lengthwise. Used for trimmings, bedspreads, and curtains.

Plain weave. A basic weave in which warp and weft are of the same size, and alternate over and under each other.

Plissé. Name refers to a method of printing on plain weave rayon or cotton which produces a permanent crinkled surface in stripes or patterns.

Plush. A fabric with a long pile. Made like velvet, the nap is sometimes pressed down to form a surface resembling fur. It may be made of silk, wool, cotton, or any synthetic fiber. Extensively used for upholstery.

Point d'Hongrie. Needlepoint having a design vaguely resembling an irregular series of chevron forms or V shapes usually made with silk and used for chair upholstery.

Pongee. A fabric of plain weave made from wild silk in the natural tan color. It is very durable and has an interesting texture. Used for draw curtains. The name is derived from a corruption of two Chinese words which signify "natural color."

Poplin. A fabric similar to a lightweight rep. It is made with a heavy filler, producing a light corded effect across the material. Cotton, silk, wool, synthetic, or combination fibers may be used in its weaving. A trimming and drapery fabric.

Quilted fabric. A double fabric with padding between the layers, held in place by stitches that usually follow a definite pattern.

Ratiné. Name of yarn, and of fabric, in plain or twill weave. Owes its coarse, spongy, nubby texture to the knotlike irregularities of the yarn used in the warp.

Rayon. A trade name for a synthetic fiber having a cellulose base. Originally highly lustrous, it can now be handled as a lusterless thread. It is more lustrous, stiffer, and less expensive than silk. In combination with silk, wool, or cotton its possibilities are limitless. Textiles manufactured of rayon are known by various trade names.

Rep. A plain-weave fabric made with a heavy filler thread giving a corded effect. A warp rep is made with heavy filler threads, producing a ribbing across the material. A filler rep uses coarse warps, and the ribbed effect is vertical. Rep is unpatterned and reversible, and may be made of cotton, wool, silk, or synthetic fibers. Used for drapery and upholstery purposes.

Sailcloth. Very heavy and durable fabric, similar to canvas. Lightweight sailcloth is often used for couch covers, summer furniture, etc.

Sateen or satine. A fabric, imitative of satin, with a lustrous surface and dull back. It is made with floating weft threads and is, therefore, smooth from side to side. It is usually made of cotton, the better quality being mercerized.

Satin. A basic weave; also, a fabric having a glossy surface and dull back. The whole face of the fabric seems to be made of warp threads, appearing smooth and glossy. No two adjacent warp threads are crossed by the same weft thread, and the skip may vary from eight to twelve fillers. Because of the length of the warp floats, it is not an extremely durable material for heavy usage. It may be made of all silk, but is stronger when linen or cotton wefts are used. Used extensively for upholstery and draperies. There are several different types, as follows:

Antique satin. Dull, uneven texture, heavy, and rich looking.

Charmeuse. Organzine warp and spun silk weft.

Hammered satin. Treated to give the effect of hammered metal.

Ribbed satin. Bengaline and faille woven with satin face ribs, giving a lustrous, broken surface. May have a moiré finish.

Scrim. A sheer fabric made like a marquisette, but with coarser cotton, wet-twisted thread. Sometimes a cheaper variety is not wet-twisted, which causes it to thicken when laundered. Used for curtains and needlework.

Serge. Silk, wool, cotton, or rayon in twill weave, with a clear and hard finish.

Shadow prints. Also called warp prints. Fabrics with a pattern printed on the warp only; the filler is a plain thread. When woven, the design is blurred and indistinct.

Shantung. A heavy grade of pongee. It is usually made of wild silk, cotton, or a combination of both.

Sheer. General name for diaphanous fabrics.

Shiki. A heavy silk or rayon rep made with irregular sized filling threads.

Spun silk. Silk yarn made from waste fibers from damaged or pierced cocoons and weaving mill waste. Heavier and less lustrous than reeled silk.

Strié (pronounced stree-ay). A fabric with an uneven color, streaked effect produced by using warp threads of varying tones. A two-toned effect may be given to taffeta, satin, or corded upholstery materials by this process, same as Jaspé.

Swiss. A very fine, sheer cotton fabric which was first made in Switzerland. It may be plain, embroidered, or patterned in dots or figures which are chemically applied. It launders well, but has a tendency to shrink. Often used for glass curtains.

Synthetic fibers. These are made from various chemical compounds and are used as yarns in modern textile weaving. They are known by trade names given to them by individual manufacturers. Combinations of natural and synthetic yarns are often used. Among the leading types are those known as rayon, bemberg, celanese, dacron, fortisan, lurex, nylon, and orlon.

Taffeta. The basic plain weave. Also, a fabric woven in that manner. The fabric is usually made of a silk fiber with warp and weft thread of equal size. It is often weighted with metallic salts. Useful for trimmings and draperies.

Tapestry. Originally a hand-woven fabric with a ribbed surface like rep. The design is woven during manufacture, making an essential part of the fabric structure. Machine-made tapestry is produced by several sets of warp and filling yarns woven with the Jacquard attachment, which brings the warp threads of the pattern to the surface. Machine-made tapestry can be distinguished from hand-woven by its smooth back and the limited numbers of colors used in the pattern.

Tarlatan. A thin, open cotton fabric of plain weave which is almost as coarse as a fine cheesecloth. It is sized, wiry, and transparent, and made in white and colors. It cannot be laundered.

Terry cloth. Heavy, loosely woven, uncut pile fabric, as used in bath towels.

Theatrical gauze. A loosely woven open cotton or linen fabric. Because of its transparency and shimmering texture, theatrical gauze is used for window draperies.

Ticking. Closely woven cotton in twill or satin weave. It usually has woven stripes, but they may be printed. Damask ticking is also made in mixed fibers used for mattress covers, pillows, and upholstery.

Toiles de Jouy. Famous printed fabrics produced at Jouy, near Paris, by Philippe Oberkampf, from 1760 to 1815. Modern reproductions continue the typical design of landscapes and figure groups in monotones of brick red, blue, or other colors on a white or cream-colored background. Effectively used for draperies, bedspreads, and wall hangings.

Toiles d'Indy. Printed cotton and linen of floral or pictorial design, which began to be imported into France during the latter years of the seventeenth century from India and Persia.

Tussah silk. Wild silk, from cocoons of worms which have fed on oak or other leaves. Light brown in color. Used for pongee, shantung, shiki.

Tweed. Originally a woolen homespun material made in Scotland. Now the term is applied to a large group of woolen goods made from worsted yarns;

they may be woven in plain, twill, or herringbone twill weaves.

Twill. A basic weave; also, the fabric woven in that manner. The weft thread is carried over one warp and under two. Sliding along one to the left on each row, still going over one and under two warp threads, a diagonal ribbed effect is achieved. A herringbone pattern is a variation of this weave, with which squares and zigzags can also be made.

Velours. A general term for any fabric resembling velvet. It is the French word for velvet, but has been so misused that it no longer has a definite meaning.

Velvet. A fabric having a thick, short pile on the surface and a plain back. A true velvet is woven with two sets of warps, one for the back and one for the pile, which is made by looping the warp thread over a wire, which later cuts the loops. Cheaper velvets and some chiffon velvets are woven face to face and have two backs using two warps and two fillers. The pile is made by slicing apart the two pieces of fabric. Velvet may be plain, striped, or patterned. It may be made of all cotton, linen, mohair, synthetic fibers, or silk, though it is seldom woven with all silk threads. The finer quality may be used for draperies, and the heavier for upholstery. There are several variations, as follows:

Brocaded. Pattern made by removing part of the pile by heat and chemicals.

Embossed. Pattern imprinted by rollers.

Façonné. Same as brocaded velvet.

Moquette. Uncut velvet with large Jacquard pattern.

Panné. Pile pressed down in one direction by rollers under steam pressure.

Plush. Velvet with deep and thinly woven pile, often with crushed effect.

Upholstery velvet. Heaviest type, with a stiff back and very thick pile.

Velveteen. A fabric which is sometimes called cotton velvet. It is not woven with a pile, but like a heavy sateen, with the weft threads floated loosely over the warp. It must then be sheared to produce a fine close pile. It is ordinarily made of cotton and is suitable for upholstery.

Vinyl fabrics. Textiles fused or coated with vinyl plastic. In the coated types the vinyl is opaque, and the surface is printed or embossed.

Voile. A light, transparent fabric of plain weave used for glass curtains. Hard-twisted thread is used to make it durable. It is usually piece-dyed, striped, or figured, and can be made of cotton, wool, silk, or any synthetic fiber.

HANDMADE TAPESTRIES

The word *tapestry* is very loosely used in the decorating trade, but as correctly used it refers only to a hand-woven fabric. The term *real tapestry* is now expressly reserved to designate hand weaving.

Tapestries are made both in all-over patterns and in pictorial subjects. Pictorial tapestries are of prime importance as wall hangings, but are sometimes cut into smaller pieces for upholstery coverings or for small panels. The design is the essential element of aesthetic value in a tapestry; materials and workmanship, while important, are secondary to the design. The chief material used in tapestries is wool, though most modern tapestries have cotton warp threads. In antique tapestries silk was sometimes used in parts, and gold and silver threads were occasionally added to give greater brilliancy.

Tapestry is distinctly a rep weave, and the warp threads of the fabric are strongly accented, a feature that distinguishes it from cross-stitch needlework. In a very fine tapestry, the warp threads are spaced about twenty-four to the inch, while in the coarser grades there may be as few as eight. The weft threads are woven between and around the warp threads, and are pushed together with a comb, so that the warp is completely hidden; they do not run across the fabric, but are used only so long as their particular color is needed in the pattern; they are then tied in a knot, and their ends hang loosely at the rear. The tapestry is reversible if the loose ends are cut off.

The art of tapestry weaving in Europe was encouraged and developed by the return of the Crusaders, who had learned much concerning it in Constantinople and the Orient. There were many similarities between early medieval European tapestries and Near Eastern art forms, notably the similarity of their pictorial compositions to Persian miniatures. It was natural that

tapestries should become a popular form of wall decoration in northern countries. Fresco work, so prevalent in Italy and other warm climates, could not be practiced in western Europe, because freezing temperatures tended to crack the plaster. Tapestries not only added color and pattern to an interior, but the heavy wool from which they were made helped to retain heat in the rooms of the medieval castles.

The earliest efforts at weaving these textiles were made in Paris during the fourteenth century. Of the tapestries woven at this time, very few still remain.* The city of Arras in French Flanders soon took the lead, under the patronage of the dukes of Burgundy, and held it during the whole of the fourteenth century and until Louis XI pillaged the town in 1477. The center of tapestry weaving then moved to Tournai, Belgium, which had become increasingly important in this field. It is extremely difficult, however, to assign the source of many fifteenth-century tapestries definitely to either Arras or Tournai. Decisions are based mainly on pattern and style. Tapestries were undoubtedly woven throughout this period in other small towns, and it is also highly probable that traveling weavers stopped to work wherever a commission was offered, making almost impossible any positive identification as to source of manufacture of many early tapestries. By the end of the fifteenth century and during the sixteenth century, Brussels held a leading position in the field. While French artists carried on the medieval tradition of excellence of design and workmanship until well into the sixteenth century, they eventually fell under the influence of the

* These include the tapestries of the Nine Worthies, made in Paris, now in the possession of the Metropolitan Museum in New York, and the series of the Apocalypse, from Angers. With the exception of some fragmentary German pieces from the twelfth to fourteenth centuries and a few other French examples, these are the oldest European tapestries known.

Renaissance painters. Technically, the quality of French work was maintained at a high level of excellence, but the competition of the Brussels weavers, who were being increasingly patronized, caused a decline in French tapestry production during the latter half of the sixteenth century. Looms were also established in Bruges, Enghien, Lille, Fontainebleau, the Loire valley, Antwerp, and Delft. The art was given renewed encouragement in France by Henry IV in the early seventeenth century by the importation of Flemish weavers to work both in Paris and in the provinces. The Gobelins looms in Paris, which had been established about 1446 by two brothers of that name, were consolidated with several other small private looms in the same neighborhood and became a huge state institution and Royal Manufactory under the patronage of Louis XIV in 1662. In the early years of its existence, furniture and other objects connected with the decorative arts were made as well as tapestries. Louis appointed his minister of fine arts, Charles Le Brun, as director and chief designer. These looms were manned by both French and Flemish weavers, and, with their enormous output, during most of the seventeenth century they shared the honors with the looms at Brussels. Later Beauvais and Aubusson came under royal support, and with the aid of the finest artists that France could produce, tapestries of wondrous beauty and weave were made to furnish the homes of the nobility and to enrich the walls of the churches and public buildings. When Louis XIV was forced to close temporarily the Gobelins works in 1690, due to financial difficulties, the production of the Beauvais factory, still under royal patronage, took a definite upward trend. Upon the reopening of the Gobelins between 1694 and 1699, the Renaissance fashion of Beauvais was well established, and the Gobelins weavers were forced to follow a style very different from that of their earlier work. In the eighteenth century, Beau-

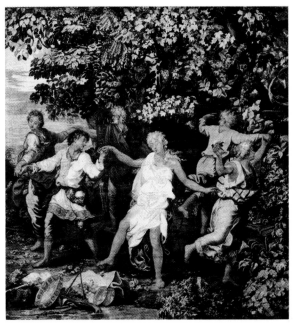

Metropolitan Museum of Art

Late seventeenth-century French tapestry after designs by Giulio Romano. "Shepherds and Shepherdesses Dancing" woven at the Royal Factory of Gobelins.

vais, Gobelins, and Aubusson were all great centers of the art, which, from the design standpoint, had lost a considerable amount of its earlier dignity and grandeur as the tendency developed to reproduce oil paintings rather than to accentuate in the pattern the substance of the textile medium.

Looms were soon started in the other countries of Europe. Particularly noted were those of Mortlake, Merton, Barchester, and Windsor in England. Germany, Spain, and Italy also were centers of production.

The use of the term *arras* as synonymous with tapestry in England* is significant of the importance of the town of that name in connection with the art. *Arrazzo* in Italian is also used as a synonym. In the United States the term

arras is used as a designation of a tapestry of the Gothic period.

Gothic tapestries. As a rule, Gothic tapestries are of the *millefleurs* variety. The translation of the French word is "thousand flowers," and refers to the fact that the background or other portions of the picture are covered with numerous small bushes, plants, flowers, and leaves. Many of these bushes have small animals of various types crouching upon or under them. It is a general conception that most millefleur tapestries were woven in the region of the Loire about 1500. Evidence suggests, however, that many of them were woven by itinerant workers.

Though Gothic tapestries cover a wide range of subject matter, they are distinct and easily recognizable because of special characteristics in their design. The laws of perspective were considered unadaptable, and pictorial depth, distance, and atmosphere were not rendered. Consequently, in Gothic tapestries objects behind other objects do not appear reduced in size, nor do they become fainter in tonal value; shadows are absent or are only vaguely suggested; the ground often appears to fold up toward the observer; horizon lines are close to the top of the composition; and the design as a whole resembles a flat-colored line drawing, with little or no gradations in the coloring or rounding of forms. The general effect is stiff and conventional, though beautiful and dignified. The range of colors is very limited, there being sometimes as few as twenty different dyes used, whereas the Gobelins factory at the present time uses thousands of different colors. Machine-made tapestries are usually limited to a maximum of twenty-eight different colored threads although very few have this number.

The subject matter of the pictorial tapestries of the fifteenth and early sixteenth centuries invariably tells a story rather than creates a picture with an important central figure or domi-

* See *Hamlet*, Act III, Scenes 3 and 4.

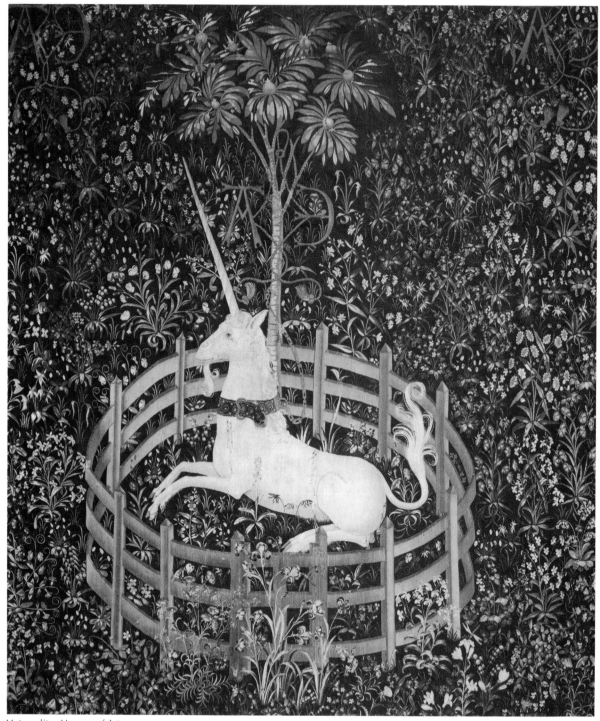

Metropolitan Museum of Art

Franco-Flemish millefleurs tapestry from the famous series, "The Hunt of the Unicorn." Late fifteenth century originally from the Chateau de Verteuil.

nating motif. Distortion of figures and objects and other artistic license are often resorted to, with a resultant lack of relationship in the scale of both objects and persons in the same plane.

The subject matter of the Gothic work also simplifies its identification. Religious subjects were paramount. Biblical, allegorical, and ecclesiastical personages were often pictured in a setting of Gothic architectural forms. Scenes of pastoral, agricultural, and courtly life were often represented. Many Gothic tapestries were made showing the unicorn and other animals chased by hounds and hunters. These are known as "hunting tapestries." In the series known as "The Lady with the Unicorn," from the Cluny Museum in Paris, the subject matter is allegorical. The lady is flanked on one side by a lion, symbol of bravery, and on the other by the unicorn, symbol of purity. She stands on an island of deep blue on a rose ground, both of which are covered with flowers and animals.

Costumes often facilitate the dating of a tapestry, and a careful study of this feature is well worthwhile. Men of the fifteenth century had short hair and wore long pointed shoes. Their vests were usually of a different material from their sleeves, or else they wore plaited jackets with full sleeves. Their legs were covered with close-fitting tights. The women wore high, pointed headdresses known as *hennins*, and their full skirts hung in stiff folds. In the sixteenth century, the men wore their hair "bobbed," and eventually grew beards. Their legs were covered with short, full trousers which were slashed.

The majority of Gothic tapestries did not have frames, although some were enclosed with a narrow border carrying out the millefleur idea.

The great beauty of Gothic tapestries lies in the qualities in which they are unlike paintings, and not in the qualities in which they resemble them. They are distinctly textile patterns, and never attempt to compete with a painted decoration. In other words, it is the design in-

terest, not the pictorial interest, which makes them superior to later weaves that followed more closely the modeling and detail of the painted *cartoon*. They are the most valuable tapestries on the market today, partially because of their rarity and partially because they are considered the finest examples of the art of tapestry weaving.

Renaissance tapestries. The transitional period between the Gothic and the Renaissance showed tapestry patterns in which details of the two periods were mixed. Often Gothic architectural forms were combined with human figures dressed in Renaissance and classic costumes. The perspective of the pictures improved. The horizon line was lowered below the middle of the picture, and distance and atmospheric effects were introduced. Shadows and highlights were shown in greater contrasts, and borders became much more important than in the Gothic period. More detailed modeling and rounding of draperies and clothing were attempted, and both Roman and Gothic letters were used.

The tapestry weaving of the Renaissance assumed its definite character when Raphael made for Pope Leo X a series of cartoons illustrating the Acts of the Apostles. Raphael was not a weaver and knew little of the art of weaving or of tapestry texture. The greatness of the artist as a painter misled the world and caused the critics of his day to admire the work that was executed from these cartoons. As a result, the Acts of the Apostles tapestries are more valuable as pictures than as masterpieces of tapestry weaving. Though Raphael and his patrons were Italians, this set was actually woven in Brussels; the originals are now in the Vatican, after having been stolen and subjected to other vicissitudes. They are perhaps the most famous tapestries in the world, and have been copied many times, the copies being owned by most of the chief museums of Europe.

Tapestry weaving was introduced into Eng-

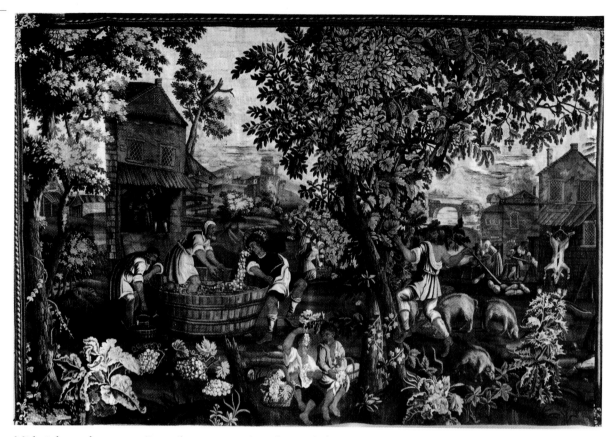

Mid-eighteenth-century Brussels tapestry after the twelfth-century Flemish painter Teniers. From the series "The Seasons."

land under James I. The Mortlake works were the earliest, and employed Flemish workmen, who produced much excellent work, though their designs were copied from foreign sources, including the Raphael cartoons. The looms at Merton and Windsor are more recent, most of their work having been produced during the nineteenth century.

The Flemish looms were the most important during the early Renaissance. They produced a great quantity of work, particularly during the seventeenth century under the leadership of Rubens and Teniers. The former produced designs of great vigor, showing high relief effects

of warlike subjects or tempestuous scenes. Wide borders of foliage and architectural motifs usually surround the central composition. Although of immense decorative value, the tapestries were merely woven paintings and helped to crush the art of tapestry weaving. Teniers' subjects were nearly all pastoral or village scenes and may be easily recognized. In addition to Rubens and Teniers, countless individual weavers sprang up in all parts of Flanders, who, although gifted with expert technical knowledge and craftsmanship, were utterly lacking in artistry of design. These weavers produced the thousands of tapestries of varying merit which are often sold in

the auction market as "Flemish Verdures" or *Verdure tapestries*, which sometimes show human beings and animals of extraordinary shapes.

Flemish workers were imported into other countries, including Spain, Germany, and Italy, though the industry in these countries never assumed very great importance. Italian tapestries of the earlier periods are scarcely distinguishable from the Flemish. Later they assumed a character of their own, and in the baroque period they took on the same characteristics as other contemporary arts.

Under Louis XIV and his successors, French tapestry weaving finally became even more important than the Flemish. This largely resulted from the royal support given to the Gobelins works on the banks of the Bièvre River near Paris. The water of this river was, and still is, said to have exceptional qualities for dyeing, although modern chemists have denied this claim. The Gobelins factory developed into one of the greatest producers of this class of work. It was taken over by the French crown in 1662 and is still owned by the French government, for which it works exclusively. The output of the Gobelins works during the period of Louis XIV, in contrast to Gothic work, showed pattern full of relief, with elaborate naturalistic shadows, fine gradations of color, strong color contrasts, atmospheric effects, low horizon lines, and a definite composition of subject matter, always with a central or important point of interest, instead of a loose distribution of decorative motifs or figures placed over the whole surface of the textile. The tapestries, in imitating paintings very faithfully, lost greatly in textile character and texture quality, though they were still rich and decorative. Borders were often imitations of wide gilt carved picture frames, and subjects were usually mythological or historical, replacing the religious subjects of earlier times. The Gobelins tapestries were made on both the high-warp and low-warp loom. In the former the weft threads were vertical to the pattern, and the outline of the design was drawn on the warp threads. In the low-warp loom, the warp threads are horizontal to the pattern, and the weaver follows a cartoon that is placed behind the weft threads. In both cases the tapestry is woven from the rear side.

Under Louis XV, pastoral, amorous, and garden scenes, executed from the paintings and designs of Watteau, Boucher, Fragonard, and other popular court painters, were much in demand. Many tapestries were woven in small panels for use as chair- and sofa-back upholstery coverings. *Vignette* patterns, in which a small scene or portrait was surrounded with a large patterned frame, were also introduced at this time. The frame became more important than the picture that it enclosed. Ornamental patterns of this and the subsequent period followed the general character of painted and carved motifs.

The Beauvais tapestry works were at first a private enterprise, but were later taken over by Louis XIV, and are still a French government factory. The early work was mainly of the verdure type, though, later, various subjects were produced. For a time rugs, too, were manufactured, but this was discontinued during the French Revolution. The looms of Aubusson, in central France, are said to be of very ancient origin. They manufacture rugs and tapestries for furniture upholstery and wall hangings. Their work is produced commercially for the general market.

Modern tapestries. Until recent years tapestry weaving has been largely confined to reproducing antique patterns, which, because they have been uninspired imitations, have lacked the spirit of original creative work. While skillful in technique, they have often been poorly designed. A few attempts have been made to weave modern patterns, but the cost of produc-

Denise René Gallery

Modern French tapestry after a design by the famous architect Le Corbusier, "Femme sur Fond Rouge" 1962.

ing a handmade tapestry is so high, and the demand has been so small, that tapestries of this type have not yet been made in any considerable quantity. There has been, however, an effort to revive tapestry weaving as an art in France and a return to the creative spirit of the Gothic period, with Aubusson and Gobelins looms in the vanguard. Such artists as Gromaire, Lurçat, Dufy, and Matisse have endeavored to rejuvenate one of France's oldest industries. Technicians in other fields have given of their knowledge and experience and have approached the problem in a new light, not merely copying old patterns, but applying the earlier sense of fantasy and poetic feeling to contemporary designs, with results that attempt to equal the Gothic productions in freshness, vigor, and sincerity of artistic effort. They are designed on the hypothesis that tapestries should afford modern man a glimpse of unreality and a means of escape from the pressures of the machine era. Since modern rooms frequently possess large areas of unrelieved wall space, these disciples of the use of modern tapestry urge its restoration to a prominent place in the decorative plan, as a source of texture, color, and pattern interest. Such usage would be comparable to that of the Gothic period, in which the hangings brightened the severity of stone walls. The weavers have adhered to the truest traditions of textile weaving, and one realizes that these productions are woven designs, not paintings. The stereotyped efforts of the nineteenth century seem dwarfed by these new productions, the vitality and integrity of which offer a promising future to an ancient art.

Denise René Gallery

Modern French tapestry after a design by the painter Jean Arp, "Famille de Formes," 1956.

The use of tapestries. It has often been said that a room in which a tapestry hangs is already furnished. It is indeed true that such a room needs little else from a decorative point of view, so rich is the effect. A large tapestry is such an important object in any room that it should al-ways have the place of honor and should be so hung that it is not only properly lighted both in natural and artificial light, but that it may be seen at a distance, also, to obtain fully its best effect. Needless to say, its full beauty is brought out only by contrasting it with plain surfaces, whether these be wall treatments, upholstery materials, or floor coverings. The use of tapestries as decorative features in contemporary rooms has reached a low ebb, but this in no way denies the fact that the art of weaving reached its apex in this medium.

Tapestries should be arranged to hang freely, the effect of the textures gaining greatly from the irregular folds into which they naturally fall. This method also allows them to be dusted and cleaned with facility or to be removed quickly in case of fire. If tapestry is tightly stretched on a frame, it loses much of its character; and to cover it with glass is to destroy its effect almost completely, as well as to furnish a breeding place for moths, which are its greatest menace.

BIBLIOGRAPHY

American Fabrics Magazine. *Encyclopedia of Textiles.* New York: Prentice-Hall, 1960.

American Standards Association. *American Standard Performance Requirements for Textile Fabrics.* New York: National Retail Merchants Association, 1960.

Bendure, Z., and Pfeiffer, G. *American Fabrics.* New York: Macmillan Co., 1947. Their origin and history, manufacture, characteristics, and uses. Well illustrated.

Birrell, Verla. *The Textile Arts.* New York: Harper and Row, 1959.

Bunt, Cyril G. E. *Byzantine Fabrics.* New York: George Wittenborn, 1967.

Candee, Helen Churchill. *Weaves and Draperies.* New York: Stokes, 1930.

Clouzot, H., and Morris, F. *Painted and Printed Fabrics.* New York: Metropolitan Museum of Art, 1927. Fully illustrated history of printed cottons in England and America.

Constantine, Mildred, and Larsen, Jack Lenor. *Beyond Craft: The Art Fabric.* New York: Van Nostrand Reinhold Co., 1973.

Cowan, Mary L. *Introduction to Textiles.* New York: Appleton-Century-Crofts, 1962.

Denny, Grace G. *Fabrics.* 8th ed. Philadelphia: J. B. Lippincott Co., 1962.

D'Harcourt, Raoul. *Textiles of Ancient Peru and Their Techniques.* Translated by Sadie Brown. Seattle: University of Washington Press, 1962.

Fleming, E. *An Encyclopedia of Textiles from the Earliest Times to the Beginning of the 19th Century.* London: E. Benn, 1928. Brief text with color plates and many photographs.

Glazier, R. *Historic Textile Fabrics.* London: B. T. Batsford, 1923. A short history of the tradition and development of pattern in woven and printed fabrics. Illustrated.

Gobel, Heinrich. *Tapestries of the Low Lands.* Translated by Robert West Hacker. 1924 (reprint 1973).

Gray, Jennifer. *Machine Embroidery: Technique and Design.* New York: Van Nostrand Reinhold Co., 1973.

Hartung, Rolf. *More Creative Textile Design.* New York: Van Nostrand Reinhold Co., 1965.

Helsel, Marjorie Borradaile, ed. *The Interior Designer Drapery Sketch File.* Whitney Publications, 1969.

Hollen, Norma, and Saddler, Jane. *Textiles.* New York: Macmillan, 1955.

Hunter, George Leland. *The Practical Book of Tapestries.* Philadelphia: J. P. Lippincott Co., 1925.

Johnson, William H. *The Textile Arts.* New York: Macmillan Co., 1944.

Joseph, Marjory L. *Introductory Textile Science.* New York: Holt, Rinehart & Winston, 1966.

Kent, Kate Peck. *Story of Navaho Weaving.* Phoenix, Ariz.: McCrew Printing and Lithography Co., 1961.

Labarthe, Jules. *Textiles: Origins to Usage.* New York: Macmillan Co., 1964.

Laliberte, Norman, and McIlhany, Sterling. *Banners and Hangings: Design and Construction.* New York: Van Nostrand Reinhold Co., 1966.

Lewis, E. *The Romance of Textiles.* New York: Macmillan Co., 1937. An interesting romantic approach to the history of textiles from the earliest times.

Linton, George. *The Modern Textile Dictionary.* New York: Hawthorn Books, 1963.

Lyle, Dorothy Seigert. *Focus on Fabrics.* Silver Spring, Md.: National Institute of Drycleaning, 1964.

Maciver, P. *The Chintz Book.* London: William Heinemann, 1925. Illustrated text.

Moss, A. J. Ernest. *Textiles and Fabrics: Their Care and Preservation.* New York: Chemical Publishers Company, 1961.

O'Neale, Lila M. *Textiles of Highland Guatemala.* Washington, D.C.: Carnegie Institution of Washington, 1945.

Pizzuto, Joseph J. *101 Weaves in 101 Fabrics.* New York: Pelham Textile Press, 1961.

Potter, Maurice, and Corbman, B. P. *Fiber to Fabric.* New York: McGraw-Hill Book Co., 1959.

Press, J. J. *Man-Made Textile Encyclopedia.* New York: Textile Book Publishers, 1957.

Priest, A., and Simmons, P. *Chinese Textiles.* New York: Metropolitan Museum of Art, 1934. An introductory study of this field.

Stenton, Frank. *Bayeux Tapestry.* New York: Phaidon Art Books, 1965.

Stephen S. Marks, Editor. *Fairchild's Dictionary of Textiles.* New York: Fairchild Publications, 1959.

Stout, Evelyn E. *Introduction to Textiles.* New York: John Wiley and Sons, 1960.

Taylor, Lucy D. *Know Your Fabrics.* New York: John Wiley and Sons, 1951. A study of standard and historic types of fabrics and their correct usage in decorative work.

Thomson, W. G. *Tapestry Weaving in England from the Earliest Times to the End of the XVIIIth Century.* New York: Charles Scribner's Sons, 1914. Illustrated text.

Thornton, Peter. *Baroque and Rococo Silks.* New York: Taplinger Publishing Co., 1967.

Thorpe, Azalea Stuart, and Larsen, Jack Lenor. *Elements of Weaving.* New York: Doubleday and Co., 1967.

Thurston, V. *A Short History of Decorative Textiles and Tapestries*. Sussex, Eng.: Pepler and Sewell, 1934. Illustrated text with history of hand weaving from the earliest times.

Von Falke, O. *Decorative Silks*. New York: William Helburn, 1922. Beautifully illustrated text.

Weibel, Adele C. *Two Thousand Years of Textiles*. New York: Pantheon Books, 1952.

Wilson, Jean. *Weaving for Anyone*. New York: Van Nostrand Reinhold Co., 1967.

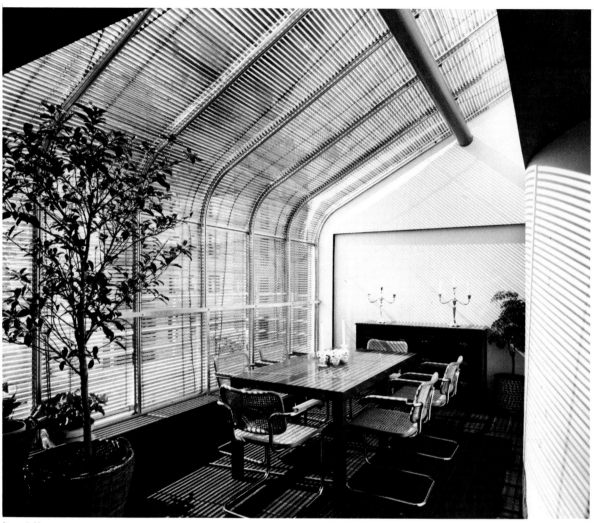

Stern & Hagmann
Photo credit Ed Stoecklein

A dramatic interplay of light and shade is achieved in this duplex apartment through the use of thin blinds electrically operated for sun control.

CHAPTER **18**

Window Treatments, Slipcovers and Upholstery

⭡ *Eclectic furnishings are well defined against a stark white background. There are sliding panels at the windows and the simplicity of the window treatment adds to the clarity of the scheme which is developed around the Picasso painting between the windows.* Parish-Hadley

⭣ *A handsome drawing room with an interesting combination of eclectic furniture. The contemporary paintings against the lacquered green walls add great style to the casual elegance of this interior.* Parish-Hadley

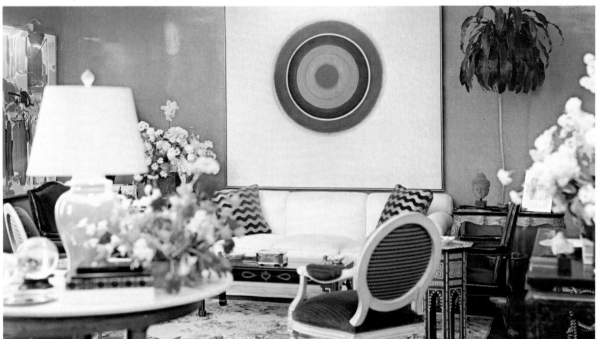

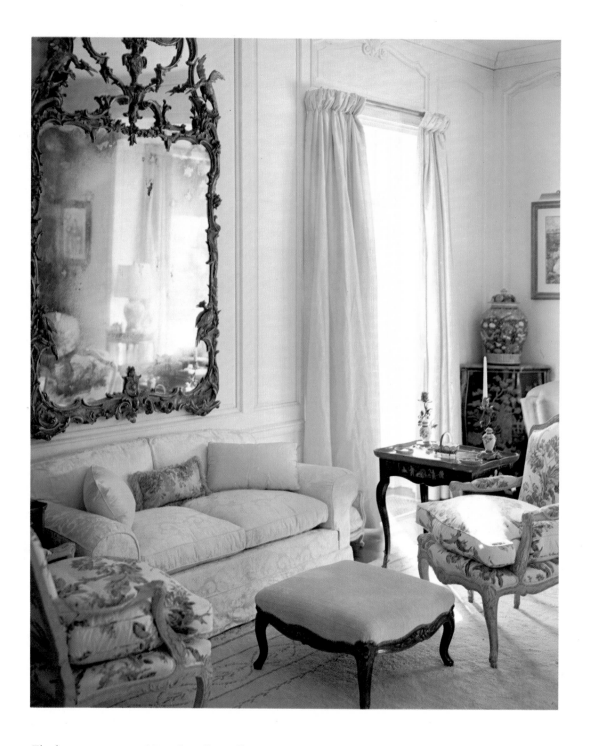

The less ornate type of French wall panelling suitable for today's use creates a handsome background in this traditional interior of the Louis XV style. The oriental influence as seen in some of the furnishings and the mirror was typical of this period. The freshness of the white and yellow scheme lends a contemporary air to this handsome room.

Parish-Hadley

Designs for window draperies taken from George Smith's Cabinet Makers' Guide, *1825.*

WINDOW TREATMENTS

As one enters a room, the windows and their treatment are, as a rule, the first features noticed. Windows serve the practical purpose of affording light and ventilation. Architecturally, they relieve the monotony of unbroken wall space both on the exterior and interior of the building.

Most windows are rectangular and, if not curtained, create hard, straight lines in a room. If for no other reason, therefore, curtains are necessary to soften this severity by trimming the outline of the window frame and opening.

Window curtains have very important decorative purposes. They may serve in the place of, or in addition to, window shades to maintain privacy, may assist in eliminating an undesirable view, may soften and regulate the amount of light permitted to enter a room, and may act as a link between windows and walls. Last, because of their size, draperies form an important element in the color scheme and may be used either to extend the color of the walls or to accentuate it with a contrasting color, texture, or pattern.

In the finest decorative work in domestic interiors there are most often two sets of curtains to every window, but in simple rooms one is permissible.

Where two sets are used, the first is a thin material placed nearest the glass. Known as the *glass curtain* or *casement curtain*, this set may be hung straight, shirred on a rod, tied back, or arranged to draw.

The second or outside set of curtains is generally known as the *overdraperies*. Their purpose is primarily decorative, but for privacy and elimination of daylight, they may be made to draw. As a rule, overdraperies consist of a pair of curtains, straight-hanging or draped, with or without a valance or cornice board across the top. Overdraperies are normally hung to cover the top and side trim or casing of a window. In rare instances, where the window is large or the woodwork of great interest, or where the window jamb is deep, the overdraperies may be hung inside the trim. Often, in this situation, only a valance is used over casement curtains.

One should never refer to overdraperies as "overdrapes" or "drapes." However, one may drop the "over" and refer to the overdraperies more simply as draperies. Therefore, in present-day terminology, the most frequent treatment of a window will consist of draperies (overdraperies) and casement curtains (or glass curtains).

When one has a window treatment consisting of casement curtains (either shirred on a rod or to draw) and draperies that are tied back, or do not draw, it may be necessary to have a third set of black-out curtains that draw behind the overdraperies when not required to cut out daylight. These curtains are made of a lightweight black-out fabric and are used in lieu of, or in addition to, some type of window shade. However, it is generally better to have the draperies draw whenever possible and to have them lined to reduce light penetration.

Metropolitan Museum of Art
The Elisha Whittelsey Fund, 1952.

Drapery designs made by Sheraton, 1793.

Period draperies. As original draperies of seventeenth- and eighteenth-century rooms are virtually nonexistent, it is necessary to search documents for information. Research may produce full details about fabrics and trimming, but it gives little information concerning specific design of window treatment. The most authentic documents for research are paintings and engravings of interiors by Vermeer, Hogarth, Boucher, and others and books on interior design published between 1750 and 1850.*

Dutch and English paintings of the seventeenth century show rather simple window curtains usually hung to the sill and set within the jambs of the window. The purpose was functional rather than decorative. In the early eighteenth century, floor-length draperies without a valance were common and were hung straight to draw. Many weaves and patterns were used,

* Most of the information concerning these matters has been obtained from Sheraton's *Director* (1793), George Smith's *Household Furniture* (1808 and 1826), Ackerman's *Repository of the Arts* (1806–1840), and Nicholson's *Practical Cabinet Maker* (1826). Sketches for draperies were also published by Chippendale, Ince and Mayhew, and Thomas Hope. There were also French books on this subject published in the eighteenth and early nineteenth century.

depending no doubt upon the wealth of the owner and the character of the room. In some paintings, shaped valances accentuated with galloons and/or fringes are indicated. This technique was used to enhance the window and to conceal the draw cord hardware. Later in the eighteenth century, soft valances such as festoons and jabots were used, often quite elaborate in design, but these never entirely displaced the exposed pole or rod. The straight pole was treated with ornamental end motifs (or finials) or enriched with a leaf or rosette ornament. Some rods were bent into graceful curves or given the shape of a cupid's bow. Sliding rings were used, or the rod served as a support for an overthrow festoon. Carved wooden or hammered brass cornices were used first with rococo and finally with classical detail. Draped valances in many designs were often hung from a visible

Metropolitan Museum of Art

Sheraton's original design for twin beds made in 1793, called by him "A Summer Bed in Two Compartments."

Drapery designs in the Chinese manner, made by Sheraton in 1792.

rod or from ceramic or metal rosette supports. Draperies were held back with ropes or hung over ornamental pins. When rich effects were desired, each window was hung with several pairs of draperies, a profusion made possible only by alternating the method of hanging or the height of the tiebacks. In these treatments, there was often an excessive use of festoons, trimmings, and tassels, producing a lavishness that is impractical today.

The state-beds of this period still in existence at Versailles, Fontainebleau, Hampton Court, and elsewhere indicate the importance of draperies not only for warmth, but also for impressive bed adornment because of the custom of receiving guests before arising. These beds had corner posts crowned with an elaborate cornice from which hung a valance composed of overlapping festoons, cascades and jabots enriched with cut or molded fringes. The ceiling of the canopy was often styled with sunbursts. Single or double full-length draperies were held

back during the daytime with tasseled ropes or tiebacks and were most often made to match the draperies on the windows.

Drapery design. While many period rooms had excessively rich and complicated drapery treatments, the present tendency is toward simplicity. Before the use of modern heating devices, draperies were depended upon to maintain the temperature of rooms, but other considerations now guide the drapery designer. It is difficult to give general rules for designs because of the great variety of window shapes and the numerous requirements and limitations in various types of rooms. The important points to consider are line, proportion, materials, colors, pattern, and scale. The line is formed by the silhouette and the folds of the curtains themselves and by the way in which they are hung. It is always advisable to avoid square effects in window treatments. The windows should usually appear to be a vertical rectangle and hence

John E. Winters

A room in the Queen Anne style from the Museum of Early Southern Decorative Arts, Winston-Salem, North Carolina.

higher than they are wide. Groups of windows should be handled as a series of vertical rectangles rather than attempting to connect these windows into one wide arrangement. Draperies should not extend beyond the window frame more than necessary to clear the glass or light area, since this extension will produce a square rather than a rectangular effect, thus tending to decrease the look of height which most rooms require. In this regard, draperies and casement curtains, when possible, should go to the floor and often extend above the window trim to increase the look of height. The window sill or window apron length may be used in small cottage interiors or when period style dictates, or whenever window seats, radiators, or other fixed objects prevent draperies from hanging to the floor. The period style of having the drap-

eries rest on the floor several inches is neither necessary nor in vogue today. This style served to prevent room heat from escaping behind the curtains.

Draperies may be hung straight, or they may be tied back to introduce a graceful curved line to contrast with furniture or architectural forms in which straight lines dominate. The tieback should not be placed in the center of the length of the curtain, but usually looks best when placed one-third the distance from either top or bottom; this proportion may vary, however, under some conditions (such as the use of two sets of tiebacks on each window, one up high and one down low). Tiebacks may harmonize in color or material with the curtains they serve.

There is no rule that tied-back draperies should never rest on the floor; but if draperies are tied back, they should remain that way and not be dropped at night for privacy or for cutting out light. The draperies will appear wrinkled when the tiebacks are released, and too much labor will be required to redrape the curtains on the tiebacks each day. As mentioned before, another set of curtains or shades may be necessary to eliminate light or secure privacy.

There are many kinds of decorative tiebacks including those made of matching or contrasting fabric. These include cord and tassels, many varieties of metal arms and rosettes, glass and/or mirrored tiebacks, or a combination of the above.

Where a pair of windows exists on the same wall, but only when close together, an interesting treatment may be obtained by considering them as a single composition—having the drapery on the outside ends of the windows with casement curtains between. This technique will give the effect of a single wide window; however, today it is more correct to have a panel of the drapery in the center separating the two windows. The draperies may or may not draw, but if they do not, and if privacy is a factor, the

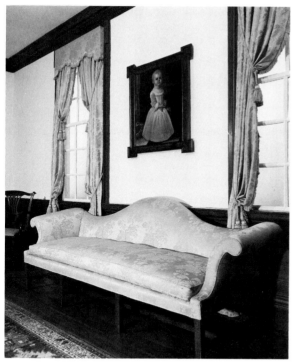

John E. Winters

A Chippendale parlor from the Museum of Early Southern Decorative Arts, Winston-Salem, North Carolina.

type of fabric used in the casement curtain may have to be of translucent weight. Generally speaking, it is best to treat a pair of windows as two separate entities, again for reasons of eliminating the square look and increasing the visual height. Remember to attempt to maintain the vertical rectangle in a window treatment.

Windows are sometimes handled with sheer materials used as overdraperies. This treatment saves in cost but is also used in expensively decorated rooms. It is especially suitable where large windows command interesting views. Then soft, sheer materials are used. The curtains may be hung straight to draw, or they may be tied back. If the window proportion is suitable, the top of the curtains may be hung with a valance or cornice. Frequently, a curtain pocket and soffit is built into the ceiling to conceal the hard-

ware and/or curtain heading. In informal rooms with small cottage windows, organdy and other crisp textiles are often edged with large ruffles which also may be used for tiebacks and a single or double row used at the top as a valance.

Casement curtains are usually made of transparent or translucent textiles, such as gauzes, marquisettes, nets, ninon, dotted Swiss, point d'esprit, or organdy. These may be made of natural fiber, such as cotton, silk, or linen, or they may be synthetics, such as dacron, nylon, fortisan, fiberglas, or rayon. They may hang free from a rod at the top, usually of ⅜" diameter, through which the curtain is shirred or gathered through a seamed pocket in the top, leaving a heading of ¾" to protrude above; or, preferably, they may be made to draw. Fullness of 100 to 200 per cent is desirable, depending upon the sheerness of the fabric; the sheerer the fabric, the greater the fullness should be. When curtains are hung with a rod on top and bottom of the window, they are referred to as stretch curtains. Since these curtains cannot be drawn or traversed, they should be used only where they will never need to be opened, such as on French doors or windows which open into a room. Stretch curtains on French doors or windows sometimes do not cover the entire glass area, but are run sufficiently high to exclude the view from the outside yet permit the entrance of light; these are sometimes known as *brise-bise,* a French word that can be roughly translated "wind screen." However, this treatment is rarely used today.

Valances, cornice boards, and drapery supports. The term *valance* refers to the horizontal decorative treatment that is usually applied to the top of a pair of draperies for the purpose of giving a more finished appearance to the framing of a window; valances also serve the practical purpose of screening the hardware and traverse cords. They may also serve to improve window proportions and structural defects; low

windows may be increased in apparent height by extending the valance top upward above the window and keeping the bottom line of the valance a little below the top of the window opening or frame; narrow windows may be made to appear wider by extending the valance beyond the trim at each side so that the drapery will cover part of the wall. Windows of different sizes may be made to appear to be of the same size by altering the visual proportions by using the above methods.

The height of a valance should be of a scale equaling 1½" for each foot of window treatment when one uses a shaped or flat valance. Height is increased to a proportion or scale of 2½" for each foot of window treatment when one uses a soft valance such as a festoon or jabot. This 2½" scale refers to the maximum depth of the festoon, whereas the jabot can be of greater depth. There are exceptions to every rule, and it is most important that one make a scale drawing of the window application to better visualize the proper height of the valance. Most important to note is that the scales or proportions mentioned here refer to the measurement from the top of the window treatment to the floor and not to the measurement from the ceiling to the floor. As a practical example, say that one is designing a shaped or stiff valance for a window that is 7'6" high in a room with a ceiling height of 9'6". It is desirable to have the treatment look as high as possible; so, upon making a scale drawing, it is decided to extend the top of the valance 6" above the window, making the top of the window *treatment* 8' from the floor (7'6" window plus 6" above). Multiply the 8' x 1½", and we have a maximum valance depth of 12". This scale, of course, is simply a rule of thumb. If the shaped valance has severe vertical lines, the scale can increase to 2" to each foot of height. Also, the ends of the valance can come down considerably below the center scale.

Valance designs require a great deal of thought. For example, one must decide whether to use a shaped (stiff) valance or a soft (festoon and jabot) valance and whether it should be of elaborate or simple design. If one is planning a traditionally correct room such as a pure Chippendale parlor, it will be necessary to research the problem in order to develop what can be established as a Chippendale design. However, in today's decoration there are few truly correct period rooms except in museums or restorations. Therefore, one has plenty of latitude in this decision of design.

It is necessary to decide on the fabric before deciding on the type or shape of the valance. Shaped valances must be designed to follow and accentuate the design of the fabric. The larger the pattern of the fabric, the more limited becomes the number of shapes that can be used. There are problems even with plain fabrics. For it is seldom that plain fabrics can be run sideways on a valance and up and down on the curtains below; the weave of the fabric creates difficulties. The warp (cross threads) and the weft (filler threads) are then reversed and may cause the color of the fabric to take on a different hue on the valance from the draperies or curtains below. Therefore, it is necessary to run the fabric on the valance the same direction as on the curtains. The problem here is in seaming a plain fabric, for the seam will show more than on a patterned fabric. In either event, the fabric should be seamed at the shallow point of a shaped valance, not at the deepest point, even if this necessitates cutting off part of the width of the fabric. It is also necessary to seam the fabric for a valance when the fabric is narrower than the valance. Seams should never be in the center of a valance but always at an equal distance from the center, depending upon the width of the fabric and the shallow points of the shape. In a shaped valance, the largest motif of a pattern fabric is in the center and on the ends, preferably with an odd amount of deep sections and ending with a half pattern on the ends. There are, of course, other types

of valances than the broad categories of shaped or soft valances; there are plaster-moulded festoons, metal-pressed floral designs mounted on boards, and, of course, valances made of wood. In most cases, these are no longer called valances, but are referred to as "cornice boards" or, more simply, "cornices." Some other materials fitting into the cornice category include wood with mouldings attached, mirrors mounted on wood frames, wallpapered surfaces acting as valances, and cornices covered in leather rather than fabric. The depth of a cornice is generally not as great as a valance and usually varies from 4" to 8", depending upon its length, the height of the room, and the material used.

In addition to helping to determine the depth of a valance, the scale drawing, suggested earlier in this chapter, has another use in that it is invaluable in presenting different types and shapes for consideration. If there is further question as to depth and design of a valance, a full-size facsimile on kraft paper (which is required in any event to fabricate the valance) could be hung over the window with masking tape in its proposed position, and a judgment could then be made by viewing its proportions from a distance.

Soft valances of fabric are generally hung from a dust board, which is applied to the wall or casing with angle irons. The valance is attached to the dust board by tacking through an attached tape with upholstery tacks or by the use of Velcro tape. Velcro is by far the most satisfactory solution in that the valances are easily removed and reinstalled, and no damage is done to the valances, as often happens with tacks.

The hardware for the draperies is attached to the dust board whether or not the draperies or curtains are to draw.

Shaped valances are stiffened with various materials. The original shaped valances were stiffened with heavy sailcloth or duck, and this is still used today, particularly in museum or restoration work. Other stiffening materials include buckram (a heavily sized burlap), pelon, crinoline, and plywood. It is recommended that ¼" plywood be used as the most suitable material for a shaped valance because of the lack of care that dry cleaners use in cleaning valances stiffened with any of the other stiffening materials mentioned. If expert dry cleaning can be obtained, a valance has a softer, more luxurious look if stiffened with canvas, buckram, pelon, or crinoline. However, both sides of these stiffening materials must be covered with flannel interlining and the back side lined with sateen. Shaped valances of other than plywood are attached to a dust board in the same manner as soft valances.

Shaped valances of ¼" plywood should have the shaped edges beveled on the inside to almost a knife edge, and this edge welted or corded in the upholstery of the valance. Generally, shaped valances have a dust board and returns attached and are installed with angle irons in the same manner as the dust board for other valances. Fabric is never applied to the raw wood, but rather the valance is first covered with glazed cotton felt to give a softer appearance and also to protect the fabric from the wood when being cleaned.

There are valances in the "soft" category other than the various festoon and jabot arrangements. These include shirred valances, with from one to four rows of shirring at the heading, box pleats, inverted pleats, pinch or French pleats, or combinations of flat surfaces with these various pleats at intervals. Valances of festoons and jabots can be made in unlimited variety, from a single festoon and a pair of jabots to a series of festoons with jabots at the end, or festoons interrupted with double-sided short jabots, or festoons overlapping a pole, or a combination of festoons and bells (the bells of which may be French-headed or flared and flat). Most valances, whether soft or shaped, are enhanced by the addition of cord (welt), fringe,

braid, or edgings on the finish edges, which come in an unlimited range of color, scale, and design.

Most valances, cornices, draperies, and curtains must "return" to the wall (except in wall-to-wall treatments). What is called the "return" should not, generally speaking, exceed 6½". This is ample for draperies, casement curtains, and valance, unless a radiator or other obstacle protrudes into the room. In that case, one must search for the best solution, but not make the "returns" greater. One solution is to change the radiator to a concealed-in-the-wall model or a modern slim line. Another is to have the casement curtains extend only to the radiator and the draperies permanently tied back. Each window treatment is unique and must be approached individually. This principle is particularly true today because of the lack of architectural detail in construction, the existence of beams, and the lack of balance in layout of windows in modern buildings.

There is no rule about whether a valance should be used. Often a window and room are enhanced by not using one, particularly a low-ceilinged room where the addition of a valance would make the ceiling look even lower. It is also unnecessary when curtains or draperies are together in the center and tied back at the sides, when a curtain pocket is recessed into the ceiling, or when an elaborate cornice or pediment crowns the window.

Casement windows that open inward often automatically eliminate a valance unless there is sufficient space above for the valance to project upward with the bottom just above the open casement window. In this event, one might consider a valance with a shape on top and a straight bottom.

When valances are not used, some of the equipment (hardware) for hanging the draperies remains visible. However, there is a broad selection of attractive and functional hardware, and again one should exercise care in selection. Metal poles, generally brass or brass-plated, or wood poles, generally lacquered to match the curtains or wall behind, may be used. These should be of 1½" diameter for brass or 1⅜" diameter for wood. If it is desired to *conceal* all the hardware when the curtains are closed, 2" wood or hollow brass rings must be used on the pole and the curtains must be headed with 5" crinoline, sewing French heading hooks down 3½" from the top of the curtain to the top of the hook. When the curtains are open, all that is seen is the pole and drawcord. If it is desired to see the rings and pole, finials must be included on the pole ends, and the brackets that support the pole should be painted to match the wall. When this arrangement is used, it is not advisable to use drawcords, since then the pulleys, which are unattractive, will also show. Instead, they should be drawn by hand pulls of the curtain fabric or metal batons from the center hooks.

Unless hardware is ornamental and part of the decoration, it should be as inconspicuous as possible. Where ceiling tracks can be used, the solution is simple, since there are several tracks available for this purpose which include a drawcord mechanism that is concealed. A curved or angled wall or bay window that is not having a valance works best with a heavy-duty I-Beam ceiling track that has a flange in the back to screw it into the ceiling. This flange must be cut with a hack saw for ⅜" approximately 1" apart so that the track can be bent to follow the curve or angles. Again, as in the case of the exposed pole, drawcords do not work, so a cloth pull or baton is used for drawing. Hardware used with drawcords (made with a system of cords and pulley) is referred to as "traverse hardware."

Draperies and valances may be given interest and at the same time symmetry of folds by means of headings, pleated or shirred. For draperies and curtains the pinch pleat or French heading is the most often used and most satisfactory. This consists of pleats pinched or stitched into folds at the base of the heading

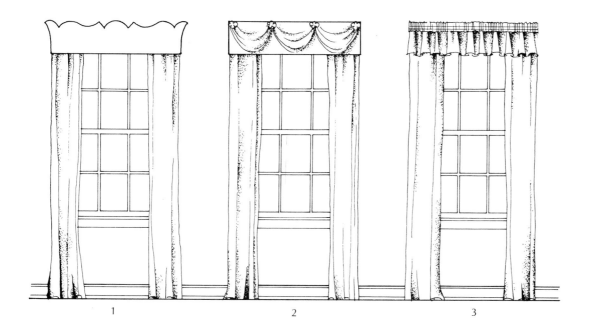

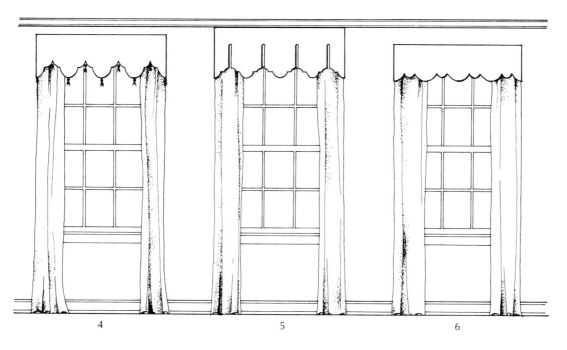

1, 2, and 3 are examples of valance styles that can be suggested for use where valance cannot extend below window trim line, as where windows open into room (French doors and/or windows. Valance 1 is shaped at the top. Valance 2 combines a stiff valance with soft festoons and rosettes. Valance 3 is a soft shirred valance with three rows of cord at top. 4, 5, and 6 are examples of stiff shaped valances. Note that the more extreme the shape the deeper the valance may be, and still be in proper scale. Note also that shaped valances should have an odd number of points and should end with ½ point.

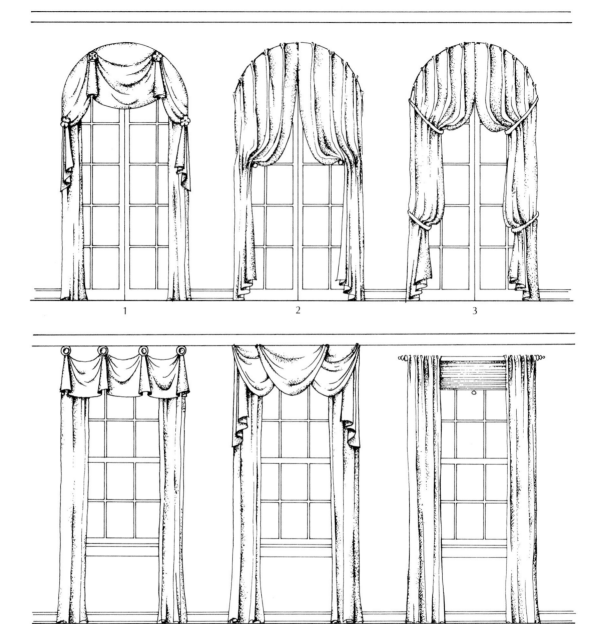

Various treatments for arch top windows. The elaborate valance of 1 conceals a draw cord pole arrangement so the draperies can be closed. Treatment 2 is a theatrical draw; it does not have tie-backs, but operates on separate cords for each curtain and can be lowered to hang straight. Treatment 3 is a double tie-back arrangement that would be impractical to open and close. Valance 4, festoon and bell arrangement with rosettes of fabric, knobs, or rings at the top. Valance 5 is based on festoon and jabot arrangement, using three festoons of the same size. Window treatment 6, straight hanging draperies to draw on heavy brass or wood pole (1½-inch diameter) with or without finials. Note woodloom shade from behind pole to conceal top of window line and increase height.

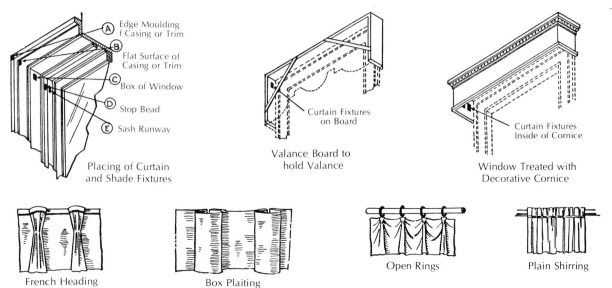

A — Edge Moulding f Casing or Trim
B — Flat Surface of Casing or Trim
C — Box of Window
D — Stop Bead
E — Sash Runway

Placing of Curtain and Shade Fixtures

Curtain Fixtures on Board

Valance Board to hold Valance

Curtain Fixtures Inside of Cornice

Window Treated with Decorative Cornice

French Heading

Box Plaiting

Open Rings

Plain Shirring

Miscellaneous details of drapery construction.

and alternate spaces of approximately 3½″ to 4½″ using a crinoline (stiffening material) of 5″ in full-length curtains or draperies where the heading is exposed (no valance) or a 3″ crinoline where the heading is covered by a valance. When a valance is used, a flat pleat or box pleat is also used on the draperies or curtains by most workrooms as a labor saver. However, the curtains do not hang as well in folds as they do when pinch-pleated, which represents additional labor. A shirred heading generally is used only when there is no valance, and again a 5″ crinoline in-heading should be used. Usually, this consists of four rows of shirring and gives the appearance of smocking.

All these headings are also used on valances, and the pinch pleat and shirred heading are used most often as headings for arch-top windows.

Casement curtains or draperies of lightweight fabric are properly weighted at the bottom of the hem with string weights, whereas draperies are generally weighted with large weights only at the center (front) corners and

on the seams. All sheer fabrics should have double-fold hems at the bottom as well as the sides, and the bottom hems should balance the length of the curtain, full-length having 6″ bottom hems and sill length no less than 4″ bottom hems. Casement curtains and draperies made as pairs normally have a smaller hem on the return sides and larger hem (1¼″) on the center or front sides. As a result, the curtains and draperies are not interchangeable. Whenever possible, they should be made with double fronts so that curtains and draperies can be reversed in the event of fading front edges. However, this can be accomplished only when the "returns" are equal to the distance of the first pleat from the front edge of the curtain (3¼″).

Drapery and curtain fabrics. There exists an almost unlimited variety of fabrics for use as draperies and/or casement curtains. It is important to note that the fabric used for draperies has a direct relationship to the fabric of the casement curtains. For example, a light- or medium-weight drapery fabric such as taffeta,

chintz, moiré, or damask could have a casement fabric of cotton, silk, dacron, or fortisan. Heavier or coarse drapery fabrics could have more weight to the casement curtains using linen, cotton, textured raw silk, etc. Casement curtain fabrics include net, lace, voile, marquisette, batiste, taffeta, and organdy, and are made of natural fibers of cotton, silk, and linen or synthetic yarns of ninon, nylon, fiberglas, rayon, dacron, fortisan, and often a combination of yarns such as rayon and cotton or fortisan and cotton. Tambour curtains (embroidered cotton) are used extensively and are purchased in panels, generally as pairs, in various widths and lengths, and often have matching valances.

Drapery fabrics are ordinarily heavier in weight than casement fabrics and include taffeta, rep, velvet, corduroy, toiles, chintz, cretonne, satin, moiré, damask, brocades, textures, matelassé, stripes, plaids, and woven patterns. These are made of yarns including natural yarns of silk, cotton, linen, wool, and horsehair or synthetic yarns such as rayon and fiberglas. One can have a combination of natural and/or synthetic yarns such as a rayon and cotton damask or a linen and cotton texture.

Some fabrics are not dimensionally stable and tend to shrink or stretch with change of atmospheric conditions. These should be avoided whenever possible. Mainly, the natural fibers are the most reliable, though if loosely knit even a linen can "travel." Some synthetics, such as dacron, are also stable. There are other fabrics of a distinctly contemporary character and weave that, although very attractive, present the greatest stability problem.

Chintz and toile are used extensively in period American, English, and French informal rooms as well as in contemporary decoration. In the more formal rooms of these styles, damasks, brocades, stripes, or velvet are more appropriate. This is not to say that a damask, stripe, or velvet should not be used in an informal setting. Factors of color, texture, fiber, and period of design enter into all selections.

Velvets, cut velvets, damasks, brocades, brocatelles, woven tapestries, and stripes are used to advantage in Spanish and Italian period rooms. Chintz and damask, satin and satin stripes, velvet and velour were all used extensively in the Victorian era.

In contemporary living all fabrics have their place and usage. The main test is one of aesthetics. There are few hard and fast rules that "this will not go with that." However, one should consider that the type of fabric to be used for windows depends upon the general character of the room and the style of the furnishings. Formal rooms call for formal types of fabrics like silk, satin, damask, and brocades, whereas informal rooms are best suited to prints, chintz, plaids, stripes, checks, and plain and design textures.

It is not possible to determine by any set of standards whether a figure or plain fabric should be used for draperies. Patterns unquestionably can produce a gay effect, whereas plain fabrics are more restful. The choice again is a matter of taste and desire. Monotony should be avoided, and the different rooms of a residence should be treated with varying materials in order to provide variety. However, there should be some factors of color, scale, and design that tie together the various rooms.

Many correct rooms will have plain fabrics for window decoration with patterned walls, or vice versa. Again, rooms can have great interest and charm with matching fabric and wallpaper, and indeed this approach is used widely. The use of other fabrics here would be of paramount importance. To avoid monotony, generally it is wise to introduce other fabrics and textures to correlate and harmonize with the matching fabric and paper. Often more than one pattern is used successfully in the same room, but this technique must be used with great care.

If pattern fabrics or pattern fabrics with matching wallpaper are to be selected, the most minute attention should be given to the character and scale of the pattern versus the character and size of the room.

Drapery linings. The lining of draperies adds to their durability, reduces fading, permits them to hang better, and gives them a weightier appearance. The weight, character, and design of the fabric should determine whether draperies ought to be unlined, lined, or lined and interlined. However, most draperies should be lined with sateen. The percentage of draperies lined and interlined is rapidly diminishing because of the addition of Milium sateen, which serves much the same purposes of interlining (durability and reducing of fading). Milium sateen's problem of being gray or silver on the side that faces the fabric caused the fabric itself to "gray" on the right side. But this problem has been eliminated with the availability of Milium that is white on both sides and can therefore be used to line white ground chintz or other lightweight or translucent fabrics. Although Milium lining is twice the cost of sateen, it more than compensates by eliminating the necessity of interlining. The same problem of color change to the right side of the draperies also occurs when one uses a lightweight or translucent fabric and lines it with regular sateen of an ecru or putty color. The penetration of daylight through the lining and drapery fabric tends to "yellow" the appearance of the curtains on the inside of the room. This effect can be avoided by using white sateen or white-on-white Milium almost exclusively, the exceptions being in an all-beige room with a beige fabric or with a heavy fabric where no light can penetrate. It is well to hold fabric and linings against the light to determine which lining to use.

Occasionally, a glosheen or colored stain is used for lining, but generally this should be interlined with white flannel. Interlining with flannel also becomes necessary if the same or contrasting fabric is used on the lining side, as on draperies across an open arch separating two rooms. These are usually referred to as "portiers."

The cost of labor is a factor in determining how draperies are best made. Most of the best workrooms sew the front and return hems by machine and the bottom hems by a blind-stitching machine. However, in the very finest of fabrics and workmanship, hand-sewn hems are still to be considered. The fabric and sateen are "tacked" or stitched together in the hems by hand stitching with a cotton thread matching the fabric. In the same way, the fabric and sateen are joined together throughout the curtains with rows of loosely pulled threads. This technique is referred to as "tacking" and is not used in commercial workrooms. The more labor involved, the finer the workmanship, but also the higher the cost.

Trimmings. Many draperies and curtains require a trimming or edging to give them a more finished effect. Because of the constant changes in style and fashions of interiors, trimmings are either discontinued or added to, but there are always available many varieties from which to choose. Frequently, a fringe or edging that is selected is not available in the necessary color, and a "special order" is required. Most fringe sources will make a fringe in any color or colors, but a minimum yardage is required, and an increase in price is necessary. The general character of the fabric and room decoration usually dictates the style and colors of the trimming.

Trimmings will include braid, bias fold edges or tapes, and fringes. Fringes have a very wide variety in design and size, color and material. The principal types are the cut, loop, bell, tassel, and mold. Among the cut and loop fringes are those known as moss, boucle, bullion, scallop, and chain. Tassel fringes are made

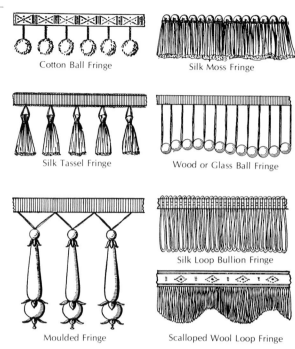

Cotton Ball Fringe

Silk Moss Fringe

Silk Tassel Fringe

Wood or Glass Ball Fringe

Silk Loop Bullion Fringe

Moulded Fringe

Scalloped Wool Loop Fringe

Examples of various types of fringes used for draperies and upholstery work. The loop, moss, tassel, and cotton ball types are also used for slipcovers.

on a heading or gimp, as most fringes are, and can be combined with a loop or scallop loop, and the tassels themselves can be either finished cut or uncut. Ball fringes can be had in silk, cotton, wood, and crystal. Molded fringes consist of round or elongated wooden turnings that are wound with one or more of a variety of yarns. The molds come in diverse shapes, such as pendants, drops, and balls, and are hung from a heading or galloon by an interlacing network of twisted strands of fiber. Mold fringes were used on draperies in the eighteenth and nineteenth centuries. They are very formal and elaborate and very expensive, since much of the fabrication is by hand work.

Tiebacks. Tiebacks may be made of the same fabric as the curtains, or they may be of rope, cord and tassels, or other contrasting materials.

Their selection depends upon the style of the curtains and the texture of the fabric. The usual and least expensive tiebacks are of the curtain fabric and can be a soft double fold or made on a shaped buckram that must be interlined on both sides of the buckram as well as lined. A 3/8" ring is sewn on each end of the inside of the tieback to attach to a hook on the wall or window trim. There are more ornamental tiebacks made of carved wood, pressed metal, glass crystal, or mirror or a combination. The cord and tassel and the self-fabric styles are the more frequently used.

Drapery measurements. Accurate measurements are of primary importance for the fabrication of the window treatments and for the estimating of yardages required. For accurate measurements, the proper tool or ruler is mandatory. A lightweight, metal-spring type of ruler is too flexible to measure to some heights. A wooden ruler can break too easily. Therefore, the best tool for this purpose is a heavy-duty twelve-foot ruler of the spring type. When measuring windows, all possible measurements required should be taken precisely. A rough floor plan should be drawn and the arrangement of windows placed thereon. Each window should be measured and the measures listed under the window to which they refer. Only one rough elevation drawing is generally required to show the style of the windows and the trim measurements. A camera such as a Polaroid instant development is a great asset for a true visual presentation. An abbreviation or code should be used to denote the measurement meaning and to save time in measuring. For example, if one is measuring from the "top of the window trim to the floor," one could code this as "TWF" or the "width of the window casing or trim" as "WC" or "WT."

To determine the amount of fabric needed for the window or windows, it is most important to have the *exact* repeat of the fabric and

the true usable width of the fabric as well as the accurate measurements mentioned above. All too frequently fabric sources list repeats on their printed identification tags inaccurately by as much as 3". On a large repeat, a 1" error can greatly increase the needed yardage and therefore the costs. An example would be a fabric listed as having a 27" repeat on the tag that is to be used in a room having four windows that require three widths per pair (1½ widths each side of the window) or 12 widths or lengths for the four pairs. After accurately measuring, we find our "finish length" to be 103½"; from the pattern repeat of 27" we multiply by four repeats and have cut lengths of 108" and a 4½" allowance over the finish length for hems; therefore 3 yards each cut length x 12 lengths required or a total of 36 yards, plus one extra repeat for starting of pattern, or 36¾ yards. For the illustration, we estimate the costs based upon the 36¾ yards required, only to find upon cutting that the tag is in error by 1" and the repeat is, in fact, only 26". If we multiply the actual repeat by four, we have cut lengths of only 104", which cannot in any way become a finish length of 103½". Allowance of 4½", though not ideal, is usable for lined draperies with 3½" used as a single hem on the bottom and a 1" fold-over at the top. If we had, in fact, physically measured the pattern repeat and knew it to be 26", we would have purchased 5 repeats per length (26" × 5 repeats = 130" or approximately 3-2/3 yds. per length × 12 lengths or 44 yds. The 2" added to 130" to make the 3-2/3 yards cut would allow for the extra repeat to start cutting). In other words, had we ordered the fabric based upon the inaccurately listed 27" repeat, we would be short 8 yards—the 36 yards ordered versus the 44 yards required. This, due to the 1" error in repeat.

The same importance applies to the width of fabric, mainly in cases of printed fabrics, as the stated width may be 50" on a tag but the usable width only 46" (due to a selvage edge of 2" each side). In addition, it is often necessary to overlap fabric 1" to 2" on each side to match seams when draperies require more than one width each side of the window. Most draperies should be 100 percent full; therefore, if a window measures 39" wide and we require only 3" returns on each side, add 6" plus 3" for overlap, and we now have a finish width per pair of 48". Add to this 3" for front and return hems, and we require 2 widths of a full 50" fabric per pair to be 100 percent full. If the fabric *printed area* is less than the 50" stated on the printed tag, these draperies would be insufficiently full, and additional width might be required.

Draperies that are lined are best with single hems at the bottom, since double hems become too bulky and do not permit the draperies to hang properly on folds. Casement curtains should have double hems of 6" (or 12") at the bottom, plus double the amount of the depth of the heading at the top; 5" crinoline requires 10" additional.

Window shades. The most widely used method of securing privacy and control of daylight in a room is by the roller shade operated by an interior coil spring and hammer catch imbedded in a wooden roller at the top. The preferred fabric for this shade is known as "No-lite," since it is opaque. It is standard in white and various shades of off-white and is durable and washable with a damp cloth. Roller shades of this type generally are installed between the window jambs; however, more light is eliminated if they can be installed on the outside flat surface of the normal window trim.

Window shades are often made with printed fabric or wallpaper laminated to the fabric surface; they can have any of various decorative additions below the bottom pull slat, such as scallops with or without a fringe, rows of braid, or a variety of tassel or ring pulls. However, shades should be simply made, unless they are to form a major part of the window treatment.

Venetian and woven wood blinds. Venetian blinds have been in existence in one form or another since the days of ancient Egypt. Their principal advantage is that they permit light penetration and ventilation to a desired degree and at the same time afford privacy. They are available in many stock colors, finishes, and tapes and can be made to order with any color of finish or tape. Slats are usually made of wood but may be had in aluminum, plastic, or steel. Venetian blinds can be quite heavy to draw up, depending upon their size. The newest blind of this type is called "Levolor" and is basically a venetian blind. However, the slats are aluminum and very narrow. They are available in a vast range of single colors, which can be arranged in alternate colors. Nylon cords are used in place of tapes, and a baton is attached to regulate the angle of the slats. The greatest advantages are their light weight and easy maintenance.

Another style of blind based upon the venetian blind is the vertical shade which is made in strips of no-lite or translucent fabric that pivot at top or at top and bottom rather than on the sides as with venetian blinds. These strips of fabric overlap when closed for maximum light elimination or privacy. The vertical strips serve to heighten the appearance of the room, whereas the venetian type with horizontal lines tends to decrease the appearance of height.

There is another general classification of blinds known as wood woven or aluminum woven blinds. They are available in many stock colors and finishes and can be made to any specifications. These include slats of flat wood, bamboo, or aluminum in various weights and thicknesses and have trade names such as "Bambino," "Woodloom," and "Temlite." Some are interwoven with colored yarns to form decorative stripes; all can be decorative as well as functional. They are all designed to reduce glare and permit adequate ventilation, and they can be operated by a spring roller at the top or by a "roll-up" process from the bottom, or they can be pulled up like a Roman shade or be drawn vertically. Complete privacy is afforded by certain styles such as "Temlite," which has beveled slats that overlap.

There remain two styles of shades or blinds that should often be considered. One is the Austrian shade or blind that has been in use for many generations. In appearance it consists of rows of lightweight fabric that fall into deep scallops, their depth dependent upon how closely together they are seamed. Normally they should be in excess of 150 percent fullness and are generally finished at the bottom with an edging or fringe. Often, weighted tassels are sewn between the scallops, but there is always a heavy rod on the back side to weight the blind down. A drawcord arrangement operates the blind up or down. The second blind operates in the same manner as the Austrian blind and is called a Roman shade or blind. When made of fabric, a Roman shade pleats up in folds, and when down has a flat surface. It is best lined with sateen and interlined with pelon, and the pelon is pre-creased to effect the proper fold when drawing up.

Slipcovers. Slipcovers offer many excellent opportunities for introducing color and pleasing design into a room that would otherwise appear dull and cheerless. They add an informal atmosphere in either summer or winter months and also serve for recovering shabby or uninteresting furniture that does not harmonize with the other decorations. Slipcovers are valuable, also, for the protection of furniture.

When choosing material for slipcovers, the character of the room should be considered, as well as the type of chair or sofa to be covered. In general, so far as the pattern is concerned, the same principles should be applied as when selecting any other type of upholstery material. The laws of harmony and contrast should be considered.

As a rule, slipcovers should be made of the medium-weight fabrics, such as glazed and unglazed chintzes, plain and printed linens, cre-

tonnes, plain and striped taffetas, satins, sateens, and silk and cotton reps. Other materials which are often suitable are plain and striped poplins, ginghams, and linen crash. Patterned fabrics may be found in practically all of the above-mentioned weaves to harmonize with period or modern rooms. Sometimes plain fabrics require contrasting colors in the piping or welting to give them additional interest. Where economy is to be considered and no particular style is to be adhered to, there are many varieties of inexpensive chintz and cretonne with all-over flower patterns which are always in good taste. Checked ginghams and percales are smart and effective and can be found in striking color combinations. For sun areas and semi-outdoor rooms, plain and striped sailcloth is very durable and makes striking and colorful slipcovers. There are also waterproof plastics and plastic-coated fabrics. Slipcovers should always be dry cleaned to prevent shrinkage.

For the purpose of obtaining unity in a room, some of the furniture covers may be in the same material as the curtains. In many instances, a colorful glazed chintz that has been chosen for the curtains may be repeated in slipcovers for one or two chairs or a sofa. Plain, printed fabric of small repeats, striped, or checked fabrics should then be combined to complete the room.

In selecting slipcovers as well as upholstery materials, the shape of the piece to be covered must be considered in selecting a pattern. Chairs and sofas that are mainly rectangular in form may be covered with stripes and plaids as well as large floral and irregular all-over patterns, but curvilinear furniture most often would be covered in irregular patterns. It is dangerous to use different patterns to cover the largest chairs and sofa. If a chintz is used for both draperies and upholstery, it is better to use the same patterned material for both. Slipcover materials should always be of a firm and closely woven type. Sleazy fabrics do not hold their shape or po-

sition, and are apt to tear at the seams and to permit dust to infiltrate. Slipcovers may have a skirt of kick pleats, box pleats, or shirring at the bottom. The upholstered slipcover is tied or tacked to the underside of the seat, which holds it firmly in place and accounts for its popularity. Seams are finished most often with a welt. The self-welt is made out of the fabric itself cut on the bias, or a ready-made or special welt may be obtained in a color contrasting to the slipcover material. For added interest, a moss, chenille, or short cut fringe may be used in the seams. Fringes are especially advantageous where plain color fabrics are used.

Accurate measurements for slipcovers and upholstery are difficult to take, and it is always wise to require the tradesman who is to do the work to take his own measurements. The disadvantage in this system is that the tradesman is usually liberal in his allowances, and he is not careful about wastage; therefore, it is always a wise precaution for a decorator to be able to check the yardage.

One of the most important points to remember in the making of a slipcover is that it should have a strictly tailored appearance. A very untidy effect is produced, and wearing quality is greatly lessened, if wrinkles are in evidence or if a tight fit is lacking. It is very difficult for an amateur to cut and make a professional-looking cover; proficiency comes only after considerable experience.

UPHOLSTERY

One of the most vital subjects concerning which a decorator should have a thorough knowledge is that of the construction and materials used in upholstered furniture and sleeping equipment. These are among the most important home furnishing articles that the average family selects. A guarantee of comfort in the home is as essential a part of a decorator's service as his advice regarding appearance.

Whenever possible, upholstered furniture should be custom-made, but if cost forbids, the decorator should investigate the character of ready-made stock, should be able to recognize the earmarks of quality, and should be able to discuss intelligently the specifications of the intended purchase with the manufacturer or salesperson. The laws of many states require that labels be attached to all upholstered products giving information as to the internal contents; however, the laws do not require data regarding construction quality. Externally, two upholstered pieces may look alike, yet one may have twice the durability of the other because of the differences in internal materials and construction. The slightly higher cost of one may be entirely offset when measured against years of comfortable service.

Co-relating upholstery textiles. In decoration, upholstery textiles must first be considered from the angle of their cost, suitability, and durability. Next, their relationship to the ensemble of the room must be considered, and this relationship will depend mainly on pattern and color. Walls appear as backgrounds to chairs and sofas placed against them, and floor coverings must be considered in their effect upon freestanding pieces. Contrast of upholstery materials with their backgrounds is usually advisable, and it may be obtained in any one or more of the usual methods, such as texture, tone, color intensity, hue, or the use or omission of pattern. Care must be taken to avoid an excessive use of patterned upholstery in a room, particularly if patterned wallpaper and a patterned floor covering is used. An excess of plain surfaces is less objectionable than an excess of patterned ones; the former is restful and may be given interest by variations in texture and color. Stripes and plaids produce a medium degree of animation, are less disturbing than elaborate patterns, and harmonize well with both these and plain colors. Plain-colored upholstery usually looks

best, but greater interest may be given if contrasting colored welting cords or chenille fringes are used with it. Patterns and weaves should be in character with the style of the room and with the character and scale of period furniture. Large all-upholstered sofas and chairs may be used in rooms that are otherwise treated in a period style, and such pieces need not be covered in period-patterned textiles. All the large upholstered pieces forming conversation groups do not have to be covered in the same materials, but some attempt at balance should be made. Where a sofa faces two chairs, the sofa may be in a different material from the chairs, but the chairs should be treated in a manner similar to each other, and unity is always increased if, in the welting, fringes, or patterns, there is some repetition of colors in the facing units. The use of several different chintzes in a room is usually inadvisable. When draperies consist of a *strongly* patterned chintz, the same chintz may be used on some of the larger upholstered pieces, but a different patterned chintz can be disturbing. In patterned wallpapered rooms a better effect is attained by using plain, striped, or plaid upholstery coverings in colors that repeat some of those used in the wallpaper. It is better to attempt to distribute evenly the patterned textiles used for furniture, rather than to concentrate them at one point. Matching wallpaper and fabric is enhanced with the addition of plain textures and correlated colors on upholstered furniture.

Upholstered furniture. Integrating cushions with the framework of furniture dates only from the time of the Renaissance, and the modern all-upholstered chair was first made in France in the middle of the nineteenth century and was called a "comfortable." This type replaced the bergere. Its origin may have been inspired by the Turkish divan, and it was the first seat that permitted one to take a semireclining position. Since that time many changes and improvements have occurred.

The decorator is often obliged to purchase ready-made upholstered furniture in which the construction and stuffing (filling materials) are entirely hidden from view. There are always a few visible clues to quality (such as the aforementioned label), but the reputation of the manufacturer or dealer is the principal guarantee. The price range is most often an indication, and, in addition to the upholstery label, some furniture has a label that indicates the primary and secondary woods used. Unfortunately, the upholstery label does not indicate the type of construction but only the filling materials used (stuffing or padding). As far as the consumer or decorator is concerned, there are principally three labels to consider—a white label, which must indicate all new filling materials, and two yellow labels, which have different purposes, one to indicate *unknown* filling materials and which may be attached, for example, to an antique or second-hand piece of upholstered furniture by a dealer, the other to be affixed by an upholsterer when reupholstering or recovering (on which he must indicate any filling materials added to the existing ones). All new filling materials are sterilized, and any filling materials added in reupholstering must be new and sterilized.

The best quality of upholstered furniture has cushions of goose down and feathers; in addition, to continue the soft, luxurious look of down and feathers, the inside back and arms may have down pads. However, this additional feature will be found in only the most expensive upholstery. As to quality, the best mixture is 80 percent white goose down and 20 percent white goose feathers. Gray goose of the same mixture is also top quality but slightly less expensive to the manufacturer. As to filling materials for the "body" of the piece, a label may indicate horsehair 60 percent and cattle tail hair 40 percent (the mixtures must always total 100 percent). This hair mixture is an excellent filling material. On the basis of finding such good quality filling materials as 80-20 goose down

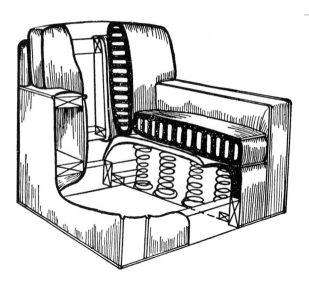

An upholstered chair showing method of construction when rubber cushion and back are used.

and feathers and 60-40 horse and cattle hair, one could be confident that the construction was really first quality. This example is not intended to imply that foam rubber, polyurethane, or dacron are bad as filling materials. Each filling material has its good and bad points and limitations. For example, foam rubber (used extensively in contemporary furniture) has a hard look and will deteriorate by first becoming hard and then rotting to powder. This deterioration will take place after several years, depending upon usage and climatic considerations. "Poly" tends to shrink, dacron to flatten. Therefore, the natural materials—down and feathers and hair and cotton—tend to be the best, whereas the synthetics involve more problems and have less wearability. Cushions of spring units, waterfowl feathers, and chicken or turkey feathers should always be avoided, as they are used only in upholstery of very poor quality.

One can tell a proper seat construction by "feel." Coil springs in the seat of a sofa or chair with a webbed base indicate good construction. One should avoid any furniture which is labeled or advertised as having "100 percent nonsag

construction." This furniture is of the very cheapest quality. Its construction consists of a zigzag bent-wire spring and no webbing, and can be felt with one's hand under the cushions.

If any wood is exposed, one can easily identify the wood unless it has a painted finish. If there is any carving, its quality is a clue to the quality of the construction. The greater one's knowledge of these details, the more valuable one's service as a decorator.

The best upholstered furniture is always custom-made, and the price quoted will be the "muslin price." This price includes the finishing of the piece, but the decorator supplies the fabric. Often, instead of saying the chair is "$600 retail in the muslin," a dealer may say, or a label may read, simply "$600 COM." The "COM" means "customer's own material," or the same as "in the muslin." By having work custom made, the decorator-designer can establish his own standards and reputation by specifying the filling materials and general construction used throughout the piece. He should therefore have an intimate knowledge of this subject.

Upholstery construction.

FRAMES. The first essential is a well-made frame. The best wood for this purpose when fully covered with upholstery is birch; however, other woods, such as poplar, soft maple, gum, and sycamore, may be used. Some harder and softer woods may split or crack from excessive tacking. These include oak, ash, hickory, and pine. Soft wood such as pine will not "hold" tacks and should be avoided. Frames should never be nailed, but rather doweled with spiral-grooved dowels which are glued into position. Hot glue is now seldom used and has been replaced with a white casein cement which is stronger and cleaner than the old hot glue pot that every workshop had to endure. (The odor was most unpleasant, and a drop of the glue on the fabric was usually fatal, requiring replace-

ment.) Corner blocks are essential to a well-constructed piece and, although glued, are usually screwed as well. Incidentally, corner blocks can be of a secondary wood, and, in cases of upholstered pieces which have wood showing, they most often are. As an example, a side chair of mahogany would have an inner frame and corner blocks of birch. There would be no point in wasting mahogany on the areas which are covered.

Webbing for seats should be of pure jute 4" wide and generally have four red lines woven into the warp to indicate seat webbing. Back webbing is also of jute but is generally 3½" wide and of a lesser weight, with black lines woven into the warp to indicate back or arm webbing. The webbing should be as near to 5" centers as possible, tightly stretched and interlaced with a 1" turnover at ends. In seats not webbed, nonsag units or wood or steel bars may be used, indicating inexpensive, poorly constructed seats that should be avoided.

SPRINGS. Coil springs of tempered wire knotted at both ends are used on seats and backs and sometimes on the tops of arms. These should be sewn to the webbing or stapled to the end slats or wood arm tops and should be close together, but not touching. In the case of end slats, a strip of webbing is attached to the slat to prevent the noise of the spring hitting against the wood. Seat springs are usually of a heavier gauge than back springs, and their height or size is dependent upon the desired height and firmness in the seat. The springs are tied in place to the desired compression with Italian eight-ply spring twine in two cross and two diagonal directions. Each cross cord is tied to two places in the top of each coil, making a total of eight knots for each spring. The ends of the spring twine are firmly tacked to the frame. The springs are then covered with ten-ounce burlap as a foundation for the filling material. The hair or other filling material is then applied over the burlap and affixed with stitching twine

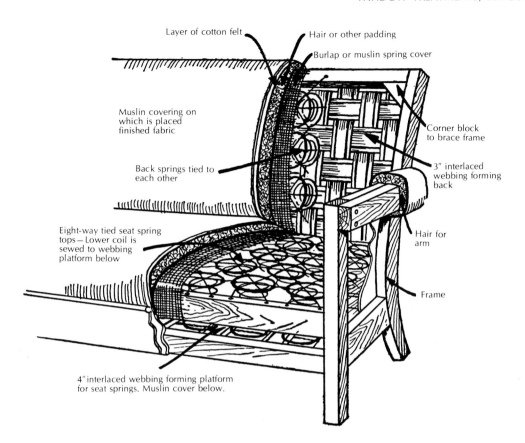

Diagram showing detail of construction of an upholstered seat.

to prevent shifting. In proper "double stuffed" construction, a second layer of burlap of eight-ounce quality is stitched through the hair and the original burlap to form a tight pad and stitched edge. Yet another layer of hair with stitching twine comes before the muslin. After the muslin, cotton felt or glazed cotton protects the fabric from hair penetration, or a down pad is used in very expensive construction. Filling materials such as kapok, moss, sisal, tow, excelsior, or seaweed should always be avoided.

TUFTING AND BUTTONING. Upholstered furniture often has a tufted back and arms with a loose cushion seat, or can be completely tufted. Tufting should not be confused with the less expensive button upholstery in which buttons

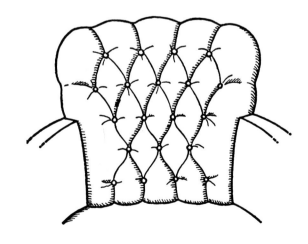

Sketch of chair back showing a combination of piping and tufting.

are tied through a flat surface of upholstery, causing a soft wrinkle around the buttoned area. Tufting is buttoned, but only after the tufts are made with an allowance in the finish fabric for "depth." As an example, to make a finished diamond-shaped tuft 3½" wide by 6" high, the upholsterer marks the flat surface of the sofa back every 3½" in width and 6" in height, but his fabric would be marked every 5" in width and 7½" in height to allow 1½" for depth. This allows for a deep fold in the fabric from button to button. The top and base of the upholstered piece generally end in a straight channel from the last row of buttons, and these are referred to as "channels." Some chair backs are upholstered with only the channels and are referred to as "channel-back."

FINISHING MATERIALS. After the final covering material is applied, a finishing material is always required where the upholstery ends and the tacks show and where the fabric joins the wood, such as on an open armchair with show wood or on the base of an upholstered piece which is all upholstered except the legs. Correct finishing materials—correct in that they have been in use for generations—include nail heads in various sizes and finishes, and are referred to as a "nail finish." Some nail heads are ornamental in that they have a pressed design as well. Another finishing material is single welting or cording, of the same or contrasting color or fabric. The use of a single welt on antique furniture denotes fine craftsmanship since the fabric must be hand-sewn to the welt where the welt joins the show wood frame and requires much tedious effort and skilled use of curved needles. A gimp, or braid, is also a "correct" finishing material, having been used for generations. A more recent adaptation of a finishing material consists of a double welt or cording, which can be contrasting in color and texture or of the same fabric as the furniture. Of recent origin (the mid-1920s), this finish would not be

"correct" on a fine eighteenth-century chair. However, it does create a splendid finish look, and, when the piece is not being used in a museum or restoration, it could be used. Whenever it is necessary to seam a fabric, such as on a chair with a curved interior (arm and back joining), a welt or cording may be used in the seam. However, this approach is not always correct and preferable, and one should consider whether a plain seam would not suffice.

Sleeping equipment. This classification includes mattresses, box springs, and pillows. Mattresses have been used since the dawn of civilization, but box springs with helical supports were not common until the middle of the nineteenth century. At the present time, the most comfortable bed is considered to be a box spring supporting a mattress made of hair, latex (foam rubber), or innersprings combined with hair and/or cotton felt. Individual taste dictates which of these interior materials shall be used, and all are good if quality and workmanship are good.

Mattresses are made with three types of edges, called *imperial, roll,* and *plain.* The imperial edge produces the most sturdy construction and is identifiable by two padded rolls or upholstery pipes that run around the mattress and four rows of visible stitching along the edge; the roll edge is similar in appearance but

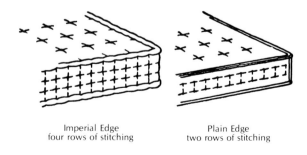

Imperial Edge
four rows of stitching

Plain Edge
two rows of stitching

Sketch showing difference in the construction of the imperial and plain edge mattress.

has only two rows of visible stitching; the plain edge has no roll and no edge-stitching except at the seams, which are often taped. The edges of all well-made mattresses should have small screened ventilators to permit the circulation of air.

Stuffed mattresses vary greatly. The best mattresses contain curled horsehair and have a 1″ layer of lamb's wool top and bottom with an imperial edge finishing 5½″ to 6″ overall, as described above. However, due to the high cost of the filling materials and the great skill required in the fabrication, only the very best of custom bedding manufacturers will attempt such a mattress, and then most reluctantly. As a result, the more favored mattress will consist of an innerspring unit with a layer of hair top and bottom, covered with a layer of cotton felt. (In some cases, the hair is the outside substance, and the cotton felt is against the springs.) These mattresses can be made in different densities—soft, medium, or firm—and are referred to as "innerspring hair and felt mattress, imperial edge." A less expensive version of this mattress would eliminate the hair and have an "innerspring and felt mattress, imperial edge." Quality suffers when cotton is used, since it lacks the resiliency of hair and tends to flatten or bog down. Still less expensive would be the above mattress with a plain edge. Most innerspring mattresses are tufted or buttoned to hold the centers of the mattress to a proper level. The best covering material for a mattress or box spring is an eight-ounce ticking. This fabric is available in many solid colors, stripes, and some floral designs.

Other mattresses consist of loose cotton or kapok and are the poorest in quality. Foam rubber or latex is used most frequently in sofa beds and has the advantage of being less thick than innersprings, finishing 4″ in thickness. It has great resiliency and can be ordered in firm, medium, or soft density. However, its drawbacks include the fact that rubber deteriorates

and that it is generally made of a flat 4″ slab with only a ticking or fabric covering. When custom-made, it is far better as a reversible mattress with "crown" (4″ outer edge and 5½″ to 7″ center) covered in a ticking or upholstery fabric.

Custom-made box springs consist of a strong wooden frame with coil springs properly affixed. Commercial spring units are generally all of uncovered metal. After the coil springs of the box spring are properly tied, the unit is covered with a ticking or burlap, and a layer of hair and/or cotton is applied before the outside ticking. The bottom can be covered in black cambric, muslin, or denim.

There are two shapes for box-spring sections, the plain and rabbeted. The plain type fits within the side boards of the bed and rests on the bed slats or metal angle irons, or, when no bed frame exists, can be furnished with legs. The edges of the rabbeted type are designed with a shelf that rests on the top of the bed frame. Beds that have a frame but no footboard should be equipped with the rabbeted type, but the plain box spring with legs will give the same effect if no bed frame exists. When a single decorative headboard is used for twin beds placed closely to appear as a double bed,

Rabbet Edge

Single Border

Single Border Dropped

Sections showing three ways of supporting a box spring on the side boards of a bed.

one or both box springs should be on casters and hinged to the side of the headboard to enable it to swing open for convenience when the bed is made.

Pillows may be stuffed with any of the materials that are used in upholstery cushions. The best quality pillow is filled with 80 percent down and 20 percent goose feathers. A down-filled pillow, if pressed, will quickly spring back to its original shape, and chicken quills can easily be felt by pressing the pillow with the fingers. In a damp climate, pillows are less resilient. Standard pillow sizes are 20 inches by 26 inches, 21 inches by 27 inches, and 20 inches by 36 inches. Ticking should be of the eight-ounce type, although other closely woven materials may be used. The six-ounce ticking makes a softer pillow but is less durable.

BIBLIOGRAPHY

Baer, Barbara. *How to Make Curtains and Draperies.* New York: McBride, 1950.

Bast, H. *New Essentials of Upholstery.* New York: Bruce Publishing Co.
Excellent illustrated handbook.

Bath, V. C. *Embroidery Masterworks: Classic Patterns and Techniques for Contemporary Application.* New York: Regnery, 1972.

Birren, Faber. *Color for Interiors: Historical and Modern.* New York: Hill and Wang, 1963.

Dal Fabbro, Mario. *Upholstered Furniture: Design and Construction.* New York: McGraw-Hill, 1969. Illustrated text.

Davis, M. J. *The Art of Crewel Embroidery.* New York: Crown Publishers, 1962.

DuBois, M. J. *Curtains and Draperies, A Survey of the Classic Periods.* New York: Viking Press, 1967.
A well-illustrated survey of traditional drapery designs.

Enthoven, Jacqueline. *Stitches of Creative Embroidery.* New York: Van Nostrand Reinhold Co., 1964.

Fitman, M. *Upholstering.* New York: Drake Publications, 1972.

Gatz, K., et al. *Curtain Wall Construction.* New York: Praeger, 1968. Illustrated text.

Halse, Albert O. *The Use of Color in Interiors.* New York: McGraw-Hill, 1968.
Chapter included on application of color to window treatments.

Hartung, Paul. *Creative Textile Design: Thread and Fabric.* New York: Van Nostrand Reinhold Co., 1964.

Helsel, Marjorie Borradaile. *The Interior Designer's Drapery Sketchfile.* New York: Watson-Guptill, 1969.
A collection of sketches of drapery designs arranged by categories: period designs, tie backs, and valances.

Luna, B C. *Upholstery Refinishing and Restyling.* Chicago: American Technical Society, 1969. Basic textbook.

Peluzzi, G. *Tendaggi Moderna e di Stile.* New York: Wittenborn, 1967.

Picken, Mary Brook. *Sewing for the Home.* Revised and enlarged editon. New York: Harper and Bros., 1946.
Contains clear step-by-step instructions, illustrated by diagrams, for making various types of slipcovers, draperies, etc.

Seager, C. W. *Upholstered Furniture*. New York: The Bruce Publishing Co., 1950.
 Well-illustrated handbook giving the fundamentals of fine upholstering work.

Stephenson, J. W. *Practical Upholstering*. New York: Hall Publishing Co., 1950.
 Well-illustrated handbook giving the fundamentals of fine upholstering work.

Stephenson, J. W. *Drapery and Slipcover Cutting and Making*. Revisions and additions
 by Stephen Fridek and Wm. O. Hall. New York: Hall Publishing Co., 1950.

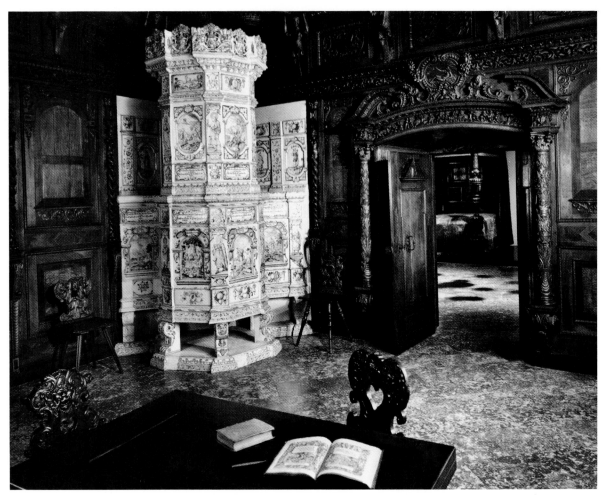

The stove of Winterthur tiles painted with Old Testament heroes was designed for a Swiss ambassador ca. 1682–85. The stove was stoked outside the room, and warmed a snug shelf for winter dozing.

CHAPTER 19

Ceramics and Glassware

Leaded glazed earthenware Staffordshire statue of a horse by Ralph Wood the Younger, 1748–1795.

The smaller decorative accessories of a room contribute to its character and color scheme, utilize space, arouse curiosity, express dignity, provoke humor, and reflect the culture, judgment, and interests of the owner. Among the most useful articles to accomplish these ends are the ornamental clay products of the kiln known as *ceramics*.

The making of pottery, apart from primitive assays in basketry, marks man's first tangible expression of emergence from primitivism to membership in a civilized societal organization. Archaeological discoveries show that it existed in all parts of the prehistoric world, and, interestingly, these early peoples simultaneously produced similar forms and the same basic painted or inscribed designs. As various specific cultures emerged, each developed individual expression resulting in an exciting array of forms.

CERAMICS

Types of ceramics. This generic term is derived from the Greek *keramos*, meaning specifically potter's clay. Ceramics is divided into three classifications essentially based on the physical properties of the material.

EARTHENWARE. Nearly any basic clay material often found at riverbeds can be shaped, cast in molds, or turned on the potter's wheel. It is fired at a low temperature. When earthenware is subjected to relatively high temperature, it assumes greater hardness and density. Typical are the sixteenth- and seventeenth-century early stonewares of Germany and, in England, the basalt wares produced by the factory of Wedgwood. Earthenware is porous and opaque. Its color varies from pale tan to reds and browns according to the chemistry of the particular deposit. As is true of all ceramics, it may be glazed or unglazed. Molten vitreous substances, usually transparent in nature, can be applied in a second firing. The methods of decoration are numerous. They include sgraffito, a technique of scratching the surface of the unfired clay, and painting upon the fired clay or upon the finished glaze. Hence the terms *under* and *overglaze* decoration. Production of earthenware varies from the mean terra-cotta flowerpot to the highly sophisticated pottery of the turquoise glazed faience of the ancient Egyptians and the products of Athens during the golden age of the fifth century B.C., the startling cobalt blues of the early Near East, rare tin glazed majolicas of Renaissance Spain and Italy and the famous eighteenth-century delftware of Holland, Bavaria, and England.

Through hundreds of years the careless employment of terms by many well-meaning writers has created some confusion concerning the various subdivisions of ceramics. It will be

Metropolitan Museum of Art

Ewer with cover from Sceaux of the eighteenth century.

helpful to realize that the following are synonymous with earthenware: pottery, majolica, faience, and delftware, the last term derived from its geographical center of production.

PORCELAIN. True porcelain probably originated in China, where it is known to have existed in sufficiently large quantities to have been exported to Mesopotamia during the ninth century. The manufacture of true porcelain was first mastered in the occidental world at the German factory of Meissen founded in 1710.

In contrast to the simplicity of earthenware, porcelain is produced only by the use of decayed granite (kaolin) used in conjunction with equally decayed feldspathic rock (petuntse). It is fired at very high temperatures in order to vitrify the ingredients, thus producing the clear white color, extreme hardness, and translucency associated with the material. Only when very thickly potted or opaquely glazed does porcelain fail to transmit light.

The term *soft-paste porcelain* represents European attempts to reproduce the much-admired imports from China. Such adventurous assays were first attempted at the end of the fifteenth century in Venice by Antonio de S. Simone, in the sixteenth century in Florence under the patronage of the Medici, and in the late seventeenth century by various alchemists in France and England. Nearly all of these experiments employed the obvious device of adding pigment to molten glass, thereby achieving something akin to milk glass, which is not a clay-based ceramic. Because of the exactness of its physical composition there are no synonymous terms for true porcelain.

CHINA. This frequently misused term applies to a subdivision broader in scope than earthenware or porcelain. It possesses some of the properties of each. China is opaque, as is earthenware, but is not as hard as porcelain. It differs from the first in its greater resiliency and often includes an amount of bone ash. It is fired at a temperature less intense than that required for porcelain. Its qualities enhance its practicality, hence its common use in the manufacture of everyday tableware. China also has synonymous terms: ironstone, creamware, Queen's ware, and Staffordshire (so called from its geographical source).

The following pages survey important production in the various world centers of China, Europe, England, and America. The ceramic art of other cultures is dealt with in Chapter 1.

Metropolitan Museum of Art

K'ang Hsi famille noire porcelain vase, about 1662–1722.

Italian ceramics. The pottery of the early Renaissance in Italy was a development and elaboration of the Moorish majolica ware, which the northern Italians began to copy in the fourteenth century. The actual body of the pieces was made in the same manner as the Moorish product. The great development in pottery design occurred during the first part of the sixteenth century. Platters, urns, bowls, apothecary jars, and other pieces were elaborately hand-painted in strong color patterns of scrolls, fes-toons, flowers, leaves, arabesques, cherubs, dolphins, masks, grotesques, and scenes taken from the Scriptures and Roman history and mythology. Heraldic devices and portraits were also occasionally used. The large panels made by the della Robbias described in Chapter 3, were extensively used for wall decoration, and figure patterns were often built into the walls of the room. The della Robbias also produced circular panels in high relief framed in leaf and fruit wreaths. It is said that Raphael in his youth was employed to decorate the pottery made in his birthplace, Urbino. Other localities where sixteenth-century Italian majolica was made were at Castel Durante, Faenza, and Caffagiolo. Much of this pottery was exported to other European countries.

The colors used in nearly all majolica ware were limited to light blue, orange, mulberry, green, and black. The patterns were usually applied over a pinkish white slip.

During the eighteenth century, the Italian potters followed the styles of France and Germany. The works at Venice were founded in 1719; at Florence in 1735; at Doccia in 1737; at Capo di Monte in 1743; at Portici in 1771; and at Naples in 1773. Most of the relief-molded wares with their classical themes now available on the market and marked with the crowned "N" are relatively modern reproductions made at the revived Italian factory of Doccia or are German, English, and Japanese copies.

The first attempt to make porcelain in Europe was made in Venice in the latter years of the fifteenth century. In the early years of the sixteenth century the Medici family supported these efforts, which produced a translucent ware that they frankly called "counterfeit porcelain," but which is now known as "Medici porcelain." The examples were usually dishes, platters, and ewers. The colored patterns are taken from both Renaissance and Oriental sources. There is very little of this ware in existence today, but at

the time it was being produced it served as an inspiration for the later makers of soft-paste porcelain in France.

Dutch ceramics. The craft of pottery making was introduced into Holland by the Spaniards at the time when Flanders was a Spanish possession. Production eventually concentrated in the city of Delft, and this name has usually been applied to all the ceramic production of Holland. A high standard of quality was maintained by a trade organization of artists and craftsmen known as the Guild of St. Luke, founded about 1610.

Delft table and ornamental ware had a remarkably brilliant and heavy glaze and was particularly noted for its blue colors and decorations used on a white field. Conventional patterns and town and landscape scenes were also represented. The patterns were painted before glazing and firing, a method of decorating known as *underglazing*.

The Dutch factories endeavored to imitate the Chinese and Japanese wares during the eighteenth century, but not with a great degree of success, because of the improvement of transportation facilities and the eventual cheapness of the real Oriental ware. Their manufacture of porcelain was also unsuccessful. Delftware was exported to England to a large extent during the early years of the eighteenth century and was much sought after by English collectors. Many pieces, such as apothecary jars and drug pots, were made for commercial use. Small flat tiles were manufactured for fireplace facings and other architectural uses. The English eventually imitated delftware in their own factories, notably at Lambeth and Bristol.

French ceramics. The first great Renaissance potter in France and one of the greatest craftsmen of all times was Bernard Palissy (1510–1589), who started work at Saintes in Brittany in 1539. Palissy, previous to that year, had been a glass painter. He experimented long and suffered much privation and hardship before discovering the materials and processes for making ceramics. He lost all his savings in these experiments, and it was only after he had, in his frenzy, burnt up the chairs and tables in his house in order to fuel his kiln that he succeeded in producing the wonderful enamel for which his pottery is noted. He lived in troubled times and was eventually imprisoned for embracing the principles of the Reformation.

His work was strongly influenced by the Italian majolica ware, which he at first tried to imitate and eventually improved upon. He drew his inspiration for modeling and coloring largely from nature; sea animals and plants, fish, crabs, shells, coral, and seaweed were naturalistically represented. Religious and mythological subjects were occasionally used. The value of original Palissy pieces is so high that many forgeries have been made. The original ware has a reddish-yellow tint to the white areas, and the reds are of poor quality. The glazes are usually crackled.

At the same time that Palissy was working, a group of potters in St. Porchaire, near Saintes, was producing heavy, ornate vases and other useful articles in the Italian style. These are sometimes known as Henry II ware, because some are decorated with the monograms or crescent symbols of Diane de Poitiers. Others, however, show motifs that were used in the Francis I period. Similar wares were also produced at Nantes, and in the mid-seventeenth century, copies of both St. Porchaire and Nantes wares were made at Nevers.

Ornamental tiles were made in the city of Rouen in the middle of the sixteenth century, but it was not until 1644 that the first pottery factories were founded in this city and faience was made, supposedly in imitation of the pottery made in Faenza, Italy; actually, however, it was quite different. Rouen pottery was delicate and more refined in size, proportions, and pat-

Metropolitan Museum of Art

Eighteenth-century faience dish from Moustiers, about 1750.

tern than the early Italian ware. The best period occurred between 1720 and 1740. The platter designs were done in blue, green, and yellow and usually followed a wheel-and-spoke radiating form, produced by small flowers and conventional shapes, with arabesques, cornucopias, and arrows. This was followed by patterns of rococo and Oriental influence.

Edme Poterat, who worked in Rouen, in 1673, was the first Frenchman to make soft-paste porcelain, and a few years later Pierre Chicaneau established a factory in St. Cloud where a similar product was produced. Small objects were made that were decorated both in low relief and flat enamel colors in patterns of both Oriental and French origin. This factory was later carried on by his heirs and finally closed its doors in 1766. Other establishments for manufacturing soft-paste wares were founded at Lille in 1711, Strasbourg in 1720, Chantilly in 1725, and Mennecy-Villeroy in 1735. Still later the factories at Sceaux, Orleans, Arras, and Tournai were established. The material called "soft-paste" was fragile, chipped easily, and lacked solidity, so that the making of large objects was difficult, and the wares produced by these early factories were largely limited to plates, saucers, cups, vases, snuff-

boxes, cachepots, cane handles, small human and animal figurines, and grotesque and humorous motifs. The patterns were often carried out with a Chinese feeling.

Between 1664 and 1770 the French East India Company imported great quantities of pottery and porcelain into France. Many of these pieces were made by Oriental workmen, in factories specially established by the company near Canton, China, to make objects that had a particular appeal to the French market. The motifs usually consisted of floral forms applied to a bluish off-white ground. A large amount of this ware is still in existence and is called by its French designation, *Compagnie des Indes*.

The most important of the French ceramic factories was established at Vincennes on the outskirts of Paris in 1738. Madame de Pompadour took a great interest in the production of this factory and induced Louis XV to become one of the principal stockholders. In 1753 the king granted the firm the privilege of using the words *Manufacture Royale de Porcelaine de France* in connection with its name. The factory

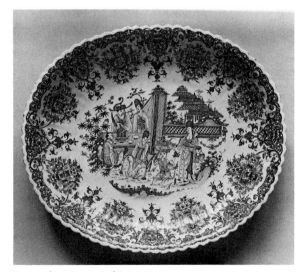

Metropolitan Museum of Art

Rouen faience platter, about 1710–1743, showing oriental influence.

produced soft-paste table and ornamental ware that was decorated with Chinese and floral patterns, and in 1747 made the first biscuit or unglazed ware. The omission of the glaze enabled the potters to obtain, with much greater accuracy, the minute detail of the sculptor's model. About the middle of the century, the factory became famous for the production of small soft-paste flowers that were mounted on wires and combined with metal leaves; these were used as bouquets and as decoration for candelabra, clocks, and table ornaments. The factory employed able chemists, and in 1749 first produced the ground color known as *bleu-du-roi* (royal blue), and in 1752 a remarkable turquoise blue. In 1756 the factory moved to a building constructed by Madame de Pompadour at Sèvres, and the ware was thereafter called by that name. In 1757 the Sèvres factory developed the pink ground color known as "rose Pompadour," sometimes miscalled "rose du Barry," and later on "yellow jonquil," green, and many other colors. For a time it was the only factory in France permitted to decorate its wares with gold.

The most capable painters, sculptors, and craftsmen were employed at Sèvres. Boucher, the painter, for a time was hired in an advisory capacity. The king used the products for gifts to his friends and foreign potentates, and they soon became regarded as the finest made in Europe. Enormous quantities of table and ornamental wares were sold to the reigning houses and noble families of countries as far away as Russia. Every sort of useful and ornamental design was made, many of them decorated with miniature paintings in the style of Watteau and Boucher, while in others the ornament was inspired by the Orient. The general character, forms, and surface enrichment closely followed the art style of each period. Pompeian patterns were introduced when the Neo-classic trend occurred, and these were followed by the Greek and Roman forms of the Empire. In 1768, kaolin was discovered near Limoges, France, and im-

mediately thereafter the Sèvres factory began to produce the hard-paste true porcelain. The factory has continued with various interruptions to the present day; the French government still acts as its patron, and its products are sold to the public.

An important type of French decorative accessory was the terra-cotta statues made by Claude Michel, known as Clodion, who was born in Nancy in 1738. He was a sculptor of great ability who won the grand prize of the Royal Academy in 1759, which permitted him to study in Rome. When he returned to France, he made terra-cotta reproductions of his figures in his own kilns. He had been impressed with the unrestrained character of the art of his period and specialized in modeling groups of amorous nymphs and satyrs that were in great demand as ornaments in the interiors of the latter portion of the eighteenth century. Clodion died in 1814.

Most of the decorated porcelains of the greater part of the nineteenth century are conveniently called *Vieux Paris*, whether or not made in or about Paris. They are heavily glazed white ware usually molded in a revived rococo style, painted with figures and flowers and enhanced with broad bandings in a somewhat brassy gold. Of these the earlier are better in quality, and the later productions, especially those with transfer-printed designs after contemporary or earlier easel paintings, tend to be gaudy and commercial.

German ceramics. Advantageous to the German potter was his easy access to woodlands, with their plentiful supply of fuel. Utilitarian wares of simple turned pottery were in common use during medieval times. Moravia produced a gray stoneware as early as the fifteenth century, and in the following century four centers in the Rhineland—Cologne, Siegburg, Raeren, and the Westerwald—were actively engaged in the same activity. Some of their pieces were salt glazed,

a technique that later gained prominence in England. At the same time tin glazed earthenware in imitation of Italian and even French products first appeared. Dating from the latter seventeenth century, and in competition with Dutch blue and white and polychromed Delft, are the faience industries of Hanau (founded by Dutch interests), Frankfurt-on-Main, Nuremberg, and the important Bavarian center of Bayreuth.

MEISSEN. In the service of Augustus the Strong, elector of Saxony and king of Poland, two men, first Ehrenfried Walther von Tschirnhausen and later Johann Friedrich Böttger, revolutionized the ceramic industry with their discovery of the ingredients and technique in the production of true porcelain after the manner of the Chinese. Böttger's first assays succeeded with a very hard red stoneware resembling the Chinese "boccaro" ware of Yi-hsing. In 1708 he found the secret of making a white translucent body; in the following year, a proper glaze. In 1710 the fortress at Albrechtsburg officially became the state factory of Meissen. In 1720, after the death of Böttger, Johann Gregor Herold became manager and brought to the industry a wide range of new designs and perfection in colored enamels. These included fanciful landscapes, some with chinoiserie figures, harbor views, stylized flowers (kakiemon), insects, and naturalistic blossoms. He came even closer to the Chinese in the whiteness and chemical composition of his paste. Fine sculptural forms were achieved upon the 1731 arrival of Johann Joachim Kaendler, who, with his several assistants, modeled so many of the small figurines and animals that became prototypes for the entire industry for many generations to come. As the rococo taste spread throughout Europe, the demand for miniaturelike landscape decoration and figure subjects after Watteau and Teniers and the richly pigmented flower painting after Sèvres led to the appointment of the French sculptor Michel-Victor Acier as director of

Meissen (1764–1781). The outbreak of the Seven Years' War in 1756 marked the decline of the fortunes of Meissen which were somewhat revived under the direction of Count Marcolini from 1774 to 1814. Thereafter only weak copies of earlier pieces were produced at the fortress and by many lesser factories in the area of Dresden which imitated the crossed sword mark of Meissen. Despite the prisonlike confinement of Meissen workers, many escaped to the courts of other princes jealous of Augustus and initiated porcelain manufacture at Vienna in 1718, St. Petersburg in 1744, Bayreuth in 1745–48, Höchst about 1750, Berlin in 1752, Nymphenburg in 1753, Frankenthal in 1755, Ansbach in 1758, and Ludwigsburg in 1758. As at Meissen, they produced extensive table services, centerpieces, and charming figurines, sometimes in white, but polychromed in the more ambitious pieces. Other eighteenth-century German factories worthy of mentioning are Fürstenberg, Fulda, Cassel, Ansbach, Kloster-Veilsdorf, Wallendorf, and Limbach.

HAUSMALEREI. From the late seventeenth through much of the eighteenth century a unique phenomenon of collector ceramics sprang up. It was known as Hausmalerei, literally meaning wares painted in the home, but actually referring to wares decorated outside government-owned and -operated factories. These small studios possessed low temperature kilns sufficient to set the painted decoration. Hausmalerei is divided into two groups, faience and porcelain.

FAIENCE. From about 1660, many artists, largely recruited from the ranks of silver engravers and enamelers of glassware, painted in monochrome and color on faience. Their work is marked by a great variety of quality and subject matter as opposed to the rigidly established standards of the larger factories. Small centers flourished at Nuremberg, Frankfurt-on-Main, and Augsburg. Principal artisans of the early period include Johann Shaper, Johann Heel,

Abraham Helmack, J. M. Gebhard, and Bartholomäus Seuter. After 1725 the important painters were Dannhofer, Ludwig, Hess, von Löwenfink, and Fliegel.

PORCELAIN. Hausmalerei on porcelain was popular from the second quarter of the eighteenth century at Augsburg, where Aufenwerth and members of the Seuter family were active. Since the small workshops had no facility or legal authority to prepare their own porcelain, white blank pieces were purloined from Meissen and other factories. They also used undecorated pieces publicly sold by official factories that were not regarded as of best quality or that had become stylistically unfashionable. Some painters used ware imported from China. Hausmalerei on porcelain sprang up throughout Saxony, Silesia, Bohemia, and other parts of Germany. Its important decorators were Preissler, Bottengruber, Mayer, Böhme, Heintze, and Herold.

Spanish ceramics. The Mohammedan potters of Persia, Mesopotamia, and Egypt excelled in their art, which in the ninth and tenth centuries was transmitted to the Spanish Caliphate of Cordova. Here, for the first time in Europe, tin glazes and such ceramic refinements as luster were used. The Kingdom of Granada and later Valencia became the centers of production. The best-known examples of the luster earthenware, called Hispano-Mauresque, are represented by tall amphora-shaped vases known as Alhambra vases, as well as by large platters bearing coats of arms of kings and princes. The decoration of the vases consists of Arabic inscriptions, beautifully executed arabesques, and, in a few instances, stylized animal forms. Hispano-Mauresque ware was coveted all over the Continent. The ships carrying it from Valencia to Italian ports made a halt on their way at the island of Majorca, from which derives the Italian term Majolica, which is now generally applied to tin-glazed and enameled earthenware.

Although the production of Hispano-Mauresque luster ware, with its remarkable and indescribable sheen and irridescence, reached its zenith in the fourteenth and fifteenth centuries, it has been carried on, based on traditional models, without interruption to the present day.

Glazed floor and wall tiles were also introduced by the Moors. The rooms of the Moorish palaces and smaller dwellings invariably had tile wainscots to a height of about four feet, covered with interlacing and geometrical patterns. Openings between rooms were often trimmed with tile borders, and small patterned tiles were used on floors. Seville became proficient in the fifteenth and sixteenth centuries in the output of beautiful polychrome tiles decorated with flower and abstract motifs, often showing a fusion of Mohammedan and Renaissance motifs.

In the sixteenth century Spain had to yield its ceramic prominence to Italy. Yet Talavera de la Reina and other kilns near Toledo produced attractive tiles and domestic ware, decorated with figural subjects, including scenes taken from contemporary life, in blue and white, in blue and ochre, or in green, blue, white, and brown.

The establishment founded by Count Aranda in 1727 at Alcora produced throughout the eighteenth century a very fine faience tableware partly inspired by current French taste, but Spanish in character. In Catalonia, wall tiles known as azulejos were often painted with entertaining scenes showing groups of people engaged in sports, amusements, dancing, or drinking the newly discovered beverages of coffee and chocolate, or humorous pictures of bullfights, boating scenes, incidents associated with Don Quixote, and other events. Religious pictures painted on tile were frequently used as altar decorations in churches.

After his accession to the throne of Spain in 1759, King Charles III transferred to Madrid the entire porcelain factory and staff of artists of the Italian manufactory of Capo di Monte,

which he had founded in 1743 when he was king of Naples. In Spain this ware was known as Buen Retiro after the royal residence, where the new plant was set up about 1760, and in which were produced beautiful figurines and groups made of soft paste porcelain. Walls and ceilings of entire rooms in the palaces of Madrid and Aranjuez are covered with huge plaques of this porcelain, and figurines are supported on ornamental wall brackets. These were features of decoration that admirably lent themselves to the modeling of spirited rococo rooms.

There have always been many small local kilns in southern Spain that made pottery for the peasants, who frequently decorate the walls of their rooms by covering them with ornamental plates or bowls and with water jars. Carried by the donkeys in the country districts and contributing so much to the picturesque landscape, these jars have maintained the same design for over two thousand years.

English ceramics

EARLY ENGLISH POTTERY. One of the most important developments in the history of decorative ceramics occurred in England and was started in the early years of the seventeenth century. Previous to this period, utilitarian pieces had been produced with little or no thought of decorative effect.

Most of the seventeenth-century pieces were heavy earthenware coated with what is known as *slip*, which consisted of a deep orange-colored mixture of clay and water. When dried, this preliminary coating was covered with another yellowish-white slip. The whole object was then covered with glaze, after which a crude and naïve pattern was scratched upon the surface with a sharp stick, the scratch being sufficiently deep to expose the underlying orange color. The glaze occasionally showed touches of green and red. The decoration often included the name of the owner, a date, and a verse or motto. Other ornaments used were rosettes, fleurs-de-lis, shields, armo-

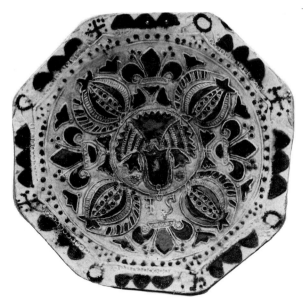

Metropolitan Museum of Art

English slipware Staffordshire dish.

rial bearings, initials, and grotesques. Thomas Toft, who lived around 1670, was the best-known master of ornamental slip ware. He produced cooking vessels, pots, porringers, saucers, basins, bowls, dishes, jars, candlesticks, and cups.

Toward the final years of the seventeenth century, much Delft and Oriental pottery was imported into England. This paved the way for the English potters to turn out goods of similar lines. Much of the English delftware was made at factories in Lambeth, but the painting of the English pieces was inferior, and the body was coarser than in the Dutch originals.

The early years of the eighteenth century were given over to experimentation and to analysis of the Oriental products and to a greatly increased public and collectors' interest in the porcelain of the Orient. As rewards increased, many skilled artists and sculptors were attracted to the industry. Easier transportation and improved technical facilities in firing made it possible to obtain and use clays from foreign

countries. It was therefore no longer necessary to work native clay.

As compared to the early pottery, the porcelain made in England was always lacking in originality of decoration and form. It is perhaps only natural that with an avowedly imitative product, the ornament should also be copied. The decoration of English porcelain in the eighteenth century falls into four periods of imitation: first, the period of Oriental influence; second, that of the Meissen style; third, the Sèvres influence; and last, the classical revival.

English wares made after 1740 are generally classified according to the town or locality where they were manufactured or by the name of the director of the company.

BRISTOL, BOW, CHELSEA, AND DERBY WARES. In these towns, factories were established between 1744 and 1755 which were active until 1810. There was a close similarity in the productions of these factories, and at times two or more of them were combined under the same ownership.

Those in charge of production and management were men of excellent taste and exceptional initiative. Considering the crude artistry and craftsmanship of their predecessors, the directors of these works were responsible for an immense advance in the English pottery industry along both technical and artistic lines.

Industry in Bristol seems to have flourished as early as 1652, when Delft earthenware was first imitated. Bristol continued to be noted for its reproduction of Delft pieces as late as the middle of the eighteenth century. Wall tiles were made, as well as the usual plates and bowls. Transfer printing is said to have been introduced as a method of ornamenting Bristol ware about 1757. Several early attempts to make porcelain were initiated in Bristol, but it was not until about 1770, at the time that the Plymouth factory was absorbed by the Bristol, that this ware was successfully made. The Bristol works closed its doors in 1782. Bristol porcelain is exceed-

ingly hard and durable; it is milk-white, with a cold glittering glaze. Biscuit wares were also manufactured. Tableware, figures, and ornamental plaques were produced. Much of the painted ornament was in the Chinese manner. The products of Meissen strongly influenced the Bristol modelers.

The Bow factory, sometimes known as "New Canton," was always associated with the making of porcelain. It is supposed first to have been organized in 1744, and in 1766 to have merged with Derby. Bow ware shows many variations in the quality of the body. Many white figures and painted statuettes were made. The painted types of chinaware were usually of Chinese character, in both underglaze and overglaze enamels. The subjects include bamboo or plum branches, partridges, grotesque animals, and sportive boys with small red flowers in gold and other colors. The early tableware was frequently edged in brown. The glaze of Bow wares now is often discolored and iridescent. Bow ware is mainly of a useful type, the ornamental forms having been left to the Chelsea factory. As compared with Chelsea ware, the bulk of the Bow productions are somewhat coarser in texture and rougher in decoration.

The Chelsea factory is supposed to have made the first piece of soft-paste porcelain in England, about 1745. A small milk jug was produced during that year, when the Chelsea works were controlled by two Frenchmen, most of whose employees were likewise French. This French management lasted until 1763, during which time the productions of tableware, vases, and ornamental figures were often inspired by Chinese and Meissen forms, the finish being in a creamy paste with a satiny texture. Other types clearly showed the influence of Vincennes and Sèvres, with rich ground colors such as dark blue and claret, and panels painted with pastoral scenes, bouquets, exotic birds, heavy gilding, and extravagant rococo vase handles and bases. In 1769 the Chelsea factory was sold to

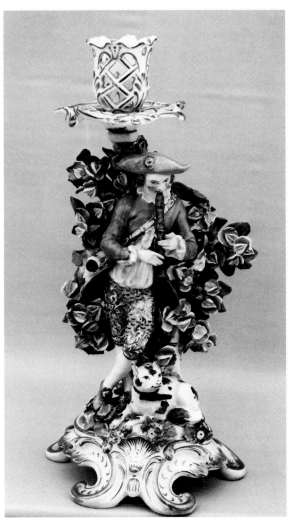

Metropolitan Museum of Art

Late eighteenth-century Chelsea candlestick.

pieces. Portrait pieces were modeled from statuary, pictures, and prints, and first-rate artists were employed in their production. Snuff bottles, scent flasks, flowers, and seals were also among the daintiest of all the Chelsea wares. Many of these bore gallant French inscriptions.

From 1770 until 1784, during the Derby-Chelsea period, the original wares of both factories continued to be made, but finally the rococo forms gave way to the colder effects of the classical revival, while in the decoration lapis lazuli, Derby blue, gold stripes, medallions, and biscuit reliefs made their appearance.

Transfer-printed Chelsea ware was of rare occurrence, although possibly some Chelsea porcelains were sent to Battersea to receive the transfers.

The Derby factory probably started about the year 1756, under the ownership of a man named Duesbury. An auction sale held by his order describes the goods of the Derby works as a "curious collection of fine figures, jars, sauceboats, services for desserts, and a great variety of other useful and ornamental porcelain after the finest Dresden models." This statement gives an idea of the variety of goods sold and of the character of their design. In 1758 the factory was enlarged. In 1770 it combined with the Chelsea factory, and in 1776 the combination bought up the Bow works.

The best period of the Derby production was from 1786 to 1811. Figures were always a specialty of the factory, although much tableware was also made. Flower paintings and particularly roses were favorite ornaments. Japanese designs were also used. The shapes of vases showed the influence of the classic revival, and landscape paintings were resorted to for ornament with meager success.

A beautiful biscuit ware was made during the best period, and the groups and figures made of this body constitute the finest ornamental productions of the Derby factory. Very skillful artists and modelers were employed. Other spe-

some Derby potters, whose work was mostly in the Japanese taste (*Kakiemon*) with paintings of flower sprays, insects, and other old Japanese patterns.

Of the figures for which the Chelsea works were so justly noted, the earliest were the undecorated examples, not always distinguishable from the Bow examples which they probably imitated. Next in date to these came the statuettes with quiet coloring and little or no gilding. Last came the richly decorated and heavily gilt

cialties of the Derby factory were the use of brilliant lapis-lazuli blue and of delicate lace trimmings of a realistic character on figures in contemporary costume. Transfer printing was introduced in 1764, but was not extensively favored.

LOWESTOFT (1757–1802). The history of the Lowestoft porcelain factory has suffered greatly for want of records, and many absurd legends have been told concerning its output. It was founded by Robert Browne, and was of sufficient importance to have a London warehouse. The ware was a soft-paste porcelain similar to that produced at Chelsea and Bow, but of varying quality. The designs were largely copied from Worcester productions or from Chinese porcelain. There was very little modeled ornamentation, although occasional relief patterns were used. Many jugs, flasks, dishes, and inkpots made at the Lowestoft factory were inscribed with the words, "A trifle from Lowestoft."

WORCESTER (1751–1840). The Worcester productions were very similar to those made at the Derby and Chelsea factories, and it was advertised that workmen from the latter places were employed in making them. The Worcester factory, in spite of frequent changes of ownership, maintained a group of highly skilled employees who kept the quality of their product on an extremely high plane over a long period. The molds of good models were kept, and many of the early models were repeated in later years with a new color treatment.

Printing on porcelain by the transfer process was brought to Worcester by Robert Hancock in 1757. Engraved prints of pictures and portraits were thereafter directly applied to the surface of the pottery, lowering the cost of producing the patterned surface. Hand painting was renewed, however, after 1768.

In 1788 King George III visited the works, and thereafter the ware became known as "Royal Worcester."

Worcester mugs, about 1770–1775.

Metropolitan Museum of Art

MISCELLANEOUS FACTORIES. Among the other types of English porcelains were those produced at Longton Hall, Coalport, Liverpool, Rockingham, Pinxton, Nantgarw, and Swansea. Many of these smaller factories were started by former employees of the larger organizations, and their output was similar in quality and design to that of the factories where their owners had served apprenticeships.

STAFFORDSHIRE POTTERIES. Staffordshire, a county of about thirty square miles, has been for centuries a most important locality for the production of earthenwares. This has been true because of the quality, variety, and color of clays that are found in the vicinity. Because of the cheapness and availability of the basic materials for making pottery, there have always been thousands of free-lance potters located in this district. Many homes have their own kilns which have been inherited from one generation to another. As a result of this long experience, the average Staffordshire potter has developed a high degree of technical ability, but he has, with few exceptions, failed to develop the same degree of aesthetic knowledge and appreciation in the modeling of his forms. The result has been that the average product turned out by the Staffordshire kilns has a provincial character in its shape, and its ornamentation and coloring cannot in any way compare with the very beautiful porcelain of Chelsea and Derby. The better grades of pottery made in Staffordshire are usually known by the individual names of their makers.

In the early years of the eighteenth century two Dutchmen, John and David Slers, became famous in the English pottery industry for their red, black, and salt-glazed stoneware produced at Bradwell Wood. John Astbury and Twyford learned the Slers' secret and started a factory at Shelton, where they made a fine earthenware of red, buff, yellow, fawn, orange, or chocolate color with relief ornaments that were sometimes lightly touched with purplish brown, the whole coated with a fine lead glaze. Salt-glazed products became common about 1720, and many teapots were made in this manner to compete with Oriental importations that were sold at a high price. The manufacture of salt-glazed ware, little of which was for ornamental purposes, was discontinued after 1780.

"Cream ware" was first made by Thomas Astbury, son of the previously mentioned John, about 1725. Variegated wares, including the fine "marbled" or "agate" wares, were at their best between 1740 and 1756 and were made by several Staffordshire potters. "Clouded wares" are most commonly associated with the name of Thomas Whieldon, who produced between 1740 and 1780. These were wares with a cream body colored by metal oxides dabbed on with a sponge, giving a mottled effect suggestive of tortoiseshell. The shapes were varied and original, but often more quaint than beautiful; the cauliflower, pineapple, and apple supplied the motifs. The cauliflower design seems to have enjoyed considerable popularity.

Thomas Whieldon was of considerable importance to the pottery industry because many of his assistants later went into business for themselves. Josiah Wedgwood was his partner from 1753 to 1759; Aaron Wood, block-cutter, occasionally worked for him; and Josiah Spode, Robert Garner, and William Greatbach were his apprentices. Several different types of luster ware were produced in Staffordshire toward the end of the eighteenth century. The Spode factory made luster ware with copper, silver, steel, and gold.

An immense number of figures was made in Staffordshire, the bulk of them being for cottage decoration and of a crude or rustic character. Portraits were modeled from life and pictures. Toby jugs, allegorical figures, sentimental arbor groups, and humorous subjects were produced in color, black, and cream ware. The figures made by Ralph Wood in the third quarter of the century are particularly well known. Others

Metropolitan Museum of Art

Leaded glazed earthenware statue,"Vicar and Moses," by Ralph Wood the Younger.

who made Staffordshire figures were Voyez Nealeolo, Enoch Wood, Wood and Caldwell, Wilson, Lakin, and Poole. Walton, Salt, and Dale were the best-known Staffordshire potters of the nineteenth century.

WEDGWOOD WARE. By far the most important name connected with the potteries of Staffordshire is that of Josiah Wedgwood, who in 1759 inherited a pottery at Burslem near Stoke-on-Trent. In 1769 he opened his celebrated factory in Burslem which he called "Etruria." Wedgwood was a genius of intense energy; he was one of the first men to unite art and industry. He was a remarkable chemist and antiquarian and sought the most beautiful specimens of antique pottery as models. He employed the best talent available and was willing to pay for it.

As he lived in the age of Robert Adam, he took advantage of the classical influence that spread over England and produced pottery that harmonized with the Adam designs for furniture and decoration. He introduced several new types of pottery and was constantly alive to new opportunities. Wedgwood's greatest fame rests upon his *jasperware*, a dull white biscuit capable of being colored and ornamented. The colors of the field were blue, olive green, black, lilac, or sage. The ornaments invariably were white, and usually showed Greek ornamental motifs or figures draped in graceful robes. This particular product obtained immense popularity for interior decorative purposes. As separate freestanding shelf and table ornaments, as panel insertions in walls, mantels, and door trim, and as furniture appliques in the designs of Hepplewhite and Sheraton, the jasperware was used repeatedly. One of the most famous of the Wedgwood pieces was his reproduction in jasperware of the famous "Portland vase," a glass relic of an unknown art found in a sarcophagus in Rome and now in the British Museum. John Flaxman, the sculptor, worked for Wedgwood and was responsible for the design of many of the most beautiful examples of jasperware.

Wedgwood was also noted for his terracotta ware colored to resemble porphyry and other stones. *Basalt ware* was the name for a black biscuit in imitation of the Egyptian stone by that name. "Queen's ware," made originally for Queen Charlotte, wife of George III, was the original creamware for which Wedgwood obtained royal patronage in 1765. The use of Queen's ware spread with amazing rapidity over almost the entire civilized world. *Agate ware* had a mottled or marbled finish in imitation of the stone by that name; the ornament thereon

Metropolitan Museum of Art

Wedgwood chocolate set decorated with relief of groups of children from Lady Templetown's drawings. Blue and white jasperware.

was usually painted in a remarkable imitation of gilded bronze.

TRANSFER-PRINTED POTTERY. Until about 1750 all English pottery decoration was done by hand. A method of transfer-printing pottery was discovered by John Sadler, a Liverpool printer, in 1754. The method involved transferring a design to paper from an engraved copper plate coated with pigment, and from the paper to the pottery, which was then refired. This was similar to the decalcomania process. The early pieces were printed over the glaze, producing crude and impermanent designs. The process was extensively used, however, to guide the enamelers, who filled in the black outlines with cobalt blue. Josiah Wedgwood regularly sent his "Queen's ware" to Liverpool for decoration from 1756 to 1794. In 1780, in Worcester, a man named Turner discovered a method of underprinting the designs with oily pigment, making possible a

Metropolitan Museum of Art

Wedgwood: Flowerpot (about 1780–1800), diced pattern with shells and scrolls, green, white, and cane colored jasperware. Drum-shaped vase with symbols in white relief on blue jasperware. Box with cover (1786–1795) decorated with white relief on light blue jasperware.

softer and more permanent effect. Turner also originated the "Willow" pattern, which was later to become the most popular transfer-printed design.

Josiah Spode, recognizing the possibilities of the new technique, hired two men from Worcester to teach him the method and commenced production in 1783, using as a base an inexpensive white earthenware. After his death in 1797, the business was carried on by his sons and William T. Copeland, and the new commercially produced pottery gained even greater popularity between 1800 and 1850, with over 700 different designs made especially for the American market. Spode's "blue and white" Staffordshire was the most widely produced and the best of its kind, although it was also available in pink, red, green, black, and other colors. Transfer wares were soon also being manufactured by Whieldon, Enoch Wood, James Clews, William Adams, Minton, and others.

After the War of 1812, the potters concen-

trated on the American market, and numerous scenic and city views of the United States were produced. Historical scenes, political events, and famous persons were depicted. Social and political satire and romantic scenes of birds, gardens, and ruins were also popular.

The interest of "old blue" ware is chiefly due to its historical subject matter. It is distinguishable from hand-painted pottery by the gaps and overlaps in the design left by inaccurate joining of the papers used to transfer the pattern. Even on the finest examples a narrow white line or a slight overlapping shows at these points. The standards of excellence are the clarity of the picture and the accuracy with which the parts of the design match. The transfer-printing process greatly reduced the cost of ornamental wares and caused less demand for the hand-painted types. As a result, the evolutionary development of fine porcelain making practically ceased by the middle of the nineteenth century.

American ceramics. Useful pieces of pottery were made in all the colonies shortly after the first settlements of the seventeenth century. Little, however, of any decorative value was produced.

The earliest pottery of interest was produced in Pennsylvania by Germans about the middle of the eighteenth century. This was a slip decorated with crude scratch carving, and was know as *sgraffito ware*. The body colors were red, brown, and cream. The slip was green, pink, and blue. The color of the body showed through the *scratch-carved* ornament on the slip covering. The subjects of the ornamental motifs consisted of strange humans and animals and flowers, with dates, names, and inscriptions. The Pennsylvanians also produced a ware with a marbleized finish. The forms produced were all for useful purposes. Connecticut and Massachusetts also produced pottery, beginning with the middle of the eighteenth century, when the decoration as well as the practical value of an object began to be considered.

The developments in America in fine pottery and porcelain making were greatly handicapped by English importations, both before and after the Revolution, and the popularity of the imported types often obliged the American craftsmen to imitate them, and to disguise their origin by omitting the stamp of their own names or factory marks. The popularity of the Oriental and French productions also increased the financial difficulties of the American producers. Vast quantities of English transfer-printed wares flooded the American market after the American Revolution.

About the third quarter of the eighteenth century several English potters who were equipped with technical training acquired in some of the English firms came to America. From this period onward, more successful attempts were made to produce china of a better quality, and there was a corresponding improve-

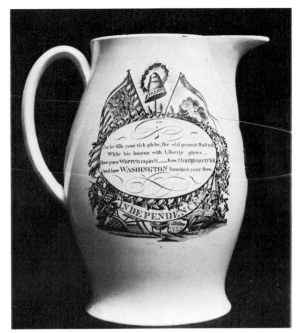

Metropolitan Museum of Art

Liverpool pitcher with design printed in black on cream ground, eighteenth century.

ment in design. By 1800 the industry had spread to practically every important city in the United States. The most interesting American pottery, from the point of view of design, was made in Vermont. John Norton at this time produced utilitarian terra-cotta objects and a salt-glazed stoneware in Bennington, Vermont, where kaolin had been found. He also later produced an imitation of English cream ware and Whieldon's Rockingham ware, the latter often having a classical appearance in its modeling. The Bennington factory frequently changed hands and reached its best period between 1847 and 1857, when both utilitarian and ornamental objects were produced, usually in the brown mottled tortoiseshell finish, although green and yellow colors were also used. Designs on the whole were heavy, quaint, and often humorous in appearance, and the glaze was rich, brilliant, and uniform.

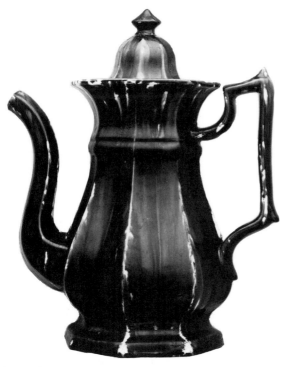

Metropolitan Museum of Art

American nineteenth-century coffeepot from Bennington, Vermont.

Daniel Greatbach, who came from England about 1839, worked for various American potters and is said to have been responsible for several of the most interesting designs produced at Bennington. The hound-handled pitcher was one of these. In this piece the body was decorated with a hunting scene, the handle formed by the curved body of a greyhound. Toby jars, cows, poodles, lions, coachmen bottles, flasks, candlesticks, toy banks, hot-water bottles, cuspidors and table and toilet ware were other forms that were made.

The Bennington factory also produced light-colored wares and a small amount of soft-paste porcelain. A Parian ware, first produced in England in 1840, having somewhat the color and texture of Wedgwood jasper, was another popular product. The shapes and ornamentation were in biscuit finish, but usually showed leaf and flower forms, and did not in any way resemble the sophisticated classic art of the original Wedgwood.

The first true porcelain made in the United States was produced in Jersey City, New Jersey, in the early years of the nineteenth century. At the same time an ambitious porcelain enterprise was operating in Philadelphia under Tucker and Hulme (later Tucker and Hemphill). It featured wares painted with floral sprays and gilded with bandings that were inspired by Rockingham of England. They also copied the Empire styles of Sèvres, France. Both porcelain and earthenware thereafter were made in Kaolin, South Carolina; Trenton and South Amboy, New Jersey; East Liverpool, Ohio; Baltimore, Maryland; and several other places, in all of which English or French wares were poorly imitated. The results were artistically crude, and many of the productions were of a commercial type. The majority of these potters lasted but a short time, and by the end of the century there was very little production in the ceramic field in the United States that could be classified as art.

Chinese ceramics. The history of pottery and porcelain making in China is as old and wondrous as the history of China itself. From 1100 B.C. through the eighteenth century, this art showed a slow but consistent development, reflecting the spiritual and religious changes of China and her rulers. Since the eighteenth century, though fine porcelain is still being made, the art has deteriorated, through a lack of originality, into a rather mechanical imitation of past excellence.

At first the ancient potter molded the clay to make necessary utensils, mortuary pieces, and vessels for the honored dead. In later centuries, when the Chinese had acquired an unsurpassable technical skill, the art of the craftsman, under Imperial patronage, was dedicated to fashioning exquisite pieces for adornment of imperial palaces and temples of worship.

To appreciate this art fully and to comprehend its significance, one must be familiar with the cultural background of China, with its sacred customs, ritual, and religion. Symbolism is the essence of Chinese decoration; it permeates every field of Chinese art and remains a mystery to the uninitiated. Every piece of ornament has a story behind it which is familiar to the student of art history. The presence of the Eight Immortals and the God of War in a pattern imparts a mysterious significance which can only be interpreted by Chinese mythology. However, certain designs are more simple in their connotations. For instance, a bundle of books is emblematic of scholarship. Ribbons tied in bowknots on books or baskets of flowers have a religious significance. The ever-present dragon is representative of the emperor and divine power, and the *kylin* signifies good and wise government.

The most popular ceramic designs, however, were floral motifs inspired by the blossoms and flowering shrubs in Chinese gardens, and these were repeated through all periods of Chinese art.

As the potters created for their emperor's favor, the names of the reigning dynasties designate the different styles of the potter's art in China. Important dynasties for ceramic production are the following.

CHOU DYNASTY (1122–256 B.C.). Archaeology has uncovered examples of wares dating to the third millennium B.C. However, from the Chou dynasty, we have the first written records clearly delineating the processes of fashioning on the wheel and molding in clay. The vessels described consisted of funerary urns, libation jars, and cooking vessels, either sacrificial or utilitarian.

HAN DYNASTY (206 B.C.–A.D. 220). After the fall of the Chou and the subsequent conquest by feudalism, tyranny, and iconoclasm, there came under the Han a period of rapid expansion and development. Stimulated by the trade route contact with Mesopotamia, Greece, and Rome, the Chinese artisan introduced naturalistic elements in the modeling of his green and brown glazed wares, such as the tree of life and various animals. Taoist motifs were likewise employed. We are indebted to the later Han for the feldspathic glaze applied to vessels fashioned after contemporary bronzes. Early in the fifth century the Tartar invasion led to the division of China into the northern and southern dynasties. Independence was achieved under the Sui dynasty (A.D. 581–A.D. 617), when the art of printing from wood blocks was invented.

T'ANG DYNASTY (A.D. 618–A.D. 906). By this time China had reached out with renewed vigor. With her northern route to Turkestan, land routes south to India, and sea expansion past the Persian Gulf, her ceramic art reflects a final sympathetic blending of Taoist and Buddhistic philosophy. Best known are mortuary figures in chalklike clay consisting of guardians, musicians, attendants, and above all the beloved Bactrian horse and camel, now modeled with the assurance of anatomical understanding. Sometimes they were glazed in uneven but transparent tones of browns, yellows, orange, and green. Otherwise they were enhanced by direct painting on the surface of the clay. Large quantities of funerary urns have come to light. Made of harder wares, these slender vessels were often molded with clearly defined zones of figures and topped by flat-brimmed conical covers. The glaze has a soft greenish gray body of the celadon type, and the accidental crackle now appears.

SUNG DYNASTY (A.D. 960–A.D. 1279). Imperial patronage so encouraged the arts of literature, painting, and ceramics as to create a golden age of Chinese culture. In this era the white porcelains with their delicacy and lyricism of form and their abundance of variously colored glazes had reached a new apex of perfection. Now, the previously accidental crackling was deliberately induced as a part of design. Some-

times the clay was first decorated with finely incised flowing lines. Concurrently the cobalt blues introduced from Persia, as well as the shapes of Near Eastern wares, broadened the scope of the art of the Chinese potter. At the kilns of Tz'u Chou, a characteristic underglaze black decoration occurs on white or glazed porcelain of the highest quality. The brush strokes are similar to the quickly executed thick and thin style of Sung painting on silk. Celadon and white slip glazed wares add to the rich assortment of the Sung. Animals and figures moved from the stiffer modeling of earlier dynasties to a far greater freedom of movement and grace as well as a further understanding of anatomical structure and proportion. Late in his reign, the emperor accepted the arms of Genghis Khan to rid his country of troublesome Tartar raiders, only to find himself under the bitter yoke of the fierce Mongol, who promptly installed his grandson Kublai Kahn on the Chinese throne.

MING DYNASTY (A.D. 1369–A.D. 1644). With the final expulsion of the Mongols, China entered into a great new era. The many years of foreign domination broke the usual pattern of gradual evolution of style thus causing a very perceptible development in the products of the imperial kilns. All types of wares of the later Sung were continued, and, additionally, the increased trade with India, Burma, and the Near East encouraged more naturalistic forms to satisfy Buddhistic tastes. Underglaze blue and white wares as well as the heavy bodied and nontranslucent celadons were highly prized far outside the borders of China and soon found their way into Europe. Newer colors, overglaze enamels of high saturation, became the vogue in contrast to the softness and delicacy of the Sung. The drawing is more firm, complex, and vigorous. The shapes of relief molded vases and bulb pots become increasingly squat and broad as well as heavier in scale. Figural sculpture shares the same qualities as the other wares. Of unique character are the soft creamy white

glazes on a white porcelain body (bisquit) peculiar to the province of Fukien. Delicate in scale and modeling, these wares comprised small vases, often relief molded with dragons at the neck and charming animals and figures. This group is often described as blanc-de-chine. Near the end of the dynasty forms and colors assumed more variety, and returned to a delicacy that anticipates a changing outlook.

CH'ING DYNASTY (A.D. 1662–A.D. 1909). Of this period we shall discuss the following: K'ang Hsi (A.D. 1662–A.D. 1722), Yung Chêng (A.D. 1723–A.D. 1735), Ch'ien Lung (A.D. 1736–A.D. 1795), Chia Ch'ing (A.D. 1796–A.D. 1820).

By the latter part of the seventeenth century an extensive export trade with the Western world resulted in an enormous output of ceramics. For example, at the populous city of Chen-Tê Chên over three thousand kilns were operating at full output to satisfy the appetite of the Western world. As in furniture and all phases of the decorative arts, the European became profoundly influenced by the art of the Orient and created new styles called chinoiserie. Merchants traded their indigenous wares and also created new forms to specific order and design of the foreign consumer known as Chinese export porcelain. The new taste called for a refinement of ceramic form and decoration. Porcelain manufacture under the rule of K'ang Hsi became fine in body and texture. Figural and animal sculptures, once symbolical, as in the Kuan Yins and the Foo-Lions, now became prized bibelots. Perforated shapes, known from their beginning in the late Ming as Devil's work, were perfected. New enamel colors were produced with such great skill in kiln temperature control as to still be the envy of all civilization. Among them were the iron oxides of red, sang de boeuf, texturally used with other colors as violet to produce flambé glazes. A granular effect in the blues was achieved by blowing powder through a tube, producing powder blue. Squat ovoid tea jars with pillbox covers sometimes had a novel

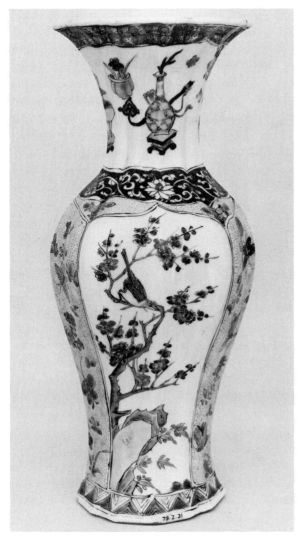

Metropolitan Museum of Art

Seventeenth-century porcelain vase from the K'ang Hsi period (1662–1722).

glaze resembling cracked ice, and with their decoration of prunus blossoms they were a symbol of ending winter and a welcome to spring. Most important was the group of translucent enamels known as *famille verte, famille jaune, famille noire,* and *famille rose.* They fired with brilliant hue and maintained a relief molded texture. Admired and copied in Europe, they have never been successfully duplicated. The reserved use of pale overglaze gold, as in the spear border, became a favored decorative device. So skillful was the work of the Chinese potter that he was plied with orders to imitate not only European ceramics but silverware, such as cow creamers, tea caddies, and serving dishes.

Activity increased still more during the subsequent reigns of *Yung Chêng* and *Ch'ien Lung.* Materials and designs basically remained the same but with an even higher degree of refinement in the fragile porcelain body and more detailed decoration. At the end of the eighteenth and in the early nineteenth century under *Chia Ch'ing* a new design was created for the insatiable foreign market. It was the *rose medallion* pattern composed of a highly complex arrangement of figures, foliage, blossoms, birds, and insects. Another was the mass-produced blue and white pattern known as Canton or as Nanking in its earlier and better quality wares. Vigor and inventiveness finally gave way to a decadence encouraged by too close a commercial contact with the occidental world.

GLASSWARE

Types of glassware. Products of glass have been made, as were ceramics, for a great variety of utilitarian purposes as well as for the decorative value of color, texture, and form. The composition of glass varies greatly, its color and hardness depending on its chemical components. Most glass is made of molten sand (silica) with inclusions of such ingredients as soda, potash, lime, or oxide of lead. A distinction should be made between the mined rock crystal and the manufactured product called crystal, a term often employed to describe glass composed of refined quartz crystals. Historically glass has been produced and processed by the following methods.

MODELED. The ancient Egyptians from the period of the Eighteenth Dynasty and perhaps earlier shaped small jars and bottles with malleable semicolored glass. This workable state is called "metal."

FREE BLOWN. From the second millennium B.C. in the regions of the eastern Mediterranean, Syrians and others employed the technique of attaching the metal to a hollow tube, then blowing it into spherical shapes altered by the controlling pontil rod. The pontil was attached to a section of the metal and by rolling and pulling controlled the contour of the vessel. When cooled, the rod was snapped off, leaving an irregular sharp prunt.

MOLD BLOWN. The pre-Roman process of blowing glass into molds of various material greatly increased the potential variety of forms and molded decoration as seen in vials shaped to resemble human portraits and representations of animals.

PRESSED. While patterns in mold-blown glass resulted from the internal application of lung power, pressed glass designs were produced by the application of external force of a plunger against the metal into a patterned mold. Early designs reflect the international styles of England's late Regency and comparable patterns in Belgium and France, thus giving rise to the belief that these nations created the new technique. It is generally accepted, however, that the nineteenth-century development of efficient machines for mass production of pressed glass is American.

ROLLED PLATE. Glass used for windows, doors, and mirrors is produced by passing rollers over the cooling metal as one rolls dough, then shearing the edges to desired sizes. The Romans of the imperial period were aware of the process, as they were of most glass techniques known to modern man.

MILLEFIORI. By placing rods of different colors side by side and fusing them by heat, one can produce a pleasing mosaic-like effect. Mosaic can be formed into various shaped vessels and objects such as paperweights.

CAMEO. When an object is cooled, it can be dipped into subsequent layers of different colors. Then the overlay can be carved back, producing a cameo such as a lighter color in relief over a darker underbody. It is an obvious imitation of antique layered gems, when sardonyx was principally employed. The Portland vase in London's British Museum is a famous example of cameo glass of ancient Rome.

ENAMELING. Painted decoration at its best is produced by using a ground glacious composition that is heated at fusible temperatures. Enameling dates back to ancient Syria and was a favored decorative device with the Germans from the sixteenth century. Important forms of enameling are those of *champlevé* and *cloisonné*. In the case of the former, channels are cut into any material, usually a metal, then colored glass is set into the depressed areas. The effect is that of an object studded with flat jewels. Cloisonné achieves much the same result but with the use of tiny raised walls of flat wire separating the enameled areas.

As a technical process employing the combined talents of the glazier and the painter, the stained glass window is wedded to the art of the architect, all reflecting the glory and aspiration of the church.

PLIQUE-A-JOUR. This is similar in effect to stained glass and to cloisonné but differs from the latter in that it is unbacked. Limited to small objects such as boxes, creamers, sugar bowls, cups, saucers, and spoons, it became especially popular in late nineteenth-century France and among lapidarists of Czarist Russia including Fabergé.

CUTTING. The relative softness of glass permits its embellishment by cutting in planes that reflect light at various angles. The term *engraving* covers the broad spectrum from linear incision to the more ambitious carving in intaglio. The modern approach to *frosting glass* is chemically achieved by the simple application of fluoric acid. An older and laborious stippling technique is the chipping away at the surface

Venetian Glass

Hurricane
Glass

Setting Hen of
Sandwich Pressed Glass

Sandwich
Glass Lamp

Sandwich Glass
Candlestick

Cockatoo Tumbler Enamelled
in Colors by Stiegel

Fluted Tumbler
by Stiegel

Waterford Glass
Sugar bowl

Irish Cut Glass Pitcher

Examples of European and American glassware.

with a hard pointed tool. The following survey recounts the history of glassware in its important centers of production.

Egypt. As previously noted, the art of manufacturing glass was known to the Egyptians who established a glassworks at Tell el-Amarna about 1375 B.C. Small objects were made in molded, blown, and mosaic techniques. They included bottles, vases, cups, saucers, and beaded necklaces. In the category of rarity are decorative plaques with representations of human heads, birds, and animals. Most extant specimens date from Greco-Egyptian and Roman times.

Assyria. Contemporary with ancient Egypt was a similar progress in the Near East. Notable are the squat jars and small alabastra with iridescent and claylike encrustations resulting from centuries of burial in the earth.

Rome. From the first century B.C., Rome developed in all phases of the art of glassmaking.* Nearly all techniques and applications known to modern man were employed during the era of the empire. Windows have been unearthed in houses not only in Italy but as far north as England. There are innumerable remnants of mosaic glass pavements as well. Glassworkers greatly expanded the range of color and form. Their skill in cameo cutting of gem quality is best known by the Barberini or Portland vase in the British Museum. Roman cut glass artisans set a pattern followed in modern times. They embedded colored glass in clear forms similar to

* The frequently used term *Phoenician glass* refers to products of the entire Mediterranean that were transported by Phoenician merchants at the time of Roman domination. The more appropriate designation, therefore, would be *Roman glass.*

nineteenth-century paperweights. The process of enclosing etched gold or silver designs between two clear panels was extensively used by the first-century Christians and at Byzantium. Its decorative potential created a splendid revival known as *Doppelwandglass* in eighteenth-century Bohemia, about 1730, where it is best represented by a variety of goblets and tumblers. Similar but less delicate wares were later made in Austria. Just as all forms of Roman culture were preserved at Byzantium, so was the art of glassmaking, which reached a high point in the enameled ewers and mosque lamps of the later Saracenic culture.

Venetian glass. Venice has been known for its glass production since the Middle Ages. During the high period of the Renaissance and thereafter, Venice was acclaimed by the whole world for the high quality of its glassware, which included ornamental as well as useful pieces, mirrors, and beads. The major portion of Venetian glass was made in Murano, a suburb of Venice, where glassware of fine quality is still produced, and although other localities in Italy had glass furnaces, their products are all called Venetian.

Venetian glass was exceptionally light and delicate. Most of it was the product of the blow-pipe. Because of its thinness it was never cut, but was modeled into extraordinary shapes, made in every variety of color, and ornamented with applied forms resembling dolphins, flowers, wings, stems, and leaves. Much of the Venetian glass was enameled and gilded in pictorial, foliate, or abstract patterns. Other surface finishes included net, crackled, marbled, lace, and spiraled effects.

Through the migration of Venetian workmen to neighboring countries and especially to Flanders, imitations of Venetian ware became widespread; this, along with improved materials and processes for glassmaking in other countries, eventually ruined the Venetian industry.

German and Bohemian glass. Glaziers were imported from Italy into Germany and the Lowlands. They established there a taste for the not too transparent, tinted and blown wares often applied with prunts achieved by the tacking of studs with a heat-softened rod of semi-molten glass. From the mid-sixteenth century most of Germany and the Netherlands created enameled decoration that expressed itself uniquely with figural and abstract designs. In the seventeenth century Bohemia produced a clear, colored, and somewhat hard glass that lent itself admirably to the frosted etching process invented by H. Schwanhart using hydrofluoric acid. Most familiar are the commemorative cut ruby and clear glass drinking vessels etched in this manner with subjects of important historical buildings. They are still manufactured today.

French glass. Very little remains of French utilitarian glass from the Roman period through the fourteenth century. After that time important centers with inspiration from Italy existed in Lorraine and Normandy. An important contribution to the industry was the first production at Paris of large plate glass mirrors (from 1665). This made possible the stunning "Gallerie des Glaces" commissioned by Louis XIV for his palace at Versailles. A water-clear, quite bubble-free product was developed by d'Artigues at Baccarat in 1818. The works are justifiably proud of their design and quality of fine tableware. Here, as well as at St. Louis and Clichy, was developed the decorative paperweight. Workers vied with each other for originality and uniqueness, encasing "candy" canes, animal figures, flowers, and insects in soft lustrous rounded weights. Highly prized today are those with faceted overlays. Related to this production were inkwells, hand-warmers, doorstops, doorknobs, curtain tiebacks, and the encased, relief-molded, white profile portraits of important personalities known as sulphide weights.

French weights were more advanced than those of other European factories and inspired glassworkers of England and the United States. From 1900 decorative glass and figurines were made with artistic aspiration at Lalique in the tradition of the Art Nouveau movement. France is well known for its perfection of enamel paintings on copper at such centers as Limoges from the period of the early sixteenth century. Her most important contribution, however, is the stained glass windows of her famous cathedrals.

English and Irish glass. Early England depended strongly on European importation of glass and glassworkers. By the mid-eighteenth century, however, she perfected flint drinking glasses by increased additions of lead oxide. The important eighteenth-century centers of Bristol and Nailsea have left us more than utilitarian wares. Beautiful white vases were made to compete with imported Chinese porcelain. They were enameled in color with landscape and figural subjects.

During the same period glassworks were flourishing in Ireland at Belfast, Cork, Dublin, and, notably, Waterford. Their finest products, including cut glass chandeliers and bowls for punch or fruit, belong to the period between the years 1780 to 1810. Much was exported. The prohibitive excise taxes introduced before 1825 succeeded in the near total destruction of all Irish glass industry by 1850. It has been revived in recent times at Waterford. By way of caution it must be observed here that far too much eighteenth- and early nineteenth-century English and Irish glass is firmly but falsely attributed to Waterford. In this connection it must be known that workers were often transient, and designs came from various sources.

American glass. Useful pieces of glass were made in the southern colonies as early as the date of the first permanent settlement. It was not until 1739, however, that ornamental pieces were first made in New Jersey.

STIEGEL GLASS. The most famous American glass was made by Henry William Stiegel, a German who came to America in 1750. Stiegel was a romantic figure, and many myths have been written concerning his activities. He started an iron foundry at Elizabeth Furnace, Pennsylvania, made *firebacks* and stoves, prospered, and expanded his business to considerable proportions. In 1762 he purchased land in Lancaster County, Pennsylvania, called it Manheim after the German city of that name, and endeavored to develop a real estate business. Land was slow in selling, and he was forced to establish a local industry to attract buyers. He knew the glassmaking industry and started a glass factory. Operations commenced in 1763. Personal extravagance caused Stiegel to be thrown into the debtor's prison in 1774. His fortunes varied thereafter, and he died in 1785.

From 1763 to 1770 Stiegel made window glass and various types of bottles and hollow ware at both Elizabeth Furnace and Manheim. In 1769 Stiegel started the manufacture of flint-glass—the first of its type in America—at Manheim, and many experienced apprentices were brought from Bristol, England; Cologne, Germany; and Venice, Italy. In the few years that this factory was in operation, many beautiful pieces were made, following English and Continental prototypes. Quaint, useful, and decorative objects of every kind, in clear glass, opaque white, emerald green, amethyst, brown, and sapphire blue were produced. Etching was occasionally employed as decoration because the glass was comparatively soft and easily treated in this manner. He also made an interesting enameled glass covered with colorful German peasant patterns of leaves, berries, and parrots. His perfume bottles, sugar bowls, and flower vases were particularly in demand.

Stiegel was a spendthrift and had poor business judgment, and after the collapse of his

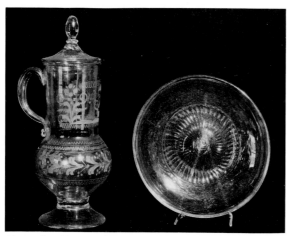

Metropolitan Museum of Art

Early nineteenth-century ewer and plate of Pennsylvania German origin.

undertakings, many of his employees organized their own factories and made the same kind of glassware that had been formerly produced by Stiegel. Factories were established in Zanesville, Ohio; New England; and New York. European wares similar to the Stiegel types also began to be imported from the early years of the nineteenth century, with a result that there is probably more imitation ware of the Stiegel type than there are original pieces. Due to the short existence of the Stiegel factory, it is doubtful that he could have made all that is attributed to him.

JERSEY GLASS. In 1739 Caspar Wistar established a glass factory in the southern part of New Jersey. It was carried on by his son, Richard, until the Revolution. Several brothers by the name of Stanger also started a glass factory in the same section, probably just after the Revolution. The productions of these factories were known as "South Jersey" glassware, and consisted mostly of useful pieces such as window glass and bottles.

Individual workmen in these factories, in their free time, became interested in blowing more ornamental forms, the majority of which were heavy, crude, and elementary in appearance. Interest was obtained by color and shape and with occasional applied ornament in swirls, crimpings, and threads. This glassware is sometimes known as "Wistarberg" ware.

MIDWESTERN GLASS. Window glass, bottles, and table and ornamental ware were made after the Revolution in the vicinity of Pittsburgh and the Ohio River. Most of this glass imitated the Stiegel ware.

SANDWICH GLASS. Table and ornamental ware were made in Sandwich, Massachusetts, between 1825 and 1885 by Deming Jarves. The enormous output of this factory was possible only because of the employment of cheap methods of manufacturing. Most of the Sandwich glass was enriched by pressing into molds which produced an imitation cut pattern. This product is known as *pressed glass* and is easily recognized by the lack of sharpness to the edge of the ornament or pattern. The early glass made at the Sandwich factory is considered the best, as the molds were comparatively sharp when first used. The outer surface of the early glass was frequently covered with a lacelike stippling and tracery causing considerable sparkle. Some blown glass products were made. Other types were the striped, threaded, mold-blown, clear, colored, overlaid, and milk glass.

Many of the Sandwich pieces were enriched with political symbols and portrait heads. Ornamental pieces were made to imitate animals. Their cats, dogs, ducks, and setting hens were used as souvenirs and premiums by commercial houses, to be given away with a purchase of goods. Whale-oil lamps, candlesticks, doorknobs, drawer pulls, decanters, mugs, and tableware were also produced in clear glass, cloudy effects, and colors. Jarves also tried at one time to make etched glass patterns. The quality of his ware was good, and much of it was exported to foreign countries. Sandwich glass, although not correctly speaking a colonial product, is frequently used, due to its informal character, as a

decorative accessory in all American period types of rooms.

During the nineteenth century, factories in Ohio, Pennsylvania, New York, Kentucky, Virginia, and Maryland manufactured bottles and flasks for various purposes, many of which have become collectors' items, due to their color, shape, or unusual design. They were made in yellow, amber, various greens, aquamarine, sapphire blue, pink, red amber, amethyst, lavender, and moonstone, the latter now very rare. The flasks were of both opaque and clear glass, decorated with ribbed, swirled, or diamond designs, or made in the shape of violins and log cabins. Among the most desirable to the collector are those decorated with historical or political themes, pictures of famous persons, masonic emblems, and American eagle or other patriotic designs.

Chinese glass. Of considerable decorative interest is the category of *Peking* glass so named from its main source of manufacture largely sponsored under the regime of the Emperor K'ang Hsi and continued in considerable production throughout the nineteenth century. Its importance stems largely from the fact that it was patiently carved in the form of small, traditionally shaped vases and snuff bottles. There are innumerable examples in clear, solid-colored, and overlay glass in two or more colors. Collectors highly prize snuff bottles meticulously painted on their interior surfaces with figures and landscapes.

Modern glass. The art of the glassworkers was developed to an extraordinary degree during the latter years of the nineteenth century. In Bohemia, France, and Sweden, glass designers concentrated their efforts on inventing new forms, types, and colors. Louis Tiffany of New York developed an iridescent glass of great brilliance and luster. In the early years of the twentieth century Lalique of Paris produced a luminous, transparent glass, ornamented by pressing and by alternating polished and dull surfaces. He designed tableware, ornaments, and lighting fixtures. Many of his designs were sculptural and architectural in character.

Today, Swedish Orrefors glass, with its engraved figures and patterns, is considered one of the finest of contemporary productions, as is the output of the Steuben factory at Corning, New York, which is noted for the purity of its crystal glass. The Corning factory produces both utilitarian and ornamental glass, with fine cut and etched patterns executed from designs of Sidney Waugh and others, and structural glass products. The latter, consisting of heavy slabs and bricks, are priced for popular consumption, and the future will probably witness a more extensive use of these forms both for practical and decorative purposes.

BIBLIOGRAPHY

Anscher, E. S. *A History and Description of French Porcelain.* Translated by Burton. London, 1905. Illustrated text.

Baker, D. V. *Pottery Today.* New York: Oxford University Press, 1962.

Barnard, H. *Chats on Wedgwood Ware.* New York: Frederick A. Stokes Co., 1924. Illustrated text.

Bergstrom, E. H. *Old Glass Paperweights.* New York: Crown Publishers, 1947.

Buckley, W. *European Glass*. Boston: Houghton Mifflin Co., 1926. Illustrated text on the history of glassmaking.

Burton, W. *A General History of Porcelain*. 2 vols. New York: Cassell and Co., 1921. Illustrated history with color plates and photographs.

Chaffers, W. *Marks and Monograms on European and Oriental Pottery and Porcelain*. Los Angeles: Borden Publishing Co., 1946. An illustrated handbook for collectors.

Cox, W. *Pottery and Porcelain*. New York: Crown Publishers, 1970. A comprehensive description of all types.

Eberlein, H. D., and Ramsdell, R. W. *The Practical Book of Chinaware*. Philadelphia: J. B. Lippincott Co., 1925. Fully illustrated text.

Glass. A catalog of a special exhibition prepared by various members of the staff of the Metropolitan Museum of Art, New York, 1936. A brief illustrated summary of glassmaking from ancient Egyptian to modern times.

Guilland, W. G. *Chinese Porcelain*. London: Chapman and Hall, 1902. Illustrated text.

Hannover, E. *Pottery and Porcelain: II, The Far East*. Translated by Rackham. London: Ernest Benn, 1925. Illustrated text.

Hayden, A. *Chats on English China*. New York: Frederick A. Stokes Co., 1904. Out of print. Illustrated text.

Hobson, R. L. *A Guide to the English Pottery and Porcelain*. London: British Museum, 1923. Illustrated text.

Hobson, R. L. *A Guide to the Pottery and Porcelain of the Far East*. London: British Museum, 1923. Illustrated text.

Hobson, R. L. *The Later Ceramic Wares of China*. London: Ernest Benn, 1925. Illustrated text.

Hobson, R. L., and Hetherington, A. L. *The Art of the Chinese Potter*. London: Ernest Benn, 1923.

Honey, W. B. *European Ceramic Art*. New York: Van Nostrand Co., 1950. Excellent illustrated listing.

Janneau, G. *Modern Glass*. London: The Studio, 1931. Illustrated text.

Knowles, W. P. *Dutch Pottery and Porcelain*. New York: Charles Scribner's Sons, 1919. Illustrated text.

Lee, R. W. *Victorian Glass*. Northboro, Mass.: Published by the author, 1944.

Lloyd-Hyde, J. A. *Oriental Lowestoft*. New York: Charles Scribner's Sons, 1936. Illustrated text.

McKearin, G., and McKearin, H. *American Glass*. New York: Crown Publishers, 1941.

McKearin, H., and McKearin, G. *Two Hundred Years of American Blown Glass*. Garden City, N.Y.: Doubleday and Co., 1950.

Moore, N. H. *The Old China Book*. New York: Frederick A. Stokes and Co., 1903. Out of print. Illustrated text on English pottery and porcelain.

Moore, N. H. *Old Glass—European and American*. New York: Frederick A. Stokes Co., 1924. Illustrated text.

Northend, M. H. *American Glass*. New York: Dodd, Mead and Co., 1926. An illustrated thorough treatment of this subject.

Parish-Watson. *Chinese Pottery of the Han, T'ang, and Sung Dynasties*. New York: De Vinne Press, 1917.

Rackham, B. *A Book of Porcelain*. London: Adam and Charles Black, 1910. Text with color illustrations.

Rohan, T. *Old Glass Beautiful*. London: Mills and Boon, 1930. Good, simple text with illustrations on English and Irish glass.

Sato, M. *Kyoto Ceramics*. New York: Weatherhill, 1973. Illustrated text.

Savage, G. *Porcelain Through the Ages*. Baltimore: Penguin Books, 1963.

Yoshida, M. *In Search of Persian Pottery*. New York: Weatherhill, 1972. Observations on Persian pottery, ancient and modern. Illustrated.

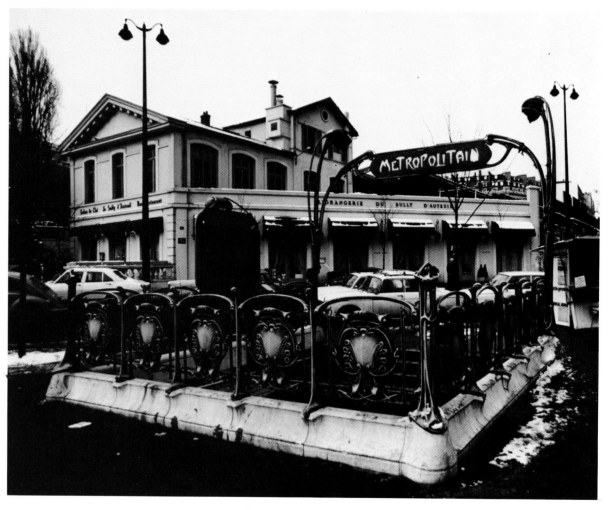

Early twentieth-century cast iron and green painted subway entrance in Paris, by the Art Nouveau designer Hector Guimard. Amber glass globes by Lalique.

CHAPTER 20

Metals, Hardware and Cabinet Woods

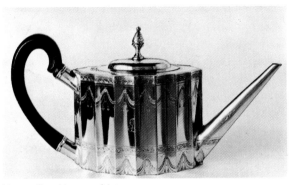

Metropolitan Museum of Art

Silver teapot by Paul Revere.

Metals, as used in art and industry, have varying physical characteristics that limit the forms into which they may be fashioned and define the character of their enrichment. To a certain extent, each historical period of art has featured certain structural and ornamental metals. The Egyptians knew the processes of making objects in iron and bronze. The Greeks and Romans cast magnificent statues in bronze, made metal furniture, and produced many household utensils and toilet articles in iron or copper alloys. During the Middle Ages in Europe great care and effort were expended by the metalworkers and locksmiths in the production of hardware, gates, screens, and grilles for the cathedrals. Heavy wooden doors were hung on elaborately scroll-patterned hinges, which served for protection as well as operation. Silver and gold jewel boxes, reliquaries, crucifixes, and other religious objects were produced in exquisite perfection in the uncounted hours of labor contributed by the monks in their cells.

During the Italian and Spanish Renaissance, less importance was given to the decorative effect of hinges and locks, but many of the greatest sculptors contributed their efforts in the design of bronze door handles and knockers, andirons, lanterns, gates, and lighting fixtures, and the Plateresco period of art was named in honor of the Spanish silversmiths whose work so influenced craftsmen in other materials.

In Italy, during the Renaissance, were also produced those extraordinary miniature reproductions of classical statuary that were used as household ornaments. These statuettes were made by the cire-perdue or "lost-wax" process, so named because the original wax model of the figure was lost in making the bronze casting. Very intricate models were made in wax, delicately tooled, and then covered with a layer of fine clay which was left to harden. When dry, the clay was heated and the melted wax permitted to run out through a small hole, leaving a beautifully finished mold in which to pour the liquid bronze. When the bronze cooled, the clay mold had to be broken and removed, leaving the finished product, but only after both the model and the mold had been destroyed so that it was impossible to produce another casting without having the sculptor make another model.

Among the many great names associated with the metalwork of sixteenth century Italy were Sansovino and his pupil Vittoria, noted for their ornamental bronzes, and Benvenuto Cellini, known for his work as goldsmith, jeweler, sculptor, and medalist.

The pinnacle of the metal arts in France occurred simultaneously with her high period of decorative work. The production of the gilded bronze furniture ornaments, clocks, andirons, and other objects in ormolu reached near perfection in design and finish under the great ciseleurs, Caffieri and Gouthière, during the middle of the eighteenth century and, with the exception of the work of Odiot and Thomire, began to decline in quality and design in the early years of the nineteenth century.

The use of metals in the interior decoration of both England and America has followed similar lines. In the seventeenth century most of the hardware in both countries was made in wrought

iron, although in England far more thought was put upon design than in America, where the village blacksmith usually made a latch, bolt, or hinge with utility as the main consideration. Fireplace accessories were also made of iron, although in the more elaborate homes in England brass ornaments often enriched the baser metal. During the eighteenth century both brass and iron were used for hardware and irons and firetools, and far greater elaboration was given to ornamental details. The eighteenth century was also the great period of silver tableware and ornaments in both countries, and France exported shelf clocks and ornaments in ormolu that were designed especially to appeal to the English and American public.

The metals used for decorative purposes. In the decorative arts ten different elementary metals are commonly used. These are iron, copper, tin, lead, zinc, chromium, aluminum, magnesium, silver, and gold. Certain of these metals, lacking needed qualities, are frequently combined with others to form what are known as *alloys;* in each case a product is obtained that has the advantages of both the combined metals. The principal alloys are bronze, a combination of copper and tin, often with inclusions of zinc and phosphorus; brass, basically copper with additions of tin and more recently zinc; and pewter, mainly tin with addition of antimony, copper, or bismuth. Inferior pewter of relatively modern date also contains lead. The more valuable metals, such as gold and silver, are often used for surfacing or plating baser materials.

Iron. Iron is the most abundant of all metals, and is found in larger or smaller quantities in almost all rocks, earth, and water. It has been known and prized from very early times. Articles made of it have been found in Egypt, Nineveh, ancient China, and Roman Britain. The iron of commerce is never entirely pure, but always contains a little carbon, silicon, sulphur, and phosphorus. All iron objects are likely to rust when exposed to damp air, but do not change when in protected places. Iron may be kept from rusting by coating it with a non-oxidizing material such as tin, zinc, or brass. Commercial iron is produced in three principal varieties—cast or pig iron, wrought iron, and steel. The principal chemical difference among these three materials is in the percentage of carbon that is contained in them. Cast iron contains the most carbon, steel the next amount, and wrought iron the least. The amount of carbon greatly affects the strength, character, and working qualities of the material.

Cast iron comes from the blast furnace in small bars or pigs. These bars may easily be liquefied under sufficient heat, and when in such condition, may be poured into a sand mold to form various useful shapes. Cast iron is exceptionally brittle, cracks easily under a blow, and is not subject to bending. It is not used to any great extent in the decorative arts, as articles manufactured by this process are coarse in finish. Ornamental firebacks and facings, stoves, and fireplace accessories are the principal decorative uses for cast iron.

Wrought iron is softer than cast iron and has less carbon and other impurities in it. It is not brittle and may be hammered into bars, rolled into plates, or drawn into wires. It can be hammered or bent to almost any shape and holds the shape to which it is bent. For this reason it is called a malleable material (derived from Latin *malleus,* a hammer). Wrought iron may be welded; that is, separate pieces may be joined together by hammering when they are red-hot.

Wrought iron has many uses in the decorative arts. From bars are made grilles, gates, railings, furniture, andirons, tools, lighting fixtures, hardware, brackets, braces, and ornaments. From sheets of various thicknesses are made

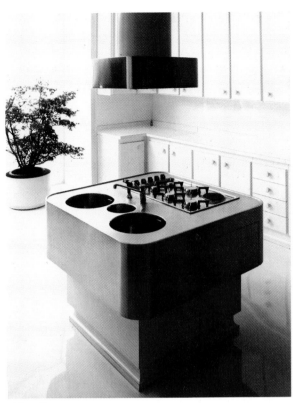

Aldo Ballo

A contemporary Italian kitchen with a stainless steel stove and simple, elegant hardware on hand-crafted cabinets.

fireplace linings, cheap hardware, and lighting fixtures. Wrought iron objects are often coated with brass.

Steel is a variety of iron with a hardness that is halfway between cast and wrought iron, and it has some of the physical characteristics of both. Steel is lighter in weight, and has a finer grain than iron; it is subject to a high polish; it may be tempered and is, therefore, elastic, and when slightly bent, springs back to its original shape. Steel is decidedly malleable at a high temperature and hardens greatly by sudden cooling. Steel is used principally as a structural material, but owing to the fact that it may now easily be worked by electrical processes, it is used for many of the same decorative purposes as wrought iron. The alloying of chromium with iron or steel will prevent rust, and the polished alloy will retain its luster. Much iron hardware and furniture, many metal bathroom accessories, table objects, and other useful and decorative pieces, are now made of an alloy of iron or steel and chromium, or are covered with a coating of the latter because of its nontarnishing quality. Steel that is alloyed with 10 percent to 20 percent chromium is called *stainless steel*, and is used for cutlery.

Copper. Copper is a soft, orange-colored, tarnishing, but nonrusting metal, which is considered everlasting. It was one of the first metals known to man and was used before iron. It is said the ancient Egyptians cut their granite with copper chisels which they hardened by a method now unknown. Nearly all the nations of antiquity used copper alloys in the making of articles of household use, weapons, coins, and statues.

Copper is much used in the industrial and decorative arts because of its strength and the ease with which it may be worked. It may be cast or hammered into desired shapes. It is often alloyed with gold or silver to harden these metals, or it may be alloyed with nickel and zinc for making German silver.

Because of its durability, copper is extensively used in decoration for the production of small ornamental objects or for structural objects that do not have to endure excessive strain. In its variations of brass and bronze, it is useful for hardware, lighting fixtures, statues, table ornaments, clocks, vases, pedestals, fireplace accessories, screens, grilles, kitchen utensils, and similar objects.

Brass has a bright yellowish appearance and is susceptible to a high polish. It tarnishes easily and is consequently often protected by a coat of lacquer, which, however, will not entirely pre-

vent it from changing color. Brass requires much polishing to keep it bright.

Bronze can be cast with great ease and in the most delicate patterns, and may be finished in a great variety of styles and colors. For these reasons it is more largely used in the manufacture of metal ornaments, statues, and finished hardware than any other material. The surface finishes are obtained by dipping the object in baths of various acids, but these finishes are only light veneers, and disappear if the object is exposed to the weather or frequently handled.

Both brass and bronze may be rolled into very thin sheets, after which spun, hammered, or repoussé forms and surfaces may be produced.

Objects that are cast in bronze and treated with ornament in relief may have the ornament sharpened or undercut by hand chiseling or chasing. The ormolu used on French seventeenth- and eighteenth-century furniture was finished in this way, the bronze finally being coated with gold by a mercury process that was very dangerous to the workmen. The ornament on fine bronze hardware is always hand-chiseled, which is responsible for its high cost. The finish of hardware that has not been touched by handwork is called "commercial."

Brass and bronze are both used as base materials for decorative and useful objects that are coated in gold or silver.

Tin and lead. Tin and lead are metals used in alloys, and are too soft for practical purposes when used alone. They are nonrusting. Lead is often used for garden statues and ornaments and occasionally for appliqués on woodwork.

Miscellaneous decorative metal objects. There are many kinds of metal objects valued for their design and workmanship even though the material from which they are made may not be "precious." Many of these objects have great decorative value, while others must be placed in the "collector's" class. There are many books concerning every type of metalwork which those who wish to pursue the subject may read. Space does not permit a full description here.

Some of the more interesting special types of decorative metalwork are described briefly in the following pages.

Table silver. Most of the antique silver that is available today to the decorator is of English and American origin. The English have always been great workers in this metal, and, to a certain extent, portions of the family fortunes were kept in the form of useful and display articles made by the silversmith. In times of stress and warfare, taxes could be paid by melting down the ancestral ware.

In addition to the design forms, which help to approximate the date of manufacture of English silverware, the law was very particular in requiring that each piece be carefully marked with the maker's name, the *hallmark*, identifying the purity of the silver, and the date letters, giving the year of manufacture. As a result of these legal requirements, all English silver can be very accurately identified by comparison with the published tables of marks. The British also established the sterling standard of .925 parts of pure silver.

Though museums contain fine examples of Gothic and Jacobean production, there is very little that is sold today that was made earlier than 1700. The introduction of tea, coffee, and chocolate drinking in the middle of the seventeenth century contributed greatly to the quantity and quality of work produced by the silversmith.

During the Queen Anne period, most of the silverware was plain, the beauty being in the gracefulness of the contour. Gradually, engraving or hand chasing was introduced in simple border patterns and coats of arms, and even-

tually the whole piece was covered with arabesques and other forms. Repoussé work was also used for enriching the surface.

During the early Georgian period, the influence of Sir Christopher Wren and William Kent was carried into the silversmith's shop, and architectural forms became common. By the middle of the eighteenth century, the rococo and Chinese-inspired Louis XV designs had crossed the Channel. Symmetry and balance gave way to elaborate scrollwork and fantastic patterns.

Under the influence of the Adam brothers, a return to simple lines occurred, with the motifs returning to the classical architectural forms and ornaments that are characteristic of the period. Straight lines, graceful Grecian curves, and chaste decoration predominated. Many pierced or perforated patterns were also used. The classic style continued during the early years of the nineteenth century in its less delicately scaled interpretation.

Almost the entire American colonial output of silverware came from New England, New York, and Pennsylvania, and many of the silversmiths were of Dutch and Huguenot origin. The Americans followed the English patterns, but much of the charm of American silverware is dependent on its simplicity of line and graceful form and the absence of the overornamentation which mars the beauty of contemporary European work. American silver cannot be identified as easily as the English. While the maker's name or initials were usually stamped in an inconspicuous place, there was no law to require accurate marking of quality or date of manufacture. The silversmiths themselves, however, held their own reputation and integrity of importance and maintained a standard of quality in all that they produced. On American silver from 1837 the letters C for coin and D for dollar were used on all silver of not over 10 percent alloy. The word *sterl* was first used on Irish silver during the eighteenth century, and in 1865 it became obligatory to use the word *sterling* on all American silver productions of a standard quality.

There are many names associated with the making of silverware in America, among them being John Coney of Boston (1655–1722), Cornelius Kierstead of New York (1674–1753), and Paul Revere of Boston (1735–1818). The productions of Revere were all characterized by astute craftsmanship and refinement of design, although, as a result of Longfellow's poem, he has received perhaps more credit than was his due, since the work of many other silversmiths was quite the equal of his. The high prices at which his productions are sold frequently reflect a superior sentimental value rather than one of design or workmanship.

The finest American silverware is seen in tankards, beakers, mugs, caudle and candle cups, porringers, punch bowls, kettles, tea, coffee, and chocolate pots, inkstands, salvers, sauceboats, and tazzas.

Pewter. This alloy has often been called the poor man's silver. It has been made and used for table and ornamental ware since the early days of history in the Orient, Europe, and America.

Because of the softness of the material, objects made in pewter must depend upon their shape and mellowness of color for their interest. Engraved ornamentation is occasionally introduced. Some repoussé or hammered ornament is also seen.

American pewter is far more rare than English, as many of the American pieces were used in the manufacture of ammunition at the time of the Revolution. When porcelain began to be imported from the East and was finally made in Europe, pewter was discarded except for use in public inns, where it was valued for its resistance to hard usage.

The forms made from pewter covered every type of container, drinking vessel, dish, candle-

Silver Tankard 1750

Silver Teapot

Silver Punch Bowl by Paul Revere

Silver Caster 1725

Silver Teapot by Paul Revere

Silver Porringer 1700

Silver Beaker 1650

Pewter Whale-oil Lamp

Pewter Jug or Flagon

Pewter Teapot

Silver Sauce Pan by Revere

Pewter Lamp

Pewter Plate

Pewter Beaker

Pewter Sugar-bowl

Pewter Caster

Pewter Porringer

Examples of American silver and pewter.

stick, and lighting fixture. Pewter objects today are valuable decorative shelf accessories for informal and provincial types of rooms.

Sheffield plate. The technique of fusing a layer of silver to a layer of another metal, such as copper, was employed by many ancient cultures, but it was not extensively used until its rediscovery by Boulsover of Sheffield, England, in 1742. His motivation no doubt was to circumvent the enormous cost of silver objects. In addition, the thin layer of silver laminated to soft copper was more easily workable than sterling, thus reducing labor costs. Important too was the absence of taxes on the new material. By 1760, under the forceful exploitation of Josiah Hancock, Sheffield plate became so extensive as to provide serious competition to the guilds of the silversmiths. New companies were created at Birmingham, Dublin, and Cork. Large quantities of tablewares were exported to the Continent and France, which, under the sponsorship of Louis XVI, formed its own factory to compete with the English imports.

Electroplating was discovered in 1830, and by the middle of the nineteenth century its even cheaper process gradually brought the manufacture of Sheffield plate to a halt.

Today fine examples of Old Sheffield in such good condition that little copper shows through worn spots are almost as highly valued as Georgian silver. Here a note of caution: to electroplate badly worn Sheffield is to destroy its aesthetic as well as its monetary value.

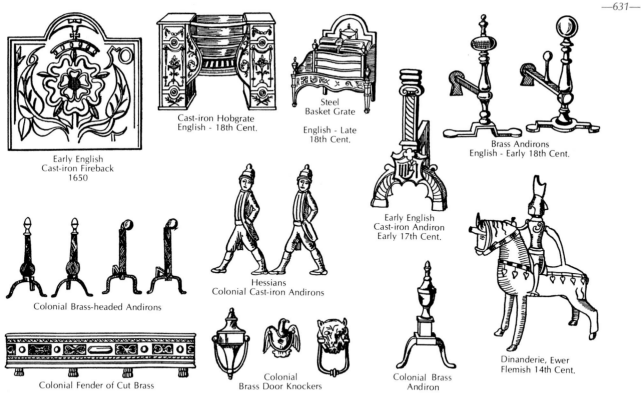

Examples of English and colonial metalwork.

Firebacks. Firebacks are made of cast iron and vary considerably in degree and quality of the finish. The eighteenth-century French firebacks and some of the earlier English examples were far more finely modeled than the American colonial ones. The French firebacks were ornamented in the relief patterns typical of each period. In the English and American firebacks many of the castings were made by local ironworkers who had little sculptural ability. The motifs used were of a very wide range, and many were of exceptional interest, reflecting local thought or persons. Human figures, ships, mythical creatures, historical scenes, family events, flowers, trees, humorous subjects, coats of arms, and many other motifs were used. It is difficult to identify the age of a fireback by the pattern, as many patterns were repeated for generations. The names of the makers and the date of casting are occasionally seen. Paul Revere and Stiegel of Philadelphia were the two best-known of the colonial ironworkers who made these articles.

Brass and copper objects. Many small objects, even of great antiquity, are still available to the collector in the antique shops of Europe, but the purchase of ornamental brasses in the United States is largely limited to objects of household use and furnishings of the colonial period.

If copper articles are kept polished, their warmth of color and patina may contribute greatly to the character and the decorative effect

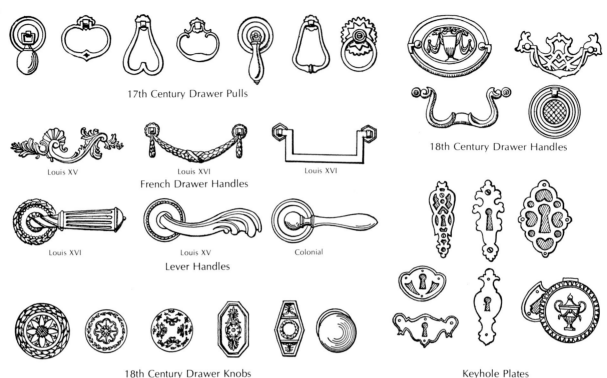

17th Century Drawer Pulls

18th Century Drawer Handles

Louis XV

Louis XVI

Louis XVI

French Drawer Handles

Louis XVI

Louis XV

Colonial

Lever Handles

18th Century Drawer Knobs

Keyhole Plates

Examples of furniture and door hardware.

of a room intended to reproduce a style that is consistent with their use. Among objects made of brass and copper and suitable for interior decoration are clocks, candlesticks, candelabra, and oil lamps; fireplace accessories such as andirons, fenders, warming pans, fire covers, coal scuttles, and tools; kitchen and cooking appliances such as caldrons, kettles, and skillets; table utensils such as jugs, water pots, drinking cups, tankards, carriage lamps, and marine fixtures.

Among the more fanciful ornamental objects made of brass and copper were lighting fixtures, water jugs, cisterns, perfume bottles, bowls, strange birds, winged dragons, and imaginary animals made during the Middle Ages in Dinant, Flanders. These have been given the name of *Dinanderies.*

Hardware. Many decorators give too little thought to the hardware used in a room, and yet the selection of practical and ornamental metalwork for the proper mechanical operation of such features as doors, windows, and drawers is of the utmost importance so far as comfort and convenience are concerned. From the decorative standpoint, hardware should be given equal consideration with the selection of any of the other smaller accessories.

Most of the hardware that was used for period rooms and furniture was of the surface variety, which means that the metalwork was visible and placed on the face of the woodwork. Under such a condition it was important that both the design and workmanship of the metalwork be harmonious with the style of the architecture of the room, and the craftsmen, having

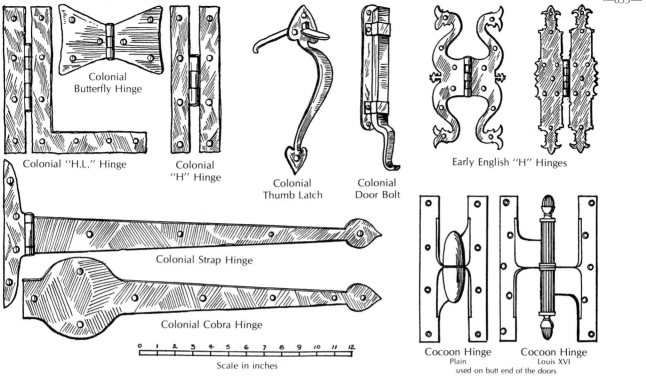

Colonial Butterfly Hinge

Colonial "H.L." Hinge

Colonial "H" Hinge

Colonial Thumb Latch

Colonial Door Bolt

Early English "H" Hinges

Colonial Strap Hinge

Colonial Cobra Hinge

Scale in inches

Cocoon Hinge
Plain

Cocoon Hinge
Louis XVI
used on butt end of the doors

Examples of furniture and door hardware.

pride in their workmanship and ability, produced by hand, hardware of great beauty. Much of the modern machine-made hardware is of the mortise type, a term referring to the fact that portions of the hardware are inserted in specially cut holes or grooves in the wood; while mechanically satisfactory, such pieces do not play an important part in the enrichment of the room.

Although hardware must be primarily functional in design, in each historical period it was either silhouetted or surface-ornamented in patterns that harmonized with the architectural and decorative treatment. The wrought iron pieces were given interest by their shape and hammer marks; the thin brass pieces, by repoussé ornament (a surface relief pattern produced by hammering the metals from the back); the heavier brass and bronze pieces, by cast relief ornament additionally finished by hand chiseling and filing, called *chasing*, which produced sharper edges and undercuts than was possible by the casting process alone.

There are innumerable varieties, sizes, qualities, and mechanical designs for hardware, and the manufacturers' catalogs appear very confusing to those who are not accustomed to this branch of decorative equipment. While a decorator should have a knowledge of the ornamental forms of metalwork that may be required for certain types of doors or furniture, the mechanical design should be checked by a manufacturer's representative or hardware dealer. Serious and quite unexpected errors may easily be made in the proper sizes and types of hinges and locks to be used, even under the simplest conditions.

The great majority of rooms today are furnished with the ordinary, commercial stock-pattern types of hardware, but in the best decorative work the hardware is specially designed and made to order. The latter type is, of course, far more costly and requires more time to produce. A description of the many available types of hardware used by decorators would occupy too much space for the purposes of this book. The reader must be referred to the commercial catalogs of hardware dealers or to the craftsmen who make special-order hardware and metalwork. Illustrations of the more common types of hardware are shown on pages 632 and 633.

Students of decoration should acquaint themselves with the following terms and articles:

Locks (tumbler and cylinder)
Bolts (plain, cremorne, and espagnolette)
Escutcheons (keyholes and pushplates)
Hinges (butt, cocoon, strap, H, HL, butterfly, double acting, and secret)
Handles (knobs, levers, and drawer pulls)
Latches (surface and secret)
Sash fittings (locks and adjusters)

CABINET WOODS

All wood is divided into hardwoods and softwoods. By definition, hardwood comes from the broadleaf trees, including oak, walnut, maple, and birch, while softwood comes from the evergreen trees, such as pine, hemlock, fir, and spruce. Some of the so-called softwoods, however, are actually harder than some varieties of hardwood, so this classification is not entirely accurate. It is true, however, that nearly all the fine woods for furniture and decoration come from the hardwood group.

The grain of wood is produced by the manner of its growth, being usually formed by the annual rings and medullary rays, which in some varieties are very conspicuous. The method of sawing the trunk of the tree has a great effect upon the appearance of the graining in the lumber. In some woods, particularly oak and mahogany, the medullary rays produce a striking pattern obtained by *quarter-sawing* the lumber (sawing toward the middle or heart of the tree trunk), though in most varieties of wood these rays are too small to affect the appearance. The term "quarter-sawing" comes from the early practice of longitudinally dividing a log into quarters and sawing each quarter into boards by cuts that run toward the center of the log. Quarter-sawing frequently produces the better graining, and such lumber has less tendency to shrink and warp. Boards that are not cut toward the center of the log are called plain-sawed or flat-grained lumber, and the grain on the top of the board approaches an elongated oval or V-shape in appearance. Usually plain-sawed lumber is cheaper than the quarter-sawed, because it can be cut with less waste; and in some kinds of wood, such as ash, chestnut, and elm, it has a better figure.

Wood to be used in building must first be seasoned, by either air-drying or kiln-drying. This removes most of the sap in the wood and causes a considerable shrinkage across the grain. Wood not sufficiently seasoned tends to warp and twist when used; and the same trouble occurs when woodwork is placed in a building before the masonry and plastering have had time to dry. If woodwork must be placed in its final position in a room before the plaster is thoroughly dry, the back should be painted with some impervious substance, such as asphaltum or lead and oil.

The best wood comes from the heart of the trunk of a tree and from the lowest portion of the trunk. The heartwood is usually darker in color than the sapwood or outside portions.

Interior trim is usually made of solid wood.

Method of quarter sawing toward the center of the trunk and at right angles to the annual rings.

The quartered trunk in the position it is run through the saw and showing the successive saw cuts.

Wide quarter-sawed planks are cut across the whole tree trunk.

Plain-sawed planks cut from the edge of the trunk.

Grain effect of a quarter-sawed plank cut through the center of the trunk.

Grain effect of plain-sawed wood cut from the edge of the trunk.

Methods of cutting the trunk of a tree for quarter- and plain-sawed graining.

Furniture is made of solid wood, but flat surfaces such as panels and table tops are often veneered. Veneer consists of thin sheets of wood about 1/16″ thick that are selected and cut for the beauty of their graining. The sheets of veneer are glued and pressed to the foundation surfaces of the furniture, the latter sometimes called the carcase or core. In antique furniture the veneer was cut by hand and was often 1/8″ thick. In modern machine-made furniture the veneer is cut by saw or knife and is sometimes only 1/32″ thick. Many modern veneers are cut by the rotary process. These are known as rotary veneers. They are peeled off in a continuous layer from a rotating log and have the advantage of being produced cheaply and in large

sheets. The thinnest sheets are glued to muslin and sold in rolls like wallpaper. They are applied to walls much in the manner of wallpaper and are popular in contemporary work.

Very handsome grained surfaces may be obtained by cutting veneers from portions of a tree in which the growth of the fibers is irregular. *Crotch veneer* is obtained from forks in the tree trunk or where large branches join the trunk in a Y-shape. The graining often appears as a pattern resembling a V-shape or a cluster of plumes. This is called the crotch figure or more often "crotch mahogany" or "crotch walnut," according to the kind of wood. Such veneers are usually matched so as to produce a panel with a symmetrical pattern in the form of an approxi-

mate square or diamond. *Burls* are large wart-like excrescences on tree trunks. They contain the dark piths of a large number of buds. Throughout the burl, the fibers are very irregularly contorted, so that the grain cannot be said to run in any particular direction. Burls may occur on almost any species, but walnut, ash, cherry, and redwood burls are among the most highly prized in furniture woods. *Bird's-eye cut* or *veneer* is somewhat similar to burl, but is caused by local sharp depressions in the annual rings, accompanied by considerable fiber distortion. The bird's-eye figure is confined almost exclusively to maple, and it occurs in only a small percentage of trees; its effect is that of a series of circles resembling rather remotely a bird's eye. *Butt-wood veneer* is taken from the junction of the larger roots with the stem of the tree, where the fibers are greatly distorted, producing cross figures, mottle, and curly grain. *Pollard veneer* or wood is cut from a tree that has been constantly trimmed at its top so that its growth is diffused into many small shoots. The shoots produce knots in the grain which add to the decorative value of the wood.

The idea that veneered furniture is cheaply made has long since passed. The present use of veneer gives added strength to furniture construction and prevents warpage. The modern method consists of gluing thin strips of veneer to plywood made of three, five, or more layers of wood glued together. The grain of each ply, as the layers are called, runs at right angles to the adjoining ply. Since wood is stronger the long way of the fiber and shrinks more across the grain than with it, this method of laying the grain of one piece across the grain of the adjoining layer helps to equalize the strength and to prevent uneven shrinkage, which causes warping. Veneered furniture of the past and present often represents the highest attainment of the cabinetmaker's craft.

Veneered woods are often enriched by marquetry patterns in which the sheets of wood for the pattern and the field are cut together so that they exactly fit each other.

Many varieties of wood are used for interior finish, cabinetwork, and furniture. Among the hardwoods, oak is the most important, others being walnut, maple, birch, ash, and chestnut, while among the softwoods the most important are white pine, cypress, and redwood. Local conditions often make possible the use of woods that are little known to the general public, and the varieties are so numerous that no list can be complete. The rare woods are, as a rule, used for veneers only. On pages 637–640 are given brief descriptions of the important woods used for cabinetwork or interior trim.

Woods used in furniture construction. Oak is the most common wood used for furniture construction and finish in both solid and veneered surfaces. Its hardness, strength, finish, and adaptability make it suitable for all grades of furniture. White oak rather than red oak is preferable where a natural finish is desired. Chestnut is used mainly for cores for veneered surfaces such as table tops and drawer fronts; it is soft and light, dries easily, and warps and shrinks little. Yellow birch is another very common furniture wood; it is strong and hard and holds its shape, takes stain and enamel well, and is often used as a substitute for mahogany and walnut. Rosewood (jacarandá), while less popular today than during the nineteenth century, is excellent for piano-cases, handles, and small objects. West Indian mahogany, with its color and beauty of grain, is used for all types of high-grade furniture, often on veneered surfaces, although many antique pieces were made in solid lumber. In the less conspicuous parts of the cheaper grades of furniture, red gum or birch is sometimes used as a substitute for mahogany. Walnut has long been popular as a furniture wood. It is hard and strong with a rich color and luster, comparatively free from warping, and has good gluing qualities; it is used for both solid

and veneered construction. Beech is used for furniture that is to be painted or stained. It bends easily and is therefore particularly adapted for curved parts such as arms and backs of chairs. It is also extensively used for the unseen portions of furniture, such as drawer sides, runways and frames. Beech is strong and hard but has a greater tendency to warp than other woods. Maple is one of the principal American furniture woods and is usually given a natural finish, for which reason the curly or bird's-eye figure is preferable. Maple is hard and strong, and has good gluing properties. Red gum has recently become one of the leading furniture woods of this country.

GLOSSARY

Woods Used in Cabinetwork

Acacia. A light brown hardwood from Australia and Africa. In ancient times it was used by the Eastern nations for religious and sacred buildings; today it is used for furniture and for architectural and ecclesiastical woodwork.

Aceitillo. West Indian hardwood with fine grain, somewhat resembling satinwood in color and appearance. Used for furniture.

Amaranth. A dark purplish wood imported from South Africa. It is usually fine-grained and figured, and is much used in contemporary furniture.

Amboyna. A rich brown wood, highly marked, with yellow and red streaks. Much used for modern cabinetwork and veneering. It is of East Indian origin.

Apple. A light-colored, fine-grained wood used for furniture. It is suitable for staining or natural finish.

Arbor-vitae. An evergreen tree of the genus Thuya, native to North America and eastern Asia. An excellent building and furniture wood.

Ash. A blond wood with a handsome figure and pleasing texture, which, because of its hardness, is not extensively used for interior work, though it can be used to produce very rich effects. It is well adapted to dark stained effects.

Avodire. A blond wood with strong, dark brown vertical streakings. It has a fine texture and is much used for modern furniture, for veneering purposes.

Bamboo. A woody, perennial plant that grows in tropical regions. The wood is used for furniture,

ornaments, building purposes, pipes, paper-making, and food.

Baywood. An alternate name for Honduras mahogany, which is lighter in color and softer than the Cuban or Spanish mahogany. Its fine marking makes the wood useful in veneered work.

Beech. A pale straight-grained wood much used for flooring and furniture. It resembles maple and birch, and can be similarly used.

Birch. A fine-grained wood, strong and hard, usually a light brown in color. It requires no filler, takes paint and stain well, and can have a natural finish or be stained to imitate walnut, mahogany, and other more expensive woods. It is much used for doors and trim as well as for flooring, where it competes successfully with oak.

Black walnut. In spite of its extensive use at a period when design was at its lowest level, it is one of the most beautiful woods grown in this country. It has a rich color, takes a high polish, and shows a very handsome figure. It is fine-grained enough to allow intricate carving, though its open pores call for the use of a filler in finishing. It is among the more expensive woods, because of wasteful cutting at the end of the nineteenth century; but it can still be found in the market in fair quantity, and for furniture it is unsurpassed for richness of effect.

Boxwood. A light-colored, fine-grained wood used for marquetry.

Butternut. Called also white walnut; resembles black walnut in all respects except color, and may be similarly used, where a lighter effect is desired. It works easily, is hard and durable, and has a handsome figure, formed by the annual rings. In some sections it is used for flooring and ceiling, elsewhere for interior finish and furniture. The trees grow throughout the United States.

Cedar. A name applied to several woods that are fine-grained and fragrant. The North American cedar is a juniper; the West Indian is of the mahogany family. The wood is used for chests and lining clothes closets, cigar boxes, and pencils. Persian cedar, or nanmu, is an eastern hardwood used for building.

Cherry. A durable hardwood of a reddish-brown color, which is produced only in small quantities, the trees being usually too small for lumbering. It is often used to imitate mahogany, which it greatly resembles, and is used for marquetry and inlay.

Chestnut. A softwood, sometimes white and sometimes brown, which resembles plain oak, but has a coarser grain. Where a quartered effect is not de-

sired, it can take the place of oak and is generally much less expensive. Because of its strongly marked rings and coarse grain, it is unsuitable for fine detail.

Circassian walnut. A brown wood with a very curly grain, one of the handsomest finishing woods, which comes from the country near the Black Sea. It is used largely for furniture and panelling, and is very expensive.

Cocobolo. A dark brown wood with a violet cast. It takes a highly polished finish and is used for modern furniture.

Coromandel (also called coromandel ebony and calamander). A hard dark-brown wood with black stripes that grows in India and China and is much used for furniture.

Cypress. A wood with a light brown color, though it varies considerably according to its origin. It is a very handsome wood for interior use, quite inexpensive, adapted to all types of finish, and remarkably free from warping and twisting. This last property recommends it for kitchen use, or wherever heat and moisture are met. Cypress is too soft for flooring, though occasionally so employed, and too weak for structural timber; but for finish, few woods can equal it. It may be given a natural finish, or may be painted or stained to give almost any effect that may be desired, including imitations of many of the expensive hardwoods. A special treatment, to which cypress alone seems adapted, is so-called *sugi* finish, an imitation of Japanese driftwood. It is produced by charring the surface with a gasoline torch and rubbing off the charcoal with a wire brush. The spring wood burns away and the harder summer wood remains, leaving the grain in strong relief.

Deal. A term used in England for designating standard merchandising dimensions of fir and pine lumber. In the United States it is generally applied to southern yellow pine, and in Canada to northern soft pine. The word is sometimes used as a misnomer for pine wood itself.

Douglas fir. A western wood that resembles white pine as to its physical properties, but has, in addition, a very handsome curly grain that makes it more suitable for natural or stained finish. It is strong and durable, works easily, and is adaptable to almost every type of use. It is, moreover, fairly inexpensive, being produced in great abundance, probably more than any other single species. There are several other species of fir, but they are of relatively little importance. It is used extensively for large plywood or laminated sheets.

Ebony. A handsome dark heartwood of a tropical tree. Black ebony or *gabon* comes from Africa, is hard and heavy, takes a high polish, and is used for furniture and inlay. *Macassar* ebony is a coffee-brown wood with black streaks, and is used for modern furniture. Coromandel and striped ebony are names that are also applied to macassar ebony. Ebony is sometimes red or green.

Elm. A strong and tough wood, with a less interesting figure than most other hardwoods. When treated with stain and polish, however, it makes a fine appearance. Because of its durability, it is used in large quantities for furniture, and its use for interior work might well be more extensive.

Eucalyptus. A pale reddish-yellow figured wood, much used in modern decoration, and also in shipbuilding. It is also called oriental wood or oriental walnut.

French burl. A term applied to a walnut that comes from Persia. It has small warts or knots that form on the side of the tree when young, giving the lumber an interesting curly grain. It is much used for cabinetwork.

Fir. See Douglas fir.

Gum. See Red gum.

Harewood. Its common name is English sycamore. It has a fine cross-fiddle figure and is much used today for cabinetwork, particularly after it has been dyed a silver gray.

Hemlock. It is little used for finish, particularly in the eastern states. The western hemlock, however, is a far better wood than the eastern variety, and can be used for finish wherever strength, lightness, and ease of working are desirable. It greatly resembles white pine, and may be used in a similar manner.

Hickory. An American tree of the walnut family. Its wood is hard, tough, and heavy and is not used for decorative purposes.

Holly. A light-colored, fine-grained wood used for marquetry.

Jacarandá. See Rosewood.

Kingwood. A dark brown wood with black and golden yellow streakings. It comes from Sumatra and Brazil and is a fine cabinetwood.

Korina. A wood resembling primavera, and having a light yellow color. Used for wall veneers.

Laurel. A dark reddish-brown with a pronounced wavy grain. It takes a high polish and is much used for modern furniture.

Mahogany. A wood with a beautiful reddish color and handsome grain which has long made it a favorite for furniture. It is imported from South America and the West Indies, the various islands of

which produce several distinct species. The best of these is found in Santo Domingo, and is sometimes known as Spanish mahogany. White mahogany or primavera has a creamy color and comes from Mexico. Mahogany is easily worked, takes a high polish, and warps and shrinks but little. Honduras mahogany is known as baywood. In addition, mahogany for various purposes comes from Cuba, Africa, Nicaragua, Costa Rica, and the Philippines.

Maple. A wood similar to birch, though usually lighter in color. It is adapted for the same uses, including flooring. Straight-grained maple is one of the handsomest woods for interior finish, while the curly or bird's-eye varieties are used for veneered furniture. It is very hard and strong.

Myrtle. A blond wood with fine markings. It is much used in cabinetwork for inlay and veneer.

Nanmu. A wood used in China for building and decoration. It is aromatic and turns a deep rich brown with age. It is also called Persian cedar.

Oak. This is the most important of all woods for interior use. It may be sawed, either plain or quartered, the latter being generally preferred for fine work, because of the striking pattern produced by the medullary rays. Plain oak is less expensive, because there is less waste in its production, and it is used for the less important features, or where durability rather than beauty is the chief consideration. Oaks are divided into over fifty species, but the differences in the wood are not great. They are all hard, durable, and very similar in grain. The wood lends itself well to carving of all kinds and is also well adapted to panelling. Because of its open grain, oak should be treated with a filler before applying stain or varnish. English and French oak have finer graining than the American variety.

Olive. A light yellow wood with greenish-yellow figures. It takes a high polish and is popular for inlay purposes.

Palisander. A brown wood with a violet cast. It comes from Brazil and the East Indies and is much used for modern furniture.

Pearwood. A pinkish-brown, finely grained wood that is frequently used for inlay and fine cabinetwork.

Pine (white). Known sometimes as soft pine, this was once the most important of softwoods, and is still used in large quantities, though its price is now rather high. It works easily and is used for both structural and finishing purposes, though it is nearly always painted, its texture being of little interest. The leaf of the trees has short needles.

Pine (yellow). Called hard pine, it has several species varying greatly in strength and other properties. In general it is stronger and harder than white pine. It makes good and cheap flooring, trim, doors, and furniture. For interior finish, its natural yellow color is not very pleasant, but by the use of dark stains, effects are obtained that are little inferior to dark oak. Yellow pine grows in Georgia and the Carolinas, and the leaf of the tree has long needles.

Primavera. A blond, smooth wood with a handsome figure, it is sometimes known as white mahogany. It takes a high polish and is much used in contemporary decoration. Comes from Mexico.

Red cedar. A wood little used for decorative purposes, though great quantities are used for making shingles and lead pencils. Its chief use as a finish wood is for the lining of clothes closets and chests. The small use made of cedar for finish is doubtless the result of its great variation in color, ranging from a decided red to almost white. Both colors are often found in a single piece, the heartwood being red and the sapwood white. Its odor is also too pungent for constant association.

Red gum. A handsome, fine-grained wood, of a reddish-brown color. *Sap gum* is the sapwood of the same tree, and is much lighter in color. Red gum is much used for veneered doors, as well as for general interior finish, though its use has only become general in recent years. It may be used as a base for white enamel, or may be stained to imitate a variety of other woods, including walnut, mahogany, and maple, while selected specimens may even be found to imitate the striking figure of Circassian walnut. The figure of red gum varies in different trees, and it must be selected according to the use intended. In addition to various stained finishes, it may be given a natural finish by the use of wax, producing a handsome satiny effect that wears remarkably well.

Redwood. A wood of a very handsome and uniformly red color, extensively used on the Pacific Coast, though seldom seen in the eastern states. It takes stain and paint readily, and can be obtained in very wide boards because of the great size of the trees. It is used for open beams and trim.

Rosewood. A fine reddish-brown wood with black streakings. There are many varieties, of which the most popular is Brazilian rosewood, called *jacarandá*. It takes a high polish and is much used for fine cabinetwork and for musical instruments.

Satinwood. A light blond wood with a satiny finish and a handsome figure, used for finishing only in

the finest work. It is largely used for furniture, and particularly for inlay and parquetry. Satinwood is cut from various species of trees that grow in India, Florida, and the West Indies.

Snakewood. A yellow-brown or red-brown wood with dark spots and markings. It is popular for inlay work.

Spruce. A variety of pine closely related to the fir. Important ornamental tree with a soft, light, straight-grained wood used for interior and exterior construction and for sounding boards of musical instruments.

Sycamore. A wood that ranges from white to light-brown in color. It is heavy, tough, and strong, and handsome in appearance. It is extensively used for finishing work.

Tabonuco. A light-colored, beautifully grained West Indian hardwood used for furniture.

Teakwood. A wood that is yellow to brown in color, often with fine black streaks. It is more durable than oak and is used for shipbuilding as well as for furniture.

Thuya. A dark red-brown wood from North Africa. It takes a high polish and is much used in contemporary cabinetwork. Arbor vitae is of the same genus. The wood was known to the Chinese and Greeks.

Tulipwood. A light yellow wood with red streaks. It comes from Brazil and is much used for ornamental inlay.

Walnut. A light brown wood taken from trees that grow throughout Europe, Asia, and Africa. Much used for cabinetwork. There are English, French, and Italian varieties. The American walnut has a coarser grain than the European varieties and is often called English walnut or black walnut. The hickory tree has a similar wood and leaf, and is often called a walnut in the United States. See also Butternut and Black walnut.

Whitewood. The trade name for poplar and cottonwood. There are several species, but all are characterized by a uniform grain of little interest, so that the wood is used mainly for shelving, interior parts of furniture, and cores in veneered work. It is soft and works easily, but is durable in ordinary use, excellent for painted surfaces.

Yew. A close-grained hardwood of a deep red-brown. It is a European evergreen and thrives especially in England. Frequently used in cabinetwork where an elastic quality is desirable.

Zebrawood. A light golden-yellow wood with dark brown stripes. It is used for ornamental cabinetwork.

BIBLIOGRAPHY

Avery, C. L. *Early American Silver.* New York: D. Appleton-Century Co., 1930. Excellent illustrated text.

Burgess, F. W. *Chats on Old Copper and Brass.* New York: Frederick A. Stokes Co., 1914. Illustrated text.

Burlington Fine Arts Club Exhibition of a Collection of Silversmith's Work of European Origin. London, 1901. Illustrated text.

Byne, A., and Byne, M. S. *Rejeria of the Spanish Renaissance.* New York: DeVinne Press, 1914. Collection of photographs and measured drawings with descriptive text.

Byne, A., and Byne, M. S. *Spanish Iron Work.* New York: Hispanic Society of America, 1915. Excellent illustrations.

Clouzet, H. *La Ferronnerie Moderne.* Paris: C. Moreau. Thirty-six plates of modern ironwork.

Contet, F. *Documents de Ferronnerie Ancienne.* Paris: F. Contet, 1908–1909. Series of portfolios containing photographic plates of ironwork in France.

Ferrari, G. *Ile Fero.* Milan: U. Hoepli. Italian ironwork.

Gardner, J. S. *Ironwork, Part I, From the Earliest Times to the End of the Medieval Period.* London: Victoria and Albert Museum, 1914. Illustrated text.

Gotterell, H. H. *Pewter Down the Ages.* London: Hutchinson and Co., 1932. Illustrated survey of pewter from medieval times to the present day.

Howard, M. *Old London Silver, Its History, Its Makers, and Its Marks.* New York: Charles Scribner's Sons, 1903. Illustrated text.

Jackson, C. J. *English Goldsmiths and Their Marks.* New York: Dover Publications, Inc., 1964. The definitive authority on the subject.

Jackson, C. J. *Illustrated History of English Plate.* London: Country Life, 1911. The most authoritative text written on the subject. Very expensive, but usually available in large public libraries.

Jones, E. A. *Old Silver of Europe and America.* London: B. T. Batsford, 1928. Illustrated text.

Kerfoot, J. B. *American Pewter.* New York: Houghton Mifflin Co., 1924. Illustrated text.

Koehler, A. *The Identification of Furniture Woods.* Washington, D.C.: U. S. Department of Agriculture, 1926. Excellent treatment of woods with illustrations.

Okie, H. P. *Old Silver and Old Sheffield Plate.* New York: Doubleday and Co., 1928.

Payson, W. F. *Mahogany, Antique and Modern: A Study of Its History and Use in the Decorative Arts.* New York: E. P. Dutton and Co., 1926. Illustrated series of essays on various uses of mahogany.

Pelton, B. W. *Furniture Making and Cabinet Work: A Handbook.* New York: D. Van Nostrand Co., 1949. Instructions and step-by-step drawings for furniture construction.

Pettorelli, A. *Il Bronze e Il Rame nell'Arte Decorativa Italiana.* Milan: U. Hoepli, 1926. Illustrated history of Italian bronze.

Rosenberg, Marc. *Der Goldschmiede Merkzeichen.* 4 vols. Frankfurt am Main: Frankfurter Verlags-Anstalt A. G., 1922. Standard work of worldwide marks of gold and silver.

Shapland, H. P. *The Practical Decoration of Furniture,* 3 vols. London: Ernest Benn, Ltd., 1926–1927. Good illustrated text.

Sonn, A. H. *Early American Wrought Iron,* 3 vols. New York: Charles Scribner's Sons, 1928. Text illustrated with plates from the drawings of the author.

Wells, P. A., and Hooper, Jr. *Modern Cabinet Work: Furniture and Fitments.* Philadelphia: J. B. Lippincott Co., 1924. Illustrated account of theory and practice in the production of all kinds of cabinet work. Working drawings, photographs, and original designs.

Weyler, Seymour B. *Sheffield Plate.* New York: Crown Publishers, 1949.

PART FIVE

Interior Planning

Mercedes-Benz

The Quickborner installation for Mercedes Benz of North America further develops the office landscape. Note particularly the life support ceiling which not only houses warm and cool air but also indirect and direct lighting and outlets for telephone, electricity and power. Additional power connections are placed on the floor.

CHAPTER **21**

Furniture Arrangement and Space Planning

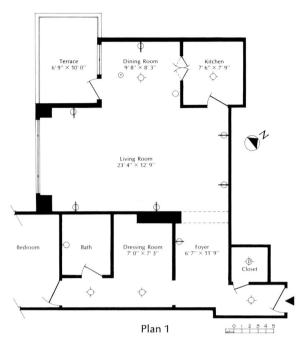

Plan 1

Conventional method of indicating walls, doors, windows, and electrical outlets in a typical floor plan.

Today few will dispute that function precedes style in any area of design. The interior designer is expected to assemble beautiful furnishings, materials, and colors in an imaginative and attractive composition, but the success of his design rests only temporarily on superficial appearances. It is eventually judged on how well the interior functions and how successfully it provides for his client's needs.

FURNITURE ARRANGEMENT

In creating a functional environment, today's designer finds standardized or memorized furniture arrangements almost useless since it is obvious that each client's needs are unique. He must give careful consideration to the proper division and allocation of space, the flow of traffic, activity planning, and the relationship of scale and mass of furnishings to the interior space before him. When this approach is applied to each client's problems, the interiors that result are individual and clearly superior to stereotyped furniture arrangements. Furniture will fall quite simply and logically into proper place, and the designer will then be free to apply his skill to the aesthetic impression he wishes to make.

Analysis of space. The designer begins by studying his interior space as intently as an architect or town planner studies his sites. If a blueprint is unavailable, he must make a floor plan of the actual space. Using a scale rule, he charts the physical dimensions, the accesses and openings, fixed architectural features, and the electrical outlets. In residential spaces, it is customary to represent these facts at a scale in which one-quarter of an inch equals one foot. In large public or commercial spaces, a scale of one-eighth of an inch to one foot is frequently used. The floor plan shows the standard method of indicating walls, windows, doors, fixed architectural features, and electrical outlets. At the end of the chapter are additional plans for architectural and mechanical features and furniture.

As the designer becomes increasingly familiar with the space before him, he will discover that it conveys a *space impression* which may seem to increase or decrease the actual footage between the walls. Thus, it is possible for two rooms of the same dimensions to give quite different space impressions. Space impression is primarily related to the location of the main entrance and is best understood if the designer actually or theoretically views the room from this spot. How expansive or how intimate the unfolding space seems is obviously proportionate to how far or near the opposite wall is to the room's threshold. But it is also conditioned by the size and placement of windows and the

width of openings to adjoining spaces, for a deep perspective, or lack of it, might well result from such factors. A test of this may be made with the two plans below, which are identical in their dimensions.

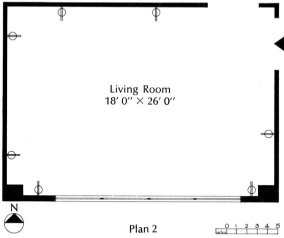

This space when viewed from the east wall entrance sweeps uninterrupted along its entire 26 feet and has a deep perspective through a large window opening along most of the south wall. The width of the opening to the adjoining room on the north wall gives additional depth.

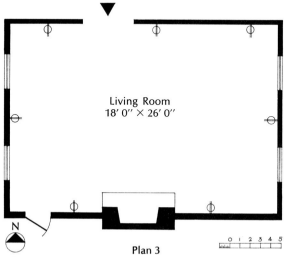

This space viewed from its north wall entrance stops at the fireplace 15 feet away. Pairs of windows on east and west walls do not provide a deep exterior perspective, as does the single large window in Plan 2 above. This space seems intimate, by comparison.

Division of space. With this understanding of his site, the interior planner is ready to proceed along a route similar to that of the exterior planner.

He is now able to sketch in "streets," thereby subdividing his space, for a room, like a city, must have a traffic plan. If a room's streets were as visible as city streets, one would see furniture obstacles as being as disruptive to interior circulation as a repair crew is to Main Street. Traffic patterns added to the plan at this stage avoid the pitfall of forgetting to leave uncluttered "streets" when the designer eventually places the furniture.

The accesses to the space and the architectural lures (those interesting features determined in the site study) provide the traffic clues. When the designer returns to the main entrance, he stands at the hub of the traffic patterns. From here he must leave uninhibited access to the centers of interest and to secondary openings (adjoining rooms, closets, built-in bars, etc.). Study the initial traffic pattern in the plan on page 647. Subsequent activity planning of the space may require additional traffic arteries.

Note how these dissecting streets have subdivided the space into distinct and obvious zones. This division has prepared the room for *activity planning*, which the designer may now undertake, and it has simplified his task considerably. Some zones clearly offer sufficient space for group activities, and some do not. Some zones include or lie close to desirable centers of interest. Others are sufficiently removed from the circulation pattern to offer privacy for intimate activities.

Activity planning. Activity planning is the phase of the project in which the designer carefully analyzes the client's intended *use* of the space and determines the furniture requirements. In residential and commercial spaces, the client frequently contributes a great deal of information to this phase. Generally it is the designer's role to project the use of a public space

Plan 4

0 1 2 3 4 5

Traffic circulation requires unobstructed lane from entrance point A toward the focal point of the curved window framing the exterior view, point B. A second lane, point A to point C, is required for access to the adjoining area. Access from points C to B completes the preliminary traffic plan and divides the overall space into three distinct zones.

by a person or persons unknown (such as a lobby, auditorium, restaurant, hotel room, etc.).

The designer researches the intended use of the space in detail, studying the residential client's life-style and the commercial client's job requirements. This study should be so individualized and specific that even the most experienced designer will seldom find a similar project in his files, a condition which helps, naturally, to keep his work fresh and his mind fertile.

As the "use study" proceeds, the designer charts the activities which the specific space before him must satisfy. In today's compressed quarters, he may well find that a living room requires work, hobby, dining, or game facilities as well as the familiar entertaining and reading activities. A room in a commercial hotel may have to provide for conferences and samples

display in addition to sleeping and dressing accommodations, etc. This concentrated study of his client's needs may provide additional pieces in the puzzle, and the designer will do well to note special conditions and preferences which will influence his furniture, materials, and color selections later.

Information gathered during the use study should be recorded in efficient, workable form, such as the simple *Activity Planning Chart* below.

CLIENT: Mr. and Mrs. Henry Stevens
ROOM: Multipurpose Living Room

ACTIVITIES	FURNITURE REQUIRED	FLOOR SPACE REQUIRED
(A) Entertaining	seating for 6–8 utility tables	8' x 12'
(B) Home Theater	audio-visual equipment accessory storage seating for 4–6	8' x 10'
(C) Game	card table 4 chairs	6' x 6'
(D) Reading	book storage 2 lounge chairs utility tables	6' x 10'
(E) Home Office	desk desk chair	5' x 5'

The first column represents a summary of the designer's preliminary study of the client's needs. Filling in the chart from left to right amplifies these facts into practical design information. In the second column, notes are made of the furniture pieces needed to support the activities in the first column. These constitute *activity groups.* By simple mathematics the designer can calculate the approximate floor space required for each activity group. He records this information in the third column.

An inexperienced designer may prefer to check catalogs or the silhouettes at the end of this chapter for furniture dimensions. Soon, however, he will become familiar with standard

sizes and *use dimensions* (how much space is required to move a chair from a table, how much space is needed between sofas and coffee tables, passage widths, etc.), and this will no longer be necessary at the activity planning stage.

Additional columns may be added to the chart for notations on special requirements, lighting, color preferences, and supply sources.

Furniture placement. Completed activity planning charts for each room in the design project permit efficient transfer of the client's needs to the zoned floor plan. The designer can quickly match the space requirements of each activity group to the space available. He would know at a glance that a zone measuring six feet by eight feet is inadequate for the entertaining activity in the hypothetical multipurpose living room above, but perhaps suitable for reading activity, home office activity, or game activity.

The character of each zone helps to precondition his selection, too. A large zone which lies close to or includes a center of interest, such as a fireplace or a window framing a superb view, is an obvious choice for a group activity. A secluded space away from major traffic circulation is both logical and comfortable for intimate activities. The designer can also determine by checking off activity groups against zones if adequate space exists for the separation of all activities or if some groups will have to overlap and do double duty.

He should note his rough space allocation by indicating the activity group keys on his floor plan. (For example, A for the entertaining group, B for home theater, etc., from the theoretical problem on page 647.) This phase of the project would produce the plan below.

Functional planning of interior space, as discussed above, is the first concern of today's designer. Once he has intelligently piloted his project through these logical steps, he may turn his attention to other design factors and aesthetics which will contribute to an overall design concept. Of these, the relationship of scale and

Plan 5

Zoning the floor plan. The entertaining activity in the hypothetical multipurpose living room should occupy the center of interest. It is placed in the zone near the curved window, indicated by A on the plan. The home theater is located in the auxiliary area (B). Game activity (C) requires small space and can take advantage of natural light if placed in the window zone of the auxiliary area. The zone at the right of the entrance offers privacy; it is behind the traffic pattern and is logical for the reading activity (D). The corner provides two adjacent walls for book shelves. The home office activity is a normal adjunct to the reading activity and might be located nearby (E).

mass of furnishings to the space, the contrast of vertical and horizontal elements, and harmonious composition of furniture groupings are probably the most important.

Relationship of scale and mass to space. Potentially, every eye is capable of discrimination in scale, since man is conditioned to objects dimensioned to human size in daily life. It does not take an expert to know that the centerpiece is too overpowering if the flowers block the opposite diner or dangle in the soup.

In an interior, the scale of furnishings is based on their proper proportion to man, to other objects used, and to the space in which they appear. An interior should seem neither crowded nor underfurnished. It should appear instead to have taken advantage of the allotted space while leaving vistas to enjoy its various objects. If an object is removed, the space should appear bare, with something obviously missing.

Large spaces permit the use of large-scaled furniture and a greater flexibility of activity groups. Small-scaled objects generally look insignificant in large spaces and fail to make a contribution to the overall composition. The distribution of groups should appear approximately equal throughout the space so that no one area is overwhelmed with weight and mass while another is uncomfortably blank.

Small spaces should be furnished with small pieces of furniture, for the eye will immediately regard a large object as ungainly in an intimate space. Important small rooms should be furnished with refined details, as the eye is particularly critical of quality in close quarters.

The designer must consider the scale and mass of furnishings not only to the overall space, but also to the specific locations in which they are to appear. A lone console on a long wall will not sufficiently hold down the space and will seem an unfortunate caricature in scale. A sofa overlapping window and wall will appear to be left over from another room.

Contrast of vertical and horizontal elements. To avoid monotony, it is generally necessary to vary the direction of the real or imaginary lines that are formed by architectural features and furnishings. A room accented by high windows and doors, or by classical or Lally columns, needs the horizontal balance of sofas, long tables, and low desks. Conversely, an interior devoid of vertical architectural accents needs the balance of high pieces of furniture or commanding wall decorations to heighten the line of a piece of furniture below.

Harmonious composition. Unity in room composition is approached when an additional balancing factor is incorporated in the emerging design concept that involves the relationship of objects to each other. The same principles of scale and mass that apply between the furnishings in toto to the overall space apply also between objects themselves. Pieces of overwhelming dimension will belittle the importance of smaller pieces, and both will appear extreme in scale. Too great a similarity in either weight and mass or line and form fails to separate the trees from the forest, and the whole composition blurs. A grouping without vertical and horizontal line contrast also begets sameness and robs each piece of interest, regardless of how beautiful they might be individually. Harmony, therefore, emerges from contrast without excess.

With these factors in mind, the designer may now fill in the activity groups with his selected furniture and complete his plan. The example on page 650 is based on the hypothetical multipurpose living room on page 647.

SPACE PLANNING

It took until 1930 for the United States to accumulate a billion square feet of office space, while during the following three decades that total nearly doubled. So far in the seventies, 500 million square feet of office space has been started, and, according to the New York Regional Plan Association, the country will double its total office space again by the year 2000.

—*Architectural Record*,
McGraw-Hill, June, 1973

The impact of this vast quantity of new office space was felt immediately after the Second World War when manufacturers of residential furniture began to produce desks, chairs and storage units for office use. Designers of residential furniture followed suit. The interior designer found this new work a great challenge and enlarged the scope of his professional services to include space planning.

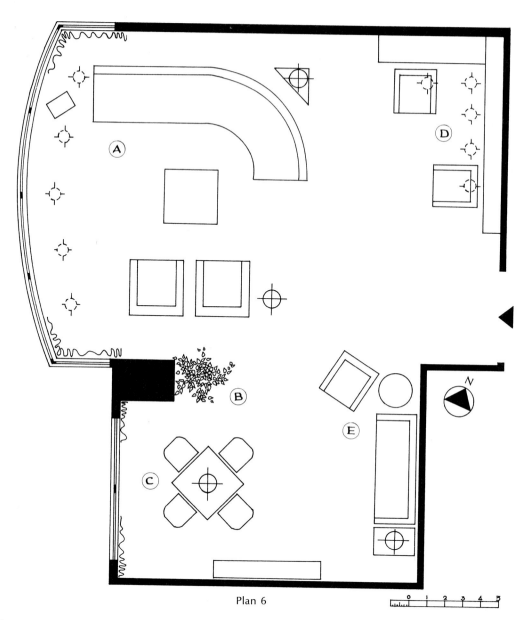

Plan 6

Completing the plan requires filling in furniture in each activity group. Seating six to eight persons in the Entertaining group (A) can be achieved with a large sofa and two chairs. Floodlighting the curved window provides dramatic illumination of the room's focal point and requires only additional soft lighting for the Entertaining group. This can be accomplished with a table lamp and floor lamp. A spotlight over a pedestal with sculpture at the window end of the sofa can be positioned in the line of recessed ceiling lights. A tall tree (B) softens the protruding column behind the chairs and serves as a shield between the Entertaining group and the Game group (C). A ceiling fixture over the game table lights the area for cards. Bookshelves lining the corner at the right of the entrance contribute a balancing mass opposite the Entertaining group and a logical backdrop for the Reading activity (D). The requirements of the Home Office activity (E) might be satisfied by re-using a comfortable chair from the Reading group at a shelf incorporated into the bookcase as a desk.

The arrangement of furniture and equipment for specific use has always been part of the professional services of the interior designer. Putting the parts together to design a visually exciting and flexibly organized living-dining room is space planning. By the same token, the subdivision and interaction of the components of raw office space is space planning as well. It is in the context of the second example, office design, that the phrase space planning is used to define this highly specialized aspect of interior design. While the design process is the same, the arrangement of space, furniture and equipment for office use requires particular training and experience. An outline of procedures will be presented to enable an interior designer who is interested in space planning to understand the content of each step within a professional overview.

The procedure for space planning. The first phase of space planning is always programming: the determination of the parts and their interrelationships. What are the parts of the client's organization and how do they relate to each other? How much space does each part and the sum of the parts require (floor area) and how closely must one part be positioned to the others (affinity)? Programming also includes an inventory of furniture, furnishings and equipment needs. The final part of the programming phase is the preparation of a schematic drawing called a flow or bubble diagram. This is a simple sketch in which a series of ovals or bubbles is drawn. Each oval is labelled with the name of a part of the organization, and straight lines are drawn between these ovals to indicate, in the simplest manner, how they relate to one another.

The second phase of space planning is preliminary design, or the analysis of the written program and the schematic flow diagram in the form of a floor plan. This plan is drawn to an architectural scale and is meant to demonstrate how much floor area must be rented, purchased or built to solve the client's space needs. The floor area is multiplied by a rule-of-thumb square-foot construction cost, and a construction cost estimate is prepared. Frequently a budget estimate for the cost of furniture, furnishings and equipment is also prepared so that a preliminary budget can be quoted for the whole project.

The floor plan and the project budget will give the client the first tangible evidence of the actual amount of space that is necessary and the cost of preparing the space for use. Modifications in the plan may be necessary to come up with a preliminary budget that is acceptable to the client. However, when the client accepts the preliminary design and the project budget (in writing, please), the actual negotiation for the rental or purchase of available space can begin. At times, this package of program, preliminary design and preliminary budget is called a *feasibility study* since this study presents, for the first time, the problem, the solution and the cost.

Phase three is developed design. The floor plans are developed and all furniture and equipment layouts are drawn. Architectural materials are chosen, and the mechanical systems (heating, cooling, power, lighting and communication) are studied and located on the plan. This developed plan, together with an outline specification of materials and equipment, will permit refinement of the initial rule-of-thumb construction costs.

Working with architectural and engineering resources, the designer commences the fourth phase of the space planning service: working drawings and specifications. These are the documents by means of which the general contractor can properly estimate the cost of the job. These drawings and specifications contain all the information necessary to build the project.

The last phase is the supervision of construction, the purchasing of furniture, furnishings and equipment, and the move into the new office space.

DEPARTMENT AFFINITIES

DEPARTMENT A RELATES TO B
DEPARTMENT A RELATES TO C
DEPARTMENT B RELATES TO E
DEPARTMENT B RELATES TO M
DEPARTMENT C RELATES TO D
DEPARTMENT C RELATES TO E
DEPARTMENT E RELATES TO J
DEPARTMENT E RELATES TO L
DEPARTMENT F RELATES TO G
DEPARTMENT F RELATES TO H
DEPARTMENT F RELATES TO I
DEPARTMENT H RELATES TO I
DEPARTMENT H RELATES TO J
DEPARTMENT H RELATES TO N
DEPARTMENT H RELATES TO O
DEPARTMENT J RELATES TO K
DEPARTMENT K RELATES TO L
DEPARTMENT L RELATES TO M
DEPARTMENT L RELATES TO N
DEPARTMENT M RELATES TO N
DEPARTMENT N RELATES TO O

```
  ABCDEFGHIJKLMNO

A * I I 0 0 0 0 0 0 0 0 0 0 0 0
B I * 0 0 I 0 0 0 0 0 0 I 0 0
C I 0 * I I 0 0 0 0 0 0 0 0 0
D 0 0 I * 0 0 0 0 0 0 0 0 0 0
E 0 I I 0 * 0 0 0 0 I 0 I 0 0 0
F 0 0 0 0 0 * I I I 0 0 0 0 0 0
G 0 0 0 0 0 I * 0 0 0 0 0 0 0 0
H 0 0 0 0 0 I 0 * I I 0 0 0 I I
I 0 0 0 0 0 I 0 I * 0 0 0 0 0 0
J 0 0 0 0 I 0 0 I 0 * I 0 0 0 0
K 0 0 0 0 0 0 0 0 0 I * I 0 0 0
L 0 0 0 0 I 0 0 0 0 0 I * I I 0
M 0 I 0 0 0 0 0 0 0 0 0 I * I 0
N 0 0 0 0 0 0 0 I 0 0 0 I I * I
O 0 0 0 0 0 0 0 I 0 0 0 0 0 I *
```

Equivalent expressions of affinities are shown in these diagrams and computer print-outs. Such drawings and tables are invaluable aids in planning preliminary designs for large and complex organizations.

With this outline in mind, the space planner's service will now be developed in detail.

Programming. Meeting first with the executives of the organization, the planner establishes the goals for the operation. The general work of the different departments and their interrelationships are clarified, and an organizational chart is prepared. This organizational chart is a flow diagram that shows how the parts of the organization ideally relate to one another. Inspection of the present facilities enables the planner to see the organization in operation and to determine the efficient and inefficient parts of the existing plant. Meetings are then scheduled with personnel in the various departments. The planner will ask for evaluation of the present layout in terms of environment, efficiency and size. He will take note of the number of people in each department, what their jobs are, and the size and quantity of furniture and equipment they require. He will also discuss expansion anticipations. Since departments frequently overestimate their importance and needs, the planner, after collecting all data, will meet again with the executives and re-evaluate actual departmental

needs. The planner now carefully writes up the program for the organization. He will list personnel, furniture, equipment and services and will compute square foot areas. This program, when approved by the executives, together with the organizational chart and the floor plans of the new location, must be available before preliminary design can begin.

Preliminary design. The purpose of preliminary design is to determine by means of architectural layouts the minimum number of square feet that the organization can purchase or rent to operate efficiently. Once this plan is designed, the project can be budgeted, and the fiscal feasibility can be measured. The computer is an excellent resource in planning for large and complex organizations. First, a drawing is made that lists all departments and graphically represents their need to relate to each other. This chart is called an affinity matrix. A flow or bubble diagram can give much of this information. Another example of this format is the chart or matrix on a conventional road map that shows distances between cities. The diagrams on page 652 show four ways of notating the same affinities. The various departments of the organization, numbering fifteen, are assigned the letters A through O. In the Triangular Spot Matrix a spot is placed in the square where the affinity between the two departments is necessary and the square is left blank when no affinity is necessary. The Bubble Diagram is another way of indicating these affinities, and the Verbal Description is obvious. However, for computer processing, numeric affinity values are required. To change a spot matrix to a numeric matrix merely use the numeral 1 where the spot occurs and substitute zero for the blank square where affinity is not necessary. In the fourth diagram a Square Numeric Matrix has been used to indicate that matrices need not follow triangular configurations. The numeric matrix can become more sophisticated. Instead of the numeral 1 to show the need for affinity, a scale of 1 through 3 might be used in which 1 indicates weak relationship, 2 medium relationship and 3 strong relationship. The fifth and most complex diagram on page 652 is a Triangular Numeric Matrix in which an affinity scale of 1 through 9 has been used. The computer interprets the larger numbers as representing stronger relationships. A computer system named SAM (Space Allocation Method) has been developed by Bruce Pearson of Semion, Limited. Using the numeric matrix as computer input, the computer will actually print out a floor plan with the best possible relationship of departments. The computer is a valuable tool in all parts of the space planner's work.

Developed design. The project is now a reality. The space must be accurately measured not only for area, including floor to ceiling dimensions, but for location and size of structural columns, wet columns (those having water and sewer lines), water coolers, kitchenettes and bathrooms, electrical risers, heating units, air conditioning equipment and ducts, and windows. Existing rooms and partitions must be located. At this time, a mechanical engineer will be retained since heating and cooling systems must be selected and their components located and sized. The engineer will assist in the technical aspects of lighting design and electric power.

In the usual floor plan, corner spaces are reserved for executives, spaces along the exterior walls are reserved for department heads and senior staff, and the interior spaces house reception and waiting areas, staff, secretaries, files and equipment. The planner can refine the preliminary plan and meet with the client to freeze the scheme.

In many buildings the rent for commercial space includes the necessary subdivision of space to suit the clients' needs. The materials and the finishes that are supplied by the building are specified when the lease is negotiated

and are called building standard. If the planner selects other materials and finishes, he must price the difference between his selections and building standard. The planner must be knowledgeable in pricing because the contractor for the project is chosen by the building, and not by the client, and this contractor will take advantage of the opportunities for bigger extras by overpricing the difference in cost between a planner-selected material and building standard.

Given the choice, the planner should let the project to three or more general contractors for competitive bidding.

Image. During the design process the planner must develop a design theme that will reflect the aims and goals of the organization. This theme is the corporate or client image, and the designer physically reflects this image in the quality and style of the environment. This quality is created by the manipulation of space, materials, textures and light. The image actually works two ways: it is not only the manner in which the client wishes to be seen by the outer world; it is also how he wishes to be seen by his employees. An organization dealing with mutual funds might want an image of responsibility, security and dependability, which, in design, might become formal planning, muted colors, bland surfaces and subdued lighting. However, this same organization might want an image of adventure, chance and youth, which, in design, might become informal planning, basic colors, rich surfaces and neon lighting. The image is fortified by graphics, logos, letterheads, advertising and the dress style of the staff.

Presentations. The developed design, usually drawn on a scale in which one quarter of an inch equals one foot, is further studied, not only as a whole but office by office. The designer will present his decisions in terms of surfacing, lighting, furniture and furnishings to his client.

Many systems are used for these presentations. Usually the macquette form is preferred in which the plans and elevations are drawn on a large scale in which one half or three quarters of an inch equals one foot and are frequently rendered in color. Photographs of furniture and furnishings and samples of fabrics and floor coverings are part of the presentation.

In many cases, rendered perspectives in color or black and white are also used. In highly complex designs the planner may build scaled models since these are easily understood by the client. The new computer graphics can effectively be used in design presentations. The computer will draw the perspective of the design, and the planner, using a light pencil, can change and rearrange the parts of the design on the computer screen. When provided with plans, elevations and sections and a system of movement through the spaces, the computer can project a motion picture that will show the client, in color, how he can move through his new environment. These presentations, frequently very costly, serve one purpose: to communicate highly technical three-dimensional information to clients who are not trained to understand the two-dimensional language of the designer. The space planner always attempts presentations by means of systems that simulate visual reality.

Production drawings and specifications. The designer now has all the necessary approvals, in writing, for planning, surfacing, lighting, power and communication, colors, furniture and furnishings. All of these selections must be systematically structured to inform the various contractors of their particular responsibilities. The first set of drawings is for the building trades. Aside from floor plans, elevations, sections, architectural details and door, window and finish schedules, the structural and mechanical drawings must be prepared. These drawings are supplemented with specifications which are written descriptions of the particular

services, materials and equipment, including product names and manufacturers. The production drawings and the specifications enable the general contractor to exact fair costs from his subcontractors and, at the same time, protect the client so that he will get the quantity and the quality of service represented by the planner. Actually, these documents, together with the contract, are the legal bind between client and contractor. In addition, in many localities these drawings must be filed with agencies for approvals and permits. While it is wise to obtain these approvals prior to sending the drawings to the contractors, pressures are usually such that the time necessary for building department processing will be used by the contractors to prepare their prices. When the bids are received and are negotiated and a final price is determined, the production drawings and specifications, the approvals and the costs, are bound into the contract, and the actual work can start.

Cabinetry. Custom cabinetry can be part of the general contract; however, most designers prefer to let this work as a separate contract. The separate contract permits careful selection of eligible bidders for this important finished work and enough time to prepare large scale drawings (the designer will have little drawing to do during the course of construction). If, however, the cabinet work is part of the general contract, the client will know the total construction cost of the project and he can hold one man, the general contractor, responsible for the work. An intelligent practitioner must decide, job by job, which approach will afford the better job. Cabinet drawings are always at large scale, in which three quarters of an inch or one and a half inches equals one foot. For details, the scale may be even larger. If the designer is not familiar with detailing, he can prepare small scale drawings and require shop drawings from the cabinetmaker for his approval. Specifications for cabinetry will include materials, fin-

ishes, hardware and special equipment. If the cabinets are wall hung, special detailing is necessary.

Supervision. It has been said that a contract is as good as the paper that it is written on. In design the terms of the contract are controlled by supervision in the shop and on the job. Interpretation of the contract documents, on-the-job decisions, organization of the trades, approval of shop drawings, changes, certification of payments—in fact, all actions needed from the designer during the construction period constitute supervision. During this time the designer must be certain that all changes, additions and on-the-job decisions are put in writing and approved by the client and the contractor. Frequency of supervision visits will vary during the different stages of construction. The designer must pay particular attention to the initial layouts and to the finishing processes. If the job is very large, the designer will keep a representative on the job at all times—the clerk of the works. Tech-

J & G Furniture Co.

The notion of a work station parallels the living environment development in residential design. In one collection of elements the designer has attempted to solve all of the needs of the person working in the office subdivision. By its very form it indicates that it will relate to additional work stations in a rigid parallel or perpendicular system.

SHIPLEY STREET

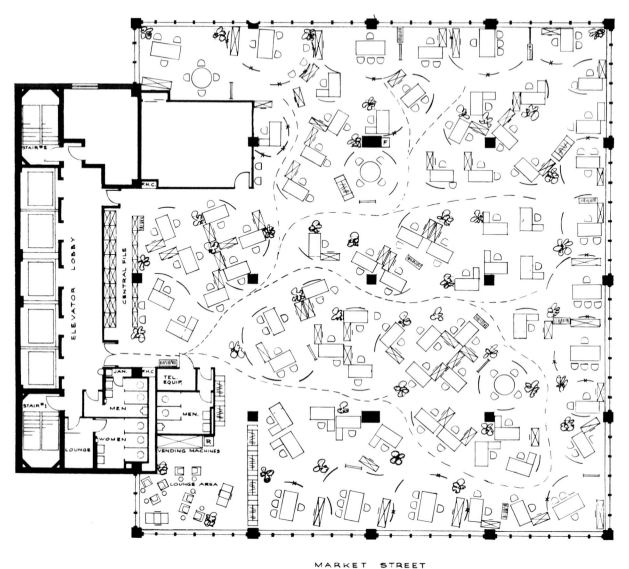

MARKET STREET

FARMERS BANK BLDG.

14TH FLOOR

DESIGN NO. 4277-A OBC-554

DRAWN BY E.A.H. 11-22-67
CHECKED BY J.E.C. 11-22-67

LEGEND

BACKBAR	BOOKSHELF 72" HIGH
SOUND ABSORBING SCREEN (LOW 55" HIGH)	PLANTER
SOUND ABSORBING SCREEN (HIGH 72" HIGH)	WARDROBE
CHALKBOARD	DRINKING FOUNTAIN

J & G Furniture Co.

This floor plan of the Freon Division of du Pont represents the first American installation of the German team, Quickborner. The design defies the orderly rectangular perimeter of the building. The purpose is to create a more human environment and to ease communication between members of the staff.

nical supervision outside the planner's experience, i.e., structure, air movement, power and light, will be provided by his professional associates, all nevertheless directly responsible to the planner.

Buying and scheduling. While programming, the planner lists all of the furniture, furnishings and equipment that must be provided. If the organization has a present facility, he will also list furniture, furnishings and equipment that can be reused (some may require repairing and refinishing). There are three categories in this part of the project: reused as is, reused as refinished, and new. Reused as refinished would include cleaning and dyeing carpeting, cleaning and refinishing hardware, spraying metal furniture, refinishing wood furniture, and reupholstering chairs. In both categories, reuse as refinished and new, several tradesmen can be involved in one product. Drapery fabric is purchased from one resource, then delivered to a drapery workshop for execution and then delivered to the job for installation. A chair covering is ordered from a fabric house, then delivered to the upholstery shop, and the finished chair is delivered to the job. The careful scheduling and coordination of these steps is essential. One counts back from the planned moving date and always allows some extra time since the delivery trucks manage to break down at least once on every job.

The conventional approach to space planning. The typical office building consists of a central core containing elevators, fire stairs, lavatories and mechanical equipment; a corridor on one, two, three or four sides (the more tenants per floor, the more corridor space); and usable office space from the exterior walls of the corridors to the window walls. Most office buildings are built of fireproofed steel with concrete floors. Ideally, the spaces would be column free, but this would prove much too expensive. Therefore, a rectan-

gular-shaped office building has structural columns along the core walls and along the exterior walls. Although columns along the corridor walls would provide shorter spans, the flexibility of changing the amount of corridor space as tenants change would be lost. In steel construction it is most economical to have all columns equally spaced and in alignment. Each square or rectangle on the floor plan that is identified by four columns is called a "structural module."

Although the spaces between columns vary from building to building, the spacing is always established to provide divisions of the module that can be reduced to a submodule of six feet by six feet. This submodule is the smallest work area for one person, providing space for a desk, a filing cabinet and a chair. It is easy to understand how modular construction has had such an impact on space planning. The basic relationships are forced into a grid perpendicular and parallel to the core and the exterior walls. As previously stated, the more important the position in the organization, the more window area in the office. The plans become rectangular offices along the window walls with the corner offices reserved for the chief executives. Interior offices with glass or glass and metal partitions are provided for lesser staff members and open interior spaces are arranged for secretaries. This then is the standard office layout.

The office landscape. A system of office space planning was originated in Germany in the early 1960's (Bürolandschaft) by the Quickborner Team. Known as the *office landscape*, this approach spread throughout Europe and was introduced in the United States by the duPont Corporation. The Quickborner Team was retained to design the offices for duPont's Freon Division. The planning is based upon systems analysis of work flow and communication which leads to floor plans and furniture layouts that are free and nonrectilinear. The office landscape is a three-dimensional representation of

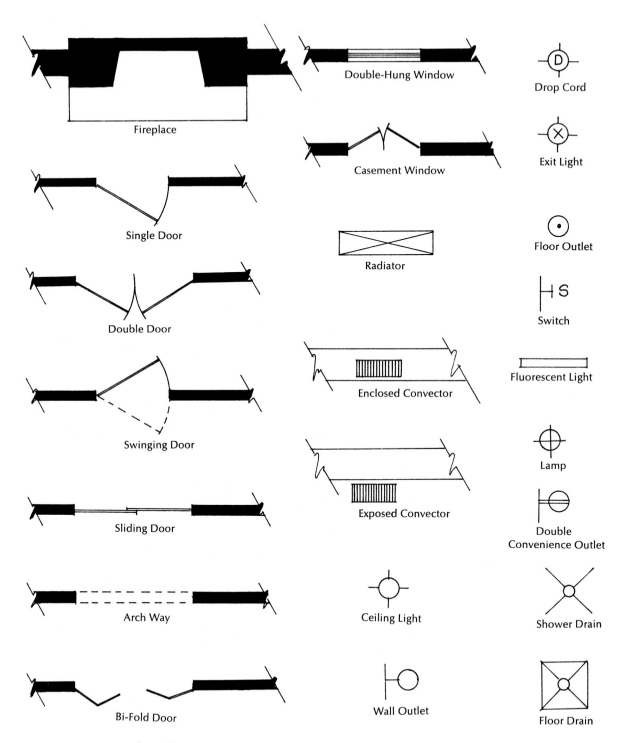

Fireplace

Double-Hung Window

Drop Cord

Single Door

Casement Window

Exit Light

Double Door

Radiator

Floor Outlet

Swinging Door

Enclosed Convector

Switch

Sliding Door

Exposed Convector

Fluorescent Light

Arch Way

Ceiling Light

Lamp

Bi-Fold Door

Wall Outlet

Double
Convenience Outlet

Shower Drain

Floor Drain

Plan indications for architectural, mechanical, and electrical features.

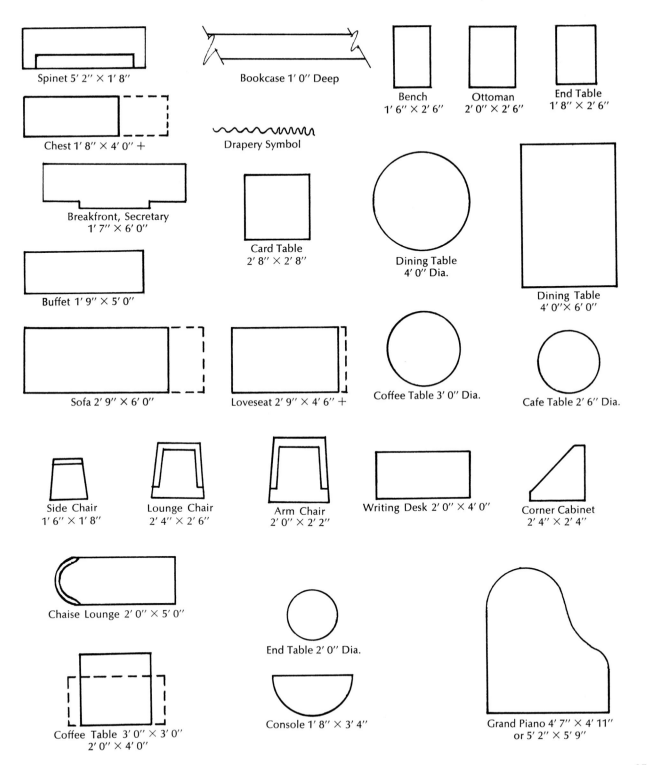

Spinet 5′ 2″ × 1′ 8″

Bookcase 1′ 0″ Deep

Bench
1′ 6″ × 2′ 6″

Ottoman
2′ 0″ × 2′ 6″

End Table
1′ 8″ × 2′ 6″

Chest 1′ 8″ × 4′ 0″ +

Drapery Symbol

Breakfront, Secretary
1′ 7″ × 6′ 0″

Card Table
2′ 8″ × 2′ 8″

Dining Table
4′ 0″ Dia.

Dining Table
4′ 0″ × 6′ 0″

Buffet 1′ 9″ × 5′ 0″

Sofa 2′ 9″ × 6′ 0″

Loveseat 2′ 9″ × 4′ 6″ +

Coffee Table 3′ 0″ Dia.

Cafe Table 2′ 6″ Dia.

Side Chair
1′ 6″ × 1′ 8″

Lounge Chair
2′ 4″ × 2′ 6″

Arm Chair
2′ 0″ × 2′ 2″

Writing Desk 2′ 0″ × 4′ 0″

Corner Cabinet
2′ 4″ × 2′ 4″

Chaise Lounge 2′ 0″ × 5′ 0″

End Table 2′ 0″ Dia.

Grand Piano 4′ 7″ × 4′ 11″
or 5′ 2″ × 5′ 9″

Coffee Table 3′ 0″ × 3′ 0″
2′ 0″ × 4′ 0″

Console 1′ 8″ × 3′ 4″

Plan indications for furniture (scale ¼″ = 1′-0″).

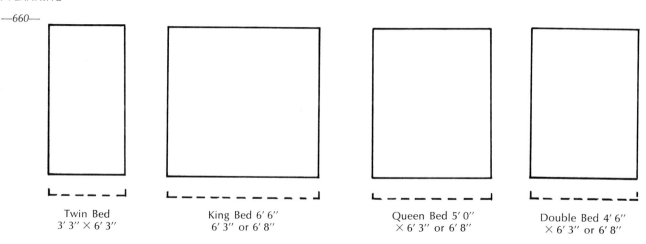

Twin Bed
3′ 3″ × 6′ 3″

King Bed 6′ 6″
6′ 3″ or 6′ 8″

Queen Bed 5′ 0″
× 6′ 3″ or 6′ 8″

Double Bed 4′ 6″
× 6′ 3″ or 6′ 8″

Plan indications for furniture (scale ¼″ = 1′-0″).

the basic flow diagram. The spaces are more open than in conventional planning since the curved screens that divide one office from another are usually four feet, six inches high rather than to the ceiling. Since the plans are so open, the ceiling must be acoustically treated and the floors are carpeted for acoustic absorption. Exotic plants are also used for acoustic treatment. Although the costs for the office landscape are slightly higher than for conventional office planning, this system is so much more flexible than conventional planning that the cost differences are more than balanced. All staff members have similar spaces. Landscape office

planning has become popular in this country because it is efficient, flexible, open, informal and democratic.

Space planning for office use is by far the most important extension of interior design during this century. In fact, many interior designers limit their services to office layout. There are new challenges for the interior designer, and they include space planning for industry, education, health and transportation. With training and experience in office planning as background, the interior designer will extend his services into these new areas.

BIBLIOGRAPHY

Bachelard, Gaston. *The Poetics of Space.* Translated from French by M. Johns. New York: Orion Press, 1964.

Casson, Hugh, Editor. *Inscape, the Design of Interiors.* London: Architectural Press.

Dal Fabbro, Mario. *Furniture for Modern Interiors*. New York: Reinhold, 1955.

Kettiger, Ernest. *Furniture and Interiors*. Switzerland: 1957.

Sommer, Robert. *Personal Space: The Behavioral Basis of Design*. New York: Prentice-Hall, 1969.

Curt Sherman

The Pruitt-Igoe Houses in St. Louis. They proved uninhabitable, and were subsequently destroyed.

CHAPTER **22**

Socio-Psychological Aspects of Interior Design

When Pruitt-Igoe, the St. Louis housing development, opened in 1958, design journals praised it as an innovation in good high-rise living for the poor and an affirmation of the aesthetic that Le Corbusier had introduced a generation earlier in Unité d'Habitation in Marseilles. But Pruitt-Igoe packed too many poor people, mostly welfare mothers and children, too densely. From the outset, burglars, dope pushers, and adolescent gangs turned the corridors into virtual free-fire zones. Because the silolike structures were built without corridors to connect all units on a floor, tenants never had a chance to become neighbors. With millions in construction fees remaining unpaid, the city government ordered the demolition of Pruitt-Igoe, which had come to symbolize the inadequacy of a design approach based primarily on aesthetics. This experience has dramatized the need for a new, user-oriented design approach emphasizing "social fit" as much as aesthetics.

For the student of interior design this development implies a new educational curriculum that will equip him to design for human needs as well as aesthetic effect. For the interior design practitioner it suggests a new partnership in which he will join the social scientist to gain information about the psychological or anthropological implications of space. Finally, it indicates a new role for the interior designer: that of environmental design researcher. How has this change in outlook come about?

Perhaps the most important factor has been a phenomenon noted by sociologist John Zeisel —the gap between user and designer. Historically, the interior designer has maintained a one-to-one relationship with his client. Usually designer and client have come from the same culture, same class, and approximately the same educational background. But as society becomes more institutionalized, the interior designer finds himself with two clients: a paying client— perhaps a large insurance company, bank, or private foundation—and a user client, who may be a blue-collar worker, a college student, or a member of a retirement community. This client, though he pays no design fee, is the ultimate user of the designed space. Since the designer often has no communication with the user-client prior to design and little direct knowledge of him, he needs to find out about his educational background, social class, ethnic background, age group, sex, and health status. These are the kinds of data that the environmental psychologist, urban sociologist, or anthropologist can provide.

Of all the social science disciplines now influencing design, environmental psychology has proved of greatest interest to interior designers. This infant science is "concerned with people, places, and the behavior of people in relation to places," according to City University of New York psychologist Harold Proshansky. At the center of the environmental psychologist's concern is the built environment, its design, content, organization, and meaning. Environmental psychology asks questions about rooms, hospitals, houses, museums, schools, airplanes, theaters, and other human settings.

Behavioral mapping, a useful and an intriguing technique used by environmental psychologists, has special promise for interior designers. Proshansky and his colleague William Ittelson utilized behavioral mapping to study the influence of psychiatric ward design on patient and staff behavior. Behavioral mapping establishes what people in the ward are doing, where they are doing it, for how long, and with whom. Using behavioral mapping, City University researchers also have explored how riders use New York subway stations, the effectiveness of open-school classrooms, how families use space in their homes, and what consequences space use has for day-to-day relationships.

Promising though environmental psychology may be, it is no panacea for the interior designer.

"The primary value of environmental psychology for design professionals," cautions Dr. Proshansky, "does *not* lie in its capacity to measure human behavior. . . . Rather the fundamental significance of environmental psychology for the design professions lies in its potential capacity to provide a body of knowledge—conceptual and empirical—for understanding the relationships between human behavior and the built environment." For the interior designer who finds himself confronted with questions about what people want, how they will react, and what they expect, environmental psychology provides at least a backdrop for educated design decisions—if not hard answers.

Dr. Proshansky also insists that unless interior designers and architects are willing to return to the physical setting after it has been designed and is operating, no one will ever know whether the assumptions that are made about people's behavior in relation to space have any validity. It is difficult, so far, to find more than a few instances of such evaluation. "Clearly," concludes Dr. Proshansky, "this is a task which is a natural for the collaboration of the design professions and environmental psychology."

California psychologist Robert Sommer has focused precisely on the subject of postdesign evaluation. In his recent book, *Design Awareness*, Sommer pioneers the evaluation of institutional environments by means of psychological techniques. He provides the interior designer with proven formulas for evaluating environments designed by himself or others. Sommer suggests that the method of evaluation should flow naturally from the problem at hand. The questionnaire, he believes, is an excellent instrument when the respondents are college students but unsatisfactory when they are children or migrant farm workers. In a chapter entitled "The New Evaluator Cookbook," Sommer provides a sample questionnaire for evaluating a hospital, a survey format for evaluating an office building, a rating system for a primary school, a self-survey technique for dormitory residents, and direct observation methods for public spaces and parks.

Robert Barker and Paul Gump, two Kansas University researchers, have led yet a third school of environmental psychology. For almost thirty years Barker and his colleagues have studied the relationship of setting to behavior in a small Kansas town. As a result, Barker has overthrown the popular notion that the environment is an unstructured arena of objects upon which man acts. Because he relates aspects of a physical setting, such as size, to types of behavior, he provides invaluable clues to the interior designer. Barker has focused much of his effort on school settings, and he observes, for example, that students in a small high school are less sensitive to individual differences in behavior; see themselves as having greater functional importance; have more responsibility; have six times more experience in leadership and two and a half times greater participation than their counterparts in larger schools. As Barker reports in his classic, *Ecological Psychology*, students in a small school are absent less often, more likely to stick to their jobs, more punctual, more apt to participate, stronger in leadership; they also are more interested in the affairs of the school and more apt to be social and likely to find their work meaningful.

Though less relevant to interior designers than environmental psychology, urban sociology often provides data at the neighborhood scale. What do urban sociologists explain? According to Toronto sociologist William Michelson, they address two aspects of the relationship between man's behavior and his physical surroundings. First, they explain behavior as a consequence of environment. Second, they evaluate alternative environments by describing and explaining behavior in particular environments.

Design and Environment

This diagram shows the four distances used by man in his transactions with other human beings. The distances range from intimate (18–30 inches), personal (30–48 inches), and social (48–84 inches) to public (84 inches to 12 feet or more). The diagram, by Dan McClain, is derived from the work of anthropologist Edward T. Hall.

Yet a third social science discipline to influence designers of physical space is anthropology, especially the branch called proxemics, which deals with unconscious as well as conscious structuring of space. According to anthropologist Edward T. Hall, the father of proxemics, spatial behavior is systematic, consistent, and interrelated with other kinds of behavior as a system. Hall says that proxemics is especially important for interior designers because it seeks to identify the hidden rules governing the use of space and the unstated rules of distancing and screening for every conceivable activity—talking, working, making love. So far, Hall's most important contribution to interior design is the observation that there are specific distances used by man in his transactions with other human beings (see diagram) and that these distances vary from culture to culture.

Hall suggests that interior designers should comprehend environments in a variety of ways, ranging from the symbolic significance of a structure, to the rules governing spatial arrangement of furniture, to the coding of sensory inputs. The Japanese, for example, may design tabletops not only in terms of color and texture, but also in terms of the acoustic quality of the tabletop as small objects come in contact with or are moved about on its surface.

Although some thinkers predict the influence of social science on design to be the most significant intellectual development for the design disciplines in the current decade, there are problems. Language is one. Because the language the social scientist speaks is different from that of the designer, there is need for "translation" or, better, for the designer to acquire the new language. Another problem is divergence in professional aims. The situation that the designer wants the social scientist to explore may not be the situation that interests the social scientist or that will win him pro-

fessional recognition. Another problem is the design school tradition that encourages the student to respond to the praise and criticism of his peers rather than his clients. Striving to make his interiors as "artistic" as possible, he may create a disaster for the user. As schools of design gain awareness of this situation, they may shift to new criteria—criteria that ask, for example, what behavior a design encourages and what behavior it inhibits. Without such a shift, viable collaboration between designer and social scientist may not be possible. Finally, there is the question of cost. Most design offices, already under financial pressure, will be hard put to pass on to their client an additional bill— which could total thousands of dollars—for behavioral research. Therefore, government agencies such as the National Institute of Mental Health, the Department of Housing and Urban Development, and the National Aeronautics and Space Administration will continue to be the chief support for social science related to design. In addition, private foundations may play a role in fostering closer cooperation between social science and design.

Besides learning to work with social scientists, interior designers and architects are beginning to engage in research on their own initiative. Called environmental design research, this activity seeks to pinpoint the social and psychological impact of the environment on man. Five separate developments now are thrusting environmental design research onto the cutting edge of interior design. First, the federal government has begun to support environmental design research. In 1970 alone it spent more than $30 million on such research. A study by architect Andrew Euston of HUD's Environmental Planning Division has identified funding for environmental design research within twenty different federal agencies involving some sixty separate offices. Among these research projects is a $390,000 effort conducted by Brown Engineering Company of Huntsville, Alabama, to

determine which construction elements are most responsible for accidents in the home. In another study, Wylie Laboratories of Los Angeles has investigated the relationship between noise in buildings and job efficiency and family interaction. Federal support of environmental design research is being further strengthened by the Environmental Protection Act of 1970. A provision of this act requires that design problems in which the federal government is involved be approached from a team standpoint—the teams to include psychologists and sociologists, together with designers, where appropriate.

Second, industry has begun to back environmental design research. The General Electric Corporation, in a program directed by engineer S. K. Guth, has developed a visual comfort probability system whereby lighting comfort is rated on a percentage basis. In a sociological research program directed by Hilary W. Szymanowski, the Westinghouse Company spent $250,000 to determine how each room in a house is actually used. These data would be useful in the design of modular housing.

Third, more than twenty schools of architecture have initiated environmental design research programs. Among the leaders are Virginia Polytechnic Institute; School of Design, North Carolina State University; College of Environmental Design, University of California at Berkeley. In addition, the National Society of Interior Designers sponsors an Interiors Environment Research Council which publishes research monographs, and the American Institute of Architects has established the AIA Research Corporation to create opportunities for architects to participate in research as an additional area of professional practice.

Fourth, scholarly journals have served to increase professional interest in environmental design research. In December, 1966, architectural psychologist Gary T. Moore established *Design Methods Group Newsletter*, which reports on new techniques in design decision-making.

Man-Environment Systems, whose objective is to document ongoing research through publication of summaries of papers, appeared in July, 1969, under the direction of architect John Archea and psychiatrist Aristide H. Esser. *Environment and Behavior*, edited by psychologist Gary Winkel, appeared in 1969. This rigorously scientific journal focuses on social and psychological research related to physical design. The most widely circulated journal in this field is *Design and Environment*, which seeks to translate social science findings into language meaningful to design practitioners.

Finally, the Environmental Design Research Association attracts a growing number of researchers to its annual meeting, providing the interior designer with an excellent opportunity to enter the world of research. EDRA was formed in 1968 to create effective environmental solutions to human needs, according to Henry Sanoff, EDRA's first chairman. Sanoff and his associates realized that analysis and solution of environmental problems requires a multidisciplinary approach, since any single discipline deals with only one segment of the environment. Environmental design research has been occupied mainly with two questions: how does man affect the environment and how does the environment affect man? Australian architectural educator Amos Rapoport, who has been an important contributor to EDRA, suggests several reasons for the appearance at this time of the environmental design research movement: the growing scope and complexity of design problems, the inability of designers to get to know the users of projects, the failure of designers to recognize social values different from their own, the absence of feedback on a given design solution, and insufficient knowledge of the environment's effect on people. Essentially, environmental design researchers seek to provide a scientific understructure to disciplines that heretofore have been treated as art forms. Because this concept is foreign to the designer's traditional preoccupation with form, practitioners have been skeptical about its value. Rapoport quotes the English scientist Faraday on this question. When asked of what use is electricity, Faraday countered: "Of what use is a newborn baby?" If allowed to develop, environmental design research will help designers avoid the mistakes made at Pruitt-Igoe.

BIBLIOGRAPHY

Ardrey, Robert. *The Territorial Imperative*. New York: Atheneum, 1966.

Barker, R. G. *Ecological Psychology: Concepts and Methods for Studying the Environment of Human Behavior*. Stanford, Calif.: Stanford University Press, 1968.

Bechtel, Robert B. "Hodometer Research in Architecture." *Milieu*, ser. 2, vol. 1 (April 1967), whole issue.

Beck, Robert. "Spatial Meaning and the Properties of the Environment in Environmental Perception and Behavior." In Research Paper no. 109, edited by David Lowenthal. Chicago: Department of Geography, University of Chicago, 1967.

Bell, Gwen, and Tyrwhitt, Jacqueline. *Human Identity in the Urban Environment*. Baltimore: Penguin Books, 1972.

Burnett, Charles. *Architecture for Human Behavior*. Philadelphia: Philadelphia Chapter, American Institute of Architects, 1971.

Byers, Paul. "Still Photography in the Systematic Recording and Analysis of Behavioral Data." *Human Organization*, Spring 1964.

de Long, Alton J. "Dominance-Territorial Relations in a Small Group." *Environment and Behavior* 2 (1970): 170–191.

Dubos, Rene. "Our Buildings Shape Us." In *So Human an Animal,* pp. 160–181. New York: Charles Scribner's Sons, 1968.

Duffy, Francis. "A Method of Analyzing and Charting Relationships in the Office." *The Architects' Journal,* March 12, 1969, pp. 693–699.

Gans, Herbert J. *People and Plans: Essays on Urban Problems and Solutions,* part I, "Environment and Behavior," pp. 1–52. New York: Basic Books, 1969.

Gutman, Robert. *People and Buildings.* New York: Basic Books, 1972.

Hall, Edward T. *The Hidden Dimension.* New York: Doubleday, 1966.

Hall, Edward T. *The Silent Language.* New York: Doubleday, 1959.

Hazard, John N. "Furniture Arrangements as a Symbol of Judicial Roles." *ETC Review of General Semantics* 19 (1962): 181–188.

Ittelson, W. H.; Proshansky, H. M.; and Rivlin, L. G. "Bedroom Size and Social Interaction of the Psychiatric Ward." *Environment and Behavior* 2 (1970): 255–270.

Katz, D., and Kahn, R. *The Social Psychology of Organizations.* New York: John Wiley and Sons, 1966.

Lipman, Alan. "Territoriality: A Useful Architectural Concept?" *RIBA Journal,* February 1970, pp. 68–70.

Michelson, William. "Most People Don't Want What Architects Want." *Trans-Action,* vol. 5, no. 8 (July-August 1968), pp. 37–43.

Moleski, W., and Goodrich, R. "The Analysis of Behavior Requirements in Office Settings." Paper presented at the Third Annual Conference of the Environmental Design Research Association, Los Angeles, California, January 1972.

Perin, Constance. *With Man in Mind.* Cambridge, Mass.: MIT Press, 1970.

Proshansky, Harold M.; Ittelson, William H.; and Rivlin, Leanne G. *Environmental Psychology: Man and His Physical Setting.* New York: Holt, Rinehart and Winston, 1970.

Rainwater, Lee. "Fear and House as Haven in the Lower Class." *Journal of the American Institute of Planners* 32 (1966): 23–31.

Rapoport, Amos. *House Form and Culture.* Englewood Cliffs, N.J.: Prentice-Hall, 1969.

Sanoff, Henry. *Techniques of Evaluation for Designers.* Raleigh, N.C.: Design Research Laboratory, School of Design, North Carolina State University, 1968.

Sommer, Robert. *Design Awareness.* Corte Madera, Calif.: Rinehart Press, 1972.

Sommer, Robert. *Personal Space: The Behavioral Basis of Design.* Englewood Cliffs, N.J.: Prentice-Hall, 1969.

Studer, Raymond G. "The Dynamics of Behavior-Contingent Systems." In *Design Methods in Architecture,* edited by A. Ward and G. Broadbent. London: Lund Humphries, 1970.

Wheeler, Lawrence. *Behavioral Research for Architectural Planning and Design.* Terre Haute, Ind.: Ewing Miller Associates, 1967.

Glossary of Decorative Art Terms

The following abbreviations are used to indicate the sources from which the technical terms defined in the glossary are derived or the particular fields in which they are used:

arch., architecture	Lat., Latin
cab., cabinetwork	O.F., Old French
carp., carpentry	orn., ornament
Fr., French	pot., pottery
It., Italian	Sp., Spanish

In addition to this general glossary, the student is referred to the glossaries on special subjects as follows:

Textile terms, page 551
Ceramic terms, page 595; glassware terms, page 615
French furniture and decorative art terms, page 185
Structural and cabinetmaking woods, page 637
Painter's pigment colors, page 513
Architects, artists, craftsmen, etc., listed at the end
of each chapter of Part One.

Abacus (arch.). The slab that forms the uppermost portion of the capital of a column.

Abstract design. Patterns or motifs that are not based on forms inspired from nature.

Acanthus. A large leaf conventionalized by the Greeks for ornamental use, as in the capital of the Corinthian column.

Acroteria. Blocks at the apex and lowest points of a pediment, often with carved ornament.

Agate ware. A type of pottery resembling agate or quartz. Made in England during the 18th century by Wedgwood and other potters.

Alabaster. A fine-grained stone with a smooth milk-white surface. Used for ornaments and statuary. Slightly translucent.

Alloy. A mixture of two or more metals; for example, brass is an alloy of copper and zinc.

Amorini (It.). Childlike figures, such as cupids or cherubs. Used for ornamental purposes, especially during the Italian Renaissance.

Amphora. A Greek vase form. A large, two-handled earthenware vessel with a narrow neck and usually an ovoid body, used for the storage of grain and other products.

Anta (pl. antae). A type of projecting pier similar to a pilaster placed behind a column at the end of a sidewall of a Greek temple. The base and capital differ from those of the column; also used in Egyptian architecture.

Antefix. An upright conventionalized spreading leaf or fanlike ornament used in classic art.

Anthemion. A conventionalized honeysuckle or palm leaf ornament or pattern seen in Greek decoration.

Antimacassar. Knit, crocheted, or embroidered doily placed over up-holstered chair back to protect it from the Macassar oil hair-dressing commonly used during the mid-19th century.

Antique. A work of art which, according to United States law, must be at least 100 years old.

Applique. An ornament that is applied to another surface. Also, a wall sconce.

Apron. A board placed at right angles to the underside of a shelf, sill, seat, or table top.

Apse. The semicircular or angular extension at the east end of a basilica or Christian church. It is typical of Continental cathedrals only. The English churches have rectangular ends.

Aquatint. A method of engraving on copper by the use of a resinous solution of nitric acid.

Arabesque. A scroll and leaf pattern with stems rising from a root or

other motif and branching in spiral forms. It is usually designed for a vertical panel, and the sides resemble each other.

Arca (Sp.). Chest.

Arcade. A series of adjoining arches with their supporting columns or piers. The arcade usually forms a part of the architectural treatment of a corridor or passageway.

Arcaded panel. A panel whose field is ornamented by two dwarf piers or columns supporting an arch form. Particularly used in early English Renaissance woodwork.

Arch. A structural feature spanning an opening, supported at the two ends, and composed of several wedge-shaped parts. An arch form is usually curved but may be flat. Sometimes an ornamental form resembling a structural arch. Concrete arches are monolithic.

Archaic. Primitive or antiquated. In reference to Greek art, it denotes the primitive period of development from 1000 to 480 B.C.

Architect's table (cab.). Combination drawing-table and desk, with an adjustable lid that lifts to make a slanting surface.

Architrave. The lowest part of the three principal divisions of a classical entablature, corresponding to the lintel; usually molded. It is directly supported by the columns and supports the frieze. The term is also used to define similar moldings used as door or window trim.

Arcuate (arch.). Archlike in form. Arched.

Argand lamp. Lamp invented by a Swiss named Argand, in 1783. Had a round wick with provision for the introduction of air inside the wick as well as around the outside.

Arras tapestries. Tapestries manufactured in Arras, France, during the 14th and 15th centuries. Their fame was so great that the name of the town is sometimes used as a synonym for handwoven tapestries of Gothic design.

Arrazzi. Italian name for the town of Arras, France. In Italy, sometimes used as a synonym for a Gothic tapestry.

Arris (arch.). The sharp edge formed by the meeting of two surfaces coming together at an angle. An example is the angle formed by the two sides of a brick. More specifically the sharp edges occurring between two adjoining concave flutings of a column shaft.

Artesonado (Sp.). Moorish woodwork or joinery, usually made of Spanish cedar. It is soft and fine-grained, somewhat like red pine.

Artifact. An article of great antiquity, made by man, especially prehistoric stone, bone, metal or clay objects.

Ashlar. Masonry constructed of flat-surfaced stones with straight clean-cut jointing.

Astragal (arch.). Small torus molding.

Astral lamp. Oil lamp with swinging tubular arms, generally furnished with an Argand burner. Used in the early 19th century.

Atrium. The principal central room or courtyard of a Roman house, with a central opening in the roof.

Attic (arch.). In classical design, a low wall above a cornice or entablature, usually ornamentally treated with statuary or inscriptions.

Axminster. A pile carpet with a stiff jute back; the weave permits a great variety of colors and designs.

Azulejos (Sp.). Wall tiles produced in Spain and Portugal, painted with scenes of sports, bullfights, or social and amorous groups.

Baldachino (It.). A canopy resting on columns, usually built over an altar.

Ball-and-claw foot (cab.). A furniture foot cut to imitate a talon or claw grasping a ball. Of Chinese origin, the motif was greatly used in English 18-century furniture.

Ball foot (cab.). Any foot or leg terminating in a ball. A loosely used term.

Baluster. An upright support which is made in a variety of turned forms. In general it curves strongly outward at some point between the base and the top; commonly an elongated vase or urn shape. Used for the support of hand railings and for furniture legs or ornament. A spindle.

Bambino (It.). Child or baby, or the representation of such in any art medium.

Bamboo-turned. Wood turnings in mahogany and other woods that imitate natural bamboo forms.

Banding (cab.). Strip of veneer used as a border for table tops, drawer fronts, etc.

Bandy-legged (cab.). Literally, "bow-legged." Old inventories mention such legs; the lay term for cabriole leg.

Banister. Same as baluster.

Banister-back chair. A late 17th century American chair with back uprights consisting of split turned spindles or flat bars.

Baptistery. A separate building or part of a church used primarily for the rite of baptism.

Baroque. A style of architecture, art, and decoration which originated in Italy during the late 16th century and spread to other parts of Europe. It is characterized by large scale, bold detail, and sweeping curves. It was followed by the rococo style and overlapped the latter.

Barrel vault. See Vault.

Basalt. Dark green or brown igneous rock, sometimes having columnar strata. Egyptian statues were frequently carved in this material. The name is also applied to a black porcelain invented by Josiah Wedgwood.

Basalt ware. Black vitreous pottery, made to imitate the mineral of the same name.

Base (arch.). Any block or moldings at the bottom of an architectural or decorative composition, particularly a series of moldings at the bottom of the shaft of a classical column.

Base molding. A molding used on the lowest portion of any object or surface.

Baseboard (carp.). A board placed at the base of a wall and resting on the floor; usually treated with moldings.

Basilica. In Roman times, an oblong, three-aisled building used as a hall of justice. The central aisle, or nave, was higher than the side aisles and was usually pierced with windows placed above the roof of the side

aisles. This plan formed the basis for later Christian churches.

Basket weave. A textile weave in which the warp and weft are usually of large threads of similar size and in which the weft crosses the top of alternate warp threads.

Bas-relief (Fr.). See Relief.

Batik. A process of decorating fabrics by applying a design to the surface of the cloth in hot wax. The cloth is then dipped into a cool vegetable dye which is absorbed by the unwaxed portion. After the dye is dried, the wax is washed off in hot water. The name is applied to all fabrics so treated.

Bay (arch.). The space between columns or isolated supports of a building. A bay window is one placed between such supports and usually projects outward from the wall surface.

Bay window. A large projecting window that is polygonal in shape. If it is curved or semicircular, it is usually called a *bow window*.

Bead. A molding ornament that resembles a string of beads. Sometimes called *pearl*.

Beaker. Tall drinking vessel with slightly flaring sides.

Beam. A long piece of timber or metal used to support a roof or ceiling, usually supported at each end by a wall, post, or girder.

Bell turning. A type of turning that is used for furniture legs and pedestal supports shaped approximately like a conventional bell. Common in the William and Mary style.

Bevel. The edge of any flat surface that has been cut at a slant to the main area.

Bird's-eye veneer. A thin sheet of wood with fine circular markings caused by fiber distortions in the growth of the annual rings of the tree. It is most frequently found in maple.

Biscuit or bisque (pot.). Pottery that has been fired once and has no glaze or a very thin glaze.

Blackamoor. A statue of a Negro used for decorative purposes during the Italian Renaissance and revived in the Victorian period.

Bleach. The process of removing the original color or of whitening a fabric by exposure to air and sunlight or by the chloride process.

Block-front. A treatment of case furniture in which the front surface is articulated by a central panel sunk between two slightly raised surfaces of equal width. Often seen in English and American 18th century furniture.

Block-printing. A process of producing a colored pattern or picture on paper or textile by wooden blocks, each one producing a portion of the pattern in a single flat color.

Body (pot.). The clay or other material of which a piece of pottery or porcelain is manufactured, as distinguished from the glaze or finish later applied.

Bolection moldings. A series of moldings which project sharply beyond the plane of the woodwork or wall to which they are applied. A *bolection panel* is a projecting panel as opposed to a *sunk* panel.

Bonader. Wall hangings of peasant subject matter, painted on paper or canvas. Made in Sweden or by Swedes in America, and used to decorate homes on feast days.

Bonnet top (cab.). In cabinet work, a top with a broken arch or pediment, or a curved or scroll top with a central finial motif in the shape of a flame, urn, etc.

Border pattern. A continuous running motif used in the design of bands, borders, and panel frames.

Boss (orn.). The projecting ornament placed at the intersection of beams or moldings. It is often a carved head of an angel, flower, or foliage motif.

Boston-rocker. General term formerly applied to any chair with curved supports. Synonymous with *rocking-chair*.

Boulle work (cab.). Marquetry patterns in tortoise shell and German silver or brass, introduced by André Charles Boulle, and used as furniture enrichment in the 17th century.

Box-plaiting. Pressed folds in a fabric, sewed in place in series, as in a drapery.

Bracket (arch.). A flat-topped underprop which projects from a wall or pier and forms a support for a beam or other architectural member above it.

Bracket foot (ab.). A low furniture support which has a straight corner edge and curved inner edges. It was used in 18th century English and American furniture. In the French bracket foot the outer corners are curved. It is a stunted cabriole form.

Brasses. General term referring to cabinet hardward such as drawer-pulls and escutcheons.

Brazier. One who works in brass; also a pan with feet, for holding embers and used as a stove for heating rooms until the 19th century.

Breakfront. Cabinet piece the front of which has one or more projecting portions.

Brewster chair. A chair named for Elder Brewster, one of the first settlers of New England. Has rush seat and turned spindles.

Broadloom. A term of the carpet trade referring to carpets manufactured in wide strips (9, 12, and 15 feet and over).

Broken pediment. A triangular pediment that is interrupted at the crest or peak.

Brussels carpet. A carpet with a looped woolen pile and a cotton back.

Buffet (Fr.). A cabinet for holding dining table accessories; also a table from which food is served.

Bulbous form (cab.). A stout turning resembling a large melon; used for furniture supports during the early Renaissance in England, France, and Italy.

Bun foot (cab.). A furniture support that resembles a slightly flattened ball or sphere. Common in Dutch furniture.

Bundle. The unit in which wallpaper is delivered. In the trade in the United States a roll is 36 square feet of paper, but paper is delivered in bundles of 1½, 2, or 3 rolls.

Burl. A curly-grained wood surface or veneer cut from irregular growths

of the tree, such as the roots or crotches. Very common in walnut.

Butt joint (cab.). A type of joint in which the squared end of a plank meets the side or end of another plank head to head or at right angles.

Butterfly table. A popular name for a small drop-leaf table used in the American colonies; the raised leaf was supported by a board bracket cut to resemble a butterfly wing.

Buttress (arch.). An exterior support built against a wall. Particularly seen in Gothic architecture, where it was introduced as extra masonry to resist the heavy thrust of the arched stone roof of the building.

Butt-wood veneer. Veneer that is cut from the part of the tree where the large roots join the trunk. It has fine curly and mottled markings.

Cabriole. A term used to designate a furniture leg or support that is designed in the form of a conventionalized animal's leg with knee, ankle, and foot; used particularly in France and England during the 18th century.

Caen stone. Limestone of a yellowish color, with rippled markings, found near Caen, in Normandy. Often used in French architecture and decoration.

Calender. A process imparting a smooth, impermanent surface to cotton goods by pressing the cloth between cylinders.

Calligraphy. In general, beautiful penmanship; specifically the brush-stroke work done by the Chinese for reproduction of the written characters of the Chinese language.

Camber. A slight upward bend or convexity; a slight rise or arch in the middle.

Camel back. Chair back of late Chippendale or Hepplewhite style, the top rail of which was in the form of a serpentine curve.

Cameo. A striated stone or shell carved in relief.

Candelabrum (pl., candelabra). A branched candlestick or lamp stand.

Canopy. A draped covering suspended over a piece of furniture, as over a bed or a seat of honor.

Canterbury (cab.). Ornamental stand having compartments and divisions for papers, portfolios, envelopes, etc.

Cantilever. A beam supported near the center and weighted at one end. The other end projects without apparent support. Used structurally for the support of projecting balconies, eaves, etc.

Canton china. Original blue-and-white china imported from the Far East from the 17th century until the Sino-Japanese War, 1938. A traditional staple in Chinese ceramic history.

Capital (arch.). The decorative crowning motif of a column or pilaster shaft, usually composed of moldings and ornament. The most characteristic feature of each classical architectural order.

Carcase or core (cab.). The structural body of a piece of wooden furniture which is covered with a veneer.

Cartoon. The term used to designate a drawing or design made for reproduction in another medium, as the original design for a rug, tapestry, or painted mural decoration.

Cartouche (orn.). A conventionalized shield or ovoid form used as an ornament, often enclosed with wreaths, garlands, or scrolllike forms.

Carved rug. A rug with the pile cut to different levels to produce a pattern.

Carver chair. A type of Early American chair.

Caryatid (arch.). A column carved in human form, used as a supporting motif in an architectural composition.

Case furniture. Any furniture used to contain objects, such as desks, bookcases, hutches, cabinets.

Casement window. A window hinged at the side to swing in or out.

Cassapanca (It.). A long wooden seat with wooden back and arms, the lower portion used as a chest with hinged lid.

Cassone (It.). A chest or box with hinged lid.

Caster. Small wheel fastened to sup-

porting legs of heavy furniture to facilitate moving. First used in early 19th century.

Catacombs. Underground chambers in Rome used by the early Christians as hiding places and for religious worship.

Catenary arch (arch.). An arch form that is in the shape that a chain takes when its ends are supported a distance apart.

Cavetto. A molding of concave form approximating a quarter-circle.

Cella (arch.). The interior chamber of a classical temple, in which usually stood the cult statue.

Cellaret. A portable chest, case, or cabinet, for storing bottles, decanters and glasses.

Cellulose. An insoluble starchlike substance taken from plants to form the base of many synthetic materials.

Ceramics. The art of molding, modelling, and baking in clay. The products of this art.

Certosina (It.). An inlay of light wood, ivory, or other materials upon a dark background.

Chair rail (carp.). The topmost molding of a dado, sometimes known as the dado cap. It is placed on a wall at the height of a chairback to protect the plaster.

Chair table. A chair with a hinged back that may be dropped to a horizontal position as a table top.

Chalice. Cup or goblet used for the sacraments of the Church.

Chamfer. See Bevel.

Champlevé. A type of enamelware in which the pattern is grooved in a metal base and the grooves are filled with colored enamels.

Chandelier. A lighting fixture suspended from the ceiling. Branches support candles or electric bulbs.

Charger. A large dish.

Chasing. Ornamentation of any metal surface by embossing or cutting away parts.

Check (carp.). Small cracks which sometimes appear in lumber unevenly or imperfectly dried; perpendicular to the annual rings, and radiating away from the heart of the trunk.

Checkerboard (orn.). A pattern consisting of alternating light and dark squares.

Chest (cab.). A piece of furniture used as a box or container.

Chest-on-chest. A chest of drawers consisting of two parts, one mounted on top of the other.

Cheval glass. Literal meaning, "horse mirror." It is a large full-length mirror, usually standing on the floor.

Chevron (orn.). An ornamental motif composed of V-shapes. Also called zig-zag.

Chiaroscuro. Literal meaning is "clear-obscure." Refers to a strong contrast of light and dark areas in painting.

China (pot.). The first European name for porcelain imported from the Orient.

Chroma. A term used to designate the degree of intensity, brilliance, luminosity, or saturation of a spectrum color. Yellow, near the center of the spectrum, is the most brilliant but has the least saturation and palest chroma. Red has a medium chroma; and blue, the darkest, with the greatest saturation. Sometimes the term "chromatic value" is used.

Churrigueresco (Sp.). The 17th century Spanish style introduced by Churriguero, the architect, characterized by elaborate ornamentation and curved lines.

Cinquecento (It.). The 16th century in Italy. The first 50 years was considered the high period of Renaissance production.

Cinquefoil (orn.). French "five leaves." A pattern resembling a five-leaved clover.

Cire-perdue (Fr., lost wax). An early method of making bronze castings, in which it was necessary to destroy the sculptor's original wax model as well as the mould, thereby allowing only one casting to be made.

Clapboard wall. A wall of planks laid horizontally, each one slightly overlapping the one below.

Classic. A term applying to a work of art of the first class or rank, or an established standard and acknowledged excellence.

Classical. A term referring to the arts of Greece and Rome or any work based on such forms.

Clavated. Club shaped. Applied to turnings used as furniture legs and stretchers, especially as seen in early Spanish furniture.

Clavichord. Seventeenth-century stringed instrument, ancestor of the piano. Known in the Carolean, William and Mary, and Queen Anne styles.

Claw-and-ball foot (cab.). A type of carved foot showing a bird's claw grasping a ball; used in conjunction with a cabriole furniture leg; introduced in the early 18th century in England, and possibly of Oriental origin.

Clerestory. A story above an adjoining roof. Clerestory windows in the nave wall of a church are those above the roof of the side aisles. In general a window placed near the top of a wall.

Cloche. Dome of glass that fitted over a wood base to protect artificial flowers and waxworks from dust.

Cloisonné. A type of enamelware in which the various colors are separated and held by delicate metal partition filaments.

Cloister. A covered passageway around an interior courtyard. Also the courtyard itself. Used particularly in medieval architecture.

Club foot. A foot used with the English cabriole furniture leg in the early years of the 18th century. The foot flares into a flat pad form that is round in shape.

Clustered columns. The system of placing several columns in close proximity or overlapping their shafts to form a support. Commonly seen in the European architectural styles of the Middle Ages.

Cobbler's bench. Shoemaker's bench with seat, last holder, bin, and compartments for pegs and tools.

Cockfight chair. Chair for reading and writing or viewing sports events used by straddling the seat and facing the back. The back had a small shelf. Popular from Queen Anne to Chippendale periods.

Coffer. An ornamental sunken panel in a ceiling, vault, or the lower surface of an arch, beam, or other architectural feature.

Collage. Composition made up of pieces of paper, photos, wallpaper, etc. glued together to a background surface to form a pattern or picture. Term sometimes used interchangeably with montage.

Colonnade. A row of columns usually supporting an entablature and forming a part of the architectural treatment of a corridor or passageway.

Colonnette. A small column.

Column (arch.). An elongated cylindrical structural support, usually having a base and a capital. May be isolated or attached to a wall.

Comb back. Windsor chair back, with a central group of spindles that extend above the back and are crowned with an additional rail.

Complementary color. An opposing color containing the primary color or colors not included in the original one; that is, red, blue, and yellow are complementary respectively to green, orange, and purple, and vice versa.

Composite order (arch.). A variant of the Corinthian order. The capital resembles the combination of an Ionic volute placed above rows of Corinthian acanthus leaves.

Composition. A term in design used to indicate a grouping of separate parts that produce the appearance of a co-ordinated whole and are esthetically related to each other by position, line, and form.

Composition ornament. An ornament made of putty, plaster, or other material, that is cast in a mould and applied to a surface to form a relief pattern. Also called "gesso" (It.) and "yeseria" (Sp.).

Connecticut chest. A type of Early American chest with double drawers, standing on four short legs; usually decorated with split spindles painted black.

Conventionalization. The reproduction of forms in nature with such changes as to make them more suitable to the particular mediums or materials in which they are repro-

duced. Simplifying or exaggerating natural forms in reproduction.

Conversation chair. S-shaped chair meant to seat two people facing in opposite directions. Used in the 18th and 19th centuries.

Conversation piece. Picture of a family group. See Genre.

Cool color. Blue and the hues that are near blue, such as blue-green and violet.

Corbel (arch.). A shoulder or bracket set in a wall to carry a beam; any stone, brick, or timber-work projecting as a shoulder to carry a burden.

Corinthian order. The most elaborate, slender, and graceful of the classical orders of architecture. The Romans standardized the column height at 10 diameters. The capital is enriched with two rows of acanthus leaves and four volutes.

Coromandel. An Eastern wood, used for furniture and often treated with a lacquered pattern.

Corner block (carp.). A square block of wood used to form a junction between the sides and head strip of door and window trim. Any block similarly used in cabinetmaking.

Cornice. The projecting, crowning portion of a classical entablature, consisting of bed moldings, fascia, and crown moldings; often used on interior walls without the frieze and architrave moldings.

Counter thrust (arch.). The opposing force or weight used to counterbalance the weight and thrust of a heavy arch.

Country-made (cab.). Cabinetmaking done by country cabinetmakers who are frequently less capable than those who are city-trained. Country-made furniture implies lower quality.

Cove. A concave surface often used to connect a wall and a ceiling. A cove-molding similar to the cavetto.

Creche. Miniature nativity scene with figures composed of wood, plaster, china, or composition, set up with stable and animals.

Crocket. Ornament used on the sides of pinnacles usually leaf or bud shaped; commonly seen in Gothic art.

Cross-banding. A narrow band of wood veneer forming the frame or border of a panel; the grain of the wood is at right angles to the line of the frame.

Crotch veneer. A thin sheet of wood cut from the intersection of the main trunk and branch of a tree, showing an irregular effect of graining.

Crown molding. The topmost molding, particularly the fillets and cymas placed above the fascia in a classical cornice.

Crystal. A clear and transparent quartz, resembling ice; an imitation of this material made in glass.

Cubism. A development of painting and sculpture based largely on abstract design and geometric pattern. Being first and foremost an abstract expression, cubism has little to do with imitations of nature or natural objects. The cubist artist has thus created new forms which live within themselves, and he has sensitized and enhanced the values of forms, line, and color in their purest sense.

Cuneiform. Literally wedge-shaped. A system of writing on clay tablets used in Sumeria, Babylonia, and Assyria in which the characters were wedge-shaped.

Cusping (arch.). Pointed termination of a trefoil or quatrefoil in Gothic architecture.

Cyma curve. An S-shaped curve. In the *cyma recta* the curve starts and ends horizontally. In the *cyma reversa* the curve starts and ends vertically.

Dado. The lower portion of a wall, when treated differently from the surface above it. In the classical styles the dado usually has a base, shaft, and cap molding, and is often panelled or ornamented. A low wainscot.

Dado cap. The crowning or cap molding of a dado; sometimes called a chair rail.

Daguerreotype. First photographic process invented in 1839 by Louis Daguerre in France. Involved action of light on plate sensitized by a solution of iodine and silver salts. Produced a faint image, which had to be viewed at an angle to be clearly seen.

Dais. A low platform raised above the level of the floor and located at one side or at the end of a room.

Damescene work. A type of metal inlay. The design is incised by means of acid applications on a metal base, and the depressions are filled in with wires or different metals cut to fit.

Deal. Generic term for any member of the pine family when it is cut up into planks. Also applied to furniture made of such planks. English and Early American use.

Decalcomania. A process of decoration in which printed designs on thin paper are transferred to other materials.

Demotic. An abridged form of hieroglyphics, used by the Egyptians for ordinary correspondence conducted by the public scribes.

Dentil. A small square projecting block in a cornice.

Derbyshire chair. A popular name for a type of Jacobean chair of provincial origin.

Desornamentado (Sp.). The name applied to the severe style of architecture and decoration developed by the architect Herrera under the patronage of Phillip II of Spain. The word means "without ornament."

Diameter. A straight line drawn through the center of a circle and touching the perimeter in two places. The length of such a line. The unit for proportioning the classical orders of architecture. The dimension is taken from the diameter of the shaft at the base of the column of that order, and all other portions of the column and entablature are given in units or fractions of the diameter of the column shaft.

Diaper pattern. An all-over or repeating pattern without definite limits.

Dinanderie. 15th century metal alloy, the ancestor of pewter, being a combination of copper, tin, and lead. Used particularly in application to ornamental figures made in Dinant, Belgium.

Diorite. A type of dark-colored, hard stone much used in Egyptian sculpture.

Dip-dyeing. The process of dyeing textiles after they are woven by dipping whole pieces into the dye. Dip-dyeing is also known as piece-dyeing.

Disk-turning. Flat circular turning used to ornament furniture.

Distant colors. Colors which produce the feeling of space and appear to recede, particularly light tones of blue and purple.

Distemper. Opaque water color pigments.

Dome. A spherical vaulted roof similar to an inverted cup.

Donjon. The massive tower which was used as a final stronghold in medieval castles. Usually located in the interior of a courtyard.

Domino wallpaper. Wallpaper imitating marble graining, similar to that which was produced by the Dominotiers in France in the latter half of the 16th century.

Doric order. The oldest and simplest Greek order of architecture. The Romans standardized the proportions and made the columns 8 diameters high and the entablature 2 diameters.

Dormer window. A projecting upright window which breaks the surface of a sloping roof.

Double-hung sash. Window sash divided into two sliding sections, one lowering from the top and the other rising from the bottom.

Doublet (orn.). A pair, or the duplication of an outline in a surface pattern, usually in a reverse form.

Dovetail (carp.). Wedge-shaped projection on the end of a piece of wood used to interlock with alternating similar grooves or projections on another piece of wood. Joint used to join the front and sides of a drawer.

Dowel (carp.). Headless pin of metal or wood which is used to hold two pieces of wood together.

Draw curtain. A curtain that may be drawn along a rail or other support by means of a traverse arrangement of cords and pulleys.

Drawnwork. A pattern made by drawing threads from both the warp and weft of a fabric.

Dresser (cap.). A cabinet with drawers or shelves.

Drier. A chemical preparation added to paint which causes it to dry quickly.

Drop-lid. A top or front of a desk hinged at the bottom and arranged to fall back, forming a surface for writing.

Drum. Circular supporting wall for a dome. Also the cylindrical stones used to build up a column shaft. Any feature in cabinetmaking resembling this shape.

Dry-point. An etching made from a metal plate upon which a picture has been scratched with a sharp-pointed metal tool.

Earthenware. Pottery of coarse clay.

Ebéniste (Fr.). Term used to designate a high-grade cabinetmaker.

Echinus (shell-shaped). An ovoid shaped molding forming part of a classical capital. It springs from the shaft of the column, just under the abacus.

Eclecticism. The borrowing and combining of art forms of various past periods, adapting them to contemporary conditions.

Egg-and-dart (orn.). An ornament used as a molding decoration, consisting of ovoid forms separated by dartlike points.

Eggshell finish. A semiflat paint finish.

Electroplating. An electrical process of coating base metals with a very thin surfacing of a more valuable metal.

Elevation (arch.). The vertical projection of any object. The delineation of an object or surface from in front in which the dimensions are at specified scale, and not foreshortened as seen by the eye. Specifically, a drawing of a wall to scale to show its length, height, and various subdivisions and ornament.

Elgin marbles. The sculptures of the pediments and friezes of the Parthenon, named after Lord Elgin, who was responsible for having them removed to the British Museum in London.

Embossing. A process of stamping, hammering, or moulding a material so that a design protrudes beyond the surface.

Enamel. A colored glaze that is used to decorate metal and ceramic surfaces; it becomes hard and permanent after firing. A paint that imitates such a surface. Enamel ware refers to objects whose surfaces are treated with this material.

Encaustic painting. A method of painting with pigments mixed with hot wax. The wax mixture may be heated and applied with a spatula or brush, or it may be applied to the surface first, and the designs drawn with a stylus.

Engaged column (arch.). A column attached to a wall.

Engraving. The process whereby a design is incised with a sharp instrument upon a copper or steel plate; also, the impression printed from this plate.

Entablature. The surfaces and moldings of a classical order of architecture, consisting of the architrave, frieze, and cornice, and forming the upper portion of the order. The portion of the order supported by the column.

Entasis (arch.). The slight curve on a column shaft. In the Roman orders the entasis reduces the diameter of the shaft at the capital to five-sixths the dimension of the diameter at the base. The curve is limited to the upper two-thirds of the shaft.

Escabelle (Fr.). An early French Renaissance stool or chair.

Escritoire (O.F.). A desk with drawers and compartments.

Escutcheon. A shield with a heraldic device. In hardware it refers to a shaped plate for a keyhole or to a metal door fitting to which a handle or knob is attached.

Estrado (Sp.). Raised platform or dais at one end of main living room in 17th century Spanish houses.

Etchings. Prints from a copper plate upon which a drawing or design has been made by a metal tool or by "biting" with acid.

Etruscan. See Tuscan.

Exedra. Public room in Roman or Pompeian dwellings.

Faïence (Fr.). A type of pottery made originally at Faenza, Italy. It is a glazed biscuit ware, and the name is now popularly applied to many such decorated wares.

Famille noire, verte, jaune, rose, etc. (Fr.). French names which designate a particular type of Chinese pottery having a colored background. Translated, the words mean "black family," "green family," "yellow family," and "rose family."

Fasces (orn.). A bundle of rods enclosing an axe, a Roman symbol of power.

Fascia (arch.). A molding whose section consists of a vertical flat surface. Particularly the projecting crown molding of a cornice.

Fenestration. The arrangement of windows in a building.

Ferronerie velvet. Antique Venetian velvet made with patterns imitating delicate wrought iron forms.

Fiddle-back chair. An American Colonial rush-seated chair of the Queen Anne type, with the back splat silhouetted in a form approximating a fiddle-back or vase shape.

Filet lace. A lace produced by embroidering a pattern on a fine net usually in thread similar to that of the net.

Filigree. Ornamental openwork in a delicate patern. Usually refers to the pattern made by fine gold or silver wires or plates formed in minute lacelike tracery.

Fillet (arch.). A molding whose section consists of a small vertical flat surface; usually used at the start or finish of a curved molding.

Finial. An ornament used as a terminating motif. A finial is usually in the form of a knob, pineapple, or foliage.

Firebacks. Metal linings, often ornamented and usually of cast iron, placed in a fireplace behind the fire to reflect heat and protect the masonry.

Fireside figures. Wooden silhouettes painted to resemble royal personages, guards, pages, etc. Used as fire

screens and fireplace adornment in Europe during the 16th and 17th centuries.

Firing. The term used in pottery manufacture to describe the heating of the clay in the kilns to harden it.

Flamboyant (Fr., flame-like). A term that is used to designate the late Gothic style in France, because the window tracery was designed in reverse curved lines resembling conventional flamelike forms.

Flemish foot. Furniture foot used in Flanders, England, and France during the 17th century. The scroll design usually followed the line of an S- or C-curve.

Flemish scroll. An S- or C-curved ornamental form, probably of Spanish origin, but associated with Dutch and Flemish furniture design and used in England during the Carolean and William and Mary periods.

Fleur-de-lis. The conventionalized iris flower used by the former kings of France as a decorative motif symbolizing royalty.

Flock paper. Wallpaper imitating velvet and made by scattering powdered wool over a pattern printed in varnish on paper sheets.

Florentine arch. A semicircular arch that springs directly from a Renaissance column capital or pier and is trimmed with an architrave molding. Usually seen in series.

Fluid plan. Type of planning in modern architecture, in which one room opens into another with little division between them, and the whole may be thrown open into one large area, if desired.

Flush (arch.). A term referring to any surface that is on the same plane or level as the surface adjoining it.

Flutes or flutings. Parallel concave grooves that are used to ornament a surface. In classical architecture they are commonly seen on column shafts and run in a vertical direction. Spiral flutings are frequently used on furniture supports. Short flutings are used as a frieze ornament.

Flying buttress. In Gothic architecture, an arch springing from the wall of a building to an exterior

stone pier, intended as a counter-thrust weight to resist the thrust of the arched roof.

Form. A stool or long bench without a back.

Fractur painting. Decorative birth, marriage certificates, etc., made by Pennsylvania Germans during the 18th and 19th centuries.

French heading. A term used in curtain making to designate the gathering of a drapery or valence into folds at regular intervals near the top. The folds are sewed together in place so that they will have a more regular appearance.

Fresco. Method of painting on wet plaster with tempera colors. The plaster absorbs the pigment, and when dry, the painting becomes hard and durable and a part of the plaster.

Fret (orn.). A Greek geometric band or border motif, consisting of interlacing or interlocking lines; also known as the meander or key pattern.

Frieze. The central portion of the three main horizontal divisions of a classical entablature; usually a flat surface decorated with ornamental features or carving. Often used in decorative work without the architrave or cornice.

Full-tone. A color of which the hue is near its full chromatic value.

Gabon. Black ebony.

Gadroon (orn.). Elongated ovoid forms placed in a parallel series and projecting beyond the surface they enrich.

Gaine. An ornament or support in the form of a square post tapering toward the lower portion. It is usually crowned with a head or bust and has ornamental human or animal feet.

Gallery (cab.). A miniature railing placed along the edge of a shelf or table top. Specifically the *gallery-top* table.

Galloon or galon. A narrow close-woven braid used for trimming draperies and upholstery. A heavy guimpe.

Gargoyle. A projecting stone water-spout grotesquely carved in fantas-

tic animal or bird form. Used in Gothic architecture.

Gazebo. Turret on a roof of a small garden shelter usually built of latticework.

Genie. A creature of ancient folklore fashioned like man but having supernatural powers. An imaginary form resembling this creature, used as an ornamental motif.

Genre (Fr.). Pictures that depict the activities of the comman man.

Gesso. A prepared plaster of chalk and white lead which may be cast to make repeating ornamental forms in relief to be applied to wood panels, plaster surfaces, etc.

Girandole. A type of branching chandelier or a wall mirror to which candle brackets are attached.

Girder. A heavy beam used over wide spans and often supporting smaller beams or heavy concentrated weights.

Gold size. An adhesive substance painted on a surface to which gold leaf is to be applied.

Gouache. An opaque water color pigment, or any picture painted in this medium.

Graffito ware. Ware of heavy pottery decorated with a rudely scratched design.

Graining. A painted imitation of the fiber lines of wood.

Granite. Granular crystalline rock of quartz, feldspar, and mica. The hardest and most durable building stone.

Great hall. The large, two-storied central hall of a medieval castle, used principally for dining and entertaining.

Greek cross. A cross formed of two bars of equal length meeting at right angles.

Grisaille (Fr.). Decorative painting in which objects are rendered in tones of one color. Often intended to give the effect of sculptured relief panels.

Groin vault. See Vault.

Gros-point (Fr.). Embroidery done in a cross-stitch on a double threaded net. Averages 64 to 256 stitches per square inch.

Grotesques (orn.). Fanciful hybrid human forms, animals, and plants.

Guadamacileria (Sp.). Decorated leather produced by the Moors in Cordova, Spain, and elsewhere.

Guilloche (orn.). A band or border running pattern having the appearance of overlapping or interlacing circular forms.

Guimpe. A narrow, flat, ornamental trimming, often having a wire or cord running through it. Used primarily to cover upholstery nails.

Hadley chest. A type of Early American New England-made chest which stood on four feet, and usually had one drawer and was decorated with crude incised carving.

Half-timber. A type of house construction in which heavy wooden posts and beams form the skeleton of the structure. The area between them is filled in with brick, stone, or plaster.

Half-tone. A color that in tonal value is approximately halfway between white and black.

Hallmark. The mark or marks which designate that a piece of metalwork has received an official approval of quality, particularly the approval issued by Goldsmith's Hall, London.

Hammer-beam truss. A form of roof support used during the early English Renaissance. It consists of a Tudor arch form in wood, each end of which rests on a large wooden bracket.

Hard paste (pot.). Name used to identify hard-bodied or true porcelain, made of kaolin, or "China clay."

Hassock. A heavy cushion or thick mat used as a footstool.

Hausmalerei (Germ.). Pottery made in Germany by independent artists and amateurs, who decorated partially fired pieces, and returned them to the kiln for glazing and further firing.

Haut-relief (Fr.). See Relief.

Heddle. The bar of a loom which controls the warp threads.

Hellenistic. Period of Greek art under Alexander (3rd century B.C.) when the center of culture moved to Alexandria from Athens. Characterized by extreme realism and theatri-

calism. Lasted until Greece became a Roman colony.

Hennin. A high pointed headgear worn by medieval women.

Hex sign. A good luck symbol often placed on the exterior of buildings by the Pennsylvania Germans. It was usually in the shape of a circle, enclosing a six-pointed star or other motif.

Hieratic. An abridged form of hieroglyphics, used by the Egyptians, and reserved for religious writings.

Hieroglyphics. A system of writing used by the Egyptians, consisting of a combination of picture-writing and phonetic indications.

Highboy. A tall chest of drawers supported by legs and usually crowned with cornice moldings or a pediment.

Hispano-Mauresque. The term used to designate Spanish art productions that show an influence of both Moorish and Renaissance origin.

Hom. Assyrian tree-of-life pattern.

Honeysuckle. A decorative motif of Greek origin resembling a conventionalized fanlike arrangement of petals.

Hooked rug. A pile-surfaced rug made by pushing threads or strips of cloth through a canvas backing. By varying the colors of the pile, any pattern can be made.

Horseshoe arch. An arch whose total curve is greater than a semicircle. Used in Moorish and Spanish architecture.

Hue. A color itself, as red or blue. Many *tones* of the same hue are possible. A *tint* is a hue with white added, and a *shade* is a hue with black added.

Hutch. Another name for the chest, most common item of furniture in the Gothic household.

Hydria. Greek water jar with three handles that was used for carrying or pouring.

Icon. Portrait or image. In the Greek and Russian church it refers to the panels containing portraits or figures of sacred personages, as the Virgin, and the various saints. Also spelled *ikon*.

Idealism. The tendency in art to express universal or spiritual concepts.

Illumination. Hand decoration of manuscripts in color and gold and silver. Practiced to a great extent by monks in the monasteries in the Middle Ages.

Impost (arch.). A feature or structural member upon which an arch rests. The top of the impost is below the spring-line of the arch.

Impressionism. A late 19th century development in the French school of painting. Brilliant atmospheric effects were produced by using spectral colors in adjoining positions on the canvas instead of mixing the pigments on the palette before application. The paintings are best seen at a distance, as the broken pigments used to produce the effect of atmospheric realism are diffused under such a condition.

Incised. Cut into; said of a pattern or carving produced by cutting into a stone, wood, or other hard surface. The reverse of a *relief* carving, the pattern of which projects from the surface or background. Intaglio.

Ingrain. A flat-woven wool or wool-and-cotton carpet with a Jacquard design; usually reversible.

Inlay. Ornament or a pattern that is produced by inserting cut forms of one material into holes of similar shape previously cut in another material. The contrast of materials or colors produces the effect as well as the design of the cutting. Correctly speaking, marquetry is not inlay work, as both pattern and field are cut at the same time from a thin veneer.

Intaglio. Incised or countersunk decoration, as opposed to *relievo* decoration, which is in relief.

Intarsia (It.). See Inlay.

Ionic order. One of the classical orders of architecture. The characteristic feature of the capital of the column is the spiral-shaped volute or scroll. The standard proportion of the Roman column is 9 diameters high.

Jamb. The interior side of a door or window frame.

Japanning. A process, much used in the 18th century, by which furniture and metalwork were enameled with colored shellac and the decoration raised and painted with gold and colors.

Jardinière velvet. Multi-colored velvet with a satin ground showing a floral design. Originally made in Genoa.

Jasper. An opaque variety of quartz which may be bright red, yellow, or brown.

Jasper ware. A name given by Wedgwood to a type of hard biscuit ware that was introduced in the late 18th century.

Joinery. The craft of assembling woodwork by means of mortise and tenon, dovetail, tongue and groove, dowels, etc.

Joist. A horizontal timber used to support a floor or ceiling.

Kakemono. A Chinese or Japanese painting, mounted on brocade and hung on the wall, without a frame.

Kakiyemon. A Japanese pottery artist who developed the use of colored enamel designs on Japanese porcelain. The name is also applied to decorations inspired by his works.

Kaolin. A white clay used in the manufacture of true porcelain; sometimes called *china-clay*.

Kapok. A filling material used for stuffing upholstery and pillows.

Keystone. The wedge-shaped central stone at the top of an arch.

Klismos. A Greek type of chair having a concave curved back rail and curved legs.

Kneehole desk. Desk with a solid lower portion but with an opening for the knees of the person seated at it.

Knotted rug. An Oriental rug weave in which the surface or pile is formed by the ends of threads knotted around the warps, the weft threads serving merely as a binder.

Krater. A wide-mouthed, two-handled bowl used by the Greeks for mixing wine and water.

Kylin. A chimerical beast often used in Chinese decoration.

Kylix. A flat-shaped Greek drinking cup on a slender center foot.

Lacquer. A varnish containing lac; or a hard varnish obtained from the sap of the lacquer tree. The latter is the base of Chinese and Japanese lacquer. Any varnish of shellac dissolved in alcohol.

Ladder back. A chair having a ladder effect produced by the use of a series of horizontal back rails in place of a splat.

Lady-chapel. The most revered and elaborately decorated chapel at the east end of a cathedral. Dedicated to the Virgin.

Lantern (arch.). A small structure placed at the crowning point of a dome, turret, or roof, with openings for light to come through. Frequently its purpose is decorative only.

Latin cross. A cross form with one arm longer than the other.

Lavabo. A washstand or washbowl, often with a fountain or water supply. The support for same.

Lectern. A pedestal support for a large book or Bible.

Lekythos. A long narrow-necked flask used by the Greeks for pouring oil.

Letto (It.). Bed.

Linenfold. A carved Gothic panel enrichment which resembles folded linen or a scroll of linen.

Linoleum cut. A print made from blocks of linoleum which have been cut into grooves to form a picture or pattern.

Lintel. A horizontal beam, supported at each end, that spans an opening and usually supports a superstructure.

Loggia (It.). A room or area with an open arcade or colonnade on one side.

Louver. An opening in a wall or ceiling protected from the rain by slats placed at an angle.

Lozenge (orn.). An alternate name for the conventional diamond-shaped motif.

Lunette (orn.). A form resembling a crescent or half moon.

Luster. A thin metallic glaze used on pottery to produce a rich, iridescent color. Used in Persian ceramics, Spanish and Italian majolica, and English and American ware.

tic animal or bird form. Used in Gothic architecture.

Gazebo. Turret on a roof of a small garden shelter usually built of latticework.

Genie. A creature of ancient folklore fashioned like man but having supernatural powers. An imaginary form resembling this creature, used as an ornamental motif.

Genre (Fr.). Pictures that depict the activities of the comman man.

Gesso. A prepared plaster of chalk and white lead which may be cast to make repeating ornamental forms in relief to be applied to wood panels, plaster surfaces, etc.

Girandole. A type of branching chandelier or a wall mirror to which candle brackets are attached.

Girder. A heavy beam used over wide spans and often supporting smaller beams or heavy concentrated weights.

Gold size. An adhesive substance painted on a surface to which gold leaf is to be applied.

Gouache. An opaque water color pigment, or any picture painted in this medium.

Graffito ware. Ware of heavy pottery decorated with a rudely scratched design.

Graining. A painted imitation of the fiber lines of wood.

Granite. Granular crystalline rock of quartz, feldspar, and mica. The hardest and most durable building stone.

Great hall. The large, two-storied central hall of a medieval castle, used principally for dining and entertaining.

Greek cross. A cross formed of two bars of equal length meeting at right angles.

Grisaille (Fr.). Decorative painting in which objects are rendered in tones of one color. Often intended to give the effect of sculptured relief panels.

Groin vault. See Vault.

Gros-point (Fr.). Embroidery done in a cross-stitch on a double threaded net. Averages 64 to 256 stitches per square inch.

Grotesques (orn.). Fanciful hybrid human forms, animals, and plants.

Guadamacileria (Sp.). Decorated leather produced by the Moors in Cordova, Spain, and elsewhere.

Guilloche (orn.). A band or border running pattern having the appearance of overlapping or interlacing circular forms.

Guimpe. A narrow, flat, ornamental trimming, often having a wire or cord running through it. Used primarily to cover upholstery nails.

Hadley chest. A type of Early American New England-made chest which stood on four feet, and usually had one drawer and was decorated with crude incised carving.

Half-timber. A type of house construction in which heavy wooden posts and beams form the skeleton of the structure. The area between them is filled in with brick, stone, or plaster.

Half-tone. A color that in tonal value is approximately halfway between white and black.

Hallmark. The mark or marks which designate that a piece of metalwork has received an official approval of quality, particularly the approval issued by Goldsmith's Hall, London.

Hammer-beam truss. A form of roof support used during the early English Renaissance. It consists of a Tudor arch form in wood, each end of which rests on a large wooden bracket.

Hard paste (pot.). Name used to identify hard-bodied or true porcelain, made of kaolin, or "China clay."

Hassock. A heavy cushion or thick mat used as a footstool.

Hausmalerei (Germ.). Pottery made in Germany by independent artists and amateurs, who decorated partially fired pieces, and returned them to the kiln for glazing and further firing.

Haut-relief (Fr.). See Relief.

Heddle. The bar of a loom which controls the warp threads.

Hellenistic. Period of Greek art under Alexander (3rd century B.C.) when the center of culture moved to Alexandria from Athens. Characterized by extreme realism and theatri-

calism. Lasted until Greece became a Roman colony.

Hennin. A high pointed headgear worn by medieval women.

Hex sign. A good luck symbol often placed on the exterior of buildings by the Pennsylvania Germans. It was usually in the shape of a circle, enclosing a six-pointed star or other motif.

Hieratic. An abridged form of hieroglyphics, used by the Egyptians, and reserved for religious writings.

Hieroglyphics. A system of writing used by the Egyptians, consisting of a combination of picture-writing and phonetic indications.

Highboy. A tall chest of drawers supported by legs and usually crowned with cornice moldings or a pediment.

Hispano-Mauresque. The term used to designate Spanish art productions that show an influence of both Moorish and Renaissance origin.

Hom. Assyrian tree-of-life pattern.

Honeysuckle. A decorative motif of Greek origin resembling a conventionalized fanlike arrangement of petals.

Hooked rug. A pile-surfaced rug made by pushing threads or strips of cloth through a canvas backing. By varying the colors of the pile, any pattern can be made.

Horseshoe arch. An arch whose total curve is greater than a semicircle. Used in Moorish and Spanish architecture.

Hue. A color itself, as red or blue. Many *tones* of the same hue are possible. A *tint* is a hue with white added, and a *shade* is a hue with black added.

Hutch. Another name for the chest, most common item of furniture in the Gothic household.

Hydria. Greek water jar with three handles that was used for carrying or pouring.

Icon. Portrait or image. In the Greek and Russian church it refers to the panels containing portraits or figures of sacred personages, as the Virgin, and the various saints. Also spelled *ikon*.

Idealism. The tendency in art to express universal or spiritual concepts.

Illumination. Hand decoration of manuscripts in color and gold and silver. Practiced to a great extent by monks in the monasteries in the Middle Ages.

Impost (arch.). A feature or structural member upon which an arch rests. The top of the impost is below the spring-line of the arch.

Impressionism. A late 19th century development in the French school of painting. Brilliant atmospheric effects were produced by using spectral colors in adjoining positions on the canvas instead of mixing the pigments on the palette before application. The paintings are best seen at a distance, as the broken pigments used to produce the effect of atmospheric realism are diffused under such a condition.

Incised. Cut into; said of a pattern or carving produced by cutting into a stone, wood, or other hard surface. The reverse of a *relief* carving, the pattern of which projects from the surface or background. Intaglio.

Ingrain. A flat-woven wool or wool-and-cotton carpet with a Jacquard design; usually reversible.

Inlay. Ornament or a pattern that is produced by inserting cut forms of one material into holes of similar shape previously cut in another material. The contrast of materials or colors produces the effect as well as the design of the cutting. Correctly speaking, marquetry is not inlay work, as both pattern and field are cut at the same time from a thin veneer.

Intaglio. Incised or countersunk decoration, as opposed to *relievo* decoration, which is in relief.

Intarsia (It.). See Inlay.

Ionic order. One of the classical orders of architecture. The characteristic feature of the capital of the column is the spiral-shaped volute or scroll. The standard proportion of the Roman column is 9 diameters high.

Jamb. The interior side of a door or window frame.

Japanning. A process, much used in the 18th century, by which furniture and metalwork were enameled with colored shellac and the decoration raised and painted with gold and colors.

Jardinière velvet. Multi-colored velvet with a satin ground showing a floral design. Originally made in Genoa.

Jasper. An opaque variety of quartz which may be bright red, yellow, or brown.

Jasper ware. A name given by Wedgwood to a type of hard biscuit ware that was introduced in the late 18th century.

Joinery. The craft of assembling woodwork by means of mortise and tenon, dovetail, tongue and groove, dowels, etc.

Joist. A horizontal timber used to support a floor or ceiling.

Kakemono. A Chinese or Japanese painting, mounted on brocade and hung on the wall, without a frame.

Kakiyemon. A Japanese pottery artist who developed the use of colored enamel designs on Japanese porcelain. The name is also applied to decorations inspired by his works.

Kaolin. A white clay used in the manufacture of true porcelain; sometimes called *china-clay*.

Kapok. A filling material used for stuffing upholstery and pillows.

Keystone. The wedge-shaped central stone at the top of an arch.

Klismos. A Greek type of chair having a concave curved back rail and curved legs.

Kneehole desk. Desk with a solid lower portion but with an opening for the knees of the person seated at it.

Knotted rug. An Oriental rug weave in which the surface or pile is formed by the ends of threads knotted around the warps, the weft threads serving merely as a binder.

Krater. A wide-mouthed, two-handled bowl used by the Greeks for mixing wine and water.

Kylin. A chimerical beast often used in Chinese decoration.

Kylix. A flat-shaped Greek drinking cup on a slender center foot.

Lacquer. A varnish containing lac; or a hard varnish obtained from the sap of the lacquer tree. The latter is the base of Chinese and Japanese lacquer. Any varnish of shellac dissolved in alcohol.

Ladder back. A chair having a ladder effect produced by the use of a series of horizontal back rails in place of a splat.

Lady-chapel. The most revered and elaborately decorated chapel at the east end of a cathedral. Dedicated to the Virgin.

Lantern (arch.). A small structure placed at the crowning point of a dome, turret, or roof, with openings for light to come through. Frequently its purpose is decorative only.

Latin cross. A cross form with one arm longer than the other.

Lavabo. A washstand or washbowl, often with a fountain or water supply. The support for same.

Lectern. A pedestal support for a large book or Bible.

Lekythos. A long narrow-necked flask used by the Greeks for pouring oil.

Letto (It.). Bed.

Linenfold. A carved Gothic panel enrichment which resembles folded linen or a scroll of linen.

Linoleum cut. A print made from blocks of linoleum which have been cut into grooves to form a picture or pattern.

Lintel. A horizontal beam, supported at each end, that spans an opening and usually supports a superstructure.

Loggia (It.). A room or area with an open arcade or colonnade on one side.

Louver. An opening in a wall or ceiling protected from the rain by slats placed at an angle.

Lozenge (orn.). An alternate name for the conventional diamond-shaped motif.

Lunette (orn.). A form resembling a crescent or half moon.

Luster. A thin metallic glaze used on pottery to produce a rich, iridescent color. Used in Persian ceramics, Spanish and Italian majolica, and English and American ware.

fiber of a cloth has been dyed after the completion of the weaving.

Pier. Heavy vertical masonry support for a superstructure. This type of support lacks the detail and proportions of a column or pilaster.

Pier glass. A glass or mirror designed to stand on the floor against a wall surface.

Pigment colors. Colors made from natural or synthetic materials and used to produce the various hues in common paints. Opposed to the spectral colors produced by the decomposition of light.

Pilaster. A flat-faced vertical projection from a wall, rectangular in plan but with the general proportions, capital, and base of a column.

Pile. In textile and carpet construction, the upright ends or loops (if uncut) of thread which are woven at right angles to the warp and weft. The nap generally has the appearance of velvet.

Pillar (arch.). The popular term used to designate a column. Also an isolated structure used for commemorative purposes.

Pinnacle. Small pyramidal or cone-shaped turret used in architecture to crown roofs and buttresses. In the decorative arts, any form resembling the architectural feature.

Piping. A method of applying and holding in place upholstery or padding to a curved surface by means of ribs resembling pipes.

Plain-sawing (carp.). The cutting of a plank of wood from the outside edge of a tree trunk. The grain appears in V-shapes opposed to *quarter-sawing* in which the plank is cut through or near the center of the trunk and causes the grain to appear in parallel lines.

Plan (arch.). The horizontal projection of any object. The delineation of an object or surface from above. The shape or internal arrangement of an object as indicated by a section cut parallel to the ground. Specifically, a drawing showing the arrangement and horizontal dimensions of the rooms of a building.

Plaque (Fr.). A plate or panel usually made of metal, glass, or pottery and treated with a surface enrichment. Used for decorative purposes.

Plateresco. The name given to the period of Spanish art during the first half of the 16th century. The word is derived from *platero*, meaning silversmith. The style of ornament often imitated the fine detail of the silversmith's work.

Plinth (arch.). Square member at the base of a column or pedestal. The *plinth-block* in carpentry is the small block of wood used at the bottom of door trim against which the baseboard butts.

Podium. A pedestal; also the enclosing platform of the arena of an amphitheater.

Pole screen. Adjustable panel mounted on a vertical pole.

Polychrome. An ornament or pattern in several colors.

Pomegranate. Decorative motif or ornament used in many periods. Symbol of fertility.

Pontil. An iron rod used in glass manufacturing to carry hot materials. *Pontil mark* is the permanent mark left by the pontil after the material has cooled.

Porcelain. A hard, vitreous, non-porous pottery. Opposed to earthenware, which, if unglazed, is absorptive. True porcelain is made of kaolin or china clay.

Porphyry. Rock composed of crystals of white or red feldspar in a red ground mass. A valuable stone for architectural or ornamental use.

Portland vase. Roman vase now in the British Museum, of blue-black glass with superimposed opaque white figures, having a cameo effect. It was copied in dark slate-blue jasper ware by Josiah Wedgwood.

Post-impressionism. The development of the modern French school of painting which immediately followed Impressionism. It was a revolt against the principles of the color interpretation of the latter school. Instead of painting the colors of an object as they appear under different lights or in different atmospheres, the Post-impressionists returned to representation of the actual colors of the object it- self without the atmospheric influence. This largely eliminated the effects of foreground and background by contrasting tonal values. It was less of a group movement than Impressionism.

Preclassic. The classification given to the arts and cultures of the Western peoples who preceded the civilizations of ancient Greece and Rome—Egypt, Babylon, Assyria, Chaldea, Persia and Crete.

Pressed glass. Glass that is ornamented in relief by pressing into a mould.

Primary colors. The three pigment colors, red, yellow, and blue, which cannot be produced by any mixture of other pigments. Combinations of any two of the primaries are known as *secondaries*. The combination of any secondary with a primary is known as a *tertiary*. The spectral primaries are those seen in the rainbow.

Priming coat. A mixture used by painters for a first or preparatory coat.

Primitive. Early, simple, naïve. The term applied to the early artists of any school or period when they have not yet mastered the later and more highly developed principles.

Psyche. Upholstered sofa dating from about 1840, designed with Greek curves.

Pure design. The theory that all art and design is based on a set of universal, fundamental, and abstract principles that create the ideal of beauty.

Putto (It.). A young boy. A favorite subject in Italian painting and sculpture. Plural "putti."

Pylon. Monumental obelisk or the heavy mass of masonry pierced with an opening at the entrance of an Egyptian temple.

Quarter-round (carp.). A convex molding in the shape of a quarter circle. An *ovolo* molding.

Quarter-sawing (carp.). To saw wood planks toward or through the center of the tree trunk. See *plain sawing.*

Quaternary. An intermediate hue in the pigment color-wheel, formed by a mixture of a tertiary color with

either its adjoining primary or secondary. A fourth mixture of primary colors.

Quatrefoil. A four-lobed ornamentation.

Quattrocento (It.). The 15th century.

Rafter. A beam supporting a roof and usually following the pitch of the roof.

Rail (cab.). In panelling, any horizontal strip forming a portion of the frame; the vertical strips are called *stiles*.

Realism. The tendency in art to represent forms and objects as they actually are; that is, detailed representation with photographic accuracy.

Reeding (orn.). A long, semicylindrical, stemlike form or a grouping of such used to enrich moldings.

Refectory. A dining hall, especially in ecclesiastical or collegiate buildings.

Relief. A type of decoration in which the design is made prominent by raising it from the surface or background of the material. *High relief* designates that the design is raised greatly; *low relief*, that the design is only slightly raised from the background.

Reliquary. A small receptacle designed to hold a sacred relic; usually made of ornamented precious metals enriched with jewels or enamel decoration.

Rep. A textile woven with a larger warp than weft thread or vice versa, producing a ribbed effect, as in poplin and corduroy.

Repoussé. Relief work on metal materials. The design is pushed out by hammering the material on the reverse side. Embossed.

Reredos (arch). A screen or wall-facing set behind a church altar, usually decorated with sculpture or carving. A retable.

Reticella (It.). Cutwork lace, similar to net work or filet.

Reverse. The side of a coin or medal, on which is placed the least important impression or design.

Rib. A projecting band on a ceiling, vault, or other surface.

Ribband back. Chair back designed with pattern of interlacing ribbons. Characteristic of Chippendale style.

Ribbed vault. See Vault.

Rinceau (Fr.). Scroll and leaf ornament sometimes combined with cartouches or grotesque forms and applied to friezes, panels, or other architectural forms. It is usually a symmetrical horizontal composition. Sometimes called an arabesque.

Rococo. A style in architecture and decoration. It is characterized by lightness and delicacy of line and structure, by asymmetry, and by the abundant use of foliage, curves, and scroll forms of decoration. The name is derived from the French words *rocaille* and *coquille* (rock and shell), prominent motifs in this decoration. The style often tended to the overornamentation of surfaces.

Roll. In the United States, a wallpaper trade and sales unit which designates 36 square feet of paper. Several rolls are usually included in a bundle or bolt or stick.

Romayne work. Carved medallion heads or knobs used as furniture ornaments or drawer pulls. Characteristic of Jacobean and Restoration periods.

Rondel. Round outline or object in a surface pattern.

Rope bed. Any bed with rope laced to the frame for holding the mattress.

Rose window. A circular window with tracery mullions radiating from a center in wheel form, the spaces between being filled with richly colored glass. Originally introduced in Gothic cathedrals, the form was later applied to wood panelling and furniture design.

Rosette (orn.). An ornamental motif formed by a series of leaves arranged around a central point. The leaves are usually conventionalized and may be arranged to form a circle, ellipse, or square.

Roundabout chair. A type of chair designed to fit into a corner; has a low back on two adjoining sides of a square seat.

Rustication (arch.). In stonework, a type of beveling on the edges of each block to make the joints more conspicuous.

Sampler. A piece of needlework intended to show a beginner's skill. Specifically, a small piece of linen embroidered with alphabets and naïve patterns; made by children in the early 19th century in Europe and in North America and South America.

Sanguine drawing. A drawing in red crayon or chalk.

Sash bar. The strip of wood or metal which subdivides the individual panes of glass within the sash frame of a window.

Sash curtain. A lightweight curtain that is hung on or nearest the sash of a window. Also called glass curtain.

Sausage turning. Furniture turning resembling a string of sausages.

Scallop shell (orn.). A semicircular shell with ridges radiating from a point at the bottom. This motif was especially common in furniture design during the Queen Anne and Georgian periods in England and the United States. It was also extensively used in the early Spanish Renaissance.

Sconce. Ornamental wall bracket to hold candles or electric bulbs.

Scotia. A concave molding approximating a curve produced by two tangential curves of different radii.

Scratch carving. Shallow or deep scratching, to form a design, used in woodwork and pottery products.

Scribe (carp.). To fit one material to another, as the side of a wooden strip to an uneven surface of plaster or adjoining wood surface. A *scribe-molding* is a small strip of wood that can be easily cut or bent to fit an uneven surface or cover up an irregular joint or crack.

Scroll (orn.). A spiral line used for ornamental purposes, as in the arabesque and rinceau. A parchment roll used as an ornament.

Scroll pediment. Broken pediment with each half shaped in the form of a reverse curve, and ending in an ornamental scroll. Usually a finial of some sort is placed in the

center between the two halves of the pediment.

Seaweed marquetry. Inlay of various woods in an arabesque design of small leaf and seaweed forms. Much used during the William and Mary period.

Secondary colors. Orange, purple, and green, each of which is produced by the combination of two primary colors.

Section (arch.). A term used to express the representation of a building, molding, or other object cut into two parts, usually by a vertical slice. The purpose of a sectional representation is better to show a silhouette shape or interior construction, showing vertical dimensions or heights.

Sedan chair. Enclosed chair, carried by four men, used for transportation in the 18th century.

Sedia (It.). Chair.

Segmental arch. An arch that is shaped as a part of a circle less than a semicircle.

Serpentine curve. An undulating curve used for the fronts of chests, desks, cupboards, and similar pieces. The curve is formed by two tangential cymas.

Sgabello (It.). A small wooden Renaissance chair, usually having a carved splat back, an octagonal seat, and carved trestle supports.

Sgraffito (It.). A method of decorating a surface. A pattern that is first scratched on a surface and then colored or reveals a colored ground beneath.

Shade. Something that serves to intercept light. A color or pigment that contains a percentage of black.

Shaft (arch.). Central portion of a column or pilaster between the capital and base.

Shaker furniture. A type of furniture made in the late 18th and early 19th centuries by the Shakers, a religious sect in New York State and later in New England. The designs were plain and functional; built-ins were characteristic.

Shed. In textile manufacture, an opening which is formed by the warp threads being lifted by a heddle; through this opening the shuttle holding the weft thread passes.

Shirring. Gathering a textile in small folds on a thread, cord, or rod.

Silhouette. A profile or outline drawing, model, or cut-out, usually in one color. The outline of any object. A shadow.

Sill (carp.). A horizontal board or strip forming the bottom or foundation member of a structure, especially the board at the bottom of a window that serves as a finishing member for the trim and casing. A door sill is usually called a *saddle*.

Singeries. Designs showing monkeys at play. Popular in France during the Louis XV period.

Size. Gelatinous solution used for stiffening textiles, glazing paper, and in other manufacturing processes. It is also often used as a first coat in painting.

Skeleton construction (arch.). Building construction of posts and beams assembled before the walls are erected. In steel construction the walls are nonbearing, being supported by the steel work, and are merely screens against the weather.

Skirt (cab.). Also called apron or frieze. The wooden strip that lies just below a shelf, window sill, or table top.

Slat-back chair. A type of Early American chair with wide horizontal ladder rails between the back uprights.

Slip (pot.). Clay and water of a creamlike consistency used as a bath for pottery, to produce a glaze or color effect.

Slipper chair. Any short-legged chair with its seat close to the floor.

Snake foot. In cabinet work, a foot carved to resemble a snake's head.

Socle. Plain, square and unmolded base or pedestal for a statue, or superstructure.

Soffit (arch.) The ceiling or underside of any architectural member.

Soft paste. Base of ceramics made before the introduction of kaolin, products of which lack the whiteness and extreme hardness of true porcelain.

Solar. A medieval term for an upper chamber in a castle. Usually the private room of the owner.

Spade foot (cab.). A square, tapering foot used in furniture design. It is separated from the rest of the leg by a slight projection.

Spandrel. The approximately triangular panel or wall space between two adjoining arches and a horizontal line above them.

Spanish foot. Foot in the shape of an inward curving scroll. Used in 18th century English and American furniture.

Spectral colors. The colors produced by a beam of white light as it is refracted through a prism. Although they are unlimited in number, they are usually designated as violet, indigo, blue, green, yellow, orange, and red. Commonly seen in the rainbow.

Spindle. A long slender rod often ornamented with turned moldings or bluster forms. See also Split spindle.

Spinet. Keyboard instrument, ancestor of the piano, in which the sound was produced by the action of quills upon strings.

Spiral leg (cab.). A furniture support carved in a twist, with a winding and descending groove or fluting. A rope twist.

Splat. A plain, shaped, or carved vertical strip of wood. Particularly that used to form the center of a chairback.

Splay. A line or surface that is spread out or at a slant. A bevel or chamfer.

Spline (cab.). A small strip of wood inserted between and projecting into two adjoining pieces of wood to form a stronger joint between them.

Split spindle. A long, slender turned and moulded wooden rod that is cut in two lengthwise so that each half has one flat and one rounded side. Used as an applied ornament in 17th century English and American furniture.

Spring-line (arch.). The theoretical horizontal line in arch construction at which the upward curve of the arch proper starts.

Stalactite work (orn.). Small vertical polygonal or curved niches rising and projecting in rows above one another so that they resemble stalactite formations.

Statuary bronze. Bronze that has been surfaced with an acid application causing its color to become a dark brown. A finish usually given to bronze statues.

Stela. A stone slab or pillar used commemoratively, as a gravestone, or to mark a site.

Stencil. The method of decorating or printing a design by brushing ink or dye through a cut-out pattern.

Sterling. A term used in connection with silverware, indicating that the silver is 92½ per cent pure.

Stile. The vertical strips of the frame of a panel. The horizontal strips are termed *rails*.

Still-life. Paintings or decorative renderings of inanimate, motionless objects.

Stipple. Process of applying paint or ink to a surface in dot form, by means of a coarse brush or spray.

Stock-dyeing. A term used in textile manufacturing to indicate that a fiber is dyed before being spun into a thread.

Stone-jointing. The shaping or cutting of stones for walls and arches so that they will properly join each other; for use in the construction of walls and arches.

Stoneware. A heavy, opaque, nonporous and nonabsorbent pottery made from a silicous paste.

Strapwork. A term applied to carved wooden arabesque and rinceau patterns in which the section of the stem of the scroll is flat, resembling a pattern cut from a sheet of leather.

Stretcher. A brace or support which horizontally connects the legs of pieces of furniture.

String course (arch.). A molding or projecting horizontal motif running along the face of a building.

Stucco. Plaster or cement used as a coating for walls.

Stud. A small post, usually 2 x 4 inches, and of any height, used to form the wall construction in wooden dwellings or partitions. The studs support the joists and receive the lath or sheet material used for the finish.

Stumpwork. A type of embroidered picture worked in silk threads over padding, giving a relief effect.

Stylobate. The stone blocks or steps forming the lowest architectural feature of a Greek temple and upon which the columns stand.

Sugi finish. A Japanese method for finishing woodwork. The surface is charred and then rubbed with a wire brush.

Summer beam. A large timber laid horizontally and used as a bearing beam. In Early American dwellings it was usually supported at one end by the masonry of the chimney and at the other end by a post, and it extended across the middle of the room. The name is derived from *sommier* (Fr.), meaning saddle or support.

Superimposed order. The placing of one order of architecture above another in an arcaded or colonnaded building; usually Doric on the first story, Ionic on the second, and Corinthian on the third. Found in the Greek stoas, used widely by the Romans, and later in the Renaissance.

Swag. Cloth draped in a looped garland effect; any imitation of same.

Swastika (fylfot or meander). A cross composed of four equal L-shaped arms placed at right angles. A good-luck symbol of ancient origin.

Symmetrical balance. Having the two halves of a design or composition exactly alike in mass and detail.

Tazza (It.). Large ornamental cup or footed salver.

Tempera. A paint composed of pigments that are soluble in water. Sometimes glue or the white of egg is also added to the solvent.

Tenon (carp.). A projection at the end of a piece of wood intended to fit into a hole (mortise) of corresponding shape on another piece of wood.

Terra cotta. A hard-baked pottery extensively used in the decorative arts and as a building material. It is usually made of a red-brown clay, but may be colored with paint or baked glaze.

Terrazzo. A concrete made of small pieces of crushed marble and cement. Used for surfacing floors and walls.

Tertiary color. A color that is formed by the combination of a primary and a secondary.

Tessera. A small cube of stone, glass, or marble, used in making mosaics.

Tester. Canopy framework over a four-poster bed.

Thimble foot. Same as spade or sabot foot.

Thrust (arch.). The outward force exerted by an arch or vault that must be counterbalanced by abutments.

Thuya wood. A rare African wood with rich graining, used for table tops and veneering of furniture.

Tie-beam. A horizontal beam which connects the rafters of a roof and prevents them from spreading. Used in truss construction to counteract the outward thrust of the slanting members.

Tilt-top. A table top that is attached to a hinge on a pedestal support so that the top may be swung to a vertical position.

Tinsel pictures. Decorative objects made from cut-out tinsel, paper, and pictures, mounted and pasted together.

Tint. A color made from a pigment that is mixed with white.

Toile-de-Jouy (Fr.). Cloth made in Jouy, France, particularly the printed cottons made by Oberkampf during the 18th and the 19th centuries.

Tole. Useful or decorative objects made of tin and ornamented with painted or enameled patterns.

Tonal value. One of the characteristics of a color. The relative

strength of a color in contrast to white or black.

Tongue-and-groove (carp.). A type of wood joint in which a long, narrow, straight projection, known as the tongue, fits into a corresponding groove in the adjacent piece.

Torus (arch.). A convex semicircular molding.

Trabeated construction (arch.). Construction in which the supporting members are the post and lintel, as distinct from arched construction.

Tracery. The stone mullions in a Gothic window.

Tracery pattern. A pattern in woodwork, textile, or other material imitating stone tracery.

Transept. In church architecture, that portion of the building that crosses the nave at right angles, near the apse or east end of the building.

Transitional. A style that shows evidence of two chronologically consecutive styles, possessing elements of both styles in its design.

Transom. The upper panel of a window or a window placed above a doorway.

Tree-of-life pattern. A pattern resembling a tree or vine, showing branches, leaves, flowers, and small animals. Originating in ancient Assyria, it was borrowed by the Persians, East Indians, and early English Renaissance designers. See also Hom and Palampores.

Trefoil. A three-lobed ornamentation resembling a clover.

Trencher. A large wooden platter upon which food is served.

Triclinium (Lat.). Dining room.

Triglyphs. Blocks with vertical channels which are spaced at intervals in the frieze of the Doric entablature.

Triptych. Any three-fold picture, in book-like form, usually of religious character.

Trumeau (Fr.). The decorative treatment of the space over a mantel, door, or window, consisting of a mirror and painting. Specifically, the overmantel panel treatment of the Louis XV and VXI periods.

Trumpet leg (cab.). A conical leg turned with flared end and shaped in the form of a trumpet.

Trundle bed. Child's or servant's bed on wheels, which was rolled under a full-sized bed when not in use. Of Gothic origin. Sometimes called "truckle-bed."

Truss. A support used for a wide span of roof or ceiling, consisting of beams or posts assembled in a triangular manner for greater strength.

Tudor arch. A flat, pointed arch characteristic of English Gothic and early Renaissance architecture and decoration.

Tudor rose. Decorative motif seen in English Renaissance work consisting of a conventionalized rose with five petals, with another smaller rose inside it. It was the royal emblem of England, symbolizing the marriage of Henry VII of Lancaster (red rose) to Elizabeth of York (white rose).

Turkey-work. A handmade textile imitating Oriental pile rugs, produced by pulling worsted yarns through a coarse cloth of open texture, then knotting and cutting them.

Turning (carp.). A type of ornamentation which is produced by rotating wood on a lathe and shaping it into various forms with cutting tools.

Turpentine. A resinous fluid used as a solvent and drying constituent in paint mixing.

Turret. A small tower superimposed on a larger structure.

Tuscan (Etruscan) order. A Roman variant of the Doric order of architecture. It is crude and heavy, and the standard proportion of the column is 7 diameters high.

Tympanum (arch.). The interior triangular surface of a pediment bounded by the sloping sides and the lower molding.

Underglaze (pot.). A term used to define a pattern that is applied to pottery before the final glazing is applied.

Unicorn. An imaginary animal often featured in the arts of the Middle Ages. The symbol of chastity.

Valance. A horizontal feature used as the heading of overdraperies and made of textile, wood, metal, or other material.

Value of a color. The relative amount of white or black in a color.

Vargueño (Sp.). A cabinet and desk with a drop-lid.

Vault. A roof constructed on the arch principle. A *barrel vault* is semicylindrical in shape. A *groin vault* is made by the intersection of two barrel vaults at right angles. In a *ribbed vault* the framework of arched ribs supports light masonry.

Velour-de-Gênes. Silk velvet. Made in Genoa and usually having a small all-over pattern.

Velvet carpet. A type of carpet closely resembling a Wilton, but without the wool backing and consequently without the wearing qualities of the Wilton.

Veneer. A thin sheet of finishing wood or other material that is applied to a body of coarser material.

Venetian blinds. Window shades made of small horizontal slats of wood strung together on tapes. The slats may be turned up or down to exclude or let in sunlight.

Venetian furniture. The name applied to the extravagantly curved and ornamented furniture of Baroque and rococo influence, produced in Italy during the late Renaissance.

Verdure Tapestry. A tapestry design showing trees and flowers.

Vernis Martin (Fr.). Literally, Martin's varnish, but used as a term to describe the lacquer work done by a cabinetmaker named Martin during the 18th century in France in imitation of Oriental lacquer.

Vignettes. Ornamental motifs, patterns, or portraits centered in a large field.

Volute (orn.). A spiral, scroll-like form, as in the Ionic and Corinthian capitals.

Voussoir (arch.) A wedge-shaped block used in the construction of a true arch. The central voussoir is called the keystone.

Wag-on-wall. A weight-driven clock with exposed weights and pendulum, intended to hang on the wall.

Wainscot. A wooden lining for interior walls. Usually panelled. Any treatment resembling same.

Wainscot chair. An early 17th century wooden chair used in England and America.

Warm color. Red and the hues that approach red, orange, yellow, yellow-green.

Warp. In weaving, the threads that run lengthwise on a loom.

Waterleaf (orn.). A conventionalized leaf pattern of classical origin used to enrich a cyma reversa molding.

Wave pattern (orn.). A continuous pattern conventionally imitating a series of breaking wave crests.

Webbing. Strips of woven burlap used as a support for springs in upholstery.

Weft or woof. In weaving, the threads that run crosswise from selvage to selvage and are woven in and out of the warp threads by means of a shuttle or bobbin. These are now more commonly called the filler threads.

Welting. Strips of material sewn between upholstery seams to give a finished appearance.

What-not. A set of ornamental shelves used to hold bric-a-brac and china.

White lead. A heavy white substance that does not dissolve in water and is used as a base in paints when mixed with linseed oil.

Wilton carpet. A carpet with cut woolen pile and a cotton back.

Woodcut. A design engraved upon a block of wood in such a way that all the wood is cut away to a slight depth except the lines forming the design. For use in printing papers and textiles.

Yarn-dyeing. A process of dyeing the yarns before they are woven into a textile. Such a textile is called yarn-dyed.

Yesería (Sp.). Small lacelike patterns of plaster relief which were colored and used extensively on the walls of Moorish rooms.

Yoke. A cross-bar in the form of two S-curves used for the top rail of chairbacks. Typical of Georgian furniture.

Yorkshire chair. A popular name for a type of Jacobean chair of provincial origin.

Index

Aalto, Alvar, 394, 395, 410, 495, 497

Accessories: American, 252, 268–69; brass, 627–28, 631–32; bronze, 98, 628; cameo, 99; cast iron, 626; chasing in, 633; Chinese, 284–87; clocks, 250–51; copper, 627–28, 631–32; daguerreotype, 269; Dinanderie, 632; English, 195, 201, 220; firebacks, 631; French, 170–71, 175, 177–78; hardware, 632–34; girandoles, 251; glassware (see Glassware); graphics, 364–68; Islamic, 295; Italian, 97–99; lead, 628; lithographs, 268–69; metalwork, 625–32; mirrors, 250; pewter, 629–30; Pompeian, 43–44; silhouettes, 269, 367; silver, 253–54, 628–29; steel, 627; wrought iron, 626–27 (see also periods and styles under national and cultural headings)

Acetate, 528

Acroteria, 170

Acrylic, 529

Activity planning, 646–48

Adam brothers, the (James and Robert), style of, 37, 103, 132, 167, 212, 215, 216, 219–20, 231, 251, 256, 546, 608, 624

Adam-Chippendale style, 219

Adam-Hepplewhite style, 219

Adler, Dankmar, 382

Aeschylus, 19

Aesthetic Movement, the, 546–47

Affleck, Thomas, 245

Afterimage, 445

Agateware, 608

Albers, Josef, 362

Alcazar, the (Toledo), 123

Alexander, 8, 10, 18, 47

Alexandria, 18

Alexandrian Age, the (Greek), 20

Alhambra, the (Granada), 114, 294

Alloys, 626

Alpujarra rugs, 501

America: accessories, 262–56, 268–69; architects (list), 272; architecture, 232–34, 240–44, 262–66, 390–93; cabinet makers (list), 272–73; ceramics, 611–12; clock manufac-

America (cont.):
turers (list), 273; clocks, 251–52; firebacks, 631; furniture, 236–40, 247–48, 256–60, 264–68, 408, 409, 410–12; glassware, 274, 619–21; graphics, 364–68; interiors, 234–36, 240–44, 248–50, 254–56, 262–67, 270; metalwork, 625–26; painters (list), 273; painting, 355–63; pewter, 629; potters (list), 273; silversmiths (list), 274; silverware, 253–54, 628–29, 631; textiles, 253, 548–49; wallpaper, 253, 508

American periods and styles: "American Eagle," 259–60; "American Empire," 263; Early, 231–40; Eclectic, 232, 270–71; Federal, 231, 254–61; Georgian, 231, 240–47; Greek Revival, 231, 262–64; Pennsylvania German, 248–50; Shaker, 261–62; Victorian, 231–32, 264–69, 278

Amorini, 37

Amphora vase, 30

Analogous colors, 449

Analysis of Beauty, The (Hogarth), 338

Ancient Kingdom, the (Egyptian), 9

Anthemion molding, 27, 37

Antimacassars, 267

Antiquing, 519–20, 521

Antiquities of Athens (Stuart and Revett), 215

Antony, Marc, 10

Apollo Temple, the, 20

Appliqué, 122

Aquatints, 220, 365

Arca, 128

Arcaded panel, 197

Arch: Florentine, 88; horseshoe (Moorish), 115–16; Gothic, 65–66; multifoil (Moorish) 116; pointed (Coptic), 295; pointed (Gothic), 65–66; pointed (Moorish), 116, 294; Romanesque, 58–59

Archea, John, 667

Archigram, 396–97

Architects (lists): American, 272; English, 223–24; French, 181–82; Hispanic, 136–37; Italian, 104–5

Architectural structure and decoration: amorini, 37; anthemion molding, 27, 37; apse, 50; arch (see Arch); architrave, 24; artesonado woodwork, 118; atrium, 39; baldachino, 91–92; basilica, 33, 59; bead molding, 26, 37; boiserie, 152; buttress, 47, 65; cabinets particuliers, 156; Caen stone, 157; cartouche, 88; caryatid, 27, 89; cavetto molding, 11, 24; clapboard wall, 234; clerestory window, 59, 64; column, 23–25, 34–36, 87, 116, 124; Composite order, 34–36; concrete, 34, 384–85; corbel, 193; Corinthian order, 23, 24, 34–36; cornice, 24, 89; cove, 151; cyma recta molding, 24; cyma reversa molding, 26; dentil molding, 37; dome, 33; Doric order, 23, 24, 34–36; echinus, 24; egg and dart molding, 25, 37; entablature, 23, 86; entasis, 24; estrada, 121; exedra, 42; fascia molding, 25; fillet molding, 25; fireplace, 71, 88–89; fluting, 21; fret molding, 37; fret scroll, 27; frieze, 24; gadrooning, 148; gazebo, 202; geometrical patterning, 27, 59, 116–17, 118, 120, 295–97; girders, 234; grotesques, 36; guilloche, 14; half timber, 193; honeysuckle molding, 24; horseshoe arch, 115–16; intarsia, 87; Ionic order, 23, 34–36; iron construction, 380, 382; limestone, 22–23, 37; lintel, 22; machiolated galleries, 146; marble, 22–23; meander scroll, 27; medallion, 88; Metabolist theory of, 396–97; module, Vitruvian, 35–36; mosaics, 40–42, 50–52; mullions, 65; multifoil arch, 116; murrine, 43; nave, 59; niche, 89, 116, 118; orders, 23–25, 34–36; oriel, 193; ovolo molding, 25; palisade wall, 234; Palladian, 198–99; palmette, 6, 14, 27; patio, 115; pedestal, 24, 86; pendentive, 49, 52; pilaster, 35, 86, 87, 89; pointed arch, 66, 116, 294, 295; porphyry, 50; proportions in, 34–